Blade Runner, Matrix und Avatare

Parfen Laszig

(Hrsg.)

Blade Runner, Matrix und Avatare

Psychoanalytische Betrachtungen virtueller Wesen
und Welten im Film

Mit 85 farbigen Abbildungen

 Springer

Dr. Parfen Laszig (Hrsg.)
Heidelberg, Germany

ISBN 978-3-642-25624-0 ISBN 978-3-642-25625-7 (ebook)
DOI 10.1007/978-3-642-25625-7

Die Deutsche Nationalbibliothek verzeichnet diese Publikation in der Deutschen Nationalbibliografie;
detaillierte bibliografische Daten sind im Internet über http://dnb.d-nb.de abrufbar.

Springer Medizin

Planung: Renate Scheddin, Heidelberg
Projektmanagement: Renate Schulz, Heidelberg
Lektorat: Dr. Brigitte Dahmen-Roscher, Hamburg
Projektkoordination: Heidemarie Wolter, Heidelberg
Layout, Satz und Umschlaggestaltung: deblik Berlin
Fotonachweis Umschlag: siehe Quellenverzeichnis im Anhang
Herstellung: deblik Berlin

Gedruckt auf säurefreiem und chlorfrei gebleichtem Papier

Springer Medizin ist Teil der Fachverlagsgruppe Springer Science+Business Media
www.springer.com

Geleitwort

Kai Wessel, Regisseur

Filmemacher und Drehbuchautoren sind Geschichtenerzähler. Wir sind die modernen Märchenerzähler mit der Ambition, die Zuschauer zu verführen und zu entführen. Wir versetzen sie in fremde oder bekannte Welten, zurück in die Geschichte oder weit in die nahe oder ferne Zukunft. Das gelingt uns manchmal besser und manchmal schlechter; aber wo und wann auch immer unsere Geschichten spielen mögen, im Zentrum stehen Menschen: „gute" Menschen, „schlechte" Menschen, Menschen, die sich beweisen, bewähren oder behaupten müssen. Selten sind sie allein. Sie stehen meist in einem sozialen Zusammenhang aus Feinden, Freunden, Betrügern, Partnern, Geliebten, Familienmitgliedern und ähnlichen Gemeinschaften. Je feiner eine Geschichte gestrickt ist, desto vielschichtiger sind die Figuren, deren Motive und Handlungen, desto dynamischer sind die Prozesse, in denen unsere handelnden Personen sich befinden. Je genauer die Erzähler eines Films die menschlichen Gefühlsprozesse kennen, desto tiefgreifender wird der Film. Genaue Kenntnis und Reflektion menschlichen Denkens und Handelns sind Voraussetzungen für eine bewegende Geschichte. Dieses Buch beleuchtet die Geschichten und deren handelnde Personen von einer „anderen" Seite. Sie sehen nicht nur die Phänomene menschlichen Handelns, sie kennen sie genau. Die Autoren sind mehrheitlich Psychoanalytiker und „entschleiern" die psychodynamischen Prozesse, in denen wir Menschen uns befinden. In diesem Buch übertragen die Autoren ihr Wissen und ihre Erfahrungen auf eine Auswahl von bedeutenden Filmen. Sie beleuchten Motive, Zwänge, innere Prozesse, konzentrieren sich auf die immer komplexer werdenden Abläufe in einer sich entwickelnden Welt und wagen damit gleichsam einen Ausblick in unsere nahe und ferne Zukunft. Dieser Ansatz ist spannend und allemal lesenswert!

Kai Wessel
Hamburg, im Mai 2012

Geleitwort

Georg Seeßlen, Filmkritiker

Leinwand und Seelenspiegel – Anmerkungen zu einem möglichen Dialog
zwischen Filmkritik und Psychoanalyse

I

Was wäre, wenn der Mensch keine Seele hätte? Unter anderem könnte er wohl nicht ins Kino
gehen. Das mag ein trivialer Satz sein oder ein furchtbarer, wie man es nimmt. Genauer gesagt
entspricht der Film, jenseits seiner technischen Realisierbarkeit, einem bestimmten Zustand
der Entwicklung von Seele und Subjekt. Es gibt Erzählungen von Angehörigen von „Naturvöl-
kern", die verstört reagiert haben sollen, als sie zum ersten Mal einen Film sahen: Warum hat
man dem armen Mann dort oben den Kopf abgeschnitten? Eine andere Erzählung der Kino-
geschichte geht an deren Anfänge zurück: Damals sollen die ersten Zuschauer schreiend aus
dem Kino gelaufen sein, weil sie einen Zug auf sich zukommen sahen. Nähere Untersuchun-
gen legen indes nahe: Die beiden Erzählungen sind nicht nur erfunden (im Fall der Gebrüder
Lumière und ihres „Einfahrt des Zugs"-Films sogar als geschickter Werbecoup), sie enthalten
auch implizit eine Kino-Theorie: Filmesehen ist eine Kulturtechnik, die man erwerben, wie
man lesen und schreiben lernen muss. Und zwei Dinge sind dabei vonnöten: Die Fähigkeit,
zwischen dem Bild und der Wirklichkeit zu unterscheiden, und die Fähigkeit, von einem Teil
aufs Ganze zu schließen.

Offensichtlich stimmt das nicht so recht. Es ist zumindest ungenau. Kino-Sehen lernt man
beim Kino-Sehen, und man lernt es erstaunlich rasch. Die meisten Kinder in unserem Kultur-
kreis wachsen ins Filme-Sehen (mittlerweile natürlich hauptsächlich am Fernseher und am
Computer) scheinbar problemlos hinein; Eltern und andere Erwachsene agieren hier allenfalls
gelegentlich als Zensoren, kaum aber als Lehrer. Und auch wenn es in der Regel in einem mehr
oder weniger familiären Kollektiv geschieht, lernt man dieses Filme-Sehen „ganz für sich". Als
Subjekt. Als psychische Entität, gleichsam.

Es gibt so gut wie keinen Menschen in unserer Kultur, der ohne das projizierte elektroni-
sche oder digitale Bewegungsbild aufwächst. Es ist Teil der Welt-Wahrnehmung und zugleich
Teil der sich entwickelnden Persönlichkeit. (Schon von daher ist es verständlich, dass in späte-
ren Stadien Mahner auf den Plan treten, die die Mitschuld dieser Bewegungsbilder an „Fehlent-
wicklungen" der Persönlichkeit, an Gewalt und Ängstlichkeit, Verrohung oder Gleichgültigkeit
anprangern. Wer behauptet: Die Medien haben an allem Schuld!, behauptet in Wahrheit: Das
bewegte Massen-Bild hat an allem Schuld! oder eben: das Kinematografische.

Das Kinematografische ist eine besondere Art mit Bilder umzugehen, nach Prinzipien, die
wir aus der Film-Analyse kennen: Die Montage. Die „Einstellung" (der Kamera). Die „Con-
tinuity" (die relative Stabilität des Hintergrunds). Das Zeichenrepertoire (Syntagmen und
Paradigmen, Indiz, Ikon, Symbol etc. – in wechselnden Bestimmungen, aber in einer Grund-
haltung: Dinge können auf verschiedene Weise „bedeuten"; eine Bedeutung kann sich hinter
einer anderen verbergen – aus Gründen der äußeren wie der inneren Zensur, aber auch aus
Gründen der Spannung). Die Rahmung und Dimensionierung. Die dreifache Bewegung: Die
Bewegung im Bild. Die Bewegung des Bildes (die Bewegung der Kamera). Und die Bewegung
zwischen den Bildern (der Schnitt).

Das Kinematografische, das es offensichtlich lange vor dem eigentlichen Kino gibt und parallel dazu in anderen Bild-Erzählungen (zum Beispiel im Medium des Comic-Strip, das sich parallel zum Kino entwickelte und immer wieder mit ihm interagierte), ist eine besondere Sprache der Bilder, aber auch eine besondere Sprache von Emotionen, Beziehungen und Entscheidungen. Es ist ein Teil unserer Katastrophengeschichte, nebenbei bemerkt, dass wir besonders heftige, schmerzhafte oder auch beglückende Erlebnisse besonders kinematografisch („wie im Kino", „wie ein Film") wahrnehmen, nämlich einerseits in einer bestimmten Sprache der Bilder (in der zum Beispiel die Zeit-Wahrnehmung nicht mehr unbedingt mit der „objektiven" Zeit übereinstimmt und Räume eher symbolisch als geometrisch wahrgenommen werden) und andererseits in einer gewissen „Äußerlichkeit", so als wäre eine Wahrnehmung, die uns auf ungeheuer drastische Art überfällt und zugleich emotional oder kognitiv überfordert, nur zu ertragen, indem sie bis zu einem gewissen Grad nicht mehr als Teil des eigenen Lebens, sondern als äußere Projektion empfunden wird. Das Kinematografische ist demnach eine Organisation der Bilder, die weder vollständig äußerlich noch vollständig innerlich sind, zugleich Teil der Innen- und der Außenwelt. Und noch etwas gehört zum Wahrnehmen der Welt (oder ihrer Reflexion im Bild) auf kinematografische Weise: Es gibt eine Institution des „anderen", die die Form vorgibt (der Projektor, das Programm), und es gibt ein Element der Verzögerung zwischen dem Bild und seiner Verarbeitung (eben das, was wir dann vergleichsweise hilflos „den Film verstehen" nennen; es setzt sich zusammen aus dem Verstehen der Worte (des Bildes), der Sätze (der Sequenzen) und des Textes (gemeint sind plot, Motiv und Stil).

Kinematografische Wahrnehmung enthält (benutzen wir dazu Vilém Flussers Unterscheidung) stets lineare und visuelle Codes, mit anderen Worten: Kinematografische Wahrnehmung ist abhängig davon, dass verschiedene Instanzen, zum Beispiel Bewusstsein und Unterbewusstsein oder Analyse und Synthese, ja sogar Neugier und Beharrung, zusammen arbeiten und dass aus Teilen ein Gesamtes geformt wird, umgekehrt aber auch ein Gesamtes in Teile zerlegt wird. Man sieht niemals einen Film so, wie man einen Satz liest, sondern man sieht den imaginären Gesamt-Film, den die Teile des Montage/Einstellungs-Angebots suggerieren. Die letzte Produktion eines Films, so geht das geflügelte Wort, findet im Kopf des Zuschauers statt. Daher ist es unmöglich, dass zwei Menschen den gleichen Film sehen (was übrigens schon daran zu sehen ist, wie unterschiedlich sie ihn nacherzählen).

Der Film, die technische und soziale Verwirklichung des Kinematografischen (das wir in den Träumen so gut wie in der Literatur, in Kinderspielen und in der Oper finden können, wenn auch nicht immer als vorherrschendes Prinzip) ist also weder vollständig Teil der Außenwelt noch vollständig Teil der Innenwelt. Das kinematografische Geschehen spielt sich vielmehr auf einer Linie zwischen beidem ab, auf der es sich mal dem einen, mal dem anderen annähern kann. Und, unnütz zu sagen, es gibt sowohl bei den Produzenten als auch bei den Konsumenten Tricks genug, diese Bewegung zwischen Innen und Außen („Traum und Wirklichkeit" meint eine laienhafte Empfindung) zu manipulieren. (Unter anderem lieben wir gelegentlich „schlechte Filme" – oder „Trash" – weil in ihnen die Äußerlichkeit gesichert ist, und wirklich große Filme, die tief in unser Inneres reichen, sind nicht unentwegt auszuhalten – es sei denn, man schaltet die Distanzierungsmaschine „Kritik" ein – wie überhaupt Filmkritiker vielleicht nur einerseits Menschen sind, die ihre Leidenschaft zum Beruf gemacht haben, und andrerseits Menschen, die eine besondere Methode der Kinematografisierung noch des Films selbst entwickelten; eine Form der Bannung.)

Das Kinematografische ist schlicht ein Element im Werden des modernen Menschen (und ganz gewiss dürfen wir Platon als ersten Filmtheoretiker in den Zeugenstand rufen; sein „Höhlengleichnis" ist wohl das Urbild aller Film-Modelle und enthält zugleich bereits

die umfassendste Film-Kritik). Umgekehrt kann man vielleicht von einer Zäsur in der Bilder-
ebenso wie in der Seelengeschichte sprechen: Vor dem Kino war die Seele etwas anderes als
mit und dann schließlich nach dem Kino, und dies gilt für die Kulturgeschichte ebenso wie für
die Biografie (Nachbeben dieser ikonopsychischen Wandlung sind Fernsehen und Internet als
neue bildgebende Begleiter des Lebens).

Das Kinematografische und seine Wandlungen sind anthropologische Wirkkräfte. Um
Mensch zu werden in einer Menschen-Gesellschaft, muss man die Fähigkeit besitzen, zu „ki-
nematografisieren" (man mag sich darüber streiten, ob diese Fähigkeit zur dritten Möglichkeit
des Bildes zwischen Innen und Außen als angeborene entwickelt wurde oder doch als Etappe
in einer Kulturgeschichte erschien). Wir leben also in gemeinsamen Kinematografisierungs-
kulturen ebenso wie in gemeinsamen Sprach- und in gemeinsamen Bilderkulturen. (Span-
nend wird die Sache, weil die drei nie vollständig synchron verlaufen, eine der anderen als
Motor ebenso wie als Bremse dienen kann.) Mit dieser Anthropologie des Bewegungsbildes
freilich ist noch so gut wie nichts darüber ausgesagt, was das Bewegungsbild in unserem Inne-
ren an- und ausrichtet. In unserer Seele mithin.

II

Nehmen wir als „Seele" ein einigermaßen kompliziertes Ineinander von Systemen der Wahr-
nehmung, der Kombination, der Reflexion, der Projektion und der Entscheidung. Dann ist ein
Film, auch wenn er gegenüber dem Leben doch erhebliche Vereinfachungen vornimmt, eine
Einladung zu nicht viel weniger komplizierten Vorgängen der Übertragung. Unter anderem
übertrage ich in einem Kino dem Geschehen auf der Leinwand für eine begrenzte Zeit die
Führung meines Innenlebens. ICH bin im Film, und der Film ist in mir. Die „normale" Ord-
nung meines inneren Hauses ist für etwa zwei Stunden außer Kraft gesetzt; ich habe höchst
eigenwillige Gäste. Ich, Es und Über-Ich, wie wir diese Ordnung nach Freud allgemein be-
zeichnen, sind jeweils verdoppelt. Mindestens.

Der Unterschied zwischen dem Kino (und was daraus geworden ist) und früheren Formen
von Erzählung, Drama, Bild, Ritus und Spiel ist auf den ersten Blick nur in seiner Totalität zu
sehen, im Grad der Absorption, in der Fähigkeit, andere Impulse der Welt „auszublenden",
Konzentration zu erzeugen. Auf den zweiten Blick wird die „Sprache" des Films als eine be-
sondere Beziehung von Zeichen und Bewegung deutlich; Filme, sagt man, „schreiben sich
in uns ein" (und natürlich: Eine Reihe von ihnen scheitert an dieser Aufgabe oder nimmt sie
gar nicht erst an). Auf den dritten Blick erkennen wir etwas durchaus Skandalöses, nämlich,
dass sich das filmische Geschehen auf eine durchaus virale Art in unseren seelischen Aufbau
drängt (der Film befällt den staunenden Zuschauer gleichsam wie eine Art Infektionskrank-
heit, setzt aber auch, so schreibt es der gesellschaftliche Gebrauch des Mediums vor, Prozesse
von Heilung und Selbstheilung in Gang). Das heißt: Während der Film läuft (jedenfalls jener,
der mich wahrhaft erreicht und mehr ist als ein medial-sozial-ideologisches Hintergrund-
rauschen) bin ich nicht nur nicht Herr in meiner Seelenarchitektur, diese muss sich auch
noch Umbauprozesse, womöglich Chaotisierung oder auch Reduzierung gefallen lassen. Der
Film löst Teile meiner „ordentlichen" Seele auf und setzt eigene seelische Ordnungen an ihre
Stelle. Und wir wissen: Dies kann auf eine menschliche, demokratische, zärtliche, vernünftige
oder heilsame Art ebenso geschehen wie auf eine gewalttätige, heimtückische, korrupte oder
tyrannische Weise. (Deshalb bedeutet „Filmkritik" stets so viel mehr als eine Betrachtung
technisch-ästhetischer Perfektion oder Mangelhaftigkeit oder ideologisch-moralisches Maß-
nehmen: Sie ist der nie vollständig gelingende Versuch, zugleich das Innenleben des Films

und das des Zuschauers sowie die gesellschaftlichen Bedingungen dieser Korrelation in einen Diskurs zu bringen.)

Wer ist der Mensch auf der Leinwand (oder auch das Pixelwesen mit den anthropomorphen Eigenschaften)? Es ist zunächst ein eigenständiges Wesen, das seine eigene Geschichte, seine eigenen Empfindungen, seine eigenen Entscheidungen etc. vorführt. Es tut dies in einer Zeit, die zwischen Gegenwart und Vergangenheit flickert (der Moment ist immer gerade eben vorbei); und es tut dies in einer Gewissheit des linearen Existierens – an dem, rabiat, der surrealistische Film und weniger rabiat das postmoderne Kino mit seinen „nicht-linearen" Erzählweisen zweifelt, einer räumlichen und zeitlichen Abschließbarkeit. Es tut dies überdies im Allgemeinen in einer Gleichung von „history = story", das heißt die Geschichte der Helden oder Protagonisten ist auf die eine oder andere Weise eine Abbildung der Geschichte von Nationen, Gesellschaften, Klassen, „Lebensumständen" etc. Als Held ist der Mensch auf der Leinwand entweder ein Problemlöser oder aber, häufiger fast noch, ein „Erlöser", der unter anderem für meine Sünden (oder jedenfalls meine Schwächen) kämpft und leidet. Helden sind die ersten Seelenspiegel für eine Zeit, eine Gesellschaft oder auch für den einzelnen Zuschauer: Der Held drückt das Problem aus, welches den Zuschauer niederdrückt. Ebenso nimmt er die Strafe auf sich, die dieser als auf sich bezogen wähnen mag. (In trotzigem Furor gegen solche Mechanismen formulierte einst Theodor W. Adorno, dass Donald Duck auf der Leinwand die Prügel bezog, an die sich das Publikum im Zuschauerraum als Alltag gewöhnen sollte. Vielleicht achtete er zu wenig darauf, wie ambivalent auch unser Lachen im Kino sein kann, denn, after all, natürlich gönnten wir Donald ein wenig Missgeschick, weil er ja immer wieder allzu großspurig, egoistisch und anmaßend auftrat, aber zugleich liebten wir ihn ja auch, den ewig Scheiternden.) Als Held also erzählt das Wesen auf der Leinwand seine eigene symbolische Geschichte, und dabei folgt es, mehr oder weniger, den Modellen der Erzählung, der Heldenreise, der Abfolge von Entzweiung – Opfer – Erlösung, den Erscheinungen von Rätsel, Orakel, fantastischem Begleiter, die wir aus den Narrativen der Zeiten und Kulturen kennen. Odysseus, der John Wayne-Cowboy, Marilyn Monroes Reisen in „Some Like it Hot", das macht da keinen großen Unterschied.

Auch die zweite Funktion des Menschen auf der Leinwand ist ohne Weiteres von anderen Formen der Repräsentation, Theater, Literatur und Spiel, zu übernehmen: Dieser Mensch auf der Leinwand ist auch ICH. Im einfachsten Fall der Mensch, der ich gerne wäre, so stark wie Superman oder so schön wie Julie Delpy. Wenn wir freilich die Bild- und Sozialgeschichte der Filmstars betrachten, stellen wir fest, dass es so einfach wohl nicht ist. Weder wird der Schönste oder Stärkste automatisch zum Star, noch ist seine „Aussage" so eindeutig, dass wir von einem Vorbild oder Vor-Bild sprechen könnten. Im Gegenteil, die meisten Stars bezeichnen besondere Transitionen, Ambivalenzen, Widersprüche. Der Inbegriff des „Stars" enthält also nicht nur, was mein Ich, sondern auch, was mein Es verlangen mag (jemand, der sein Begehren erfüllt, auch und gerade jenes, das „verboten" scheint), und das, was mein Über-Ich verlangt (nicht nur in der patriarchalisch-bürgerlichen Form, sondern auch in der des dämonischen Tricksters).

Damit sind wir bei der dritten Funktion des Wesens auf der Leinwand: Es ist, natürlich, das Objekt des Begehrens. Meine „Projektion" sagt also nicht nur, ich will sie oder er sein, sondern auch, ich will sie oder ihn haben. Aus dieser Differenz mag ein gesamtes Analyserepertoire von Geschlechterbestimmung und Geschlechterrollen entwickelt werden. So wie einst das Theater, so definiert in seiner klassischen Form das Spielfilm-Kino nicht nur, was guter Bürger oder böser Fremder ist, sondern auch, was Mann und was Frau ist. Aber von Anbeginn an, also keineswegs erst, nachdem sich die gesellschaftlichen Regeln und der Mainstream-

Geschmack diesbezüglich änderten, steckte darin eine subversive, mehrdeutige Macht. Ein männlicher Zuschauer mag beim Betrachten von „Some like it Hot" nicht nur Marilyn Monroe begehren (oder sich, via Tony Curtis, von ihr begehren lassen), er mag auch ausprobieren, wie es wäre, wenn man, via Marilyn Monroe, eine Frau sein könnte.

Und wie wäre es, wenn dieser Mensch auf der Leinwand, vierte Funktion, nicht nur Objekt der Verschmelzung und „Identifikation", nicht nur Objekt des sozialen und sexuellen Begehrens (crossover, wie das nun geschehen mag, wenn ich mir selbst beim Zuschauen nicht allzu kritisch zuschaue) wäre, sondern auch ein autonomes Gegenüber, ein DU? Ein anderes Wesen, mit dem ich auf Augenhöhe, wie man so sagt, korrespondiere, mit ihm eine imaginäre Zwiesprache halte, einen Dialog führe, Rat und Kritik austausche. Es gibt Filmemacher, wie Ingmar Bergman einer war, die es gerade auf eine solche dialogische Beziehung abgesehen haben. Filmisch ist sie, natürlich, durch die Form der Einstellungen zu erzeugen, durch die Unabgeschlossenheit der Erzählung, durch die Imagination für den Zuschauer, einen Raum mit den Menschen auf der Leinwand zu teilen, ihnen näher zu sein als selbst die Kamera, in den Dargestellten so viel Frage wie Antwort zuzulassen etc..

Das ist nicht zuletzt eine Frage der Schauspielkunst und des Schauspielstils. Und damit gelangt man zu einer weiteren Identität des Wesens auf der Leinwand. Es ist immer auch der Darsteller (bzw., nehmen wir einen digitalen Animationsfilm, sind es reale Vor-Bilder des „Darstellers" oder aber die Technik der Darstellung selber, ein Knetmassentier, das seine Knetmassenhaftigkeit ausdrückt), der mehr oder weniger durch den Dargestellten durchschimmert. So werden wir Teilhaber eines Prozesses des reenactment, das magisch, technisch oder auch therapeutisch sein kann. John Wayne spielt den harten John Wayne auf der Leinwand, um das Leiden der Person John Wayne zu lindern, die im wirklichen Leben kein harter John Wayne sein konnte. Oder: Lauren Bacall erzählte von Humphrey Bogart, dass er im wirklichen Leben nur in wenigen Augenblicken unerträglich sein konnte, nämlich dann, wenn er sich selbst mit Humphrey Bogart verwechselte.

All das veranschaulicht nur von den Rändern her, wie sehr wir im Kino (oder eben auch: im Kinematografischen) Teil magischer, therapeutischer und sozialer Übertragungsprozesse sind, die, noch einmal, das Wesen auf der Leinwand zu wesentlich mehr machen als einem Stand-In für Figuren einer kohärenten Narration. (Eine weitere Randerscheinung liegt in der regelmäßig wiederkehrenden Erzählung von Menschen, bei denen diese Beziehung zu einer gefährlichen Krankheit wird; selbst Filme wie „The Fan" oder „Die schönen Morde des Eric Binford" erzählen von solchen Störungen der ansonsten gesellschaftlich mehr oder weniger kontrollierten Psychodramen der Mediennutzung.)

Übrigens ist es eine Standardantwort von Filmemacherinnen und Filmemachern, Schauspielern und Schauspielerinnen auf die Frage, warum sie (solch seltsame) Filme machen: weil Filmemachen besser ist, als verrückt zu werden, Selbstmord zu begehen oder Menschen umzubringen. Lassen wir das Maß an Koketterie in solchen Antworten auf (törichte) Reporterfragen dahingestellt sein, so ist doch klar genug, dass wir, alle Beteiligten einer „Filmkultur" (und sei es die Filmkultur der krudesten Zombiestreifen auf der Teenager-Kellerparty), auf die eine oder andere Art wissen, dass das Kinematografische sich um Symptome von Krankheiten, um therapeutische Selbstversuche und um ein Spiel von Offenbaren und Verbergen psychischer und psychosozialer Verletzungen entwickelt.

III

Auch dies wiederum, nämlich, dass Kino nichts anderes bedeutet, als individuelle und kollektive Therapie vermittels einer besonderen Form von Übertragungen, Projektionen, Symbolen, Wunscherfüllungen, Management überschießender Energien von Angst und Begehren mit einer mehr oder weniger perfekten formalen und sozial akzeptierten Hülle zu umgeben, kann man als triviale oder als furchtbare Aussage werten.

Dass Kino dem Träumen verwandt ist, dass vieles von seinem Geschehen, je nachdem, ins Unterbewusste oder ins Unbewusste reicht, dass Kino-Erzählungen, ebenso wie mit Modellen von „Bild", „Erzählung", „Roman", „Theater" etc., mit Modellen wie „Mythos", „Ritual", „Neurose", „Psychose" etc. erklärt werden können, hat sich jedenfalls herumgesprochen (in einem Hase- und Igel-Wettlauf zwischen Filmproduktion und gesellschaftlichem, wissenschaftlichen oder pädagogischen Diskurs, möglicherweise).

Jean-Luc Godard hat das Problem gelöst (oder wenigstens genau beschrieben), indem er den Film den „rêve extérieur" nannte, den äußeren oder auch veräußerten Traum.

Damit schließt sich ein Kreis unseres Modells von Kinematografie als Austausch von Elementen innerer und äußerer Bilder, der stets zugleich soziale Probleme (in Form des Mythos, so wie ihn Roland Barthes in „Mythen des Alltags" verstand) und psychische Konflikte (Kränkung, Versagung, Bindung/Befreiung, Obsession, Neurose, Psychose, Verdrängung) be- und verhandelt.

Die wahre Kunst des Films indes besteht darin, über die Erfüllung dieses psychosozialen Auftrags hinaus zu gehen, die Probleme, Konflikte und Widersprüche nicht nur wiederzugeben, sondern auf einer anderen Ebene bewusst zu machen. Und die wahre Kunst der Kritik besteht darin, über den Nachweis der psychosozialen Grundierung des Kinematografischen im Allgemeinen und von einzelnen Filmen im Besonderen hinaus zu gehen, um den Dialog zwischen dem Kinematografischen und dem Psychoanalytischen (im weitesten Sinn) bewusst und gesellschaftlich fruchtbar zu machen. Eben davon handeln die Beiträge dieses Buches.

Georg Seeßlen
Kaufbeuren und Borgo di Vendone, im Juni 2012

Vorwort des Herausgebers

Der Film eröffnet den Zuschauern eine andere Form der Wirklichkeit, und nicht von ungefähr ist die besondere Nähe zwischen Film, Traum und Psychoanalyse vielfach und facettenreich beschrieben worden.

In Europa fand die erste öffentliche Filmvorführung am 1. November 1895 im Berliner „Wintergarten" durch die Brüder Max und Emil Skladanowsky statt. Nur einige Monate zuvor, im Juli 1895, gelang es Sigmund Freud, zum ersten Mal einen eigenen Traum zu analysieren. Durch die Analyse von „Irmas Injektion" gewann er eine der wichtigsten Grundlagen für seine Traumdeutung: die Erkenntnis, dass jeder Traum eine wunscherfüllende Funktion hat. Fortan entfalteten die Psychoanalyse und die „Wunschmaschine Kino" ihr revolutionäres Potenzial. Weltweit begannen Künstler, sich mit den beiden neuartigen „Techniken" auseinanderzusetzen und sie in ihr Schaffen zu integrieren.

Durch die Filmtechnik tauchen wir in eine künstliche Welt, die Walter Benjamin das „Optisch-Unbewusste" nennt. Das Unbewusste ist zeitlos. Erfahrungen aus unserer Vergangenheit halten Einzug ins Bewusste und ins Unbewusste. Sie werden dort gewissermaßen individuell gespeichert: Manche Erlebnisse werden verdrängt, manche können nur mühsam erinnert werden, andere bleiben zugänglich – erfahren aber auch Veränderung, weil auch wir uns verändern.

Wir alle erinnern uns wahrscheinlich an unseren allerersten Kinobesuch: an die Menschen, die uns begleitet haben, den großen Saal, die Sessel, den Vorhang, die Leinwand und vielleicht ja auch an das erwartungsvolle Eintauchen in die Welt der Bilder, der Musik, der Stimmungen; an einen Zustand des Versunkenseins und das eigenartige Gefühl beim Verlassen des Kinos, nach eineinhalb Stunden innerer Reise. Der erste Film, den ich in einem Kino sah, war Walt Disneys Verfilmung von Rudyard Kiplings „Dschungelbuch". An der Seite meines Vaters und meines kleinen Bruders erkundete ich mit dem Jungen Mogli, dem Panther Baghira und dem Bären Balu den indischen Dschungel, tanzte und sang mit Affenkönig Louie, salutierte vor Elefantencolonel Hathi, kämpfte mit dem mächtigen Tiger Shir Khan, ließ mich von den gelb-hungrigen Augen der Schlange Kaa hypnotisieren und dem Lächeln des Mädchens Shanti verzaubern. Kiplings Erzählung aus dem Jahr 1894 las ich erst danach, und auch später (ver-)führte mich der eine oder andere Film zum Lesen der ursprünglichen Romanvorlage. Wie die Weltliteratur erforscht die Psychoanalyse das unbewusste Seelenleben. Seit den Anfängen der Psychoanalyse steht sie mit den Künsten in dynamischer Wechselwirkung. Die Kinematografie, als die sogenannte neue, siebte Kunst, vereint Bild, Sprache und Musik und verändert damit deren Einzelwirkung.

Glen O. Gabbard, der „amerikanische Psychiater und Lehrstuhlinhaber der Brown Foundation für Psychoanalyse, vermerkt in seinem 2001 erschienenen Buch „Psychoanalysis and Film", dass seit den 1950er-Jahren die psychoanalytische Betrachtung der Filmkunst als wissenschaftlich fruchtbar erachtet wird.

So werden psychoanalytische Filmbesprechungen nicht nur in Fachzeitschriften wie „PSYCHE", „International Journal of Psychoanalysis" oder „Psychoanalyse im Widerspruch" publiziert, sondern haben auch in verschiedensten Filmzeitschriften („Cahiers du Cinéma" in Frankreich, „Screen" in England, „Camera Obscura" und „Discourse" in den USA) ihren festen Platz. Der Psychoanalytiker und ehemalige Filmkritiker Andrea Sabbadini betonte die Wichtigkeit des interdisziplinären Austauschs und gründete das „European Psychoanalytic Film Festival" (EPFF), das seit 2001 in zweijährigen Abständen in London stattfindet. Vor

allem im deutschsprachigen Raum hat sich in den letzten Jahren der Dialog zwischen Psycho-
analyse und Kino zunehmend entwickelt. Inzwischen werden in vielen Städten in Deutsch-
land, Österreich und der Schweiz regelmäßig Filmvorstellungen veranstaltet, bei denen aus-
gewählte Spielfilme von Psychoanalytikern und Psychoanalytikerinnen kommentiert und mit
dem anwesenden Publikum diskutiert werden. Wie es Gerhard Schneider filmpsychoanaly-
tisch ausgeführt hat, können Filme als Oberflächenphänomene gesellschaftlich vor- und un-
bewusster soziokultureller Befindlichkeiten und Veränderungsprozesse verstanden werden.

Auf der Welt gibt es nichts, was sich nicht verändert. Wir leben – wie es der Soziologe und
Philosoph Zygmunt Bauman bezeichnet – in der „flüchtigen Moderne". In den vergangenen
Jahrzehnten haben technische Fortschritte, leistungsstarke Microchips und rasante Entwick-
lungen im Internet das menschliche Leben bis in die persönlichsten Bereiche verändert und
auch die Produktion von Filmen revolutioniert.

Das mediale Bild ist scheinbar lebendiger und wirklicher geworden als die unmittelbare
körperliche Präsenz selbst. Verglichen mit der „realen Realität" sind die „Virtualität" und der
damit verbundene mediale Raum vermeintlich unbegrenzt.

Auf der Grundlage dieser kulturpsychoanalytischen Überlegungen entstand die Idee zum
vorliegenden Buch.

Als Herausgeber hatte ich eine Liste mit ausgewählten Filmen zum Thema „Virtuelle Wel-
ten und Wesen im Film" erstellt. Als Stichworte bzw. Themenkomplexe dienten: die Welt als
Konstrukt, die Sehnsucht nach einer besseren, perfekteren Welt, albtraumhafte Visionen,
grundlegender Zweifel an der Welt, künstliche Welten, Parallelwelten, Übergangsmotive,
künstliche Wesen, künstliche Intelligenz, Wunschmedien, das Medium als Erweiterung des
menschlichen Körpers, Immersion, Eintauchen in virtuelle Welten, virtueller Sex, Befriedigung
von Allmachtsfantasien, Kontrolle versus. Erinnerung, Identität und Identitätsdiffusion etc.

Diese Themen stießen bei den angesprochenen Kolleginnen und Kollegen auf große Reso-
nanz. Ich bat um eine persönliche Filmauswahl oder um einen entsprechenden Filmvorschlag
und um Reflexion des Stoffs unter psychodynamischen Gesichtspunkten. Die einzelnen Filme
wurden auf unterschiedlichste Weise „behandelt".

Die ausgewählten Filme umfassen einen Zeitraum von vierzig Jahren und spiegeln somit
auch ein kleines Stück unserer Zeitgeschichte wieder. Den Auftakt bildet *Soljaris*, die Verfil-
mung des Romans von Stanislaw Lem durch Andrei Tarkowski aus dem Jahr 1972, gefolgt
von Rainer Werner Fassbinders visionärem TV-Zweiteiler *Welt am Draht* und *Westworld* von
Regisseur, Drehbuch- und Bestsellerautor Michael Crichton, beide aus dem Jahre 1973. Dann
folgt ein Sprung in die 80er-Jahre mit den Filmen *Der gekaufte Tod*, *Blade Runner*, *Videodro-
me*, *Brazil* und *Purple Rose of Cairo*. In den 90er-Jahren entstanden *Total Recall*, *Bis ans Ende
der Welt*, *Ghost in the Shell*, *Strange Days*, *Gattaca*, *Virtual Nightmare – Open your Eyes*, *Dark
City*, *Die Truman Show*, *Pleasantville*, *Matrix*, *The 13th Floor* und *eXistenZ*. Den Übergang
zum Millennium bilden *The Cell* und – der im deutschsprachigen Raum weitgehend unbe-
kannte – *Thomas est amoureux*, gefolgt von *A.I.*, *Vanilla Sky*, *Minority Report*, *Inland Empire*,
A Scanner Darkly, *Avatar* und *Surrogates – Mein zweites Ich*. Den vorläufigen Schlussakkord
bildet *Inception*, der siebte Spielfilm des amerikanisch-britischen Regisseurs, Produzenten
und Drehbuchautors Christopher Nolan aus dem Jahr 2010.

Die in diesem Band versammelten Kinofilme sind so unterschiedlich wie ihre geistigen
Schöpfer und subjektiven Betrachter. Die Filme wurden unter anderem daraufhin untersucht,
wie sie sich mit Fragen um unsere veränderte Identität beschäftigen, welche Bilder und Fan-
tasien sie im Spannungsfeld zwischen Realität und Virtualität, zwischen Künstlichkeit und
Natürlichkeit produzieren und welche Gefühle dabei im Gegenüber entstehen.

Mein besonderer Dank gilt „meinen" cinephilen Autorinnen und Autoren, die sich mit großem Engagement, analytischem Auge und „drittem Ohr" den Filmen widmeten. Die kollegiale Zusammenarbeit und der lebendige Austausch haben mich auf den verschiedensten Ebenen bewegt, zum Nach- und Weiterdenken angeregt und auch in Zeiten hoher Arbeitsintensität dem Projekt Leichtigkeit verliehen.

Ebenso herzlich bedanken möchte ich mich beim Team des Springer-Verlags, angefangen bei Frau Regine Karcher-Reiners, die mich zur Verlagspublikation ermutigte und das Projekt in die Wege leitete, bei Frau Renate Scheddin für das erfrischende, konturierende Planungsgespräch und die überaus kompetente, redaktionelle Leitung, bei Frau Renate Schulz für ihr umsichtiges Projektmanagement, bei Frau Heidemarie Wolter für die abschließende Projektkoordination und im Besonderen bei Frau Brigitte Dahmen-Roscher für das hervorragende Lektorat und die freundliche Geduld, die sie allen nachträglichen Korrektur- und Änderungswünschen entgegenbrachte.

Last not least möchte ich Kristin „Ting" Köhler, Anja Guck-Nigrelli, Kathy Rieg, Loubna Bouharrour, Heike Peters und Andreas Renzel danken. Sie standen mir auch bei diesem Projekt mit Rat und Tat beiseite und sorgten für die mitunter notwendige Verortung in der Realität.

Parfen Laszig
Heidelberg, im Juni 2012

Inhaltsverzeichnis

Autorenverzeichnis

Adamson, William, Dr.
Zentrum für Sprachen und Philologie,
Universität Ulm
Oberer Eselsberg, 89069 Ulm
william.adamson@uni-ulm.de

Banholzer, Bernd, Dr.
Otto-Beck-Str. 50, 68165 Mannheim
dr.banholzer@gmx.de

Bliersbach, Gerhard
Burgstr. 31a, 41836 Hückelhoven
GerhardBliersbach@t-online.de

Blothner, Dirk, Prof. Dr.
Zülpicher Str. 83, 50937 Köln
blothner@images-wanted.de

Böhme, Isolde, Dr.
Händelstraße 28, 50674 Köln
isolde-boehme@t-online.de

Boothe, Brigitte, Prof. Dr.
Universität Zürich, Psychologisches Institut
Binzmühlestr. 14/16, CH-8050 Zürich
b.boothe@psychologie.uzh.ch

Danckwardt, Joachim F., Dr.
Im Buckenloh 2, 72070 Tübingen
JFDanckwardt@t-online.de

Däuker, Helmut, Dr.
Werderstr. 36, 68165 Mannheim
H.Daeuker@t-online.de

Decker, Oliver, PD Dr.
Universität Siegen, Fakultät II,
Department für Pädagogik und Psychologie
Adolf-Reichwein-Str. 2, 57068 Siegen
decker@psychologie.uni-siegen.de

Emrich, Hinderk M., Prof. Dr. Dr.
Medizinische Hochschule Hannover,
Zentrum für Seelische Gesundheit,
Klinik für Psychiatrie, Sozialpsychiatrie
und Psychotherapie
Carl-Neuberg-Str. 1, 30625 Hannover
Emrich.hinderk@mh-hannover.de

Ettl, Thomas, Dr.
Schadowstr. 15, 60596 Frankfurt/M
ettlth@web.de

Fäh, Markus, Dr.
Postfach, Theaterstr. 4, CH-8024 Zürich
info@markusfaeh.com

Frenzel Ganz, Yvonne K.
Kreuzbühlstr. 1, CH-8008 Zürich
frenzel@psypraxis.ch

Grammatikov, Lily, Dr.
Neuer Friedhofsweg 5,
69151 Neckargemünd
Lily.Gramatikov@web.de

Hamburger, Andreas, Prof. Dr.
International Psychoanalytic
University Berlin
Nußbaumstr. 10, 80634 München
AHamburger@t-online.de

Hirsch, Mathias, Dr.
Simrockstr. 22, 40235 Düsseldorf
mathias.hirsch@t-online.de

Jacke, Andreas, Dr.
Schloßstr. 33, 14059 Berlin
a.jacke@gmx.de

Janus, Ludwig, Dr.
Jahnstr. 46, 69221 Dossenheim
janus.ludwig@gmail.com

Janus, Ulrich, Dr.
Planckstr. 17, 70184 Stuttgart
ulrichjanus@gmail.com

Lamott, Franziska, Prof. Dr.
Abt. Psychosomatische Medizin
und Psychotherapie, Universität Ulm
Am Hochsträß 8, 89081 Ulm
F.Lamott@t-online.de

Laszig, Parfen, Dr.
Hauptstr. 29, 69117 Heidelberg
kontakt@parfen-laszig.de

Piegler, Theo, Dr.
BKB, Haus C, 1. OG,
Glindersweg 80, 21029 Hamburg
theo@piegler.de

Rauchfleisch, Udo, Prof. Dr.
Delsbergerallee 65, CH-4053 Basel
Udo.Rauchfleisch@unibas.ch

Reffert, Rainer, Dr.
Schöpflinstr. 5, 68165 Mannheim
Dr.R.Reffert@t-online.de

Riepe, Manfred
Töplitzstr. 10, 60596 Frankfurt
mriepe6341@aol.com

Ruhs, August, Prof. Dr.
Univ.-Klinik für Psychoanalyse
und Psychotherapie
Währinger Gürtel 18–20, A-1090 Wien
august_ruhs@yahoo.de

Georg Seeßlen
Unter dem Berg 23, 87600 Kaufbeuren
georg.seesslen@gmx.de

Springer, Alfred, Prof. Dr.
Salztorgasse 6/5/8, A-1010 Wien
alfred.springer@meduniwien.ac.at

Wessel, Kai
Schlüterstr. 63, 20146 Hamburg
kai-wessel@hamburg.de

te Wildt, Bert T., PD Dr.
Klinik für Psychosomatische Medizin und
Psychotherapie, LWL-Universitätsklinikum
Bochum der Ruhr-Universität Bochum
Alexandrinenstraße 1–3, 44791 Bochum
bert.te_wildt@ruhr-uni-bochum.de

Wohlrab, Lutz, Dr.
Langhansstr. 64a, 13086 Berlin
info@wohlrab-verlag.de

Wollnik, Sabine, Dr.
Franzstr. 21, 50931 Köln
Wollnik-Krusche@t-online.de

Zahn, Manuel, Dr.
Universität Hamburg, Fak. IV,
FB Erziehungswissenschaft,
Ästhetische Bildung und Bildungstheorie
Von-Melle-Park 8, 20146 Hamburg
manuel.zahn@uni-hamburg.de

Zimmermann, Thomas, Dr.
Institut für Allgemeinmedizin,
Zentrum für Psychosoziale Medizin,
Universitätsklinikum Hamburg-Eppendorf
Martinistr. 52, W37, 20246 Hamburg
t.zimmermann@uke.de

Zwiebel, Ralf, Prof. Dr.
Lopikerstr. 7, 34393 Grebenstein
rzwiebel@web.de

Über die Autoren

Dr. phil. William Adamson

Studium der Anglistik und Germanistik, Promotion zum Thema „Stolz und Wahnsinn" im Romanwerk Tobias Smolletts. Mehrere Jahre Vorsitzender der Raymond-Chandler-Gesellschaft Deutschland e. V. und Herausgeber des Chandler-Jahrbuchs. Leiter des Fachbereichs Englisch am Zentrum für Sprachen und Philologie der Universität Ulm, Co-Leiter des Fachbereichs „Vergleichende Kulturwissenschaften". Leitet seit ca. 20 Jahren eine englische Theatergruppe an der Universität Ulm.

Dr. med. Bernd Banholzer

Niedergelassener Facharzt für Psychosomatische Medizin und Psychotherapie, Psychoanalyse, tiefenpsychologisch fundierte Psychotherapie, Verhaltenstherapie. Psychoanalytische Weiterbildung am C. G. Jung-Institut Stuttgart. Beschäftigung mit dem Film als Mittel für Lehre und Therapie seit Mitte der 90er-Jahre. Seit ca. 10 Jahren Referententätigkeit für die Reihe „Psychoanalyse und Film" in Heidelberg. Initiierung und Leitung einer Arbeitsgruppe zum Thema „Der Film als therapeutisches Medium in der tiefenpsychologisch fundierten Psychotherapie" von 2007–2009.

Gerhard Bliersbach

Dipl.-Psych., Psychologischer Psychotherapeut, Autor. Veröffentlichungen u. a.: „So grün war die Heide … Der deutsche Nachkriegsfilm in neuer Sicht" (1985, 1989); „Schön, daß Sie hier sind! – Die heimlichen Botschaften der TV-Unterhaltung" (1990); „Leben in Patchwork-Familien. Halbschwestern, Stiefväter und wer sonst noch dazu gehört" (2000, 2007); „Der Einzug in die Finsternis. Roman Polanskis ‚Der Mieter' und der Abscheu vor dem Fenster zum Hof" In: „Projektion und Wirklichkeit. Die unbewusste Botschaft des Films" (2007).

Prof. Dr. phil. Dirk Blothner

Seit 1994 selbständig als Film- und Fernsehwirkungsforscher und als Berater von Produktionsfirmen tätig. Praktizierender Psychoanalytiker und Professor für Psychologie an der Universität zu Köln. Habilitation mit einer empirischen, tiefenpsychologischen Untersuchung zum Thema „Glücksgefühl". Veröffentlichungen u. a.: „Erlebniswelt Kino – Über die unbewusste Wirkung des Films", „Das geheime Drehbuch des Lebens – Der Film als Spiegel der menschlichen Seele" und (mit Marc Conrad) „Invasion! TV-Weltmuster erobern den Fernsehmarkt" (2008). Herausgeber der Zeitschrift *anders* (www.zeitschrift-anders.de) und seit 2010 (zusammen mit Wilhelm Salber) der *Zeitschrift für Psychologische Morphologie*.

Dr. med. Isolde Böhme

Psychoanalytikerin und Gruppenanalytikerin in eigener Praxis in Köln, Lehr- und Kontrollanalytikerin der DPV/IPA. Veröffentlichungen zu einer Reihe von Filmen, zur Foto- und Videokunst Shirin Neshats und zu Samuel Becketts „Geistertrio".

Prof. Dr. phil. Brigitte Boothe

Psychoanalytikerin DPG, DGPT, Psychotherapeutin FSP. Ordinaria für Klinische Psychologie an der Universität Zürich, Lehrstuhl für Klinische Psychologie, Psychotherapie und Psychoanalyse. Aktuelle Forschungsschwerpunkte: Klinische Narrativik und qualitative Methoden; Literatur- und Textanalyse; Lebensrückblick- und Interviewforschung; Kooperations-, Vertrauensbildung und Kreditierung. Aktuelle Publikationen u. a.: „Das Narrativ: Biografisches Erzählen im psychotherapeutischen Prozess" (2011), „Erzählen im medizinischen und psychotherapeutischen Diskurs" (2009).

Dr. phil. Helmut Däuker

Dipl.-Psych., Psychoanalytiker in eigener Praxis in Mannheim. Dozent am Institut für Psychoanalyse und Psychotherapie Heidelberg/Mannheim. Zahlreiche Publikationen; Buchveröffentlichung: „Bausteine einer Theorie des Schmerzes: Psychoanalyse, Neurobiologie, Philosophie" (2002).

Dr. med. Joachim F. Danckwardt

Ausbildung in Choreographie, Medizin, Psychiatrie, Psychotherapie und Psychoanalyse. Wolfgang Loch-Preisträger 2010. Zahlreiche Veröffentlichungen zu den Fachgebieten. Ästhetische und Ergo-biografische Studien zu Paul Klee, Gerhard Richter, Neo Rauch sowie zu zahlreichen Filmen; u. a.: „Was könnten Dritte-Reich-Verfilmungen bewirken?" (2010). danckwardt.homepage.t-online.de.

PD Dr. phil. Oliver Decker

Studium der Psychologie, Soziologie und Philosophie an der Freien Universität Berlin, Dipl.-Psych. 2003 Promotion zum Doktor der Philosophie mit der Schrift „Der Prothesengott", 2010 Habilitation an der Leibniz Universität Hannover. Seit 2010 Vertretungsprofessor für Sozialpsychologie an der Universität Siegen. Er ist Herausgeber der Zeitschrift *Psychoanalyse – Texte zur Sozialforschung* und Mitherausgeber der Zeitschrift *Psychotherapie & Sozialwissenschaften*. Unter seiner Leitung entstanden die „Mitte"-Studien zum Rechtsextremismus. Aktuelle Publikation: „Der Warenkörper – Zur Sozialpsychologie der Medizin" (2011), die englischsprachige Veröffentlichung ist in Vorbereitung.

Prof. Dr. med. Dr. phil. Hinderk M. Emrich

Psychoanalytiker (DGAP), Nervenarzt und Arzt für klinische Pharmako-
logie, emer. Ordinarius für Psychiatrie an der Medizinischen Hochschule
Hannover, Hochschullehrer für Philosophie an der Leibniz-Universität
Hannover, Gastprofessor an der Kunsthochschule für Medien Köln
(1995–2005); Lehraufträge Deutsche Film und Fernseh-Akademie Berlin
(DFFB) und Hochschule für Film und Fernsehen Potsdam (HFF) sowie
Muthesius-Kunsthochschule Kiel.

Dr. phil. Thomas Ettl

Dipl. Psych., psychoanalytische Ausbildung am Sigmund-Freud-Institut
Frankfurt/M, in eigener Praxis niedergelassen. Mehrere Jahre Lehrbe-
auftragter am Institut für Sonder- und Heilpädagogik der Universität
Frankfurt/M. Zehn Jahre Mitherausgeber der *Zeitschrift für psychoana-
lytische Theorie und Praxis*. Aufsätze und Vorträge zu Psychoanalyse und
Kunst, Literatur, Pädagogik und Essstörungen. Buchveröffentlichungen:
„Das bulimische Syndrom" (2001), „Geschönte Körper – geschmähte
Leiber. Psychoanalyse des Schönheitskultes" (2006). Homepage:
www.thomas-ettl.de.

Dr. phil. Markus Fäh

Psychoanalytiker SGPSa/IPA in eigener Praxis in Zürich. Lehraufträge
und Ausbildnertätigkeit an der Sigmund-Freud-Privatuniversität in
Wien sowie am Freud-Institut Zürich, am Psychoanalytischen Seminar
Innsbruck und an verschiedenen psychoanalytischen Instituten in
Moskau, St. Petersburg, Ekaterinburg und Minsk. Mitbegründer des
psychoanalytischen Kinoprojekts „Cinépassion" in Zürich. Autor
verschiedener Bücher und zahlreicher Artikel. Mitherausgeber von
Cinépassion – eine psychoanalytische Filmrevue (2010).
www.markusfaeh.com.

Yvonne Frenzel Ganz

Yvonne Frenzel Ganz, lic.phil., Dipl.-Päd., Psychoanalytikerin SGPsa/IPA
in eigener Praxis in Zürich. Dozentin am Freud-Institut Zürich. Initiantin
des Projekts „Cinépassion" in Zürich (www.cinepassion.ch). Publikation
u. a.: Yvonne Frenzel Ganz, Markus Fäh (Hrsg.) *Cinépassion – eine
psychoanalytische Filmrevue* (2010). Mitherausgeberin einer Übersetzung
der Schriften Michel de M'Uzans, die 2013 erscheint. Derzeit mit
Kollegen Entwicklung eines Internet-Blogs zur Psychoanalyse.

Dr. sc. hum. Lily Gramatikov

Psychologische Psychotherapeutin, Psychoanalytikerin (DGPT),
Dozentin am Institut für Psychoanalyse und Psychotherapie Heidelberg-
Mannheim e. V. Promotion im Fach Medizinische Psychologie
Universität Heidelberg. 1994–1999 wissenschaftliche Mitarbeiterin an
der Psychosomatischen Klinik der Universität Heidelberg. Seit 2000 in
eigener Praxis niedergelassen. Schwerpunktthemen: Transsexualität,
Migration, Gender.

Prof. Dr. phil. Andreas Hamburger

Germanist und Dipl.-Psych., Professor für Klinische Psychologie an der International Psychoanalytic University Berlin, Privatdozent für Psychoanalytische Psychologie an der Universität Kassel, Psychoanalytiker (DPG), Lehranalytiker und Supervisor (DGPT) in München. Forschungs- und Publikationsgebiete: Traum- und Sprachentwicklung, Literatur- und Filmpsychoanalyse, narrativ-szenische Mikroanalyse und Supervisionsforschung. Mitglied der Münchener Arbeitsgruppe „Film und Psychoanalyse" (www.ipu-berlin.de, www.pramataroff.de).

Dr. med. Mathias Hirsch

Niedergelassener Facharzt für Psychiatrie und Facharzt für psychotherapeutische Medizin, Psychoanalytiker (DGPT, affiliiertes Mitglied DPV), Gruppenanalytiker. Ehrenmitglied des Psychoanalytischen Seminars Vorarlberg (Zweig des Psychoanalytischen Arbeitskreises Innsbruck), Lehrbeauftragter der Universität Hamburg, Institut für Psychotherapie. Zahlreiche Veröffentlichungen, z. B.: „Die Gruppe als Container – Mentalisierung und Symbolisierung in der analytischen Gruppenpsychotherapie" (2008); „Liebe auf Abwegen – Spielarten der Liebe im Kino aus psychoanalytischer Sicht" (2008).

Dr. phil. Andreas Jacke

Freiberuflich tätig als Filmwissenschaftler, Regisseur u. Darsteller im Film. Studium der Philosophie u. der Filmwissenschaften an der FU-Berlin. Zahlreiche Veröffentlichungen mit psychoanalytischem Hintergrund: „Marilyn Monroe und die Psychoanalyse" (2005), „Stanley Kubrick – Eine Deutung der Konzepte seiner Filme" (2009), „Roman Polanski – Traumatische Seelenlandschaften" (2010), „David Bowie – Station to Station" (2011). In Planung sind eine psychoanalytische Filmtheorie mit Walter Benjamin und eine größere Studie über Lars von Trier und Jacques Derrida.

Dr. med. Ludwig Janus

Psychoanalytiker und Psychotherapeut in eigener Praxis, Dozent und Lehranalytiker in der psychoanalytischen und tiefenpsychologischen Weiterbildung in Heidelberg. Er ist Mitglied verschiedener Fachgesellschaften, unter anderem der DPG, DGPT, ISPPM und der DGPPF. Zahlreiche Veröffentlichungen zur Pränatalen Psychologie und zur Psychohistorie. www.ludwig-janus.de

Ulrich Janus

PhD, promovierte in Mathematik an der University of Warwick, Coventry, UK. Er war im pädagogischen Bereich als Lehrer und ehrenamtlich in Vereinen (Dilettanten e. V., Waldritter e. V.) tätig. Derzeit arbeitet er in der Produktentwicklung einer Lebensversicherung in Stuttgart.

Prof. Dr. rer.soc. Franziska Lamott

Studium der Soziologie und Psychologie. Mehrjährige Tätigkeit am Institut für Strafrecht & Kriminologie der Universität München. Gruppenanalytikerin. Venia legendi für Sozialpsychologie. Seit 1999 an der Sektion Forensische Psychotherapie der Universität Ulm, dort mehrjähriges Filmseminar zum Thema „Psycho, Sex and Crime". Dokumentarfilm „Tödliche Beziehungen" (ARTE 2005, mit Michael Appel). Forschungsprojekte und Publikationen in den Bereichen Kriminologie, Psychotherapie- und Genderforschung, Gruppen- und Kulturanalyse.

Dr. sc. hum. Parfen Laszig

Dipl.-Psych., Psychologischer Psychotherapeut, Psychoanalytiker (DGPT), Supervisor und Lehrtherapeut. 1993 – 2004 wissenschaftlicher Mitarbeiter an der Psychosomatischen Klinik, Abteilung Psychosomatik des Universitätsklinikums Heidelberg. Seit 2005 niedergelassen in eigener Praxis. Supervisions-, Lehr- und Forschungstätigkeiten an verschiedenen Kliniken und Instituten; Leitender Redakteur der Zeitschrift *Psychoanalyse im Widerspruch* und Redaktionsmitglied der Zeitschrift *Psychotherapeut*. Zahlreiche Veröffentlichungen, u. a. Parfen Laszig, Gerhard Schneider (Hrsg.) „Film und Psychoanalyse – Kinofilme als kulturelle Symptome" (2008). www.psychoanalytische-ressourcen.de

Dr. med Theo Piegler

Niedergelassener Facharzt für Psychotherapeutische Medizin, Psychiatrie und Psychotherapie sowie Nervenheilkunde. Langjährig in leitender Funktion in der Psychiatrie tätig; Dozent, Supervisor und Lehrtherapeut am Hamburger psychotherapeutisch/psychoanalytischen Fort- und Weiterbildungsinstitut APH. Vorträge und Publikationen zu Themen der psychodynamischen Psychiatrie, Psychotherapie sowie zu „Psychoanalyse und Film".

Prof. emer. Dr. rer. nat. Udo Rauchfleisch

Dipl.-Psych., Studium der Psychologie an den Universitäten Kiel und Lubumbashi/Kongo. Promotion 1970, Habilitation 1978 an der Universität Basel. (Venia: Klinische Psychologie). Psychoanalytische Ausbildung am Institut für Psychoanalyse und Psychotherapie in Freiburg i. Br. (DPG, DGPT). Klinischer Psychologe 1966–1970 LKH Schleswig, 1970–1999 Psychiatrische Universitätspoliklinik Basel. Seit 1999 Psychotherapeut in privater Praxis für Kinder, Jugendliche und Erwachsene. Zahlreiche Publikationen zur psychoanalytischen Theorie und Praxis. www.udorauchfleisch.ch

Dr. med. Rainer Reffert

Facharzt für Psychotherapeutische Medizin, Psychoanalytiker, seit 1990 in eigener Praxis niedergelassen. Spezialisierung in Traumatherapie, zertifizierter EMDR-Therapeut. Tätig in der Ausbildung von Psycho-analytikern und Psychotherapeuten (Tiefenpsychologie), Lehranalytiker (DGPT). Arbeits- und Interessengebiete: Psychoanalyse und Film (Veröffentlichungen über die Filme „Alien", „Blade Runner" und „Die Klavierspielerin"), Psychoanalyse und Musik, Psychotraumatologie.

Manfred Riepe

Studium der Germanistik und der Theater- Film- und Fernseh-wissenschaft in Frankfurt/M, arbeitet als freier Journalist, Autor und Filmkritiker, u. a. für epd Film. Veröffentlichungen zur Problematik medialer Gewalt sowie zu psychoanalytischen Themen, u. a. in der Psyche, der Zeitschrift für psychoanalytische Theorie und Praxis sowie im Riss. Lehraufträge an der Universität Basel, Monografien zu David Cronenberg (2002) und Pedro Almodóvar (2004).

Prof. Dr.med. August Ruhs

Facharzt für Psychiatrie und Neurologie, Psychoanalytiker (IPV), Gruppenpsychoanalytiker, Psychodramalehrtherapeut. Stellv. Leiter der Univ.-Klinik für Psychoanalyse und Psychotherapie der Medizinuni-versität Wien. Vorsitzender des „Wiener Arbeitskreises für Psycho-analyse" und der „Tiefenpsychologisch-psychoanalytischen Dachgesell-schaft". Mitbegründer und Vorsitzender der „Neuen Wiener Gruppe/Lacan-Schule", Mitherausgeber der Zeitschrift *texte. psychoanalyse. ästhetik. kulturkritik.* Zahlreiche Veröffentlichungen, u. a.: „Der Vorhang des Parrhasios. Schriften zur Kulturtheorie der Psychoanalyse" (2003), „Unbewusstes Inszenieren. Symptom-Werk-Leben" (2007), „Lacan. Eine Einführung in die strukturale Psychoanalyse" (2010).

Georg Seeßlen

Studium der Malerei und Kunstgeschichte in München. Freier Autor für Zeitungen, Zeitschriften und Rundfunk, Lehraufträge für Filmanalyse und populäre Kultur. Letzte Veröffentlichungen: „Tintin und wie er die Welt sah", „Träumen Androiden von elektronischen Orgasmen?", „Blödmaschinen", „Wir Untote", „Kapitalismus als Spektakel" (die letzten drei zusammen mit Markus Metz). Lebt in Kaufbeuren und Borgo (SV).

Prof. Dr. med. Alfred Springer

Facharzt für Psychiatrie und Neurologie; Univ. Prof.; Habilitation in
Psychiatrie und Psychotherapie. Psychotherapeut, Psychoanalytiker.
Mitglied in der Wiener Psychoanalytischen Gesellschaft. Mitglied des
Lehrkörpers der Medizinischen Universität Wien, der Sigmund Freud
Universität Wien und der Fachhochschule Campus. Zahlreiche
wissenschaftliche Arbeiten und Publikationen, u. a. aus den Bereichen
Psychoanalyse, Kultur-/Sozialgeschichte, Jugendkultur und Populär-
kultur Arbeiten zum Thema Film: sowohl Publikationen zu einzelnen
Filmen („The Wall", „Des Blut eines Dichters", „Requiem für einen
Traum", „Chappaqua") wie auch zu filmischen Genres generell
(Drogenkino; Horror).

PD Dr. med. Bert Theodor te Wildt

Facharzt für Psychiatrie und Psychotherapie. Als Oberarzt der Klinik
für Psychosomatische Medizin und Psychotherapie des LWL-Universi-
tätsklinikums Bochum leitet er die Mediensprechstunde für Menschen
mit Internet- und Computerspielabhängigkeit. Habilitation 2009 mit
der Arbeit „Medialität und Verbundenheit – Zur psychopathologischen
Phänomenologie und Nosologie von Internetabhängigkeit". Seit 2010
1. Vorsitzender des von ihm mitbegründeten Fachverbands Medien-
abhängigkeit. www.lwl-uk-bochum.de

Kai Wessel

Der vielfach preisgekrönte Regisseur Kai Wessel arbeitete nach Schule
und Ausbildung zunächst als Standfotograf und Regieassistent. Nebenbei
produzierte und inszenierte er seine ersten Kurzfilme. Seinen Durch-
bruch hatte er mit „Martha Jellneck", der 1988 für den Bundesfilmpreis
nominiert war. Zu seinen bekanntesten Fernsehinszenierungen zählen
„die Flucht" (2006), die mehrteilige Verfilmung der Tagebücher des
jüdischen Literaturprofessors Victor Klemperer „Klemperer – ein Leben
in Deutschland" (1999), „Hat er Arbeit" (2000) sowie „Goebbels und
Geduldig" (2001). Seine bekannten Arbeiten für das Kino sind: „Hilde"
(2009), „Das Jahr der ersten Küsse" (2000) und „Martha Jellneck" (1988).

Dr. med. Lutz Wohlrab

Facharzt für Neurologie und Psychiatrie, Facharzt für Psychotherapeu-
tische Medizin, Psychoanalytiker in eigener Praxis in Berlin. Dozent an
der Berliner Akademie für Psychotherapie. Daneben ist er auch künst-
lerisch tätig und betreibt einen Verlag (wohlrab-verlag.de). 2002–2009
Initiator und Moderator der Berliner Reihe Film & Psychoanalyse im
BrotfabrikKino. Publikationen u. a.: „Filme auf der Couch, Psychoanaly-
tische Interpretationen" (2006), „Zur Darstellung von Psychoanalytikern
im Kino" (2005) und „Lemming von Dominik Moll" (2007) in *Psycho-
analyse im Widerspruch*.

Dr. med. Sabine Wollnik

FÄ für Psychiatrie sowie FÄ für Psychosomatische Medizin und Psychotherapie, Gruppenanalytikerin und Psychoanalytikerin (DPV), Lehrtherapeutin am Köln-Düsseldorfer Institut (DPV), niedergelassen in eigener Praxis. Arbeitsschwerpunkte: Relationale Psychoanalyse, Film und Psychoanalyse. Im Jahr 2008 Herausgeberin von *Zwischenwelten* und 2010 Mitherausgeberin von „Trauma im Film".

Dr. phil. Manuel Zahn M. A.

Studium der Philosophie, Erziehungswissenschaft und Psychologie an der Universität Hamburg, 2011 Promotion am Fachbereich Erziehungswissenschaft mit einer Arbeit zur Filmbildung. Seit 2011 Wissenschaftlicher Mitarbeiter im Arbeitsbereich Medienpädagogik und Ästhetische Bildung des Fachbereichs Erziehungswissenschaft der Universität Hamburg. Freier Filmvermittler zwischen Kunst, Kino und Schule und Autor des weblogs „Film-Bildung" (http://blogs.epb.uni-hamburg.de/zahn). Gründungsmitglied der „Hamburger Forschungsgruppe für Psychoanalyse" (HaFPa) und der Assoziation „Psychoanalyse und Film".

Dr. sc. hum. Thomas Zimmermann

Dipl.-Psych., Studium der Psychologie in Heidelberg. Wissenschaftlicher Mitarbeiter am Institut für Allgemeinmedizin, Universitätsklinikum Hamburg-Eppendorf. Aktuelle Arbeitsfelder: Selbstmanagementförderung in der hausärztlichen Versorgung, das Gesundheitssystem und dessen Versorgungsstrukturen sowie metaanalytische Übersichtsverfahren und andere quantitative Auswertungsmethoden. Publikationen zu Themen wie der Kommunikation zwischen Mensch und Maschine oder der von der Maschine vermittelten Kommunikation zwischen Menschen (v. a. in *Psychologie Heute*). http://www.zettmann.de.

Prof. Dr. med. Ralf Zwiebel

Psychoanalytiker (DPV, IPA), Lehranalytiker der DPV, Vorsitzender des Alexander Mitscherlich Institutes Kassel, ehemals Professor für Psychoanalytische Psychologie der Universität Kassel. Arbeitsschwerpunkte: Klinische Theorie, Filmpsychoanalyse, Psychoanalyse und Buddhismus. Letzte Veröffentlichungen: „Der Schlaf des Analytikers", 3. Auflage (2010); zusammen mit G. Weisched: „Neurose und Erleuchtung" (2009); „Von der Angst Psychoanalytiker zu sein" (2007).

Andreas Hamburger

Wo Es war, soll Ich werden

Soljaris – Regie: Andrej Tarkowskij

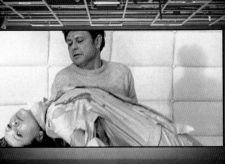

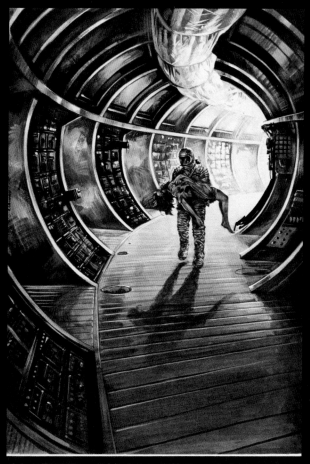

LA RISPOSTA DELLA CINEMATOGRAFIA SOVIETICA A
"2001 : ODISSEA NELLO SPAZIO"

SOLARIS

UNA PRODUZIONE "MOSFILM"

**NATALIA BONDARCIUK • DONATAS BANIONIS • JURIJ JARVET
VLADISLAV DVORZHETSKIJ • NIKOLAJ GRINKO • ANATOLIJ SOLONITSYN** IN SOLARIS

TRATTO DALL'OMONIMO ROMANZO DI FANTASCIENZA DI STANISLAW LEM – EDITO IN ITALIA DALLA EDITRICE NORD-MILANO

REGIA : **ANDREJ TARKOVSKIJ** TECHNICOLOR

Filmplakat *Solaris* **(Italien)**
Quelle: Cinetext/RR

Soljaris

Regie: Andrej Tarkowskij

„Der Mensch ist sozusagen eine Art Prothesengott geworden, recht großartig, wenn
er alle seine Hilfsorgane anlegt, aber sie sind nicht mit ihm verwachsen und machen ihm
gelegentlich noch viel zu schaffen."

Sigmund Freud, *Das Unbehagen in der Kultur* (1930)

Die Handlung

Der Plot von *Soljaris* (◨ Abb. 1) wäre schnell erzählt: Der Psychologe Kris Kelvin (Donatas Banionis)
verabschiedet sich von seinem alten Vater, weil er auf die Forschungsstation beim Planeten Solaris reisen
muss, von der nur noch wirre Nachrichten eintreffen. Ein Freund des Vaters, der Exkosmonaut Berton
(Vladislav Dvorzhetsky), beschwört ihn, die Forschungsmission nicht abzubrechen, da Solaris ein uner-
hörtes Geheimnis berge: Er könne aus seiner Lava menschliche Gestalten reproduzieren. Auf der Station
trifft Kelvin eine verwirrte und paranoide Crew, und er sieht fremdartige Personen. Plötzlich ist auch
seine durch Suizid verstorbene Frau Hari (Natalya Bondarchuk) wieder bei ihm. Kelvin versteht schnell,
dass sie eine materialisierte Ausgeburt des Planeten ist, und schießt sie mit einer Rakete in den Weltraum.
In der nächsten Nacht ist sie wieder da, und Kelvin begreift, dass die „Gäste" in der Station Ausgeburten
der eigenen Schuldgefühle sind. Der immer wieder scheiternde Versuch, sich dieser Fantasiegestalten zu
entledigen, treibt die Astronauten Dr. Snaut (Jüri Järvet) und Dr. Sartorius (Anatoli Solonizyn) zur Ver-
zweiflung – wie schon zuvor den dritten, Dr. Gibarian (Sos Sargsyan), der sich kurz vor Kelvins Ankunft
suizidiert hat. Lediglich Kelvin kann seinen „Gast" nach und nach akzeptieren. Alles ändert sich, als die
Hari-Gestalt ihre eigene Künstlichkeit zu begreifen beginnt. Sie ringt um das Verständnis ihrer Identität
und wird dadurch menschlicher als die in Angst und Gewaltstrategien verstrickten Kosmonauten, de-
ren ganzes Trachten darauf gerichtet ist, die „Gäste" loszuwerden. Zwei Pläne werden ersonnen: Kelvin
soll sein EEG als Bild seiner Hirnaktivität per Röntgenstrahlung auf den Planeten einwirken lassen, in
der Hoffnung, dieser werde durch diese Botschaft sein grausames Experiment mit den Wiedergängern
einstellen. Andererseits soll ein „Annihilator" gebaut werden, der die Truggestalten nachhaltig auflösen
kann. Parallel dazu reift Haris Selbstsuche zur schonungslosen, tragischen Selbsterkenntnis. Sie versucht,
sich mit flüssigem Sauerstoff zu töten – es gelingt ihr aber ob ihrer Unzerstörbarkeit nicht, und sie er-
wacht wieder zum Leben. Durch diese Verzweiflungstat entwickelt sich eine echte, gegenseitige Liebesbe-
ziehung zwischen Kris und Hari. Er kann ihr sagen, dass er nun sie, die Wiedergängerin, als eigenständige
Person liebe und nicht nur das Bild seiner toten Frau, das sie verkörpert. An diesem Punkt fällt Kelvin
in ein Fieber und sieht in seinen Träumen seine Frau Hari und seine Mutter in ähnlichen Posen. Als er
erwacht, erfährt er, dass der Planet aufgehört hat, Gestalten zu schicken. Hari ist weg. Sie hat Snaut und
Sartorius gebeten, sie zu annihilieren. Die Kosmonauten wirken erleichtert und gesund. Kelvin soll zur
Erde zurückkehren, aber er will in der Station bleiben, um in Haris Nähe zu sein. In einer Schlussszene
sehen wir ihn wieder im Garten seines Vaters, am inzwischen zugefrorenen Teich. Er sieht den Vater im
Innern des Hauses, wo Regen auf ihn niederfällt. Auch der Vater sieht ihn, tritt vor das Haus, und Kris
sinkt vor ihm auf die Knie. Die Kamera zoomt nach oben in die Vogelperspektive, und wir sehen, dass
Haus und Garten eine schwimmende Insel auf dem Solaris-Ozean sind.

Dieser Plot freilich kann so nur im Rückblick erzählt werden. Der Film selbst entpackt seine Handlung über fast drei Stunden in einem dichten, kunstvollen Erzählstil, entsprechend Tarkowskijs Filmpoetik. Er sah die eigentliche Kunstform des Kinos in einem „Modellieren der Zeit" (Tarkowskij 1984, S. 94):

> Ähnlich wie ein Bildhauer … entfernt auch der Filmkünstler aus dem riesengroßen, ungegliederten Komplex der Lebensfakten alles Unnötige…

Wenn – wie so oft in Tarkowskijs Filmen – die Erzählung von erratischen Bildern und Sequenzen durchzogen ist, so handelt es sich dabei nicht um die vom Regisseur verabscheuten „poetischen" Illustrationen (ebd., S. 98), sondern um realistische Bilder aus dem Bereich des Erzählten, die er aufgrund eines inneren Zusammenhangs mit der Erzählung stehen lässt.

Soljaris besteht zu weiten Teilen aus solchen Sequenzen, die dem oberflächlichen Plot diesen inneren Zusammenhang verleihen.

Hintergrund

Romanvorlage

1961 erschien „Solaris" von Stanislaw Lem. Die Handlung des Romans beschränkt sich – im Gegensatz zu Tarkowskijs Verfilmung – auf die Raumstation. Das Thema, das ihn durchzieht, ist in erster Linie die epistemologische und ethische Fragestellung nach dem Verhältnis von Mensch und Maschine.

Lems Roman wird als erstes Manifest der Virtualität betrachtet. Der Roman wurde neben einer wenig bekannten Fernsehverfilmung (Soljaris, UdSSR 1968) zweimal in großen Produktionen verfilmt (1972 von Tarkowskij und 2002 von Soederbergh), mehrfach auf dem Theater inszeniert und hat zwei Mal die Gestalt einer Oper gefunden: 1996 als Kammeroper von Michael Obst (Uraufführung: München) und 2012 als Oper von Detlev Glanert (Uraufführung: Bregenz).

Umsetzung des Stoffes im Vergleich

Bedeutsam sind die unterschiedlichen Akzente, die die Aufbereitungen des „Solaris"-Stoffes von Lem setzen: Während Soderberghs Film die Liebesgeschichte als solche in den Mittelpunkt stellt, erweitert um die Frage nach dem Verhältnis von Liebe und Illusion, geht es Tarkowskij um die persönliche Anerkennung der Schuld und den Zusammenhang von Subjektbildung, Natur und Zivilisation. Im Vergleich zur Romanvorlage von Stanislaw Lem thematisiert Tarkowskijs Soljaris nicht so sehr die erkenntniskritische oder moralische Dimension des Sujets als vielmehr die psychologische. In der Textur seiner eigenen künstlerischen Sprache, der Bildkonstruktion und des Timing, entfaltet er eine spezifisch psychologische Dimension des Virtuellen. Um diese persönliche Ebene einzuflechten, fügt Tarkowskij dem Film eine Rahmenhandlung hinzu, den Abschied vom alten Vater und sein (virtuelles) Wiedererscheinen in der Schlusseinstellung des Films.

Der Regisseur

Andrej Tarkowskij hat ein schmales Oeuvre von sieben Spielfilmen hinterlassen (sein Abschlussfilm *Die Walze und die Geige* von 1960 nicht mitgerechnet). Sein magisches, von der Lichtmalerei inspiriertes Werk hat ihn zu einem weltweit verehrten Filmkünstler werden lassen – „Herrscher des Lichts" nennt ihn Andreas Kilb in seinem Nachruf in der „Zeit" nach seinem frühen Tod 1986. Auf seinem Grabstein im Russischen Friedhof Sainte-Geneviève-des-Bois in Paris steht: „Человеку, который увидел ангела" – Dem Mann, der den Engel gesehen hat.

Schon Tarkowskijs erster großer Spielfilm, die Literaturverfilmung *Iwanowo Detstwo* (Iwans Kindheit), gewann 1962 den Goldenen Löwen in Venedig. Sein zweites Werk, die in assoziativen Bildern erzählte monumentale Biografie des Kirchenmalers Andrej Rubljov, stieß in der Sowjetunion auf heftigen Widerstand der Zensur und musste drei Jahre lang umgeschnitten werden, bis es 1969 in Cannes gezeigt werden konnte und sogleich den Kritikerpreis erhielt. Tarkowskij war nun der Star des Westens, aber mit umso größerem Misstrauen wurde sein als individualistisch betrachtetes Schaffen in der Sowjetunion gesehen.

Soljaris stellt in Tarkowskijs Werk einen Wendepunkt dar. Die bereits in *Andrej Rubljov* entwickelte Bildsprache hatte die westeuropäischen Zuschauer in Begeisterung, die russische Zensur jedoch in tiefe Ablehnung versetzt. Tarkowski beharrt wie Rubljov auf der Kunst und wendet sich entschlossen der Bildsprache zu. Im Gewand der technischen Utopie von *Soljaris* facht er das Eigenleben der Bilder radikal weiter an und entwickelt es zu einer eigenen signifikanten Ebene, weit über die Filmerzählung hinaus. Diese charakteristische lichtpoetische Bedeutungsebene jenseits des Plots – und teilweise unter immer stärkerer Abweichung von der Oberflächenlogik des Handlungszusammenhangs – wird er konsequent in seinen folgenden Filmen weiterführen: *Zerkalo* (*Der Spiegel*, UdSSR 1975), *Stalker* (UdSSR 1979), *Nostalghia* (UdSSR/I 1983) und *Offret* (*Opfer*; S 1986).

Hartmut Böhme (1988) stellt Tarkowskijs Bildästhetik in die Tradition der barocken Vanitas-Ikonografie, die angesichts vernichtender Seuchen und Kriege den aufbrechenden Zweifel an der Güte des Schöpfers ins Bild gesetzt hätte, die Nichtigkeit des Diesseitigen, insbesondere der Schönheit selbst – dies aber oft in kunstvollen, ja gefällig arrangierten Szenarien. Jahrhunderte später taucht das Vanitasmotiv im Genre der mantischen Ruinendarstellung wieder auf, als Zeichen eines vergeblichen Fortschritts, dessen kulturelle Errungenschaften, von Vegetation überwuchert, der Natur wieder anheimfallen. Sie spiegeln den Zweifel an der Wirkmächtigkeit der Vernunft. An zahlreichen Bildparallelen zeigt Böhme (1988), dass Tarkowskij mit den Mitteln der „melancholischen Kamera", des „mortifizierenden Lichts" und einer von Bildzitaten überfrachteten Ikonik letztlich immer eines in Szene setzt: den Verlust von Bedeutung. Wenn Kunstwerke nach Adorno vollbringen wollen, „was Natur vergebens möchte ...: Sie schlagen die Augen auf", so erteile Tarkowskij diesem noch immer erkenntnisoptimistischen Gestus eine Absage. Mit ihm könne man bloß „den Tod sehen lernen, der uns am Ende die Augen schließt" (Böhme 1988, S. 375). Tarkowskijs Symbole zielen trotz aller religiösen Bezüge nicht auf Erlösung (ebd., S. 371).[1] Auch die biografischen Bezüge – überdeutlich in *Zerkalo* und *Nostalghia* – dienen der Herstellung dieses erloschenen Blicks mehr als der Restitution von Kindheit. Nur vordergründig sprechen die Figur des Vaters in *Soljaris*, die Gedichte des Vaters, die Stimme der Mutter in *Zerkalo* von Versöhnung. Was hier beschrieben wird, ist nicht das Leben. Auch nicht das in eine romantisierte Vergangenheit entschwundene oder aufbewahrte, sondern immer nur die Illusion davon (so auch Deleuze [1] 1985; 1997, S. 104).

Die Desillusionierung, die Böhme bei Tarkowskij diagnostiziert, und die sowohl gängigen religiösen Interpretationen (z. B. Kirsner 1996) als auch Tarkowskijs eigener Betonung der Religion zuwiderläuft, bleibt auch in *Soljaris* durchgehalten. Die Schlusssequenz, die zunächst darauf hinauszulaufen scheint, dass Kelvin zu seinen Wurzeln zurückkehren könne, wenn er seinen alten Vater durch das Küchenfenster beobachtet, wird sogleich durchkreuzt: Wir sehen, wie der Regen im Innern des Hauses fällt, und die in die Vogelperspektive entschwebende Kamera enttarnt die Idylle als „Gedächtnisinsel" auf dem Inkarnationsplaneten Solaris. Wenn die Credits aufziehen, wissen wir: Nichts ist, alles ist Schein. Aber wir sind bereit, ihn zu lieben.

1 Anders Kirsner 1996, Kap. 2.4., die den Ozean in Soljaris als „göttlich" interpretiert, und Hari als Inkarnation.

Filmwirkung

Lems „Solaris" und Tarkowskijs *Soljaris* stehen im Schnittpunkt vieler Motiv- und Wirkungslinien. Betrachtet man nur das Science Fiction-Genre, genauer das Genre der Weltraumabenteuer oder „Space Operas", so reicht diese Linie mit George Méliès' *Le Voyage dans la Lune* (1902) zurück bis in die Anfangszeit des Kinos (und von dort aus zu literarischen Vorlagen wie Jules Vernes „De la Terre à la Lune" 1865) und vorwärts bis in die Weltraumabenteuer der Gegenwart, von *Star Wars* bis *Avatar*. Das SF-Genre selbst ist aber nur eine Hülle, in der verschiedenste Themen und Motive verhandelt werden. Der unmittelbare Vorläufer-Film *Forbidden Planet* (USA 1956, Wilcox), der ebenfalls von einer gefährlichen, von einem hochtechnisierten Planeten produzierten Truggestalt handelt, unbewusst gesteuert von der Psyche eines gestrandeten Kosmonauten, reinszeniert in dieser fiktionalen Hülle Shakespeares „Tempest": Das Unbewusste des Kosmonauten will eifersüchtig sein einsames Leben mit der schönen Tochter gegen die irdischen Eindringlinge verteidigen.

Kubricks *2001 – A Space Odyssey* (USA 1968), der oft mit *Soljaris* verglichen und sogar als Vorlage gesehen wurde, auf die Tarkowskij mit *Soljaris* geantwortet habe, verhandelt die Entstehung der Kultur und das Mensch-Maschine-Dilemma. Dieses Thema, das auch im Kern von *Soljaris* liegt, ist Teil der Pygmalion-Motivlinie, die sich über Ovid, G. B. Shaw, Mary Shelley (Frankenstein; vgl. Pardo Garcia 2008) und Collodi (Pinocchio) zieht. Im Kino hat dieses Motiv weit über Kubrick und *Soljaris* hinaus seine Wirkungen entfaltet, bis hin zu modernen, nicht unbedingt ebenbürtigen Produktionen wie *Bicentennial Man* (USA 1999), *A. I. – Artificial Intelligence* (USA 2001), *I, Robot* (USA, D 2004), oder *Avatar* (USA 2009) und vielen anderen.

Die wichtigste Motivlinie aber, der *Soljaris* zuzuordnen ist, ist die Beschäftigung mit der illusionären/virtuellen Realität. Sie reicht zurück bis auf Platons Höhlengleichnis. Thomas von Aquin gebrauchte erstmals den Begriff des Virtuellen im Sinne einer nichtmateriellen Kraft, von der ein materieller Körper im „tactus virtualis" berührt werden kann, z. B. die Anmutung durch einen Engel, die in Form eines Gefühls wahrnehmbar wird (vgl. Drieger 2008, S. 11). Leibniz ([1]1714; 1998) geht davon aus, dass die Wirklichkeit in einer Vielzahl unteilbarer Monaden in je unterschiedlicher Perspektive abgebildet ist; eine Theorie, die Vorstellungen moderner konstruktivistischer Modelle vorwegnimmt. In den Automaten des 18. Jahrhunderts wurden ältere mechanische Projekte perfektioniert und stark vom Aspekt der Illusion geprägt. In dieser Welt der Automaten und Illusionen, die im späten 19. Jahrhundert die Jahrmärkte erobert hatte, ist auch die Geburt der Kinounterhaltung anzusiedeln, etwa mit dem bereits erwähnten Illusionisten Georges Méliès, der mit *Le Voyage dans la Lune* (1902) zugleich das Genre des SF-Films begründete. Von hier aus geht eine Entwicklungslinie zur Computertechnologie und der mit ihr verbundenen Möglichkeit der Simulation von Wirklichkeit. Seither ist das Virtuelle nicht nur ein nicht-materielles, ideelles Bild, sondern zugleich ein technisch erzeugtes; es wird oft vorgestellt nach dem in der Optik bekannten Phänomen des virtuellen Bildes bei der Spiegelung. Dieser Zusammenhang zwischen Spiegelung und Virtualität erklärt auch, warum der Spiegel eines der häufigsten Filmmotive ist; vertritt er doch paradigmatisch jene Erzeugung eines nichtkörperlichen Wirklichkeitsraums, der auch das Kino seine Wirkung verdankt. In neueren Theorien der Virtualität wird vor allem auf die Totalität des virtuellen Raums abgehoben; eines der wichtigsten Werke dazu ist die „Summa Technologiae" von Stanislaw Lem ([1]1964; 1981) mit ihrem Konzept der „peripheren Phantasmatik". Lems Roman „Solaris" stellt einen wichtigen Baustein in diesem Diskurs dar. In seinem Roman „die verbesserung von mitteleuropa" beschreibt Oswald Wiener (1969) eine komplette virtuelle Lebenswelt. Der heute vielzitierte Begriff „Cyberspace" wurde erst 1982 von William Gibson, einem amerikanischen Science-Fiction-Autor, eingeführt. In der Philosophie hat Jean Baudrillard mit dem „fraktalen Subjekt" (Baudrillard 1989) den Gedanken fortgeführt; er reflektiert die Tatsache, dass mit der Entwicklung der Computertechnologie der Unterschied zwischen Mensch und Maschine schwindet. In den „virtual realities" und den sozialen Netzwerken der Gegenwart erleben wir zunehmend diese Spekulationen real verwirklicht.

In der Filmgeschichte folgen auf *Soljaris* bedeutsame Stationen des Virtuellen wie *Welt am Draht* (D 1973, Rainer Werner Fassbinder), *Total Recall* (USA 1990, Paul Verhoeven), *The Net* (USA 1995), *eXistenZ* (CA, UK 1999, David Cronenberg), *The Matrix* (USA 1999), *Vanilla Sky* (USA 2001, Cameron Crowe) und *Inception* (USA, UK 2010, Christopher Nolan).

Aus psychoanalytischer Sicht steht die Erzeugung virtueller Welten oder Objekte in Verbindung mit einem angeborenen Spiegelungsbedürfnis, das zur vorgängigen Errichtung eines „virtuellen Anderen" führt (Stein Bråten 2003; vgl. Dornes 2006, Kap. 3). Zum zweiten kann der Begriff sozialphilosophisch erschlossen werden über den bereits von Baudrillard (1989) verwendeten, Freuds „Unbehagen in der Kultur" entliehenen Begriff der Prothese (Freud [1]1930; 1972; Decker 2004). Er beschreibt sowohl ein kulturelles Ideal, etwa die Gottesvorstellung, als auch die Technik. Aber als Phantasma menschlicher Allmacht führt er im Gegenzug zum Verschwinden des Subjekts durch Unterjochung der inneren Natur. Die Prothese schafft Leiden ab und reproduziert zugleich Gewalt gegen das Widerständige, „die Inseln der Lusterfahrung, da sie Zeuge der Unterwerfung sind und an die unkontrollierte Natur erinnern" (Decker 2004, S. 70).

Psychodynamische Interpretation

Filminterpretation aus psychoanalytischer Sicht stützt sich, wie die angewandte Psychoanalyse von Kunstwerken allgemein, vor allem auf die im Zuschauer evozierten unbewussten Prozesse (Hamburger 2003; Zeul 2007; Hamburger u. Pramataroff-Hamburger 2010; vgl. dazu auch Schneider 2008).

Hari und Kris oder die Psyche der Protagonisten

Ein erster Zugang dazu ist die Rekonstruktion der Identifikationen mit den Protagonisten (Gabbard 2001); die Aufforderung zur Identifikation ist eine der gängigsten Einladungen, die der Film ausspricht. Auf dieser Ebene könnte man Kris Kelvin – die einzige Filmfigur, deren Backstory einigermaßen ausgeführt ist – als Träger sich überkreuzender, konflikthafter Identitäten begreifen, und ihm eine nachvollziehbare Entwicklung zuschreiben. Geschildert ist er zunächst als nüchterner Psychologe, wenig anfällig für emotionale Appelle. Andererseits wird seine zwiespältige Beziehung zum Vater gezeigt, sowohl in der Anfangs- wie auch der Schlussszene in der Datscha des Vaters – dem Rahmen also, den Tarkowskij der Romanhandlung hinzufügt. Nach und nach erfahren wir auch eine traumatische Dimension seiner Biografie. Hari, seine Frau, hat sich nach einem Streit mit ihm umgebracht, und er trägt die Schuld mit sich, ihre Selbstmorddrohung nicht ernstgenommen zu haben. Und schließlich erfahren wir auch noch andeutungsweise, dass es eine spezifische Beziehung zur verstorbenen Mutter geben muss; wir sehen Ähnlichkeiten und hören von Konflikten zwischen Hari und der Mutter. Im Lauf des Films entwickelt Kris sich vom distanzierten, kühlen Rationalisten zum liebesfähigen Menschen.

Deutlicher noch als Kris aber ist Hari die Protagonistin, mit deren Innenwelt sich der Zuschauer identifizieren kann – was verwundern mag, weil sie ja gerade als Kunstfigur ohne Innenwelt eingeführt wird. Sie weiß nicht, wer sie ist, nicht einmal, wie sie in das Zimmer gelangt ist, in dem sie sich materialisiert hat. Dennoch vermittelt Natalya Bondarchuk glaubhaft emotionalen Kontakt auch zum Zuschauer. Wissend, sie ist ein „Automat", erleben wir sie doch als fühlendes Wesen. Hari macht auch die deutlichste Entwicklung aller Protagonisten des Films durch. Von der geschichtslosen Kopie entwickelt sie sich zur fühlenden, der existenziellen Verzweiflung fähigen und authentisch liebenden Frau, ohne dass je eine veritable Transformation, ein „Umbau" erfolgt. Diese Entwicklung berührt das ethisch-erkenntnistheoretische Problem, das schon Stanislaw Lem in seinem Roman „Solaris" beschäftigt hat: Inwiefern ist das künstliche Geschöpf des Menschen weniger beseelt als dieser selbst? Die Frage taucht bei Lem als Konsequenz des Materialismus auf, dem Beseelung ja nur als Überschreitung einer (bislang nicht definierbaren) Komplexitätsschwelle psychischer Organisation denkbar ist, also ein relatives, kein absolutes Prädikat darstellt (vgl. Lem [1]1957; 1980, Dialog V, S. 100 ff.). In Lems Denken verschwistert

sich diese Relativität interessanterweise mit dem Moment der Solidarität, unsterblich ausgedrückt in einer Reflexion des Piloten Pirx (Lem [1]1965; 1979, S. 80):

> Im Stillen malte er sich jene legendäre Situation aus, die – er wußte es längst – niemals Wirklichkeit werden konnte: den Aufstand der Roboter. Und während er die dumpfe, schweigende Gewißheit verspürte, dass er dann auf ihrer Seite stehen würde, schlief er augenblicklich wie geläutert ein.

Dieser Lem'schen Utopie allerdings schließt sich Tarkowskij nicht an. Seine Leidenschaft liegt auf einem anderen Gebiet. Auch er inszeniert die Menschwerdung von Hari, aber sein utopischer Fluchtpunkt dabei ist nicht die Solidarität, sondern die Poesie.[2]

Zeitbildhauerei oder die Psyche des Zuschauers

Es genügt aber nicht, *Soljaris* auf der Ebene personaler Identifizierungen zu analysieren. Zu deutlich sind die filmischen Signale, die über Charakter und Plot hinaus eine Geschichte auf einer gänzlich anderen Ebene erzählen, und zwar vor allem mithilfe der Zeitdramaturgie. Als die eigentliche Aufgabe des Filmemachers hat Tarkowskij die „Bildhauerei aus Zeit" gesehen (Tarkowskij 1984, S. 180). Damit meint er nicht so sehr die Montage, sondern die Kombination von Einstellungen mit unterschiedlichem „Zeitdruck" innerhalb des Filmbildes.

Wie ausdrucksstark diese Zeitsprache angelegt ist und wie der sorgfältige Aufbau des Films, die innere Struktur der Einstellungen, die Sukzession der Sequenzen Wahrnehmung und Interpretation des Films steuern, zeigt eine genaue Rekonstruktion der Reise des Zuschauers durch *Soljaris*, entlang der Szenenfolge und unter Berücksichtigung der erzählerischen Mittel. Dieses filmanalytische Verfahren ist verwandt mit dem technischen Vorgehen von Fritz Morgenthaler in der klinischen Psychoanalyse, der immer wieder darauf hinweist, dass der Analytiker die genaue Assoziationsfolge ebenso wie die Atmosphäre der Mitteilung zu beachten habe (Morgenthaler 1978).

Tarkowskijs Umgang mit einer sich mal ballenden, mal springenden Zeit, die surrealen Elemente wie etwa der unwirklich prasselnde Regen weisen die diegetische Ebene selbst als traumhaft verfremdet auf. Diese ästhetische Komposition wendet sich direkt an den Zuschauer. Es hieße den Film in seiner ästhetischen Dimension verkürzen, wollte man die Fülle der rätselhaften Leinwandereignisse, die er enthält, nur als Illustrationen psychischer Zustände der Protagonisten interpretieren. Denn im Zentrum der Botschaft des Films stehen der Zuschauer selbst und sein Umgang mit dem eigenen Unbewussten, mit dem eigenen Zeiterleben. Der Zuschauer selbst ist es, der skeptisch-nüchtern, aber mit einer vagen Hoffnung im Herzen (vgl. Tarkowskij[1]1984; 2009, S. 94 f. und passim) das Kino betritt und dort auf Gestalten trifft, die letztlich seiner eigenen Fantasie entspringen, weil sie von ihr belebt werden. Pointiert gesagt: *Soljaris* ist für seinen Zuschauer, was der Planet Solaris für seine Besucher ist: ein Rätselbildgenerator, in dem jeder sich selber, und zwar seine unbewusste Identität, findet.

Heimat

Schon mit dem schwarzgrundigen, langen, von einer Variation über Bachs Orgelpräludium f-Moll unterlegten Titelvorspann beginnt eine massive Entschleunigung, die sich in die ersten Bilder des Films hinein fortsetzt. (00:02:52) Wir sehen saftig grüne Wasserpflanzen sich in einem klaren Bachlauf wiegen (im Vergleich zur gleichmäßig aufsteigenden Titelei ein langsam wachsender „Zeitdruck"), und es scheint eine Ewigkeit zu dauern, bis die Kamera in Großaufnahme die Hand des Protagonisten Kris Kelvin erfasst (00:03:34) und sich langsam an ihm hochtastet, bis sie auf seinem Gesicht ruht, auf seinem Blick, der weit in die Ferne geht, um schließlich auf den Wasserspiegel zurückzusinken. Die

2 Žižek (1999) verortet Tarkowskijs Abweichung von der Vorlage dagegen als „materialistische Theologie".

statische Eingangssequenz geht nun in weiter zunehmende, aber immer noch ziellose Bewegung über: Kelvin bewegt sich in üppiger Vegetation, langsam durch einen tiefgestaffelten, lichten Eichengrund gehend, bis er zu einem Teich kommt. Der Blick hebt sich, das Haus taucht auf. Ein Pferd läuft durchs Bild. Weiter am Teich entlang, er wäscht sich die Hände im klaren Wasser. Erst mit dem Autogeräusch der ankommenden Gäste (00:06:33), mit dem Schwenk auf eine moderne Betonbrücke, die sich über das Unterholz spannt, und Kelvins Vater, der ihn herbeiruft, wird der traumverlorene Anfang relativiert, ein rascheres Handlungstempo setzt ein.

Ein Mann ist mit seinem kleinen Sohn oder Enkel gekommen, der von einem Mädchen artig begrüßt wird. Wir verstehen im Dialog der beiden Alten: Es ist der letzte Tag vor Kelvins Abreise zur desolaten Forschungsstation Solaris, und der Ex-Kosmonaut Berton will Kelvin zur Fortsetzung der Forschungsmission bewegen. Die beiden alten Männer sprechen über das Haus, das Kelvins Vater sich nach dem Muster des Hauses seines Großvaters erbaut hat. „Ich mag keine Neuerungen" (00:09:06). In diesem Moment setzt ein heller Gewitterregen ein, wir sehen Kinder und Hund zum Haus zurücklaufen, nur Kelvin steht ungerührt neben dem gedeckten Tisch, auf dem noch eine volle Kaffeetasse steht, im Wolkenbruch – bis hin zum angebissenen Apfel ein perfektes Vanitas-Arrangement. Über einen Zwischenschnitt auf den Teich, in den die letzten Tropfen fallen, ins Wohnzimmer, wo Berton ein altes Video zeigt. Er will Kris von der mysteriösen Fähigkeit des Planeten überzeugen, Gestalten zu schaffen. Auf dem Video sehen wir seinen Kommissionsvortrag: Er habe auf der Suche nach einem auf Solaris vermissten Kosmonauten ein vier Meter großes Neugeborenes auf der Planetenoberfläche schwimmen sehen (00:19:37). Aber die Aufnahmen, die er der Kommission vorführt – ein doppelter Film-im-Film – zeigen nur Wolken. Bertons Bericht wird zur Halluzination erklärt. Aber auch sein Plädoyer an Kelvin bleibt seltsam fragmentarisch; denn immer, wenn es persönlich wird, unterbricht Berton die Vorführung und springt weiter zu einer anderen Stelle.

Berton geht. In einem kurzen, unterbrochenen Dialog sprechen Vater und Sohn von Abschied; Schnitt auf das Foto der Mutter (00:25:19). Der Dialog spiegelt Kontaktvermeidung und ein Gefühl von Peinlichkeit. Kris fühlt sich gestört von Bertons Besuch. Die Tante – der Zuschauer erfährt erst jetzt, dass sie die Tante ist, nicht etwa die Mutter – fragt, wo sie die Gäste unterbringen soll, dadurch wird das Gespräch endgültig zum Erliegen gebracht. Kris geht zu Berton, leise ruft der Vater noch seinen Namen. In einer eingeschobenen Szene sehen wir Bertons Jungen, der panisch vor dem Pferd davonläuft („In der Garage steht etwas, das kuckt!"), und von der Tante beruhigt wird.

Als Berton in der folgenden Besprechung Kelvin, der einen kühl-rationalen Standpunkt vertritt, nicht überzeugen kann, reist er wütend ab (00:28:42). Nun setzten Vater und Sohn ihr unterbrochenes Gespräch fort; ebenso wie Berton hält Kelvins Vater ihm seine Kälte vor.

💬 „Solche wie dich in den Kosmos zu lassen, ist gefährlich, weil dort alles so zerbrechlich ist!"

Nun erst wird klar: Die beiden werden sich in diesem Leben nicht mehr wiedersehen können.

💬 „Bist du eifersüchtig, weil er mich begraben wird, nicht du?" (00:29:37)

Während Kelvins Tante auf dem (riesigen) ovalen Fernsehschirm eine Sendung über Solaris verfolgt, erscheint genau in dem Moment, in dem Gibarian vorgestellt werden soll, plötzlich Berton auf dem Schirm. Es ist ein Video-Anruf aus dem Auto, das führerlos durch eine futuristische Stadt gleitet: Er habe etwas Wichtiges zu sagen vergessen. Das Kind auf dem Planeten ähnele dem echten Kind des Vermissten. Nach diesem Anruf folgt eine Sequenz futuristischer Fahrten, in deren zeitlicher Überdehnung (auf fast fünf Minuten) Zuschauer und Plot verlorengehen. Ist dies noch Bertons Anruf? Begonnen hatte die Fahrt auf dem Schwarzweißbildschirm im Vaterhaus, war dann aber plötzlich farbig gewor-

den. Sind wir inzwischen selbst in diesem technischen Utopia?[3] – all dies bleibt offen, ein harter Schnitt führt uns zurück zum Teich und zu Kelvin. In einer blaugrau getönten **Schwarz-Weiß**-Sequenz sehen wir den Vater und die weinende Tante auf Kris zukommen, der vor dem Haus alte Notizen und Bilder verbrennt (00:39:24). Schnitt auf das Foto einer jungen Frau im Holzrahmen, das neben dem Feuer am Boden liegt. Im selben dunklen Licht, aber im Innern des Hauses, streicht die Kamera in Großaufnahme über Teetasse und Apfel auf das offene, jedoch nicht einsehbare Metallkästchen, das neben Erdkrümeln auf dem aufgeschlagenen „Don Quijote" liegt. Kris schließt das Kästchen und packt es ein. Nachdenklich geht er auf der Veranda hin und her. Das Pferd geht an ihm vorbei (00:41:57).

Der erste Akt, die Exposition des Films, hat uns in einen Zustand versetzt, in dem wir das Auftauchen erratischer Bilder, die starke Dehnung der Handlungszeit akzeptieren und – immerhin 40 Minuten lang – in eine Wirklichkeit gleiten, die Züge der Trance aufweist. Zeul (2007) hat diesen Zustand mit Bezug auf Lewins (1946) Konzept des „dream screen" und auf die „Urhöhle" von René Spitz (1955) als grundsätzliches regressives Muster der Filmrezeption beschrieben. Mag dies vielleicht nicht für alle Filme zutreffen, und mag insbesondere die Analogie von Film und Traum zu kurz greifen (vgl. Brütsch 2009), so ist der Anfang von *Soljaris* damit doch gut beschrieben. Der Zuschauer wird durch die raffinierte Zeitdramaturgie des Filmbeginns in einen traumartigen Zustand erhöhter Rezeptivität versetzt.

Ähnlich wie dieser erste Akt werden auch die weiteren Episoden des Films mit unterschiedlich modulierter Zeitdichte montiert. Erratische Objekte, wie der Metallkasten, den Kris in der Hand hält, oder Bildzitate – Brueghel, Rembrandt – tauchen immer wieder an verschiedenen Orten auf Die Interpretation, die im Folgenden unternommen werden soll, wird sich auf diese Darstellungsmittel stützen.

Die merkwürdige Station

Der zweite Akt von *Soljaris*, der die Ankunft auf der verlotterten Raumstation und das dort herrschende paranoide Klima schildert, kann hier nur in groben Zügen skizziert werden: Nach und nach entdeckt Kelvin die fremdartigen, menschlichen Gestalten, die sich auf der Station herumtreiben: Bei Snaut ist es nur ein Ohr des Gastes, das sichtbar wird, bei Sartorius ein Zwerg; im Abschiedsvideo Gibarians sieht man ein Mädchen, das, reifer wirkend, auch nach seinem Tod noch durch die Station wandelt. Wir erfahren davon, dass die Astronauten versucht haben, den Ozean mit Röntgenstrahlen zu beschießen. Kris zieht sich mit Gibarians Pistole und dem Video in seine Kabine zurück, deren Tür er verbarrikadiert.

Hari

Kris untersucht seine leere Schlafkabine. Im Schrank hinter Raumanzügen ein Spiegel (01:06:56). Er legt sich angezogen mit Pistole auf das mit Plastikfolie abgedeckte Bett. Nun sehen wir den schlafenden Kris von unten und ihm gegenüber, in farbiger, von Rottönen geprägter Großaufnahme, eine junge Frau (Hari). Das Bild ist mit einem dröhnenden Klang unterlegt. In einer Gegenschuss-Sequenz sehen wir – immer begleitet von rätselhaftem, halligem Sound – Kris auf seiner Plastikliege, dann Hari mit einem Kamm. Sie nähert sich der Liege und küsst ihn.

🔊 Er staunt: „Woher bist du…?" – Sie antwortet nur: „Wie schön."

Augenfällige Zeitsignatur dieser Sequenz ist die fast unwirkliche Gelassenheit, mit der Hari sich bewegt und antwortet. Kris' offenkundige Verwirrung löst bei ihr keinerlei Anspannung aus; sie begegnet ihr

3 Diese Szene war Tarkowskij sehr wichtig; er kämpfte monatelang um Dreh- und Reiseerlaubnis sowie um Devisen für eine Reise zur Expo 1970 in Osaka, die die futuristische Kulisse liefern sollte. Als er schließlich alles erhielt, war die Expo bereits vorbei. Die Szene wurde in Tokio gedreht (Tarkowskij 1989, S. 50).

mit schwereloser Grazie. Auftakt dieser zeitlosen Begegnung ist das Signum der Identität, der Spiegel, den Kelvin als Rückwand seiner Garderobe entdeckt.[4]

Im folgenden Gespräch zeigt sich an verschiedenen Details, dass mit Hari etwas nicht stimmt: Warum weiß sie selbst nicht, wie sie Kris gefunden hat? Nicht einmal wie sie aussieht? Sie erkennt sich auf dem Foto von Hari erst, als sie es neben ihr Spiegelbild hält. Warum zeigt ihr Oberarm eine Injektionswunde? Warum hat ihr Kleid, das dem auf dem Foto genau gleicht, zwar Knöpfe, jedoch keine Knopfleiste, sodass Kris es mit der Schere aufschneiden muss? Sie erweist sich als außerordentlich anhänglich („Ich habe das Gefühl, dass ich dich immer sehen muss"), ohne selbst zu wissen, warum. Kris versteht – und diese erschütternde Einsicht wird filmisch sehr knapp erzählt –: Hari ist eine körpergewordene Halluzination. Er muss sie loswerden. Er lockt sie in eine Rakete und schießt sie in den Weltraum. Aus dem Fenster sehen wir den sonnigen Ozean.

Die Sequenz führt Hari als falsche, halluzinierte Figur ein und mit ihr das Identitätsthema der Automaten. Nun haben wir ein zweites dramaturgisches Moment, das die Handlung vorantreibt: Das Mensch-Maschine-Problem. Psychoanalytisch gesehen ist das einflussreiche Paradigma des Maschinenmenschen (vgl. Baruzzi 1973) eine narzisstische Allmachtsfantasie, geboren aus realer Ohnmacht (vgl. oben und Decker 2004). In der sinnlichen Konkretisierung des Spielfilms ist der Zuschauer mit dem Protagonisten Kelvin identifiziert, dem eine anziehende junge Frau, die er offenbar gut kennt, als unbeseelte Maschine begegnet. Damit eröffnet sich ein Dilemma zwischen Begehren und Abscheu, zwischen Fremdheit und Vertrauen. Dieses Dilemma ähnelt der von der psychoanalytischen Objektbeziehungstheorie beschriebenen frühesten Erfahrung des Säuglings, der die Mutter und insbesondere die Brust im Wechsel von überwältigender Schönheit und Freundlichkeit, dann aber wieder Fremdheit und Verfolgung erlebt (vgl. z. B. Meltzer u. Harris Williams [1]1988; 2006).

Im folgenden Gespräch mit Snaut erzählt Kris – und beantwortet damit auch eine Frage, die der Zuschauer sich gestellt hatte – dass Hari, seine Frau, zehn Jahre tot sei; Snaut lässt durchblicken, dass seine Entsorgung der Truggestalt zwar radikal, aber nicht erfolgreich gewesen sei. Er vermutet, dass das Auftreten der Gestalten die Antwort des Ozeans auf die – gesetzwidrige – Attacke mit Röntgenstrahlung sei, die die Forscher zuvor vorgenommen hatten, und stellt damit die Existenz der ambivalenten Fremden in einen Kontext von Rache.

Im gelben Licht des dämmernden Solarismorgens ist Hari wieder da (01:24:00). Kris sagt nur: „Komm her" – und diesmal kann sie sich selbst ausziehen, indem sie das Kleid wie selbstverständlich mit einer Schere öffnet. Ihr Cape hat sie ordentlich über eine Stuhllehne gelegt – genau neben das Kleid ihrer Vorgängerin, das dort noch liegt.

Inzwischen sind 90 Minuten, eine normale Spielfilmlänge, vergangen. Nun erhöht sich das bisher immer noch langsame, traumverlorene Tempo der Filmhandlung dramatisch. Kris hat Hari, bei dem Versuch, ihr erstes Kleid zu verstecken (also: sie vor der Selbsterkenntnis zu schützen), einen Moment in der Kabine alleine gelassen. Panisch wirft sie sich, im Versuch ihm zu folgen, gegen die Metalltür, ohne zu begreifen, dass diese sich nach innen öffnet. Blutüberströmt bricht sie durch die zerfetzte Tür und stürzt zu Boden. Kris trägt die Verletzte in die Kabine und versucht ihr zu helfen (◼ Abb. 2). Rätselhafterweise heilen ihre Wunden von selbst. Verwirrt fragt die immer noch Ahnungslose ihn: „Was ist mit mir? Hab ich vielleicht Epilepsie?" (01.29:02).

4 Dies ist ein „Faktum" im Sinne der Tarkowskij'schen Poetik, das der Zeitbildhauer stehen gelassen hat: Der als Rückseite eines Schranks immerhin etwas merkwürdige Spiegel macht diesen zu einem magischen, reflexiven Ort. Das bezieht sich implizit auf die Romanvorlage: Dort hatte Gibarian sich durch eine Injektion getötet – wie Hari – und war stehend in diesem Schrank gefunden worden (Lem [1]1961; 1978, S. 42).

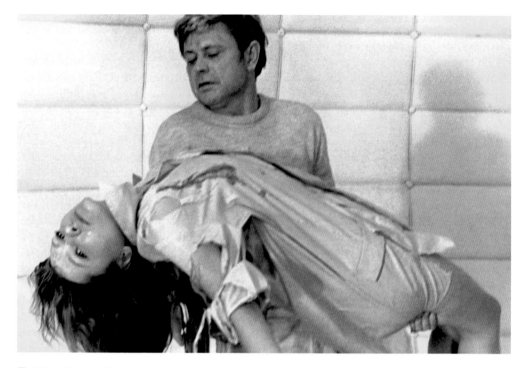

🔘 **Abb. 2** Kris trägt Hari auf seinen Armen. (Quelle: Cinetext Bildarchiv)

In dieser Sequenz wird die Hari-Projektion zum ersten Mal mit Gewalt assoziiert[5], zugleich werden ihre Naivität und Unschuld gezeigt. Hari ist dadurch als Kindwesen etabliert, das, noch ohne Impulskontrolle, sein Nähebedürfnis agieren muss.

Statt Hari loswerden zu wollen, akzeptiert Kris nun ihre Gegenwart. Er nimmt sie mit in die Besprechung der Kosmonauten und stellt sie als seine Frau vor. Er verteidigt sie gegen Dr. Sartorius, der nur von „Exemplaren" spricht und eine Obduktion empfiehlt.

Geschichte

Vor dem Hintergrund eines bewegten Ozeans, in gleißend hellem Tageslicht, sieht Kelvin in seiner Kabine ein Kindheitsvideo, das er aus dem Haus seines Vaters mitgenommen hat. Wir sehen Winterszenen mit Schaukel und Lagerfeuer, die Mutter im Strickkleid, während der Vater mit Kris spielt, die Mutter in einem weißen Pelzmantel, distanziert rauchend. Wir sehen Kris das Holz fürs Lagerfeuer herbeischleppen. Dann Kris und die Mutter in einer späteren Zeit, am Teich. Wir sehen die Mutter und Hari in ähnlichen Posen aus verschiedenen Zeiten. Dann Schnitt auf Hari in der Gegenwart der Kabine, die sich im Spiegel betrachtet:

💬 „Ich kenne mich nicht. Ich erinnere mich nicht an mein Gesicht … Kennst Du dich?" (01:38:31)

Auf der Ebene der Bildsprache ereignet sich hier etwas Wesentliches: Zum ersten Mal werden Mutter und Hari gleichgesetzt – und zugleich wird die „Echtheit" der toten Hari in Frage gestellt. Dies ge-

5 Wenn man die kaum hörbaren Schreie aus der Rakete vernachlässigt, mit der Kris die erste Hari-Kopie entsorgt; im Roman sind diese sowie Haris ungeheure physische Kraft deutlich hervorgehoben (Lem [1]1961; 1978, S. 72, S. 77 f.).

schieht durch die Bildwirkung selbst, streng der Filmpoetik Tarkowskijs folgend, nicht durch den Text. Die Hari, die wir sehen, die sich auf der Suche nach ihrer Identität im Spiegel betrachtet, wirkt echter, bewegter, emotionaler als die stummfilmartig Winkende im Video. Und als habe dieser Echtheitsbeweis ein Wunder bewirkt, kann Hari (unsere, die jetzige Hari) nun plötzlich mit Bezug auf Kris' Mutter im Video sagen:

> Hari: „Die Frau im Pelz hat mich gehasst."
> Kris widerspricht: „Sie starb, bevor wir uns getroffen haben."
> Hari beharrt: „Aber ich verstehe nicht, warum du mich täuschen willst. Doch, ich erinnere mich genau. Wir waren beim Teetrinken und sie hat mich rausgeworfen. Und ich bin gegangen. Und du?"
> Kris: „Ich bin weggefahren, und seitdem haben wir uns nie wieder gesehen."
> [Mit einem Mal plätschert ein feiner Regenstrahl mitten im Zimmer.]

Bedeutsam ist dieser Moment, weil Hari nun Zugang zu Teilen von Kris' Gedächtnis gewonnen hat, jedoch offenbar nur zu einer Schicht emotionaler Erinnerung. Sie bemerkt Kris' Versuch zu lügen, sie kann sich an den Hass erinnern, an den Rauswurf, an den Tee – aber sie weiß nicht, dass die Person, um die es geht, Kris' Mutter ist. Wenn wir uns darauf besinnen, dass Hari tatsächlich aus Kris' Erinnerung besteht, also eine materialisierte Projektion ist, dann sagt das etwas aus über die Struktur seiner „inneren Welt". Auch dort ist wohl der Hass erinnerbar, nicht aber die Mutter als Person. Diese Mutter-Aussparung war bereits im ersten Akt fühlbar gewesen, wenn sich die Frau an der Seite des Vaters plötzlich als Tante entpuppt, und von der Mutter nichts bleibt als ein langer Blick auf ein Foto. Hari spricht zu Kris wie eine Analytikerin, die ein wesentliches emotionales Geschehen spürt, den Hass, aber, bedingt durch eine Auslassung in der Erzählung des Analysanden, die Szene noch nicht vollständig erfassen und einem inneren Objekt zuordnen kann. Sie bleibt unbeirrbar in ihrer Wahrnehmung, auch wenn sie die Zusammenhänge noch nicht kennt. Mehr noch: Die Lücke, hier die Identität der „Frau im Pelz" als Mutter, ist signifikant. Durch Haris „lückenhaftes" emotionales Erinnern wird auf die Lücke in Kris hingewiesen, wird Kris' – im Film ja erst konstituierte – „innere Welt" als lückenhaft etabliert. Und um uns nicht in der illusionären Identifikation mit dem Helden vergessen zu lassen, dass dies sich nicht in einer lebendigen, organisch gewachsenen Psyche eines Kris Kelvin abspielt, sondern durch deren mit filmischen Mitteln bewirkte Etablierung in der Psyche des Zuschauers, geschieht nun etwas „Merkwürdiges", das die Filmillusion stört: Es beginnt zu regnen. Tarkowskijs Regenbilder sind Momente des „tactus virtualis", in dem der Mann, der den Engel gesehen hat, uns berührt, um uns an uns selbst zu erinnern.

Die folgende Sequenz vertieft die neugewonnene analytische Ebene zwischen Hari und Kris und ergänzt sie um ein wesentliches Element, die Empathie.

Während Hari schläft, berichtet Snaut Kelvin von dem Plan, dem Planeten mithilfe von Röntgenstrahlen ein EEG zu übermitteln, sozusagen als Verständigungsangebot. Kris ist dagegen, aber Snaut erpresst ihn: Sartorius mache schon Fortschritte mit einem Annihilator, der die Neutrino-Struktur der „Gäste" nachhaltig auflösen kann. Hari belauscht das Gespräch. Kelvin geht mit Snaut zu Sartorius, Hari wirft sich auf das Bett. Unterwegs packt Kelvin eine böse Ahnung, er läuft zurück und findet Hari, die verzweifelt versucht hat, die Trennung auszuhalten, bewusstlos. In seinen Armen belebt sie sich wieder, und er flüstert: „Verzeih mir."

Wir sehen den Ozean in Doppelbildern, durchzogen von Gischt, in heftig wirbelnder Bewegung, wir hören einen kurzen Klang. Es ist, als wollte die Abstraktion selbst Kontakt mit uns aufnehmen (01:44:45).

Die Sequenz behandelt das Thema des emotionalen Kontakts auf mehreren Ebenen: Zum einen die Kontaktaufnahme zum Planeten durch das EEG als neuartige Idee, die Kelvins Unbewusstes direkt an den Ozean übermitteln soll; zum zweiten der Akt der Einfühlung, der Kelvin umkehren lässt und ihn zu Hari treibt, die bis zur Bewusstlosigkeit versucht hat, den Trennungsschmerz auszuhalten (auch dies möglicherweise lesbar als ein Akt der Einfühlung in Kelvins Bedürfnis nach Unabhängigkeit); und schließlich die mit erhöhtem „Zeitdruck" übermittelte Bereitschaft des Ozeans, auch seinerseits direkt zu kommunizieren – abstrakte, reine Zeitbilder im Sinne von Deleuze ([1]1985; 1997), die auch im Zuschauer erhöhte Aufmerksamkeit und den Wunsch auslösen, etwas zu sehen, gewissermaßen das EEG des Planeten zu lesen. Eingebunden in die Sukzession des Films besagt diese Abfolge, der erhöhte Wunsch nach empathischem Kontakt direkt nach der Einführung der mütterlichen Lücke, dass zwischen beidem ein Zusammenhang besteht. Wie Kris und Hari werden wir im schmerzhaften Bemerken der Mutter-Lücke vom Wunsch nach Kontakt erfasst. Genauer: „Mutter" ist auf dieser Ebene der primären Bezogenheit noch keine ganze Person, sondern etwas wie eine empathische Präsenz, die uns hilft, durch Benennen der auseinanderstrebenden Pole von Geborgenheit und Verlassenheit erst das Gemeinsame, eben die Mutter als ambivalent besetztes Gesamtwesen, zu konstruieren. Was Kris und Hari hier versuchen, was der Zuschauer mit dem Film versucht, ist genau jene noch rudimentäre Mentalisierung (Fonagy et al. [1]2002; 2004) jenes Erschließen der Intentionen des Anderen aus seinen Verhaltenssignalen, die die Psychoanalyse als wesentliche Entwicklungsvoraussetzung betrachtet. Einen der ersten Schritte dieser Entwicklung hat Daniel Stern ([1]1986; 1992) als „subjektives Selbst" in der intimen Bezogenheit zwischen Mutter und Baby in der zweiten Hälfte des ersten Lebensjahres beschrieben. Es ist gekennzeichnet durch subjektive mentale Zustände sowie durch ein Innewerden der Subjektivität des Anderen.

Die nächste Sequenz baut die gewonnene Empathiebrücke weiter aus und ergänzt sie um die Dimension der Geschichtlichkeit. Hari steht an Kris' Bett und bittet ihn, ihr zu sagen, woher sie kommt. Als er ausweicht, konfrontiert sie ihn mit der Wahrheit, die sie von Sartorius erfahren hat, während er schlief:

> „Ich bin nicht Hari. Die Hari ist nämlich tot, hat sich vergiftet. Und ich bin etwas ganz anderes."

Sie fragt nach der echten Hari. Er erzählt ihr von ihrem Suizid, und fügt etwas hinzu, was wir als Zuschauer noch nicht wissen: nämlich dass er sich die Schuld gibt, ihn nicht verhindert zu haben.

> „Sie hat gespürt, dass ich sie nicht mehr richtig liebte. Aber jetzt liebe ich" (01:49:17).

Damit betreten Hari und Kris (und mit ihnen der Zuschauer, der an ihren Lippen hängt und der als realer Mensch diese Entwicklung tatsächlich einmal durchlaufen hat) in einer Art beschleunigter psychischer Entwicklung die nächste von Daniel Stern ([1]1986; 1992) geschilderte Stufe der Bezogenheit, die das Kind etwa im zweiten Lebensjahr erreicht. Das „verbale Selbst" ist nach Stern auf Seiten des Kindes gekennzeichnet durch Empfindung von persönlicher Welterfahrung, Verbalisieren von Urheberschaft und Geschichte. Die Mutter hilft dem Kind durch Versprachlichen von Bedeutungen, Interaktionen und Empfindungen. Genau das ist es, was Kris und Hari hier tun: Sie sprechen über ihre Empfindungen und ihre Geschichte.

Der kurze Dialog, der nun folgt, enthält weit mehr, als auf der Ebene der „Liebesgeschichte" notwendig wäre und stellt damit die konstruktivistische Option in den Raum, dass die vom Menschen erfahrene „Realität" keinen anderen ontologischen Status besitzt als der Traum von Solaris.

 Hari: „Kris, ich liebe dich."
Kris: „Schlaf jetzt."
Hari: „Es ist kein Schlaf, nur am Rande."
Kris: „Wahrscheinlich sind es doch nur Träume" (01:50:03)

Diese Option wird in der nächsten Sequenz weitergeführt: Nacht, Bibliothek, Snauts Geburtstag wird gefeiert. Snaut, der mit zerrissenem Abendanzug und Stunden verspätet zur Feier erscheint, betrinkt sich und lässt einen galligen Monolog über die Raumfahrt ab:

„Wir brauchen gar keine andere Welt. Wir wollen nur die unsere bis an die Grenzen des Kosmos erweitern. Wir wissen nicht, was wir anfangen sollen mit anderen Welten. Wir brauchen – einen Spiegel brauchen wir." (01:54:23).

Es entspinnt sich ein Dialog zwischen Hari und Sartorius über die Frage, ob die „Kopien" lieben und geliebt werden können. Hari erscheint in diesem Konflikt mutiger, menschlicher als Sartorius, der ihr entgegenhält:

Sartorius: „Sie sind nur eine Matritze".
Hari: „Ja. Schon möglich. Aber ich werde zu einem Menschen. Und ich fühle nicht ein bisschen weniger als Sie. … Jawohl, ich kann schon auskommen ohne ihn. Ich – ich liebe ihn. Ich bin ein Mensch! Und Sie, Sie sind sehr grausam."

Nach ihrem Plädoyer, das Hari unter Tränen vorgetragen hat, greift sie nach einem Glas und stößt einen Leuchter um, der zwischen Papieren auf dem Boden zu liegen kommt; sie versucht, ein Glas Wasser hinunterzustürzen, aber die Flüssigkeit läuft ihr wieder aus dem Mund. Kris fällt vor ihr nieder und legt sein Gesicht in ihre Hand.

Sartorius: „Stehen Sie auf!"
Snaut: „Wir sollten uns nicht streiten. Wir verlieren sonst noch unsere Würde. Und unser Antlitz als Mensch."
Hari: „Nein, Sie sind Menschen. Jeder auf seine Weise. Und darum streiten Sie auch" (02:00:39).
Snaut: „Störe ich euch?"
Kris: „Snaut, du bist ein guter Kerl. Aber vielleicht doch ein bisschen."

Beeindruckend an dieser Sequenz ist die Klarheit, mit der die Diskussion zwischen Mensch und Maschine verbal auf Augenhöhe geführt wird, und zugleich die filmische Imagination des Schmerzes, den diese Klarheit auslöst. Erstere fügt sich in das Register der an den Protagonisten gezeigten Entwicklung des „verbalen Selbst"; aber die Bildsprache zeigt uns zweitens, dass die sprachliche Vernunft den paradigmatischen Konflikt nicht lösen, nicht heilen kann. Hari plädiert, versucht zu trinken, aber die Flüssigkeit läuft ihr aus dem Mund – wir sehen sie hilflos wie ein Neugeborenes; und sehen zugleich auch: Sie hat keine inneren Organe, mit denen sie Flüssigkeiten aufnehmen und verdauen könnte. Kris' Kniefall – wir werden ihm am Ende des Films, beim Vater, wieder begegnen – zeigt die Scham der Vernunft angesichts ihrer Überheblichkeit. Denn Sartorius' vernünftige Grenzziehung zwischen Mensch und Nichtmensch ist zugleich grausam: Haris regressiver Schmerz macht fühlbar, wie die vordergründige Abgrenzung vom „Geschöpf" zugleich die innere Naturbedingtheit, die Abhängigkeit des Menschen selbst zutage bringt. In Haris Trauer zeigt sich genau die kindliche Hilflosigkeit, die die technische Zivi-

lisation zu überwinden unternommen hat. Eindringlich symbolisiert der erloschene Leuchter zwischen den Papieren auf dem Boden das Stranden der aufklärerischen Vernunft. Nur Kris ist bereit, mit seiner kindlichen Vertrauensgeste diese Abhängigkeit bei sich selbst anzuerkennen. Die Kamera senkt den Blick auf Haris nackte Füße – wir wissen, sie ist ohne Schuhe nach Solaris gekommen. Es ist auch der Blick des Zuschauers, der sich senkt und Haris engelhafte Unschuld bemerkt.[6]

Bemerkenswert ist, dass diese Verhandlung über Identität und Abhängigkeit offenbar dazu geführt hat, dass das Paar nun von den anderen Astronauten anerkannt werden kann. Snauts schüchterne Frage, „Störe ich Euch?" zeigt die Geltung ihrer Intimität.

Er lässt sich dann aber doch von Kelvin begleiten; wir sehen ihn betrunken schimpfend den weißen Gang entlang torkeln. Hari bleibt allein, und diesmal ganz ruhig, in der Bibliothek. Sie kann jetzt warten. Als Kris eilig zurückkehrt, findet er sie tief versunken in die Betrachtung von Brueghels „Jäger im Schnee", in das nun auch die Kamera eintaucht. Wir hören Stimmen aus dem Off in unverständlichen Gesprächen, langsame Überblendungen zeigen uns die heimkehrenden Jäger, Hunde, Krähen, wir hören Vogelgezwitscher, hallende Töne. Wir sehen Eisläufer, eine Kirche. Dann erscheint mit einem Mal Kris' Kinderszene mit der Schaukel. Hari betrachtet völlig versunken das Bild. Sie raucht, wie die Mutter (02:05:58).

Alltagsszenen aus dem winterlichen Dorfleben aus der Sicht der heimkehrenden Jäger versinnbildlichen die Heimatbindung der Astronauten; sie sind gefüllt mit Zitaten aus dem ersten Akt: Teich, Bäume, ein Haus. Durch das Kunstwerk kann die geschichtslose Hari eine Vorstellung vom Innenleben der menschlichen Astronauten gewinnen, von den Erinnerungsbildern, die in ihnen leben, die sie mit den Filmbildern aus Kelvins Video verknüpft. Wieder ist ein Schritt zur Vertiefung der Verbindung geschehen; Haris Einfühlung umfasst nun auch die Geschichte des Anderen.

Diese Vertiefung spiegelt sich auf wunderbar anmutende Weise im Film: Als Kris seine Hand an den Kandelaber legt, beginnt dieser plötzlich zu schweben (wie angekündigt, tritt das Raumschiff vorübergehend in den Zustand der Schwerelosigkeit[7] ein). Auch Hari und Kris schweben jetzt sachte im Raum, Orgelmusik setzt ein, langsam segelt das Buch mit dem aufgeblätterten Stich von Don Quijote vorbei. Die zärtliche Nähe der Beiden wird gerahmt von Kelvins Kinderszene mit Feuer. Wir sehen den Ozean düster erregt.

Die Schwerelosigkeit etabliert einen Ort, an dem die Liebenden sich begegnen können; sie enthält aber auch mit dem Don Quijote-Zitat den Verweis auf Illusion, präzisiert durch den Kandelaber, die Lichtquelle, als optische Illusion, als Kino.

Das mit empathischem Kontakt und Geschichte verbundene Identitätsthema transformiert sich in einen Wirbel von Schwerelosigkeit, Traumzeit und Erinnerung. Wir nehmen Teil an der Reorganisation einer inneren Welt. Konsequent inszeniert Tarkowskij diese Reorganisation nicht nur in einem Reigen signifikanter, überdeterminierter Bilder, sondern vor allem im Rhythmus. Statt nur „über" eine solche Reorganisation zu berichten, zieht er den Zuschauer in eine aktive Anteilnahme. Mehr noch als die Identifikation mit den Protagonisten bringt die räumliche und zeitliche Komposition des Filmbildes den Zuschauer selbst in die Rolle dessen, der die Entwicklung durchmacht. Nach diesem Tanz ist uns Hari so nahe wie Kris, denn wir waren zum ersten Mal in ihren inneren Bildern.

Virtuelle Menschlichkeit

Die traumverlorene Erinnerungsszene wird durch einen plötzlichen Knall unterbrochen, harter Schnitt auf ein rauchendes, zerbrochenes Glasgefäß am Boden. Daneben liegt Hari, steifgefroren wie zuvor Gibarian. Sie hat flüssigen Sauerstoff getrunken. In verzerrter Detailaufnahme fährt die Kamera über

6 Lem ([1]1961; 1978) schildert ausführlich die Unberührtheit der Fußsohlen der „Gäste"; wie Engel haben sie kaum je den Boden berührt.

7 Ein Motiv, das auch in *Zerkalo* an einer Schlüsselstelle auftaucht.

ihr kaltes Gesicht. Sie hat in der Verzweiflung die einzig dem Menschen mögliche Handlungsalternative gewählt, den Selbstmord. Und jetzt kann Kris, der zuvor sein Liebesempfinden nur unpersönlich formulieren konnte, sagen: „Ich liebe sie" – worauf Snaut kühl entgegnet: „Welche?" Und der Film gibt zugleich dem Zyniker und dem Liebenden Recht: Ihre Unzerstörbarkeit zwingt Hari in einer ergreifenden Szene des Erwachens, das einem Orgasmus oder einer Geburt ähnelt, unter Schmerzen ins Leben zurück. Als könnte sie spüren, dass ihr der freiwillige Gang durch den Tod[8] ein eigenes Ich verliehen hat, stammelt sie, von Kris eng umschlungen:

💬 Hari: „Bin ich das? … Nein, das bin ich nicht – das ist nicht – ich bin nicht Hari – und du – du – du vielleicht auch – ich bin nicht Hari!" (02:13:59).
Kris: „Gut, vielleicht sollte dein Erscheinen für mich eine Folter sein oder eine Gefälligkeit des Ozeans – aber welche Bedeutung hat das denn, wenn du mir teurer bist als alle wissenschaftlichen Wahrheiten die es je auf der Welt gegeben hat! …
Du warst ihr ähnlich. Aber jetzt – bist du – nicht mehr die echte Hari."
Hari (versucht sich loszureißen): „Sag mir, bin ich dir zuwider, weil ich so bin?"

Während Kris das Gegenteil beteuert, sehen wir Snaut im Hintergrund aus seiner Kabine stürzen und mit einem Metallkasten durch den Gang eilen; auch er hat offenbar jemanden, dem er helfen muss. Die Kamera folgt ihm ein Stück in den roten Gang, schwenkt dann ruhig nach rechts in die Quertraverse, wo sie verweilt – aber Snaut kommt auf seinem Rundlauf an deren anderem Ende nicht vorbei. Dann schwenkt sie ebenso gelassen weiter, bis wir ihn aus der Gegenrichtung wieder auf uns zulaufen sehen. Kann er die Station so schnell umrundet haben? Warum sahen wir ihn nicht auf der anderen Seite vorbeilaufen? Der langsame Kamerablick, der seinem rasenden, humpelnden Lauf kontrastiert, setzt sich in dem Staunen aus Haris noch vom Eis gezeichneten Augen fort. Was ist Sein, was Schein? Der Kasten, den Snaut trägt, ist zugleich eine Erinnerung an jenen kleinen Metallkasten, den Kris im ersten Akt gepackt hat und der seither immer wieder im Bild erscheint.

Wie stets bedeutet das Auftauchen solcher objets trouvés, dass wir nicht in einer distanzierten Zuschauerrolle einer entfernten Liebesgeschichte beiwohnen, bei der eben nur leider die Geliebte eine Art haptisches Hologramm ist, sondern selbst in der Illusionsmaschine sitzen, deren Schattenspiele Szenen aus unserem Langzeitgedächtnis anstoßen. Diese Szenen sind nach Daniel Stern vor allem durch ihre zeitlichen Eigenschaften charakterisiert; sie bilden den Niederschlag von Affektabstimmungsprozessen, die vor allem in der Zeit spielen (Stern [1]1995; 1998). Die Bedeutung des Metallkastens, der immer wieder erscheint, bleibt ebenso offen wie sein Inhalt unbekannt; als McGuffin zieht er aber die gesamte Fülle des visuellen Begehrens auf sich – wir wollen wissen, was er enthält, so wie wir in der Kindheit das Innere des Körpers der Mutter erforschen wollten (vgl. Meltzer u. Harris Williams [1]1998; 2006).

Der Ozean wird erregter, wirbelnde Nebel, Sonne. Hari und Kris sprechen im Bett über die Zukunft. Kris will nicht zur Erde zurück, er möchte bei ihr auf Solaris bleiben. Hari hat Angst. Die Kamera verliert sich in langsamen Überblendungen zwischen den Beiden, wir sehen den schweißüberströmt schlafenden Kris, hören das leise Klingeln, das die erste Erscheinung begleitet hatte. Kris erwacht, schleppt sich dem Klingeln nach auf den Gang. Eine extrem lange Überblendung zwischen Vorder- und Rückenansicht von Kris erzeugt für einen Moment den Eindruck, sein Kopf würde verschwinden. Er stolpert durch die Raumstation, alles wirkt wieder entschleunigt, wir spüren ein Innerlich-Werden des Zeitpulses. In einer später folgenden Einstellung sehen wir Kris, gestützt von Hari und Snaut. „Gibarian

8 Darin kann man mit Kirsner (1996) ein Christusmotiv sehen.

starb aus Scham. Ja, Scham. Das ist das Gefühl, das die Menschheit rettet." Über blendendes Weißlicht und das Bild des Wohnzimmers der Kindheit geraten wir in Kelvins Kabine, in der plötzlich Blumen auf spiegelndem Boden stehen, in seine Fieberträume. Hari versorgt ihn, sie legt ihr Cape ab, mit einem Mal sitzt da die Mutter im gleichen Unterkleid, der Hund am Fenster, wir sehen Blumen, Quitten – und Hari, vielfach multipliziert ...

In einem schwarzweiß gefilmten Traumeinschub (02:21:58) erwacht Kris im Haus seiner Kindheit, er umarmt Hari, wir sehen das nun geöffnete Metallkästchen, in dem aus der Erde eine Pflanze wächst, Münzen liegen daneben. Als er die Umarmung löst, ist es die Mutter. „Ich bin zwei Stunden zu spät." (Eine Anspielung auf Haris Selbstmord, den er nicht verhindern konnte). Auf der Mattscheibe des übergroßen Fernsehers klebt eine Reproduktion des Brueghel-Bildes, alles ist mit Plastik abgehängt. Kris spricht von seiner Einsamkeit. Die Mutter beißt in einen Apfel (ein Rückverweis auf das Vanitas-Stillleben der Eingangsszene): „Warum kränkst du uns so? Warum hast du nicht angerufen? Du führst ein seltsames Leben. Ungepflegt. Ganz schmutzig. Wo hast du dich nur so zugerichtet?" Wir sehen Blutverkrustungen an seinem Unterarm, wie an Haris, nachdem sie durch die Metalltür der Kabine gebrochen war. Die Mutter holt Wasser und wäscht seinen Arm, alles geht ab, wie damals bei Hari. Kris: „Mama!" (er weint). Schwarzblende. (02:26:54).

Aus dem Schwarz schwenkt die Kamera in Kelvins taghelle Kabine. Er ruft nach Hari. Snaut antwortet: „Hari gibt es nicht mehr." Er liest ihm ihren Abschiedsbrief vor: „Kris, es ist schrecklich dass ich dich betrügen musste. Aber anders war es nicht möglich. Und so ist es besser für uns beide. Ich habe sie selber darum gebeten. Gib niemandem die Schuld. Hari." Snaut setzt hinzu: „Sie hat es um deinetwillen getan." Kris fragt unter Trauer: „Wie ist das, Annihilation?" – Snaut. „Ein Aufblitzen und eine schwache Druckwelle." Kris dreht leidend den Kopf, scheint sich aber rasch zu erholen. „Ja, es ging mit uns in letzter Zeit nicht gut." Auf einem Stuhl sehen wir den Metallkasten und den Waschkrug aus seinem Traum. Später erzählt Snaut vom Erfolg des EEG-Experiments: „danach kam keiner zurück. ... und es bildeten sich Inseln." Kris: Du willst doch wohl nicht sagen er habe uns verstanden? – Snaut: „Hoffnung haben wir gewonnen, nicht wahr, Kris?" (02:30:17)

Was wie eine Lösung wirkt – die Gäste sind weg, die Station wird gesund – wird auf der Bildebene nachdrücklich in Frage gestellt. Der Waschkrug aus dem Traum steht plötzlich „wirklich" im Zimmer, der Liebende ist plötzlich unwirklich kühl, selbstvergessen wie Hari bei ihrem ersten Auftreten. Es gibt Signale, die uns annehmen lassen, Kelvin sei nicht erwacht, sondern träume nur einen anderen, helleren Traum.

Später, in der nächtlichen Bibliothek, hören wir Kelvins nachdenklichen Schlussmonolog aus dem Off über Winter- und Wolkenbildern:

💬 „Habe ich denn das Recht, auch nur auf die imaginäre Möglichkeit zu verzichten des Kontaktes zu diesem Ozean, zu dem meine Rasse seit Jahrzehnten ein Fädchen der Verständigung zu knüpfen versucht? Also hierbleiben? ... In der Luft, in der noch ihr Atem schwebt? – Das einzige, was mir bleibt, ist Warten. ... Auf neue Wunder?"

Am Fenster sehen wir nun den geöffneten Metallkasten stehen, mit der Pflanze darin, wie im Traum. Wieder ertönt das Orgelpräludium.

Das Licht ist wärmer, heimeliger, sodass uns der folgende Schnitt auf grüne Erden-Natur, Algen, die sich in klarem Wasser wiegen, zwar inhaltlich nicht, aber ästhetisch überrascht. Wir sehen Kris von hinten, wie im ersten Akt, in blauer Jacke. Der Teich ist jetzt gefroren, wie auf dem Brueghel-Bild. In das Orgelstück mischt sich Gesang. Schwenk auf das Haus des Vaters, Rauch steigt auf. Freudig läuft sein Hund auf ihn zu. Kris geht zum Haus, sieht durchs Fenster den Vater mit Büchern hantieren. Regen fällt im Zimmer, durchnässt den Vater, der davon nichts zu bemerken scheint. Dann fällt sein Blick auf Kelvin vor dem Fenster, auf der Fensterbank der verschlossene Metallkasten. Hallender Ton. Der Vater

tritt aus dem Haus, Kelvin sinkt vor ihm auf die Knie und umarmt ihn[9]. Die Kamera zoomt nach oben in die Vogelperspektive, wir sehen in zunehmender Totale durch aufziehenden Nebel das Haus und den Garten als Insel inmitten eines grün wogenden Ozeans. Schwarzblende, Schluss.

Abschließende Betrachtung

Wir haben gesehen, dass *Soljaris* weniger das Seelendrama eines verlorenen und schuldigen Sohnes und Ehemannes verhandelt, denn das Drama der Virtualität. Das Kunstwerk, das uns mit der Konstruiertheit von Erfahrung konfrontiert, ist selbst ein solches Konstrukt, und es wendet sich an einen, der es mit seinen Fantasien füllt. Der Planet Solaris selbst wäre ein Kantisches Ding an sich[10], wenn nicht seine Erforscher sich ihm ausliefern, ihn erst „für sich" zu ihrem Spiegel ernennen würden. Schon bei Lem ist dieses sozusagen hysterische, reaktive Moment des Planeten angedeutet – in den Jahrhunderten der Solaristik, die Lem referiert, scheint der Planet sich stets den Forschungsinteressen seiner Beschreiber angepasst zu haben. Kelvin erkennt: Solaris ist das eigene, persönliche Unbewusste, nicht als Erkenntnisproblem, sondern als sinnliche Erfahrung.

Soljaris gestaltet das Unbewusste als Planeten, der das Verdrängte dessen, der sich ihm nähert, durch materiale Projektion enthüllt, in der höchst sinnlichen Gestalt seiner Emanationen. Sie treten als Nebenfiguren, oft nur skizzenhaft angedeutet, auf: Ein Mädchen, das durchs Bild wandelt, ein Kind, das einen Mann tyrannisiert, ein Zwerg, ein Ohr. Eine von diesen Ausstülpungen der Solaris-Intelligenz aber wird zur Hauptfigur: Hari.[11] Ihre unbedingte Anhänglichkeit an Kris, ihre Hingabe bis hin zur Selbstauslöschung zeigen ein Ausmaß von Verschmelzung mit dem Anderen, wie es die Psychoanalyse als Vorläufer der Objektbezogenheit beschreibt. Das Baby erlebt sein aufkeimendes Ich nur als Teil einer gemeinsamen Matrix mit der Mutter, jede Trennung erscheint ihm als tödliche Gefahr. Hari vertritt – jedenfalls zu Beginn ihrer Entwicklung auf Solaris – diese kindliche Position. Sie ist ein Phantasma aus dem Repertoire von Kris' eigenem Unbewussten, die Projektion seiner eigenen, abgewehrten Abhängigkeit. Ihre zunächst nur skizzenhaft angelegte Psyche besteht nur aus seinen Gedanken und Erinnerungen. Der Film inszeniert die Psyche des Protagonisten in zwei Gestalten: Als Kris, den bewussten, und Hari, den unbewusst-projizierten Anteil. In beiden Gestalten wird eine Entwicklung durchlaufen (eine Vorstellung, die der Auffassung von Pinchas Noy [1979] entspricht, der Primär- und Sekundärprozess nicht hierarchisch untereinander, sondern als zwei sich ergänzende „Sprachen" mit je eigener Entwicklungsmöglichkeit nebeneinander stellt.) Sowie Hari zum Bewusstsein ihrer selbst und damit auch zu einer erweiterten Autonomie findet, kann auch Kris sie vom Odium des Artefakts befreien. Er kann ihr ein Eigenleben, ja eigene Gefühle zubilligen und sein Liebesempfinden auf sie richten. Mit dieser Anerkennung dessen, was er zuvor als sein Anderes in Hari projiziert hatte, hat er zugleich dem eigenen Unbewussten Raum und Anerkennung gegeben.

Hari jedoch lediglich als Projektion von Kris' abgewehrten Abhängigkeitswünschen zu sehen, wäre zu kurz gegriffen. Es ist nicht die Filmfigur Kris Kelvin, der projiziert, sondern der Zuschauer selbst. Solaris ist nicht ein rätselhafter Planet weit draußen, sondern eine höchst irdische Illusionsmaschine, nämlich die, in der eben dieser Zuschauer gerade sitzt und sich mit Bildern füllt. Zudem ist Hari mit weiteren signifikanten Bezügen versehen, „überdeterminiert", wie Freud das genannt hätte. Sie ist nicht nur Kris projizierte Abhängigkeit, sondern liefert, wie uns *Soljaris* gerade in seiner filmisch-sinnlichen Gestaltung verrät, auch Hinweise auf die Ursache dieser Abwehr.

9 Oft bemerkt, aber selten weiter verfolgt, wird der Hinweis, dass dies ein Zitat von Rembrandts Leningrader Gemälde „Rückkehr des verlorenen Sohnes" (um 1662) ist. Es weist ikonografische Besonderheiten auf, die die Deutung ermöglichen, Rembrandt habe zugleich auf die Salbung des David aus 1. Samuel 16, 1–13 anspielen wollen (Busch 1970).

10 Žižek (1999) hält ihn tatsächlich dafür.

11 Harey bei Lem, ein Anagramm der Muttergöttin Rhea; deshalb nennt Soderbergh sie in seinem Remake von 2002 auch Rhea.

Nicht von ungefähr parallelisiert der Film Hari mit Kris' Mutter, und nicht von ungefähr tritt diese in seinem Fiebertraum auf, aus dem er am Ende erwacht, um festzustellen: Hari ist nicht mehr da, der Planet hat aufgehört, Figuren zu senden. Psychoanalytisch gesehen, hat das Unbewusste – Solaris – aufgehört, Symptome zu bilden, weil es anerkannt worden ist. „Wo Es war, soll Ich werden". Aber was genau ist anerkannt worden? War es nur die Abhängigkeit? Abhängigkeit wovon?

Die Filmsprache selbst, die Zeit- und Bilddramaturgie, die mimische und gestische Ähnlichkeit Mutter/Hari führen uns auf eine Spur, die die genauere, qualitative Bestimmung dessen erlaubt, was abgewehrt werden muss. Hari ist geschaffen, nicht gezeugt, das ist ihr Daseinsgrund. Nehmen wir Hari als Projektion (man möchte angesichts ihres Eigenlebens eher von einer projektiven Identifikation, mit Bion ([1]1962; 1963) von einem Beta-Element sprechen), so repräsentiert sie nicht nur die Abhängigkeit, sondern auch und vor allem die Nicht-Existenz als Mensch. Etwas in Kris (etwas im Zuschauer, das er in Kris wiedererkennt) ist nicht-menschlich, hat keine Geschichte, keine Heimat. Was Kris (stellvertretend für den Zuschauer) auf Hari projiziert und als fremdes Geschöpf auf sich zukommen sieht, ist eine existenzielle Lücke.

Diese Lücke verbindet der Film kompositorisch mit der Hari-Mutter-Gestalt. In die rhythmische Anordnung, in die Bildinterferenzen ist diese Figur eingeschrieben. Wie in Sterns ([1]1995; 1998) Theorie des Zusammenseins mit der depressiven Mutter ist der Wechsel von Kontakt und Nichtkontakt in die „protonarrativen Hüllen", eingeschrieben, die sich aus den Grunderfahrungen der frühen Interaktion herausbilden. Sie bilden im narrativen Gedächtnis des Kindes eine Art szenischer Zeit-Moleküle. Die Spannungsdramaturgie des Films, die sich dem Zuschauer vermittelt, ist die Klaviatur, auf dem die untergründige Musik der Kommunikation spielt (vgl. auch Hamburger 2006).

Wenn Hari in ihrem Dialog mit Sartorius über Liebe und Realität für den Primat der Liebe eintritt – also dafür, dass Realität relativ sei – plädiert sie nur oberflächlich für das konstruktivistische Programm des virtuellen Selbst; sie meint damit den Primat der Emotion. Kris kann dies akzeptieren und seine Hari-Inkarnation annehmen; durch dieses Paar wird deutlich, dass der Ozean nicht Rache nehmen will, sondern lernen. Das Bild des Unbewussten also, das Tarkowskij in *Soljaris* entwirft, ist nicht das einer seelischen Giftmülldeponie, sondern das eines lernenden Organismus, gekleidet in die anorganische Fantasie des fühlenden Steins.

Damit verleiht der Film der von Stanislav Lem aufgeworfenen Frage eine neue, emotionale Dimension. Das Selbstbewusstsein als Konstrukt, wie eine schwimmende Insel auf einem Meer unbegriffener Emotion – deutlicher hätte auch Freud das Verhältnis von Ich und Es nicht zeichnen können. Hari, die Virtuelle, ist zugleich die Analytikerin des Films; von ihrer Selbsterkenntnis geht die Heilung aus. In dieser Dimension wurde der Film auch als christliche Erlösungsfantasie betrachtet (Kirsner 1996): Hari, die Menschgewordene, opfert sich, um den Menschen den Zugang zu sich selbst zu ermöglichen. So sehr dieses Christus-Zitat auch der Intention des Regisseurs entsprechen mag, so sehr muss es aus psychoanalytischer Sicht doch relativiert werden: Der Gott, den *Soljaris* in der Natur ansiedelt, sei es die anorganische des Planeten Solaris oder die organische der russischen Landschaft, bleibt doch ein virtueller; oder, wie Freud es genannt hätte, eine menschliche Illusion. Slavioj Žižek (1999) bestreitet vehement eine „jungianische", auf eine versöhnende Symbolik abzielende Lesart. Für ihn ist der Planet das „Ding aus der inneren Welt", die Verkörperung des inkommensurablen Lacanschen „Realen" (Lacan 11973; 1978).

Die psychoanalytische Untersuchung von *Soljaris* zeigt: Dass die Christusgestalt in *Soljaris* mit einer Frau besetzt ist, die starke Anklänge an die Mutterfigur aufweist, gibt uns den entscheidenden Hinweis auf die Grunderfahrung, aus der diese notwendige Illusion ihre Nahrung erhält. In der frühen Beziehung zur Mutter erleben Kinder das, was ihre seelische „Handschrift" für immer prägt, die Spiegelung und Modulation der zeitlichen Affektabstimmung (Stern 11986; 1992; 1995; Fonagy et al. 12002; 2004). Was in den ersten Lebensmonaten geschieht, kann man mit „Bildhauerei aus Zeit" sehr präzise umschreiben. In der spezifischen Sprache der Filmkunst lockt uns Tarkowskij fast drei Stunden lang in

eine Sitzung, in der wir diese Begegnung mit der Intensität einer noch unbekannten, ihre Gestalt erst gewinnenden Zeit erleben, wie im Arm einer Mutter.

Noch vor den Dreharbeiten zu *Soljaris* war Tarkowskij vor allem von einem Gedanken besessen: Einen Film über seine Mutter zu drehen (Tarkowskij 1989: 44 und passim). Er sollte „Der helle Tag" heißen. Er hieß dann: *Zerkalo* (*Spiegel*).

Literatur

Baruzzi A (1973) Mensch und Maschine. Das Denken sub specie machinae. Fink, München

Baudrillard J (1989) Videowelt und fraktales Subjekt. In: Ars Electronica (Hrsg) Philosophien der neuen Technologie. Merve, Berlin, S 113–131

Bion WR (1963) Eine Theorie des Denkens. Psyche – Z Psychoanal 17: 420–435 (Ersteröff. 1962)

Böhme H (1988) Ruinen-Landschaften. Zum Verhältnis von Naturgeschichte und Allegorie in den späten Filmen von Andrej Tarkowskij. In: Böhme H: Natur und Subjekt. Suhrkamp, Frankfurt/M

Bråten S (2003) Beteiligte Spiegelung. Alterozentrische Lernprozesse in der Kleinkindentwicklung und der Evolution. In: Wenzel U, Bretzinger B, Holz K (Hrsg) Subjekt und Gesellschaft. Zur Konstitution von Sozialität. Festschrift für Günther Dux. Velbrück, Weilerswist, S 139–169

Brütsch M (2009) Dream Screen? Die Film/Traum-Analogie im theoriegeschichtlichen Kontext. In: Pauleit W et al (Hrsg) Das Kino träumt. Projektion. Imagination. Vision. Bertz & Fischer, Berlin, S 20–49

Busch W (1970) Zur Deutung von Rembrandts „Verlorenem Sohn" in Leningrad. Oud Holland 85: 179–183. http://archiv.ub.uni-heidelberg.de/artdok/volltexte/2011/1509/. Zugegriffen am 17. 2. 2012

Decker O (2004) Der Prothesengott. Subjektivität und Transplantationsmedizin. Psychosozial, Gießen

Deleuze G (1997) Das Zeit-Bild. Kino 2. (stw 1289) Suhrkamp, Frankfurt/M (franz. 1985)

Dornes M (2006) Die Seele des Kindes. Entstehung und Entwicklung. Fischer, Frankfurt/M

Drieger P (2008) Virtuelle Welten – Eine neue Dimension unseres Wirklichkeitsverständnisses? MA Uni Eichstädt-Ingolstadt. public.noumentalia.de/data/Text/MA_Virtuelle_Welten.pdf. Zugegriffen am 12. 10. 2011

Fonagy P et al (2004) Affektregulierung, Mentalisierung und die Entwicklung des Selbst. Klett-Cotta, Stuttgart (engl. 2002)

Freud S (1972) Das Unbehagen in der Kultur. Gesammelte Werke Bd XIV. 5. Aufl. Fischer, Frankfurt/M, S 419–506 (Erstveröff. 1930)

Gabbard GO (2001) Introduction. In: Gabbard GO (Hrsg) Psychoanalysis and film. Karnac, London, S 1–16

Gibson W (1982) Burning Chrome. Omni, July 1982

Hamburger A (2003) Erinnerter Abschied. Zur psychoanalytischen Interpretation des Trakl-Epitaphs von Else Lasker-Schüler nebst Anmerkungen zum Übertragungsangebot der Lyrik. In: Mauser W, Pfeiffer J (Hrsg) Trauer. Königshausen & Neumann, Würzburg, S 185–226

Hamburger A (2006) Traum und Zeit. Traumerzählungen als Elemente der Spannungsdramaturgie. Forum Psychoanal 22: 23–43

Hamburger A, Pramataroff-Hamburger V (2010) Sexuelle Besessenheit in Lous Malles „Damage". In: Möller H, Döring S (Hrsg) Batman und andere himmlische Kreaturen. Nochmal 30 Filmcharaktere und ihre psychischen Störungen. Springer, Heidelberg, S 195–212.

Kilb A (1987) „Herrscher des Lichts". ZEIT 9. 1. 1987

Kirsner I (1996) Erlösung im Film. Praktisch-theologische Analysen und Interpretationen. Kohlhammer, Stuttgart

Lacan J (1978) Das Seminar von Jacques Lacan XI. Die vier Grundbegriffe der Psychoanalyse. Walter, Olten (Erstveröff. 1973)

Leibniz GW (1998) Monadologie (Französisch/Deutsch). Übersetzt von Hecht H (Hrsg) Reclam, Stuttgart (Erstveröff. 1714)

Lem S (1978) Soljaris. Suhrkamp, Frankfurt/M (poln. 1961)

Lem S (1979) Der Unfall. In: Die Jagd. Suhrkamp, Frankfurt/M, S 69–99 (poln. 1965)

Lem S (1980) Dialoge. Suhrkamp (es 1013), Frankfurt/M (poln. 1957)

Lem S (1981) Summa technologiae. Suhrkamp, Frankfurt/M (poln. 1964)

Lewin B (1946) Sleep, the mouth, and the dream screen. Psychoanal Quarterly 15: 419–434

Marotzki W (2007) Über das schwierige Finden der verlorenen Zeit. Biographisierungsprozesse im Film aus bildungstheoretischer Perspektive. In: Koller H-C, Marotzki W, Sanders O (Hrsg) Bildungsprozesse und Fremdheitserfahrung: Beiträge zu einer Theorie transformatorischer Bildungsprozesse. Transcript, Bielefeld, S 181–198

Meltzer D, Harris Williams M (2006) Die Wahrnehmung von Schönheit. Der ästhetische Konflikt in Entwicklung und Kunst. Edition Diskord (Veröffentlichungen des Klein Seminars Salzburg, Bd 5) (engl. 1988)

Morgenthaler F (1978) Technik – Zur Dialektik der psychoanalytischen Praxis. Syndikat, Frankfurt/M

Noy P (1979) The psychoanalytic theory of cognitive development. Psychoanal Stud Child 34: 169–216

Pardo G, Javier P (2008) From Blade Runner to Solaris: covert adaptations of Mary Shelley's Frankenstein in contemporary cinema. In: Multidisciplinary Studies in Language and Literature – English, American, and Canadian. Univ Salamanca SP, S 249–256

Schneider G (2008) Filmpsychoanalyse – Zugangswege zur psychoanalytischen Interpretation von Filmen. In: Laszig P, Schneider G (Hrsg) Film und Psychoanalyse. Kinofilme als kulturelle Symptome. Psychosozial, Gießen, S 19–38

Spitz R (1955) Die Urhöhle. Psyche – Z Psychoanal 9: 641–667

Stern DN (1992) Die Lebenserfahrung des Säuglings. Klett-Cotta, Stuttgart (engl. 1986)

Stern DN (1998) Die Mutterschaftskonstellation. Eine vergleichende Darstellung verschiedener Formen der Mutter-Kind-Psychotherapie. Klett-Cotta, Stuttgart (engl. 1995)

Tarkowskij A (1989) Martyrolog. Tagebücher 1970–1986. Limes, Berlin

Tarkowskij A (2009) Die versiegelte Zeit. Gedanken zur Kunst, zur Ästhetik und zur Poetik des Films. Dt. Neuausgabe. Alexander Verlag, Berlin (russ. 1984)

Turowskaja M, Allardt-Nostiz F, Allardt-Nostiz J (1981) Andrej Tarkowskij. Film als Poesie – Poesie als Film. Keil, Bonn

Žižek S (1999) The thing from inner space. Mainview, September 1999. http://www.lacan.com/Žižekthing.htm. Zugegriffen am 4. 3. 2011).

Zeul M (1994) Bilder des Unbewussten. Zur Geschichte der psychoanalytischen Filmtheorie. Psyche – Z Psychoanal 48(11): 975–1003

Zeul M (2007) Das Höhlenhaus der Träume. Filme, Kino &Psychoanalyse. Brandes & Apsel, Frankfurt/M

Originaltitel	Солярис (Soljaris)
Erscheinungsjahr	1972
Land	UdSSR
Buch	Andrej Tarkowskij, Friedrich Gorenstein
Regie	Andrej Tarkowskij
Hauptdarsteller	Donatas Banionis (Kris Kelvin),Nikolay Grinko (Kelvins Vater), Natalja Bondartschuk (Hari), Jüri Järvet (Snaut), Anatolii Solonizyn (Sartorius), Sos Sargsyan (Gibarjan), Vladislav Dvorshetsky (Henri Berton)
Verfügbarkeit	DVD: Meisterwerke von Andrej Tarkowskij, Disk 1. Ice Storm

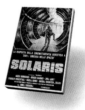

Hinderk M. Emrich

Gibt es eine „wirkliche" Welt?

Welt am Draht – Regie: Rainer Werner Fassbinder

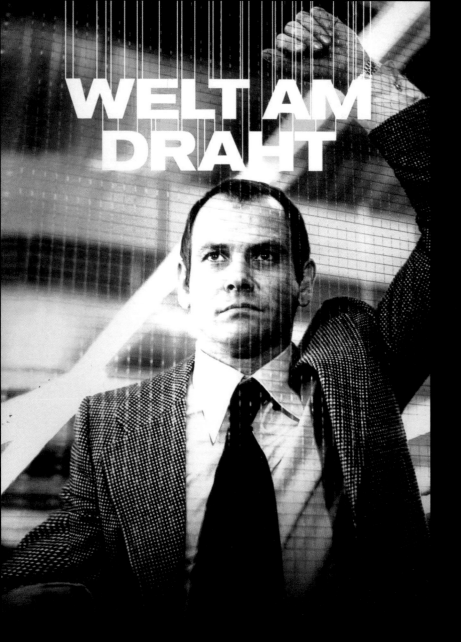

DVD Cover *Welt am Draht*
Quelle: DVD Arthaus Premium 2010

„Welt am Draht"

Regie: Rainer Werner Fassbinder

„Nämlich der Grundzug unseres Zeitalters ist meines Erachtens der, daß in ihm das Leben nur historisch und symbolisch geworden ist, zu einem wirklichen Leben aber es gar selten kommt."

Johann Gottlieb Fichte (1834)

Die Handlung

Die Handlung des Films (■ Abb. 1) ist durch ein philosophisches Thema geprägt, das Fassbinder (1973)[1] folgendermaßen beschreibt:

> Ich habe einen Fernsehfilm von zweimal anderthalb Stunden gedreht ... der die *Welt am Draht* heißt und eine Welt schildert, in der man mit einem Computer Projektionen von Menschen schaffen kann. ... Dadurch entsteht natürlich der Zweifel, inwieweit man selber nur eine Projektion ist, denn in dieser Welt gleichen die Projektionen der Wirklichkeit. ... Es dreht sich hierbei um ein altes philosophisches Modell, das hier einen gewissen Horror erzeugt.

Die Handlung bewegt sich auf drei „Realitäts"-Ebenen, von denen die oberste Ebene erst zum Schluss des zweiten Teils des Films – quasi als Überraschung – „entdeckt" wird: die „wirkliche Welt". Eine Stufe darunter gibt es eine elektronisch simulierte Wirklichkeit und schließlich – noch weiter „unten" (im Sinne der Abhängigkeit) – eine von der simulierten Welt erzeugte Simulation. Der Film spielt fast ausschließlich in der „Mittelwelt", die aber eben davon handelt, in welcher Weise mit einem neu entwickelten Supercomputer eine ganze kleine Stadt nachgebildet werden kann – nicht nur mit allen ihren biologischen und technischen Funktionen, sondern auch mit den Sozialfunktionen menschlicher Personen, in deren Simulationen die Eigenschaften scheinbar autonomer Subjektivität einprogrammiert sind und in Funktion gehalten werden. So „leben" hier also Erscheinungsformen menschlicher Wesen in der Vorstellung, sich selbst zu simulieren, nicht ahnend, dass sie ihrerseits abhängige Konstrukte höherstufiger maschinaler Prozesse sind, die von intelligenten (Subjektivität tragenden) Wesen gesteuert werden. Ihnen allen voran (in der „Mittelwelt") der mächtige Chef des Unternehmens, Herbert Siskins (Karl-Heinz Vosgerau), sowie der Hauptentwickler des Computers Prof. Henri Vollmer (Adrian Hoven), der aber zu Beginn des Films stirbt. Und schließlich ist da sein Nachfolger, der Physiker Fred Stiller (Klaus Löwitsch), die tragende Ich-Figur des Films, anhand derer letztlich die Fragen nach Ich-Identität und Selbst-Sein sowie nach der Existenz von Selbstbewusstsein gestellt und abgearbeitet werden. Die Simulationsprozesse dienen dabei allerdings nicht kognitionsphilosophischen wissenschaftlichen, sondern letztlich kapitalistischen Interessen, um Wirtschaftsprozesse besser steuern zu können, wobei das Konsumverhalten, die Vorlieben und Abneigungen lebendiger menschlicher Wesen – auch gerade für die Zukunft – erforscht werden sollen, um Wirtschafts- und Kapitalströme rechtzeitig zu optimieren.

Wie gesagt: Was die „Simulationseinheiten" dieser Mittelwelt nicht wissen, ist das Geheimnis des Films: dass nämlich sie selbst „Avatare", Computersimulationen der höheren Ebene sind, von der sie

1 Zitiert nach dem Film von Juliane Lorenz (DVD): „Rainer Werner Fassbinder Foundation präsentiert: Blick voraus ins Heute" (2007)

Abb. 2 Fred Stiller (Klaus Löwitsch) entlarvt Einstein als Fritz Walfang (Günter Lamprecht). (Quelle: DVD Arthaus Premium 2010)

abhängen und erschaffen wurden, wie im Alten Testament[2] nach dem Vorbild ihrer Kreatoren. Nun macht aber der Forschungsdirektor Prof. Vollmer eines Tages die ihn tief erschreckende Entdeckung[3], dass er selbst und seine ganze Forschungs- und Lebenswelt nicht autonom sind, sondern abhängig: eine Virtualitäts-Welt, die von einer anderen Seinsebene aus konstruiert wurde und „lebendig" gehalten wird. Diese Entdeckung will er weiter kommunizieren, was ihn aber das (künstliche) „Leben" kostet (er wird quasi „abgeschaltet" durch die höhere Ebene, wobei ein Suizid/Unfall simuliert wird). Nur seinem Sicherheitschef Günter Lause kann er gerade noch seine Desillusionierungsentdeckung mitteilen. Nun wird aber auch Günter Lause (Ivan Desny) aus dem Verkehr gezogen, denn er möchte weitere Mitarbeiter des „Instituts für Kybernetik und Zukunftsforschung" (IKZ) von Vollmers Entdeckung Mitteilung machen. Durch diese völlig undurchsichtige, thrillerhaft-geheimnisvolle Gefahrensituation wird der neu ernannte Nachfolger des Institutsdirektors Vollmer, der Physiker Fred Stiller (Klaus Löwitsch), zum Forscher und Detektiv – zum Teil in eigener Sache – indem er herausfinden will:

- Was ist passiert?
- Was beinhaltet die Entdeckung seines Vorgängers?
- Welche Konsequenzen ergeben sich hieraus für sein „Leben"?

Er gerät immer mehr in psychische und somatische Ausnahmezustände und macht unerklärbare Beobachtungen tiefer Paradoxie. Er bewegt sich auf schwankendem Boden (Schwindelanfälle), und es kommt immer wieder zu Kopfschmerzattacken und Absence-Zuständen (im wahrsten Worte „Filmrissen") bis hin zu dem Phänomen, dass bei der Autofahrt eine Straße vor ihm plötzlich zu verschwinden und nach kurzer Zeit wieder vorhanden zu sein scheint. Letztlich kommt es in turbulenten Szenen, Verfolgungsjag-

2 Moses I, 26:„Dann sprach Gott:„Laßt uns Menschen machen nach unserem Abbild, uns ,ähnlich'…" (Die Bibel 2002)
3 Vgl. das desillusionierende Ergebnis der Meditationen des René Descartes im Jahre 1641.

den und einer sanften amourösen Beziehung zu Vollmers Tochter, Eva Vollmer, die daran interessiert ist, den Tod ihres Vaters und dessen Hintergrund aufzuklären, zur Wiederholung der Vollmer'schen Entdekkung. Hierzu dient nun das Phänomen der „Kontakt-Einheit", einer einprogrammierten Identitätseinheit, die Kontakt mit der oberen, sie steuernden Wirklichkeit hat und von ihrem Zustand des Programmiert-Seins auch tatsächlich weiß. Darüber hinaus gibt es das Phänomen, dass Personen des Bedienungspersonals des Simulacron-Supercomputers in der „Mittelwelt" sich selbst als Projektionsschaltungen in die (untere) Simulationsebene hineinprojizieren können und dort quasi am sozialen Leben in der simulierten Wirklichkeit teilnehmen. Aus dieser Situation heraus gelingt es nun der Kontakteinheit „Einstein" (Gottfried John), in die Identität des Freundes von Stiller, des Programmierers Fritz Walfang (Günther Lamprecht), einzudringen, als dieser in die Simulationsebene hineinprojiziert wird. Als scheinbarer Fritz Walfang (in Wirklichkeit aber als „Einstein") taucht er auf in der Ebene des IKZ-Instituts.

💬 Einstein:„Ich will nicht mehr zurück, das ist meine einzige Chance, ich will ein Mensch sein."

Dies aber wird von Stiller entdeckt, und Einstein wird wieder in die Simulationsebene zweiter Ordnung zurückprojiziert (💬 Abb. 2). Auf diese Weise – in einer extrem dramatischen und ergreifend inszenierten Episode des Films – wird nicht nur das Geheimnis der verschiedenen Projektions- und Identitätsebenen gelüftet, sondern auch das Prinzip deutlich, nach welchem der Protagonist Fred Stiller und die insgeheim geliebte Partnerin Eva Vollmer in die „wirkliche Wirklichkeit" gelangen können. So schließt denn der Film auch mit der „harten Landung" im „wirklichen Leben": Wir sehen das Liebespaar, schließlich auf dem Boden liegend, auf der Ebene des Computersimulations-Forschungsinstituts, der „wirklichen Welt". In dieser hatte sich (quasi als Doppelgänger) der „eigentliche" Physiker Fred Stiller eine zweite Identität in der Simulationswelt erschaffen, gegen die er dann aber von Eva, seiner Mitarbeiterin und Partnerin, ausgetauscht wird.

Interessanterweise ist hier die „Simulationseinheit"[4] sympathischer und liebenswerter als das Original, welches – durch seinen gottähnlichen Status im Hinblick auf seine Computerwelt – „verrückt" geworden ist[5].

Entstehung des Films

Welt am Draht von 1973 gilt als „einziger Ausflug von Rainer Werner Fassbinder auf das Terrain der Science-Fiction" und als „meisterhafte Vorwegnahme" der Debatten um Cyberspace und virtuelle Realität (Völckers 2010). Auf Anregung des Fernsehredakteurs des WDR, Peter Mertesheimer, mit dem Fassbinder schon längere Zeit zusammengearbeitet hatte, interessierte sich Fassbinder für den Roman „Simulacron 3" des amerikanischen Autors Daniel F. Galouye ([1]1964; 1980) und entwickelte zusammen mit seinem Regieassistenten Fritz Müller-Scherz das Drehbuch. Das Schreiben des Scripts erfolgte in Paris, weil – wie Müller-Scherz in einem Interview mit Julia Lorenz beschreibt – „wir eine halbwegs futuristische Kulisse brauchten. Zu dem damaligen Zeitpunkt war die Architektur in Paris eine völlig ungewohnte – Neubaugebiete, deren Straßen ins Nichts führten, keine Vorgärten – das sah schon ein wenig nach naher Zukunft aus." Das Drehbuch sei – wie Müller-Scherz berichtet – im Schnellverfahren in einem Bistro entstanden, wobei er, auf Fassbinders Anweisung, „nicht so viele direkte Dialoge" geschrieben habe. Fassbinder habe das Gefühl gebraucht, nicht beeinflusst zu werden, und Fassbinder habe an einem anderen Tisch die Szenen bearbeitet, wobei das Buch so umfangreich gewesen sei, dass der WDR letztlich einen Zweiteiler habe hinnehmen müssen und dies allerdings auch für gut befunden habe.

4 das „Simulacrum" (Baudrillard)

5 Eva Vollmer:„Der Mann am Computer: das hat ihn verrückt gemacht. Er hält sich für eine Art Gott. Er hatte Spaß an Angst und Verzweiflung."

Der Regisseur

Rainer Werner Fassbinder, auch „Wunderkind des Neuen Deutschen Films" genannt (Jürgen 2002), ist eine in ihrem Facettenreichtum kaum beschreibbare Filmemacher-Ausnahmepersönlichkeit mit herausragender Expressivität und Hyperproduktivität, ein Multitalent (Theaterautor und Regisseur, Schauspieler und Filmemacher von über 44 Filmen), dessen Werk eine ganze Epoche filmisch geprägt hat und in dessen Werk das gesellschaftskritische „Melodram" im Mittelpunkt steht mit der Besonderheit des stets zutiefst Menschennahen und damit sogar Affirmativen. In der Regel wird eine mutige, fast immer zum Scheitern verurteilte autonome Zentralfigur dargestellt, die sich an problematischen übermenschlichen gesellschaftlichen Prozessen und Mächten abarbeitet. So sagt Fassbinder in einem von Florian Hopf und Maximiliane Mainka 1977 gefilmten Interview über sich: „Meine Motivation, Filme zu machen, hat sich geändert. Anfangs war es so, dass ich mir über meine eigenen Obsessionen klar werden wollte, während ich Filme machte. Ich habe dann in dieses Aufarbeiten von Leidenschaften oder so ein kritisches Gewissen eingebracht und bin dann irgendwann einmal aufs reine Erzählen, meiner Ansicht nach, gekommen. Erzählen, in dem alles drin ist, was ich denke, was die moralischen Begründungen sind, die müssen drin sein; aber ich glaube nicht, dass das Kino, das man macht, die bewusste moralische Absicherung braucht.

Für mich ist es so, dass ich sage, ich kann gar nichts ganz Falsches mehr erzählen, klar? Ich möchte jetzt eigentlich, wenn überhaupt noch, nur noch erzählen. Dinge erzählen, die ich für wichtig finde, dass sie erzählt werden; für aufregend, für wichtig. Und wichtig nicht in dem Sinn, dass sie jetzt was weiß ich auch auf die Narben der Gesellschaft drücken, sondern dass sie Menschen – und das finde ich eine ganz wichtige Formulierung – dass sie Freiheit geben und Lust machen, ihre Schmerzen zu formulieren.[6]

Drehbuch und Besetzung

Das Drehbuch hält sich nur zum Teil an die Romanvorlage, wobei die Hauptveränderung darin besteht, dass politische und gesellschaftskritische Aspekte der geheimen Kollaboration von kapitalistischen Privatinteressen und der Politik einbezogen wurden.

Zur Bebilderung des virtuellen Raumes in der Welt 2 („Mittelwelt") werden Filmstars der Vergangenheit herzitiert (wie Ingrid Caven, Eddie Constantine, Christine Kaufmann, Bruce Low, Barbara Valentin, Joachim Hansen u. a.) und in Form einer statuarischen Einfrierung in Szene gesetzt, häufig fast unbeteiligt wirkend und emotionsarm, distanziert und entfremdet, wie wir dies von A. Resnais' Film *Letztes Jahr in Marienbad* (1961) her kennen, wo ja auch das zeitphilosophische Problem behandelt wird, dass eine mögliche (virtuelle) Vergangenheit die gegenwärtige Wirklichkeit überformen, ja ersetzen kann.

Reiner Langhans als Kommunarde der 68er tritt beim Galaempfang der kapitalistischen Funktionäre als Kellner auf, dies wohl als diskreter Hinweis darauf, dass die 68er Ideologie auch dahin umschlagen mag, dass ihre Protagonisten zu Lakaien des kapitalistischen Systems mutieren, was sich dann später ja auch teilweise eingelöst hat. Der Kameramann, Michael Ballhaus, sagt in einem Interview mit Juliane Lorenz (2010) zur Besetzung:

6 „Rainer Werner Fassbinder, 1977", DVD Rainer Werner Fassbinder Foundation (2010)

Das war eine bunte Mischung aus hervorragenden, wunderbaren Schauspielern und jeder Menge bunter Vögel. Leute, die man nicht im normalen Fernsehprogramm gesehen hat. Und das war auch das Spannende: Diese Figuren hatten etwas sehr Fremdes und Ungewöhnliches. Alle Figuren in diesem Film haben ein Geheimnis: Wie die gucken, wie die sich bewegen, wie die Gesichter geschminkt sind, wie die angezogen sind – das waren alles Kunstfiguren, bis auf die Hauptfigur. Aber alle anderen waren schon vom Stil her verfremdet, und das macht natürlich auch das Geheimnis dieses Films aus.

Konzeptueller Hintergrund des Films

Der Film hat einen fundamentalen philosophisch-konzeptuellen Hintergrund. Wie der Philosoph Arbogast Schmitt (2011) in seinem Buch über Descartes und Plato schreibt, beginnt – aus heutiger Sicht – die Moderne im Jahre 1641 mit den Meditationen und Reflexionen des französischen Philosophen René Descartes am Kaminfeuer, der, im Sessel sitzend und erwachend, darüber nachgrübelt, ob nicht sein Erwachen eine Illusion innerhalb einer Welt von Traum und Fantasie sein könnte und ob nicht auch unser alltägliches Wachbewusstsein eine imaginative Seite purer Fiktionalität beinhalten könnte, innerhalb derer es unmöglich ist, „reale Wirklichkeit" von konstruierter Wirklichkeit präzise zu unterscheiden und damit zum „Eigentlichen" des Lebens, (was immer das sein mag), vorzudringen. Damit stellt sich grundsätzlich die Frage nach dem (dialektischen) Verhältnis zwischen „Realität und Fiktionalität" (Emrich u. Roes 2011), und es wird, wie A. Schmitt ausführt, die ältere, von der Antike des platonisch-aristotelischen Denkens geprägte Philosophie als „naiv" angesehen, was – wie Schmitt ausführlich darlegt – der kritischen Sicht der Dinge bei Plato allerdings nicht wirklich gerecht wird. Diese kritische Sicht wird übrigens auch in „Welt am Draht" dargestellt, z. B. im Hohlengleichnis.

„Wer sagt uns denn, dass das hier auch nicht ein Computer ist? Sie, ich, alle hier. Vielleicht sind wir auch nur elektronische Schaltkreise. … Der Whisky, die Erdnüsse, alles künstlich. Vollmer muss unendliche Angst gehabt haben, weil er es wusste, dass diese Welt nicht die wirkliche Welt ist. Haben Sie 'ne Zigarette für mich? Danke: ich denke. Walfang: Ja. Also bin ich nicht? Walfang Ja …
Doch, doch, ich existiere, und doch bin ich nicht der einzige, der sich mit dem Gedanken befasst, dass nichts wirklich existiert, oder? Nein, nein.
Eben – schon Plato hat die letzte Realität in der reinen Idee gesehen und erst Aristoteles – der hat die Materie als passive nicht-Substanz begriffen, die nur durch Denken Realität produziert hat.
So, so.
Sind Sie sicher, dass das eine Zigarette ist? … Die Idee einer Zigarette.
Die echten Zigaretten werden woanders geraucht, nämlich da, wo richtige Leute auf richtigen Stühlen sitzen. Da ist die Idee einer Idee einer Idee. Sie sind ein Nichts, weil nichts nichts denkt.

Naiv oder nicht: Tatsache ist, dass in der Gegenwart eine Vielzahl von Filmen entstanden sind, die unser Denken, Fühlen und Handeln immer stärker auf die Differenz zwischen dem Konstruierten, dem künstlich Erzeugten einerseits und dem „natürlichen Bewusstsein" (G. W. F. Hegel) andererseits beziehen. Solche Filme spielen für unser Leben eine große Rolle, nicht in erster Linie, weil sie ein philosophisches Thema und Problem beleuchten – das tun sie auch – sondern weil sie eine metaphorische Welt etablieren, die sich auf unser Gegenwartsthema bezieht: Wie weit ist unsere von Technik, Rationalität und Konstruktivität auch begrifflich durchdrungene Welt bereits „Avatar-haft" geworden und in einem so ausgeprägten Maße „entfremdet" (G. W. F. Hegel), dass Künstlichkeit uns als unsere „zweite Natur" (Jonas 1979) erscheint.

Auch ein zweiter kritischer Aspekt unserer Gegenwarts-Verfasstheit kommt in diesen Filmen zum Tragen, nämlich die Mächtigkeit des „Medialen" in dem Sinne, dass es immer weniger in unserem Leben um das konkret Erfahrbare, das authentisch Erlebte, das Unmittelbare geht („die Berührung") (Schlimme et al. 2008). „Realität" erscheint uns immer stärker als auf der Basis des technisch Übertragenen, Mediatisierten und somit Manipulierbaren beruhend.

So ist auch die Welt der *Welt am Draht* eine solche der sich selbst perpetuierenden Elektronenwolken, der Software-Programme, die auf riesigen Elektronenrechnern bewegt werden und uns als Sklaven dieser „Draht-Welten" erscheinen lassen.

Fassbinder war bezüglich dieser elektronisch-virtualisierten Lebensform ein Visionär: Menschen hängen ja heute z. T. wirklich „am Draht". Sie sind im alltäglichen Leben verkabelt, hören ständig Musik und Unterhaltung und sind von Handys und I-Pads in ihrem Leben ständig unterbrochen, verschwinden z. T. im Internet (Facebook oder „World of Warcraft") als computersüchtige Menschen. Sie leben – wie in diesem Film – in einer entfremdeten Realität und gehen oft achtlos aneinander vorbei. Sie sind wie unerlöste, unerwachte Monaden (Leibniz), wie die „Simulationseinheiten", unpersönlich, austauschbar – dies im Sinne des gegenwärtigen Funktionalismus, in dem es nur noch um die Funktionen geht, die optimiert werden müssen, nicht aber um Personen.

Wie kommt Fassbinder nun zu dieser Sicht der Dinge, und warum erzählt er sie uns? Fassbinder hat einmal so treffend (zu dem Schauspieler Karl Heinz Böhm) über sich gesagt: „Ich schieße einfach in jede Richtung" (Pflaum 1992). Wie Karl Heinz Böhm berichtet, sagte Böhm (im Jahre 1974) zu Rainer Werner Fassbinder: „Sag mal, ich habe jetzt dieses Buch gelesen. Ich weiß, dass Du gegen die Rechten bist, ich weiß, dass Du gegen die Linken bist, gegen die Extremisten, gegen die und den – für wen bist du eigentlich?" Antwort: „Weißt Du, ich sehe nur, wo überall was brennt und wo was schief läuft und wo was stinkt. Und ob das jetzt rechts oder links, oben oder unten ist, ich schieße einfach in jede Richtung."… Böhm: „Das war Fassbinder." In diesem Fall schießt er in eine Ecke der entfremdeten Wirklichkeit in modernen Massen-Gesellschaften, in denen Menschen von Industriekonzernen und medialen Systemen wie Insekten gesteuert und manipuliert werden.

Dabei kann man wohl bezüglich der Staffage-Funktion der wie eine Komparserie auftretenden Gestalten der meisten „Identitätseinheiten" im Film quasi eine „Avatar-Realitäts-Hirarchie" aufstellen, die besagt: Es gibt die ohne Bedeutungsgehalt auftretenden „leeren" Simulationseinheiten. Diese sind rein funktionelle, ohne wirklichen Gehalt auftretende Identitätshülsen: austauschbar. Es gibt ferner die Simulationseinheiten, die sich zum „Wissen" vorgearbeitet haben (wie Vollmer und Christopher Nobody); über diese sagt Eva Vollmer, Programmiererin aus der „wirklichen Welt": „Ja, das war ein Fehler, dass wir euch ein eigenes Simulationsmodell entwickeln ließen. Da lernt einer schnell zuviel!"

Und schließlich gibt es die Avatare, die die Projektionen von lebenden Menschen in der „wirklichen Welt" sind, wie Fred Stiller und Eva Vollmer, die das spätere Liebespaar repräsentieren, das sich am Ende (durch „Individuation") „erlöst".

Filmwirkung

Filmwirkung in den Jahren 1973 ff

Der Film wurde 1973 überwiegend sehr positiv aufgenommen. So schreibt „Die Zeit" (1973), es handele sich um ein „Computer-Traumspiel, zelebriert als psychedelischer Sinnenrausch" mit „suggestiven Kamerabewegungen in spröden, kahlen Vorstadt-Landschaften und im IBM Design, verfremdet zu einer Mixtur aus ‚2001‘, Jugendstil, Interlübke und Futurismus …" In „Bild und Funk" wird hervorgehoben, dass Fassbinder nach den „alten Stars" greife und Fassbinder wurde gefragt, ob er auch künftig mit Stars aus früheren Filmen drehen wolle. Fassbinder: „Ja, da gibt es viele. Ich könnte mir auch vorstellen, mal mit Maria Schell zu arbeiten. Auch O. W. Fischer finde ich prima!" Zum 25-jährigen Todestag von Fass-

binder wird von der Stuttgarter Zeitung im Juni 2007 hervorgehoben, dass es sich bei *Welt am Draht* um einen prophetischen Science-Fiction-Film gehandelt hat, mit einem „Melodram als Grundperspektive der Existenz" und einem „Existenzsprung nach oben".

Filmwirkung heute

Von der Frankfurter Allgemeinen Zeitung (18.2.2010) wird die auf der Berlinale gezeigte restaurierte Fassung regelrecht gefeiert und als „fabelhaft gelungen" bezeichnet. Der Film sei hochaktuell geblieben. Zum Schluss des Films schenke Fassbinder dem Protagonisten „doch noch ein richtiges Leben, möglicherweise sogar jenseits der großen falschen Wirklichkeit". Marie Andersen nimmt in „Kino-Zeit.de" zur restaurierten Fassung Stellung und formuliert:

> … seinerzeit vom WDR produziert birgt dieser ungeheuer dichte Film eine kuriose Schauspieler-truppe, die in den Nebenrollen mit markanten Gestalten … besetzt ist. Das Spiel mit dem Spiel um Realitäten ist durch starke Bilder von einer Atmosphäre schwelender Eindringlichkeit bestimmt, die durch permanent präsente Elemente wie Videokameras, Spiegel und Glas verdichtet wird. *Welt am Draht* jongliert gekonnt mit den vielschichtigen Ebenen von Wahrnehmung, Bewusstsein sowie Konstruktion und demaskiert eine objektive Realität als Ausprägung einer Deutungshoheit – eine Erkenntnis, die in diesem Universum zunächst als Wahn deklariert wird … für die damalige Zeit, aber auch heute noch stellen diese philosophischen Betrachtungen ein immens spannendes, nachhaltig anregendes Territorium dar.

In der Gegenwart wurde *Welt am Draht* geradezu enthusiastisch aufgenommen und gefeiert. So wurde getitelt: „*Welt am Draht* – die bessere *Matrix*"[7].

Exkurs: Medialität und Vermittelung – zu den psychischen Wirkungen moderner Medien

Von dem Chanson-Sänger Georg Kreisler stammt das Lied:

> Hab ich geschlafen, hab ich geträumt, gab ich nicht acht, war´s eine Fliege, die mich plötzlich geweckt hat? Oder der Sessel, auf dem ich saß, hat der geknackt, war´s eine Hupe, die von fern mich erschreckt hat? Jedenfalls tut es mir leid, dass ich schlief, denn es ist doch erst dreiviertel zehn; lange vor Mitternacht, also zu zeitig, um endgültig schlafen zu gehen … Dreh das Fernsehen ab, Mutter, es zieht … irgendwer schreit, irgendwer flieht, dreh das Fernsehen ab Mutter, es zieht …

Dieses Lied konfrontiert die allabendliche friedvolle ganz persönliche Atmosphäre charakteristischer Eigenwelt und Subjektivität mit dem modernen öffentlichen Medium, dem Fernsehen, in der Weise, dass gesagt wird „es zieht", d. h. hier kommt etwas ins Spiel, das von Außen her kommt, die Atmosphäre verändert. Von der Zugluft hat man von alters her gemeint, dass sie Schaden bringen kann, krank machen kann: Was hat es damit auf sich? Es wird eine Welt der Anonymität geschildert, die gefahrvoll ist: „Irgendwer schreit, irgendwer flieht". Es ist eine eigentümliche Weise der Anonymisierung und Abstrahierung unserer Wirklichkeit, die unauthentisch, jederzeit beliebig und auswechselbar erscheint; und in dieser Wirklichkeit geht es um Gefahr und um Aggressivität … Der Medientheoretiker Marshall McLuhan ([1]1951; 1996) hat in einem seiner Texte ausführt

7 www.moviepilot.de. Zugegriffen am 22.10.10.

Wir leben in einem Zeitalter, in dem zum ersten Mal Tausende höchst qualifizierter Individuen einen Beruf daraus gemacht haben, sich in das kollektive öffentliche Denken einzuschalten, um es zu manipulieren, auszubeuten und zu kontrollieren.

Moderne Massenkommunikationsmedien sind nicht nur gut für „Information", für die Befriedigung des Wissensdurstes einer „wissenssoziologisch" orientierten Gesellschaft: Vielmehr geht es um die Beeinflussung vom Meinungen durch „Wissen", es geht um gezielte Lenkung in politischer und ökonomischer Hinsicht. Das allerdings als solches ist keineswegs neu: Bereits Julius Cäsar hat als Konsul dafür gesorgt, durch geeignete Massenveranstaltungen in den großen Arenen Roms, durch Feste und geschickte politische Reden die Bevölkerung Roms zu manipulieren. McLuhans Bedeutung liegt in diesem Sinne eben auch nicht darin, die Prinzipien der Manipulation von Massen entdeckt zu haben – das war eher den gigantischen Inszenierungen von Joseph Goebbels vorbehalten –, sondern seine Bedeutung liegt darin, die Bedeutung des Mediums „als Medium" herausgearbeitet zu haben; zunächst anhand der Charakterisierung des „linearen Denkens" in dem, was er „die Gutenberg-Galaxie" genannt hat, nämlich die Tatsache, dass durch die massenhafte Verbreitung von Druckmaterial, Büchern, Zeitschriften etc. die Logik „linearer Texte" in massenhafter Form verfügbar wurden. Nach McLuhans Überzeugung ist das „lineare Medium" dabei eben nicht nur Träger, sondern in der formalen Struktur der Wissensvermittlung liegt bereits eine Inhalte mittransportierende kognitive Struktur, nämlich die lineare Struktur von sprachlich dominierten „Texten". Für McLuhan ist das Medium Fernsehen weniger linear, sondern assoziativ und in der Art, wie ein Medium kulturell funktioniert, sei die soziologische Bedeutung des Mediums stärker ausgeprägt als in dem Inhalt als solchem. So findet sich im New Yorker Magazine eine Karikatur mit dem Satz (Dunn 1966):

Sieh mal, Vati, Professor McLuhan sagt, dass die Umwelt, die der Mensch sich schafft, zu seinem Medium wird, in dem er seine Rolle definiert. Die Erfindung des Buchdrucks schuf das lineare oder folgernde Denken, wobei das Denken sich vom Handeln löste. Heute mit dem Fernsehen und Folk-Singing, kommen sich Denken und Handeln wieder näher, und das gesellschaftliche Engagement wird größer. Wir leben wieder in einem Dorf. Klar?

Fragen nach „medialen Wirklichkeiten" haben mit philosophischen Betrachtungen zu tun, die mit der Entstehung und Begründung der abendländischen Philosophie zu tun haben, nämlich mit dem platonischen Sokrates. Sokrates sagt in einem seiner Dialoge: „Das Buch muss immer seinen Vater bei sich haben". Und zwar dies deshalb, weil es sonst zu einer Entfremdung des Geistes kommt. Das Buch kann man nicht für Rückfragen verwenden, wenn es Unklarheiten und Widersprüche im Text des Buches gibt. Das Wesen der sokratischen Methode ist aber eben der Dialog: das Frage- und Antwort-Geschehen. Die Grundidee ist es, zu sagen: „Oida ouden eidos"; dies bedeutet, dass jederzeit der – ja kein feststehendes Wissen habende – Philosoph Fragen stellen können muss. Kann man aber einen Fernsehredakteur während der Sendung unterbrechen, und dies als Zuschauer vor dem Fernsehgerät? Kann man eine Zeitung oder einen Rundfunksprecher als Hörer unterbrechen und nachfragen? Wir haben uns längst daran gewöhnt, dass man nur von Medien berieselt wird, aber eben nicht hinterfragen kann. Wegen der fehlenden Rückfragemöglichkeit hat Sokrates sich geweigert, Bücher zu schreiben. Er sah die philosophische Aufgabe, die Chance der Wahrheitssuche, im „authentischen Moment", nicht in der entfremdeten Vermittlung. Entweder unmittelbare, „ab ovo" Vermittlung des authentischen Kairos oder gar keine Vermittlung. So sah es Sokrates. Und so heißt es im „Phaidros" des Plato (um 370 v. Chr.; 1965) als Rede des Sokrates:

> Jede Rede, wenn sie nur einmal geschrieben, treibt sich allerorts umher, gleicherweise bei denen, für die sie nicht passt, und sie selber weiß nicht, zu wem sie reden soll, zu wem nicht. Gekränkt aber und zu Unrecht betadelt, bedarf sie immer der Hilfe des Vaters, denn selbst vermag sie sich weder zu wehren noch zu helfen.

Sein Dialogpartner und Autor Plato sah es anders: Er glaubte an das Medium „Vorlesung" im Rahmen der von ihm gegründeten philosophischen Akademie und an das Vorlesungsmanuskript, an das Buch. Aber das Buch war damals eben noch ein Unikat. Es konnte nur abgeschrieben werden. Der Buchdruck von Gutenberg, das Gutenberg-Universum McLuhans, lag noch ca. 1500 Jahre weit in der Zukunft. Wird nach großen Theoretikern zum Thema „Medialität und Vermittlung" durch moderne Medien gefragt, so fallen uns einige wenige große Namen ein: das Buch von Walter Benjamin „Die Bedeutung des Kunstwerks im Zeitalter seiner technischen Reproduzierbarkeit", dann das Werk von Horkheimer und Adorno, „Dialektik der Aufklärung" von 1969, ein Buch, in dem die beiden Philosophen und Soziologen das Massenmedium Fernsehen dahingehend kritisieren, dass die fundamentalen Änderungen, die sich aus den manipulativen Rückwirkungen des Fernsehens ergeben, zu Schädigungspotenzialen führen können, die sie allerdings durch quantifizierende Studien und qualitative Erhebungen noch nicht absichern konnten.

Erst neuere Untersuchungen konnten die möglichen Schädigungspotenziale der neuen elektronischen Medien für Kinder und Heranwachsende aufzeigen (te Wildt 2004):

> Es existiert eine Reihe von Untersuchungen über Störungen, die einen Zusammenhang mit Medienwirkungen aufweisen. Einige fallen in den Bereich somatischer Disziplinen, hier dann meist in das Fachgebiet der Pädiatrie. So wurde bei Kindern mit ausgeprägtem Computerspielverhalten eine Beeinträchtigung der Sehfähigkeit (Kerr 2002), ein Hand-Arm-Vibrations-Syndrom und eine charakteristische Tendinitis, die sog. „Nintendonitis" beschrieben. Die meisten medizinischen Publikationen zum Thema „Medienwirkungen" sind erwartungsgemäß im Fachbereich der Psychiatrie angesiedelt. Auch hier spielen Beobachtungen an Kindern und Jugendlichen eine besondere Rolle, da die mögliche Rückwirkung von Gewaltdarstellungen in Film, Fernsehen, Video und Computerspielen zunächst die gesellschaftlich relevantesten und in diesem Zusammenhang augenfälligsten Fragen aufwerfen. Da sich aus den zumeist empirischen Forschungsergebnissen aus Psychologie, Pädagogik und Soziologie bisher keine nachhaltigen Impulse für den Umgang mit Gewaltdarstellungen ergeben haben, erscheint eine Einbeziehung psychiatrischer Herangehensweisen geboten, um die Problematik im Zuge experimentelle Untersuchungen unter anderem auch neurobiologischer Dimensionen zu erschließen.

Psychodynamische Interpretation

Vom psychoanalytisch-tiefenpsychologischen Standpunkt aus bedeutet der seelische Prozess, der sich in *Welt am Draht* abspielt, die Selbstwerdung des Menschen aus seinen Teilelementen heraus; bedeutet im Sinne Sigmund Freuds die Aussage: „Wo Es war, soll Ich werden", bzw. im Sinne von C. G. Jung den Prozess der „Individuation". Dabei geht es aber letztlich – vom philosophischen Standpunkt aus – um eine Form der „Transzendierung". Wie Sören Kierkegaard in seinem Frühwerk „Entweder-Oder" ([1]1843; 1987) skizziert hat und in seinem Spätwerk „Krankheit zum Tode" (1991) weiter ausführte, geht es dabei um „Selbstwahl", d. h. die „Wahl eines eigenen Selbst", aus den Elementen der präpersonalen Existenz. Später, in der existentialistischen Sicht von Jean Paul Sartre („Das Sein und das Nichts"), ist die Selbstwahl eine Form der Autonomisierung der Person aus Freiheit heraus. Beschreibt man diese Vorgänge aus der Sicht der vorpsychoanalytischen „dynamischen Psychologie" der Romantik (vgl. das Buch von

Ellenberger „Die Entdeckung des Unbewussten"), so ist dieser Prozess so zu sehen, wie wenn die Puppe „Olympia" (Hoffmann 1991) sich – emanzipatorisch – in eine lebende Person hochentwickeln würde.

Vergleicht man *Welt am Draht* mit dem groß angelegten *Matrix*-Werk der Gebrüder Wachowski, so zeigt sich einerseits sehr eindrucksvoll und dabei sehr schön, wie es Fassbinder mit einfachen filmischen Mitteln gelingt, das große Thema der „elektronischen" Wirklichkeitsentfremdung darzustellen. Bei ihm sind es die Nuancen der quasi „mikroskopischen" Bild-Verzerrung, die dies in geheimnishafter Weise deutlich machen. Dabei schreckt Fassbinder natürlich auch nicht vor einigen Karikaturhaftigkeiten und kleinen Grotesken zurück.[8] Im *Matrix*-Werk dagegen ist das Besondere, dass der Film als solcher bereits gewissermaßen die Sprache der Elektronen „spricht" und eine neue Ästhetik entwickelt hat, innerhalb derer die völlig glatten Oberflächen das Konstruierte aller dieser Wirklichkeiten bereits filmästhetisch durchdeklinieren und damit einen völlig neuen filmischen Stil, eine neue Filmepoche kreieren. Insofern wird in *Matrix* der mythologische Charakter künstlicher Welten filmstilistisch sehr viel stärker realisiert. Bei Fassbinder dagegen ist die elektronisch geformte und konstruierte Wirklichkeit nicht – von unserer Warte aus – ver-formt und als solche entfremdet: Sie ist vielmehr zugleich „unsere Welt". Nur wird sie anders beleuchtet und hat damit den eigentümlichen Gestus, dass damit gesagt wird: Schaut sie euch an, unsere Wirklichkeit, sie ist bereits als solche entstaltet. Es braucht nichts weiter, sie in ihrer Unnatürlichkeit zu zeigen, als sie so, wie sie ist, abzufilmen, so wie sie sich präsentiert.

Obwohl ein Fernseh-Film, handelt es sich um ein filmisches Meisterwerk (vgl. Presseartikel „Die bessere Matrix"[9]), allerdings ist *Welt am Draht* nicht „besser" als *Matrix* sondern anders. *Matrix* etabliert eine neue Filmsprache, geprägt durch künstliche Oberfläche und reine Artefakte, was zu Fassbinders Zeit noch gar nicht möglich war. So bemerkt Fassbinder (2010, S. 183) in seinem Text „Welt am Draht – einige allgemeine Überlegungen":

> Welt I muss unbedingt real und szenisch im Film vorkommen. Wenn man eine ganze Weile nur Welt II gesehen hat, muss man plötzlich genau die gleiche Welt sehen, die sich aber merkwürdigerweise über das, was auf dem Bildschirm passiert, amüsiert zeigt, Sorgen macht, irgendwie eingreift usw., ohne dass der Zuschauer genau wüsste, was das eigentlich soll.

Zur inhaltlichen Begründung schreibt Fassbinder hierzu (ebd., S. 179–180):

> Die Intelligenz, die kulturellen, zivilisatorischen, technologischen Qualifikationen, mit denen Welt I Welt II hat programmieren müssen, werden von deren Bewohnern schließlich dazu benutzt, ihrerseits ein Simulationsmodell für ihre eigenen Bedürfnisse zu schaffen. Weil sie jetzt selbst ein von ihnen abhängiges System haben, lernen sie etwas über Abhängigkeit und darüber, dass sie selbst nur auf fremde Rechnung existieren. Aus den Simulationseinheiten von Welt II werden Identitätseinheiten, mit denen Welt I nichts mehr anfangen kann. So gesehen scheint es einfach um die Frage des richtigen Bewusstseins, der Einsicht in seine Lage zu gehen (‚Wer seine Lage erkannt hat, wie sollte der noch zu halten sein?') Aber Bewusstsein ist keine abstrakte Angelegenheit, die Hall (der Programmierer in der Romanvorlage) den Simulationseinheiten bloß durch die Information (hört mal, Jungens, ich hab da was entdeckt!) mitteilen brauchte, und schon wären sie freie Menschen. Man muss also zeigen, wie das Bewusstsein über seine Lage sich an konkreten Dingen bildet, also: die Leute müssen unter den Bedingungen ihrer Gesellschaft auch leiden und endlich beschließen, die Welt jetzt einmal so einzurichten, wie sie ihnen selbst passt und nicht nach Maßgabe von irgendwelchen anderen Instanzen. Das heißt auch, dass sie den Simulator, der in ihrer Welt entwickelt

8 www.moviepilot.de. Zugegriffen am 22.10.10.
9 So sagt die Vorsitzende der Rainer Werner Fassbinder Stiftung, Julia Lorenz, in einem Gespräch mit dem Kameramann Michael Ballhaus (2010): „Die Figuren sind wirklich von einem anderen Stern."

worden ist, jetzt auch für ihre eigenen Bedürfnisse in Anspruch nehmen, anstatt mit ihm die Kampagne für die neue Waschmittelmarke ausrechnen zu lassen.

Aus diesem Text Fassbinders, den er in einer frühen Phase der Arbeit an diesem Film geschrieben hat, lässt sich ableiten, dass für Fassbinder hier Konstruktion und Simulation künstlerische Metaphern darstellen für den gesellschaftskritischen, psychosozialen, geistig-seelischen Impuls, die eigene Situation neu zu verstehen und sie damit in die Hand zu nehmen und neue autonome Aktivitäten in Gang zu setzen. Letztlich geht es dabei um eine genuine geistige Eigenschaft des Menschen, Wirklichkeit nicht „unmittelbar" real wahrnehmen zu können, sondern sie vorab (a priori, im Sinne von Immanuel Kant) konstruieren zu müssen. Insofern leben wir ja tatsächlich in unserer Geistigkeit immer in einer Art „Zwischenwelt", zwischen einerseits reiner Phantasie, Imagination, Konstruktion und sogar Wahnideen, andererseits der unmittelbaren Realität des „Hier und Jetzt", dessen, „was sich zeigt" (Phänomenologie, Husserl 1985), dessen, was wir konkret erleben (Schmitz 1997) und im Sinne der Kant-kritischen Philosophie von F. H. Jacobi „vernehmen" können („vernehmende Vernunft"). Der Philosoph Gadamer spricht vom „Abhören". Auf diese Weise leben wir Menschen in unserem Alltag, in dem konkreten Leben der unmittelbaren Lebenswirklichkeit immer – ohne es zu bemerken – in einer Doppelwirklichkeit: einerseits der Realität des „Hier und Jetzt" – andererseits der (fiktionalen) „abgehobenen" Realität des „Aboutism" (Perls [1]1969; 1976). Diese Doppelung der Welterfahrung hat der philosophisch geprägte russische Dichter Lew Tolstoj in seinem großen Roman „Anna Karenina" in den Figuren von zwei Brüdern dargestellt: Der eine ist Landwirt, der andere ein Intellektueller aus Moskau. Beide machen in dem von Tolstoj beschriebenen Moment gerade dieselbe Naturerfahrung und doch sind sie in ihrem Erleben ganz verschieden. Der eine ist der intellektualisierenden Ebene des „Darüber-Hinweg" von geistigen Wirklichkeitskonstruktionen verhaftet, der andere taucht in die Natürlichkeit der unmittelbaren Seinsrealität der Agrarlandschaft ein (Tolstoj 2010, S. 366):

> Sergej Iwanowitsch weidete sich die ganze Zeit an der Schönheit des dicht mit Laub zugewucherten Waldes, wies den Bruder bald auf eine alte, an der Schattenseite dunkle Linde hin. … Konstantin Lewin hörte und redete nicht gerne von den Schönheiten der Natur. Für ihn nahmen die Wörter dem, was er sah, die Schönheit.

Beim Mähen erlebt der Landwirt (Tolstoj 2010, S. 381):

> In seiner Arbeit vollzog sich nun eine Veränderung, die ihm riesiges Vergnügen bereitete. Mitten in der Arbeit gab es Minuten, da vergaß er, was er machte, ihm wurde leicht …

In diesem Sinne sind die verschiedenen Simulationsebenen von *Welt am Draht* radikalisierende Metaphern für etwas, was vorab in allen geistigen Wesen angelegt ist, aber durch technische Realisation und Manifestation massiv verstärkt werden kann und dann ein Eigenleben entfaltet, das einen bedrohlichen Charakter annimmt: Der Boden schwankt für Fred Stiller (vgl. auch *Vertigo* von Hitchcock), die Identität wird fraglich und der „Filmriss" wird zur Alltagserfahrung.

Solche Erfahrungen prägen unser Leben in einer Weise, die – wie Freud sagt – bedeutet, sich zur „Ich-Werdung"[10] vorzuarbeiten, bzw. mit C. G. Jung gesprochen, uns zur „Individuation" zu führen. Letztlich geht es bei dem Film allerdings nicht um Tiefenpsychologie und Psychoanalyse, es geht vielmehr um die Darstellung der Rätselhaftigkeit und Undurchdringlichkeit des psychosozialen Daseins in einer mediengesteuerten kapitalistisch durchdrungenen Massengesellschaft. Man schaut gewisser-

10 www.moviepilot.de. Zugegriffen am 22.10.10.

maßen, wie in dem Film von Jim Jarmusch *Night on earth*, aus einer „dritten Perspektive" in unsere alltägliche Welt hinein. Fred Stiller:

 „Unser Simulationsmodell muss man sich als verkleinertes repräsentatives Abbild unserer Gesellschaft vergegenwärtigen."

Was aber bedeutet aus dieser – künstlerischen, filmischen – Sicht Virtualität im Hinblick auf Realität? Nicht nur das Kino – und Cyberspace – auch der Roman, ja bereits die Odyssee, das älteste mythische große Narrativ – ist in gewissem Sinne virtuelle Realität, fiktionale (durch Poiesis entstandene) Wirklichkeit; und dies gilt auch für die Wissenschaft, die Welt der Theorien. Die Figur, die „ganz von unten" heraus aus der von der Simulation simulierten Wirklichkeit nach oben strebt – übrigens interessanterweise „Kontaktperson" – heißt nicht umsonst „Einstein": Offenbar ist dieser von Avataren erzeugte Avatar ein guter Theoretiker. Alle Szenen, die wir nach der Eruption Einsteins „Ich will nicht mehr zurück" sehen, haben einen besonderen Gestus der Verunsicherung und Entfremdung, der angedeuteten Derealisation und Depersonalisation der Figuren bis hin zu der in einen Kindermund gelegten Aussage „Ich sehe was, was du nicht siehst" und:

 „Was sehen Sie? Bitte, bitte: was sehen Sie? … Ich will Ihnen helfen … Was Sie sehen, wenn Sie in den Spiegel schauen, ist nämlich genau das Bild, das man sich von Ihnen gemacht hat, nichts anderes."

Entfremdungsphänomene finden sich bereits in der allerersten Einstellung des Films. Diese ist aufregend, wenn auch scheinbar belanglos: Denn es wird in eine Verwaltungs- und Fabrikarchitektur eingeführt mit vorfahrenden Autos (auch einer Minister-Staatskarosse), die – ähnlich wie in dem Film von Martin Scorsese *Shutter Island* – vorwegnimmt, dass da mit der Realität etwas nicht stimmt. In *Shutter Island* zeigt sich eine schlecht zusammenkopierte, an Studioaufnahmen der 50er-Jahre erinnernde Komposition aus Außen- und Studiowirklichkeit, in *Welt am Draht* sieht man zu Beginn bewegte Bilder mit leichten Verzerrungen und Bild-Schwankungen, Bildqualitäten die andeuten: „Dies ist nicht real", dies ist eine Projektion. Der Kameramann Michael Ballhaus erklärt dies im Interview so (Juliane Lorenz 2010):

Lorenz: ‚Habt ihr euch nicht mal gefragt, was ist nun wahr und was nicht?'
Ballhaus: ‚Ich glaube, das hat jeder für sich selber erlebt … na ja, da ist schon was dran: wer sagt uns, dass wir nicht auch sozusagen „am Draht" sind? Dieses Eingangs-Bild des Films, als ich das zum ersten Mal wieder gesehen habe, da hat des gewabert, was war denn da? Dann habe ich mich erinnert, dass wir das mit einer sehr langen Brennweite gedreht haben, mit glaube ich 250mm, ich bin fast versucht zu sagen, dass wir unter die Linse einen Bunsenbrenner getan haben, dass das Bild dadurch auch ein bisschen wabert, das war glaube ich sogar Absicht; dann kam da noch ein bisschen Dampf dazu …'

Der Beginn des Films ist somit wellig, vergrisselt, und hat lokale Unschärfen. Und in das Geheimnis des Prof. Vollmer, der seine wirkliche Lage als „künstliches Wesen" entdeckt, wird eingeführt über das Paradox – als „logische Illusion" – des Zeno mit der Schildkröte, die der laufende Krieger niemals einholen kann, da die Schildkröte in jedem Zeitmoment durch die Bewegung des Kriegers ein bisschen weitergekommen ist. Dieses Paradox ist als Paradigma der Illusion über das Selbstsein zu sehen, wobei im Film Zeno für die Identitätseinheit Ce-Nobody steht, einen Avatar 2. Ordnung, der das Geheimnis seiner Identität entdeckt hat und deshalb „abgeschaltet" wird.

Das Zeno-Paradox ist in diesem Film als philosophische Geheimbotschaft aufzufassen, die die Aufgabe hat, einerseits auf den illusionären Charakter von Wirklichkeit hinzuweisen, andererseits auch

Abb. 3 Eva Vollmer (Mascha Rabben) und Fred Stiller (Klaus Löwitsch) in der Berührung nach der „Landung" in der wirklichen Welt. (Quelle: DVD Arthaus Premium 2010)

zu zeigen, dass es in der computersimulierten Welt 2. Ordnung (Welt 3) eine „wissende" (suizidale) Simulationseinheit C.Nobody gibt, von der die Lösung des philosophischen Rätsels zu erfahren ist.

Letztlich geht es aber nicht um die Auflösung dieses Paradoxons, sondern um das Welt- und Wirklichkeitsverhältnis, das im Film von Stiller: philosophisch so dargestellt wird:

> „… schon Plato hat die letzte Realität lediglich in den reinen Ideen gesehen. Und erst Aristoteles, der hat die Materie als eine passive Nicht-Substanz begriffen, die nur durch das Denken Realität produziert hat."

Durch diese die Wirklichkeit relativierende Grundstruktur des Films kommt es immer wieder zu Entfremdungsphänomenen, innerhalb derer sich viele Verhaltensweisen der Figuren im Film als marionettenhaft darstellen. Es geht um so etwas wie ein „Leben in Floskeln", so wie dies Vincent van Gogh (in einem Brief an seinen Bruder Theo) einmal gesagt hat (van Gogh 1959): „Ein Leben, in dem es nur auf Konventionen ankommt". Durch sein desillusionierendes Wissen ist für Stiller die ganze Welt rätselhaft und undurchdringlich, er steht vor Prozessen der Identitätsauflösung und der Identitätsdiffusion, wie sie nach schweren Traumatisierungen und in psychotischen Prozessen bekannt sind, und so wird Stiller ja auch von dem Institutspsychologen beurteilt.

Ausschlaggebend für die Bedeutung des Films ist aber letztlich das „transzendierende Moment", der Überstieg, das „nach oben hin zur wirklichen Welt" Streben und zwar dies – im melodramatischen Sinne Fassbinders – durch die Liebe: Denn der Forschungsleiter Stiller hat in der „oberen" (realen) Welt der tatsächlichen Programmierer einen Doppelgänger, nach dessen Bild er geformt ist; einen Stiller, dessen Charaktereigenschaften im Laufe seiner Karriere verrohen, während der simulierte Stiller in der Subtilität und Ernsthaftigkeit seiner Suche nach Wahrheit – mit einem geradezu faustischen Charakter („Wer ewig strebend sich bemüht, den werden wir erlösen.") – der von ihm geliebten Eva, der gesuchten „Kon-

taktperson", immer besser gefällt, sodass sie ihn dem Vorbild vorzieht. So ist Stiller in diesem Sinne ein echter Fassbinder'scher Held, der Authentizität und Leidensfähigkeit mit Mut zum Scheitern verbindet und dadurch – auch wenn man, wie Fassbinder sagt, „auf alles schießen" muss – uns alle ein ganzes Stück weiterbringt und sogar Avatare nobilitieren kann, denn der Film endet mit der sicherlich ironisch zu verstehenden Paradoxie, dass ein Mensch sich sonderbarerweise im Cyberspace vervollkommnen kann. Im Schluss des Films geht es immer stärker um die Frage nach emanzipatorisch subversiven und sozialkritischen Aspekten von *Welt am Draht*. Aus der Welt der Elektronen wird uns zugerufen: „Wir wollen ins wirkliche Leben hinein." So wie Imre Kertesz in seinem „Fiasko"-Roman die Arbeiter rufen lässt: „Wir wollen leben". Fassbinder'sche Helden sind immer irgendwie der Freiheit verpflichtet, auch wenn sie an dieser Anforderung scheitern (z. B. wenn der „Händler der vier Jahreszeiten" sich zum Ende des Films vor Familie und Freunden zu Tode trinkt). Es geht aber immer auch auf vertrackte, gewissermaßen verquere Weise, so auch in *Welt am Draht*, um ein Melodram: Es ist die Liebe von Fred und Eva, die die beiden zur Transzendierung hin, zum „wirklichen Leben" (S. das Motto von Johann Gottlieb Fichte) hinauf treibt. Und diese Liebe wird im Schluss sogar manifest, indem in der „harten Landung" in der „wirklichen Welt" das Liebespaar sich findet und eine Fühlwelt real wird (Müller-Scherz u. Fassbinder 2010, S. 176) (◘ Abb. 3):

Stiller steht auf, geht vorsichtig einige Schritte, befühlt seinen Körper. Eva nimmt Stiller bei der Hand. Führt ihn hinaus aus dem Transferierungsraum in ein Nebenzimmer, geht mit ihm zum Fenster. Stiller sieht Straßen, Verkehr und Menschengewühl auf den Bürgersteigen. Eva: ‚Jetzt schau mal – das ist die wirkliche Welt. Und du bist ein wirklicher Mensch. Du lebst. Ich liebe dich.'

Literatur

Descartes R (1972) Meditationen. Meiner, Hamburg (Erstveröff. 1641)

Die Bibel (2002) Pattloch Verlag, München, S 14

Donner W (1973) EDV-Elegie. Die Zeit 43, 19. 10. 1973

Dunn A (1966) Karikatur, Text. New Yorker Magazine 2. 7. 1966. Condé Nast Publications, New York

Emrich HM, Roes M (2011) Engel und Avatare. Matthes & Seitz, Berlin

Fassbinder RW (2010) Welt am Draht – einige allgemeine Überlegungen. In: Müller-Scherz F (Hrsg) Rainer Werner Fassbinder: Welt am Draht. Matthes & Seitz, Berlin, S 183

Galouye DF (1980) Welt am Draht. Goldmann, München (Erstveröff. 1964)

Hoffmann ETA (1991) Der Sandmann. Reclam, Ditzingen

Husserl E (1985) Die phänomenologische Methode. Reclam, Ditzingen

Jonas H (1979) Das Prinzip Verantwortung. Versuch einer Ethik für die technologische Zivilisation. Suhrkamp, Frankfurt/M

Jürgen F (2002) Rainer Werner Fassbinder. 1945–1982. In: Koebner T (Hrsg) Filmregisseure, Biographien, Werkbeschreibungen, Filmographien. Stuttgart, Reclam, S 213–220

Kant I (1974) Kritik der reinen Vernunft. Suhrkamp, Frankfurt/M

Kierkegaard S (1987) Entweder-Oder. Gütersloher Verlags-Haus, Gütersloh (Erstveröff. 1843)

Kierkegaard S (1991) Die Krankheit zum Tode. Europäische Verlagsanstalt Hamburg

Lorenz J (2010) Interview mit Michael Ballhaus. Welt am Draht. Presseheft. R. W. Fassbinder Foundation, S 12

McLuhan M (1951) The mechanical bride. Folklore of industrial man. The Vanguard Press, New York. McLuhan M (1996) Die mechanische Braut. Volkskultur des industriellen Menschen, Verlag der Kunst, Amsterdam

Müller-Scherz F, Fassbinder RW (2010) Welt am Draht. Matthes & Seitz, Berlin

Perls FS (1976) Gestalttherapie in Aktion. Klett, Stuttgart (im Original: Gestalt Therapy verbatim, 1969)

Pflaum HG (1992) Rainer Werner Fassbinder. Bilder und Dokumente. Edition Spangenberg, München, S 43

Platon (1965) Phaidros oder vom Schönen Reclam, Stuttgart (um 370 v.Chr.)

Schleider T (2007) Voller Kraft, Verzweiflung, Gewalt und Anarchie. Stuttgarter Zeitung, 9. 6. 2007

Schlimme JE, te Wildt B, Emrich HM (Hrsg) (2008) Scham und Berührung im Film. Vandenhoek & Ruprecht, Göttingen

Schmitt A (2011) Denken und Sein bei Platon und Descartes – Kritische Anmerkungen zur Überwindung der antiken Seinsphilosophie durch die moderne Philosophie des Subjekts. C. Winter Universitätsverlag, Heidelberg
Schmitz H (1997) Höhlengänge. Über die gegenwärtige Aufgabe der Philosophie. Oldenbourg Akademie Verlag, Berlin
Tolstoj L (2009) Anna Karenina. Hanser, München
van Gogh V (1959) Als Mensch unter Menschen; Briefe I und II. Henschelverlag, Berlin, Bd 1, S 426
Völckers H (2010) Welt am Draht. Presseheft. R. W. Fassbinder Foundation, S 7
te Wildt BT (2004) Psychische Wirkungen der neuen digitalen Medien. Fortschr Neurol Psychiatr 72: 574–585

Originaltitel	Welt am Draht
Erscheinungsjahr	1973
Land	BRD
Buch	Fritz Müller-Scherz, Rainer Werner Fassbinder
Regie	Rainer Werner Fassbinder
Hauptdarsteller	Klaus Löwitsch (Fred Stiller), Mascha Rabben (Eva Vollmer), Karl-Heinz Vosgerau (Herbert Siskins), Adrian Hoven (Prof. Henri Vollmer), Ivan Desny (Günter Lause), Margit Carstensen (Maya Schmidt-Gentner)
Verfügbarkeit	Als DVD in OV und deutscher Sprache erhältlich

Rainer Reffert

Schockmomente im Kinosessel

Westworld – Regisseur: Michael Crichton

Westworld

Regisseur: Michael Crichton

Die Handlung

Der Film, 1973 in den Kinos erstmals gezeigt (☐ Abb. 1), spielt in einer nicht genauer benannten Zukunft, was am futuristischen Design in zahlreichen Sequenzen des Films deutlich wird. Der Freizeitpark Delos, zu dem zahlreiche Urlauber in einem modernistischen Flugzeug unterwegs sind, bietet drei komplett ausgestattete künstliche „Welten". Die Besucher können eine römische Welt, eine mittelalterliche Welt um 1300 oder eine Wildweststadt um 1880 besuchen. Diese Örtlichkeiten sind sehr aufwändig nachgebaut, außer den Urlaubern gibt es eine große Anzahl von künstlichen Menschen, im folgenden Androiden oder Roboter genannt, die den Besuchern für sexuelle Ausschweifungen, aber auch für Kämpfe und Duelle zur Verfügung stehen. Im Wilden Westen (Westworld) können die Gäste nach Herzenslust in Saloons Whisky trinken, an Schlägereien oder Banküberfällen teilnehmen, sich mit Prostituierten vergnügen und als Revolverhelden ihre Rivalen (die Androiden) erschießen. Der Film zeigt, dass im Hintergrund ein enormer technischer Aufwand betrieben wird, um die zahlreichen Roboter, bis hin zu künstlichen Pferden und Schlangen, funktionsfähig zu halten und zu warten. Es gibt aufwändige Kontrollräume mit zahlreichem technischem Personal, das die Aktionen der Roboter überwacht und sich dabei riesengroßer Computer (entsprechend dem damaligen technischen Stand von Großcomputern) bedient. Nachts werden die, insbesondere durch Zweikämpfe und Schießereien, beschädigten Roboter geborgen, repariert und wieder in den Verkehr gebracht, am frühen Morgen wird über Computerprogramme die inzwischen stillgelegte Roboterwelt erneut in Gang gesetzt.

Die Hauptperson des Films ist der unsicher wirkende Peter Martin (Richard Benjamin), ein Rechtsanwalt aus Chicago, der von seinem wesentlich selbstbewussteren Freund John Blane (James Brolin), der Westworld schon öfter besucht hat, begleitet wird. Dieser animiert Peter, eine Schießerei zu beginnen und sich mit einer Prostituierten zu vergnügen. Peter ist anfangs noch zurückhaltend, zögerlich, gewinnt aber zusehends Spaß an dieser Form des Lebens im Wilden Westen.

Der Zuschauer des Films erfährt noch vor den Protagonisten, dass sich Unheil anbahnt. Die Techniker müssen immer mehr Fehlfunktionen der Roboter beheben, im Kontrollzentrum häufen sich Fehlermeldungen und Pannen. Es treten immer mehr Situationen auf, in denen die Androiden nicht mehr wie programmiert reagieren. Nun gerät alles außer Kontrolle. In der mittelalterlichen Welt wehrt sich ein Zimmermädchen („ein Sex-Modell") gegen einen zudringlichen Gast, der sich als Ritter vergnügen will. Schließlich wird eben dieser Gast von einem Zweikampf-Roboter, dem schwarzen Ritter, getötet. Die Roboter lassen sich nicht mehr kontrollieren und auch nicht mehr abschalten. Im Kontrollzentrum stellt man notfallmäßig den Strom ab, um die Androiden zu stoppen. Danach lässt sich der Strom nicht mehr einschalten, der Sauerstoff wird knapp und die Temperatur steigt stark an, das Personal gerät selbst in Lebensgefahr.

In der mittelalterlichen und der römischen Welt greifen die Roboter die Gäste an und veranstalten unter diesen ein Blutbad.

Im Wilden Westen hat Peter Martin schon zweimal einen Revolverhelden, den so genannten „Gunslinger", gespielt von Yul Brynner, im Duell getötet. Jetzt taucht der frisch reparierte und mit einer verbesserten sensorischen Wahrnehmungseinheit versehene Roboter wieder auf und fordert Peter und John zum Duell, in dem er John erst anschießt und dann tötet. Dies ist nur möglich, weil die Programmierung der Waffen, mit denen man nicht auf Menschen und deren Wärmestrahlung schießen konnte, nicht mehr funktioniert. Der Revolverheld wendet sich dann Peter zu, der gerade noch flüchten kann. Dies ist der Beginn einer Verfolgungsjagd, die fast das letzte Drittel des Films über andauert. Peter wird

von Gunslinger zunächst zu Pferde in der Wüste verfolgt, später in den unterirdischen Räumen des Kontrollzentrums von Delos, wo es Peter schließlich gelingt, den Gunslinger mit Säure zu verätzen, so dass er nicht mehr sehen kann. Dieser nimmt dennoch die Verfolgung wieder auf (er kann noch Wärmestrahlung erkennen), schließlich kann Peter ihn in Brand setzen und damit „töten".

Regie und Drehbuch

Michael Crichton schrieb das Drehbuch zu dem im November 1973 in den USA uraufgeführten Film und führte, erstmals in seiner Karriere in einem Kinofilm, auch Regie.

Crichton (geboren am 23. Oktober 1942 in Chicago, gestorben am 14. November 2008 in Los Angeles) war ein äußerst erfolgreicher US-amerikanischer Schriftsteller, Drehbuchautor und Regisseur. Er machte 1964 in Harvard einen Abschluss als Bachelor of Arts, studierte dann an der Harvard Medical School Medizin und promovierte 1969 (Abschluss als M. D. und Doctor of Medicine). Er verfasste 26 Romane und 11 Drehbücher, die sehr erfolgreich waren. Viele seiner Bücher wurden auch als Filme zu Kassenschlagern. Als Regisseur und Drehbuchautor drehte er 1977 mit *Coma*, 1979 mit *Der große Eisenbahnraub* sowie 1984 mit *Runaway* kleine Genre-Klassiker.

Sein erfolgreichster Film als Drehbuchautor war sicherlich *Jurassic Park*, eine, wenn man so will, Neuauflage des Themas von Westworld. Auch in *Jurassic Park* wird technologischer Fortschritt benutzt, um in einem exklusiven Vergnügungspark den Reichen dieser Welt etwas Besonderes zu bieten – und wiederum gerät die Technik (hier die Technik, die die wieder erschaffenen Dinosaurier im Zaum halten soll) durch einen Sabotageakt eines korrupten Technikers außer Kontrolle, die Dinosaurier können ausbrechen und töten viele der Besucher in spektakulären Verfolgungsjagden.

Crichton hat seine Erfahrungen als Arzt bereits 1974 in einem Drehbuch verarbeitet, aus dem Steven Spielberg später einer der erfolgreichsten Fernsehserien überhaupt, *Emergency Room – Die Notaufnahme*, machte. In Westworld (ein Jahr zuvor geschrieben) erinnern die Reparaturszenen in der Roboterwerkstatt stark an Szenen aus chirurgischen Operationssälen, jeweils mehrere Techniker, keim- und staubfrei gekleidet wie Chirurgen, kümmern sich um die Roboter.

Mit „Westworld" gelang ihm 1973 sein erster großer Durchbruch als Regisseur und Drehbuchautor. Das Budget für den Film war verhältnismäßig gering (low-budget), er war wirtschaftlich recht erfolgreich und einer der ersten Filme, die nicht zunächst nur in New York und Los Angeles, sondern zeitgleich landesweit in 300 Kinos in den USA gezeigt wurden.

Westworld war der erste Film der Geschichte, bei dem Computeranimation bzw. digitale Bildbearbeitung angewandt wurde, etwa bei dem computeranimierten Sichtfeld des Gunslinger.

Der Film ist sicherlich ein Science-Fiction-Film, er wird aber auch in den Kategorien „Action" und „Thriller" aufgeführt. In der Internet-Film-Datenbank „Imdb" (www.imdb.com) wurde er von 12.238 Benutzern mit durchschnittlich 7.0 von 10 möglichen Punkten geratet.

Zur Wirkung auf den Zuschauer

Ein „Männerfilm"?

Der Film beginnt mit einem Werbetrailer für den Freizeitpark Delos, in dem drei Männer und eine Frau zu ihren Erlebnissen interviewt werden. Die drei Männer vermitteln, dass ihre Erlebnisse (einer hat sechs Männer erschossen; der andere war zwei Wochen lang Sheriff in Westworld) etwas ganz Besonderes für sie waren. Man sieht förmlich, wie sich ihre Haltung aufrichtet und strafft, wie sie selbstbewusster werden, wie sich ihre Brust vor Stolz schwellt. Die Frau beteuert wortreich, wie eindrucksvoll ihre erotischen Erlebnisse in der römischen Welt waren. Die in diesem Vorspann gezeigten Erlebnis- und Verhaltensweisen ziehen sich durch knapp zwei Drittel des Films wie ein roter Faden.

Da im Film die beiden Protagonisten männlich sind, beschränke ich mich auf die Reaktionsweisen der männlichen Urlauber. Sie freuen sich wie Kinder auf ihren Abenteuerurlaub, werfen sich beim Einkleiden in Westernkleidung in die Brust, probieren ihre Waffen aus. Dabei sind zwei Stimmungen auszumachen: eine Unsicherheit in der neuen Welt, ob sie sich in der neuen Rolle bewähren werden sowie gewachsenes männliches Selbstbewusstsein, das mit der Annahme der neuen Rolle offensichtlich einhergeht. Dies fällt bei dem bebrillten Urlauber, der später Sheriff wird, und ganz besonders bei Peter Martin auf. Der stellt dem erfahrenen John Blane penetrant Fragen, wie es in Westworld zugeht, seine Unsicherheit vermittelt sich dem Zuschauer deutlich. Die Ruhe und selbstbewusste Ausstrahlung von Peter Martin, dem Erfahrenen, steht dazu in deutlichem Gegensatz. John führt also den unsicheren Peter in den Wilden Westen ein, ermutigt ihn und fordert ihn regelrecht zum ersten Duell mit dem Gunslinger auf. Dieses Duell ist eine klare Sache, Peter zieht viel schneller als der Revolverheld und gewinnt den Kampf ohne Probleme. Meine Reaktion in dieser Anfangsphase war hier eine Identifikation mit dem ruhigen, selbstbewussten John, verbunden mit einem Mich-Mokieren über den unsicheren und etwas ängstlichen Peter. Offensichtlich lächerlich ist auch der Urlauber mit der Brille, der vorm Spiegel übt seinen Revolver zu ziehen, und versehentlich auf sein Spiegelbild schießt. Wir, die Zuschauer, sollen uns über ihn lustig machen. Solche Szenen wiederholen sich auch später im Film, etwa als er das Amt des Sheriffs übernimmt, großspurig vor der Menge verkündet, dass er ab sofort der Sheriff sein werde und dann die Tür vom Büro des Sheriffs aus Ungeschick kaum öffnen kann. Die freudige Erregung der Urlauber wird im Film durch heitere Wildwest-Musik unterstrichen, die im Film wiederholt verwendet wird und die mich als Zuschauer in eine fast ausgelassene, erwartungsvolle Stimmung versetzt hat. Auch im Saloon, vor Peters sexuellem Abenteuer mit der Bardame, animiert geradezu die Saloonmusik. Zusammenfassend kann man sagen, dass bei den dargestellten Männern eine deutliche Unsicherheit in ihrem Auftreten als Mann besteht, die bis hin zur Lächerlichkeit reicht. Bei den Interviewten, die den Urlaub hinter sich haben, lässt sich genau das Gegenteil feststellen, sie sind stolz auf ihre Abenteuer, auf das, was sie Tolles geleistet haben (in Duellen und im Bett mit den Roboter-Animierdamen).

Schockmomente

Aber der Film nimmt seinen Lauf. Durch die Szenen mit den Fehlfunktionen der Androiden und die Dialoge im Kontrollzentrum spürt man sehr deutlich, dass sich Unheil anbahnt. Eine künstliche Klapperschlange beißt John Blane. Dieser Moment markiert das erste Mal, dass ein Roboter einen Menschen angreift und verletzt und ist daher gewissermaßen Vorbote des weiteren Geschehens. John ist darüber ebenso entsetzt wie der Cheftechniker im Kontrollraum. Und dieses Entsetzen überträgt sich auch auf den Zuschauer. Man überlegt, Delos für einen Monat zu schließen, entscheidet sich aber aus Profitsucht dagegen; man glaubt „die Sache in der Hand zu haben". Die Magd Daphne widersetzt sich einem Verführer und ohrfeigt ihn, der schwarze Ritter gerät außer Kontrolle und tötet seinen Nebenbuhler bei der Königin. Im Kontrollzentrum versucht man panisch, die Roboter abzuschalten, die überhaupt nicht mehr reagieren, Fazit: „wir haben jede Kontrolle verloren."

Diese Ereignisse haben bei mir eher ein Gefühl von unterschwelliger, wachsender Gefahr ausgelöst, jedoch keine Angst- oder Schreckmomente. Diese stellten sich bei mir immer dann ein, wenn es bei dem zunehmend gefährlichen Zweikampf zwischen Peter Martin und dem Gunslinger zu lebensgefährlichen Zuspitzungen, die sich immer mehr steigerten, kam. So ergab sich für mich eine Reihe von Angst-, ich würde durchaus auch sagen Schreck- und Schockmomenten, die sich auch körperlich äußerten, insbesondere durch plötzliches heftiges Herzklopfen und beschleunigte Atmung (also körperliche Begleiterscheinungen von Angst). Der erste, vergleichsweise kleine Schreck stellte sich ein, als Gunslinger, nach dem ersten Duell im Saloon repariert, den ahnungslosen John beim Rasieren überfiel. Obwohl zu diesem Moment eigentlich (noch) klar war, dass den Menschen „nichts passieren kann" und die Menschen keinesfalls verletzt werden, stellte sich der Schreckmoment trotzdem ein. Vielleicht wur-

de hier die Gefährlichkeit des Gunslinger, der völlig überraschend in die private Sphäre eingedrungen war, deutlich. Sigmund Freud hat sich zu Schreckmomenten folgende Gedanken gemacht (Freud [1]1920; 1960a, S. 10):

> Schreck, Furcht, Angst werden zu Unrecht wie synonyme Ausdrücke gebraucht; sie lassen sich in ihrer Beziehung zur Gefahr gut auseinanderhalten. Angst bezeichnet einen gewissen Zustand wie Erwartung der Gefahr und Vorbereitung auf dieselbe, mag sie auch eine unbekannte sein; Furcht verlangt ein bestimmtes Objekt, vor dem man sich fürchtet; Schreck aber benennt den Zustand, in dem man gerät, wenn man in Gefahr kommt, ohne auf sie vorbereitet zu sein, betont das Moment der Überraschung.

Zur Orientierung seien die nächsten, sich immer mehr steigernden Gefahren- und Schreckmomente kurz beschrieben: Die beunruhigendste Figur im Film, der Gunslinger, schießt John Blane an; sowohl John als auch sein Freund Peter sind schockiert und entsetzt. Aber nicht genug, der Revolvermann erschießt John danach und will auch Peter töten, der gerade noch flüchten kann. Spätestens jetzt ist klar, dass dies kein Spaß mehr ist, sondern blutiger Ernst, es geht um Leben und Tod. Es folgt eine fünfundzwanzig Minuten dauernde, für den Zuschauer nervenaufreibende Verfolgungsjagd, in der der Gunslinger Peter ständig verfolgt. Die Schockmomente werden immer von Gunslinger hervorgerufen: Er entdeckt Peter, der sich versteckt hat, um auf ihn zu schießen und deckt ihn mit einer ganzen Salve von Gewehrkugeln (er hat eine dem Revolver von Peter weit überlegene Winchester) ein, unter der dieser vor Schreck auch noch seinen Revolver verliert. In der nächsten Szene erschießt Gunslinger plötzlich und völlig unerwartet den Techniker, der Peter gerade erzählt hat, dass er gegenüber dem perfekten Roboter keine Chance habe, der ihm andererseits aber sagt, dass man das Gesichtsfeld mit Säure verätzen könne. Peters Flucht führt nun in das Labyrinth der unterirdischen Gänge von Delos, das eine klaustrophobe Wirkung hat, in dem sich Peter nicht zurechtfindet und in dem er bald die verfolgenden Schritte des Roboters hinter sich hört. Jetzt, auf dem Höhepunkt der Anspannung und des Angstlevels, findet Peter in der Roboter-Reparaturwerkstatt eine Säure, die er Gunslinger ins Gesicht schüttet. Man sieht, wie Gunslinger von der Säure angegriffen wird, wie es stark qualmt und raucht – und auf einmal tut der Roboter dem Zuschauer leid! Peter meint schon, entkommen zu sein, als er wieder die Roboterschritte hinter sich hört. Seine Flucht führt jetzt in die Welt des Mittelalters. Gunslinger spürt ihn auf, indem er seine Wärmestrahlung „sehen" kann, es wird wieder sehr gefährlich für Peter. Aber er hat Glück, die überall aufgehängten Fackeln überstrahlen seine Wärmeabgabe, Gunslinger kann ihn nicht mehr ausmachen. Als er versehentlich ein Geräusch von sich gibt, nimmt ihn der Roboter sofort wieder ins Visier, aber er kann diesen mit einer Fackel in Brand setzen.

Der nächste Schockmoment ist der brennende Roboter, der in Flammen aufgeht, in seiner langen Qual um sich schlägt und umher taumelt. Als Peter später eine um Hilfe wimmernde, gefesselte Frau in einem Verlies befreit, ihr gegen ihren Willen Wasser einflößt und sie durch einen dadurch verursachten Kurzschluss stirbt, wird nochmals das Missverhältnis oder das Missverständnis zwischen Mensch und Roboter deutlich. Urplötzlich, der letzte Schreck, taucht der völlig verkohlte Gunslinger neben Peter auf, streckt die Hand nach ihm aus – und stürzt zu Boden. Mit unbändigem Überlebenswillen richtet er sich nochmal auf, fällt dann aufs Gesicht und dreht sich um. Wir sehen die leere Höhlung seines Kopfes, die Gesichtseinheit ist abgefallen und die Elektronik im Inneren qualmt und schlägt Funken, gleichsam

im letzten Todeskampf[1]. Man kann kaum umhin, den gefürchteten und gehassten Roboter, dem man vorher den Tod gewünscht hat, zu bemitleiden. Am Ende des Films sitzt der völlig erschöpfte und unter Schock stehende Peter, fast in Embryohaltung, auf einer Treppe, um sich notdürftig zu erholen – und in seinem Kopf hallt der Werbetext von Delos nach:

> „Auf Sie wartet der Urlaub Ihres Lebens, der Urlaub Ihres Lebens, Lebens …"

Es sei nicht verheimlicht, dass nicht alle Zuschauer und Kommentatoren die von mir erlebten und beschriebenen Angst- und Schreckmomente teilten. Interessanterweise wurde die von mir als besonders spannend empfundene Verfolgungsjagd von einigen Zuschauern als langatmig, ja langweilig erlebt. Im „Lexikon des Science-fiction-Films" (Hahn et al.1997, S. 1016) heißt es gar: „Der Film geht nicht in die Tiefe." und: „Der Film liefert nur (zuweilen etwas langatmiges) Action-Kino." Dies mag zum einen damit zusammenhängen, dass der Film eben aus dem Jahre 1973 stammt, modernere Filme bei Verfolgungsjagden ein sehr viel höheres Tempo und einen sehr viel höheren Technik- und Materialeinsatz betreiben, an die wir uns gewöhnt haben. Dies wird beim Vergleich mit dem 1984 erstmals aufgeführten Film *Terminator* (der „Terminator" ist ein, im Vergleich zum Gunslinger, weit verbesserter Killer-Roboter), sehr schnell deutlich. Statt Verfolgung zu Fuß und zu Pferde gibt es Verfolgungsjagden mit schnellen Motorrädern und Autos, es gibt sehr viel schnellere Schnittfrequenzen, die ein höheres Tempo erzeugen und damit Spannung erhöhen können. Trotzdem wage ich die Hypothese, dass man in älteren Filmen, sofern man sich von Vergleichen freimacht, sehr wohl die ihnen innewohnende Spannung erleben kann (die hier aus dem äußersten Kontrast zwischen dem Protagonisten Peter, der unbedingt überleben will und seinem Antagonisten Gunslinger, der ihn unbedingt töten will, erwächst). Andererseits kommt aus psychoanalytischer Sicht auch die Möglichkeit von psychischen Abwehrmechanismen infrage, die dazu führen können, dass gefährliche, spannende Situationen etwa verleugnet werden und daraus so etwas wie Langeweile entsteht. Dieses Phänomen wurde mir besonders deutlich, als ich den Horrorfilm *Alien* einem Heidelberger Kinopublikum vorstellte und danach psychoanalytisch deutete. Während eine neben mir sitzende Kollegin sagte, sie habe die Augen schließen müssen, weil die Szenen für sie zu grausam und belastend gewesen seien, meldete sich in der Diskussion ein Zuschauer und betonte mit fast triumphierenden Unterton, dass er sich während des Films die ganze Zeit gelangweilt habe.

Psychodynamische Interpretation

Auf Leben und Tod: Ein Vater-Sohn-Konflikt

Wenn man aus psychoanalytischer Sicht den Film auf seinen innersten Kern reduziert, so ist dies der Kampf auf Leben und Tod zwischen Peter und dem Gunslinger. Dieser erstreckt sich fast über das letzte Drittel des Films und gestaltet sich über weite Strecken so, dass Peter um sein Leben fürchtet und vor dem überlegenen Rivalen flüchten muss. Es löst offensichtlich große Ängste aus, von einem böswilligen Gegner verfolgt zu werden, der einen um jeden Preis töten will. Diese Ängste, zunächst in einer Identifikation mit dem flüchtenden Peter erlebt, umfassten bei mir außer einer spürbaren körperlichen Angstreaktionen auch, wie beschrieben, mehrere, sich steigernde Schockmomente. Diese Schreck-

1 Die Angst- und Schreckmomente in einem Horrorfilm, und man kann *Westworld* durchaus so einordnen, stehen und fallen natürlich mit der Glaubwürdigkeit des Monsters (Reffert 2001, S. 80), in diesem Fall des Gunslinger, des Roboters. Im Film trägt dazu bei, wie Brynner über weite Strecken völlig ohne Mimik agiert, auch, wie er roboterhaft-mechanisch geht. Der immer wieder zitierte „eisige" oder „metallische" stechende Blick von Brynner, der viel zum Angstmoment beiträgt, kam durch metallisch glänzende Kontaktlinsen zu Stande, die er trug.

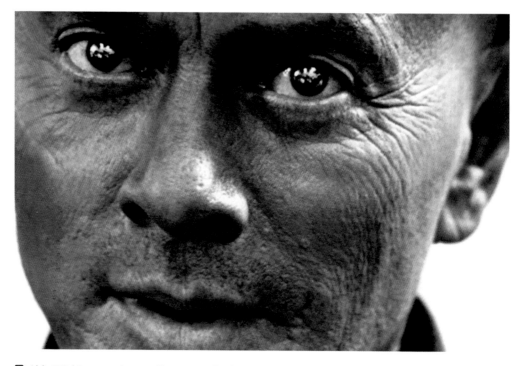

■ **Abb. 2** Yul Brynners „icy stare" in seiner Rolle als der „Gunslinger". (Quelle: Cinetext Bildarchiv)

momente entstehen dadurch, dass der Roboter Gunslinger in allen Situationen haushoch überlegen erscheint. Er ist eindeutig entschlossen, Peter unter allen Umständen und mit allen Mitteln zu töten, während Peter nur noch seine Haut retten will. Der Gunslinger verfügt über schier unerschöpfliche Energie, macht sich völlig kaltblütig und ruhig an die Verfolgung, ohne außer Atem zu geraten. Er hat die bessere Waffe, ein Gewehr, und, auch wenn er nur recht ungenau sieht (wir sehen sein grobpixeliges Gesichtsfeld), reicht dies völlig aus, um Peter zu verfolgen und auf ihn zu schießen. Zusätzlich kann er noch Wärmestrahlung wahrnehmen, was ihm erlaubt, sowohl Hufspuren als auch die Fußabdrücke von Peter zu sehen und ihn so unentrinnbar zu verfolgen. Die nächsten Überraschungs- und Schreckmomente beziehen sich darauf, dass Peter jetzt den Roboter angreift, ihm Säure ins Gesicht schüttet, ihm damit seine Augen verätzt und ihn später mit einer Fackel in Brand setzt. Auch hier zeigt sich eine (roboterhafte) Überlegenheit des Gunslinger, ein Mensch wäre durch den Säureangriff sofort außer Gefecht gesetzt worden und hätte auch die Verbrennungen nicht so lange überlebt.

Was könnte der innere, psychodynamische Grund sein, dass gerade diese Verfolgungsjagd, gerade diese Konstellation so erschreckend und verstörend verläuft? Oder, anders ausgedrückt, was kommt im speziellen Fall von Peter und dem ganzen Setting des Films hinzu, dass dieses Duell nicht nur erschreckt, sondern schockiert und sich bei vielen Zuschauern auch im Gedächtnis eingebrannt hat?[2] Natürlicherweise lösen tödliche Konfrontationen, wenn sie im Film glaubhaft dargestellt werden, ge-

2 Bemerkenswerterweise hatten fast alle Männer, die ich auf den Film ansprach, eine klare Erinnerung an den Film und die bedrohliche Verfolgungsjagd, während die meisten Frauen den Film nicht kannten und nicht im Detail erinnerten. Im Internet finden sich mehrere Besprechungen und Kommentare, die zum einen die besondere Schockreaktion, zum anderen eine Art „Einbrennen" ins Gedächtnis beschreiben. Kommentator J. D., der beispielhaft angeführt sei, schreibt: „I can remember seeing this on TV as a kid and Yul Brynner's icy stare, devoid of any humanity really scaring the crap out of me … it's a primal image that has never left me and still gives me the heebie jeebies when I watch it" (Muir et al. 2011).

wisse Ängste, auch Schockmomente, aus. Die Konfrontation einer der Hauptfiguren mit dem Tod und damit, in Identifikation mit ihm, mit dem eigenen Sterben, ist sicherlich der Schockmoment überhaupt. Aber die Szenerie des Films und die Beziehung der beiden Hauptakteure Peter und Gunslinger legen doch spezifischere innere Konstellationen und Fantasien nahe.

Meine These geht davon aus, dass im Film eine infantile Konstellation dargestellt und ausgearbeitet wird, die große Ängste auslöst. Aus meiner Sicht ist dies die ödipale Situation, mit der sowohl Jungen als auch Mädchen konfrontiert sind. Die ödipale Konstellation ist eine Dreieckssituation, die die Beziehung zwischen Mutter, Vater und Kind in ihren verschiedenen Aspekten beinhaltet. Für einen Jungen, wir untersuchen hier ja den speziellen Fall der männlichen Hauptfigur des Films, stellt sich dieser Komplex wie folgt dar: Der positive Ödipuskomplex ist dadurch gekennzeichnet, dass Todeswünsche dem gleichgeschlechtlichen Vater gegenüber bei gleichzeitigem sexuellen Begehren gegenüber der Mutter bestehen. Der Rivale soll verdrängt, ausgeschaltet, wie in der Sage von König Ödipus getötet werden. Bei Freud heißt es, dass die Beziehung zum Vater „eine feindselige Tönung" annimmt (Freud [1]1923; 1960b, S. 260):

… sie [die Beziehung zum Vater] wendet sich zum Wunsch, den Vater zu beseitigen, um ihn bei der Mutter zu ersetzen.

Der negative Ödipuskomplex beinhaltet entgegengesetzte Wünsche, nämlich vom Vater geliebt zu werden und die Mutter als Rivalin von diesem fernzuhalten. Beide Formen des Komplexes treten in verschiedenen Mischungen nebeneinander auf, in *Westworld* spielt die negative Variante eine untergeordnete Rolle.

Wie passt aber diese psychoanalytische Theorie zu den beiden Rivalen Peter und Gunslinger, die doch offensichtlich beide Erwachsene sind? Nach der Freud'schen Theorie begehrt der kleine Junge, etwa zwischen dem dritten und fünften Lebensjahr, seine Mutter und möchte seinen Vater verdrängen, in der Fantasie beseitigen. Nun sind diese Tötungswünsche dem Vater gegenüber deshalb gefährlich, weil der Rivale ein erwachsener Mann und somit in jeder Hinsicht haushoch überlegen ist. Ich meine, dass genau das die innere Konstellation ist, in die Peter gerät, ebenso wie die Zuschauer, indem sie sich mit ihm identifizieren und deshalb exzessive Ängste gegenüber dem Gunslinger erleben. Dieser scheint auf schreckliche Weise überlegen. Der Techniker, den Peter auf seiner Flucht in der Wüste trifft, sagt:

🗨 „Wenn er hinter Ihnen her ist, kriegt er Sie auch. Sie haben keine Chance."

Zudem scheint er völlig emotionslos zu sein, wir können keine emotionale Regung auf seinem Gesicht ausmachen und ihn damit auch nicht einschätzen und ausrechnen. Seinen Handlungen, seinem stechenden, metallischen Blick entnehmen wir aber Hass und Tötungsabsicht (🖭 Abb. 2). Insofern gerät Peter genau in die emotionale Situation eines kleinen Jungen hinein. Er hat sicher die Größenfantasie, dem Rivalen überlegen zu sein und diesen gleichsam „mit links" töten zu können, was sich im Film in den beiden Situationen zeigt, in denen er Gunslinger mühelos niedergeschossen hat. In Delos wird alles dafür getan, dass die Grenze zwischen Fantasie und Wirklichkeit verwischt wird, dass ein „als ob" entsteht, wie es für Kinderspiele typisch ist. Durch enormen Materialeinsatz und Technik soll die Realität außer Kraft gesetzt werden und kindlichen, ödipalen Fantasien freien Lauf gelassen werden. Delos ist die Realität gewordene ödipale Trieb- und Wunscherfüllung. Dieses „Spiel", dieser fantasierte und getürkte Zweikampf (die Roboter sind ja so programmiert, dass sie keine Chance haben, ihre Duelle zu gewinnen) verwandelt sich auf einmal in blutige Realität und die ungeheure, panikauslösende Überlegenheit der Maschine kommt in der Verfolgungsjagd deutlich zum Ausdruck. Ich glaube, dass die Überlegenheit und Gefährlichkeit des Gunslinger dadurch so enorm erscheint, weil vorher die Größenfantasie bestand, diesem massiv überlegen zu sein. Wenn Peter überleben will, muss er schnellstens die gefühlsmäßige Situation des kleinen Jungen verlassen und alle seine erwachsenen Möglichkeiten

und Fähigkeiten einsetzen, was er auch tut. Interessanterweise unterschätzt er immer noch die Gefähr-
lichkeit seines Rivalen, als er nach dem gelungenen Säureangriff auf den Roboter davon ausgeht, dass
er diesen ausgeschaltet oder getötet habe – und plötzlich wieder dessen verfolgende Schritte hinter sich
hört.

Betrachten wir den zweiten Aspekt der positiven ödipalen Situation: Der kleine Junge begehrt seine
Mutter und möchte diese für sich allein haben, den Vater möchte er aus dieser Beziehung als Rivalen
ausschließen, ausschalten, dessen ältere Rechte und dessen Überlegenheit will er nicht anerkennen. Ich
möchte an dieser Stelle einen gedanklichen Zwischenschritt einfügen, dass nämlich die künstliche Welt
mit ihren Androiden, die den Menschen für ihre Wünsche und Fantasien vollständig zur Verfügung
stehen, nicht als Realität zu verstehen ist, sondern als Ausdruck der Fantasien und Wünsche der betei-
ligten Personen. Dann lässt sich die psychische Situation von Peter unschwer als ödipale Wunschwelt
verstehen: Alle Frauen stehen ihm uneingeschränkt für seine sexuellen Wünsche zur Verfügung, ohne
dass ein anderer Mann (der Vater) gleichfalls Ansprüche auf sie erhebt. Sein Zögern, als er mit der Bar-
frau ins Bett gehen will, lässt sich, wenn man alles als Ausdruck seiner Fantasiewelt betrachtet, dann so
verstehen, dass er eine Grenze überschreitet, nämlich die, dass diese Frau und auch alle anderen Frauen
nur ihm zur Verfügung stehen und zu Willen sein werden. Verständlicherweise ist er unsicher, ob er
seiner Fantasie- und Wunschwelt trauen und einfach nachgeben kann. Eine ähnliche Konstellation ist
im Roman „Ich und Er" von Alberto Moravia, auch in der gleichnamigen Verfilmung kommt dies zum
Ausdruck, dargestellt: Das vernünftige Ich des männlichen Protagonisten hört die Stimme seines Penis
(„Er"), der ihm immer wieder sagt: „Du kannst sie alle haben." In der wirklichen Welt, der Welt der
Erwachsenen, ist dies natürlich eine trügerische Größenfantasie, die bald durch die Realität auf pein-
liche Art und Weise enttarnt werden würde. In der realen Welt müssen wir für diese Größenfantasien
und uneingeschränkten Wünsche, so wir diese in die Realität umsetzen, mit Verfolgung und Bestra-
fung (Rache) durch die ausgebooteten Rivalen rechnen (außerdem damit, dass Frauen auch jederzeit
zurückweisen können). Ich glaube, dass diese in jedem von uns unbewusst wirkende Verbindung eben-
falls dazu beiträgt, dass der Gunslinger als so bedrohlich und gefährlich erlebt wird. Er ist ein Rächer,
er rächt sich für Peters Anmaßung, ihm, dem Roboter, die Roboterfrauen weggenommen zu haben.

Auch die im Film gezeigte Unsicherheit von Peter (mehr noch von seinem Alter Ego, dem Bankan-
gestellten mit der großen Brille) passt genau zur ödipalen Situation. Der Junge, später der Pubertie-
rende, ist eben noch kein ausgereifter Mann, er muss noch viel über die Welt, über die Frauen, über
das Leben lernen und erfahren. Anders ausgedrückt: Er weiß und kann eben vieles noch nicht. Von
daher ist die gezeigte Unsicherheit oder ein gewisses Unterlegenheitsgefühl verständlich und auch an-
gebracht. Bei dem Bankangestellten wird dies am deutlichsten, er übt mit dem Revolver und schießt
unbeaufsichtigt auf sein Spiegelbild; er maßt sich an, Sheriff zu sein und kann die Tür zum Büro auf
lächerliche Weise nicht richtig öffnen.

Im Film wird ausschließlich über Peter etwas Innerpsychisches ausgesagt. In einer Szene zu Beginn
des Films fällt ihm seine Frau ein, von der er offensichtlich getrennt lebt, und er wünscht sich, dass diese
bei ihm wäre und die antike Einrichtung sehen könnte (fast verträumt sagt er: „Hey, Julie würde hier
auf ihre Kosten kommen."). Der wesentlich erwachsener und selbstsicherer wirkende John rügt ihn:

💬 „Bei Dir ist wohl 'ne Schraube locker. Du bist Anwalt, Du solltest beurteilen können,
wie schamlos sie Dich betrogen hat." … „Sechs Monate später, und Du denkst immer
noch an Julie."

Im Zusammenhang mit der ödipalen Konstellation könnte man annehmen (dies ist aber eine Ver-
mutung), dass er sich von der ersten Frau in seinem Leben, also seiner Mutter, nicht richtig hat lösen
können und dass ihm dies auch bei seiner Ehefrau nicht recht gelingen will. Jedenfalls wird bei Peter
deutlich, dass die Abenteuer in Westworld dazu dienen sollen, sein Selbstbewusstsein als Mann zu

heben und sich sicherer, besser, anderen Männern (den auf Unterlegenheit programmierten Robotern; dem Mann gegenüber, mit dem ihn seine Frau betrogen hat) überlegen zu fühlen. John Blane, sein Freund aus Chicago, wirkt wie sein Mentor, wenn er ihm am Anfang des Films die vielen, für Peter brennenden Fragen zum Leben in Westworld beantwortet. Peter wirkt wie ein kleiner Junge, der seinen Vater nach der Welt befragt (er sagt: „Ich bin nicht die Spur nervös, ich bin nur neugierig."). Gleich seine erste Frage („Wie viel wiegen die etwa?", gemeint sind die Revolver im Film) entbehrt nicht einer gewissen phallischen Symbolik. Johns Antwort: „Schätze, eineinhalb Kilo etwa", quittiert Peter mit einem erstaunten „Donnerwetter! So viel?". Er wirkt dabei wie ein Junge, der sich über reale und fantasierte Penisgrößen bei seinem Mentor kundig machen möchte. Die symbolische Gleichung Revolver ist gleich Penis bzw. Phallus ist offenkundig.[3]

Insgesamt stellt der Film vor dem beschriebenen ödipalen Hintergrund eine unangenehme Gesellschaftsdiagnose: Anscheinend gestandene Männer (Banker, Ärzte, Rechtsanwälte wie Peter) fühlen sich als Männer unsicher und nicht vollständig, man kann sicher auch sagen minderwertig – und möchten dies durch machohaftes Verhalten kompensieren. In Delos, einer virtuellen Welt, können diese Fantasien, sich über die eigenen Unsicherheiten und begrenzten Möglichkeiten und Fähigkeiten hinwegzusetzen, ausagiert werden.

Hybris

Man kann den Film auch als Darstellung einer gewissen Form von Hybris der Menschen verstehen. Unter Hybris (griechisch ὕβρις: „Übermut, Anmaßung") versteht man gemeinhin eine Selbstüberhebung, im Sinne der griechischen Tragödie ein Überschreiten der menschlichen Möglichkeiten und Grenzen, ein Überschreiten der Regeln und Gesetze der Götter. Walter Kaufmann hat darauf hingewiesen, dass das griechische Verb ὑβρίζειν bei Homer „zügellos werden" oder „sich austoben" bedeutet, auch „mutwillige Gewalt" und „Frechheit" (in der Odyssee wird der Ausdruck für Penelopes Freier verwendet). Es kann auch „Gier" und „Lüsternheit" bedeuten. Hybrisma steht nach Kaufmann (1980, S.74) für „Frevel, Vergewaltigung, Raub" und fasst das zusammen, was Menschen einem anderen Menschen an schwerem Unrecht zufügen können. Ganz offensichtlich treffen diese Beschreibungen sowohl auf die menschlichen Urlauber in Delos als auch auf die Betreiber bzw. Ingenieure und Techniker zu, die die Roboter kreiert haben – wenn man in den hoch komplizierten, „sensiblen" (wie es im Film heißt) Androiden menschenähnliche Wesen oder Menschen sehen möchte, die in einer Art Sklaverei gehalten werden.

Der Film zeigt reiche oder zumindest sehr wohlhabende Amerikanerinnen und Amerikaner, die sich den Luxus leisten können, 1000 Dollar pro Tag (im Jahre 1973!) für einen durch und durch hedonistischen Urlaub ausgeben zu können. Bei diesem Aufenthalt im Freizeitpark wird mit höchstem technischem Einsatz vermittelt, in einer vergangenen Welt zu leben und nach Lust und Laune schalten und walten zu können. Es erscheint nicht zufällig, dass die Themenparks Welten der Vergangenheit darstellen, die für nahezu unbeschränktes Ausleben von Triebwünschen (Essen und Trinken, Ausübung von Gewalt und Kriminalität sowie uneingeschränkte Sexualität) berühmt und berüchtigt sind. Im Einzelnen sind dies (ich führe umgangssprachliche Bezeichnungen an) „das alte Rom", „das finstere Mittelalter" und der „Wilde Westen". Alle drei Zeiten bzw. Welten sind uns für Ausschweifungen, De-

3 Alexander Emmerich hat mich darauf aufmerksam gemacht, dass, von den Archetypen her betrachtet, Peter dem jungen, noch unerfahrenen, aber zukünftigen Helden entspricht, während John seinen Mentor darstellt (Emmerich 2011, Persönliche Mitteilung). Psychoanalytisch gesehen, habe ich ihn als Vaterfigur eingeordnet. Vom archetypischen Ablauf her verliert der Held früher oder später im Film seinen Mentor und muss nun mit dem, was er inzwischen von ihm gelernt hat, zurechtkommen und sich den Gefahren alleine stellen. Wenn er die Gefahren und Prüfungen bestanden hat, ist er reifer geworden, damit seinem Mentor ähnlicher, und erhält typischerweise eine Belohnung: hier eine reifere Männlichkeit und sein Leben. Er ist damit der Welt des Kinderspiels entwachsen und kann sich weiteren Herausforderungen der erwachsenen, realen Welt stellen.

kadenz, fehlende Begrenzung und Kontrolle von Gewalt und Habgier, zumindest in den Oberschichten, bekannt. Zum einen werden die Vergnügungen der Besucher durch enormen Einsatz von Bauten, Interieurs, Ausstattungen sowie Essen und Trinken erreicht. Zum anderen, da es in unserer Zeit und Kultur nicht mehr möglich ist, Menschen ungestraft in Raubüberfällen oder Zweikämpfen zu töten und sie nach Belieben sexuell zu benutzen, haben die Betreiber von Delos wirklichen Menschen äußerst ähnliche Roboter entwickelt und steuern diese mit höchstem technischen Aufwand, damit diese von den Besuchern nach Lust und Laune benutzt, man könnte auch sagen ausgebeutet, werden können. Es sei angemerkt, dass es durchaus auch weibliche Gäste gibt, für die männliche Roboter zum sexuellen Vergnügen zur Verfügung stehen. Im Film werden in der mittelalterlichen Welt und im Wilden Westen Zweikämpfe gezeigt, für die etwa der so genannte „schwarze Ritter" oder der Revolverheld „Gunslinger" zur Verfügung stehen, und zwar so, dass auf gar keinen Fall ein Gast verletzt wird und die Gäste die Zweikämpfe durch „Töten" der Roboter gewinnen. Insbesondere in Westworld wird auch das Bedürfnis, gefährliche und spannende Abenteuer zu erleben, durch bestimmte Einrichtungen und Programme simuliert (Banküberfall; Schlägerei im Saloon; Angriff durch eine Klapperschlange beim Austritt in die Wildnis).[4]

Die Urlauber wollen sich über Regeln und Grenzen, auch persönliche Grenzen und Beschränktheit, hinwegsetzen. Sie wollen so tun, als gebe es für sie praktisch keinerlei Grenzen mehr, als stünde ihnen etwas zu, was normalen Menschen, die sich einen solchen Urlaub nicht erlauben können, eben nicht zusteht. Im Film heißt es:

 „Ein Urlaub auf Delos ist kostspielig und extravagant und ist nicht jedermanns Sache."

Diesen Satz kann man auch so verstehen, dass sich eben nicht jedermann an einer solchen Hybris beteiligen möchte. Die Betreiber von Delos, die Techniker und Computerprogrammierer, vielleicht auch die „Bühnenbildner", unterliegen ebenfalls einer Hybris. Sie glauben nämlich, dass sie mit den Robotern dem Menschen sehr ähnliche Kreaturen geschaffen haben, die sie dennoch glauben, vollkommen kontrollieren zu können. Der Techniker, den Peter auf seiner Flucht in der Wüste trifft, sagt:

 „Eine phantastische Maschine. Aber was immer Sie tun, er wird Ihnen immer einen Schritt voraus sein."

Nach dem Motto „Hochmut kommt vor dem Fall" werden beide Gruppen für diese Hybris schwer bestraft. Die Roboter, die, wie es im Film heißt, teilweise von Computern kreiert wurden, widersetzen sich den menschlichen Programmierungen und Befehlen, entwickeln gleichsam einen eigenen Willen. Gunslinger reagiert jetzt offensichtlich höchst menschlich, er will sich für die Demütigungen, zweimal ohne Chance einfach niedergeschossen worden zu sein, rächen und beginnt seinen Rachefeldzug. Auch die anderen Roboter widersetzen sich, geraten außer Kontrolle und töten die männlichen und weiblichen Gäste. Als die Techniker im Kontrollraum versuchen, die Roboter abzuschalten und dabei auch den Hauptstrom ausschalten, gelingt es ihnen nicht, den Stromkreis wieder zu schließen. Sie

4 Der Film, obwohl offiziell ein Science-Fiction-Film, beinhaltet alle Motive des klassischen Westerns wie einen Banküberfall, eine Schlägerei im Saloon, „shootouts" und am Ende der Geschichte einen finalen „Showdown". „Westworld", die im Film gezeigte Kleinstadt, wird auf das Jahr 1880 datiert, liegt damit in zeitlicher Nähe zum Ende des Wilden Westens. Der berühmte Revolverheld Billy the Kid wurde 1881 erschossen; Jesse James, der unter den amerikanischen Outlaws den Ruf eines „Robin Hood" des Wilden Westens hatte, weil er bei Zugüberfällen stets nur den Tresor plünderte und nie die Reisenden, fand 1882 durch ein Mitglied seiner Bande den Tod. „Der Zensus des Jahres 1890 stellte zum ersten Mal fest, dass es keine durchgehende Grenzlinie mehr zwischen den bewohnten Gebieten und der vermeintlichen Wildnis gab" (Emmerich 2009, S. 155), damit war der Wilde Westen Vergangenheit geworden.

sitzen in ihren Kontrollräumen in der Falle, die Temperatur steigt an, schließlich sterben sie einen grausamen Erstickungstod durch Sauerstoffmangel. Im Hintergrund arbeiten die Computer ungestört weiter, man könnte fantasieren, dass die Computer sich selbstständig gemacht haben und ihre Herren beseitigen wollten. In einigen Kommentaren wurde darauf hingewiesen, dass Crichton uns vor den Gefahren der Technik warnt, das Problem (und, wie ich meine, seine Botschaft) liegt aber wohl eher in der Selbstüberschätzung der Menschen, ihrer eigenen Technik und ihren technischen Fähigkeiten zu viel zuzutrauen. Weder für die Gäste noch für die Techniker im Kontrollraum gibt es einen Notausstieg, die Techniker können nicht einmal ihre Tür manuell öffnen, nachdem die Stromzufuhr ausgefallen ist. In der klassischen griechischen Tragödie werden Anmaßung, Zügellosigkeit und Selbstüberhebung durch die Rache der Götter, die Nemesis, gerächt und diese führt häufig zum Untergang und zum Tod derjenigen, die diese Selbstüberhebung begehen.[5] Umgangssprachlich ist mit „Hochmut kommt vor dem Fall" genau diese Thematik gemeint. Offensichtlich werden sowohl die Urlauber als auch die Betreiber von Delos und ihre Ingenieure und Techniker für ihre Hybris, für ihr Überschreiten der menschlichen Grenzen und Gesetze mit ihrem Untergang bestraft. Einzig Peter kann diesem Untergang, durch enorme eigene Anstrengung und Durchstehen der Leiden seiner Flucht, die man ebenfalls als Bestrafung ansehen kann, entkommen. Es gehört eben auch zum Privileg der griechischen Götter – oder dem Privileg von Drehbuchautoren und Regisseuren – einzelne Menschen vor dem Untergang zu bewahren.

Nun ist Hybris, verbunden mit Nemesis, keine psychoanalytische Konzeption im engeren Sinn. Sie kommt allerdings in der von Freud psychoanalytisch ausgedeuteten Sage von Narziss, der sich dadurch selbst überhebt, dass er nur sich selbst liebt und die Liebe der Nymphe Kalypso verschmäht, vor. Für diese Hybris wird Narziss in der ursprünglichen Form der Sage bestraft, indem er in eine Narzisse verwandelt wird. Wenn man jedoch wiederum den Zwischenschritt einführt, dass die im Film gezeigten Vorgänge und Handlungen der inneren Welt der Akteure entsprechen, lässt sich die Sequenz Selbstüberhöhung und Überschreitung von Regeln und Gesetzen, gefolgt von tödlicher Bestrafung, auch als innere Dynamik der Personen im Film verstehen. Es erscheint ganz nahe liegend, wenn man anderen gegenüber Mordgelüste hegt, auch Vergewaltigungsabsichten, dass man fürchten muss, dass der andere einem genau dasselbe antun bzw. sich rächen will. Diese Befürchtungen vor Verfolgung und Rache sind zum einen realitätsbezogen (jeder Mörder muss damit rechnen, dass sich sein Opfer wehrt und den Spieß umdreht; nach dem Prinzip „Auge um Auge, Zahn um Zahn" muss auch mit Vergeltung gerechnet werden), zum anderen entstehen diese Befürchtungen auch durch Projektion der eigenen aggressiven Impulse in das Gegenüber.[6]

Fehlendes Schuldgefühl

Es ist auffallend, dass die Menschen im Film keinerlei schlechtes Gewissen für ihr Handeln gegenüber den Robotern zeigen. Sie können oder wollen nicht sehen, dass sie sensiblen, zumindest Menschen ähnlichen Wesen gegenüberstehen und diese unmenschlich behandeln. Dies hat offensichtlich damit

5 Nemesis (griechisch Νέμεσις: „Zuteilung [des Gebührenden]") bezeichnet in der griechischen Mythologie die Göttin des „gerechten Zorns", die Göttin der Rache. Sie bestraft eben gerade die menschliche Selbstüberhebung und die Übertretung des göttlichen Rechts und der Sittlichkeit.

6 Man könnte hier Melanie Kleins Konzept der paranoid-schizoiden Position anführen und diskutieren. Diese frühkindliche Modalität von Objektbeziehungen ist nach Klein für die ersten vier Lebensmonate spezifisch, kann aber auch im Erwachsenenleben jederzeit aktiviert werden (Klein [1]1946; 1975, S. 5 f., S. 33). Diese Modalität ist durch Ängste vor Zerstückelung, Vergiftung und Aufgefressenwerden gekennzeichnet und fußt auf den eigenen aggressiven Triebregungen der Mutter gegenüber (dem Teilobjekt der mütterlichen Brust), die Brust anzugreifen, sie fressen usw. Diese Impulse werden vom Kind also in die Mutter bzw. deren Brust projiziert. Da es bei dem von mir gewählten Fokus um ödipale Fantasien geht, würde die Einbeziehung dieser früheren Lebensphase das Gesagte unnötig komplizieren. Als Modell für die Projektion eigener aggressiver Triebregungen und die Furcht vor Verfolgung und Vernichtung ist sie hier durchaus interessant.

zu tun, dass sie ihre eigenen Triebwünsche, ohne Rücksicht auf das Gegenüber, ausleben wollen. Nun kann man argumentieren, dass die Roboter wirklich nur Roboter sind und keinen Schmerz und kein menschliches Leid erleben und somit kein Verschulden seitens der Menschen vorliegt. Dem widerspricht jedoch, dass die Roboter unter den ihnen zugedachten Rollen leiden und eine Art Sklavenaufstand betreiben, durch den fast alle Menschen umgekommen, lediglich Peter kann sich retten. Aus psychoanalytischer Sicht gibt es zwei Erklärungsmöglichkeiten für das fehlende Schuldgefühl und das fehlende schlechte Gewissen der Menschen. Zum einen könnten Abwehrprozesse gegenüber dem Erleben von Schuldgefühlen bestehen, indem die eigenen Schuldgefühle verleugnet oder verdrängt werden. Hierzu würde auch der Abwehrprozess gehören, zu postulieren, dass keine Schuld vorliegt, weil das Opfer unter der Tat gar nicht leidet. Oder aber, man spricht den Opfern grundsätzlich die Menschlichkeit ab, also auch eigenes menschliches Erleben, dann wäre man wiederum von Schuldgefühlen befreit und könnte mit den Opfern schalten und walten, wie man wollte. Solche Dehumanisierungsprozesse sind uns aus Zeiten der Sklavenhaltung, aus Zeiten von tödlichen religiösen Auseinandersetzungen (die guten Christen gegen die bösen Muslime, etwa während der Kreuzzüge) oder auch aus Zeiten der Judenverfolgung und Ermordung im Dritten Reich bekannt.

Die andere Möglichkeit besteht darin, dass das Über-Ich, dem Freud die Funktionen des Gewissens, der Selbstbeobachtung und der Bildung von Idealvorstellungen zuschreibt, bei den Akteuren im Film nicht vollständig ausgebildet bzw. unreif ist. Dies passt gut zu der von mir postulierten ödipalen Fixierung von Peter Martin, denn nach der klassischen psychoanalytischen Theorie entsteht das Über-Ich als Erbe des Ödipuskomplexes und enthält verinnerlichte elterliche Forderungen und Verbote. Um dies etwas anschaulicher zu machen: Kleine Kinder können ohne Gewissensbisse, ohne mit der Wimper zu zucken, Insekten die Beine ausreißen, Frösche auf den Boden werfen und zusehen, was passiert oder bei Raufereien anderen Kindern Verletzungen zufügen. Ihnen fehlen noch die Fähigkeit zur Einfühlung in das Gegenüber und die Verbindung zu eigenem Leiden, beispielsweise von passiv erlittenem Schmerz mit der Vorstellung, dass ein Gegenüber bei der gleichen eigenen Handlung ebensolchen Schmerz erleben würde. Dem entspricht die umgangssprachliche Regel, dass Eltern ihren Kindern manchmal sagen müssen: „Was du nicht willst, das man dir tu', das füg' auch keinem andern zu." Bei Peter Martin gehe ich vor allem vom Vorliegen der zweiten Konstellation aus, ihm scheint es nicht ganz klar zu sein, was er anderen, besonders dem Gunslinger, antut. Am Ende des Films, nachdem Gunslinger den Spieß umgedreht hat und Peter zumindest ansatzweise hat empfinden lassen, wie es ihm unter der Verfolgung und beim Erschießen ergangen sein muss, hat dieser wohl eine Vorstellung von den Folgen seiner Taten bekommen. Dem entspricht auch, dass die Verletzung und Verbrennung des Roboters im Zuschauer wohl Mitleid und Mitgefühl auslösen sollte. Ich denke, dies spiegelt die innere Befindlichkeit von Peter wieder. Am Ende des Films dürfte Peter also auch in Bezug auf sein Gewissen, auf sein Über-Ich, gereift und erwachsener geworden sein.

Literatur

Emmerich A (2009) Der Wilde Westen. Mythos und Geschichte. Konrad Theiss Verlag, Stuttgart

Freud S (1960a) Jenseits des Lustprinzips. Gesammelte Werke, Bd 13. Fischer, Frankfurt/M (Erstveröff.1920)

Freud S (1960b) Das Ich und das Es. Gesammelte Werke, Bd 13. Fischer, Frankfurt/M (Erstveröff.1923)

Hahn RM, Jansen V (1997) Lexikon des Science-fiction-Films. 2000 Filme von 1902 bis heute. 2 Bde, 7. Aufl. Heyne, München

Internet-Film-Datenbank „Imdb" www.imdb.com. Zugegriffen am 14. 12. 2011

Kaufmann W (1980) Tragödie und Philosophie. Mohr, Tübingen

Klein M (1975) Notes on some schizoid mechanisms. Envy and gratitude and other works 1946–1963. Hogarth Press and the Institute of Psycho-Analysis, London (Erstveröff. 1946)

Laplanche J, Pontalis J-B (1982) Das Vokabular der Psychoanalyse. 2 Bde, 5. Aufl. Suhrkamp, Frankfurt/M

Muir JK et al (2011) Cult Movie Review: Westworld (1973) http://reflectionsonfilmandtelevision.blogspot.com/2011/02/cult-movie-review-westworld-1973.html. Zugegriffen am 14. 12. 2011

Reffert R (2001) „Ein Film ist wie ein Kuchen mit 700 Schichten …". Psychoanalyse im Widerspruch 25: 77–95

Originaltitel	Westworld
Erscheinungsjahr	1973
Land	USA
Buch	Michael Crichton
Regie	Michael Crichton
Hauptdarsteller	Yul Brynner (der „Gunslinger"), Richard Benjamin (Peter Martin), James Brolin (John Blane), Norman Bartold (Mittelalterlicher Ritter), Alan Oppenheimer (Cheftechniker), Victoria Shaw (Mittelalterliche Königin), Dick Van Patten (Banker)
Verfügbarkeit	Als DVD in OV und deutscher Sprache erhältlich

Udo Rauchfleisch

„Death Watch" oder die Inszenierung der Realität

Der gekaufte Tod – Regie: Bertrand Tavernier

Eine Zukunft, die morgen schon Gegenwart ist?

ROMY SCHNEIDER · HARVEY KEITEL

EIN FILM VON

BERTRAND TAVERNIER

TV-13 / JANINE RUBELZ präsentieren eine Produktion von
ELLIE KFOURI mit
HARRY DEAN STANTON · THERESE LIOTARD · VADIM GLOWNA ·
EVA MARIA MEINEKE · MAX von SYDOW in der Rolle des Mr Mortenhoe
Als Gast BERNHARD WICKI
Drehbuch: DAVID RAYFIEL und BERTRAND TAVERNIER
nach einem Roman von DAVID COMPTON
Musik: ANTOINE DUHAMEL · Gesamtleitung: GABRIEL BOUSTANI ·
Herstellungsleitung: Georg M. Reuther / Jean Serge Breton ·
Produktionsleitung: SIGMUND GRAA

**DEATH
WATCH**

Eine deutsch-französische Coproduktion der TV-13 München/CORONA Film/ZWEITES DEUTSCHES FERNSEHEN mit SELTA-FILM/LITTLE BEAR/SARA Film/GAUMONT im Verleih JUGENDFILM ◄

Das Buch zum Film erscheint bei: ⓖ Goldmann Verlag als Taschenbuch

Filmplakat *Der gekaufte Tod*
Quelle: Interfoto/NG Collection

Der gekaufte Tod

Regie: Bertrand Tavernier

Handlung

Der Film *Der gekaufte Tod* (◘ Abb. 1) spielt in einer ungewissen Zukunft und verwendet die marode Kulisse von Glasgow in Schottland. Es ist eine Zeit, in der alle Krankheiten so gut wie ausgerottet sind und die Menschen im hohen Alter, von Drogen umnebelt, sterben. Deshalb ist der Tod durch eine Krankheit, erst recht bei einem jüngeren Menschen, ein besonderes Ereignis, das vom Fernsehen NTV medial groß ausgeschlachtet wird.

Eine besondere Attraktion stellt die unheilbare Krankheit von Katherine Mortenhoe, einer erfolgreichen Schriftstellerin (Romy Schneider), dar, deren Arzt ihr nur noch maximal zwei Monate Lebenszeit vorhersagt. In Zusammenarbeit mit dem Arzt überredet der NTV-Produzent Vincent Ferriman (Harry Dean Stanton) Katherine, ihren Tod öffentlich zu machen, indem sie sich in ihren letzten Lebenswochen filmen lässt. Um dieses Ereignis publikumswirksam zu inszenieren, hat sich der Journalist Roddy (Harvey Keitel) eine High-Tech-Kamera hinter seine Pupille operieren lassen, wodurch seine Augen zu einem Kameraobjektiv umfunktioniert worden sind (◘ Abb. 2).

Unter dem Druck des Produzenten unterschreibt Katherine, nicht zuletzt auch um ihrem Mann die von NTV versprochene Summe zukommen zu lassen, den Vertrag mit NTV für die Sendung „Death" Watch. Als ihr klar wird, was dies für sie bedeutet, und das Geld in den Händen ihres Mannes ist, begibt sie sich, mit einer Perücke verkleidet, auf die Flucht. Der Journalist Roddy findet sie jedoch in einer Kirche, in der Obdachlose Unterkunft finden, und freundet sich mit ihr an. Katherine weiß jedoch nicht, dass er für Death Watch arbeitet. Alles, was er sieht, wird vom TV-Sender NTV aufgezeichnet und ausgestrahlt. Die beiden begeben sich gemeinsam auf eine Reise – Katherine im Glauben, dem NTV-Kamerateam damit entfliehen zu können – und kommen sich dabei immer näher.

In Roddy entstehen langsam Zweifel an der Rechtmäßigkeit seines Auftrags. Ein Schock ist es für ihn, als er beim Einkaufen in einem Dorfladen seine eigene Übertragung der Fahrt mit der ahnungslosen Katherine sieht. Voller Gewissensqualen und völlig verzweifelt wirft er auf dem Rückweg in das Strandhaus, wo er mit Katherine lebt, seine Taschenlampe weg. Da er für die Kamera in seinem Auge ständig Licht braucht, bedeutet dieser Verlust bei Nacht totale Erblindung.

Roddy gesteht Katherine seine wahre Identität und seinen Auftrag für NTV. Trotz der massiven Enttäuschung, die dies für sie bedeutet, verlässt Katherine ihn nicht und flüchtet mit ihm zu ihrem Ex-Mann (Max von Sydow), der in der Nähe wohnt und bei dem die beiden Unterschlupf finden. Da mit Roddys Erblindung die Übertragung zum Sender NTV abgebrochen ist, startet der Produzent eine groß angelegte Suchaktion nach Katherine, um seine Death Watch-Sendung doch noch retten zu können.

In dieser Situation erfährt Katherine – ebenso wie die Zuschauerinnen und Zuschauer des Films –, dass die Protagonistin in Wirklichkeit gar nicht krank ist, sondern nur als Publikumsmagnet missbraucht worden ist. Ihr Arzt und der Produzent von NTV haben ihr vorgegaukelt, sie sei unheilbar krank, um auf diese Weise eine spannende Reportage über den Todeskampf einer bekannten Frau filmen zu können. Als Katherine dies erfährt, sieht sie die einzige Chance, sich am Produzenten zu rächen, darin, sich umzubringen, um damit seine Death Watch-Sendung zu Fall zu bringen und ihn auf diese Weise zu ruinieren.

◘ Abb. 2 Harvey Keitel als Roddy. (Quelle: Interfoto/Mary Evans)

Hintergrund

Der 1980 gedrehte Film ist in einer Zeit entstanden, in der die Medienwelt das Privatleben von Menschen noch nicht in dem Maß öffentlich gemacht hat, wie es heute der Fall ist. Er konnte deshalb damals zu Recht als Science-Fiction-Film bezeichnet werden. Der Film thematisiert die Zerstörung der Privat- und Intimsphäre durch die Massenmedien. Die Vorlage des Films stellt ein Roman des Schriftstellers D. G. Compton dar.

Der englische Titel *Death Watch* bezieht sich auf die gleichnamige TV-Sendung, um die es in diesem Film geht. Der französische Originaltitel *La mort en direct* thematisiert die Tatsache, dass der Tod live, „direkt", übertragen wird. Der deutsche Titel *Der gekaufte Tod* trifft den Inhalt des Films nur annäherungsweise und weist auf die kommerzielle Seite des gefilmten Todeskampfes der Protagonistin hin.

Der Film wurde so bearbeitet, dass die Farben insgesamt eher blass wirken. Auf diese Weise entsteht eine interessante Spannung zwischen dem unwirklichen Eindruck einerseits und den realistischen Orten, an denen der Film gedreht worden ist, andererseits. Wegen dieser Diskrepanz, unter Verzicht auf ein futuristisches Ambiente, wurde der Film auch als „minimalistischer Science Fiction" bezeichnet.

Filmwirkung

Seine besondere Wirkung erzielt der Film durch die erwähnte Diskrepanz zwischen der futuristischen Idee einer ins Auge eingebauten Kamera einerseits und den realistischen Schauplätzen, an denen gedreht wurde, andererseits. Dadurch entsteht in den Rezipientinnen und Rezipienten der Eindruck einer wesentlich größeren Realitätsnähe als bei den sonst üblichen Science-Fiction-Filmen, die sich im Allgemeinen einer nicht unserer Realität entsprechenden Umgebung bedienen und Protagonisten verwenden, die uns schon von ihrem äußeren Erscheinungsbild her völlig fremdartig erscheinen. Auf

diese Weise fühlt man sich als Betrachter von *La mort en direct* sehr stark in die dargestellte Situation hineingezogen und verliert mehr und mehr den Eindruck, mit einem unrealistischen, fiktiven Geschehen konfrontiert zu sein. Es kommt auf diese Weise zu einer engen Verschränkung, bis hin zu einem Verwischen der Grenzen zwischen Realität und Irrealität.

Auf uns heute lebenden Zuschauerinnen und Zuschauer hat der Film insofern eine besondere Wirkung, als wir in der Gegenwart – im Unterschied zum Entstehungsjahr 1980 – durch das heute weit verbreitete Reality-TV weitgehend daran gewöhnt sind, dass uns die Massenmedien immer wieder schonungslos Einblicke in die Privatsphäre von Menschen gewähren und auch vor ethisch höchst bedenklichen Reportagen nicht mehr zurückschrecken.

Da im Zentrum des Films *La mort en direct* das Thema des Reality-TV steht, sei hier kurz auf diese Programmform des Fernsehens eingegangen (S. hierzu auch Wegener 1994). Das Reality-TV hat seine Ursprünge bereits in den 40er-Jahren des letzten Jahrhunderts. Die US-amerikanische Sendung „Candid Camera" filmte schon 1948 die Reaktionen von normalen Passanten auf Gags, eine Reality-TV-Variante, die im deutschsprachigen Fernsehen bis heute in Form der „Versteckten Kamera" weitergeführt wird.

Die erste Reality-Show im heutigen Sinne war „An American Family" (1973), in welcher der Weg einer „normalen" Familie durch Scheidung gezeigt wurde. *La mort en direct* thematisiert eine Form des Reality-TV, die – wenn auch nicht in ganz so skrupelloser Form wie in *La mort en direct* – Ende der 80er und vor allem in den 90er-Jahren des letzten Jahrhunderts große Verbreitung gefunden hat. In den Reality-Gameshows – und dies ist die Situation in *Death Watch* – werden Personen, die sich dazu bereit erklären, rund um die Uhr oder zu bestimmten Tageszeiten permanent gefilmt: Äußerst erfolgreich waren die Sendungen „The Real World" von MTV (1992), die „Changing Rooms" (1996) im britischen Fernsehen, die 1997 in Schweden entwickelte „Expedition Robinson" (in Deutschland in Gestalt von „Gestrandet") sowie die ab 1999 im deutschen Fernsehen gezeigte Reality-Gameshow „Big Brother".

Um die Einschaltquoten hochzutreiben (davon ist ja auch im Film *La mort en direct* immer wieder die Rede), werden in der Gegenwart in den USA und vor allem in Japan extreme Formen des Reality-TV gezeigt: z. B. in den USA die Durchführung von Schönheitsoperationen vor laufender Kamera und die anschließende Bewertung durch die Zuschauerinnen und Zuschauer, welche der operierten Frauen dann die „Schönste" ist; oder in Japan Sendungen, in denen junge Männer in Südafrika ausgesetzt und dabei gefilmt wurden, wie sie nach Skandinavien trampen mussten, um dort ihr Heimflugticket abzuholen. Das Prinzip dieser Art des Reality-TV besteht über alle Unterschiede der einzelnen Sendungen hinweg darin, dass in der Öffentlichkeit unbekannte, „normale", Menschen „wie Du und ich", sich bereit erklären, sich in für sie schwierigen Situationen filmen zu lassen.

Dabei schrecken die Produzenten solcher Sendungen – ebenso wie in *La mort en direct* der NTV-Produzent Vincent Ferriman – nicht vor ethisch höchst bedenklichen Situationen zurück und sichern sich in den Verträgen mit den Protagonisten juristisch durch Klauseln ab, die beispielsweise den Hinweis enthalten, dass die Protagonisten auf die ihnen zustehenden Persönlichkeitsschutzrechte verzichten (Hansen 2006). Außerdem ist durch solche Verträge für die Protagonisten die Geltendmachung von Unterlassungs-, Schadensersatz- und Bereicherungsansprüchen sowie Ansprüche auf Gegendarstellung und Widerruf vertraglich ausgeschlossen (zu den juristischen Fragen im Zusammenhang mit dem Reality-TV S. Hansen 2006).

Neben den erwähnten Reality-Gameshows finden sich solche Sendungen etwa in Form von Reportagen über und Interviews mit Opfern von Gewalt jedweder Art, etwa mit Opfern jahre- bis jahrzehntelanger sexueller Übergriffe, die ihre „Story" meistbietend an Illustrierte und TV-Sendungen verkaufen, ohne zu ahnen und abschätzen zu können, auf was sie sich dabei einlassen. Dies ist ja auch eine Erfahrung, welche die Protagonistin Katherine Mortenhoe in *La mort en direct* macht, als sie die Rechte an der Verfilmung ihrer letzten Lebenswochen an NTV verkauft hat und ihr erst dann klar wird, dass sie sich dem Fernsehsender völlig ausgeliefert hat.

Was in *La mort en direct* noch Science-Fiction war, ist in der Gegenwart längst zur Gewohnheit geworden, indem reißerisch aufgemachte, allein auf Einschaltquoten ausgerichtete Reportagen über das Unglück oder über intimste Details aus dem Leben von Menschen einer breiten Öffentlichkeit auf dem Bildschirm ins Haus geliefert werden.

Insofern schockiert uns ein Film wie *La mort en direct* nicht mehr in dem Maße wie die Rezipientinnen und Rezipienten in den 80er–Jahren und erscheint uns längst nicht mehr so futuristisch wie damals. Genau darin liegt aber das Erschreckende dieses Films: dass die Privatsphäre anderer Menschen heute längst nicht mehr als ein zu respektierendes und schützenswertes Gut empfunden wird. Wie in *La mort en direct* existiert in der Gegenwart weithin keine Trennung mehr zwischen der privaten Welt und der Öffentlichkeit, die über die Massenmedien den „Kick" durch den Einblick in die intime Welt anderer Menschen sucht.

Dies bedeutet keineswegs Anteilnahme am Geschick anderer, sondern stellt – wie bei der Protagonistin von *La mort en direct* – eine aus kommerziellen Gründen betriebene Ausbeutung derer dar, die sich dadurch „Publicity" oder materiellen Gewinn versprechen, ohne sich selbst des Übergriffs einer solchen Aktion bewusst zu sein. Im Film realisiert Katherine Mortenhoe erst nach und nach die Ungeheuerlichkeit der mit ihr geplanten Sendung und sucht sich ihr durch Flucht zu entziehen. Die Tragik liegt darin, dass gerade der Mensch (der Journalist Roddy), der in der Situation größter Not Nähe zu ihr herstellt und ihr Vertrauen gewinnt, der ist, der sie verrät, indem er jedes Details ihres gemeinsamen Weges über die in seinem Auge eingebaute Kamera an den TV-Sender weiterleitet und diese Informationen an eine breite Öffentlichkeit ausgestrahlt werden.

Letztlich sind Katherine wie Roddy beide Opfer einer sie rücksichtslos ausbeutenden Medienwelt und können sich diesem unheilvollen Einfluss nur durch Selbstzerstörung (Katherine durch Suizid, Roddy durch Zerstörung des eigenen Auges) entziehen. Dieses Ende verleiht dem Film eine düstere Perspektive und stimmt pessimistisch, was die Fähigkeit des Individuums, sich gegen den Einfluss der Massenmedien zu wehren, angeht.

Psychodynamische Interpretation

Grandiosität und Ohnmacht

Der Film schildert eine Welt, die einerseits grandiose Züge trägt, indem dargestellt wird, wie Menschen (hier die Öffentlichkeit durch den Produzenten des NTV-Senders) Einblick bis in die letzten, privatesten Räume des Individuums nehmen. Es ist eine Thematik, die George Orwell bereits in den Jahren 1946/48 in seinem Roman „1984" behandelt hat, in dem ebenfalls (hier aus politischen Gründen) die Privatsphäre von Menschen außer Kraft gesetzt wird und „Big Brother" die Existenz der im geschilderten Staat Lebenden bis ins letzte Detail kontrolliert.

Die Kehrseite dieses grandiosen Entwurfs ist andererseits die Ohnmacht, in der sich in einer solchen Konstellation das Individuum befindet. Die angeblich todgeweihte Schriftstellerin Katherine Mortenhoe ist ebenso Opfer dieser Gewalt wie der sie permanent durch die in sein Auge eingebaute Kamera filmende Reporter Roddy. Beide Protagonisten haben gleichsam einen „Pakt mit dem Teufel" geschlossen, in der Hoffnung, dadurch finanzielle Vorteile und öffentliche Anerkennung zu erlangen. Beide erweisen sich am Ende aber als hilflose Opfer einer übermächtigen Gewalt in Gestalt des TV-Senders, die rücksichtslos über sie verfügt und sie als Mittel zum Zweck missbraucht, indem NTV mit der Sendung „Death Watch" „the unlimited adventure" verheißt, wie auf den Plakaten zu dieser Sendung zu lesen ist.

Die in diesem Film angesprochene Thematik ist unter psychodynamischem Aspekt der Konflikt zwischen Grandiosität und Ohnmacht, der sich vor dem Hintergrund einer willkürlichen Manipulation der Realität abspielt. Wir finden diese Dynamik in besonders ausgeprägter Weise bei Menschen

mit narzisstischen Persönlichkeitsstörungen. In der filmischen Aufbereitung sind diese beiden Persönlichkeitsaspekte der Grandiosität und der Ohnmacht auf verschiedene Protagonisten verteilt, die aber jeweils auch Züge des anderen Persönlichkeitsanteils erkennen lassen.

Auf der einen Seite ist es Katherine, die ohnmächtig im Netz des mächtigen Produzenten gefangen ist, ohne über lange Zeit zu wissen, dass dem so ist, da sie denkt, sich ihm durch Flucht entzogen zu haben. Sie verfügt aber auch über einen grandiosen Anteil mit der Hoffnung, durch den Vertrag mit NTV eine enorme Summe Geld zu erhalten, das sie ihrem Mann zukommen lässt, ohne dass sie den Vertrag mit NTV einhalten würde. Auf der anderen Seite repräsentiert der Produzent Vincent Ferriman vor allem den grandiosen, rücksichtslos agierenden Teil. Aber auch er enthält Züge des anderen Persönlichkeitsanteils, nämlich der Ohnmacht, als er am Ende des Films, nach Katherines Suizid und der Zerstörung der ins Auge von Roddy eingebauten Kamera und damit am Ende der Sendung „Death Watch", allein zurückbleibt.

Zu gleichen Teilen Grandiosität wie Ohnmacht finden sich beim Journalisten Roddy, der für die grandiose Möglichkeit, andere Menschen, ohne dass sie dies bemerken, permanent filmen zu können, bereit ist, sich eine Kamera in das Auge einbauen zu lassen. Dabei nimmt er die Gefahr in Kauf, sein Augenlicht zu verlieren, wenn er der Kamera nicht das zu ihrem Funktionieren nötige Licht zuführt. Wie ohnmächtig er selbst im Netz der Mächtigen von NTV zappelt, wird ihm in dem Moment klar, als er eine von ihm durch seine Augen aufgenommene Sequenz mit Katherine im Fernsehen sieht.

Die vergebliche Flucht – Größenidee und Selbstzerstörung

Es ist ein interessanter Aspekt des Drehbuchs, dass der Kamera im Auge des Reporters stets Licht von außen zugeführt werden muss, damit diese funktioniert. Psychodynamisch könnte man dies als Hinweis darauf verstehen, dass in einer Situation der narzisstischen, rücksichtslosen Ausbeutung anderer, wie sie in *La mort en direct* thematisiert wird, der Mensch seine Funktionen der Wahrnehmung – und damit der Realitätskontrolle – nicht mehr selbst steuern kann, sondern auf einen „technischen", „kalten" Input von außen angewiesen ist.

Denken wir an die Formulierung Kohuts (1973), das Kind entwickle sein Selbstwertgefühl, indem es sich im Augenleuchten der Mutter spiegle, so bedeutet dies für den Film *La mort en direct*, dass es eine seelenlose Kraft von außen ist, die den Menschen zum „Funktionieren" bringt. Hier geht es eben nicht, wie bei Kohut, um ein mitmenschliches Gegenüber, das eine bestätigende und den Selbstwert stützende Funktion ausübt, sondern um die Abhängigkeit des Individuums von einer außerhalb seiner selbst liegenden „technischen" Kraft, der es auf Gedeih und Verderben ausgeliefert ist

Auf die verschiedenen Protagonisten aufgeteilt, schildert der Film *La mort en direct* die Vergeblichkeit narzisstischer Grandiosität, der es letztlich nie gelingen kann, durch ihr aufgeblähtes Größenselbst (Kernberg 2009) die Gefühle von Ohnmacht und Selbstwertzweifeln abzuschütteln. Immer wieder brechen quälende Insuffizienzgefühle auf. Der mit der Verschiebung der Realität (im Sinne des Selbstsuggestion: „Ich lebe nicht in der bedrückenden Realität, sondern bin allmächtig") unternommene Versuch, diesen quälenden Gefühlen auszuweichen, ist letztlich zum Scheitern verurteilt und endet – dies zumindest die Aussage des Films *La mort en direct* – in der Selbstzerstörung. Der Aufprall des grandiosen Selbst auf die harte Realität ist so schmerzhaft, dass die Existenz in ihren Grundfesten erschüttert wird und ein Weiterleben wie bisher unmöglich erscheint.

Der Reporter Roddy zerstört sein Augenlicht durch die Vernichtung der Taschenlampe, deren Licht er für das Funktionieren der in sein Auge eingebauten Kamera und damit für seine Sehfähigkeit benötigt. Er bezahlt, psychodynamisch gesprochen, das Spiel mit Realität und Irrealität (niemand sieht ihm an, dass er kein „normaler", sondern ein „spezieller" Mensch ist, der in seinem Auge eine Kamera trägt, mit der er seine Umgebung permanent filmt) durch den totalen Verlust seiner Wahrnehmungsfähigkeit (im Film durch seine Erblindung). Auf Dauer lassen sich, so die Botschaft von *La mort en direct*, Realität und Irrealität nicht willkürlich vermischen und zur Ausbeutung anderer Menschen einsetzen.

Trotz aller Abwehrbemühungen drängt die Realität doch immer wieder an und lässt das betroffene Individuum an der Konfrontation mit dieser verdrängten Wirklichkeit zerbrechen.

Auf ähnliche Weise wird durch die Konfrontation mit der Realität auch die Protagonistin Katherine Mortenhoe zerstört. Als sie wahrnimmt, dass der sie scheinbar unterstützende und liebende Reporter Roddy in Wirklichkeit ihr Zusammensein mit ihm permanent gefilmt und zur Ausstrahlung an den NTV-Sender geliefert hat, ist ein Weiterleben für sie nicht mehr möglich. Die einzige Art, ihre Selbstachtung zu retten und sich an den sie ausbeutenden Mächtigen, vor allem am NTV-Produzenten Vincent Ferriman, zu rächen, sieht sie in der Selbstzerstörung durch Suizid.

Die gesellschaftliche Dimension

Über die Deutung des Films als soziale Inszenierung eines innerseelischen Konflikts hinaus kann *La mort en direct* unter psychodynamischem Gesichtspunkt auch als Darstellung eines gesellschaftlichen Trends hin zur Ausbildung narzisstischer Züge (mit den beschriebenen, dafür typischen Konflikten zwischen Grandiosität und Insuffizienz) interpretiert werden. Unter diesem Aspekt stellt er eine in den 80er-Jahren formulierte Warnung dar, in welche unheilvolle Richtung sich die Gesellschaft bewegt, wenn Gefühle von Anteilnahme, Einfühlung und Solidarität verloren gehen, die Gewalt in der Gesellschaft allgegenwärtig wird (Rauchfleisch 1996) und die Menschen es nicht mehr ertragen – resp. nicht mehr dazu bereit sind –, Hilflosigkeit, Ohnmacht und die eigene Endlichkeit zu akzeptieren.

Eine solche Welt scheint frei von Leid und allein auf Lustgewinn ausgerichtet zu sein. Im Film wird es denn ja auch als besonders vorteilhaft dargestellt, dass es den alten Menschen durch Verabreichung von Drogen erspart bleibe zu wissen, dass sie sterben. Dies wird durch Manipulation der Realität erreicht. Zugleich wird aus *La mort en direct* aber auch ersichtlich, dass es eine unmenschliche, rücksichtslose Welt ist, die an ihrem eigenen Untergang arbeitet.

Es liegt nahe, hier eine Parallele zum Umgang des Menschen mit der Natur zu sehen. Ähnlich wie im Film *La mort en direct* ist es auch in dieser Hinsicht eine grandiose Vorstellung, die Gesetze und Grenzen, welche die Natur uns Menschen setzt, missachten und die Natur ungestraft, rücksichtslos ausbeuten zu können. Im Verlauf der Jahrhunderte ist im Zuge der enormen technischen Entwicklung weithin das Gefühl von uns gesetzten Grenzen abhanden gekommen, und es bedarf inzwischen großer Anstrengungen, stets von Neuem zu prüfen, ob das, was machbar ist, auch ethisch vertretbar ist. Dies ist eine der Fragen, mit der sich die Rezipientinnen und Rezipienten von *La mort en direct* konfrontiert sehen.

Ein unreflektiertes, allein vom Streben nach Allmacht bestimmtes, Handeln führt – so könnte man die Botschaft des Films *La mort en direct* unter sozial-psychoanalytischem Aspekt verstehen – unweigerlich für Opfer wie Täter ins Verderben. Eine düstere Prognose, die immerhin angesichts von zunehmenden Naturkatastrophen und Klimaproblemen zumindest eine gewisse Berechtigung zu haben scheint und als Warnung dienen kann. In dieser Hinsicht können wir heutigen Rezipientinnen und Rezipienten den 1980 dem Genre „Science-Fiction" zugeordneten Film kaum mehr als futuristisch empfinden, sondern erleben ihn als Darstellung einer mehr oder weniger realen Situation, wodurch *La mort en direct* für uns jedoch umso bedrängender und unheimlicher wird.

Das Gefühl der Unheimlichkeit wird vom Regisseur dieses Films (◘ Abb. 3) in den Rezipientinnen und Rezipienten nicht zuletzt dadurch ausgelöst, dass er Realität und Irrealität ineinander verschwimmen lässt. Die realistischen Landschaften und Personen gaukeln uns vor, es sei eine völlig realistische Geschichte. Dadurch empfinden die Zuschauerinnen und Zuschauer die Tatsache der ins Auge des Reporters eingebauten Kamera wesentlich realistischer, als wenn die Umgebung und die Protagonisten wie in anderen Science-Fiction-Filmen völlig irreal dargestellt worden wären. Durch diesen Umgang mit Realität und Irrealität erzielt der Film eine bedrängende, zum Teil geradezu beängstigende Qualität und zieht uns in seinen Bann.

Abb. 3 Der Regisseur Bertrand Tavernier bei den Dreharbeiten, hier mit Romy Schneider. (Quelle: Cinetext Bildarchiv)

Das Inszenieren der Realität

Betrachten wir *La mort en direct* aus unserer heutigen gesellschaftlichen Perspektive, so liegt ein interessanter Aspekt darin, dass in der Gegenwart das bereits erwähnte Reality-TV auf viele Zuschauerinnen und Zuschauer eine große Faszination ausübt und zu hohen Einschaltquoten führt. Wie oben ausgeführt, steht das Thema „Reality-TV" ja im Zentrum des Films. Es ist deshalb lohnend, die Forschungsbefunde der Medienwissenschaft auch auf diesen Film anzuwenden. Der Medienwissenschaftler Neumann-Braun (2011, S. 39) sieht die Attraktivität der Reality-TV-Sendungen vor allem in der Befriedigung der Neugierde und der Sehnsucht der Zuschauerinnen und Zuschauer, „durch ein ,Medienfenster' schauend an der Welt anderer Leute ,wirklich' teilhaben zu können". Nach seiner Ansicht kommt es im Reality-TV – und dies trifft in ganz besonderer Weise für *La mort en direct* zu – zu einer „unauflösbaren Mischung aus Realitäts(vor)spiegelung und Realitätsintervention … mit der Folge, dass dieses Inszenieren selbst Realität hervorbringt" (ebd.).

Auf „Death Watch" bezogen, lässt sich dieser medienwissenschaftliche Befund auf zwei Ebenen deuten:

Die Filmebene

Eine erste Ebene betrifft den Film: Hier nehmen die Zuschauerinnen und Zuschauer von NTV durch das von Neumann-Braun geschilderte „Medienfenster" an der Welt anderer Menschen – hier an den letzten Lebenswochen von Katherine Mortenhoe – teil und befriedigen ihre Neugier darüber, wie das Sterben eines Menschen „wirklich" aussieht (der Film spielt ja in einer Welt, in der alle Krankheiten so gut wie ausgerottet sind und die Menschen im hohen Alter, von Drogen umnebelt, fern von der Gesellschaft sterben. Aus diesem Grund sind die unheilbare Krankheit und das Sterben einer relativ jungen Frau ein besonderes mediales Ereignis). Durch die Information am Ende des Films, dass die

Protagonistin in Wirklichkeit gar nicht krank ist, erhält dieses „Wirklichkeit" aber einen irrealen Charakter, indem Katherine, ohne es zu wissen, zur Schauspielerin geworden ist, die, ungewollt, ein ihr vom Produzenten der NTV-Sendung vorgegebenes Skript (sterben-„spielen") ausführt.

Die Zuschauerebene

Auf der Ebene der Rezipientinnen und Rezipienten des Films wiederholt sich noch einmal die gleiche Situation: Wir haben durch das „Medienfenster Film" teil an einer scheinbar „realen" Welt der NTV-Sendung „Death Watch" und am Sterben von Katherine Mortenhoe und erfahren am Ende des Films, dass die angeblich unheilbare Erkrankung der Protagonistin nicht der „Wirklichkeit" entspricht, sondern ein Schachzug des Produzenten war, um das NTV-Publikum ebenso wie uns dazu zu verführen, die Reportage des angeblichen Sterbens von Katherine anzuschauen. Auf diese Weise geraten auch wir in den Strudel des Spiels mit Realität und Irrealität.

Literatur

Hansen R (2006) Aspekte der Zerstörung von Privatheit und Intimität. Telepolis, Print. http://www.heise.de/tp/druck/mb/artikel/22/22849/1.html. Zugegriffen am 6. 4. 2012
Kernberg OF (2009) Borderline-Störungen und pathologischer Narzissmus. Suhrkamp, Frankfurt/M
Kohut H (1973) Narzissmus. Suhrkamp, Frankfurt/M
Neumann-Braun K (2011) Die Faszination von Reality-TV. UNI NOVA Basel. No. 118. Universität Basel, Basel, S 39
Orwell G (1994) 1984. Ullstein, Berlin
Rauchfleisch U (1996) Allgegenwart von Gewalt. 2. Aufl. Vandenhoeck & Ruprecht, Göttingen
Wegener C (1994) Reality-TV: Fernsehen zwischen Emotion und Information? Leske & Budrich, Opladen

Originaltitel	La mort en direct
Erscheinungsjahr	1980
Land	Frankreich, Deutschland, Großbritannien
Buch	David Rayfiel, Bertrand Tavernier
Regie	Bertrand Tavernier
Hauptdarsteller	Romy Schneider (Katherine Mortenhoe), Harvey Keitel (Roddy), Harry Dean Stanton (Vincent Ferriman), Thérèse Liotard (Tracey), Max von Sydow (Gerald Mortenhoe)
Verfügbarkeit	Als DVD in OV und deutscher Sprache erhältlich

Parfen Laszig

Der Glanz im Auge des Replikanten

Blade Runner – Regie: Ridley Scott

Blade Runner

Regie: Ridley Scott

Early in the 21st Century, THE TYRELL CORPORATION advanced Robot evolution
into the NEXUS phase – a being virtually identical to a human – known as a **Replicant**.
The NEXUS 6 Replicants were superior in strength and agility, and at least equal
in intelligence, to the genetic engineers who created them.
Replicants were used Off-World as slave labor, in the hazardous exploration
and colonization of other planets. After a bloody mutiny by a NEXUS 6 combat team
in an Off-World colony, Replicants were declared illegal on earth – under penalty of death.
Special police squads – BLADE RUNNER UNITS – had orders to shoot to kill, upon detection,
any trespassing Replicant. This was not called execution. It was called retirement.

Los Angeles, November, 2019

Die Filmhandlung[1]

Los Angeles im Jahr 2019 (◻ Abb. 1): Nachdem Überbevölkerung und Umweltverschmutzung unerträgliche Dimensionen erreicht haben, sind Millionen von Menschen gezwungen, auf andere Planeten überzusiedeln. Diejenigen, die auf der Erde geblieben sind, leben in gewaltigen, überbevölkerten Städten, auf die unablässig ein Säureregen niedergeht. In den Straßen herrscht ein unübersichtliches multikulturelles Gewirr von Menschen, Sprachen und Verkehr, illuminiert durch grell-bunte Neonreklamen. Die genetische Manipulation ist zu einem der größten Industriezweige geworden, und es werden künstliche Haustiere feilgeboten, weil die meisten Tierarten ausgestorben sind. Eine Weiterentwicklung stellen genetisch hergestellte Menschen, sogenannte „Replikanten" dar. Als Arbeits-, Lust- und Kampfsklaven werden sie auf die extraterrestrischen Kolonien geschickt und gelten auf der Erde als „illegal". Da sie von echten Menschen nahezu nicht mehr zu unterscheiden sind, werden sie als potenzielle Bedrohung betrachtet. Einer Gruppe von besonders hochentwickelten Replikanten der Nexus-6-Serie ist es gelungen, sich eines Spaceshuttles zu bemächtigen, die Besatzung zu töten und auf die Erde zurückzukehren. Einer der entflohenen Replikanten, Leon, schleicht sich als Arbeiter in die Herstellungsfirma „Tyrell Corporation" ein. Als Leon (Brion James) einem Assoziations-/Empathietest (genannt Voight-Kampff) unterzogen wird, tötet er seinen Verhörer Holden.

Der zuständige Polizeichef Bryant (M. Emmet Walsh) lässt daraufhin nach dem ehemaligen Polizisten und Blade Runner Rick Deckard (Harrison Ford) suchen. Er zwingt ihn, den Fall zu übernehmen und schickt ihn zur Tyrell Corporation. Auf Diktat des Großindustriellen Dr. Tyrell (Joseph Turkel) soll er an dessen Assistentin Rachael (Sean Young) den besagten Voight-Kampff-Test exemplarisch durchführen. Im Verlauf der Testung wird Deckard deutlich, dass die unnahbare Schöne auch als Testobjekt eine besondere Herausforderung darstellt: Aufgrund implantierter Erinnerungen ist sie sich ihrer künstlichen Identität nicht bewusst. Inzwischen sind die vier geflohenen Replikanten im Moloch der Stadt untergetaucht. Deckard nimmt die Fährte auf. Nachdem er die Replikantin Zhora (Joanna Cassidy) aufgespürt und getötet hat, wird er von deren Partner Leon attackiert. Rachael erschießt Leon und rettet Deckard damit im letzten Moment das Leben. Die beiden verlieben sich ineinander.

1 vgl. auch Presseinformationen zum Director's und zum Final Cut.

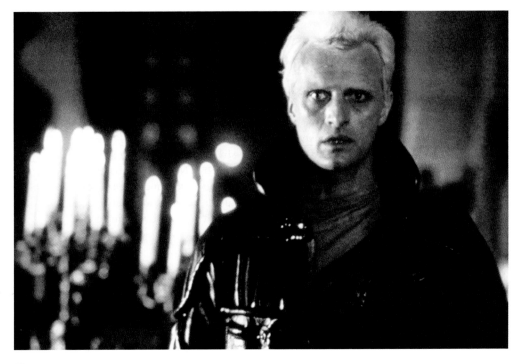

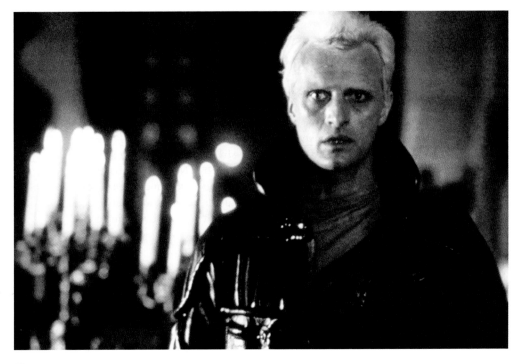 **Abb. 2** Roy Batty (Rutger Hauer), der Anführer der Replikanten. (Quelle: Cinetext Bildarchiv)

Durch seine attraktive Gefährtin Pris (Daryl Hannah) kommt der Anführer der Replikanten, Roy Batty (Rutger Hauer) (■ Abb. 2), in Kontakt mit dem genetischen Ingenieur J. F. Sebastian (William Sanderson). Von ihm lässt er sich in Tyrells Refugium einschleusen. Als er von seinem „Schöpfer" erfährt, dass es keine Möglichkeit gibt, seine auf vier Jahre festgelegte Lebensspanne zu verlängern, tötet er ihn. Zurück im Haus des ebenfalls getöteten Sebastian, kommt es zum finalen Showdown. Nachdem Deckard auch Pris getötet hat, beginnt ein unheimliches Katz- und Maus-Spiel zwischen ihm und Batty. Der Replikant rettet in einer humanen Geste Deckards Leben und stirbt vor den Augen des Blade Runners. Deckard kehrt in seine Wohnung zurück und findet Rachael, die inzwischen auch auf der Todesliste der Polizei steht. Gemeinsam fliehen die beiden aus dem Gebäude, und Deckard entdeckt den entscheidenden Hinweis auf seine eigene Identität[2].

Die Geschichte im Hintergrund

Der dem Film zugrunde liegende Roman[3] „Do Androids Dream of Electric Sheep?" (1968) zählt zu den Hauptwerken des 1928 in Chicago/USA geborenen Philip Kindred Dick. Kurz bevor die Verfilmung seines Romans unter dem Titel *Blade Runner* 1982 in die Kinos kam, erlitt der das Genre[4] prägende

2 In den vorangegangen Filmversionen fehlt diese szenische Verbindung. Es folgt ein Happy-End und Deckard weiß über Rachael, dass sie „ohne Endedatum" ist (vgl. Laszig 1998, S. 96; S. auch Schnittbericht unter http://www.dvd-forum.at/schnittbericht/1467-der-blade-runner).

3 Roman im Original als pdf-Datei unter http://www.kejvmen.sk/dadoes.pdf.

4 Der nach ihm benannte „Philip K. Dick Award" ist ein US-amerikanischer Literaturpreis für zeitgenössische Science-Fiction-Literatur. Er zählt nach dem Hugo Award und dem Nebula Award zu den wichtigsten Science-Fiction-Preisen; http://www.philipkdickaward.org/.

Schriftsteller einen Schlaganfall. Er verstarb am 2. März 1982. Biografisch berichtet wird – neben dem frühen Tod seiner Zwillingsschwester – über seine tiefe Abneigung gegenüber Autoritäten, angefangen bei seinen Eltern (der Vater war Regierungsangestellter, die Mutter zensierte Statements eines Regierungssprechers), die er als äußerst angepasst und regierungskonform erlebte. Zeitweiser Drogen- bzw. langjähriger Medikamentenabusus – u. U. auch paranoid-gefärbte Wahnvorstellungen während psychotischer Phasen – fanden ihren Niederschlag in seinem künstlerischen Schaffen. In seinen Romanen schilderte Dick immer wieder „ausweglos verstrickte Charaktere in ihrem Kampf um die eigene Identität, um das Erkennen der wahren Struktur ihrer manipulierten Umwelt"[5]. Sein veröffentlichtes Gesamtwerk umfasst insgesamt über einhundertzwanzig Kurzgeschichten und mehr als vierzig Romane[6]. „Do Androids Dream of Electric Sheep?" zählt inzwischen zu den modernen Klassikern der amerikanischen Literatur. Geschrieben während des US-Kriegseinsatzes gegen Vietnam, beruhten Dicks Überlegungen zur Unmenschlichkeit des Menschen auf Tagebüchern von in Polen stationierten SS-Mitgliedern.[7]

Im Roman unterscheidet er zwischen dem authentischen Menschen und der reflektierenden Maschine, die er Androide nannte (Dick, zit. nach Whitehead 2002; S. auch Schnelle 1997, S. 7):

> In my mind android is a metaphor for people who are psychologically human but behaving in a nonhuman way.

Die Empathie spielt im Roman eine zentrale Rolle, sodass ein entsprechender Test entwickelt wurde (vgl. Dick [1]1968; 2010, S. 48):

> Die neuesten und genauesten analytischen Methoden zur Bestimmung des Persönlichkeitsprofils …, – also der Voigt-Kampff-Test – sollten bei einer sorgfältig ausgewählten Gruppe schizoider und schizophrener menschlicher Patienten ausprobiert werden. Insbesondere bei solchen, die unter einer sogenannten ‚Affektabflachung' leiden.

Dick verpackte diese und viele andere philosophische, ökologische und soziologische Überlegungen in eine postapokalyptische Erzählung, bei der am Ende beinahe jeder Hoffnungsschimmer erdrückt wird.

Zur Entstehung des Films – Vom Androiden zum Replikanten

Bereits ein Jahr nach Erscheinen von „Do Androids Dream of Electric Sheep?" interessierten sich die ersten Filmemacher für den Stoff. Den endgültigen Zuschlag bekam Ridley Scott, der mit seinem zweiten Spielfilm, *Alien – Das unheimliche Wesen aus einer fremden Welt* (1979) als angesagter Kult-Regisseur gehandelt wurde. In Deutschland war der Film zunächst unter dem Titel „Aufstand der Anti-Menschen" (Cinema 1981) angekündigt. Den endgültigen Filmtitel *Blade Runner* entlieh Drehbuchautor Fancher einem gleichnamigen Science-Fiction-Roman von Alan E. Nourse. Da die ersten Testvorführungen auf Kritik stießen, entschied sich Scott für das Hinzufügen eines bereits vorliegenden Happy Ends. Die Produzenten verlangten zusätzlich Voice-over-Kommentare. Durchweg gelobt und mit Preisen ausgezeichnet wurde die formale und ästhetische Gestaltung des Szenenbildes, eine Hybri-

5 http://www.gnosis.org/pkd.FAQ.bio.html; http://www.philipkdick.de/biografie
6 Weitere Verfilmungen seiner Kurzgeschichten und Romane sind u. a. *Screamers* (Second Variety), *Paycheck, Next* (The Golden Man), *Der Plan* (Adjustment Team), *Total Recall* (We Can Remember It For You Wholesale) und *A Scanner Darkly*
7 „Nachts werden wir vom Jammern der verhungernden Kinder wachgehalten" – „There is obviously something wrong with the man who wrote that. I later realized that, with the Nazis, what we were essentially dealing with was a defective group mind, a mind so emotionally defective that the word ‚human' could not be applied to them. „Worse," Dick continued, „I felt that this was not necessarily a sole German trait. This deficiency had been exported into the world after World War II and could be picked up by people anywhere, at any time." (Dick, zit. in Sammon 2007, S. 16).

disierung unterschiedlicher Genres und Stile, weitere Auszeichnungen gingen u. a. an Musik, Kamera und Kostümausstattung. Beim US-amerikanischen Publikum war das Interesse an dem düster gehaltenen Science-Fiction Film jedoch eher gering und er konnte – auch wegen des zeitgleich erschienenen, putzig anzusehenden E. T. – kommerziell nicht reüssieren.[8]

Im Gegensatz zur literarischen Vorlage avanciert im Film – ähnlich wie schon in *Metropolis* (1926) – die Architektur der Großstadt zum Handlungsträger „welche die Handlungen der einzelnen Charaktere sowie deren seelische und emotionale Motivationen geografisch verortet" (Jung 2011, S. 4). Das Prinzip der „Bricolage" (Levi-Strauss 1962, S. 26; vgl. Will 2007), bei dem Architektur, Kleidung, Symbole und Embleme künstlich neu zusammenstellt und damit deren Bedeutung verändert werden, bestimmt sowohl die Entwicklungsgeschichte als auch die ästhetische Gestaltung von *Blade Runner*. Deutelbaum (1989, S. 69) schreibt – in Anlehnung an ein Interview mit dem Filmdesigner Mead – von einem den Film durchdringenden akkumulierenden Prozess, einem Prinzip der Schichtung („principle of layered accumulation"). Im Film entstehen dadurch architektonische Bauwerk-Hybride unterschiedlichster zeitlicher Einflüsse, die laut Scott der Wohnungs- und Gebäudegestaltung in der Zukunft am nächsten kämen, da dann immer weniger finanzielle und räumliche Möglichkeiten vorhanden seien, um gänzlich neue Objekte zu errichten. Das Prinzip der Schichtung findet sich am eindrücklichsten in den Gebäuden, deren Architektur Stilelemente der Maya-Tempel und ägyptischer Pyramiden mit solchen des 19. bis 21. Jahrhunderts kombiniert[9]. Übertragen wir das Prinzip der Schichtung in die Begrifflichkeit der Psychoanalyse, erinnert die Verwendung von Formen und Symbolen aus verschieden Religionen, aus Kunst und Mythologie entfernt an C. G. Jungs Schalenmodell, in dessen innerstem Kern er das kollektive Unbewusste verortete.

Bis heute ist der atmosphärische „Look" von *Blade Runner* stilprägendes Vorbild für zahlreiche Romane, Graphic Novels und Filme. Er gilt als einer der wichtigsten Filme des Sci-Fi-Genres[10]. Der enorme künstlerische Einfluss, den der visuelle Stil des Films ausübte, lässt sich nicht nur in späteren Kinowerken ablesen, sondern u. a. auch auf dem Gebiet des Grafikdesigns und des Cyberpunk-Genre. Seit unzähligen Jahren wird auch über eine Fortsetzung spekuliert, deren Regie Scott inzwischen bestätigt hat.

Filmwirkung

Dirk Blothner, der sich intensiv mit der unbewussten Wirkung von Filmen beschäftigt, gibt uns den poetischen Hinweis,

[dass] … das Leben Verwandlung ist. Es ist ein Bild, das sich dreht, wendet und entwickelt. Dabei ändern sich die Werte und Bedeutungen der Menschen und Dinge …. Da der Film solche Verwandlungen spürbar und sichtbar macht, ist er ein Spiegel der menschlichen Seele.[11]

8 In den Vereinigten Staaten spielte er damals die Produktionskosten von 28 Millionen Dollar nicht wieder ein.

9 An dieser Stelle können nur einige Aspekte der enormen Vielschichtigkeit benannt und nicht differenzierter ausgeführt werden – wie die etappenweise nachgerüsteten Fahrzeuge, die multikulturelle Zusammensetzung der Stadtbevölkerung, deren Kleidungs-, Schrift- und Sprachstile.

10 1993 wurde er – als einer von 25 Filmen seines Jahrgangs – für das US-amerikanische National Film Registry als „culturally, historical or aesthetically" (Kolb 1997, S. 300) signifikanter Film nominiert

11 Zitiert nach http://www.filmwirkungsanalyse.de/; s. auch Blothner (1999; 2003)

Auch *Blade Runner* hat sich in seiner jahrzehntelangen Geschichte verwandelt. Damit sind natürlich nicht nur die unterschiedlichen Versionen[12] und ihre Abweichungen[13] gemeint, sondern auch mein persönlicher Zugang zum Film. Seit ich *Blade Runner* zum ersten Mal gesehen habe, wurde ich durch ihn immer wieder fasziniert, berührt und in unterschiedlichster Weise zum Denken animiert. Meine erste Begeisterung – damals war ich noch keine zwanzig Jahre alt – galt vordergründig der dargestellten Technik (wie beispielsweise der wunderbaren Esper-Maschine, die sich mit der Stimme per Zuruf bedienen ließ und ein eingelegtes Foto per Zoomsteuerung in Planquadrate bis ins kleinste Detail auflösen konnte – heute im Zeitalter von per Sprachbefehl gesteuerten Handys und digitaler Bildbearbeitung durch Photoshop ist dies natürlich kein Wunderwerk mehr). Korrelierend mit der neugierigen Technikaffinität lockte mich das triebhafte Seelenleben der Protagonisten, ihr zur Schau getragenes mythisches, tragisches und romantisches Leiden, letztendlich die Vehemenz, mit der sie um ihre Identität ringen – und wie im Film trügen mich dabei unter Umständen meine Erinnerungen. Haftengeblieben ist, wie verwirrend ich es fand, dem heldenhaften *Star Wars*-Cowboy Han Solo alias Harrison Ford als desillusioniertem Verlierer und Anti-Bogart Rick Deckard wieder zu begegnen. Auch sein Antagonist, der hühnenhafte Replikantenanfüher Roy Batty alias Rutger Hauer lud anfangs nicht gerade zur Identifikation ein – ganz im Gegenteil, meinte ich doch in ihm einen Riefenstahl'schen Olympioniken bzw. das Körperideal der verachteten Nazis wiederzuerkennen. Demgegenüber war die geheimnisvoll-erotische Rachael, gespielt von der damals 21-jährigen Sean Young, einfach nur traumhaft begehrenswert – und der Moment, als sie am Klavier sitzend zum ersten Mal ihr Haar öffnet, ruft in mir noch heute eine leise prickelnde Gänsehaut hervor. Inzwischen sind dreißig Jahre vergangen und immer noch wirft der Film mich als Betrachter in wechselhafte körperliche, emotionale und innerpsychische Zustände. Ähnlich wie die Protagonisten gerate auch ich als Zuschauer in Verwirrung, ins Erinnern und in nachdenkliches Zweifeln.

Die Irritation ist dem Film förmlich eingewoben. Wiederholt werden grundlegende Zweifel an der Verlässlichkeit der eigenen Wahrnehmung erzwungen. Sind die von Leon, Rachael und Deckard liebevoll behüteten Fotos „ein kleines Stück Wahrheit … die Wahrheit der Abstammung" oder sind sie ein „bizarres Medium … eine neue Form der Halluzination?" (Barthes [1]1980; 2010, S. 43 u. 47). Wir sehen künstliche Wesen, die sich menschlicher als die Menschen verhalten, Fotos, die sich plötzlich bewegen, Gefühlsausbrüche, wo scheinbar nur Gefühllosigkeit herrscht. Wir erleben Momente der Überraschung, des Angewidertseins, tiefer Verzweiflung und Leidenschaft – der Film berührt, erzeugt Sensationen, die sich zeitweise bis ins Körperliche fortpflanzen – beispielsweise, wenn, während der Voight-Kampff-Testung der vermeintlich affektlosen Replikanten, als lautmalerischer Hintergrund der Herzschlag des Verhörten (oder des Verhörers?) „tachykardiert".

Im Verlauf des Films wird wiederholt gegen die eigenen – auch kulturell und medial geprägten – Erwartungen verstoßen. Ein erster Eindruck erweist sich auf den zweiten Blick als Inversion, als Umkehrung. Evoziert der Replikant Batty zu Beginn des Films noch das Bild eines kalt-mordenden Teufels, eines gefallenen Engels, der gegen seinen Schöpfer rebelliert, so entwickelt er sich zunehmend zum melodramatischen Helden und in seinem letzten Moment zum messianischen Retter. Im postmodernen Weltentwurf scheint es schwieriger zu werden, sich zu verorten, einen äußeren wie auch inneren Standpunkt aufrecht zu erhalten. Der Film zwingt uns, unsere Position zu überdenken, er bleibt uns jedoch eindeutige Antworten schuldig.

12 *Blade Runner* wurde inzwischen in acht verschiedenen Versionen veröffentlicht. Am bekanntesten sind der *International Cut* (1982), der *Director's Cut* (1992) und – die von Regisseur Ridley Scott favorisierte und aktuellste Version – der *Final Cut* (2007).

13 „Auch wenn jede Fassung des Stoffs für sich selbst stehen und verstanden werden kann, so eröffnet Scott doch ein Verweisspiel, indem er durch die von ihm vorgenommenen Änderungen auf frühere Lektüre- oder Seherinnerungen anspielt und zu Neuinterpretationen des zuvor anders gesehenen anregt." (Simine 2006, S. 233)

Psychodynamische Interpretation

Zurück zum Anfang: Der Film beginnt mit einem Paukenschlag, untermalt von sphärischer Synthesizer-Musik folgen die Namen der Hauptdarsteller, des Produktionsteams und weitere Paukenschläge – wie ferne Detonationen. „Early in the 21st Century, THE TYRELL CORPORATION advanced Robot evolution …“: weiße Schrift auf schwarzem Grund, nur das Wort **Replicant** sticht hervor. Die Musik wird zunehmend düsterer. Wir werden hineingezogen in das Panorama des nächtlichen Los Angeles, November 2019. Riesige Industrieschornsteine speien Feuer, durch das elektrische Lichtermeer kommt ein Fluggerät schräg auf uns zu, und plötzlich füllt ein einzelnes Auge die gesamte Leinwand. In der blauen Iris spiegeln sich die Lichter und eine feurige Explosion, Feuer der Zerstörung und Lebensflamme zugleich. Eines der Fluggeräte steuert – sozusagen mit uns – direkt auf eine zentrale Pyramide zu, eine Mischung aus gigantischem Mikrochip und aztekischem Sonnentempel. Einer Doppelung und Prolepsis zugleich blicken wir erneut in die Pupille und sehen die Spiegelung einer weiteren Explosion. Per Zoom landen wir in einem Büro inmitten der Pyramide, dem Sitz der Tyrell Corporation. Das Licht ist bläulich-fahl, ein Mann im grauen Anzug raucht eine Zigarette, eine Durchsage im Hintergrund kündigt dem Wartenden die Testung eines neuen Angestellten aus der Abfallbeseitigung an. Der besagte Leon Kowalski soll mit Hilfe eines insektenartigen Iris-Scanners einem Assoziationstest unterzogen werden – die Apparatur dient der Erfassung emotionaler Reaktionen bzw. dem Aufspüren von Replikanten, die über solche vermeintlich nicht verfügen. Was von dem arroganten Verhörer Holden als kühle Testsituation eingeführt wird, entwickelt sich von der interaktionellen Stimmung schnell zum paranoid getönten Machtkampf. Die Stimmen der beiden Protagonisten verändern sich, beginnen zu hallen, und im Hintergrund hören wir einen ansteigenden Puls, ohne diesen individuell zuordnen zu können. Wie Kontrahenten eines Schachspiels sitzen sich die beiden am Schreibtisch gegenüber, und es folgt der entscheidende Wortwechsel.

 Holden: „Beschreiben Sie nun in einzelnen Worten alle positiven Dinge, die Ihnen in den Sinn kommen … über Ihre Mutter!"
Leon: „Meine Mutter?"
Holden: „Ja!"
Leon: „Ich erzähl' Ihnen was von meiner Mutter!"

Der erste Schuss fegt den überraschten Holden samt seinem Stuhl durch die dünne Bürowand – ein scheinbar kaltblütiger Mord, doch unterschwellig voller Hassgefühl. Kurz sehen wir Leon, der, nun aufrecht stehend, einen weiteren Schuss abfeuert – diesmal in den Rücken des Widersachers. Der folgende Schnitt ist ebenso abrupt – das Gesicht einer Geisha auf der Videowerbetafel an der Wand eines Wolkenkratzers. Im Hintergrund wirbt eine Stimme für den persönlichen Neuanfang, ein neues Leben in den Kolonien, ein goldenes Land voller Möglichkeiten und Abenteuer …

Diese ersten Filmszenen antizipieren bereits zentrale Motive von *Blade Runner*. Nach dem Einführungstext eröffnet das einzelne Auge einen mehrdimensionalen Assoziationsraum. In der gezeigten Pupille sehen wir die Außenwelt, die moderne Großstadt, die Megacity. Ihre feuerspeienden Schornsteine gelten als Symbole der Industrialisierung. Die Geschichte der Luftverschmutzung begann, als die Menschen das Feuer bändigten. Die Katastrophe von Tschernobyl ereignete sich 1986. Fünfundzwanzig Jahre später beschäftigen die Welt weiterhin der „saure Regen", die Umwelt- und Klimazerstörung – zuletzt aus Richtung Fukushima-Daiichi. Das Auge ist ein Tor, das in zwei Richtungen offen ist, nach außen und nach innen. Als Zugang zur Innenwelt ist der Zusammenhang von Auge und Psyche in allen Kulturen bekannt. Hier wird das Auge jedoch losgelöst von einem bestimmten Körper gezeigt – als Zuschauer können wir nicht unterscheiden, ob es zu einem Menschen oder einem Replikanten, einem humanen oder einem künstlichen Organismus, gehört. Die Differenz von Subjekt

und Objekt wird damit verwischt. In der gezeigten Pupille sehen wir zudem eine gespiegelte Welt. Der Psychoanalytiker Heinz Kohut (1971) bezieht den Begriff der „Spiegelung" auf die einfühlsame Reaktion der Mutter auf die Äußerungen ihres Kindes, die Imitation seiner Gestik und Mimik (und gegebenenfalls deren Versprachlichung). Mary Ayers (2003, S. 62) sieht im ersten Augenkontakt den „Beginn der Objektbeziehung, die wiederum die Schablone dafür ist, wie das Individuum letztendlich mit der Welt später in Beziehung steht" (zit. nach Tiedemann 2007, S. 56). Der „Glanz im Auge der Mutter" (Kohut 1988, S. 141) definiert demzufolge nicht nur die unmittelbare, affektive Welt des Säuglings, sondern ist unerlässlich für seine weitere seelische Entwicklung. Im Film erkennt man die Replikanten an ihren Augen. Wäre Holden kein Blade Runner sondern Psychoanalytiker, würde er mit Leon klären wollen, warum die Frage nach der Mutter zu einem mörderischen Impuls führt? Für einen Replikanten kann die Beziehung zur Mutter nur auf einer Ent-Täuschung beruhen. Nicht nur Leon, sondern auch sein Mutterbild wurden „enttarnt"[14], und er überträgt seinen Hass auf diejenigen, die er für die Zerstörung der fantasierten „guten Mutter" verantwortlich macht. Doch bevor wir Zeit für weiteres Nachsinnen erhalten, reißt uns der Film – oder, psychoanalytisch gesprochen, die Abwehr – hinfort. Wir fliegen vorbei an dem Gesicht einer schönen asiatischen Frau, aus westlicher Sicht einer verführerischen Fremden, und landen im nächtlichen Getümmel der regenüberströmten Straßen bei etwas scheinbar Altbekanntem. Der zeitunglesende Rick Deckard wirkt in seinem zerknitterten Trenchcoat wie eine Detektivgestalt aus den 50er-Jahren, ein desillusionierter Privat Eye, der als Einzelgänger das Labyrinth der Großstadt durchstreift. Der Auftritt des etwas dandyhaften Handlangers Gaff[15] markiert Deckard als Blade Runner und damit als (scheinbaren) Menschen. Doch wie seine „Verhaftung" und der anschließende Dialog mit dem schmierigen Polizeicaptain Bryant verdeutlichen, ist auch Deckard nicht wirklich frei. „Es ist aus mit dir, wenn du nicht mitmachst", „you are no cop, you are little people", droht ihm der ehemalige Vorgesetzte. Das Mitmachen des „kleinen Mannes" bezieht sich auf die staatliche Ermordung von Replikanten. Euphemistisch wird dies als „in den Ruhestand versetzen" bezeichnet. Für den grobschlächtigen Bryant sind die Replikanten nur „Hautjobs". Ein Off-Kommentar erklärt: In Geschichtsbüchern ist Bryant der Typ Polizist, der die Schwarzen „Nigger" zu nennen pflegte. Im Vorspann wurden die Replikanten bereits als „Sklaven" benannt. Sie sind Opfer von rassistischen Verallgemeinerungen und bekommen per projektiver Zuschreibung „die Qualität des Dunklen und Unheimlichen als Träger des Unerwünschten" (Wangh 1992, S. 1156). Und weiter (ebd., S. 1166):

> Je mehr die Identitätsgewissheit verlorengeht, desto stärker der Versuch, Außengruppen mit ursprünglich eigenen Charakterzügen zu belasten, durch sie die Grenzen des Selbst zu definieren, eines Selbst, das sich weniger und weniger kennt, eines Selbst, das weniger und weniger von seinen eigenen Gefühlen und Wünschen weiß.

Rachael und der Traum vom Lieben & Geliebtwerden

Als Mensch wirkt Deckard verloren und desillusioniert, einen Zugang zu empathischen Gefühlen kann er nur technisch herstellen. Er gehorcht – wenn auch widerwillig – der staatlichen Autorität und nimmt die Verfolgung der Unerwünschten auf. Im tempelähnlichen Empfangsraum der Tyrell-Coporation trifft er auf zwei Schönheiten: Eine künstliche Eule (eine Anspielung auf die jungfräuliche Athene,

14 Zum „enttarnten schlechten Objekt, das in der Maske eines guten aufgetreten" ist, siehe Thomas H. Ogdens Ausführungen zum Erleben im paranoid-schizoiden Modus (Ogden [1]1989; 1995, S. 18 ff.).
15 Raimar Zons verweist darauf, dass in der Filmbranche der „gaffer" der Beleuchter ist. Seiner Interpretation nach ist Gaff eine Art „Seelenführer", der Deckard auf seinem Weg begleitet und mit selbstgefalteten Origami-Tierchen immer wieder dessen Psyche ausleuchtet (vgl. Zons 2000, S. 273).

Kopfgeburt des Zeus und Schutzgöttin des Odysseus) und auf Tyrells anmutig-kühle Assistentin Rachael (eine weitere „Vatertochter"). Die dunkelhaarige Schönheit mit den großen braunen Augen und dem rotgeschminkten Mund kommt gleich zum Punkt:

 „Darf ich Ihnen eine persönliche Frage stellen? Haben Sie je aus Versehen einen Menschen in den Ruhestand versetzt? Nein. Aber in Ihrer Position könnte das passieren!"

Im Gegensatz zu Deckard stellt Rachael die Andersartigkeit in Frage und verweist auf eine moralische Verantwortlichkeit. Eine Stimme aus dem Hintergrund ertönt: „Ist dies ein Sensibilitätstest, Kapillarerweiterung, die sogenannte Errötungsreaktion, Fluktuation der Pupille, unfreiwillige Vergrößerung der Iris?" Für einen kurzen Moment bleibt unklar, ob sich die Frage auf die gerade stattgefundene Unterhaltung bezieht. Doch Dr. Tyrell beschreibt den im ersten Verhör bereits gezeigten Voight-Kampff Test und fordert Deckard auf, ihn zuerst an einem Menschen, Rachael, zu demonstrieren (im Orginalton heiß es doppeldeutig: „try her"). Rachael ist ein Replikant – aber sie weiß es nicht, sie vermutet es nur. „Wie kann es nicht wissen, was es ist?", fragt Deckard und spricht damit Rachael ihre Menschlichkeit, ihre Subjekthaftigkeit ab. Tyrell sieht Rachael aus der ökonomischen Perspektive: „Profit ist, was unser Handeln bestimmt, menschlicher als der Mensch ist unser Motto." Für den Konzernchef ist sie/es ein Experiment oder, mit Oliver Decker (2011) gesprochen, ein „Warenkörper" (später wird Rachael zu Deckard sagen, „ich gehöre nicht zum Geschäft, ich bin das Geschäft"). Ein Ware hat kein „Ich", kein zur Reflexion fähiges „Selbst" und damit keine Identität. In seiner Fallgeschichte „Eine Frage der Identität" formuliert Oliver Sacks (2011, S. 165):

[dass wir uns als Individuen]…biologisch und physiologisch nicht sehr voneinander unterscheiden – historisch jedoch, als gelebte Erzählung, ist jeder von uns einzigartig. Um wir selbst zu sein, müssen wir uns selbst haben; wir müssen unsere Lebensgeschichte besitzen oder sie, wenn nötig, wieder in Besitz nehmen. Wir müssen uns er-innern – an unsere innere Geschichte, an uns selbst. Der Mensch braucht eine solche fortlaufende innere Geschichte, um sich seine Identität, sein Selbst zu bewahren.

Im Film ist Deckard im Besitz von Rachaels (Lebens-) Geschichte, er kennt ihre vermeintlich einzigartigen Erinnerungen:

 „Wie war das, als Sie sechs waren, Sie und Ihr Bruder haben sich in ein verbotenes Gebäude geschlichen, durch ein kaputtes Kellerfenster. Sie wollten Onkel Doktor spielen, er hat Ihnen seins gezeigt und als Sie dran waren, da haben Sie Angst gekriegt und sind weggelaufen … oder wie war das mit der Spinne, die im Gebüsch vor Ihrem Fenster lebte … das Ei öffnete sich und Hunderte von Babyspinnen kamen heraus und haben Sie gefressen."

Er erklärt Rachael, dass er dies weiß, da es sich um keine „wirklichen" Erinnerungen handelt, sondern um Implantationen, die einer anderen, Tyrells Nichte, gehörten. Wie wir wissen, lösen Entdeckungen unterschiedlichste Entwicklungen aus. Psychoanalytisch betrachtet beschreiben die re-konstruierten Erinnerungen die von Freud beschriebene psychosexuelle Entwicklung eines Mädchens: Die Entdeckung des Geschlechtsunterschieds, die damit verbundenen Ängste und die ödipale Beziehung zur

Mutter.[16] Jenseits dieser Deutung werden für Rachael ihre Erinnerungen jedoch enteignet und damit wertlos – sie wirft ein mitgebrachtes Foto (von ihr als Kind zusammen mit ihrer Mutter) traurig-trotzig weg. Deckard wird es aufheben und das Bild wiederholt betrachten. Er behandelt die Erinnerung damit nicht als wertlos, sondern nimmt sich ihrer an (Will 2007, S. 392 ff.):

> Das gefälschte Bild von einem Mädchen mit seiner Mutter, das Rachel bislang für eine Momentaufnahme aus ihrem Leben hielt, wird eine Sekunde lang vor dem inneren Auge Deckards zu Wirklichkeit; es beginnt zu leben, wird zum bewegten Moment, als ob ein Windhauch durch das Bild ziehe.

Wir hören Kinderstimmen und nicht nur in Deckard, sondern auch in uns als Zuschauern bewegt, verändert sich etwas. Auch Rachael durchläuft eine zunehmende Verwandlung. Nachdem sie Deckard vor dem Tod bewahrt hat (S. u.) und dieser eingeschlafen ist, sitzt sie am Klavier und betrachtet seine sepiagetönten Erinnerungsfotos. Ihr Blick gleicht dem in einem Spiegel. Die erste Porträtaufnahme zeigt ein Mädchen mit streng zurückgebundenen Haaren, auf der zweiten ist eine Frau mit offenen Haaren abgebildet. Roland Barthes ([1]1980; 2010, S. 75) schreibt in seinen Bemerkungen zur Fotografie: „Die Zeit, in der meine Mutter vor mir lebte, das ist für mich die Geschichte." Im Angesicht von Deckards abgebildeter Geschichte beginnt Rachael vorsichtig auf dem Klavier zu spielen[17], dann öffnet sie ihr hochfrisiertes Haar, zupft es zurecht und lässt die Haare links und rechts niederfallen.[18] Sinnbildlich reift sie von dem abgebildeten Kind zu kreativen Frau – und damit auch zum Liebesobjekt von Deckard.

 Deckard: „Ich habe Musik geträumt."
Rachael: „Ich wusste nicht, ob ich spielen kann, ich habe mich an Klavierstunden erinnert, ich weiß nicht, ob ich es war oder Tyrells Nichte."
Deckard: „Du spielst wundervoll, Rachael."

In diesem Moment erkennt Deckard, dass, auch wenn die Fotografien und Erinnerungen nicht real, die damit verbunden Gefühle dennoch authentisch sind, „alles so wahr ist, wie man es empfindet" (Will 2007, S. 393). Liebevoll sieht er Rachael an und versucht sie zu küssen. Doch wie in ihrer „Kindheitserinnerung" läuft sie aus Angst weg. In einer Mischung aus Brutalität, Begehren und auch Beruhigung reißt er sie an sich:

 Deckard: „Ich will, dass du mich küsst."
Rachael: „Ich kann mich nicht erinnern."
Deckard: „Sag küss mich."
Rachael: „Küss mich."
Deckard: „Ich will dich."
Rachael: „Ich will dich."
Deckard: „Nochmal."
Rachael: „Ich will dich. Leg deine Arme um mich."

16 Die amerikanische Filmtheoretikerin Kaja Silverman (1991, S. 120 ff.) vertieft diesen Gedanken in Bezug auf die psychoanalytische Theorie des weiblichen Kastrations- und negativen Ödipuskomplexes.

17 eine romantische Variation von Chopins Nocturne c minor op. 48 No. 1

18 Koebner (1999, S. 71) vergleicht Rachael mit einem Idol des viktorianischen Zeitalters, da sie seines Erachtens unverkennbar den fragilen jungen Frauen auf den Gemälden des Präraffaeliten Dante Gabriel Rossetti gleicht.

Erst Rachaels letzter Satz hat etwas wirklich Eigenes. Rachael kann ihr eigenes Begehren nun fühlen und aussprechen.

Leon und die juckende Stelle, die man nie kratzen kann

Am Ende des Films wird Rachael zu Deckard sagen: „Ich liebe dich, ich vertraue dir."

Der Psychoanalytiker Erik H. Erikson führte das Konzept des Ur-Vertrauens (basic trust) in die Literatur ein. Laut Erikson ([1]1950; 2005) erwirbt der Säugling durch die liebende und sorgende Zuwendung zuverlässiger Pflegepersonen im Verlauf des ersten Lebensjahres eine Art Grundgefühl. Es bildet die Grundlage des Vertrauens in sich selbst, der Liebesfähigkeit, des Selbstwertgefühls, („Ich bin es wert, geliebt zu werden."), des Vertrauens in andere, z. B. in eine Partnerschaft („Ich vertraue dir") und des Vertrauens in die Gemeinschaft bzw. die Welt. Der Replikant Leon begegnet der Welt auf andere Weise. Er wird eingeführt als ein Symbol männlicher Potenz und Zerstörungswut, ein „Munitionsnachlader für intergalaktische Missionen; er kann 400 Pfund Nuklearwaffen den ganzen Tag lang stemmen. Der einzige Weg ihn aufzuhalten, ist ihn zu töten". In der Sequenz, in der er von Holden nach Einfällen zu seiner Mutter gefragt wird, macht dieser eine kurze Pause vor dem Wort „Mutter". Es entsteht dadurch eine „Leerstelle", die kennzeichnend für den gesamten Film ist. Als Replikant weiß er zwar – wie es Roland Barthes ([1]1980; 2010, S. 114–115) formuliert – um die „Wahrheit seiner Abstammung", doch „der Gedanke an den Ursprung" hat hier nichts Versöhnendes oder Tröstliches, sondern ist voll abgespaltenem Hass. Doch auch für Leon sind seine Fotos etwas „Kostbares". Statt eines Fotos von der Mutter, sammelt er alltägliche Schnappschüsse seiner Wohnung, seiner Geliebten – denn „in der Fotografie läßt sich nicht leugnen, dass die Sache dagewesen ist" (Barthes 2010, S. 86). Nach dem Wahrnehmen von Verlust und Kontinuität, ist es der Versuch der (Wieder-) Aneignung. Doch wie es Susan Sonntag (2011, S. 21) formuliert:

> … jede Fotografie [ist] eine Art memento mori. Fotografieren bedeutet teilnehmen an der Sterblichkeit, Verletzlichkeit und Wandelbarkeit anderer Menschen (oder Dinge). Eben dadurch, dass sie diesen einen Moment herausgreifen und erstarren lassen, bezeugen alle Fotografien das unerbittliche Verfließen der Zeit.

Gegen dieses unerbittliche Verfließen ihrer kurzen Lebenszeit kämpfen die Replikanten an. Tragischerweise führen Leons Fotografien Deckard auf Zhoras Spur und damit zur ihrer Ermordung. Leon verprügelt Deckard daraufhin auf brutalste Weise und stellt ihn zur Rede.

Leon: „Wie alt bin ich?"

Deckard: „Ich weiß es nicht!"

Leon: „Mein Geburtstag ist der 10. April 2017. Wie lange habe ich zu leben?"

Deckard: „Vier Jahre."

Leon: „Mehr als du!"

Leon: „Schmerzhaft in Furcht zu leben – nicht wahr? Nichts ist schlimmer als eine juckende Stelle zu haben, die man nie kratzen kann."

Deckard: „Ja, finde ich auch."

Leon: „Wach auf – Zeit zum Sterben!"

Kurz bevor Leon seine Drohung wahr machen und mit den Fingern Deckards Augen ausstechen kann, wird er von Rachael durch einen Kopfschuss getötet. Eine Replikantin tötet ihresgleichen, einen Replikanten. Sowohl Deckard als auch Rachael zittern. Doch bereits zuvor wird eine Gemeinsamkeit benannt. Leon spricht von schmerzhafter Furcht. Auch Deckard kennt dieses Gefühl. Es ist die „tote", die

gefühllose Mutterimago in den Protagonisten, die schmerzvolle Einsamkeit im Dasein und natürlich letztendlich auch der physische Tod, der juckt.[19]

Zhora – die Schöne und das Biest

In *Blade Runner* werden wir unter die „Membran des Bewusstseins" geführt. Deckard analysiert einen von Leons Appartment-Schnappschüssen in der sog. „Esper-Maschine". In Planquadrate aufgeteilt, lässt er sich per Sprachbefehl auf dem Monitor einzelne Bildausschnitte vergrößern, zoomt in einen Spiegel, erhält dadurch den Blick in ein Nebenzimmer und entdeckt eine schlafende Frau auf der Couch.[20] Deckard und damit wir als Zuschauer durchdringen das Foto in einer Art dreidimensionaler Suche und erblicken dadurch das vordergründig Unsichtbare. Für Walter Benjamin ([1]1936; 2010) ermöglicht der Film „das Erblicken des ‚Optisch-Unbewussten', also all dessen, was uns erst durch Vergrößerung, Zeitlupe, ausgefallene Winkel oder Zeitraffer erkennbar wird." (Elsaesser u. Hagener 2011, S. 107). Deckard erkennt in der schlafenden Schönen die Replikantin Zhora, eine rothaarige Amazone, ausgebildet für eine außerweltliche Elitemordtruppe. Durch die Analyse des Fotos (und einer in der Badewanne gefundenen Hautschuppe) entdeckt Deckard die neu angenommene Identität von Leons (un)heimlicher Geliebter. Im Nachtclub, in dem Zhora auftritt, wird sie angekündigt als: „Miss Salome und ihre Schlange – sehen Sie, welche Lust sie empfängt, von dem Wesen, das einst die Menschheit verdorben hat." Salome und ihre Schlange – die unbewusste Verschmelzung verschiedener Aspekte wird in der Psychoanalyse als „Verdichtung" (Freud: Vorlesungen zur Einführung in die Psychoanalyse [1]1916; 1989, S. 178 ff.) bezeichnet. Zhora wird als symbolische Frau mit den Attributen Verführungskunst, mütterliche Einflussnahme, weibliche Grausamkeit und Mord-Lust ausgestattet[21]. Deckard gibt sich ihr gegenüber als Kontrolleur im Auftrag des „geheimen Komitees für moralischen Missbrauch" aus, der ihre Garderobe bezeichnenderweise nach „Löchern" durchsuchen will. Zhora durchschaut ihn. Doch kurz bevor sie den neu-gierigen Mann mit seiner Krawatte (!) erwürgen kann, droht Entdeckung, und sie muss fliehen. Ihre Exekution wird in „totaler, transparenter Sichtbarkeit" (Bruno 2002, S. 70) in Form einer nahezu schwebenden, überirdischen[22] Zeitlupe gezeigt. Deckard jagt die flüchtende Frau und schießt ihr in den Rücken. Ihr Körper durchbricht drei Schaufensterscheiben, sie stürzt, steht wieder auf, rennt weiter und wird nochmals getroffen. Nachdem sie zwei weitere Schaufenster durchbrochen hat, kommt die Gefallene zwischen Schaufensterpuppen und künstlichem Schnee zum Erliegen. Ihr Gesicht liegt auf einer spiegelnden Glasfläche und hat in diesem Moment etwas Puppenhaftes, im Hintergrund hören wir, untermalt von Musik, ihren Herzschlag verstummen. Nach dem Mord braucht Deckard eine Flasche Schnaps – sein Gesichtsausdruck hat etwas bitter Leidendes, so, als wäre er angewidert von seiner Tat. Es ist der Beginn eines menschlichen (Mit-)Gefühls, und nicht von ungefähr erfährt er an dieser Stelle des Films, dass auch Rachael „ein Teil des Geschäfts" ist – er also auch sie töten soll.

19 Der Tod juckt … juckt die ganze Zeit – er ist immer bei uns, kratzt an der inneren Tür, summt leise, kaum hörbar, direkt unter der Membran des Bewußtseins" (Yalom 2008, S. 16).

20 Marshall Deutelbaum (1989) zeigt auf, dass Leons Foto zwei Gemälde holländischer Meister, Jan van Eycks „Die Arnolfini-Hochzeit" und Emanuel de Wittes „Interieur mit einer Dame am Virginal" kombiniert und sie in der Filmszene in einen neuen Zusammenhang gestellt werden: „At the least, this combination of Fifteenth and Seventeenth Century paintings alluded to in a Twentieth Century improvement (the instant snapshot) of a Nineteenth Century Invention (the photograph) searched by a Twenty-First Century optical device (the Esper aptly illustrates the principles of layering – which guides the film's visual design program. In addition, the Esper photo search uses the paintings of van Eyck and de Witte to underline how technology available in 2019 will have extended the limits of representational Illusion far beyond what we understand them to be today." (Deutelbaum 1989, S. 70

21 Salome ist – der Legende nach – die Tochter der Herodias und des Herodes. Durch ihren Tanz versetzt sie den Vater derart in Verzücken, dass er bereit ist, ihr alles (bis zur Hälfte seines Reiches) zu geben. Das Mädchen fragte ihre Mutter, was sie sich wünschen solle und diese flüsterte ihr das eigene Begehren ein.

22 Siehe dazu Walter Benjamins Ausführungen zu Strukturbildungen, unbekannten Bewegungsmotiven durch Zeitlupe nach Rudolf Arnheim (Benjamin 2010, S. 61).

Pris und die Angst der Männer vor Frauen, die denken (und fühlen)

Die drastische Darstellung der Exekution von „Miss Salome" verdeutlicht die archaische Angst des Mannes vor dem ursprünglich Weiblichen, vor den vereinnahmenden Einflüsterungen und der kastrierenden Macht der Mutter – gerade auch dann, wenn sich eine autonom bewegende Frau der männlichen Kontrolle zu entziehen vermag. Bezeichnenderweise sind alle weiblichen Protagonisten Replikanten, also von Männern erschaffene Objekte. Vermeintlich gefühllos, sind sie „materiell gewordene Männerphantasien" (Simine 2006, S. 238), die man nach Belieben benutzen und ausbeuten darf. Pris ist per Definition „ein Standardposten für die Militärclubs in den äußeren Kolonien" („Military/Leisure)", sozusagen eine Lustmaschine. Es ist kein Zufall, dass die am puppenhaftesten gestaltete Frau den genetischen Ingenieur J. F. Sebastian mit ihrer künstlichen Perfektion bezirzt. Mit seiner Ledermütze und dem verschmitzten Lächeln wirkt der genetische Konstrukteur wie ein elfenhafter Puk. Er haust in einem verlassenen Haus, inmitten seiner von ihm konstruierten (Puppen-)„Freunde". Eine Art Zwischenwesen zwischen Kind[23] und altem Mann, der durch seine Erkrankung (das „Methusalemsyndrom" – seine Drüsen altern zu schnell, und er würde durch die medizinischen Tests der Auswanderungsbehörde nicht durchkommen) besonders sensibel für die Erfahrung der Begrenzung und des Ausgeschlossen-Seins ist. Doch auch Sebastian ist nicht frei davon, die Replikantin zu verdinglichen und fordert sie auf, ihm „mal etwas zu zeigen". „Wir sind keine Computer, Sebastian, wir sind physisch" lautet Roys Antwort und Pris ergänzt „ich denke, Sebastian, also bin ich". Auf der Grundlage von Descartes, der das zweifelnde Ich analysierte und es als ein urteilendes, denkendes definierte, geht Pris einen Schritt weiter. Sie bezieht das Gegenüber, Sebastian, mit ein. Sie interagiert mit ihm und lässt ihn kurz darauf ihre Anwesenheit leibhaftig spüren. Pris holt mit bloßer Hand ein Ei aus kochendem Wasser und wirft es Sebastian zu. Er greift instinktiv zu, kann es aber nicht halten. Als Mann konnte er scheinbar nicht antizipieren, dass er sich an ihr (und ihrer aggressiven Entschlossenheit) die Finger verbrennt. Auch wenn Pris die männlichen Fantasien verführerisch zu bedienen scheint, will sie keine Wunsch-Maschine sein, sondern als denkendes Gegenüber wahrgenommen und an-erkannt werden. Als Deckard in J. F. Sebastians Automatenkabinett[24] nach ihr sucht, kann (und vielleicht auch will) sie ihn nicht mehr täuschen. Als er ihren Schleier lüftet, versetzt sie ihm einen Fußtritt, der ihn in einen anderen Raum schleudert. Sie vollführt einen kunstvollen Flic-Flac und nimmt seinen Kopf wie eine Schraubzwinge zwischen ihre Oberschenkel. Danach verdreht sie ihm im wahrsten Sinne des Wortes den Kopf, prügelt auf ihn ein und packt ihn schmerzhaft an seiner Nase. Die ganze Szene wirkt wie die getanzte Choreografie männlicher (Sexual-) Ängste. Aus dem begehrten weiblichen Objekt wird eine (über-) mächtige Frau, die durch ihre festhaltende und kastrierende Seite den sich ausgeliefert fühlenden Mann unterwirft. Deckards Reaktion ist eine perverse Mischung aus Angst, Erregung und Gewalt. Die Szene hat etwas enorm Sexualisiertes. Er schießt mehrfach auf die Frau. Mit den Kugeln aus seiner Pistole penetriert er den Körper der wild um sich strampelnden Frau. Wie bereits bei der unheimlich-verführerischen Zhora, muss das Objekt (des Begehrens), die – sexuell betrachtet – enthemmte Frau, nicht nur bestraft, sondern vollständig vernichtet werden.

Roy – Vatermord und „Erlösung durch die Liebe"

Nachdem Deckard die Frau(en) exekutiert hat, bleibt ihm nur noch die Auseinandersetzung mit Roy Batty. Der Replikant stellt die Inversion des Blade Runners (Roy Batty/Blade Runner) und gleichzeitig

23 „Wir erinnern uns, daß das Kind im frühen Alter des Spielens überhaupt nicht scharf zwischen Belebtem und Leblosem unterscheidet und daß es besonders gerne seine Puppe wie ein lebendes Wesen behandelt"(Freud [1]1919; 1989, S. 25).
24 Wie J.F. Sebastian war auch E.T.A. Hoffman, Autor der Erzählungen „Die Automate" und „Der Sandmann", „zugleich ein begeisterter Sammler von Marionetten und Puppen, der wie ein Kind mit ihnen spielte und sie wie menschliche Lebewesen behandelte. Er soll selbst Pläne verfolgt haben, künstliche Automaten zu bauen" (Geier 1999, S. 98).

eine Art Doppelgänger dar[25]. Im Gegensatz zu dem schwächelnden Rick Deckard wirkt sein Gegenspieler Roy Batty, ein „Gefechtsmodell mit optimaler Unabhängigkeit", wie ein omnipotentes idealisiertes Selbst. Symbolisch eingeführt wird er als pathetischer Kämpfer gegen Unterdrückung, für persönliche Unabhängigkeit und Freiheit. Wie Freud ([1]1919; 1989) in seiner Schrift über „Das Unheimliche" beschreibt, ist er damit auch gleichzeitig ein unheimlicher Vorbote des Todes und löst Furcht, Hass und Gewalt aus. In seiner mimisch gezeigten Emotionalität gebärdet er sich im Verlauf des Films wiederholt wie ein vierjähriger Junge (der er von seiner „Lebenszeit" her betrachtet auch ist). Im Gegensatz zu Deckard ist er jedoch nicht (mehr) auf der Suche nach der Mutter, sondern auf der nach seinem Vater. Instinktiv erkennt er in dem intellektuellen Kräftemessen der Ingenieure, einem Schachspiel zwischen J. F. Sebastian und Dr. Tyrell, einen Zugang zu seinem Schöpfer. In dessen Schlaf-und Arbeitszimmer, seinem symbolischen Entstehungsort, stellt Roy den „Vater" zur Rede:

> Tyrell: „Ich bin überrascht, dass du nicht früher hergekommen bist."
> Roy: „Das ist keine einfache Sache, deinem Schöpfer zu begegnen."
> Tyrell: „Und was kann er für dich tun?"
> Roy: „Kann der Schöpfer das reparieren, was er geschaffen hat?"
> Tyrell: „Du möchtest also modifiziert werden?"
> Roy: „Nein, ich glaube ich hatte etwas Radikaleres im Sinn."
> Tyrell: „Was, ich frage mich, wo das Problem liegt?"
> Roy: „Tod."
> Tyrell: „Tod. Nun, ich fürchte, das liegt etwas außerhalb meiner Zuständigkeit."
> Roy: „Ich will mehr Leben, Vater."

[Es folgt eine Diskussion über biomolekulare Zusammenhänge]

> Tyrell: „Aber all das ist rein akademisch. Du bist so gut gemacht worden, wie wir dich machen konnten."
> Roy: „Aber nicht auf Dauer."
> Tyrell: „Das Licht, das doppelt so hell brennt, brennt eben nur halb so lang. Und du hast für kurze Zeit unglaublich hell gebrannt, Roy. Sieh dich an, du bist der verlorene Sohn. Für alle ein beachtlicher Gewinn."
> Roy: „Aber ich habe fragwürdige Dinge getan."
> Tyrell: „Ja, aber auch bemerkenswerte Dinge. Genieße deine Zeit."
> Roy: „Da ist nichts, wofür der Gott der Biomechaniker dich in den Himmel lassen würde."

Nach diesen Worten nimmt Roy den Kopf Tyrells zwischen seine Hände, küsst ihn auf den Mund und drückt ihm die Augen aus. Tyrell ist als Vater für seinen Sohn Roy eine Ent-Täuschung. Als zweifelnder Sohn („ich habe fragwürdige Dinge getan") findet Roy in Tyrell kein Vorbild. Indem der Vater die Un-Taten seines Sohnes nicht verbietet, sondern bagatellisiert („Ja, aber auch bemerkenswerte Dinge. Genieße deine Zeit") stellt er ihn (und sich) außerhalb des Gesetzes. Der in seiner Identität nach Halt suchende Sohn erfährt durch den Vater keine haltgebende Grenzsetzung. Der narzisstisch ausgebeutete Sohn kann dadurch auch den ödipalen Konflikt nicht überwinden. Roy kann sich nicht in die

25 Der Psychoanalytiker Otto Rank (1925) erkennt im Bild des Doppelgängers „eine anthropologische Motivstruktur, die sich vom Mythos über die Literatur bis zum Film beobachten läßt" (Martynkewicz 2005, S. 28).

symbolische Ordnung (Lacan [1]1964; 1996), in eine Welt sozialer und ethischer Normen, einfinden. Im Gegenteil: Indem Roy den Kopf von Tyrell zerquetscht (die väterliche Denkfähigkeit zerstört), tötet er den symbolischen Vater und besiegelt damit beider Schicksal. Doch „der blonde, blauäugige Übermensch, dessen intellektuelle und poetische Brillanz zunächst mit emotionaler Unreife und einer Art hyperbolischem Wahnsinn korrelieren, macht in dem Film eine erstaunenswerte Entwicklung durch" (Zons 2000, S. 290). Wie schon Rachael, wird auch Roy durch die Liebe zunehmend mitfühlender. Als Roy seine blutüberströmte Geliebte, die getötete Pris, entdeckt, schließt er ihr nicht die Augen, sondern küsst sie. Mit dem Kuss führt er zärtlich ihre Zunge zurück in ihren Mund und gibt ihr damit die menschliche Würde zurück. Kurz darauf eröffnet Deckard das Feuer auf Roy:

 Roy: „Nicht sehr sportlich auf einen unbewaffneten Gegner zu schießen. Ich hatte mir vorgestellt, dass du gut bist. Bist du nicht ein guter Mann? Komm schon, Deckard! Zeig' mir, woraus du gemacht bist."

[Roy bricht mit dem Arm durch die Wand, ergreift Deckards rechten Arm und zieht ihn gegen die Wand].

 Roy: „Du bist zu selbstsicher, kleiner Mann! Das ist für Zhora!" [Roy bricht ihm einen Finger] „Das ist für Pris." [Er bricht ihm einen weiteren Finger] „Also gut, Deckard. Du weißt ich bin hier, aber du musst gut zielen." [Deckard schießt erneut]
Roy: „Ich sagte gut, das war nicht gut genug. Jetzt bin ich dran. Ich werde dir ein paar Sekunden geben, bevor ich komme. Eins … zwei … drei … vier … Pris …."

[Roy sitzt weinend neben der toten Pris, betastet ihren verwundeten Körper und schmiert sich ihr Blut wie Kriegsbemalung ins Gesicht, heult wie ein Wolf und verfolgt – mit nacktem Oberkörper – den verängstigten Deckard.]

 Roy: „Ich komme, Deckard. Vier, fünf, wie man am Leben bleibt. … Ich seh' dich … Noch nicht … Noch …"

[Roys Hand krampft, und er treibt einen Nagel hindurch. Auch Deckard hat Schmerzen in der Hand. Dann durchstößt Roy mit seinem Kopf die Wand].

 Roy: „Lass es noch einmal vorüberziehen, denn ich muss dich nun töten; wenn du nicht lebst, kannst du nicht spielen, und wenn du nicht spielst … sechs, sieben, geh zur Hölle, geh in den Himmel."

[Deckard schlägt Roy mit einem Rohr].

 Roy: „Das ist der Geist, den ich haben will. … Das hat weh getan. Das war irrational. Ganz zu schweigen davon, dass es unsportlich war. Wo willst du denn hin?"
[Deckard klettert über Umwege auf das Dach und springt zum nächsten Gebäude, doch er rutscht ab und kann sich nur an einem hervorstehenden Eisenträger festhalten. Roy springt mit Leichtigkeit hinterher.]
Roy: „Eine beachtliche Erfahrung, in Furcht leben zu müssen. So ist es, wenn man ein Sklave ist."

[In dem Moment, als Deckard abstürzt, ergreift Roy seine Hand, zieht ihn nach oben und rettet ihm damit das Leben. Er wirft Deckard auf den Boden, setzt sich ihm gegenüber. Während er im Gegenlicht sitzt, vermischen sich seine Tränen mit den über das Gesicht laufenden Regentropfen].

💬 Roy: „Ich habe Dinge gesehen, die ihr Menschen niemals glauben würdet. Gigantische Schiffe, die brannten draußen vor der Schulter des Orion. Und ich habe C-Beams gesehen, glitzernd im Dunkeln nahe dem Tannhäuser Tor. All diese Momente werden verloren sein, in der Zeit. So wie Tränen im Regen. Zeit zu Sterben."

[Im Moment des Todes lässt er los, und eine weiße Taube, die er im Arm gehalten hat, fliegt – seiner Seele gleich – in den Himmel].[26]

Die Szene ist vielschichtig. Wie bereits bei Tyrell hat Roy Fragen an sein Gegenüber. Er will von Deckard wissen, ob der „ein guter Mann ist"? Der Zweikampf hat auch hier einen sexuellen, „homo-erotischen Oberton" (Morrison 1990, S. 6). Zu Anfang scheint Roy noch ganz im Hass verwurzelt zu sein. Er kastriert Deckard (indem er ihm die Finger bricht), er penetriert ihn („ich gebe dir ein paar Sekunden, bis ich komme") doch dabei bleibt Roy nicht stehen. Roy spielt mit Deckard (wie mit einem Kind). Wenn Roy sich einen Nagel durch die Hand treibt, dann fühlt er den gleichen Schmerz wie Deckard. Auf unterschiedlichste Weise spiegelt er Deckard. Roy entwickelt dadurch nicht nur sich, sondern ermöglicht auch Deckard eine „Mentalisierung und Entwicklung des Selbst" (Fonagy et al. 2004). Wenn Roy wie ein verwundeter Wolf heult und Deckard durch die Gänge hetzt, dann vermittelt er – mit übertriebener Mimik und Gestik – Deckard die damit verbundenen Gefühle. Wäre Deckard ein Säugling, würde er mit der Zeit zunehmend verstehen, dass sein Gegenüber (im Falle des Säuglings die Pflegeperson) auf seinen eigenen, emotionalen Zustand reagiert. Roy lässt den emotional noch undifferenzierten Deckard erleben, was es heißt, Gefühle wie Wut, Schmerz, Angst und Trauer zu empfinden. Im Angesicht des Todes erfahren wir gleichzeitig etwas über Humanität und Lebendigkeit. Roy überwindet den Hass und verhilft Deckard ins Leben. Nach der Geburtsszene (Roy zieht Deckard wie einen Säugling aus dem Mutterleib) folgt eine nahezu opernhafte Todesszene. Im Sterben reflektiert Roy über die Vergänglichkeit. Er geht zurück ins Dunkle der Zeit, artikuliert die Trauer über das Verlorene. Seine Worte bleiben dennoch (oder gerade deswegen) kryptisch, wen hat er gesehen, was sind wohl C-Beams – Muttertiere?

Am Ende – der Zweifel!

Hollywood lässt uns nicht „im Regen stehen", es lässt uns nicht allein. Der Blade Runner hat überlebt. Noch einmal taucht Gaff auf und attestiert Deckard, „einen Männerjob getan" zu haben. Deckard ist tatsächlich gereift, als Mensch und Mann hat er sich entwickelt und ist dadurch zu einer (Liebes-) Beziehung fähig. Zu Hause findet er Rachael unter einem Laken auf der Couch. Wir sehen ihn zitternd vor Angst, denn für einen Moment ist nicht klar, ob Rachael getötet wurde. Als Deckard sie zu liebkosen beginnt, wacht Rachael auf.

Auch als Zuschauer sind wir erleichtert. Der Zustand bedrohlicher Verfolgung scheint überwunden, die projektive Spaltung zwischen Replikant und Mensch aufgelöst. Zu Anfang konnten die Protagonisten weder ihre eigenen Gefühle noch die des (fremden) Gegenübers verstehen. Die innere Leere führte zu falscher Anpassung an die Macht und hasserfüllter Destruktivität.

26 s.a. Videotranscript unter http://bladerunner.yodahome.de/film_story.html

Erst durch die Empathie eines Gegenübers und das Mitgefühl mit der Wirklichkeit des Anderen, erlangen die Protagonisten Verständnis und Anerkennung: die Voraussetzung für ein lebenswichtiges Selbst(wert)gefühl und der Weg zur Mitmenschlichkeit.

An dieser Stelle könnte die Geschichte enden. Doch Ridley Scott führt seine Melodie des Zweifels fort. In der ersten Fassung des Films entfliehen die beiden Liebenden in eine Art Garten Eden. Im Final Cut spielt Ridley Scott noch einmal mit den Kategorien. Bei der Flucht aus dem Gebäude tritt Deckard auf ein Origami-Einhorn aus Silberpapier. Das Einhorn ist ein Bild aus Deckards Traum. Indem er es aus Papier faltet, verweist Gaff auf Deckards Replikantenstatus. Aus dem Off hören wir ein weiteres Mal Gaffs Stimme: „Ein Jammer, dass sie nicht leben wird, aber wer tut das schon?!" Wir bleiben mit der Frage zurück: Leben wir oder tun wir nur so?

Literatur

Ayers M (2003) Mother-infant attachment and psychoanalysis – the eyes of shame. Brunner-Routledge, New York NY

Barthes R (2010) Die helle Kammer. Bemerkung zur Photographie. 13. Nachdr. Suhrkamp, Frankfurt/M (Erstveröff. 1980)

Benjamin W (2010) Das Kunstwerk im Zeitalter seiner technischen Reproduzierbarkeit. Suhrkamp, Berlin (Erstveröff. 1936)

Bertrand FC (1980) Philip K. Dick on Philosophy: A Brief Interview. In: Philip K. Dick Trust (2003-2010) Philip K. Dick The official Site. http://www.philipkdick.com/media_bertrand.html. Zugegriffen am 12.09. 2012

Bertrand F (1982) Philip K. Dick on philosophy: a brief interview. http://www.philipkdick.com/media_bertrand.html. Zugegriffen am 24. 4. 2012

Blothner D (1999) Erlebniswelt Kino. Über die unbewußte Wirkung des Films. Bastei Lübbe, Bergisch Gladbach

Blothner D (2003) Das geheime Drehbuch des Lebens. Kino als Spiegel der menschlichen Seele. Bastei Lübbe, Bergisch Gladbach

Blothner D (2012) Prof. Dr. Dirk Blothner - Website. http://blothner.de. Zugegriffen am 12.09. 2012

Bruno G (2002) Ramble City – Postmoderne und Blade Runner. In: Jürgen F (Hrsg) Die Postmoderne im Kino. Ein Reader. Schüren, Marburg, S 65–79

Brutto PL, Silbersack J, Van Gelder G (2012) The Official Philip K. Dick Awards Home Page (2009-2012). http://www.philipkdickaward.org. Zugegriffen am 12.09. 2012

Cinema (1981) Helden und Mythen. Die Welt des Fantasy Films. Hrsg: Manthey D. Sonderband 5. Kino Verlag, Hamburg

Decker O (2011) Der Warenkörper. Zur Sozialpsychologie der Medizin. Zu Klampen, Springe

Deutelbaum M (1989): Memory/visual design: the remembered sights of Blade Runner. Literature-Film Quarterly 17(1): 66–72. http://purdue.academia.edu/MarshallDeutelbaum/Papers/514951/Memory_Visual_Design_The_Remembered_Sights_of_Blade_Runner. Zugegriffen am 30. 12. 2011

Dick PK (1968) Do Androids Dream of Electric Sheep? Doubleday, New York

Dick PK (2010) Blade Runner/Ubik/Marsianischer Zeitsturz. Drei Romane in einem Band. Heyne, München

Elsaesser T, Hagener M (2011) Filmtheorie zur Einführung. 3. Aufl. Junius, Hamburg

Erikson EH (2005) Kindheit und Gesellschaft, 14. Aufl. Klett-Cotta, Stuttgart (Erstveröff. 1950)

Fonagy P et al (2004) Affektregulierung, Mentalisierung und die Entwicklung des Selbst. Klett-Cotta, Stuttgart

Freud S (1989) Das Unheimliche in: Psychologische Schriften. Studienausgabe Bd 4, 11. Aufl. Fischer, Frankfurt/M S 241–274, (Erstveröff. 1919)

Freud S (1989) 11. Vorlesung: Die Traumarbeit (1916 [1915-16]) in: Vorlesungen zur Einführung in die Psychoanalyse (1916-17) [1915-17]) Neue Folge der Vorlesungen zur Einführung in die Psychoanalyse (1933 [1932]). Studienausgabe Bd. 1, 11. Aufl. Fischer, Frankfurt/M, S 178–189

Gaca C (2002) Das Leben von Philip Kindred Dick. http://www.philipkdick.de/biografie. Zugegriffen am 12.09. 2012

Geier M (1999) Fake. Leben in künstlichen Welten. Mythos, Literatur, Wissenschaft. Rowohlt, Reinbek

Jung S (2011) Zeitebenen in Ridley Scotts Blade Runner. Univers. Regensburg. Institut für Information, Medien, Sprache & Kultur. Lehrstuhl für Medienwissenschaften. http://drippink.com/archive/Zeitebenen_in_Blade_Runner-FINISH+PUBLIC.pdf. Zugegriffen am 24. 4. 2012

Koebner T (1999) Halbnah. Schriften zum Film (Filmstudien, Bd 12). Zweite Folge. Gardez!, St. Augustin

Kohut H (1971) The analysis of the Self. A systematic approach to the psychoanalytic treatment of narcisstic personality disorders. International University Press, New York NY

Kohut H (1988) Narzißmus. Eine Theorie der psychoanalytischen Behandlung narzißtischer Persönlichkeitsstörungen. 6. Aufl. Suhrkamp, Frankfurt/M

Kolb WM (1997) Reconstructing the Director`s Cut. In: Kerman JB (Hrsg): Retrofitting Blade Runner. Issues in Ridley Scott's Blade Runner and Philip K. Dick's Do Androids Dream of Electric Sheep? 2. Aufl. University of Wisconsin Press, Madison WI, S 294–307

Lacan J (1996) Die vier Grundbegriffe der Psychoanalyse. Das Seminar, Buch XI, 4. Aufl. Quadriga, Weinheim (Erstveröff. 1964)

Laszig P (1998) Deus ex Multimedia – Körperlichkeit im digitalen Raum. Psychoanalyse im Widerspruch 10 (19): 93–98

Lévi-Strauss C (1962) La pensée sauvage. Plon, Paris http://www.archive.org/stream/lapenseesauvage00levi#page/n7/mode/2up. Zugegriffen am 24. 4. 2012

Margot J (1993) Philip K. Dick. In: Owens L (1995-2012) The Gnosis Archive. Gnostic Studies on the Web. http://www.gnosis.org/pkd.FAQ.bio.html. Zugegriffen am 12.09. 2012

Martynkewicz W (2005) Von der Fremdheit des Ichs. Das Doppelgängermotiv in Der Student von Prag (1913). In: Jahraus O, Neuhaus S (Hrsg) Der fantastische Film. Geschichte und Funktion in der Mediengesellschaft. Königshausen & Neumann, Würzburg, S. 19–40

Morrison R (1990) Casablanca meets Star Wars: the Blakean dialectics of Blade Runner. Literature/Film Quarterly 18: 2–10

Ogden TH (1995) Frühe Formen des Erlebens. Springer Wien (Erstveröff. 1989)

Rank O (1925) Eine psychoanalytische Studie. Internationaler Psychoanalytischer Verlag, Leipzig http://ia600403.us.archive.org/33/items/Rank_1925_Doppelgaenger_k/Rank_1925_Doppelgaenger_k.pdf. Zugegriffen am 24. 4. 2012

Sacks O (2011) Eine Frage der Identität. In: Sacks O: Der Mann, der seine Frau mit einem Hut verwechselte. 33. Aufl. Rowohlt, Reinbek

Sammon PM (2007) Future noir. The making of „Blade Runner". 2. Aufl. Gollancz, London UK

Schnelle F (1997) Ridley Scott's Blade Runner. 2. akt. Aufl. Wiedleroither, Stuttgart

Schnittbericht (2010) http://www.dvd-forum.at/schnittbericht/1467-der-blade-runner. Zugegriffen am 24.4.2012

Silverman K (1991) Back to the future. Camera Obscura 9: 108–132

Simine S Arnold-de (2006) Ich erinnere, also bin ich? Maschinen – Menschen und Gedächtnismedien in Ridley Scotts Blade Runner (1982/1992). In: Kormann E, Gilleir A, Schlimmer A (Hrsg) Textmaschinenkörper: Genderorienterte Lektüren des Androiden. Rodopi, Amsterdam, S 225–242

Sontag S (2011) Über Fotografie. 20. Aufl. Fischer, Frankfurt/M

Tiedemann J (2007) Die intersubjektive Natur der Scham. FU Dissertation online, Berlin http://www.diss.fu-berlin.de/diss/servlets/MCRFileNodeServlet/ FUDISS_derivate_000000002943/. Zugegriffen am 24.4.2012

Videotranscript (2004) http://bladerunner.yodahome.de/film_story.html. Zugegriffen am 24.4.2012

Wangh M (1992) Psychoanalytische Betrachtungen zur Dynamik und Genese des Vorurteils, des Antisemitismus und des Nazismus. Psyche 46(12): 1152–1176

Warner Bros. Entertainment Inc. (2007) Blade Runner - The final cut - The film that started it all. http://bladerunnerthemovie.warnerbros.com. Zugegriffen am 12.09. 2012

Whitehead JW (2002) Blade Runner. What it means to be humans in the cybernetic state. http://www.gadflyonline.com/02-18-02/film-blade_runner.html. Zugegriffen am 24.4.2012

Will F (2007) Blade Runner. In: Koebner T (Hrsg) Filmgenres Science fiction. 2. bearb. Aufl. Reclam, Stuttgart, S 385–396

Yalom ID (2008) In die Sonne schauen. Wie man die Angst vor dem Tod überwindet. btb Verlag, München

Zons R (2000) De(s)c(k)art(e)s Träume. Die Philosophie des Bladerunner. In: Faßler M (Hrsg) Ohne Spiegel leben. Sichtbarkeiten und posthumane Menschenbilder. Fink, Paderborn, S 271–293

Internetquellen

http://bladerunnerthemovie.warnerbros.com. Zugegriffen am 12.09. 2012

http://bladerunner.yodahome.de/film_story.html. Zugegriffen am 12.09. 2012

http://blothner.de. Zugegriffen am 12.09. 2012

http://drippink.com/archive/Zeitebenen_in_Blade_Runner-FINISH+PUBLIC.pdf. Zugegriffen am 12.09. 2012

http://ia600403.us.archive.org/33/items/Rank_1925_Doppelgaenger_k/Rank_1925_Doppelgaenger_k.pdf. Zugegriffen am 12.09. 2012

http://purdue.academia.edu/MarshallDeutelbaum/Papers/514951/Memory_Visual_Design_The_Remembered_Sights_of_Blade_Runner. Zugegriffen am 12.09. 2012

http://www.archive.org/stream/lapenseesauvage00levi#page/n7/mode/2up. Zugegriffen am 12.09. 2012

http://www.diss.fu-berlin.de/diss/servlets/MCRFileNodeServlet/FUDISS_derivate_000000002943/. Zugegriffen am 12.09. 2012

http://www.dvd-forum.at/schnittbericht/1467-der-blade-runner. Zugegriffen am 12.09. 2012

http://www.gadflyonline.com/02-18-02/film-blade_runner.html. Zugegriffen am 12.09. 2012

http://www.gnosis.org/pkd.FAQ.bio.html. Zugegriffen am 12.09. 2012

http://www.kejvmen.sk/dadoes.pdf. Zugegriffen am 12.09. 2012

http://www.philipkdickaward.org. Zugegriffen am 12.09. 2012

http://www.philipkdick.com/media_bertrand.html. Zugegriffen am 12.09. 2012

http://www.philipkdick.de/biografie. Zugegriffen am 12.09. 2012

Originaltitel	Blade Runner
Erscheinungsjahr	1982
Land	USA
Buch	Hampton Fancher, David Peoples
Regie	Ridley Scott
Hauptdarsteller	Harrison Ford (Rick Deckard), Rutger Hauer (Roy Batty), Sean Young (Rachael), Daryl Hannah (Pris), Edward James Olmos (Gaff) M. Emmet Walsh (M. Bryant), William Sanderson (J. F. Sebastian), Joanna Cassidy (Zhora), Joseph Turkel (Dr. Eldon Tyrell)
Verfügbarkeit	Als DVD in OV und deutscher Sprache erhältlich

Manfred Riepe

Videodrome und die traumatische Begegnung mit dem Weiblichen

Videodrome – Regisseur: David Cronenberg

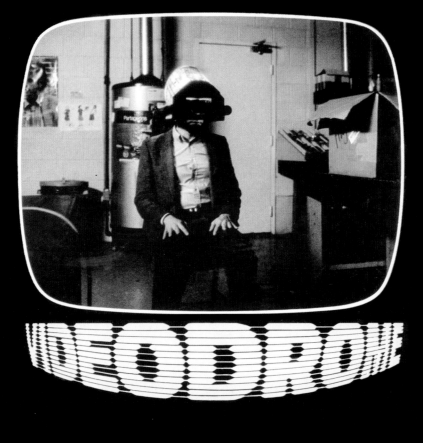

Filmszene *Videodrome*
Quelle: Interfoto/Mary Evans

Videodrome

Regisseur: David Cronenberg

„Wer würde sich wohl einen Scheißfilm wie „Videodrome" ansehen?"

Barry Convex in *Videodrome*

Hintergrund: Eine kurze Geschichte über Medien und Gewalt

Zu Beginn seiner Karriere galt David Cronenberg als „King of venereal Horror" (König des Geschlechter-Horrors) oder als „Dave Deprave" (to deprave: moralisch verderben). Das ist kein Wunder, denn in seinen frühen Filmen, entstanden in den 70er und frühen 80er-Jahren, zeigt der Kanadier, wie seltsame Parasiten in alle möglichen und unmöglichen Körperöffnungen eindringen, und *Scanners*, sein erster internationaler Erfolg, wurde berüchtigt durch die Zeitlupenaufnahme eines detonierenden Schädels. In dreißig Jahren hat sich dieses Image radikal gewandelt. Die Wende zum „Psychoanalytiker des Grauens" (Süddeutsche Zeitung) markiert seine sechste Regiearbeit, *Videodrome* aus dem Jahr 1983 (�"Abb. 1), die in den Augen der meisten Cronenberg-„Aficionados" bis heute seine interessanteste ist, obwohl sie an der Kinokasse keinen Erfolg hatte und hierzulande – Nomen est Omen – nur auf Video veröffentlicht wurde. Cronenberg zeigt hier nicht einfach nur brutale Szenen, er reflektiert über die Medienindustrie und die ökonomischen Hintergründe von Pornografie und Gewaltdarstellung. Das allein aber macht Videodrome nicht zu einem Kultfilm, den Andy Warhol gar als „Uhrwerk Orange der 80er-Jahre" bezeichnete. Das vielen Interpretationen offen stehende Werk fasziniert dank seiner ungewöhnlichen Erzählstruktur, die den Betrachter in ein kaum entwirrbares Labyrinth aus Gewalt-, Erotik-, und Verschwörungsfantasien entführt. Dabei haftet dieser melancholischen Satire nicht das Etikett „Achtung! – besondere Erzählform" an. *Videodrome* ist „Kunst ohne Vorwarnung".

Ohne Hintergrundinformationen zum Begriff Video könnte man diese dreißig Jahre alte Mediansatire nicht mehr verstehen. Die heute kaum mehr gebräuchliche Aufzeichnung audiovisueller Informationen auf Magnetband war zwar bereits von AEG/Telefunken in den 30er-Jahren entwickelt worden. Ein in Serie hergestelltes Konsumentengerät konnte man auf dem amerikanischen Markt jedoch erstmals 1975 kaufen (Hoffmann 1990). Der im Film gezeigte Videorekorder war sogar erst ab 1977 erhältlich. So erklärt sich die für den heutigen Zuschauer unverständliche Frage der Filmfigur Bianca O'Blivion, „in welchem Format" sie der Hauptfigur Max Renn Videobänder zustellen soll. Auf dem Markt gab es seinerzeit noch mehrere konkurrierende Videoformate. Erst der Siegeszug des (technisch schlechtesten) VHS (Video Home System) führte zu jenem sprunghaften Absatz von Abspiel- und Aufnahmegeräten, um die es in Videodrome neben dem Phänomen des Kabelfernsehens geht. Mit dem massenhaften Verkauf von Rekordern ging nämlich auch die leichtere Verfügbarkeit von Sex- und Gewalt-Filmen auf Kassette einher. Dies führte zu einer heftigen und nachhaltigen Zensur-Debatte, die, mit der üblichen Verspätung, in Deutschland ihren Höhepunkt erst 1985 erreichte. (Zum historischen, juristischen und filmgeschichtlichen Hintergrund der so genannten Horrorvideo-Debatte in Deutschland und ihrem Verhältnis zur ästhetischen Zensur (Riepe 1995; 2005a).

Regelmäßiger Konsum gewalthaltiger Filme, eines der Themen in *Videodrome*, wurde und wird heute noch, obwohl sich die Debatte auf Computerspiele verlagert hat, als schädlich erachtet und unter vier verschiedenen Grundthesen diskutiert. Gemäß der so genannten Inhibitionsthese wirkt Gewaltdarstellung auf den Zuschauer abschreckend und angsterzeugend. Diese These wird selten vertreten, ungleich populärer ist die Stimulationsthese, gemäß der häufiger Konsum von Gewaltdarstellung mo-

◨ **Abb. 2** Max Renn (James Woods) in seiner Wohnung. (Quelle: Cinetext Bildarchiv)

dellbildend wirkt und zur Nachahmung reizt. Die abgemilderte Version dieser Ansicht formuliert die so genannte Habitualisierungsthese, nach der Gewaltbilder zwar nicht zur Nachahmung reizen, jedoch auf Dauer einer so genannten „entsittlichenden Verrohung" Vorschub leisten. Videokonsumenten akzeptieren irgendwann, dass „Gewalt ein probates Mittel zur Konfliktlösung" ist. Mit diesen argumentativen Klischees befinden wird uns unmittelbar in Cronenbergs *Videodrome*.

Zur Filmhandlung

Sex and Crime in Derealisation

Die Hauptfigur Max Renn (◨ Abb. 2) wird vorgestellt als Betreiber des kleinen, privaten Kabelsenders „Civic TV". Zu Beginn des Films rechtfertigt er sich in einer Talkshow, dass die von seinem Kanal ausgestrahlten Filme „zu einer gewissen Form von Gewalt und sexueller Brutalität betragen. Interessiert Sie das nicht?" Max, in seiner Eloquenz eine Vorwegnahme des früheren RTL-Chefs Helmuth Thoma[1], antwortet mit einem aalglatten Lächeln: „Doch, sehr sogar. Doch es liegt mir sehr daran, meinen Zuschauern ein harmloses Ventil zu geben für ihre Fantasien und Frustrationen. Und ich meine, es ist eine positive Sache." Diese Antwort entspricht der von Medien- und Fernsehbetreibern in der Tat häufig vertretenen vierten These – der so genannten Katharsisthese: „Danach können Gewaltdarstellungen eine Ventilfunktion erfüllen und die Aggressivität des Zuschauers abbauen" (Hoffmann 1990, S. 227).

1 Helmuth Thoma war berüchtigt, weil er als Chef von RTL Fernsehen erstmals schamlos und konsequent als rein wirtschaftliches Unternehmen definierte. Sein Programm, das immer wieder neu die Niveaugrenzen nach unten austestete, rechtfertigte er mit berühmt gewordenen Sprüchen wie: „Der Wurm muss dem Fisch schmecken und nicht dem Angler" oder „Wir haben Filme gezeigt, die vor uns zurecht keiner gezeigt hat."

Cronenberg geht es nicht um eine Verteidigung einer dieser Thesen. Sein Film unterwandert die populistische Sichtweise von „Zensoren" und Jugendschützern, für die es als ausgemacht gilt, dass der regelmäßige Konsum von Gewaltdarstellung zu psychischen Störung führen kann: „Ich wollte sehen, wie es ist, wenn sich das, was die Zensoren sagen, tatsächlich ereignet", merkt Cronenberg an. Nun gibt es, hierzulande ebenso wenig wie in den USA, keine Zensur im strengen Sinn. Wie ich verschiedentlich dargelegt habe, existiert stattdessen ein engmaschiges Netz aus einer unumgehbaren „freiwilligen Selbstkontrolle", einer Bundesprüfstelle und einem juristischen Instrument zum nachträglichen Verbot unliebsamer Filmbilder (vgl. Riepe 2005a). Da es einen gesellschaftlichen Konsens hinsichtlich einer ganz bestimmten Wirkungsmechanik gibt, gemäß der mediale Reize Rezipienten zu „medialen Marionetten" (Vogelgesang 1991, S. 5) degradieren, zensiert besagte „Kontrolle" Gewaltdarstellungen. „Zensoren", so Cronenberg, „tendieren zu dem, was wir nur von Psychotikern kennen: sie verwechseln Realität mit Illusion" (Cronenberg in: Morris 1994, S. 98).

Dieser Grundgedanke strukturiert den Film *Videodrome*, dessen Hauptfigur sich tatsächlich in eine solche „mediale Marionette" verwandelt. Max erweist sich am Ende gar als ein leibhaftiger Videorekorder, der nach medialen Instruktionen handelt, die ihm in Form einer Kassette buchstäblich in den Leib geschoben werden, in dem sich eine Art „Kassettenschacht" befindet. Cronenberg bemerkt dazu:

> Mit „Videodrome" wollte ich zeigen, dass ein Mann, der gewalttätigen Bildern ausgesetzt ist, zu halluzinieren beginnen kann …

Doch diese Halluzinationen werden nicht, wie im Hollywood-Spielfilm üblich, als optisch verfremdete Sequenzen kenntlich gemacht. Das Gegenteil ist der Fall: In dem Maße, in dem das Unterscheidungskriterium zwischen Halluzination und Realität für den Protagonisten Max Renn verloren geht, wird es auch für den Zuschauer immer schwieriger, zwischen einer objektiven Filmebene und den Halluzinationen der Hauptfigur zu unterscheiden. Der Film lässt den Betrachter ganz bewusst alleine und verzichtet auf die üblichen gut gemeinten „Hilfestellungen". Die Geschichte, die Cronenberg in *Videodrome* erzählt, ist so konzipiert, dass sich die halluzinierten Szenen bruchlos in die Darstellung jenes Mediengeschäfts eingliedern, das Max Renn bereits zu Beginn des Films in der Talkshow erläutert. So fragt beispielsweise die Moderatorin:

💬 „Max, Ihr Sender bietet den Leuten einfach alles, von Softcore-Pornografie bis zur Gewalt. Warum?" Max (ganz entspannt):„Weil wir uns wirtschaftlich behaupten müssen, wir sind klein. Und aus Gründen des Überlebens müssen wir den Leuten zeigen, was sie sonst nicht sehen, und das tun wir."

Das könnte eine Antwort von Helmut Thoma sein.

Aus diesem wirtschaftlichen Grund beschäftigt Max also auch den so genannten „Videopiraten" Harlan. Dessen Aufgabe besteht darin, auf der Suche nach immer härteren Gewaltbildern sogar fremde Satelliten anzuzapfen, seine Figur ist eine Vorwegnahme dessen, was wir heute als „Hacker" bezeichnen. Auf der Erzählebene klingt das bislang plausibel – doch bereits hier zeigt uns der Film keine realistische Darstellung von Medientechnologien, sondern eine (pathologische) Fantasie über Medien. Das gilt schon für jene Szene ganz zu Anfang des Films, in der Max ein Meeting mit den japanischen Vertretern einer dubiosen Medienfirma namens „Hiroshima Video" hat. Warum trifft er die Händler in einem schäbigen Stundenhotel, wo auf dem Hotelflur lautstark gestritten wird? Der aus einschlägigen Krimis vertraute Schauplatz suggeriert, dass Max in dieser Nische der Gesellschaft eine Art Drogendeal abwickelt, was auch irgendwie stimmt. Doch das Mediengeschäft ist Teil eines öffentlichen Rundfunks. Es macht folglich keinen Sinn, Softcore-Pornos illegal einzukaufen, um sie anschließend legal der Öffentlichkeit zu präsentieren.

Dieser „Widerspruch" zeugt nicht von einer Schwäche des Drehbuchs. Cronenberg erzeugt die kaum greifbare Atmosphäre einer Verschwörung. Der Zuschauer nimmt diesen vermeintlich illegalen Handel mit Softcore-Pornovideos für bare Münze und wird damit unmerklich zum Komplizen der Hauptfigur. Dem Betrachter entgeht dies, denn Max agiert dabei anscheinen völlig rational. Er tritt auf als ausgebuffter Medienprofi, der das Angebot von „Hiroshima Video" einer Nagelprobe unterzieht. Um abschätzen zu können, ob das Programm „nachlässt", lässt er sich nur die letzte Folge der Softsex-Serie zeigen. Max' beruflicher Alltag erscheint also als realitätsnahe Beschreibung eines Fernsehmachers, in dessen Büroräumen geschäftig mit Kameras und Monitoren hantiert wird.

Dieser Realismus setzt sich fort in der pointierten Beschreibung des Jobs eines weiteren Talkshowgasts. Die Radiomoderatorin Niki Brand betreibt eine dieser psychologischen Beratungsshows, die in Deutschland erst gut zehn Jahre später u. a. mit Brigitte Lämmle in Mode kamen und inzwischen längst wieder aus den Sendeplänen verschwunden sind. Die Szenarien während der ersten 20 Minuten des Films zeigen also einen quasi dokumentarischen Ausschnitt aus dem Alltag des Mediengeschäfts. So kommt der Zuschauer gar nicht auf die Idee, zu hinterfragen, was der Videopirat Harlan in seinem seltsamen Labor eigentlich treibt. Wir erfahren, dass er ein schwaches, undeutliches und verschlüsseltes Signal aufzeichnet, dessen Herkunft angeblich schwer zu lokalisieren ist. Harlan erklärt die mitgeschnittenen Bilder, auf denen Mord und Totschlag erahnbar sind, wie folgt:

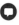 „Es gibt keine Handlung. Es geht noch eine Stunde so weiter. Folter, Morde, Gewalttätigkeit."

Der Videopirat bezeichnet die Bilder als „krank", doch Max frohlockt. Er denkt sogleich ökonomisch und findet es „brillant, absolut brillant, es gibt so gut wie keine Produktionskosten. Ich kann nicht aufhören hinzusehen". Die hier erstmals thematisierten „Videodrome-Bilder" erfüllen zwei Kriterien: Dieses „Programm" ist quasi umsonst, und es ist absolut spektakulär: Es zeigt etwas, das im Fernsehen zugleich nicht mehr Fernsehen ist, sondern real. Es hat etwas mit Sexualität zu tun, erscheint aber auf eine irritierende Art gewalttätig. Ist das nicht der kindliche Blick durch das Schlüsselloch ins elterliche Schlafzimmer?

Dass Max sich auf die Suche nach diesen ominösen Videodrome-Bildern macht, versteht sich vor dem Hintergrund seines professionellen Ehrgeizes von selbst. Wollte man den Film jedoch als eine typische Medienkritik im Stil von Sidney Lumets *Network* aus dem Jahr 1976 interpretieren, so müsste man die Augen verschließen vor jenen immer seltsamer erscheinenden Figuren, denen Max auf seiner Suche begegnet. Masha, eine Produzentin, deren altmodisches Softsex-Programm er zunächst als „zu naiv" ablehnt, rät Max, er solle seine eigene Show zu produzieren. Irgendwie scheint der Film zu diesem Zeitpunkt längst schon Max' eigene „Show" zu sein. Doch wie ist das zu verstehen?

Eine unmerkliche Verwischung der Grenzen zwischen Realität und pornografischer Fantasie zeichnet sich schon bei Max' erstem Treffen mit der Radiomoderatorin Niki ab, die er in der Talkshow kennen lernte. Schnell sind die beiden sich einig, dass sie ins Bett gehen – doch diese Frau hat selbst für den abgebrühten Zyniker Max noch Überraschungen parat. Was Max mit ihr erleben wird, scheint längst Teil des Videodrome-Programms zu sein. Aber wann hat dieses Programm eigentlich begonnen? Der Zuschauer hat es, wie Max selbst, nicht so recht mitbekommen.

Realität und Fake

Nach der irritierenden Begegnung mit Niki folgen wieder einige unspektakuläre Szenen. Max hat erfahren, dass besagtes Videodrome-Signal – das obskure „Objekt" seiner Begierde – etwas mit einer gewissen Bianca O'Blivion zu tun hat. Sie ist die Tochter jenes exzentrischen Medienphilosophen, den der Zuschauer ebenfalls aus der Talkshow kennt. Er wurde hier per Monitor als typischer „Talking Head" zugeschaltet, um zur Frage der Gewaltdarstellung sein unverständliches Experten-Blah Blah

hinzuzufügen. Mit solchen monotonen telegenen Ritualen ist der Zuschauer auch hierzulande vertraut, man sieht sie in jeder Ausgabe der ARD-„Tagesthemen".

Max ist jedoch nicht am Ziel seiner Suche, denn O'Blivions Tochter Bianca eröffnet ihm völlig überraschend, dass ihr Vater Brian eigentlich schon lange tot ist. Wie kann er aber dann im Fernsehen auftreten? Bianca, so erfahren wir sogleich, hält ihn in den Medien künstlich am Leben. Sie beliefert Fernsehsender mit vorgefertigten Bändern, auf denen ihr Vater eine dieser klugen Reden hält, die wir aus der Talkshow kennen. Hierfür verwendet sie ein Videoarchiv, durch das sie den staunenden Max führt. Diese schöne Idee ist, realistisch betrachtet, ebenso blanker Unsinn, aber auch diese Unplausibilität ist nicht als dramaturgischer Fehler des Films zu werten. Erneut spielt Cronenberg hier mit einer gewissen Gutgläubigkeit des Zuschauers gegenüber „technischen' bzw. technisch klingenden Erklärungen. Viele Autoren, die sich über *Videodrome* auslassen, nehmen diese „Fake-Erklärung", gemäß der die lebendige Präsenz eines Menschen mit Videobändern vorgegaukelt werden könne, als realistisches Element des Plots bzw. der „Diegese", wie man es mit einem modischen Begriff der Filmtheorie ausdrücken würde. Der Zuschauer unterliegt damit derselben Täuschung wie die Hauptfigur Max: Beide verirren sich immer tiefer in ein Labyrinth aus Fakten und „Halluzinationen".

Von nun an wird es immer merkwürdiger. Max erhält von Bianca eine solche Videokassette mit der Aufzeichung eines „Vortrags" ihres Vaters. In Max' Hand beginnt das Band irgendwie zu „leben", und beim Abspielen der Kassette verwischt die Grenze zwischen Realität und Halluzination vollends. Obwohl er mit dem Einlegen der Kassette nur eine „tote" Videoaufzeichnung abspielt, gerät Max unversehens mit besagtem Brian O'Blivion in einen lebendigen Dialog, ein Phänomen, das man von Demenzkranken kennt, die mit ihrem Fernseher sprechen. Das abgespielte Band zeigt Brian O'Blivion, der Max eindringlich vor dem gefährlichen Videodrome-Signal warnt. „Fernsehstrahlen" – das wissen wir aus unserer Kindheit, wurden schon immer als gefährlich eingestuft; Kinder sollten dem Apparat nicht zu nahe kommen – aber dass diese Strahlen gleich einen „Tumor im Gehirn" erzeugen? Im entsprechenden Kapitel meiner Monografie habe ich es so formuliert, dass nicht das Signal den Schaden anrichtet; es ist „der angerichtete Schaden selbst", der sich hier halluzinativ zu Wort meldet (vgl. Riepe 2002, S. 92).

Wenn wir uns hier nicht hoffnungslos verirren wollen, müssen zwei Aspekte scharf voneinander unterschieden werden. Denn die Fantasien in *Videodrome* haben tatsächlich alle etwas mit Medien, Fernsehen, Technologie und dem Problem der Gewaltdarstellung zu tun. Die Idee, dass es einen geheimen Fernsehsender gibt, der nur reale Folter- und Mordbilder ausstrahlt, weil die Produktionskosten für authentische Quälereien geringer sind als ihre aufwendige Fingierung mit Spezialeffekten, hat einen realistischen Kern. Es gibt solche Filme – aber es gibt sie weder im professionellen Handel (weil man den Mörder durch die mediale Spur, die er in Form eines Films zwangsläufig hinterlässt, leicht dingfest machen kann) noch im Fernsehen, wo die Ausstrahlung jeder einzelnen Sendung schon im Vorfeld von einer unüberschaubaren Anzahl politisch korrekter Redakteure kontrolliert wird. Trotzdem fungieren solche Fantasien – z.B. bei dem Film *Snuff* (Masha verwendet den Begriff „Snuff-TV"), der diesem „Subgenre" den Begriff gab – als Mythos bzw. als „Urban Legend", als Mythen des Alltags.

Ein ähnliches Mischungsverhältnis zwischen Plausibilität und Irrealität gilt auch für die geniale Filmidee, der so genannten „Kathodenstrahl-Mission", die von O'Blivions Tochter Bianca geleitet wird. Zur Erinnerung: Der Kathodenstrahl ist jener elektronische Strahl, der vor der Zeit der LCD- und Plasma-Bildschirme in der so genannten Bildröhre Zeile für Zeile das Fernsehbild erzeugte. Der Kathodenstrahl ist ein Synonym für „die Glotze", vor der in besagter Mission Obdachlose hinter provisorischen Raumteilern sitzen. Sie erhalten eine warme Suppe und werden dabei mit Fernsehbildern versorgt. Cronenberg zeichnet hier ein immer skurriler werdendes Zerrbild der Realität – das mit einem Zerrbild der Medien verquickt wird. Der Zuschauer nimmt dieses Kaleidoskop aber nur aus der Perspektive von Max Renn wahr, dem das alles völlig normal erscheint. Und so wundert er sich, als er

besagte Kathodenstrahl-Mission besucht, auch nicht über das fragwürdige karitative Konzept, wonach ausgerechnet Fernsehbilder die Clochards wieder in die soziale Realität eingliedern sollen. Ebenso wenig verwundert es ihn, dass er mit einem Fernsehapparat dialogisiert. Die Irritation über diese „unrealistische" Gesprächssituation ist für den Zuschauer nicht recht fassbar, denn Cronenberg lässt Max' Dialog mit dem halluzinierten Gesprächspartner ausgerechnet um das Thema der Halluzination selbst kreisen. Die Halluzinationen, so erfährt Max, sind angeblich technisch erzeugt worden: „Das Videodrome Signal kann unterhalb eines Testbildes ausgestrahlt werden", erklärt Bianca O'Blivion später. Dieses Grundthema der Halluzination schlägt sich zuweilen in komischen Dialogen nieder. So fragt Max seinen Videopiraten Harlan einmal: „Hast Du halluziniert?" Worauf dieser zurückfragt: „Nein, hätte ich müssen?" Mit dieser humorvollen Bagatellisierung imitiert Cronenberg die Technik des Zauberkünstlers, der die Aufmerksamkeit des Betrachters ablenkt, sodass er seine Tricks unbemerkt „am Rande der Szene" ausführen kann.

Der Betrachter des Films wird dazu eingeladen, zu übersehen, dass der inhaltliche Aspekt, die Auseinandersetzung mit den Medien Video und Fernsehen und mit Gewaltbildern, von dem formalen Aspekt auf subtile Art überlagert wird. Diese subtile Koinzidenz stellt Cronenberg her, indem er konsequent Max Renns Tunnelblick abbildet. Das irritierende Zusammenfallen von Form und Inhalt kommt zustande, weil der Regisseur eine Hauptfigur zeigt, die halluziniert und sich dabei auf eine vordergründig plausibel erscheinende Art mit der Struktur von Halluzinationen selbst auseinandersetzt. Der Film sagt uns nicht, dass diese medientechnische Erklärung der Halluzinationen in Wahrheit selbst nur eine halluzinierte Erklärung ist; und er verschweigt auch dieses Verschweigen. Wenn der vermeintliche Medienphilosoph Brian O'Blivion darüber spricht, dass Videodrome einen Schaden im Gehirn erzeugt, dann ist es, wie gesagt, der Schaden selbst, der hier spricht. Das „Medium ist die Botschaft" – dies jedoch buchstäblich und nicht im Sinne des berühmten Landsmanns Marshall McLuhan, der hier von Cronenberg auf den Arm genommen wird.

Fleischwerdung des Halluzinativen

In einer der nächsten Szenen sitzt Max wieder alleine vor dem Fernseher. O'Blivions programmatische Äußerung „Fernsehen ist die Netzhaut des geistigen Auges" kommentiert der abgebrühte Medienprofi zunächst mit einem abfälligen Lächeln – bis er die Auswirkung dieser Botschaft am eigenen Leib spürt. In seinem Bauch hat sich aus unerfindlichen Gründen ein vierzig Zentimeter langer, vertikaler Schlitz geöffnet, durch den wir ins Körperinnere hineinsehen können. Von einem seltsamen Zwang angetrieben, steckt Max die Pistole, mit der er sich zwischenzeitlich bewaffnet hat, in diese Öffnung, deren sexuelle Konnotation dem Zuschauer fast noch unheimlicher ist als Max selbst. Einen Augenblick später hat sich dieses „Loch" wieder geschlossen, Max ist unverletzt – doch die Pistole bleibt spurlos verschwunden. Die Waffe verwandelt sich in „neues Fleisch". Aber was bedeutet diese Chiffre?

Der Zuschauer wird mit der massiven Körperlichkeit einer Halluzination konfrontiert, die auf eine merkwürdige Art und Weise sexuell ist. Aus dieser Fremdartigkeit wird rasch etwas merkwürdig Vertrautes, denn der Film bindet diese körperlichen Halluzinationen in ein skurriles, aber in sich logisches Spiel von Assoziationen ein. Auf der Ebene des Plots, dem wir nach wie vor problemlos folgen, gerät Max zwischen die Fronten zweier Verschwörungen, die ihn jeweils für sich instrumentalisieren wollen. Zu den scheinbar Bösen gehört ein gewisser Barry Convex, der sich bei Max meldet und Hilfe verspricht. Convex, der „billige Brillen für die Dritte Welt und Fernlenkgeschosse für die Nato" produziert, erschleicht Max' Vertrauen, indem er vorgibt, dessen Halluzinationen mit einer seltsamen Apparatur aufzuzeichnen und zu analysieren. Max ergreift diesen Strohhalm und nimmt an einem seltsamen Experiment teil – doch dadurch gerät er noch tiefer in den Strudel der Halluzinationen.

So entpuppt Convex sich überraschend als Verschwörer. Er will den kleinen Sender „Civic TV" übernehmen, um mit ihm das Videodrome-Signal heimlich zu verbreiten. Max wird zu seiner willfährigen Marionette: Auf die doppeldeutige Aufforderung „Öffne dich" klafft erneut der Spalt in Max' Bauch, worauf Convex hier eine Videokassette einführt, die ihn zum Morden „programmiert".[2]

Der Medienprofi ist nun Opfer einer verschärften „deformation professionelle", er ist nun die metaphorische Verkörperung eines Videorekorders, darauf programmiert, zunächst seine Teilhaber bei „Civic TV" und dann Bianca O'Blivion umzubringen. Letztere erweist sich jedoch, wie die Frauen überhaupt, als nicht wehrlos. Es gibt in *Videodrome* eine klare Rollenverteilung, bei der die Frauen die Oberhand gewinnen. Entsprechend vereitelt Bianca den ihr geltenden Mordanschlag und zeigt Max im Gegenzug, wie er die vermeintliche Manipulation durch das Videodrome-Signal für sich „nutzbar" machen kann. Wie das funktioniert, sehen wir in einer der nächsten Szenen, als der Videopirat Harlan – auch er hat sich zwischenzeitlich als Convex' Agent entpuppt – Max für seinen nächsten „Auftrag" wie üblich eine Kassette „einführen" will. Doch der Spalt in Max' Bauch verwandelt sich diesmal in eine Vagina dentata, die den Manipulator „beißt". Als Harlan den Arm wieder hervorzieht, hat seine Hand sich in eine mit dem Arm verwachsene Handgranate verwandet.

Wie in meiner Monografie ausgeführt, wird spätestens in dieser Szene klar, dass die Logik der Halluzinationen nicht auf eine konkrete Medienkritik abzielt. Die Verwandlung der Kassette und der Hand des Aggressors in einen Sprengkörper, der sich nicht wegwerfen lässt, weil er als wortwörtlich aufgefasste „Hand-Granate" mit dem Arm verwachsen ist, ist gewissermaßen die szenisch-bildliche Entsprechung zu einer ironischen Replique, die jemanden bloßstellt (der schon von Freud und von Lacan entdeckte Komplex, wonach psychotische Halluzinationen sich nach der Struktur einer wörtlich genommenen Metapher bilden, kann aus Platzgründen nur angedeutet werden [vgl. Riepe 2002, S. 87–119; zum Zusammenhang zwischen Metapher und Unbewusstem vgl. Riepe 2010b, S. 57–120]).

Der vermeintliche Triumph über Convex und dessen Mitverschwörer bedeutet für Max allerdings nur einen weiteren Schritt auf dem Weg zu seiner zunehmenden Depersonalisierung. So hat er sich am Ende des Films unmerklich in einen jener Stadtstreicher verwandelt, die wir aus der Kathodenstrahl-Mission kennen. Schon bei seinem ersten Besuch trug er den gleichen Look wie diese Clochards, denen er sich jedoch nur anverwandelte, weil dies den neuesten Modetrend entsprach: Die psychotische Logik greift gnadenlos ineinander. Und so kehrt Max nun dorthin zurück, wo er offenbar die ganze Zeit über lebte: auf ein verlassenes, abgewracktes Schiff, das vielleicht als Symbol für seine Isolation zu lesen ist. Er sitzt hier vor jenem Fernseher, den wir aus seiner Wohnung kennen. Aus dem Apparat spricht jene Niki zu ihm, die zuvor mit masochistischem Genuss angekündigt hatte, sich als Protagonistin für das Folterprogramm Videodrome zur Verfügung zu stellen. Sie befiehlt Max nun, er solle sich in „neues Fleisch" verwandeln. Dazu müsse er „das alte Fleisch töten". Er holt daraufhin „seine" Pistole wieder dort her, wo sie verschwand – aus seinem Bauch. Die Waffe ist in der Zwischenzeit mit seiner Hand auf ähnliche Weise verwachsen wie die „Handgranate" mit dem Arm des Aggressors Harlan – sie ist „neues Fleisch" geworden. Max erschießt sich, und damit endet der Film. Es schließt sich hier ein Kreis, der mit dem ersten Bild begann: Auf dem Fernsehschirm erscheint eine Frau, Max' Sekretärin Bridey, die diesen sanft aufweckt.

2 Cronenbergs filmische Fantasie, wonach das Medium Video einen Menschen zum Morden programmiert, wird zehn Jahre später scheinbar Wirklichkeit: 1993 entführten in Liverpool zwei zehnjährige Jungs den zweijährigen James Bulger und erschlugen ihn mit einer Eisenstange. Der Fall erregte auch hierzulande ein großes Echo in der Presse, weil ein Medienpädagoge aus Augsburg seinerzeit beim zuständigen „distric court" anrief und diesen auf die Idee brachte, die beiden kindlichen Mörder wären durch ihren exzessiven Videokonsum zu dieser Tat programmiert worden. Die beiden hätten zwanghaft ein Modell umgesetzt, das in dem Horrorfilm *Chucky 3* eins zu eins vorgeprägt sei. Weil man dieses unterstellte „Modellhandeln" in der deutschen Presse seinerzeit als realistische Erklärung für den grausamen Mord ansah, führte die Ausstrahlung dieses Films in einem deutschen Pay-TV-Sender seinerzeit zu einer tiefen Entrüstung. Ich habe diesen Vorgang mehrfach kommentiert (Riepe 1995; 2005a).

Der Film – Traum oder Halluzination?

Das Kafkaeske bei Cronenberg

Zur Beantwortung der Frage, ob der Film halluziniert ist oder nicht, müssen drei argumentative Ebenen unterschieden werden. Die Erklärung der Erzählstruktur korrespondiert mit einer analytischen Deutung nach der Psychosentheorie von Freud (1911) und Lacan ([1]1981; 1997). Gestützt wird diese Deutung durch den Verweis auf weitere Filme David Cronenbergs, die dieses Thema nicht einfach nur illustrieren, sondern ihre Form selbst der Struktur psychotischer Halluzinationen verdanken. Die Analyse dieser Erzählform trägt dem möglichen Einwand Rechnung, die Filmfigur Max Renn würde wie ein Patient „auf die Couch gelegt". Diese Bedenken sind nicht völlig zu entkräften. Sie relativieren sich jedoch, wenn wir sehen, dass der psychische Konflikt des filmischen Charakters nicht eins zu eins auf einen konkreten Patienten übertragbar ist. Stattdessen drückt dieser Konflikt sich in jener ungewöhnlichen Erzählform aus, die in *Videodrome* besonders markant ist.

Diese psychoanalytische Untersuchung der filmischen Form ist inspiriert durch einen Aufsatz von Janine Chasseguet-Smirgel aus dem Jahr 1969 (Chasseguet-Smirgel 1972). Die französische Analytikerin kritisiert darin die überkommene Figurendeutung am Beispiel der voluminösen Edgar-Allan-Poe-Monografie von Marie Bonaparte (Bonaparte 1981). Chasseguet-Smirgel hebt hervor, dass Bonaparte sich nur auf den Inhalt der erzählten Motive bezieht. Die konventionelle Ineinanderspiegelung von Leben und Werk dient der Bestätigung der These, wonach der Autor einen Ödipuskomplex hatte. Die Form des Poe'schen Werks, so die Pointe dieser Kritik, wird dabei völlig ignoriert. Im Gegenzug führt Chasseguet-Smirgel anhand der Deutung von Alain Resnais' Meisterwerk *Letztes Jahr in Marienbad* vor, wie gerade die besondere Form dieses Films ein Ausdruck des ungelösten Konflikts der Hauptfigur ist. Diese Deutung, die ich in meiner Monografie kommentiert habe (Riepe 2002, S. 104 f.), möchte ich überspringen, um sogleich zu zeigen, wie sich auch in der Erzählstruktur von *Videodrome* ein Konflikt der Hauptfigur ausdrückt. Was ist das Besondere an dieser Struktur?

In einem Interview macht Cronenberg selbst hierzu folgende Anmerkung (McGreal 1984):

Videodrome „ist der erste First-person-Film, den ich je gemacht habe. Und Jimmy Woods [also die Hauptfigur Max Renn] ist jene erste Person [Singular]. Er ist in jeder Szene, und alles wird aus seinem Blickwinkel gesehen. Es ist unerbittlich Erste Person [Singular], und aus diesem Grund entsteht eine Menge Konfusion bei den Leuten, die den Film sehen. Denn wenn ich [als Regisseur] sage, dass sich für diese Figur die Realität verändert, so verändert sich damit zugleich die Realität des Films, und dadurch werden auch die physikalischen Gesetze des Universums, so wie wir es kennen, gebeugt. Für Max ist es ganz so, wie Brian O'Blivion erklärt, seine Wahrnehmung der Realität wird zu dem, was für ihn real ist. Sein ganzes Selbst verändert sich. Diese Regel habe ich in „Videodrome" aufgestellt und konsequent verfolgt.

Es gibt eine ähnliche Formulierung aus der Feder von William S. Burroughs, mit dessen Schriften Cronenberg von Jugend an vertraut ist – nicht umsonst hat er Burroughs' als unverfilmbar geltenden Roman „Naked Lunch" ([1]1959; 1984) adaptiert. Und nicht zufällig hat „Naked Lunch" eine ähnliche Erzählstruktur (deren möbiusbandartige Verschlingung, wie ich in meiner Monografie gezeigt habe, auch noch in den Filmen *eXistenZ* und *Spider* variiert wird). In den frühen 50er-Jahren macht Burroughs in einem Brief an seinen Freund Allan Ginsberg eine Anmerkung über die Arbeit an seinem Roman „Homo" (zit. nach Miles1994):

> Die 3. Person ist in Wirklichkeit die 1. Person. Das heißt, die Story wird von Lees Standpunkt aus geschrieben [Das heißt, aus der Sicht der Hauptfigur]. Wenn jemand das Zimmer verlässt, in dem Lee sich befindet, bleibt er so lange von der Bildfläche verschwunden, bis Lee ihn wiedersieht. Es gibt in der Story nichts, was Lee nicht sieht, verstehst Du, genau wie in der 1. Person.

Dieses Erzählen aus der Sicht der ersten Person Singular, also der subjektiven Perspektive eines Ichs, unterscheidet sich von der konventionellen Perspektive eines „allwissenden" Erzählers: „Eduard – so nennen wir einen reichen Baron im besten Mannesalter …" – so lautet der berühmte erste Satz in den „Wahlverwandtschaften", mit dem Goethe den so genannten „auktorialen" Erzähler bemüht, über den wir uns kaum mehr Gedanken machen. Wir denken nicht darüber nach, dass das die Erzählposition markierende, unpersönliche „Wir" nicht Bestandteil der durch den Text erzeugten erzählerischen Realität ist. Der Erzähler schwebt gewissermaßen wie in der Vogelperspektive über der nicht von ihm selbst entworfenen Szenerie. Er ist ein objektiver Beobachter, dessen allwissende Neutralität nicht zur Debatte steht.

Ein Gegenbeispiel literarischen Erzählens aus der Perspektive der ersten Person Singular, des Erzählens einer reinen „Innenweltgeschichte", die aber nirgends dieses verräterische Etikett trägt, stammt aus der Feder Franz Kafkas. „Der Prozess" schildert die hermetische Weltsicht Josef K.s. Doch dessen durchweg subjektive Sicht vermittelt inhaltlich das Gegenteil, nämlich den Anschein juristisch strenger Objektivität. Nur indirekt bemerkt der Leser, dass er sich durch das halluzinative Universum des Prokuristen K. bewegt.

Videodrome ist in diesem Sinne kafkaesk, unterscheidet sich dabei jedoch auch von einem durchgehend mit subjektiver Kamera gedrehten Film. Betrachten wir das berühmte Beispiel, Robert Montgomerys *The Lady in the Lake* (*Die Dame im See* 1947). In diesem Krimi fällt die permanent hin und her schwenkende Kamera mit den Augenbewegungen der Hauptfigur zusammen. Doch dieser formale Aspekt ist von der ersten Szene an unzweifelhaft erkennbar. Dem Zuschauer ist sofort klar, dass er durch die Augen der Hauptfigur blickt, und dementsprechend wirkt dieser Manierismus ermüdend, weshalb die formale Spielerei der subjektiven Kamera selten eingesetzt wird.

Videodrome ist auch subjektiv – aber nicht durch eine subjektive Kamera. Oberflächlich betrachtet, arbeitet Cronenbergs Film konventionell mit Schuss und Gegenschuss. Die formale Besonderheit der First-Person-Perspektive wird nicht offenbart. Genau dadurch aber wird die vermeintlich objektive Erzählhaltung unmerklich getrübt durch die pathologischen Wahrnehmungen der in jeder Szene anwesenden Hauptfigur Max Renn. *Videodrome* zeigt den Tunnelblick der Hauptfigur, dessen Sicht auf die Welt immer mehr von Halluzinationen getrübt wird. Welche Art von Konflikt spiegelt diese Bildung von Halluzinationen wider?

Jenseits der Lust …

Einen Hinweis liefert das Thema der Wahnbildung. Max versucht mit einem technischen Hilfsmittel, dem Fernsehen, ein obskures „Objekt" der Begierde zu erlangen, das scheinbar eine größere sexuelle Befriedigung ermöglicht als der konventionelle Geschlechtsakt. Mit diesem Bestreben ist Max im filmischen Universum Cronenbergs nicht isoliert. Schon in seinem Experimentalfilm *Stereo*, den der Kanadier 1969 noch vor seinem Spielfilmdebüt realisierte, geht es um eine solche „wissenschaftliche" Optimierung des Lusterlebens. In diesem sciencefiction-artigen Film, der strukturiert ist wie das Protokoll eines Laborversuchs, lässt Cronenberg eine Gruppe von Studenten auftreten, die nach einem operativen Eingriff das Sprechvermögen eingebüßt, dafür aber „telepathische Fähigkeiten" ausgebildet haben. Im Stil eines nüchternen Versuchsprotokolls beschreibt der Versuchsleiter und Off-Erzähler die damit einhergehende Optimierung der Sinnlichkeit:

> „Der Telepath braucht eine Brust, einen Schenkel oder eine sexuelle Bewegung nicht auf direktem Wege wahrzunehmen. Er kann den Gedanken an eine Brust, einen Schenkel oder eine erotische Bewegung aus dem Gehirn eines anderen Telepathen übernehmen. Und dieser Gedanke wird mit einer tieferen Stimulation wahrgenommen, als die Wahrnehmung der tatsächlichen Brust, des Schenkels oder der erotischen Bewegung selbst es sein könnte".

In *Shivers*, seinem ersten abendfüllenden Spielfilm von 1975, tritt ein „Mad Scientist auf", um „eine Kombination zwischen Aphrodisiakum und Psychoneutralisator [zu] züchten. Das heißt, einen Parasiten, der die Potenz steigert und gleichzeitig das Gehirn lähmt, damit sich die ganze Welt in eine hemmungslose Orgie stürzt". Die von dieser „Lustseuche" Befallenen verhalten sich zunächst wie „Zombies". Allerdings fressen sie ihre noch nicht infizierten Mitmenschen nicht auf – sie vergewaltigen sie nach allen Regeln der Perversionen, die hier augenzwinkernd durchdekliniert werden. Die skurrile Pointe dieses Debütfilms läuft darauf hinaus, dass die Opfer sich jener rigiden, technizistischen, aus dem Bauhaus resultierenden Logik anverwandeln, nach der jenes Luxus-Apartmenthaus konstruiert wurde, in dem sie wohnen. Kaum hat die Tollwut der Lust alle Bewohner infiziert, geschieht mit ihnen eine gespenstische Verwandlung: Ganz und gar nicht mehr triebhaft, sondern maschinenartig diszipliniert wie eine gedrillte Armee, verlassen die Infizierten im Wagenkonvoi das Gebäude, um die „Lustseuche" über die Welt zu verbreiten.

Die totale Entfesselung der Lust führt bei Cronenberg also nicht zu einer utopischen „Befreiung" der Sinnlichkeit, von der Wilhelm Reich träumte. Stattdessen erfolgt immer wieder eine seltsame Verwandlung der Menschen in maschinenartige Mischwesen. So baut in *The Fly* ein Erfinder einen Apparat, der Menschen wie Telefaxe durch den Raum „beamt" und so eigentlich das Transportsystem revolutionieren soll. Doch die Nebenwirkung dieser Apparatur, die den Menschen in seine Atome zerlegt und „gereinigt" wieder zusammensetzt, steigert nicht nur die Körperkräfte, sondern insbesondere die sexuelle Potenz des Erfinders, der praktisch unbegrenzt mit seiner verdutzten Freundin schlafen kann. Die technisch optimierte sexuelle Ekstase führt zur qualvollen Verwandlung des Erfinders in ein Monster, das im Zuge seiner Verwandlung in eine mannsgroße Fliege nach und nach zerfällt.

In *Crash*, Cronenbergs verstörendstem Film, inszenieren die „Lustingenieure" real nachgestellte Karambolagen, um so das Gefühl prominenter Unfallopfer wie James Dean oder Jane Mannsfield nachzuerleben. Der Unfall-Guru Vaughn, der seinen Jüngern „eine wohlwollende Psychopathologie" predigt, erläutert dieses Projekt wie folgt:

> „Eine Freisetzung sexueller Energie, die die Sexualität ... mit einer Intensität vermittelt, die auf andere Weise unmöglich zu erreichen ist. Das zu spüren, das zu durchleben – darin, darin – darin besteht mein Projekt ..."

Das gilt für alle „Mad Scientists" aus Cronenbergs Welt. Sie zielen folglich darauf ab, jene humanspezifische Grenze zu überschreiten, die Freud als Quintessenz seiner Überlegungen in dem Aufsatz „Über die allgemeinste Erniedrigung des Liebeslebens" (1912, S. 89) wie folgt beschreibt:

Ich glaube, man müsste sich, so befremdend es auch klingt, mit der Möglichkeit beschäftigen, dass etwas in der Natur des Sexualtriebes selbst dem Zustandekommen der vollen Befriedigung nicht günstig ist.

Der mit Freud vertraute Cronenberg macht auf seine Weise deutlich, dass diese Schranke, welche die Lust von einem „Jenseits des Lustprinzips" trennt, keiner gesellschaftlichen Deformation entspricht, die durch bessere Erziehung zu beseitigen wäre. Stattdessen illustriert er immer wieder, was geschieht, wenn seine Helden eine „künstliche" Herstellung dieser „vollen Befriedigung" mit fiktiven (para-)wissenschaftlichen Mitteln erzwingen. Die Überschreitung dieser Grenze, die Lacan ([1]1994; 2003), als symbolische Kastration bezeichnet verwandelt die Wissenschaftler in maschinenartige Wesen, für die Lustempfinden keine Befriedigung mehr darstellt, sondern eine fiebrige Mischung aus Sisyphusarbeit und körperlichem Zerfall.

„Der Körper der Frau ist irgendwie falsch"

Da Cronenberg seine Filme aus der Perspektive männlicher Protagonisten erzählt, wird ihre Misere durch die traumatische Begegnung mit einer Frau ausgelöst. Entsprechend beginnen Max Renns Probleme in *Videodrome* nach der Begegnung mit der rätselhaften Niki Brand. Die Suche nach dem ominösen Sender endet damit, dass er Niki „findet". Was er dabei durchlebt, ist gewissermaßen eine Fortsetzung jener Episoden, in denen Cronenberg in seinen Filmen *Spider* und *Dead Ringers* die Kindheit und Jungend eines Subjekts zeigt, welches das ödipale väterliche Verbot in Gestalt der symbolischen Kastration nicht verinnerlicht.

Spider erzählt die Geschichte des von Ralph Finnes gespielten, gleichnamige Psychiatrie-Freigängers, der zu seinem verlassenen Elternhaus zurückkehrt. Vergangenheit und Gegenwart sind für ihn ununterscheidbar. In der Fantasie sieht er sich selbst in seinem Elternhaus als Kind mit der Mutter am Küchentisch sitzen. Während er ihr die Haare bürstet, schaut sie in den Spiegel und schminkt sich mit einem Lippenstift. Für wen macht sie sich schön? Als erwachsener Zuschauer dieser Szene halluziniert Spider eine harmonische Welt aus Mutter und Kind (Riepe 2002, S. 197):

> Cronenberg bebildert damit auf subtile Weise eine inzestuös gefärbte, dyadische Mutter-Kind-Beziehung, aus der das väterliche Element ausgeschlossen ist.

Um den traumatischen Einbruch „des Sexuellen" abzuwehren, rivalisiert Spider nun nicht wie üblich gegen den Vater – was ja bereits eine Anerkennung seiner symbolischen Position des Dritten als Agent der symbolischen Kastration bedeuten würde. Stattdessen spaltet er seine Mutter auf in eine „präsexuelle" gute Mutter und eine bedrohliche Megäre, die den Platz der liebevollen Mutter einnimmt. Spider bringt die „böse" Mutter um, doch diese Wahrnehmung spaltet er ab und imaginiert den Vater als ihren Mörder.

Obwohl der Film *Dead Ringers* sechzehn Jahre früher entstand, könnte man die Geschichte der Mantle-Zwillinge lesbar machen als Fortsetzung von Spiders Schicksal. Die Mantle-Zwillinge, Koryphäen auf dem Gebiet der Gynäkologie, erscheinen zunächst nicht als typische Mad Scientists. Auf den zweiten Blick zeigt sich jedoch, dass sie Frauen mit ihrer neuen wissenschaftlichen Methode sozusagen „seriell schwanger" machen. Entsprechend liegen die Patientinnen diesen attraktiven, bestens situierten Junggesellen zu Füßen und gehen mit ihnen reihenweise ins Bett. Doch die Zwillinge verkehren mit diesen Frauen nie wie mit erotischen, sondern immer nur wie mit „wissenschaftlich neutralisierten" Objekten. Der Konflikt beginnt folglich mit der ersten Frau, die einem der beiden Zwillinge nicht mehr als „wissenschaftliches Objekt" begegnet, sondern als begehrende Frau. Sie will ein Kind, gewissermaßen auf die „altmodische" Art, haben, worauf die schleichende Katastrophe beginnt. Beverlys ungestüme, kindliche Liebe zu dieser Claire manifestiert sich in einer Drogensucht, derweil sein Zwillingsbruder Elliot halluziniert, dass plötzlich nur noch „mutierte Frauen" in die gynäkologische Praxis kommen. Diese Mutation entspricht einem wahnhaften Ausdruck dafür, dass Frauen plötzlich jene bedrohliche sexuelle – sprich: kastrierende – Präsenz haben, mit der schon der kleine Spider seine Probleme hatte. Um der (Kastrations-)Drohung Herr zu werden, entwickelt Elliot jene „Instrumente zu

Behandlung mutierter Frauen" die bereits im Filmvorspann zu sehen sind. Die grotesken Werkzeuge, die den außer Kontrolle geratenen weiblichen Körper domestizieren sollen, entsprechen „parodistischen Nachahmungen des Phallus" (Riepe 2002, S. 61). Es handelt sich insofern um eine Parodie der phallischen Funktion, als sie durch ihre überdimensionierte, martialische Form suggerieren, dass sie bei diesen Frauen „nicht schlapp machen". Die Funktion des Phallus, die darin besteht, das zügellose Genießen „jenseits des Lustprinzips" auf eine homöostatische Form von Lust zu reduzieren, wird ausgehebelt. Die damit einhergehende psychotische Ablösung von der Außenwelt stellt Cronenberg auf seine unnachahmliche Art dar – und zwar in Form eines Kurzschlusses zwischen Elliots halluzinativen Wahrnehmungen und jenem wissenschaftlich-medizinischen System, in dem er sich als Koryphäe der Gynäkologie perfekt auskennt: Während eines chirurgischen Eingriffs mit einem jener Instrumente, für welche die Mantle-Zwillinge berühmt sind, beklagt eine Patientin sich über Schmerzen. Elliot erklärt daraufhin kategorisch:

> 💬 „Das Gerät hat überhaupt nichts zu tun damit. Der Körper ist es. Der Körper der Frau ist irgendwie falsch."

Um diesen Körper der Frau, der „irgendwie falsch" ist, geht es auch in *Videodrome*, wo wir nun erfahren, was genau „falsch" ist. Stellvertretend für den Köper „der Frau" begegnet Max der Radiomoderatorin Niki. Das erste Mal erblickt er sie in der bereits erwähnten Fernsehshow. Wenn ihr Gesicht zunächst auf dem TV-Monitor erscheint, so ist dies bereits ein Hinweis auf den fiktiven Charakter dieser Figur. Sie trägt ein knallrotes Kleid, und auf die Frage, was „Freud dazu gesagt hätte", erklärt sie lachend, dieser „hätte recht gehabt". Niki erklärt, sie lebe „in einem Zustand hochgekitzelter Überstimulation". Was das bedeutet, erfährt Max gleich beim ersten Rendezvous, bei dem sie zufällig bei ihm eine Kassette mit der Videodrome-Show findet. Sie ist von diesen Bildern stimuliert und animiert Max, sein „Schweizer Armeemesser" auszupacken – eine Anspielung auf seinen „kleinen" Phallus – um sie ein wenig zu ritzen. Dabei bemerkt Max: „Da war schon jemand dran".

Cronenberg hat hier keine realistische Darstellung einer Frauenfigur im Sinn. Niki ist eine Projektion von Max' Fantasie. Wenn Niki sich bereitwillig zum Objekt seiner sadomasochistischen Gelüste macht, so bezweckt sie damit die Aushebelung dieser Fantasien, indem diese gemäß ihrer eigenen unbewussten Logik auf die Spitze getrieben werden. Wenn Niki sich beim zweiten Treffen provozierend eine Zigarette auf der Brust ausdrückt, so sehen wir in Max' entsetztem Blick, wie Freud im „Rattenmann" sagt, das „Grausen vor seiner ihm selbst unbekannten Lust" (Freud 1909, S. 392).

Diese ihm selbst unbekannte Lust wird Max einholen, denn in der Folge zieht Nicki die Stellschraube für die Drastik sadomasochistischer Praktikern immer weiter an. Der Film selbst setzt dieses Szenario aus Folter und Mord nur indirekt in Szene. Zwar nähert der Film sich diesem „anderen Schauplatz" sukzessive an, doch der Zuschauer sieht die Torturen nur als verschneite, unscharfe Fernsehbilder: Maskierte Folterknechte binden jeweils eine Frau an einen Pranger und peitschen sie aus. Dieser Pranger befindet sich an einer merkwürdigen ockerfarbenen Wand aus Lehm, die irgendwie zu leben scheint. Erst später wird klar, dass diese „Wand" Max' eigener Bauch ist – in dem sich schließlich jener monströse Spalt öffnen wird.

Das weibliche Genitale, mit dem dieser Spalt assoziiert ist, fungiert nach Freud und Lacan als Symbol für die Drohung der Kastration durch die Frau (Freud 1927; Lacan [1]1994; 2003). Man darf hier aber nicht übersehen, dass der biologischen Frau im Realen nichts fehlt. Erst die psychische Einschreibung der Kastration macht die Frau für den Mann (und auch für sich selbst) zu einem sexuellen Wesen. Diese Einschreibung ist bei Max auf ähnliche Art defizitär wie für die Figuren in den oben geschilderten Filmen *Spider* und *Dead Ringers*. Die Videodrome-Fantasie kann vielleicht als scheiternder Versuch einer solchen Einschreibung gedeutet werden. Sie entspricht daher der wahnhaften, nach außen projizierten Beantwortung der Frage: Was ist eine Frau?

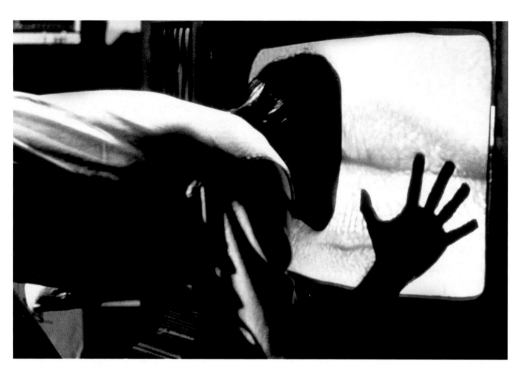

🔲 **Abb. 3** Grenzen lösen sich auf. (Quelle: Interfoto/Mary Evans)

Dem Gewaltaspekt kommt dabei eine Schlüsselfunktion zu. In der fantasierten Videodrome-Show müssen Frauen diverse Qualen erdulden. Handelt es sich dabei nicht um eine Deckerinnerung für deren symbolische Kastration? Nach der voyeuristischen Logik dieser Fantasie soll die Frau sich davor fürchten. Die Angst in den Augen des gequälten Opfers dient nach Lacan dazu, die Kastration an den anderen zu delegieren (Lacan [1]2004; 2010, S. 134; Riepe 2009a). Sie signalisiert jene Spaltung, die der Betrachter bei sich selbst verleugnet. Die Aufzeichnung dieser Angst: Das ist nun das Projekt des Videodrome-Programms – es soll Max Lust verschaffen, die er als Objekt in Gestalt einer Videokassette verfügbar machen will. Max Renn ist folglich ein Seelenverwandter von „Peeping Tom". Die Obsession dieses Kameramannes, der die Angst seiner weiblichen Opfer nicht per Video, sondern auf Zelluloid bannen will, habe ich an anderer Stelle analysiert (Riepe 2009a; 2010a). Ähnlich wie in Michael Powells Film macht das „Objekt" sich in „Videodrome" auf fatale Weise selbständig. Diese Verselbständigung hängt damit zusammen, dass Niki ihr Versprechen, in dieser Show aufzutreten, dadurch wahr zu machen scheint, dass sie mit Videodrome auf eine seltsame Weise koinzidiert. Wenn die Radiomoderatorin nach ihrem Verschwinden als Bild wiederkehrt, das den Fernseher von innen heraus belebt, dann ist Niki – aus Max' wahnhafter Sicht – mit Videodrome mehr oder weniger identisch. Sie hat den Spieß umgedreht, der Film schildert eine „Verschwörung der Frauen": Das „Fleisch gewordene Video", das O'Blivions Tod wie eine Live-Aufzeichnung präsentiert, stammt von dessen Tochter Bianca. Auf die Spur geführt wurde Max von Masha. Auch die Sekretärin Bridey, die Max in der ersten Szene des Films als „Talking Head" auf dem Fernsehschirm „langsam und schmerzlos aus deiner Bewusstlosigkeit herauslocken" soll, ist Teil der „Verschwörung". Die Frauen verkörpern jeweils Aspekte einer einzigen Figur. Die fürsorglich-warnende Masha, die verführerische Niki und die Kuratorin Bianca: Diese auf mehrere Charaktere aufgeteilte mütterliche Figur verkörpert Videodrome: eine Variation jener „mutierten Frauen" aus *Dead Ringers*. Cronenberg merkt in einem Interview an (McGreal 1984):

> Tatsächlich glaube ich, dass Frauen wichtige und starke Rollen in „Videodrome" spielen.

Es bleibt die bange Frage: Was „wollen" diese Frauen? Hier weist jene Szene den Weg, in der Niki Max aus dem wie lebendes Fleisch pulsierenden Fernseher heraus zu sich lockt: „Komm zu Niki!". Die Mattscheibe wölbt sich nach außen wie zwei Brüste, zwischen denen Max eintaucht (◻ Abb. 3). Entspricht die Suche nach Videodrome nicht einem wahnhaften Eindringen in den weiblichen Körper? Einen halluzinierten weiblichen Körper, technisierte Fantasie einer nicht kastrierenden Frau. Dieses „Eindringen", das einen sexuellen Akt parodiert, geht mit Max' Verwandlung in das so genannte „neue Fleisch" einher. Was also verbirgt sich hinter dieser schillernden Fantasie?

In der Schluss-Szene sitzt Max wiederum vor dem Fernseher, aus dem heraus Niki ihm das letzte Stück seines Wegs beschreibt. Dieser begann mit harmlosem Ohrloch-Stechen und vollendet sich im Suizid, der in zwei Etappen erfolgt. „Um neues Fleisch zu werden, muss du zuerst das alte Fleisch töten", erklärt Niki, die nun wie der Hohepriesterin der Kathodenstrahl-Religion erscheint. Er solle keine Angst haben, seinen Körper sterben zu lassen, alles wird gut: „Komm zu Niki", erklärt sie wie eine verschlingende Mutter. Sie zeigt ihm ein Fernsehbild, auf dem Max selbst zu sehen ist, wie er sich erschießt. Aus der berstenden Mattscheibe quellen Gedärme: Das alte Fleisch. Das neue Fleisch können wir nicht wirklich sehen, es liegt außerhalb der „Szene". In meiner Monografie (Riepe 2002) habe ich angedeutet, dass es mit jenem Loch in Max' Bauch korrespondiert: Das neue Fleisch müsste ein paradoxes „Loch im Film selbst" sein. Die Realisierung dieses Loches im Film koinzidiert mit Max' finalem Suizid, auf den der Film unweigerlich zusteuert. Das „neue Fleisch" ist somit jenes nicht im Film sichtbare „Etwas", in das Max sich durch diesen Suizid selbst verwandelt. Diese Verwandlung hat, wie wir gesehen haben, ein Motiv: Max verwandelt sich in dieses „Etwas", das Niki fehlt. Diese „begehrt" Max wie eine Mutter ihr Kind.

Max' Suizid: eine halluzinierte Kastration

Wir haben zuvor gesehen, dass der Revolver und die Videokassette, die in Max' halluzinierten Bauchschlitz eingeführt werden, bildhafte Entsprechungen des Phallus sind. Dass nun dieser Phallus nach Lacan ([1]1994; 2003) weder den Penis noch eine sonstige „positive Entität" darstellt, zeigt die Erzählung des Films. Den Suizid, dem Max sich hingibt, könnte man als wahnhafte Auslegung dessen deuten, was im Zuge eines „normalen" Geschlechtsaktes mit ihm geschehen würde. Die symbolische Kastration, die beim nicht-psychotischen männlichen Subjekt dazu führt, dass der Penis nach dem Akt abschwillt und das Subjekt dem Zyklus aus Begierde und Entspannung überantwortet, wird von Max konkretistisch gedeutet. Er will sich nicht von diesem Phallus trennen, und die Kastration soll nicht stattfinden. Das Bild der Hand, die metastasenartig mit der Pistole verwachsen ist, entspricht einem imaginären Phallus, von dem er sich nicht trennen kann. Nun ist aber diese Trennung von seinem Phallus genau das, was Niki von Max fordert. Folglich deutet Max auf seine wahnhafte Weise diese Trennung vom Phallus, indem er sich in neues Fleisch verwandelt. Diese Verwandlung impliziert, dass er sich als Ganzer in jenen Phallus verwandelt, welcher der mütterlichen Niki fehlt – und den sie einfordert. Folglich muss Max sich selbst dieser symbolischen Abwesenheit des Phallus real anverwandeln: Er muss sich umbringen. Die Fantasie eines Fernsehprogramms, in dem sexuelle Gewaltfantasien nicht gespielt, sondern real sind, wird so durch die psychotische Logik bis „zur Kenntlichkeit entstellt". So klärt sich am Ende, was es auf sich hat mit „Civic TV", dem „Sender, den Sie mit ins Bett nehmen". Max denkt die Logik der Gewaltpornografie zu Ende; dabei wird er von seiner eigenen Fantasie verschlungen wie der chinesische Maler, der in seinem selbst gemalten Bild verschwindet.

Literatur

Bonaparte M (1981) Edgar Poe. Eine psychoanalytische Studie. 3 Bde. Suhrkamp, Frankfurt/M (Erstveröff. 1934)

Burroughs WS (1984) The Naked Lunch. Ullstein, Frankfurt/M (Erstveröff. 1959)

Chasseguet-Smirgel J (1972) Letztes Jahr in Marienbad. Zur Methodologie der psychoanalytischen Erschließung des Kunstwerks. In: Mitscherlich A (Hrsg) Psychopathographien 1. Fischer, Frankfurt/M, S 182–231

Freud S (1909) Bemerkung über einen Fall von Zwangsneurose. Gesammelte Werke Bd 7. Fischer, Frankfurt, S 379–463

Freud S (1911) Psychoanalytische Bemerkungen zu einem autobiographisch beschriebenen Fall von Paranoia (Dementia paranoides). Gesammelte Werke Bd 8. Fischer, Frankfurt, S 239–320

Freud S (1912) Über die allgemeinste Erniedrigung des Liebeslebens. Gesammelte Werke Bd 8. Fischer, Frankfurt, S 78–91

Freud S (1927) Fetischismus. Gesammelte Werke Bd 14. Fischer, Frankfurt/M, S 309–317

Hoffmann K (1990) Am Ende Video – Video am Ende? Sigma, Berlin, S 185

Lacan J (1997) Das Seminar, Buch III: Die Psychosen. Weinheim, Quadriga (franz. 1981)

Lacan J (2003) Das Seminar, Buch IV: Die Objektbeziehung. Turia + Kant, Wien (franz. 1994)

Lacan J (2010) Das Seminar, Buch X: Die Angst. Turia + Kant, Wien (franz. 2004)

McGreal J (1984) Interview with David Cronenberg. In: Drew (Hrsg) BFI Dossier 21: David Cronenberg, S 9

Miles B (1994) William S. Burroughs – Eine Biographie. Kellner, Hamburg

Morris P (1994) David Cronenberg. A Delicate Balance. EWC Press, Toronto

Riepe M (1995) Das Gespenst der Gewalt. Was Sie schon immer über Gewaltdarstellung wissen wollten, sich aber bislang nicht zusammenzureimen trauten. In: Florian R (Hrsg) Das Böse. Steidl, Göttingen, S 299–328

Riepe M (2002) Bildgeschwüre. Körper und Fremdkörper im Kino David Cronenbergs. Psychoanalytische Filmlektüren nach Freud und Lacan. Transcript, Bielefeld

Riepe M (2005a) Maßnahmen gegen die Gewalt. In: Köhne J, Kusche R, Meteling A (Hrsg) Splatter Movies. Essays zum Modernen Horrorfilm. Bertz, Berlin

Riepe M (2005b) Film und Metapher. In: Schade S, Sieber S, Tholen GCh (Hrsg) SchnittStellen. Baseler Beiträge zur Medienwissenschaft. Schwabe, Basel, S 319–329

Riepe M (2009a) Schauen und stechen. Anmerkungen zu Michael Powells „Peeping Tom". In: Riss Nr 72/73(II-III), S 97–116

Riepe M (2009b) Der unmögliche Blick. Medientechnik und inszenierte Weiblichkeit in Michael Powells „Peeping Tom". In: Engell L, Siegert B (Hrsg) Zeitschrift für Medien und Kulturforschung 0/09: 151–166

Riepe M (2010a) Wenn Blicke töten. In: Höltgen S, Wetzel M (Hrsg) Killer/Culture. Serienmord in der populären Kultur. Bertz/Fischer, Berlin, S 39–49

Riepe M (2010b) Rückkehr zu Saussure – Elemente einer Linguistik des Kalauers. Riss Nr 76(III)

Vogelgesang W (1991) Jugendliche Videocliquen. Action- und Horrorvideos als Kristallisationspunkte einer neuen Fankultur. Westdeutscher Verlag, Opladen

Originaltitel	Videodrome
Erscheinungsjahr	1983
Land	Kanada, USA
Buch	David Cronenberg
Regie	David Cronenberg
Hauptdarsteller	James Woods (Max Renn), Deborah Harry (Niki Brand), Sonja Smith (Bianca O'Blivion), Peter Dvorsky (Harlan), Les Carlson (Barry Convex), Jack Creley (Brian O'Blivion), Lynne Gorman (Masha), Julie Khoner (Bridey)
Verfügbarkeit	Als DVD in OV erhältlich, deutschsprachig nur als Video erschienen

Franziska Lamott, William Adamson

BRAZIL – ein Traum?

Brazil – Regie: Terry Gilliam

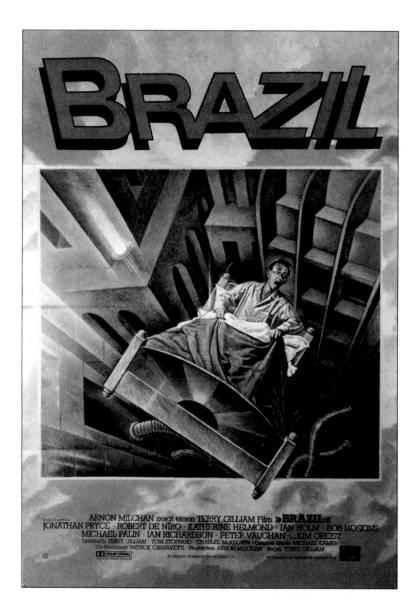

Brazil

Regie: Terry Gilliam

„Es gibt Länder ohne Orte und Geschichten ohne Chronologie. Es gibt Städte, Planeten, Kontinente, Universen, die man auf keiner Karte und auch nirgendwo am Himmel finden könnte, und zwar einfach deshalb, weil sie keinem Raum angehören. Diese Städte, Kontinente und Planeten sind natürlich, wie man so sagt, im Kopf der Menschen entstanden oder eigentlich im Zwischenraum zwischen ihren Worten, in den Tiefenschichten ihrer Erzählungen oder auch am ortlosen Ort ihrer Träume …"

Foucault ([1]1967; 2005, S. 9)

Die Handlung

Terry Gilliams Film *Brazil* (1985) (◼ Abb. 1) spielt „somewhere in the 20th Century", in einem von Technologie und Bürokratie beherrschten Land und verfolgt das Leben und die Träume des bescheidenen Regierungsangestellten Sam Lowry (Jonathan Pryce). Als kleines Rädchen einer staatlichen Maschinerie entflieht er dem seelenlosen Dasein in Tagträume, in denen er sich als geflügelter Held, als Retter einer wunderschönen Frau fantasiert.

Eines Tages wird Sam Lowry vom Ministerium beauftragt, einen Fehler zu beseitigen, der durch einen Käfer (engl. „bug" = umgangssprachlich „Fehler") verursacht wurde, der in einen Drucker gefallen ist und damit einen folgenschweren Rechtschreibfehler auslöst. Die dadurch entstandene Personenverwechslung führt zur Verhaftung und letztendlich zur Tötung des unschuldigen Archibald Buttle statt zur Festnahme des gesuchten Terroristen Archibald „Harry" Tuttle (Robert De Niro). Sam Lowry kommt die Aufgabe zu, der Witwe des unglücklichen Opfers eine Entschädigung für den Tod ihres Mannes zukommen zu lassen und macht sich auf den Weg zu den „Shangri-La Towers", wo die Familie Buttle wohnt.

Bei der Witwe angekommen, stellt Sam fest, dass die Frau seiner Träume – Jill Layton (Kim Greist) – im Obergeschoß des gleichen Wohnblocks lebt. Er erfährt, dass Jill entschlossen ist, herauszufinden, was mit dem armen Archibald Buttle passiert ist. Bei ihren Erkundungen sieht sie sich einer menschenverachtenden Bürokratie gegenüber, die sie umgehend als Komplizin des Terroristen Tuttle einstuft.

Tuttle arbeitete selbst einst für die Regierung, hatte dem Staat jedoch den Rücken gekehrt und sich als Dissident eine neue Identität als Spezialist für Klimatechnik zugelegt. Als Sam eines Tages seine Dienste in Anspruch nimmt, trifft er zum ersten Mal mit dem polizeilich gesuchten Terroristen zusammen. Doch bevor er realisiert, wer vor ihm steht, ist Tuttle schon wieder verschwunden.

Sam träumt weiter von Jill und sieht als einzige Chance, mehr über sie zu erfahren, sich in die Abteilung „Information Retrieval" versetzen zu lassen, um dort Zugang zu ihren Verschlussakten zu bekommen. Er bittet seine Mutter um Hilfe, eine eitle Person, die sich in die Obhut des skurrilen Dr. Jaffe, eines Schönheitschirurgen, begeben hat, der ihr ein junges Gesicht verspricht. Die Mutter, mit einem Hang zum Höheren, pflegt seit jeher Kontakt zu wichtigen Beamten und sorgt nun dafür, dass Sam versetzt und gleichzeitig befördert wird. Sam verschafft sich Jills Akte und, bevor die Regierung sie verhaften kann, rettet er sie, indem er ihre Unterlagen fälscht und sie für tot erklärt. Nachdem das Paar eine romantische Liebesnacht verbracht hat, wird Sam von der Regierung gefangen genommen. Auch Jill wird abgeführt und nun – so lässt sich vermuten – endgültig „stillgestellt".

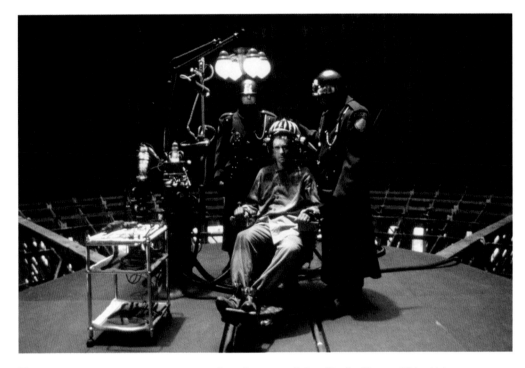

Abb. 2 Sam (Jonathan Pryce) ist seinen Widersachern ausgeliefert. (Quelle: Cinetext Bildarchiv)

Gefesselt an einen Stuhl, steht Sam die Folterung durch Jack Lint, einen ehemaligen Freund, und Mr. Helpman bevor (▣ Abb. 2). Doch bevor Lint mit der Tortur beginnen kann, brechen Tuttle und andere Mitglieder des Widerstands in das Ministerium ein, erschießen Lint und befreien Sam.

Sam und Tuttle fliehen. Während Tuttle in einem Sturm von Papierfetzen verschwindet, findet sich Sam plötzlich an der Seite seiner Mutter wieder, die gerade der Beerdigung ihrer Freundin – die an den Folgen exzessiver kosmetischer Chirurgie verstorben ist – beiwohnt. Beim Anblick der Mutter nimmt diese für ihn plötzlich die Gestalt Jills an, die von einer Schar junger Bewunderer umgeben ist. Angesichts dieser Verwandlung fällt Sam in den leeren, bodenlosen Sarg. Er landet in einer anderen Welt und versucht, aus diesem Universum von Kanälen und imaginären Monstern zu fliehen, bis er schließlich durch eine Tür entkommt und sich in einem Wohnwagen an der Seite von Jill wiederfindet. Zusammen verlassen sie die Stadt.

Doch das Happyend entpuppt sich als Wunschfantasie, wenn der Zuschauer realisiert, dass Sam immer noch gefesselt, unter der Aufsicht von Lint und Mr. Helpman, im Stuhl sitzt. Er wirkt entrückt, in einem Zustand innerer Glückseligkeit, ein Lächeln auf seinem Gesicht, die Melodie „Brazil" vor sich hin summend. Lint und Helpman begreifen, dass Sam anwesend und abwesend zugleich, verrückt geworden, ein hoffnungsloser Fall ist. Während Sam immer noch lächelnd auf dem Stuhl verharrt, verlassen die Folterer den Raum, wie kurz darauf die Zuschauer das Kino.

Entstehung und Rezeption des Films

Terry Gilliam machte sich in den 1970er-Jahren als Mitglied der Monty-Python-Gruppe einen Namen. Nach der letzten Produktion der Gruppe, in der er als Co-Regisseur von *Monty Python and the Holy Grail* (1974) fungierte, folgten mehrere eigene Filme, darunter *The Adventures of Baron Munchausen* (1988), *The Fisher King* (1991), *12 Monkeys* (1995) und natürlich, als erste eigenständige Arbeit, in den 80er-Jahren *Brazil*.

Die Konzeption und Entwicklung des Films basiert, so Gilliam, auf einer losen Sammlung von Ideen (Christie 1999, S. 111):

> I had this pile of ideas, a general story I was trying to tell, which was a loose connection of scenes running to about a hundred pages.

Um der „losen Sammlung" von Einfällen eine Form zu geben, engagierte er Charles Alverson, der bereits das Drehbuch zu seinem Film *Jabberwocky* (1977) geschrieben hatte. Alverson war an der Entwicklung der ersten schriftlichen Fassung von *Brazil* beteiligt; erschien aber nicht mehr im Vorspann des Films. Der Grund dafür scheinen „unversöhnliche Differenzen" zwischen den Beiden gewesen zu sein, die Gilliam so beschreibt: „We were going in slightly different directions" (Christie 1999, S. 111). In der Folge tat er sich mit dem Dramaturgen Tom Stoppard und dem Schauspieler Charles McKeown zusammen, um seinen Film voranzutreiben.

Brazil war nicht der erste Titel des 1985 erschienenen Films. Ursprünglich sollte er „1984 and ½" heißen – ganz offensichtlich eine Anspielung auf George Orwells dystopischen Roman „1984" sowie auf Federico Fellinis Film 8½. Die Anknüpfung an Orwells „1984" ist naheliegend, da Gilliams Film ebenfalls dem Science Fiction Genre angehört. Die Bezugnahme auf Fellinis 1963 produzierten Films 8½ – dessen Titel sich der Anzahl seiner bis dato produzierten Filme verdankte sowie eine autobiografische Auseinandersetzung mit seiner Schaffenskrise und der Kunst des Filmemachens darstellte – könnte ein Hinweis darauf sein, dass auch Gilliam sein Werk als einen selbstreflexiven Beitrag zum Kino ansieht. Wie in Fellinis Film nehmen auch bei Gilliam Ängste und latentes Material Gestalt an und lassen Traum und Wirklichkeit verschwimmen: eine Selbstthematisierung des Mediums im Medium.

Doch wie kam es dann zu *Brazil*? Der Titel hat wenig mit dem Land, sondern vielmehr mit dem Titelsong des Films zu tun, der auf den 1939 von Ary Barroso komponierten „Aquarela do Brasil" zurückgeht. *Brazil* erzeugt eine gewisse Stimmung, die durch den Rhythmus, die Komposition und die Klangfarbe dieses musikalischen Leitmotivs kreiert wird.

Den musikalischen Einfluss von Brazil kommentiert Gilliam wie folgt (2003, Interview mit Salman Rushdie):

> And so Brazil became the title – because of the song. Brazil started when I was sitting out on a beach in Wales – Port Talbot, which is a steel town. They bring the coal in from the ships on these great conveyor belts. So the beach is pitch black. It's covered with coal dust. It was a miserable, awful day, and I just had this image of some lonely guy sitting on that beach and tuning in a radio and suddenly [Hums the tune to „Brazil"] this music he's never heard before – there was no music like that in his world – was there. And that would trigger him to believe there is another world out there, a better world.

Im Januar 1985 lieferte Terry Gilliam das Endprodukt *Brazil* termin- und budgetgerecht an Sid Sheinberg, das heißt an die Universal Studios. Universal hatte die nordamerikanischen Rechte für den Film erworben, und der Film war in Europa bereits erfolgreich angelaufen. Doch die amerikanische Produktionsfirma war mit dem düsteren Schluss des Films, mit der Botschaft über die unmenschlichen

Folgen technologischer Entwicklung, nicht einverstanden und bestand auf einer radikalen Kürzung. Zehn Minuten wurden geschnitten, negativ wirkende Szenen verschwanden, und der Schluss wurde in ein „Happy End" verwandelt.

Gilliam war empört und teilte den Universal Studios mit, dass er, im Fall einer Beibehaltung dieser überarbeiteten Fassung, seinen Namen aus dem Abspann entfernen lassen würde. Das Hin und Her währte so lange, bis Gilliam eine ganze Werbeseite im Filmmagazin „Variety" kaufte und darin folgendes Inserat platzierte (Gilliam 1985, Variety, S. 24):

Dear Sid Sheinberg. When are you going to release my film BRAZIL?

In der Zeitschrift „California" beschrieb Kenneth Turan, ein bekannter Filmkritiker, *Brazil* als „das Meisterwerk, das ihr nie zu sehen bekommt" (Christie 1999, S. 151, Fn. 19). Beide Seiten mussten sich kompromissbereit zeigen. Der Film erschien 1985 in den USA zwar in einer veränderten Fassung, aber nicht so radikal gekürzt, wie von den Universal Studios ursprünglich vorgesehen.

Die Rezeptionen des Films unterschieden sich länderspezifisch und divergierten jeweils nach der Fassung des Films. Terry Gilliam stellte fest (Christie 1999, S. 147 f.):

I remember the British reviews … seemed to think it was all about visual pyrotechnics. … But the great revelation was when I got to Paris to promote it – All the reviewers and journalists were thanking me for the wonderful work, and calling it „poetic" and „symphonic". … 60% of the US reviews were really good, and the rest were hateful – which is fine. The worst thing is being dismissed: you want to be hated or loved, but not ignored.

Am Ende zeichnete die Los Angeles Film Critics Association den Film mit drei Preisen aus: „Bester Film", „Beste Regie" sowie „Bestes Drehbuch". 1986 erhielt *Brazil* zwei Oscar-Nominierungen in den Kategorien „Bestes Drehbuch" und „Beste Ausstattung".

Strukturelemente

Musik

„Brazil" von Ary Barroso ist das musikalische Leitmotiv des gleichnamigen Films. Die uns vertraute Sambamelodie wurde weltweit bekannt, nachdem sie in einem anderen Film verwendet wurde: in Walt Disneys 1942 gedrehter Animation *Saludos Amigos*. Gilliam äußert sich in Bezug auf die Musik und die Hauptfigur dieses Films wie folgt: „The music transported him somehow and made his world less grey" (Gilliam 1986), und in der Tat sind es die leichten Rhythmen, die eine entlastende, fast sonnige Stimmung in ihm und in uns, den Zuschauern, auslösen.

Brazils Soundtrack wurde von Michael Kamen komponiert und arrangiert und spielt eine tragende Rolle im Film. Die symphonische Fassung umfasst verschiedene Arrangements der Leitmelodie sowie eine Vielzahl neukomponierter Stücke, die Erinnerungen an bekannte Melodien und damit bestimmte Gemütszustände hervorrufen. Durch Kamens geschickt variierte Auslegung der Leitmelodie und den raffinierten Einsatz musikalischer Passagen – sei es durch langsamen Blues, der die melancholischen Nuancen des Film Noirs der 1940er- und 1950er-Jahre evoziert, oder mit sanften bis dramatischen, orchestralen Tönen – werden stimmungsgeladene Momente des Films musikalisch untermalt und verstärkt. So zum Beispiel die öffentliche Ansprache Mr. Helpmans, die mit patriotischer Musik unterlegt ist und stark an Elgars „Land of Hope and Glory" erinnert; ein Lied, das in England als pathetisches musikalisches Sinnbild für Patriotismus steht und dessen erste Zeile lautet: „Liebes Land der Hoffnung, deine Hoffnung ist gekrönt."

Gilliam lässt uns fortwährend – auch musikalisch – seinen Sinn für Ironie und schwarzen Humor spüren. So auch in einer Szene im Restaurant, wo sich Sam mit seiner Mutter trifft. Die Szene ist purer Surrealismus und erinnert an die „Mad Hatters Tea-Party" aus Lewis Carrols *Alice im Wunderland*. Zu Beginn der filmischen Sequenz spielt ein Orchester leise eine träge Hintergrundmusik, bis eine plötzliche Explosion alles in Flammen und Trümmer aufgehen lässt, abgesehen von dem Tisch, an dem Sam mit seiner Mutter sitzt. Die Kamera schwenkt auf das Orchester, das – wie in dem von Negulesco 1953 verfilmten Untergang der Titanic (1913) in Momenten des Chaos und des Untergangs – stoisch weiterspielt. Diesmal ist es das flotte Stück „Hava Nagila", ein hebräisches Volkslied, dessen Titel übersetzt so viel wie „lasst uns glücklich sein" bedeutet – ein Lied zum Feiern. Neben dem ironischen Einsatz dieses fröhlichen Liedes angesichts des Untergangs, gibt es noch einen weiteren Antagonismus: Die Szene ist zeitlich in die christliche Weihnacht eingebettet, während die begleitende Melodie ein Metonym für das Judentum ist.

Die musikalischen Anspielungen und die mehr oder weniger verborgenen Hinweise auf filmgeschichtliche Vorläufer begleiten das Werk und sind bedeutende Strukturelemente des selbstreflexiven Films. Die Zitate erfreuen den Cineasten beim Wiedererkennen und ziehen den Zuschauer in den Bann, indem sie auf spöttische und manchmal sarkastische Weise die Bitterkeit des dystopischen Entwurfs ironisch durchbrechen.

Zeit und Raum

Zeit und Raum spielen in *Brazil* eine herausragende Rolle. So zieht der erste Bildtext die Aufmerksamkeit auf beide Dimensionen, wenn dem Zuschauer zwar eine konkrete zeitliche Orientierung vorgegeben, gleichzeitig jedoch die eindeutig räumliche verweigert wird:

8 : 49 P. M.
SOMEWHERE IN THE 20TH CENTURY

Die im Anhang mit „P. M." (post meridiem) gekennzeichnete Zeitangabe gibt zu verstehen, dass wir uns in der filmischen Erzählung am Abend befinden. Der Ort bleibt fraglich, nur die Zeitangabe hilft der Orientierung: irgendwo im 20. Jahrhundert …

Gilliam spielt mit dystopischen Entwürfen, die eine spezifische zeitliche und räumliche Struktur haben: Sie sind durch Zeitschnitte gekennzeichnet und bewegen sich an einem Ort, an dem mehrere Räume zusammenliegen, die an sich unvereinbar sind. So trägt in *Brazil* der Wohnblock, in dem die Familie Buttle wohnt, den Namen Shangri-La Towers. Shangri-La ist ein fiktionaler utopischer Ort, der zuerst 1933 in dem Roman von James Hilton „Lost Horizon" (2007) beschrieben und 1937 von Frank Capra unter dem gleichen Namen verfilmt wurde. Shangri-La ist ein mystischer Ort, mit Anklängen an ein irdisches Paradies. In der englischen Alltagssprache wird Shangri-La als Synonym für einen Ort glücklichen und friedlichen Rückzugs verwendet. In *Brazil* hingegen benutzt Gilliam diese Anspielung als ironischen Kommentar, denn ganz offensichtlich steht sein dystopischer Entwurf im krassen Gegensatz zum utopischen Shangri-La.

Die Fragen nach Raum und Zeit – ontologische Themen menschlicher Existenz – bestimmen die grundlegende Struktur des Films. Hamel (2006) sagt dazu:

During the course of the film, it becomes impossible to distinguish between the two, making the task of locating the story in some identifiable frame of reference impossible.

Eindeutigkeit in der räumlichen und zeitlichen Situierung ist nicht gegeben. Gilliam betont (Christie 1999, S. 129):

> It's everywhere in the twentieth century … I wasn't thinking retro particularly, but there are bits of everything coming from all directions.

So sind die „mise-en-scene" der technologischen Innovationen in *Brazil* eine Art Sammelsurium an Vorrichtungen und Erfindungen, die das 20. Jahrhundert repräsentieren. Das heißt, die meisten technischen Errungenschaften reflektieren eher futuristische Visionen aus Science-Fiction-B-Movies der 50er-Jahre und früher. *Brazil* repräsentiert eine retrograde Fantasie, in der mechanisierte Abläufe des alltäglichen Lebens eher hinderlich als hilfreich dargestellt werden. Und in der Tat funktioniert recht wenig. Die zeit- und arbeitssparenden Vorrichtungen, die den Utopien der 50er-Jahre entsprungen zu sein scheinen, sind gänzlich ineffizient, wie zum Beispiel eine vollautomatisierte Küche, in der sich der Kaffee auf einen Toast ergießt. Die bittere Ironie und der schwarze Humor, mit dem Gilliam den Fortschritt als Rückschritt konnotiert, kann man in Anlehnung an Monty Python durchaus als „pythonesk" bezeichnen.

Robert Blumen (2003) schreibt in seinem Essay „Brazil and the Economic Problems of Socialism":

> In Brazil, technological progress has gone into reverse, stupidity has won out over innovation, shirking takes the place of productivity, and the absurd is accepted as normal. There is a repeated visual motif of overly complex technologies that perform simple tasks badly. Many devices are broken, malfunctioning, or otherwise not user-friendly.

Im technologischen Futurismus *Brazils* kommt es zu einer Gleichsetzung von Vergangenheit und Gegenwart, in der die Apparate der Zukunft jene der Vergangenheit reflektieren (Christie 1999). So sind die Computer zum Beispiel kaum mehr als aufgemotzte Schreibmaschinen aus den 1930er-Jahren mit winzig kleinen Bildschirmen, auf denen die Texte nur mit Hilfe einer Vergrößerungsscheibe zu lesen sind.

Bildschirme und Spiegel sind wesentliche Elemente der Szenografie in Brazil, sie sind allgegenwärtig. Das Sich-Spiegeln ist ein wiederkehrendes Motiv, das einerseits die Frage nach subjektiver Identität, nach Selbstvergewisserung in Zeiten drohender Fragmentierung und andererseits Fragen nach der Realität des Anderen wirkmächtig ins Bild setzen. Spiegel produzieren Doppelgänger und Wirklichkeitsbrüche. Sie sind Projektionsflächen oder „Übertragungs'flächen'" (Haubl 1991, S. 388) eigener Wünsche. Doch was ist dann Wirklichkeit und was ist Illusion, was Offenbarung und was Verhüllung? Das Verwirrspiel ergreift auch den Zuschauer, dessen Wahrnehmung durch das Erblicken der Bilder im Spiegel, durch Spiegelbilder, dezentriert wird.

Neben dieser Form der szenischen Verunsicherung hat Gilliam in seinem Film eine Welt geschaffen, in der zeitlich geordnete Abfolgen eine geringe Rolle spielen oder wie Albert Einstein ([1]1955; 1972, S. 193) diese Weltwahrnehmung für Seinesgleichen formulierte:

> People like us who believe in physics know that the distinction between the past, the present and the future is only a stubbornly persistent illusion.

Demnach ist Zeit in ihrem Verlauf eine Illusion, und nur die Gegenwart, also das augenblicklich empirisch Erlebte, besitzt einen realen Status. Zeit ist ein ständiger Wandel zwischen Gegenwart, Vergangenheit und Zukunft.

Brazil thematisiert quasi einen „zeitlosen" Zustand, in dem Vergangenheit, Gegenwart und Zukunft in jener Gleichzeitigkeit zusammenfallen, die auch für das Unbewusste charakteristisch ist. Die Vorgänge im Unbewussten sind zeitlos, „das heißt, sie sind nicht zeitlich geordnet, werden durch die verlaufende Zeit nicht abgeändert, haben überhaupt keine Beziehung zur Zeit" (Freud 1 1913–1917; 1991, S. 286). Denn das Unbewusste kennt keine Zeit. Die Zeitbeziehung ist an die Arbeit des Bewusstseins geknüpft, die Vorgänge des Unbewussten hingegen nehmen keine Rücksicht auf die Realität; denn sie sind dem Lustprinzip unterworfen.

Sprache

Gilliam hat uns mit seinem Film einen medialen Traum geschenkt. Ähnlich dem Traum gelten in *Brazil* weniger Gesetzmäßigkeiten der Logik, als die der Arbeit des Unbewussten, in der verdichtet, verschoben und verhüllt wird. Das zeigt sich auch in der Bedeutung des Sprachgebrauchs im Film: So maskiert sich Mr. Helpman, seinem Namen entsprechend, als warmherziger Helfer und freundlicher Sprecher einer Regierung, die alles andere als wohlwollend, sondern autoritär und unterdrückend ist. Seine Sprache ist verharmlosend und soll beruhigend wirken. Konflikthaftes Material wird beschönigt; die Sprache zur Verschleierung in den Dienst genommen. Begriffe, die eine faktische Realität kennzeichnen, wie „dead", werden vermieden, stattdessen benutzt man Euphemismen wie „dormant" (ruhend, schlafend) „inoperative" (unwirksam) oder „completed" (erledigt, vollzogen). Um die Befürchtungen der Öffentlichkeit zu zerstreuen und das brutale Handeln der Staatsmacht zu verdecken, wird eine irreführende Sprache verwendet, die charakteristisch für dystopische Welten (siehe zum Beispiel Orwell, Huxley) ist.

Brazil repräsentiert eine bewusst gewählte Politik der Fehlinformation und der sprachlichen Verdunklung, die die brutale Realität des Staates verbirgt. So wird bei der Verhaftung von Buttle folgender Text verlesen.

> „… Mr. Buttle, Archibald, … has been invited to assist the Ministry of Information with certain enquiries, the nature of which may be ascertained on completion of application form BZ/ST/486/C fourteen days within this date, and that he is liable to certain obligations as specified in Council Order 173497, including financial restitutions which may or may not be incurred if Information Retrieval procedures beyond those incorporated in Article 7 subsections 8, 10 & 32 are required to elicit information leading to permanent arrest notification of which will he served with the time period of 5 working days as stipulated by law" (Drehbuch Brazil 1983, S. 6).

Der Verfolgte muss nicht nur die Kosten seiner Festnahme und des eigenen Folterprozesses tragen, sondern ihm wird darüber hinaus, mit der Mitteilung über die Verurteilung zum „permanent arrest", ganz beiläufig sein Todesurteil mitgeteilt. In diesem Jargon werden Wahrheiten als Unwahrheiten und Unwahrheiten als Wahrheiten verbrämt. Dieser Prozess wird verstärkt durch visuelle Motive, die an Orwells *1984* und an sowjetische Propaganda erinnern. Plakate mit verdrehten Parolen begleiten das filmische Narrativ:

> "Be Safe: Be Suspicious"
> „Suspicion Breeds Confidence"
> „Trust in hate, Regret at leisure"
> „Don't suspect a friend, report him".

Die Parolen klingen wie Handlungsanweisungen aus einer paranoiden Welt, die keine vertrauensvolle Beziehung erlaubt, eine Welt in der die öffentlichen Verkehrsformen weitgehend dehumanisiert sind. Dazu trägt in *Brazil* die Omnipräsenz der Bürokratie bei, die zwanghafte Beobachtung und Dokumentation von Handlungsvollzügen der Untertanen. Besonders prägnant zeigt sich das in einer Folterszene, die eine Sekretärin akribisch wie ein Tonbandgerät aufzeichnet, indem sie selbst das schmerzhafte Stöhnen eines Mannes protokolliert, der unter der Qual des „Information Retrieval"- Prozesses stirbt. Die sprachliche Rationalisierung der Unterdrückung und die kleinteilige Zergliederung von Handlungsabläufen als Teil der Professionalisierung bilden die Basis der Gewalt, wie ein Dialog zwischen Sam Lowry und dem Folterer Lint zeigt. Als Sam Lint damit konfrontiert, dass er den falschen Mann hat töten lassen, erwidert dieser:

Abb. 3 Sam, der geflügelte Held. (Quelle: Cinetext Bildarchiv)

„The wrong man was delivered to me as the right man. I accepted him on good faith as the right man. Was I wrong?" (Drehbuch Brazil, 1983, S. 70)

Wie der fiktive Lint, so vollziehen auch reale Folterer an namenlosen, ihnen zugewiesenen Opfern, dem eigenen Selbstverständnis gehorchend, professionelle Geständnisarbeit (Gourevitch u. Morris 2009). Terry Gilliam knüpft in *Brazil* ein Netzwerk aus unterschiedlichen dystopischen und utopischen Fragmenten, aus filmischen und literarischen Zitaten. Er reichert es an mit weitergehenden Assoziationen und treibt die Geschichten durch Überzeichnungen voran. So entwirft er in *Brazil* eine Welt, in der eine alles erdrosselnde bürokratische Macht die Oberhand gewinnt. Er konstruiert einen Kosmos, in dem Formulare und Verfahren wichtiger sind als menschliche Bedürfnisse, in der die Opfer bürokratischer Akte schuldig und die anordnenden Bürokraten prinzipiell unschuldig sind. In Orwells *1984* erliegt Winston Smith vollkommen der Macht des Staates. Seine Individualität hat einer kollektiven Gleichschaltung Platz gemacht, die in dem Geständnis gipfelt: „Ich liebe Big Brother", die allumfassende Kontrollinstanz. Es ist eine Welt der Stagnation, eine Welt, in der Kreativität und Individualität ohne Bedeutung sind. Doch Gilliams Protagonist Sam, der geflügelte Held (Abb. 3), gleicht auch Ikarus, der sich in die Lüfte erhebt, seiner kreativen Lust frönt und das Gesetz des Vaters, wie die Gehorsamspflicht, verletzt (Schütz 1996). Und wie Ikarus riskiert auch Sam den Tod. Doch Gilliam spielt mit dem Mythos: Sein „Ikarus" entflieht dem repressiven Vater Staat und fliegt traumversunken, gänzlich unverletzt, der Sonne entgegen. Eine utopische Wunschphantasie als Ausweg aus einem dystopischen Weltentwurf?

Obwohl uns am Ende des Films Sam geistig und körperlich gebrochen, an einen Stuhl gefesselt, präsentiert wird, gönnt er den Vertretern der staatlichen Macht – wie der letzte kurze Wortwechsel im Film zeigt – keinen Triumph.

 Mr Helpman: "He's got away from us, Jack."
Jack: "I'm afraid you're right, Mr. Helpman. He's gone."

Sam hat sich auf seine Weise der Staatsmacht entzogen. So nehmen wir, das Kino verlassend, sein lächelndes Gesicht, die Melodie von *Brazil* im Ohr, als Sinnbild für die Freiheit des menschlichen Geistes mit hinaus.

Zwischen Traum und Wirklichkeit

Brazil ist wie ein Traum, dessen assoziative Bildreihen dem Primärprozess, mithin dem Lustprinzip, folgen, während das sekundärprozesshafte Denken den Regeln der Logik und Syntax gehorcht (Leichsenring 2002). Doch Träume sind nicht das ganz Andere der Vernunft. Zwischen Realem und Irrealem fließen die Grenzen, und es ist eine Leistung des Ich, diese Grenze im Dienste des Realitätsprinzips immer wieder auszuloten. Poetischer formuliert Strümpell (1874, S. 87) das Wesen des Traums:

> … das Traumgebilde (hebt sich) gleichsam von dem Boden unseres Seelenlebens ab und schwebt im psychischen Raum wie eine Wolke am Himmel, die der neu belebte Atem rasch verweht.

Primärprozesshaftes Denken ist im Traum, wie in der Symptombildung, in der Psychose, bei Fehlleistungen, im Witz und in der Kunst zu finden (Freud [1]1900; 1987, S. 510 f., Hervorhebung im Original).

> Der Traum ist im Grunde nichts anderes als eine besondere Form unseres Denkens, die durch die Bedingungen des Schlafzustandes ermöglicht wird. Die **Traumarbeit** ist es, die diese Form herstellt, und sie allein ist das Wesentliche am Traum, die Erklärung seiner Besonderheit. … Dass der Traum sich mit den Lösungsversuchen der unserem Seelenleben vorliegenden Aufgaben beschäftigt, ist nicht merkwürdiger, als dass unser bewusstes Wachleben sich so beschäftigt, und fügt nur hiezu, dass diese Arbeit auch im Vorbewussten vor sich gehen kann …

Oder wie es Elias Canetti (1973, S. 269) formulierte: „Alles, was man vergessen hat, schreit im Traum um Hilfe". Und wie im Traum beschäftigt sich *Brazil* mit dem kollektiv Unerledigten, dem Ungelösten, mit dem im Alltag Unterdrückten, oder, wie Freud es einmal formulierte, mit den „gleichgültige(n) Abfälle(n) des Tages" (Freud 11900; 1987, S. 594). So ist in beiden Fällen, im Traum wie im Film, das Konfliktträchtige Quelle wie Wunsch der Bearbeitung.

Während im Schlaf der seelische Apparat dazu tendiert, die Tätigkeit des Sekundärprozesses und die Realitätsprüfung einzuschränken und sich im Traum dem Primärprozess hinzugeben, schafft auch Gilliam mit *Brazil* einen Rahmen, in dem er das „lose Sammeln von Einfällen", die freie Assoziation, künstlerisch entäußert. Da die Traum- wie die Filmsprache eine an symbolischen Beziehungen reiche Sprache ist, artikuliert sie sich überwiegend bildhaft. Gedanken werden also in Bilder transformiert (Freud 11900; 1987, S. 511, Hervorhebung im Original):

> Dieses Produkt, der Traum, soll vor allem der Zensur entzogen werden und zu diesem Zwecke bedient sich die Traumarbeit der **Verschiebung der psychischen Intensitäten** bis zur Umwertung aller psychischen Werte; es sollen Gedanken ausschließlich und vorwiegend in dem Material visueller und akustischer Erinnerungsspuren wiedergegeben werden, und aus dieser Anforderung erwächst für die Traumarbeit die **Rücksicht auf Darstellbarkeit**, der sie durch neue Verschiebungen entspricht. Es sollen (wahrscheinlich) größere **Intensitäten** hergestellt werden, als in den Traumgedanken nächtlich zur Verfügung stehen, und diesem Zwecke dient die ausgiebige **Verdichtung**, die mit den Bestandteilen der Traumgedanken vorgenommen wird.

Was Freud für den Traum formuliert, gilt auch für den Film. Auch er bedient sich der Verdichtung und der Verschiebung. Diese haben zur Folge, „dass die manifeste Erzählung im Vergleich zu dem latenten Inhalt lakonisch ist: sie stellt eine abgekürzte Übersetzung von ihm dar" (Laplanche u. Pontalis 1977, S. 580), das heißt, durch Auslassung wird verdichtet. In *Brazil* verdeutlicht sich dieser Kunstgriff eindrucksvoll in einer Szene auf dem Friedhof, als Sam beim Anblick seiner Mutter Jill wahrnimmt und beide Frauen zu einer Person, zur Geliebten verschmelzen. Der Schrecken über diese Verdichtung ist für ihn nahezu tödlich, als er ins Grab stürzt. Wäre da nicht ein Ausweg: Ein Traum im Traum, eine Tür, die ihm den Weg zu seiner Geliebten weist. Doch bevor er die Geliebte wiederfindet, muss er sich durch eine gefahrvolle Welt aus Kanälen und Schläuchen kämpfen, sich aus dem Würgegriff von Nabelschnüren und verschlingenden Gedärmen befreien.

Brazil verkörpert auf der symbolischen Ebene einen „Verdauungsprozess", in dem das Unverdauliche der Realität klein gearbeitet wird, in dem unerfüllte Wünsche nach Autonomie und Selbstverwirklichung, Sehnsüchte nach Liebe und Geborgenheit Gestalt annehmen. Anstelle repetitiver Abläufe, anstelle von Bewegungen, die in kreisförmigen Wiederholungen einen Stillstand markieren, soll das abenteuerliche Leben treten. Das ist der Traum im Traum.

Neben der Verdichtung, die für die sinnliche Qualität der Träume, besonders für ihren visuellen Charakter verantwortlich ist, ist ein Hauptmittel der Traumentstellung die Verschiebung, da sie zu Ersetzungen der Traumgedanken führt (Leuschner 2002, S. 722):

> Latente Elemente werden wie bei der Metonymie, entlang von naheliegenden konzeptuellen, klanglichen oder durch Erleben zustande gekommenen Assoziationsreihen verschoben und durch das weiter Entfernte dann im manifesten Traum vertreten. Thematisch entstehen so Anspielungen, etwa durch die Verwandlung ins Gegenteil.

Gilliam inszeniert mit Vorliebe diese Verwandlungen ins Gegenteil. So zum Beispiel, wenn er den orchestralen Einsatz eines zum Glücklichsein auffordernden hebräischen Volksliedes wählt, während die Welt in Schutt und Asche fällt. Er spielt in *Brazil* mit den Methoden der Traumarbeit und wechselt unablässig zwischen den Ebenen von Realität und Fiktion, zwischen Rationalem und Irrationalem und betreibt auf seine Weise das, was Lévi-Strauss das „wilde Denken" nannte.

Filmwirkung

Nicht nur der Film nimmt den Zuschauer mit in eine Traumwelt, auch das Kino selbst ist ein Ort der Träume, der kleinen Fluchten. Es ist ein intermediärer Raum, in dem die „Imagination einer magischen Befriedigungserwartung" (Hamburger 1999, S. 313) erfahren werden kann.

Die Träume, die dystopischen Welten, die utopischen Universen nehmen in *Brazil* Gestalt an. Der Wechsel zwischen Realität und Fiktion, die Aufhebung von räumlicher und zeitlicher Orientierung, das Changieren zwischen Ironie, Sarkasmus, spöttischem Kommentar und Herrschaftskritik ebenso wie das musikalische Verwirrspiel verlangen eine gewisse Durchlässigkeit vom Betrachter. Dabei können die Dunkelheit des Raumes, der Wechsel zwischen düsteren und heiteren Bilder, ebenso wie die immerwährende Verführung des Zuschauers durch die sich widersprechenden Reize, durchaus sein Ich dezentrieren und in ihm einen nahezu somnambulen Zustand erzeugen. Man kann beim Betrachten des Films das Gefühl für die Zeit und den Ort, für Rationalität und Irrationalität verlieren. Ähnlich dem Tagtraum rauschen die Stunden vorbei, während die Überlänge des Films (mehr als 120 Minuten) in Vergessenheit und der Zuschauer in einen regressiven Schwebezustand gerät. Das zähflüssige Zeitgefühl und das Hineingezogen-Werden in einen uterusähnlichen Raum, in dem man durch die innere Welt nach außen blickt und die äußere Welt nach innen holt, verändert beim Betrachter – ähnlich wie unter dem Einfluss von Drogen – das Bewusstsein (Grof 1978). *Brazil* wirkt wie eine Droge und ist ein

Traum, ein dystopischer, ein sarkastisch bitterer Traum, der durch seine Mehrdeutigkeiten, seine Ironie und seinen Witz zum Nachdenken anregt und eigene Einfälle stimuliert. Von dem epistemologischen Wert klarer Unterscheidungen zwischen rational und irrational hat er einiges eingebüßt. Dadurch wird es jedoch auch möglich, den Rationalismus auf seine irrationalen Momente zu befragen und das, was bloß ein Traum war, auf seine rationalen Momente.

Und so lässt sich zum Schluss über *Brazil* Ähnliches sagen, was Philosophen über den Traum formuliert haben (Schnädelbach 1989, S. 15):

> Den Träumen ihre Rationalität zurückgeben, das heißt auch immer der Rationalität ihre Träume zurückgeben. Nur die Vernunft, die so wieder zu träumen gelernt hat, wird im Traum nicht nur Ungeheuer erzeugen. Die Träume sind einmal die Hüter der Seele genannt worden; vielleicht sind sie auch die Hüter der Vernunft.

Literatur

Blumen R. (2003) Brazil and the economic problems of socialism. http://www.lewrockwell.com/orig3/blumen2.html. Zugegriffen am 3. 4. 2012

Canetti E (1973) Die Provinz des Menschen: Aufzeichnungen 1942–1972. Hanser, München

Carroll L (1975) Alice im Wunderland. Insel Verlag, Frankfurt/M

Christie I (Hrsg) (1999) Gilliam on Gilliam. faber & faber, London

Drehbuch Brazil (1983), Final Draft, Copyright © October 1983, http://www.dailyscript.com/ scripts/brazil.html. Zugegriffen am 3. 4. 2012

Einstein A (1972) Kondolenzbrief anlässlich des Todes eines Freundes. In: Correspondance avec Michele Besso. Hermann, Paris (Erstveröff. 1955)

Foucault M (2005) Die Heterotopien. Der utopische Körper. Suhrkamp, Frankfurt/M (Erstveröff. 1967)

Freud S (1987) Die Traumdeutung. GW Bd II/III. Fischer Verlag, Frankfurt/M (Erstveröff. 1900)

Freud S (1991) Das Unbewusste. GW Bd X. Fischer Verlag, Frankfurt/M (Erstveröff. 1913–1917)

Gilliam T (2003) Interview mit Salman Rushdie. In: The Believer, März 2003. http://www.believermag.com/issues/200303/?read=interview_gilliam

Gilliam T (1986) Interview http://www.losttv-forum.com/forum/showthread.php?t=38196. Zugegriffen am 3. 4. 2012

Gourevitch P, Morris E (2009) Die Geschichte von Abu Ghraib. Hanser, München

Grof S (1978) Topographie des Unbewussten – LSD im Dienst der tiefenpsychologischen Forschung. Klett-Cotta, Stuttgart

Hamburger A (1999) Traum und Sprache. In: Deserno H (Hrsg) Das Jahrhundert der Traumdeutung. Perspektiven psychoanalytischer Traumforschung. Klett-Cotta, Stuttgart, S 289–327

Haubl R (1991) Unter lauter Spiegelbildern. Zur Kulturgeschichte des Spiegels. Nexus, Frankfurt/M

Hamel (2006) http://www.imagesjournal.com/issue06/features/brazil3.htm#9. Zugegriffen am 3. 4. 2012

Heise J (1989) Traumdiskurse. Die Träume der Philosophie und die Psychologie des Traums. Fischer, Frankfurt/M

Hilton J (2007) Der verlorene Horizont. Piper, München (Erstveröff. 1933)

Laplanche J, Pontalis JB (1977) Das Vokabular der Psychoanalyse. Bd II. Suhrkamp, Frankfurt/M

Leichsenring F (2002) Primär- und Sekundärprozess. In: Mertens W, Waldvogel B (Hrsg) Handbuch psychoanalytischer Grundbegriffe. Kohlhammer, Stuttgart, S 570–572

Leuschner W (2002) Traum. In: Mertens W, Waldvogel B (Hrsg) Handbuch psychoanalytischer Grundbegriffe. Kohlhammer, Stuttgart, S 721–727

Strümpell LA (1874) Die Natur und Entstehung der Träume. Veit & Comp, Leipzig

Schnädelbach H (1989) Vorwort. In: Heise J: Traumdiskurse. Die Träume der Philosophie und die Psychologie des Traums. Fischer, Frankfurt/M, S 9–15

Schütz E (1996) Abstürze-Aufschwünge. Die „Unriskanz" der Bilder im „Ikarischen Zeitalter". In: Bolz N et al (Hrsg) Riskante Bilder: Kunst, Literatur, Medien. Fink, München, S 203–219

Variety (1985) Inserat am 2. 10. 1985. Reed Business Information, Los Angeles CA, S 24

Originaltitel	Brazil
Erscheinungsjahr	1985
Land	GB
Buch	Terry Gilliam, Tom Stoppard, Charles McKeown
Regie	Terry Gilliam
Hauptdarsteller	Jonathan Pryce (Sam Lowry), Robert De Niro (Archibald „Harry" Tuttle), Kim Greist (Jill Layton), Katherine Helmond (Mrs. Ida Lowry)
Verfügbarkeit	Als DVD in OV und deutscher Sprache erhältlich

Brigitte Boothe

Verzauberter Alltag

The Purple Rose of Cairo – Regie: Woody Allan

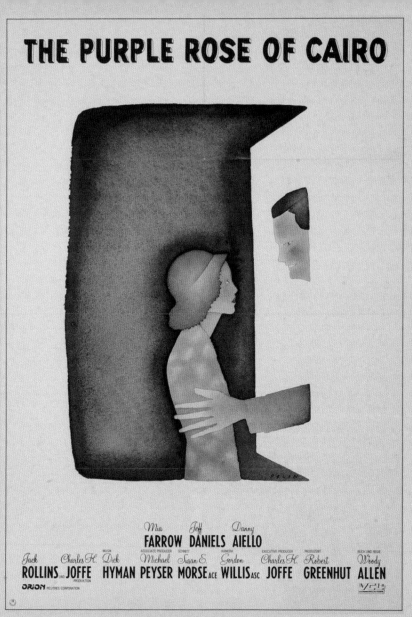

The Purple Rose of Cairo

Regie: Woody Allan

> Entweder sind die Aufsässigen,
> ohne es zu wissen,
> nur Attrappen der Gesellschaft,
> die sie am Gängelband führt,
> während sie sich zu empören glauben,
> oder sie werden aus Selbsterhaltungstrieb
> zu Kompromissen gezwungen.
>
> Siegfried Kracauer (1927)

Die Handlung

Die junge Cecilia (Mia Farrow), in New Jersey wohnend, arbeitet als Serviererin in einem Imbissrestaurant. Es ist Weltwirtschaftskrise. Sie lebt mit ihrem arbeitslosen, der Arbeit abgeneigten, den Frauen und dem Glücksspiel zugeneigten Mann in prekären finanziellen Verhältnissen. Häufiger Kinobesuch im „Jewel" schafft Ablenkung. Fünfmal sieht sie den Film „The Purple Rose of Cairo"; dort kommt der attraktive Ägyptologe Tom Baxter (Jeff Daniels) vor. Dieser bemerkt, obwohl er nur eine Leinwandfigur ist, die wiederholte Anwesenheit von Cecilia; es ereignet sich ein Kinowunder: Er eilt an ihren Platz, und beide versuchen, jenseits der Leinwand als verliebtes Paar zusammenzukommen. Doch Baxter kennt nur die Welt des Drehbuchs und erlebt in der realen Welt zahlreiche Missgeschicke.

Baxters Rebellion gegen das Leinwandgefängnis hat längst für öffentliche Unruhe gesorgt und die restlichen Protagonisten in Zorn und Verwirrung gesetzt. Daher bestimmt der Produzent in Hollywood (Alexander H. Cohen), dass Gil Sheppard, der Darsteller Tom Baxters (Jeff Daniels), seine Figur zurück auf die Leinwand bringt. Das gelingt ihm, indem er Cecilia mit falschen Liebesschwüren von Baxter weglockt. Baxter ist zur Ordnung gebracht. Sheppard stiehlt sich davon und lässt Cecilia sitzen. Und diese geht wieder ins Kino, bereit und fähig, sich neu verzaubern zu lassen.

Regisseur und Drehbuch

Woody Allen (Allen Stewart Konigsberg), geboren 1935 in New York, war bereits als Jugendlicher ein guter Klarinettist mit ersten Auftritten und nannte sich als Sechzehnjähriger Woody Allen. Rasch vernachlässigte er sein Studium, um als erfolgreicher Gagschreiber in Film- und Fernsehgesellschaften Fuß zu fassen. Vor allem aber trat er ab 1960 selbst als Stand-Up-Comedian auf, rang aber lange Zeit um sein unverwechselbares Profil unbeholfener Un- und Antimännlichkeit. Große Prominenz als Filmregisseur und -schauspieler erlangte er in den Siebzigerjahren mit *Der Stadtneurotiker* (zwei Oscars) und *Manhattan*.

Neben zahlreichen Kinofilmen, die wiederum zahlreiche Oscar-Nominierungen erhielten (darunter auch für *The Purple Rose of Cairo*, einen Film, den er selbst sehr gern hatte), trat er mit Theaterstücken und Erzählungen hervor.

Zu *The Purple Rose of Cairo* (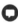Abb. 1) sagt er (Björkman 2004, S. 148):

> Ich schrieb eine Story, die nur darauf basierte: der Traummann einer Frau kommt von der Leinwand und beide verlieben sich ineinander. Schließlich kommt noch der richtige Schauspieler hinzu und sie wird dazu gezwungen, sich zwischen Realität und Fiktion zu entscheiden. Natürlich kann man sich nicht für die Fiktion entscheiden, weil einen das wahnsinnig machen würde, also muss man sich für die Realität entscheiden. Und wenn man das tut, wird man verletzt. So einfach ist es.

Filmwirkung

The Purple Rose of Cairo gehört zu den Filmklassikern (Björkman 2004). Die Komödienstruktur des Films (Preussner 1988), die Beziehungen zur Romantik (Downing 1989) und insbesondere sein Charakter als „Metafilm" (Dunne 1987; Munoz 1989) fanden bereits früh wissenschaftliches Interesse. Häufig wird er als Theaterstück aufgeführt. Eine viel beachtete neue Inszenierung hatte am 11. 12. 2009 am Wiener Volkstheater Uraufführung, in der Übersetzung und Bühnenbearbeitung von Gil Mehmert. Am Ludwigsburger Theatersommer fand am 26. Juli 2011 die Premiere des Theaterstücks als erfolgreiche Wiederaufnahme statt. Für den Schauspieler Jeff Daniels, geboren 1955, war die Kooperation mit Woody Allen für den Film *The Purple Rose of Cairo* äußerst bedeutungsvoll, auch für die eigene zukünftige Arbeit.

Psychodynamische Interpretation des Films

„Film im Film", Verschachtelung von Ebenen der „Realität"

Ginger Rogers und Fred Astaire tanzen als glanzvolles Paar im Film *Top Hat* (1935) auf der Leinwand; Gesang und Musik erfüllen den dunklen Kinosaal. Das berühmte Lied wurde von Irving Berlin getextet.

> 🔊 „Heaven ... I'm in heaven, / And my heart beats so that I can hardly speak. / And I seem to find the happiness I seek, / When we're out together dancing cheek to cheek."

Cecilia sitzt im Publikum; ihr schwärmerisch entzücktes Gesicht erscheint in Großaufnahme. Der Filmanfang ist eine Vorwegnahme des Filmendes: Auch in der Schlusseinstellung tanzt sich das glanzvolle Filmpaar in den Himmel, und die Kamera bringt Cecilias seliges Gesicht wiederum in Großaufnahme. Zwischen diesen Einstellungen zu Beginn und Ende der Filmhandlung steigt eine Filmfigur von der Leinwand, um Cecilia zu begegnen, kommt der Darsteller der Filmfigur als Dritter hinzu und zerschlagen sich ihre Hoffnungen.

Zurück zum Anfang: Die Anfänge oder Einstiegssituationen einer Erzählung, eines Theaterstücks oder eines Films schaffen Erwartungen auf Seiten des Publikums und Verpflichtungen für den Autor (Boothe 2007). Die Initialsituation konstelliert Ausgangsbedingungen, die im Gang der folgenden Handlungsentwicklung als Publikumserwartung und als Gestaltungsverpflichtung wirksam werden. Wie ist das beim Beginn des Films *The Purple Rose of Cairo*? Der Anfang konstelliert sich wie folgt: Zwei prominente Hollywood-Schauspieler und -tänzer führen einen festlichen Tanz auf, Musik und Lied erhöhen die Tanzszene als hochzeitliche Erfüllung. Es handelt sich um eine artifizielle Darbietung als technische Konserve, beliebig wiederholbar, hergestellt als professionelles Arrangement unterhaltender theatraler Darstellung, nach ausgearbeitetem Drehbuch und Programm mit finanzieller

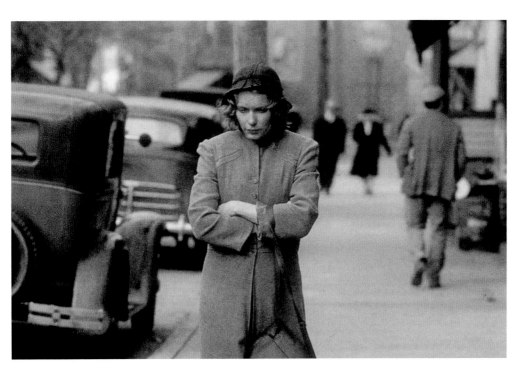

Abb. 2 Celia (Mia Farrow) ist einsam. (Quelle: Interfoto/Mary Evans)

Erfolgskalkulation, angelegt auf breite Öffentlichkeitswirkung, mit Aussicht auf Eingang in die Mediengeschichte. Das gilt sowohl für den Film im Film *Top Hat* als auch für den Film im Film *The Purple Rose of Cairo*, wie schließlich auch die Hauptgeschichte. Die von der schönen jungen Schauspielerin Mia Farrow dargestellte Figur der Cecilia erscheint beim ersten Anblick als lieblich-unschuldiges Mädchen, scheu, arglos und ärmlich ausstaffiert. Sie gehört zum zahlenden Publikum und ist beseligt vom Himmelsgesang.

Der Anfang konstelliert eine erotische Voyeurszene. Zwei sind erotisch intim in einem abgegrenzten Raum verbunden, einer schaut erregt von draußen zu. Die hier inszenierte arrangierte Voyeurszene ist gegen Bezahlung an technisch ausgerüsteten Orten beliebig repetierbar. Die Szene zeigt, anders als im pornografischen Film, keine sexuellen Handlungen. Der virtuose Tanz ersetzt die sexuelle Interaktion, und die extreme Ästhetisierung tritt an die Stelle roher Körperlichkeit.

Erfüllung ödipaler Wünsche auf der virtuellen Ebene der Filmhandlung

Das Tanzpaar inszeniert nicht nur kultivierte Erotik, sondern auch eine ödipale Erfüllungssituation: Das auserwählte schönste Paar ist vereint, verfügt über das Intimitäts- und Exklusivitätsprivileg und zeigt sich hochzeitlich vor den Augen der Öffentlichkeit (Boothe 2002; 2008).

Für die Weiterentwicklung der Filmhandlung bleibt die hier eröffnete Beziehungstriade verbindlich (Silvio 1994): Das Mädchen im Zuschauer-Status, ausgeschlossen aus der ödipalen Situation, und auch die erregte Mädchen-Voyeurin bei der intimen Vereinigung des privilegierten Paares. Verbindlich für die Weiterentwicklung der Handlung bleibt auch die Situation technischer Artifizialität. Die Erwartung des Publikums richtet sich auf wünschbare Veränderungen: Kann das Mädchen an die Stelle der privilegierten Filmdiva treten? Kann sich die Als-ob-Situation des Film-Surrogats in gelebte Wirklichkeit verwandeln? Die Sympathieträgerin ist Cecilia, daher wünscht das Publikum für sie das glückliche Ende (■ Abb. 2). Im Fall eines idealen Endes würde es sich um eine weiblich-ödipale Erfüllungssituation

◘ **Abb. 3** Celia (Mia Farrow) und der Mann ihrer Träume (Jeff Daniels). Quelle: (Cinetext Bildarchiv)

handeln, im passiven Modus: Die Frau wird vom Mann gewählt und vor allen Rivalinnen ausgezeichnet. Das ist die privilegierte, anerkannte, exklusive öffentliche **Dyadenbildung im triadischen Raum**. Das Publikum wünscht für Cecilia: Es möge ein prächtiges Mannsbild aus Fleisch und Blut alle Schönen der Welt stehen lassen, um dem schönen armen Mädchen sein Herz, seine Macht und seine Schätze zu Füssen zu legen. Die Verlockungsprämien der ödipalen Erfüllungskonfiguration sind der Genuss sexueller und erotischer Intimität und Exklusivität. Die Frau mit ihrem weiblichen Potenzial findet die Anerkennung des privilegierten Mannes für ihre erotischen Ressourcen und Partnerqualitäten. Sie steht in Verbindung mit dem exklusiven Gefährten in einer gemeinsam geschaffenen Welt, und dieser Ort der persönlichen Etablierung erfährt wiederum Anerkennung durch die umgebende Welt.

In der Tat operiert der Film konsequent mit dem Gestaltungspotenzial der passiv-weiblich-ödipalen Konfiguration. Folgen wir der Handlung. Nach dem Einstieg folgt ein Szenenwechsel: Cecilia und ihre Schwester sind bei der Arbeit als Serviererinnen im Schnellimbiss und schwärmen nebenbei über Filmidole. Cecilia hat der Schwester die Arbeitsstelle zu verdanken. Der Wirt ist gar nicht zufrieden mit Cecilia. Sie ist ungeschickt und unkonzentriert, Geschirr geht zu Bruch, Kunden murren. Die Entlassungsdrohung steht im Raum. Beim Wechsel vom Illusionsraum Kino in die Arbeitswelt wird Cecilia als untüchtig gezeigt. Sie ist dem Job nicht gewachsen und in prekärer Lage. Wie prekär sie ist, wird klar, als der arbeitslose, Arbeit verweigernde, untreue Ehemann Monk auftritt, der den kleinen Verdienst der Ehefrau aufzehrt, die er im Übrigen vernachlässigt, sexuell ignoriert, herumkommandiert und gewalttätig attackiert. Cecilia figuriert als Ehefrau, ohne aber der Vorzüge und Ansprüche dieses Status teilhaftig zu sein. Sie genießt keine sexuelle und erotische Intimität und Exklusivität. Sie findet als Frau keine Anerkennung. Auch hier steht sie außen. Sie ist überdies sozial marginalisiert. Das Paar hat ein miserables Zuhause, und weder Mann noch Frau verfügen über Ressourcen gesellschaftlicher Anerkennung. Cecilia verhält sich dem Mann gegenüber ängstlich und verschüchtert. Sie ist nicht Partnerin, sondern ausgebeutetes kleines Mädchen. Zwar mobilisiert sie, angesichts einer besonders dra-

stischen Zumutung, Kräfte, den Mann zu verlassen und eigenständig zu werden: Sie findet den Mann mit einer Bettgefährtin in der eigenen Wohnung vor und wird überdies dreist verspottet. Doch sinkt ihr, wie der Mann prophezeit hat, rasch der Mut. Sie ist nicht nur entmutigt, weil die Chancen in der wirtschaftlichen Depression extrem schlecht stehen, sondern auch, weil sie als Mädchen figuriert, dem kein Eigenwillen zusteht und das fremde Obhut braucht. Die Möglichkeit, Prostituierte zu werden, wird ihr als schöner und nun mitteloser Person angetragen, doch diese Aussicht verwirft sie mit Abscheu – sie, die Ehefrau eines Mannes, der sich sexuell jenseits der Ehe rücksichtslos auslebt. Obwohl Cecilia verheiratet ist, bleibt sie von der Sexualität ausgeschlossen. Der bezahlte Genuss kultivierter erotisierter Darbietung durch Filmstars erlaubt zwar voyeuristische Partizipation, jedoch unter der Bedingung des Ausgeschlossen-Seins aus dem Geschehen, das überdies nur als artifizielles Surrogat verfügbar ist. Die Option, selbst bezahlte Sexualität anzubieten, wird mit Ekel abgelehnt. Die unverhüllte sexuelle Offerte an beliebig viele fremde Männer ist mit dem Bild des scheuen Mädchens unvereinbar.

Sie flieht ins Kino. Dort wird „The Purple Rose of Cairo" gegeben. Im Film laden gelangweilte nordamerikanische Müßiggänger der Upper Class einen jungen Ägyptologen ein, mit ihnen eine Zeitlang das New Yorker High Society Nachtleben zu genießen. Der attraktive Forscher Tom Baxter sucht das Grab einer Königin, an dem Purpurrosen wachsen. Diese sagenumwobenen Purpurrosen am verschollenen Grab gelten als ein kleines Liebeswunder; sie sind das lebendige Andenken an die Liebesgabe des Pharaos, der seiner Königin einst eine künstliche Purpurrose überreicht hatte. Der edle und tüchtige Wissenschaftler Tom Baxter kommt mit, in voller Expeditionsausrüstung und mit Panamahut. Der junge Wissenschaftler, ein unverdorbenes Gemüt und enthusiastisch seiner Arbeit ergeben, sucht die Rose, wie die romantischen Dichter einst die blaue Blume. Für die übersättigten Müßiggänger der Upper Class stellt er den Inbegriff unverfälschter Lebendigkeit dar wie einst die „edlen Wilden" in den französischen Salons der Aufklärungszeit. Auch ist er als stattlicher Liebhaber und Heiratskandidat in Aussicht genommen.

Cecilia betet ihn beim inzwischen fünften Kinobesuch unverändert vom dunklen Zuschauerraum aus an, da wendet Tom Baxter sich ihr zu mit den Worten: „Sie müssen den Film wirklich lieben!", steigt von der Leinwand, nimmt sie bei der Hand, und beide gehen davon. Dies könnte das Happy End sein (◻Abb. 3). Cecilia hat den Mann ihrer Träume gewonnen. Was Film war, wird Wirklichkeit. Die Verlockungsprämien der ödipalen Erfüllungskonfiguration sind scheinbar erreichbar: Exklusivität, Anerkennung des privilegierten Mannes für die Frau. Mit Tom Baxter lässt sich – so mag das Publikum, vom Wunder amüsiert, erwarten – eine gemeinsam geschaffene Welt aufbauen, mit überraschenden, amüsanten und wunderbaren Mitteln vielleicht. Aber: Es gibt keine Anerkennung durch die umgebende Welt. Baxter ist nicht Mensch unter Menschen, Mann unter Männern, sondern ein Filmidol, das sich nur im Film zurechtfindet. Unerhörtes hat er vollbracht, als Rebell gegen die Zelluloidexistenz und in Huldigung für Cecilia. Doch kann er sie nur lieben, wie ein Filmheld Szenen der Liebe gestaltet, und kann sich nur verhalten, wie man sich drehbuchorientiert aufführt. Er küsst seine Königin voll zärtlicher Innigkeit, doch denkt er sich küssend in Großaufnahme und erwartet die Abblende. Die Liebesgaben, wie sie seiner Rolle entsprechen, bleiben keusch. Sexuelle und erotische Intimität sind im Drehbuch nicht vorgesehen. Beiden ist die Sexualität vorenthalten. Doch Tom Baxter will frei sein und im Leben ankommen.

Das Realitätsprinzip „schlägt zurück"

Zwei Probleme sorgen für Spannung in der Handlungsentwicklung. Erstes Problem: Das Filmwesen Tom Baxter hat zwar etwas Unerhörtes getan, kennt aber letztlich nur die Gesetze der Filmexistenz. Wie kann man mit ihm ein Leben aufbauen? Zweites Problem: Man ist Tom Baxter auf den Fersen. Er hat den Filmfrieden gestört. Die übrigen Filmfiguren zetern, schimpfen und kommen in der Filmhandlung nicht weiter. Sie beschimpfen auch das Publikum, und das Publikum ist empört. In anderen Kinos gibt es ebenfalls Ansätze zur Entfesselung der Baxter-Figur. Die Produktionsfirma und die Agentur des

Baxter-Darstellers Gil Shepphard fürchten, dass Tom Baxter in anarchischer Enthemmung die Städte unsicher machen und Frauen vergewaltigen könnte. Ausgerechnet Tom Baxter! Die sexuelle Annäherung ist ihm verwehrt, erst recht sexuelle Gewalt. Wie könnte er zum Vergewaltiger werden? Wenn diese Befürchtung im Umlauf ist, dann doch nur, um hinter der Hemmung die Enthemmung sichtbar zu machen, der Imagination eines entfesselten Trieblebens in Form einer Befürchtung Ausdruck zu geben. Auch ist nicht absehbar, wie weit die Rebellion der Leinwandfigur gehen mag: Kann Baxter sogar das Drehbuch abschütteln? Kann aus dem wissenschaftlichen Rosensucher ein rasender Gewaltbursche werden? Gil Shepphard, aufsteigender Stern in Hollywood, folgt dem dringenden Auftrag, seine Figur einzufangen, zu zähmen und auf die Leinwand zurückzubringen.

Zum ersten Problem: Eine aussichtsreiche Lösung wäre, dass die Figur der Cecilia im Dienst der glücklichen Erfüllung von der passiv-rezeptiven Liebeserwartung zur aktiv-initiativen Liebestätigkeit übergeht. Im Fall der aktiven ödipalen Erfüllungssituation handelt es sich wiederum um die privilegierte, anerkannte, exklusive öffentliche Dyadenbildung. Jetzt aber geht es darum, aktiv ein Gegenüber in das exklusive privilegierte Objekt zu verwandeln. Man genießt aktives Verführen im Dienst sexueller und erotischer Intimität und Exklusivität. Man findet das geliebte Objekt geneigt, sich als privilegiertes und exklusives Zielobjekt formen und modellieren zu lassen. Man schafft mit dem exklusiven Gefährten eine gemeinsame Welt und sucht dafür erfolgreich Anerkennung durch die soziale Umgebung. In diesem Sinn sollte Cecilia ihren Tom Baxter lebens- und liebestüchtig machen, sollte auf seine glühende Bereitschaft setzen, das Leben zu gewinnen und frei zu sein an der Seite der Frau. Tatsächlich handelt Cecilia zunächst mit bescheidenen Mitteln als Lebensexpertin und Mentorin, doch hat das Publikum sie bereits kennen gelernt als lebenspraktisch fragil, leicht einzuschüchtern, zu scheu und zu ängstlich, die eigene Sache zu vertreten und sich gegen Manipulation und Ausbeutung zu wehren. Oder anders gesagt: Cecilia ist noch immer ein wehrloses Mädchen. Tom Baxter ist wehrlos der Keuschheit und Tugendhaftigkeit des ihm aufgenötigten Drehbuchs ausgeliefert. Das ist beider Charme und ihr Verhängnis. Ein komisches Verhängnis, denn die Situation ist als Burleske gestaltet. Zwei Kinder, die ein Stück von der großen Liebe spielen wollen, ohne – was den Mann angeht – über die entsprechenden Werkzeuge und die notwendige Freiheit zu verfügen – und ohne – auf Seiten der Frau – sich zu trauen.

Zum zweiten Problem: Gil Shephard, der Schauspieler, glaubt, Tom Baxter in die Zelluloidexistenz zurückscheuchen zu müssen, um nicht unter die Herrschaft seiner Figur zu geraten. Das gelingt ihm einerseits mit einer überraschenden Gabe, die sich als kostbar erweist: einer Ukulele, die Cecilia an den einst geliebten Vater erinnert (Silvio 1994) – und die zweifellos interfilmisch auf die Ukulele der Marilyn Monroe aus *Manche mögen's heiss* anspielt. Das gelingt ihm andererseits und hauptsächlich, indem er Cecilia mit falschen Versprechen und erlogenen Liebesschwüren dazu bringt, Tom Baxter den Abschied zu geben. Der Erfolg ist naheliegend, denn Shepphard kann aus Cecilias wehrloser Manipulierbarkeit und Gläubigkeit Nutzen ziehen. Baxter wird wieder Leinwandfigur. Das ist konsequent, denn ohne Mentor und Coach kommt er in der Welt außerhalb des Kinos nicht weiter.

Cecilia, die Sitzengelassene, geht ins Kino und lässt sich von Ginger Rogers und Fred Astaire verzaubern. Sie findet Genügen am Surrogat. Sie lässt sich abspeisen und ruhig stellen. Die Protagonistin bleibt zurückverwiesen auf den Status der Zuschauerin. Das Wunder der Leinwandrebellion hat nichts verändert. Cecilia bleibt marginalisiert und intimidiert. Die wirtschaftliche Depression geht weiter.

Das Scheitern ödipaler Wünsche als Element des Humoristischen

Der Film ist weder sozialkritisch noch psychologisch noch surrealistisch. Er wird dem Komödiengenre zugerechnet. Die Komik entsteht in diesem Film dadurch, dass Kinder gleichsam Erwachsene spielen, innerhalb eines Ambientes, das selbst den Charakter der Kulissen- und Requisitenhaftigkeit betont. Das Kapital der komischen Darbietung sind kindliche Imaginationen von Sexualität, Intimität und ödipaler Privilegierung, vor allem aber das ödipale Tabu: Das Kind, das voyeuristisch an der Intimität des

privilegierten (Eltern-)Paares teilhat, übertritt ein Verbot. Das Mädchen, das an die Stelle der Mutter treten will, um den Vater für sich zu gewinnen, wird zurückverwiesen auf den unterlegenen Status der kleinen Tochter.

Cecilia ist kleines Mädchen geblieben und begnügt sich resignativ mit dem legitimen Surrogat bezahlbaren und repetierbaren Liebesglanzes, der so gewaltig schön daherkommt, dass der Abstand zwischen armem Mädchen und großer ferner Diva riesig ist. Wenn ihre Augen glänzen, dann nicht nur wegen der willkommenen freundlichen Ablenkung von der Misere, sondern auch, weil die ödipale Gefahr gebannt ist: Sie tritt nicht ein in verbotene Felder, verlangt nichts außer den Genuss künstlicher Welten.

Cecilia ist für das Publikum Sympathieträgerin, auch am Ende. Der Charme der lebenspraktisch untauglichen Cecilia bleibt ihre das Publikum entwaffnende Wehrlosigkeit. Sie wird nicht Teil der Misere. Triumph ist nicht Stärke, sondern Blumenhaftigkeit. Wer, wie das Publikum, Augen hat zu sehen, sieht, dass Cecilia, mitten im Elend der Depression, die Purpurrose ist. Tom Baxter hat sie gefunden. Ja, es handelt sich um eine romantische Komödie.

„Madame Bovary, c'est moi", sagte Flaubert von seiner berühmtesten Romanfigur. „Cecilia, c'est moi", könnte Woody Allan sagen. In *Top Hat* finden sich die prächtigen Liebenden. In Woody Allans romantischer Komödie findet eine komische und kreative Inszenierung der Kapitulation vor dem ödipalen Verbot statt. Cecilia wird als Ehefrau nicht ernst genommen, Tom Baxter ist kein richtiger Mann, darf dem Drehbuch seiner Väter nicht entkommen und muss daran gehindert werden, auf Frauen loszugehen. Cecilia taugt nicht fürs erwachsene Berufs- und Liebesleben. Doch angesichts des Scheiterns der sympathischen Protagonisten disqualifiziert sich die Welt der Ehe, der Geschäftswelt und sozialen Beziehungen. Jenseits von Cecilia und Tom herrschen Manipulation, Kalkulation und Ausbeutung. Das gilt auch für die Filmbranche, die Traumfabrik. Ganz anders als im Lehrstück und im epischen Theater Brechts und im Agitationsthater schafft sie Opium fürs Volk und macht reichen Gewinn. Auch Cecilia zahlt und hält still. Doch gehört sie nicht zu den Manipulatoren, Kalkulatoren und Ausbeutern. Sie war es, die Film und Leben durcheinandergebracht hat. Sie hat die Grenze auf höchst überraschende Weise durchbrochen. Ihre Hingabe ans ferne Idol hat es aus der Entrückung geholt.

„Cecilia, c'est moi." Auch Woody Allan, der Komiker, gewinnt in den von ihm selbst gespielten Rollen unwiderstehlichen Charme aus der Inszenierung von Ungeschicklichkeit, Unbedarftheit, Wehrlosigkeit, linkischem Auftreten, aus dem vergeblichen Eifer, in Liebe und Erotik Fuß zu fassen. Auch hier wird die Imagination evoziert, dass er keinen Anspruch habe, in die Welt der ödipalen Privilegierung einzutreten, dass er nicht Manns genug sei, in der Welt der Erwachsenen mitzutun. Doch wie bei Cecilia kommt aus der ödipalen Zurücksetzung eine anarchische Befreiung, die Lust an der Disqualifikation von Respektabilität wie auch die Inszenierung des Sexuellen als bunte Serie komischer Praktiken und des Erotischen als bunte Serie komischer Beziehungsanstrengungen. – Das Leben der Anderen ist hier weitaus komischer oder auch lachhafter als das Leben der Träumer und Spieler, die angewiesen sind auf kleine Wunder.

Schön sind die Schauspielerinnen, anbetungswürdig und bekanntlich oft, wie auch im Fall der Mia Farrow, mit dem Filmemacher und Regisseur liiert. Woody Allen bleibt nicht wie seine Kunstfigur der Cecilia in der Zuschauerrolle. Er wird zum Regisseur der Traumwelt, zum Schöpfer der künstlichen Purpurrose. Die Selbstinszenierung als komischer Kerl wurde zum glänzenden Erfolg. Sie verband sich mächtig mit der Fähigkeit, Werke zu schaffen und über Menschen Regie zu führen, nicht aus dem Geist der Macht, sondern der des anarchischen Spiels.

Literatur

Björkman S (Hrsg) (2004) Woody Allen on Woody Allen (revised edition). Faber & Faber, London

Boothe B (2008) Psychoanalyse bildet. Ein Beispiel: die ödipale Situation. In: Bittner G, Fröhlich V (Hrsg) Ich handelte wie ein Mensch, nicht wie ein Formalist. Pädagogisches Handeln im Kontext aktueller Handlungsdiskurse. Königshausen & Neumann, Würzburg, S 129–150

Boothe B (2007) Glück des Lesens: Das Märchen als intelligentes Wunschvergnügen. In: Beisbart O, Kerkhoff-Hader B (Hrsg) Märchen. Geschichte – Psychologie – Medien. Schneider-Verlag, Hohengehren, S 90–106

Boothe B (2002) Oedipus complex. In Erwin E (Hrsg) The Freud encyclopedia. Theory, therapy, and culture. Routledge, New York, S 397–404

Downing C (1989) Broadway roses: Woody Allen's romantic inheritance. Literature-Film Quarterly. 17(1): 13–17

Dunne M (1987) Stardust Memories, The Purple Rose of Cairo, and the tradition of metafiction. Film Criticism 12(1): 19–27

Kracauer S (1977) Die kleinen Ladenmädchen gehen ins Kino. In: Kracauer S: Das Ornament der Masse. Essays. Suhrkamp, Frankfurt/M, S 279–294 (Erstveröff. 1927)

Munoz WO (1989) Beyond the Copacabana: The Purple Rose of Cairo as metafilm. Romance Language Departement. Kent State University, Kent OH; S 99–104

Preussner AW (1988) Woody Allen's The Purple Rose of Cairo and the genres of comedy. Literature-Film Quarterly 16(1): 39–43

Silvio JR (1994) Woody Allen's The Purple Rose of Cairo: a psychoanalytic allegory. J Am Acad Psychoanal Dyn Psychiatr 22: 545–553

Originaltitel	The Purple Rose of Cairo
Erscheinungsjahr	1985
Land	USA
Buch	Woody Allen
Regie	Woody Allen
Hauptdarsteller	Mia Farrow (Cecilia), Jeff Daniels (Gil Shepherd/Tom Baxter), Danny Aiello (Monk), Dianne Wiest (Emma)
Verfügbarkeit	Als DVD in OV und deutscher Sprache erhältlich

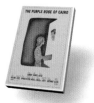

Markus Fäh

Futurum 2, oder: „I want to do something with my life – I want to be somebody!"

Total Recall – Regie: Paul Verhoeven

SCHWARZENEGGER

They stole his
mind,
now he wants
it back.

CAROLCO ®

18

TOTAL RECALL
™

Total Recall

Regie: Paul Verhoeven

> Was sich in meiner Geschichte verwirklicht, ist nicht die bestimmte Vergangenheit (passé défini) dessen, was war, weil es nicht mehr ist, noch ist es das Perfectum dessen, was gewesen ist in dem, was ich bin, sondern die zweite Zukunft (futur antérieur) dessen, was ich gewesen sein werde, für das, was ich dabei bin zu werden.
>
> Jacques Lacan ([1]1953; 1966b, Fonction et champ de la parole et du langage en psychanalyse)

Die Schlüsselthemen

„Who the hell am I?"

Es gibt wohl keine beunruhigendere und gleichzeitig spannendere Frage als die nach dem, was wir sind. Weil diese Frage schon mitten in die noch viel beunruhigendere Frage führt, wie wir überhaupt erkennen können, wer oder was wir sind, und wie so etwas entsteht, das wir als das erleben, „wer" oder „was" wir sind, mit anderen Worten: wie sich ein menschliches Subjekt konstituiert. Mit diesen Fragen eng verbunden sind die Ebenen oder Register unserer menschlichen Erfahrung. Mitten in dieses Thema zielt dieser Film (◘ Abb. 1), der 1990 trotz zwiespältiger Aufnahme durch die Kritik den Nerv des Publikums traf und ein gigantischer Blockbuster wurde.

Beginnen wir mit einer der vielen kleinen Szenen, in denen die Hauptfigur Douglas Quaid alias Hauser alias Arnold Schwarzenegger von seiner Frage getrieben wird, die den Zuschauer von Anfang bis Ende des Films in Atem hält (und zwar nicht primär der brachialen Action, sondern der drängenden Frage wegen): Er hat seine Ehefrau Lori überwältigt, die es offensichtlich auf sein Leben abgesehen hat, hält ihr die Pistole an den Kopf und verhört sie:

💬 "Our wedding? Our friends? The job? All implanted?"

[Und Lori alias Sharon Stone sortiert – von ihm in den Schwitzkasten genommen – aus:]

💬 „Die Hochzeit … implantiert! Der Job … real … aber von der Agentur organisiert …"

Eine wirklich bedrängende und verstörende Frage: Was an meinem Leben ist real, das heißt wirklich von mir selbst in einer realen Welt mit realen Bezugspersonen erlebt, und was ist nur „implantiert", das heißt eine virtuelle, externe, computergenerierte Realität und demzufolge bloß, zum Beispiel aufgrund einer Hirnprogrammierung und sensorischen Simulation, „halluziniert"? Was ist Halluzination, was ist Illusion, was Erfahrung? Gibt es Mischformen von „reiner Realität" und „virtueller Realität", derer wir nicht gewahr sind? Wenn wir diese Frage nicht beantworten können, wenn das Realitätszeichen nicht mit Sicherheit gesetzt werden kann, sind wir im psychotischen Universum, wir werden verrückt. Oder um es mit Lacan auszudrücken: Der Stepp-Punkt („le point de capiton") fehlt, die Vatermetapher ist nicht installiert, und damit fehlen dem Subjekt die feste Verankerung in der Sprache, der Zusammenhalt von Signifikant und Signifikat. Die grundlegende Metapher des Mangels bzw. des Begehrens fehlt und damit die Verfügung über Sprache und die Befreiung durch die symbolische Dimension. Begehren und Genießen, Wirklichkeit und Wahn fallen in eins, jegliche subjektive Wahnbildung und

persönliche Realität sind möglich, es gibt keine Fragen mehr, nur noch überwältigende unzählige Gewissheiten.

Unsere menschliche Grundverfasstheit: Wir wären gerne jemand anderer (gewesen), um dasjenige werden zu können, aber wir können es nie einholen, es ist uns immer einen Schritt voraus, wie der Trieb, dem wir hinterher hecheln. Was, wenn wir das Angebot von REKALL Inc. in seiner vollen Fülle und Radikalität einlösen und jede beliebige Identität annehmen und halluzinieren könnten, uns in beliebig viele Avatare vervielfachen und parallel viele Leben leben könnten? Könnten wir das Angebot überhaupt annehmen oder wären wir nicht skeptisch, weil wir ja immer wüssten, dass es „nur" ein Traum, eine Halluzination wäre? Und wenn wir den hypothetischen Bezug verlören und das verlorene Reale wiederfänden, wären wir dann nicht psychotisch? Müssen wir nicht die Kastration akzeptieren, die Alienation durch die Sprache und die Separation vom Genießen des primären Objekts, weil wir sonst buchstäblich verloren wären?

Springen wir zur Dialogschlusszeile des Films: Quaid fragt seine Geliebte Melina besorgt:

> „What if it is a dream?"
> „Then kiss me quick before you wake up!"

Die Frage im Film bleibt unentscheidbar, während das Gegenlicht der Sonne den ganzen Bildschirm ausfüllt: Wacht Quaid als einfacher Bauarbeiter wieder aus seinem virtuellen Mars-Urlaub auf, das heißt, ist die implantierte experimentelle Psychose vorbei und er wieder im „Leben B" angelangt? Oder ist die Halluzination die Realität, und Hauser hat sich von der virtuellen Identität und Halluzination „Quaid" befreit und damit die völlige Erinnerung an sein wahres Selbst wieder erlangt? Wissen wir letztlich, ob wir leben oder nur träumen? Ob unser Ich- oder Selbst-Bewusstsein lediglich eine Illusion ist, erzeugt von unserem Gehirn, oder noch schlimmer: von einem Super-Computer, gesteuert von einer anderen Instanz, die Macht über unser Bewusstsein hat und uns alles, was wir erleben, und selbst die Tatsache, dass wir es sind, die wir es erleben, dass es dieses „Wir" bzw. „Ich" überhaupt gibt (im Sinne des Lacanschen „je"), nur vorgaukelt? Können wir wissen, ob unsere Erfahrung etwas von der letzten objektiven Realität (Bion's O) wiederspiegelt und in welchem Umfang und wie akkurat? Ist es entscheidbar, ob wir „Wissende" oder nur „fools in paradise" (oder „in hell") sind, ferngesteuert, ein illusionäres Produkt neuronaler Impulse, spontan oder computergesteuert?

Diese Kränkung geht über die Freud'sche psychoanalytische Kränkung, dass wir nicht Herr im eigenen Hause sind (das heißt, fundamental gespalten und unseres unbewussten Subjekts nicht bewusst), hinaus. Es steht nicht nur der Ort innerhalb unserer Subjekthaftigkeit zur Debatte, sondern unsere Subjekthaftigkeit selbst: Gibt es uns als Subjekte möglicherweise gar nicht, ist alles nur virtuell, sind wir lebende Roboter, denen man die Illusion eingepflanzt hat, die Krone der Schöpfung und unbewusste handelnde Subjekte zu sein? Oder wie es auf einer der Kult-Websites zum Film „Matrix"[1] heißt:

Was wir als Matrix bezeichnen, ist ein gigantisches ebenenübergreifendes Konstrukt aus geschichtlicher Verfälschung, medialer Irreführung und Täuschung, Fehlinformationen, Betäubung und Ruhigstellung, welches es Dir unmöglich macht, die Wahrheit hinter dem Schleier zu erkennen. Du lebst in einer Scheinwelt. Alles was du glaubst zu wissen, ist vielleicht nur ein einem intelligenten Wesen entsprungener Gedanke, der dich davon abhalten soll zu erkennen, dass du ein Sklave bist, unfähig selbständig zu erkennen und zu schlussfolgern. Du wirst von einer Brut seelenloser Roboter kontrolliert, welche dich nach ihrem Belieben steuern und lenken können.

1 www.die-matrix.net, zugegriffen am 30. 12. 2011

Dies treibt Quaid/Hauser in letzter Konsequenz um: Unter dem imaginären Begehren: „Ich will etwas sein! Ich will ein Anderer sein!" öffnet sich der Abgrund der Frage: „Wer bin ich? Bin ich ferngesteuert? Bin ich „ich selbst"? Ist meine Melina wirklich sie oder doch eine andere, zum Beispiel eine auf mich angesetzte Agentin wie meine Frau Lori? („Are you still you?" fragt er sie, nachdem er sie aus dem Implantator befreit hat.). Er könnte ebenso gut fragen. „Am I me, am I still me?"). Ist die Übereinstimmung zwischen der (womöglich) real vergangenen und der (womöglich) nur virtuell halluzinierten (begehrten bzw. psychotisch genossenen) zukünftigen und letztlich doch nur erinnerten Mars-Identität nicht zufällig, sondern subjektimmanent, weil es die Kernfrage ist, die aus uns erst Menschen macht: Werde ich das gewesen sein, was ich womöglich nie ganz sein werde? Werde ich mich nie vollständig erinnern können, weil es keine abgeschlossene Erinnerung gibt, weil diese Erinnerung selber immer im Werden ist? Verflüchtigt sich das Subjekt nicht unter der Hand, je genauer wir uns mit diesen Fragen auseinandersetzen? Ist aber nicht gerade diese Flüchtigkeit das, was uns als Subjekte ausmacht?

Wollen wir uns diesen Fragen auf Dauer stellen? Ist das aushaltbar? Flüchten wir uns nicht immer wieder in die Identifikation mit dem Begehren des „großen Anderen"? Wollen wir aus dem Zustand der Identifikation und Knechtschaft erwachen oder doch lieber unser kleines entfremdetes und kastriertes Leben leben?

Der Film berührt damit auch die Frage nach den unbewussten Gründen unserer Knechtschaft. Warum unterwerfen wir uns bereitwillig den Herrschenden, was ist genau das unbewusste Motiv, sich beherrschen, hinters Licht führen, unterdrücken zu lassen? Warum wählen wir die blaue Pille des seichten ahnungslosen Lebens, und nicht die rote Pille der Erkenntnis, der Neugier, des Wissen-Wollens (Quaid schluckt die Pille nicht, im Gegensatz zu seinem „Nachfolger" Neo in „Matrix" zehn Jahre später, doch geht es nicht beiden um die gleiche Frage?)

Total Recall ist eine der zahlreichen Produktionen des Science-Fiction-Genres, die das Projekt der Verlinkung von Mensch und Maschine und damit die absolute (technologisch perfektionierte) Beherrschung des Subjekts durch den „großen Anderen" thematisieren.

Die Grundfrage der „virtuellen Realität" ist: Was ist „reale Erfahrung"? Ist real, was unser Hirn uns als real erleben lässt? Wenn die virtuelle Realität das Problem der Kontrolle gelöst hat, sodass wir überzeugende Protagonisten, Avatare in unserer virtuellen Realität sind, das heißt, wenn die afferente und efferente Simulation so perfekt und die virtuelle Realität derart gelungen simuliert und mit dem Hirn so störungsfrei verlinkt sind, dass das erlebende Gehirn keinen Unterschied zur „reinen sensorischen Realität" merkt – ist dann die virtuelle Realität der reinen Realität nicht ebenbürtig oder gar überlegen?

Total Recall ist einer der ersten und aufwändigsten Produktionen zu diesem Thema, die immer noch zahlreiche weniger inspirierte Nachahmungen in den Schatten stellt (als eines der aktuelleren Beispiele zum Beispiel *Inception* von Christopher Nolan). Man muss sich vergegenwärtigen, dass die technischen Möglichkeiten 1989 weit bescheidener waren als heute. So merkt man dem Film an, dass er über weite Strecken noch „Handwerk" ist, die Maskenbildner hatten viel zu tun, und Miniaturen von Szenerien mussten physisch aufgebaut werden, die deutlich als Attrappen erkennbar sind. Computeranimation und Spezialeffekte waren noch nicht so ausgereift und atemberaubend wie beispielsweise kaum zehn Jahre später in Matrix. Das gibt dem Film aus heutiger Sicht den Touch charmanter Unbeholfenheit. Er changiert zwischen Science-Fiction, James Bond, klassischem Action Thriller, Fantasy Movie. Und Arnold Schwarzenegger hat einen seiner besten Auftritte, der *Kindergarten Cop* oder *Terminator* nach Ansicht vieler überragt. Die Spannweite von muskelbepackter Kampfmaschine bis zu kindlich-weicher jungenhafter Zärtlichkeit gibt der Figur Tiefe – mit welch warmer und doch entschlossener Sehnsucht spricht er sein Begehren aus:

 „I want to do something with my life. I want to be somebody!"

Der „technische" Clou des Plots: Es ist möglich, das Gehirn des Menschen maschinell zu programmieren, das heißt, fiktionale Inhalte als tatsächlich erlebte Erfahrungen zu implantieren, sodass das Individuum zwar noch das gleiche Ich-Bewusstsein seiner selbst hat (gewissermaßen das Zentralselbst einer multiplen Persönlichkeit), sich aber über ein gewisses Segment seiner Erfahrung halluzinatorisch täuscht; die Steuerung durch die „Matrix" ist partiell und reversibel (prinzipiell aber unendlich, und das ist das Unheimliche).

Die Grundidee der maschinellen virtuellen Gehirnmanipulation ist im Gegensatz zu späteren Vertretern des Genres in *Total Recall* noch etwas rudimentär und erst in Ansätzen ausgearbeitet, und die psychologischen Finessen der ursprünglichen Vorlage geraten ob der stampfenden Action gelegentlich unter die Räder bzw. aus dem Blick. Die Komplexität des Drehbuchs, das nach dem klassischen Thriller-Schema für Spannung sorgt, hält den Zuschauer jedoch bei der Stange und wirft ihn in die unheimlichsten Fragestellungen. Das Abgründige bzw. die philosophische Grundfrage der Implantation einer anderen Identität bzw. der Auslöschung der Grundidentität und deren maschinelle Überschreibung werden gründlich durchdekliniert, insofern ist der Film ein Vorläufer der *Matrix*-Trilogie. Wir können das Genre gewissermaßen in statu nascendi studieren.

„Total recall" kann verschieden übersetzt werden: „Lückenlose Erinnerung", „absolutes Gedächtnis", „absolutes Erinnerungsvermögen". Der Zustand des „total recall" ist ein utopischer Zustand, ein Zustand, in dem sämtliche in uns vorliegenden Informationen zugänglich sind. Nichts ist verworfen worden, nichts ist verdrängt, weder horizontal, noch vertikal, nichts ist abgespalten, unterdrückt. Das Subjekt weiß alles über sich und ist im Zustand des vollen Selbst-Bewusstseins, die Spaltung des Subjekts und damit die Idee eines Unbewussten werden damit letztlich aufgehoben. Da per definitionem nur das Unbewusste alles weiß, bedeutet „total recall" letztlich die völlige Auslöschung des Unbewussten und damit die Psychose.

„Vacation from yourself"

In einer Schlüsselszene des Films preist der Verkäufer McBlane das Produkt seiner Firma REKALL mit folgenden Worten an:

 „Wissen Sie, was in jedem Urlaub, den Sie machen, immer gleich ist? SIE! Sie sind immer gleich! Wollen Sie nicht einmal Urlaub von sich selbst machen? Einen Ego-Trip?"

Der Bauarbeiter Douglas Quaid wirkt zunächst nicht sonderlich begeistert von dieser Idee. Als ihm jedoch McBlane die möglichen Optionen aufzählt und ihm das Alter Ego eines Geheimagenten vorschlägt, der von Feinden verfolgt wird, die Frau seiner Wünsche bekommt und am Schluss trotz aller Widrigkeiten die Oberhand behält und auch noch den ganzen Planeten rettet, bekommt Quaid glänzende Augen, legt sich willig in die REKALL-Maschine (◯ Abb. 2) und lässt sich den Mars-Abenteuer-Urlaub implantieren: „The brain will not know the difference!", wie McBlane versichert, eben mit der Aussicht, sein sattsam bekanntes Ego für ein paar Wochen gegen ein grandioseres einzutauschen und vor allem auch, die Illusion dieses Tausches zu vergessen!

Doch erstens kommt es anders und zweitens, als man denkt: Der Zuschauer wird in einen Strudel von Bildern und überraschenden Handlungssprüngen gerissen, von einer Einstellung zur nächsten fragt er, sich die Augen reibend, in welcher Wirklichkeit er nun ist: Während die Techniker von REKALL die Implantationen bei Quaid vornehmen, zeigt die nächste Einstellung McBlane mit einer neuen Kundin, doch dieses Gespräch wird durch das entsetzte Gesicht von Dr. Lull, der Ärztin von REKALL, auf dem Monitor unterbrochen, die sagt, dass „wieder ein Fall von schizoider Embolie" passiere, und wir sehen darauf, wie Quaid ausrastet, McBlane würgt, und es den Technikern in letzter Not gelingt, ihn mit Spritzen ruhigzustellen. Wir vernehmen Rätselhaftes: Die Agentenidentität ist noch gar

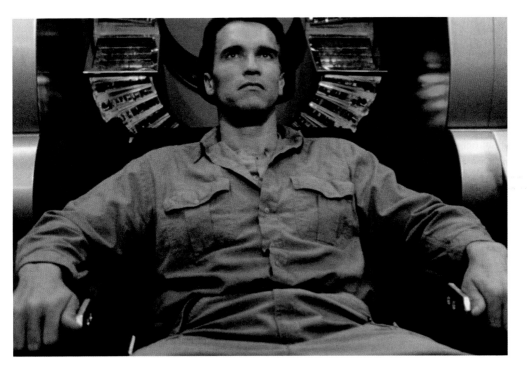

🔲 **Abb. 2** Arnold Schwarzenegger als Douglas Quaid. (Quelle: Interfoto/Mary Evans)

nicht implantiert worden, doch bei Quaid kommt Agentenverhalten zum Durchbruch. Eine offenbar unvollständig gelöschte Erinnerung bricht durch, ein Techniker spricht von der „Agency" (CIA lässt grüßen) und kassiert dafür eine Ohrfeige, weil er ein Staatsgeheimnis verrät. Offenbar wird in diesem Staat (im Jahre 2084, sic!) nicht nur mit dem Implantieren, sondern auch mit dem Löschen von Erinnerungen experimentiert, und zwar von der Staatsmacht!

Und was ist eine „schizoide Embolie"? Nun, Embolie ist der Verschluss eines Blutgefäßes durch mitgeschwemmtes Material. Die Metapher drückt wohl aus, dass ein abgespaltener Teil der Persönlichkeit nicht gelöscht, sondern nur „gestaut", das heißt verdrängt wurde, und nun durchbricht bzw. einen Zusammenbruch verursacht.

Der Zuschauer ist mit zwei Wirklichkeiten konfrontiert, die nicht entscheidbar sind: Wirklichkeit 1 handelt von einem Bauarbeiter Quaid, der implantierten Marsurlaub machen will, Wirklichkeit 2 handelt vom Ex-Agenten Quaid, dessen mangelhaft gelöschte Erinnerungen an seine vormalige Tätigkeit durchbrechen. Die unentscheidbare Frage ist: Gibt es ein Problem mit der Implantierung von virtuellen Marserlebnissen bei einem realen Bauarbeiter oder gibt es ein Problem mit dem Einbruch realer Agentenerinnerungen bei einem virtuellen Bauarbeiter?

Diese Frage zielt ins Zentrum psychoanalytischen Forschens: Gibt es eine subjektive Wahrheit? Wo ist die? Wie zeigt sich die? Ist aufgrund der Erfahrungen, das heißt, des Erinnerns, Träumens, Sprechens entscheidbar, wo das Subjekt ist, wer ich bin? Oder entzieht sich uns das Subjekt, ist es ein im Unendlichen liegender gesuchter Punkt (wie die zwei Parallelen, die sich nur im Unendlichen treffen)?

Die These ist, dass in diesem Film mit seiner hochkomplexen Story zentrale Fragen psychoanalytischer Erkenntnis, wie sie von Freud, Bion und Lacan behandelt wurden, aufgegriffen und thematisiert werden. Die Frage des Subjekts, der Erfahrung, des Träumens, Denkens und Sprechens, werden meiner Meinung nach inhaltlich wie formal in raffinierter Weise dargestellt. Zudem lassen sich andere psycho-

analytische Fragen, unter anderen der Männlichkeit, des passiven Triebwunsches, des Aggressionstriebes und der damit zusammenhängenden Ängste und Schuldgefühle, untersuchen.

Hintergrund

Das Filmdrehbuch ist eine Adaption der Kurzgeschichte „We can remember it for you wholesale" des amerikanischen Science-Fiction-Autors Philip K. Dick (der auch die Romanvorlage zu *Blade Runner* geschrieben hat).

Die Drehbuchautoren Ronald Shusett, Dan O'Bannon und Gary Goldman haben einiges aus der Vorlage entfernt und Neues ins Skript hineingeschrieben. Aus Douglas Quail (in der Kurzgeschichte) wurde Douglas Quaid („Quail" bedeutet im Amerikanischen „Wachtel" und als Verb „verzagen", ruft also Assoziationen zu einem Versager und Schwächling hervor, während „Quaid" an „squad" anknüpft und Assoziationen zu Kampfeinheit und Militär weckt. Man erkennt unschwer die Handschrift Schwarzeneggers).

Die Produktionsrechte wechselten vor dem Dreh mehrmals die Hand, weil die Produktion der Story zunächst als zu teuer eingestuft wurde. Dann wandte sich David Cronenberg, der am Drehbuch weiterarbeitete, vom Projekt ab, da der die Rechte besitzende Ron Shusett eher eine Art Indiana-Jones-Geschichte im Visier hatte. Dino de Laurentiis begann den Film zu produzieren, allerdings nicht mit Schwarzenegger, den er für ungeeignet hielt, einen kleinen Angestellten zu spielen. Der Bankrott von de Laurentiis Produktionsfirma war die Chance für Schwarzenegger: Er bat Carolco Studios, die Rechte zu kaufen und sicherte sich in seinem Vertrag nicht nur ein Gehalt von über zehn Millionen Dollar (und 15 Prozent des Gewinns), sondern auch Mitsprache bei der Wahl des Regisseurs, des definitiven Drehbuchs und der Besetzung.

Dicks Kurzgeschichte handelt von einem Versager, „a miserable little salaried employee", der seine Frau Kirsten nie zufrieden stellen kann und deshalb täglich vom „Mars" träumt. In der Kurzgeschichte, die übrigens nur auf der Erde spielt und psychologisch äußerst raffiniert aufgebaut ist, ist die Wirklichkeitsfrage nicht entscheidbar: Ist Quail psychotisch und leidet an einem Wahn, der Weltretter zu sein, oder wurde eine solche Idee implantiert oder hat er wirklich die Welt vor Außerirdischen gerettet, und ist seine Größenfantasie, mit den Außerirdischen einen Deal geschlossen zu haben, zu seinen Lebzeiten den Planeten nicht anzugreifen, reell und somit gar kein Wahn? Will es der Geheimdienst darauf ankommen lassen, ihn töten, und damit eine Invasion Außerirdischer riskieren? Oder würden sie damit einen Geheimnisträger eliminieren, der eine verrückte Agentenstory auftischt, oder doch nur einen harmlosen kleinen Büroangestellten, der auf einem „Horrortrip" made by Rekal Inc. (ohne zweites „I" wie im Film) ist?

Die Schlüsselszene der Verführung Quails durch McBlane von REKALL Inc. ist in der Vorlage schärfer auf diese psychologische Problematik fokussiert:

⬤ „Mr. Quail, Sie haben keine Chance, je auf den Mars zu kommen, noch haben Sie eine Chance, ein Geheimagent zu werden. Sie können das nicht SEIN! Sie können das nicht TUN! Aber Sie können es GEWESEN SEIN! Es GETAN HABEN!"

Das berühmte Futurum 2! Ich will nicht auf dem Mars sein. Ich will auf dem Mars gewesen sein. Ich bin nicht auf dem Mars. Ich werde auf dem Mars gewesen sein (und davon meinen Enkeln erzählen können)!

Quail(d) ist erschüttert, er hat keine feste Identität. Es gibt das Hegel'sche Subjekt, das schon immer gewesen ist, das sich lediglich seiner selbst voll erinnern muss, eben gerade nicht! Es gibt keinen festen Halt in der Gewissheit: Das war ich, und das bin ich schon immer gewesen, und das will ich wieder und endlich sein! Weber (2000, S. 23) bemerkt dazu:

Dagegen setzt sich die zeitliche Struktur des Subjekts ab, wie sie Lacan nach Freud zu denken versucht. Denn hier ist nicht mehr das Perfekt, das die Geschichtlichkeit des Subjekts bestimmt, sondern das futur antérieur. Dieses erschüttert die Identität des Subjekts als eine des sich-erinnernden Denkens in ihren Grundfesten, und zwar in seiner doppelten Funktion. Erstens setzt es an die Stelle der abgeschlossenen Vollendung des Immer-schon-gewesen-Seins die unabschließbare Vollendung des Immer-schon-gewesen-Sein-wird, das durch kein Denken je ganz er-innert werden kann, weil sie immer noch aus-bleiben wird. Und dieses „wird" ist es, welches das Subjekt fortwährend verhindern muß, um je ganz zu sich selbst zu kommen.

Zur Filmhandlung

Die erste Einstellung: Zwei Astronauten auf einem Mars-Spaziergang, Mann und Frau Händchen haltend. Leider können sie sich durch die Scheiben ihrer Raumanzüge nicht küssen, doch sie schauen einander sehnsüchtig durch die Glasscheiben an. Sie gehen ein paar Schritte, da bricht das „Reale" ein, der Mann bricht im Mars-Geröll ein, fällt sich überschlagend einen Abhang hinunter, schlägt sich den Kopf auf, und die Scheibe seines Anzugs zersplittert, der Mann erstickt an der sofortigen Dekompression – da erwacht der Bauarbeiter Douglas Quaid mit einem Angstschrei neben seiner attraktiven Ehefrau Lori aus seinem Albtraum, seine Frau ist eifersüchtig, weil er wieder von „ihr", der brünetten Anderen, geträumt hat, sie streiten, necken, versöhnen sich … Doch Quaid ist getrieben von seinem Traum, er sehnt sich nach einem anderen Leben; er will etwas sein, etwas Bedeutendes vollbringen, die Liebe seiner Frau und sein Job auf dem Bau und sein Wohlstand genügen ihm nicht, er wünscht sich ein aufregendes und vor allem sinnvolleres Leben auf dem Mars. Auf dem Weg zur Arbeit sieht er in der U-Bahn einen Werbespot der Firma REKALL, und beschließt, trotz der Warnungen seines Arbeitskollegen, durchgeknallt und lobotomiert zu werden und trotz der Einwände seiner Ehefrau, deren Dienste in Anspruch zu nehmen. REKALL verspricht ihm, künstliche Erinnerungen einzupflanzen, die nicht von echten zu unterscheiden sind, und obwohl er vorher darüber informiert wird, dass das „Erlebte" nicht real ist, sollen die „Erinnerungen" dieselben Emotionen wie echte Erlebnisse auslösen. Eben: Urlaub vom eigenen Selbst, als echt erlebt, und doch nicht echt, mit Rückkehrgarantie in das vertraute Selbst. Quaid wählt eine maßgeschneiderte Erinnerungsimplantation, innerhalb derer er auf den Mars reist, und kauft, vom Verkäufer dazu verführt, den zusätzlichen Urlaub vom eigenen bekannten Ego und wird zum Geheimagenten umprogrammiert. Die Aussicht, als Geheimagent Großtaten zu vollbringen, verschafft Quaid einen solchen Kick, dass er sich ohne Umschweife für diese spezifische Erinnerungsimplantation entscheidet. Mitten in der Implantierung dieser Erinnerung treten jedoch Probleme auf, er erleidet eine „schizoide Embolie". Offenbar brechen durch den Implantationsversuch, bei dem ein „Gedächtnisblocker" getroffen wurde, Erinnerungen eines anderen Selbst durch (die mit der zu implantierenden Wunschidentität seltsamerweise übereinstimmen); wir würden sagen, abgespaltene bzw. verdrängte Erinnerungen, und uns Zuschauern dämmert, dass wir mit Doug Quaid schon mitten im gefährlichen Geheimagentenleben sind. Quaid ist zu einer muskelbepackten Kampfmaschine mutiert: Wir schwanken und fragen uns: Ist Quaid fehlprogrammiert worden und erlebt seine „Urlaubsidentität" nicht mehr mit dem Vorzeichen des „Gespielten" und „Gewünschten", aber Unechten? Mit anderen Worten, ist es nicht mehr eine täuschend echt inszenierte (hysterische) Wunschfantasie, sondern ein psychotischer Wahn? Oder sind alle unsere bisherigen Vorannahmen falsch? Ist Quaid gar nicht Quaid, sondern ein Anderer, der bisher die Quaid-Rolle gespielt hat? Die Firma REKALL versucht ihre Haut zu retten, programmiert bei Quaid eine Amnesie an den Besuch und entlässt ihn sediert und verwirrt. Er findet sich in einer „Johnnycab", begegnet in der U-Bahn seinem Arbeitskollegen, der ihn zusammen mit anderen Komplizen angreift und ihm vorwirft, über „Mars" geredet und offenbar ein gefährliches

Geheimnis verraten zu haben. Der Zuschauer wird wieder in einen Wirklichkeitsschock geworfen. Ist der Bauarbeiter Quaid in Wirklichkeit ein Anderer, der bereits auf dem Mars war, aber die Erinnerung daran verloren hat und sie jetzt wieder findet? Und gibt es Leute, die ein Interesse daran haben, dass seine Mars-Amnesie bestehen bleibt, und die ihm nun nach dem Leben trachten? Wie auch immer: Quaid tötet seine Angreifer, ohne seines Wissens jemals ein Kampftraining absolviert zu haben. Ein weiterer Punkt für die Theorie, dass er „ein anderes Leben hatte" und nun mit diesem wieder konfrontiert wird, via unbewusster Übernahme der alten Rolle und via Personen, die ihn in der alten Identität ansprechen. Doch Quaid hält an seiner vertrauten Bauarbeiter-Identität fest und flieht zu seiner Frau Lori. Aber auch diese ist auf einmal hinter seinem Leben her, wir sehen auf dem Bildschirm (sie gibt vor, einen Arzt zu kontaktieren) ihren Geliebten Richter, den verbissenen Bösewicht und Gegenspieler Quaids (Michael Ironside). Quaid kann Lori überwältigen und erfährt von ihr in Andeutungen und Bruchstücken, dass sein bisheriges Erdenleben nur aus künstlich implantierten Erinnerungen besteht und somit eine einzige Lüge ist. Als neue Verfolger auftauchen, kann Quaid gerade noch mit der Metro entkommen. Auf seiner Flucht steigt er in einem Hotel ab, in dem ihn ein Fremder, der sich als Geheimagent vom Mars zu erkennen gibt, kontaktiert und ihm einen Koffer mit Geld, Waffen, Ausrüstung und falschen Ausweisen zuspielt. Ebenfalls in dem Koffer ist eine Videobotschaft; ein Mann, der wie Quaid aussieht und sich als Hauser vorstellt, fordert ihn darin auf, zum Mars zu reisen („Get your ass to Mars!"). Der Zuschauer erfährt nun die zusammenhängende Geschichte der Doppel-Identität: Quaid ist eigentlich Hauser, der als Geheimagent auf dem Mars gearbeitet hatte, bis er schließlich aus Liebe zu einer Frau (Melina, dargestellt von Rachel Ticotin) die Seiten gewechselt und seitdem gegen den Mars-Gouverneur und -Diktator Vilos Cohaagen gekämpfte hatte. Als Hauser einige gefährliche Geheimnisse entdeckte und sein Verrat aufflog, wurde sein Gedächtnis gelöscht und er selbst auf der Erde, ausgerüstet mit der Quaid-Identität, unter Beobachtung gestellt.

Quaid kann, nunmehr besser gerüstet (unter anderem mit einer Hologramm-Option, mit der er sich ein unverletzliches Double zulegen kann) und über seine Vergangenheit besser informiert, seine Häscher schließlich abschütteln und in Verkleidung auf den Mars gelangen. Dort begegnet er Personen, die ihn als Hauser wiedererkennen, und findet über diese Identität Anschluss an eine Rebellengruppe um einen legendären aber mysteriösen und bis dahin unsichtbaren Anführer namens Kuato, die gegen Cohaagen kämpft.

Er trifft nun die Untergrundkämpferin Melina (◘ Abb. 3), die sich als die brünette Frau aus seinen Träumen entpuppt. Melina kennt ihn als Hauser und ihren ehemaligen Geliebten. Gejagt durch Richter und seine Agenten, gewinnt er das Vertrauen der Rebellen. Beinahe wird er von Richter und Lori zur Strecke gebracht, Melina kann ihn im letzten Moment befreien.

Quaid findet Kuato, der sich als Mutant entpuppt, als sprechendes Baby am Brustkorb. Als er Kuatos Babyhände in die Hand nimmt, und dieser suggestiv „Open your mind, open your mind!" flüstert, scheint sich Quaid die gefährliche Wahrheit über den Mars zu eröffnen.

Doch Richter findet die Rebellen, erschießt Kuato, der – für die anderen unhörbar – Quaid den Auftrag gibt: „Start the reactor!" So erkennt Quaid, dass er in Wirklichkeit (als Hauser) immer noch ein Agent Cohaagens ist. Cohaagen ließ ihm die Erinnerung an das fiktive Leben von Douglas Quaid, zusammen mit einem unwiderstehlichen Drang zum Mars, als falsche Erinnerung in sein Gehirn einpflanzen, um ihn dazu zu bringen, zum Mars zu reisen und so – unfreiwillig – die Marsrebellen zu enttarnen. Cohaagen will um jeden Preis verhindern, dass die Widerstandsbewegung hinter ein unglaubliches Geheimnis kommt: Bei Minenarbeiten haben Arbeiter Cohaagens eine gigantische Höhle entdeckt, die bis auf den Eiskern des Planeten hinabreicht. In diese Höhle haben Außerirdische vor langer Zeit einen riesigen Reaktor gebaut, der in der Lage ist, einen Teil des Eiskerns zu schmelzen und so eine dichte, atembare Atmosphäre zu schaffen. Sollte die Existenz dieser Maschine bekannt und zur Produktion von Luft aktiviert werden, wäre Cohaagens, an die Kontrolle der Atemluft gebundene, Herrschaft über die Marsbevölkerung beendet.

○ **Abb. 3** Arnold Schwarzenegger (Douglas Quaid/Hauser) und Rachel Ticotin (Melina) in einer Szene. (Quelle: Cinetext Bildarchiv)

Zuvor, nachdem ihn Melina erst misstrauisch zurückgewiesen hatte und er im Hotelzimmer etwas zu sich kommen wollte, hatte ein letzter Versuch stattgefunden, Quaid mit Hilfe seiner „Ehefrau" Lori zu neutralisieren: Sie versuchte, zusammen mit einem Arzt von REKALL, ihn davon zu überzeugen, dass er noch immer in dem Gehirnlabor von REKALL auf der Erde sei und sich noch im Koma befinde. Er müsse nur eine Pille als Medium einnehmen, um aus diesem Koma zu erwachen. Quaid fällt beinahe auf die beiden herein, kann den Arzt jedoch enttarnen und tötet daraufhin ihn und Lori. Der Schweiß-tropfen, der die Stirn des Arztes hinunter rinnt – erneuter Einbruch des Realen – überzeugt Quaid, dass der Arzt lügt, und er erschießt ihn kurzerhand.

Quaid und Melina werden von Cohaagen gefangen, können aber fliehen, kurz bevor Hausers Iden-tität zurück in sein Gehirn implantiert werden kann. Nun ruft Cohaagen den Notstand aus und dreht einem Armenquartier, dem Sektor G, die Luft ab, um Quaid zur Aufgabe zu zwingen. Quaid und Me-lina können nach dem finalen Kampf gegen Cohaagen und seine Handlanger den Reaktor aktivieren und so eine atembare Atmosphäre auf dem Mars herstellen. Melina und Quaid werden durch die vom Alien-Reaktor produzierte Luft in letzter Minute gerettet; Cohaagen jedoch wird früher aus dem Mars-dom geschleudert und erstickt qualvoll. Der Film endet mit einer Einstellung von Quaid und Melina auf einem Berg. Melina sagt, sie könne das Geschehene nicht glauben, es wäre wie ein Traum. Quaid antwortet, er habe den furchtbaren Gedanken, es könnte alles wirklich nur ein Traum sein. Melina fordert ihn auf, sie schnell zu küssen, bevor er aus diesem Traum wieder aufwache. Der Film endet mit einem langen romantischen Kuss, bis die Sonne durch die Wolken bricht und alles überstrahlt. Es bleibt für den Zuschauer unentscheidbar, welche Wirklichkeit die wirkliche und welches die virtuelle ist: Ist Quaid am Ende wieder in seinem Bett und wacht aus seinem Abenteuerurlaub auf? Oder ist Quaid in Wirklichkeit Hauser und hat den Planeten tatsächlich gerettet?

Psychoanalytische Annäherung

O und die erfahrene Wirklichkeit

Der Film konfrontiert uns eindringlich mit einer erkenntnistheoretischen Aporie, die Bion zu einem Angelpunkt seines Denkens gemacht hat (S. Grotstein 2007): Wir können die Wirklichkeit, die letzte Realität (ultimate reality) prinzipiell nicht erkennen, da sie uns immer nur durch die Sinneseindrücke und unseren Denkapparat vermittelt wird (der seinerseits ja auch ein Teil der letzten Realität ist, mit seinen ihm inhärenten Präkonzeptionen). Unser Verlangen nach Wahrheit treibt uns also danach, uns so nahe und so genau wie möglich mit unseren Sinnen und unserem Traum- und Denkapparat der Wirklichkeit anzunähern, bei gleichzeitiger Anerkennung der Tatsache, dass wir die letzte Realität immer verfehlen werden.

Unsere Konzepte, mit denen wir die Wahrheit zu begreifen versuchen, sind in ihrer Begrenztheit selber ein Teil des Problems, verstellen und erhellen die Wahrheit gleichermaßen. Es sind Präkonzeptionen, mit denen wir uns gleichzeitig vor dem vollen Impact der letzten Wahrheit zu schützen versuchen. Ohne Theorien und Konzepte über die Wahrheit wären wir der prinzipiell traumatisch überwältigenden und ohne das „Hilfsmittel" der Präkonzeptionen nicht zu fassenden und erfahrbaren Realität schutzlos ausgeliefert. Wir schützen uns also vor dem grellen, uns blendenden Licht der letzten Realität durch mehr oder weniger seichte perzeptive, kognitive und theoretische Schutzmaßnahmen.

Die Menschen unterscheiden sich in der Art und Weise, wie sie träumen, sich ihre Version der absoluten Wahrheit über die letzte Realität erträglich „hinträumen".

Die den ganzen Film durchziehende Unsicherheit und Ungewissheit Quaids darüber, wer er wirklich ist, entspricht Bions Konzeption des Unbewussten als dem Sitz unendlicher und unbeschreiblicher Ungewissheit , die er als O bezeichnete, als Zeichen für die letztlich nicht erkennbare absolute Wahrheit über die letzte Realität.

Quaid ist wie Bion angetrieben durch ein „Verlangen nach Wahrheit" (Quest for Truth), Die Funktion des Wissenstriebes als Träger dieses Verlangens ist nach Bion die Transformation der absoluten Wahrheit über eine unpersönliche bzw. überpersönliche Realität in eine persönliche und subjektive Wahrheit über die Realität (Grotstein 2007).

Was anderes sucht Quaid? Er sucht den Punkt der Gewissheit, den festen Punkt in seinem Leben, er bewegt sich auf dem schwankenden Boden einer Psychose, nichts hat eine definierte Bedeutung, alles könnte auch ganz anders sein. Die Realität, die über ihn hereinbricht, ist überwältigend und kann nicht gefasst werden, es sei denn, sie wird in eine subjektive Geschichte, eine subjektive Wahrheit übersetzt.

Die äußeren Sinneseindrücke (Was? Warum? Wann? Wie? Wo? Wer?) sind durch das Sinnesbewusstsein repräsentiert, doch die innere Welt ist durch ein anderes Bewusstsein, die psychische Qualität, repräsentiert. Die Schlüsselszene, die Konfrontation Quaids mit Kuato, dem mutierten unheimlichen „weisen alten Baby", das am Bauch seines Trägers lebt, stellt die Konfrontation mit O dar, das Ergreifen der Babyhände Kuatos repräsentiert das Verlangen nach der Wahrheit (Kuato suggeriert ihm eindringlich „open your mind, open your mind"). Quaid muss es „wissen wollen", durch das Verlangen nach Wahrheit den Horror vor O überwinden, seine Seele öffnen, um das Geheimnis des Planeten Mars (der einen Kern aus Eis hat, der mittels des Reaktors geschmolzen werden und damit den Planeten zu Leben erwecken kann) zu erfahren.

Die ganze Geschichte ist eine Metapher für den psychischen Prozess der lebendigen Erfahrung. Wir erwachen erst zu Leben, wenn aus unseren rohen Sinneseindrücken, den Beta-Elementen, mit Hilfe der Neugier und im Verbund mit unseren Präkonzepten und, darauf aufbauend, mittels der Alpha-Funktion, diese Beta-Elemente zu lebendigen Alpha-Elementen werden, die eine emotionale Wahrheit über uns und unsere Beziehungen ermöglichen.

Total Recall hat damit etwas von einer mystischen Saga. Der Film transportiert eine Aussage, die alle Sagen über die Selbstfindung in sich tragen: die Suche nach der Wahrheit über sich selbst, angetrieben durch das Verlangen nach Wahrheit, Quest for Truth, den Abkömmling des „Truth Drive". Der Film ist eine Geschichte über den Weg der Selbsterkenntnis und gleichzeitig über die Unmöglichkeit der (vollständigen) Selbsterkenntnis. Die Spaltung bleibt am Ende bestehen, wir können nicht entscheiden, welche Wahrheit die richtige ist. Wir müssen uns zuerst träumen, bevor wir uns denken können. Und finden die eindeutige Wahrheit doch nie.

Das Begehren und das Genießen

Auffällig ist, wie im Implantator während der Implantation die Körper zu zittern beginnen, wie das Genießen von Quaid und Melina Besitz ergreift. Es kann nicht ausgehalten werden, dass das (der) Andere, das Begehren des Anderen, völlig von einem Besitz ergreift und keine Separation, Trennung durch das Wort, möglich und die Identifikation damit total ist. Rettung kann nur noch der gewaltsame Ausbruch aus der psychotisierenden wahnproduzierenden Maschine verschaffen, zurück in die symbolische Dimension, der Ausbruch aus der Gewissheit in die Ungewissheit, in den Zweifel: „Are you still you?" *Total Recall* ist eine faszinierende Darstellung des Kampfes um die symbolische Dimension, der ständigen Bedrohung dieser Dimension durch den tödlichen Einbruch des Realen und der immerwährenden Versuche, diesen Einbruch durch das Begehren zu bannen und dem Genießen Grenzen zu setzen. Gehen wir zurück an den Anfang des Films:

Quaid gibt sich nicht mit dem Leben zufrieden, das er führt: Job, Frau, Sicherheit. Er will „es wissen", er träumt von einer „anderen Frau", einer gleichzeitig zurückhaltenden, aber auch gerissenen Frau, er träumt davon, eine wichtige Rolle, eine Aufgabe zu erfüllen, er will jemand sein, und er träumt vom roten Planeten, dem Mars. Der Mars, die brünette zurückhaltende Frau (oder besser: etwas am Mars, an der brünetten Frau), sie sind die Ursache seines Begehrens, das von Lacan ([1]1953; 1966b) so benannte „Objet a". Das „Objet a" ist das, was sich vom Realen der Symbolisierung entziehen konnte, dasjenige, das wir unwiederbringlich verloren haben, das Objekt, das wir dennoch um jeden Preis wiederfinden möchten, das wir nicht benennen können, „das Ding", das unvergessliche prähistorische Andere, das sich uns und Quaid als das „Gute" schlechthin präsentiert.

Die reizende Ehefrau (und, wie wir später erfahren, Agentin Coohagens und Geliebte Richters) Lori versucht ihn zu verführen, seinem rätselhaften Begehren zu entsagen und sich dem simplen und flachen Genießen ihrer falschen Beziehung hinzugeben. Quaid ist im Zwiespalt: er will zwar der liebende und gute Ehemann sein, aber er begeht die Lacanianische Sünde nicht, die darin bestünde, von seinem Begehren abzulassen. Kaum hört er die Nachrichten vom Mars, dass Terroristen mit einem Anschlag die Öffnung der Pyramiden-Mine wieder erzwingen wollen, beginnen seine Augen zu glänzen, er starrt gebannt auf den Bildschirm und ist taub für Loris Botschaften. Lori gibt ihr Bestes, ihn von seinem Begehren abzulenken, doch was kann sie anderes als scheitern?

Das Begehren lässt Quaid keine Ruhe: Auf dem Weg zur Arbeit taucht es in der Metro am Bildschirm in der Gestalt von Dr. Edgemar (REKALL Inc.) wieder auf. Zwar versucht der Arbeitskollege, ihn von seinem Vorhaben abzubringen, was das Begehren jedoch nur noch steigert (das Gesetz ist die Vorbedingung des Begehrens). Alle – Lori, Edgemar, die Arbeitskollegen – sind Agenten. Das Begehren ist immer das Begehren des Anderen.

Wir lernen: Da hat ein „großer Anderer" (mit dem seltsamen Namen Cohaagen) ein Interesse daran, Quaid von seinem Begehren abzubringen (später erfahren wir, dass er es sich zu Nutze machen will, Quaids Begehren Cohaagens Begehren ist, das Begehren ist eben immer das Begehren des Anderen!). Und eine sadistische Verfolgerfigur namens Richter (Über-Ich) versucht um jeden Preis, Quaid zur Strecke zu bringen und die Befriedigung (das Erreichen des Mars) zu vereiteln, ihn zu töten (und wird damit geradezu zum Garanten des Begehrens, denn überall, wo Richter auftaucht, muss Quaid noch ein Stück weiter voraus sein, was wäre das Begehren ohne das Gesetz!).

Rot als die Farbe des aggressiven Begehrens taucht überall auf: Bereits die Empfangsdame mutiert ihre Fingernägel von Blau zu Rot, bevor sie Quaid empfängt. Quaid ist der männliche Hysteriker auf der Suche nach der „anderen Frau", auf der Suche nach der ultimativen ödipalen Befriedigung, auf der Suche nach der ultimativen aggressiven und auch passiven Befriedigung. Er will alles, und er geht über jedes Hindernis. Was er (bereits erobert und abkastriert) hat, ist schal und flach, nur das Unerreichbare ist das Attraktive, der Film thematisiert diesen Fluchtpunkt visuell immer wieder. Die Verfolgungsjagden durch die unterirdischen Gänge, das Grau in Grau, sie lassen offen, ob Quaid wirklich vor etwas flieht (mit dem Über-Ich im Nacken) oder einer Beute nachjagt, die im Fluchtpunkt liegt (der Mars, die Wahrheit, der Reaktor, die Frau, das Glück, usw.).

Der Einbruch des „Realen", des „Dings"

„Isn't that worth amazing 300 credits?" fragt der Verkäufer McBlane von REKALL Inc. Quaid, als er diesem die Topagenten-Halluzination anpreist. Tatsächlich, die halluzinatorische Wunscherfüllung der ultimativen ödipalen Wunschfantasie (alle besiegen und töten, die Frau kriegen, den Planeten retten) ist unbezahlbar, die Neurotiker halten ihr Phantasma mit aller Kraft im Unbewussten, um sicherzustellen, dass es sie ein Leben lang antreiben kann.

So gesehen ist die Katastrophe für den Hysteriker nicht die fehlende Befriedigung, sondern das plötzliche Eintreten der Befriedigung, das Einbrechen des Realen, das Wiederfinden des verlorenen Objekts. Schon der Anfang des Films zeigt es: Der Alptraum entsteht, wenn die beiden sich wirklich bekommen und er Händchen hält mit der Frau seiner Träume. Da bricht ihm der Boden unter den Füßen weg, und er wird konfrontiert mit dem primären Trauma. Und als ihm die Halluzination implantiert wird und er auf dem Wege zur Wunscherfüllung ist, bricht die Psychose durch. Er nähert sich wieder der Brünetten in der Implantation, er kommt dem Objekt zu nahe, und das ist tödlich.

„Wir haben einen Gedächtnisblocker getroffen", sagt Dr. Lull, und hat damit wohl recht. Wenn das verlorene Objekt aufersteht, geschieht etwas, das wir nicht symbolisieren können. Wir sind dem „Ding" ausgesetzt, der Überflutung durch die traumatische Wahrheit.

Das „Ding" ist das, was wir nicht symbolisieren können, per definitionem das „Signifikats-Außerhalb", das nicht ins Unbewusste eintreten und sprachlich gefasst werden kann. Zwar ist das Leben „im Imaginären" nur ein Traum, im Symbolischen wird es sowohl gebrochen wie gerettet und geborgen, aber wenn das Reale einbricht, wird es tödlich.Quaid sucht seine wahre Identität, das verbotene und verlorene Objekt des inzestuösen Begehrens, die Mutter, das „Ding", gleichzeitig wird es tödlich, wenn er ihm nahe kommt. Coohagen verkörpert den despotischen Vater, der das verhindern will. Er will Quaid zurück haben, als seine Kreatur, sein Agent, der Träger seines Begehrens. Er ist außer sich vor Wut, als er Hauser/Quaid der Mordlust Richters opfern muss (und lässt diese an den unschuldigen Goldfischen aus), er nicht mehr über seinen Sohn verfügen kann. Und doch muss er es zulassen; es gibt keinen anderen Weg, die „totale Erinnerung" zu verhindern. Die potenzielle Aufhebung der Ur-Verdrängung wäre das größte Trauma.

Die Pille

Warum bietet Dr. Edgemar („Rand-Figur", Grenz-Gänger?) Quaid eine Pille an, mit der Bemerkung, sie als Symbol für die Tatsache, dass er einsichtig wird und seinen Trip als experimentell induzierte Psychose erkennt, zu schlucken?

Quaid/Hauser erlebt den Einbruch des Realen, die Angst vor dem übermächtigen archaischen Objekt, in der Schweißperle auf Edgemars Gesicht. Er weigert sich, die Pille zu schlucken, erschießt den Arzt und spuckt sie wieder aus. Er möchte an seiner eindimensionalen Sicht festhalten, dass er der gute Retter des Planeten Mars ist, er will nicht erkennen, dass er manipuliert ist, er will das Symbol seiner Kastration, die Pille, nicht schlucken und provoziert den Durchbruch der Gewalt. „Now you have done it!", kreischt Lori. Quaid hat die letzte Barriere gegen die völlige Erinnerung niedergerissen,

die letzte Chance, das neurotische Opfer zu bringen und sich dem despotischen Vater Cohaagen zu unterwerfen, verspielt. Die Pille ist hier das Symbol der Unterwerfung unter die symbolische Ordnung, unter die Willkür des sadistischen kastrierenden Vaters Cohaagen – weniger ein Symbol der Erkenntnis und der potenziellen symbolischen Befreiung, wie zehn Jahre später in „Matrix", als Neo die rote Pille wählte, um gegen die blinde Unterwerfung zu protestieren. Die Gemeinsamkeit von Quaid und Neo: Beide weigern sich, sich mit dem „kleinen kastrierten Glück" zu arrangieren, beide votieren letztlich für das „Genießen" (der männlichen Größenfantasie, wenn man so will). Bei Neo steht die rote Pille jedoch trotzdem eher für die Anerkennung der Separation (von der Matrix) und die symbolische Befreiung, was die Anerkennung der Kastration voraussetzt, bei Quaid steht sie mehr für die Verleugnung der Differenz. Quaid ist mitten im Genießen, die Verweigerung der Pille ist die Weigerung, sich kastrieren zu lassen und die Separation vom Begehren der Mutter (und nach der Mutter) zu akzeptieren.

Die Verfolger tolerieren die Vaterkastration und -tötung nicht. Quaid verfolgt seinen Weg unbeirrt, doch die niedergestreckten und kastrierten Vaterfiguren erstehen immer wieder von Neuem auf und verfolgen ihn. Das ist das Schicksal jedes erfolgreichen Neurotikers: Sein Triumph wird mit dem Preis von Verfolgungsängsten erkauft. Je aggressiver er sein eigenes Ziel verfolgt, desto größer sind seine Ängste, selber verfolgt, kastriert und getötet zu werden. Wir können unseren Triebbewegungen nicht entrinnen. Wir können ihnen nur auf dem Fuße folgen, uns von ihnen und ihren psychischen Folgen nicht terrorisieren lassen.

Doppelgänger und Spiegelstadium

Der Zuschauer ist mit den spiegelbildlichen, sich ausschließenden Versionen der Realität konfrontiert: Quaid ist Quaid und lebt auf der Erde, ihm wurde das ganze Abenteuer bei REKALL Inc. eingepflanzt, und am Schluss des Films erwacht er wieder aus dem Traum. Der Eingangstraum ist sein Wunsch- und Angsttraum.

Quaid ist in Wirklichkeit Hauser, und Hauser wurde von Cohaagen auf die Erde geschickt und überwacht (als Quaid) und von diesem darauf programmiert, wieder auf den Mars zu wollen und ihm zu helfen, die Rebellen unschädlich zu machen. Es muss irgendeinen Programmierfehler oder eine übermächtige Erfahrung, die Liebe zu Melina, gegeben haben, denn der Rebell Hauser (alias Quaid) lehnt sich gegen das Programm auf und überwindet es, findet zu sich zurück.

Es lässt sich nicht entscheiden, welche Version die richtige ist. Wir können nicht wissen, ob wir im Traum- oder im Wachbewusstseinsmodus „wirklich" leben.

Bei genauerer Analyse wird auch das Doppelgänger-Motiv nochmals gespiegelt: Es gibt zwei Versionen von Hauser, den guten und den bösen Hauser: Der gute Hauser hat sich gegen die Agentenrolle im Dienst von Cohaagen aufgelehnt, wurde geschnappt, zu Quaid umprogrammiert und für das fiese Szenario aufgebaut, das am Schluss aus Liebesgründen schiefgeht, weil Hausers wahres gutes Selbst sich durchsetzt und den Mars befreit. Die andere Version ist der böse Hauser, der von Anfang an mit Cohaagen paktiert und aus freiem bösen Willen sich zu Quaid umprogrammieren lässt, um die Mission von Cohaagen zu erfüllen und der am Schluss wieder zurückprogrammiert werden soll. Auch da läuft etwas schief, Liebe oder Fehlprogrammierung, weiß der Teufel, Hauser kann nicht mehr in sein wahres böses Selbst zurück und bleibt der gute Hauser alias Quaid.

Das Spiel mit den gespiegelten Identitäten berührt die fundamentale Frage des gespaltenen Subjekts (Lacan[1] 1949; 1966a): Wer sind wir wirklich? Sind wir das, was wir denken, das wir sind, oder sind wir gerade, was wir nicht wissen (das Unbewusste)? Das Idealbild im Spiegel, welches das Kleinkind im Alter von ca. acht Monaten (im so genannten Spiegelstadium) jubilierend erkennt, ist ein illusionärer Vorgriff. Es gaukelt dem Kind eine Ganzheit und Körperbeherrschung vor, über die es noch nicht verfügt. Das Spiegelstadium steht für unsere Spaltung in ein Idealbild unserer Selbst, mit dem wir uns identifizieren, das wir aber nie erreichen, und einem unbewussten körperlichen Selbst, das wir im Kon-

trast und Nachgang sogar als zerstückelt erleben (auf die Körperzerstückelungsorgien in diesem Film hinzuweisen, erübrigt sich).

Quaid ist ständig auf der Flucht, und diese Flucht findet in unterirdischen Gängen statt; man hat den Eindruck einer Fluchtperspektive, alles deutet auf diesen Fluchtpunkt hin: Wer bin ich? Wo ist mein wahres Selbst? Die gedoppelten Identitäten laufen auch visuell auf diesen Punkt hin. Die immer wieder auftauchenden Bildschirme aggressivieren Quaid, weil er ständig mit einem Spiegelbild, seinem eigenen idealen Hauser-Spiegelbild konfrontiert ist; Hauser, den er hasst, weil er ihn nie erreichen wird. Das Subjekt ist fundamental gespalten; wo ich spreche, bin ich nicht, und wo ich bin, spreche ich nicht. Aber es gibt diese Sehnsucht nach der Ungespaltenheit, nach dem Zustand vor der Entfremdung, die mit der Sprache ins Leben tritt, nach dem Punkt vor der Spaltung, wo wir noch ein Ganzes waren. Sobald die Sprache ins Spiel kommt, kommt der „große Andere" ins Spiel, repräsentiert durch die „Agency", durch Cohaagen, durch das Kollektiv, dem Quaid zu entrinnen versucht. Letztlich ist der große Andere aber auch anders als despotisch denkbar, kosmisch, spirituell, durch die Verbundenheit, die Liebe zu den Menschen, das, was Kuato repräsentiert. Auch so betrachtet, ist die Idee eines geschlossenen autonomen Selbst eine Illusion: Wir sind nicht nur nicht Herren im eigenen Haus, es gibt gar kein eigenes Haus, keine Grenzen, die wir schützen könnten …

Total Recall or: The Matrix has you

Wie nahe ist die heutige technologische Realität der Gehirn-Manipulation bereits an der in *Total Recall* gezeigten Fantasie? Im Tierversuch können Hirnteile durch implantierte Chips ersetzt werden, die deren Funktionen übernehmen. Noch ist die Beeinflussung des menschlichen Hirns durch computergesteuerte Hirnteil-Prothesen in den Anfängen, doch prinzipiell wird es möglich werden, mehrere Leben zu leben; neben dem einen, rein realen, ein paar andere, virtuelle, und dies nicht nur via Steuerung über Joystick und Bildschirm, sondern durch direkte Stimulation des Gehirns. Der Trend, sich zu vervielfachen und Wunschidentitäten auszuleben, hat durch das Internet ohnehin bereits beträchtlich zugenommen und dürfte in dieser Richtung weitergehen. So gesehen ist es nicht verwunderlich, dass zwanzig Jahre nach dem ersten Kassenerfolg ein Remake von *Total Recall* aufgelegt wird, das im August 2012 in die Kinos kommen soll. Der Inhalt des Drehbuchs ist weniger fantastisch und fiktiv als damals, wir sind der Unterwerfung unter die von uns geschaffene Technologie einen gewaltigen Schritt näher gekommen.

Literatur

diematrix Der Weg des Auserwählten http://www.die-matrix.net/?page_id=16. Zugegriffen am 4.1.2012
Evans D (2002) Wörterbuch der Lacanschen Psychoanalyse. Turia + Kant, Wien
Grotstein JS (2007) A beam of intense darkness – Wilfred Bion's legacy to psychoanalysis. Karnac, London
Lacan J (1966a) Le stade du miroir comme formateur de la fonction due Je". In: Lacan J: Ecrits. Seuil, Paris, S 93–100 (Erstveröff. 1949)
Lacan J (1966b) Fonction et champ de la parole et du langage en psychanalyse. In: Lacan J: Ecrits. Seuil, Paris, S 237–322 (Erstveröff 1953)
Weber S (2011) Rückkehr zu Freud: Lacans Ent-stellung der Psychoanalyse. Seminar-Reader. http://www.hjlenger.de/reader/LacanReader1.pdf. Zugegriffen am 28. 12. 2011Box

Originaltitel	Total Recall
Erscheinungsjahr	1990
Land	USA
Buch	Ronald Shusett, Dan O'Bannon, Gary Goldman
Regie	Paul Verhoeven
Hauptdarsteller	Arnold Schwarzenegger (Douglas Quaid/Hauser), Rachel Ticotin (Melina), Sharon Stone (Lori), Ronny Cox (Vilos Cohaagen), Michael Ironside (Richter), Marshall Bell (George/Kuato)
Verfügbarkeit	Als DVD in OV und deutscher Sprache erhältlich

Andreas Jacke

Apocalypse, not now …

Bis ans Ende der Welt – Regie: Wim Wenders

WIM WENDERS

Eine Reise
in das Land
der Träume

Bis ans Ende der Welt

Ein Tanz rund
um die Erde

mit William Hurt
Solveig Dommartin
Max von Sydow
Sam Neill
Ernie Dingo
Rüdiger Vogler
und Jeanne Moreau

Die Musik
von 1999
schon am 12.9.
im Kino

U2
Talking Heads
Lou Reed
T-Bone Burnett
Peter Gabriel
Can
Elvis Costello
Crime and
the City Solution
Patti Smith
Robbie Robertson
and Blue Nile
R.E.M.
Neneh Cherry
Depeche Mode
Daniel Lanois
Nick Cave and
the Bad Seeds

Bis ans Ende der Welt

Regie: Wim Wenders

"News had just come over, we had five years left to cry in
News guy wept when he told us, earth was really dying
Cried so much his face was wet, then I knew, then I knew he was not lying"

David Bowie, Five Years (1972)

Wim Wenders ist nach Rainer Werner Fassbinder und neben Werner Herzog einer der wichtigsten Repräsentanten des Neuen Deutschen Films. Seine Autorenfilme zeichnen sich durch einen kargen, zurückhaltenden, introvertierten Stil mit großer Sensibilität aus. Die Isolation von Menschen im Zusammenhang mit der Last der deutschen Geschichte war ursprünglich sein Thema. Meine folgende Beschreibung und Analyse gilt aber einem späteren Film. Er nimmt sich als Grundlage den Director's Cut von *Bis ans Ende der Welt* (◨ Abb. 1), der 2005 auf DVD erschienen ist. In dieser Version ist der Film in einer umfassenderen, epischen Länge von 279 Minuten gegenüber der ursprünglichen Kinofassung von 179 Minuten zu sehen. Wenders sprach von einer längeren Fassung bereits 1991 (Jansen u. Schütte 1992, S. 92 f.) und stellte sie auch unmittelbar im Anschluss an die kürzere Version her. Seit 1996 machte er diese Version in Sondervorführungen publik (Fleig 2005, S. 97).

Die Handlung

Bis ans Ende der Welt (1991) beschreibt eine nahe Zukunft (1999) und vermischt dabei geschickt reale Settings mit leicht futuristischen. Die politische Grundsituation besteht darin, dass ein indischer nuklearer Satellit auf die Erde abzustürzen droht. Die Amerikaner wollen ihn abschießen, bevor es zur Vernichtung der Erde kommt. Aber sowohl der Absturz wie auch der Abschuss des Satelliten könnten eine Kettenreaktion hervorrufen und die tödlichen Atomwaffen auslösen.

Die Hauptperson des Films, Claire Tournier (Solveig Dommartin), hat jedoch ganz andere Probleme. In der ersten Szene wacht sie am frühen Morgen auf einer Party in Venedig auf. Ihr Aussehen und der ganze Look dieser Party, hinterlassen den schalen Eindruck von Techno-Dekadenz. In einem Raum steht ein überdimensionaler Bildschirm, und man hört die hektische, neurotische Musik von den Talking Heads. Claire ist auf diese Feier geflüchtet. Der Off-Kommentar berichtet uns, dass sie in der vergangenen Nacht jede Designerdroge, die es dort gab, ausprobiert habe. Sie ist zudem verkleidet und trägt eine Perücke mit schwarzen Haaren über ihrem natürlichen blondgelockten Haar.

Der Anlass für ihre Flucht nach Venedig war, dass ihr Freund, der Schriftsteller Eugene Fitzpatrick (Sam Neill), fremdgegangen ist. Das Verhältnis zwischen den beiden ist damit vorbei. Sie gibt Fitzpatrick später den Kosenamen „die zerbrochene Leiter".

Der Film als „Roadmovie"

Auf dem Rückweg nach Frankreich gerät Claire in einen Autounfall und lernt dabei zwei Bankräuber kennen, die gerade einen erfolgreichen Coup in Nizza hinter sich gebracht haben. Die harmlosen Gangster bieten ihr kurzerhand den Job an, die Beute für sie nach Paris zu bringen, wofür die junge Frau ein Drittel des Geldes abbekommen soll. Claire willigt ein und lernt auf der weiteren Fahrt den Wissenschaftler Sam Farber (William Hurt) kennen, in den sie sich auf Anhieb verliebt. Der erste Kontakt zwischen den beiden entsteht nicht zufällig, während sie gleichzeitig neuartige Bildtelefone benutzen. Es ist während der Benutzung neuartiger Bildtelefone, bei dem der erste Kontakt zwischen ihnen hergestellt wird. Farber reist mit einer gestohlen Spezialkamera herum, um überall Bilder aufzunehmen. Sie

Abb. 2 Elemente des Roadmovie: Fitzpatrick (Sam Neill), Philip Winter (Rüdiger Vogler), Chico Remy (Chick Ortega). (Quelle: Interfoto/NG Collection)

sind für seine blinde Mutter Edith Farber (Jeanne Moreau) bestimmt. Die neuartige Apparatur hat sein Vater Henry Farber (Max von Sydow) erfunden. Seine Mutter wird damit „sehen" können, indem seine Gehirnströme bei der Wahrnehmung der Bilder später auf ihr Gehirn übertragen werden. Sam hat die Kamera jedoch aus einem australischen Labor gestohlen. Auch die Amerikaner sind an ihr interessiert. Er wird aufgrund des Diebstahls von einem australischen Kopfgeldjäger (Ernie Dingo) verfolgt. Sam flüchtet vor dem Mann in Claires Auto, die ihn mit nach Paris nimmt. Farber stiehlt während der Fahrt etwas von der Beute.

In Paris angekommen, zählt Claire glücklich zusammen mit Fitzpatrick das Geld und merkt, dass etwas fehlt. Mithilfe des kruden Privatdetektivs Philip Winter (Rüdiger Vogler) gelingt es ihr nun, Farbers Spur zu verfolgen. Sie jagt aber weniger dem gestohlenen Geld als der geheimnisvollen Person hinterher. Sam reist für seine Aufnahmen in hohem Tempo um die halbe Welt. Obwohl er sich ihr immer wieder entzieht, folgt sie ihm. Die Reise geht von Paris nach Berlin, über Lissabon nach Moskau. Von dort fahren sie mit der transsibirischen Eisenbahn nach Peking und dann nach Tokio. Weiter geht es über San Francisco und Sydney und von dort schließlich in den australischen Busch. Abwechselnd wird Claire dabei von Winter, Fitzpatrick, Chico, Sam oder allen zusammen begleitet. In Lissabon flieht Sam nach einem gelungenen One-Night-Stand vor ihr. In Tokio gelingt es ihr, sich erneut mit ihm zu verbinden. Die meisten Stationen ihrer Odyssee sind kurz, aber sie zeigen stets sehr präzise das Flair der verschiedenen Weltmetropolen. Der Film ist kurze Zeit nach dem Zusammenbruch des Ostblocks gedreht worden. Der kalte Krieg spielt darin keine Rolle mehr.

Sam ist durch die häufige Verwendung der Spezial-Kamera in Tokio schließlich ebenfalls fast blind geworden. Claire wird so zu seiner „Seherin" und führt ihn aufs Land. Dort lässt sich Sam von einem japanischen Arzt behandeln, der seine Augen mit Kräuterumschlägen wieder in Ordnung bringt. An diesem Ort, wo Claire sich wie eine Mutter um sein Wohlergehen kümmern kann, gesteht sie ihm endlich ihre Liebe. Von da an sind die beiden ein Paar. In San Francisco werden sie bei dem Versuch,

ein Auto zu kaufen, von einem Händler beraubt, und Claire wird wegen vermuteten Drogenbesitzes festgenommen. Sie kommt aber wieder auf freien Fuß und trifft Sam mit drei Tagen Verspätung in einer Bar. Es ist das erste Mal, dass er auf sie gewartet hat. Weil er zu schwach ist, die Bilder von seiner Schwester (Lois Chiles) für seine Mutter aufzunehmen, erklärt sie sich bereit, die Spezial-Kamera anzulegen, die nun ihre Gehirnströme aufzeichnet. Sams Schwester freut sich, dass ihre Mutter sie nun sehen wird. Gleichzeitig wirft sie aber ihren Eltern vor, dass sie vor vielen Jahren in den australischen Busch verschwunden sind, sodass sie und Sam annehmen mussten, sie wären verstorben.

Danach geht die Reise mit einem Frachter weiter nach Sydney. Von dort fliegen Claire und Sam mit einem kleinen Flugzeug zu seinen Eltern. Sein Vater hat sein Labor in einem sicheren Versteck mitten in der australischen Wildnis aufgebaut. Bei dem Flug fallen alle technischen Geräte aus. Der Flugzeugmotor und auch alle Uhren bleiben stehen, weil alle elektronischen Schaltkreise unterbrochen sind. Die atomare Katastrophe durch den indischen Satelliten scheint eingetreten zu sein! Nach einer Notlandung können sich Sam und Claire zunächst zu Fuß, dann auf einem Motorrad und schließlich auf einem Lastwagen bis zu Sams Eltern durchschlagen. Sie werden mit einem Geigerzähler auf ihre mögliche Verstrahlung hin untersucht, sind aber in Ordnung. Wie bereits einige Mal zuvor, treffen hier im australischen Busch nun Alle wieder zusammen: Fitzpatrick, der Detektiv, Winter, der australische Kopfgeldjäger und auch der Bankräuber Chico finden sich ein und bleiben (◫ Abb. 2).

Das Elternpaar Farber bietet allen Gästen ein Heim. Die früheren Einzelgänger bilden nun eine Gemeinschaft. Musik spielt dabei eine wesentliche Rolle, sie bilden eine Band. Winter spielt Mundharmonika, Chico trommelt, Eugen spielt Klavier. Dazu kommt noch das australische Blasrohr, genannt Didgeridoo. In der Nacht zum Millennium singt Claire mit allen zusammen. Sie geben ein Konzert für den verwundeten Planeten Erde, von dem sie immer noch nicht genau wissen, wie es um ihn steht. Die Narration verläuft nun in zwei Strängen. Auf der einen Seite gibt es das Labor, in dem Henry Farber seine Forschung weiter vorantreibt. Auf der anderen Seite stehen dieses Kollektiv, die Musik und die Dialoge außerhalb des Labors (◫ Abb. 3).

Der Film als Zukunftsvision

Bei der Übertragung ins Gehirn muss die Person, welche die Aufzeichnungen gemacht hat, ihre eigenen Bilder nochmals ansehen, weil auch die aktuellen Gehirnströme als Verstärkung übertragen werden. Bei seiner Ankunft ist Sam für eine solche Betrachtung der von ihm aufgenommen Bilder zu müde. Am nächsten Tag wird das Experiment deshalb mit Claire wiederholt. Es gelingt nun erstmals, die Mischung von mentalen und aufgenommenen Bildern von Sams Schwester in das Gehirn von Edith Farber zu übertragen. Nach diesem Durchbruch erfolgen viele weitere Überspielungen.

Edith Farber war mit acht Jahren erblindet und ist nun eine alte Frau. Sie wird immer trauriger, je mehr Bilder sie aus der realen Welt zu sehen bekommt. Die Bilder sind viel hässlicher und dunkler als ihre Vorstellungen und Erinnerungen. Schließlich stirbt sie am Vorabend zum Jahr 2000. Wahrscheinlich steht die Rezeption der enttäuschenden Bilder, über die sie mit keinem spricht, damit in einem engen Zusammenhang. Vater und Sohn trauern, können diesen Verlust kaum verarbeiten.

Mit dem Tod der Mutter nimmt die Forschung eine andere Stufe an. Nun sollen die eigenen Gehirnströme beim Träumen abgetastet und anschließend visualisiert werden. Die australischen Mitarbeiter halten dieses Experiment vom Ansatz her schon für eine Grenzüberschreitung und verlassen das Labor. Claire, Sam und auch sein Vater forschen jedoch weiter. Als die ersten Übertragungen aus dem Unbewussten gelingen, ist Henry Farber stolz darauf, dass er nun die Träume der Menschen aufzeichnen kann:

💬 „Herr Dr. Jung, Herr Dr. Freud – wenn Sie uns jetzt sehen könnten."

Schließlich werden sie aber alle drei süchtig nach ihren eigenen Traumbildern. Wie Drogenabhängige sitzen Claire, Sam und Henry Farber nur noch vor ihren tragbaren Handmonitoren und haben jedes

■ **Abb. 3** Szene mit Solveig Dommartin (Claire) und Max von Sydow (Henry Farber). (Quelle: Interfoto/NG Collection)

Interesse an der Umwelt verloren. Sie werden von den biochemischen Bildern aus ihrer Seele förmlich verschlungen.

Der süchtigen Claire wird von ihrem ehemaligen Freund Eugene Fitzpatrick der Handmonitor schließlich entzogen, und es findet eine „Bilderentwöhnung" statt. Kurze Zeit darauf gibt Fitzpatrick ihr sein Manuskript zu lesen, in welchem er ihre bisherige Geschichte, die auch zugleich die erzählte Geschichte des Films ist, aufgeschrieben hat. Die Lektüre hilft Claire dabei, wieder gesund zu werden. Sams Weg ist ein anderer. Er durchläuft den Entzug, indem er eine Nacht zwischen zwei Eingeborenen schläft und Aquarelle von der natürlichen Umgebung zeichnet.

Schon während ihrer Genesung sind Sam und Claire voneinander getrennt. Sie finden am Schluss auch nicht wieder zusammen. Sams Vater macht keinen Entzug und stirbt. Sein Sohn besucht ihn auf einem Friedhof. Claire Tournier arbeitet am Ende für Greenspace, einen Ableger von Greenpeace, der den Weltraum überwacht. Sie kontrolliert nun jenen Raum, aus dem zu Anfang der Weltuntergang durch den Absturz des Satelliten drohte. Der Film zeigt, wie Eugene Fitzpatrick an ihrem Geburtstag eine internationale Bildtelefon-Konferenz organisiert hat, um ihr ein Ständchen zu bringen. Vier Männer wünschen Claire von vier verschiedenen Orten der Welt aus einen „Happy Birthday".

Über die Hintergründe: Vom Wort zum Bild

Die finanzielle Dimension

Für Wenders gehört *Bis ans Ende der Welt* (1990) zweifellos zu seinen ehrgeizigsten Projekten. Die ursprüngliche Idee für den Film stammte bereits vom Winter 1977/78, den der Regisseur in Australien verbrachte. Vierzehn Jahre sollten zwischen den ersten Plänen und der Fertigstellung vergehen. Es handelt sich um einen seiner aufwendigsten und teuersten Filme. Er wurde in einem Zeitraum von einem

Jahr auf insgesamt vier Kontinenten gedreht und kostete 25 Millionen Dollar. Die hohe Summe kam nicht allein durch die geplante Überlänge, sondern ebenso durch das teilweise futuristische Design und die vielen Ortswechsel zustande. Die Finanzierungskosten spiegeln sich auch in der Narration wieder. Das quasi geschenkte Geld, dass die Bankräuber Claire überlassen und mit dem sie ihre umfassende Weltreise finanziert, weist in diese Richtung. Nicht zufällig hieß ein späterer Film des Regisseurs *Das Millionen Dollar-Hotel* (2000). In *Bis ans Ende der Welt* stellen die Männer das Kapital zur Verfügung, damit Claire ihrem Traum von einer romantischen Liebe nachgehen kann. Einer der Gangster, Chico (Chick Ortega), wird ihr sogar nach San Francisco folgen, um ihr als Sponsor finanziell unter die Arme zu greifen. In einer Szene in Paris ist ein Kühlschrank mit einer Glastür zu sehen, auf dem allzu groß das Schild von Bauknecht zu sehen ist. Das ist eine der Stellen, in denen das „Name-Sponsoring", welches für die Finanzierung notwendig war, etwas zu deutlich ins Auge fällt.

Die globale Dimension

Die Produktion des Films hatte aufgrund der vielen Drehorte selbst globale Ausmaße. Diese kosmopolitische Dimension wird jedoch nicht nur vorgeführt, sondern mehrfach als narzisstische Befriedigung enttarnt. Der Zugriff des Menschen auf den ganzen Planeten erweist sich für Wenders zumindest als fragwürdig. Er nahm für seinen einzigen Science-Fiction-Film deutliche Anleihen bei Stanley Kubrick. Die Idee der atomaren Bedrohung stammt aus *Dr. Strangelove or: How I learned to Stop Worrying and Love the Bomb* (1964). Dieser Film parodierte das Schreckenarsenal der atomaren Bedrohung als Größenwahn. Und am Schluss, wenn Claire im All schwebt und ihre Geburtstagsgrüße im Empfang nimmt, zitiert der Film Elemente aus *2001: A Space Odyssey* (1968) von Kubrick. Hier erhielt der Astronaut Frank Pool von seinen Eltern einen ähnlichen Geburtstagsgruß über den Bildschirm. Und auch Dr. Floyd gratulierte seiner kleinen Tochter aus dem All zum Geburtstag. Der Focus in *Bis ans Ende der Welt* lag, ähnlich wie bei Kubrick, auf visionären Spielräumen der Technik, die heute zum Teil längst Alltag geworden sind. Beispielsweise nahmen die Bildtelefone die Möglichkeit zu „skypen" vorweg. Die vielen „gadgets", die in dem Film – vom Navigator bis zur technischen Gedankenübertragung – angewendet werden, stehen im Vordergrund. Während Amerikas Technologie dabei etwas chaotisch und veraltet wirkt, geht von Asien nun die größte Macht im Bereich der aktuellen Technik aus. Von den Orten, die der Film durchläuft, hat zunächst Tokio eine exponierte Stellung. Das seltsame Nachthotel, in dem die Gäste in winzigen Boxen schlafen, und eine Spielhölle, die wirklich einen befremdenden Eindruck beim europäischen Zuschauer hinterlassen, tragen dazu bei. In der japanischen Hauptstadt werden die vielen medialen, technischen Hilfsmittel am radikalsten angewendet. Hier ist die Realität selbst am eindringlichsten, und ganz und gar selbstverständlich, mit einem elektrifizierten, virtuellen Überbau verbunden. Wenders hatte sich zuvor bereits in zwei Dokumentarfilmen *Tokyo-Ga* (1985) und *Aufzeichnungen zu Kleidern und Städten* (1989) mit Tokio beschäftigt. In dem letzteren Film hatte er auch eine ausführliche Diskussion über den, für ihn zunehmend attraktiveren, Einsatz von elektronischen Aufzeichnungen durch Videokameras geführt. Das war in einer Zeit, in der die Bildbearbeitung, zumindest in der Postproduktion, endgültig von mechanischen Schneidetischen auf Computer verlagert wurde.

Inflation der Bilder

Bis ans Ende der Welt problematisiert vor allem die Grenze unserer Möglichkeiten der Visualisierung und den Anstieg der Bilderwelten durch ihre digitale Verbreitung. Die Inflation der Bilder gehört für Wenders zu den großen Zivilisationskrankheiten des 20. Jahrhunderts (Jansen u. Schütte 1992, S. 70). Sein eigener Filmverleih trägt den Namen „Revers Angel". Das ist nicht nur eine Anspielung auf seinen bekanntesten Film *Der Himmel über Berlin* (1987), sondern zugleich auf die neunte geschichtsphilosophische These von Walter Benjamin (1991, S. 698); Hier gibt es einen Engel, der sich rückwärts gewendet hat, und so auf die zurückliegende Geschichte als einen Trümmerhaufen zurückschaut. Und ein Sturm weht ihn immer weiter vom Paradies weg:

Das, was wir Fortschritt nennen, ist dieser Sturm.

Der Fortschritt der Bilder wurde schon in *Im Lauf der Zeit* (1976) von Wenders vor allem negativ bestimmt. Bruno (Rüdiger Vogler) bastelte für Pauline (Lisa Kreuzer) eine Endlosschleife aus Filmresten, in denen nur Action, Pornografie und Gewalt gezeigt wird. Am Ende hört er sich die Klage einer älteren Frau an, die ihr Kino geschlossen hat, weil sie die Filme, die sie nun angeboten bekommt, nicht zeigen möchte. Die Qualität ist so schlecht, dass es sich nicht mehr lohnt.

Überflutung und Wiederholung treten an Stelle von Qualität, Originalität und Anspruch. In seinem Dokumentarfilm *Aufzeichnungen zu Kleidern und Städten* (1989), der unmittelbar vor *Bis ans Ende der Welt* realisiert wurde, begann Wenders eine zeitliche Standortbestimmung mit der Bemerkung, dass durch die digitale Bildaufzeichnung der Unterschied zwischen Original und Kopie sinnlos geworden sei. „Alles ist Kopie". Er zeigte in dieser Dokumentation den aktuellen Fortschritt immer wieder, indem durch einen Videobildschirm ein zweites Bild im Bild errichtet wurde. Diese Dopplung beschrieb dabei bereits einen narzisstischen Anstieg des Selbstbildes. Die „Drogenabhängigkeit" von Henry Farber, Sam und Claire durch die Bilder wollte er als paradigmatisch in Bezug auf die Gefahren medialer Überflutung verstanden wissen. Das Versinken in einem narzisstischen Bildermeer stellt im Film das eigentliche „Ende der Welt dar" (Jansen u. Schütte 1992, S. 82–91):

> Es ist eine Bilderflut, weil die Zukunft eine Bilderflut wird… „Die Bilder sind in eine Inflation reingerutscht, die sich nicht mehr aufhalten lässt, im Gegenteil das wird sich mehr und mehr verstärken … Ich glaub aber, daß unser Zeitgefühl, unser Raumgefühl sich verändert hat in den letzten zehn, zwanzig Jahren. Wir reisen anders, wir sind anderes gewohnt zu sehen, wir sehen viel schneller.

Um die Inflation der Bilder darzustellen, hat Wenders seinen kontemplativen Erzählstil in diesem Film, vor allem im ersten Teil, weitgehend aufgegeben. Seine bisherige Ästhetik bestand vor allem in betont langsamen, elegischen Bildfolgen, die häufig eine romantische Versenkung in die einzelnen Aufnahmen für den Betrachter ermöglichten. An ihre Stelle rückten nun viel schnellere, aktionsreiche Bildfolgen, die zudem um die halbe Welt führen. „Nach den Regeln, die jetzt gelten, kann niemand mehr so erzählen wie vor zwanzig Jahren" erklärte Wenders 1991 (Jansen u. Schütte 1992, S. 101). Die Langfassung von *Bis ans Ende der Welt* erreicht zwar wieder eine eher epische Breite. Aber auch sie hat ein ungewöhnlich rasches Tempo. Wenders führte in einem Interview mit Roger Willemsen den Misserfolg des Films zu Recht auf das Paradox zurück, die Sintflut der Bilder gerade anhand eines Films voller Bilderreichtum zeigen zu wollen. Dies sei, wie bei Don Quijote, ein Kampf gegen Windmühlenflügel gewesen. Es hätte aber keine andere Möglichkeit gegeben.

Kraft der Sprache versus Macht der Bilder

Gegen die Macht der vielen Bilder werden nun erstmals sehr umfangreich die Kräfte der Sprache in Anschlag gebracht. In *Bis ans Ende der Welt* wird die Handlung immer wieder von dem Schriftsteller Fitzpatrick kommentiert. Dieser verbale Rahmen der Narration wurde in der längeren Fassung noch weiter verstärkt. Nun ist neben Claire die Stimme von Fitzpatrick die zweite Hauptfigur des Films. Fitzpatrick nimmt die Position eines allwissenden Erzählers ein, der dem zeitlichen Ablauf der Chronik enthoben ist, da er bereits die ganze Geschichte kennt. Durch seine Worte wird der Zuschauer immer wieder zu einer distanzierten Haltung gegenüber den gesehenen Bildern genötigt. Das verstärkt aber den Genuss, die Geschichte „wie von Oben" betrachten zu können. Die Kommentare schwächen also den Eindruck der Beherrschbarkeit keineswegs. Im Gegenteil, sie tragen beträchtlich dazu bei, zu einem Gefühl von Omnipotenz zu gelangen. Und wenn am Ende Claire von ihrer Bildersucht mithilfe der sprachlichen

Aufzeichnungen geheilt wird, so geschieht das so schnell, dass es keineswegs einen tieferen Eindruck hinterlässt. Die verbale Sprache, die symbolische Vermittlung erlöst also nicht aus dem Joch, das die imaginären Bilderwelten hinterlassen, sondern im Gegenteil: Fitzpatricks Worte verstärken dieses sogar innerhalb der Narration. Er spricht den Sinn der Bilder aus, einen Sinn, den sie sonst gar nicht hätten. Wenders (Jansen u. Schütte 1992, S. 70) hatte gesagt, dass ihm die Bilder wichtiger seien als die Story. In den Bildern stecke die Wahrheit eines Films, während die Geschichten, die Narration, latent immer eine Lüge seien (ebd., S. 70). Das Wahrnehmen von Bildern enthält für ihn mehr Wahrheit als das Denken (ebd., S. 68). Ein weiteres Mal zeigt er so, dass er an die Sprache nicht glaubt. Sie ist für ihn ein Konstrukt. Zugleich „verrät" sie aber in diesem Film die Bilder. Das ständige Schweigen in einem Film wie *Im Lauf der Zeit* (1976) rückte die Bilder magisch in den Vordergrund. Die wenigen philosophischen Reflektionen und Beschreibungen des anderen, die sich die beiden Männer hier gegenseitig zuschrieben, waren Standpunktbestimmungen, die aufgrund des kargen Rests eine starke Wirkung entfalten konnten. *Bis ans Ende der Welt* ist demgegenüber überfrachtet mit vielen Figuren, vielen Bildern einer komplizierten Geschichte und einem allzu ausgedehnten Kommentar.

Überfrachtung mit Bezügen

Der Film war so weder beim Publikum noch bei den Kritikern besonders erfolgreich und hat Längen, die auch in der neuen Fassung unangenehm auffallen. Er schnitt damals in Konkurrenz mit *Homo Faber* (1991) von Volker Schlöndorff deutlich schlechter ab. Diese Verfilmung mit Sam Shepard in der Hauptrolle (mit Shepard zusammen hatte Wenders das Drehbuch zu *Paris, Texas* geschrieben) steht mit dem Projekt in einem engeren Zusammenhang. Denn *Bis ans Ende der Welt* enthält ebenfalls deutliche Spuren aus dem Roman „Homo faber" (1957) von Max Frisch. Nicht nur die Notlandung von Sam und Claire mit dem Flugzeug, sondern auch der Nachname von Sam Farber sind Anspielungen auf den bekannten Roman. In „Homo faber" ist der Gegensatz zwischen (männlicher) Technik und (weiblicher) Natur und Mythos ganz anders ausgearbeitet worden. Wenders gelang zumindest für den Genderbereich der komplexere und bei weiten aktuellere Bezug auf die Technikrezeption. Das Science-Fiction-Genre ist dabei leider zuweilen etwas hölzern inszeniert, weil der Film gleichzeitig so viele Elemente aus der realen Umgebung übernommen hat. Beispielsweise wirken die seltsamen Hüte, die Claire und zwei andere Frauen bei einer Wohnungsbesichtigung in Paris tragen, einfach nur aufgesetzt, weil die leere Wohnung ganz gewöhnlich aussieht. Ein weiteres Problem ist, dass die atomare Bedrohung nicht ernst genug genommen wird. So wird ein Motiv entfaltet, das sich am Ende scheinbar in völliges Wohlgefallen auflöst. Diese Rahmenhandlung müsste entweder anders zu Ende geführt werden oder von Vornherein um Einiges leichter gewichtet werden. Die interessante Transformation von dem wirklichen Weltuntergang zu einem rein psychischen bleibt zu abstrakt. Eine Stärke des Films hingegen ist sein Soundtrack, der insgesamt von sechzehn namhaften Bands komponiert wurde. Neben der Titelmusik von U2 kann man unter anderem Leonard Cohen, Nick Cave, Peter Gabriel, Lou Reed und andere Bands an wichtigen Stellen hören. Die Musik, besonders die tiefen männlichen Stimmen, unterstützt oft längere reine Bildabfolgen, die so eine interessante Atmosphäre im typischen Stil von Wenders zeigen.

Mehr Narziss als Ödipus – eine psychoanalytische Deutung

„On the road" – die Flucht vor dem Selbst

Die nahezu ununterbrochene Reise im ersten Teil gibt es in vielen Wenders Filmen. Er beginnt so als ein überdimensionaler Roadmovie. Die Fluchtlinie hat nicht unbedingt ein Ziel. So flüchtet beispielsweise Claire mit dem blinden Sam aus Tokio, ohne zu wissen, wohin sie überhaupt hinfahren. Sie kauft einfach Zugtickets, kann aber die Namen der japanischen Städte nicht lesen. Es geht allein um die Bewegung. „Auch ich selbst mache das sehr gerne, nicht ‚ankommen' sondern „gehen" (Wenders 1988, S. 49).

Diese ständige Bewegung, die eine permanente Suche nach etwas anderem ist, stellt gleichzeitig die Flucht vor dem Zuhause dar, der eigenen Herkunft. In seinen früheren Filmen, wie in *Falsche Bewegung* (1975) oder *Alice in den Städten* (1974), verfolgen die Reisenden ebenso nur scheinbar ein Ziel. Wenn es für Wenders wirklich einen Fluchtpunkt aus Deutschland heraus gab, dann lag dieser in Amerika, welches das Unbewusste der Deutschen kolonisiert hatte, wie Robert (Hanns Zischler) dies betrunken in *Im Laufe der Zeit* (1976) erklärt (vgl. Elsaesser 1994, S. 308 f.). Die Flucht vor der faschistischen Erbschaft bestand in der Annahme des „American way of life", und zu dem gehörte es, „on the road" zu sein und Popmusik zu hören. In *Paris, Texas* (1984) durchlief dann aber auch Travis (Harry Dean Stanton) die amerikanische Wüste auf einer Flucht. Und diese Flucht war nun die vor sich selbst: Travis floh in die Isolation aufgrund der Konflikte seiner eigenen Herrschaftsfantasien, wegen einer krankhaften Eifersucht, die seine Ehe zerstört hatte. Amerika als Land war schon in der *Der Amerikanische Freund* (1977), keine Lösung mehr, sondern wurde mit dem schizophrenen Tom Ripley (Dennis Hopper) von Patricia Highsmith identifiziert. Die amerikanische Kultivierung der virtuellen Genussmittel von Kino und Pop wurde als ein schizoider Mechanismus geortet. Diese latent psychotische Fluchtlinie landet in einigen Wenders Filmen in einem festeren sozialen Gefüge. Seine Helden versuchen auch stets, zumindest für einige Zeit, festere Bindungen eingehen. So durchlaufen Sam und Claire in *Bis ans Ende der Welt* eine globale Topografie, die schließlich in Sams Elternhaus zum Stillstand kommt und sich dann aber nochmals in einer anderen, virtuellen Form fortzusetzen.

Claires Suche nach dem Paradies

Immer wieder weist der Film auf Claires Affinität zu Rauschmitteln hin: Am Anfang, wenn sie auf der Party jede Designerdroge testet; im weiteren Verlauf, wenn sie wegen Drogenbesitzes in San Francisco verhaftet wird. Und schließlich sind es ihre Sucht vorm Monitor und ihr Entzug, die am ausgiebigsten gezeigt werden. Am Ende, wenn sie durch All schwebt, befindet sie sich erneut in einer anderen Weise in einem Rauschzustand. Sie hat sich nun endgültig in einer übergeordneten Position mit Blick auf die Welt eingerichtet. Das Motiv der weltfremden künstlichen Paradiese durch Technik, das die Handlung durchläuft, ist am stärksten mit ihrer Person verknüpft. Ihr asiatischer Look, den sie im ersten Teil lange Zeit durch ihre schwarzhaarige Perücke vortäuscht, deutet schon auf eine zweideutige Persönlichkeit hin, die sich selbst gern versteckt, indem sie sich verkleidet. Und Claire ist die Person, um die sich alle Männer außer Sam Farber scharen. Sie ist die attraktive Frau, um die die Männer sich bemühen. Sie verliebt sich aber gerade in den Mann, der sich kaum für sie interessiert. Fitzpatrick erklärt eifersüchtig im Off, dass ihr Verhältnis zu Sam Farber mehr von der Idee von Liebe als von echter Liebe getragen sei. Das Verhältnis zwischen ihr und Farber ist ein narzisstisches, weil es nicht um Erfüllung, sondern vielmehr um den Traum davon geht. Der Film endet nicht bloß in einer virtuellen Welt, er beginnt mit ihr. Claires Trennung von Fitzpatrick ist der Anfang ihrer virtuellen Odyssee. Vermutlich ist das narzisstische Verhältnis zwischen Sam und Claire mit geprägt durch Wenders Erfahrungen mit Solveig Dommartin (Claire). Die beiden waren zu dieser Zeit ein Paar. Wenders und Dommartin erneuerten insoweit das ursprüngliche Konzept, als sie nun gemeinsam im Vorspann als verantwortlich für die Idee des Films genannt sind.

Das Element des „Komischen"

Claires Unfall bei ihrer Rückreise kommt zustande, weil der Bankräuber Chico einfach eine Bierflasche aus dem Auto wirft, die in ihre Windschutzscheibe knallt. In diesem absurden Stil sind die beiden Verbrecher generell beschrieben. Sie scheinen aus einem Slapstick Film zu kommen und erinnern an ähnliche Figuren wie in den Komödien *Cul-de-Sac* (*Wenn Katelbach komm*t,1966) von Roman Polanski oder *Some Like It Hot* (*Manche mögen's heiß*, 1959) von Billy Wilder. Ebenso ist es mit dem Detektiv Philip Winter. Er verfügt über ein eigentümliches Computersuchprogramm, mit dem er Sam Farber an allen möglichen Orten in der Welt ausfindig machen kann. Es arbeitet mit einer Darstellung von

Max und Moritz als Spürnasen. Mithilfe dieses lustigen Programms, das später durch ein ähnliches mit einem russischen Bären ersetzt wird, nimmt er immer wieder die Verfolgung auf. Ähnlich wie die Gangster ist er als ein Anti-Detektiv in Szene gesetzt. Er widerspricht den Konventionen der Genrefilme und ist sowohl das Gegenteil eines Philip Marlowe wie auch eines Sherlock Holmes. Winter ist weder abgebrüht noch cool, weder sexistisch noch frauenfeindlich, weder stark noch besonders intelligent, sondern versponnen, infantil und verspielt. So spricht er gerne in komischen und schlechten kleinen Reimen, wie „Sie heuern und sie feuern mich" oder „Ich bin ein Detektiv und liege selten schief." Insofern der Film die narrative Struktur eines Krimis verfolgt, ist er so mit allerlei absurden Elementen ausgestattet, die jeden Anflug zum Thriller vermeiden. Die ganze zwangsneurotische Ebene ist damit nur ein „Surfboard" für die Story, die ihre Akzente woanders gelegt hat. Wenders parodiert vor allem die tradierten Vorstellungen der Männerrollen, ebenso wie die ganze Chose von Kriminalität und Verfolgung. Seine freundlichen Gangster und der freakige Detektiv sind anders gestrickt. Viele dieser komischen Elemente fielen bei der ersten Kurzfassung der Schere zum Opfer, weil sie nicht erforderlich waren, um die Story weiterbringen. Die Nebenfiguren und die mit ihnen verbunden Nebenhandlung sollen vor allem witzige Unterhaltung bieten.

Die Dominanz des weiblichen Prinzips

Der ödipale Konflikt zwischen Sam Farber und seinem Vater spielt für die gesamte Handlung eine bei weitem nicht so wichtige Rolle, wie es viele der bisherigen Interpretationen annahmen. Es gehört zu den Standards der Wenders-Rezeption, einem permanenten Vater-Sohn-Konflikt, der sich in einigen Film zeigt, eine größere Aufmerksamkeit zu geben. In *Bis ans Ende der Welt* spielt aber nicht nur eine Frau in einem Wenders-Film erstmals die Hauptrolle, der Konflikt hat unterdessen auch eine weitere Ebene erreicht.

Demgegenüber ist der Tod von Sam Mutter das entscheidende Ereignis in der Handlung. Danach nämlich regredieren Sam, sein Vater und Claire mithilfe technischer Mittel. Aus der fluchtartigen Expansion, deren letzter Reflex die aufgezeichneten Bilder aus der Welt waren, wird so eine seelische Introversion. Das klassisch ödipale Verhältnis zwischen den Männern ist gegenüber diesem narzisstischen Motiv zweitrangig. In einer auch aus der zweiten Fassung herausgeschnittenen Einstellung betrachtet Henry Farber seine eigenen Traumbilder, die ihm seine Träume und Erinnerungen an seine verstorbene Frau zeigen. Seine Motivation, die Apparatur umzustellen, ist ebenfalls direkt vom Tod seiner Frau beeinflusst. Es ist sein Versuch, sie wieder zum Leben zu erwecken. Den Film hat Wenders vor allem seiner Mutter und zugleich dem Andenken an seinen Vater und seinen Bruder gewidmet. Weil die ödipale Ebene nicht so wesentlich ist, wird auch der Kampf der Männer untereinander nicht selten persifliert und so ebenfalls ins Absurde geführt. Daher sind die Gangster Claires Geldgeber, der Privatdetektiv ein verkappter Dichter und deshalb ist der Boxkampf, den Eugene Fitzgerald an einer Stelle mit Sam Farber austrägt, mehr Witz als Ernst, obwohl er die beiden Männer ins Gefängnis bringt. Es geht nicht vorrangig um die ödipale Rivalität, sondern um eine einfachere Form von Konkurrenz, die auf Neid und Vorteil bei der Mutter basiert. Stets ist es aber eine Frau, um die sich mehrere Männer versammeln. Einmal ist es Claire, die viele Männer versammelt, dann ist es Edith Farber, der Vater und Sohn gleichermaßen helfen wollen. Weil die ödipale Dimension karikiert wird, geht es um ein Verschmelzen mit dem weiblichen Kosmos für alle Beteiligten. Der ödipale Komplex wird weitgehend durch die Dominanz eines positiven Mutterbildes ersetzt. Der Preis dafür ist Isolation. Was man bekommt, ist Romantik. So stand schon Wilhelm Meister (Rüdiger Vogler) in *Falsche Bewegung* am Schluss auf der Zugspitze, wie in einem Bild von Caspar David Friedrich. In *Bis ans Ende der Welt* wird nun die Symbiose aufgrund ihrer technischen Verifikation zum Problem.

Symbiotische Verstrickung

Sein Vaterbild hatte Wenders spätestens durch die Dokumentation *Nick's Film – Lightning Over The Water* (1980) zumindest durch Verehrung einer amerikanischen Vaterfigur revidiert. Obwohl auch Nicholas Ray darin als eine Figur gezeigt wird, die durchaus ihre Ecken und Kanten hatte, wollte Wenders ihm ein filmisches Denkmal setzen. Gleichzeitig war schon dieser Film ein Zeugnis für die Aussichtslosigkeit des imaginären, amerikanischen Fluchtwegs. Deutsche Vaterfiguren wurden in anderen Filmen, wie beispielsweise in *Falsche Bewegung* oder *In weiter Ferne, so nah!* (1993) durch die Last ihrer Teilnahme an einem faschistischen Regime gezeigt. Im zweiten Film wird aber Heinz Rühmann von der Schuld seiner Mitarbeit beim Nazi-Regime freigesprochen.

In *Bis ans Ende der Welt* haben sich Sams Eltern bei der Flucht vor den Nazis in Lissabon getroffen. Henry war damals zwölf Jahre und Edith Farber vierzehn Jahre alt. Sie habe ihre beiden Kinder in Amerika geboren, bevor sie in Australien, ohne dass ihre Kinder es wussten, untergetaucht sind. Sam ist also von seinen Eltern einmal im Stich gelassen worden. Dafür ist die fanatische Forschung seines Vaters verantwortlich. An dessen positiver, politischer Gesinnung besteht jedoch kein Zweifel. Seine herablassende Art ist Ausdruck eines narzisstischen Problems. Er ist unfähig auszudrücken, dass er seinen Sohn liebt. So ist es nur die enge Bindung an Edith Farber, was Sam und seinen Vater verknüpft. Sam Farber hat jedoch dieselbe narzisstische Struktur wie sein Vater. Er hat seine eigene Familie verloren, weil er sich voller Besessenheit in die Forschung gestürzt und sie dabei vernachlässigt hat. Er ist selbst ein beziehungsunfähiger, selbstbezogener Mensch. Er ist viel zu eng verstrickt in den Lebensentwurf seiner Eltern, um sich einer Frau wirklich zuwenden zu können. Sam möchte nur eines, dass seine Mutter die Welt mithilfe seiner Augen sehen kann. Er will der Blinden seine Augen leihen und damit zugleich die Anerkennung seines Vaters erreichen, der stolz auf seinen Sohn sein soll. Diese beiden Ziele kann er aber nicht erreichen. Denn Edith Farber ist enttäuscht über die Bilder aus der realen, äußeren Welt. „Das Herz sieht anders als die Augen", erklärt Fitzpatrick im Off.

Ihre Emotionen entsprechen inneren Vorstellungen, die durch die Bilder von außen nur gestört werden. Sie hat sich längst eingerichtet in ihrer inneren Welt. Die erfundene Technik kann ihr nicht helfen, weil sie kein dauerhaftes Tor zu gegenwärtiger Wirklichkeit darstellt und zu spät kommt. Und Sams Vater weiß die Unterstützung seines Sohns nicht zu würdigen. Er fordert von ihm unbedingte Loyalität und Engagement für seine Arbeit. Emotionale Nähe, Dank und wirkliche Anerkennung hingegen kann er nicht zulassen. Da seine Mutter die Forschungen seines Vaters stets kritiklos unterstützt hat, bekommt Sam auch in diesem Punkt von ihr keine Hilfe. Sein eigener Narzissmus ist also ein Rückzug, der aus einer tiefen Resignation stammt. Claire wird von ihm erst angenommen, als er selbst nicht mehr sehen und sie ihm weiterhelfen kann. In Australien ist für ihn die Forschung seines Vaters schon sehr bald wieder viel wichtiger als sie. Claire erreicht Sam nur durch ihre Teilnahme an dem Forschungsprojekt; so, wie auch Edith für die Forschung ihres Mannes die wichtigste Versuchsperson darstellt. Die Liebesgeschichte zwischen Claire und Sam erweist sich als eine Fiktion.

Rückkehr zu „Mutter Natur"

Bei seiner Heilung von der Bildersucht bleibt Sam dann noch viel enger in die Bilderwelt verstrickt als Claire. Er wird allein durch mimetische Akte mit seiner realen Umgebung wieder gesund: Er schläft zwischen zwei gesunden Menschen. Dieser echte Schlaf bindet ihn zurück an eine Gemeinschaft. Es ist ein magisches Ritual, indem die Assimilation mit den gesunden Menschen gelingt. Und auf seinen Aquarellen malt er ebenfalls die Natur, um sich mit der realen Umgebung wieder zu verbinden.

Sam ist also die Figur, in der Wenders immer wieder zeigt, wie der Rückgriff auf die Ethnologie einer gesunden Natur von den Verletzungen durch die marode, technische Zivilisation heilt. Deshalb können seine Augen durch japanische Kräuterbinden gesunden. Deshalb leben seine Eltern im australischen Busch. Deshalb ist Weltuntergang vor allem ein Stromausfall. Es gibt einen eindrucksvollen Moment, in dem sie lautlos durch die Luft segeln. In dem Moment, wo die technischen Hilfsmittel ausfal-

len, setzen die natürlichen Möglichkeiten wieder ein. Der Film sieht in dem Fortschritt der Zivilisation einen Feind. Wie in *Wo die grünen Ameisen träumen* (1984) von Werner Herzog oder *Australia* (2008) von Baz Luhrmann werden die australischen Ureinwohner als die klügeren Menschen betrachtet. Es handelt sich um ein Stück Zivilisationskritik, dessen Wurzeln im Imperialismus und der Kolonisation liegen. Edith Farber wird zwar nach australischem Brauch begraben, aber Henry Farber hält sich nicht an die Trauerbräuche der Ureinwohner. Er erklärt nüchtern, dass er letztendlich eben doch ein Weißer sei. Danach beginnt er mit seiner gefährlichen Reise zum Kontinent der Träume, den die australischen Mitglieder seines Teams weder gutheißen noch unterstützen. Die Herrschaftsverhältnisse wenden sich gegen die imperialistische Tradition. Die eroberte, meist rückständigere Kultur erweist sich als klüger gegenüber der hochzivilisierten. Schon am Anfang schenkt Sam Claire eine Aufnahme der Gesänge von afrikanischen Pygmäen. Später erklärt er ihr auf der Fahrt zu seinen Eltern die Gesänge eines Aborigines. Für den Ureinwohner ist das ihn umgebende Land wie eine Bibel. Er ist der Hüter des Landstrichs, den sie gerade durchqueren. Anfangs sollte der Film in Südamerika gedreht werden, und er sollte in Afrika enden. Dieser ethnologische Zugang gehört zu Sam.

In den meisten von Wenders vorherigen Filmen lag diese Art männlicher Rückbesinnung in der Kindheit. Der Kindheit wurde ein größerer Erfahrungsreichtum zugesprochen, als dem Leben der erwachsenen Menschen. Die Kinder wissen mehr als ihre Eltern, weil sie noch näher am Ursprung leben. Sie sind noch nicht verdorben durch die Kultur. In einem Interview erklärte Wenders (1992, S. 95), dass die Kinder ein besseres Urteilsvermögen haben als die Erwachsenen. In vielen Filmen haben die Erwachsenen einen besseren Bezug zu den Kindern als untereinander. In *Alice in den Städten* (1973) fährt Philip Winter (Rüdiger Vogler) mit einem Kind durch halb Deutschland. In *Im Lauf der Zeit* beobachtet der Kinderpsychologe Robert immer wieder, wie Kinder sich verspielt die Welt aneignen. Und in *Paris, Texas* haben beide Elternteile einen guten Bezug zu ihrem Sohn Hunter (Hunter Carson), während das Verhältnis zwischen ihnen schwer gestört ist und es auch bleibt. Travis und Jane (Nastassja Kinski) unterhalten sich am Ende durch einen komplizierten technischen Apparat. Jane sieht dabei sogar nur sich selbst im Spiegel. Sie müssen die Beleuchtung ändern, damit sie Travis überhaupt sehen kann. Es so als ob hier ein Trauma einen narzisstischen Schutzschirm errichtet hat, der jeden direkten Kontakt unmöglich macht.

Technik und Regression

Der Rückgriff auf die Kindheit und die Ureinwohner hängt auf den ersten Blick eng zusammen mit der Regression, der die Erwachsenen erliegen. Der Ureinwohner und das Kind dürfen in einer animistischen, selbstgenügsamen Welt verharren, ohne dass dies als ein Defizit angesehen wird. Aber Wenders arbeitet gar nicht auf einen solchen generellen Gegensatz hin. Vielmehr geht es um die Rückkehr regressiver Tendenzen, die sich ihren Weg durch die komplizierten technischen Medien bahnen. Weil der erwachsene Mensch seinem Narzissmus nur im Kino oder in anderen fantastischen Welten ungehindert nachgehen darf, kann er davon süchtig werden. Darin liegt das Paradoxon dieser Auffassung: Die Technik selbst ermöglicht jene ersehnte Rückkehr zur narzisstischen Welt der Kindheit. Aber weil ihr Weg ein künstlicher ist, misslingt er. Weil vom erwachsenen, aufgeklärten Menschen gefordert wird in komplexen, sozialen Strukturen zu agieren, kann er nur in alternativen Lebensentwürfen oder virtuellen Lebenswelten seinen selbstgenügsamen Interessen nachgehen.

In keinem anderen Film hat Wenders das Feld zwischen Kultur und Natur als eine solche drastische Opposition beschrieben wie in *Bis ans Ende der Welt*. Aber auch hier bezieht es sich vor allem auf die Bildermeere. Und bereits in *Alice in den Städten* oder *Der amerikanische Freund* (1977), wenn Philip Winter oder Tom Ripley (Dennis Hopper) aus Verzweiflung Polaroid-Fotos von sich selbst anfertigen, war das ebenfalls ein ähnlich unsinniger, selbstbezüglicher Akt. Er zeigt ihnen nichts von sich. Sie können sich selbst Nichts über sich geben, denn dafür benötigen sie einen anderen Menschen. Wenn Lana (Michelle Williams) hingegen in *Land of Plenty* (2004) sich vertraut mit ihrer Umgebung in Los Angeles

macht, indem sie mit ihrer besten Freundin, die weit entfernt lebt, über ihren Laptop kommuniziert, so ist das etwas anderes. Um sich selbst wieder zu finden, benötigt man mehr als ein Bild von sich. Und stets geben die Medien, durch ihren Spiegeleffekt, den Subjekten dennoch scheinbar ihre Selbst-Sicherheit zurück. Zugleich begrenzen sie aber durch ihre Virtualität den wirklichen Austausch. Die Frage, ob sie ein Fenster zur Wirklichkeit oder doch nur ein Spiegel der eigenen Psyche sind, wird bei Wenders häufig nicht zugunsten einer der beiden Positionen entschieden. Auf jeden Fall sind die Geräte nicht nur Instrumente zur Berechnung und Aneignung der Welt, sondern dienen zugleich einer fragwürdigen Selbstbestätigung. Sie können als Substitute die zwischenmenschlichen Verluste kompensieren, aber auch völlig ersetzen, wie in *Bis ans Ende der Welt*. Es handelt sich dann um eine selbstreferenzielle, narzisstische Schleife, die das Subjekt in voller Selbstgenügsamkeit zufrieden stellt.

Die Medien als Weg in den narzisstischen Selbstbezug

Insofern nach Freud jeder Traum eine Wunscherfüllung ist, kommt ihm das Potenzial zu, den Menschen am Schlafen zu halten. Werden nun die Monitore zu Sichtfenstern der Träume, so erfüllen sie die individuellen Wünsche. Diese Überdosis Narzissmus entwickelt ein Suchtpotenzial, in dem der Betrachter zum Dauerschlaf gebracht wird. Die Bilder trennen das Subjekt in einem regressiven Akt von der Welt ab. Sie kappen den Realitätsbezug. Der Mensch, der nur wochenlang nach den Schemen sucht, die aus seinem tiefsten Inneren kommen, braucht, wie Henry Farber stolz erklärt, nichts mehr außer sich selbst. Er wird so zu einem Wanderer zwischen den Welten, wobei die virtuelle Welt immer auch das Reich des Todes, der Vergangenheit und das Gewesene betrifft. Es sind nur noch Schatten, die daraus auftauchen können. Durch den Handmonitor wird der Rezipient an seine Erinnerungen, seine Wünsche gefesselt, ohne sich noch mit ihrer Realisierung auseinander setzen zu müssen. Das nur noch sich selbst konsumierende Subjekt ist völlig isoliert und genießt sich selbst in dieser Symbiose mit den unbewussten Erinnerungen. Das Gaukelspiel der Wunscherfüllung wird zum Wirklichkeitsersatz. Die Frage ist, wo die Medien diese Funktion einnehmen und sich auf Surrogate für die Wirklichkeit reduzieren. Die Rezeption von jedem Film enthält eine narzisstische Ebene. Wenn es dabei bleibt, geht der Bezug zur realen Welt verloren.

Die psychotische Auflösung „findet nicht statt"

Freud (2000, S. 192) erklärte das Motiv des Weltuntergangs innerhalb einer paranoiden Struktur so:

> Der Kranke hat den Personen seiner Umgebung und der Außenwelt überhaupt die Libidobesetzung entzogen, die ihnen bisher zugewendet war; damit ist alles für ihn gleichgültig und beziehungslos geworden …

In diesem Zusammenhang erklärt er ferner, dass im Fall von starker Liebesekstase dasselbe passieren kann. Die Welt geht unter, weil alle Besetzungen in der Außenwelt auf das Liebesobjekt übertragen werden. Im ersten Fall saugt das Ich – im zweiten das Objekt alle der Außenwelt geschenkten Besetzungen auf (ebd.). Der Film entwickelt nacheinander genau diese beiden Varianten des psychischen Weltuntergangs. Zunächst ist Sam das Liebesobjekt, für das Claire alles andere vernachlässigt. Auf der zweiten Stufe ist es dann die narzisstische Höhle der Traumbilder, in der das Ich alle Objektbesetzungen an sich gerissen hat. Der Realitätsverlust wird so in der zweiten Stufe noch gesteigert, in dem es zur vollständigen Abwendung von der Außenwelt kommt. Schon Narziss sah die Vollendung eines Bildes nur in seinem eigenen Selbstbild. Das mag der Hauptgrund sein, weshalb Wenders der Leistung von Bildern misstraut (Ganter 2003, S. 49f.), obwohl er sie weiterhin verehrt.

Am Ende misslingt in *Bis ans Ende der Welt* aber auch die Inszenierung des zweiten, psychischen Weltuntergangs. Denn dieser würde eine psychotische Struktur freilegen. Wenders zeigt zwar die visualisierten Traumbilder in ungewöhnlichen HDTV Auflösungen, aber dies reicht keineswegs aus, um

den Zustand der süchtigen Personen nachvollziehen zu können. Mit ihrer Psychose müsste er zu einer Infragestellung der Identität gelangen, die sich nicht mehr in seiner solch distanzierten, epischen Narration, wie der Film sie zeigt, erzählen lässt. Alle psychotischen Elemente des konventionellen Kino wurden aber zuvor bereits parodiert: So ist beispielsweise die Verfolgungsjagd, die gemeinhin im Action-Film eine paranoide Struktur hat, bei ihm eine harmlose Verfolgung aus Liebe. Ebenso lassen sich kaum ernsthaft schizoide oder depressive Konstrukte finden. Der Habitus des Regisseurs ist vielmehr umgekehrt an einer neurotischen Dekonstruktion der konventionellen, psychotischen Kinomotive interessiert. Das Spiel der Identifikation reduziert er bewusst auf das gute Objekt von Melanie Klein. Die Depression wird abgemildert durch die Trauer und die Beerdigung der Mutter. Anders als bei Lars von Trier in *Melancholia* (2011), ist die Darstellung einer Apokalypse innerhalb einer tiefgründigen, depressiven Struktur in einem Film von Wenders undenkbar. Die Filme agieren immer auf einem Niveau, auf welchem das gute Objekt als Ausgangspunkt zur Identifikation bereits feststeht. Wenders sagte 1989 dazu (Jansen u. Schütte 1992, S. 78):

> Ich möchte eigentlich nur etwas zeigen, was ich mag. Ich mag nichts zeigen und dann sagen, das ist etwas, was ich verabscheue. Der Akt des Filmemachens, was man auf die Leinwand bringt, denke ich, damit identifiziert man sich auch.

Rein faktisch findet so der Weltuntergang, aufgrund des Glaubens an das gute Objekt, zweimal nicht statt: Zunächst löst der Abschuss des indischen Satelliten durch die Amerikaner keine nukleare Katastrophe aus und dann werden zumindest die Hauptprotagonisten vom psychischen Weltuntergang durch die Überflutung mit ihren eigenen Bildern wieder geheilt.

Jacques Derrida hat 1983 in zwei Aufsätzen das Phänomen der Diskurse über die Apokalypse eingehender erörtert. Insbesondere der Übergang in Wenders Film vom äußeren zum inneren Weltuntergang lässt sich so nochmals etwas genauer aufrollen. Derrida wendet sich dabei gegen die übliche Vorstellung eines finalen Ereignisses (Derrida 1985, S. 89):

> Die Katastrophe wäre hier vielleicht die der Apokalypse selbst, ihre Entfaltung und ihr Ende, eine Geschlossenheit ohne Ende, ein Ende ohne Ende.

Die mediale Simulation der Welt enthält das Trugbild eines endlosen Weitersehens. Das Ende der Welt fällt mit der ins Endlose gehenden Sucht zusammen, innerhalb derer der Süchtige nicht nur den realen Raum, sondern auch die gegenwärtige Zeit vergisst. Diese Dimension der endlosen Bildersinnflut ist für Wenders die eigentliche Apokalypse.

Am Ende dieser Betrachtungen möchte ich noch einen anderen, paradoxen, Entwurf zeigen, der eine große Nähe zu Wenders Motiven enthält. 1979 notierte der russische Regisseur Andrej Tarkowskij in seinem Tagebuch die Idee zum Drehbuch für einen Film, der ebenfalls „Das Ende der Welt" heißen sollte (Tarkowskij 1989, S. 226):

> Ein Mann hat sich in Erwartung des Endes der Welt mit seiner Familie (Vater, Mutter, Tochter und Sohn) in seinem Haus eingekerkert. Es wird ihnen noch ein Sohn geboren. Der Vater ist sehr religiös. Sie verbringen ungefähr vierzig Jahre in diesem Kerker. Am Ende werden sie von Polizei und Rettungswagen weggebracht, nachdem man auf irgendeine Weise von ihrer Existenz erfahren hat. Ihr Zustand ist entsetzlich. Der älteste Sohn wirft dem Vater vor, ein Verbrechen an ihm begangen zu haben, indem er ihm vierzig Jahre lang das wirkliche Leben vorenthielt. Als sie weggebracht werden, sagt der kleine Sohn sich umschauend: Papa, ist das das Ende der Welt?

Literatur

Benjamin W (1991) Gesammelte Schriften, Bd 1. Suhrkamp, Frankfurt/M
Derrida J (1985) Apokalypse. Edition Passagen 3, Wien
Elsaesser T (1994) Der Neue Deutsche Film. Heyne, München
Fleig H (2005) Wim Wenders. Transkript, Bielefeld
Freud S (2000) Studienausgabe Bd VII. Fischer Taschenbuch Verlag, Frankfurt/M
Ganter M (2003) Wim Wenders und Jacques Derrida. Tectum, Marburg
Jansen PW, Schütte W (1992) Wim Wenders. Reihe Film Bd 44. Hanser, München
Tarkowskij A (1989) Martyrolog I. Tagebücher 1970–1986. Limes, Frankfurt/M
Wenders W (1988) Die Logik der Bilder. Essays und Gespräche. Verlag der Autoren, FrankfurtM

Originaltitel	Bis ans Ende der Welt
Erscheinungsjahr	1991
Land	Deutschland, Frankreich, Australien
Buch	Michael Almereyda, Peter Carey
Regie	Wim Wenders
Hauptdarsteller	Solveig Dommartin (Claire Tourneur), William Hurt (Sam Farber), Sam Neill (Eugene Fitzpatrick), Rüdiger Vogler (Philip Winter), Max von Sydow (Henry Faber), Jeanne Moreau (Edith Farber), Chick Ortega (Chico Remy)
Verfügbarkeit	DVD erhältlich als Director's Cut, Kinoversion lediglich auf Video

Ulrich Janus, Ludwig Janus

Der Individuationsprozess im japanischen Mangafilm

Ghost in the Shell – Regie: Mamoru Oshii

Filmplakat *Ghost in the Shell*
Quelle: Cinetext/RR

Ghost in the Shell

Regie: Mamoru Oshii

Zum Hintergrund

Ghost in the Shell (◘ Abb. 1) ist ein japanischer Science-Fiction-Film des Regisseurs aus dem Jahr 1995, der auf einem Manga, einem japanischen Comic von Masamune Shirow von 1989 basiert. Er ist ein Zeichentrick- oder Animationsfilm, japanisch Anime, der als ein Klassiker seiner Gattung gilt und weltweit Aufmerksamkeit erregte.[1] Es gab Nachfolgefilme und Fernsehserien[2], wir konzentrieren uns jedoch in unserer Interpretation ganz auf den Ursprungsfilm.

Gegenüber dem eigenwillig humoristischen Charakter der Comicvorlage zeichnet sich der Film durch eine dunklere und nachdenkliche Stimmung aus. Insbesondere durch den Einsatz eindrucksvoller visueller Tricktechniken gelingt Oshii die Schaffung einer anderen Welt jenseits der unseren – seiner Aussage nach ein wesentliches Ziel seiner Arbeit. Der Film entwickelt auf der Grundlage des Comics eine eigene Geschichte und in seiner ästhetischen Gestaltung einen neuen Stil, der die westliche Welt faszinierte.

Insgesamt verstehen wir den Film als ein Mythologem der japanischen Gesellschaft und Kultur in einer Zeit der Hochtechnologie.

Um dies verständlich zu machen, ist die Vergegenwärtigung der fremdartigen Science-Fiction-Welt des Films jedoch eine Voraussetzung. Darum werden wir zunächst den Rahmen und den Handlungsablauf darstellen, um dann die Interpretation auf mehreren Ebenen durchzuführen. Nur so ist es möglich, die Komplexität des Films ausreichend zu erfassen.

Die Filmhandlung

Der Rahmen

Im Jahr 2029 sind viele Menschen Cyborgs. Das bedeutet, dass ihre Körper ganz oder teilweise durch künstliche Bauteile ersetzt worden sind. Sie sind Wunderwerke aus Mechanik und Elektronik, stets in direktem Kontakt mit einer computerisierten und vernetzten Welt. Sie verfügen auf diese Weise über übermenschliche Kräfte und Fähigkeiten. Den Kern dieser Wesen bilden einige Gehirnzellen, die ihr menschliches Zentrum, ihren Ghost darstellen.

Das Verbrechen hat sich in dieser Welt durch die Möglichkeit des Einhackens in die Datennetze auf einem hochentwickelten Niveau etabliert. Um es zu bekämpfen, wurde von der Regierung die Einheit Sektion 9 gegründet. Sie besteht überwiegend aus Cyborgs.

Den Schauplatz des Films bildet eine eindrucksvolle Riesenmetropole (vermutlich Hong Kong), die durch ihre wuchtigen Silhouetten eine erdrückende Qualität erhält (◘ Abb. 2). Die Gesellschaft ist zum einen von einer futuristischen Computertechnologie durchdrungen, auf der anderen Seite sind auch gewöhnliche Straßenmärkte weiterhin Teil des Alltags. Die politische Macht scheint im undurchsichtigen Apparat der Regierungsministerien verborgen, von denen insbesondere das Außenministerium

1 Insbesondere Filmemacher ließen sich von dem Film inspirieren: Larry und Andy Wachowski zeigten den Film dem Produzenten Joel Silver, um für ihn für ihr Vorhaben „Die Matrix" zu gewinnen. (Interview mit Joel Silver in „Making the Matrix"). In 2009 sicherte sich Spielberg über sein Studio „Dreamworks" die Rechte an einem Remake. ("Hollywood is haunted by *Ghost in the Shell*", Steve Rose, 19. Oktober 2009, The Guardian).

2 *Ghost in the Shell 2: Innocence (2005, Mamoru Oshii). TV-Serie Ghost in the Shell: Stand Alone Complex (2002–2005, Kenji Kamyama).*

⬛ Abb. 2 Bedrohlich: die Schluchten der Großstadt. (Quelle: Interfoto/Mary Evans)

und dessen Sektion 6 im Film als Akteure auftreten. Die Ministerien betreiben abenteuerliche diplomatische Schattenspiele, die ohne moralische Skrupel rein machtpolitisch orientiert sind.

Das Geschehen

Der Film beginnt mit einer gemeinsamen Aktion von Sektion 9, einer Spezialeinheit des Innendienstes, und Sektion 6, einer verwandten Einheit des Außenministeriums. Agenten der Sektion 6 greifen ein, als der Botschafter des politisch instabilen Landes Gavel versucht, einen hochtalentierten Programmierer abzuwerben. Nach einem kurzen Feuergefecht beruft sich der Botschafter auf seine diplomatische Immunität, wird jedoch kurz darauf von der Sektion 9-Agentin Kusanagi erschossen.

Bei seinem Besuch im Außenministerium erfährt „Chief Aramaki", der Leiter von Sektion 9, dass man nach einem kürzlich erfolgten Putsch in Gavel nun diplomatische Beziehungen mit der neuen Regierung aufnehmen möchte. Das Problem sei allerdings der vormalige Präsident und nunmehr Anführer der Rebellion, der um Asyl gebeten habe. Leider habe man noch keinen guten Grund, den Asylantrag abzulehnen. Daher bedankt sich das Außenministerium bei Aramaki für die kürzlich erfolgte Aktion, da das Außenministerium auf diese Weise eine „weiße Weste" habe behalten können.

Chief Aramaki beauftragt Major Motoko Kusanagi, die Einsatzleiterin von Sektion 9, mit der Jagd auf einen gefährlichen Hacker, bekannt unter dem Namen „Puppet Master". Dieser ist gerade dabei, sich in den Geist der Dolmetscherin des Außenministers zu hacken, mutmaßlich um die Geheimkonferenz über Gavel zu sabotieren. Die Angriffe werden in schneller Folge von mehreren öffentlichen Telefonzellen aus durchgeführt. Eine Verfolgungsjagd führt zur Festnahme des Fahrers eines Müllautos sowie dessen Komplizen. Ersterer ist davon überzeugt, sich mit Hilfe des Programms seines Komplizen in den Geist seiner geschiedenen Frau einhacken zu können. Letzterer glaubt, vom Rebellenführer angeheuert worden zu sein, um die Geheimkonferenz zu sabotieren.

Diese Geschichten entpuppen sich jedoch als Hirngespinste, die den beiden Männern vom Puppet Master eingegeben wurden. Keiner der beiden kann sich an seine wahre Identität erinnern.

Die nächsten Szenen zeigen eine nachdenkliche Kusanagi, zunächst bei einem Tauchgang, dann im abendlichen Gespräch mit ihren Kollegen Batou und schließlich, wie sie sich am nächsten Morgen in den Straßenschluchten der Stadt verliert. Als sie dann zu spät zur Arbeit erscheint, informiert Batou sie über die neuesten Entwicklungen:

In der Nacht wurde im Konzern Megatech ohne Genehmigung ein weiblicher kybernetischer Körper gefertigt, der aus dem Gebäude ausbrach und kurz darauf von einem Laster überfahren wurde. Der Körper wurde zur Sektion 9 gebracht, um den Fall zu untersuchen. Batou eröffnet weiter die eigenartige Tatsache, dass dieses Wesen zwar keine menschliche Gehirnzelle, aber scheinbar dennoch einen Geist besitzt. Währenddessen trifft Nakamura, der Direktor von Sektion 6, zusammen mit Dr. Willis ein, um den Cyborg zu beschlagnahmen. Es handle sich um den Puppet Master. Im Rahmen eines Geheimprojekts namens „2501" sei es gelungen, den Puppet Master in einem Cyborg-Körper zu fangen. Plötzlich und unerwartet erwacht der Cyborg und leugnet die Geschichte der Sektion 6-Agenten. Er stellt sich als eine aus dem Netz geborene Bewusstseinsform vor und beantragt aus diesem Grunde Asyl in Sektion 9. Im gleichen Augenblick wird Sektion 9 angegriffen, und einem unsichtbaren Eindringling gelingt es, den Puppet Master zu stehlen. Jedoch können Agenten der Sektion 9 den Fluchtwagen mit einem Peilsender belegen.

Der Sektion 9-Agent Ishikawa hat zwischenzeitlich über das Projekt 2501 recherchiert und herausgefunden, dass dieses – im Widerspruch zur Aussage der Sektion 6 – bereits vor dem Auftauchen des Puppet Masters in Gang gesetzt wurde. Ishikawa glaubt, dass der Puppet Master selbst ein Werkzeug des Außenministeriums ist, um dessen Schmutzarbeit zu erledigen. Die Flucht des Puppet Masters wäre demzufolge eine Gefahr für Sektion 6, und das Ministerium müsste befürchten, dass vertrauliche Informationen an die Öffentlichkeit gelangen.

Währenddessen haben Kusanagi und Batou die Verfolgung der Entführer begonnen, bei der sie sich trennen, um verschiedene Wagen zu verfolgen. Kusanagi folgt dem einen Wagen in ein scheinbar verlassenes Gebäude. Dort befindet sich jedoch ein schwer bewaffneter und getarnter Spinnenpanzer, mit dem der Fahrer des Wagens ihr auflauert und sie fast tötet. Batou trifft im letzten Moment mit schwerem Geschütz ein und zerstört den Panzer.

Kusanagi stellt eine Verbindung mit dem Körper des Puppet Masters her. Er bestätigt ihr, dass er das Projekt 2501 darstellt – ein Projekt, das Sektion 6 in die Lage versetzte, seine Ziele durch das Einhacken in Ghosts zu verfolgen. Der Puppet Master hält sich für eine neuartige bewusste Lebensform, empfindet sich jedoch zugleich als unvollständig. Daher bittet er Kusanagi, ihren Geist mit dem seinen zu verschmelzen, um daraus ein neues Wesen zu erschaffen. Batou versucht, die Verbindung zwischen den beiden zu unterbrechen und die Fusion zu verhindern, was ihm aber misslingt. Zugleich nähern sich mehrere Helikopter von Sektion 6 dem Gebäude, deren Scharfschützen die Körper von Kusanagi und dem Puppet Master zerstören.

Kusanagi erwacht schließlich in einem Versteck Batous im Körper eines Mädchens. Batou berichtet von den Ereignissen, die sich seit der Zerstörung vor etwa zwanzig Stunden ereignet haben: Der Außenminister ist aufgrund des Verschwörungsskandals zurückgetreten. Nakamura von Sektion 6 ist in Untersuchungshaft.

Das Mädchen entscheidet sich zu gehen. Sie eröffnet Batou, dass sie nun weder Kusanagi noch der Puppet Master sei, sondern vielmehr eine Vereinigung beider. Nach Verlassen des Hauses lässt sie ihre Augen über die Stadt gleiten und fragt sich, was sie wohl als nächstes tun wird: „Denn das Netz ist weit und unendlich".

Interpretationsansätze

Die Geschichte wird in ihrer Dramatik auch wesentlich durch eine Folge von Kriminalfällen, die aufeinander aufbauen, zusammengehalten: Der Film beginnt damit, dass Sektion 9 einen amerikanischen Hacker jagt. Doch was sind die Motive dieses Hackers? Zugleich hat der Umsturz des Nachbarlandes Gavel eine neue despotische Regierung und einen Rebellenführer hervorgebracht. Arbeitet der Hacker für den Rebellenführer, um die Verhandlungen mit Gavel zu sabotieren? Warum aber verwendet der Hacker dann einen veralteten Virus und impft seinen Puppen ein, für den Rebellenführer zu arbeiten, sodass die Spur auf ihn gelenkt wird? Ferner macht Sektion 6 keinen Hehl daraus, dass sie einen Vorwand suchen, um den Asylantrag des Rebellenführers abzulehnen. Den Angelpunkt dieser Ungereimtheiten bildet die Tatsache, dass das Außenministerium ein Hackerprogramm schuf, um seine eigenen Interessen auf kriminelle Weise zu verfolgen. Die unvorhergesehene Eigendynamik, die der Puppet Master entwickelt, führt schließlich zur Aufdeckung des falschen Spiels von Sektion 6.

Während sich die Handlung im Film überschlägt, bleiben zugleich die Motive vieler Parteien in einem Gewebe von Lügen und Verwirrungen verborgen. Dies bestimmt wesentlich den Aktionscharakter des Filmes und erzeugt Spannung.

Aber das ist eher der äußere Rahmen. Denn die entscheidende gestaltende Bedeutung kommt mehreren nachgelagerten Ebenen zu, bei denen unsere Interpretation ansetzt. Genauer gesagt, setzen wir drei Schwerpunkte. Zum einen greifen wir die Frage nach der Identität der Hauptfiguren noch einmal auf – die wir insbesondere auch als Frage nach der menschlichen Identität im Licht der modernen Naturwissenschaft interpretieren. Zum zweiten begreifen wir den Film als Ausdruck unbewusster Elemente im japanischen Lebensgefühl, insbesondere unter Berücksichtigung mythologischer und historischer Wurzeln Japans. Den dritten Schwerpunkt schließlich bildet die Konfliktdynamik der Hauptfiguren. Danach folgen abschließende kulturpsychologische Überlegungen dazu, welche Aspekte der japanischen Identität oder Mentalität in dem Film zum Ausdruck kommen.

Die Komplexität der Filmhandlung erfordert ein solches Vorgehen, weil alle diese verschiedenen Ebenen gestaltend wirksam sind und nicht einfach eine Geschichte erzählt wird. Wir beginnen mit der wissenschaftsphilosophischen Ebene.

Menschliche Identität und Bewusstsein im Licht der modernen Naturwissenschaft

Eine Leitlinie des Films ergibt sich aus der Problematisierung der Bedeutung des menschlichen Bewusstseins und dem biologischen Fundament der menschlichen Existenz. In der radikalen Argumentation des Puppet Masters spiegeln sich die Erkenntnisse und die Denkweise der modernen Biologie wider. Daher erinnern wir hier zunächst noch einmal an jenen bedeutenden Paradigmenwechsel der Evolutionsbiologie, wie ihn Richard Dawkins in seinem Buch „The Selfish Gene" (Dawkins 1976) auf den Punkt gebracht hat, und seine Konsequenzen. Anschließend betrachten wir im Lichte des Gesagten die Gedanken der beiden Hauptfiguren bezüglich ihrer Identität.

Der Mensch als funktionale Hülle seiner Gene

Die Veröffentlichung von „The Selfish Gene" (deutsch: „Das egoistische Gen") markierte einen Paradigmenwechsel in der Biologie. Demnach sind bei Fragen zur Evolution nicht mehr die Art, der einzelne Organismus oder gar die Zelle zu betrachten. Vielmehr war nun das Gen als treibende Kraft der Evolution erkannt. Diesem Erklärungsmodell nach erschaffen sich die Gene schützende Hüllen, um ihre geordnete Replikation sicherzustellen. Die Hülle stirbt und wird wieder neu aufgebaut – das Gen aber bleibt und wird von Organismus zu Organismus weitergereicht.

Denn Gene sind im Wesentlichen nichts anderes als sich selbst replizierende Agenten. Sie sind in der Lage, sich mit Hilfe von Mutation von Generation zu Generation weiterzuentwickeln. Ferner kann durch Rekombination ein Genom an die nächste Generation weitergereicht werden, das aus der Verei-

nigung zweier Genome hervorgegangen ist. Dies ermöglicht größere Veränderungen, als es mit einer einfachen Kopie möglich wäre.

Der entscheidende Punkt für den Kontext der Filmhandlung (Argumentation des Puppet Masters) ist, dass die primitiven Eigenschaften des Gens, Selbsterhalt durch Selbstreplikation und Mutation, letztendlich ausreichten, um sich Hüllen in Form hochkomplexer biochemischer Maschinen zu schaffen, die ihrerseits schließlich ein Bewusstsein hervorbrachten.

Der Puppet Master

Für seinen Antrag auf Asyl in Sektion 9 fordert der Puppet Master für sich den Status einer bewussten Lebensform ein. Dabei verweist er darauf, dass seine Programmierung dem Ziel des Selbsterhalts der genetischen Grundlage der Menschen entspricht. Da sich der Mensch, und somit Bewusstsein auf biochemischer Basis, ganz auf Selbsterhalt im obigen Sinne zurückverfolgen lasse, müsse sich Bewusstsein auch auf der Basis eines elektronischen Systems oder auch nur von Informationen denken lassen. Mit dieser argumentativen Wende offenbart er die Erklärungslücke der modernen Wissenschaft bei der Entstehung des Bewusstseins und nutzt sie für sich.

Auch bei seinem Auftritt gegen Ende des Films stützt er sich auf Bilder der modernen Evolutionsbiologie. Er empfindet seine Existenzform als unvollkommen. Denn zum „echten Leben" gehört für ihn auch die Fähigkeit zur Veränderung und zur Erlangung von Vielfalt. Diese kann er alleine nicht erreichen. Im biologischen Vorbild sieht er den Schlüssel hierfür in der Fortpflanzung durch Rekombination, also der Verschmelzung zweier Genome. Damit motiviert er die Fusion seiner selbst mit dem Ghost von Kusanagi als Lösung zum Übergang in das „echte" Leben.

Wie genau dies funktionieren soll, bleibt jedoch unklar. Denn die Metapher der genetischen Evolution für die Situation des Puppet Masters stößt hier an ihre Grenzen. Dessen Argumentation lässt sich allerdings auch als Rationalisierung eines psychologischen Motivs auffassen, worauf später noch eingegangen wird.

Kusanagi

Kusanagi ihrerseits gerät durch die Aktivitäten des Puppet Masters in eine Nachdenklichkeit über die Natur der menschlichen Identität. Das unglückliche Schicksal des Müllmanns erschüttert ihren Glauben an eine objektive Wirklichkeit der Erfahrungen. Der Eingriff des Puppet Masters offenbart die Verletzlichkeit der Seele und die flüchtige, möglicherweise trügerische Natur der eigenen Erinnerungen. Kusanagi muss daher neu über die Grundlage ihrer Identität nachdenken.

Auf dem Boot formuliert sie Batou gegenüber ihre Überlegungen wie folgt: Abgesehen von ihren gesammelten subjektiven Eindrücken konstituiert sich ihre Persönlichkeit durch das Zusammenwirken vieler Aspekte, seien es Äußerlichkeiten wie ihre Stimme oder subjektive Gefühle wie das eines eigenen Lebensschicksals. Damit kann sie das Fundament ihrer Persönlichkeit weiter fassen. Zugleich äußert sie aber auch eine intensiv empfundene Begrenzung ihrer selbst, die sie zu ihren Tauchgängen veranlasst. Am nächsten Morgen sieht sich Kusanagi mit der Möglichkeit eines Bewusstseins ohne Menschlichkeit konfrontiert. Denn der in Sektion 9 eingelieferte Puppet Master ist ein reiner Roboter, der dennoch einen Ghost besitzt. Aufs Neue ist sie verunsichert – was, falls sie selbst eine rein künstliche Existenz wäre? Ihrer Antwort gemäß käme es dann darauf an, von den Anderen dennoch als menschliches Wesen anerkannt und entsprechend behandelt zu werden.

Die Unsicherheit Kusanagis lässt sich zu einem Teil als Folge der Infragestellung der überkommenen Identität durch die erwähnten Ergebnisse der molekularen Biologie deuten. Denn durch den Erfolg der biochemischen Erklärungsmodelle auch für höhere biologische Funktionen konnte die Wissenschaft auf den unklaren Begriff des Bewusstseins zunehmend verzichten. Diese Entwicklung birgt das Potenzial einer Verunsicherung bezüglich der subjektiv empfundenen Identität, wie sie bei Kusanagi zum Ausdruck kommt.

Diese intensive Auseinandersetzung mit gefühlter Identität und Individualität berührt das allgemeinere Thema des japanischen Verhältnisses gegenüber westlichen Einflüssen.

Psychohistorische Wurzeln des japanischen Lebensgefühls

Im Folgenden wollen wir untersuchen, inwieweit sich der Film aus dem mythologischen und psychohistorischen Hintergrund Japans heraus interpretieren und verstehen lässt. Die beiden Ankerpunkte bilden hierbei die Grundstimmung der östlichen Mythologie und die abrupte Öffnung Japans gegenüber westlichen Einflüssen in der Mitte des 19. Jahrhunderts.

Mythologischer Hintergrund – die Trennung von Ost und West

Während die Religionen der westlichen Welt vom jüdischen Monotheismus geprägt sind, übernimmt diese Rolle im östlichen Raum der im Hinduismus wurzelnde Buddhismus – in Japan der Shinto-Buddhismus. Wir gehen davon aus, dass die Grundmotive dieser Mythologien die geistigen Grundstimmungen der jeweiligen Kulturräume nachhaltig prägen.

Joseph Campbell hat in seiner Arbeit zur Evolution der Mythologien (Campbell 1959–1968) einen fundamentalen Scheideweg zwischen den westlichen und den östlichen Mythologien beschrieben und anhand eines Bildes aus der Genesis erläutert: Im Garten Eden stehen zwei Bäume – der Baum der Erkenntnis von Gut und Böse und der Baum des ewigen Lebens. Im westlichen Mythos wurden die Menschen aus dem Paradies vertrieben und verwirkten damit das ewige Leben, da sie sich am Baum der Erkenntnis vergangen und so zwischen Gut und Böse zu unterscheiden gelernt hatten. Im Christentum führt dies zu der zentralen Stellung des Sünden- und Schuldbegriffs, zum Fokus auf die eigenen Handlungen und die Einmaligkeit des Lebens auf dieser Erde. Aus der Perspektive dieses biblischen Bildes gesehen, wählte der Osten nun nicht die Erkenntnis, sondern das ewige Leben, was sich im Glauben an die Reinkarnation widerspiegelt. Anstelle der tatbezogenen Sünde steht hier die Idee des Karmas, das mehr von der Intention als dem Ausgang der Handlung beeinflusst wird, im Vordergrund. Man könnte behaupten, dass sich die beiden Wege in den Erlösermythen wieder nähern – Christus erlöst den Menschen von seiner Schuld und schenkt ihm das ewige Leben. Buddha hingegen zeigt den Weg der Erkenntnis auf, durch den der Mensch dem leidensvollen Zyklus von Tod und Wiedergeburt entkommen kann.

Dieser Exkurs beschreibt zwei Pole, zwischen denen sich notwendigerweise ein Spannungsfeld auftut. Begreift man den Film als eine unbewusste Auseinandersetzung von westlichen und östlichen Ideen, so bietet dieser Grundkonflikt einen hilfreichen Bezugspunkt. Der östlichen Grundstimmung gemäß stände also nicht die Individualität im Vordergrund, sondern das große Ganze, das schicksalhaft vorgegeben ist und in das man sich widerspruchslos einfügt. Und in der technikgeprägten Moderne ginge es eben um die Perfektion der Technik, der die Individualität geopfert wird, sodass sie nur verborgen in einer Shell überlebt, aber doch auch als Zentrum weiterlebt. In diesem Sinne würde sich der Film mit den Gefahren einer einseitig kollektivistisch geprägten Technikorientierung befassen. Doch ist hier auch die historische Ebene zu berücksichtigen.

Japans Modernisierung und plötzliche Öffnung gegenüber dem Westen

Der Vertrag von Kanagawa im Jahr 1854 gilt als das Ende der japanischen Isolationspolitik gegenüber dem Westen. Die plötzliche Öffnung Japans gegenüber den wirtschaftlich und politisch expandierenden westlichen Nationen führte zu einem Bruch in Japans kultureller und politischer Entwicklung und zum Ende des Shogunats, der bis dahin bestehenden japanischen Feudalordnung der Samurai. Die neue Elite unter der kaiserlichen Herrschaft der Meji-Restauration verordnete ihrem Land einen kulturpolitischen Quantensprung durch die Übernahme westlicher Technik, Ideen und Institutionen in eine Gesellschaft, die bis dahin von starren Feudalstrukturen geprägt war. In kürzester Zeit forcierte die japanische Elite, ausgebildet an westlichen Universitäten und geprägt durch den dort vorherrschenden

wissenschaftlichen Rationalismus, den Übergang in eine auf westlichen Errungenschaften gründende bürgerlich-kapitalistische Eigentumsgesellschaft.

Der Übergang Japans in die Moderne war also weniger das Ergebnis eines von innenpolitischen Kräften vorangetriebenen Umbruchs, sondern ein von äußeren Notwendigkeiten erzwungener Prozess, der von der zentralen Macht des restaurierten Kaisertums mit aller Kraft umgesetzt wurde. So katapultierte sich Japan innerhalb weniger Jahrzehnte in die Liga imperialistischer Großmächte.

Wenn man davon ausgeht, dass die innere Befindlichkeit Japans retrospektiv von seinem Kulturerbe und seiner mythologischen Grundstimmung geprägt ist, so bedingt die beschriebene Entwicklung ein geistiges Spannungsfeld zwischen Japans seelischer Verfassung und den äußeren Gegebenheiten. Das führt zu einer psychohistorischen Ebene.

Überlegungen zur psychohistorischen Entwicklung der japanischen Identität und japanischen Gesellschaft

In der Gestaltung der Charaktere als Cyborgs könnte ein unbewusstes Entfremdungsthema in der japanischen Gesellschaft gestaltet sein. Ab der Mitte des 19. Jahrhunderts musste sich eine Gesellschaft mit einer langen Geschichte und Tradition in einem Gewaltakt der westlichen Kultur und Zivilisation öffnen, um ihren gesellschaftlichen Status in der modernen Welt zu wahren. Es blieb keine Zeit zu einer wirklichen Verarbeitung. Man musste die westliche funktionale Identität, die in einer individualistischen Handlungsorientierung wurzelt und hieraus ihre Kraft gewinnt, über die gewachsene japanische Identität stülpen. Dabei legierte sich die Tradition der bedingungslosen Gefolgschaft der Samurai mit den Anforderungen einer zweckorientierten westlichen funktionalen Mentalität. Der Preis war eine Einschränkung und Verkümmerung der individuellen seelischen Identität und Intimität. So sind die Charaktere des Filmes als funktionale technische Wesen gestaltet, deren Restseele in einer Kapsel oder Shell eingeschlossen und geschützt ist.

Das Opfer seelischer Vollständigkeit in einer übertechnisierten und überfunktionalisierten Welt ist ein Hauptthema des Films. Dies spiegelt sich in der Konfliktdynamik der Heldin des Filmes, Motoko Kusanagi.

Die psychologische Konfliktdynamik in der Heldin Motoko Kusanagi als Leitlinie des Films

Der Ausgangspunkt der psychologischen Konfliktdynamik ist die einseitige Orientierung der Heldin. Sie ist als Einsatzleiterin eines Sicherheitssystems völlig in die funktionalisierte und kollektivistische Struktur der Regierungsbehörden eingebunden. Gnadenlos jagt sie den unbotmäßigen Hacker Puppet Master, der das herrschende System steuern und kontrollieren will. Dabei besteht seine besondere Fähigkeit darin, auch den seelischen Teil der von ihm kontrollierten Cyborgs steuern zu können. Im Laufe des Films beschäftigt sich Motoko Kusanagi zunehmend mit ihrer eigenen Identität und deren Schattenseiten. Dies äußert sich besonders darin, dass sie in – für einen Cyborg ungewöhnlichen – Tauchgängen ihren geheimsten und ureigensten Gefühlen nachzuspüren versucht. Dabei erkennt sie ihre eigene Verlassenheit und Einsamkeit, die die Folge ihrer einseitigen Orientierung an der kollektiv vorgegebenen technischen Funktionalität sind. Diese Orientierung bedeutet ein Opfer an seelischer Individualität, Autonomie und eigener Gefühlswelt. Tiefenpsychologisch erscheint sie als unreife, an ihren Vater-Direktor Aramaki gebundene, Vatertochter, die dem Vater zuliebe auf ihre eigene weibliche Individualität verzichtet hat, was sie im Lauf des Films allmählich entdeckt. Eine parallele Entwicklung zu einer zunehmenden Selbsterkundung vollzieht sich in der Figur des Puppet Masters. Er macht sich aus seiner Einbindung in die Aufträge der Sektion 6 selbstständig und scheint die Nähe von Motoko Kusanagi zu suchen, die auch mit ihm, dabei zunehmend persönlicher motiviert, beschäftigt ist. Dies kulminiert in der wechselseitigen Begegnung, die in dem Plan des Puppet Masters zu einer Fusion mündet, in die die Heldin einwilligt. Dadurch wird ein durch ein Todeserlebnis hindurchführendes

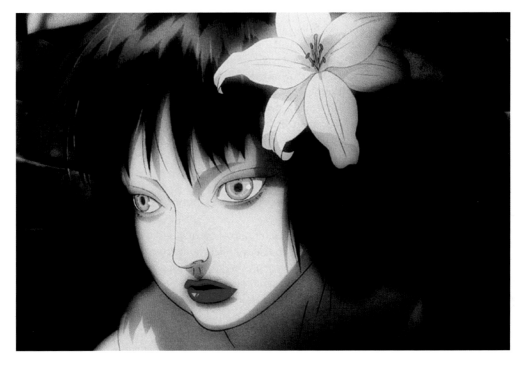

◻ Abb. 3 Kusanagi in Gestalt eines Mädchens. (Quelle: Interfoto/Mary Evans)

Transformationsgeschehen ermöglicht, das zu einer Wiedergeburt Kusanagis mit einer neuen Identität in einem jugendlichen Körper führt (◻ Abb. 3).

Tiefenpsychologisch gedeutet, lässt sich der Puppet Master als Schatten im Sinne C. G. Jungs verstehen: Er repräsentiert in verzerrter Form die von der Heldin verdrängte Autonomie und Eigenwilligkeit, wie auch den Wunsch nach einer menschlich-vollständigen Lebenswelt.

In diesem Sinne ist der Leitfaden des Films der seelische Reifungsprozess der Heldin. Das deutet sich auch dadurch an, dass es heißt, seit dem Auftauchen des Puppet Masters sei Motoko Kusanagi verändert und irritiert, was typisch für jemanden ist, der sich in einem seelischen Entwicklungsprozess befindet.

Die Entwicklung wird in den Monologen und schließlich Dialogen der Hauptfiguren deutlich. Kusanagi und Batou auf dem Boot:

> 💬 Batou: „So, what's it feel like when you go diving?"
> Kusanagi: „Didn't you go through underwater training?"
> Batou: „I'm not talking about doing it in a damned pool."
> Kusanagi: „I feel fear. Anxiety. Loneliness. Darkness. And perhaps, even hope."
> Batou: „Hope? In the darkness of the sea?"
> Kusanagi: „As I float up towards the surface I almost feel as though I could change into something else."

Dabei wird der Diskurs von Motoko Kusanagi zunehmend mehr weiblich bestimmt: Es geht ihr darum, in den Anderen einzutauchen, um ein vertieftes Verstehen des Anderen, das zunächst technisch bestimmt ist, aber zunehmend auch einem persönlichen Klärungsbedürfnis nachgeht. Das wird beson-

ders im letzten Dialog deutlich, wo es um Fusion und Transformation geht. Der Diskurs des Puppet Masters hingegen ist eher männlich bestimmt – das wäre sein Animusaspekt im Sinne C. G. Jungs; er verfolgt eine theoretisch-technische Vorannahme, wie sie sich aus der modernen Genbiologie ergibt: Der Mensch ist im Wesentlichen eine biochemische Maschine, die vom Genom gesteuert wird und dessen Zwecken dient. Über die Gedächtnisfunktion gewinnt sie ein Bewusstsein ihrer selbst und einer begrenzten Autonomie. Aber sowohl der weibliche wie auch der männliche Diskurs bleiben in sich geschlossen, was der Puppet Master dadurch explizit macht, dass er sich als unvollständig schildert, weil er sich nicht fortpflanzen kann und er nicht sterblich ist. Nur durch die Fusion, die auch den Charakter einer Bewusstwerdung durch wechselseitige Selbstbegegnung hat, entsteht das Wesen, das beide transzendiert.

Dabei kommt es zu dem Paradox, dass diese Transformation von zwei scheinbar erwachsenen Figuren zu einer jugendlichen Frau führt, die erläutert, dass sie nun alles Kindliche hinter sich gelassen habe. Dies impliziert die Feststellung, dass die beiden Hauptfiguren Motoko Kusanagi und der Puppet Master eigentlich kindlich waren. Das entspricht der psychologischen Charakterisierung der Motoko Kusanagi als einer vatergebundenen perfektionistischen Tochter und des Puppet Masters als eines rebellischen Sohnes mit autistischen Zügen. Damit wäre auf die Gefahr in der Mentalität der Menschen der technischen Moderne hingewiesen, dass sie Schwierigkeiten haben, die Möglichkeiten der technischen Perfektion, die etwas Übermenschliches haben, in den natürlichen menschlichen Lebensrahmen einzufügen. Die narzisstische Grandiosität verführt zu einem Steckenbleiben in kindlicher Omnipotenz, der gegenüber die anderen Lebensmöglichkeiten verkümmern.

Wie anfangs erläutert, zwingt die moderne Biologie der Gene zu einem neuen Blick auf den Menschen. Die besondere Bedeutung des einzelnen Menschen, die er auf der religiösen Ebene als Ebenbild Gottes oder aus der Perspektive der Evolutionsbiologie als Krone der Schöpfung oder als das am höchsten entwickelte Wesen hatte, wird durch das moderne Verständnis der Gene als den eigentlichen steuernden Strukturen dramatisch relativiert. Die Besonderheiten des Homo sapiens verlieren ihre Bedeutung gegenüber den basalen Funktionen der Gene. Der Mensch erscheint als biochemische Maschine und muss sich, wie es sich in den beiden Protagonisten realisiert, ganz neu aus seiner ursprünglichen Kreativität heraus in der wechselseitigen Selbstbegegnung seelisch wiederfinden.

Unabhängig hiervon gibt es in jener Geschichte auch eine dramatische Struktur, wie sie Aristoteles in seiner Poetik entwickelt hat.

Ghost in the Shell als ein ost-westliches Drama

Der Film folgt in wesentlicher Hinsicht der klassischen Form des Dramas: Im Anschluss an die Exposition folgt eine Explikation des Konflikts und die Anagoresis des Helden beziehungsweise hier der Heldin, das Gewahrwerden ihrer wirklichen Situation, dass sie eigentlich allein ist und sich nach der Begegnung mit einem anderen Menschen sehnt. Auch der andere Held des Films, der Puppet Master, macht eine psychologische Entwicklung durch und wird der Begrenztheit seiner rebellischen Omnipotenz gewahr. Das Besondere dieses Films und möglicherweise ein Zeichen für seine Modernität ist die Tatsache, dass es nicht wie bei Aristoteles zum Untergang des Helden, sondern zu einer Transformation und dadurch zu einem Überstieg auf eine neue Ebene kommt. Das entspricht der Lösungsform des Märchens. Vielleicht könnten ja die ost-westlichen Begegnungen und die damit verbundenen Integrationspotenziale dabei helfen, die transformativen Möglichkeiten des Märchens, die ja ein Ausdruck der Potenziale der menschlichen Seele sind, auch in der Wirklichkeit zu realisieren, sodass es nicht mehr zum Scheitern wie beim westlichen Helden kommen muss, sondern, in einem neuen Bezug zum großen Ganzen, auch eine Transformation möglich wird. Dabei scheitert ja der Held im westlichen Drama an der Verabsolutierung der Individualität oder der zu geringen Beachtung des großen Ganzen, während im östlichen Paradigma des Bezuges auf das große Ganze die Potenziale des Individuellen,

der persönlichen Verantwortlichkeit zu kurz kommen. Diese Überlegungen ermöglichen noch einmal einen zusammenfassenden Blick auf den Film.

Ghost in the Shell als Verarbeitung des Kulturschocks der Begegnung mit dem Westen

Auf dieser Ebene geht es um die psychologische Verarbeitung der überwältigenden kulturellen Anpassung, den die japanische Gesellschaft seit der Mitte des 19. Jahrhunderts zu leisten hatte und geleistet hat. Die Eigenständigkeit der Bilder, des Stils und der Handlungsführung zeigen, dass sich die japanische Kultur mit den Mangas und den Animes von den westlichen Vorbildern emanzipiert hat und zu einem eigenständigen kulturellen Stil gelangt ist, der die eigene Tradition integriert und aus dieser Kraft zu einem eigenen Weltverständnis gefunden hat.

Die Mangas und der Film sind kulturell eigenständige Ausdrucksformen zentraler psychologischer Konstellationen in der japanischen Gesellschaft. Ein wesentliches Charakteristikum sind dabei Entfremdungsstrukturen als Folge der aufgezwungenen Verwestlichung, wie sie sich in den technisch perfekten Cyborgkörpern ausdrücken. Der lebendige Körper wird usurpiert von einem technisch-funktionalen Leistungskörper, in dem sich die seelisch-geistige Qualität als Ghost in einer Kapsel verbirgt. Die technische Perfektion der umfassenden Computerisierung gefährdet auch noch diesen Zufluchtsort, wie es sich in der Fähigkeit des Puppet Masters ausdrückt, sich sogar in die Ghosts einhacken zu können. Die Cyborgkörper repräsentieren aber darüber hinaus den Schockcharakter des kulturellen Selbstverlustes durch die Begegnung mit dem Westen. Nur durch seelenloses Kopieren und Funktionieren war die zivilisatorische Behauptung möglich. Die seelische Verarbeitung und die seelische Eigenheit blieben auf der Strecke und führen in den Shells ein Restdasein. In dieser Situation könnten die leeren und gesichtslosen Stadtpanoramen auch etwas von einer Entwurzelungsdepression der asiatischen Kulturen repräsentieren.

Dadurch aber, dass dies in den Mangas und den auf ihnen aufbauenden Filmen möglicherweise erstmals in aller Deutlichkeit zum Ausdruck gebracht wird, können die beschriebenen Zusammenhänge allmählich einer seelischen Verarbeitung zugänglich gemacht werden. Dies gelingt durch die Gestaltung mythischer Bilder und Szenen, die die aktuelle Lebenssituation mit den Urkräften und deren integrierender Kraft wieder in Verbindung bringen.

Die mythenhafte Gestaltung hat die Qualität, allgemein menschlich verstanden zu werden und ermöglicht so eine kulturelle Begegnung und ein tieferes Verstehen. Am Anfang stand in der westlichen Welt die Faszination von dieser neuen künstlerischen japanischen Ausdruckskraft der Mangas und den ihnen nachfolgenden Filmen. Jetzt kann die verstehende Reflexion nachfolgen, wie wir sie im Beitrag versuchen.

Wir möchten hier noch einmal auf die von Campbell herausgearbeitete Dichotomie in den mythologischen Grundorientierungen von West und Ost zurückkommen. Für den Osten würde es dann um eine Entdeckung der immer individuell geprägten Erkenntnis gehen, wie es in dem Erkenntnis- und Entwicklungsprozess der Heldin zum Ausdruck kommt. Dies führt im weiteren Fortgang dazu, dass sie, nachdem sie ihre Individualität gewonnen hat, auch eine lebendige Körperlichkeit wiedergewinnt. Für den Westen würde es darum gehen, die Folgen einer Überindividualisierung zu reflektieren, die einen Verlust des Bezugs zum großen Ganzen, in dem unsere unerschöpfliche Lebendigkeit wurzelt, zur Folge hat.

Literatur

Campbell J (1959–1968): The Masks of God, Bd 1–4. Viking, New York City NY
Dawkins R (1976) The Selfish Gene. Oxford University Press, New York City NY

Originaltitel	Ghost in the Shell
Erscheinungsjahr	1995
Land	Japan
Buch	Kazunori Itō
Regie	Mamoru Oshii
Verfügbarkeit	Als DVD in OV und in deutscher Sprache erhältlich

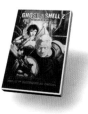

Alfred Springer

Die Subjektivität der Kamera

Strange Days – Regie: Kathryn Bigelow

Filmplakat *Strange Days*
Quelle: Cinetext/RR

Strange Days

Regie: Kathryn Bigelow

Der Hintergrund

Kathryn Bigelows *Strange Days* aus dem Jahr 1995 ist als filmisches Produkt ein Hybrid aus Science Fiction, Action Thriller, politischem Thriller und Film Noir (◻ Abb.1). Das Drehbuch stammt von James Cameron und Jay Cocks. Cameron soll zu dem Drehbuch von den Geschehnissen stimuliert worden sein, die vom „Fall Rodney King", einem skandalbehafteten Verfahren nach einem schwerwiegenden rassistischen Übergriff des LAPD, ausgelöst worden waren. Den gesellschaftlichen Hintergrund des Filmes bietet somit ein Los Angeles, das von massiven gesellschaftlichen Unruhen erschüttert ist; darüber hinaus werden auch die AIDS-Krise und die damit verbundene Verunsicherung hinsichtlich sexueller Beziehungen reflektiert. Bemerkenswert ist, dass es Bigelow gelungen ist, die Klischees, Konventionen und Erwartungen, die sich an die Vielfalt von Genres richten, die den formalen Reiz des Streifens ausmachen, zugleich zu nutzen und zu hinterfragen und in Gestaltung und Text den Begriff und die Wirksamkeit der Traumfabrik infrage zu stellen. Auch ist das Gemisch von Genres kein Selbstzweck, sondern steht in Bezug zu psychischen Befindlichkeiten der Protagonisten.

Die Technologie

In technischer Hinsicht ist der Film äußerst aufwendig gestaltet. Matthew F. Leonetti, der Kameramann, berichtet, dass die Fotoarbeiten 80 Tage in Anspruch nahmen, 77-mal in der Nacht gedreht wurde und oftmals schwierige Aufgaben zu erfüllen waren. Der extreme und teilweise innovative Einsatz der „subjektiven Kamera" erforderte die Entwicklung neuer fotografischer Instrumente. Die Aktionssequenzen, die mit subjektiver Kameraführung gedreht wurden, bedurften sorgfältiger Planung und Vorbereitung, die ungefähr ein Jahr in Anspruch nahmen, bevor man mit den Dreharbeiten beginnen konnte. Kathryn Bigelow ließ ein eigenes Kamerasystem entwickeln, da sie erkannte, dass kein existentes die Aufnahmen ermöglichte, die den subjektiven Shots, die sie plante, entsprechen würden. Insgesamt wurden vier Kamerasysteme zum Einsatz gebracht, die verschiedene Belichtungssysteme aufwiesen. Da sehr viele subjektive Aufnahmen in einem Winkel von 360 Grad durchgeführt wurden, musste man die Beleuchtung trickreich einsetzen, um zu vermeiden, dass die Lichtquellen von der rotierenden Kamera erfasst würden (◻ Abb. 2).

Der Plot

Die Hauptgestalt des Films, Lenny Nero (Ralph Fiennes), ist ein früherer Mitarbeiter der Sittenpolizei, der in Los Angeles mit illegal produzierten Apparaturen, die einen Ausflug in virtuelle Erfahrungen ermöglichen, sogenannten SQUIDS, Handel betreibt. Lenny ist oberflächlich gesehen charmant und gewinnend, in Wirklichkeit aber zutiefst depressiv, einsam, vergangenheitsorientiert und von seinem eigenen Produkt abhängig. Der Gebrauch der SQUIDS ermöglicht es ihm, die erfreulichen Momente einer längst vergangenen Beziehung zu seiner Ex-Freundin Faith, verkörpert von Juliette Lewis, immer wieder zu erleben. Faith ist eine Cybergrunge-Musikerin, die in der harten Musikszene lebt. Lenny hatte sie vor Zeiten aus einem desperaten Leben gerettet, und sie verließ ihn bald darauf wieder, als sich für sie Erfolge abzeichneten. Sie ist jetzt mit Philo zusammen (◻ Abb. 3). Er selbst verbringt ein einsames Leben, das überwiegend von seiner Trauer um den Verlust bestimmt wird. Er ist an Faith mit allen Charakteristika einer romantischen Liebe gebunden, kann sie nicht vergessen und sie nicht verlassen.

Abb. 2 Kathryn Bigelow am Set mit Ralph Fiennes (Lenny). (Quelle: Cinetext Bildarchiv)

Er fühlt sich verpflichtet, sie auch nach dem Bruch weiter zu beschützen. Immer wieder gibt er sich SQUIDS aus der gemeinsamen Vergangenheit hin und stellt damit diese Instrumente in den Dienst seiner Flucht aus dem Hier und Jetzt.

Seine Flucht aus der Realität und sein Romantizismus sind allerdings nicht nur von dieser verflossenen Liebschaft bestimmt. In gleicher Weise wirken die Erfahrungen aus seiner Polizeitätigkeit und aus der Wirklichkeitserfahrung mit. In einer Szene sagt er von sich:

> „Ich bin durch die Gosse gekrochen, durch jede Windung des menschlichen Gehirns. Romantik ist mein Schwert und mein Schild."

Die romantische Pose verwirklicht sich innerhalb eines allgemeineren narzisstischen Rückzugs, der symbolisiert wird durch Larrys Bindung an modische Kleidung und Accessoirs: „Diese Krawatte kostet mehr als deine ganze Garderobe… Sie ist das einzige Objekt, das zwischen mir und dem Dschungel steht."

Zunächst scheinen zwei Personen als Freunde von Lenny auf: Max, ebenfalls ein ehemaliger Polizist, und Mace, gespielt von Angela Bassett, die als Chauffeur und Bodyguard arbeitet und ihn liebt, obwohl sie seine Lebensweise ablehnt.

Lennys Leben wird einige Tage vor der Jahreswende ins nächste Jahrtausend zunehmend kompliziert, als ihm anonym ein SQUID zugesandt wird, auf dem die Vergewaltigung und Ermordung von Iris, einer Prostituierten, festgehalten ist, die Lenny kannte und die ihn noch kurz vor ihrer Ermordung voll Verzweiflung und Angst aufgesucht hatte. Da Iris ihn vor irgendetwas warnen wollte, das Faith betraf, vermutet Lenny, dass diese das nächste Opfer sein könnte und versucht sie zu schützen, wobei ihn Mace zunächst begleitet und unterstützt. Es wird klar, dass die ganze Angelegenheit auf irgendeine Weise mit der Ermordung eines politisch aktiven Rappers in Zusammenhang steht, der immer wieder

🔲 **Abb. 3** Juliette Lewis (Faith), Michael Wincott (Philo). (Quelle: Cinetext Bildarchiv)

Songs gegen das Los Angeles Police Department verfasst und vorgetragen hatte. Iris hatte, kurz bevor sie ermordet wurde, in Lennys Auto eine SQUID-Kassette deponiert. Als Lenny und Mace die Kassette aus dem Auto nehmen, werden sie von zwei Polizisten gejagt, die offenkundig darauf abzielen, sie auf jede erdenkliche Weise zum Schweigen zu bringen. In der Intrige, die die zweite Hälfte des Films bestimmt, wird deutlich, dass Max keineswegs als Freund von Lenny agiert und dass Iris und Faith in die Geschehnisse um die Ermordung des Rappers verwickelt waren; Faith scheint daher von einem ähnlichen Schicksal wie Iris bedroht zu sein. Diese Erkenntnis weckt erneut Lennys schützerische Instinkte gegenüber Faith, die ihn allerdings brüsk zurückweist. Max verbreitet das Gerücht, dass die Ermordung des Rappers auf das Konto von Todesbrigaden innerhalb der Polizei von Los Angeles geht. Als Lenny und Mace endlich dazu kommen, den Inhalt der Kassette in Erfahrung zu bringen, die Iris in Lennys Wagen deponiert hatte, erleben sie die Tötung des Rappers mit: Iris hatte in Philos Auftrag, als lebender Tape-Recorder, aufgenommen, dass diese im Rahmen einer banalen Polizeiaktion stattgefunden hatte. Zwei Polizisten hatten das Auto des Rappers angehalten, in dem sich auch zwei seiner Freunde sowie Iris und ein anderes Mädchen befanden. In der Auseinandersetzung, die diesem Anhalten folgte, wurden die Männer und das Mädchen von den Polizisten getötet, während Iris die Flucht gelang. Mace erkennt die Bedeutung der Aufnahme und möchte sie unter allen Umständen politisch zum Einsatz bringen. Zunächst möchte Lenny die Kassette als Lösegeld für Faith nutzen, schließlich aber gibt er nach und empfiehlt Mace, die Kassette Strickland, einem ehrlichen Polizisten, zuzuspielen. Mace gelingt dies auch. Lenny wird erneut eine Kassette zugespielt; diesmal scheint sie die Vergewaltigung und Ermordung von Faith zu beinhalten. Es folgt jedoch die Erkenntnis, dass diese Kassette ein Spiel zwischen Faith und Max wiedergibt, die eine Beziehung aufgenommen haben, und dass Max ständig ein Doppelspiel gespielt hat und auch der Mörder von Iris ist. Als er auch Lenny töten will, kommt Mace dazwischen, und auch Faith stellt sich wieder an die Seite von Lenny. Max wird getötet und Mace macht sich auf die Suche nach den Mordpolizisten. Schließlich gelingt es ihr, die beiden zu stellen und durch

das Eingreifen des „guten" Kommandanten Strickland kommt der Plot zu einer guten Lösung, die Hoffnung für das nächste Jahrtausend aufkommen lässt. Auch Lenny und Mace scheinen schlussendlich zueinander zu finden.

Virtuelle und gesellschaftliche Realität

Da wir uns mit dem Streifen im Kontext virtueller Realitäten auseinandersetzen wollen, ist es zunächst notwendig, der Frage nachzugehen, auf welche Weise Bigelow die Möglichkeiten und Probleme der virtuellen Realität zur Darstellung bringt – und inwieweit die von ihr dargestellte Technologie dem Prinzip der virtuellen Realität entspricht.

Den Überlegungen wird die Definition von Linda Williams zugrundegelegt, wonach unter virtueller Realität jede illusionistische Reproduktion zu verstehen ist, die Realität eher simuliert als repräsentiert. In diesem Sinn kann man alle Bilder, seien sie analog oder digital, als Formen der virtuellen Realität begreifen. Andererseits scheint virtuelle Realität etwas zu bieten, das die anderen Repräsentationen und Simulationen nicht enthalten, nämlich die Illusion, sich in der Welt des Cyberspace aufzuhalten und in dieser mit ihr selbst und mit den Körpern, die in ihr platziert sind, in Interaktion zu treten.

Das Instrument der virtuellen Realität: „Jacking in"

Bigelow erfand für ihren Film die sogenannte SQUID-Technologie als ein neues Instrument zur Vermittlung einer speziellen Form der virtuellen Realität. Die Sensationssucher in ihrem fiktiven Los Angeles an der Wende zum nächsten Jahrtausend finden ihr ultimatives High-Erleben in der Verwendung eines SQUID-Apparats („Superconducting Quantum Interference Device"). Dieser Apparat, eine Art Hirnwellen-Transmitter, wird auf den Schädel aufgesetzt und ermöglicht es, in die Erfahrungswelt einer anderen Person oder in die eigene Erinnerungswelt einzutauchen. Diese Erfahrungen sind auf Mini-Discs gespeichert, die dadurch entstehen, dass Personen als lebende Aufnahmegeräte ihrer eigenen Sensationen fungieren. Die SQUID-Software nimmt die Erfahrungen auf und spielt sie ab. Die Übermittlung der Erfahrung läuft sozusagen auf kürzestem Weg zwischen Hirnrinde der aufzeichnenden Person und Hirnrinde des Empfängers/Konsumenten ab. Dem Käufer/Konsumenten dieser Trägermedien wird es dadurch ermöglicht, Momente aus dem Leben anderer Personen mit allen emotionellen und affektiven Begleiterscheinungen so zu erleben, als ob es die eigenen wären. Der Apparat des SQUID erlaubt es, alles mitzuerleben, was die Person, von der die Aufnahme der eigenen Erfahrung gemacht wurde, zur Zeit dieser Aufnahme gesehen, gehört, gefühlt und gedacht hat. Der Gebraucher kann alles empfinden: sexuelle Erfahrungen, Drogenerfahrungen, selbst Todeserfahrungen. Weitere Möglichkeiten der SQUID-Technologie bestehen darin, dass durch bestimmte Kopplungen und Schaltungen die Erfahrungen anderer, in die Situation verwickelter, Personen mit vermittelt werden können und dass der Gebraucher in die Erfahrung bzw. Erinnerung einer anderen Person eingebaut werden kann. Auch der Gebrauch zum Zweck der lebhaften Aufrechterhaltung bestimmter Erinnerungen ist möglich, ebenso die ständig erneute Erfahrung der Reaktion Anderer in der zwischenmenschlichen Kommunikation und in sexuellen oder erotischen Kontexten.

In der Story wird gezeigt, dass die Entwicklung dieser Technologie zunächst sicherheitspolitisch motiviert war und der Kontrolle dienen sollte, dass aber rasch die drogenähnlichen Möglichkeiten der SQUIDS erkannt wurden und sie in den hedonistischen Untergrund gelangten. Seither werden sie in verschiedenen Segmenten des illegalen Markts angeboten. Dabei steht, entsprechend den Bedürfnissen der Konsumenten, ein breites Spektrum von Erfahrungskategorien zur Verfügung, die durch diese SQUID-Technologie vermittelt werden können. Das Spektrum reicht von banalen Wünschen aus dem Alltagsleben bis hin zu äußerst extravaganten Wunschvorstellungen. Ein Hauptsegment stellen erotische Erfahrungen in weitestem Sinn dar. Weiter kursieren auch „Black Jacks" auf dem Markt, worunter SQUID-Äquivalente von „Snuff-Filmen" zu verstehen sind. Diese Black Jacks wieder sind in zwei Kate-

gorien unterteilt. Eine Kategorie umfasst Produkte, in denen die Person, die als Aufnahmegerät für die Software diente, starb, während die Aufnahme lief (wodurch der Betrachter der Software das Gefühl vor und während des Todes erfahren kann), die zweite umfasst die subjektive Wahrnehmung des Täters, während er seine Tat ausübt; über eine Verbindungsschaltung sind eventuell auch die Reaktionen des Opfers zu spüren. Wie bei allen anderen Sujets des SQUID-Materials geben die Aufzeichnungen ein reales Geschehen wieder. Auch bei den Black Jacks müssen die horriblen Geschehnisse im realen Leben stattgefunden haben, um mittels der Hirnstromwellen des Missetäters und seines Opfers aufgenommen werden zu können.

Der Film beginnt mit einem furiosen Beispiel der erstgenannten Black Jack-Variante, mit dem uns Katheryn Bigelow in die Wirkungsweise der SQUID-Apparatur und in die Erfahrungswelt Lennys einführt.

Lenny selbst hält sich aus dem Vertrieb der Black Jacks heraus. Dennoch spielen die Snuff-Varianten der SQUID-Technologie in der Dramaturgie des Films und in der Entwicklung der Story eine wesentliche Rolle. Des Weiteren dienen sie auch der Reflexion der Möglichkeiten des filmischen Mediums. Die Sequenz über den Mord an Iris enthüllt die komplexen Möglichkeiten der SQUID-Technologie. Der Mörder bringt das Opfer dazu, mittels subjektiver Kamera die Erfahrung der Vergewaltigung an ihr selbst mit der Erfahrung des Vergewaltigers zu teilen und kann dann Lenny Nero die Aufnahme senden, sodass dieser die Erfahrung des Opfers von der subjektiven Erfahrung des Mörders von der von ihm verübten Vergewaltigung teilen kann. Gleichzeitig enthält die Sequenz aber auch eine Reflexion über die Gestaltungsmöglichkeit des Kinos, insbesondere in Hinsicht auf Gewaltdarstellungen, ihre Bedeutung und ihre Fragwürdigkeit.

Die SQUID-Technologie als Variante einer Techno-Droge

Die SQUIDS ersetzen in der dystopischen Vision des Los Angeles vor der Jahrtausendwende keineswegs die traditionellen Konsumrituale der Freizeitkultur, sondern erweitern lediglich das Angebot. Im Pleasure Dome der Cybergrunge-Generation, metaphorisch „Retinal Fetish" genannt, werden elektronische Medien, SQUIDS und Drogen jeder Art in austauschbarer Form und auch gemeinsam genutzt. „Jacking in" wird in dem Film als ein Verhalten präsentiert, das große Analogien zum illegalen Drogengebrauch aufweist. Diese Analogien schließen sowohl die gesellschaftliche Dimension des Zusammenspiels von Angebot und Nachfrage innerhalb einer illegalen Szene ein, wie auch die Bedürfnisse der Gebraucher und die Darstellung des Initialeffekts des „Jacking in", der wie ein Flash-Erleben abgebildet wird. Wie bei illegalen Drogen ist die Anwendung illegitim; es besteht ein illegaler Markt illegaler Angebote für illegale Nachfrage. Wie beim Umgang mit Drogen bestehen verschiedene Gebrauchsmuster mit verschiedenen Risikoniveaus. Einerseits wird ein relativ risikofreier Raum der Anwendung gezeigt, gleichzeitig besteht aber auch kein Zweifel daran, dass es „weiche" und „harte" SQUIDS (Black Jacks) gibt und dass es Bereiche gibt, in denen ein „Konsumrisiko" entsteht. Die „Überdosis" kann zu Wahrnehmungsverzerrungen, Illusionen, zu Paranoia führen. Der Apparat kann auch missbraucht werden und zerstörerischen Absichten dienen. Wird das SQUID-Wiedergabegerät mit einem speziellen Verstärker gekoppelt, kann das Hirn des Gebrauchers verkocht werden.

Lenny selbst und seine Kunden werden in einer Weise zur Darstellung gebracht, wie wir sie sonst aus Drogenfilmen kennen. Lennys Verhalten als SQUID-Händler entspricht dem romantischen Klischee des Dealers als Freund und Verführer:

💬 „Ich geb dir alles, das du willst. Du musst mir's nur sagen. Ich bin dein Priester, dein Psychiater, deine Hauptverbindung zum Schaltpult der Seelen. Ich bin der Magier, der Weihnachtsmann des Unbewussten. Du sagst es, du musst nur dran denken und du kannst es haben …"

Lennys Abhängigkeit

Lenny entspricht weitgehend dem Klischee eines selbst von seiner Ware abhängigen Dealers. Lustvoll gibt er sich in seinen SQUID-Sessions der schier unendlichen, immer gleichen Repetition seinen Erinnerungen hin.

An ihm wird verdeutlicht, dass die SQUID-Technologie, nicht anders als bestimmte Drogen, eine Flucht aus der Realität in Wunschbezirke ermöglicht und dass auch der „weiche" Gebrauch der Technologie bestimmte Gefahren in sich birgt: Er zieht Derealisierung und Abhängigkeit nach sich.

Allerdings ist die SQUID-Abhängigkeit komplexer Natur. Man könnte sagen, dass die Konsumenten nicht vom Apparat allein abhängig sind , sondern von ihren Erinnerungen, von ihrem Bedürfnis, ihre Erfahrungsdimension zu erweitern und ihre Identität kurzfristig zu tauschen, demgemäß auch von sich selbst und von anderen Menschen und deren Erfahrungen. Diese Thematik wurde auf ganz andere Weise von Samuel Beckett vorgezeichnet, der in seinen Stücken „Endspiel", „Glückliche Tage" und „Das letzte Band" diese Abhängigkeit von glückhaften Erinnerungsspuren nachzeichnete, wobei in „Das letzte Band" ebenfalls eine Technologie, das Tonband, als Träger und Widerspiegler der Erinnerung fungiert. Lenny produziert seine eigene virtuelle Realität, in der er an seine Vergangenheit gebunden bleibt und in der er beständig ein Phantom umarmt. Die SQUIDS benutzt er, um diese Vergangenheit aufrecht zu erhalten und um zu verhindern, dass Erinnerungen verblassen. Letztlich ist es dieser Prozess der Abhängigkeit von sich selbst, der ihn auch an seine Rolle innerhalb seines privaten Film Noir bindet.

An Lennys Schicksal wird verdeutlicht, dass die Anwendung des SQUID als situationstypische narzisstische Rückzugsfigur aus einer paranoid-depressiven Welt verstanden werden kann, in der zwischenmenschliche Begegnung, insbesondere sexuelle Kontaktaufnahme, bedrohlich geworden ist und in der auch das Begehren nach der Erfahrung des Anderen nur mehr als quasi-halluzinatorische Wunscherfüllung und in narzisstischer Transformation möglich ist.

In kritischen Stellungnahmen zu Lennys Lebensweise werden zwei Analogien zum SQUID verbalisiert. Philo, der neue Lebensgefährte von Faith, nennt ihn „Altwarenhändler, der gestohlene Träume verhökert", Mace bezeichnet ihn als Anbieter von „Porno für verdrahtete Köpfe".

In welcher Beziehung stehen die SQUID-Tapes zu den beiden Phänomenen Traum und Pornografie?

SQUID und Träume

Die SF-Fantasie vom SQUID repräsentiert sowohl eine Lesart der Träume wie auch der medial vermittelten „Wirklichkeit" und der Auswirkung der beiden Phänomene auf Bewusstsein (Geist) und Körper der Rezipienten.

Die SQUID–Apparatur soll die Erfahrung, einschließlich der psychosomatischen Reaktion, einer anderen Person vermitteln. Damit soll sie einen kurzfristigen (zeitlich beliebig andauernden) Identitätswandel ermöglichen. Sie steht damit dem Traum näher als dem Film, dessen Impakt auf die psychosomatische Ganzheit geringer ausgeprägt ist. Eine Analogie zum Traum wird auch dadurch hergestellt, dass die SQUID-Erfahrung voraussetzt, dass man die Augen schließt. Sie korrigiert die Traumaktivität aber insofern, als der Inhalt der SQUID-Erfahrung gewählt werden kann, der der Umsetzung eines bewussten Wunsches und einer bewussten Zielsetzung entspricht. Damit setzt sie die Persönlichkeit nicht dem Risiko des Traumes aus, dass unbewusste Wünsche und Vorstellungen, die ins Bewusstsein drängen, schockhafte Erfahrungen auslösen. Selbst die Albträume, die SQUID vermittelt, sind selbst gewählt.

SQUID, Erotik und Pornografie

Fundamental erscheint zunächst Linda Williams Auffassung, dass prinzipiell ein Bezug zwischen virtueller Realität und pornografischen Erzeugnissen besteht: Wenn der Erotismus der virtuellen Realität darin bestehe, dass man mit jemandem „Sex habe", der nicht da ist, dann treffe das in gewissem Sinn auf jegliche Pornografie zu, die sich laufender Bilder bediene (Williams 1999).

In *Strange Days* werden mehrfach Analogien textlicher und formaler Art zwischen der SQUID-Technologie und der Produktion und Rezeption von erotisch explizitem Material hergestellt. Darüber hinaus bedient sich Bigelow bei der Gestaltung des Films entsprechender Inszenierungen. Das führte zu einer Kritik an der formalen Gestaltung des Films. Es wurde darauf hingewiesen, dass bestimmte Szenen des Films an alte, sogenannte Dokumentarfilme über Pornografie erinnern, in denen es „o. k." war, pornografisches Material nicht als Selbstzweck, sondern zur Unterstützung des dokumentarischen Werts zu veröffentlichen. Insbesondere wurde kritisch vermerkt, dass Bigelow snuff-artiges Material in ähnlicher Weise verwende.

Im Film wird Lenny nicht nur wie ein Drogendealer, sondern auch wie ein Porndealer dargestellt. Mace bezeichnet seine Aktivitäten als „peddling sleaze". Sie fragt ihn auch, ob er wieder einmal „Pornos für ‚wireheads'" zu verkaufen habe. Tatsächlich umfasst Larrys thematisches Angebot erotische und sexuelle Sujets. Auch er selbst als Konsument seiner eigenen Tapes schwelgt in aufgezeichneten erotischen Erinnerungen. Weiter werden die Akteure, die ihm als lebende Aufnahmegeräte dienen, in einen Kontext gerückt, wie er der pornografischen Produktion nachgesagt wird. So steht etwa das Mädchen, das ihm eine erotische Szene liefert, deutlich unter Drogeneinfluss. Eine Aussage Larrys über seine „präventive" Funktion entspricht der Bedeutung, die man in der Zeit der Entstehung des Films der Pornografie als „Risk Reduction"-Strategie im Kampf gegen die Ausbreitung von AIDS zuordnete, als der „erzieherische Wert" von Pornos neu bewertet wurde (Butler 2004). Die SQUID-Technologie passt in eine Epoche, in der man nach risikofreien Lustbezirken jenseits sexueller Begegnungen forschte und in der selbst Michel Foucault (11982; 2005) eine Utopie von guten Drogen entwarf, die intensive Lusterfahrungen außerhalb der Sexualität ermöglichen sollten.

Ein weiterer Bezug zur Pornografie ist in der „Snuff"-Thematik gegeben. Obwohl im illegalen Raum angesiedelt, grenzt Lenny sich von „Snuff" ab und verhält sich insofern wie ein gebräuchlicher Produzent oder Händler von Mainstream-Pornos. Er möchte der „Magic Man" sein, ein Vermittler von (erwünschten) Grenzerfahrungen, aber nicht von Erfahrungen, die geeignet sind, einem den ganzen Tag zu verpatzen: „I hate the zap when they die", sagt Lenny selbst, als er in der Eingangssequenz in die Todeserfahrung involviert wird.

Bezüge zwischen SQUID, Pornografie und Snuff sind in dem Film also reich vertreten. Ist aber deshalb die erotische Welt der SQUIDS der virtuellen Pornografie zuzuordnen? Laut Williams (1999) scheint die Besonderheit der virtuellen Pornografie darin zu bestehen, dass es eine paradoxe Anwesenheit im Cyberspace („a cyberspace ‚there'") gibt, die eine Flucht aus der Präsenz und der Unmittelbarkeit des menschlichen Körpers zu ermöglichen scheint.

Nun zeigt Bigelow in *Strange Days* einen heftigen Impakt der Technologie auf den Körper, der nicht in dem Sinn manipulierbar ist, wie es für den Gebrauch virtueller Erotik kennzeichnend ist. Die Person, die ein SQUID-Tape erfährt, kann die Erfahrung nicht über einen Schalthebel manipulieren, und sie kann auch nicht mit einer andern Person im Cyberspace in Interaktion treten. Damit entspricht die SQUID-Erfahrung nicht den beiden elementaren Charakteristika des „Cyberporn". Die SQUID-Erfahrung ist an die Erfahrung der Realität der Andern gebunden, ist ihr ausgeliefert. Dieser Zustand kann nicht verändert werden; er kann nur beendet werden, indem der Gebraucher des Apparats diesen vorzeitig ablegt. Insofern ist die SQUID-Erfahrung in ihrer Körperlichkeit der traditionellen Erfahrung pornografischen Materials näher als dem Gebrauch virtueller Erotik. Williams hat bereits früher filmische Genres identifiziert, die „auf den Körper wirken": Melodram, Horror, Pornografie. Und sie zeigt

auch auf, dass das Bedürfnis nach traditioneller Pornografie stets aus den Quellen gespeist ist, die auch die Konsumenten der SQUID-Tapes zu motivieren scheinen:

> As a porn consumer who seeks to stimulate my sensorium, I find that moves me the most is the one form that has probably never considered my response: Gay male porn."..."At least some of the fun of porno is watching sexual play that is different from what we may actually do.

Und Williams wagt eine Prognose:

> ... it seems more apt to assume that pornographies are becoming part of the process by which spectators discipline themselves to enjoy different varieties of visual and visceral pleasure – pleasures that are both produced in the imagination and felt in the body.

Man kann sich des Eindrucks nicht erwehren, dass die SQUID-Technologie gerade diesem Bedürfnis entgegenkommt, das eben nicht in den Räumen der virtuellen Realitäten anzusiedeln ist, sondern im psychosomatischen Raum der erotischen Begierde. Insofern stellt sich die Frage, welche Bedeutung der virtuellen Realität in *Strange Days* zukommt, ob wirklich dieses Phänomen thematisiert und problematisiert wird.

Sehen mit dem Körper

Die Darstellung des körperlichen Impakts der SQUID-Erfahrung ist von Interesse für das filmtheoretisch-psychoanalytische Verständnis des Films. Die psychoanalytische Filmtheorie fokussiert in ihrer Interpretation der Wahrnehmung des Films, der triebdynamischen Implikationen des Wahrnehmungsprozesses sowie der von ihm ausgelösten psychosexuellen Mechanismen auf das Auge. Verwiesen sei auf die klassische Interpretation von Laura Mulvey (1989), wonach die subjektive Kameraführung in den Filmen Hitchcocks in besonderer Weise den „männlichen Blick" forciere und den Zuschauer in die Rolle des männlichen Protagonisten versetze, damit keine „weibliche Betrachtungsweise" zulasse. Mulvey rückte bekanntlich von einer feministischen Position aus diese These in den Kontext der Auseinandersetzung zwischen den Geschlechtern. Die Frau stelle für den Mann sowohl sexuelle Faszination wie auch Katrationsdrohung dar. Der letzteren wolle der Mann durch Schuldzuweisung und/oder Fetischisierung entgehen. Und letzterer diene auch der „männliche Blick" des Kinobesuchers.

In einer der wenigen verfügbaren ernstzunehmenden Studien, die sich *Strange Days* widmen, blieb auch Laura Rascaroli (1998) den herrschenden Klischees der psychoanalytischen Fiminterpretation treu, dem Blick eine besondere Bedeutung in der Wahrnehmung und Verarbeitung der optischen Medien zuzuschreiben, und sie überträgt diese Bedeutung auch in ihre Überlegungen zur Rezeption und Wirkung des SQUID-Apparates. Gleichzeitig hebt sie allerdings hervor, dass Bigelow in dem Film die metaphorische Figur eines Kinos, das direkt auf das Gehirn wirke, gefunden habe.

Gegenüber der Bedeutung, die dem (männlichen) Blick in der filmischen Erfahrung zugeordnet wird, scheint die Erkenntnis, dass der Betrachter/die Betrachterin, die den Film „erfährt", ihn mit ihrem gesamten Sensorium, dem ganzen Körper aufnimmt, in der Filmtheorie unterrepräsentiert. Linda Williams (1999) spricht in diesem Kontext kritisch von einem „entkörperlichten Auge/Blick (disembodied eye/gaze)". Für das Verständnis von Strange Days scheint eine alternative Interpretation der filmischen Wahrnehmung von Bedeutung zu sein, die von Vivian Sobchack (2000) eingeführt und von Linda Williams aufgegriffen wurde, wonach der „lebende, betrachtende Leib" als körperliche Dimension eingeführt werden muss, der die Verbindungen zwischen Gesehenem und Sprache, Erfahrung und Bild herstellt, um einen Film (sinnlich) begreifbar zu machen. Sie verweist in einer Analyse des Films The Piano in besonderer Weise auf die Bedeutung des Tastgefühls in der sinnlichen Erfahrung des Films, das durch die optische Wahrnehmung angeregt wird. Sie beschreibt ihre Reaktion auf eine Sequenz in

diesem Film, in der ein Bein durch ein Loch in einem Strumpf berührt wird. Diese Szene habe in ihr einen „taktilen Schock" bewirkt. Dieser Schock habe nicht auf der identifikatorischen Illusion beruht, dass sie selbst das Bein berührt habe. Vielmehr habe er ihr die allgemeine erotische Bedeutung des Fleisches eröffnet, und sie habe sich – ambivalent – und in diffuser Weise als die beiden Körper der handelnden Personen empfunden, die Aufhebung der Grenze zwischen dem „filmischen" Körper und dem „eigenen" Körper erlebt. Ihre Finger waren gleichzeitig berührt und berührend.

Linda Williams (1999) erkennt dieser phänomenologisch-analytischen Zugangsweise besondere Bedeutung für das Verständnis der Reaktion auf das Betrachten pornografischer Inhalte zu:

> Here is a model of visual pleasure that includes the visceral, a model that does not limit itself to the disembodied eye – one in which all the senses of a body, on the rebound from an attraction toward a moving image are implicated. It is a model that certainly fits the diffuse yet powerful encounter with one's own flesh entailed by watching moving.image pornography. And it is a model that could prove more useful than that of a disembodied and distanced „male gaze" so frequently employed to describe the „phallic mastery" of objectified bodies on the screen.

Dieser medientheoretische und feministische Diskurs läuft in den Universitäten von Los Angeles und Berkeley ab. Es ist fast anzunehmen, dass Bigelow mit ihm vertraut war, als sie ihren Film gestaltete und dass sie ihn in ihrer Darstellung der geschlechtsbezogenen Bedürfnisse der SQUID-Konsumenten und der Reaktionen, die die Erfahrung der SQUIDS auslösen, berücksichtigte. Diese Darstellung ist weit davon entfernt, einen distanziert-objektivierenden Blick auf die Geschehnisse zu vermitteln. Vielmehr bringt sie eine totale sensuelle Erfahrung in einer die geschlechtliche Differenzierung egalisierenden passiven Überwältigung anschaulich zur Darstellung.

Das Medium, der Blick, das Gehirn, der Körper

Gerade in diesem Aspekt scheint eine besondere Bedeutung des Filmes und des Einsatzes des Prinzips der virtuellen Realität zu liegen. Mit dem SQUID ist ein Apparat gefunden, der die Hegemonie des Blicks und damit die phallische Interpretation der Betrachtung des Films infrage stellt. Die Erlebnisse, die im SQUID aufgezeichnet sind, werden nicht vom Auge wahrgenommen, setzen geschlossene Augen voraus. Sie umgehen das Auge und wirken direkt im visuellen Cortex, aber auch in anderen Hirnarealen, die der Wahrnehmung und der emotiven Reizantwort dienen. Damit unterliegen beide Geschlechter in gleicher Weise einer „non-genderisierten" passiven Aufnahme der vermittelten Erfahrung. Sowohl Lenny wie auch der anonyme Kunde, das „jungfräuliche Gehirn" und Tick, der Kurier der SQUID-Erfahrungen, werden in orgasmischen Reaktionen abgebildet, die diesen Impakt beweisen. Da kann keine Rede sein von einer aktiven aggressiven Bewältigung der Bilder. Insofern stellt die Darstellung Bigelows die vorhin erwähnte feministische These der Filmrezeption infrage.

Das Subjekt, das aktiv seine SQUID-Erfahrung gewählt hat, wird zum eigenen Objekt durch die passive Aufnahme und das sinnlich-emotionale Miterleben der Erfahrung der Anderen. Diese Sensation, die darin besteht, eine andere Person zu sein und die die Aufgabe der eigenen Subjektivität und Identität zwecks der Erfahrung anderer Identitäten als notwendige Voraussetzung hat, ist ein zentrales Anliegen und ein zentraler Lustfaktor der SQUID-Erfahrung. Es ist wohl kein Zufall, dass die Initiation des „jungfräulichen Gehirns" durch die Probekassette die Erfahrung eines temporären Geschlechtswandels impliziert.

Bigelows Film durchzieht somit eine subversive Ambivalenz gegenüber feministischen Positionen. Einerseits konterkariert sie das Klischee der männlich-phallischen Dominanz, das einen Grundstein der feministischen Filmtheorie bildet, andererseits wird durch die spezifische Nutzung des Prinzips der virtual reality die darin inhärente Möglichkeit genutzt, die maskuline Dominanz noch weiter infrage zu stellen. Die Vorstellung der männlichen Dominanz wird auch in der Kontrastierung des „weiblichen"

Realitätsbezugs, der durch Mace repräsentiert wird, und des Bezuges von Lenny zur virtual reality, der wesenhaft auf einer fragilen männlichen Identität errichtet zu sein scheint, unterlaufen. Generell sind in dem Film die männlichen Charaktere zwar eventuell brutal, aber gleichzeitig schwach, von der Sehnsucht nach Identitätswechsel erfüllt und ambivalent hinsichtlich ihrer geschlechtlichen Identität. In dem Plot scheint keine einzige männliche Gestalt auf, die auch nur annähernd eine stabile Identität und einen ungebrochenen Bezug zur „wirklichen Wirklichkeit" aufweist, wie dies bei Mace der Fall ist. Die Persönlichkeit des „guten" Übervaters Stricklands, der als „deus ex machina" fungiert, ist nicht ausreichend charakterisiert, um hier einen Ausgleich zu schaffen.

Virtual reality, reality, gender: der ödipale Triumph

Bigelow ist ständig bemüht, auf die Differenz zwischen virtueller Realität und der „Realität der Welterfahrung" hinzuweisen. Diese Differenzierung gebraucht sie sowohl für ihre Grundaussage als auch für die Charakterisierung ihrer Protagonisten.

Die „Wirklichkeit", in der sich die Protagonisten der Story bewegen, entspricht einem Katastrophenszenario. Die Umwelt der Protagonisten wird in einer Weise dargestellt, dass man den Eindruck einer Gesellschaft im Belagerungszustand, einer besetzten Nation, gewinnt, einer Gesellschaft unter Observanz, in der das Auge der Kamera und die Lichter der Polizei die Realität definieren. Die Silvesternacht 2000 kann ein Fest sein oder ein Kriegsschauplatz: oder beides. Oder es kann das eine ins andere übergehen. Die Feuerwerksraketen klingen wie automatische Waffen. Es soll die Party des Jahrhunderts sein. Aber wir fühlen uns in eine Situation versetzt, die dem Ausbruch einer Revolution in der dritten Welt entspricht. Außerdem beherrschen Gangs die Straßen, schützen bewaffnete Limousinen die Reichen, und der Weihnachtsmann wird auf dem Hollywood Boulevard überfallen.

Diese Welt ist dominiert von Paranoia.

> 💬 „Paranoia' ist nichts anderes als Realität – auf einer feineren Messskala" sagt einer der Protagonisten des Films. Und ein anderer: „Es ist nicht die Frage, ob du paranoid bist. Vielmehr musst du dich fragen, ob du paranoid genug bist."

Bigelow findet zu einer Vielzahl von Metaphern, die diesen Zustand beschreiben und illustrieren sollen. So wird der Raum der Disko „Retinal Fetish" mit Videos bestrahlt, die als „MTV baptized by William Burroughs" charakterisiert werden.

Für die Protagonisten ergibt sich die Möglichkeit, dieser Realität zu entfliehen, oder sie zu erkennen, sie anzunehmen, sie zu bewältigen, sie zu verändern. Die letztere Position, innerhalb der „wirklichen" Realität wirksam zu werden, wird von Mace „der Keule", der weiblichen Protagonistin, vertreten. Sie wird als Vertreterin/Hüterin der Realität eingeführt. Sie stellt sich den Problemen ihrer individuellen und gesellschaftlichen Wirklichkeit und vertritt die Position der realen Erkenntnis:

> 💬 „Larry, das ist dein Leben. Jetzt und hier. Das ist reale Zeit, kein Playback. Es ist Zeit, sich in diese Realität einzuklinken. Erinnerungen sind dazu bestimmt, zu verblassen. Und das hat seine guten Gründe."

Ihre gefestigte Identität trägt dazu bei, dass Mace nicht den Impuls spürt, aus einer unerträglich werdenden „Realität" zu fliehen, sondern aus ihrer Erkenntnis den Wunsch zur Veränderung zu schöpfen. Sie lässt sich nicht selbst verändern, passt sich nicht dem inneren Druck nach Anpassung an, in ihr bringt auch die Konfrontation mit den Möglichkeiten der virtuellen Realität, die erste Erfahrung des SQUID-Apparats, das Bedürfnis nach Veränderung der äußeren Realität zum Durchbruch. Sie ist imstande die Realität zu erfassen, die von dem Apparat vermittelt wird und deformiert sie nicht zu ihrer eigenen selbstgeschaffenen virtuellen Realität.

Lenny hingegen, der männliche Protagonist, hat „alles erfahren …" – und sucht nunmehr den „easy way out", stellt sich der Fluchtbewegung, die das Eintauchen in virtuelle Realitäten ermöglicht, zur Verfügung, ergibt sich ihr, verfällt ihr. Die Nutzung der virtuellen Realität beinhaltet eine Identitätsdiffusion, ein lustvolles Wechseln zwischen Identitäten. Die SQID-Technologie ermöglicht Erfahrungen, die die Begrenztheit der eigenen Identitätsentwicklung in individueller wie professioneller Hinsicht ebenso wie die Grenzen gesellschaftlicher Regulierungen außer Kraft setzen. Ganz wesentlich erscheint auch, dass die Begrenztheit der geschlechtlichen Identität überschreitbar wird. Erotische Erfahrung wird „trans-genderisiert", was offenkundig als grundsätzliches narzisstisches Bedürfnis angenommen wird.

Gleichzeitig kann die SQID-Erfahrung aber auch dem Bedürfnis dienen, traditionelle obsolete geschlechtsbezogene Identitäten und Rollen aufrecht zu erhalten. Lenny zum Beispiel versetzt sich in seiner virtuellen Wunschwelt immer wieder in die traditionelle Rolle des männlichen Liebhabers und Geliebten, Unterstützers und Beschützers und ist verzweifelt bemüht, diese Rolle auch in der Realität aufrecht zu erhalten. Damit ist er auch bestrebt, das gesellschaftliche Rollenklischee aufrecht zu erhalten. Er hält der ungetreuen „Faith" die Treue, er folgt seinem Beschützerinstinkt, verweigert es, zur Kenntnis zu nehmen, dass diese Haltung nicht mehr gefordert wird.

Rollen, insbesondere Geschlechtsrollen, zu hinterfragen, wird dementsprechend als wesentliches Charakteristikum des Films erkennbar. Auch Mace ist eine Gestalt, die diese Grenzen andauernd überschreitet, bzw. die Rollendifferenz egalisiert; aber sie gibt deshalb nicht ihre grundsätzliche „ödipale Position", ihre geschlechtliche Differenziertheit und Identität auf. Sie verspürt auch kein Interesse daran. Sie lebt in der Realität einer Frau und in den diversen Rollen, die diese Realität vermittelt. Sie ist Mutter, Ehefrau, Liebende und zuletzt Geliebte, ist aber den Männern ebenso wenig ausgeliefert wie der Gewalt, die sie umgibt. Sie muss nicht beschützt werden, sie wird selbst zur Beschützerin und wendet Gewalt an, wo sie notwendig wird. In ihrer Sprache überschreitet sie ebenfalls Rollenklischees, indem sie Sprachmuster entwickelt, die dem Stil der „männlichen" Rapper entsprechen: „You are a pussy-whipped sorry-ass motherfucker, you know that?"

In diesem Sinn ist sie eine „androgyne" Gestalt, die jedoch niemals ihre basale Weiblichkeit verleugnet. Ganz im Gegenteil: Ihre Weiblichkeit wird Lenny klar, als sie in „weiblicher" Kleidung eine „männliche" Geste setzt. Im Drehbuch, nicht im Text des Films in seiner endgültigen Gestalt, erkennt Lenny zum ersten Mal Mace als Frau, als sie sich eine Pistole in einen Pistolenhalter steckt, der an einem ihrer Beine angebracht ist, – der möglicherweise maskulinsten Szene, die je von einer Schauspielerin gespielt wurde, wie in einem Kommentar zum Film geschrieben wurde (Mirasol 2010). Diese Geste entspricht jener der Monroe, wie sie sich in *Some Like It Hot* eine Whiskyflasche in ihren Strumpfgürtel steckt. Lenny schaut auf Mace, wagt einen zweiten Blick und ist betroffen von der plötzlichen Erkenntnis: „Mace, du bist ein Mädchen." Worauf Mace im Drehbuch reagiert: „Gut, Lenny; ich versteh jetzt, warum du kein guter Detektiv bist. Komm weiter." Im Film, wie wir ihn sehen können, ist diese Szene entschärft. Lenny sagt zu Mace, dass sie in ihrem Kleid gut aussehe, wofür Mace sich entsprechend erfreut bedankt.

Für Lenny ist diese „ödipale" Erkenntnis offenkundig ein wichtiger Entwicklungsschritt aus der SQUID-Abhängigkeit. Sie hilft ihm, sich aus seiner narzisstischen Erstarrung zu lösen und der Aufforderung und Anforderung nachzukommen, sich der Realität zu stellen. Dieser Entwicklungsprozess wird in der dramaturgischen Entwicklung nachgezeichnet. Lenny möchte das Tape über den polizeilichen Übergriff zunächst gemäß seiner Position innerhalb seiner virtuellen Realität, seiner Rolle im Film Noir, nutzen. Indem er sich dafür entscheidet, es der „wirklichen Realität" und ihrer Bewältigung und progressiven Veränderung zur Verfügung zu stellen, wird er frei, seine Rolle innerhalb des Film Noir anders zu gestalten, aktiv zu kämpfen und die „narzisstische Nabelschnur", symbolisiert durch seine Krawatte, zu durchtrennen. Dieser Befreiungsakt beendet seine Verhaftung an seine virtuelle Realität und damit seine Partizipation im privaten Film Noir und ermöglicht es ihm, eine neue Rolle als realer männlicher Partner einer realen Frau zu übernehmen, mit der gemeinsam er dazu beitragen kann, für eine bessere Zukunft zu arbeiten.

Es kann angenommen werden, dass diese Überschreitung der Geschlechterklischees auch die Position Katheryn Bigelows bezeichnet, sie selbst sich in Mace repräsentiert. Bigelow hat den Film in einer Weise gedreht, die in Manchem einer Sichtweise entspricht, wie wir sie von männlichen Filmemachern kennen. Die Bereitschaft, sich mit der Cyberpunk-Welt in gerade den Bereichen einzulassen, die in *Strange Days* vorgeführt werden, signalisiert eine Bereitschaft, die Grenzen der Geschlechterrollen zu überschreiten und sich in transgressiver Weise mit Sexualpolitik auseinander zu setzen. Das Portrait von Mace entspricht einerseits einer Vorstellung von „Gleichberechtigung zur Härte" in einer männlich dominierten Welt, wie wir sie aus den Werken männlicher Regisseure kennen, andererseits einer weiblichen Sicht, wenn Mace auch als basal weiblich empfindend dargestellt wird. Die Art und Weise, wie Sexualität dargestellt wird, insbesondere die Verschränkung von Sexualität und Gewalt, entspricht Vorstellungen vom „männlichen Blick" und hätte eventuell zu feministischer Kritik geführt, wenn sie in gleicher Weise von einem männlichen Regisseur in Szene gesetzt worden wäre. Schließlich konfrontiert sie mit der Erfahrung eines „Snuff"-Videos und bezieht den Betrachter durch ihren Einsatz der subjektiven Kamera stark in das Geschehen ein. Darüber hinaus „pornografisiert" sie das „Snuff"-Sujet. Indem sie die Reaktionen abbildet, die das Betrachten derartiger Produkte bewirken kann, gewährt sie einen Einblick in ihre Auffassung von der ambivalenten, aber durchaus verführerischen Kraft, die von ihnen ausgeht.

Gleichzeitig lässt sie aber keinen Zweifel, dass derartige Produkte gefährlich sind und nutzt sie, um die Bösartigkeit des Schurken entsprechend zu untermauern.

Virtuelle Realität, Realität, das Kino

Strange Days kann, wie wir gesehen haben, nicht den üblichen Virtual Reality-Produkten zugeordnet werden. Viel eher ist es ein Streifen, der einen Diskurs über VR eröffnet, in dem das Prinzip selbst und seine Technologie genutzt werden, um Reflexionen über die Möglichkeiten, Vorzüge, Gefahren und Grenzen des Mediums Film und seine Wirkungen und Auswirkungen anzubieten. Auch die kritische Darstellung der SQUID-Technologie zielt nur vordergründig auf eine Kritik der virtuellen Realität ab. In diesem Kontext ist beachtlich, wie Bigelow den fragilen Bezug zwischen Realität und Virtualität herausarbeitet, indem sie erkennen lässt, dass jeder SQUID eine Realität transportiert, die erst beim Konsumenten zur Virtual Reality transformiert wird. Dass die Kritik sehr differenziert verstanden werden sollte, geht meines Erachtens daraus hervor, wie die Folgen und Auswirkungen der Konfrontation mit dem Apparat der Virtual Reality dargestellt werden. Die Konsumenten der SQUID-Tapes steigen in ihre selbstgewählte virtuelle Realität ein, indem sie „ihr Gehirn verdrahten", erleben den Ausflug in die Realität eines Anderen, kehren aber wieder in ihre eigene Realität zurück, wenn sie den Apparat ablegen. Hier besteht eine Analogie zwischen der Erfahrung eines Films und einer SQUID-Kassette. Die Gebraucher der SQUIDS werden von ihren Ausflügen in Wunscherfahrungen nicht einschneidend verändert. Die Wunschwelt, die sie verlassen, bleibt als solche bestehen, kann und muss als solche wieder aufgesucht werden. Zum Vergleich sei auf eine andere Variante der filmischen Auseinandersetzung mit Virtual Reality, Cronenbergs *Videodrome* hingewiesen. Cronenberg beschreibt eindrücklich die psychischen und körperlichen Mutationen, die von der Konfrontation mit dem Apparat ausgelöst werden.

Laure Rascaroli kommt in ihrer 1998 veröffentlichten Analyse von *Strange Days* zu einer ähnlichen Schlussfolgerung. Sie versucht darzustellen, dass es Bigelow darum gehe, mit den Mitteln der Virtual Reality ein „transparentes Kino" zu verwirklichen. Als geeignete Demonstration dieses Vorhabens erscheint ihr die Eröffnungsszene des Films, aus der hervorgehe, wie Bigelow die subjektive Kameraführung nutzt, um „die Distanz zwischen Auge der Kamera und dem menschlichen Auge" zu reduzieren. Rascarolis Analyse deckt auf, dass die Analogie zwischen dem SQUID und visuellen Medien den ganzen Film durchzieht und dass das Kino, stärker als das Fernsehen, ein ständiger Bezugspunkt des Films ist. Der Begriff SQUID sei metalinguistisch, weil er das Funktionieren des visuellen Apparats des Kinos reproduziere und spiegele. Wie im Falle des SQUID werde auch im Kino der Apparat von zwei

Maschinen konstituiert: von der Kamera, die Stücke der Realität aufzeichnet und dem Projektor, der die aufgezeichneten Bilder auf die Leinwand projiziert. Die Leinwand wieder reflektiert, wie ein Spiegel, die Projektion auf den Betrachter, als ob sie ein reales Objekt wäre, das von außen betrachtet wird.

Rascaroli meint, dass Bigelow mit dem metaphorischen Prinzip des SQUID eine Art Cyborg der Wahrnehmung kreiert habe, das halb menschlich und halb technologisch sei. Damit sei sie sowohl ihrer eigenen Tendenz, ein zunehmend transparentes Kino zu schaffen, treu geblieben, wie sie auch eine Vision Artauds umgesetzt habe, der ein Kino gefordert habe, das direkt auf die graue Gehirnmasse wirke, ein „Kino der Grausamkeit", das unsere sinnliche Beschaulichkeit zu stören vermag und unsere Verdrängungen aufhebt.

Vom guten und schlechten Gebrauch der Medien

💬 „Versuchs mal und erzähl mir, was du darüber denkst. Vielleicht kannst du heute noch nichts damit anfangen, aber es wird sich in deinem Hirn festsetzen wie Saatgut und in etwas wirklich Schönes auswachsen."

Dies sagt Lenny zu dem sechsjährigen Sohn von Mace, als er ihm eine Kopie von John Coltranes Meisterwerk *A Love Supreme* schenkt.

Diese Sequenz scheint signifikant für die Auffassung, die in *Strange Days* transportiert wird, dass jegliches Medienprodukt in der Erinnerung seine Spuren hinterlässt. Es kann dann gute oder böse Entwicklungen einleiten. Dabei ist nicht von rascher Veränderung die Rede, eher von der langsamen Auswirkung des Intellekts im Sinne Freuds. Dem Film ist zu entnehmen, dass Bigelow und Cameron nicht die Auffassung teilen, dass inszenierte Medienprodukte spontane tiefgreifende Veränderungen in der individuellen und der gesellschaftlichen Struktur auslösen können. Auch das „böse" Produkt mutiert den Konsumenten nicht zum Monster. Daher sind auch die Erfahrungen, die von der SQUID Apparatur vermittelt werden, nicht geeignet, einen spontanen und bleibenden Persönlichkeitswandel einzuleiten. Vielmehr sind sie in ihrer hedonistischen Anwendung eine Möglichkeit, sich der eigenen Wunschstruktur anzunähern, ihr zu entsprechen und ähneln daher in gewissem Ausmaß den Auswirkungen des Konsums pornografischen Materials.

Darüber hinaus erkennen Cameron und Bigelow den Medien jedoch eine gesellschaftliche und individuelle Sprengkraft zu. Daraus ergibt sich in *Strange Days* eine ambivalente Haltung gegenüber der Verwendung des Apparates. Die hedonistische Anwendung ist illegal, naturgemäß auch der Missbrauch zu privaten Kontrollzwecken. Andererseits bedingt gerade der Missbrauch sowohl die private Katastrophe als auch die politische Veränderung zum Besseren, zu einem Zustand, den man sich für das neue Millennium ersehnt, der eine Annahme der Realität ermöglicht und die Flucht in eine apolitische Traumwelt weniger notwendig erscheinen lässt. In den Medien ist die Macht zur Veränderung gegeben, wenn sie eine entsprechende Wahrheit enthalten und wenn diese Wahrheit erkannt und angenommen wird. Dann sind sie mehr wert als alles andere. Diese Erkenntnis lassen Bigelow/ Cameron Mace aussprechen – sie ist die Vertreterin und Hüterin der ödipalen Realität. Letztlich liegt diesem Standpunkt ein historisch reales Geschehen zugrunde, in dem sich die aufdeckende gesellschaftliche Funktion des fotografischen Mediums bewiesen hatte. Cameron soll die Idee zum Film anhand des „Falles Rodney King" gekommen sein, in dem die Aufzeichnung der Übergriffe der Polizei an Farbigen durch eine unbeteiligten Nachbarn eine gerechte Beurteilung des Falles durch die Justiz ermöglichte.

Nathan Wolfson (1996) meinte, dass Bigelows Verwendung des SQUID eine interessante, nahezu selbstreflexive Stellungnahme über die Rolle der Kunst und insbesondere des Films in unserer Gesellschaft repräsentiere. SQUID in seiner Gestalt als Bestandteil des Underground in einer zunehmend auf aggressive Kontrolle erpichten Gesellschaft, die auf einen Polizeistaat zusteuere, sei eine Vision einer

Form der elektronischen Unterhaltung, die einerseits schlechter zu kontrollieren sei als andere elektronische Medien, eventuell aber auch stärker als diese Abhängigkeit erzeuge.

Der Film entließ 1995 die Zuseher mit einem „soft ending", mit der tröstlichen Zukunftsvision, dass es eine Welt gibt und geben wird, in der der Gebrauch der Drogen und der drogenähnlichen Apparate der virtuellen Realität auch eine positive Funktion haben kann. Die Droge muss nur in die richtigen Hände geraten und an die richtigen Gehirne herangebracht werden, um eine Empathie auszulösen, die eine Bewegung in eine bessere Zukunft auslösen kann. Allerdings ist diese Vision ist von mehreren Grundbedingungen abhängig: Da muss es Männer und Frauen geben, die empathiefähig sind und denen dieser gesellschaftliche Wandel etwas bedeutet. Diese Menschen müssen sich aus ihrem narzisstischen Rückzug lösen und dürfen sich nicht in ihren individuellen Nostalgien verlieren. Sie müssen ein Bedürfnis nach zwischenmenschlichem Kontakt und genderisierter Begegnung haben. Und vor allem: In dieser Welt muss es noch „gute" Ordnungsmächte geben, positive Vaterfiguren, die kontinuierlich am Aufbau eines „guten Environments" interessiert sind. Heute, mehr als zehn Jahre nach dem fiktiven Wechsel ins neue Millenium, den *Strange Days* entwarf, sind wir in der Lage zu überprüfen, ob in unserer Zeit Bigelows Hoffnung der Verwirklichung näher gerückt ist, als man es in der finsteren Periode von Los Angeles annehmen konnte, jenen „strange days", deren Erfahrung die Produktion des Filmes anregte: die Hoffnung auf eine Welt, in der es nur vereinzelte „bad cops" gibt, die aus einem System herausfallen, das an sich nicht korrupt ist und von „guten Vätern" geleitet wird, in der die technologische Entwicklung Instrumente bereitstellt, die der sozialen Gerechtigkeit dienen und in der „wahre Liebe" noch verwirklichbar ist.

Literatur

Cameron J, Cocks J (2000) Strange Days. Treatment. http://www.simplyscripts.com/treatments.html. Zugegriffen am 20. 12. 2011

Foucault M (2005) Michel Foucault, ein Interview: Sex, Macht und die Politik der Identität. In: Schriften 4, 1980–1988, Suhrkamp, Frankfurt, S 909–924 (Orig: Sex, power and the politics of identity. Interview by B. Gallagher and A. Wilson, Toronto June 1982. In: The Advocate 40, August 7 1984: 26–30, 58)

Mirasol M (2010) Kathryn Bigelow›s uncanny «Strange Days». Chicago Sun Times; uploaded by Roger Ebert on January 21, 2010; http://blogs.suntimes.com/foreignc/2010/01/kathryn-bigelowsstrangedays. Zugegriffen am 20. 12. 2011

Mulvey L (1989) Visual and other pleasures. Indiana University Press, Bloomington IN

Rascaroli L (1998) Strange visions: Kathryn Bigelow›s metafiction. Enculturation 2(1)

Sobchack V (2000) What my fingers knew: the cinesthetic subject, or vision in the flesh. Senses of Cinema Bd 5

Sobchack V (2002) What My Fingers Knew. The cinesthetic subject, or vision in the flesh, Senses of Cinema 5. http://www.sensesofcinema.com/contents/00/5/fingers.html. Zugegriffen am 20. 12. 2011

Williams L (1999) Hard Core, 2. Aufl. University of California Press, Berkeley CA

Wolfson N (1996) Turn on, tune in – and fight? Kathryn Bigelow's „Strange Days". http://www.nathanwolfson.com/scholarship/strange.htm. Zugegriffen am 20. 12. 2011

Originaltitel	Strange Days
Erscheinungsjahr	1995
Land	USA
Buch	James Cameron, Jay Cocks
Regie	Kathryn Bigelow
Hauptdarsteller	Ralph Fiennes (Lenny Nero), Angela Bassett (Lornette „Mace" Mason), Tom Sizemore (Max Peltier), Juliette Lewis (Faith Justin), Michael Wincott (Philo Gant)
Verfügbarkeit	Als DVD in OV und in deutscher Sprache erhältlich

Yvonne Frenzel Ganz

Macht der Gene, Sieg des Wunsches

Gattaca – Regie: Andrew Niccol

ETHAN HAWKE UMA THURMAN

G A T T A C A

WIE ENTKOMMST DU, WENN DU VOR DIR SELBST DAVONLÄUFST?

HTTP://WWW.COLUMBIATRISTAR.DE

Filmplakat *Gattaca*
Quelle: Cinetext/Richter

Gattaca

Regie: Andrew Niccol

Vorbemerkung

In seinem 1932 erschienenen Zukunftsroman „Schöne neue Welt" verlegte Aldous Huxley die negative Utopie der beliebigen menschlichen Klonung in eine ferne Zukunft rund 600 Jahre später. Im Vorwort zur Ausgabe von 1946 schrieb Huxley bereits (2010, S. 20ff.):

> Alles in allem sieht es so aus, als wäre uns die Utopie viel näher … Heute scheint es durchaus möglich, dass uns dieser Schrecken binnen eines einzigen Jahrhunderts auf den Hals kommt …

Es dauerte nur fünfzig Jahre, bis es soweit war. 1996 glückte die Klonung des ersten Säugetiers. Das Schaf Dolly erlangte Weltruhm. Bereits fünf Jahre später, also 2001, gelang den Forschern der „Human Genome Organisation" (HUGO) die vollständige Kartografierung bzw. Sequenzierung des menschlichen Genoms, die den Weg zu neuen Therapiemethoden bei Erbkrankheiten eröffnete, aber auch die Gefahr weitreichender Möglichkeiten der Genmanipulation in sich birgt. Als Regisseur Andrew Niccol seinen 1997 produzierten Film *Gattaca* (■ Abb. 1) in die Kinos brachte, beteiligte er sich damit an der brisanten, bis heute aktuellen Biotechnologie-Debatte.

Handlung

DNA als Schicksal

Die ersten Bilder des Films, ganz in kalten Blautönen gehalten, stimmen auf das Thema dieser Dystopie ein. Verfremdet, weil überdimensioniert groß, zeigen sie menschliche Kopf- und Barthaare, Hautschuppen und Partikel von Fingernägeln, die krachend und klirrend zu Boden fallen. Als Reverenz an Aldous Huxley heißt „die nicht allzu ferne Zukunft" (*Gattaca*, DVD 2008, 4'14) den Zuschauer in der wenig schönen Welt von Gattaca willkommen: Hier bestimmt allein die Genetik über das menschliche Schicksal. Das menschliche Genom ist vollständig entschlüsselt, jede Hautschuppe, jede verlorene Augenwimper ist Datenchip und verrät alles über ihren Besitzer.

Der Zuschauer blickt in eine Gesellschaft, die durch Eugenik determiniert ist. Die berufliche Karriere eines Menschen hängt hier ausschließlich von den Genen ab. Die kontrollierte In-vitro-Zeugung ist für alle, die es sich leisten können, die Methode der Wahl, um zum Wunschkind zu kommen und dem eigenen Nachwuchs die bestmöglichen Chancen zu garantieren. Die Menschen werden in zwei Gruppen geteilt, die „Valids" – die Gültigen, Wertvollen – und die „Invalids" – die Ungültigen, Wertlosen, Kränklichen. Euphemistisch werden die auf natürlichem Weg Gezeugten, die Ungültigen, allgemein als „Gotteskinder" bezeichnet, doch haben sie keinerlei Aussicht auf gesellschaftlichen Aufstieg und bilden somit die Unterschicht dieser Zweiklassen-Gesellschaft. Insbesondere die Teilnahme am Raumfahrtprojekt von Gattaca ist nur den Top-Selektionierten vorbehalten. Der einzig gültige Badge, der den genetisch Optimierten täglich die Pforte zur Raumstation Gattaca öffnet, ist der Bluttest.

Unterwegs zur falschen Identität

Protagonist der Geschichte ist der junge Vincent Anton Freemann (Ethan Hawke) (■ Abb. 2). Er ist Teilnehmer des Raumfahrtprogramms, obwohl er, wie er dem Zuschauer anfangs aus dem Off erzählt, auf natürlichem Weg gezeugt wurde. Ein Gentest bei seiner Geburt hatte die Eltern schonungslos über

Abb. 2 Vincent (Ethan Hawke) in reduzierter, in kühlen Farben gehaltener Szenerie. (Quelle: Cinetext Bildarchiv)

Vincents Herzfehler und seine geringe Lebenserwartung aufgeklärt. Vincent wird damit auch für seinen Vater Antonio zum Menschen zweiter Klasse. Doch der kurzsichtige Vincent träumt seit seiner Kindheit davon, Astronaut bei Gattaca zu werden.

Bei ihrem zweiten Kind überlassen die Eltern dann nichts mehr dem Zufall. Das Design von Vincents Bruder Anton wird vom Genetiker gemäß Bestellung in der Retorte optimiert. Der Bruder, der den Vornamen des Vaters an erster Stelle trägt, wächst rascher als Vincent und überflügelt den älteren Bruder bald in allen Bereichen. Auch bei den Wettschwimmen der Brüder fällt Vincent stets auf den zweiten Platz zurück, bis er eines Tages den total erschöpften Anton vor dem Ertrinken rettet. Warum ihm das gelingt, erfährt der Zuschauer erst viel später.

Vincent hält unbeirrbar an seinem ehrgeizigen Traum fest und verlässt als junger Mann das Elternhaus. Er findet den Gen-Dealer German (Tony Shalhoub), der ihm zu einer neuen Identität verhilft. In Jerome Morrow (Jude Law), einem ehemaligen Hochleistungssportler, der nach einem Unfall an den Rollstuhl gefesselt ist, findet sich der geeignete Kandidat. Der depressiv wirkende Jerome ist dem Alkohol und dem Nikotin ergeben. Um sich sein luxuriöses Leben weiterhin leisten zu können, verkauft er seinen Namen und die dazu gehörende Erbinformation an Vincent: Jerome wird für Vincent fortan die notwendigen Blut- und Urinproben produzieren, mit deren Hilfe dieser alle Hürden nehmen soll.

Vincent wird zu Jerome, und der von Gattaca damit beauftragte Arzt Dr. Lamar (Xander Berkeley) nimmt ihn ins Raumfahrtprogramm auf. Den Direktor Josef (Gore Vidal), Chef des Titan-Trainingsprogramms, beeindruckt Vincent-Jerome durch seinen Perfektionismus und seine Pedanterie. Aus Angst vor Entdeckung ist Vincent-Jerome zwanghaft darauf bedacht, seine eigenen genetischen Spuren stets sogleich zu tilgen, um dann seine falsche Identität mit dem präparierten Gen-Material des echten Jerome zu sichern: Er hinterlässt gezielt dessen Hautschuppen, Kopf und Barthaare.

Die verräterische Wimper

Eine Woche vor Vincents geplantem Abflug auf den unwirtlichen Saturnmond Titan erschüttert ein Mord die Raumfahrtstation. Einer der Direktoren von Gattaca, ein Gegner des Titan-Programms, wird brutal erschlagen. In der Nähe der Leiche findet man eine echte Wimper von Vincent, und Detective Hugo (Alan Arkin) beginnt seine Jagd auf den unbekannten „Invaliden". Vincent-Jerome reagiert zunächst panisch. Aber der echte Jerome, der sich nun mit seinem zweiten Namen Eugene ansprechen lässt, motiviert Vincent zum Durchzuhalten. Das Netz zieht sich jedoch immer enger zusammen. Denn auch Vincents Bruder Anton (Loren Dean), inzwischen hoher Polizeibeamter im Überwachungsstaat, wird in die Ermittlungen eingeschaltet und beginnt, die wahren Zusammenhänge zu ahnen.

Vincent, der sich in seine Raumfahrtkollegin Irene Cassini (Uma Thuman) verliebt hat, gesteht ihr wenige Tage vor dem Abflug ins All seine Gefühle. Irene hatte Vincent in Verdacht, für den Mord verantwortlich zu sein. Bereits zuvor ließ sie heimlich eines von Vincents – also von Jeromes – Kopfhaaren an einem der zahlreichen öffentlichen Genlabor-Schalter sequenzieren. Von Vincents Makellosigkeit überzeugt, regte sich in ihr der Neid: Sie weiß, dass sie selbst wegen eines leichten Herzfehlers nie ins All fliegen wird. Irene gesteht Vincent ihr anfängliches Misstrauen, entschuldigt sich und bietet ihm im Gegenzug eines ihrer eigene Haare zur Analyse an. Er jedoch lässt das Haar fallen. Damit beginnt eine Liebesgeschichte, in der Irene Vincents falsche Identität mehrfach deckt und sich zugleich seiner wahren Identität immer mehr annähert.

Die Macht des Wunsches

Anton ist seinem Bruder Vincent-Jerome immer dichter auf den Fersen. Noch bevor Anton die Entlarvung gelingt, wird der eigentliche Mörder aufgrund einer genetischen Untersuchung gefunden. Doch Anton gibt nicht auf. Er kehrt an Vincents Computerarbeitsplatz in Gattaca zurück und trifft dort auf den Bruder. Vincent erinnert Anton daran, dass dieser einst seiner Hilfe bedurfte und dass er, Vincent, es war, der Anton vor dem Ertrinken rettete. Damit trifft er Anton an seiner empfindlichsten Stelle. Anton fordert Vincent zu einem Schwimmduell heraus. Die erwachsenen Brüder stürzen sich wie einst in die Fluten, und die Geschichte wiederholt sich: Erschöpft muss Anton aufgeben, Vincent rettet ihn abermals aus dem Wasser. Und nun verrät Vincent Anton das Geheimnis seines Erfolgs: Er, Vincent, spare sich nie Kraft für den Rückweg auf. Anton verzichtet auf die Enttarnung seines Bruders, und der Weg in den Weltraum ist frei.

Jerome-Eugene bereitet sich inzwischen auf eine eigene Reise vor. Er produziert unzählige Blut- und Urinproben für Vincent, die nach dessen Rückkehr aus dem All für ein ganzes Leben ausreichen sollen. Die beiden verabschieden sich im Wissen, dass sie sich nicht wiedersehen werden. Vincent, wie immer im tadellosen Straßenanzug, geht am Tag des Abflugs durch die Eingangskontrolle von Gattaca. Unmittelbar vor dem Start der Weltraumrakete verlangt Dr. Lamar überraschend eine letzte Urinprobe. Vincent ist darauf nicht vorbereitet. Er hat keine von Jeromes Proben mehr dabei. So ist er gezwungen, den eigenen Urin abzugeben und sich zu seiner Identität zu bekennen. Er scheint gescheitert.

Dr. Lamar prüft und betrachtet das Ergebnis: „invalid". Dabei erzählt er Vincent beiläufig von seinem eigenen Sohn, welcher der Vorhersage der Genetiker nicht ganz entsprochen habe. Schließlich ändert der Arzt das Ergebnis stillschweigend in „valid" ab, spricht Vincent bei seinem richtigen Namen an und lässt ihn passieren. Die Rakete hebt in den Weltraum ab. Vincents Geist und sein Wille haben triumphiert. Zeitgleich begeht Jerome in seinem hauseigenen Müllverbrennungsofen Suizid, in der Hand die Silbermedaille eines Schwimmwettkampfs. Im Briefumschlag, den Jerome seinem Alter Ego zum Abschied überreicht hat, findet Vincent nach dem Start der Rakete eine Locke von Jeromes Kopfhaar.

Hintergrund

Der Regisseur

Mit dem Film *Gattaca* debütierte der damals 33-jährige Neuseeländer Werbefilmer Andrew Niccol im Kino-Regiefach. Niccol hatte das klug durchdachte Drehbuch zum Film selbst geschrieben. Der große Durchbruch blieb Andrew Niccol mit diesem Film jedoch verwehrt. Erst ein Jahr später, 1998, wurde er als Drehbuchautor von *The Truman Show*, in dem Peter Weir Regie führte, international bekannt; das Drehbuch war für den Golden Globe und den Oscar nominiert. Auch in seinen späteren Filmen und Drehbüchern, die fast alle im Genre des Science-Fiction angesiedelt sind, entwirft Andrew Niccol pessimistische Zukunftsvisionen und stellt düstere Zeitdiagnosen.

Das Making-of

In verschiedenen Interviews äußern sich Mitglieder der Filmcrew rückblickend zu den Dreharbeiten von *Gattaca* (vgl. *Gattaca*, DVD 2008, Kapitel Making-of). Sie alle beschreiben Andrew Niccol als Ästheten und äußerst perfektionistischen Regisseur. Jude Law, Darsteller von Jerome, bemerkte, dass das Drehbuch auf dem Set kaum abgeändert werden musste, da es sehr ausgereift daherkam; der Film sei, so Law, zum eigentlichen Spiegelbild des Drehbuchs geworden. John Woodward, erster Regieassistent, verglich Niccol mit einem Pit Bull, der sich an einer Szene festbeißen konnte, bis sie genau so war, wie er sie sich vorstellte. Auch Production Supervisor Bradley Cramp bestätigt, dass alles stets perfekt sein musste, die Requisiten eingeschlossen.

Die finanziellen Mittel für die Produktion waren allerdings beschränkt. Erfindungsgabe war deshalb von allen Beteiligten gefordert. Unter anderem war es aufgrund des kleinen Budgets nicht möglich, eine völlig neue Filmwelt zu schaffen. Man habe deshalb, so Cramp, jeweils die besten Stücke aus der nahen Vergangenheit genommen, sie in die nahe Zukunft transponiert und auf diese Weise die futuristische Vision von *Gattaca* geschaffen. Ein Konzept, das seinen Anspruch durchaus einlöst, denn auch heute – 15 Jahre später – hat der Film von seiner zeitlos retro-futuristischen Ausstrahlung nichts verloren.

Architektur und Requisiten

Die Dreharbeiten fanden mehrheitlich in Kalifornien statt. Location Manager Bob Craft sagt, *Gattaca* sei der Film, auf den er bis heute am stolzesten sei. Die Architektur, so Craft, sei in diesem Film eine „eigene Figur". In der Tat wurden die Gebäude bezogen auf die Storyline oder auf einzelne Charaktere ausgesucht. Abgerundete Formen und nicht Ecken dominieren die Kulisse; sie erinnern an die Fünfzigerjahre und damit an die Zeit, als James Watson und Francis Crick die DNA-Struktur entdeckten. Die runden Formen sind aber auch Hinweis auf die totalitäre Struktur der perfektionistischen Welt von Gattaca, in der das Individuum seine Kanten verliert, abgerundet und gleichgemacht wird (vgl. Lienkamp 2002, S. 104).

Für die Innenaufnahmen des Raumfahrtzentrums wählte Andrew Niccol das „Marin County Civic Center" in San Rafael, Kalifornien. Es wurde vom amerikanischen Stararchitekten Frank Lloyd Wright 1957 entworfen, aber erst nach dessen Tod zu Beginn der 60er-Jahre fertig gestellt. Das noch immer futuristisch anmutende, monumentale Gebäude bildet auch bei Außenaufnahmen häufig die Kulisse für *Gattaca*. Sowohl in der Praxis des Genetikers als auch in Jeromes Duplexwohnung taucht zudem als mahnendes Motiv jeweils eine Wendeltreppe auf – in Anlehnung an die Doppelhelix, die Molekularstruktur der DNA.

Bei den Möbeln wurde auf moderne Klassiker gesetzt; unter anderem sieht man Stühle von Charles Eames und den Sessel „Barcelona" von Mies van der Rohe. Die Autos sind die schönsten der Sechzigerjahre und wurden auf Elektromotoren umgerüstet; Irene zum Beispiel ist in einem der legendären, nur

in geringer Stückzahl gebauten Citröen DS 19 Cabriolet unterwegs. Die Kostüme – von Coleen Atwood entworfen – sind in der kühlen Welt von Gattaca ebenfalls von zeitlosem Design: Dunkle Anzüge und Deux-pièces beherrschen das Bild, nur bei den kurzen Ausflügen in das reale Leben im Rahmen der Liebesgeschichte trägt Irene eine prächtige Garderobe, befinden wir uns zudem im Interieur eines üppig ausgestatteten Restaurants.

Titel und Namen

Der Arbeitstitel des Films, „The Eighth Day", bezog sich auf die Schöpfungsgeschichte und verwies auf den gentechnischen Eingriff des Menschen in die Natur, darauf also, dass im Film der Mensch den Schöpfer spielt. Im Lauf der Dreharbeiten erhielt das Projekt den abstrakter klingenden Titel *Gattaca*. Sowohl im Vorspann als auch im Abspann des Films sind die Buchstaben A, C, G und T hervorgehoben. Diese Buchstaben stehen für die vier Basen Adenin, Cytosin, Guanin und Thymin in den chemischen Bausteinen des DNA-Moleküls, das im Zellkern aller Lebewesen vorkommt und Träger der Erbinformation ist. Die Sequenz G-A-T-T-A-C-A findet sich besonders häufig im menschlichen Genom.

Die Namen der meisten Figuren im Film sind historischen Vorbildern nachempfunden und voll von Anspielungen (vgl. Lienkamp 2002, S. 105). Irene Cassinis Name erinnert an den Astronomen Giovanni Domenico Cassini, der im 17. Jahrhundert unter anderem vier Saturnmonde entdeckte. Der zweite Vorname des genetisch makellosen Jerome Eugene Morrow bedeutet „der Wohlgeborene" und verweist auf die Lehre der Eugenik. Im Nachnamen Morrow steckt zudem auch eine Anspielung auf H. G. Wells' Ende des 19. Jahrhunderts erschienenen fantastischen Roman „The Island of Dr. Moreau", der die operative Verbesserung menschlichen Lebens zum Thema hat.

Der Name von Detektiv Hugo ist auch die Abkürzung für die Human Genome Organization, die zwischen 1990 und 2003 das Human Genome Project zur Entschlüsselung des menschlichen Genoms koordinierte. Direktor Josefs Nachname Gregor erinnert an die Vererbungslehre von Gregor Johann Mendel. Der Name Lamar schließlich ist eine Referenz an Jean-Baptiste Lamarck (1744–1829), der die inzwischen überholte Evolutionstheorie vertrat, gemäß derer erworbene Eigenschaften an Nachkommen vererbt werden können.

Auch der Name des Protagonisten Vincent Anton Freeman ist von Interesse: Der aus dem Lateinischen stammende Vorname Vincent steht bekanntlich in christlicher Tradition und meint „den über das Leid der Welt Siegenden". Auch der Nachname Freeman impliziert den Gedanken an eine Erlöserfigur. Diese Assoziation wird auch durch Vincents Geburt geweckt: In dieser Filmszene hält Vincents Mutter Maria – nomen est omen – einen Rosenkranz mit Kreuz in der Hand.

Die Filmmusik

Adrew Niccol konnte für sein Filmprojekt den klassisch ausgebildeten Komponisten Michael Nyman gewinnen, der durch die Musik zum Film *The Piano* 1993 international bekannt geworden war. Für *Gattaca* besann sich Nyman auf das ästhetische Konzept der einfachen, sich wiederholenden Muster der Minimal Music, einer Musikgattung der Siebzigerjahre, als deren eigentlicher Begründer Michael Nyman selbst gilt. Harte, klirrende Töne kontrastieren mit sanften, kitschig anmutenden Passagen. Vermitteln erstere etwas unterschwellig Bedrohliches, verursachen letztere Widerwillen, denn die süßlichen Klänge befremden. So erzeugt die Musik beim Zuschauer eine kognitive Dissonanz und damit auch einen Bruch in der vermeintlichen Idealwelt des Unechten, in der gentechnisch manipulierten Welt von Gattaca. Das romantisch angehauchte Impromptu für zwölf Finger, im Film von einem Pianisten mit einer Polydaktylie gespielt – er hat tatsächlich zwölf Finger – begleitet die wachsende Liebe zwischen Vincent und Irene und markiert auch musikalisch die beginnende Wende zur Authentizität.

Die Kamera

Mit dem polnischen Kameramann Slawomir Idziak, der mehrfach mit Krysztof Kieslowski zusammengearbeitet hat, verpflichtete Regisseur Niccol einen virtuosen Meister der Farbgebung. Für seine Arbeit im Film *Trois Couleurs: Bleu* von Kieslowski erhielt Idziak 1993 in Venedig den Kamerapreis. Idziak beeindruckt auch in *Gattaca* durch den gezielten Einsatz von Farben, die zu entscheidenden Elementen im narrativen Bogen des Films werden. Mattes Licht und kalte, fahle Farbtöne in allen Schattierungen dominieren und sprechen so von der perfekt-künstlichen, aber eben monochromen Welt Gattacas, in der nichts wirklich lebt und Gefühle keine Rolle spielen. Auch die Außenaufnahmen der Gebäude und die wenigen Naturaufnahmen sind mit entsprechenden Filtern gefilmt, kräftige Farben werden nur sparsam eingesetzt. Das Auftauchen des knallgrünen Autos als Ort von Vincents Zeugung erscheint wie ein erster Hinweis auf Natur und damit auf Leben.

Die umgebende Natur tritt auch dann in stärkerem Grün in Erscheinung, als Vincent ohne Kontaktlinsen, fast blind, über die Straße zu Irene stolpert, nur noch seinem Verlangen gehorchend und nicht mehr vernünftigem Kalkül. Kräftiges Grün sehen wir zudem in der um 180 Grad verdreht gefilmten Szene, in der Vincent und Irene sich in Irenes Haus vor der Kulisse des Pazifiks unkontrolliert lieben – hier wird die Welt von Gattaca buchstäblich auf den Kopf gestellt. Tendenziell sind die Farben im letzten Drittel des Films weniger matt, in dem Maße nämlich, so hat es den Anschein, in dem die Protagonisten authentischer werden. Schließlich tragen auch die ruhige Kameraführung und die eher langen Einstellungen dazu bei, aus dem Film einen Zukunftsthriller zu machen, der unspektakulär und ohne knallige Spezialeffekte daherkommt und vielleicht gerade deshalb beängstigend stark unter die Haut geht.

Filmwirkung

Die Marketingstrategie

Im Herbst 1998 lancierte Sony Pictures den Filmstart von *Gattaca* in den USA mit einer einzigartigen Werbekampagne, an deren Gestaltung Regisseur Andrew Niccol maßgeblich beteiligt war. In ganzseitigen Inseraten in Tageszeitungen wie „New York Times", „USA Today" und „Wall Street Journal" sah man ein gesundes Baby in die Kamera lächeln, daneben der Text „Children made to order". Ein fiktives gentechnisches Forschungslabor bot an, Babies nach den Wünschen der bestellenden Eltern zu gestalten. Die Information, dass es sich um einen Film handelte, war so klein gedruckt, dass in den ersten Wochen Tausende die Inserate als Offerte missverstanden und bei der im Inserat aufgeführten Telefonnummer anriefen, um dann ab Tonband über ihren Irrtum aufgeklärt zu werden. Sony hatte zudem im Internet einen Fragebogen aufgeschaltet, bei dessen Beantwortung der Benutzer unterwegs zu seinem optimierten Wunschkind schien (vgl. *Gattaca*, DVD 2008, Making-of; Lienkamp 2002, S. 99 ff.). Die Werbekampagne zielte auf die nahezu religiös erscheinende Verpflichtung der US-Amerikaner zur ständigen Selbstoptimierung (vgl. Gibbs 1998) und sollte die öffentliche Debatte anregen.

Im Vorspann des Films erscheint ein Zitat von Williard Gaylin, einem amerikanischen Psychiatrie- und Rechtsprofessor, der als Bioethiker die Euthanasie verficht (deutscher Untertitel, DVD 2008):

I not only think that we will tamper with Mother Nature, I think Mother wants us to. – Ich glaube nicht nur, dass wir an Mutter Natur herumpfuschen werden, sondern ich glaube auch, dass Mutter Natur das will.

Dieser Satz wurde ursprünglich im Abspann wieder aufgenommen; der Abspann zeigte Bilder von Künstlern und historischen Persönlichkeiten, die auf Grund ihrer Gendefekte vermutlich nie geboren worden wären, hätte man Präimplantationsdiagnostik und Gentechnik im Ausmaß von Gattaca schon

zur Verfügung gehabt: Vincent van Gogh, Emily Dickinson, Albert Einstein, Stephan Hawking, John F. Kennedy und andere mehr. Die genetischen Defekte dieser Persönlichkeiten, ihre Krankheiten, werden dabei benannt, ihre Leistungen verschwiegen.

Der Abspann endete mit dem Satz (deutscher Untertitel, DVD 2008):

> Of course, the other birth that would surely never have taken place is your own. – Eine andere Geburt, die niemals stattgefunden hätte, ist freilich Ihre eigene.

Aus Rücksicht auf das Publikum wurde die ganze Passage aus dem Film geschnitten; man fürchtete, die Zuschauer damit persönlich zu sehr zu belasten. Eine Entscheidung, die Produzent Dany DeVito später sehr bereute. Denn in dieser Sequenz war die Botschaft des Films nochmals treffend verdichtet; sie hätte das Publikum erreicht, denn sie berührte. Glücklicherweise ist der Abspann wenigstens noch auf der DVD Deluxe Edition im Kapitel „Making-of" zu sehen.

Presse und Publikum

Bei der Presse kam *Gattaca* gut bis sehr gut an, wie sich auch heute noch in unzähligen Filmkritiken im Internet nachlesen lässt. Der Film wurde als gelungener Beitrag zu den ethischen und moralischen Fragen rund um Gentechnik und Präimplantationsdiagnostik – jene vorgeburtliche Diagnostik, die ausschließlich bei In-Vitro-Fertilisation möglich ist – sowie als bemerkenswertes Regiedebüt erkannt. Für zahlreiche Preise nominiert, aber nie wirklich prämiert, zollten die Juroren der internationalen Filmfestivals dem Erstlingswerk letztlich jedoch nicht die erhoffte Anerkennung. Beim Publikum war dem Film ein vergleichsweise geringer Erfolg beschieden; im deutschsprachigen Raum blieb *Gattaca* nahezu unbeachtet.

Die schwache Resonanz beim Publikum hat wohl zwei Gründe. Erstens bedient *Gattaca* als Science-Fiction-Film nicht die Sehgewohnheiten des Mainstream-Publikums. Der Zuschauer bekommt nicht die übliche Bedrohung durch außerirdisch-feindliche Mächte und die dazu gehörenden gigantischen Vernichtungskämpfe geboten, aus denen er am Ende des Films wieder erleichtert auftauchen und wonach er beim Verlassen des Kinosaals den Fuß auf den sicheren Planeten Erde setzen kann. Die Bedrohung in *Gattaca* ist subtiler, denn sie kommt von innen. Sie entstammt dem menschlichen Optimierungswahn, den nicht allein die Amerikaner ihr Eigen nennen, sondern der den Zeitgeist der globalisierten Welt des 21. Jahrhunderts widerspiegelt. *Gattaca* liefert also nicht einfach spannende Unterhaltung, sondern entlässt den Zuschauer mit beklemmenden Fragen.

Zweitens bietet sich eigentlich kein Charakter als echte Identifikationsfigur an, auch Protagonist Vincent nicht. Die Figuren wirken eher fad und langweilig, keine ist wirklich sympathisch, man findet sich in keiner so recht wieder. Die Regie und die beachtliche Leistung der Schauspieler verunmöglichen eine Identifikation – auch das macht den Film für den Zuschauer anstrengend. In der einförmigen, gleichgeschalteten Welt von *Gattaca* sind eigentlich alle Verlierer. Das Ende des Films macht es deutlich. Und wer möchte sich schon als Verlierer fühlen?

Reaktion des Fachpublikums

Lehrer zahlreicher Fachgebiete – Biologie, Philosophie, Religion, aber auch Psychologie, Englisch und Geschichte – haben den Film in den letzten Jahren entdeckt und ihm inzwischen zu einem Ort verholfen, an dem er geradezu enthusiastisch rezipiert wird: der Schule. Der Film wird heute bevorzugt als Einstieg zur Diskussion über ethische Fragen im Rahmen der Biotechnologie-Debatte gezeigt. Dies belegt das Unterrichtsmaterial, das im Internet zahlreich zur Verfügung steht (vgl. Vision Kino GmbH 2011).

Gattaca eignet sich auch als Diskussionsgrundlage zum Thema Eugenik im Dritten Reich. Die Frage, was eigentlich den Wert des Menschen und die menschliche Identität ausmacht, nämlich Körper oder Geist, hat Thomas Mann bekanntlich mit gekonnter Ironie in seiner Erzählung „Die vertauschen Köpfe" in Hinblick auf die rassenhygienischen Maßnahmen des Nationalsozialismus im Jahr 1940 thematisiert. Die ins ferne Indien verlegte Legende handelt von zwei Freunden, die einander wie Brüder sind: Der eine intelligent, aber schmächtig, der andere stark und von prächtiger Gestalt. Sie begehren dieselbe Frau. Der schöne Nanda verhilft seinem klugen Freund Schirdaman zur Ehe mit Sita. Sita wird schwanger, doch Schirdaman verdächtigt sie der Untreue mit Nanda. Verzweifelt schlägt er sich in einem Tempel den Kopf ab. Nanda findet ihn und tut es ihm gleich. Sita kann beide retten, indem sie die Köpfe wieder auf die Rümpfe setzt, doch Sita vertauscht sie. Die Verzweiflung über die Identität beginnt, und sie endet für die Freunde schließlich in gegenseitiger Ermordung (vgl. Mann 11940; 2010). Das von Mann so meisterlich behandelte Thema von Körper und Geist ist auch jenes von *Gattaca*. Und auch hier fehlt die Anspielung auf das Dritte Reich nicht. Tag für Tag versucht Vincent, unter der Dusche seine minderwertige genetische Identität abzuschrubben. Der genetisch überlegene Jerome, der keinen eigenen Traum hat, begeht am Ende im hauseigenen Müllverbrennungsofen Selbstmord. Die assoziative Verknüpfung von Dusche und Verbrennungsofen ist und bleibt unauslöschliches Mahnmal des Genozids an den Juden. Diese – zunächst eher unbewusste – Assoziation wird durch *Gattaca* im Zuschauer wieder geweckt: ein kühner Einstieg in jede historisch-ethische Diskussion, nicht nur mit jugendlichem Publikum.

Psychoanalytische Interpretation

Fehlender Konflikt

Was kann die Psychoanalyse zur Interpretation dieses Filmes beitragen? Der ödipale Konflikt als Dreh- und Angelpunkt psychoanalytischer Theoriebildung, der fundamentale Konzepte wie Urszene, Verführung und Kastration impliziert, lässt sich im Plot von *Gattaca* auf den ersten Blick nicht ausmachen. Es scheint fast, als verlören der ödipale Konflikt und die erwähnten Konzepte in einer Welt wie Gattaca tendenziell an Relevanz. Es stellen sich in der Tat Fragen: Wenn die In-vitro-Zeugung zur bevorzugten Methode menschlicher Fortpflanzung wird, welche Konsequenzen hat dies für das Individuum? Wohin führt die damit einhergehende kollektiv geteilte und gesellschaftlich sanktionierte Verleugnung der Urszene? Welches Schicksal ereilt dann die Fantasien über den Ursprung (vgl. Laplanche u. Pontalis 1992), und welche Folgen hat dies für die Bedeutung des ödipalen Konflikts und das daraus resultierende Selbstverständnis des Individuums?

Die sogenannten „Grenzfälle" narzisstischer Provenienz sind unter anderem dadurch charakterisiert, dass die Urszene, also die Abhängigkeit der eigenen Existenz von der elterlichen Sexualität, verleugnet wird – mit entsprechendem Niederschlag in den Selbst- und Objektrepräsentanzen. Die Pathologie des Grenzfalls, so lässt sich postulieren, bekäme in einer Welt der In-vitro-Zeugung den Status der Norm. Und das menschliche Zusammenleben wäre in einer Weise verändert, die nicht nur Huxley als Horrorvision auf uns hat zukommen sehen. Christopher Lasch (1980) spricht von einem Zeitalter des Narzissmus und prognostiziert die „Kultur der Bindungslosigkeit" sowie die Idealisierung des Alleinseins. Herbert Marcuse ([1]1963; 1968) kündigt das Veralten der Psychoanalyse an, da das Individuum zunehmend vergesellschaftet werde.

Der Wahrheitsgehalt der Psychoanalyse wird dadurch aber in keiner Weise tangiert. Ihre Kerngedanken treten vielmehr umso deutlicher hervor, was Marcuse übrigens in seiner kleinen Schrift überzeugend darlegt. Den Film *Gattaca* könnte man nicht nur als Verteidigung der Gattung Mensch gegen gentechnische Eingriffe durch den Menschen, sondern auch als Plädoyer für die Unvollkommenheit und den Mangel als Conditio humana und Agens jeglicher Entwicklung verstehen. Schon Sigmund

Freud hat im siebten Kapitel seiner „Traumdeutung" die Bedeutung der „Not des Lebens" für die Ausbildung des psychischen Apparats und für die Entwicklung des Denkens als Ersatz des halluzinatorischen Wunsches umrissen (vgl. Freud [1]1900; 1998, S. 538 ff.).

Der Fokus des Interesses liegt zweifellos auf dem Protagonisten Vincent und seinen beiden Antagonisten, dem Bruder Anton und dem im Rollstuhl sitzenden Jerome. Die Charaktere von Anton und Jerome sind die zentralen Referenzfiguren, auf die sich die Entwicklung der Geschichte bezieht. Im Lauf des Films erfährt der Zuschauer, dass Jerome ein Spitzenschwimmer war, der auf dem Siegerpodest allerdings stets nur den zweiten Platz belegte, so wie auch Anton beim Schwimmen Vincent letztlich immer unterlag. Zum Schluss wird klar, dass Jerome für Anton steht und letztlich mit ihm identisch ist. Denn als Jerome sich im Feuer umbringt, hält er eine Silbermedaille in der Hand, auf der zwei Schwimmer zu sehen sind. Die Geschichte ist also mehrdeutig: Sie erzählt nicht nur von der alten Dichotomie zwischen Körper und Geist, sondern zeigt auch eine weitere Variante hasserfüllter Geschwisterrivalität im Sinne von Kain und Abel.

Kränkende Urszene

Aus dem Off führt Vincent den Zuschauer in seine Geschichte und in die Welt von Gattaca ein. Schon bald erfahren wir von Vincents natürlicher Zeugung und seinem Ärger über die Mutter, die nicht ihrem Hausgenetiker vertraut, sondern sich auf (Gott-)Vater verlässt. Spricht hier aus Vincent der allgemein menschliche Ärger über die Konfrontation mit der Urszene? René Roussillon (2004, S. 421 f.).sagt, die erste absolute Abhängigkeit, welcher kein Mensch entgeht, sei jene der Zeugung und der Geburt. Die Erkenntnis, dass man die eigene Existenz einem Vater und einer Mutter verdankt, die man sich nicht auswählen konnte, ist für den Narzissmus schwer zu akzeptieren, denn sie erinnert empfindlich an die menschliche Unvollkommenheit. Diese Kränkung lässt sich nur dadurch lindern, dass sich der Mensch als in Liebe gezeugt und damit in die Urszene eingeschlossen denken kann.

Nun ist Vincent zwar in Liebe gezeugt, doch nützt ihm dies in der Welt von Gattaca nichts. Denn sein genetisches Eintrittsticket bringt ihn automatisch auf einen hinteren Rang. Als sein Vater nach der Geburt das Ergebnis des Gen-Schnelltests mit den schlechten Prognosen vernimmt, wendet er sich sogleich von Vincent ab und verweigert ihm seinen Vornamen. Anders die Mutter: Sie ist davon überzeugt, dass Vincent etwas leisten wird und zu Besonderem geboren ist. Die primäre libidinöse Besetzung durch die Mutter Maria erscheint als Vincents Rettung und wird für sein weiteres Schicksal bestimmend.

Diese primäre Besetzung ist im Sinne Anzieus (1992) Voraussetzung für die Bildung einer gemeinsamen, schützenden Haut, die Vincent im narzissierenden Sinn umhüllt und in der sich sein Ich und seine Identität entwickeln können. Wegen des genetischen Damoklesschwerts, das über ihrem Sohn hängt, ist Maria ängstlich und fürsorglich – denn sie liebt ihn. Die Primärbeziehung zur Mutter scheint gut genug gewesen zu sein, um den kleinen Vincent eine hinreichend stabile Identität erwerben zu lassen. Gut genug auch, dass er trotz Bevorzugung des Bruders durch den Vater ausreichend Selbstvertrauen entwickelt, um in Konkurrenz mit dem genetisch überlegenen Bruder Anton zu treten.

In der Hoffnung, doch noch die Anerkennung des Vaters zu gewinnen? Und vielleicht auch die ödipale Mutter für sich zu erobern? Im Vergleich zu Anton ist der kurzsichtige Vincent vom Mangel gezeichnet, aber gerade das beflügelt schon früh seine kindliche Fantasie: Er träumt sich in die Zukunft, er träumt sich groß, und er träumt sich weit fort – ins All. So werden für den Zuschauer die große Einsamkeit des Latenzkindes im Familienleben und zugleich eine regressive Sehnsucht nach der ursprünglichen Einheit mit dem primären Objekt, der frühen Mutter, spürbar. Das Ende des Films scheint erstmals angedeutet.

Identitätsproblematik

Bruder Anton ist Vincent bald in allen Disziplinen überlegen. Nur beim Schwimmen siegt der adoleszente Vincent und rettet dem ertrinkenden Anton sogar das Leben. Das ist der erste Achtungserfolg, den Vincent bei seinem Bruder erringt. Anton ist nachhaltig beunruhigt; seine Identität, die so sicher scheint, bekommt einen ersten Riss. Was hat Vincent, das er, Anton, nicht hat? Bevor er das Rätsel lösen kann, verlässt Vincent das Elternhaus.

Jerome Eugene, der ehemalige Spitzenschwimmer, angeblich eines Unfalls wegen querschnittgelähmt, ist bereit, seine genetische Identität an Vincent zu verkaufen. Jerome tritt nun an die Stelle von Anton. Körper oder Geist: Wer ist überlegen? Der eigentlich so wohlgeborene Jerome ist zunächst voller Spott und Hohn über Vincent, allein dies ändert sich im Verlauf des Films. Denn später offenbart er Vincent, dass seine Invalidität die Folge eines gescheiterten Selbstmordversuchs ist. Das vordergründige Motiv dafür lässt sich erahnen. Der perfekte Jerome leidet darunter, trotz seiner guten Gene nur immer auf Platz zwei gelandet zu sein – ein Schicksal, das er mit Anton teilt, sei es beim Wettschwimmen oder bei Irene. Denn auch Anton und Jerome begehren Irene, aber Vincent ist es, der sie erobert hat.

Was Jerome fehlt, erfährt der Zuschauer erst bei Jeromes Abschied von Vincent: Jerome selbst hatte nie einen wirklichen Traum, hatte nie einen Wunsch, der eine Entwicklung in Gang gesetzt hätte. Das Fehlen jeder Fantasie und Leidenschaft und eine damit einhergehende quälende Sinnlosigkeit haben, so lässt sich hypostasieren, zu Jeromes Suizidversuch geführt. Erst mit seiner eigenen Invalidisierung und der für ihn neuen Erfahrung des Mangels – er kann sein bisheriges Leben nicht mehr fortführen – beginnt Jerome zu träumen. Und diesen Traum hat Vincent ihm geschenkt. Vom ursprünglichen Antagonisten ist Vincent für Jerome zum eigentlichen Doppelgänger geworden, der dem gelähmten Mann im Rollstuhl zu einer authentischen Identität verhilft. Jerome wird dank Vincent im Verlauf des Films immer menschlicher. Der französische Psychoanalytiker Michel de M'Uzan (2003) postuliert, dass ein Doppelgänger, beziehungsweise die Erschaffung eines „Übergangssubjekts", für die Identitätsbildung notwendig ist.

Narzisstische Integrität

Dr. Lamar verkörpert jene wohlwollend unterstützende Vaterfigur, die Vincent stets gefehlt hat. Vincent begegnet dem Arzt regelmäßig anlässlich der obligatorischen Urinproben und Blutentnahmen. Schon bei der ersten Urinprobe beobachtet Dr. Lamar Vincent genau und bezeichnet Vincents Penis voller Bewunderung als außergewöhnliches Exemplar. Und fügt bei, er wünschte sich, seine Eltern hätten einen solchen auch für ihn bestellt. Diese Bemerkung kann freilich metaphorisch verstanden werden; sie scheint weniger den anatomischen Penis zu betreffen als den imaginären Phallus, der für alle Menschen Symbol und Garant der eigenen narzisstischen Integrität ist (vgl. Grunberger [1]1963, 1976). Dr. Lamar – er selbst ist genetisch optimiert – erweist dem genetisch invaliden Vincent hier seine Referenz. Es sind Vincents unbeirrbarer Wunsch und seine Triebstärke, die ihn im phallischen Sinn absolut valide machen. Am Ende des Films erfahren wir, dass Dr. Lamar seit der ersten Urinprobe um Vincents fast perfekte Täuschung wusste, davon beeindruckt war und sie immer deckte. So gibt Dr. Lamar Vincent zum Abschied einen Tipp mit auf den Weg: Rechtshänder, so Lamar, hielten den Penis beim Pinkeln nicht mit der linken Hand. In der Tat ist der echte Jerome Rechtshänder, wie der Zuschauer aufgrund von Vincents mühsamen Schreibversuchen mit der rechten Hand erfährt.

Vive la différence

Welchen Sinn macht die Liebesgeschichte mit Irene? Warum wird Irene – als einzige Frau neben Vincents Mutter – in die Handlung eingeführt? Vincent und Irene verbindet ihr jeweils angeborener Herzfehler, es verbindet sie damit auch das Bewusstsein von der Unvollkommenheit und Endlichkeit ihrer eigenen Existenz. Ein Bewusstsein, das in der perfekten Welt von Gattaca und mit Hilfe der Genetik

leicht verleugnet werden kann. Als Irene Vincent ein Haar übergibt, damit er sich Einblick in ihren genetischen Pass verschaffen kann, lässt er es fallen. Damit verteidigt Vincent die Differenz zwischen den Geschlechtern und den Menschen schlechthin als Bedingung für jede Liebesbeziehung. Viel später offenbart Vincent Irene seine wahre Herkunft und überlässt ihr seinerseits ein Haar zur Analyse.

Doch auch Irene lässt das Haar fallen. Beide haben sich gegenseitig in ihrer Unvollkommenheit akzeptiert, haben die menschliche Erfahrung des Mangels, der Kastration, integrieren können. Eine Leistung, die sie endgültig von der Welt Gattacas trennt. Authentizität prägt nun ihre verletzlichen Charaktere, ganz im Gegensatz zu jener makellosen Gleichförmigkeit der Figuren, die in der homogenen Welt Gattacas dominieren – einer Welt, in der die Idealisierung des Unechten und Falschen sowie die Verleugnung der genitalen Zeugung zur gesellschaftlichen Realität geworden sind (vgl. Chasseguet-Smirgel [1]1975; 1987). Vor Vincents Abflug ins All mag der Zuschauer allerdings Irenes Hoffnung auf den Fortbestand der Liebe nicht so recht teilen, denn er ahnt: Es kann kein richtiges Leben in einer falschen Welt wie Gattaca geben. Oder mit Theodor Adorno (1969, S. 228) gesprochen: „Keine Emanzipation ohne die der Gesellschaft."

Schlusssequenz

Jerome, der Repräsentant erstklassiger Gene, erkennt, dass sein Leben ohne Vincent, den Repräsentanten des Geistes und der Fantasie, sinnlos und invalid ist. Der gentechnisch Optimierte fühlt sich nun plötzlich als der eigentlich Degenerierte. Jerome kapituliert und begibt sich auf seine letzte Reise. Der Suizid im Müllverbrennungsofen erscheint als logische Konsequenz.

Das aufflackernde Feuer im Ofen reflektiert zeitgleich die Zündung der Weltraumrakete. Das Übereinanderlegen der beiden Bilder legt nahe, dass auch Vincents Flug ins All eine Reise ohne Wiederkehr ist. Nach dem Start öffnet Vincent den Briefumschlag, den ihm Jerome zum Abschied übergeben hat. Er findet darin Jeromes Haarlocke, ein Stück jenes Körpers also, ohne den Vincent in Gattaca nicht existieren kann. So werden am Schluss des Films auch die Figuren von Vincent und Jerome gewissermaßen zur Deckung gebracht, als Ausdruck der unauflösbaren Einheit von Soma und Psyche. Vincents letzte Worte deuten seine endgültige Rückkehr zur Mutter an: Er sei, sagt er, ja eigentlich nie für diese Welt bestimmt gewesen, gehe vielleicht aber gar nicht weg, sondern nachhause. Vincents vermeintlicher Sieg ist auch seine Niederlage.

Fazit

Der äußerst komplex angelegte Film problematisiert ethische Fragen rund um Gentechnik-Debatte und Präimplantationsdiagnostik und stellt zahlreiche historische Bezüge her. Inhaltlich klug durchdacht, ist Gattaca auch formal in ausgereifter Weise komponiert und reflektiert so bestens seinen Gegenstand: die durch den menschlichen Eingriff in die Natur perfektionierte Welt. Der Film konfrontiert den Zuschauer mit zentralen Fragen des Lebens, Fragen des eigenen Ursprungs, des Mangels, der Endlichkeit, der Einheit von Soma und Psyche und der Identität. Aus psychoanalytischer Sicht thematisiert der Film die sich verändernde Bedeutung der Urszene in einer gentechnisch determinierten Gesellschaft und die damit eingehende konsequente Verleugnung der Kastration als eigentliches Charakteristikum der menschlichen Existenz. In seiner kulturpessimistischen Dimension ist Gattaca ebenso anstrengend wie desillusionierend.

Literatur

Adorno T (1969) Minima Moralia. Suhrkamp, Frankfurt/M

Anzieu D (1992) Das Haut-Ich. Suhrkamp, Frankfurt/M

Chasseguet-Smirgel J (1987) Das Ichideal und die Perversion. In: Chasseguet-Smirgel J: Das Ich-Ideal. Suhrkamp, Frankfurt/M, S 18–32 (Erstveröff. 1975)

De M'Uzan M (2003) Die Identität und die Frage des Doppelgängers. ZPTP 1: 87–105

Freud S (1998) Die Traumdeutung, Studienausgabe Bd II. Fischer, Frankfurt/M (Erstveröff. 1900)

Gibbs N (1999) If we have it, do we use it? Time Magazine, 13. 9. 1999

Grunberger B (1976) Das phallische Bild. In: Grunberger B: Vom Narzissmus zum Objekt. Suhrkamp, Frankfurt/M, S. 227–244 (Erstveröff. 1963)

Huxley A (2010) Schöne neue Welt. Fischer Taschenbuch Verlag, Frankfurt/M

Laplanche J, Pontalis JB (1992) Urphantasie. Fischer Taschenbuch Verlag, Frankfurt/M

Lasch C (1980) Das Zeitalter des Narzissmus. Steinhausen, München

Lienkamp A (2002) „GATTACA" – Eine Parabel auf die gegenwärtige Biopolitik? In: Lienkamp A, Söling C (Hrsg) Die Evolution verbessern? Utopien der Gentechnik. Bonifatius Verlag, Paderborn, S 99–116

Mann T (2010) Die vertauschten Köpfe. In: Die vertauschten Köpfe und andere Erzählungen. Fischer, Frankfurt/M (Erstveröff. 1940)

Marcuse H (1968) Das Veralten der Psychoanalyse. In: Kultur und Gesellschaft Bd 2. edition suhrkamp, Frankfurt/M, S 85–106 (Erstveröff. 1963)

Niccol A (2008) Gattaca, DVD, Deluxe Edition. Sony Pictures Home Entertainment, München (Erstveröff. 1997)

Roussillon R (2004) La dépendance et l'homosexualité primaire „en double". Revue française de psychanalyse 2: 421–439

Vision Kino GmbH (Hrsg) (2011) Das Filmprogramm zum Wissenschaftsjahr 2011, Forschung für unsere Gesundheit. Eine Initiative des Bundesministeriums für Bildung und Forschung, Berlin (www.visionkino.de). Zugegriffen am 29. 12. 2011

Wells HG (1996) The Island of Dr. Moreau. Dover Thrift Publications, Mineola NY

Originaltitel	Gattaca
Erscheinungsjahr	1997
Land	USA
Buch	Andrew Niccol
Regie	Andrew Niccol
Hauptdarsteller	Vincent Freeman (Ethan Hawke), Irene Cassini (Uma Thurman), Jerome Eugene Morrow (Jude Law), Anton Freeman (Loren Dean), Antonio Freeman (Elias Koteas), Maria Freeman (Jayne Brook)
Verfügbarkeit	Als DVD in OV und deutscher Sprache erhältlich

Sabine Wollnik

Wachen oder träumen wir?

Virtual Nightmare – Regie: Alejandro Amenábar

Virtual Nightmare

Regie: Alejandro Amenábar

Die Handlung

„Öffne die Augen", sagt eine sanfte Frauenstimme und damit beginnt und endet der Film (◘ Abb.1). Dazwischen entfaltet sich die Geschichte von César, die am Morgen seines 25. Geburtstages einsetzt.

In der Filmerzählung verschwimmen Traum, Albtraum, Tagraum, Fantasie, Halluzination, Hypnose und simulierte Realität.

Aber der Reihe nach, zumindest der biografischen: César (◘ Abb. 2) verlor beide Eltern im Alter von zehn Jahren durch einen Autounfall. Über seine Mutter erfahren wir nichts, wohl aber über seinen Vater, einen erfolgreichen Geschäftsmann, der ihm eine Restaurantkette und damit ein erhebliches Vermögen hinterließ und dem Sohn wenig wohlgesonnene Geschäftspartner. Die Vater-Sohn-Beziehung war dadurch kompliziert, dass César sich durch die Vorwürfe seines Vaters abgewertet fühlte.

Im Alter von 25 Jahren hat César sich sein Leben eingerichtet – in einer schicken, kühl modern eingerichteten Maisonettewohnung, auf deren Treppe er sich jedoch beinahe den Kopf einstößt, sofern er ihn nicht rechtzeitig einzieht. Er besitzt drei Autos, hat einen engen, ihm treu ergebenen Freund Pelayo, der sein negatives Pendant ist. Dieser hat wenig Geld, ist unattraktiv und hat wenig Erfolg bei Frauen. César hat reichlich Affären, die sich dadurch auszeichnen, dass er mit jeder Frau nur einmal schläft.

Diese Stabilität gerät durch zwei Frauen ins Wanken: zum einen durch Nuria, eine attraktive Verführerin, die ihm nachsetzt, und zum anderen durch die sanfte Sofia, in die er sich verliebt, als Pelayo sie abends als seine neue große Liebe zur Geburtstagsfeier mitbringt (◘ Abb. 3). César flüchtet vor Nuria zu Sofia und verbringt die Nacht in ihrer Wohnung, ohne dass es zu Sex kommt. Am nächsten Morgen erscheint Nuria vor Sofias Wohnung, lädt ihn mit dem Versprechen auf Sex in ihr Auto ein und steuert dann den Wagen in rasendem Tempo einen Abhang hinunter. Bei dem Unfall kommt Nuria zu Tode und Césars Gesicht wird so grauenhaft entstellt, dass auch den besten Operateuren keine zufriedenstellende Rekonstruktion möglich ist.

Sofia zieht sich zurück und wendet sich Pelayo wieder zu. Bei einem Treffen mit beiden in einer Bar trägt César eine Maske. Abgewiesen von allen und tief verzweifelt betrinkt er sich. Er erwacht unter einer Straßenlaterne und plötzlich wendet sich alles zum Guten. Durch neue Operationsmethoden ist eine vollständige Gesichtsrekonstruktion möglich, und Sofia wendet sich ihm wieder zu. In intimen Begegnungen verschwimmt jetzt allerdings zunehmend Sofia und wird zu Nuria. Während eines Liebesaktes, als sich Sofia erneut in Nuria verwandelt, erstickt César sie mit einem Kissen.

Im Gefängnis verdeckt César in Gesprächen mit dem Psychiater Antonio, der ihn vor dem Prozess begutachten soll, sein Gesicht mit einer Maske. Es wird im Folgenden immer undeutlicher, welche Teile seiner Erzählung Erinnerungen entsprechen, welche erinnerten Träumen. In seine Erinnerungen drängen sich ein geheimnisvoller Name „Eli", ein Vertrag, den er unterschrieben haben soll, ein gewisser Duvernois, den er in der Bar und im Fernsehen gesehen haben will.

Auf dem Fernsehbildschirm im Gefängnis erkennt er in einer Reklame für eine Firma namens „Life Extension" Versatzstücke seiner Erinnerung wieder. Gegen eine hohe Zahlung kann man sich nach seinem Tod tiefgefrieren lassen, mit der Hoffnung, wieder auferweckt zu werden, wenn sich die Medizin so weit entwickelt hat, dass durch neue Methoden quasi ein ewiges Leben möglich wird. Er motiviert Antonio, die Firma aufzusuchen.

Dort erfährt er, dass es auch eine zweite Option gibt: Man könne nach der Reanimation in einer virtuellen Realität leben, in der alle Wünsche erfüllt werden. Als er auf einer Toilette seine Maske abnimmt, erkennt César sein entstelltes Gesicht im Spiegel. Als Antonio ihm jedoch versichert, sein Ge-

○ **Abb. 2** César (Eduardo Noriega). (Quelle: Interfoto/Mary Evans)

sicht sei perfekt, erkennt er, dass Antonio Teil der virtuellen Realität ist. In einer Auseinandersetzung mit dem Wachpersonal der Firma werden er und Antonio angeschossen. Nach einem kurzen Bewusstseinsverlust erwacht er ohne Schussverletzungen.

Auf dem Dach des Gebäudekomplexes, in dem die Firma „Life Extension" untergebracht ist, erkennt er den Geschäftsführer Duvernois. Dieser eröffnet ihm in der Tat, dass er vor einem Suizid, den er in völliger Verzweiflung nach der Nacht in der Bar begangen habe, einen Vertrag mit der Firma unterschrieben habe und sich jetzt in einer virtuellen Realität befinde. Als César ihn fragt, wie er aus dem virtuellen Alptraum erwachen könne, antwortet Duvernois: „Wie bist Du als Kind immer aus Deinen Albträumen aufgewacht?" Daraufhin stürzt sich César vom Hochhausdach.

Hintergrund

Virtual Nightmare – Open Your Eyes wurde 1997 von dem damals 25-jährigen Spanier Alejandro Amenábar gefilmt, nach einem Drehbuch, das er zusammen mit Mateo Gil geschrieben hat. Amenábar komponierte auch die Filmmusik. Bei den Kritikern fand der Film eine überaus positive Aufnahme und gilt als einer der hundert besten Filme über virtuelle Realität.[1]

2001 erfolgte ein amerikanisches Remake unter dem Namen *Vanilla Sky* mit Tom Cruise in der Hauptrolle und erneut Penelope Cruz als Sofia. Die Bewertung dieses Films durch die Kritiker war sehr verhalten.

Amenábar galt lange als Experte für Thriller in der Nachfolge Hitchcocks. Inhaltlich sind die Auseinandersetzungen mit dem Tod, mit träumerischen Verfassungen, Fantasien und übersinnlicher Rea-

1 http://en.wikipedia.org/wiki/Open_Your_Eyes_%281997_film%29. Zugegriffen am 17. 6. 2011

📀 **Abb. 3** Pelayo (Fele Martínez) und Sofia (Penélope Cruz). (Quelle: Interfoto/Mary Evans)

lität die Themen des Filmemachers. Bereits in seinem Debutfilm *Thesis* oder auch in seinem international erfolgreichen englischsprachigen Film *The Others* setzt er sich mit Fragestellungen zum Tod, bzw. übersinnlichen Phänomenen auseinander. Amenábar gewann mit seinem Film *Das Meer in mir* 2005 den Auslandsoscar. In diesem Film geht es wie auch in *Virtual Nightmare – Open your Eyes* um einen Unfall, um körperliche Entstellung und den Tod.

Amenábar arbeitet sowohl in Spanien als auch international erfolgreich als Drehbuchautor, Regisseur und Filmkomponist.

In Deutschland ist der Film zwar auf DVD erhältlich, kommt zurzeit aber wohl kaum in die Kinos, da die Aufführungsrechte beim Weltvertrieb liegen, der sündhaft teure Lizenzen verlangt. Die deutschen Aufführungsrechte lagen bei Helkon Media, die kurz nach der Veröffentlichung insolvent wurden, nachdem der Vorstandsvorsitzende tödlich verunglückt war (Christian Schmalz, Leiter des OFF Broadway Kinos, Köln, persönliche Mitteilung 2011). Und so hat die äußere Realität mit der Unabänderlichkeit des Todes den Film doch noch eingeholt.

Filmwirkung

An wen richtet sich die sanfte Frauenstimme mit dem Satz: „Öffne die Augen"? An César oder nicht auch an uns als Zuschauer, die wir auf eine schwarze Leinwand gucken? Wir sollen uns einlassen auf den Film, auf dessen virtuelle Realität. Wie unsicher Realität ist, erleben wir im Laufe des Films, in dem der wiederholt vorgebrachte Satz „Ich glaube nur, was ich sehe" ad absurdum geführt wird.

César erwacht, duscht, vergewissert sich seiner selbst mit ironischem Lächeln in einem Spiegel, fährt aus der Tiefgarage auf die Straßen im Zentrum Madrids, um 10.00 morgens, er gerät in Panik, die Stadt ist menschenleer, er ist ganz alleine.

Es erfolgt ein harter Schnitt, und der Film beginnt noch einmal von vorne. César wird erneut geweckt. Aus dem Off hören wir einen Dialog zwischen César und einem älteren Mann, offensichtlich einem Psychiater, und in dieser Realität entspricht die erste Szene einem Traum.

Wir sind verwirrt und müssen uns in zumindest drei Realitäts- und Zeitebenen orientieren, wobei die visuelle und die akustische Ebene auseinanderfallen. Im Nachhinein entsprach die erste Szene einem Traum, wir sehen das aktuelle Filmgeschehen auf der Leinwand, das aber offensichtlich in einer Art Rückblende läuft, denn der Dialog findet hierzu in einer Zukunft statt. Der Film läuft also anfangs in einer Erzählung über die Vergangenheit. Es sind verschiedene Erwartungen geweckt worden, wie die Filmerzählung weiterlaufen könnte, so entsteht ein Spannungsbogen, den der Film bis zum Ende aufrecht erhält, da die Auflösung erst in der letzten Szene erfolgt.

In der zweiten Szene, die das Aufwachen von César zeigt, liegt eine Frau in seinem Bett, eine attraktive dunkelhaarige, die er barsch abweist. Die Straßen Madrids sind dieses Mal voller Menschen, der Autoverkehr ist lebhaft. In einer kurzen Filmszene sehen wir das Filmteam beim Dreh, den nun wiederum wir beobachten. Der Film läuft fünf Minuten, und wir müssen uns bereits auf vielen Ebenen zurecht finden: Wir befinden uns im Kino, die Geschichte wird teilweise aus dem Off erzählt, ein Teil des Filmes war ein Traum, und wir haben gesehen, wie der Film gefilmt wurde.

Es sind verschiedene Handlungsmomente angerissen, die in unserem Kopf eine Erwartungshaltung wecken, wir befinden uns in einem Spannungszustand.

Die Geschichte entfaltet sich, es gibt aber weitere irritierende Momente: Die Musik verstärkt ein sich zuspitzendes Gefühl von Unheimlichkeit.

Während auf einer Ebene Césars 25. Geburtstag, die Geburtstagsfeier, der Morgen danach und die Situation einige Monate später dargestellt werden, gibt es immer wieder scharfe Schnitte, die zu der Gefängnisszene führen, die dann ab der Mitte des Films weitergeführt und letztlich erst am Ende des Filmes in der letzten Szene verständlich wird.

So sehen wir nach einem scharfen Schnitt eine befremdliche Szene: César liegt versteckt hinter einer Gesichtsmaske, die an die Züge Pelayos erinnert, auf dem Boden zusammengekauert im Gefängnis, wohin er nach einem Mord gebracht worden ist. Er wird befragt von dem Psychiater Antonio. Wir sehen jetzt im Bild die Szene, die wir vorher auf der Tonspur erlebt haben. César ist genauso verunsichert wie vielleicht wir die Zuschauer, er glaubt nur noch, was er fühlt, deshalb liegt er zusammengekauert in Embryonalhaltung, um einen festen Boden unter sich zu spüren.

💬 „Ich mag den Fußboden, er ist das einzige, was mir echt erscheint. Alles andere ist eine Lüge."

Gegen Ende des Films wird César und uns auch der Boden entzogen, da dieser Teil des Films eine virtuelle Realität darstellt, die durch die Firma „Life Extension" bewirkt worden ist.

In der zweiten Hälfte des Filmes nimmt die Kamera, die zu Beginn immer wieder eine Außensicht dargestellt hat, zunehmend die subjektive Wahrnehmung Césars auf und filmt dessen subjektive Wirklichkeit, sodass wir, die Zuschauer, die Welt mit seinen Augen wahrnehmen, wie übrigens schon in der zweiten Filmszene, und eintauchen in seine tiefe Orientierungslosigkeit. Wir erleben den Realitätsschein.

In der Person des Harlekins, den Sofia auf den Straßen Madrids in eingefrorenen Positionen darstellt, verdichtet sich das Identitätsthema Césars, das der Film als Thema aufnimmt. Ist er lebendig oder eine Statue, eine Maske oder eine lebendige Figur.

Ein Klima des Misstrauens entfaltet sich in allen Beziehungen. Im Gefängnis sagt César, er habe keine Freunde: Césars Geschäftspartner wollen ihn über den Tisch ziehen, eine Frau, Nuria, verfolgt ihn, fährt ihn später in den Abgrund. Pelayo und Sofia sind Schauspieler, die Gefühle vorspiegeln können, kann César ihnen vertrauen? „Ich mag keine Katzen, sie sind genauso falsch wie Schauspielerinnen."

César betrügt seinen Freund, indem er ihn belügt, später ihm die Freundin ausspannt. César trägt im Gefängnis eine Maske, die an das Gesicht Pelayos erinnert. Sofia tritt im Retiro-Park in eingefrorenen Positionen als Harlekin auf. Die Vaterfiguren wie der Gefängnispsychiater Antonio oder Duvernois sind entweder virtuelle Figuren oder eiskalte Geschäftsleute. Vertrauen kann César niemandem, so wie niemand ihm vertrauen kann.

Auf der emotionalen Ebene erleben wir als Zuschauer Angst und Hilflosigkeit, das Durcharbeiten im Verlauf des Films ermöglicht uns Freiheit.

Bei aller Unsicherheit, in die der Film die Zuschauer immer weiter hinein treibt, können wir uns auf eines verlassen, unseren Denkapparat. Und so sind wir nicht dem Geschehen hilflos ausgeliefert wie über lange Zeit der Protagonist, sondern werden zu Mitwirkenden. Wir versuchen ununterbrochen, die angefangenen Handlungsfäden zu Ende zu fantasieren, um uns orientieren können, bauen bereits Gesehenes im Nachhinein innerlich um, um es in dem Erzählfluss für uns verständlich zu machen. Mit dem überraschenden Schluss müssen wir die Geschichte noch einmal neu konfigurieren. So bleibt das Denken etwas, das bis zuletzt funktioniert, und es ist das einzige, auf das wir uns verlassen können.

Psychodynamische Interpretation

Auf der narrativen Ebene beschreibt der Film die adoleszente Entwicklungs- und Identitätskrise von César. Dabei wird diese nicht aus einer Außenperspektive dargestellt, sondern durch den Einsatz verschiedener Wirklichkeitsebenen gelingt es Amenábar, diese aus der Innenperspektive des Protagonisten zu schildern.

Schutz im narzisstischen Kokon

Die Spätadoleszenz ist, wie Bohleber (1996) schreibt, eine Phase der Konsolidierung und Integration, wobei unterschiedliche Identifizierungen zu einer Ich-Identität integriert werden. Der Film beschreibt eine Identitätsdiffusion, da die adoleszente Krise dadurch kompliziert ist, dass der Protagonist César im Alter von 10 Jahren durch einen Unfall beide Eltern verloren hat.

Das schwere Verlusttrauma, das zudem noch durch gewalttätige Szenen eskaliert ist, in denen Körper zugerichtet und zerstört werden, hat einen komplizierten Trauerprozess zur Folge, eine „eingefrorene Trauer". César konnte die elterlichen Objekte nicht in einer Auseinandersetzung allmählich entidealisieren, sondern sie blieben eingefroren in seinem Inneren, dissoziiert. In Abwehr des Verlusttraumas hat César sich eingerichtet in einem narzisstischen Universum, dessen perfekte Ausgestaltung ihm das Erbe des Vaters ermöglicht hat.

Seine Wohnung ist durchgestylt, wodurch Hässlichkeit, Zufall, Zerstörung und Verfall abgewehrt werden. Der Blick in den Spiegel am Morgen zeigt ihm den jungen, schönen Mann, der er ist, wobei der Zuschauer durch den Kamerawechsel in die Spiegelposition gerät. Und so definieren Laplanche und Pontalis Narzissmus: „In Anlehnung an die Sage von Narcissus: die Liebe, die man dem Bild von sich selbst entgegenbringt" (Laplanche u. Pontalis 1972, S. 317). Lediglich in der Kühle der Einrichtung zeigt sich bereits der Mangel an wärmenden, inneren Beziehungen. Als er seinen narzisstischen Kokon verlässt, das Garagentor sich vor seinem ausfahrenden Auto öffnet, und er eintaucht in das Straßenleben Madrids in der ersten Szene, die einem Traum entspricht, sind die Straßen menschenleer. Wir, die Zuschauer, werfen einen Blick in Césars Innenwelt, in einen Zustand vollkommener Verlassenheit, auf den er mit Angst, ja Panik reagiert.

César wehrt diesen Zustand innerer Verlassenheit ab, in die er nach dem Tod der Eltern gefallen ist. Um nie wieder verlassen zu werden, schläft César mit jeder Frau nur einmal und bindet sich nicht. Sein Freund Pelayo ist der Träger aller entwerteten Eigenschaften, denn dieser fühlt sich hässlich, arm und so, als könne ihn nie eine Frau begehren.

Dieses Konzept bricht ein an Césars 25. Geburtstag, einem Alter, in dem für viele die verlängerte Adoleszenz endet, da man sich auf die zweite Hälfte des dritten Lebensjahrzehnts und somit auf die Dreißig zubewegt, das Lebensalter also unerbittlich das Erwachsenwerden einfordert. Themen wie Partnerwahl und erste körperlich Alterserscheinungen werden zwingender.

„Das Ende der Adoleszenz ist also das Stadium einer sichtbaren Identitätskrise", schreibt Erikson (¹1959; 1966, S. 140) Und er führt weiter aus (ebd., S 145):

Es ist natürlich richtig, dass der Jugendliche im letzten Stadium seiner Identitätsbildung oft schwerer denn je zuvor (und jemals danach) an einer Rollendiffusion leidet.

Erikson beschreibt weiter, dass der Jugendliche sich in ein soziales Spiel bewegt, das die Fortsetzung des kindlichen Spieles ist. Häufig handelt es sich um ein gewagtes Experimentieren mit der Fantasie (ebd., S 145 f.):

Dieses Hinauslehnen des Jugendlichen über Abgründe ist normalerweise ein Experimentieren mit Erfahrungen, die so einer besseren Ich-Kontrolle unterstellt werden können.

Der Traum von Omnipotenz zerbricht

Das soziale Spiel und das Experimentieren brechen bei César zusammen, als er eine Liebesbeziehung eingeht und in Rivalität zu seinem Freund gerät, der zuvor ganz narzisstisch als Projektionsfigur für Césars abgespaltene Anteile gebraucht wurde. In diesem Moment wird César eingeholt von den abgespaltenen inneren Selbst- und Objektbeziehungen. Dissoziierte unbewusste Inhalte werden an die Oberfläche gespült und beherrschen die Szenen. Er wird konfrontiert mit dem Unfall, gerät in eine innere Auseinandersetzung mit seinen verinnerlichten Elternbildern und seinen eigenen abgewerteten und zerstörten Persönlichkeitsanteilen. Um darzustellen, wie der Protagonist in einer inneren Auseinandersetzung mit dissoziierten Selbstanteilen beschäftigt ist, wendet Amenábar einen Kunstgriff an, indem er eine virtuelle Welt kreiert.

Aber César reagiert auch mit heftigen Abwehrbewegungen, trägt eine Maske, um die eigene monströse und beschädigte Seite nicht wahrzunehmen. Die Maske erinnert andererseits an das Gesicht Pelayos, was man als einen Versuch auffassen kann, den abgewerteten, vormals auf Pelayo projizierten Selbstanteil zu integrieren. Dazu könnte auch passen, wie César in der ersten visuell im Film aufscheinenden Gefängnisszene dargestellt wird: Er liegt unterhalb der Schuhsohle des Psychiaters auf der Erde zusammengekauert, die narzisstische Omnipotenz ist zusammengebrochen. Und so ist das Geschehen in der virtuellen Realität ein Kompromiss aus dissoziierten Persönlichkeitsanteilen, die sich durchsetzen, und es stellt gleichzeitig eine Flucht dar, die Abwehr von Verlust und Sterblichkeit in dem Traum von Omnipotenz und Unsterblichkeit.

Blos (1979) sprach von einer normativen adoleszenten Regression, in der der junge Mensch in Berührung kommt mit seinen infantilen Abhängigkeiten, Bedürfnissen und Traumatisierungen. Ein Durcharbeiten dieser inneren Muster ermöglicht auch immer eine Chance zu einer weiteren Entwicklung.

Scheitern der „reifen" Objektwahl

Das Unglück nimmt seinen Lauf, als César sich mit Nuria, einer sexuell attraktiven, dunkelhaarigen Frau mehrfach trifft. Mit ihrer weißen Haut, ihrer aufreizend roten Kleidung und ihrem geheimnisvoll theatralischem Gebaren macht sie den Eindruck von Unwirklichkeit, auch wenn ihr Auftritt in der scheinbaren Realität angesiedelt ist. Sie bekommt zunehmend einen verfolgenden Charakter, sodass immer mehr der Eindruck entsteht, dass sich die „reale" Person mit einem verinnerlichten, sexuell aufreizenden, verfolgenden Objekt überlagert.

Eine der wichtigen Aufgaben in der Adoleszenz besteht in der Aufgabe der ödipalen Liebesobjekte und im Treffen der Objektwahl außerhalb der Familie. In dem Moment, in dem César eine Beziehung eingeht, indem er eine Frau mehrfach sieht, wird er eingeholt von den traumatischen, inneren ödipalen Objekten.

César verlor seine Eltern im Alter von zehn Jahren durch einen Unfall. Seine eigenen präödipalen Selbstanteile, geprägt durch eine altersentsprechende Zunahme der sexuellen und aggressiven Triebimpulse, blieben lebenslang gebunden an entsprechende elterliche Partialobjekte, da eine Abarbeitung und Entwicklung durch deren Tod in der Außenwelt nicht stattfinden konnte. So ist es stimmig, dass er zusammen mit Nuria, dem sexuell und aggressiv aufgeladenen mütterlichen Partialobjekt, in den Tod fährt, dass sich also das ehemalige Trauma reinszeniert. Er selbst bleibt versehrt zurück. Er ist aufgetaucht aus seinem narzisstischen Kokon und muss sich auseinandersetzen mit seinen eigenen, durch den Tod der elterlichen Objekte zerstörten, aber auch zerstörerisch aggressiven Selbstanteilen. Er ist allerdings ab der zweiten Filmhälfte auch mit Abwehrbewegungen in seinem Traum beschäftigt.

Wer ist Sofia? Zuerst scheint sie als eine Person der Außenwelt wahrgenommen zu werden, sie verkörpert die sanfte, liebevoll zugewandte Frau, die ihm gleichwohl in ihrer Eigenart ein Gegenüber sein kann. Ihre Wohnung ist warm und lebendig eingerichtet, sie kennt ein Familienleben. Aber zunehmend schillert die Person hinweg und wird überlagert durch Césars Projektionen. Die dissoziierten Persönlichkeitsanteile gewinnen die Oberhand und verunmöglichen eine neue Erfahrung in einer andersartigen Beziehung.

Sofia ist Schauspielerin, kann César ihr trauen? Hier spielt der Film die Krise des Urvertrauens an, die komplizierte adoleszente Identitätskrisen eben auch beinhalten. Sofia spielt im Film zunehmend die Rolle eines internalisierten Objekts, weshalb es auch stimmig ist, dass sich ihrem Bild immer mehr das Nurias überlagert.

Dies ist früh angelegt, da Sofia, um ihren Lebensunterhalt zu verdienen, auf den öffentlichen Plätzen Madrids einen Harlekin in eingefrorenen Positionen darstellt. Auf die Thematik übertragen, repräsentiert sie ein eingefrorenes, totes inneres Objekt. César ist gebunden an das ödipale, mütterliche, tote Liebesobjekt. In der Androgynität des Harlekins nimmt die Person der Sofia die Androgynität der Adoleszenz auf, in der die sexuelle Identität erst gefunden werden muss. Zudem repräsentiert der Harlekin eine Gestalt aus der Unterwelt, aus einem Todes- oder Zwischenreich. Im Karneval von Barcelona besiegt der Harlekin den Tod. Die Versuche, Entstellung und Tod in einer manischen Abwehr rückgängig zu machen, beherrschen ab der zweiten Hälfte den Film. In der Interpretation wäre dies der Versuch, die toten Eltern und den mit ihnen verbundenen Selbstanteil wieder lebendig zu machen und so einer Entwicklung zuzuführen.

So verwiesen mehrere Kritiker auf Ähnlichkeiten des Films zu Alfred Hitchcocks Film *Vertigo*, bei dem es thematisch auch um die Auseinandersetzung oder Wiederbelebung eines toten Objektes geht. Erikson ([1]1959; 1966, S. 147) führt dazu aus:

Das sich bildende Identitätsgefühl dagegen wird vorbewusst als psychosoziales Wohlbefinden erlebt. Die erkennbarsten Begleitumstände sind das Gefühl, Herr seines Körpers zu sein, zu wissen, daß man „auf dem rechten Weg ist", und eine innere Gewißheit, der Anerkennung derer, auf die es ankommt, sicher sein zu dürfen.

César aber gerät in eine schwere Krise, in der er sich des eigenen Körpers nicht mehr sicher ist und die Anerkennung seiner Freunde verliert.

In der Identitätsdiffusion, in die César gerät, entsteht „eine Zersplitterung des Selbst-Bildes, ...ein Verlust der Mitte, ein Gefühl von Verwirrung und in schweren Fällen die Furcht vor völliger Auflösung" (ebd., S. 154).

Halten kann einen verwirrten Jugendlichen die Peer-Group, die César aber schnell abhandenkommt. Weder Sofia noch Pelayo wollen mit seinen zerstörten und zerstörerischen Seiten in Kontakt kommen. Beide distanzieren sich nach dem Unfall. Das Alleinsein und der Verlust empathischer Resonanz verhindern eine Integration dieser Selbstanteile und lassen ihn in die virtuelle Realität flüchten.

Die Rolle von Vaterfiguren

Jetzt noch zur Rolle des Psychiaters Antonio und der von Duvernois; repräsentieren sie nicht Vaterfiguren? Einerseits nimmt César auch Antonio nur wie seinen eigenen Vater wahr:

 „Sie sehen aus wie mein Vater, wenn er mir den ganzen Tag Vorhaltungen gemacht hat."

In dieser Funktion ist Antonio virtuell, da nur eine Projektion von César. Andererseits repräsentiert Antonio den Vater, den César nicht hatte. Der Psychiater versucht, zusammen mit César die Vergangenheit aufzuklären, insbesondere den Mord und den Suizid. Er ist einfühlsam, an César interessiert, er sagt ihm, dass er ihn mag. Er hilft ihm durch seine Fragen weiter. Er erträgt seine Aggressionen und hält die schwierige Beziehung aus, anders als seine Freunde Sofia und Pelayo, die sich abwenden. Er ist in der Lage, auf Konflikte einzugehen und diese mit ihm durchzustehen. Allerdings sieht er die monströse Seite von César nicht. An dieser Stelle bleibt er virtuell, da er Träger der verleugnenden Abwehr ist. Er muss deshalb am Ende in der virtuellen Welt zurückbleiben.

Duvernois ist vorwiegend Träger der narzisstischen, omnipotenten Abwehr. Er repräsentiert eine Welt, in der Zerstörung, Entstellung, Tod und Verluste keinen Raum haben, da alles möglich zu sein scheint. Und doch treibt auch Duvernois die Entwicklung weiter, wenn er César am Ende des Films ermöglicht aufzuwachen. Eine Entwicklung hat stattgefunden. Duvernois formuliert es so:

 „Du hast Deine Ängste überwunden." … „Du wirst sterben."

Es ist, als habe César in seinem wunscherfüllenden Traum, den er im Text mit der virtuellen Realität und dem Kino verbindet, eine Entwicklung durchgemacht. In dem virtuellen Traum reinszeniert sich das Trauma, das so verstanden und durchgearbeitet werden kann. Indem César die mit dem Trauma verbundenen Selbstanteile aus der Dissoziation szenisch wiederbelebt, kann er diese einer Entwicklung zuführen. Gleichzeitig inszeniert sich in der virtuellen Realität Césars Abwehr, nämlich seine omnipotenten Wunschvorstellungen. Aber der Traum generiert auch Antonio, den Psychiater, der ihm in seiner einfühlsamen Gegenwart hilft, das Trauma zu bearbeiten. Und so können César und der Zuschauer am Ende Trauer empfinden, Antonio trauert, Sofia trauert, auch César kann sich abfinden mit der Endgültigkeit von Verlusten durch Abschied und Tod. Und so tauchen César und der Zuschauer, der bereits in der Anfangsszene in die Spiegelposition zu César gerutscht ist, ihm aus dem Kinosessel aber keine reale Antwort geben kann, ein in die Innenwelt des Traumas, die aufgezeigt wird, und in der es eine Entwicklung gibt. Diese kann dann in der Wirklichkeit fortgeführt werden – nach dem Aufwachen oder dem Verlassen des Kinosaals.

Die (Un)-Wirklichkeit des Wahrgenommenen

Zu solch einer adoleszenten Krise gehört auch eine Diffusion der Zeitperspektive. Der Film spielt mit dieser Thematik, indem er auf der „Realebene" in einer Gegenwart spielt, die aus einer virtuellen Zukunft 150 Jahre später betrachtet wird. Auch dem Zuschauer kommt so im Laufe des Films die Zeitdimension immer wieder abhanden, die erst am Ende wieder hergestellt wird.

César erleidet einen Zusammenbruch, der mit großer Angst einher geht. In diese Verfassung bezieht der Filmemacher die Zuschauer ein, indem er *Open Your Eyes* als Thriller inszeniert, in dem

wir in eine immer größere Verwirrung geraten und in dem nur die künstlerische Gestaltung und die letztlich in ihrer Stringenz aufgelöste Narration, der wir unter großer Denkanstrengung und ständigem Umbau des Gesehen folgen können, eine Orientierung geben. Letztlich können wir dem Geschehen entfliehen und uns wieder in die äußere Realität begeben, indem wir die Augen öffnen nach Ende des Abspanns und Auftauchen aus der virtuellen Realität des Films. César löst sein Identitätsproblem mit dem Wunsch, noch einmal von vorne anzufangen, vielleicht in seiner Kindheit vor dem entsetzlichen Objektverlust. Indem er sich in die Tiefe stürzt, hofft er auf einen Neubeginn. Ob er versucht, Teile seiner Identität abzuspalten, die mit dem ursprünglichen Trauma verbunden sind, wobei der Sprung in den Abgrund doch wieder eine Wiederholung des Unfalltods der Eltern ist, oder ob das Durcharbeiten des Traumas und die Wiederbelebung dissoziierter Selbstanteile zu einer Integration führen, bleibt etwas offen. Die Trauer, die spürbar wird am Ende des Filmes, und die Anerkennung der Realität sprechen für letztere Entwicklung.

Auch wenn der Film auf der narrativen Ebene konstruiert ist, wie die in sich psychologisch stimmige, schwere adoleszente Entwicklungskrise von César, die in einer Identitätsdiffusion eskaliert, so ist der Film doch zugleich eine Auseinandersetzung mit Wahrnehmung von Wirklichkeit, virtueller Realität, Traum und Film, und dem Tod.

In den letzten Jahren beschäftigen sich Filmemacher zunehmend mit der Wirklichkeit des Wahrgenommenen. Sie thematisieren damit die Auswirkungen durch die veränderten Medienlandschaften, in denen sich Menschen in virtuellen Realitäten wie dem Internet oder dem Web 2.0 tummeln. *Open your Eyes* entstand schon 1997, also zu Beginn dieser Entwicklung.

Damit ist dies ein zeitlich früh anzusiedelnder Film, der, wie es Nico Hofmann (Vorwort zu Laszig u. Schneider, 2008) beschreibt, Themen der globalisierten Moderne wie Realität/Virtualität, strukturelle Identitätsveränderungen und spezifische Umgangsformen mit dem Tod aufnimmt.

In einem nächsten Schritt will ich einen Blick auf den Film werfen, indem ich die Frage des Kontaktes zur äußeren Realität aufgreife.

Realitätsbezüge des Films

In der Zeitschrift „communichator" des Instituts für Kommunikationswissenschaft und Medienforschung der LMU München befassen sich die jungen Redakteure, vielleicht in einem ähnlichen Alter wie César oder Amenábar beim Drehen des Filmes, in ihrer Ausgabe aus dem Sommersemester 2011 in einem ganzen Heft entspannt mit dem Thema Träume, genauer mit Klarträumen, Fantasien, Tagträumen, Kryonik, Fantasy und der Suche nach dem Traumpartner. Nebenbei werden Statistiken angeführt, die belegen, dass mittlerweile 5,4 Millionen Deutsche ihren Traumpartner im Internet gefunden haben. Junge Leute bewegen sich im Jahr 2011, also 14 Jahre, nachdem dieser Film entstanden ist, angstfrei und entspannt auf verschiedenen Wirklichkeitsebenen. Aber die Themen bleiben gleich: Wie kann man die Grenzen verändern, die das Leben durch Verlust, Zerstörung und Tod setzt?

Zwei Artikel möchte ich aufnehmen, zuerst einen zur Kryonik, der Konservierung eines Leichnams bei -196 Grad: Es wird in der Tat von den Kryonikern damit gerechnet, dass sich bis etwa 2100 oder 2150 die Wissenschaft so weit entwickelt hat, dass man die eingefrorenen Leichen reanimieren, wieder heilen und verjüngen kann. Bis heute haben sich etwa 200 Personen einfrieren lassen, wobei die Kosten je etwa 120.000 Euro betragen. Es gibt drei Firmen: zwei amerikanische, eine russische. Eine amerikanische heißt: „Alcor Life Extension Foundation". Amenábar hat diese Vorstellungen aufgenommen, sich mit dieser äußeren Realität auseinandergesetzt und sie in seinem Film verarbeitet.

Ein zweiter Artikel beschäftigt sich mit luziden Träumen. Max Dressler, Schlaf- und Gedächtnisforscher am Max-Planck-Institut für Psychiatrie, beschreibt, dass luzides Träumen ein Phänomen sei, das man seit 30 Jahren naturalistisch erklären könne. Luzide Träumer wissen im Schlaf, dass sie träumen, und können das Traumgeschehen sogar willentlich beeinflussen; allerdings ist auch im Luzidtraum

dem Träumer nicht immer die Regie überlassen, da „die Dynamik aus neuronalen Zufallsprozessen und Assoziationen oft die Oberhand" (Communichator, SS 2011, S. 13) gewinnt.

Reflexionsfähigkeit und Bezug zur äußeren Wirklichkeit bleiben teilweise vorhanden. In luziden Träumen gibt es Kommunikationsmöglichkeiten mit der Außenwelt. Der Luzidtraumpionier Stephen LaBerge bewies Anfang der 80er-Jahre (ebd., S. 12):

… dass Luzidträume ein reales Phänomen sind … In seiner Studie machte er sich die Annahme zunutze, dass Augen das Traumgeschehen abbilden. In der Schlafphase des Rapid Eye Movements, dem klassischen Traumschlaf, ist der gesamte Körper bis auf die Augen gelähmt. Sobald die Probanden – geübte Luzidträumer – merken, dass sie träumen, führten sie eine zuvor vereinbarte Augenbewegung aus, die durch das Elektrookulogramm (EOG) registriert wird. Dadurch kann der Träumer im Grunde aus dem Traum heraus mit dem Wissenschaftler kommunizieren.

Es gibt sogenannte Reality Checks, mit denen man in der Schlafphase überprüfen kann, ob man sich in einem Traum- oder in einem Wachzustand befindet. Ein zuverlässiger Indikator ist der Lesetest, da die meisten Träumer schon beim Lesen scheitern, spätestens aber, nachdem sie den Blick abgewandt haben, da eine erneute Texterzeugung im Traum offensichtlich zu schwierig ist.

Vor allem im Text über luzides Träumen wird deutlich, wie wichtig es der Interviewerin ist, den Bezug zur äußeren Realität zu halten, etwas, das innerhalb des Films César und dem Zuschauer, der ja in Césars Innenwelt hineingezogen wird, verloren geht, da visuelle Kontrolle oder Bodenhaftung nicht weiterhelfen. César versucht in den Gesprächen mit Antonio verzweifelt, einen Bezug zur äußeren Wirklichkeit herzustellen. Im Film findet er nur über die Erinnerung an den Vertrag aus dem Traum heraus, kann aber im Traum, der noch durch die Hypnose kompliziert ist, den Text nicht lesen. Schließlich gelingt dies über die Person des Duvernois, der Teil der äußeren Realität ist. Mal abgesehen davon, dass hier ein Realitätszeichen aus luziden Träumen aufgenommen wird, nämlich der Text, der sich nicht lesen lässt, weil der Träumer nicht in der Lage ist, einen solchen zu generieren, stellt der Vertrag auch einen Gegenstand dar, der sowohl von César als auch von Duvernois klar beobachtbar ist, und der, wie sich dann herausstellt, einer raumzeitlichen Welt angehört. Allerdings wird ganz ironisch der Realitätsbezug über das Fernsehbild, also ein mediales Bild von Duvernois, hergestellt.

Standpunkte der Psychoanalyse zum Realitätsbezug

Freud vertrat ein pragmatisches positivistisches Realitätsverständnis; darin sah er die äußere Welt als objektiv gegeben an. Allerdings stellte er mit Aufgabe der Verführungstheorie der materiellen eine psychische Realität gegenüber, „die auf dem unbewußten Wunsch und den daraus entstehenden Fantasien beruht und vom Subjekt wie die äußere Realität betrachtet wird" (Bruns 2002, S. 601). Das Realitätsprinzip verlangt die Berücksichtigung der Anforderungen und Bedingungen der Außenwelt und wird dem Lustprinzip gegenübergestellt. Die Wahrnehmung ist in direkter Verbindung mit den äußeren Objekten und liefert „Realitätszeichen", allerdings können diese auch durch Erinnerungen hervorgerufen werden (nach Laplanche u. Pontalis 1972).

Nach Ferenczi ([1]1913; 1970) ist der Wirklichkeitssinn erst mit der vollen psychischen Ablösung von den Eltern erreicht, vorher herrschen die umfassenden Allmachtsvorstellungen der Kindheit.

Hartmann ([1]1956; 1972) unterschied zwischen innerer und äußerer Realitätsprüfung, wobei letztere der Unterscheidung zwischen Wahrnehmung und Vorstellung dient, erstere der Wahrnehmung innerer Strebungen und Fantasien.

Allerdings wird es verworren und unbestimmt, sobald die Frage der Realitätsprüfung aufkommt. So beschreiben Laplanche und Pontalis (1972, S. 433), dass im halluzinatorischen Zustand oder im Traum keine Möglichkeit mehr besteht, Halluzination oder Wahrnehmung voneinander zu unterscheiden:

> Ebenso müßig ist die Vorstellung, der Halluzinierende könne sich zur Unterscheidung des Subjektiven vom Objektiven seiner Motorik bedienen.

Auch die moderne Psychoanalyse beschäftigt sich mit der Frage nach der äußeren Realität.

Hilfreich erscheint hier ein Aufsatz der Philosophin und Psychoanalytikerin Marcia Cavell, die aus der sprachphilosophischen Tradition im Anschluss an Wittgenstein, Putnam, Rorty und Donald Davidson kommt.

Subjektivität entsteht zusammen mit Intersubjektivität auf Grundlage einer geteilten Objektivität, d. h. auf dem Boden einer gemeinsamen, realen äußeren Welt, die als solche von den Beteiligten anerkannt wird. Daraus folgt, dass Realität eben nicht subjektiv ist, sonst verliert der Realitätsbegriff seinen Sinn. „Gibt man die Vorstellung einer objektiven Wirklichkeit ‚da draußen' auf …, bleibt uns als Paradigma nur die „Ein-Personen-Psychologie" (Cavell 2006, S. 181). Das ist das Dilemma von César: So lange er sich in einem Traum befindet, in dem es kein Gegenüber und keine äußere Realität gibt, auf die sich beide beziehen, kann das Denken nicht stattfinden. Dann kommt es zu einer grundsätzlichen Störung mentaler Vorgänge.

Die virtuelle Realität, die der Film entstehen lässt, ist nicht nur kein sicherer Ort, da überlagert mit traumatischen Projektionen, sondern die Bewältigungsversuche wie Auflösung der Zeitperspektive, Unsterblichkeit, Schutz vor körperlicher Beschädigung und Omnipotenz bringen auch keine Lösung. César und Antonio suchen nach der Wahrheit, den Bezug zu etwas Drittem, eine Verständigungsmöglichkeit über die Welt, in der die Protagonisten leben. Dies ist nicht möglich, solange alle Beteiligten in der virtuellen Welt von César leben, also in einem narzisstischen Universum, oder in dem des Filmemachers, möchte man hinzufügen. Was aber nicht so stimmt, da ja die Übereinkunft besteht, dass es sich um einen Film handelt, den wir spätestens nach dem Abspann verlassen können. Das heißt, dass wir uns als Zuschauer immer auf eine äußere Realität beziehen, die von Filmteam und Zuschauern gleichermaßen anerkannt wird. Christian Metz beschreibt den Film als Traum eines wachen Menschen (1982, S. 123):

> … der weiss, dass er nicht träumt, der weiss, dass er im Kino sitzt, und der weiss, dass er nicht schläft.

Ich möchte hinzufügen, dass er es deshalb weiß, weil er dieses Wissen mit den anderen Beteiligten unter Bezug auf die äußere Realität teilt. Innerhalb des Films muss der Regisseur Filmmarker setzen, denn innerhalb des Films sind die Figuren nicht in der Lage, die Realität zu klären. Cavell schreibt dazu (2006, S. 195):

> Wahrheit ist ein Begriff, der nur in der interpersonellen Welt einen Gehalt hat.

Nur wenn ich anerkenne, dass es eine äußere Realität gibt und verschiedene Sichtweisen auf diese möglich sind, kann ein Dialog entstehen. Sonst verschwindet die Welt als Ganzes aus dem Blick.

Subjektivität entsteht nur im Zusammenhang mit Intersubjektivität. Ein Mensch hat Subjektstatus dann erworben, wenn er weiß, dass einige seiner Überzeugungen eigene Überzeugungen sind und wenn er gleichzeitig auch anderen Subjekten einen Bewusstseinszustand zuerkennt (ebd., S. 190):

> … er versteht dann, dass er zum Bewusstsein von anderen einen Zugang hat, den er zum eigenen Bewusstsein nicht hat, genau wie er zu eigenen Gedanken einen Zugang hat, den andere nicht haben. Nicht nur können andere sein Verhalten, sondern er selbst kann auch das von anderen verstehen.

Fonagy beschreibt, wie allmählich Mentalisieren entsteht, nämlich nur durch die Beihilfe einer zweiten Person. Wir können andere Psychen nur kennenlernen, „indem wir mit ihnen interagieren und ihre Reaktion auf uns sowie unsere Reaktionen beobachten" (Fonagy u. Luyten 2011). Von daher führt der Blick, den César in den Spiegel wirft nicht weiter. Ein Mensch, der diese Fähigkeiten zur Mentalisierung erworben hat, verfügt nach Fonagy (1989) über eine „Theorie des Geistes" (theory of mind) und nur ein solcher Mensch ist, jedenfalls ab und zu, in der Lage, „zwischen Spiel und Realität, Fantasie und Tatsache zu unterscheiden" (Cavell 2006, S. 191). Der Begriff der Fantasie hat überhaupt erst dann eine Bedeutung, wenn eine derartige Unterscheidung möglich ist.

Voraussetzung ist, dass der andere ein wirklicher Mensch ist, der mit der Person über eine wirkliche äußere Welt voller materieller Gegenstände kommuniziert. Von daher wären die Versuche Césars, mit Antonio eine Klärung herbei zu führen, zum Scheitern verurteilt, wenn Antonio und die Welt, über die beide kommunizieren, virtuell wären. Da aber in den Gesprächen mit Antonio eine Entwicklung stattfindet, scheint Antonio, auch wenn der Film dies behauptet, kein rein virtuelles Objekt zu sein, sondern ein Übergangsobjekt in einem Übergangsraum. Winnicott, der dieses Konzept für die frühkindliche Entwicklung aufgestellt hat, definiert es so (1953/1979, S. 21 f., zitiert nach Tenbrink 2002):

> Der intermediäre Bereich … ist jener Bereich, der dem Kind zwischen primärer Kreativität und auf Realitätsprüfung beruhender objektiver Wahrnehmung zugestanden wird. Die Übergangsphänomene repräsentieren die frühen Stadien des Gebrauchs der Illusion, ohne den ein menschliches Wesen keinen Sinn in der Beziehung zu einem Objekt finden kann, das von anderen als Objekt wahrgenommen wird, das außerhalb des Kindes steht.

Übergangsphänomene bleiben für Entwicklung und Kreativität lebenslang bedeutsam.

Fazit

Antonio erfüllt in seinen realen Anteilen die Aufgaben eines guten Therapeuten, der die Mentalisierung fördert. Er fördert die Bindung an ihn und regt immer wieder das Behandlungsengagement von César an. Er fokussiert auf die Ereignisse, die für César bedeutsam sind. Er verleugnet allerdings die Destruktivität und erkennt nicht Césars zerstörte und zerstörerische Seiten. Er bleibt in einem intermediären Entwicklungsraum, weshalb er am Ende des Filmes in der virtuellen Realität zurückbleibt, von César verlassen, so wie ein Kind sein Übergangsobjekt zurücklässt, wenn es sich weiterentwickelt.

Der Film zeigt verschiedene Wirklichkeits- und Zeitstufen: Gegenwart, Vergangenheit, Zukunft in 150 Jahren, sowie Träume, Fantasien, luzide Träume, Dissoziation und virtuelle Realität.

Im Bereich dissoziierten Erlebens gibt es keine Mentalisierung und keine Symbolisierung. Aber der Film ist ein Mentalisierungs- und Symbolisierungsangebot im Dreieck zwischen dem Film, der von den Filmschaffenden gestaltet wird, den Zuschauern und der gegebenen Alltagsrealität, auf die sich alle beziehen.

In ihrer Einführung zum Thema „Die neuen Medien als Lebensräume" regen Parfen Laszig und Gerhard Schneider eine Reflexion an zu Themen wie Entgrenzung, Omnipotenz, psychischer Rückzugsort, Allein-sein-Können (Laszig u. Schneider 2010, S. 16).

Meine Antwort darauf ist folgende. Beim Eintauchen in virtuelle Realitäten stellt sich immer die Frage, ob es sich um Fluchten handelt in Welten, in denen keine Entwicklungen stattfinden können, oder doch eher um Betreten von Übergangsräumen, die anzusiedeln sind zwischen Fantasie und Realität, in denen Entwicklung stattfindet. Es spricht vieles dafür, dass César letztere betritt: Antonio und Duvernois sind als Personen eben keine reinen Projektionen, die Ängste auslösen, sondern sie treiben mit ihren hilfreichen Interventionen die Entwicklung voran, sodass letztlich doch der Realitätsbezug greift, in dem Endlichkeit, Grenzen und Verluste anerkannt werden. Und so ist die Welt, die César

betritt, eine zwischen zerstörten Hoffnungen und Fantasien, die durch diese generiert werden. Der Unterschied zwischen Räumen, in denen keine Entwicklung stattfindet, Orte seelischen Rückzugs, und Räumen, in denen Kreativität und Entwicklung möglich sind und die Integration dissoziierter Selbstanteile über ein Durchleben im Fantasieraum stattfindet, besteht eben darin, dass der Realitätsbezug wie im Spiel grundsätzlich erhalten bleibt.

Literatur

Blos P (1973) Adoleszenz. Eine psychoanalytische Interpretation. Klett Stuttgart. (Erstveröff. 1962)

Blos P (1979). The adolescent passage. Developmental issues. International Universities Press, New York NY

Bohleber W (1996) Einführung in die psychoanalytische Adoleszenzforschung. In: Bohleber W (Hrsg) Adoleszenz und Identität. Klett-Cotta, Stuttgart, S 7–40

Bruns G (2002) Realitätsprinzip, Realitätsprüfung. In: Mertens W, Waldvogel B (Hrsg) Handbuch psychoanalytischer Grundbegriffe. Kohlhammer, Stuttgart

Cavell M (2006) Subjektivität, Intersubjektivität und die Frage der Realität in der Psychoanalyse. In: Altmeyer M, Thomä H (Hrsg) Die vernetzte Seele. Die intersubjektive Wende in der Psychoanalyse. Klett-Cotta, Stuttgart

Communichator (2011) Die Zeitschrift am IfKW der Uni München no 23/SoSe2011

Erikson EH (1966) Identität und Lebenszyklus. Suhrkamp, Frankfurt/M (Erstveröff. 1959)

Ferenczi S (1970) Entwicklungsstufen des Wirklichkeitssinnes. In: Ferenczi S: Schriften zur Psychoanalyse I. Fischer, Frankfurt/M, S 148–163 (Erstveröff. 1913)

Fonagy P (1989): On tolerating mental states: Theory of mind in borderline personality. Bull Anna Freud Centre 12, London, S 91–115

Fonagy P, Luyten P (2011) Die entwicklungspsychologischen Wurzeln der Borderline-Persönlichkeitsstörung in Kindheit und Adoleszenz: Ein Forschungsbericht unter dem Blickwinkel der Mentalisierungstheorie. Psyche 9/10: 900–952

Hartmann S (1972) Bemerkungen zum Realitätsproblem. In: Hartmann S: Ich-Psychologie. Studien zur psychoanalytischen Theorie. Klett, Stuttgart, S 236–260 (Erstveröff. 1956)

Hartmann S (2011) Reality 2.0: When loss is lost. Psychoanal Dialog 21: 468–482

Karasek J (2008) Zur dichotomen Antizipationsbildung im Frühwerk des Regisseurs Alejandro Amenábars. Diplomarbeit, Universität Wien, Institut für Theater-, Film- und Medienwissenschaften

Laplanche J, Pontalis J-B (1972) Das Vokabular der Psychoanalyse. Suhrkamp, Frankfurt/M

Laszig P, Schneider G (2010) Informations- und Kommunikationsformen. Psychosozial 122: 5–18

Laszig P, Schneider G (Hrsg) (2008) Film und Psychoanalyse. Kinofilme als kulturelle Symptome. Psychosozial, Gießen

Lingiardi V (2011) Realities in dialogue: Commentary on paper by Stephen Hartmann. Psychoanal Dialog 21:483–495

Loewald HW (1974) Psychoanalyse als Kunst und der Phantasiecharakter der psychoanalytischen Situation. In: Loewald HW Psychoanalyse. Aufsätze aus den Jahren 1951–1979. Klett-Cotta, Stuttgart

Metz C (1982) The fiction film and its spectator: A metapsychological study. In: Metz C Psychoanalysis and cinema. The imaginary signifier. Macmillan, London

Seeßlen G (2000) Traumreplikanten des Kinos. In: Aurich R, Jacobsen W, Jatho G (Hrsg). Künstliche Menschen. Deutsches Filmmuseum und Jovis Verlagsbüro, Berlin

Tenbrink D (2002) Übergangsobjekt, Übergangsraum. In: Mertens W, Waldvogel B (Hrsg) Handbuch psychoanalytischer Grundbegriffe. Kohlhammer, Stuttgart

Žižek S (2004) What can psychoanalysis tell us about cyberspace? Psychoanal Rev 91: 801–830

Internetquellen

http://www.gegenschnitt.de/abre-los-ojos-open-your-eyes/das-spiel-mit-traum-und-wirklichkeit. Zugegriffen am 28. 10. 2011

http://de.wikipedia.org/wiki/Harlekin. Zugegriffen am 8. 10. 2011

http://web.org.uk/picasso/harlequin.html. Zugegriffen am 8. 10. 2011

http://en.wikipedia.org/wiki/Open_Your_Eyes_%281997_film%29. Zugegriffen am 17. 6. 2011

Originaltitel	Abre los ojos
Erscheinungsjahr	1997
Land	Spanien, Frankreich, Italien
Buch	Alejandro Amenábar, Mateo Gil
Regie	Alejandro Amenábar
Hauptdarsteller	Eduardo Noriega (César), Penélope Cruz (Sofía), Chete Lera (Antonio), Fele Martínez (Pelayo), Najwa Nimri (Nuria), Gérard Barray (Duvernois)
Verfügbarkeit	Als DVD in OV und deutscher Sprache erhältlich

Mathias Hirsch

Die Fremden haben die Macht übernommen ...

Dark City – Regie: Alex Proyas

Filmplakat *Dark City*
Quelle: Interfoto Archiv Friedrich

Dark City

Regie: Alex Proyas

„Ohne Gedächtnis wären wir nichts!"

Eric Kandel (in: „Auf der Suche nach dem Gedächtnis – der Hirnforscher Eric Kandel".
Dokumentarfilm v. Petra Seeger, Deutschland 2009)

Handlung

Der Arzt Daniel Paul Schreber erklärt, dass „die Fremden" die Macht übernommen hätten. (◘ Abb. 1)

> „Erst wurde es dunkel, dann kamen die Fremden. Sie verfügten über die höchstmögliche Technologie, die Fähigkeit, allein durch ihren Willen die psychische Realität zu ändern. Sie nannten diese Fähigkeit Tuning, aber ihr Sterben hatte schon begonnen, ihre Kultur war dem Untergang geweiht. Deshalb verließen sie ihre Welt und begaben sich auf die Suche nach einem Heilmittel gegen ihre Sterblichkeit."

So kamen sie „in unsere Welt, hier glaubten sie endlich gefunden zu haben, wonach sie suchten."
Dr. Schreber sei ein x-beliebiger Mensch, er helfe den Fremden, ihre Experimente durchzuführen:
„... ich habe meine eigenen Artgenossen verraten."
Es ist 12 Uhr, alle Bürger versinken in den Schlaf, Dr. Schreber jedoch nicht.

In einem Hotelzimmer wacht der Held, John Murdoch, in einer Badewanne auf. Er hat eine kleine Wunde auf der Stirn, er ist verwirrt, desorientiert; er erschrickt, er ist gangunsicher, stürzt, zerschlägt eine Glaskugel, in der sich ein Fisch befand, setzt ihn in die Badewanne. Auf dem Boden liegt ein merkwürdiges Gerät, das man später als Injektionsspritze kennenlernen wird. Er will das Hotel verlassen, wundert sich über einen Schlüsselbund und einen Koffer mit den Initialen K. H. (später erfahren wir, dass es sich um seinen Onkel Karl Harris handelt). Er kann mit beidem nichts anfangen. Im Koffer sind Kleidung, die ihm nicht passt, und eine alte Postkarte, die Shell Beach zeigt. Jetzt sehen wir eine einschießende Erinnerung: Strand, Meer, ein kleiner Junge (durch filmische Mittel wird die Erinnerung durch extreme Verzerrung des Bildrands kenntlich gemacht). Das Telefon klingelt, Dr. Schreber erklärt John aufgeregt, dieser habe sein Gedächtnis verloren; ein Experiment habe stattgefunden, etwas sei schiefgegangen. Er solle abgeholt werden und müsse sofort fliehen (vielleicht regt sich sein Gewissen, ist Dr. Schreber doch ein Verräter!) (◘ Abb. 2). John sieht eine Frauenleiche in seinem Zimmer und erschrickt; auf ihrem Körper sind mit Blut spiralförmige Zeichen angebracht.

Das Hotelpersonal wacht auf, die Uhren bewegen sich wieder. Der Portier sagt, er solle bezahlen, er sei schon seit drei Wochen hier. Man habe angerufen, John habe seine Brieftasche im Automatenrestaurant verloren. John Murdoch versteht nichts.

Die Fremden suchen Murdoch. Dr. Schreber hat Murdochs Frau, eine Sängerin, zu sich bestellt. Er behauptet, er sei der Psychiater ihres Mannes; John habe Sitzungen wegen der Eheprobleme (die Frau hatte ihn betrogen) bei ihm gehabt. Sie hat ihn vor drei Wochen zuletzt gesehen, er hat einen Koffer gepackt und das Haus verlassen. Dr. Schreber: John habe einen psychotischen Zusammenbruch mit Gedächtnisverlust erlitten, er könnte sogar gewalttätig werden, sie solle ihn sofort benachrichtigen, wenn sie ihn sehe. „Er ist auf der Suche nach sich selbst."

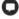 **Abb. 2** Bedrohlich: Dr. Schreber (Kiefer Sutherland) manipuliert John (Rufus Sewell). (Quelle: Cinetext Bildarchiv)

Die Polizei unter der Leitung von Inspektor Bumstead macht sich daran, den Mord an der Prostituierten, die im Hotelzimmer lag, aufzuklären. John nimmt auf der Straße Blickkontakt zu einer Prostituierten auf, bekommt im Automatenrestaurant die Brieftasche zurück. Zufällig sind dort Polizisten, die ihn fragen, wer er sei; die Prostituierte rettet ihn aus der Situation, er geht mit ihr.

Im Hotel stellt Bumstead fest: „Sechs Nutten mit der hier", also ist es eine Serie von Morden; der Killer hätte es eigentlich eilig haben müssen, rettete aber den Fisch. Bumsteads Kollege Walenski sei mit den Nerven herunter, er sei paranoid; fest überzeugt, dass alle beobachtet würden. Walenskis Büro ist völlig chaotisch, man findet Zeichnungen von Spiralen an der Pinnwand (wie die auf der Leiche der Frau im Hotel). Murdochs Frau gibt eine Vermisstenanzeige auf – John sei der Mörder, meint Bumstead.

Murdoch findet in seiner Brieftasche ein Bild seiner Frau und seinen Führerschein. Er sieht eine große Reklametafel in der Stadt: Shell Beach. Er klettert hoch, und wird von den Fremden, blassen, schwarzgekleideten Wesen, verfolgt, aber ihre Macht, die Menschen mit einer Handbewegung zum Schlafen zu bringen, versagt bei ihm. Er besiegt sie; aus dem Schädel eines der Wesen entweichen gelartige, streifenförmige Gebilde. In der Zentrale der Fremden beraten ihre Führer vor einer großen Menge: „Was muss getan werden? Dieser Mann ist gefährlich." (Diese Massenszene in einem riesigen unterirdischen Gewölbe erinnert stark an die Versammlung der Ganoven in Fritz Langs *M – eine Stadt sucht einen Mörder*).

John trifft sich mit seiner Frau; sie sagt ihm, sie wisse, dass er sein Gedächtnis verloren habe, sein Arzt habe das gesagt. Sein Arzt? John kann sich nicht erinnern.

> „Ich habe das Gefühl, ich erlebe den Albtraum eines Anderen." … „Wer ich auch bin, ich bin immer noch ich, und ich bin kein Killer."

◘ Abb. 3 Dr. Schreber (Kiefer Sutherland) macht mit den „Fremden" gemeinsame Sache. (Quelle: Cinetext Bildarchiv)

Die Fremden verhören Dr. Schreber. Er hatte Murdoch eine andere Erinnerung einpflanzen wollen (ihn „prägen"), aber der habe ihm die Spritze aus der Hand geschlagen. Also habe er keine Erinnerung? – Nur Fragmente, die Prozedur wurde unterbrochen (◘ Abb. 3).

Inspektor Bumstead will John verhaften, dieser entkommt, weil er sich eine Tür „tunen" kann, die wieder verschwindet, nachdem er sie passiert hat. Der Inspektor findet die Visitenkarte von Dr. Schreber.

John fragt einen Taxifahrer, wie man nach Shell Beach kommen kann, der kann sich aber überraschenderweise nicht erinnern.

Der Inspektor besucht seinen Kollegen Walenski. Dieser ist psychotisch und malt Spiralen auf alle Wände seines Zimmers. Er fragt: „Wer ist überhaupt wer – denkst du viel über die Vergangenheit nach?" Walenski kann sich an nichts Konkretes erinnern.

💬 „Es ist, als würde ich dieses Leben irgendwie nur träumen."

Dr. Schreber mixt mit der Begeisterung eines Forschers, der Moral und Gewissen zurückstellt, Erinnerungsseren. Er wird wieder von den Fremden verhört: „Warum schläft John Murdoch nicht, wieso kann er tunen?"

John auf der nächtlichen Straße. Alle Menschen schlafen – in den Autos, in den Zügen – er versteht nichts. Er wird Zeuge, wie die Stadt erweitert wird; von den Geisteskräften der Fremden bewegt, wachsen ganze Hochhäuser aus dem Boden. Er beobachtet, wie Bürgern von Dr. Schreber Erinnerungsseren in die Stirn injiziert werden. John stellt Dr. Schreber zur Rede: „Wer sind die?!" Dr. Schreber spielt ein Doppelspiel: Gemeinsam könnten sie sie aufhalten, könnten die Stadt zurückholen. Jetzt wird ein Fremder mit dem Erinnerungsserum Murdochs geimpft:

💬 „So wie er seinen Erinnerungen folgt, verfolgen wir ihn, auf den Spuren seiner
Erinnerung."

Nun hat der Fremde flashback-artige Erinnerungen an Shell Beach, an den Jungen, ein brennendes Haus, an Feuerwehrleute, an die Begegnung Johns mit seiner späteren Frau, (leider) auch an die Morde an den Prostituierten.

Die Postkarte stammt von Onkel Karl, John will ihn besuchen. In der U-Bahn sieht er eine Endstation „Shell Beach" angekündigt, der betreffende Zug fährt aber ohne Halt vorbei. Walenski ist auf dem U-Bahnhof:

💬 „Es gibt keinen Ausweg aus der Stadt. Sie tauschen Gedanken aus. Wenn aber
jemand aufwacht bei der Prozedur, was manchmal passiert, erinnert er sich."

Das war auch bei Walenski so. Der einzige Ausweg für Walenski: Er wirft sich vor einen Zug. Gleichzeitig sucht Murdochs Frau Emma die Prostituierte auf, die John getroffen hatte. Auch sie ist ermordet worden, der Inspektor ist schon da.

Onkel Karl zeigt John alte Dias: Shell Beach ist Johns Heimatort. Auch Onkel Karl kann sich nicht erinnern, wie man da hinkommt, aber: Johns Eltern sind gestorben, das Haus ist abgebrannt. Auf einem Foto sieht man eine großflächige Narbe von einer Brandwunde – jetzt hat er aber keine Narbe an dieser Stelle! „Was bedeutet das, Johnny?" – „Dass alles gelogen ist!" John wundert sich, dass es dunkel ist: „Es kann doch noch nicht Nacht sein." Er hat ein altes Malbuch aus seiner Kindheit gefunden – darin aber nur weiße Blätter.

Karl hat Emma verraten, wo John ist. Wieder wird die Stadt mit großem Getöse erweitert, Häuser bewegen sich, wachsen in die Höhe, werden geordnet und verschoben, während John von Dach zu Dach flieht. Er trifft auf den geprägten Fremden:

💬 „Es gibt keinen Ausweg, die Stadt gehört uns, wir haben diese Stadt gestaltet,
auf dem Fundament gestohlener Erinnerungen, aus den verschiedenen Epochen
formten wir sie zu einer einzigen Symphonie! Jede Nacht formen wir sie, um zu
lernen." (Was zu lernen?) „Von Ihnen, Mr. Murdoch, was Sie menschlich macht.
Wir müssen so werden wie Sie, wir hüllen uns in die Leiber Ihrer Toten."

In diesem Filmdialog handelt es sich wohl um eine Anspielung auf Walter Ruttmanns Film von 1927: *Berlin – Sinfonie einer Großstadt*.

Der Inspektor rettet John vor den verfolgenden Fremden, verhört ihn, präsentiert ihm das Malbuch mit den Kinderbildern. John fragt den Inspektor, wie man nach Shell Beach kommt – er kann sich nicht erinnern. Wann zuletzt Tag war? Der Inspektor wird ärgerlich, auch er kann sich nicht erinnern. Emma besucht ihn im Gefängnis, es täte ihr so leid, dass sie ihn betrogen hat. Er entgegnet: Sie habe es nicht getan: Jemand will, dass sie sich so erinnern. Nein, sagt Emma, ihre Liebe sei real, die könne man nicht künstlich schaffen.

John, wieder entlassen, sucht Dr. Schreber auf. Eine weitere Injektion solle alle Fragen beantworten; Nun ergreift John jedoch die Initiative und zwingt Dr. Schreber, ihm und dem Inspektor den Weg zu Shell Beach zu weisen. Dr. Schreber berichtet noch einmal: Die Fremden pflanzen Erinnerungen ein, neue Biografien. Würde sich jemand zum Beispiel wie ein Mörder verhalten, wenn er die Erinnerung eines Mörders transplantiert bekäme? „Die Sache mit den Morden beruht auf einem unglücklichen Zufall", John habe schon viele Leben implantiert bekommen. – Warum?

„Sie wollen wie die Menschen sein, es geht um unsere Seelen, sie glauben, sie können die menschliche Seele für sich vereinnahmen, wenn sie wissen, wie unser Gedächtnis funktioniert. Sie haben nur ein Kollektivgedächtnis, einen Gruppenverstand, sie sterben und glauben, wir könnten sie davor bewahren."

John: „Und was ist mit mir, mit Shell Beach?" Er sei nie da gewesen, alles sei eine Erfindung, „genau wie bei uns allen. Keiner von uns erinnert sich, was wir einmal waren, was aus uns geworden wäre." Sie rudern mit einem Boot einen Kanal entlang, links und rechts unheimliche Trümmer, gehen weiter durch ein zerstörtes Viertel, gelangen an eine Mauer mit einem großen Shell-Beach-Plakat. Dr. Schreber: „Es gibt nichts, nur diese Stadt, so etwas wie Heimat existiert nur in Ihrer Vorstellung."

John und der Inspektor zerschlagen die Mauer – dahinter ist nichts, das Weltall. Sie kämpfen mit Fremden, sehen nun die Stadt auf einer riesigen Plattform im All, der Sonne abgewandt. Der Fremde, der Johns Erinnerung in sich trägt, bedroht Emma. John gibt auf; er lässt sich in Schlaf versetzen, wird in die Zentrale der Fremden gebracht. Die Menge der Fremden fordert: „Tötet ihn!" (Wieder wie in Fritz Langs „M") Der Anführer, Mr. Book, ist dagegen. John sei besonders, er könne sie zu dem führen, was sie suchen, der menschlichen Seele: „Wir wollen eins werden mit ihm." Deshalb soll John mit den kollektiven Erinnerungen der Fremden „geprägt" werden. Sie wollen, dass er zu einem der Ihren werde, damit sie an seiner Seele teilhaben können. Dr. Schreber jedoch vertauscht die Spritzen, injiziert Johns eigene Erinnerungen.

Wieder Flashbacks: Strand – brennendes Elternhaus (auch filmtechnisch werden die Erinnerungen jetzt viel deutlicher gezeigt): Ein Eisverkäufer sagt zu dem jungen John, er sei zu Höherem berufen, ein Polizist mahnt: „Lass dich nie von Fremden (!) ansprechen!". Beide haben das Gesicht Dr. Schrebers, ebenso ein Lehrer des Kindes. Dann der Brand des Elternhauses, Feuerwehrleute retten einen Jungen. Der Junge geht zu Onkel Karl, er gleitet schwerelos die Treppe hinauf, am Fuße der Treppe steht Dr. Schreber und sagt: „Vielleicht werde ich eines Tages für Sie arbeiten."

Die Fremden entdecken den Betrug der vertauschten Injektion. Dr. Schreber sagt zu John: „Sie haben die Kraft, alles geschehen zu lassen, aber Sie müssen handeln, sofort." John kämpft mit seiner Geisteskraft gegen Hunderte von Fremden. Zum Schluss ein Zweikampf gegen den Anführer: John siegt, der Anführer fliegt gegen einen Wassertank, völlige Zerstörung der Zentrale der Fremden.

Wo ist Emma? „Emma ist nicht mehr Emma, sie ist neu geprägt worden, informiert ihn Dr. Schreber und fragt: „Was werden Sie jetzt tun, John?" – „Ich muss was in Ordnung bringen." Er habe doch die Macht dazu, er könne doch die Welt verändern, wie er wolle. Er demonstriert dies, indem eine Maschine Wasser produziert, Unmengen von Wasser. – „Wo wollen Sie hin?" – „Nach Shell Beach."

Emma ist jetzt Anna, sie steigt in den Bus nach Shell Beach; man sieht die Stadt aus der Ferne, die sich im Zentrum einer riesigen Spirale aus Wasser befindet. John schafft eine Landzunge mit einem Leuchtturm, die sich aus dem Wasser erhebt. Sein Doppelgänger, der Fremde, der seine Erinnerungen hat, muss sterben. Johns Erinnerungen „vertragen sich nicht mit meiner Art." Er habe wissen wollen, wie die Menschen fühlen. John erklärt ihm, dass seine Gefühle ja fremdgesteuert und nicht die eigenen gewesen seien.

John bewirkt, dass in der immer noch expressionistisch aufgetürmten (Film-) Stadt die Sonne wieder scheint; er öffnet eine Tür – helles Sonnenlicht am Ende eines Stegs. Am Strand steht Anna/Emma: Er tritt zu ihr, sie fragt: „Ist es nicht wunderschön hier?" – Er: „Wissen Sie, ob Shell Beach hier in der Nähe ist?" Auch sie will dahin: „Wollen wir zusammen gehen?" – „Gern." – „Ich heiße Anna" – „Ich bin John Murdoch."

Filmwirkung

Alex Proyas verbindet in seinem Film zwei zurückliegende Zeitebenen. Einmal scheint die Handlung in den 60er-Jahren des 20. Jahrhunderts stattzufinden: Angedeutet durch entsprechende Autos (sogar ein Citroën DS ist zu sehen), die damalige Kleidung und kleine Zeichen der US-amerikanischen Alltagskultur. Die andere Zeitebene liegt eher in den 20er-Jahren: Die Verwendung von charakteristischen Stilmitteln des filmischen Expressionismus, auch mit der damals zeittypischen Art der Filmmusik, versetzen den Zuschauer in eine fremde Welt mit entsprechenden Affekten von Bedrohung und Fremdheitsgefühlen. Anklänge an *Metropolis* (1927) von Fritz Lang und *Berlin – Sinfonie einer Großstadt* (1927) von Walter Ruttmann springen, sozusagen, ins Auge. Die „Stadt" bedeutet im Gegensatz zum idyllischen „Shell Beach" aber auch Tempo, Aktivität und Leben. Diese in die Vergangenheit gelegten Zeitebenen erleichtern dem zeitgenössischen Zuschauer aus der Distanz die Identifikation mit dem Helden, die sich ja nicht leicht einstellt. Wegen seiner anfänglichen Verwirrung und besonders wegen seines Erinnerungsverlusts spürt auch der Zuschauer Verwirrung und Unsicherheit. Dieser bekommt auch eine Ahnung von der Bedeutung des Gedächtnisses. Sein Verlust erzeugt ein Gefühl der Unheimlichkeit, ein Gefühl des unbekannten Bekannten (entsprechend der verschiedenen Gedächtnistypen: Das episodische, explizite Gedächtnis ist verloren; der Körper „weiß" viel mehr, das implizite, prozedurale Gedächtnis liefert Nachrichten aus der Vergangenheit. Unheimlich auch, nicht zu wissen, wer man ist, welche Identität man hat, wenn der Kontakt zur eigenen Vergangenheit verloren ist. Darin findet sich der Zuschauer wieder; auch seine Erinnerungen an die seine Identität konstituierenden Lebensereignisse sind lückenhaft, jeder kennt in belastenden oder angstmachenden Situationen ansatzweise Gefühle von Derealisation und Depersonalisation.

Die unmittelbare Identifikation des Zuschauers mit einem traumatisierten Kind wird vermieden durch die Projektion der Innenwelt des Opfers von damals – des Helden von heute – auf die fantasmatischen „Fremden", die an die Stelle des für ein Kind unerklärlichen traumatischen Ereignisses treten, das es in sein Weltbild nicht einordnen kann; die (wenn auch bizarre) Motivation der Fremden bildet in der Fantasie wenigstens eine Erklärungsmöglichkeit für das Unbegreifbare, das dem Trauma der Kindheit entspricht.

Der Zuschauer wird auch insofern einbezogen, „gefesselt", als er die intensive Suche des Helden nach Erklärung für die zunächst einmal unheimlichen, nicht verstehbaren und nicht einzuordnenden Geschehnisse nachvollzieht. In diesem Sinne enthält der Film Elemente des Film Noir, in dem es ja auch um die Suche nach Erklärung unverstehbarer Ereignisse (Verbrechen) geht. Gerade auch in dem Maße, in dem der Zuschauer merkt, dass diese Suche eigentlich eine Rekonstruktion verdrängter Vergangenheit und damit eine Suche nach sich selbst ist.

Psychodynamische Interpretation des Films

Die Gegenwart als Traum

Schon auf den ersten Blick wirkt der ganze Film wie ein Traum. Der Held, John Murdoch, befindet sich in einer irrealen Welt, in der er sich nicht zurechtfindet, die zeitliche und örtliche Orientierung ist gestört, durch den Verlust des Gedächtnisses hat er keinen Begriff von sich selbst, seiner Identität und seiner Vergangenheit. Was besonders zu Beginn als angstmachender Mangel wirkt, erscheint zunehmend als Voraussetzung für eine Aufgabe, die der Held dann auch prompt in Angriff nimmt: Gedächtnis wiederzugewinnen, also die Kontinuität der Identitätsentwicklung und damit ein verlorenes Identitätsgefühl. Der Held ist mit einer fremden, irritierenden Gegenwart konfrontiert, in der außerirdische Wesen zu einem bestimmten, erst einmal unbekannten Zweck die Menschheit überwältigt haben und sie beherrschen. Diese „Fremden" manipulieren die Erinnerung der Menschen, also ihre

Identität. Dieser Umgebung einer fremden Stadt wird eine andere, ländlich-idyllische, entgegengesetzt und erst einmal durch nicht verstehbare Zeichen mit der Stadt verbunden: Aus weiter Ferne winkt das Bild einer Strand-Idylle, die Ruhe, Harmonie und Frieden verspricht. (Die erste große Reklametafel für Shell Beach, an einem Hochhaus, zeigt wirklich eine junge Frau im Bikini, die mit ihrem angewinkelten, von einem Motor angetriebenen Arm dem Fremden, vielleicht möglichen Touristen, einladend zuwinkt.) Diese idyllische Gegenwelt wird auch durch die immer häufiger auftretenden, fragmentarisch wie Flashbacks einschießenden Erinnerungen bebildert; der Film kann das sehr schön darstellen durch die unscharfen Ränder dieser Bilder, in deren Zentrum das Meer, ein Strand und immer wieder ein kleiner Junge zu erkennen sind. Im Laufe des Films werden diese Bilder immer deutlicher und schärfer, wie um zu bezeichnen, dass die Erinnerungen immer realistischer geworden sind. Verwendet der Film aber zunächst unerklärte Flashbacks, verweist er auf ein Trauma, ein traumatisierendes Ereignis also, das den Helden in der Kindheit getroffen haben mag. Der Zuschauer weiß auch, dass der Held sich an einen kleinen Jungen erinnert, der er selbst gewesen sein dürfte (wenn er sich selbst auch immer wieder in der Rückenansicht erinnert).

Während Sigmund Freud (1900) in seiner „Traumdeutung" den Traum im Wesentlichen als beruhigende Erfüllung libidinöser, den Schlaf störender Wünsche und Bedürfnisse verstand, die für sich allein den Traum nicht produzieren können, sondern sich der Tagesreste bedienen müssen, um die libidinösen Bestrebungen an sie anzuheften (vgl. Leuschner 2008), muss man dagegen heute dem „Tagesrest", also dem Einfluss der Realität in jüngerer und auch weiter zurückliegender Vergangenheit des Träumers, einen viel größeren Stellenwert einräumen. Meltzer ([1]1984; 1988, S. 55) schreibt:

Die klarste Abfolge scheint zu sein, eine Definition des Traumvorgangs zu bilden, die in ihm ein Nachdenken über emotionale Erlebnisse sieht; danach wäre der Weg für eine Untersuchung dessen frei, was Freud die ‚Rücksicht auf Darstellbarkeit' (worunter wir die Symbolbildung und das Wechselspiel zwischen visuellen und sprachlichen Symbolformen verstehen wollen) und die ‚Traumarbeit' nennt (worunter wir die Phantasietätigkeit und die Denkvorgänge verstehen wollen, durch die emotionale Konflikte und Probleme zur Lösung zu kommen suchen).

Ich denke, der Film *Dark City* von Alex Proyas ist den Mechanismen der Traumentstehung entsprechend geschaffen worden. Der Zuschauer wird mit dem Helden in eine traumartige, fantasmatische Welt versetzt, die er nicht ohne Weiteres verstehen kann, d. h. deren Bedeutung und Symbole, die visuell, also in Bildern, dargestellt werden, erst einmal für ihn nicht entschlüsselbar sind, sodass Gefühle von Unheimlichkeit, Unwirklichkeit, auch von Fremdheit der eigenen Existenz und Identität (Depersonalisation) erzeugt werden. Allerdings unterscheidet sich der Film vom Traum insofern, als er eine Art aufdeckender Detektivarbeit leistet, an deren Ende ein einigermaßen konsistentes Gefühl der Bedeutung der erst einmal verwirrenden Ereignisse und ihrer Abbildungen eintritt, auch wenn das Happy-End noch nicht einmal den Bedürfnissen des Wachzustands nach logischer Erklärung der Ereignisse und ihrer folgerichtigen Auflösung gerecht wird.

Heute denkt man, über Freud hinausgehend, dass der Traum nicht nur libidinöse Bestrebungen bebildert, sondern dass er einer Aktivität entspricht, die aktuelle oder zurückliegende Lebensereignisse konfliktuöser und besonders traumatischer Qualität zu verarbeiten sucht. Für die Kleinianische Psychoanalyse formuliert Meltzer ([1]1984; 1988, S. 40):

… dass wir nicht in einer Welt leben, sondern in zweien – dass wir auch in einer inneren Welt leben, die ein ebenso wirklicher Ort des Lebens ist wie die Außenwelt.

Beide, der Traum und der Film, um den es hier geht, bebildern die innere Welt des Träumers bzw. im Film die des Helden. Traum und Film sind somit auch aktive Bewältigungsversuche von Vergangenem,

also Darstellung der inneren Welt. Der Film verschlüsselt diese aber ebenso gründlich wie der Traum, sodass der Träumer bzw. der Held und auch der Zuschauer erst einmal über die Inhalte dieser inneren Welt im Unklaren gelassen werden: Es existiert keine Erinnerung. Wenn die Inhalte der Innenwelt zu bedrohlich sind, sodass man sie nicht denken kann, werden sie eben im Traum und im Film in symbolische Bilder verwandelt, die das Undenkbare sowohl ausdrücken als auch verbergen.

Darüber hinaus stellen Traum und Fantasie, insbesondere auch psychotische Vorstellungen, einen Reparationsversuch dar; auch wenn die traumatischen Inhalte denen des Traums entsprechen, sind sie nun vom Subjekt in Szene gesetzt, passives Erleiden in aktives Tun verwandelnd. Der Traum hat nicht nur bloße Abwehrfunktion (des Unerklärlichen oder Verpönten), sondern er ist Meltzer (11984; 1988) zufolge, der sich auf Bion (1962) beruft, ein aktives Handeln.

Der Name Daniel Paul Schreber kann ja nur zu Ehren des und zum Gedenken an den schwer paranoiden historischen Daniel Paul Schreber gewählt worden sein, des Sohnes des fanatischen Arztes Moritz Schreber, der sich im 19. Jahrhundert in obsessiver, aber durchaus populärer und erfolgreicher Weise um die korrekte Körperhaltung der deutschen Kinder „verdient gemacht" hat. Dazu Niederland (11974; 1978, S. 44 f.):

> Auf dem Höhepunkt seiner Krankheit war [Daniel Paul] Schreber überzeugt von einer unmittelbar bevorstehenden großen Katastrophe, dem Weltuntergang. … Er war ‚der einzige noch übrig gebliebene wirkliche Mensch', und die wenigen menschlichen Gestalten, die er noch sah – der Arzt, die Wärter, die anderen Patienten –, gehörten zu den ‚angewunderten, flüchtig hingemachten Männern'. … Freud betrachtete Schrebers Weltuntergangsvorstellung als eine Projektion des Gefühls des Patienten von einer inneren katastrophalen Veränderung. Der Weltuntergang ist die Projektion des unheimlichen Gefühls einer verheerenden und pathologischen inneren Veränderung.

Die Traumarbeit erfolgt Freud (1900) zufolge im Primärprozess, der Funktionsweise des Unbewussten, also unstrukturiert, assoziativ, Unlust vermeidend, sofortige Befriedigung verlangend (während der Sekundärprozess den Regeln der sprachlichen Logik folgt, überwiegend verbal ist, Triebaufschub duldet). Wie wir es auch für den Traum gesehen haben, verlassen neuere Vorstellungen des Wesens des Primärprozesses die enge Verknüpfung mit der Trieben. Leichsenring (2008, S. 598) referiert Holt (1989):

> Der Primärprozess hat vielmehr seine eigene bizarre Logik, die hochentwickelte Formen der Kompromissbildung einschließt und synthetische Funktionen und organisierende Strukturen impliziert … Holt schlägt vor, primärprozesshaftes Denken als spezielle Form der Informationsverarbeitung zu konzeptualisieren: Unter ungünstigen Bedingungen (z. B. mangelnde Information, ungenügende kognitive Voraussetzungen) versucht ein Individuum mittels primärprozesshafter Denkvorgänge dem Bedürfnis nachzukommen, sinnvolle Zusammenhänge (Synthese) zu konstruieren."

Aber keineswegs alle Ereignisse und Handlungsstränge des Films sind logisch auflösbar: Welchen Sinn hat es z. B., dass Dr. Schreber in so vielen Gestalten der Vergangenheit auftritt, wieso sind die Fremden dem Tode geweiht, wie ist das Gegenmittel, nämlich die Erinnerungen der Menschen auszuwechseln, zu verstehen, warum haben die Fremden keine individuellen Erinnerungen und müssen sterben, weil sie nur ein Kollektivgedächtnis haben? Warum hat John später keine Brandnarbe, warum enthält das Malbuch weiße Blätter? Sind das Symbole, eben primärprozesshafte, für die fehlende Identität, fehlende Biografie, ist eigentlich seelisches Sterben gemeint?

Verdichtung und Verschiebung als filmische Mittel

Hauptmerkmal der Arbeitsweise des Primärprozesses sind Verdichtung und Verschiebung; in der Verdichtung können gegensätzliche, auch widersprüchliche Vorgänge in einem einzigen Bild ausgedrückt werden, und ein herausragendes Beispiel für die Anwendung von Verdichtung im Film ist das Zusammenfallen von Katastrophe und Reparation: Der durch die Fremden drohende Untergang der Menschheit scheint einer persönlichen Katastrophe des Helden zu entsprechen (auf die ich weiter unter zurückkommen werde), gleichzeitig aber verleiht diese katastrophale Bedrohung dem Helden eine übermenschliche, sozusagen ebenfalls außerirdische Macht, die Katastrophe zu vermeiden und letztlich zum Guten zu wenden. Oder die Person Dr. Schrebers, der Bösewicht, Verräter, dann aber auch solidarischer Wohltäter gleichermaßen ist, der in den immer häufiger auftretenden Erinnerungen in Gestalt eines Feuerwehrmanns, eines Eisverkäufers, eines Polizisten und schließlich eines mentorartigen Lehrers des damals jungen Helden in Erscheinung tritt; diese Figuren können wir allesamt als Elternersatzpersonen verstehen. Leuschner (2008, S. 763):

> Verschiebung bestimmt in besonderem Maße auch das Schicksal der Traumaffekte. Im Gefolge der Fraktionierung der Traumgedanken werden sie von den Einzelvorstellungen abgetrennt und erleiden nun ganz eigene Schicksale. Sie können (1) in voller Stärke auf beliebige andere Vorstellungsinhalte verschoben, (2) inhaltlich verwandelt oder (3) ganz unterdrückt werden und damit im manifesten Traum fehlen.

Als Beispiel für Verschiebung im Film kann man die Verwendung der Prostituierten sehen; warum werden gerade diese ermordet? Anscheinend sollen die – mörderischen – Aggressionen des Helden gegen die Mutter (die ihn durch den Tod verlassen hat) und die Ehefrau (die ihn betrogen hat) gegen die Prostituierten gerichtet werden, das ist leichter zu denken und zu träumen. Auch die eigenen Allmachtswünsche werden auf die „Fremden" verschoben und von ihnen wieder auf den Helden selbst zurückgeschoben – ist dieser doch auch allmächtig:

💬 „Sie beherrschen alles, auch die Sonne."

Verdichtung und Verschiebung scheinen vom Filmemacher intuitiv in die Bilder der emporschießenden Hochhäuser gekleidet worden zu sein, die zur Schaffung und Erweiterung der Stadt ineinander verschoben und immer dichter zusammengerückt werden. Eher einer Projektion dürfte es entsprechen, wenn der Held, der einmal ein traumatisiertes Kind war, seine entsprechenden Aggressionen in den Fremden erlebt; die Zerstörung von Elternhaus und Familie, die sich in der Fantasie von der Zerstörung der Welt durch die Fremden wiederfindet, verschmilzt mit den eigenen reaktiven Zerstörungsimpulsen, die sich durch Projektion ein denkbares, vorstellbares Objekt suchen.

Traumatisierung

Durch die einschießenden Erinnerungen begreifen wir immer mehr, dass ein katastrophales Ereignis, nämlich der Brand und damit der Verlust des Elternhauses und Verlust beider Eltern durch Tod in einem vorpubertären Alter des Jungen für ihn extrem traumatisierend waren. Traumatisierende Ereignisse, die das Ich überschwemmen, können so überwältigend sein, dass sie im expliziten, episodischen Gedächtnis nicht repräsentiert sind, der vollständigen Amnesie verfallen, als ob das Ich sich dadurch vor erneuter Überflutung, also einer Retraumatisierung, schützen wolle. Dafür werden traumatisierende Ereignisse im impliziten, sogenannten prozeduralen Gedächtnis gespeichert, auch als Körpergedächtnis bezeichnet; aus diesem dringen manchmal einschießende Erinnerungsfetzen ins Bewusstsein, zum Teil ohne entsprechenden Affekt, zum Teil aber auch mit diesem, also erneuter großer Angst, verbunden. Solche sogenannten Flashbacks werden getriggert durch scheinbar harmlose Ereignisse

oder Situationen, die dem traumatisierenden Ereignis entsprechen; gleich am Anfang des Films löst die Postkarte mit dem Shell Beach-Motiv ein solches Erinnerungsfragment aus.

Amnesie als Traumafolge

Amnesie dient nicht nur dem Schutz vor einer befürchteten Retraumatisierung, sie hat einen negativen Effekt auf das Identitätsgefühl des Opfers, da sie die Kontinuität des Gefühls für den Lebenslauf, dessen Ergebnis ja die jeweilige aktuelle Identität ist, unterbricht und eine empfindliche Verunsicherung des Gefühls, wer man denn sei, verursacht. Deshalb ist der Kampf um die Wiedergewinnung von Erinnerung immer eine Suche nach dem Selbst (man nennt dies auch biografisches Gedächtnis). So sagt Dr. Schreber zu Emma, Murdochs Frau: „Er ist auf der Suche nach sich selbst." Und der verzweifelte John: „Wer ich auch bin, ich bin immer noch ich, und ich bin kein Killer." Auch Walenski verbindet Identität und Erinnern: „Wer ist überhaupt wer – denkst du viel über die Vergangenheit nach?" Und wie soll man ein Heimatgefühl erwerben und aufrechterhalten ohne Kontinuität des Lebenslaufs, Erinnerung und Identitätsgefühl? So bemerkt Dr. Schreber, als Murdoch mit Inspektor Bumstead unbedingt nach Shell Beach gelangen will: „Es gibt nichts, nur diese Stadt, so etwas wie Heimat existiert nur in Ihrer Vorstellung."

Wenn es schließlich zu einem, wenn auch nicht logisch nachvollziehbaren, eben traumartigen, Happy-End kommt, scheint der Held das Trauma überwunden zu haben. Er ist zu einem Neuanfang mit einer neuen – alten – Frau in der Lage und sagt als letzten Satz in diesem Film: „Ich bin John Murdoch."

Der Kampf um Erinnerung muss aber ambivalent sein. Einerseits bedeutet Erinnerung Wiederaufleben des traumatisierenden Geschehens, Realisierung des katastrophalen Verlustes (der Film verdichtet dies, indem einem Fremden Johns Erinnerungen eingepflanzt werden: Erinnerung mit Bösem verknüpft), andererseits ist es das Ringen um Kontinuität des Lebenslaufs. In dieser Ambivalenz wäre es ja geradezu ein Wunsch (dessen Erfüllung auf die „Fremden" projiziert wird), eine neue Biografie eingepflanzt zu bekommen[1], die dann aber nicht die eigene wäre: „Alles gelogen", bemerkt John aufgebracht seinem Onkel gegenüber, als er ihm seinen Arm zeigt, der keine Brandnarbe aufweist wie das Foto aus seiner Jugendzeit. Auch das ist ein Beispiel für die primärprozesshafte Bearbeitung der Ambivalenz von Erinnern und Verdrängen, ebenso übrigens wie die weißen Seiten im Malbuch der Kinderzeit, das dann doch wieder mit den Zeichnungen gefüllt ist – auch im Traum ist nicht alles logisch erklärbar und deutbar.

Wenn Freud gemeint hatte, dass jeder Traum einer Wunscherfüllung diene, so kam er in Erklärungsnot, wenn es sich um traumatische Träume handelte, weil „Personen, die ein Schockerlebnis, ein schweres psychisches Trauma durchgemacht haben, … vom Traum so regelmäßig in die traumatische Situation zurückversetzt werden." (Freud 1933, S. 29) Solche Albträume seien dann wenigstens der Versuch einer Wunscherfüllung. Leuschner (2008, S. 763) zufolge gleichen Albträume dem Wiederholungszwang: „… sie sind ein Kurzschluss, der die Leistungen der Traumarbeit überspringt." Ich selbst (Hirsch 2004, S. 95) habe die Werke schwer traumatisierter Künstler mit dem Albtraum verglichen:

Das Werk eines Künstlers wie Poe scheint mir genau dem Prinzip des Albtraums zu folgen: Es stellt den traumatischen Horror da, um ihn zu bannen, um ihm seine Macht zu nehmen, ihm etwas Selbstgeschaffenes entgegenzusetzen, aber die Anstrengung reicht nicht aus, der Albtraum versetzt den Träumer in Angst und Schrecken und hütet keineswegs den Schlaf.

Das ist ja in dem Film anders: Der Held hat anscheinend nicht so viel Angst wie der Zuschauer in Identifikation mit ihm; wenn man den Film und den Fortgang der Handlung als Entwicklungsprozess

1 Es gibt heute bereits Bestrebungen, traumatische Erinnerungen medikamentös auszulöschen.

verfolgt, muss man sehen, dass es möglich wird, das Trauma gerade doch zu verarbeiten und sich vom traumatisierenden, verinnerlichten Geschehen zu emanzipieren. Das schafft der Albtraum in aller Regel nicht. Der Wiederholungszwang, dessen Mechanismus der wiederholte Albtraum folgt, verfolgt ein positives Ziel, wenn er auch jedes Mal zunächst dem Trauma entspricht: Zum einen die (unbewusste) Vorstellung, die einmal erlittene Tat jetzt wenigstens selbst hervorgerufen zu haben, aus eigener Macht, zum anderen aber insbesondere, dass das Wiederaufsuchen einer Situation, die der ursprünglichen Traumatisierung entspricht, wenigstens die Möglichkeit enthält, dass der Täter sich wie durch ein Wunder verwandelt und nun endlich ein kindgerecht liebender Vater etc. wäre. Im Falle von schweren Verlusten kann man davon ausgehen, dass auch dann in der Fantasie diese Hoffnung, so unrealistisch sie sein mag, im Wiederholungszwang und auch im Albtraum enthalten ist – der Film erfüllt ja genau diese Hoffnung. Und auch John spricht von dem „Gefühl, er erlebe den Albtraum eines Anderen", natürlich eines Anderen, des Kindes von damals nämlich, während er ja durch die Amnesie die Verbindung zu diesem verloren hat. Den Reparationsversuch im albtraumartigen Film sieht man auch in der Filmhandlung, denn die Fremden, vom Tode bedroht, suchen Unsterblichkeit – schließlich sind beide Eltern Johns verstorben. Meistens gelingt das Abreagieren der schrecklichen Affekte im Albtraum nicht, er muss stets wiederholt werden; der Film ist an diesem Punkt, wie gesagt, sehr viel optimistischer. In diesem Sinne sind auch die prophetischen Äußerungen zu verstehen, an die sich John erinnert; ein Feuerwehrmann mit dem Gesicht Dr. Schrebers sagt: „Sie werden die Kraft in sich selbst finden, und Sie werden sich durchsetzen." Der Lehrer in derselben Gestalt erklärt dem Jungen von damals:

> „Dies ist die Maschine, die sie (die Fremden) befähigt, ihre Gedanken zu materialisieren, durch die steuern sie ihre Welt. Sie [John] müssen die Kontrolle über sie gewinnen. – Die Maschine muss Ihnen gehorchen!"

Das entspricht den Allmachtsgedanken des traumatisierten Kindes, das die absolute Ohnmacht kompensieren muss.

Ödipalität

Es gibt im Film zudem eine ödipale Ebene – die Katastrophe des Verlusts der Eltern könnte der kleine Junge als furchtbare Bestrafung für seine ödipalen Fantasien gedeutet haben. Und die Ehefrau Emma zieht ihm wenigstens vorübergehend einen anderen Mann vor: In dieser Situation beginnt ja die Geschichte von Johns Gedächtnisverlust. Er könnte sein Frauenbild in zwei Teilobjekte gespalten haben: Madonna und Hure sozusagen; das würde ein Licht darauf werfen, warum es Prostituierte sind, die in Serie ermordet werden. Eine von ihnen, May, hat anscheinend ein größeres Interesse an ihm; sie ist gut zu ihm, sie rettet ihn, das wäre eine Integration der gegensätzlichen Teilobjektbilder in ihrer Figur. In „Mister Book", dem Anführer der „Fremden", könnte er einen väterlichen Rivalen erlebt haben, den zu besiegen schon schwieriger wird, zumal er ihn mit dessen eigenen Mitteln – der Kraft der Gedanken – bekämpfen muss. Hier könnte eine Projektion seiner immensen unterdrückten Aggression stattgefunden haben – immerhin haben ihn beide Eltern alleingelassen. Der Inspektor dagegen ist eine positive Vaterfigur, er glaubt an ihn; auch der Onkel ist im Grunde recht positiv eingestellt.

Den Schluss, das relative Happy-End – im Traum, in der Phantasie – kann man so verstehen, dass der Held die ödipale Aggression und auch das sexuelle, ödipale Begehren überwunden hat und auf einer neuen, reiferen Stufe die alte, neue Frau findet, Anna an der Stelle von Emma.

Als nun Erwachsener kann er sagen: „Ich bin …"

Literatur

Bion WR (1990) Lernen durch Erfahrung. Suhrkamp, Frankfurt/M, Erstveröff. 1962

Dark City in der Internet Movie Database: www.imdb.com/title/tt0118929. Zugegriffen am 3. 5. 2011

Freud S (1900) Die Traumdeutung Gesammelte Werke Bd II/III. Fischer, Frankfurt/M

Freud S (1933) Neue Folge der Vorlesungen zur Einführung in die Psychoanalyse. Gesammelte Werke Bd XV. Fischer, Frankfurt/M

Hirsch M (2004) Psychoanalytische Traumatologie – Das Trauma in der Familie. Psychoanalytische Theorie und Therapie schwerer Persönlichkeitsstörungen. Schattauer, Stuttgart

Holt R (1989) The development of the primary process: a structural view. In: Holt R (Hrsg) Freud reappraised. A fresh look at psychoanalytic theory. Guilford Press, New York NY

Leuschner W (2008) Traum. In: Mertens W, Waldvogel B (Hrsg): Handbuch psychoanalytischer Grundbegriffe, 3. überarb. Aufl. Kohlhammer, München

Leichsenring F (2008) Primär- und Sekundärprozess. In: Mertens W, Waldvogel B (Hrsg) Handbuch psychoanalytischer Grundbegriffe, 3. überarb. Aufl. Kohlhammer, München

Meltzer D (1988) Traumleben. Eine Überprüfung der psychoanalytischen Theorie und Technik. Verlag Int. Psychoanalyse, München (Erstveröff. 1984)

Mertens W, Waldvogel, B (Hrsg) (2008) Handbuch psychoanalytischer Grundbegriffe, 3. überarb. Aufl. Kohlhammer, München

Niederland WG (1978) Der Fall Schreber. Das psychoanalytische Profil einer paranoiden Persönlichkeit. Suhrkamp, Frankfurt/M (Erstveröff. 1974)

Originaltitel	Dark City
Deutscher Titel	Dark City
Erscheinungsjahr	1998
Land	USA
Buch	Alex Proyas, Lem Dobbs, David S. Goyer
Regie	Alex Proyas
Hauptdarsteller	Rufus Sewell (John Murdoch), William Hurt (Inspector Bumstead), Kiefer Sutherland (Daniel P. Schreber), Jennifer Connelly (Emma Murdoch/Anna), Ian Richardson (Mr. Book), Colin Friels (Walenski)
Verfügbarkeit	Erhältlich als DVD in OV und in deutscher Sprache

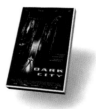

Dirk Blothner

Nothing real? – Medienwirklichkeit am Beispiel des Films „Die Truman Show"

Die Truman Show – Regie: Peter Weir

Die Truman Show

Regie: Peter Weir

Hintergrund

Die Truman Show (■ Abb. 1) ist ein Film, der von einem ungeheuerlich anmutenden TV-Experiment erzählt. Ein Kind wird von einer Filmproduktionsgesellschaft adoptiert. Sie errichtet für dieses Kind das größte Filmset der Welt: Seahaven, eine saubere Stadt am sonnigen Meer mit freundlichen und optimistischen Einwohnern. In dieser Stadt wächst Truman Burbanks heran und wird erwachsen. Hunderte von Schauspielern geben sich als seine Eltern, Freunde, Nachbarn und Kollegen aus. Millionen von Zuschauern auf der ganzen Welt nehmen vierundzwanzig Stunden am Tag an seinem Leben teil. Sie beobachten Truman in seinem Badezimmer, sie begleiten ihn im Auto zur Arbeit und sind an seinem Schreibtisch im Versicherungsbüro dabei. Alle wissen es, nur Truman selbst ist nicht darin eingeweiht, dass sein Leben eine „Real-Life-Soap" ist, die von Christof, ihrem Schöpfer, mit allen Mitteln der Technik und der Dramaturgie inszeniert wird. Aber Truman spürt ein Unbehagen, geht ihm nach und bricht aus seiner künstlichen Umgebung aus.

Drehbuchautor Andrew Niccol schrieb schon im Jahr 1991 ein erstes Exposé für *Die Truman Show*. Es wird berichtet, dass es sich bei dieser Version um ein eher düsteres Sciencefiction-Drama handelte. Auf Verlangen des Produzenten Scott Rudin machte Niccol in mehreren Bearbeitungen eine satirische Komödie daraus. Bevor der Australier Peter Weir die Regie übertragen bekam, war Brian De Palma für diese Aufgabe vorgesehen. Der Film wurde für 60 Millionen Dollar produziert und spielte in den Kinos weltweit ca. 250 Millionen Dollar ein. Die Einnahmen aus den zahlreichen Fernsehausstrahlungen bis heute sind hierbei nicht berücksichtigt. In Deutschland sahen fast 3 Millionen Menschen den Film in den Kinos. *Die Truman Show* wurde zwar für drei Oscars nominiert, bekam aber keine dieser Auszeichnungen verliehen. Dafür wurde der Film mit einigen „Golden Globes" und Preisen der britischen Filmakademie geachtet.

Brearley und Sabbadini (2008) nehmen in ihrer sehr lesenswerten, psychoanalytischen Abhandlung über *Die Truman Show* den Protagonisten in den Blick und vergleichen seine Situation mit der des Heranwachsenden, der die Aufgabe habe, sich aus dem Einflussbereich der Elterngeneration herauszulösen und seinen eigenen Weg im Leben zu finden. Dabei beziehen sie sich im Wesentlichen auf Winnicotts Konzept des „falschen Selbst" (Winnicott [1]1954; 1983). Dem Heranwachsenden, ähnlich wie Truman im Film, bleibe zunächst nichts anderes übrig, als sich an die Formangebote der Eltern anzupassen und eine Art „falsches Selbst" auszubilden. Aber er habe die Aufgabe und die Chance, im Laufe seiner Entwicklung zu authentischeren Lebensvollzügen zu finden, die man als „wahres Selbst" bezeichnen kann.

Ich möchte im Rahmen dieses Bandes über mediale Wirklichkeiten näher an der Oberfläche des Films verweilen. Dabei werde ich zum einen mit dem Nacheinander der Bilder und Töne gegebene Wirkungsprozesse beschreiben und zum anderen an ihnen einige typische Probleme und Drehpunkte unserer durch eine mediale Verdoppelung des Lebens geprägten Zeit herausheben. In gewisser Weise sind wir alle in der Situation Truman Burbanks. Wir wachsen in Bilder von Wirklichkeit hinein, die wir zunächst als selbstverständlich annehmen. Aber wir können dabei nicht stehen bleiben. Ein Entwicklungsdrang führt uns dazu, Schritte ins Offene zu wagen und dem Leben eine neue Ordnung zu geben, damit es weitergehen kann. An dem Film *Die Truman Show* können wir die Vorbereitung dieses Schrittes auf einem sicheren Stuhl erleben. Er lässt an aufeinanderfolgenden Phasen einer Revolte gegen eine mehr und mehr als Bemächtigung verspürte Ordnung teilnehmen. Von einem „sicheren Stuhl" spreche ich, weil das Filmerleben alle nur erdenklichen Verwandlungen der menschlichen Wirklichkeit

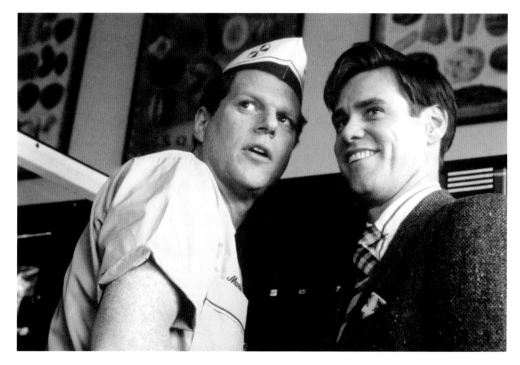

◨ **Abb. 2** Truman (Jim Carrey) und sein Freund Marlon (Noah Emmerich). (Quelle: Cinetext Bildarchiv)

erfahren kann, ohne mit den damit verbundenen Konsequenzen belastet zu werden. Der theoretische Hintergrund meiner beschreibenden Analyse ist hier also weniger die klinische Psychoanalyse wie in dem Aufsatz von Brearley und Sabbadini, sondern mehr eine Alltags- und Kunstpsychologie wie sie zum Beispiel in den Büchern „Der Alltag ist nicht grau" und „Kunst. Psychologie. Behandlung" von Wilhelm Salber (1989; 1977) niedergelegt ist.

Analyse von Handlungsverlauf und Filmerleben

Risse in der Oberfläche

Gleich zu Beginn des Films wird den Zuschauern die Fernsehserie „The Truman Show" präsentiert. Ihr Schöpfer Christof (Ed Harris) wendet sich direkt an die Zuschauer. Er räumt die Künstlichkeit der Sendung ein, stellt aber zugleich heraus, dass an ihrem Protagonisten alles echt sei. Schauspieler kommen zu Wort und berichten, wie sehr die Serie zu ihrem Leben geworden sei. Dazwischen beobachten wir Jim Carrey als Truman Burbanks in einem privaten Moment vor dem Badezimmerspiegel. Es ist ein befremdliches Fantasiespiel, das er mit Flüsterstimme ausgestaltet. Darin stellt er sich und einen Freund auf einer beschwerlichen Bergtour vor. Würde er sterben, so schärft er dem Begleiter ein, solle dieser sich nicht scheuen, seinen Körper als Notproviant zu verzehren.

Wohlfühlunterhaltung und Kannibalismus bilden bei diesem Filmanfang einen seltsamen Missklang. Psychologisch gesehen schließen sie jedoch einander nicht aus. Sie sind Phänomene ein und derselben Wirklichkeit. Die Tiefenpsychologie hat festgestellt, dass in der menschlichen Fantasie täglich Menschen vernichtet, in Stücke zerrissen und auch gegessen werden. Die Menschen sind zu solchen Handlungen durchaus fähig, aber die Kultur hat Tabus eingerichtet, die sich ihrer Umsetzung entgegenstellen. Vielleicht weil sie diese ungeheuerliche Seite der menschlichen Natur in sich als wirksam

verspüren, brauchen die Menschen auf der anderen Seite Unterhaltungsformen, deren Optimismus und Freundlichkeit sie zu beruhigen verstehen. Zum Beispiel die so freundlich, sauber und hell anmutenden Bilder einer täglich laufenden Fernsehserie wie „The Truman Show".

Es gibt noch mehr, was sich in den ersten Minuten des Films dem schönen, glatten Design der TV-Unterhaltung entgegenstellt. Da ist ein plötzlich vom Himmel fallender Scheinwerfer. Truman sieht ihn vor seinem Haus auf die Straße krachen und wendet seinen Blick verwundert zum Himmel. Wo kommt der her? Da sind konspirativ anmutende Handlungen Trumans. Was macht er mit den Modezeitschriften? Warum reißt der Versicherungsangestellte in seinem freundlich eingerichteten Büro heimlich die Fotos mit den Frauengesichtern heraus? Seine Kollegen nehmen ihn argwöhnisch in den Blick. Außerdem sind da immer wieder Kameraeinstellungen mit ungewöhnlichen Perspektiven, die den Eindruck erzeugen, dass Truman von früh bis spät beobachtet oder gefilmt wird. Das kennt man aus Sciencefiction-Geschichten, die in totalitären Staaten spielen. Und während es zum Alltag der anderen Serienfiguren zu gehören scheint, stets ein appetitliches, gesittetes Bild abzugeben, streckt Truman seiner gut gelaunt plappernden Ehefrau Meryl (Laura Linney) – und damit auch den Zuschauern – in der neunten Minute des Films sein rot gewandetes Hinterteil entgegen, als wäre er ein schamloses Äffchen im Zoo, das sich über die Besucher mokiert.

So geht durch die heitere Serienwelt von Anfang an ein Riss. Und es klingt schon sehr früh ein Eingeschlossen-Sein an. Denn Truman treibt eine drängende Sehnsucht nach der anderen Seite der Erdkugel. Wie gerne würde er zu den Fidschiinseln aufbrechen, aber eine Phobie vor den Untiefen der See hält ihn in der Inselstadt Seahaven zurück. Als Kind verlor er seinen Vater bei einem Segelunfall und kann sich seitdem nicht mehr auf das schwankende Nass begeben. Sein alter Freund Marlon (Noah Emmerich) (▶ Abb. 2) versucht, ihm seine Heimatstadt schön zu reden, und Ehefrau Meryl erinnert ihn an die Verpflichtungen, die er mit Ehe, Haus und Arbeit eingegangen ist. Das sind Beschränkungen von Trumans Unruhe, aber je länger wir dem Film folgen, desto mehr neigen wir dazu, seine Revolte zu unterstützen.

Denn es passieren auch hässliche Dinge in Seahaven. Auf der Straße trifft Truman auf einen abgerissen aussehenden Mann und erkennt in ihm seinen für tot gehaltenen Vater. Doch ehe er mit ihm sprechen kann, entsteht ein Tumult. Passanten stürzen hinzu und reißen den Mann von Truman weg. Der kann kaum fassen, was um ihn herum passiert. Ein unangenehmer Geschmack von Gewalt und Willkür entsteht. Das schön Gemachte der Serienwelt dreht sich in Bemächtigung. Uns Zuschauer rückt Truman über diese Wendung ein weiteres Stück näher. In aller Regel schlagen wir uns im Film auf die Seite der Unterdrückten, der gegen das Unrecht, die Übermacht Revoltierenden. Es kann uns daher nicht zufriedenstellen, wenn in der nächsten Szene Trumans aufgesetzt wirkende Mutter die Wogen in der Seele ihres Sohnes wieder zu glätten sucht.

Die Revolte der Liebe

In einer Rückblende erfahren wir nun, dass „The Truman Show" schon vor einiger Zeit mit dem Eigensinn ihres Protagonisten zu tun hatte. Auf der Abschlussfeier des Colleges fing Trumans Blick den einer Frau ein. Ihr Name ist Sylvia (Natasha McElhone). Es ging einige Male hin und her, und schon war eine Anziehung entstanden, die sich ausbreiten und betätigen wollte. Wir kennen solche Momente: Zwei Blicke kreuzen sich, bleiben aneinanderhängen und der Keim einer Anziehung entsteht. Diese sucht sich weitere Anhaltspunkte, baut sich über sie aus und setzt einen Sog in Gang, der schließlich ein Eigenrecht gewinnt. Je mehr er sich ausformen kann, desto schwerer lässt er sich nun stoppen. Er nimmt den Kampf mit Widerständen auf und sucht sich gegen sie durchzusetzen. Ein solches Aufblühen der Liebe erleben wir als spontan oder echt, weil es eine ungeahnte Kraft entfaltet, die selbst unseren eigenen Willen übergreift. So gehen „natürliche" Prozesse. Sofort einsetzende Versuche, sie abzubiegen, ihnen ein anderes – auf den ersten Blick vielleicht appetitlicheres – Objekt anzubieten, mussten vor dieser Kraft kapitulieren. Truman verliebte sich in eine Statistin, auch wenn diese Wendung des Plots im Drehbuch nicht vorgesehen war!

Aber auch hier versuchten energisch zupackende Kräfte, die Entfaltung der spontan entstandenen Liebe schließlich doch noch zu verhindern. Denn als es Truman schließlich gelang, mit Sylvia für ein paar Minuten am nächtlichen Strand allein zu sein, raste plötzlich mit hellen Scheinwerfern und heulendem Motor ein Auto heran. Der Fahrer stellte sich als Sylvias „Vater" vor. Er erklärte sie dem erstaunten Truman gegenüber für verrückt und nahm sie einfach mit. Sie würden nach Fidschi ziehen, rief er Truman noch zu und brauste mit der protestierenden Sylvia davon. Als Zuschauer ist man bereit, auf diese subversiv entstandene Liebe zu setzen und erlebt ihre Unterdrückung als Willkür.

Hier schließt sich ein Kreis des Verstehens. Truman zieht es zum Inselreich Fidschi, weil er noch immer das Versprechen dieser Anziehung in sich trägt. Eine vielversprechende Gestalt, die auf Entfaltung drängt. Zwar hat er dann doch die ihm von den Autoren der Serie so offensichtlich und plump ans Herz gelegte Meryl geheiratet, aber ihn quält etwas, was noch nicht zum Abschluss gekommen ist. Wir verstehen seinen Wunsch, Seahaven zu verlassen, nun als Ausdruck der alten, unterdrückten Sehnsucht. Das „Jetzt", das Silvia in der Bibliothek aussprach – „Jetzt oder nie" – ist ein Merkmal solcher, gegen die Willkür revoltierenden, Liebe.

In einem unbeobachteten Moment nimmt sich Truman ein gerahmtes Foto seiner Frau Meryl vor. Optimistisch posierend blickt sie aus der Umrahmung. Truman dreht das Bild um, öffnet den Deckel der Rahmenrückseite, und es kommt eine versteckte Kollage zum Vorschein. Er hat sie mit den aus Zeitschriften herausgerissenen Frauenfotos zusammengestellt. Es ist ein Suchbild, bei dem die Kombination von Stirn-, Augen- und Mundpartien verschiedener Frauenbilder das Gesicht Sylvias ergeben soll. Truman schiebt die einzelnen Teile solange hin und her, bis der Eindruck von Ähnlichkeit entsteht. Diese Szene fasst den im Erleben der Zuschauer wirkenden Konflikt wie ein Symbol zusammen: Auf der Frau, die ihm das spontane Wunder der Liebe nahe gebracht hat, sitzt die Frau, die er schließlich, dem Drehbuch folgend, dann doch heiraten musste. Die spontan entstandene revoltiert gegen die gemachte Liebe. So sehr sich Truman auch anstrengen mag, Meryl zu lieben und mit ihr glücklich zu sein, das Bild Sylvias treibt ihn dennoch um. Vieles ist steuerbar im Leben eines Menschen, aber manche Regungen lassen sich nicht unterdrücken. Dazu gehört das, was man als „Wunder der Liebe" bezeichnen könnte.

Nun haben die Zuschauer ein konturiertes Gefühl für die Situation Trumans herausgebildet. Der Film räumt ihnen einen weiteren Überblick ein als seinem Helden. Vieles von dem, was Truman als rätselhaft empfindet, können die Zuschauer bereits als den Kampf einer Ordnung um ihren Erhalt verstehen. Das Filmerleben wird von einem bedeutsamen Komplex strukturiert, der weiter auf Entfaltungen, Steigerungen und Lösungen drängt. Es geht um die Revolte gegen eine noch nicht ganz fassbare Macht. Letztere hat zu tun mit der Fernsehshow, in der Truman offenbar den Protagonisten abgibt. In einer nächsten Wendung wird es darum gehen, dass Truman das ungeheuerliche Ausmaß dieser Macht bewusst wird.

Aufbrechen des Selbstverständlichen

Dieser Abschnitt beginnt damit, dass Truman im Auto zufällig den Funkverkehr der Regiezentrale empfängt. Er wird darauf aufmerksam, dass man seine Handlungen genau im Blick hat. Was soll das bedeuten? Nach dem täglichen Besuch beim Kiosk rennt er auf die Straße. Der vorbei fahrende Bus stoppt genau fünf Zentimeter vor seiner ausgestreckten Hand. Wie kann das sein? Truman hebt seinen Arm, und das Auto auf der anderen Seite der Fahrbahn hält ebenfalls an. Er rennt in ein Haus, will den Lift betreten, doch statt in die Kabine, schaut er auf einen Tisch mit Kaffeekannen und belegten Broten. Ein Lift ohne Rückwand? Truman ist verwirrt, er kann sich diese Dinge nicht erklären. Für die weitaus besser informierten Filmzuschauer setzen sich diese Momente zum Set der TV-Serie zusammen. Die Seltsamkeiten, die eindrucksvoll von dem Musikscore von Burkhard Dallwitz und Philip Glass untermalt werden, weiten sich für deren Protagonisten zu einer Art paranoiden Stimmung aus. Die Zuschauer nehmen an diesem Aufruhr teil. Truman kommt ihnen wie ein Insekt im Spinnennetz

vor. Die Erklärungen, die man ihm bietet, können sie nicht befriedigen. Im Radio wird nun verbreitet, die Frequenz des Senders habe sich mit der des Polizeifunks überschnitten. Und Ehefrau Meryl erklärt ihrem aufgebracht nach Hause kommenden Mann, in Anspielung auf sein vorheriges Erlebnis, eine Fahrstuhlkabine sei abgestürzt, es habe Verletzte gegeben.

Truman jedoch lässt sich nicht von schnell gegebenen Erklärungen beruhigen. Er wird aktiv und beginnt, die Stadt, in der er lebt, genau zu beobachten. Heimlich folgt er seiner Frau Meryl, die als OP-Schwester arbeitet, ins Krankenhaus. Dort beobachtet er eine Amputation und stellt fest, dass diese alles andere als professionell durchgeführt wird. Es ist, als würden Schauspieler Chirurgie spielen. Dann wagt Truman die Probe aufs Exempel und begibt sich in ein Reisebüro, um einen Flug nach Fidschi zu buchen. Er ist schon nicht mehr überrascht zu hören, dass alle Plätze bis auf Weiteres ausgebucht sind. Truman löst am Busbahnhof ein Ticket nach Chicago. Als der Fahrer losfahren will, versagt die Schaltung. Alle Passagiere müssen wieder aussteigen. In diesen Unbeholfenheiten und Verhinderungen scheint System zu stecken. Ein Rhythmus von Ausbrechen und Wieder-Einkreisen durchformt das Erleben dieser Szenen.

Aber Truman fehlt noch ein letzter Beweis. Er sucht nach Regelmäßigkeiten, nach Wiederholungen in den Vorkommnissen. Dafür nimmt er einen festen Punkt ein und beobachtet das Verhalten der Passanten auf der Straße. Und als Meryl zu ihm stößt, kann er ihr nachweisen, dass die Menschen in Seahaven offenbar immer wieder die gleiche Strecke zurücklegen. Zum wiederholten Male passieren vor seinem Blick eine Frau, ein Mann mit Blumen und ein gelber Volkswagen. Truman triumphiert, er hat das System geknackt. In seiner Umwelt steckt ein Plan. Es ist alles gemacht!

Hiermit ändert sich die Beziehung der Zuschauer zu ihrem Helden. Dieser wird nun als aktiver und raffinierter erlebt, und man beginnt daran zu glauben, dass er sich aus seiner Lage befreien wird. Vom Plot her gesehen, haben wir es mit einem so genannten „midpoint" (Field 1984, S. 131 ff.) zu tun. Eine Wendung in der Handlung, die alles neu ordnet und anzeigt, dass die Story nun eine neue Richtung nimmt. Viele Filmautoren haben den Ehrgeiz, einen solchen, alles entscheidenden Wendepunkt genau in der Mitte des Films zu platzieren. Hierüber erhalten die Erlebensprozesse eine spürbare Durchformung. Bei *Die Truman Show* ist der midpoint in der 45. Minute (von insgesamt 92 Minuten) eingerichtet.

„Verrückter" Übergang

Beim Filmerleben ergibt sich eine Formation aus der vorhergehenden. Wir erleben Film als Kontinuität, wenn die Abschnitte psychologisch aufeinander aufbauen. Demgemäß werden die Zuschauer in den nun folgenden Sequenzen immer mehr in das Auf- und Umbrechen der bisher als selbstverständlich gegebenen Ordnung einbezogen. Dabei ergeben sich Momente, in denen mal Truman den Eindruck vermittelt, er sei kurz davor, den Verstand zu verlieren, mal gibt seine Frau Meryl ein verrücktes Bild ab. Solch ein verrückter Übergang ist ein als sinnvoll verspürter Zwischenschritt auf dem Weg zu einer anderen Ordnung des Ganzen. Das Neue erscheint verrückt aus dem Blickwinkel des Alten und das Alte eigenartig aus der Sicht des Neuen. Wenn sich Bilder der Wirklichkeit auflösen und umbilden, ist ein Phase der Verstörung nicht zu vermeiden.

Nachdem Truman sich bewiesen hat, dass er in einer Welt lebt, die von einer für ihn noch unfassbaren Macht gesteuert ist, sucht er das Heil in der Flucht. Zusammen mit der skeptischen Meryl macht er sich im Auto auf den Weg. Fidschi ist das ferne Ziel. Zunächst aber rast er wie wild in einem Kreisverkehr herum und ruft dabei aus: „Wir sind spontan!" Dann schert er aus dem Kreisverkehr aus. Im selben Moment stoßen mehrere Autos aus den Seitenstraßen hinzu und bilden einen Stau. Nichts geht mehr. Für Truman ist dies nur ein weiterer Beweis für das Gemachte, das in allen Ereignissen liegt. Er will es Meryl beweisen, steuert zurück in den Kreisverkehr, dreht ein paar Runden und wählt noch einmal dieselbe Abzweigung. Jetzt hat sich der Stau aufgelöst.

Truman überzieht in diesen Szenen. Man hat das Gefühl, er spiele Theater, wisse womöglich selbst nicht mehr, was er tut. Aber die beunruhigte Meryl bietet in diesem Abschnitt der Handlung auch keinen wirklichen Halt. Ihre stereotypen Ermahnungen, ihre Ängstlichkeit wirken wie Vorboten eines Zusammenbruchs. Das Filmerleben gerät auf eine schiefe Ebene. Man hat das Gefühl, es breche etwas auf, finde aber noch keine neue Richtung.

Die Flucht der Beiden aus Seahaven stößt auf weitere Hindernisse. Zunächst ist es eine Brücke, die Truman mit Meryls Hilfe überwindet. Dann geraten sie in einen Waldbrand, den Truman schnell als künstlich hergestelltes Feuer entlarvt, indem er das Auto mitten hindurch steuert. Aber an dem Atomreaktorunfall, der hierauf die Straße blockiert, kommen sie nicht mehr vorbei. Ein ihm völlig fremder Feuerwehrmann spricht Truman mit dem Vornamen an. Diese Vertraulichkeit wirkt, Meilen entfernt von Seahaven, verstörend. Truman verlässt schreiend das Auto. Er tobt, will den Mann zur Rede stellen. Sicherheitsleute umstellen ihn und wollen ihn festnehmen. Truman rennt davon, wird überwältigt und wie ein ausgerasteter Irrer in Gewahrsam genommen. Erneut wirkt er hilflos wie das Insekt im Netz einer Spinne. Die Anläufe zum Ausbruch sind damit erst einmal gestoppt. Mitleid kommt auf, und die Frage entsteht, wie er sich jemals aus einer solch perfiden Übermacht wird befreien können.

Truman wird von den Ordnungsmächten und von seiner Frau Meryl für verrückt erklärt. Das ist nicht selten das Schicksal von Menschen, die gegen überholte Ordnungen und Weltanschauungen revoltieren. Aber ist es nicht auch verrückt, wenn Meryl auf Trumans Frage, ob sie ihn liebe, mit dem Herunterleiern eines Werbeslogans antwortet? Sie könne ihm einen Schokodrink zubereiten, der tue ihm jetzt gut. Das wirkt ihrerseits irre. So wird das „Verrücken" noch einmal gesteigert und wendet sich schließlich in eine tätige Auseinandersetzung zwischen den Eheleuten. Ein gefährliches Handgemenge entsteht. Truman bedroht seine Frau mit einem Küchengerät. Sie gerät in Panik und ruft nach einem rettenden Eingriff der Regiezentrale: „Tut etwas!" Truman ist über diesen Ausruf mehr als verwundert. Mitten in diese Eskalation kommt Freund Marlon mit ein paar Dosen Bier zu ihnen. Meryl ist außer

sich von Panik, wirft sich in die Arme des Besuchers und beklagt sich heulend über die Not, in der sie als Schauspielerin versetzt wurde: Es sei unprofessionell, sie mit Truman allein zu lassen. Das falsche Spiel bricht damit noch ein Stück weiter auf. Truman fühlt sich verraten und umstellt. Alles drängt darauf, einen neuen Sinn zu finden.

Konstruktion von Wirklichkeit

Im nächsten Abschnitt gerät das Filmerleben in die zugleich erstaunlichste und wuchtigste Wendung des Films. Es ist Nacht. Truman hat sich zusammen mit seinem Freund Marlon auf dem Ende einer in Bau befindlichen Brücke niedergelassen. Er erzählt ihm von der Verwirrung, die ihn erfasst habe. Um ihn herum gehe etwas vor, in das alle anderen, nur er nicht, eingeweiht seien. Er habe Angst, verrückt zu werden. Mit ernster Stimme erinnert Marlon Truman an ihre lebenslange Freundschaft und schwört, mit all dem nichts zu tun zu haben. Um Trumans Skepsis endgültig auszuräumen, versichert er, er würde sogar sein Leben für ihn opfern.

In diesem Augenblick gerät das Filmerleben in die angekündigte Drehung. Mit einem Mal kommt eine ganz andere Ansicht des Ganzen in den Blick. Der Film rückt Figuren ins Bild, die bisher nie zu sehen waren. Er führt in die Regiezentrale der Serie. Umringt von seinen Mitarbeitern spricht deren Schöpfer Christof Marlon über Funk die Dialogsätze vor, mit denen dieser Truman zu beruhigen sucht. Als Zuschauer versteht man diese Wendung in dem Moment, in dem der Regisseur Marlon sagt, er solle Truman versichern, er – Marlon – werde ihn niemals belügen. Das ist ungeheuerlich! Marlon spricht nicht aus sich heraus, er führt nur die Sätze aus, die Christof ihm ins Ohr flüstert. Seine Beteuerung der Wahrheit ist offensichtlich eine Lüge!

Der Umschwung im Erleben der Zuschauer ist gewaltig. Gerade noch waren sie bereit, den Treueschwüren des Freundes zu glauben, und jetzt erweisen sich diese als absichtsvolle Täuschung. Und damit nicht genug. Bild für Bild wird nun die ganze, bisher ausgesparte Rückseite des Schauplatzes der Handlung enthüllt (◘ Abb. 3). Nun sind auch Zuschauer der Serie zu sehen, die gebannt dem Geschehen auf dem Bildschirm folgen. Ein Mann in der Badewanne, zwei ältere Damen auf dem Sofa, zwei Parkwächter in einem Aufenthaltsraum, Menschen in einer bis auf den letzten Platz besetzten Bar und Sylvia, die Statistin, in die sich Truman vor seiner Ehe mit Meryl verliebt hatte. Ein multiperspektivischer, ungemein komplexer und zugleich einheitlicher Zusammenhang wird enthüllt, der die unglaubliche Wirkungseinheit dieser weltumspannenden Fernsehserie ausmacht. Das perfide Getriebe der Macht, das man schon lange in kleinen Anzeichen hat verspüren können, wird offen sichtbar. Natürliches kippt in Gemachtes, und Trumans Revolte, an die man seine Hoffnungen geknüpft hat, wendet sich in Ohnmacht.

Ehe man die Konsequenzen der letzten Wendung im Filmerleben schon ganz ermessen kann, geht es auf der Ebene der Handlung weiter. Marlon hat Trumans Vater auf die Brücke mitgebracht. Wie ein Geist tritt er aus dem Dunkel und kommt auf seinen „Sohn" zu. Um dem Weltpublikum einen möglichst anrührenden Moment zu bieten, dirigiert Christof selbst die Einstellungen der Kameras und den Einsatz der Musik. Als Truman schließlich seinen „Vater" umarmt, in starker Rührung seinen Blick in den dunklen Himmel wendet und ihn – jetzt in einer Naheinstellung – „Dad" nennt, geht ein Jubel durch die Regiezentrale. Die Inszenierung hat die Gefühle des Protagonisten der Serie perfekt steuern können. Truman erlebt als echt, was wir als „gemacht", also künstlich erfahren. Die Mitarbeiter klatschen in die Hände, gratulieren sich zu ihrer Leistung. Vor den Bildschirmen auf der ganzen Welt vergehen die Fans der Serie vor Ergriffenheit. Es findet nicht nur eine Bemächtigung der Gefühle Trumans, sondern auch der von Abermillionen von Zuschauern statt. Die Produzenten kommen in die Regiezentrale gelaufen, um Christof für seine Leistung zu danken. Seine geschickte Modellierung der Emotionen wird gefeiert. Er hat die wohl größte Krise im Leben des Protagonisten zum Guten gewendet. Christof wirkt erschöpft und müde. Wie ein Torero, der den Stier erlegt und im Applaus der Masse gebadet hat, verlässt er die Stätte seines Triumphes.

Die Wendung des Zuschauerblicks auf das Ganze geht nun in einem anderen Tempo weiter. In einer Art Trailer werden der Inhalt der Serie und das Leben ihres Protagonisten aufgerollt. Man erfährt, dass die Sendung in dem größten Fernsehstudio der Welt hergestellt wird. So groß, dass man das kreisrunde Gebäude wie die Chinesische Mauer vom Weltall aus erkennen kann. Man sieht, dass es offenbar die gesamte Erdbevölkerung ist, die die 24-Stunden-Show täglich einschaltet. In einer zweiten Wendung wird Christof in seinem Büro hoch oben über dem Set von Seahaven als genialer Designer und Schöpfer des Ganzen positioniert und in ein Interview verwickelt. Hierdurch rücken offene Fragen zur Produktion der Sendung und zu Trumans Lebenslauf in einen klärenden Zusammenhang. Aufkommende kritische Fragen werden in eine kontroverse Diskussion überführt, wenn Trumans heimliche Liebe Sylvia die Gelegenheit zum Telefonat mit Christof wahrnimmt. Sie macht dem Mann harte Vorwürfe, spricht von unrechtmäßiger Gefangennahme eines Menschen.

Die beschriebene Wendung der Handlung ist ungewöhnlich mitreißend. Der Zuschauer ist von ihr gefesselt und vergisst normalerweise, dass er im Kino sitzt und einen Film sieht. Aber das ist nicht alles. Denn die Änderung der Perspektive ermöglicht zugleich eine „Konstruktionserfahrung". Damit hat Wilhelm Salber den Moment im Erleben von Kunst bezeichnet, in dem sich in Anbetracht des Werkes eine komplexe Einsicht über das Funktionieren der menschlichen Wirklichkeit herausbildet. (Salber 1977, S. 102 f.) Um zu solch einer Einsicht zu gelangen, muss man sich freilich aus dem unmittelbaren Eingebunden-Sein herauslösen. Wenn das gelingt, kann an der beschriebenen Filmszene nachvollziehbar und zugleich als Zusammenhang sichtbar werden, wie Medienunterhaltung und Alltagsleben ineinandergreifen: So wie Christof von der Regiezentrale aus Trumans Gefühle modelliert, so geben Romane, Filme, Bilder unseren Erregungen eine konkrete Gestalt. Unser Seelenleben findet in ihnen Ausdrucksformen. Über die Ausbreitung der Filmunterhaltung bis in unsere Wohn- und Schlafzimmer ist auf diese Weise ein beachtlicher Anteil unserer Gefühle zu Zitaten geworden. Das sind Wirkungszusammenhänge, die in der Regel kaum bewusst werden, und es gibt viele Menschen, die sich gegen diese Auffassung verwahren würden. Aber über Filmkunstwerke wie *Die Truman Show* können wir auf sie aufmerksam werden.

Macht und Ohnmacht

Die Krise scheint überwunden, Trumans seelisches Gleichgewicht wieder hergestellt. Im Schnelldurchgang lässt der Film die Zuschauer nun einen weiteren Tag seines Lebens miterleben. Er verläuft noch glatter, noch freundlicher als am Anfang und für den Versicherungsverkäufer Truman Burbanks zudem ungewöhnlich erfolgreich. Der eine oder andere Zuschauer mag das als eine Überzeichnung erleben, die auf eine erneute Wendung der Handlung vorbereitet. Eine Ahnung, die sich auf eindrucksvolle Weise bestätigen wird.

Gerade noch hatte die Regie die Gefühle des Protagonisten der Serie fest im Griff und konnte ihren Einfluss genießen. Doch jetzt müssen Christof und seine Assistenten feststellen, dass sich Truman ihrem Einflussbereich entzieht. Trotz intensivster Überwachung ist es ihm gelungen, dem Fokus der allgegenwärtigen Kameras zu entkommen. Christof schickt Marlon in Trumans Haus, doch der kann nur dessen rätselhaftes Verschwinden bestätigen. Marlon wirkt in diesen Szenen nicht mehr als Trumans Freund, sondern als dessen Verräter, besonders in dem Moment, in dem er höchst angespannt direkt in die Kamera spricht: „Er ist weg!" Christof verliert zum ersten Mal die Geduld. Er herrscht seine Mitarbeiter an und verlangt die sofortige Unterbrechung der Übertragung. Die Zuschauer auf der ganzen Welt sehen sich mit einer „Bildstörung" konfrontiert.

Hatte die im letzten Abschnitt beschriebene Wendung die Macht der Medienproduktion und demgegenüber die Ohnmacht Trumans spürbar gemacht, so dreht sich in diesem Kapitel das Verhältnis wieder herum. Eine ungewohnte Hektik geht durch die Regiezentrale. Alles läuft durcheinander. In seiner Nicht-Auffindbarkeit entfaltet Truman eine beeindruckende Macht. Und wenn nun Schauspieler der Serie mit Taschenlampen den in Dunkelheit getauchten Set der Serie durchkämmen und dabei zuvor

überaus freundlich wirkende Statisten eine gefährlich wirkende Schärfe zum Ausdruck bringen, werden Anklänge an totalitäre Regimes belebt. Die Revolte gegen einen als drückend erlebten, unfassbaren Zusammenhang, die sich schon früh im Film andeutete, wendet sich in einen alles entscheidenden Machtkampf. Wer wird ihn für sich entscheiden? Truman oder Christof?

Die Wendung von Macht in Ohnmacht ist ein Urphänomen des menschlichen Lebens. Aber dies hat in einer Kultur, die sich zunehmend aus materialbezogenen Produktionsabläufen herauslöst und sich an Börsenkursen, wechselnden Unterhaltungsprogrammen und „Blasen" orientiert, eine ungeheure Kippligkeit erreicht. Die Existenz von immer mehr Menschen wird darüber entschieden, ob eine Kampagne, ein Produkt, eine Sendung wirksam ist oder nicht. Schauspieler, Showmenschen, aber auch Politiker haben die Chance, innerhalb kürzester Zeit die Massen mitzureißen und einen enormen Einfluss zu gewinnen. Aber sie müssen auch immer damit rechnen, diesen genauso schnell wieder zu verlieren. Vermittelt über Medien werden jedes Jahr Stars und Hoffnungsträger geschaffen, aber ebenso rasch wieder demontiert. Unbekannte verschaffen sich auf diese Weise Aufmerksamkeit und Einfluss, verschwinden aber auch schnell wieder in der Masse. Diesen Umschwung von Ohnmacht in Macht und umgekehrt macht der Film mit der beschriebenen Wendung des Erlebens erfahrbar und verwickelt im Folgenden in ein Ringen um Einfluss, das sich bis zu einem Kampf auf Leben und Tod steigert.

Die ersten sechzig Minuten stand Truman stets im Zentrum des Films. Jetzt ist er schon seit geraumer Zeit nicht mehr im Bild zu sehen, und der Plot konzentriert sich in den nächsten fünfundzwanzig Minuten auf die angestrengten Versuche der Serienmacher, seinen Ausbruch aus der Serienwelt zu verhindern. Denn ohne Truman – das ist allen klar – ist „Die Truman Show" tot. Eine Zuspitzung des Verhältnisses von Macht und Revolte ergibt sich aus den Wendungen, in denen das fiktionale Regelwerk der Serie von Christof absichtlich durchbrochen wird. An packenden Wirkungsqualitäten wird mitvollziehbar, wie ein mächtiges Unternehmen alle Möglichkeiten einsetzt, um seine Existenz zu retten und dabei eine totalitäre Ausrichtung und Konsequenz bekommt.

Die erste Zuspitzung findet statt, wenn Christof die Anordnung gibt, am Set vorzeitig die „Sonne aufgehen" zu lassen, damit die nach dem Verschwundenen Suchenden nicht im Dunkeln tappen müssen. Um ein Vielfaches schneller als in der Realität erhebt sich der künstliche Feuerball aus dem Meer und taucht die Serienwelt ohne den Übergang der Dämmerung in ein schrilles, schmerzendes Licht. Das Rad der Natur wird künstlich angetrieben. Im hellen Licht entdeckt Christoph den Flüchtigen in einem Segelboot auf dem Meer. Da er ihn nicht zum Umkehren bewegen kann, ordnet er einen zweiten Eingriff an. Das Wetterprogramm soll Truman mit einem heftigen Sturm, mit Regen und Blitzen zur Aufgabe zwingen. Als sich zeigt, dass Truman nicht aufzugeben bereit ist, werden Sturm und Wellenbildung noch einmal verstärkt. Das ist die dritte Zuspitzung. Christof ist offenbar bereit, Truman vor den Augen des Weltpublikums sterben zu lassen. Wie besessen verfolgt er am Bildschirm dessen Überlebenskampf. Erst als Truman neben dem gekenterten Segelboot leblos unter Wasser treibt, gibt Christof die Anordnung, das Sturmprogramm zurückzufahren. Das Boot richtet sich wieder auf. Die bange Frage steht im Raum, ob Truman den Kampf verloren hat. Leblos hängt er am Bootsrand. Als er dann doch zu sich kommt, geht eine sichtliche Erleichterung durch die Regiezentrale und löst sich die Anspannung der Millionen und Abermillionen Zuschauer auf der ganzen Welt in einem befreienden Jubel. Die Figur, an die sich die Herzen des Publikums gebunden haben, hat sich durch diese Eingriffe nicht zerstören lassen und setzt seine Segelfahrt im wärmenden Sonnenschein fort.

Der Schritt ins Ungewisse

Im letzten Drittel des Films ist Truman für die Zuschauer kaum mehr fassbar. Während der Plot ihnen zuvor seine intimsten Geheimnisse verriet, erlaubt er nun weder Einblicke in sein Erleben noch in seine Absichten. Truman beschäftigt das Filmerleben durch Abwesenheit. Auf diese Weise wird sein Ausbruch aus der Serienwelt als eine Mischung aus Befreiung und Entgleiten erlebt. Wir Zuschauer spüren,

dass er zu einem anderen geworden ist und sich auch uns entzieht. Im Folgenden wird beschrieben, wie sein Schritt ins Ungewisse erlebt wird.

Trumans wieder aufgenommene Segelfahrt kommt plötzlich, mit einem lauten Ruck, zum Stehen. Das Boot hat eine unendlich ausgedehnte, himmelblau gemalte Wand aus Gips gerammt. Der geflohene Held hat den äußersten Rand der Serienwelt, der ihn von der Wirklichkeit trennt, erreicht. Das ganze Elend dieses in einer künstlichen Welt gefangenen Menschen wird spürbar. Immer wieder wirft er seinen Körper gegen die harte Begrenzung. Kommt hier sein Ausbruchversuch ein für alle Mal zum Ende? Die Zuschauer bekommen in dem vom Seriengeschehen gebannten TV-Publikum gespiegelt, wie es ihnen selbst ergeht. So viele Hoffnungen haben sich an Trumans Flucht geheftet, so unrechtmäßig erscheint das Regiment der Serienwelt! Man ist gebannt zu sehen, wie sich diese Situation auflösen wird.

Truman verlässt das Segelboot und folgt der himmelblauen Wand bis zu einer Treppe. Eindrucksvoll von dem Musikstück „Father Kolbe's Preaching" untermalt, das Burkhard Kollwitz und Phillip Glass für den Film komponiert haben, werden seine Schritte zu einem bewegenden Erlebnis. Als Truman oben auf der Treppe vor einer Tür ankommt, auf der das Wort „Exit" zu lesen ist, schaltet sich Christof über hallende Lautsprecher aus der Regiezentrale ein und bittet Truman, in der Serie zu bleiben. Die Musik erlischt, ein abschließender Dialog entfaltet sich.

> **◖** Truman: „Was nothing real?"
>
> Christof: „You were real. That's what made you so good to watch. There is no more truth out there than there is in the world I created for you. The same lies, the same deceit. But in my world, you have nothing to fear."

Auch mit diesem Dialog überschreitet der Film den Rahmen seiner Story und spricht allgemeine Verhältnisse der Medienwirklichkeit an: In unserer Zeit lassen sich Abermillionen von Menschen täglich auf die medialen Wirklichkeiten der Filmunterhaltung ein. Sie können alle erdenklichen Entwicklungen und auch Risiken erleben, ohne die damit verbundenen Gefahren und Konsequenzen auf sich nehmen zu müssen. Auf der anderen Seite ahnen wir: Die Welt wartet darauf, dass wir drängende Fragen nach deren Erhalt, nach der Organisation des Zusammenlebens, nach Sinngebung und Wertsetzung angehen und lösen lernen. Vielleicht auch, weil uns das als zu aufwändig erscheint, verbringen wir viel zu viele freien Stunden in den Sinnschleifen der Film- und Fernsehunterhaltung. Hier können wir uns von anstehenden Aufgaben zurückziehen oder auf dem bereits erwähnten „sicheren Stuhl", ohne Wagnis und Aufwand, mit Veränderungen experimentieren. So wie wir am Ende von *Die Truman Show* vor der Frage stehen: Sollen wir im überschaubaren, scheinbar sicheren und bequemen Rahmen bleiben oder sollen wir den Schritt ins Ungewisse wagen, in das Dunkel hinter der Tür in der himmelblauen Wand des Films treten, das Risiko wagen und die Verantwortung eines offenen Lebens auf uns nehmen?

Der Film als Kritik an der Mediengesellschaft

Überblicken wir die bisherigen Wirkungsprozesse: *Die Truman Show* regt die Zuschauer von Anfang an zu Vergleichen der schön gefärbten Serienwelt mit eigenen Alltagserfahrungen an. Das Leben in Seahaven erscheint als zu ordentlich, zu bunt, zu sauber und zu heiter. Zwar hat das etwas Anziehendes, aber man kann es nicht wirklich ernst nehmen. Auch deswegen, weil viele Dinge darauf hinweisen, dass der Film eine künstliche und nicht-natürliche Welt zeigt: Ein Scheinwerfer fällt vom Himmel, die Figuren tragen ohne Rücksicht auf den Kontext Werbeslogans vor, jeder Winkel des Ortes scheint von Kameras erfasst zu sein, der Regen kommt in einer Szene wie von einer Dusche herunter etc. Auf der anderen Seite werden die Zuschauer auch mit Momenten konfrontiert, die offenbar nicht künstlich hergestellt sind: vor allem die Liebe Trumans zu seinem Vater und zu Sylvia.

So dreht sich das Filmerleben zunächst um das Verhältnis von „künstlich" und „natürlich". Ein Komplex, der aus seinen Spannungen heraus das Leben immer wieder antreibt, neue Formen zu finden. Denn Vieles in unserem Leben ist gemacht und kalkuliert. Das verspricht Sicherheit und Kontrolle. Je länger wir mit solchen Zuständen zu tun haben, desto mehr erleben wir sie jedoch als falsch. Wir vermissen den Fluss des Lebens, der sich eher in Sprüngen, Unregelmäßigkeiten und in Momenten zum Ausdruck bringt, die stärker sind als unsere bewusste Absicht. Im Verlauf des Films schließt sich das Natürliche, Spontane zu einer Revolte zusammen. Das Künstliche, Gemachte spitzt sich zu einem mächtigen Kontrollsystem zu. Das Verhältnis von „natürlich" und „künstlich" verwandelt sich in das Verhältnis von „Revolte" und „Bemächtigung".

An diesen Zuspitzungen machen sich Assoziationen fest, die an totalitäre Regime erinnern, aber auch eine Medienkritik wird von ihnen angeregt. Sind wir nicht schon längst an einem Zustand angekommen, den der Film uns wie in einen Spiegel vorhält? Sind die Verhältnisse, die George Orwell in seinem Roman „1984" beschrieb, nicht längst Realität geworden? Haben nicht die Medien, vor allem das allgegenwärtige Fernsehen, inzwischen unser Leben in einer Art und Weise geformt, dass wir uns – ohne es zu wissen – in einer ähnlichen Situation wie Truman Burbanks befinden? Glauben wir unser Leben zu führen und sind in Wirklichkeit nur Figuren im Drehbuch von Werbung und Fernsehen? Solche und ähnliche Fragen können sich beim Zusehen regen.

So eröffnet *Die Truman Show* Einsichten in das Leben in der modernen Mediengesellschaft. Besonders beeindruckend macht der Film deutlich, in welchem Ausmaß unsere zwischenmenschlichen Beziehungen durch die emotionalen Wendungen von Filmen und Serien bestimmt sind. Nicht wir allein gestalten unsere Annäherungen, Streitpunkte und Beziehungsdramen. Über die Allgegenwart der Medienunterhaltung ist die Regie für solche Wendungen des Lebens in großen Teilen an Hollywood übergegangen. Wexman (1993) hat dieses Phänomen an Liebesfilmen untersucht. Wir bemerken es oft gar nicht, wenn wir Zitate aus Filmen aufgreifen, um unsere Beziehungen zu gestalten. Nicht nur ein großer Teil unserer Liebeserklärungen, unserer Einflussnahmen sind Zitate, sondern auch unserer Gefühle.

Die meisten Zuschauer werden sich diese Zusammenhänge auch in den letzten Filmminuten nicht vergegenwärtigen. Denn die Sehnsucht nach Trumans Befreiung, die das Filmerleben erfasst hat, die Euphorie, die bei seiner Ausdauer und seinem Mut im Kampf mit dem Unwetter aufgekommen ist, diese Wirkungen verbergen, dass die Welt jenseits der blauen Wand, die Wirklichkeit außerhalb der „Real-Life-Soap" offen, komplex, schwierig und kaum berechenbar ist. So setzen die Zuschauer alles auf den Ausbruch, der als ein Aufbruch in eine „bessere Welt" verstanden wird. Sie lassen sich von der Begeisterung des im Film gezeigten Fernsehpublikums, der Freude Sylvias, die den Moment vor dem Fernseher verfolgt hat, mitreißen.

Doch ganz am Ende zeigt der Film noch einmal, dass er mehr ist als bloße Unterhaltung. Er ist ein Kunstwerk mit provokativer Wirkung. Das wird in der letzten Minute noch einmal deutlich, wenn im Film die bereits erwähnten Parkwächter zum Abschluss das Wort erhalten. Auch sie sind von Trumans Mut begeistert. Doch als die Sendung abgeschaltet wird, sehen sie sich mit der Aufgabe konfrontiert, die Offenheit des Augenblickes selbst zu gestalten. Offenbar ist ihnen das zu viel. Ihr Gesichtsausdruck zeigt Enttäuschung und Ratlosigkeit. „Was läuft denn sonst noch?", fragt der eine. Und der andere Mann antwortet: „Sieh mal nach." Der erste will daraufhin wissen: „Wo ist die Fernsehzeitung?" Ende! Solange ihnen die Revolte im Fernsehen geboten wird, gehen die Menschen gerne mit. Sind sie aber selbst als Gestaltende gefragt, sehnen sie sich nach Unterhaltung. Die letzte Szene von *Die Truman Show* hält uns Zuschauern einen Spiegel vor und hinterlässt einen bitteren Nachgeschmack.

Literatur

Brearley M, Sabbadini A (2008) The Truman Show: how's it going to end? Int J Psychoanal 89(2): 433–440
Field S (1984) The screenwriter's workbook. Dell Publishing, New York NY
Salber W (1977) Kunst. Psychologie. Behandlung. Bonnier, Bonn
Salber W (1989): Der Alltag ist nicht grau. Alltagspsychologie. Bonnier, Bonn
Wexman VW (1993) Creating the couple – love, marriage, and Hollywood performance. Princeton University Press, Princeton
Winnicott DW (1983) Metapsychologische und klinische Aspekte der Regression im Rahmen der Psychoanalyse.
In: Winnicott DW (Hrsg) Von der Kinderheilkunde zur Psychoanalyse. Fischer, Frankfurt/M, S 183–207 (Erstveröff. 1954)

Originaltitel	The Truman Show
Erscheinungsjahr	1998
Land	USA
Buch	Andrew Niccol
Regie	Peter Weir
Hauptdarsteller	Jim Carrey (Truman Burbank), Laura Linney (Meryl Burbank/Hannah Gill), Ed Harris (Christof), Noah Emmerich (Marlon/Louis Coltrane), Natasha McElhone (Sylvia)
Verfügbarkeit	Erhältlich als DVD in OV und in deutscher Sprache

Ralf Zwiebel

Die Farbe der lebendigen Wirklichkeit

Pleasantville – Regie: Gary Ross

Pleasantville

Regie: Gary Ross

Kurze methodische Vorbemerkung

Warum habe ich gerade diesen Film (◘ Abb. 1) für einen filmpsychoanalytischen Kommentar aus-
gewählt? Vergleichbar mit der Traumerfahrung, bei der man den geträumten Traum, den erinnerten
und den erzählten Traum unterscheiden kann (Moser u. v. Zeppelin 1996), führt das Erlebnis mancher
Filme zum „Nacharbeiten" in Form von Erinnern, Erzählen und manchmal sogar Schreiben eines Tex-
tes. Vermutlich sind es – vergleichbar mit manchen eindrucksvollen Träumen – solche Filme, die eine
besondere ästhetische Erfahrung, eine Art „Ergriffenheit" oder auch „Ratlosigkeit" auslösen (Freud
1914; Götzmann 2011). Diese Erfahrung der emotionalen Berührtheit und des Nicht-Verstehens der
bewegenden und rätselhaften Bilder weckt, so könnte man postulieren, einen Deutungswunsch, der
eine wesentliche Quelle in einer latenten und zentralen Deutungsfantasie des Betrachters hat, die wäh-
rend der Filmrezeption geweckt wird. Diese zentrale Deutungsfantasie wäre danach ein latent bereit
liegendes inneres Muster der Selbst- und Weltbetrachtung, ein Ausdruck der psychischen Realität des
Zuschauers und seiner bisherigen ästhetischen Erfahrungen und Konzeptualisierungen, die in der Fil-
merfahrung (oder anderen ästhetischen Erfahrungen) und der „Nacharbeit" nach einer Realisierung
sucht. Die Wahl eines speziellen Films und das Sprechen oder Schreiben über diesen Film dient dann
der Elaborierung dieser zentralen Deutungsfantasie. Meine eigene „Ergriffenheit" beim Betrachten von
Pleasantville, eines auf den ersten Blick recht typischen Hollywood-Produkts, rührte an zwei für mich
unbeantwortete Fragen der Filmpsychoanalyse:

— Wie lassen sich die Berührungspunkte und Wechselbeziehungen zwischen der lebendigen
 Wirklichkeit des realen Lebens und der medialen Fiktion beispielsweise des Films aus
 psychoanalytischer Sicht näher fassen?
— Wie kommt der Zuschauer zu einer lebendigen Filmerfahrung und der filmpsychoanalytisch
 inspirierte Zuschauer zu einer lebendigen Filmdeutung, einer Erfahrung, die den Film nicht durch
 Theorie „tötet", sondern die Protagonisten des Films (oder den Filmkünstler als Schöpfer des
 Films) und den Zuschauer in einen gleichsam intersubjektiven emotionalen Dialog treten lässt,
 der sowohl dem Zuschauer als auch den Figuren des Films einen Wandlungsprozess ermöglicht?

Eine Rolle dürfte bei dieser Auswahl auch gespielt haben, dass ich selbst Ende der 50er-Jahre ein Jahr in
einer amerikanischen Kleinstadt des Mittleren Westens als Austauschschüler verbrachte und dort das
im Film dargestellte „Pleasantville" am eigenen Leibe erlebte. Unabhängig von einer filmästhetischen
oder filmkritischen Bewertung rührte und evozierte der Film also – und dies sei hier als Vermutung
formuliert – an eine zentrale Deutungsfantasie, die durch diese nachträgliche Bearbeitung des Films
eine mögliche Realisierung versprach. Das folgende „Deutungsopus" verstehe ich als Versuch, dieser
eigenen zentralen Deutungsfantasie näher zu kommen.

Filmhandlung

Die adoleszenten Geschwister David und Jennifer leben mit ihrer frustrierten und geschiedenen Mutter
in einer amerikanischen Kleinstand in den 90er-Jahren. Diese Welt wird von den Medien dominiert,
die die apokalyptischen Zukunftsszenarien übermitteln, mit denen die Highschool-Schüler bombar-
diert werden: Arbeitslosigkeit, Klimakatastrophe, HIV-Gefahren. Der Träumer David ist ein großer
Fan einer beliebten Schwarz-Weiß-Fernsehserie, „Pleasantville" aus den 50er-Jahren, die häufig im
Fernsehen zu sehen ist und die an dem bevorstehenden Wochenende in einer Dauersendung über

den Bildschirm gehen soll – ein „Pleasantville Marathon", der gleichzeitig als Quiz den besten Kenner der Serie prämieren wird. David hat sich intensiv darauf vorbereitet und kennt die Serie praktisch in- und auswendig. Durch eine magische Fernbedienung werden die beiden Geschwister in die fiktive Schwarz-Weiß-Welt von Pleasantville „geschossen": beide befinden sich plötzlich zu ihrem eigenen Erstaunen, wenn nicht Entsetzen, in der fiktiven Welt der Fernsehfamilie Parker, deren beide Kinder sie jetzt sind, nämlich Bud und Mary Sue Parker. Vergleichbar dem Film *Truman Show* ist „Pleasantville" natürlich eine abgeschlossene, weil fiktive Welt, deren Straßen am Stadtrand enden, in der alles nur dem Drehbuch der Serie folgt und es daher auch keine unvorhergesehenen Ereignisse etwa in Form von Unglücken gibt: Der Feuerwehr ist das Feuer völlig unbekannt, ihr Haupteinsatz besteht in der Rettung von auf Bäumen verirrten Katzen. Das neue Elternpaar, George und Betty, der beiden in der Serie „Pleasantville" eingeschlossenen Geschwister führt ein absolut geregeltes Leben, in dem Sexualität ebenfalls unbekannt ist. Es ist sozusagen die Gegenwelt zur wirklichen Welt, eine absolut schöne Schein-Welt, die von absoluter Perfektion beherrscht ist: Der Vater kommt immer zur gleichen Zeit nach Hause – „Schatz, ich bin zu Hause", seine Frau antwortet stereotyp und wartet mit dem Essen auf ihn. Die Highschool-Basketballspieler versenken jeden Ball aus unmöglicher Lage erfolgreich im Korb und eine Niederlage haben sie noch nie erlebt. Die Bücher haben leere Seiten, die Häuser keine Toiletten, und es gibt nichts außerhalb des vorgesehenen Drehbuchs. Mit anderen Worten: Bud und Mary Sue sind in eine fiktive, künstliche, wiederholbare, zeitlose und imaginäre Wunschwelt geraten, in der die Kontingenzen des Lebens, die ständigen Wandlungen, die Körperlichkeit und vor allem damit auch das Unglück oder Unbehagen eliminiert worden sind.

Diese Körperlichkeit, Ungewissheit und Unvorhersehbarkeit des wirklichen Lebens wird nun aber durch Mary Sue eingeführt, weil sie sich nicht wie Bud an das „Drehbuch" von „Pleasantville" hält: Es beginnt damit, dass sie ihren neuen Verehrer in „Lovers Lane" – einem Treffpunkt für unschuldig Verliebte – sexuell verführt: Als dieser Skip seine lustvolle Erektion bemerkt, ist er zu Tode erschrocken. Als Skip anschließend jedoch nach Hause fährt, sieht er am Straßenrand das erste Mal eine vereinzelte rote Rose. Es ist dies der erste farbige Tupfer in der Schwarz-Weiß-Welt von „Pleasantville". Als er später in der Basketballhalle mit den Spielern spricht und ihnen offenbar von seinen erschreckenden, wenn auch lustvollen Erfahrungen erzählt, springen plötzlich die Bälle nicht mehr in den Korb. Bud ist, als er dies alles beobachtet, entsetzt und attackiert Mary-Sue, dass sie mit ihrem Verhalten das ganze Universum der Menschen in „Pleasantville" durcheinander bringe, was Mary Sue aber mit der Bemerkung beantwortet:

💬 „Vielleicht muss ihr Universum durcheinander gebracht werden."

Dies passiert nun in einem atemberaubenden Tempo: Ein besonders eindrucksvoller erster „Höhepunkt" ist es, wenn die Mutter Betty in der Badewanne auf lustvolle, masturbatorische Weise ihren Körper entdeckt und ihr Orgasmus den Baum vor dem Haus zum Brennen bringt. Immer farbiger werden nun die Filmbilder, und gleichzeitig werden die Jugendlichen immer neugieriger, was denn außerhalb von „Pleasantville" sei. Auch die Bücher beginnen plötzlich nicht nur leere Seiten, sondern wirkliche Texte zu enthalten, die mit dem Lesen vor den eigenen Augen entstehen. Bud zeigt dem Besitzer der Eisdiele, Bill, farbige Bilder berühmter Maler, der davon so begeistert ist, dass er selbst mit dem Malen beginnt und zum Künstler wird. Auch Bud macht nun eine Eroberung, und als er mit dieser Freundin auf dem Weg zur „Lovers Lane" ist, blüht die Idylle am See in wunderschönen bunten Farben.

Mehr und mehr gerät also die bislang „heile Schein-Welt" von „Pleasantville" völlig durcheinander: Mutter Betty verliebt sich in Bill, der jetzt seine Lust am Malen entdeckt hat; daher ist sie nicht mehr zu Hause, wenn der Vater heim kommt, was auch andere Männer als absolute Katastrophe empfinden, und es beginnt tatsächlich zu regnen wie in der wirklichen Welt. Der Bürgermeister und die Bürger beginnen, sich gegen die entstehenden Veränderungen aufzulehnen, versuchen neue Verbote und Gesetze

einzuführen, um ihre bisherige Ordnung aufrecht zu erhalten: Am Morgen kündigt ein Schild an, dass keine „Farbigen" erwünscht seien. Bill hat von Betty ein riesiges Gemälde im Fenster der Eisdiele gemalt, die entsetzten Bürger stehen empört davor, und es kommt schließlich zu einer massiven Randale und der Zerstörung der Eisdiele. In der Bürgerversammlung werden noch strengere Gesetze erlassen, dem sich die Jugendlichen aber mehr und mehr widersetzen. Bud landet schließlich als Rädelsführer im Gefängnis und wird in einer öffentlichen Gerichtsverhandlung angeklagt. Nach einigen Affektausbrüchen des Vaters, aber auch des Bürgermeisters, sind plötzlich alle Bürger von „Pleasantville" koloriert: Aus dem eintönigen „Pleasantville", das keine Farben außer Schwarz und Weiß kannte, ist nach und nach eine durch und durch farbige Welt geworden. Dies hängt offenbar vor allem mit der Entdeckung der Gefühle zusammen: nicht nur der Erotik und der Sexualität, wie bei Betty schon mehr als angedeutet, sondern auch mit dem Wahrnehmen von Wut und auch von Trauer (als George den Verlust seiner Betty realisiert, laufen ihm die Tränen über die Wangen, und das führt auch bei ihm endlich zu einem „farbigen Gesicht"). Bud kehrt am Ende in seine alte Welt zurück, wo er seiner weinenden Mutter, die von einer frustrierenden Verabredung verzweifelt zurückkehrt ist, sagt, dass es keine Regeln gäbe, wie das Leben sein soll. In der Schlussszene sehen die Zuschauer Betty, Bill und Georg zu Dritt auf der Bank sitzend und sich gegenseitig fragen: „Und was passiert jetzt?" „Ich habe keine Ahnung", sagen alle drei abwechselnd in jeweiliger Großaufnahme, und damit endet der Film.

Hintergrund und Wirkung des Films

Der von dem Drehbuchautor und Regisseur Gary Ross in den USA produzierte Film kam 1998 in die Kinos und wurde von der Filmkritik und auch vom Publikum überwiegend positiv aufgenommen. Dazu mögen vor allem die besondere Gestaltung des Films – die langsame Wandlung eines Schwarz-Weiß-Films in einen Farbfilm, die einen erheblichen technischen Aufwand bedeutete, und die gute Besetzung mit bekannten Schauspielen (Tobey Maguire, Reese Witherspoon, William Macey, Joan Allen und Jeff Daniels) beigetragen haben. „Pleasantville" war im Jahre 1999 dreimal für den Oscar nominiert und Maguire, Macey, die Designer und Kostümbildner sowie Gary Ross gewannen Preise auf anderen Festivals. Ross ist eher als Drehbuchautor und Produzent denn als Regisseur bekannt: Neben *Pleasantville* hat er als Regisseur die Filme *Seabiscuit* (2003) und *The Hunger Games* (2011) realisiert. Das Besondere von *Pleasantville* ist also diese technische Gestaltung, die der Farbe in dem Film einen ganz besonderen, zu beachtenden Stellenwert gibt. Ich selbst habe den Film erst vor einigen Jahren durch Zufall gesehen und war sofort sehr berührt, weil er mir auf sehr gelungene Weise die schon erwähnten Fragen auf filmisch überzeugende Weise darzustellen schien, nämlich die Beziehung zwischen Vorstellung und Wirklichkeit, eine Thematik, die auch in anderen Filmen, wenn auch auf andere Weise, bearbeitet wird. Neben diesem zentralen und im Grunde philosophischen Problem berührt der Film jedoch auch eine Thematik, die sich an den Zuschauer und vielleicht sogar noch spezieller an den filmpsychoanalytischen Zuschauer wendet: Wie kommt man als Zuschauer, als Betrachter von Kunst, zu einem lebendigen, „farbigen" Verständnis des Films oder des Kunstwerks oder erliegt man immer wieder der Gefahr von überwertigen und abtötenden Interpretationen? Wie sehr muss man in das Kunstwerk, in den Film „hineinschlüpfen", um zu einer wirklich lebendigen ästhetischen Erfahrung zu kommen? Und ist es dazu nicht notwendig, die fiktiven Personen zu verlebendigen, aus ihrer „Schwarz-Weiß-Welt" zu befreien, um so einen emotionalen, lebendigen Dialog zwischen Film und Zuschauer zu ermöglichen? Neben weiteren anderen Fragen sprach mich jedoch vor allem die Verwendung der Farbe in dem Film an: Sie schien mir der Schlüssel zum Verständnis des Films zu sein und weckte gleichsam meine zentrale Deutungsfantasie, wodurch ich weniger die Geschichte selbst, als die Rolle der Farbe in dem Film betrachten wollte. Gleichzeitig wurde mir bewusst, dass in psychoanalytischen Filmdeutungen oft das Narrative den Vorrang vor den Farben, der Musik und anderen formalen Gestaltungen hat. Der Film weckte also vor allem durch seine Gestaltung eine für mich und für den Filmpsychoana-

lytiker interessante und wichtige Frage: Wie entstehen eine lebendige, stimmige Interpretation und eine lebendige ästhetische Erfahrung von Kunst, und ist dieser Film nicht auch eine Visualisierung der Gefahren, die auf den Filmanalytiker lauern, wenn er umgekehrt den „farbigen" oder lebendigen Film mit seinen Interpretationen „tötet", indem er ihn als Container für seine psychoanalytischen Theorien und seinen „Schwarz-Weiß-Text" verwendet, damit aber seine ganze Fülle und Lebendigkeit verfehlt? Obwohl der Film eine Fülle weiterer komplexer und interessanter Fragen auszulösen vermag, werde ich im Folgenden versuchen, diese zentrale Deutungsfantasie weiter auszuarbeiten.

Psychoanalytische Deutung des Films

Lebendig und farbig: Hier besteht eine Korrelation, die ein wesentlicher Aspekt meines Deutungsansatzes ist. Eine Annäherung könnte in einer Art „Top-down-Verfahren" darin bestehen, etwa die sehr informative Arbeit über „Farben im Traum" von Joachim F. Danckwardt (2006) als Ausgangspunkt zu nehmen. Er untersucht dabei das unbewusst-affektive und vorbewusste fantasierende Denken bei Freud anhand von dessen Farbauffassungen; Freud ließ danach keinen Zweifel daran, dass er Affekte durch Farben im Traum repräsentiert sieht. Ich ziehe es hier allerdings vor, im Sinne eines „Bottom-up-Verfahrens" von dem Duktus der Filmbilder sukzessive auszugehen und dabei vor allem auf das Auftauchen der Farbe in der Schwarz-Weiß-Welt von „Pleasantville" zu achten, um die beiden mich interessierenden Fragen etwas näher zu umkreisen:

- Wie unterscheidet sich die mediale Welt von der lebendigen Wirklichkeit?
- Wie entsteht ein lebendiger, intersubjektiver Dialog zwischen Film und Zuschauer?

Alle anderen möglichen Kontexte dieses Films müssen in dieser Arbeit unberücksichtigt bleiben.

„Perfekte" Schwarz-Weiß-Welt kontra reale Tristesse

Der Titel *Pleasantville* lässt das Thema des Films anklingen: Es geht um einen Ort der Freude und des Wohlbefindens, einen Ort, der anscheinend überall in Amerika zu finden ist, ein uniformer Ort einer amerikanischen Kleinstadt, in dem sich der amerikanische Traum eines glücklichen Lebens mit Familie, Haus, Beruf, Auto und Fernsehen erfüllt. Aber der unmittelbare Beginn des Vorspanns zeigt verschiedene diffuse Farben, dann Stimmen aus dem Radio, Fernsehbilder und schließlich die Ankündigung der TV-Show „Pleasantville-Marathon", eine Zusammenfassung der schönsten Episoden aus dieser Fernsehserie der 50er-Jahre. Die ersten Bilder des Films spielen also in der Jetztzeit und natürlich in Farbe, aber auch mit allen Facetten dieser Farben: die Kleinstadt, die Schule, das Werben der Jugendlichen untereinander, die düsteren Zukunftsaussichten, der fehlende Vater und die frustrierte Mutter der beiden Geschwister David und Jennifer. David liegt auf der Couch und schaut eine Episode von „Pleasantville" an. Er zeigt sich als absoluter Kenner der Serie, denn er kann jeden Satz der Protagonisten auswendig voraussagen. Man versteht aber sofort, dass „Pleasantville" für ihn ein Fluchtpunkt aus einer versagenden, realen Welt ist, so wie es die Medien, nicht nur für viele Adoleszente, sind. Es handelt sich gleich zu Beginn also um die Kontrastierung zweier Welten, nämlich der realen Welt in Farbe (geprägt von Sehnsucht, Wünschen, Ängsten und Frustrationen und der Unvorhersehbarkeit der Ereignisse) und einer fiktiven Fernsehwelt in Schwarz-Weiß (geprägt von immer strahlenden, glücklichen Menschen mit der Vorhersehbarkeit und Wiederholbarkeit der kommenden, monotonen Ereignisse, einer Welt, die auf einem festen, unverrückbaren Drehbuch beruht). Durch einen Streit der beiden Geschwister (auch Konflikte gehören in diese reale Welt) und das Auftauchen eines geheimnisvollen Fernsehtechnikers gelangen David und Jennifer auf gleichsam märchenhafte Weise in diese fiktive Welt von „Pleasantville": Sie sind durch diese Transformation zu Charakteren der Serie geworden, die jetzt Bud und Mary Sue genannt werden und dort ihre Rollen nach dem vorgegebenen Drehbuch zu spielen haben – was Bud nicht schwer fällt, weil er die Serie in- und auswendig kennt, aber Mary Sue in erhebliche Probleme stürzen wird.

Wie wird die Welt von „Pleasantville" in diesen ersten Einstellungen präsentiert? Das oberste Ziel scheint, wie auch in der realen Welt, das Glück der Menschen zu sein; sie scheinen aber diesen glücklichen Zustand erreicht zu haben, weil sie in einer Welt leben, die durch ein festes Drehbuch absolut vorhersehbar und dadurch zeitlos ist, klare Grenzen kennt – Mary Sues Frage nach der Umgebung von „Pleasantville" löst entsetzte Blicke in der Schulklasse aus –, feste Rollenzuschreibungen hat, die Körperlichkeit ausgrenzt (getrennte Ehebetten als Ausdruck für „safer sex" sowie fehlende Toiletten) und Versagungen, Enttäuschungen und Niederlagen eliminiert hat. Alles dies ist durch die monotone Schwarz-Weiß-Farbe repräsentiert – man könnte auch von einer Monochromie sprechen, die eben auch nur einen Einheitsaffekt kennt, nämlich das uniforme, allgegenwärtige Lächeln und Lachen als Ausdruck eines umfassenden Wohlbefindens, das sich jedoch als Oberfläche, Fassade oder sogar Lüge erweist, nicht zuletzt, weil damit das Leben auch farblos ist. Alles ist festgelegt und perfekt – und damit aber auch gleichzeitig unlebendig, was aber den Figuren und Rollenträgern selbst nicht bewusst ist. Sie haben keine wirkliche Individualität und sind im Grunde personale Attrappen. Diese Schilderung könnte man durchaus als kritischen Impuls gegenüber der amerikanischen Kultur, und vor allem der Fernsehkultur gegenüber, begreifen, eine Erinnerung an die scheinbar „glücklichen" 50er-Jahre, die den amerikanischen Traum besonders eindrücklich verkörperten, bevor die sexuelle Revolution vieles zum Einsturz brachte. Aber es könnte auch als Parodie auf die moderne mediale Kultur überhaupt angesehen werden, in der der Kitsch und die Klischees ein groteskes und verzerrtes Abbild der wirklichen Welt zeichnen; ein Bild aber, das so verführerisch damals wie heute war und ist, weil es diese so schwer erträgliche Wirklichkeit überhaupt tolerabel macht: „Pleasantville" als ewiger Fluchtpunkt vor der Unerträglichkeit des Daseins.

Der erste Riss in diesem perfekten System entsteht, als Skip Bud nach seiner Schwester fragt und der plötzlich nicht mehr genau weiß, in welcher Episode der Serie er sich gerade befindet; als er Skip rät, Mary Sue vielleicht nicht nach einer Verabredung zu fragen, scheint für Skip eine Welt zusammenzubrechen. Als er einen Ball auf den Korb wirft, trifft dieser das erste Mal überhaupt nicht den Korb – alle Mitspieler weichen vor dem wegrollenden Ball entsetzt zurück. „Veränderung" als Abweichung vom Drehbuch, als Ausdruck des Zusammenbruchs von Vorhersehbarkeit, ist in dieser Welt eine angsterregende Vorstellung: Kommt es zu Veränderung, dann bricht diese Welt der Perfektion, der Vorhersehbarkeit und der Normierung zusammen. Dies ist im Film dermaßen übertrieben dargestellt, dass man als Zuschauer immer wieder lachen muss – aber wohl auch über sich selbst, weil man selbst diese Wunschvorstellungen, diese Sehnsucht nach einem „Pleasantville" selbstverständlich kennt. Und man meint auch zu verstehen, woher die Lust auf und die Sucht nach den Bildern der Filme, des Fernsehens, des Computers rührt, wenn sie genau diese Illusion der Perfektion und der Vorhersehbarkeit und der Wunscherfüllung mobilisieren. Psychoanalytisch formuliert könnte man auch von einer narzisstischen Welt sprechen.

Die Farbe erobert das „Filmleben": La vie en rose?

Wann taucht das erste Farbmuster in dieser scheinbar heilen und glücklichen Schwarz-Weiß-Welt auf? Mary Sue hat sich von Skip einladen lassen und schreitet sofort zur Sache: In Lovers Lane verführt sie den Jungen und stürzt ihn damit in eine heilsame Krise: Als er seine Erregung spürt, glaubt er an eine plötzliche Krankheit und ist zwischen Lust und Entsetzen hin- und hergerissen. Als er mit seligem Lächeln in seinem schnittigen Sportwagen nach Hause fährt und versonnen in den Garten des Nachbars schaut, sieht er zum ersten Mal eine einzige rote Rose – als Ausdruck seiner erwachten männlichen Erotik. Es sind also die Triebe, die dem Leben erst ihre Farbe verleihen; ohne diese ist die Welt vielleicht perfekt, aber gleichzeitig auch trist und tot. Das narzisstische Universum wird also durch das affektive Triebleben aufgebrochen. Dies erscheint wie ein Plädoyer für die psychoanalytische Grundannahme, dass das Triebleben den Kern des menschlichen Lebens bestimmt, im Grunde alle Lebensbereiche durchdringt und damit auch für die „Farbigkeit" der lebendigen Wirklichkeit sorgt. Aber diese trieb-

Abb. 2 Mary Sue (Reese Witherspoon) in ihrem roten Pullover zieht die Blicke der Männer auf sich. (Quelle: Cinetext Bildarchiv)

haften Gefühle sind eben nicht kontrollierbar, perfektionierbar, herstellbar, nach Drehbuch abrufbar, sondern sie gehorchen ihren eigenen Gesetzen der Psyche und des Körpers. Sie bedingen vor allem die unvermeidliche Konflikthaftigkeit menschlichen Lebens; gerade dies belegt einmal mehr die Auffassung Freuds, dass das Ich nicht Herr im eigenen Hause ist. Oder in einem anderen Bild (Norretranders, zit. nach Danckwardt 2006, S. 166):

Der Mensch treibt auf einem kleinen Boot namens ‚Ich‘ auf dem unermesslichen Ozean des Unbewussten.

Der Zusammenbruch des narzisstischen Universums von „Pleasantville" führt direkt zu dieser Erkenntnis und damit dem Anerkennen des Unbewussten als triebhaft-affektiver Dimension des Menschen. Genau diese Erfahrung steht den Einwohnern von „Pleasantville" gerade bevor. Dies zeigt sich besonders deutlich in der Sequenz, als Bud versucht, die Verabredung von Mary Sue mit Skip zu verhindern; er ruft ihr noch nach: „Er ist kein wirklicher Mensch!" Eben: Alle Einwohner von „Pleasantville" sind ja nur Figuren in einem Fernsehstück, Vorstellungen von Menschen, aber keine lebendigen Menschen aus Fleisch und Blut. Lebendiges Erleben im Sinne einer lebendigen Wirklichkeit beginnt eben erst dann, wenn die Imagination und die „wirkliche" Wirklichkeit in Gestalt von realen Menschen zusammentreffen. Insofern sind die Figuren in „Pleasantville" auch Gefangene in einer nur imaginierten, narzisstischen Welt, die durch die beiden eingeschleusten realen Menschen befreit werden könnten. Dies berührt die von mir schon eingangs erwähnte Überlegung, dass die Filmfiguren, wie andere Kunstfiguren auch, aus ihrer „Schwarz-Weiß-Welt" – man denke auch an die gedruckten Romane – durch den Leser und Zuschauer befreit werden müssen, indem sie in ihrer rein imaginativen Rolle durch die sinnliche Lebendigkeit des Zuschauers oder Lesers berührt werden. Aber dies gelingt nur, wenn der Zuschauer oder Leser selbst die Figuren mit seiner eigenen Sinnlichkeit, Fantasie und Erotik besetzt, ja, verführt,

und sie damit zum Leben erweckt – und aus ihrer monochromen Eintönigkeit erlöst. Genau dies ist für mich ein zentraler Aspekt des Films, nämlich die gegenseitige Verlebendigung der Protagonisten des Films und der Zuschauer, die in der „Farbigkeit" der Bilder symbolisiert ist.

„Farbiger" Einzug von Lust und Leid

Folgt man nun dem weiteren Verlauf der Films und achtet auf das weitere Auftauchen der Farbe, dann kann man festhalten: Die Farbe „rot" dominiert eindeutig – das rote Kaugummi, das rote Rücklicht der Autos in Lovers Lane, die rote Zunge der jungen Frau mit ihrer besorgten Mutter beim Arzt, die rote Kirsche von Mary-Sue, die roten Karten beim Bridge, die roten Blumen an der Decke über der Badewanne, in der Betty die Masturbation entdeckt, das rote Gesicht des Jungen in der Eisdiele (◧ Abb. 2). Allerdings tauchen auch andere Farben auf: das grüne Auto, ein gelber Kamm, eine bunte Juke-Box, das gelbe Feuer, die gelbe Uhr, die braunen Kaffeetassen.

Es handelt sich also nicht nur um belebte, sondern auch um unbelebte Dinge und Objekte, die langsam eine Farbe bekommen. Dies erinnert an die Traumtheorie von Moser und v. Zeppelin, die beschreiben, wie in den Objekten des Traums Affekte gespeichert sind, also latent vorhanden und möglicherweise auch mobilisierbar sind (Moser u. v. Zeppelin 1996). Die belebten und unbelebten Objekte werden also langsam libidinös-affektiv besetzt, was mit der sukzessiven Kolorierung filmisch dargestellt wird. Der erste Höhepunkt dieser Libidinisierung der fiktiven Welt ist die Entdeckung der Masturbation von Betty, die fast die ganze Welt zum Beben, in jedem Fall den Baum vor dem Haus zum Brennen bringt: Das Feuer ist damit in die Welt von „Pleasantville" eingeführt, ein Phänomen, das selbst der Feuerwehr bislang unbekannt war. Damit ist aber auch die unschuldige und heile Welt nicht mehr zu halten, und das „Feuer" der Libidinisierung breitet sich nach und nach aus: Selbst die Bücher sind keine Attrappen mehr, sondern beleben sich beim Lesen, indem die Buchstaben vor den lesenden Augen entstehen und die Bilder farbig werden. Bei der Kolorierung scheint es sich also um eine affektiv-libidinöse Besetzung des eigenen Körpers, der anderen Menschen, aber auch der ganzen übrigen Welt zu handeln: Dazu zählen eben auch die Bücher, die durch diese Besetzung zu „leben" beginnen, aber auch die Bilder des Kunstbuches, das Bud seinem Freund Bill in dem Eisladen zeigt. Hier könnte man eine Anspielung auf die Entstehung von echter Kunst sehen, indem nämlich die Objekte libidinös-affektiv – im Film durch die Farbigkeit dargestellt – besetzt werden. Es ist aber auch die libidinös-affektive Besetzung der intellektuellen Welt, denn Mary Sue interessiert sich plötzlich nicht mehr nur für Jungen und den Sex mit ihnen, sondern entdeckt plötzlich ihre Leidenschaft für die Literatur und die Wissenschaft. Sie hatte Bud gefragt, warum sie denn immer noch in Schwarz-Weiß sei, wo sie doch doppelt so viel Sex gehabt habe wie alle anderen; „Ja", sagt Bud, „vielleicht ist es nicht nur der Sex." Ja, es handelt sich eben um die ganze unbewusste Affektivität, die mit dem Aufbrechen des narzisstischen Universums von „Pleasantville" geweckt wird – der riesige Ozean des affektiven Unbewussten. Aber es wird auch die Angst und die Abwehr gegenüber dieser unbewussten Affektivität gezeigt: Betty hatte in der Küche gestanden und war ganz entsetzt über ihr farbiges, rosa blühendes Gesicht, mit dem sie unmöglich ihrem Mann unter die Augen treten könnte. Bud schminkt ihr die Farbe weg, damit sie wieder unter die Leute gehen kann (◧ Abb. 3). So also entsteht das „falsche Selbst" der Leute von „Pleasantville", indem sie ihre wirklichen libidinös-affektiven Besetzungen verbergen, übertünchen, also abwehren, um so eine Konformität zu erreichen, die sie in scheinbarer Harmonie mit ihren Mitmenschen leben lässt. Als sie sich Bill nähert und seine neuen Malversuche bewundert – unter anderem eine weinende Frau von Picasso – beginnt auch sie zu weinen, die Tränen lösen ihre Schminke auf und ihre „wahren" und „echten" Gefühle kommen zum Vorschein: ihre Verliebtheit in Bill. Es geht also nicht nur um die schönen Gefühle, nicht nur um Sex und Leidenschaft, sondern auch um die schmerzlichen, traurigen, sehnsuchtsvollen Gefühle, die zur „Farbe des Lebens" gehören. Genau dies versucht Bud seiner neuen Freundin zu erklären, mit der er verliebt nach „Lovers Lane" fährt – die Welt ist in wunderbares Rosa getaucht – und ihr auf die Frage, wie es draußen in der Welt sei, antwortet:

■ Abb. 3 Bud (Tobey Maguire) hilft Mutter Betty (Joan Allen), ihre neue Farbigkeit zu verbergen. (Quelle: Cinetext Bildarchiv)

💬 Bud: „Es ist lauter, man hat mehr Angst und es ist viel gefährlicher."
Seine Freundin: „Das klingt fantastisch!"

Während also die fiktive Welt von „Pleasantville" eine Welt des Entweder-oder ist, in dem der eine Pol möglichst erfolgreich eliminiert wird – und wodurch eine traurige „happiness" entsteht – ist die lebendige Wirklichkeit eine Welt des Sowohl-als-auch, eine Welt der Freude, der Lust, der Neugierde auf das Unbekannte, der Angst, des Leides, der Trauer und noch vieles mehr.

Natürlich könnte man den Film auch als eine Anspielung auf die prüden 50er-Jahre sehen, die dann durch die farbigen 60- und 70er-Jahre mit der sexuellen Liberalisierung abgelöst wurden. Eine andere Anspielung findet sich in der Liebesbegegnung zwischen Bud und seiner neuen Freundin, als sie in Lovers Lane einen roten Apfel vom Baum pflückt, als seien beide Adam und Eva, die aus dem scheinbaren Paradies in die wirkliche Welt befreit werden. Mir scheint jedoch gerade in dieser Passage der Gedanke wesentlicher, dass es auch um die Wechselbeziehung zwischen dem Zuschauer (oder Leser oder Betrachter eines Bildes) und den Protagonisten des Films (oder des Buches oder des Gemäldes) geht: Damit ein Film, ein Buch, ein Bild für den Betrachter oder Leser lebendig wird, muss er dieses libidinös-affektiv besetzen, er muss sich ein Stück in sie hineinversetzen, in ihre Welt einsteigen und sie mit seiner lebendigen Welt aus ihrer „Schwarz-Weiß-Welt" befreien, was aber auch gleichzeitig bedeutet, dass diese Figuren oder Protagonisten den Zuschauer, Betrachter und Leser wiederum aus ihrer geschminkten „Schwarz-Weiß-Welt" befreien können. Es ist wie ein wechselseitiger, sich befruchtender, ja, ein infizierender Prozess, der im Wesentlichen durch die Aktivierung der affektiven Resonanz bewirkt wird.

Je länger der Film nun andauert, um so mehr wird das Drehbuch von „Pleasantville" außer Kraft gesetzt: In dem einsetzenden Regen scheint dieser Aspekt zu kulminieren. Georg kommt wie immer nach Hause, aber Betty ist da und hat auch nicht für ihn gekocht. Damit bricht seine infantil-narzissti-

sche Welt der Wunscherfüllung zusammen; er schreit nur noch wie ein kleines Kind in die Dunkelheit des Regens hinaus: „Wo ist mein Essen?" Während die Männer noch an ihrem Drehbuch festzuhalten versuchen, sind einige der Einwohner von „Pleasantville" bereits aus ihrer „Schwarz-Weiß-Welt" ausgebrochen: Bill ist „farbig" wie seine ganze Eisdiele und auch Mary Sue ist endlich in Farbe, obwohl sie sich doch so vehement gegen die Welt der „Bekloppten" gewehrt hat. Der Ausstieg aus dem Drehbuch bedeutet einen Schritt der Individuierung und der Befreiung aus einer Welt der Rollenklischees und sozialen Erwartungen, den Mary Sue auf ihre Weise, ihre „Mutter" Betty auf andere Weise geht: Sie gehorcht nicht mehr ihrem Mann, fällt aus der Rolle und erscheint mit einem kleinen Köfferchen bei ihrem Geliebten Bill.

 George: „Nimm doch etwas Make-up, um das farbige Gesicht loszuwerden."
Betty: „Das will ich aber nicht, dass die Farbe weggeht."

Hier an dieser Stelle spricht sie etwas aus, was eine zentrale unbewusste Bedeutung der Farbe in diesem Film zu sein scheint: Die Farbe steht für die Liebe zum Leben – mit Erich Fromm könnte man von Biophilie sprechen –, während das Schwarz-Weiß für die Negation dieser Liebe steht, vielleicht sogar für den Tod oder die Nekrophilie – oder eben für den ewigen Gegensatz von Eros und Thanatos. So gesehen wäre die Schwarz-Weiß-Welt von „Pleasantville" eine verkappte nekrophile Welt, aus der die „nicht lebenden Menschen" durch die affektiv-libidinöse Besetzung, wofür die Kolorierung steht, befreit werden müssen. Das Drehbuch des lebendigen, farbigen Lebens kann also nicht aus Regeln und Vorschriften bestehen, sondern muss die Vielfalt und die Unvorhersehbarkeit integrieren; wenn man sich mit den vorgeschriebenen Rollen, dem Skript identifiziert, dann lebt man letztlich in einer toten Scheinwelt. Die Welt da draußen ist dadurch allerdings gefährlich, aber auch faszinierend, eben lebendig. Die Protagonisten sagen am Ende: „Ich habe keine Ahnung!", (nämlich, was als Nächstes passiert, und wie die Dreieckssituation zwischen Betty, Jim und George ausgehen wird). Und genau darin besteht ja die Farbigkeit und Lebendigkeit des Lebens, dass es in Wirklichkeit kein Drehbuch gibt, das von Gott, den Eltern, der Gesellschaft für einen selbst geschrieben wird, sondern dass Individuierung gerade darin besteht, sein eigenes Drehbuch des Lebens zu entwerfen.

Diese Überlegungen müssen hier aus Raumgründen abgebrochen werden. Zum Schluss möchte ich noch einmal den mir besonders wichtigen Aspekt der Entdeckung der zentralen Deutungsfantasie des Zuschauers hervorheben: Der Filmpsychoanalytiker interpretiert dabei den Film mit seinen Grundannahmen, die auch die Theorie und Technik der Psychoanalyse spiegeln, lässt sich aber gleichzeitig von dem Film zeigen, welche Probleme und Antworten dieser für ihn bereit hält. Es ist dabei völlig klar, dass man jeden Film – und natürlich auch *Pleasantville* – aus ganz verschiedenen Perspektiven verstehen kann: Die Deutung reflektiert immer auch die Subjektivität des Betrachters. In diesem Sinne sagt mir der Film etwas über meine Funktion als Filmpsychoanalytiker, in der ich mich mit Filmen auf eine psychoanalytische Weise auseinandersetze und meine Hauptaufgabe darin sehe, den Film für mich und damit auch für andere „lebendig" werden zu lassen und ihn nicht durch einen „Schwarz-Weiß-Text" abzutöten. Dazu muss ich mich als Zuschauer in die Welt des Films hineinbegeben, mich förmlich aufsaugen oder inkorporieren lassen, die fiktiven Protagonisten durch meine eigene Lebendigkeit, meine affektiv-libidinöse Besetzung aus ihrer Rollenfixiertheit, aus ihrem starren Drehbuch befreien, ja, vielleicht sogar den Autor des Films, der ja der Schöpfer des Drehbuchs ist, absetzen – vergleichbar dem Aufstand von Truman gegen seinen Schöpfer in dem Film „Truman-Show" – und meine eigene innere Welt in diese fiktive Welt projizieren, übertragen. Man könnte vielleicht sogar sagen: Das Drehbuch des Filmkünstlers und mein eigenes Drehbuch stehen sich dann gegenüber, können aber in einen emotionalen Dialog treten. Dann erwachen die Protagonisten zu ihrem eigenen Leben und treten mit mir als Zuschauer in einen ebenfalls lebendigen Kontakt, wodurch ich selbst die eigenen affektiv-libidinösen Quellen meines Daseins erfahre. Aus dieser Sicht ist es die Aufgabe des Filmpsychoanalytikers, diesen

Prozess des intersubjektiven Dialogs zu fördern – für die Leser von Texten, für die Zuschauer in öffentlichen Kinoveranstaltungen, für die Filmanalyse insgesamt. Dann komme ich auch wieder aus der fiktiven Welt heraus – wie Bud es ja auch tut –, aber ich habe eine veränderte Sicht auf meine Welt und mein Selbst durch den Kontakt mit der fiktiven Welt der vielen medialen „Pleasantvilles", mit denen wir heute alle konfrontiert sind. Gleichzeitig scheint aber auch klar zu sein, dass dieser intersubjektive Dialog umso besser funktioniert, als die fiktiven Personen bereits vom Künstler affektiv-libidinös besetzt sind und auf diese Weise ein Stück der wirklichen Welt verkörpern. Und gerade hier könnte sich der Unterschied von Kunst und Kitsch zeigen.

Ein letzter Aspekt soll nicht unerwähnt bleiben: so wie der Film *Pleasantville* mich persönlich an meine Erfahrungen in den 50er-Jahren in USA erinnert hat und manche Erinnerung dadurch wieder lebendig wurde, so kann man den Film auch als eine Visualisierung der „Erinnerungsarbeit" verstehen, die gerade darin besteht, die „Schwarz-Weiß-Bilder" der Vergangenheit libidinös-affektiv zu besetzen, um so die eigene Geschichte mit „lebendigen Erinnerungen" zu rekonstruieren (Zwiebel 2006). Dies wird in dem Film darin ausgedrückt, dass David zwar ein Kenner der Serie „Pleasantville" ist, aber die Serie aus einer distanzierten Sicht auf seinem Sofa vor dem Fernseher betrachtet, ohne eine wirkliche Verbindung zu seinem eigenen, realen Leben aufzunehmen. Mit dem affektiv-libidinösen Eintritt in die Welt von „Pleasantville" beginnt er als Repräsentant der amerikanischen Jugend der Jetztzeit, sich an eine Periode der amerikanischen Geschichte, nämlich der 50er-Jahre, auf eine Weise zu erinnern, die diese Vergangenheit lebendig werden lässt. Und dies führt zum Anfang meiner Überlegungen zurück, als es um den Traum und die Traumerinnerung ging: Eine lebendige ästhetische Erfahrung erfordert eine „lebendige Erinnerung" an den Film, das Buch, das Bild, die im Kern als eine affektive Besetzung des Vergangenen betrachtet werden kann. So wird eine komplexe Wechselbeziehung zwischen Vergangenheit und Gegenwart angedeutet, die in dem Bild der Kolorierung ihren Ausdruck findet: Die Lebendigkeit der Gegenwart entsteht auch durch die affektive Besetzung mit Vergangenem, ebenso wie die „lebendige Erinnerung" durch die affektive Besetzung durch Gegenwärtiges realisiert wird.

Literatur

Danckwardt JF (2006) Farben im Traum. Forum Psychoanal 22: 165–181

Freud S (1914) Der Moses des Michelangelo. GW X. S 172–201

Götzmann L (2011) „The Sounds of Silence" – O in der Malerei. Psyche – Z Psychoanal 65: 1139–1155

Moser U, Zeppelin I von (1996) Der geträumte Traum. Kohlhammer, München

Zwiebel R (2006) Zur Dynamik der „lebendigen Erinnerung" in der analytischen Situation. Psyche – Z Psychoanal 59 (Beiheft): 78–90

Originaltitel	Pleasantville – Zu schön, um wahr zu sein
Erscheinungsjahr	1998
Land	USA
Buch	Gary Ross
Regie	Gary Ross
Hauptdarsteller	Tobey Maguire (David/Bud), Reese Witherspoon (Jennifer/Mary Sue), Jeff Daniels (Bill Johnson), William H. Macy (George Parker), Joan Allen (Betty Parker)
Verfügbarkeit	Als DVD in OV und deutscher Sprache erhältlich

Oliver Decker

eXistenZ und transCendenZ: Kommodifizierung des Körpers

eXistenZ – Regie: David Cronenberg

JENNIFER JASON LEIGH JUDE LAW

IN WIRKLICHKEIT

IST DIE WIRKLICHKEIT

NICHT WIRKLICHKEIT

eXistenZ
DU BIST DAS SPIEL

WWW.eXISTENZ-FILM.DE

Filmplakat *eXistenZ*
Quelle: Cinetext Bildarchiv

eXistenZ

Regie: David Cronenberg

Hintergrund

Xenotransplantation, das ist jene Behandlung des terminalen Organversagens, die auf der Nachzucht von Organen in genetisch manipulierten Tieren basiert. Im genetisch veränderten Schwein herangewachsen, soll etwa eine Niere die Artengrenzen überspringen und, auf den Empfänger übertragen, die Aufgabe des erkrankten Organs ersetzen. Die Forscher kündigen an, die Xenotransplantation stehe kurz vor dem Durchbruch. Da steht sie allerdings schon seit 20 Jahren. Nur sollte dieser Befund die Skeptiker weniger beruhigen als warnen: Die Dauer des Versprechens zeigt den Bedarf an. Warum sonst sollte diese Forschung auch bezahlt werden? Genauso, wie seit einigen Jahren immer mehr Anstrengungen – und das heißt auch: steigende finanzielle Mittel – in die regenerative Medizin fließen. Hier wächst die Hoffnung in der Petrischale, das „Tissue Engineering" verspricht nachgewachsene Organe aus dem Bioreaktor – dank manipulierter Zellen sollen in einer Nährlösung auch HLA-identische Herzen gedeihen. Sie würden vom körpereigenen Immunsystem der Organempfänger nicht mehr als fremd erkannt. Ein alter Menschheitstraum würde wahr, soviel stellt die Medizin in Aussicht. Und gleichzeitig wird ein Wachstumsmarkt angestoßen, denn wer über die Patente an den Zellen und den Verfahren zu ihrer gezielten Vermehrung verfügt, der hat ein heiß ersehntes Produkt im Angebot. Was passiert hier? Diese Frage zu beantworten ist nicht ganz so einfach, und vielleicht hilft es, die Antwort an einem ganz anderen Ort zu suchen. Bei einem Kino-Film, der den Einsatz von genetisch manipuliertem Gewebe am menschlichen Körper zum Thema hat.

Die folgende Filmbetrachtung behandelt einige Aspekte des Films *eXistenZ* von David Cronenberg (◨Abb. 1). 1999 erstmals in den Kinosälen gezeigt, werden in dem Film „Körpererweiterungen" zum Thema. Diese Erweiterungen sind das Ergebnis einer genetischen Manipulation an Tieren, welche dann zur Simulation einer virtuellen Realität am Körper zum Einsatz kommen. *eXistenZ* ist bereits Thema verschiedener Deutungen geworden, seine Interpretation scheint „auserzählt". Dass es so noch nicht ist, spricht für den Film. Und dafür, dass das im Film behandelte Thema über die Gegenwart seiner Produktion hinausweist. Die Verschmelzung von Mensch und Maschine, die Bearbeitung der Natur und ihre Kommodifizierung, werden in diesem Film behandelt. In *eXistenZ* wird in einem wie Träume anmutenden Surrealismus das Überspringen der bisher nur von Außen angelegten Prothesen in das Körperinnere gezeigt. Es kommt zu einer Verschmelzung der Prothesen mit dem Organischen.

Handlung

Die Anfangsszene

Der Beginn des Films *eXistenZ* führt in einen schlichten Saal mit einer Versammlung von Menschen unterschiedlichen Alters. Die fast karge und etwas verstaubte Ausstattung des Saals lässt auf den ersten Blick keine Rückschlüsse auf seine Funktion oder den Anlass der Versammlung zu. Es ist eine unruhige Szenerie, obwohl die meisten Anwesenden bereits in hintereinander angeordneten, fast raumtiefen Bänken Platz genommen haben. Eine spannungsvolle Erwartung zeigt sich in den Gesichtern der Versammelten. Die erkennbare Vorfreude richtet sich auf einen Redner und Seminarleiter (Christopher Eccleston), welcher, auf einer Empore an der Schmalseite des Raums stehend, mit anpreisenden Worten eine Neuigkeit vorstellt. Dieses Novum ist der Anlass für die Zusammenkunft an diesem Abend. Bei den Anwesenden handelt es sich um die Fan-Gemeinde eines Computerspiels, bei dem Redner um den

Vertreter einer Softwarefirma namens „Antenna Research", der ihnen die neueste Generation dieses Computerspiels ankündigt. Es ist ein exklusiver Kreis Erwählter, welcher der ersten Präsentation des Spiels beiwohnen darf.

Und noch etwas offenbart sich: Der karge Saal ist ein Kirchen- oder Gemeinderaum. Ein Ort für Zusammenkünfte von Gläubigen, der aber seines Schmucks beraubt ist. Keine Verzierung, kein Heiligtum deutet noch auf seine vergangene sakrale Nutzung hin. Nicht nur fehlt die Verzierung. Der Raum ist auch herunter gekommen, verwahrlost. Epiphanie, so scheint es, ist hier nicht mehr erfahrbar und wohl auch schon lange nicht mehr gesucht worden. Lediglich durch jene profanen Gegenstände, die trotzdem vornehmlich in Kirchenräumen oder Gemeindesälen anzutreffen sind, wird erkennbar, welche Bestimmung der Erbauer dem Gebäude zugedacht hatte: Die langen Sitzreihen, die den Anwesenden Spielern Platz bieten, sind Kirchenbänke. Der Erker, von dem aus den Zuhörern im Gemeindesaal das Ungeheure, noch nie Dagewesene angepriesen wird, ist der Chor.

Die Kamera hebt zwei Menschen aus der Menge hervor: Eine junge Frau (Jennifer Jason Leigh) steht an einem improvisierten Getränketisch. Und ein junger Mann (Jude Law) sitzt tatenlos am Eingang, hatte dort wohl Einlasskontrollen durchgeführt und beobachtet nun heiter das Geschehen im Saal.

Die Zusammenkunft läuft auf ihren ersten Höhepunkt zu, als der Redner der Gemeinde die Anwesenheit der Spieldesignerin Allegra Geller verkündet. Die junge Frau vom Getränketisch betritt zwar mit einem verlegenen Lächeln die Bühne, aber ihre Reaktion kündet von einem professionellen Habitus. Der zweite Höhepunkt des Abends wird den Versammelten in Aussicht gestellt: Zwölf Mitglieder der Gemeinde werden ausgewählt. Sie haben das Privileg, als erste die Exkursion in die nicht-materielle Realität des Spiels zu unternehmen, zusammen mit der Designerin.

Während der Firmensprecher die Teilnehmer auswählt, betritt ein verspäteter Besucher, Noel Dichter (Kris Lemchen), den Gemeindesaal. Er wird vom jungen Mann an der Tür aufgehalten, um ihn mit einem Metalldetektor abzusuchen. Nun erfahren wir auch den Namen von Ted Pikul, dem Kontrolleur am Eingang. In der Tasche des späten Besuchers kommt ein für den Filmzuschauer zunächst undefiniertes Objekt zum Vorschein. Es ähnelt einem fleischlichen Kissen und wird von seinem Besitzer fast nervös als Gamepod einer älteren Generation beschrieben. In Zwischenschnitten sehen wir, wie Allegra ein langes, ebenfalls fleischliches, an eine Nabelschnur erinnerndes Kabel entrollt. Und während sich der späte Besucher auf einem jener Plätze in der ersten Reihe einfindet, kann er die sich entwickelte Szenerie auf dem erhabenen Chor beobachten. Die zwölf Erwählten haben zwischenzeitlich in einem Halbkreis Platz genommen. In ihrem Zentrum sitzt Allegra Geller, zwischen ihnen verlaufen die nabelschnurähnlichen Verbindungen, die die Teilnehmer miteinander und mit jenen Gamepods zu verbinden scheinen, wie er in der Tasche des späten Besuchers zu sehen war. Es handelt sich offensichtlich um Spielkonsolen, mit einem wichtigen Unterscheid: Sie sind aus organischem Material und, wie die Stimme des Seminarleiters aus dem Off heraus verkündet, ebenfalls Ergebnisse der Antenna Research. Mit dem Blick der Kamera rückt das Gamepod von Allegra Geller fast in die Totale. Der Zuschauer kann es näher betrachten, und, wenn die Kreateurin des Spiels ihren Pod an einer nippelähnlichen Erhebung berührt, reagiert es mit organischen Bewegungen und Geräuschen. Sie scheint dabei wie in Trance versunken, den amorphen, nun zum Leben erwachten Pod auf ihrem Schoß.

Während dessen öffnet Dichter seinen Pod. Sichtbar wird ein schleimig-feuchtes Innenleben – und ein undefinierbares Objekt. Auch wenn es selbst organisch wirkt, Dichter hält und bedient es wie eine Pistole. Mit der Waffe in der Hand steht er auf und zielt er auf Allegra Geller. Bevor er den ersten Schuss abgibt, ruft er laut seine Parole aus: „Tod der Dämonin Allegra Geller".

Allegra Geller wird unterhalb der rechten Schulter von dem Geschoß getroffen und fällt mit ihrem Stuhl hintenüber, wo sie bewusstlos liegen bleibt. Der Seminarleiter wird beim Versuch, den Attentäter zu entwaffnen, von einem Schuss schwer getroffen. Während zwei weitere Mitarbeiter den Attentäter mit herkömmlichen Schusswaffen regelrecht exekutieren, erhält Ted Pikul die Anweisung, Allegra

Geller in Sicherheit zu bringen. Niemandem sei zu trauen, das gibt der Seminarleiter von Antenna Research dem Flüchtenden noch mit auf den Weg. Im Tumult des Geschehens sammelt Ted die am Boden liegende Waffe des Attentäters ein und verlässt mit der benommenen Allegra Geller den Raum. Während der Flucht kann nun auch von außen das Gebäude betrachtet werden: Es ist eine Kirche.

Auf der Flucht

Es beginnt ein zweiter Abschnitt des Films. Ted Pikol und Allegra Geller sind in einem Auto auf der Flucht. Teds Versuch, auf seinem Telefon einen Anruf entgegen zu nehmen, wird von Allegra vereitelt. Sie wirft sein Telefon aus dem Wagenfenster. Wie das Gamepod ist das Telefon aus organischem Material, aber gewissermaßen noch mit „analoger Schnittstelle" versehen: Ted führt es sich ans Ohr. Offensichtlich schätzt Allegra ihre Bedrohung als sehr groß ein, und sie möchte verhindern, geortet zu werden. Wer ihre Feinde sind – das ist ihr selbst wie dem Zuschauer unbekannt. Nun geht es darum, sich selbst zu helfen, und Ted übernimmt die Erste Hilfe: Er operiert Allegra das Geschoss aus der Schulter. Mit der Frage „Hat Dich jemand gebissen?" präsentiert er Allegra das vermeintliche Projektil. Und dieser in Frageform vorgebrachte Kommentar illustriert den Fund treffend. Ted hat seiner neuen Weggefährtin einen menschlichen Zahn aus der Schulter gezogen. Bei näherer Augenscheinnahme offenbart sich auch die Waffe als eine Konstruktion aus Knochen. Wohl um die Einlasskontrolle zu umgehen, hat der Attentäter keine Waffe aus Metall, sondern eine aus organischem Material bei sich geführt.

Allegra hat aber keine Muße, sich dem eigentümlichen Objekt zu widmen. Eine andere Folge des Attentats beschäftigt sie viel mehr: der Zustand ihres Gamepods. Durch das abrupte Ende des Spiels hat ihr „Baby" Schaden genommen, und damit ist auch das auf dem Pod gespeicherte Spiel möglicherweise beschädigt. Sichere Antwort ist aber nur zu erlangen, wenn sie das Spiel mit einem „Freund" startet. Ted aber – und diese Nachricht findet bei ihr ein belustigtes und befremdetes Echo – hat keinen Bioport. Dies ist jene Körperöffnung im Rücken, welche den Anschluss des Gamepods an den Spielerkörper gestattet.

„God, the Mechanic".

Nun ist das nächste Ziel der Flucht bekannt: Eine Werkstatt muss gefunden werden, die Ted illegal einen Bioport einpflanzt. Und „Werkstatt" ist hier wörtlich zu verstehen, denn sie treffen an einer solchen Gas, den Mechaniker (Willem Dafoe). Er betankt ihren Wagen, behauptet aber im Gespräch mit Allegra einen Moment lang, nicht zu wissen, was ein Bioport ist. Dann stutzt er, fingert nervös einen Zeitungsausschnitt mit dem Bild der vor ihm stehenden Allegra aus seiner Brieftasche und fällt auf die Knie. Nun ist das Eis gebrochen, und zum stillen Entsetzen von Ted erklärt sich Gas bereit, den Bioport anzulegen. Während Gas die Geräte für den Eingriff vorbereitet, erfahren wir mehr über die Spiele von Allegra Geller. Ihr Spiel „SeiGott" hat „sein Leben verändert", so Gas, er habe diese „erbärmliche Ebene der Realität" verlassen. Gas spricht wahrscheinlich für die ganze Fan-Gemeinde; er ist zwar weiterhin noch Mechaniker, aber nun ist er „God, the Mechanic".

Allegra wartet während dieses Gesprächs auf dem Vorplatz der Werkstatt, bei den Zapfsäulen. Sie erkundet die Struktur der Wand, die Kiesel auf dem Boden und den Geruch der Zapfsäulen und scheint fasziniert. Allegras Aufmerksamkeit richtet sich auf ein Reptil, welches die Zapfsäule erklimmt. Der surreale Eindruck wird nun zu einer manifesten Irritation: Das Reptil hat nur noch Anklänge an seine Artgenossen. Es verfügt über eine Statur wie ein kleiner Drachen mit filigranen Fächern am Schwanz. Aber Spannung löst beim Zuschauer etwas Anderes aus: Das Reptil hat zwei Köpfe auf zwei Hälsen. Diese beiden, aus dem gemeinsamen Rumpf gewachsenen, Augenpaare scheinen miteinander und mit Allegra zu kommunizieren. Allegra ist dabei alles andere als verwirrt. Sie streichelt jeweils Kopf und Kinn der kleinen Existenz und betrachtet es mit derselben belustigten Neugier wie zuvor die Tankstelle. Ted hat derweil der Mut verlassen, und er liefert sich mit Gas einen nahezu handgreiflichen Streit – er scheint bereit, die Unversehrtheit seines Körpers (oder zumindest, das ist auch Thema: die Fiktion

▣ **Abb. 2** Allegra (Jennifer Jason Leigh) und Ted (Jude Law) in einer Spielszene. (Quelle: Interfoto/NG Collection)

derselben) auch mit Gewalt zu verteidigen. Mit einem Kopfnicken schickt Allegra Gas vor die Tür, und wenig später ist Ted wieder überzeugt: Nun kann Gas operieren, und das macht er zwar mit martialischen Apparaturen, aber erfolgreich –, und Allegra beginnt nun gleich mit der Vorbereitung für das gemeinsame Spiel. Sie verbindet Ted mit ihrem Bioport und aktiviert es mit der gleichen, nun schon gewohnten, streichelnden Geste. Allerdings passiert etwas Unerwartetes: Der Gamepod bekommt einen Schock, das Spiel muss abgebrochen werden. Gas erscheint wieder, dieses Mal aber bewaffnet mit einem doppelläufigen Gewehr. Auf Allegra Gellers Leben und auf die Zerstörung ihres Spiels, das erfahren wir nun von Gas, ist eine Prämie ausgelobt: „5 Millionen und keine Fragen". Von wem, das weiß Gas auch nicht, aber es reicht ihm, um Allegra zu töten und ihr Spiel zu zerstören. Er hat Teds Bioport so manipuliert, dass er den Gamepod zerstören musste. Mit einem der martialischen Geräte, die Gas verwendete, um ihm den Bioport einzusetzen, erschießt Ted ihn von hinten.

„eXistenZ", das Spiel

Mit der nächsten Einstellung beginnt offensichtlich der nächste Tag, und die Protagonisten befinden sich an einem neuen Ort. Immer noch auf der Flucht befinden sie sich nun in einem Skigebiet. Obwohl kein Schnee liegt, hat Ted Sorge davor, entdeckt zu werden, wenn Menschen das Skigebiet aufsuchen. Er bemerkt das Reptil mit zwei Köpfen, welches der Zuschauer bereits vom Vortag kennt. Anscheinend ist es auch für Ted ungewohnt, nur Allegra nimmt es weiter als Selbstverständlichkeit: „Eine mutierte Amphibienart, ein Zeichen der Zeit."

Beim Betreten des Raums werden sie von einem älteren Mann begrüßt, der Allegra offensichtlich kennt. Kiri Vonkur (Ian Holm) weiß von der Flucht, der Gefahr, in der sich Allegra befindet, und nachdem sie ihm die Probleme geschildert hat – defekter Bioport und zerstörter Gamepod – bietet er beiden die notwendige Hilfe an. Sie können in einem der Chalets des Gebiets wohnen, und zusammen mit seinem Assistenten wird er sich des Bioports und des Gamepods annehmen. In dieser Szene erklärt

sich auch die Entstehung der Pods: Sie ist das Ergebnis von synthetisch erzeugter DNA, mit welcher der Laich von Amphibien angereichert wird: „Das hat nur Antenna Research". Und noch eine weitere Erläuterung der Technik erhält Ted: Der Gamepod bezieht seine Energie für das Spiel aus dem Nervensystem und aus dem Stoffwechsel des Spielers, der damit zum Wirtsorganismus der organischen Spielstation wird. So oder so: Pod und Port sind nun funktionstüchtig, Allegra und Ted können nun endlich in das Spiel „eXistenZ" einsteigen.

Das Spiel beginnt

Ted und Allegra befinden sich in einem Geschäft, von dem der Zuschauer zwar nur einen kleinen Ausschnitt sieht, aber in dem erkennbar mit Spielezubehör gehandelt wird. Ted wird auf eine verpackte Konsole im Miniaturformat aufmerksam. Dieser neue Pod ähnelt dem Gamepod, welchen Allegra bereits in Verwendung hat und der von Antenna Research hergestellt und vertrieben wird. Dieser hier angebotene stammt aber von der Firma „Cortical Systematics" und ist deutlich kleiner. Während Ted den Pod in der Verpackung in Augenschein nimmt, ist im Bildhintergrund zum zweiten Mal eine Werbung für ein chinesisches Lokal zu erkennen: „Will you make it out alive?"

Der Verkäufer und Ladeninhaber D'Arcy Nader (Robert A. Silverman) spricht die beiden an und empfiehlt ihnen die Konsole von Cortical Systematics. Er bietet den beiden an, „was sie suchen" und führt sie in einen hinteren Raum des Ladenlokals. Im Dialog mit der Spielfigur stellt Ted zweierlei fest. Erstens, dass er anders, aggressiver spricht, ohne es selbst zu wollen. Es ist seine „Figur" im Spiel, die spricht. Und zweitens, dass sich Situationen wiederholen, bis die Eigenlogik der Rolle, welche man im Spiel eingenommen hat, erfüllt ist. Erhält der Ladeninhaber die falsche Antwort oder tauschen sich Allegra und er über das Spiel aus, ist die Spielfigur des Ladeninhabers in einer „Spielschleife", er bewegt sich in einem Leerlauf und wartet auf seinen „Dialogsatz". Nachdem der Ladeninhaber die Funktion des kleineren Pods erklärt hat, setzen Ted und Allegra sich die Pods ein. Die Konsolen bleiben aber nicht wie die großen Gamepods von Antenna im Port stecken, sondern erhalten plötzlich ein Eigenleben und schlängeln sich in den Körper. So sind nun beide von einem Pod penetriert und warten auf die Fortsetzung des Spiels: Welche sich auch einstellt, indem beide lüstern über einander herfallen. Bevor sich jedoch der eigentliche Geschlechtsakt anbahnen kann, wechselt überraschend die Szenerie.

Wechsel der Spielebenen

Das Spiel wird auf einer neuen Ebene fortgesetzt. Der Zuschauer sieht nur noch Ted in einer fabrikähnlichen Halle. Vor ihm läuft ein Fließband mit toten Amphibien, welche ein undefinierbares Äußeres haben. Halb Fisch, halb Frosch oder Echse, unterscheiden sie sich gleichermaßen voneinander und von den bekannten Amphibienarten. Trotz seiner Irritation über die neue Szenerie des Spiels „weiß" Ted intuitiv, was zu tun ist: Er entfernt einige Innereien aus den Amphibien, schlägt sie in ein Papierkuvert ein und gibt dieses in einen wartenden Transportwagen. Seine Fähigkeiten werden vom Nachbar, Yevgeny Nourish (Don McKellar), am Fließband bewundert. Und wieder reagiert die Figur erst auf eine an eine Losung erinnernde Antwort. Als der weitere Spielfluss ausgelöst ist, empfiehlt Nourish Ted für die Mittagspause ein chinesisches Restaurant. Ted soll dort die „Spezialität" bestellen und auch gegen Widerstand auf dieser Bestellung beharren.

Ted geht auf die Suche nach Allegra und wird fündig: Sie arbeitet in einem Kabuff, welches eine Mischung aus Stall und Labor ist (■ Abb. 2). Dies ist vielleicht das Charakteristische dieser Fabrikhalle. Sie wirkt einerseits wie ein verdreckter Stall und andererseits finden sich Elemente eine High-Tech-Produktionsstätte. Allegra reagiert ebenfalls für einen Moment wie eine Spielfigur, die auf ihre Spielsatz wartet. Erst dann gehen sie in das chinesische Restaurant. Zunächst sitzen sie noch mit anderen Arbeitern an einem großen Tisch, aber nachdem Ted die Bestellung der „Spezialität" aufgegeben hat, verlassen sie sofort die Runde. Auch der chinesische Kellner (Ted Hsu) will die Bestellung zunächst nicht aufnehmen, fügt sich aber schließlich.

⬥ Abb. 3 Ted (Jude Law) richtet die Waffe auf den chinesischen Kellner. (Quelle: Cinetext Bildarchiv)

Nicht so Ted. Weil er sich „losgelöst von seinem richtigen Leben fühlt", das „Gefühl für seinen Körper verliert", unterbricht er das Spiel durch den lauten Ausruf: „eXistenZ ist unterbrochen". In der nächsten Szene finden sich Ted und Allegra auf dem Bett im Chalet des Skigebiets wieder. Sie haben die Zwische-nebene übersprungen, die offensichtlich zu „eXistenZ" gehört. Sie sind noch etwas benommen, und Ted kommt das echte Leben unwirklich vor: Ein Kuss von Allegra soll ihn überzeugen, nicht mit einer Spielfigur auf dem Bett zu liegen. Vor der Sicherheit des richtigen Lebens und der Langeweile treten sie den Rückweg in das chinesische Restaurant an – dieses Mal löst Ted den Spielstart am organischen Gamepod aus.

Im chinesischen Restaurant bekommt Ted die „Spezialität" serviert: Eine große Platte mit Speisen aus mutierten Fischen, samt der mutierten zweiköpfigen Echse, die Ted erkennt und die doch eigentlich der Ebene der Realität angehört. Es ist wie ein Tagesrest, der den Weg in den Traum gefunden hat. Ted überwindet seinen Ekel und beginnt von der servierten Spezialität zu essen. Er schlingt das Essen förm-lich in sich hinein, dabei benutzt er die Finger, um Knochen abzunagen. Mit der Zeit fügen sich immer mehr Knochen zusammen, es entsteht die Waffe, mit welcher zu Anfang auf Allegra geschossen worden ist. Als Ted aus seinem Mund auch noch eine Brücke mit Zähnen zieht, die er als Magazin in die nun vollständige Waffe einführt, stellt er fest: „Ich muss jemanden töten" und richtet die Waffe zunächst auf Allegra. Auch den Ruf des Attentäters wiederholt er: „Tod der Dämonin Allegra Geller!". Ted bezwingt sich aber und erschießt stattdessen den chinesischen Kellner (⬥ Abb. 3).

Die Anwesenden im Restaurant zeigen eine indifferente Reaktion: Die Gespräch verstummen, aber keiner begehrt auf. Es wirkt wie jener Leerlauf im Spiel, wenn die Handlung den angelegten Strang ver-lassen hat. Erst als Ted die Menge beruhigt, gehen die Gespräch unberührt weiter und ein Hund kommt und liest die Knochen-Waffe auf. Während Ted und Allegra über die Küche aus dem Restaurant flüch-ten wollen, begegnen sie dem Nourish, der Ted das Restaurant und die Spezialität empfohlen hat. Und der nun erklärt, warum der chinesische Kellner hat sterben müssen: für einen Verrat. Nourish berichtet

weiter, dass es sich bei dem Ort um eine stillgelegte Forellenfarm handelt, die von Antenna Research zur Produktion von Gamdepods genutzt wird. Sie züchten Mutanten, deren Nervensysteme einerseits in den Gamepods verarbeitet werden, andererseits auch im chinesischen Restaurant angeboten werden, weil sie schmackhaft sind. Und zu guter Letzt nutzen sie die Knochen, um Waffen herzustellen. Ted und Allegra hätten durch den Mord am Kellner bewiesen, dass sie „wahre Freunde der Realität" sind. Was sich im Auftauchen von Elementen anderer Spielebenen ankündigte, wird nun zu einem dichten Teppich verwoben: eine die Handlungslogik verlierende Erzählung.

Das Spiel wird auf der ersten Ebene fortgesetzt, im Laden von D'Arcy Nader. Von seinem Assistenten Hugo Carlow (Callum Keith Rennie) werden Ted und Allegar aber nur noch zur Leiche Naders geführt, scheinbar erdrosselt mit einem Gamepod-Verbindungskabel. Dafür weiß Carlow nicht nur vom Tod des chinesischen Kellners auf der zweiten Spielebene, sondern verfügt auch über die Knochenwaffe. Der Hund des chinesischen Kellners habe sie ihm gebracht. Nourish ist ein Doppelagent, und eigentlich wäre der chinesische Kellner ihr Kontaktmann auf der Forellenzuchtfarm gewesen. Nader wiederum arbeitete für Cortical Systematics und mit Nourish zusammen, während Carlow zu den „Freunden der Realität" gehört. Im Laden sei er, um Nader im „Auge zu behalten". Er schickt sie zurück auf die zweite Spielebene und damit in die Forellenzucht, um Nourish auszuschalten.

Grenzüberschreitungen

In der Forellenzucht aber befinden sie sich dann auf der Suche nach etwas Anderem, nicht näher bezeichnetem, das „an einem Ort läge, den sie kennen". Den Ort, den sie dort kennen, ist ihre „Montagebox". Nicht mehr um Nourish auszuschalten, sondern um „es" zu finden, sind sie auf der zweiten Ebene des Spiels. Sie finden einen Gamepod und schließen ihn an Allegras Bioport an. Sofort beginnt ein Alptraum, Allegra windet sich vor Schmerzen. Ted versucht zwar, den Gamepod wieder aus dem Bioport zu entfernen, aber die Schmerzen Allegras werden dadurch noch gesteigert. Mit einem Messer durchtrennt Ted das Kabel/die Nabelschnur, welche nun unmittelbar beginnt zu bluten. Offensichtlich verliert Allegra durch die gekappte Schnur ihr eigenes Blut. Nourish betritt nun ebenfalls die Kabine – bewaffnet mit einem Flammenwerfer und, mit dem Schlachtruf „Tod dem Realismus", versucht er, den verseuchten Gamepod zu zerstören. Unter der Flamme kommt es zu einer Explosion des Gamepods – ein Regen aus kleinen Flocken, wie schwarze Asche, geht über allem nieder. Der zerstörte Gamepod verstreut Sporen und verseucht so die gesamte Produktion. Allegra tötet Nourish mit dem Messer. Die Fabrik fängt Feuer.

In der nächsten Einstellung wird das Chalet gezeigt, in dem sie in „eXistenZ" eingestiegen sind. Auch dieses brennt. Allerdings ist das Allegras Pod weiterhin verseucht, er wird sterben.

💬 „Es ist hier, wir haben das Virus mitgebracht, wir haben es aus dem Spiel mitgebracht".

Die traumhafte Logik von Tageresten funktioniert nicht mehr nur in eine Richtung. Auch Teds Port ist infiziert, und eine Infektion dehnt sich bereits erkennbar aus. Gegen die Infektion von Ted hat Allegra ein Mittel. Sie platziert eine Kapsel in der Port-Öffnung, welche die Wunde reinigen soll. Aber der Pod ist zu ihrer Verzweiflung unwiederbringlich verloren und damit auch das Spiel. In diesem Moment gibt es eine große Explosion: Ein bewaffneter Mann in soldatischer Kleidung stürmt das Chalet und fordert sie auf, mit zu kommen. Es ist der Kassierer Carlow aus der ersten Ebene des Spiels. Allegras Gamepod wird von ihm mit einer Salve aus seiner automatischen Waffe zerstört, aber nun ist nicht mehr sicher: Auf welcher Ebene sind sie gelandet? Ist es weiterhin das Spiel? Ist es die Realität? Sie gehen ins Freie, da das Gebäude ebenfalls zu brennen beginnt, und kommen so in eine Kampfszene. Nachdem Carlow den „Sieg der Wirklichkeit" preist, will er Allegra töten. Bevor er abdrücken kann, wird er von Vinikur erschossen – mit der Knochenwaffe, die ihm sein Hund gebracht hat. Auch sei keinesfalls mit Allegras

Gamepod das Spiel verloren, bei der Operation des Pods habe er das Nervenzentrum ausgetauscht und kopiert. Er besitzt es nun und arbeitet für Cortical Systematics. Allegra soll es ihm gleichtun. Sie erschießt ihn mit der Waffe des getöteten Kämpfers, was wiederum Ted zum Wüten bringt: Es könne sein, dass sie einen realen Menschen getötet habe! Er greift sich wiederum die Waffe und gibt sich als Mitglied der „Freunde der Realität" zu erkennen. Er richtet die Waffe auf Allegra, welche nun aber die Plombe zur Explosion bringt, die sie selbst in Teds Port platziert hat.

Nun, da Ted tot ist, taumelt Allegra voller Freude über das Schlachtfeld und feiert ihren Sieg: „Tod dem Dämon Ted Pikol". Sie ruft imaginäre Mitspieler an, dass sie nun gewonnen hat. Plötzlich hat sie eine Ausbuchtung an der rechten Hand und eine Art langgezogenen Kopfpanzer auf dem Haar. Vor ihr tauchen die leeren Kirchenbänke auf.

Das Spiel ist zu Ende (?)

Alle Figuren des Films befinden sich nun wieder in der Kirche. Diese ist allerdings bis auf die Spieler und die Assistentin Merle (Sarah Polley) leer. Sie sitzen im Chor, im Halbrund, und beenden das Spiel. Spielkonsolen sind nicht die Gamepods aus mutierten Amphibien, und sie sind auch nicht mit dem Rückenmark verbunden. Es handelt sich scheinbar um Konsolen, welche das Zentralnervensystem von außen soweit beeinflussen können, dass alle Spieler in einer Phantasmagorie des Spiels sind. Nun werden Erfahrungen ausgetauscht, und es zeigt sich, dass Allegra Geller und alle anderen Figuren zu einem Spiel namens „TransCendenZ" gehört haben, das scheinbar schon gespielt wurde, als der Zuschauer des Films in die Situation der Ouvertüre eintauchte. Der Spieldesigner ist Yevgeny Nourish. Alle Mitspielenden sind ausgewählte „Beta-Spieler", die seine neue Kreation „TransCendenZ" als erste begleiten durften. Das Spiel wurde entwickelt für die Firma „Pllgrimage". Langsam löst sich die Spannung des Spiels von den Teilnehmenden, und sie rüsten zum Aufbruch. Allegra und Ted, welche im realen Leben ein Paar sind, holen ihren Hund wieder aus der Obhut einer Betreuung: Es ist jener Hund aus dem Spiel, welcher die Waffe auf den unterschiedlichen Spielebenen jeweils fort trägt. Derweil berät Nourish mit Merle den Verlauf des Spiels. Nourish ist das Auftauchen der „Anti-Spiel-Haltung" nicht geheuer, und sie beschließen, später das Programm in der „Analysegruppe" durchzugehen.

Sie werden von Ted und Allegra angesprochen: Wegen überaus wirksamer „Deformation der Realität" werden sie mit mehreren Schüssen regelrecht hingerichtet. Verborgen waren die Waffen unter einem Fellimitat ihres Hunds. Die anderen Spieler nehmen diese Entwicklung irritiert hin, fast wie die Spielfiguren in TransCendenZ: Es fehlt das richtige Stichwort, um weiter zu spielen. Selbst die Ausrufe „Tod dem Dämon Yevgeny Nourish!" von Allegra und „Tod Pilgrimage, Tod TransCendenZ!" von Ted ändern an der Apathie der Anwesenden nichts. Mit den Waffen in der Hand begegnen Ted und Allegra auf dem Weg zur Tür einem Mitspieler, dem „chinesischen Kellner". Er bedient ein Gerät, welches an ein iPad erinnert. Als er die beiden auf sich zukommen sieht, reagiert er panisch, entspannt sich aber dann: „Sagt mir die Wahrheit: Sind wir immer noch im Spiel?" Die Frage bleibt unbeantwortet, während der Film mit einem Blick auf die Waffen und in die Gesichter von Ted und Allegra endet.

Cronenberg als Regisseur und Drehbuchautor

Seine Thematik

Am 15. März 1943 in Toronto geboren, entstammt der Regisseur David Cronenbergs einer mittelständischen Familie. Nicht kulturelle Widersprüche, Prüderie oder Repressionen prägten das Leben in der Familie, allerdings werden der Tod der Eltern und die schwere Erkrankung des Vaters als zentral für Cronenbergs Entwicklung ausgemacht. Stiglegger (2011, S. 14 ff.) stellt fest:

Seine Filme bilden die Bausteine eines weit größer angelegten Planspiels, das sich mit dem ultimativen existenziellen Problem auseinandersetzt: mit dem Tod. Zugleich ermöglichen es seine Filme, die Stadien dieses Experiments mit der Sterblichkeit und dem Verfall des menschlichen Körpers in Mutationen, Erkrankungen und bewussten Transformationen zu beobachten.

Sein Weg führte ihn zunächst an die Universität, er begann ein naturwissenschaftliches Studium und schrieb sich anschließend für ein Studium der Philosophie ein. Letzteres beendete er erst 1967 – während er bereits als Regisseur etabliert war und seit 1966 eigene Filme gedreht hatte. Nach dem Bachelor-Abschluss gab Cronenberg seine weitere akademische Ausbildung zugunsten der Tätigkeit als Filmemacher auf. Tatsächlich besuchte er auch nie eine Filmschule (ebd.).

Der „Body horror" seiner Filme schließt nicht nur an die medizinische und technische Entwicklung an, sondern scheint diese zum Teil sogar vorweg zu nehmen. Es sind Filme von einer surrealistischen Präsenz, so etwa, wenn er 1977 in *Rabid* die Verpflanzung von künstlichen Organen als Auslöser einer Epidemie des Wahnsinns schildert und dabei Organe als „vampirisch-phallisch" entwirft (ebd., S. 20). Mit genau diesem Film, genauer, mit seinen Einspielergebnissen, etablierte sich Cronenberg mit seinen „beängstigenden Phantasmagorien" (ebd., S. 13) als Regisseur. Wie Stiglegger (ebd., S. 34) es ausdrückt:

Seit Videodrome sind mit ihm zwei Konzepte verknüpft, die immer wieder als Schlüssel zu seinem Werk herangezogen werden: creative cancer und das „neue Fleisch". Unter creative cancer ist eine Krankheit oder vielmehr organische Wucherung zu verstehen, die zugleich eine Erweiterung der physischen Möglichkeiten bedeutet. Das Leben mag daran zugrunde gehen, doch die Grenzen des Körpers werden erweitert.

Für *Crash* beschreibt Stiglegger eine Zuspitzung dieser Thematik, der Sehnsucht nach Grenzüberschreitung am Körper durch den Einsatz von Prothesen, „um sich noch einmal als sexuelles Wesen definieren zu können." Und weiter (ebd., S. 35)

Dabei kann und muss der Körper verschwendet werden, muss er ganz auf seine (abjekten) Qualitäten zurückgeführt werden. Doch wo endet dieser Potlatsch (Verschwendungswettkampf) der Körper? Wenn der Körper seine abjekte Qualität verloren hat, muss er – so zeigt es *Crash* – „re-abjektifiziert" werden, in einem Akt der Körpermodifikation.

In *Crash* gelingt das durch die Prothetisierung des Körpers, die Herstellung des Körpers durch Prothesen, welche gleichzeitig im Körper neue Öffnungen hinterlassen.

Und mit dem „Potlatsch" erinnert Stiglegger daran, dass es nicht nur um Begehren geht, sondern auch um Tausch, sakralen Tausch. Denn aus dieser Region stammt der Potlatsch. Er ist ein Objekt des Austauschs in archaischen Gesellschaften. Cronenbergs Thema ist damit nicht nur der menschliche Körper und die kontinuierliche Entwicklung seiner Überwindung (ebd., S. 33), sondern mit dem Tausch auch die Ökonomie.

Ein „visionäres" Drehbuch

Dabei bedient sich Cronenberg im Film einer Realistik der Computerspiele, die zu dieser Zeit eigentlich noch nicht existierte. Computer- und Videospiele waren zum damaligen Zeitpunkt alles andere als dazu angetan, mit der Realität verwechselt zu werden. Und Spielkonsolen, wie etwa die Wii des japanischen Unternehmens Nintendo, kamen erst Ende 2006 auf den Markt. Mit letzterer werden die Bewegung des Spielers im Raum registriert; was in vergangenen Generationen der Joy-Stick war, ist nun ein Controller, mit dessen Bewegung im Raum das Spiel geführt wird. Dabei läuft man zwar auch

mit der Wii noch nicht Gefahr, die Simulation mit der Realität zu verwechseln, aber allzu weit davon entfernt ist der Erwerb einer Fähigkeit, beispielsweise mit der Wii Gitarre zu spielen, von diesem Realitätsverlust nicht. Der Tatbestand einer Verleugnung könnte fast erfüllt sein, denn unter der Herrschaft des Wunsches gerät leicht in Vergessenheit, dass eine reale Gitarre auch vom besten Wii-Gitarrenspieler nicht beherrscht wird. Insofern ist zumindest psychisch die Grenze zwischen Simulation und Realität überschritten. Interessant ist, dass auch die heute so allgegenwärtigen iPods noch nicht auf den Markt geworfen waren: deren Markteinführung und Namenseinführung erfolgte erst im Oktober 2001. Cronenberg ist zwar nicht selbst der Visionär, welcher die technische Entwicklung voraus gesehen hat: Die Idee von Tablet-PC und Hypertext stammt aus den 1970er-Jahren, die Verwendung der Gamepods als Verbindungsstationen eines imaginären Spiels ähnelt der „consensual hallucination", als welche William Gibson den Cyberspace in den 1980er-Jahren entworfen hat (Hantke 2011, S. 51) Aber es ist eine seiner Leistungen, das Kommende in einen Spielfilm eingebettet zu haben. Die Identifizierung von Noel Dichter mit einer Art Smartphone in der Eingangsszene des Films bis hin zur Verwendung eines dem iPad sehr ähnlichen Tablet-PCs am Ende des Films – Cronenberg hat die Explosion der Technik aufgenommen. Aber dass sie explodieren würde, das konnte auch Ende der 1990er-Jahre bereits abgesehen werden. Vielleicht sogar die Produktinszenierungen, welche der Seminarleiter im Film (und Steven Jobs in der Realität) zur Markteinführung wählte. Aber die Ebene des Spiels „eXistenZ", die Gamepods aus genmanipulierten Tieren, die am Körper angeschlossen werden, das ist noch nicht Realität. Die simulierte Ebene der „eXistenZ" hat diese biogenerischen Prothesen im Angebot. Ist mehr über den realen Wunsch zu erfahren, wenn man die Simulation näher betrachtet?

Psychoanalytische Interpretation

„Kulturelle Objektivationen" so nannte Moritz Lazarus im 19. Jahrhundert die Forschungsobjekte seiner Völkerpsychologie. An ihnen lassen sich Gesellschaften untersuchen, die sie hervor bringen. Lazarus befand, dass man sich gar nicht genug wundern könne, wenn man mit gesellschaftlichen Phänomenen konfrontiert ist. Und man wundert sich viel zu selten. Etwa über einen Wochenmarkt (Lazarus [1]1862; 2003, S. 27):

> Woher wissen die Besucher des Marktes, was sie zu tun und was sie zu lassen haben? Wie Schlafwandler folgen sie alle gemeinsam einer Choreografie. Das können sie, weil sich in ihrem Denken die gesellschaftliche Praxis soweit verdichtet hat, dass nicht mehr alles von jedem gewusst werden muss.

Sich zu wundern, das ist mit heutigen Worten eigentlich die Fragestellung einer Sinn-verstehenden Sozialpsychologie. Um Sinnverständnis geht es der Psychoanalyse im Allgemeinen und der psychoanalytischen Filminterpretation im Besonderen. Für letztere macht Zeul drei Zugänge aus. An erster Stelle jenen, welcher biografisch-pathografisch die Person des Regisseurs betrachtet. Zum zweiten nennt sie jene Traditionen, die sich am manifesten Inhalt des Films abarbeiten, um einen, dem eigenen Selbstverständnis nach, unbewussten Gehalt in der Symbolsprache des Films aufzuspüren. Dem dritten jedoch gibt sie den Vorzug: jenem Zugang zum Film, „der von der ästhetischen Gestaltung eines Films ausgehend, seinen symbolischen Gehalt entschlüsselt." (Zeul 2007, S. 17) Erst dieser ist im engeren Sinne als psychoanalytischer Zugang zu verstehen, weil er das Medium der Erfahrung – nämlich der des Betrachters – nutzt. Ohne subjektives Erleben, so ihr Diktum, kein psychoanalytisches Verstehen.

Aber ganz so kategorisch, wie Zeul es macht, kann auch die manifeste Ebene des Films nicht aus der Interpretation ausgeschlossen werden. Was wäre denn von einem Analytiker zu halten, der den erzählten Traum seines Analysanden links liegen lässt, um ohne Umstände zum latenten Gehalt zu drängeln? In jedem Fall käme er dort auch kaum an. Mindestens als Zugang muss die manifeste Ebe-

ne gewürdigt werden. Zudem ist auch in der Deutung des Traums das manifeste Material nicht bloß Zierrat, Schutt, der zur Seite geräumt gehört. Es ist vielmehr wie in der Wissenschaft: Die Erscheinung ist beides, bloßer Schein und Erscheinung des Wesens. Damit ist die Erscheinungsebene nicht ohne Bedeutung, an der Erscheinung selbst lässt sich auch etwas vom Wesen ablesen. Traum, Übertragung, Assoziation, das sind in der psychoanalytischen Therapie die Zugänge zum Sinn – meistens der Symptome.

Allerdings ist mit dem Verweis auf die Klinik auch schon der Rahmen abgesteckt, in dem die psychoanalytische Technik streng genommen verwendet werden kann. Er ist eng begrenzt. Zwar wird auch im Film etwas reinszeniert. Aber bei seiner Betrachtung fällt beides aus, was sonst Auskunft über Sinn geben kann: die Übertragungsanalyse und die Assoziationen des Analysanden. Neuland wird betreten, mit gewichtigen Konsequenzen (Gabbard 2001, S. 4):

… psychoanalytically informed film critic must be creative in identifying material for analysis.

Zudem: Gilt nicht für die Haltung des Analytikers die Forderung „No memory, no desires"? Aber anders als zu Beginn einer Psychotherapie geht der Kontakt nicht vom Analysanden, sondern vom Kinobesucher aus. Ein kuratives Ziel stiftet nicht den Anlass der Unternehmung. Aber welches dann? Gabbard fächert sieben psychoanalytische Annäherungen an den Film auf. Im Grunde wiederholt sich in ihnen, was Zeul schon beschrieb; manche von Gabbard genannten Methoden überschneiden sich, und eine der aufgeführten, ausgerechnet die erste von ihm genannte, ist eigentliche keine Methode. Die „Explication of the underlying cultural mythology" (Gabbard 2001, S. 5) kommt einem Erkenntnisziel viel näher als einer Methode zur Interpretation. Es wird ein Erkenntnisinteresse formuliert, das vielleicht einen Umweg nimmt (den Film und die individuelle Reaktion auf ihn), aber doch vor allem etwas über die Gesellschaft in Erfahrung bringen will (Gabbard 2001, S. 6):

Just as dreams function as wish-fulfilments (at least in many cases), so do films provide films wish-fulfilling solutions to human dilemmas.

Nun ähnelt das tatsächlich der einleitend zitierten Aufforderung von Lazarus, sich ausreichend über kulturelle Phänomene zu wundern. Und als solche Phänomene müssen ja Filme angesehen werden: Sie sind als Produkt eines gemeinschaftlichen Wirkens auch Ausdruck von etwas – hier mit aller Vorsicht formuliert – „Kollektiven". Damit sind Filme aber, wie Kracauer es schon vorstellte, sozial-psychologischen Untersuchungsobjekte ersten Ranges (Kracauer [1]1947; 1958) oder auch „kulturelle Symptome" (Laszig u. Schneider 2008, S. 13). Sie haben Sinn. Und mit dem Sinnverständnis wird Auskunft über die Gesellschaft eingeholt, die diese Symptome produziert. Ob man deshalb von kollektivem Unbewussten sprechen muss, sei dahin gestellt: Von selbst weiß die Gesellschaft diesen Sinn auf jeden Fall nicht. Aber wie soll er ermittelt werden? Ist in der psychoanalytischen Therapie die Sprache das Leitmedium, so gilt das augenscheinlich beim Film nicht mehr, zumindest nicht mehr exklusiv. Liegt nicht mehr ein Analysand auf der Couch und sitzt kein Analytiker hinter ihm, müssen wir eine grundlegende Veränderung des Settings konstatieren. Will sagen: Im Kinosaal wird ein anderes Arbeitsbündnis eingegangen als im Behandlungszimmer.

Das „Arbeitsbündnis" bezeichnet in der psychoanalytischen Klinik die Voraussetzungen, die geschaffen werden, um die Arbeit von Analytiker und Analysand zu ermöglichen. Es umfasst einerseits die Vereinbarung über den Rahmen – Stundenfrequenz, Liegen auf der Couch, Honorar – andererseits auch Beziehungsaspekte – Anerkennung der Übertragung, Nutzung der therapeutischen Ich-Spaltung. Der Arbeitsbündnisbegriff geht auf Greenson ([1]1967; 1975) zurück und ist von Deserno (1990) gerade wegen dessen Vernachlässigung der gesellschaftlichen Realität einer deutlichen Kritik unterzogen worden (vgl. Decker 2004, S. 127 f.). Das Arbeitsbündnis spezifisch für einen erhellenden Zugang zur

sozialen Realität zu nutzen und aus dem klinischen Rahmen zu lösen, diese Idee stammt jedoch von Steinert (1998; 1999). Er bemerkt (1998, S. 59):

> Wir verstehen, indem wir uns die Regeln einer Situation klarmachen, in der wir uns ... im Rahmen der äußeren gesellschaftlichen Vorgaben und der vorhandenen Requisiten befinden. Diese Regeln, die also vom organisatorischen, institutionellen und sonst gesellschaftlichen Rahmen der Interaktion und von den Beteiligten vorgegeben, vorausgesetzt und ausgehandelt werden, kann man als Arbeitsbündnis zusammenfassen. Wir verstehen, indem wir ein Arbeitsbündnis rekonstruieren, in denen ein Phänomen verstanden werden kann. Das gilt für das Verstehen von Texten wie von Artefakten und Ereignissen.

Verstanden werden sollen jene (im engeren Sinne) gesellschaftlichen „Objektivationen" von psychosozialen Konflikten (Steinert 1999, S. 95/96):

> Die so gewonnenen Interpretationen sind daran zu messen, wie viel Reflexivität ihnen gelingt, wie sehr sie also die verschiedenen möglichen Perspektiven und Arbeitsbündnisse zu integrieren und auf ihre soziale Position, die Konflikte zwischen ihnen und den Grundtatsachen der Vergesellschaftung in der jeweiligen Produktionsweise zu beziehen verstehen.

In Frage steht zunächst die Ebene des Arbeitsbündnisses des Films. Das heißt nicht, dass nicht auch Subjektives einfließt. Aber es heißt, dass der Film verstanden werden soll, gerade über die Regeln, denen er folgt – und über die, mit denen er bricht. Und dann reicht es fürs Erste, wenn die manifeste Erscheinungsebene in den Blick genommen wird.

Das Arbeitsbündnisangebot von Filmen ist, dass sie funktionieren wie ein Traum, Gabbard nannte es: als Wunscherfüllung. Aber dieses Verständnis ist gerade für das filmische Schaffen eines Regisseurs, das von Stiglegger als „Phantasmagorie" bezeichnet wird, mehr als interessant. Auch Zeul gilt die Nähe von Film und Traum zwar dem eigenen Anspruch nach nur als Metapher (Zeul 2007, S. 36), aber es kann doch zur Analyse des Arbeitsbündnisangebots von Filmen dienen. Dafür muss man ausholen.

Für Zeul nimmt der Film Maß an einer weit zurückliegenden Epoche individueller Entwicklung: der Mutter-Kind Dyade. Die Kontaktaufnahme mit der Mutter vollzieht sich nicht nur über den Mund, sondern auch durch den Blick. Es kommt zwar zu einer Erotisierung des Mundes durch das Stillen, aber in dieser „Urhöhle" des Mundes ist mehr enthalten: nicht nur die Mutterbrust, auch der Blickkontakt und die sich an beides anschließende Befriedigung. Alles zusammen ist die Bedingung des wunsch- und damit auch traumlosen Sättigungsschlafes. Der Traum ist eine Wunscherfüllung, das kann sehr wohl bei vielen Träumen so sein. Aber „wunschlos glücklich sein" heißt eigentlich, traumlos zu sein. Der Blick der Mutter ist Begleiter dieses Zustands, fast scheint es, als bereite er ihn vor (Zeul 2007, S. 35). Der Film bereitet ihn nach. Seine besondere Erlebnisqualität erhält er als Nachvollzug dieser Vorbereitung des traum- und wunschlosen, weil eigentlich mangelbefreiten Zustandes. Die Wahrnehmung von Filmen nimmt Modell am mütterlichen Blick, der Film wird „gegessen", aber auch der Zuschauer von ihm „verschluckt". (Zeul 2007, S. 29). Folgen soll hier wie dort ein „bildloser Traum" (Zeul 2007, S. 28). Zumindest ist mit dem Film die Hoffnung verbunden, dass er jenes Moment des Hinübergleitens wiederholt. Die Leinwand gerät zu „Höhlenhäusern" (Zeul 2007, S. 36) und Film-Sehen ist ein Übergangsstadium zwischen Wach-Sein und Schlafen, ein „waches Dösen" (Zeul 2007, S. 29).

Die Traumleinwand als Versuch der halluzinatorischen Wunscherfüllung: Das mag in etwa so richtig sein, wie die von Freud zunächst aufgestellte Behauptung, der Traum würde in seiner Funktion als Hüter des Schlafes dem Schlafenden die Wünsche erfüllen, um ihn am Schlafen zu halten. Das kann sowohl für die meisten Filme gelten wie auch für die meisten Träume. Aber schon Freud musste eingestehen, dass es Träume gab, an denen seine Theorie zerschellt wäre – wenn er sie nicht modifiziert hätte.

Jene Träume von schwer traumatisierten Teilnehmern des 1. Weltkriegs, die immer wieder schreckhaft wiederholten, was sie so schwer beschädigte, konnte er nicht als Wunscherfüllung ansehen (Türcke 2002).[1] Und was ist davon zu halten, wenn zwei andere aufmerksame Beobachter über diese wunscherfüllende Traumleinwand, diesen „Dream Screen", schreiben: „In eineinhalb Stunden soll der Film den Zuschauer ko geschlagen haben" (Horkheimer u. Adorno 1944, S. 325) Das ist nicht einmal nur der Wunsch der Kulturindustrie alleine, sondern kann getrost auch als Wunsch des Filmzuschauers gelten. Dies erkennt auch Zeul (2007 S. 30), denn sie sagt:

> … [der] Inhalt eines Films kommt psychoanalytisch metaphorisch verstanden eher dem manifesten Traum eines Erwachsenen oder eines Kindes gleich, dessen Bilder die Befriedigung des leeren Säuglingsschlafes stören.

Auch war es metaphorisch gemeint, als Ehrenburg zu Anfang der 1930er-Jahre Spielfilme als Produkte einer Traum-Fabrik beschrieb (Ehrenburg 1931). Aber wenn der Film auch nur wie ein Traum funktioniert: Wie diesem wohnt ihm eine Ambivalenz, wohl eher sogar noch ein Paradox inne (Türcke 2008, S. 25/26). Der Traum ist ein Paradox: Er kann gar nicht anders, als die Befriedigung des Wunsches nur vorzugaukeln. Der Surrogatcharakter seiner Wunscherfüllung macht ihn zum perfekten Hüter des Schlafes, das ist zwar seine Stärke, aber begehrt wird vom Träumenden und vom Kinobesucher etwas anderes. Wunsch und Traum liegen nicht weit auseinander, wie seit Freud bekannt ist, der „den Menschen konsequent als das wünschende Tier darstellt." (Lohmann 1998, S. 36) Und der Wunsch ist der des Säuglings geblieben: die auf Dauer sichergestellte Befriedigung, das Stillstellen der Triebspannung. Aber der Traum ist nicht der Wunsch, nur die Simulation seiner Erfüllung.

Massenmedial inszenierte „Heilssuche"

Das für Filme allgemein gültige Arbeitsbündnisangebot ist bereits jenes einer Gesellschaft, die das Spannungsfeld zwischen Ausbleiben der dauerhaften Wunscherfüllung und Fortbestehen des Wunsches massenmedial inszeniert. So neu ist diese Erkenntnis zwar nicht, aber wichtig ist sie hier trotzdem. Nicht nur das Bemühen um die methodische Klärung des Zugangs bringt es mit sich, zunächst anstelle des Films den Traum zu betrachten. Cronenberg selbst vergleicht den Einfluss der Handlungsebenen in seinem Film *eXistenZ* aufeinander mit jenem Einfluss, den die Realität auf den Traum und der Traum auf die Realität haben (Sternenborg 2011, S. 227). Und er geht verschwenderisch mit seinen Einfällen um, reich an Bildern, Metaphern und Querverweisen wird die Geschichte erzählt. Kein Wunder ist es, dass dieser Film so oft Gegenstand von Filminterpretationen geworden ist: Der psychoanalytisch informierte Filmemacher Cronenberg hat den Psychoanalytikern eine ganze Reihe von Ostereiern versteckt. Überall wird in Verweisen geschwelgt, Verbindungen werden aufgemacht, wo eine assoziative Nähe irgend besteht. Die anderthalb Stunden, die Cronenberg hat, um den Zuschauer zu „erschießen" (Horkheimer u. Adorno), nutzt er. Sparsam ist der Regisseur mit der Umsetzung seiner Einfälle nicht. Er inszeniert über den ganzen Film hinweg einen Assoziationsstrom, der zum reißenden Fluss wird.

Cronenberg hat am Surrealismus Maß genommen. Es war nicht nur deshalb das Verhältnis von Film und Traum metapsychologisch zu klären. Cronenberg gestaltet dieses Arbeitsbündnis neu, es ist fast schon eher ein Imperativ als ein Angebot, ihn als Traum zu sehen. Der gestalterische Nachvollzug des Films kommt dem ungelenkten Fluss der Gedanken nahe, welcher die Linearität des Textes im Surrealismus ablösen sollte. Traum- und rauschartig liefert Cronenberg eine überbordende Inszenie-

1 Der „traumatische Wiederholungszwang" als Kulturstifter, von Türcke an dieser Stelle entwickelt, steht mit diesen „abgeschossenen" Bildern des Kinos in einem unmittelbaren Zusammenhang. Wie im Übrigen auch mit den Spielen und Spielkonsolen. Aber dieser Bezug zu *eXistenZ* kann an dieser Stelle nicht aufgemacht werden. Wichtig sind die Ausführungen zum Traum, die im Folgenden mit in die Interpretation einfließen (Türcke 2008).

rung des Surrealen ab. Gleichzeitig muss ein Film – und damit auch *eXistenZ* – das Dementi des Surrealen sein. Er kann dessen ideale Produktionsidee vom freien Fluss am Übergang zum Traum nicht gewährleisten: Vorbereitung, Dreharbeiten, Schnitt, all das verlangt nach einer geordneten Handlung des Künstlers. Dabei gehen das unbewusste Schaffen, das traumhafte Anfliegen, die Befreiung aus der Linearität für den Film verloren.

Zwar verliert spätestens nach der Ermordung des chinesischen Kellners der Film jede Logik. Er wird sozusagen „primärprozesshaft", Handlungsstränge reißen ab und andere, bis dahin nicht ausgeführte, werden aufgegriffen. Wer sind die Freunde der Realität, was „Antenna Systems", wer Nourish und wie überschneiden sich die Interesse aller mit „Cortical Systematics"? Das sind nicht die Assoziationen des Zuschauers, sondern die der Produzenten des Films. Eins bleibt klar: alle Beteiligten erweisen sich als Doppelagenten (Sternenborg 2011, S. 224) bis in die letzte Ebene oder Szene des Films. Aber weil es ein Film ist, kann er auch nicht anderes, als nur „sozusagen" dem Primärprozess überantwortet zu sein. Damit sind nicht nur die Figuren allesamt Doppelagenten, es ist auch das Arbeitsbündnis des Films doppelt bestimmt: Er selber ist ein Doppelagent. Er inszeniert sich viel stärker als Traumgeschehen als andere Spielfilme. Aber wie alle Spielfilme ist er es nicht, kann es gar nicht sein.

Die Doppelebene des Films

Der Film als Doppelagent folgt aber Motiven. Was auf der Traumleinwand von *eXistenZ* zu sehen ist, hängt eng mit der Eingangsfrage nach der Realität der Medizin, zusammen. Es sollte ja an dieser Stelle Auskunft über eine Medizin eingeholt werden, welche verspricht, durch die Manipulation in der Keimbahn einen Menschheitstraum zu erfüllen. Einem Traum von erfolgreicher Leid- und Todesbekämpfung. Zwar wird der Mensch im Film nicht selbst genetisch verändert und auf den Markt geworfen. Das widerfährt nur Amphibien. Aber spurlos geht das Geschehen am solcherart prothetisierten menschlichen Körper nicht vorbei. Ganz sichtbar wird dieses Überspringen des Machtkampfes zweier Konzerne um die Vormachtstellung auf dem Markt mit Spielkonsolen („Die hat nur Antenna Research") am Körper Ted Pikols. Er wird vom selben Virus befallen, der auch das Gamepod infiziert hat. Aber nicht nur diese sichtbare Infektion zeigt den Einbezug des menschlichen Körpers in die Ökonomie an.

Während der Körper im Vexierspiel von *eXistenZ* leicht als zentrales Motiv zu erkennen ist, verschwinden Tausch und Markt dagegen fast vollständig. So gibt es im ganzen Film keine Markenartikel, bis auf „Perky Pat's": der Werbeaufdruck auf der Tüte eines Schnellrestaurants, aus der Ted im Motel isst. „Perky Pat's" ist aber weniger eine simulierte Marke als eine Verneigung David Cronenbergs vor dem Autor Philip K. Dick. Dieser ist Autor von Science-Fiction-Romanen, die sich um das Grundthema von *eXistenZ* drehen: die Unzuverlässigkeit der Wirklichkeit. Perky Pat ist im Roman „Die drei Stigmata des Palmer Eldritch" eine Puppe, in deren Inneren die Menschen Trost finden, Ablenkung von der unwirtlichen Welt um sie herum (Sternenborg 2011, S. 225). *eXistenZ* kam im selben Jahr in die Kinos wie *Matrix* der Brüder Andy und Larry Wachkowski. Beide Filme spielen mit der Verschachtelung von Realität und virtueller Welt und setzen dabei an der Frage an, wie die Grenze zwischen ihnen zu erkennen ist. Während *Matrix* diese Frage durch einen Messias beantworten lässt, bleibt sie in *eXistenZ* trotz Allegras anfänglicher Verehrung bis zum Ende offen – dafür werden Trostmittel gezeigt, um das Ausbleiben des Messias auszuhalten. Und diese Trostmittel sind Waren, um deren Marktanteile auf allen Ebenen des Spiels gekämpft wird. „Die Konzerne Antenna Research, Cortical Systematics und PIlgramage dagegen operieren über die jeweiligen Spielsphären hinaus und streben damit eine Marktpräsenz an, die bis ins virtuelle Zentrum des Spiels reicht." (Greschonig u. Horak 2004, S. 143) Die Produktvorstellung vollzieht sich auf jeder Ebene des Spiels in einer Kirche. Als Ort der Begegnung mit einem jenseitigen Gott scheint sie selbst funktionslos geworden zu sein. Aber um das Weihevolle des Neuen, die Pracht des Spiels gegenüber der Verstaubtheit des Alten zu dokumentieren, dafür ist sie ideal geeignet. Der Kontrast mit dem alten Heilsversprechen verleiht dem Neuen besonderen Glanz. Die Spiele „eXistenZ" wie auch „transCendenZ" inszenieren den simulierten Körper am Bioadapter als den

„nicht-kastrierten" (Riepe 2002, S. 182), und das stimmt, wenn man zweierlei mitbedenkt. Zum einen, dass „kastriert" heißt: unvollständig zu sein. Ein Schock, der viel früher verkraftet werden muss, als der Nippel zwischen den Beinen überhaupt bemerkt wird. Zum anderen, dass der „Adapter" den Mangel nur noch stärker sichtbar macht. Das ist die „Prothesenlogik" des Bioadapters: Als Hinzufügung behebt er den Mangel, aber als Prothese erinnert er ihn auch. Es ist die Inszenierung eines Trostmittels, wie es die Religion einmal war. Das Gamepod ist in jedem Sinne ein Fetisch, als Objekt zur Verleugnung der Kastration und als Warenfetisch. Und dass der Markt nicht mehr Rindenschicht des sakralen Raums, sondern in ihn eingedrungen ist, macht auch das Neue dieser sozialen Marktordnung sichtbar. Sie ist invasiv, sie muss den menschlichen Körper erfassen. Ob diese „invasive soziale Ordnung – besonders mit ihren medizinischen und medialen Technologien ihre Durchdringung des Subjekts abgeschlossen hat" (McLarty nach Hantke 2011, S. 55), dass darf dahin gestellt bleiben. Der Film *eXistenZ* kündigte eher an, was noch folgen wird. Dass der menschliche Körper handelbar ist, ist heute Realität. Dass er auch denen, welche ihre Organe hergeben, als das Minderwertige gegenüber der neuen Technik gilt, davon wusste vor kurzem die Frankfurter Allgemeine Zeitung zu berichten (22. 8. 2011): Ein chinesischer Jugendlicher verkaufte eine Niere gegen ein iPhone und ein iPad.

Wunschbilder und Traumbilder, „Bilder in denen sich das Neue mit dem Alten durchdringt" (Benjamin 1935, S. 46), helfen, „dem Kollektiv die Unfertigkeit des gesellschaftlichen Produkts aufzuheben und zu verklären." Benjamin erkannte bereits: „Ein solches Bild stellt die Ware schlechthin: als Fetisch" (ebd.). Mit dem prothetisierten Körper scheint der Kollektivtraum seiner Erfüllung nahe zu kommen. Gleichzeitig wird die Grenze zur Dingwelt verschoben. Und da alle Produkte in dieser Gesellschaft Waren sind, springt mit der Prothese auch dieses Merkmal auf den Körper über: Er wird von Waren vervollständigt, selbst zu einer solchen, wie es im Film noch die genmanipulierten Tiere sind. Das wäre dann nicht mehr nur ein ständiger Prozess von De- zur Re-Kommodifizierung, wie er zuerst von Polanyi (Polanyi [1]1944; 2001) und noch in den 1970er-Jahren von Lenhardt und Offe (1977) als dauerhaftes Bewegungsmoment der kapitalistischen Akkumulation ausgemacht wurde, sondern es ist wirklich eine „commodification of the body and ist parts", die Transformation des menschlichen Körpers in einen Warenkörper (Decker 2011). Markt und Medizin teilen einen „theologischen Glutkern" (Adorno 1934 in einem Brief an Benjamin, abgedruckt in: Benjamin 1928–40, S. 1130), es treibt die Kapital akkumulierende Gesellschaft und die moderne Medizin eine untergründige Geschichte des Körpers an.

Literatur

Benjamin W (1935) Das Passagen-Werk. Exposé: Paris, die Hauptstadt des XIX. Jahrhunderts. In: Tiedemann R (Hrsg) Walter Benjamin, Gesammelte Schriften Bd V-1. Suhrkamp, Frankfurt/M, S 45–59

Decker O (2004) Der Prothesengott. Subjektivität und Transplantationsmedizin. Psychosozial, Gießen

Decker O (2011) Der Warenkörper. Zur Sozialpsychologie der Medizin. Zu Klampen, Springe

Deserno H (1990) Die Analyse und das Arbeitsbündnis. Eine Kritik des Arbeitsbündniskonzepts. Verlag Internationale Psychoanalyse, München

Ehrenburg I (1931) Traum-Fabrik. Malik-Verlag, Berlin

Gabbard GO (2001) Introduction. In: Gabbard GO (Hrsg) Psychoanalysis and film, 1–16. Karnac, London

Greenson RR (1975) Technik und Praxis der Psychoanalyse. Klett, Stuttgart (Erstveröff. 1967)

Greschonig S, Horak V (2004) „Sagt mit die Wahrheit! Sind wir noch im Spiel?" Zur Anthropologie, Ökonomie und Ontologie in David Cronenbergs eXistenZ. In: Kratochwill K, Steinlein A (Hrsg) Kino der Lüge. Transcript, Bielefeld

Hantke S (2011) Autorenkino und Verschwörungstopos. Selbstreflexion in Videodrome und eXistenZ. In: Stiglegger M (Hrsg) David Cronenberg. Bertz & Fischer, Berlin, S 45–56

Horkheimer M, Adorno TW (1944) Dialektik der Aufklärung. In: Tiedemann R (Hrsg) Theodor W. Adorno – Gesammelte Schriften Bd 3. Suhrkamp, Frankfurt/M

Kracauer S (1958) Von Caligari bis Hitler. Ein Beitrag zur Geschichte des deutschen Films. Rowohlt, Reinbek (Erstveröff. 1947)

Laszig P, Schneider G (2008) Filme als kulturelle Symptome – Einleitung und Überblick. In: Laszig P, Schneider G (Hrsg) Film und Psychoanalyse – Kinofilme als kulturelle Symptome 11–18. Psychosozial, Gießen

Lazarus M (2003) Grundzüge der Völkerpsychologie und Kulturwissenschaft. Felix Meiner, Hamburg (Erstveröff. 1862)

Lenhardt G, Offe C (1977) Politisch-soziologische Erklärungsansätze für Funktionen und Innovationsprozesse der Sozialpolitik. KZfSS Sonderheft 19: 98–127

Lohmann HM (1998) Sigmund Freud. Rowohlt, Reinbek

Polanyi K (2001) The great transformation. Beacon Press, Boston MA (Erstveröff. 1944)

Riepe M (2002) Bildgeschwüre: Körper und Fremdkörper im Kino David Cronenbergs – psychoanalytische Filmlektüren nach Freud und Lacan. Transcript, Bielefeld

Steinert H (1998) Kulturindustrie. Westfälisches Dampfboot, Münster

Steinert H (1999) Arbeitsbündnisse in der Kunst des 20. Jahrhunderts. Texte aus dem Colloquium Psychoanalyse 4: 84–102

Sternenborg A (2011) eXistenZ. In: Stiglegger M (Hrsg). David Cronenberg, Bert & Fischer, Berlin, S 222–228

Stiglegger M (2011) Fleisch und Geist. Einführung in das Werk von David Cronenberg. In: Stiglegger M (Hrsg) David Cronenberg. Bertz & Fischer, Berlin, S 12–44

Türcke C (2002) Erregte Gesellschaft. Beck, München

Türcke C (2008) Philosophie des Traums. Beck, München

Zeul M (2007) Das Höhlenhaus der Träume. Filme, Kino & Psychoanalyse. Brandes & Apsel, Frankfurt/M

Originaltitel	eXistenZ
Erscheinungsjahr	1999
Land	Kanada, GB
Buch	David Cronenberg
Regie	David Cronenberg
Hauptdarsteller	Jennifer Jason Leigh (Allegra Geller), Jude Law (Ted Pikul), Ian Holm (Kiri Vinokur), Willem Dafoe (Gas), Don McKellar (Yevgeny Nourish)
Verfügbarkeit	Als DVD in OV und deutscher Sprache erhältlich

Lily Gramatikov, Thomas Zimmermann

„Die Matrix" und die Frage: Kann es doch ein richtiges Leben im Falschen geben?

Matrix – Regie: Andy und Lana Wachowski

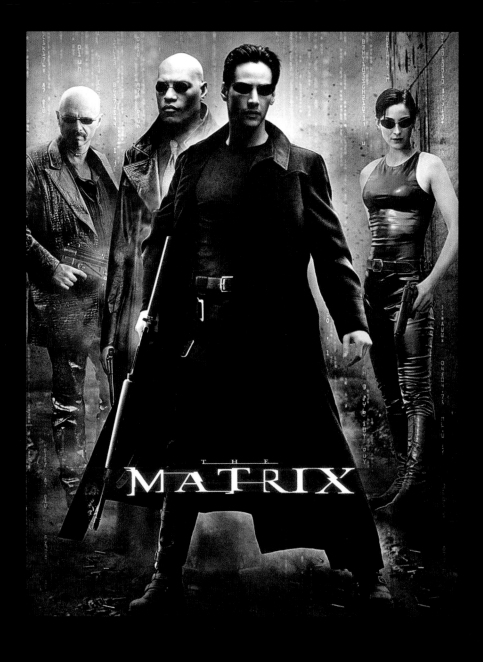

Filmplakat *Matrix*
Quelle: Interfoto/Mary Evans

Matrix

Regie: Andy und Lana Wachowski

Login

Die dreiteilige Science-Fiction-Serie „Matrix" (◼ Abb. 1) wurde von den Geschwistern Wachowski in den Jahren 1999 (*Matrix*) und 2003 (*Matrix Reloaded/Matrix Revolutions*) veröffentlicht. Das Autoren- und Regie-Duo spielt mit den globalisierten Technologien und deren virtuellen Wirklichkeiten und Identitäten der späten 1990er-Jahre. Mit hochgerüsteter Rechenkapazität, einer Vielzahl parallel arbeitender Kameras und einer ausgeklügelten Storyline entwerfen sie ein Zukunftsszenario, bei dem es zu einem Endkampf zwischen Mensch und Maschine kommt. Die Aktualität des Entwurfs für unsere heutigen, westlichen Identitäten und Sichtweisen auf die Technik ist ein wesentlicher Aspekt der künstlerischen Leistung der Wachowskis.

Die Handlung

Der Softwareprogrammierer Thomas Anderson (Keanu Reeves) arbeitet tagsüber für die Firma „Meta-Cortex". Nachts klebt er an Tastatur und Bildschirm, beschafft sich unrechtmäßig Kopien von begehrter Software – und verkauft sie zwischen Tür und Angel. Immer wieder beschleichen ihn Zweifel an der Welt, in der er lebt – ohne genau zu wissen, was diese Gefühle auslöst. Er schläft unruhig und träumt schlecht. Eines Tages erwacht er vor seinem Bildschirm, weil jemand seinem Hacker-Alter-Ego Neo eine Nachricht schickt:

💬 „Die Matrix hat dich!" ... „Folge dem weißen Kaninchen!"

Nach einem der Deals an der Wohnungstür sieht er ein Kaninchen-Tattoo und trifft die Entscheidung, der Aufforderung zu folgen. In einem Nachtclub offenbart sich ihm Trinity (Carrie-Anne Moss), eine Szene-Berühmtheit, wie sich Neo erinnert: Vor Jahren war sie in das Computersystem der Steuerbehörde eingedrungen. Trinity nährt Neos Zweifel und beunruhigt ihn weiter. Trinity weiß, dass Neo wissen will, was sich hinter der Matrix verbirgt und sagt:

💬 „Die Antwort ist irgendwo da draußen. Sie ist auf der Suche nach dir. Sie wird dich finden. Wenn du es willst."

Geheimdienstleute haben Neos Spur aufgenommen und wollen ihn in der Firma verhaften. Er versucht zu fliehen – und bricht den Versuch ab, als es lebensgefährlich wird. Der Agent Smith (Hugo Weaving) verhört ihn und verdeutlicht Neo unmissverständlich, dass er nicht anders kann, als zu kooperieren – um Morpheus (Lawrence Fishburne) gefangen zu nehmen, den Anführer einer Widerstandsgruppe.

Neo begegnet Morpheus, der ihm erzählt, dass er in Wahrheit als Sklave geboren ist, in einem Gefängnis für seinen Verstand. Bevor Morpheus ihn jedoch weiter hinab führt in die tiefsten Tiefen des Kaninchenbaus, muss Neo sich entscheiden: Schluckt er eine rote Pille, wird er erfahren, was die Matrix ist. Entscheidet er sich für die blaue Pille, geht sein Leben so weiter wie bisher. Neo wählt rot. Er will wissen, was die Matrix ist. Daraufhin wird das Ich des Thomas Anderson verwandelt und gleichsam neu geboren in einer ihm bis dato unbekannten Wirklichkeit.

Nach Neos (Wieder)-Geburt, hinein in eine Welt außerhalb seiner bisherigen Existenz (und seiner bisherigen Vorstellungskraft), durchlebt er eine Phase der Regeneration, der Rehabilitation und des

Trainings. Neo muss seine Muskeln aufbauen. Und er muss mit dem Umstand leben lernen, dass es sich bei seinem bisherigen Leben um eine computergenerierte Illusion gehandelt hat. Morpheus zeigt Neo, dass Menschen nicht mehr geboren, sondern von Maschinen in gigantischen Farmen gezüchtet und in einem geschlossenen Inkubator-System am Leben erhalten werden. Die Maschinen haben die Macht über die Menschen erlangt und schöpfen die menschliche Körperwärme ab, um sich selbst mit der gewonnenen Energie zu versorgen. Die menschlichen Körper sind in dieser Welt im 22. Jahrhundert die letzten noch existierenden Energiequellen.

Zuvor hatten die Maschinen jedoch lernen müssen: Nur wenn auch der Geist in der Hülle („Ghost in the shell"), nur wenn auch der Verstand Nahrung bekommt, funktioniert die menschliche Biomasse optimal. Ansonsten verkümmert sie – und kann keine Energie mehr liefern. Deswegen erfanden die Maschinen eine virtuelle Wirklichkeit, die Matrix, und speisen diese als kollektiv geteilte, interaktive Neurosimulation in die Menschenhirne ein. Die sozialen Existenzen in der Matrix (Programme für die Gehirne) werden durch die Maschinenintelligenz (fast) vollständig kontrolliert. Stirbt ein Mensch in den Zuchtfarmen, wird auch sein zugehöriges Matrix-Programm gelöscht. Bzw. umgekehrt: Wer in der Matrix aus der Reihe tanzt, zu viel Eigenständigkeit entwickelt und damit das System bedroht, dessen Persönlichkeit kann jederzeit durch den computergesteuerten Zugriff manipuliert oder sogar überschrieben werden.

Das Überschreiben der Matrix-Existenz kann aber auch – wie bei Neo, Trinity und Morpheus – als Akt der Subversion genutzt werden, um einen Menschen aus den Farmen zu befreien. Dadurch werden Mischwesen erschaffen, die zwar den Gesetzen der Schwerkraft unterworfen sind, deren Biologie sich aber die digitale Infrastruktur zu Nutze machen kann. Daneben steht der Preis dieser Wiedergeburt des Ich und der Wiedervereinigung von Leib und Seele: Die befreiten Menschen sind selber zu einem großen Teil maschinelle Existenzen. Sie sind vollständig künstlich erzeugt und leben als Cyborgs[1] mit einer Schnittstelle ins Zentralnervensystem.

Diese Wesen können sich über die Schnittstelle verschiedene Programme, zum Beispiel Orte und räumliche Gegebenheiten sowie Fähigkeiten und Fertigkeiten (Kung-Fu, Fliegen eines Hubschraubers), in die Tiefen ihrer Hirnstruktur laden lassen. Damit sind Neo und die anderen in der Lage, in die Matrix zu reisen, Kontakte zu knüpfen, die Aufgaben zu erledigen, die zu tun sind, um den Krieg zwischen den Maschinen und den Menschen zu beenden. Zunächst dient die Schnittstelle dazu, die Biomasse Mensch in den Farmen am Leben zu erhalten, weil sie ohne geistigen Input nicht überleben kann. Für diejenigen, die den Farmen entkommen sind, wird das Interface zum geöffneten Tor, mit der die Matrix, ihre Urheber und ihre Kontrollprogramme gezielt angegriffen werden können.

Denn die Menschen nehmen die Allmacht der Maschinen nicht länger hin. Morpheus war durch das Orakel (Gloria Foster) prophezeit worden, er würde den Auserwählten finden, der den Krieg mit den Maschinen beendet. Weil Morpheus in Neo den Auserwählten sieht, bringt er ihn zum Orakel. In dieser ersten Begegnung kommt allerdings eine ganz andere Möglichkeit ins Spiel: Neo ist nicht der Auserwählte. Weil Neo sich dennoch getrieben fühlt zu handeln, nimmt er zumindest den Kampf mit dem Agenten Smith auf. Und er verliebt sich in Trinity.

Die Liebe und das wachsende Bewusstsein für die eigenen Stärken verändern Neo. Dadurch gelingt es ihm, Morpheus' Leben zu retten und ihn Smith und den anderen Agenten zu entreißen. Mit dem

1 Das Wort „Cyborg" bezeichnet ein Mischwesen, zusammengesetzt aus einem lebenden Organismus und einer Maschine bzw. maschinellen Teilen. Der Begriff ist ein Akronym und besteht aus der Verbindung der zwei englischen Worten „cybernetic" und „organism" (dt.: „kybernetisch" und „Organismus"). Cyborgs sind demnach technisch veränderte biologische Lebensformen. In Diskussionsforen im Internet (vgl. z. B. http://www.matrix-explained.com/is_neo_a_program.htm, zugegriffen am 22. 2. 2012) wird eine Diskussion darüber geführt, ob es sich bei Neo, Morpheus, Trinity etc. tatsächlich um Menschen handelt, deren Körper technische Bauteile ausweisen oder ob sie – wie viele andere Figuren, die in den Matrix-Filmen zu sehen sind – lediglich Programme darstellen. Wir vertreten jedoch die Ansicht, dass es sich bei Neo, Morpheus und Trinity um Cyborgs im oben genannten Sinn handelt.

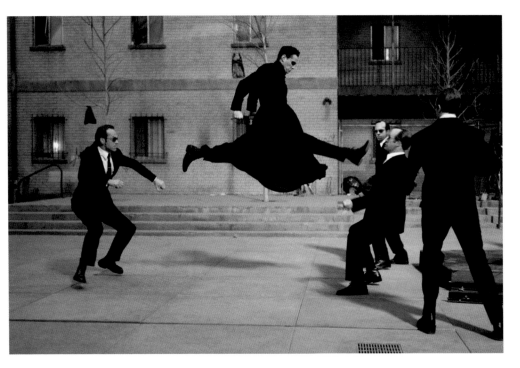

■ **Abb. 2** Neo kämpft gegen Smith und die wachsende Zahl der Smith-Kopien. (Quelle: Cinetext Bildarchiv)

dadurch gesteigerten Selbstbewusstsein stattet Neo erneut dem Orakel einen Besuch ab. Er erfährt, dass er zur Quelle muss, das heißt einen Weg finden, zurück zur Stadt der Maschinen. Er muss dahin zurück, wo die Matrix, deren Kontrollsysteme und letztendlich er selbst ihren Ursprung haben. Neo wird bewusst, dass er sich bereits entschieden hat, diesen Weg zu gehen, um Zion zu retten, jenes Refugium tief unter der Erde, in dem die letzten freien Menschen leben.

Auf dem Weg zur Quelle trifft Neo den Architekten (Helmut Bakaitis), das Programm, das die Matrix erschaffen hat. Neo muss sich anhören, dass der Architekt auch Neos virtuelle Existenz als Auserwählter bereits (vor)-programmiert hat. Neo ist mit speziellen Fähigkeiten ausgestattet, die es ihm ermöglichen, den Kampf der Menschen gegen die Maschinen besonders zu unterstützen. Läuft – laut Architekt – alles nach Plan, wird Zion den Krieg verlieren und Neo eine neue Kolonie im Erdinneren gründen. Die Maschinen erhalten Zion, weil sie den Menschen eine Möglichkeit zur Flucht aus der Matrix und aus der Gefangenschaft ermöglichen müssen. Auch die Maschinen (und speziell der Architekt als Programmierer der Matrix) können ihre komplexen Programme und deren Interaktionen und Anomalien nicht vollständig kontrollieren, und so ist Neos Matrix-Ich – als Bündelung aller Anomalien – in *Matrix Reloaded* bereits die Version 6.0. In einem ewigen Zyklus wird die Matrix mit einem Update neu gestartet und Zion neu gegründet.

Doch Neo entscheidet sich, aus dem Zyklus auszusteigen. Er unterläuft die Erwartungen der programmierten Vernunft und entzieht sich der weiteren Kontrolle. Er lehnt die Vorgabe des Architekten ab, rettet Trinity und versucht auf eigene Faust, den Kampf mit den Maschinen aufzunehmen und Zion zu retten.

Allerdings steht ihm dabei zunehmend Smith im Weg. Obwohl Neo den Robocop in der Matrix bereits einmal überschrieben hat, kehrt er zurück in die Handlung – wie ein Virus auch noch tausendfach vervielfältigt (■ Abb. 2). Während die Maschinen also zum Endkampf gegen Zion rüsten, will Smith die Macht in der Matrix übernehmen und wird somit selbst zur Bedrohung für die Maschinenintelligenz,

die ihn geschaffen hat. Neos Weg, den Krieg zu beenden – oder zumindest einen Waffenstillstand zu erreichen – führt zur finalen Konfrontation mit dem außer Kontrolle geratenen Programm Smith, das er stellvertretend für die Maschinenintelligenz in der Matrix besiegt. Die Maschinen stoppen dafür ihren Vernichtungsfeldzug gegen Zion. Am Ende ist Zion gerettet, aber sowohl Neo als auch Trinity haben sich für den Frieden geopfert.

Hintergrund (Zur Entstehung des Films, Regisseur, Drehbuch)

Als der erste Teil der Matrix-Trilogie 1999 erschien, hatten die Wachowski-Geschwister eine lange Wegstrecke zurückgelegt. Sie waren zwar in Hollywood bereits als Drehbuchautoren bekannt, doch der Produzent Joel Silver, dem sie das Matrix-Drehbuch vorlegten, verstand die Story zunächst nicht. Erst nachdem die Geschwister ihn mit dem Manga-Film *Ghost in the Shell* (*Geist in der Hülle*, siehe Janus u. Janus in diesem Band) vertraut gemacht hatten und ihm erklärten, wie sie sich den Film vorstellten, nämlich als Pendant zu *Ghost in the Shell*, aber mit echten Schauspielern in einem Action-Spektakel, begeisterte sich Joel Silver für die Idee des Films[2]. Filmtechnisch ging die Filmtrilogie neue Wege. Die gleichzeitige Verfilmung der Szenen mit bis zu 122 Kameras[3] ermöglichte eine bis dahin unbekannte Zeitlupenauflösung, die in den Actionszenen eingesetzt wurde, und zu neuartig inszenierten Bildern führte. Dies läutete eine neue Ära in der filmischen Gestaltung ein. Neben den drei Filmen wurden weitere Materialien veröffentlicht, wie das Videospiel „Enter the Matrix" und die Kurzfilme von „Animatrix", die den Hintergrund der Storyline weiter ausleuchten.

Inhaltlich sucht die Matrix-Reihe in einer kaleidoskopisch–phantasmorgischen Art Antworten auf Fragen, wie sie sich seit Gibsons *Neuromancer* aus dem Jahre 1984 in Buch und Film entwickelt haben und die seitdem in den kulturellen Kanon eingeflossen sind. Zum kulturellen Hintergrund zählen neben dem bereits erwähnten Manga *Ghost in the shell* auch das Buch „Snow Crash" von Neil Stephenson oder die Bücher von Ray Kurzweil. Die theoretischen Überlegungen zum Transhumanismus (die Überwindung des Menschseins und das Hineinwachsen ins Maschinesein) gehören ebenso dazu wie die Cyborg-Ideen der Donna Haraway.

Die Trilogie hat eine beachtliche Zahl von Veröffentlichungen nach sich gezogen, die allesamt versuchen, die impliziten Bedeutungsebenen weiter zu entschlüsseln (vgl. Cartwright 2005, Haslam 2005, Kimball 2001, McGrath 2010, Stucky 2005). Bis heute dauert der durchaus kontrovers geführte, kultur- und religionsphilosophische Diskurs über die Werthaltigkeit dieses filmischen Entwurfs an. Die Anzahl der Beiträge zeigt unseres Erachtens die der Trilogie inne wohnende Tiefenwirkung. Die Matrix-Trilogie stellt alte Fragen zum Sinn unseres Lebens auf neue und vor allem bildergewaltige Weise: Wer bin ich? Wer sind wir? Was ist unser Weg? Ist uns das Schicksal unseres Lebens einkodiert? Können wir unserer Bestimmung entrinnen? Oder müssen wir ihr zwangsweise folgen? Treffe ich meine Entscheidungen selbst oder werde ich von einer anderen – inneren oder äußeren – Instanz gesteuert?

Die Trilogie spielte weltweit etwa 1,6 Milliarden Dollar ein[4]. Auch das Computerspiel hat sich hunderttausendfach verbreitet, wohl weil es den Benutzern erlaubt, sich selbst Zugang zur Matrix zu verschaffen.

2 http://www.matrix-architekt.de/wachowskis/leben.shtml. Zugegriffen am 23. 12. 2011
3 http://de.wikipedia.org/wiki/Matrix_(Film). Zugegriffen am 28. 12. 2011)
4 http://boxofficemojo.com/franchises/chart/?id=matrix.htm. Zugegriffen am 6. 1. 2012.

Filmwirkung

Die Wachowski-Geschwister bedienen sich in der von ihnen erschaffenen Filmwelt global entlehnter Bilderwelten und verweisen auf philosophische, religiöse und mythologische Traditionen, die weltweit Assoziationen wecken und verstanden werden. Buddhismus, christlich-jüdische Traditionen, asiatische Kampfkunst, sinnstiftende Schöpfungsmythen (vgl. Kimball 2001) und Bezüge zur Traumreise bei „Alice im Wunderland" verdichten sich zu einem visuellen Rausch. Manche Kritiker sehen deshalb in dem Film *Die Matrix* bei all dem durchmischten kulturellen Rückbezug ein postmodernes Beliebigkeit-Märchen, einen filmischen „Rorschach-Test" (Žižek 2000), zusammengesetzt aus allerlei Versatzstücken – und nicht eine absichtsvolle Komposition, die uns einen globalen Spiegel vorhält. Unseres Erachtens liegt ein Teil der Faszination der Film-Trilogie jedoch genau darin begründet. Die Geschichte und ihre Bilder berühren uns wegen unserer Mythengläubigkeit, unserer Sinnsuche, unserer Dauerthemen: Warum sind wir hier? Was ist unsere Aufgabe? Warum ist die Welt so, wie sie ist?

Unsere Empfänglichkeit dafür, solche Fragen mit kulturell verankerten Geschichten und gerade nicht mit wissenschaftlichen Fakten zu beantworten, scheint allerdings anzusteigen. Und zwar in dem Maße, wie die Neurowissenschaften Belege finden, dass unser Bewusstsein allenfalls eine Art weiterer Kontrollinstanz darstellt, geschaffen vom Unbewussten, das damit das Ich glauben lässt, im Freud'schen Sinne Herr im eigenen Haus zu sein.

Zu diesem eher „subkutan" wahrgenommenen Eindruck, zunehmend die Kontrolle über die eigenen Entscheidungen zu verlieren, gesellt sich eine verwirrende Technologisierung unseres Alltagslebens. Die Verwirrung entsteht durch die Ambivalenz, die mit der Technologie einhergeht: Einerseits können wir beispielsweise unliebsame Arbeiten an Computer und roboterähnliche Maschinen delegieren. Damit könnten wir irgendwann dem alten Menschheitstraum des Schlaraffenlandes nahekommen. Andererseits werden jedoch für die Beherrschung der Technologie neue Kompetenzen benötigt, sodass für Viele der Traum zum Alptraum wird. Je komplexer die technischen Möglichkeiten werden, desto undurchschaubarer werden die real stattfindenden Abläufe innerhalb der Maschinen. Die beschriebene Ambivalenz wird weiter verschärft, weil sich parallel zur Technologisierung menschliche und künstliche Daseinsformen vermischen (Transhumanismus), die stark verunsichernd wirken (können). Die Technikphilosophin Haraway pointiert das Verhältnis von Mensch und Maschine so (1995 S. 37):

> Die Maschinen des späten 20. Jahrhunderts haben die Differenz von natürlich und künstlich, Körper und Geist, selbstgelenkter und außengesteuerter Entwicklung sowie viele andere Unterscheidungen, die Organismen von Maschinen zu trennen vermochten, höchst zweideutig werden lassen. Unsere Maschinen erscheinen auf verwirrende Weise quicklebendig – wir selbst dagegen aber beängstigend träge.

Was Haraway in ihrem „Manifest für Cyborgs" theoretisch begründet, setzen die Geschwister Wachowski filmisch um. Der Zuschauer gerät zunächst selbst in einen Zustand äußerster Verwirrung darüber, was und wer in diesem Film „echt" und was und wer „unecht", also programmiert ist. Haraways Postulat der sich auflösenden Differenz zwischen „natürlich" und „künstlich" wird im Film dargestellt in den fließenden Grenzen zwischen maschineller und organischer Intelligenz, der Prothetisierung der menschlichen Biomasse (filmisch repräsentiert durch den dornartigen Stecker, der in die Schnittstelle am Stammhirn geschoben wird) und der Emotionalisierung der Maschine.

Drei Spezies treten im Film auf und repräsentieren die verschiedenen Universen des Plots:

- Robotergleiche Gestalten, reine Maschinenwesen, „Digital Code only", die über eine hoch entwickelte, ursprünglich der menschlichen Intelligenz nachempfundene AI (Artificial Intelligence) verfügen, verkörpert im Orakel, im Architekten und im Agenten Smith, die ausschließlich innerhalb der virtuellen Wirklichkeit der Matrix existieren können.
- Die Mischwesen aus Mensch und Maschine, die Cyborgs, diejenigen mit den Schnittstellen zur Matrix, die bei geschickter Anwendung in der Lage sind, jeweils das Beste aus der fleischlich-analogen und aus der geistig-ephemeren Welt herauszuholen. Zu ihnen zählen die Helden der Trilogie: Neo, Trinity und Morpheus.
- Schließlich jene selten gewordene Spezies, die erdkernnah in Zion leben müssen, weil ihre überirdische Lebensgrundlage endgültig zerstört ist: Menschen aus Fleisch und Blut, geschaffen im sexuellen Akt zwischen Mann und Frau. Menschen, die jedoch auch im Refugium Zion für ihr Überleben unabdingbar auf Maschinen angewiesen sind, um beispielsweise die dort genutzte geothermische Energie umzuwandeln, um elektromagnetische Impulse zu erzeugen oder trinkbares Wasser aufzubereiten.

Von diesen drei Formen intelligenten Lebens präsentiert uns der Film die Maschinenwesen als die erfolgreichste Art. Sie haben die Menschen an zentraler Stelle entmachtet, indem sie ihnen den Zeugungsakt entrissen haben. Nicht nur, dass sie sich selbst ohne menschliches Dazutun reproduzieren, vielmehr haben sie die Fähigkeit entwickelt, auch den gesamten menschlichen Reproduktionszyklus ihrer Kontrolle zu unterwerfen. Die Maschinen stehen im Film für die kalte Logik, für die reine Effektivität, eine in ihrer Sachlichkeit grausame Lebensform. „Bio Code only" repräsentiert im Film das Gegenteil dazu: Das Gute, die Hoffnung, das zu Bewahrende. Diese Form der Existenz wird durch Zion als Heimat der Menschen, und durch die Brüder Tank und Dozer verkörpert, die als Steuerleute und Matrix-Hacker auf Morpheus' Kampfkreuzer Nebukadnezar arbeiten – ohne je selber in die Matrix reisen zu können.

Emotionaler Ausgangsort der Filmhandlung sind die unendlichen Weiten der Zuchtfarmen, die den Maschinen als Energielieferanten dienen. Nahezu unmittelbar stellt sich beim Zuschauer eine erschreckende Assoziation an die Effizienz nationalsozialistischer Konzentrationslager ein. In den Zuchtfarmen wird die Conditio humana programmtechnisch auf ein absolutes Minimum reduziert – und der Rest negiert. Die dahinvegetierenden Menschen sind ohne jede subjektive Ausdrucksmöglichkeit, ihr Körper bleibt auf seine basalen lebenserhaltenden Funktion reduziert. Zwischenmenschliches Handeln ist über die Matrix simuliert, keine eigene Erfahrung, sondern ein eingespieltes Programm. Als Vorlage dient die US-Gesellschaft von 1997.

Die Totalität der Maschinenmacht erzeugt eine traumatische Grundsituation – aus der zunächst kein Erwachen vorgesehen ist. Um die allumfassende Ohnmacht und Abhängigkeit der Menschen zu kompensieren, wird dem menschlichen Gehirn die Matrix als Fluchtpunkt beziehungsweise wie eine Droge angeboten: Flucht in die illusionäre Scheinwelt der computeranimierten Matrix. Doch selbst hier herrscht Kontrolle. Smith und seine Agenten-Kollegen überprüfen fortwährend die Abläufe in der Matrix und unterbinden notfalls gewaltsam unerwünschtes Verhalten. Erlaubt sind alle (betäubenden) Vergnügungen, verboten ist eigenständiges Denken.

Der unerträglichen Existenzform in den Zuchtfarmen wird im Film das reale Leben in Zion gegenüber gestellt. Im Gegensatz zu den Zuchtmenschen ist es den Menschen in Zion möglich, eine soziale Gemeinschaft zu bilden und ihre Bedürfnisse zu befriedigen. Insbesondere in der Tempelszene (*Matrix Reloaded*) werden die originären, menschlichen Wünsche nach Zusammenhalt, Nähe, Leidenschaft und Sexualität dargestellt. Zwar ist Zion von der äußeren Macht der Maschinen bedroht, dennoch ist die Macht hier (be)greifbar, kann als „Außen" wahrgenommen und dort bekämpft werden.

Die Darstellung Zions wirkt allerdings anachronistisch. Unwillkürlich denkt man an einen indigenen Stamm, der vor den Zumutungen einer aggressiv-imperialen Kultur geschützt werden will. Um die eigene Kultur zu erhalten, wird Zion bis zum letzten Blutstropfen verteidigt. Entgegen dem ersten Anschein ist Zion, das Gute, jedoch kein sicheres Refugium für die menschliche Freiheit. Spätestens in *Matrix Reloaded* wird deutlich, dass Zion eine kontrollierte Größe in der von den Maschinen aufgestellten Gesamtgleichung ist. Zum einen verwenden die Maschinen Zion als Sicherheitskopie, das Original „Mensch" wird in eine Art Zoo gesperrt, um bei Gelegenheit und vor allem bei Bedarf darauf zurückgreifen zu können. Zur optimalen Manipulation der Biomasse werden einige Abkömmlinge des Originals benötigt. Zum anderen brauchen die Maschinen Zion als ein Ventil, um den nicht kontrollierbaren Anteilen des Menschen, seiner spezifischen Lebendigkeit, einen Ort zu bieten.

Indem sich die Menschen aus den Zuchtanlagen befreien, entsteht für sie subjektiv das Gefühl einer freien Entscheidung. Doch Neo (und damit dem Zuschauer) wird nach und nach bewusst, dass dieser scheinbar freien Entscheidung keine tatsächliche Freiheit zu Grunde liegt. Vielmehr wird all das – wie auch der Kampf Zions gegen die Maschinen insgesamt – von der Maschinenmacht antizipiert und gewollt inszeniert. Aufgrund dieser perfiden Eigenschaft des Herrschaftssystems lassen sich in der Filmreihe weitere Bedeutungsdimensionen erkennen, nämlich existenzielle Fragen der menschlichen Gemeinschaft: Was macht das Mensch-Sein aus? Wie entwickelt sich das Mensch-Sein unter totalitären Bedingungen? Wie ist moderne Totalität beschaffen? Ist Subversion möglich?

Das Gespräch mit dem Architekten (*Matrix Reloaded*) öffnet Neo die Augen darüber, wie pervers das durch die Maschinen geschaffene Macht- und Kontrollsystem ist. Erst in Folge dieser Konfrontation begreift Neo, und mit ihm der Zuschauer, wie allumfassend und allmächtig die Matrix ist. Beispielhaft für die allgegenwärtige Macht der Kontrolle steht das Orakel. Auch das Orakel ist ein Programm. Es ist erschaffen worden, um spontanes, abweichendes, nicht normiertes Verhalten, wie es Menschen immer wieder zeigen, besser kontrollieren zu können[5]. Dieses Wissen destabilisiert Neos Beziehung zum guten Objekt Orakel. Es gibt keinen machtfreien Ort, keine hilfreiche Institution, keine wohlwollende Prophezeiung, wie von Morpheus angenommen. Die Macht reproduziert sich selbst in allen Strukturen. Unabhängigkeit jenseits der Maschinenwelt ist nicht möglich.

Es ist eine Welt a là Foucault (Foucault 1987; Wilchins 2006), in der die Idee eines autonomen Subjekts und dessen konsistenter Biografie als Herrschaftsinstrument entlarvt wird. Die subjektiven Bedeutungen, die sich Personen zuschreiben – als Mann, Frau, in beruflicher Hinsicht, etc. – sind nach Foucaults Analyse durch die Herrschaft des Systems vorgegeben. Das Subjekt fügt sich in seinem biografischen Verständnis seiner selbst in das vorgefertigte, bereitgestellte Muster ein. Auch im jeweils aktuellen, subjektiven Erleben wird nur der vorhandene Code abgerufen. Aus dieser Herrschaft gibt es kein Entrinnen. Der Wunsch mancher der gezüchteten Menschen, sich aus den Zuchtanlagen zu befreien, ist bereits vom System mitgedacht.

Hier entfaltet das Orakel als Machtinstrument seine Wirkung. Das Orakel betont die Entscheidungsoption des Einzelnen als Weg, sich subjektiv seiner selbst zu versichern. In den Zuchtanlagen verbleiben oder aussteigen und kämpfen? Diese Entscheidung entpuppt sich als Scheinfreiheit, und so offeriert das Orakel lediglich eine weitere Illusion. Der Kampf gegen die Maschinenwelt ist im Ergebnis sinnlos, weil das Ende vorgegeben ist: Zion wird regelmäßig zerstört und wieder erschaffen. An dieser Herrschaftsstruktur kann auch Neo nicht rütteln und die Filmreihe endet genau mit dieser Einsicht: Alles bleibt wie es war. Die Entscheidungen der Menschen in den Zuchtanlagen sind begrenzt. Die Befreiung bleibt Teil des Systems. Der Film ist in dieser Hinsicht durchweg pessimistisch.

5 Das Orakel als gutes therapeutisches Objekt zu verstehen und gleichzeitig als Teil der Herrschaftsstruktur zu erkennen, wirft Fragen auf: Welche Rolle spielen Therapie, Therapeuten und die anderen psychosozialen Hilfssysteme, wenn es ihre Aufgabe ist, Abweichungen und Anomalien zu behandeln, damit das System funktionieren kann? Ist die Verringerung individuellen Leids der Anreiz, die übergeordnete Herrschaftsstruktur zu akzeptieren bzw. zumindest nicht mehr in Frage zu stellen?

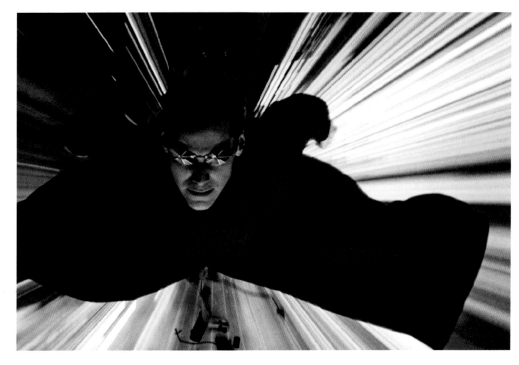

◘ Abb. 3 Neo bewegt sich in der Matrix jenseits von Raum und Zeit. (Quelle: Cinetext Bildarchiv)

Folgen wir Foucault, gelangen wir von der deskriptiven Analyse der Macht zu den Formen der Subversion[6]. Dafür steht Neo. Im Gegensatz zu Morpheus, Trinity und seinen fünf Vorgängern ist Neo in der Lage, Nicht-Vorgesehenes zu denken und Entscheidungen zu treffen, die so vom System nicht vorhergesehen waren. Durch diese Fähigkeit, sein Denken und Handeln zu erweitern, eröffnen sich Neo neue, bis dahin undenkbare Verhaltensmöglichkeiten. Foucault betont die Subversivität dessen, was als krankhaft gilt und vom System ausgesondert wird. Und es ist gerade das Schizoide (siehe nachstehendes Unterkapitel „Psychodynamische Interpretation/Deutung des Films") in Neos psychischer Ausstattung, das ihm ermöglicht, das System zu durchschauen und zu dekonstruieren, das heißt, die Bedeutungszuschreibung von Begriffen als Teil der Machtausübung zu verstehen.

Etwas Subversion ist den meisten der befreiten Menschen aus den Zuchtanlagen eigen. Sie können in der Matrix von einem Dach zum nächsten springen und so der (staunenden) Polizei entkommen. Sie können in blitzschnellen Reaktionen Gewehre abfeuern. Oder gegen die Schwerkraft asiatische Kampfkunst einsetzen. Damit überwinden sie die vorgegebenen Grenzen und die Vorstellungen davon, was einem Menschen möglich ist. Dennoch entstehen in der subversiven Kultur der befreiten Zuchtmenschen erneut Regeln. In der Gruppe bilden sich spezifische Bedeutungen und Begriffe aus, die die Erfahrungswelten (vor-)strukturieren. Auch hier werden Begrenzungen des Möglichen vorausgesetzt. Es ist allein Neo vorbehalten, über die etablierten Gesetze hinauszugehen. Weil Neo aufgrund seines

6 Subversion bezeichnet im allgemeinen Vorgänge, die darauf abzielen, eine bestehende Ordnung in Frage zu stellen bzw. zu verändern. Im poststrukturalistischen Diskurs, zu dem Foucault nachhaltig beigetragen hat, wird vor allem der konstruktive Aspekt der Subversion betont – im Gegensatz zu gewalttätigen, umstürzlerischen Vorgängen, die ausschließlich auf die Abschaffung der Machtstrukturen abzielen. Nach Foucault kommt Subversion vor allem durch Aneignung, Umbewertung und Verschiebung der herrschenden Strukturen, des herrschenden Diskurses, zustande, wodurch die bestehende Ordnung außer Kraft gesetzt wird. Erst dadurch wird die Gewordenheit der Machtverhältnisse aufgezeigt und einer Veränderbarkeit zugeführt (vgl. auch Kurz 2009).

Charakters ein fundamentaler Zweifler ist, dem Glauben und beruhigende Anlehnung nicht möglich sind, kann er sich an das Vorgegebene nicht halten. Neo begreift, dass auch Raum und Zeit in der Matrix nur eine Illusion sind. Deshalb kann er sich in der Matrix außerhalb dieser Dimensionen bewegen. Auf dieser Art der Erkenntnis beruht auch das Aufhalten von Gewehrkugeln. Nur die Anerkennung der Gewehrkugel als eine solche macht diese zur tödlichen Waffe (◙ Abb. 3).

Mit Smith gerät Neo allerdings an einen Gegner, der wie er die Regeln der Matrix nicht anzuerkennen bereit ist. Dass Smith von einer anderen Motivation getrieben wird, spielt dabei keine Rolle. Auch Smith verkörpert eine subversive Alternative. Zunächst verficht Smith die Maschinenideale mit effizienter Konsequenz. Er scheint keinen Zweifel zu kennen. In seiner maschinell-reduzierten Ausstattung ist nicht vorgesehen, dass ein Thomas Anderson/Neo in der Lage ist, ihn auszuschalten, das heißt ihn zu überschreiben. Die Subversion des Smith beginnt am Ende des ersten Films. Neo kopiert einen Teil seines Selbst auf das Programm Smith. Dadurch dringt etwas Falsches, nämlich Menschliches, in das Agentenprogramm ein. Damit entgleist der Code des Agenten und Smith durchläuft in Folge eine furiose Menschwerdung.

Für ein Programm völlig sinnlos, beginnt Smith seinen eigenen Daseinszweck zu hinterfragen. Die Frage nach dem Sinn der eigenen Existenz kann von ihm zwar nicht beantwortet werden, und sein Versuch damit umzugehen bleibt rein mechanistisch: Smith meint die Leerstelle durch maximale Vervielfachung kompensieren zu können. Doch das per se ohne Emotionen ausgestattete Programm des kalten Agenten entwickelt zunehmend Leidenschaft, tiefe Gefühle von Hass und Abscheu und ergibt sich in sehr menschliche Allmachtsfantasien. Damit sprengt Smith die für ihn festgeschriebenen Gesetze, er gerät für die Matrix außer Kontrolle. Weil weder Neo noch Smith die gesetzten Regeln akzeptieren, kann keiner den anderen besiegen. Beide befinden sich außerhalb der geltenden Bedeutungszuschreibungen und können deshalb keine Macht über den anderen ausüben. Am Ende erweisen sie sich als gleichstark und es ist erneut das herrschende System, das die Oberhand behält.

Der Film endet ohne eine tatsächliche Veränderung der bestehenden Welt. Der Waffenstillstand mit den Maschinen ist temporär. Neos Tod lässt sich als Ausdruck der Camus'schen Haltung interpretieren, das Leben analog dem Sisyphos-Mythos zu verstehen (Camus 1999). Dennoch haben Neos subversive Akte Spuren hinterlassen. Sie haben die Dualität in Frage gestellt und die Option eines dritten Weges eröffnet. Die Subversion ist die Hoffnung: Jedes totalitäre System produziert die Subversion immer mit, die es zum Einstürzen bringt. Dabei gilt: Ein kontrollierendes System ist umso stabiler bzw. umso erfolgreicher, je mehr Subversion, Abweichung und Anomalie es zulässt.

Psychodynamische Interpretation des Films

Zunächst lernen wir Neo, den Hacker, in seiner Existenz in der Matrix kennen. Nach seiner Befreiung aus der Zuchtanlage wird jedoch deutlich, dass diese Existenz lediglich eine Scheinexistenz war. Was Neo bislang für sein Leben hielt, stellt sich als computeranimierte, sensorische Stimulation seiner Nervenzellen heraus, als Illusion. Neos Körper, seine Sinne und Muskeln, sind unbenutzt. Im Sinne der ursprünglichen altgriechischen Bedeutung seines Namens ist er tatsächlich „neu", als er auf der „Nebukadnezar" erstmals willkürlich über seinen Körper verfügen kann. Auch arbeitet sein Intellekt erstmals ohne computergesteuerten Input. Als in diesem Sinne Neugeborener trifft Neo auf den Kommandanten Morpheus und seine Crew, die nun seine soziale Umwelt sind. In der erschütternden Situation, in einer anderen Welt erwacht zu sein, wird die Crew zu seiner Familie, die ihn trägt und die ihn mit den neuen Umständen vertraut macht. Neo muss sich selbst (er)finden, seine Persönlichkeit erkennen. Folgerichtig verweist dann das Orakel, das in dem Film die therapeutisch-analytischen Funktionen der Spiegelung, Konfrontation und Deutung übernimmt, in der ersten Begegnung auf eine Inschrift über der eigenen Küchentür:

💬 "Temet Nosce. Erkenne dich selbst."

Insofern lässt sich der Film zunächst wie eine Reise Neos zu sich selbst verstehen. Neo wendet sich im Prozess der Persönlichkeitsentwicklung zunächst an Morpheus. Dieser vertritt als Vaterfigur die Werte und Ideale, mit denen Neo in seiner neuen Familie konfrontiert wird. Morpheus ist selbst aus den Feldern befreit worden. Er hat seinen Lebenssinn im Kampf gegen die Macht der Maschinen und das Überleben von Zion gefunden. Als Soldat einer guten Sache hat er das Ideal der Selbstopferung verinnerlicht. Als Kompensation für die potenzielle körperliche Auslöschung gelten im Ideal des Kriegers die Anerkennung und Verehrung durch die soziale Gruppe sowie das Weiterleben in der Erinnerung der Gruppe. Neben diesem idealisierten Krieger-Selbstbild ist Morpheus' Charakter geprägt durch einen geradezu naiven Glauben an die Weissagungen des Orakels, das für Morpheus mit einer Art höherer Macht ausgestattet ist und dem er die Funktion eines Gurus oder Priesters zuweist. Auf Morpheus' Wertvorstellungen und seinem Glauben beruht der Zusammenhalt auf der Nebukadnezar. Deshalb wird die gegenseitige Frage der Crewmitglieder, ob sie Neo für den Auserwählten halten, zum Loyalitätstest gegenüber der Vaterfigur Morpheus.

Neo steht aufgrund seiner vorgesehenen Rolle als Auserwählter jedoch außerhalb der Crew. So ist es ihm verwehrt, sein Selbst durch die Identifikation mit der Gruppe zu bestimmen. Er ist der Lieblingssohn des Vaters Morpheus, der ihn bevorzugt und ihn unterrichtet. Seine Sonderstellung zwingt ihn dazu, die Differenz zwischen sich und den Anderen zu betonen. So bindet sich Neo ganz an Morpheus, den er bewundert und liebt. Neo erweist sich als ergebener Sohn – und sieht sich zunächst, prophezeit durch das Orakel, dazu bestimmt, sein Leben zu opfern, um Morpheus' Leben zu retten.

Morpheus erweist sich als guter Vater, der den Sohn fördert, ohne ihn zu unterwerfen. An seiner Seite kann Neo wachsen, und auch wenn Morpheus den Glauben an Neo als den Auserwählten nie aufgibt, lässt er diesem wiederum seine Zweifel und Geheimnisse. Er verlangt keinen Gehorsam. Die Beziehung zwischen Morpheus und Neo beruht auf gegenseitiger Anerkennung, in der die Selbst-Objekt-Grenzen gewahrt sind. So betont Morpheus nach Neos Unterredung mit dem Orakel die Vertraulichkeit des Gesprächs. Neos Liebesbeziehung zu Trinity verändert seine Beziehung zu Morpheus. Trinity ist zunächst als zweite Offizierin die Mutterfigur der Crew, um deren Anerkennung die Crewmitglieder konkurrieren. Durch die sexuelle Beziehung mit Trinity entwächst Neo der Sohnrolle. Morpheus selbst akzeptiert Neos Reifungsprozess, denn er glaubt bedingungslos an ihn.

Neos psychische Entwicklung im Verlauf der drei Filme ließe sich also als adoleszente Ablösung vom Vater begreifen: Konfrontiert mit den Wertvorstellungen seiner sozialen Umwelt und der ödipalen Auseinandersetzung mit dem Vater, entwickelt sich Neo vom Schüler/Sohn zu einer reifen, eigenständigen Persönlichkeit. (In diese Richtung wurde der erste Teil, *Matrix*, von Ludwig Janus interpretiert; vgl. Janus 2001).

Diese Sichtweise ist eine mögliche Lesart der Psychodynamik der Filmhelden und des im Film dargestellten unbewussten Materials. Wir werden nun eine weitere Lesart vorstellen.

Die psychische Grundsituation

Als Erzeugnis der Zuchtanlagen ist Neo in einer mechanischen, ausbeuterischen und invasiven Mutterumgebung aufgewachsen. Das mütterliche Maschinenerbe ist auch nach Neos Befreiung aufgrund der digitalen Schnittstellen an seinem Körper zu sehen, und diese machen ihn zu einem Cyborg, dessen Körper neben der Biomasse auch Maschinenteile beinhaltet. Die gezüchteten Menschen unterscheiden sich damit auch äußerlich von den Menschen aus Zion, die solche Schnittstellen nicht aufweisen. Psychodynamisch fehlt Neo – wie allen Menschen, die in die Felder hinein geboren werden – in seiner frühen biografischen Entwicklung die ausreichende emotionale Versorgung durch eine mütterliche Person, die ihn hält und kindgerechte Fürsorge bereitstellt. Seine soziale Umgebung wird ihm nur via Schnittstelle eingespielt. Bezeichnenderweise tauchen in den Filmszenen, die in der Matrix spielen,

keine Kinder auf[7]. Wir erfahren also nichts darüber, ob Neo als Kind in der Matrix lebte, ob er dort Eltern, Geschwister oder Freunde besaß und so eine illusionäre Resonanz erhielt. Sein frühkindliches Ich erhält in der realen Maschinenumgebung jedoch zu wenig Wärme, Zuwendung und Resonanz. Aus dem Mangel entsteht ein unterversorgtes, einsames Selbst voller Sehnsucht nach einem guten versorgenden Objekt. Mit Rudolf ließe sich diese frühe innerpsychische Situation als massive Ausprägung des depressiven Grundkonflikts verstehen, der aufgrund seiner Intensität von dem Individuum nicht verarbeitet werden kann (Rudolf 2000, S. 149 ff.).

In Neos Wesen findet sich demnach eine tief verankerte Hinterlassenschaft der einstigen Verlorenheit und des Ausgeliefertseins. Die bewusst nicht wahrnehmbare Realität der Versklavung durch die Maschinen bleibt als unbewusstes Vorstellungsbild der mütterlichen Maschinenumgebung, als hochambivalente Mutterimago in Neo und den anderen Cyborgs bestehen. Charakteristisch für die Mutterimago sind zwei Aspekte: Zum einen die sadistisch-kalte Maschinenseite, die unbeirrt Energie erntet. Zum anderen die verführerische Seite, die den Subjekten dazu verhilft, die Wirklichkeit verleugnen zu können und das emotionale Defizit auf diese Weise scheinbar eliminiert.

Entsprechend nähert sich die Maschinenmutter dem Subjekt, ihrem Kind, mittels zweier Beziehungsfiguren: Sie verlangt zum einen absoluten Gehorsam, die Unterordnung unter ihre Bedürfnisse. Und sie verspricht zum anderen Teilhabe an ihrer Grandiosität, ihrer allumfassenden Macht. Eingeloggt in die Matrix ist scheinbar alles möglich. Die Grenzen der körperlichen Belastbarkeit sind aufgehoben. Die Schwerkraft ist überwindbar. Welt-Wissen ist unbegrenzt verfügbar und jederzeit nachladbar. Der Selbstobjektcharakter, mit dem die Maschinenmutter ihre Kinder funktionalisiert, führt zu einem innerpsychischen Kampf. Auf der einen Seite steht der Drang nach Subjektwerdung, Autonomie und Selbstbehauptung, der darin gipfeln kann, aus der Matrix befreit zu werden. Diese Loslösung von der Mutterimago führt allerdings unweigerlich dazu, von den eigenen Defiziten und Grenzen zu erfahren. Die Affekte sind plötzlich spürbar, müssen im Subjekt ausgehalten und verarbeitet werden. Auf der andern Seite steht die Verführung, die Trennung von der Mutterimago zu vermeiden. Hier erfüllt sich der Wunsch, verschmolzen zu bleiben mit der mütterlichen Welt, in der Differenzen nicht wahrgenommen und die Affekte nicht ausgehalten werden müssen. Die Einsamkeit des Subjekts ist hier scheinbar aufgehoben. Alle befreiten Zuchtmenschen kämpfen letztendlich mit der Wahl dieser beiden Möglichkeiten.

Nach der Befreiung hat das befreite Subjekt Zugang zu der vormals unbewussten Mutterimago. Die Individuen werden sich der eigenen biografischen Bedingungen bewusst. Sie können nun spüren, wie fundamental benachteiligt sie als versklavte Körper bisher gelebt haben. Im Verlauf der Filme wird gezeigt, wie Neo, Morpheus und Trinity versuchen, die traumatische Grundsituation zu bewältigen und einen Umgang mit dem emotionalen Mangel zu finden.

Neo

Thomas Anderson/Neo ist schon in der vorbewussten Situation der Matrix ein Zweifelnder. Bereits in seinem Matrix-Leben nagt an ihm das Gefühl, dass etwas nicht stimmt. Diese Ahnung basiert einerseits auf dem Wissen, das er sich als Hacker aneignet. Zum anderen scheint er aber auch eine sensorische Unstimmigkeit wahrzunehmen, was ihm seine besondere Sensitivität gepaart mit einer großen Willensstärke ermöglicht. Dazu kommen hohe Intelligenz und eine kognitive Schnelligkeit, die es ihm erlauben, komplizierte digitale Zusammenhänge zu durchschauen. Neo ist ein Cyber-Punk, ein typischer Nerd, der es vorzieht, seine Freizeit alleine vor dem Computer zu verbringen. Er kann sich mit den illusionären Vergnügungen innerhalb der Matrix nicht betäuben, ist aber auch nicht angebunden an die Community der Hacker. Er misstraut jedem. Seine psychische Grundausstattung erlaubt ihm

7 Einzige Ausnahmen sind im ersten Teil das Kind mit dem Löffel in der Wohnung des Orakels, das sich als Programmvariante (im englischen Original „potential") des Orakels erweist und, im dritten Teil, Sati, ebenfalls ein Programm.

keine Bezugnahme auf andere. Es sind allein die Computerwelten, in denen er sich wohl fühlt. Sein Modus ist die schizoide Verarbeitungsform des depressiven Grundkonflikts: Er erlebt die soziale Welt feindlich, muss seine tiefe Sehnsucht nach Zuwendung und Geborgenheit in seinem Selbst verschlossen halten. Deshalb bleibt er auch bei den Kontaktversuchen von Morpheus und Trinity misstrauisch. Als Morpheus ihn via Telefon vor Smith schützen will, kann er ihm nicht vertrauen.

Nach seiner Befreiung aus den Zuchtanlagen konfrontiert Morpheus Neo mit den endlosen Feldern der millionenfachen Brutkästen und zwingt ihn so, sein biografisches Defizit wahrzunehmen. Neo muss diese traumatische Erfahrung zunächst erneut verleugnen. Da er zu spät entkoppelt wurde, hat er offensichtlich den Zeitpunkt verpasst, an dem er sich noch leicht hätte verändern können, sein Selbst und die inneren Einstellungen noch flexibler waren. Hinzu kommt, dass Neo lernen muss, außerhalb der Matrix anderen Menschen ausgeliefert zu sein: Ohne die Gruppe, die ihn stützt und trägt, kann er nicht mehr existieren. Neo hat jedoch eine fundamentale Kontaktschwierigkeit. Er kann sich anderen nicht emotional annähern. Er kann sich in der Gegenwart anderer nicht unbefangen wohl fühlen und sich fallen lassen. Auch Morpheus gewinnt sein Vertrauen nur langsam. Was zunächst als väterliche Beziehung wirkt, verändert sich aus Neos Sicht zur Parentifizierung, also zu einer Umkehr der Rollen.

Das Orakel legt Morpheus Leben in Neos Hände: du oder er. Für Neo ist sofort klar, dass er sich für Morpheus opfern wird. Da er in seinem Leben in der Realität zunächst nichts Gutes, Lohnenswertes findet, erhält es einen Sinn durch die Aufgabe, Morpheus zu retten. Die Opferbereitschaft Neos zeigt das Ausmaß der Depression, die dieser mit all seinen Aktivitäten innerhalb und außerhalb der Matrix maskiert. Die Konstellation zwischen Morpheus und ihm verstärkt jedoch Neos Einsamkeit weiter. Er bleibt mit seinen Fragen und Zweifeln, über sich, wer er ist oder sein soll, und warum er hier ist, allein. Neo flüchtet nach seiner Befreiung auch wegen dieser Unauflösbarkeit seiner Einsamkeit erneut in die Matrix, in eine Umgebung, die er kennt. Gerade weil er sich vom Leben außerhalb der Matrix nichts verspricht und sein (Über-)Leben für ihn keinen höheren Wert darstellt, kann er sich ganz dem Kampf hingeben. Auf seinen Reisen in die Matrix perfektioniert er das, was er schon immer sehr gut konnte: mit Schnelligkeit und intellektueller Schärfe mediale Welten zu erobern. Neo bleibt auch in der Realität der schizoide Nerd, der sich nur in den Computerwelten wirklich auskennt und auch nur dort ein Gefühl subjektiver Sicherheit erlangen kann. Das wird vor allem daran deutlich, dass er nicht danach strebt, in Zion zu leben. Dort wäre er fern der Matrix.

Morpheus

Wie bereits erwähnt, versteht sich Morpheus als Soldat – und flüchtet zunächst in eine narzisstische Vorstellung seiner selbst. Ausgelöst durch die Aussage des Orakels, er werde den Auserwählten finden, erhöht er sich selbst. In seinem Selbstideal wird er zu einer mächtigen Figur, die bei der Befreiung der Menschheit eine entscheidende Rolle spielt. Das Scheitern der fünf Vorgänger von Neo hat Morpheus jedoch zur Einsicht gezwungen, dass er viel weniger Kontrolle über die Objekte hat, als er glaubte. Diese Erkenntnis hat ihm ermöglicht, seine narzisstische Allmachtsfantasie aufzugeben.

Als er und seine Crew Neo befreien, ist Morpheus Flucht in die Vorstellung des eigenen Größenselbst bereits gebrochen. Er beweist Demut und Zurückhaltung im Umgang mit Neo. Morpheus hat zu einer mehr altruistischen Verarbeitung seiner Herkunft aus den Zuchtfeldern gefunden. Er stellt sein Selbst ganz in den Dienst der Anderen. Das Überleben der Menschheit wird zur grundlegenden Motivation seiner Handlungen. Morpheus ist damit das Sinnbild des Gerechtigkeitskämpfers. Er versucht, durch seine Selbstaufopferung die ersehnten guten Objekte für sich zu gewinnen. Durch den gemeinsamen Kampf erfährt er Entgrenzung in der Gruppe und kann dadurch die schmerzhafte Einsamkeit (der Zuchtfelder) zumindest partiell überwinden. Er bleibt jedoch darauf angewiesen, die verlorene narzisstische Allmacht in eine andere Instanz zu projizieren. Das Orakel hat deshalb für Morpheus eine mütterlich-göttliche Funktion, dem er bedingungslos traut und dem er sich ganz überantwortet. Daraus resultiert bei ihm auch der naiv wirkende Glaube an den Auserwählten. Er delegiert die Ver-

antwortung an eine höhere Macht und kann sich auch in sozialen Konfliktsituationen geborgen und geschützt erleben.

Allerdings missversteht Morpheus die therapeutisch-analytische Funktion. Er interpretiert die Worte des Orakels auf konkretistische Weise und offenbart dadurch seine innere Labilität, die hinter seiner nach außen dargestellten Selbstsicherheit lauert. Morpheus zentraler Konflikt stellt sich in *Matrix Reloaded* dar, als deutlich wird, dass sich die Vorhersage des Orakels nicht bewahrheitet. Der Krieg zwischen den Maschinen und Zion ist nicht beendet, obwohl Neo zur Quelle vordringt. In dieser Sequenz wird Morpheus psychisches System erschüttert. Er wirkt plötzlich unsicher und verzweifelt. Morpheus behält zwar seine Position als Kommandeur der Nebukadnezar – und er spielt eine wichtige Rolle, Zion auf die letzte Schlacht vorzubereiten. Aber in *Matrix Revolutions* hat er seine Führungsrolle an Neo und Trinity abgegeben.

Trinity

Trinity hat, wie alle befreiten Zuchtmenschen mit ihrer kalten, lieblosen Herkunft, die innere Aufgabe, ihr emotionales Defizit auszugleichen. Auch sie muss angesichts der kaum erträglichen Wirklichkeit der Zuchtfarmen einen Sinn für die eigene Existenz finden. Das Orakel sagte ihr voraus, sie werde sich in den Auserwählten verlieben. Diese Weissagung verspricht wie bei Morpheus, der den Auserwählten finden soll, eine große narzisstische Verheißung. Doch Morpheus benötigt den kindlich-konkretistischen Glauben an das Orakel als Wiedergutmachung für das emotionale Defizit in seinem Inneren – und wird damit von der realen Existenz des Orakels abhängig. Trinity hingegen verhilft die Prophezeiung dazu, Neo bedingungslos zu lieben. Ihre Liebe ist frei von der Angst, abgelehnt zu werden. Sie erwartet keine Gegenliebe, fordert nichts ein. Es gelingt ihr, sich einzulassen und gleichzeitig losgelöst von Neos Anwesenheit zu agieren. Die Liebe macht Trinity unabhängig; sie kann so ihr innerpsychisches Defizit kompensieren. Zwar macht Trinity Neo zu ihrem Lebenssinn. Aber sie folgt ausschließlich ihrem Gespür und trifft eigene Entscheidungen. Während Morpheus seine Entscheidungen durch die scheinbare Macht des Orakels absichert – und so nicht allein für seine Entscheidungen verantwortlich ist, lässt Trinity keinen Zweifel daran aufkommen, dass sie es selbst ist, die bestimmt, was mit ihr passiert. Ihre Liebe zu Neo hat keinen handlungsanweisenden Effekt. Im Gegenteil: Sie widersetzt sich Neos Wünschen. Trinity wächst dadurch zu derjenigen der drei Hauptfiguren des Films mit der größten psychischen Reife. Trinity verkörpert eine Weiblichkeit, in der sich Emotionalität und Kraft und Entschlossenheit zu maximaler innerer und äußerer Stärke verbinden.

Neos Entwicklung in der realen Welt

Neos psychische Entwicklung nach seiner Befreiung wird im Wesentlichen durch zwei Beziehungen geprägt: die zu Trinity und die zum Agenten Smith. In beiden Beziehungen kämpft er um die Erlangung seiner Autonomie – vergebens, wie sich zeigen wird. Er fühlt sich fundamental defizitär, will seine Herkunft aus den Zuchtfeldern loswerden. Dabei schwankt er, ob er diesem Defizit durch die Befriedigung seiner Sehnsucht oder besser durch den Beweis seiner Unverletzbarkeit und absoluten Überlegenheit entkommen kann.

Seine sehnsüchtige Seite sucht den intensiven Kontakt zu einer anderen menschlichen Person, die er in Trinity findet. Trinity wird für Neo zur Quelle der ersehnten mütterlichen Zuwendung und Geborgenheit. Zwar teilen die beiden auch eine sexuelle Beziehung. Für Neo ist Trinity jedoch in erster Linie die schützende und wegweisende Verbindung zu seiner sozialen Umwelt, seine Beschützerin. Von Beginn an begleitet ihn Trinity auf seinem Weg. Zunächst hilft sie ihm, seine Zweifel an seiner Matrix-Existenz zu verstehen. Sie hilft ihm aus der Matrix und den Zuchtanlagen heraus. Auf Morpheus' „Nebukadnezar" verteidigt sie Neo vor den wiederholten Angriffen der Crew. Auch in Zion, wo Neo verloren wirkt, ist es Trinity, die ihm Sicherheit gibt und ihn stützt. Neo lernt durch Trinity menschliche Gefühlswelten zu verstehen, inklusive seiner eigenen. Ihre bedingungslose Zuneigung und

ihre Bereitschaft, sich auf seine psychische Verfasstheit einzulassen, öffnen Neo die bis dahin verschlossenen Türen zu seiner kindlich-emotionalen Bedürftigkeit. Doch auch wenn Neo mit Trinity schläft: Er scheint nicht allein von der sexuellen Erregung, sondern vor allem von der Erfahrung der intensiven körperlich-emotionalen Nähe überwältigt zu sein.

Die Beziehung zu Trinity erweist sich für Neo als notwendig, um in der unbekannten und unvertrauten Wirklichkeit zu überleben. Vor allem aber erlebt er sich nur in ihrer Gegenwart als emotional vollständig, sodass er bald meint, Trinity immer bei sich haben zu müssen. Besonders deutlich wird dies in der Szene, in der er Trinity reanimiert. Es sind jedoch gerade die Nähe und das Beziehungsangebot, das Trinity ihm macht, die Neo dazu bringen, sich immer weiter auf den Kampf gegen Smith einzulassen. An Trinitys Seite fühlt er sich abhängig. Aufgrund seiner schizoiden Grundstruktur kann er Trennungen von Trinity nicht aushalten, die Distanz nicht phantasmatisch überbrücken. Nur in der Vertrautheit der medialen Welten, in denen er sich auskennt und – vor allem – in denen er sich nicht wie in der Realität als bedürftig und unbeholfen erleben muss, kann er auch ohne Trinity ein Gefühl der Sicherheit und Stärke herstellen.

Neo sucht also die Konfrontation mit dem Agenten Smith. Da es sich bei Smith um ein Programm handelt, das ursprünglich von den Maschinen erschaffen wurde, kämpft Neo mit Smith einen Bruderkampf. Neo, der Cyborg, mehr Mensch als Maschine, gegen Smith, der mehr Maschine bleibt, als menschlich sein zu können. Smith steht für zwanghaftes Funktionieren, das leblos bleiben muss, weil es sich keine Abweichung von der Norm gewähren kann. Der Agent unterwirft sich der Maschinenmutter. Als er aber nach einem Sinn zu suchen beginnt, versucht auch er sich von ihr zu befreien, sie durch ihre eigene Methoden zu besiegen: kalte Effizienz, eigene Vervielfältigung, maximale Herrschaft.

Neo hingegen pendelt zwischen den Welten. Er hat aus seiner Maschinenherkunft ein striktes, Perfektion verlangendes Über-Ich zurückbehalten. Das verlangt ihm die Willenskraft und die Ausdauer ab, mit denen er gegen Smith antreten kann. Für Neo geht es in dem Kampf um den Versuch, sich seiner Autonomie zu versichern. Er will sich von der Mutterimago in seinem Inneren befreien. Die erniedrigende Herkunft aus den Zuchtanlagen beschämen Neo aufgrund des Defizits, das er in sich trägt und das ihn von Trinity abhängig macht. Neo kämpft gegen Smith und die Maschinen, um sich seiner menschlichen Überlegenheit zu versichern. Auf der Suche nach seiner Identität erlebt Neo im Kampf mit Smith, dass er zwar Cyborg, aber dennoch menschlich ist – nämlich fähig, zu fühlen.

In der Realität fühlt sich Neo seinen Emotionen eher ausgeliefert. In der Matrix stellen sie einen entscheidenden Vorteil dar. Smith kann Gefühle nicht verarbeiten, sie irritieren ihn, bringen ihn im wahrsten Sinne aus der Fassung. Die menschliche Fähigkeit, auch irrational scheinende Entscheidungen treffen zu können, entziehen Smith' Wirklichkeit den Boden. Auch das Überschreiben durch Neo hat Smith diesbezüglich nicht weiter gebracht. Er bleibt eine Mangelmaschine, die nicht gewinnen kann, weil sie die Welt, die sie umgibt, nicht versteht. Der Zugang zu diesem Verständnis bleibt Smith verschlossen.

Neo hofft, durch den Sieg über Smith zu seiner wahren Identität zu finden. Das Gefühl der Unbesiegbarkeit, so sein Wunsch, soll ihn ausstatten mit Selbstvertrauen und Sinnhaftigkeit. Durch die Wahrnehmung der Differenz zwischen sich und dem Agenten-Bruder will sich Neo selbst aus dem Selbstsubjektstatus der Maschinenmutter befreien. Am Ende erkennt Neo jedoch, dass dieser Versuch scheitern muss. Er kann seiner Herkunft nicht entkommen. Seine Möglichkeiten sind begrenzt. Als Cyborg kann er in beiden Welten nicht ganz dazu gehören.

Neos Tod – Psychodynamische Schlussfolgerungen

Neo scheitert zwar daran, eine reifere Lösung für seine konflikthafte innerpsychische Situation zu finden, aber ihm bleibt am Ende die Möglichkeit, eine eigene Entscheidung zu treffen. Darin liegt unseres Erachtens die immense Faszination der Filmreihe. Neo kann den schizoiden Modus nicht verlassen, mit dem er versucht, sein psychisches Defizit zu bewältigen. Psychoanalytisch würde man ihm deshalb

eine strukturelle Störung attestieren, eine mangelnde Entwicklung zu einem reiferen Status des psychischen Funktionierens. Es ist jedoch gerade sein Verharren in seiner Sicht auf die äußere Welt und auf seine inneren Zustände, die ihm ermöglichen, den bereitliegenden Verführungen stand zu halten: Er erliegt nicht dem Wunsch, das Geschehen zu verleugnen, wie Cypher[8] es tut. Er regrediert nicht auf ein narzisstisches Niveau wie Morpheus. Er flieht nicht in die romantische Beziehungswelt wie Trinity, die am Ende trotz aller psychischen Eigenständigkeit ihr Leben für Neo opfert. Es ist Neos zweifelnde Distanz, die ihn den vorgesehenen Lebensweg (den seiner fünf gescheiterten Vorgänger) ausschlagen lässt, um sich der Realität in ihrer ganzen Grausamkeit zu stellen. Diese illusionslose Sicht auf die Dinge stellt die Voraussetzung für Neo dar, eine eigene Entscheidung bezüglich seiner Existenz zu treffen.

In der Schlusseinstellung von *Matrix Revolutions* wird deutlich, dass die Menschen in den Farmen eine (vielleicht vorbewusste) Entscheidung treffen, ob sie in dem Zustand illusionärer Befriedigung verbleiben oder sich mit ihrer tatsächlichen Herkunft auseinandersetzen wollen. Die Befreiung stellt nämlich einen „point of no return" dar. Der Blick auf die Felder, die Konfrontation mit der eigenen Herkunft, ist die große innerpsychische Herausforderung. Damit stellt der Film die selbst unter traumatischen Bedingungen mögliche Fähigkeit, sich zu entscheiden, ins Zentrum der menschlichen Existenz.

Neos Entscheidung ist der Tod. Er entscheidet sich dafür, weil das Leben für ihn keinen anderen zentralen Wert besitzt. Weil er sich nicht in den vorgegebenen Lebensentwürfen wiederfinden kann und er sich überall – in der Matrixwelt wie auch in der Realität nach seiner Befreiung – als außenstehend und nicht zugehörig erlebt hat, konnte er seine innere emotionale Leere nicht füllen. Zwar konnte Neo sein falsches Selbst[9] ablegen, das von der Maschinenmutter gefordert war. Er kam aber mit dem Selbst nicht zurecht, das sich nach seiner Befreiung in ihm verwirklichte. Auch die Liebe und Trinitys Angebot, in einer Beziehung aufzugehen, konnte Neo nicht annehmen. Deshalb blieb für ihn nur der eingeschlagene Weg zurück an die Quelle, den Ort seiner Herkunft, zurück in den Schoß der Mutter, die ihn ein letztes Mal für ihre eigenen Zwecke verwendet, um sich selbst zu erhalten.

Fazit

Mit der „Matrix-Trilogie" nähren die Wachowski-Geschwister den Verdacht, es könnte doch ein richtiges Leben im Falschen geben.
Die Matrix ist in uns. Uns ist die Entscheidung vorbehalten, was wir daraus machen.

Logout

Literatur

Camus A (1999) Der Mythos des Sisyphos. Rowohlt, Reinbek
Cartwright D (2005) ß-Mentality in The matrix trilogy. Int J Psychoanal 86: 179–190
Foucault M (1987) Warum ich Macht untersuche: Die Frage des Subjekts. In: Dreyfus H, Rabinow P (Hrsg) Michel Foucault. Jenseits von Strukturalismus und Hermeneutik. Athenäum, Frankfurt/M, S 243–361

8 In Teil 1 der Filmtrilogie entscheidet sich Cypher, der bereits befreit ist, in die Matrix zurückzukehren. Sein ausdrücklicher Wunsch dabei ist, jede Erinnerung an die Wirklichkeit außerhalb der Matrix zu verlieren.
9 Winnicott beschrieb mit dem Begriff des falschen Selbst eine Persönlichkeitsentwicklung, die durch die mangelhafte Einfühlung der Mutter in die Bedürfnisse des Kindes verursacht wird. Das Kind muss sich so an eine als unsicher oder überwältigend erlebte soziale Umwelt anpassen und reagiert aus Abwehrzwecken mit Gefügigkeit. Dadurch entsteht ein Verhaltensmuster, das die (unbewussten) Wünsche der Mutter befriedigt, im Subjekt jedoch ein dauerhaftes Gefühl von Depression, Leere und Leblosigkeit auslöst (Winnicott [1]1965; 2006).

Haraway D (1995) Ein Manifest für Cyborgs. Feminismus im Streit mit den Technowissenschaften. In: Haraway D Die Neuerfindung der Natur. Primaten, Cyborgs und Frauen. Campus, Frankfurt/M, S 33–72

Haslam JW (2005) Romancing the (electronic) shadow in The Matrix. Coll Lit 32(3): 92–115

Janus L (2001) Filmbesprechung von „Matrix". Manuskript erhältlich unter http://85.214.73.226/laszig/wp-content/uploads/2009/04/Matrix.pdf

Kimball AS (2001) Not begetting the future: technological autochthony, sexual reproduction, and the mythic structure of The Matrix. J Pop Cult 35(3): 175–203

Kurz I (2009) Zur Subversion der Bildung bei Koneffke und bei Foucault. Sic et Non. Zeitschrift für Philosophie und Kultur. Im Netz, Kap 3.2: Zur Subversion bei Foucault: 36–45 http://www.sicetnon.org/content/pdf/zur_subersion_der_bildung.pdf. Zugegriffen am 22. 2. 2012

McGrath JF (2010) The desert of the real: christianity, buddhism & Baudrillard in The Matrix films and popular culture. In: Leaning M, Pretzsch B (Hrsg) Visions of the human in science fiction and cyberpunk. Inter-Disciplinary Press, Oxford UK, S 161–172. http://www.inter-disciplinary.net/wp-content/uploads/2010/08/visions1ever1a4040810.pdf. Zugegriffen am 15. 5. 2012

Mischoulon D, Beresin EV (2004) „The Matrix": an allegory of the psychoanalytic journey. Acad Psychiatr 28: 71–77

Rudolf G (2000) Psychotherapeutische Medizin und Psychosomatik. Thieme, Stuttgart

Stucky MD (2005) He is the One. The Matrix Trilogy's postmodern movie messiah. J Relig Film 9(2) http://www.unomaha.edu/jrf/Vol9No2/StuckyMatrixMessiah.htm. Zugegriffen am 21. 12. 2011

Wilchins R (2006) Gender Theory. Eine Einführung. Kap 5: Homosexualität: Foucault und die Politik des Selbst. Querverlag, Berlin, S 63–74

Winnicott DW (2006) Reifungsprozesse und fördernde Umwelt. Kap 12: Ich-Verzerrung in Form des wahren und des falschen Selbst. Psychosozial-Verlag, Gießen, S 182–199 (Erstveröff. 1965)

Žižek S (2000) Philosophie der Matrix – Zwei Seiten der Perversion. Schnitt-Filmmagazin 17(1) http://www.schnitt.de/414,0017. Zugegriffen am 21. 12. 2011

Internetquellen

http://boxofficemojo.com/franchises/chart/?id=matrix.htm. Zugegriffen am 6. 1. 2012

http://www.inter-disciplinary.net/wp-content/uploads/2010/08/visions1ever1a4040810.pdf. Zugegriffen am 21. 12. 2011

http://www.matrix-architekt.de/wachowskis/leben.shtml. Zugegriffen am 23. 12. 2011

http://ap.psychiatryonline.org/article.aspx?Volume=28&page=71&journalID=17. Zugegriffen am 6. 1. 2012

http://de.wikipedia.org/wiki/Matrix_(Film). Zugegriffen am 28. 12. 2011

Originaltitel	The Matrix, The Matrix Reloaded, The Matrix Revolutions
Erscheinungsjahre	1999, 2003, 2003
Land	USA
Buch	Andy u. Lana Wachowski
Regie	Andy u. Lana Wachowski
Hauptdarsteller	Keanu Reeves (Neo), Lawrence Fishburne (Morpheus), Carrie-Ann Moss (Trinity), Hugo Weaving (Smith), Gloria Foster (Orakel)
Verfügbarkeit	Als DVD in OV und deutscher Sprache erhältlich

Manuel Zahn

Bist Du, was Du denkst? – Reflexionen auf das Spiel mit der Simulation

The 13th Floor – Regie: Josef Rusnak

Vincent D'Onofrio (Jason Whitney/Jerry Ashton)
Quelle: Interfoto Archiv Friedrich

The 13th Floor

Regie: Josef Rusnak

Josef Rusnaks Film (◘ Abb. 1) thematisiert nicht nur die Interaktion verschiedener medialer Realitäten und den Transfer von Bewusstsein(sinhalten) von einer in die andere, er ist selbst Produkt eines solchen Transfers. Dem Film liegt der englische Science-Fiction-Roman „Simulacron-3" von Daniel F. Galouye (11964; 1983) zugrunde. Rusnak hat den Roman zusammen mit Ravel Centeno-Rodriguez in ein Filmskript umgearbeitet. Galouyes Buch wurde unter dem Titel Welt am Draht bereits 1973 von Rainer Werner Fassbinder zusammen mit Michael Ballhaus als Kameramann für den WDR realisiert. Ballhaus hatte sich die Filmrechte an Galouyes Roman gesichert und fungierte daher mit seiner Frau auch bei The 13th Floor als ausführender Produzent, zusammen mit Roland Emmerich, Ute Emmerich und Marco Weber.

Der filmgeschichtliche Hinweis auf Fassbinders Welt am Draht soll nicht der einzige bleiben, denn es ist bemerkenswert, dass The 13th Floor in einer Zeit entsteht, in der weitere Filme ähnliche Themen an- und umspielen. Die Rede ist von Filmen wie Nirvana – Die Zukunft ist eine Spiel (Salvatores, F/I/GB 1997), Abre los ojos (Amenabar, S/F/I 1997), eXistenZ (Cronenberg, USA 1999) und Matrix (Wachowskis, USA 1999). All die genannten Filme inszenieren auf jeweils unterschiedliche Weise die virtuellen Realitäten von Computersimulationen aus der Perspektive der damals bekannten und prominenten Diskursmuster: der Interaktion, Virtualität und Immersion. Die dargestellte Welt bzw. Wirklichkeit erweist sich in allen Filmen als gigantische Computersimulation, in der nicht nur erkenntnistheoretische und anthropologische Gewissheiten fraglich, sondern auch moralische Maßstäbe durch die computergenerierten Simulationen auf ihre Gültigkeit überprüft werden. Die Filme bringen damit, entsprechend ihren Möglichkeiten, die in den 1980er- und 1990er-Jahren prominenten Fragestellungen und Themen hinsichtlich durch Computer simulierte Wirklichkeiten zur Darstellung.

All die zuvor genannten und noch weitere Filme zum Ende der 1990er-Jahre können somit als Reaktionen auf die rasante Entwicklung der Computertechnologie und deren Verbreitung in unserer westlichen Lebenswelt verstanden werden. Zu der ubiquitären Integration des Mediums Computer haben nicht unwesentlich die Computerspiele beigetragen. Waren diese zuerst im Kontext von militärischen Simulationen verortet, gewannen sie recht schnell über experimentierfreudige, technisch versierte jugendliche Randgruppen die Aufmerksamkeit eines Massenpublikums. Den parallel geführten öffentlichen Debatten zum Umgang mit Computern und insbesondere Computerspielen war sowohl in ihren utopischen als auch dystopischen Visionen ein Wunsch[1] inhärent: Dieser Wunsch lässt die computergenerierte Simulation, die virtuelle Wirklichkeit als eine spielerische Zwischensphäre erscheinen, in der sich der Mensch ausprobieren kann. Über die Auswirkungen dieser Probehandlungen in den medialen Arenen der Spielsimulationen auf die Welt- und Selbstverhältnisse, auf die Ich-Identität oder die moralische Disposition ihrer „User" gehen die Einschätzungen dann weit auseinander. Im Folgenden möchte ich versuchen herauszuarbeiten, was Rusnaks Film zur skizzierten Debatte beizutragen hat. Dazu werde ich zuerst (auch in ästhetischer Perspektive) der Handlung des Films folgen.

1 Hartmut Winkler beschreibt in Docuverse (1997), dass den Debatten um computergenerierte Simulationen immer (wieder) Wünsche eingewoben sind. Ganz gleich, ob in überschwänglich-bejahenden oder in kulturpessimistisch-verneinenden Formen, an jedem visionären Szenario weben Wunschvorstellungen der Benutzer eines Mediums mit, die mit seinem tatsächlichen Funktionieren und Gebrauch keineswegs identisch sind. Die Diskurse über Medien generieren daher immer auch Wunschmedien.

Die Handlung

Einstieg in die virtuelle Welt

The 13th Floor beginnt mit den üblichen filmischen Paratexten, dann zeigt sich auf der schwarzen Leinwand in weißer, schneidiger Schrift René Descartes Formel der reflexiven Selbstverständigung des Subjekts: „Ich denke, also bin ich". Es geht also, wie zuvor schon angedeutet, um ein philosophisches Thema: um das der Identität des Menschen und seiner Wahrnehmung von Welt und Selbst. Nach dem Filmtitel hören wir über Schwarzfilm eine Stimme aus dem Off sagen:

> ◐ „Es heißt, ‚Unwissenheit ist ein Segen', dem stimme ich heute zum ersten Mal zu …
> Ich wünschte, ich hätte die furchtbare Wahrheit niemals aufgedeckt …"

Die folgenden Bilder des schreibenden Hannon Fuller präsentieren sich in einem Sepiaton. Es sind zudem sehr sinnliche Bilder: weitestgehend Großaufnahmen der schreibenden Hand, wie die Feder in die Tinte getaucht und über das Blatt geführt wird, das Abtrocknen der Tinte, das Anlecken der Klebeflächen des Briefumschlags usw. Diese ersten Bilder des Films etablieren eine Welt, deren stilisierte Insignien des Amerikas der 1930er-Jahre sich in einer auffällig braunstichigen Farbigkeit präsentieren. Wir folgen der Fuller-Figur in einem ruhigen Kameraschwenk; sie steht vom Schreibtisch auf, schreitet durch ein Hotelzimmer, im Bett liegt eine leicht bekleidete, bedeutend jüngere Frau, Fuller legt ihr Geld auf den Nachttisch und geht. Im Salon des „Wilshire Grand Hotels" spricht er mit dem Barkeeper Ashton und gibt ihm den zuvor verfassten Brief. Er ist adressiert an „Douglas Hall". Er verlässt das Hotel und nimmt ein Taxi nach Hause, während dessen der Barkeeper den Brief heimlich öffnet und liest.

Zuhause angekommen räumt die Fuller-Figur seinen Smoking weg (oder versteckt er ihn?) und legt sich zu seiner Frau ins Bett. Die Kamera fährt an seine Augen heran, etwas bewegt sich in ihnen. Plötzlich stößt die Kamera vor und dringt in Fullers Augen ein, so wird es zumindest vom Film nahe gelegt, und fährt durch ein Feld von bläulichen Lichtblitzen. Am Ende dieser „Fahrt" sieht man den gleichen Schauspieler in einem anderen Raum und zu einer anderen Zeit „aufwachen". „Download abgeschossen. Verbindung zur Simulation beendet", sagt eine Frauenstimme. Die Fuller-Figur ist jetzt in einem Großcomputerraum, der sich im 13. Stockwerk eines modernen Bürohochhauses im Los Angeles der 1990er-Jahre befindet. Er verlässt kurz darauf den Computerraum und geht in eine Bar. Wir sehen aus dem Blickwinkel des Barkeepers, wie Fuller telefoniert; er spricht einem „Douglas" auf den Anrufbeantworter, aber wir können nicht hören, was er ihm im Einzelnen sagt. Die Hintertür zur Bar öffnet sich, er scheint jemanden zu begrüßen, geht hinaus und wir sehen, dass er einem ihm bekannten Mann (dessen Gesicht wir nicht sehen können) gegenübersteht. Er sagt zu ihm „Ich weiß nicht, wo ich anfangen soll…", dann zieht der andere Mann plötzlich ein Springmesser und sticht auf den fassungslosen Fuller ein.

Nach circa neun Minuten hat Rusnak seinen Zuschauern eine kurze Skizze vom Setting und dem „Plot" des Films gezeichnet. Im Los Angeles des Jahres 1999 hat es eine Gruppe von Computerspezialisten geschafft, eine perfekte Simulation der Stadt im Jahr 1937 zu programmieren, die wiederum von „selbständig lernenden Cyberwesen" bevölkert wird. Zudem haben sie einen Weg gefunden, um sich mit ihrem Bewusstsein in dieser Simulation zu bewegen, indem sie es in den „Körper" der Cyberwesen bzw. in die entsprechenden Programmeinheiten oder Avatare – die nebenbei das gleiche Aussehen haben wie ihre „User" – transferieren bzw. „downloaden". Nun scheint dabei aber irgendetwas schief zu laufen oder zumindest etwas anders zu sein, als es zu sein scheint. Die Fuller-Figur will ihr Wissen über diese Differenz von Sein und Schein an einen gewissen Douglas Hall weitergeben und fürchtet, dafür umgebracht zu werden – was auch zum Ende der Sequenz geschieht. Von da an entfaltet sich die Inszenierung des Films als komplexes Spiel auf und zwischen mehreren zeitlichen (Spiel-)Ebenen (◐ Abb. 2).

Die Odyssee des Douglas Hall „zwischen den Welten"

Douglas Hall wacht in seinem Appartement auf, steigt aus dem Bett und geht ins Bad, wo er geronnene Blutstropfen auf dem Waschbecken und ein blutiges Hemd in der Schmutzwäsche entdeckt – hat er also etwas mit dem zuvor gezeigten Mord an Hannon Fuller zu tun? Nebenbei läuft sein Anrufbeantworter aus dem „off" und just als er das blutige Hemd entdeckt, hört er die Stimme eines Detektivs namens McBain, der ihn auf das Polizeirevier bestellt. Hall soll, dort angekommen, seinen Freund und Vorgesetzten Fuller identifizieren. McBain begleitet ihn zurück in sein Appartement, das sich im gleichen Bürohaus wie der zuvor gezeigte Computerraum befindet. Dort wartet eine Jane Fuller, die sich als Tochter von Hannon Fuller vorstellt. Hall kennt sie nicht und gibt an, Fuller habe sie auch nie erwähnt. Hall stellt Nachforschungen über sie an, auch weil sich diese Frau als Fullers Erbin ins Spiel bringt. Bei seinen Nachforschungen erfährt er, dass Fuller ihn als Alleinerben der Firma eingesetzt hat. Zudem gelingt es ihm, Fullers Nachricht auf seinem Anrufbeantworter zu rekonstruieren – wer aber hat zuvor die Maschine manipuliert?

Unterdessen spricht Detektiv McBain im 13. Stock mit Whitney, einem Computertechniker und Arbeitskollegen Halls, der dem Barkeeper Ashton in der Simulation der 1930er-Jahre ähnelt, und erfährt Genaueres über Fullers Firma und die Funktionsweise der Computersimulation: Fuller habe mit dem programmierten System von Los Angeles des Jahres 1937 die Zeit seiner Jugend wieder erschaffen (● Abb. 3). Die Einheiten des Systems seien selbständig lernende und sich entwickelnde Cyberwesen, simulierte Identitätseinheiten, die nach dem Vorbild des Menschen gestaltet seien. Während der User sich in die Maschine „einloggt" und damit gleichsam sein Bewusstsein in eines der Cyberwesen transferiert, erlebe er die Welt im Stile der 1930er-Jahre.

Douglas Hall begibt sich zu weiteren Recherchezwecken zum ersten Mal in die Simulation und loggt sich dazu in den Bankangestellten Ferguson ein, der ihm wie aus dem Gesicht geschnitten ist. Dort trifft er auf alle Figuren, mit denen auch Fuller zuvor in Kontakt gekommen war: den Antiqui-

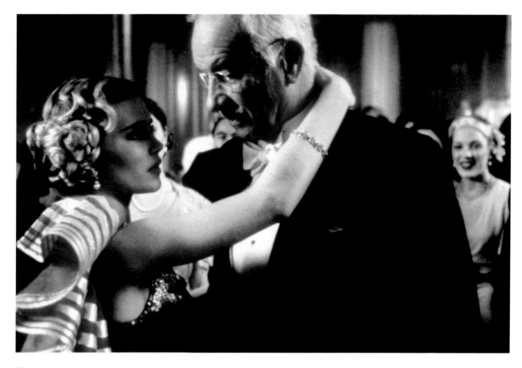

◼ **Abb. 3** Armin Mueller-Stahl (Hannon Fuller/Grierson). (Quelle: dpa-Film Jugendfilm)

tätenhändler Grierson, Fullers Avatar, die jungen Mädchen, Ashton, ohne jedoch etwas über die von Fuller versteckte Botschaft an ihn zu erfahren, da Ashton leugnet, von der Existenz des Briefs zu wissen. Wieder aus der Simulation zurück, wird Hall von Tom Jones aufgesucht, dem Barkeeper, der Fuller kurz vor seinem Tod gesehen hat, angeblich zusammen mit Hall. Jones will Geld von Hall, doch dieser lässt sich nicht auf die Erpressung ein. Wenig später wird Jones Leiche gefunden – und der zuvor schon vom Film gestreute Verdacht, Hall sei für die Morde verantwortlich, erhärtet sich. Aber Jane Fuller, die sich in ihn verliebt zu haben scheint, gibt ihm für die Tatzeit des letzten Mordes ein Alibi.

Um den Mordverdacht gegen ihn zu entkräften, geht Hall erneut in die Simulation. Zusammen mit Grierson fährt er zum „Wilshire Grand Hotel", wo sich Grierson – der an ähnlichen Erinnerungslücken wie Hall leidet – wieder an Einiges von dem erinnern kann, was das Bewusstsein von Fuller in seinem „Körper" erlebt hat. Schließlich stellt Hall den Barkeeper Ashton zur Rede, und der gibt zu, Fullers Brief gelesen zu haben. Aufgewühlt von seinem Inhalt sei Ashton aus der Stadt gefahren, immer weiter, bis er an „das Ende der Welt" gekommen sei. Hall verlangt den Brief, aber der aufgebrachte Ashton greift Hall an und schießt auf ihn. Es kommt zu einem Zweikampf, bei dem Ashton versucht, Hall zu töten. Doch Hall wird von Whitney aus der Simulation zurückgeholt. Er ist durch seine Begegnung mit Ashton davon überzeugt, dass die programmierten Identitätseinheiten, die simulierten Personen, ein eigenes Bewusstsein entwickelt haben, und er ist daher fest entschlossen, die Simulation abzuschalten – was, nähme man die Aussage der Hall-Figur ernst, einem Massenmord gleichkäme und ihn in einen noch größeren Gewissenskonflikt stürzen müsste. Diese Nebenbemerkung verweist auf einen moralischen Subtext des Films, der in seinem weiteren Verlauf noch deutlicher zu Tage treten wird.

Hall schaltet also die Computersimulation nicht ab und macht sich stattdessen auf die Suche nach Jane Fuller, findet aber nur eine gewisse Natascha Molinaro, eine Supermarktangestellte, deren „Körper" wiederum als Avatar für ein Bewusstsein einer weiteren Realitätsebene dient. Um sich der schreck-lichen Ahnung, selbst nur die simulierte Identitätseinheit eines Computerprogramms zu sein, zu verge-

wissern, fährt auch Hall mit seinem Wagen aus der Stadt, durchbricht eine Straßensperre und erreicht wie zuvor schon Ashton das „Ende der Welt", wo sich diese Simulation, quasi ihrer imaginären Haut entledigt, als gerastertes Computergebilde zeigt. Jane Fuller hat derweil wieder Besitz von Natascha Molinaros „Körper" genommen und ruft Hall an, um sich mit ihm zu treffen. Während des Zwiegesprächs in Halls Wohnung erklärt sie ihm, dass es tausende simulierter Welten gebe, dass aber diejenige, in der sie sich gerade befinden, die einzige sei, die eine Simulation in der Simulation erschaffen habe. Sie offenbart ihm zudem, dass ihr Ehemann David seinen „Körper" als Avatar benutze und durch ihn als sein User die Morde an Fuller und dem Barkeeper Jones begangen habe. Zuletzt gesteht sie Hall ihre Liebe, was auch sie zu einem potenziellen Opfer von Davids Mordlust mache.

Unterdessen beschließt Whitney, die Simulation zu testen (bevor sie möglicherweise durch Hall abgeschaltet wird), loggt sich in seinen Avatar Ashton ein, während dieser Auto fährt, und hat einen Unfall. Ashton wird daraufhin von einer Polizeistreife kontrolliert. Als diese bemerkt, dass Ashton den gefesselten Ferguson im Kofferraum transportiert, weicht Ashton zurück auf die Straße aus und wird von einem Lastwagen überfahren. Gleichsam wacht das „Bewusstsein" der Ashton-Figur im Körper von Whitney im Labor des 13. Stocks auf. Ashton hat als Whitney große Orientierungsschwierigkeiten in der für ihn fremden Realität, was sich beispielsweise daran zeigt, dass es ihm zuerst nicht gelingt, die elektronisch gesteuerte Glastür des Computerlabors zu öffnen. Der Wachmann ruft, als er das beobachtet, Hall an, er möge kommen und nachsehen, was mit Whitney los sei.

Als Hall im Labor ankommt, liegt der Wachmann bewusstlos und entwaffnet am Boden. Whitney sitzt in einem Konferenzraum vor mehreren Fernsehbildschirmen, deren unterschiedliche Filme und Sendungen er für Abbilder der Realität hält, bis Hall ihm bei einem Blick durchs Fenster erklärt, dass dies seine Welt sei und dass sie ebenfalls nur als eine simulierte existiere.

💬 „Ich bin wie Sie nur ein Bündel elektronischer Schaltkreise. (…) Wir sind nichts weiter als eine Simulation in einem Computer" (1:21:00–1:22:00 min).

Als Hall mit Ashton zurück in den 13. Stock fährt, um ihm den Computer zu zeigen, mit dem die Simulation der 1930er-Jahre generiert wurde, loggt sich David in Hall ein und erschießt Ashton.

Zurück in Halls Wohnung, setzt sich David zu Jane ans Bett. Sie erkennt ihn, sie streiten sich und er versucht, sie zu erwürgen. Sie kann sich befreien und aus der Wohnung fliehen. In der Lobby des Hochhauses holt David Jane ein und bedroht sie mit einer Pistole, doch bevor er sie erschießen kann, wird er von Detektiv McBain erschossen. Es scheint, dass dieser zuvor von Jane zu Halls Haus bestellt wurde. McBain, der mittlerweile auch seine Existenz als Programm einer Computersimulation erkannt hat, gibt Jane zu verstehen, dass sie und die anderen „da oben" ihn und alle anderen Cyberwesen von 1937 in Zukunft in Ruhe lassen sollen.

Douglas Hall erwacht im Körper von David im Jahre 2024 und trifft dort in einer lichtdurchfluteten Wohnung auf Jane. Sie führt ihn hinaus auf einen Balkon. Von dort sehen sie über das Meer in der Ferne die Silhouette einer futuristischen Stadt und am Strand den Vater von Jane, der für die Figur des Hannon Fuller als Vorbild diente. Das letzte Bild des Films erinnert an das Ausschalten eines elektronischen Bildschirms. Die seltsam gelbstichige Färbung der Welt im Jahre 2024, zusammen mit dem letzten Bild, legen die Interpretation nahe, dass es sich auch bei dieser Wirklichkeit um eine simulierte, womöglich durch einen Computer generierte handelt. Damit wäre die letzte Sequenz von *The 13th Floor* nicht die Außensicht auf die zuvor präsentierten medialen Wirklichkeiten (des Los Angeles in den Jahren 1937 und 1999), sondern selbst wiederum eine Innensicht eines Supermediums, eines Medienverbunds, dessen „Außen" sich im Laufe der Filmhandlung nie positiv zeigt, sondern auf das nur in Form von Spuren (Irritation, Dysfunktionen u. a. m.) verwiesen wird.

Die Welt als (Konstellation von) Computersimulation(en): ontologische und erkenntnistheoretische Perspektiven des Films

Bleiben wir bei der letzten These, der Film präsentiere lediglich die Innensicht eines digital konnotierten Supermediums, mit anderen Worten: Die filmische Weltdarstellung und das durch diese Welt behauptete Supermedium seien identisch. Da dieser These folgend die im Film thematisierte Computersimulation weltumspannend ist, kann die sie generierende Apparatur logischerweise nicht positiv in Erscheinung treten; es gibt jedoch einige Momente des Films, in denen die Medialität dieses Supermediums als eine ästhetische Differenz inszeniert wird:

- Am Auffälligsten scheint mir in dieser Hinsicht die Farbgebung des Films zu sein. Die verschiedenen Simulationen (als Ebenen in einer Simulation) werden in je unterschiedlicher Farbigkeit dargestellt. Während die simulierte Welt der 1930er-Jahre in Sepiatönen erscheint, folgt die der 1990er-Jahre eher zeitgenössischen Darstellungskonventionen (mit etwas mehr Gewicht auf Blautönen, wie es sich für einen „Neo-Noir" gehört) und die Simulation der 2020er-Jahre ist gelblich gefärbt. Die ästhetische Strategie der Verfärbung der Filmbilder verweist allerdings nur insofern auf die Medialität der simulierten Welten, als dass wir als Zuschauer des Films auf die Medialität des Films selbst hingewiesen werden. Und es gibt weitere Momente des Films, in denen er auf sich als Medium verweist. So gibt es beispielsweise auffällig viele Spiegel und spiegelnde Glas- und Metallflächen in den Filmbildern und dementsprechend viele Lichtreflexionen und Spiegelungen oder auch eine Vielzahl von Aufnahmen im Gegenlicht.
- Das Eintreten in eine Spielsimulation (und ihr Verlassen), genauer: die Übergänge von einer Simulationsebene in eine andere – das „Downloaden" des Spielerbewusstseins in seinen Avatar – werden mithilfe digitaler Effekte inszeniert. Zum einen ist da eine Art neongrüne Lasershow, deren Strahlenfächer sich um den Körper desjenigen legt, der im Los Angeles des Jahres 1999 dessen Simulation von 1937 spielt. Zum anderen wird der Downloadvorgang des Spieler-Bewusstseins in eine Spielfigur durch eine bläuliche Lichtreflexion in deren Augen begleitet.
- Die „Downloads" der User in die Simulation werden in *The 13th Floor* zudem von Störungen oder Irritierungen der Erinnerungen, Wahrnehmungen und auch Handlungen der Cyberidentitäten begleitet. Es gibt eine Vielzahl von Szenen in denen die jeweiligen Avatare und damit das Bewusstsein ihrer „User" nach dem Download zuerst irritiert wirken und sich mit der Situation und ihrer Wahrnehmung erst langsam (wieder) zurechtfinden. Unter ähnlichen passageren Adaptionsproblemen leidet auch das Bewusstsein eines Avatars, wenn es plötzlich (zum Beispiel nach seinem Tod, während er von einem User gespielt wurde) im Körper seines Users „aufwacht", wie der Film am Beispiel der Ashton-Figur im „Körper" von Whitney deutlich macht.
- Die Spielfiguren Ashton und Hall sind es auch, die ein weiteres ästhetisches Phänomen an den Grenzen der simulierten Spielwelt zum Vorschein bringen, das im Film als „das Ende der Welt" bezeichnet wird. Dort gehen die filmisch präsentierten Landschaften in computergenierte Rasterlinien über, die einer imaginären Oberfläche entbehren. Die Grenze der filmisch dargestellten Welt ist zugleich der Riss in der totalen, weltumspannenden Computersimulation. Wer denkt angesichts dieser Szenen nicht an Platons Höhlengleichnis (vgl. Platon 2002, S. 420 ff), dessen Protagonist sich aller illusionärer Fesseln befreit und die Konstruktion der Illusion selbst „sieht".
- Ähnlich wie der Sehende in Platons Gleichnis versucht nun die Hall-Figur in der Simulation von Los Angeles im Jahr 1999 einem Anderen zu erklären, dass dessen Wahrnehmungen sich nicht auf etwas Seiendes, sondern nur auf dessen Schein in Form einer Computersimulation beziehen. Hall tut das, indem er Ashton das Prinzip der Spielsimulation am Modell eines mechanischen Baseball-Spiels erklärt, das in einem der Büroräume des 13. Stocks steht (1:21:00 min).

Die entscheidende Differenz zwischen Platons Gleichnis und dem Setting von *The 13th Floor* besteht allerdings darin, dass es außerhalb (oder „über", wie der Film immer wieder behauptet) der computergenerierten Simulation einer Welt kein wahres Sein gibt, sondern wiederum nur die Scheinwelt einer anderen, weiteren Simulation. Jeder „Höhlenausgang" ist in Rusnaks Film gleichsam der Eingang in eine andere „mediale Höhle". Zudem können die „Menschen" in *The 13th Floor* nicht mehr (wie noch in Platons Denken) eine Differenz zur simulierten Welt behaupten, sondern sie sind selbst als computergenerierte Programmeinheiten Teil dieser Simulation.

Simulation und Traum

An den letzten Gedanken schließt sich eine weitere Frage an: Wie aber kann es sein, dass die Programmeinheiten einer Computersimulation ein Bewusstsein über dieselbe und sich selbst als künstliche Intelligenzen erwerben können, wenn sie doch gar nicht den Unterschied zwischen Simulation und Realität kennen können? Wie können sie ein „Außen" der Höhle denken, wenn sie doch noch nicht einmal wissen, dass sie sich in einer Höhle befinden? Hans Blumenberg, der in seinem Buch „Höhlenausgänge" (1996 S. 192) ein ähnliches Problem an Platons Höhlengleichnis analysierte, gibt zur Antwort: mittels ihrer Träume, Wünsche und Ahnungen.

> In Träumen stellt sich dar, daß es anderes gibt als das alltäglich Vorgestellte, Ausgestellte, Dargestellte. Anders ausgedrückt: Was Theorie, Phantasie, Rhetorik nicht zu leisten imstande sind, macht der Traum erahnbar. Und Ahnung genügt zur Bereitschaft, auf ein ‚Mehr' gefasst zu sein als auf die Bekanntheiten der Gehäusegeborgenheit.

Ähnliches legt auch Rusnaks Film (zunächst) nahe, wenn er den Download eines Users in die Spielsimulation mit der Traumerfahrung in Verbindung bringt. Schon die erste Sequenz des Films, in der sich die Fuller-Figur mittels seiner Programmeinheit Grierson in die Simulation von 1937 transferiert, analogisiert die Erfahrung in der virtuellen Realität mit der Traumerfahrung. Das „Aufwachen" der Fuller-Figur aus der Spielsimulation, dem elektronischen Datentraum im Großcomputerraum im Los Angeles von 1999, wird auf der visuellen Ebene des Films durch die typischen Gesten eines aus dem Schlaf Erwachenden unterstützt: das Aufrichten des Oberkörpers, sich mit beiden Händen durchs Gesicht reiben, einmal tief durchatmen, dann (close up auf die Schuhe, die quasi neben dem „Bett" stehen) in die Schuhe schlüpfen und in der „Realität" ankommen. Diese Analogie wird im weiteren Verlauf des Films noch verstärkt, wenn wir erfahren, dass sich die simulierten Räume, Dinge und Personen aus Wahrnehmungen, Vorstellungen, Erinnerungen und Wünschen, allgemeiner: aus Material vom Wachbewusstsein der Programmierer, zusammensetzen. Zudem dient die Simulation wie der Traum zur Wunscherfüllung der Spieler, wenn Fuller sich darin mit jungen Geliebten vergnügt oder sich die David-Figur seinen Mordgelüsten hingibt.

Analogien treffen selbstverständlich nie ganz, denn Träume lassen sich nicht programmieren und sind demnach auch nicht wie Computerspiele intentional steuerbar. Denn im Traum bin ich zwar als Träumer/Handelnder beteiligt an meinen Handlungen, kann aber gerade nicht bewusst Regie führen, Handlungsverläufe planen, Entscheidungen treffen. Es ist vielmehr so, dass mir die Träume und ihre Geschichten als Ereignisse widerfahren, ich erleide sie (ob nun lustvoll oder unlustvoll konnotiert). Die Filmfiguren Grierson, Natascha Molinaro und allen voran Douglas Hall scheinen als Avatare etwas Ähnliches zu erleben, wie wir es aus der Traumerfahrung kennen, wenn sie über den Zeitraum, in dem sie von ihrem User gespielt werden, keine bewusste und willentliche Kontrolle über ihren Körper haben und sich daher auch nur schemenhaft bis gar nicht an diese Zeiträume erinnern. Der zugegeben etwas „schiefen" Analogie zum Trotz, werden in der Überlagerung der genannten Traummotive mit der computergestützten, virtuellen Realität der Spielsimulationen interessante Fragen bezüglich der

„Realitätsprüfung" (vgl. Freud [1]1900, [1]1938; 1999[2]) der beteiligten Subjekte/Programmeinheiten aufgeworfen: Welche Wahrnehmungen garantieren den Unterschied zwischen simulierter/geträumter und sozialer Realität, zwischen Innen und Außen, zwischen Schlafen und Wachen? Wann oder wie kann ich mit Sicherheit sagen, dass ich nicht mehr träume bzw. mich nicht mehr in einer computergenerierten Simulation befinde? Wie kann es mir überhaupt gelingen, eine endgültige, „wahre" Antwort auf die Frage nach dem Realitätsstatus der Realität zu geben?

Der Film legt nahe, dass sich auch die Fuller-Figur solche Fragen gestellt haben könnte und so aufgrund der von ihm erfundenen, „erträumten" Simulation seine eigene Realität als „natürliche"/„wahre"/soziale Realität angezweifelt hat. Diese These bleibt jedoch rein spekulativ, da der Film diese Fragen nicht bearbeitet, sondern es bei den genannten Anspielungen belässt.

Rusnak präsentiert uns stattdessen mit *The 13th Floor* die filmische Version einer Welt, in der Immersion und Realitätsillusion der computergenerierten Simulationen so total funktionieren, dass eine ontologische Unterscheidung in Realität und Simulation nicht länger sinnvoll scheint. Vielmehr haben wir es bei dem Film mit einer Ontologie zu tun, deren „Wahrheit" in unendlich vielen, sowohl parallel existierenden als auch in sich verschachtelten simulierten Realitäten besteht. Die erkenntnistheoretischen und anthropologischen Konsequenzen einer solchen immanenten Ontologie simulierter Realität oder mediatisierter Wirklichkeit werden allerdings vom Film nicht weiter ausgearbeitet. Beispielsweise verwendet der Film metaphysische Konzepte wie „Bewusstsein" oder „Seele" als gesetzte. Mit anderen Worten: Er spitzt das Konzept des cartesischen Subjekts zu und imaginiert ein entkörperlichtes, entmaterialisiertes Subjekt, dessen Bewusstsein frei von einer virtuellen Realität in die andere gleitet und dem dabei klar wird, dass jede Realität eine Täuschung ist. Er thematisiert aber an keiner Stelle, wie es möglich ist, dass aus der technischen und technologischen Physis programmierter, lernender Identitätseinheiten – also künstlerischer Intelligenzen – der qualitative Sprung hin zu einem reflexiven Bewusstsein, einem Selbstbewusstsein entsteht? Ebenso macht er keine Aussage darüber, ob es überhaupt noch sinnvoll ist, von „Bewusstsein" oder „Selbstbewusstsein" zu sprechen. Darüber hinaus klärt der Film nicht, wie es möglich ist, dass das Selbstbewusstsein eines Avatars sich von diesem ablöst und in seinen „User" (der selbst ein Avatar in einer weiteren Simulation ist) transferiert? Umgekehrt fragt der Film auch nicht weiter nach, ob es eine hinreichende oder gar notwendige Begründung ist, Maschinenprogrammen bzw. künstlichen Intelligenzen ein dem Menschen ähnliches „Bewusstsein" und „Selbstbewusstsein" zu unterstellen, wenn diese „Ich" sagen können.

Das paranoische Subjekt des „Neo-Noir" oder der real existente „große Andere"

 Ich bin (zeitweise) ein Anderer.

Diese und weitere in höchstem Maße spannenden und irritierenden Fragen gibt der Film meines Erachtens für die dramaturgische Kreuzung seiner „mixed realities" mit einer den Filmzuschauern womöglich vertrauteren, filmgeschichtlichen Realität des „Film Noir" auf. Rusnaks Film ist bei aller ontologischen Komplexität unverkennbar als ein „Neo-Noir" inszeniert; zu viele Momente des Film Noir sind durch *The 13th Floor* aufgerufen, um diesen Bezug übersehen zu können. Da wären beispielsweise der Verschwörungsplot inklusive seiner Mordfälle, der ermittelnde Detektiv, der moralisch fragwürdige

2 Freuds Begriff der „Realitätsprüfung" ist nicht scharf ausgearbeitet. Er wird von Freud zwar oft, aber auch in den unterschiedlichsten Kontexten benutzt (vgl. Laplanche/Pontalis 1973, S. 431 ff). Es wäre sicher reizvoll, Rusnaks Film im Hinblick auf eine weitere Differenzierung des Freudschen Konzepts zu lesen, was allerdings den Rahmen dieses Textes sprengen würde, daher bleibt es hier nur bei diesem Verweis.

„Held" Douglas Hall; die Liebesbeziehung zwischen ihm, der „Femme fatale" Jane Fuller und ihrem eifersüchtigen Ehemann David (Halls „Vater" und User). Zudem leidet der Protagonist Hall von Beginn des Films an unter Erinnerungsstörungen. Die Gedächtnisproblematik ist ebenfalls kennzeichnend für den Film Noir. Der vorübergehende Bewusstseinsverlust, die Erinnerungslücken, wachsen sich bei Hall zu einem Zweifel und dann zur paranoischen Gewissheit aus, dass ein Anderer seinen Körper benutzt, um die ihm angelasteten Morde zu begehen. Mit Hilfe dieses Plots bringt *The 13th Floor* eine paranoische Ontologie zur Darstellung, die auch anderen, thematisch ähnlich gelagerten Filmen zugrunde liegt. Slavoj Žižek (2000) hat das in seinem Essay zu *Matrix* gezeigt. Diese Filme spielen subtile Ängste an, die durch die in den 1990er-Jahren beginnende und noch andauernde Digitalisierung unseres Alltagslebens geschürt werden (ebd., S. 49):

> … sobald unsere ganze (soziale) Existenz nach und nach in den großen anderen des Computernetzes veräußert/materialisiert wird, liegt die Vorstellung eines bösartigen Programmierers nahe, der unsere digitale Identität auslöscht und uns in Nicht-Personen verwandelt.

In dieser dramaturgischen Figur liegt auch der Grund dafür, dass sich Rusnaks Film letztlich nicht ernsthaft für ontologische, erkenntnistheoretische und anthropologische Fragestellungen interessiert. Die mit dem deutschen Untertitel des Films („Bist Du, was Du denkst?") und seinem Thema der simulierten Welt aufgerufenen philosophischen Fragen bezüglich der Identität von Welt und Selbst, samt ihren prominenten Gewährsmännern Platon und Descartes, werden letztlich in ein „Zweifeln am Zweifel" oder positiv formuliert: in die absolute Gewissheit eines manipulierenden, real existierenden großen Anderen überführt. Die von Descartes noch als methodischer Zweifel lancierte Denkfigur, dass ein Subjekt nicht ganz Herr seines Wahrnehmens, Denkens, Fühlen und Handelns sein und durch einen „bösen Dämon" getäuscht werden könnte, wird in Rusnaks Film zur absoluten Gewissheit einer (zumindest zeitweise) totalen Fremdbestimmung durch einen böswilligen Anderen.

Dadurch reduziert der Film Descartes Bemühungen, im Zweifeln einen positiven Grund für das philosophische Wissen zu denken, auf ein paranoisches Element seines Denkens, das in der ersten seiner Mediationen eingeführt wird. Descartes ([1]1641; 1986) fragt in seinen „Mediationen über die Erste Philosophie" nach der Gewissheit des Wissens: Wie kann ich wissen, was ich zu wissen meine? Ist es nicht möglich, dass mich meine Sinne oder die Meinungen der anderen täuschen, dass mich mein Körper täuscht? Die Formel „Ich denke, also bin ich." ist seine Antwort. Wenn auch alles Wissen nur Täuschung, Traum oder Einbildung wäre, so wäre doch der Zweifel an diesem Wissen selbst gewiss: Ich weiß, dass ich zweifle, also denke. Als Zweifelnder bin ich denkenden Seins. Descartes kommt zu dieser Gewissheit, indem er von Allem zu abstrahieren sucht, was der Körper mit seinen Sinnen und was die soziale Umwelt in das subjektive Denken eintragen könnten. Sein Wissensmodell ist damit die Grundfigur neuzeitlicher Wissenschaften. Denn sofern Gewissheit des Wissens für Descartes in der Selbstgewissheit des Denkens begründet ist, führt sein Modell in die Trennung von denkendem Subjekt einerseits und zu denkenden, materiellen Objekten andererseits, von res cogitans und res extensa. Diese Differenz liegt auch Descartes anthropologischen Überlegungen zugrunde, die in seiner Schrift „Über den Menschen" (De Homine [1]1662; 1969) posthum veröffentlicht wurden, wenn er den Unterschied zwischen Mensch und Maschine an des Menschen Verstand, seiner Seele festmacht. Auch diese Differenzfigur von Descartes wird in Rusnaks Film aufgerufen und neu gewendet, wie sich an einem für die Dramaturgie entscheidenden Dialog zwischen Jane Fuller und Douglas Hall gegen Ende des Films zeigen lässt (vgl. 01:10:00 min). Die Hall-Figur vergleicht darin seine Existenz als Avatar in einer Spielsimulation mit der einer „Puppe", also eines Spielzeugs:

💬 Douglas Hall: „Ich hab ihn ermordet."

Jane Fuller: „Aber das warst nicht du. Es war dein User. Er hat sich in dich downgeloadet, dich manipuliert…"

DH: „Wie ein Puppe."

JF: „Eine Puppe hat keine Seele…"

DH: „Ich kann keine Seele haben, genauso wenig wie Fuller!"

JF: „Aber die hast du, Fuller auch… Das war es, was ich nie erwartet hatte. Wir hatten diese Welt so programmiert, dass niemand darin jemals die Wahrheit erfahren konnte und du und Fuller, ihr habt es erfahren. Verstehst du denn nicht, was das bedeutet?"

Die Frage der Jane-Figur danach, was es (epistemologisch und anthropologisch) bedeute, dass Computerprogramme keine vom Menschen manipulierbare Puppen oder Spielzeuge sind, sondern „eine Seele" haben – also künstliche Intelligenzen sind, die nicht nur extrem schnell lernen, sondern gleich dem Menschen Schmerz, Leid, Freude, Zweifel, Hoffnung u. a. m. erfahren – bleibt unbeantwortet. Diese Frage wird bestenfalls dem Zuschauer des Films überantwortet, allerdings muss der sich zuvor von der moralischen Perspektivierung des Identitätsthemas, wie der Film sie vornimmt, lösen.

Moralische Perspektiven des Films

💬 Du bist, was du spielst!

Meine Interpretationsspur des Films ist folgende: Die zuvor skizzierten ontologischen und erkenntnistheoretischen Fragen (Was kann ich wie, also mit welcher Gewissheit, über das Sein der Welt und mich wissen?) und auch die anthropologischen Fragen (Was unterscheidet mich von anderem Seienden wie Dingen, Maschinen oder Tieren in dieser Welt?), die der Film durchaus stellt, handelt er recht oberflächlich ab bzw. verdrängt sie, zugunsten von moralischen Fragen im Umgang mit virtuellen Welten, die er mit einem dystopischen Unterton inszeniert. Identitätsstörungen werden in Rusnaks Film eben nicht nur als epistemische Probleme verstanden, sondern vielmehr als moralische. Denn je mehr die Filmfiguren über die Grenzen und Wahrheit ihrer (jeweils medial generierten, simulierten) Realität erfahren, desto stärker werden sie in Fragen nach dem richtigen Handeln verstrickt.

Damit sind zum einen Fragen gemeint, die der Film hinsichtlich eines Umgangs mit von ihm erschaffenen, künstlichen Kreaturen stellt, wie beispielsweise: Darf man in der Spielsimulation von Figuren Besitz ergreifen, diese manipulieren und töten, obwohl die dort agierenden Kreaturen eine gewisse Selbstständigkeit und gar ein Selbstbewusstsein, eine Seele zu besitzen scheinen? Fragen dieser Art werden im Film von den Figuren Hannon Fuller, Douglas Hall und Jane Fuller artikuliert. Gemeinsamer Fluchtpunkt der drei Figuren ist die Erkenntnis, dass die Avatare der Simulation nicht nur intelligente, sondern selbstbewusste Wesen sind (bei Fuller und Hall kommt die Erkenntnis hinzu, dass sie selbst solche Wesen innerhalb einer Simulation sind). Aus ontologischer und „anthropologischer" Perspektive gibt es damit keine wesentlichen Unterschiede mehr zwischen der computergenerierten Simulation samt deren virtuellen Wesen und der jeweils eigenen Realität und Identität der Figuren. Die Konsequenz dieser Einsicht ist für Hannon Fuller, Hall und auch Jane Fuller, dass das Spiel mit und in der Simulation beendet werden muss, da es zu einem unmoralischen Umgang mit den virtuellen Wesen verführt.

Diese moralische Perspektive wird dadurch akzentuiert, dass der Film auf unterschiedliche Art und Weise die Irritierungen und Verunsicherungen zeigt, die die Spielfiguren durch die Manipulationen ihrer User erleiden: Grierson, Ferguson, Natascha Molinaro und Douglas Hall werden von fragmentierten Erinnerungen, Déjà-vus u. ä. heimgesucht; Ashton und Hall geraten in existenzielle Nöte; Hall „entdeckt" Spuren des aggressiven Verhaltens seines Users David an sich, als er den Kopf des Barkeepers Jones durch eine Autoscheibe schlägt. Am stärksten wird die genannte Perspektive aber durch ihr negatives Zerrbild gestützt: Die Rede ist von der David-Figur, die aus dramaturgischen Gründen für den Zuschauer unsichtbar agiert. Dieser nutzt die Simulation, um seinen Aggressionen freien Lauf zu lassen und hemmungslos, vermittelt über seinen Avatar Hall, zu „morden". Er fürchtet dabei weder Strafe, ein schlechtes Gewissen noch andere Konsequenzen in seiner Realität, da er sich jederzeit aus der Simulation zurückziehen kann und zudem dort aus seiner Sicht keine menschenähnlichen Wesen, sondern lediglich zu Spielzwecken generierte Computerprogramme spielt, manipuliert oder zerstört. Die äußerst brutalen Eingriffe von David in den Film/Spielverlauf von *The 13th Floor* sind dann meines Erachtens zugleich Versuche, diese, seiner Sicht inhärente, ontologische und anthropologische Differenz und seine privilegierte Position als Kreator, Spieler und Lenker aufrecht zu erhalten, d. h. seine Existenz als User einer Spielsimulation zu verschleiern und die Realitätsillusion seiner Spielfiguren andauern zu lassen. Er schreckt dabei nicht einmal vor der Ermordung seiner Ehefrau Jane zurück. Über weitere Motive der (recht eindimensionalen) David-Figur erfahren wir im Film wenig, nur in dem zuvor schon erwähnten Dialog zwischen Douglas Hall und Jane Fuller kommt etwas von Davids Antrieb zur Sprache – und damit noch eine weitere moralische Dimension des Films:

Douglas Hall: „Ich hab' ihn ermordet."
Jane Fuller: „Aber das warst nicht du. Es war dein User. Er hat sich in dich downgeloadet, dich manipuliert…"
DH: „… wie ein Puppe."
JF: „Eine Puppe hat keine Seele…"
DH: „Ich kann keine Seele haben, genauso wenig wie Fuller!"
JF: „Aber die hast du. Fuller auch… Das war es, was ich nie erwartet hatte. Wir hatten diese Welt so programmiert, dass niemand darin jemals die Wahrheit erfahren konnte und du und Fuller, ihr habt es erfahren. Verstehst du denn nicht, was das bedeutet?"
DH: „Ja … nur gibt es in deiner These einen kleinen Schönheitsfehler. Nichts von all dem hier ist real. Wenn jemand den Stecker rauszieht, dann verschwinde ich. Und nichts, was ich jemals sage, nichts, was ich jemals tue, wird von Bedeutung sein… Warum liebst du nicht meinen User? Ich bin sicher, er ist eine weit bessere Partie."
JF: „Ich habe dir von meinem anderen Leben erzählt. Ich habe damit meinen Ehemann gemeint. Er ist dein User. Er hat Fuller getötet."
DH: „Ich bin seine Programmeinheit… Ein Spiegelbild seines Charakterprofils."
JF: „Ich hatte mich in einen anständigen Mann verliebt. Aber er, …irgendetwas ist mit ihm passiert. Er fing an, die Simulation als seinen eigenen persönlichen Spielplatz zu benutzen."
DH: „Wie Fuller mit den jungen Frauen."

JF: „Er machte sich zu einem Gott, und es hat ihn korrumpiert. Er fing an, das Töten zu genießen. Er wurde süchtig."

DH: „Wie meinst du das?"

JF: „Er sagt, er würde mich töten"

DH: „Wieso?"

JF: „Ich hatte mich in dich verliebt …"

Die David-Figur genieße also das Töten in der Spielsimulation. Und, das scheint mir entscheidend an Janes Rede, dieser Genuss soll einen Effekt auf seine Persönlichkeitsstruktur in der Realität von 2024 haben. Dieser ginge soweit, dass er aus Eifersucht sie selbst töten wolle. Die Spielsimulation verführt ihre User demnach nicht nur dazu, „unmoralische" Lebensentwürfe und Verhaltensweisen auszuprobieren, sondern die Spielhandlungen und virtuellen Identitäten haben wiederum ganz konkrete Effekte und Konsequenzen auf die Spieler. Um nur einige weitere Beispiele zu nennen:

- Fuller probiert mit seinem Avatar Grierson die Identität eines Ehebrechers und Liebhabers von sehr jungen Frauen aus – und stirbt sehr bald darauf;
- der Nichtraucher Hall geht im „Körper" seines Avatars Ferguson in der Simulation auf die Suche nach Fullers Brief, der ihn in seiner Realität von einem Mordverdacht entlasten soll – und raucht kurz darauf, so wie Ferguson es tut;
- die verheiratete Jane-Figur verliebt sich in der Simulation als Natascha Molinaro in den Avatar Douglas Hall.

Diese Beispiele sollen genügen, um zu verdeutlichen, wie *The 13th Floor* den Umgang mit Computerspielen nicht nur in Frage stellt, sondern vielmehr direkt mit einem moralisch fragwürdigen Verhalten in Verbindung bringt: Du bist, was Du spielst!

Mit diesem Interpretationsangebot ruft der Film Ängste und Diskursfiguren auf, die spätestens mit der kommerziellen Vermarktung von Video- und Computerspielen im öffentlichen Diskurs über dieselben mal mehr und mal weniger präsent sind. Gemeint sind die verschiedenen Spielarten des Diskurses, der einen Zusammenhang zwischen gewalthaltigen Spielen und aggressivem Verhalten ihrer Spieler herstellen will oder auch der heute stärker werdende Diskurs über das Suchtpotenzial von Computerspielen. Gemeinsamer Fluchtpunkt dieser Diskurse ist die Annahme – die auch *The 13th Floor* zur Darstellung bringt – dass sich unsere Persönlichkeitsstruktur an und mit den uns umgebenden, medialen Umwelten bildet und daher auch umbilden kann. Auf welche Art und Weise dies aber geschehen soll, darüber gibt der Film keine Auskunft. Auf die zuvor schon dargelegte Weise ignoriert Rusnaks Film sogar die medialen Differenzen zwischen sozialer Realität und Spielsimulation, wenn er sie unter der filmästhetischen „Couverture" des „Film Noir" verschwinden lässt und zudem mit moralischen Maßstäben operiert, die über die verschiedenen Realitäts- und Simulationsebenen hinweg Gültigkeit beanspruchen. Seltsamerweise entspringt aus dieser scheinbar so starken moralischen Sensibilität einiger Figuren kein Aufbegehren gegen die äußeren (durch Programmierer und User der Simulation ausgeübten) Zwänge, sondern sie arrangieren sich mit ihren Umständen, nutzen die ihnen zur Verfügung stehenden Möglichkeiten und handeln damit paradoxerweise „unmoralisch". Dies gilt insbesondere für die Jane-Figur. Sie arrangiert die Erschießung ihres Ehemanns David in der Simulation durch Detektiv McBain, um mit dem Bewusstsein von Hall (verkörpert in ihrem Mann David) im Los Angeles von 2024 ihr privates Glück zu leben – und damit eben auch das Rollenklischee der Femme fatale zu erfüllen.

Wie sich hier zuletzt nochmals in verdichteter Form zeigt, ist Rusnaks Science-Fiction-Film ein Hybrid aus mehreren konkurrierenden Perspektiven, die die Inszenierung seiner Handlung organisieren. Das vordergründige Spiel mit dem existenziellen Zweifel der Figuren von *The 13th Floor* und die damit durch den Film angespielten ontologischen und anthropologischen Perspektiven in Form

der Differenzen von Sein und Schein, Realität und Simulation, Mensch und Maschine sind lediglich dramaturgische Strategien des Films, die vor allem auf die Immersion der Protagonisten und auch der Zuschauer zielen. Die Protagonisten werden durch diesen Zweifel in das Spiel selbst hineingesogen; der Zweifel ist Teil der filmischen/medialen Konstruktion und nicht deren Infragestellung. Erkenntniskritik wird somit durch den Film verweigert, die spannenden Fragen, die sich mit Galouyes Geschichte stellen, bleiben unbearbeitet und Descartes streitbare Formel menschlicher Selbstvergewisserung „Ich denke, also bin ich" wird in die platte Erkenntnis umgedeutet, dass auch Maschinen bzw. künstliche Intelligenzen denken, also (wie) Menschen sein können. Diese Erkenntnis wird zudem mit moralischen Wertungen kurzgeschlossen, dass man mit künstlichen Intelligenzen nicht spielen darf, bzw. dass man aufpassen muss, was und wie man mit ihnen spielt, da das spielerische Probehandeln reale Effekte zeitigt. Daher präsentiert der Film seinen Zuschauern auch über weite Strecken menschliche Figuren mit menschlichen Schwächen, mit Handlungen, die wiederum von moralischen Überlegungen motiviert sind. Die Dramaturgie des Verdachts von *The 13th Floor* ist daher nicht als ein Verdacht gegen die Medialität der Welt oder gegen die Medialität eines fragmentierten Subjekts inszeniert, sondern fügt sich den dramaturgischen Konventionen einer „Neo Noir"-Kriminalgeschichte.

Bestenfalls hinterlässt das zuvor schon angesprochene letzte Bild des Films bei den Zuschauern eine Irritation, die es ihm ermöglicht, denselben gegen die ihn dominierende genretypische und moralische Perspektivierung zu lesen. Dieses Bild legt die Interpretation nahe, dass es sich auch bei der Welt im Jahre 2024 um eine simulierte Realität handelt, und damit alle Protagonisten des Films das gleiche Schicksal als maschinengenerierte, virtuelle Wesen teilen. In dieser posthumanen Interpretationsperspektive wären es dann also Maschinen, die für Maschinen solche Menschensimulationsspiele aufführen – aber warum tun sie das?

Literatur

Blumenberg H (1996) Höhlenausgänge, 3. Aufl. Suhrkamp, Frankfurt/M

Descartes R (1986) Meditationes de Prima Philosophia/Meditationen über die Erste Philosophie. Reclam, Stuttgart (Erstveröff. 1641)

Descartes R (1969) Über den Menschen. Schneider, Heidelberg (Erstveröff. 1662)

Freud S (1999) Die Traumdeutung. Gesammelte Werke Bd II. Fischer, Frankfurt/M (Erstveröff. 1900)

Freud S (1999) Abriß der Psychoanalyse. Gesammelte Werke Bd XVII. Fischer, Frankfurt/M (Erstveröff. 1938)

Galouye DF (1983) Simulacron Drei. Heyne München. Im Original: Simulacron-3 (1964)

Laplanche J, Pontalis JB (1973) Das Vokabular der Psychoanalyse. Suhrkamp, Frankfurt/M

Platon (2002) Sämtliche Werke Bd 2, 29. Aufl. Rowohlt, Reinbek

Winkler H (1997) Docuverse. Zur Medientheorie des Computers. Boer, Grafrath

Žižek S (2000) Lacan in Hollywood. Turia + Kant, Wien

Originaltitel	The 13th Floor
Erscheinungsjahr	1999
Land	USA
Buch	Josef Rusnak
Regie	Josef Rusnak
Hauptdarsteller	Craig Bierko (Douglas Hall/John Ferguson/David), Gretchen Mol (Jane Fuller/Natasha Molinaro), Vincent D'Onofrio (Jason Whitney/Jerry Ashton), Armin Mueller-Stahl (Hannon Fuller/Grierson)
Verfügbarkeit	Als DVD in OV und deutscher Sprache erhältlich

August Ruhs

The Cell – Im Kerker des Organismus

The Cell – Regie: Tarsem Singh

Filmplakat *The Cell*
Quelle: Cinetext/Richter

The Cell

Regie: Tarsem Singh

Vorbemerkung

The Cell (◘ Abb. 1) von Tarsem Singh, im symbolisch aufgeladenen Jahr 2000 fertiggestellt, ist ein Science-Fiction Thriller, welcher Thematiken und Fragenbereiche aufwirft, die einem psychoanalytisch und psychiatrisch interessierten Publikum keineswegs gleichgültig sein können.

Bezogen auf den Hauptaspekt der Filmhandlung, welcher in der innerhalb eines medizinischen Dispositivs vollzogenen Verwirklichung einer uralten Vorstellung besteht, nämlich auf direkte und unvermittelte Weise und damit jenseits von Identifizierung und Empathie in das Seelenleben eines Anderen so einzudringen, dass ein authentisches Miterleben im Sinne einer Co-Subjektivität gewährleistet ist, spiegeln sich hier die Ambitionen der so genannten modernen Neurowissenschaften wider, die unter verschiedenen und wohl auch fragwürdigen Neuro-Begrifflichkeiten (von Neuropsychologie über Neuropsychoanalyse bis hin zu Neurotheologie u. ä.) auch angestammte Forschungs- und Behandlungsfelder von Psychoanalyse und Psychotherapie mehr und mehr zu besetzen versuchen.

Die in einer solchen Situation miteinander konkurrierenden Positionen und Konzeptionen hinsichtlich der menschlichen Persönlichkeits- und Charakterentwicklung und hinsichtlich der Genese psychopathologischer Phänomene werden in *The Cell* einerseits innerhalb der klinischen Bereiche von Perversion und Psychose respektive Schizophrenie verhandelt, andererseits finden sie in den mit derartigen Fragen befassten Subjekten des Streifens ihren personifizierten Ausdruck. In diesem Sinn sind die auf der Forschungs- und Aufklärungsseite stehenden Protagonisten des Films zum einen Teil Vertreter biologistischer Konzeptionen und zum anderen Teil Repräsentanten geistes- und sozialwissenschaftlicher Erklärungsansätze.

Darüber hinaus gehend wird sich erweisen, dass der eher dem B-Movie-Genre und dem Unterhaltungskino zuzuordnende Film auch für eine postmoderne Filminterpretation nach dem Vorschlag Slavoj Žižeks und der um ihn zentrierten Theoretikergruppe aus Ljubljana geeignet ist (Žižek 1992).

Deren filmische Deutungsarbeit, die an der Psychoanalyse Lacans orientiert ist und sich zunächst hauptsächlich auf das Hollywood-Kino und auf das Werk Hitchcocks bezogen hat, baut auf zwei miteinander verbundenen Grundannahmen auf, deren erste die Unterscheidung zwischen angewandter und theoretischer Psychoanalyse berücksichtigt und diese Differenzierung anhand von Beispielen aus verschiedensten kulturellen Bereichen rechtfertigt: Während es in der angewandten Psychoanalyse darum geht, mit Hilfe der analytischen Theorie ein kreativ-künstlerisches Produkt besser oder anders als zunächst angenommen zu verstehen, wird in der theoretischen Psychoanalyse durch Umkehrung der Fragestellung ein entgegengesetzter Weg eingeschlagen: Welchen Beitrag kann ein kulturelles Produkt wie etwa ein Film für das Verständnis und für das Begreifen komplexer und abstrakter Konzepte der psychoanalytischen Theoriebildung leisten? Unter der zweiten Voraussetzung, dass nämlich sowohl die Moderne als auch die Postmoderne ihren Zugang zum Kunstwerk immer (noch) über die Interpretation sucht, hat sich Žižeks Gruppe einem postmodernen Vorgehen verschrieben: Während es für eine moderne Interpretation gelte, in einem modernen Kunstwerk mit seinem definitionsgemäß „unverständlichen" und schockierenden Charakter gerade das Unverständliche verständlich zu machen, laufe ein postmodernes Interpretationsverfahren darauf hinaus, ein Alltägliches zu verfremden. Daher sind auch die Gegenstände derartiger Analysen Produkte mit ausgesprochenem Massen-Appeal (zumeist scheinbar reines Unterhaltungskino), wobei es die Aufgabe der Interpretation sei, darin Darstellungen der esoterischsten theoretischen Finessen eines Lacan, eines Derrida oder eines Foucault zu erkennen (ebd., S. 10):

⬤ **Abb. 2** Vom Ertrinken bedroht: Julia Hickson (Tara Subkoff). (Quelle: Interfoto/Mary Evans)

Wenn also die Freude der modernistischen Interpretation im Effekt einer Wiedererkennung besteht, die das Beunruhigende und Unheimliche ihres Gegenstandes plausibel und vertraut macht (‚Aha, jetzt verstehe ich, was dieser augenscheinliche Unsinn soll!'), so ist es das Ziel einer postmodernistischen Behandlung, das anfänglich Vertraute des Gegenstandes zu verfremden: ‚Sie glauben, dass das, was Sie sehen, ein einfaches Melodram ist, dem auch Ihre senile Oma problemlos folgen könnte? Aber ohne in Betracht zu ziehen, was es hier mit … [der Differenz zwischen Symptom und Sinthom; der Struktur des borromäischen Knotens; dem Umstand, dass ‚Die Frau' einer der Namen-des-Vaters ist etc.] auf sich hat, haben Sie die Pointe überhaupt nicht begriffen!

Die Filmhandlung

Die Psychologin und Psychotherapeutin Catherine Deane (Jennifer Lopez) ist aktives Mitglied einer neurowissenschaftlichen Forschergruppe, welcher es gelungen ist, sich auf direkte Art und Weise in das Seelenleben komatöser Patienten einzuschleusen. Anhand eines exemplarischen Falles soll durch elektronische Vernetzung der jeweiligen Gehirnaktivitäten die junge Wissenschaftlerin mit der noch funktionierenden Gedanken-, Erinnerungs- und Fantasiewelt des kleinen und absolut autistischen Jungen Edward (Colton James) Kontakt aufnehmen, um ihn zu einer Rückkehr in das bewusste und gesellschaftliche Leben zu bewegen. Die Bemühungen sind allerdings nur bedingt erfolgreich, da die Versuche, das Vertrauen des Kindes zu erlangen, von einer ihm innewohnenden bösen Gestalt immer wieder vereitelt werden.

In einer Parallelhandlung wird der Zuschauer Zeuge der perversen Aktivitäten des Serienmörders Carl Rudolph Stargher (Vincent D'Onofrio), welcher in einer Mischung aus Sadismus und Nekrophi-

lie gewaltsam entführte junge Frauen in einem Versteck seinen sexuell determinierten Mordritualen unterzieht: In einer gläsernen Kammer, die sich nach einer bestimmten Zeit automatisch mit Wasser füllt, gehen die Opfer einem qualvollen Ertrinkungstod entgegen, um danach, mit Bleichmitteln gereinigt, als mumifizierte Puppen den sexuellen Bedürfnissen des Killers zu dienen (◘ Abb. 2). Durch verschiedene Spuren, wie etwa Haare seines Albinohundes oder seiner Wagenreifen, aber auch durch Hinweise, die Carls offensichtlicher Neigung, entdeckt zu werden, entsprechen, gelingt es dem FBI, den Mörder zu identifizieren. Die Jagd auf ihn endet schließlich damit, dass er in einem psychotisch-komatösen Zustand auf dem Boden seiner Küche liegend aufgefunden wird. In seinem Haus, das wie ein Museum seiner Perversionen anmutet und welches über eine Videoanlage mit dem geheimen Ort der Verbrechen verbunden ist, müssen die Polizeiagenten mit Entsetzen feststellen, dass das zuletzt entführte Opfer zwar noch am Leben ist, aber in absehbarer Zeit den Tod in der durchfluteten Glaszelle erleiden wird. Da von Carl selbst kein Beitrag zur Auffindung des Verstecks zu erwarten ist, soll Catherine mit den Methoden ihres Labors versuchen, in seine Innenwelt einzudringen und ihm auf diese Weise sein Geheimnis zu entreißen. Letzteres gelingt ihr zwar nicht, aber sie kann andererseits tief in sein perverses Seelenleben eintauchen und hinter dessen Obszönitäten und Grausamkeiten die Stationen einer noch grausameren Lebens- und Familiengeschichte erfahren und erleben, welche in ihrer Prägung durch die Gewalttaten eines unfassbar brutalen Vaters die Motivationszusammenhänge für Carls verbrecherische Handlungen zu liefern imstande sind. Als ein Schlüsselerlebnis mit besonders nachhaltiger Erinnerungswirkung erweist sich eine Taufe im Rahmen eines fragwürdigen Sektenrituals, als Carl als Halbwüchsiger in den brutalen Armen seines sadistischen Vaters an die Grenze des Ertrinkens geführt worden ist.

In ihren Versuchen, die Person Carls über seine guten und kindlichen Persönlichkeitsanteile positiv zu beeinflussen, wird sie allerdings immer wieder von seiner bösen Vorstellungswelt behindert, bis sie sich schließlich darin so verstrickt, dass sie ihr Realitätsbewusstsein verliert und zu ihrer wirklichen und eigenen Identität nicht mehr zurückfindet. Um Catherine zu retten, erklärt sich der FBI-Mann Peter Novak (Vince Vaughn) dazu bereit, virtuell in das nun gemeinsam gewordene Innenleben von Carl und Catherine einzutauchen. Während er erfolgreich Catherines Realitätsempfinden wiederherstellt, sodass sie in ihr gewohntes Leben zurückkehren kann, findet Peter in den Vorstellungsinhalten Carls ein Indiz für den unbekannten Aufenthaltsort der vom Tod bedrohten jungen Frau: Das Firmenlogo auf einer zu einer Folterapparatur umgebauten Gerätschaft führt die Polizei tatsächlich auf eine richtige Spur, sodass das mit seiner grausamen Bestimmung ringende Opfer buchstäblich im letzten Augenblick vor dem Ertrinken gerettet werden kann

Eine letzte Begegnung zwischen Catherine und Peter, die durch den Kriminalfall psychisch aufs Innigste miteinander verbunden waren, zeigt auch ihre endgültige Entzweiung: Peter, der für die von Catherine vertretenen lebensgeschichtlich orientierten Theorien zum Verständnis von perversen Verbrechen letztlich nichts übrig hat, kann auch Catherines weiterem Engagement für ihre Art psychischer Manipulation nichts Positives abgewinnen. Sie wiederum will ihre weitere Arbeit an Kranken mit den an Carl gewonnenen Erkenntnissen mit mehr Aussicht auf Erfolg fortsetzen. Insbesondere soll dabei die Technik der nicht ungefährlichen „Umkehrung" verstärkt zum Einsatz kommen, indem entsprechend ihrer traumatisierenden Erfahrung bei Carl nicht sie in das seelische Universum des Anderen eindringt, sondern indem vielmehr sie bereit ist, den Anderen in ihre Vorstellungs- und Erinnerungswelt aufzunehmen.

Regie, Kontext, Entstehungs- und Wirkungsmomente

Den Angaben von IMDb (Internet Movie Database)[1] und Wikipedia[2] zufolge war der von den USA und Deutschland produzierte Film für mehrere Filmauszeichnungen in verschiedenen Sparten und insbesondere für einen Oscar in der Kategorie „Bestes Make-up" nominiert gewesen. Tatsächliche Awards erhielten schließlich Jennifer Lopez (Blockbuster Entertainment Award: „Beste Schauspielerin-Science Fiction" und MTV Movie Award: „Best Dressed") und die Stuntfrau Jill Brown (Taurus World Stunt Award in der Kategorie „Bester Stunt in der Höhe").

Aus derartigen Würdigungen wird auch ersichtlich, dass Ausstattung und Kostüme bei diesem ästhetisch opulenten Streifen zumindest eine ebenso große Rolle gespielt haben wie die auf einem Drehbuch von Mark Protosevich beruhende Handlung. Der aus Indien stammende Film- und Videoregisseur Tarsem Singh (geb. 1961), der mit *The Cell* sein Regiedebut als Filmregisseur feierte, konnte, was das Formale betrifft, die Erfahrungen aus seiner von zahlreichen Auszeichnungen begleiteten Arbeit als Designer und Regisseur von Videoclips und Werbespots in das Filmprojekt einbringen, woraus sich schließlich eine Doppelkarriere mit zwei weiteren Spielfilmen (*The Fall* 2006 und *Immortals – Der Krieg der Götter* 2011) und mit einer Vielzahl von bekannten Werbefilmen bis in die Gegenwart ergab. Abgesehen von Selbstzitaten aus Videoclips hat Singh die Ausstattung des vorliegenden Films mit Bild- und Objektmaterial angereichert, das sich an Werken bekannter Künstler wie Damian Hirst, H. R. Giger oder Odd Nerdrum orientiert. Kritiker haben den Streifen auch mit dem *Schweigen der Lämmer* verglichen (an dessen Erfolg er sich allerdings nicht messen kann) und auf Einflüsse prominenter Regisseure wie Andrej Tarkowski hingewiesen. Es ist möglich, dass technologiebegeisterte Esoteriker den Hauptanteil des dem Film enthusiastisch gegenüberstehenden Publikums ausmachen.

Prämissen, Vermutungen und Reflexionen

Aufgrund außergewöhnlicher Bedingungen im Sinne einer Vorherrschaft des Sozialen und Kulturellen gegenüber dem Naturgegebenen ist menschliches Zusammenleben in besonderer Weise an die Notwendigkeit gebunden, dass sich der Einzelne in das Innenleben der ihn umgebenden Mitmenschen hineinzuversetzen imstande ist, ohne dass dabei Intimitäten zerstört oder individuelle Begrenzungen aufgehoben werden. In Anbetracht der Komplexität, dass zwar jedes Subjekt einzigartig ist, dass aber gleichzeitig alle Menschen aus demselben Lehm geformt sind und dass sie schließlich im Rahmen definierter Kulturbereiche unter allgemein verbindlichen Mentalitäten, Normen und Wertesystemen stehen, ist ein solcher Kompromiss aufrechtzuerhalten, indem wir diesen Zugang zum Anderen indirekt über dessen Verlautbarungen und Mitteilungen sowie über Einfühlungs- und Identifizierungsvorgänge erlangen. Letzteres gelingt uns insofern nicht so schwer, als wir uns, wie wir uns, wie Freud unter anderem in „Massenpsychologie und Ich-Analyse" (Freud 1921, S. 65) deutlich hervorgehoben hat, in unserer ontogenetischen Entwicklung weitgehend an den Nebenmenschen aufrichten. Daran anknüpfend hat Lacan zeigen können, wie sich unser Ich als kohärentes Selbst erst im Rahmen des Spiegelstadiums durch Identifizierung mit dem Bild eines „anderen" bzw. mit unserem eigenen Spiegelbild konstituiert (Lacan [1]1949; 1973). Aus einer auf diese Weise angelegten primären Intersubjektivität können sich in einer Übersteigerung der Beziehungsdichte und in einer Überschreitung von Ich-Grenzen transsubjektive Phänomene entwickeln, welche in der Hypnose und in der mit ihr verwandten Massenbildung ihre geläufigsten Ausdrucksformen finden. Damit ist auch die Grundlage für alle Phänomene geschaffen, die sich unter dem Begriff der Telepathie subsummieren lassen, welche wir wiederum unter die diversen Figuren des Unheimlichen einreihen können.

1 http://www.imdb.com/title/tt0209958/. Zugegriffen am 11. 11. 2011
2 http://www.imdb.com/title/tt0209958/. Zugegriffen am 11. 11. 2011

Das reizvolle Phantasma, ganz in die Subjektivität eines Anderen einzudringen und dessen Erleben authentisch mitzuerleben, wird zu einer faszinierenden Herausforderung, wenn Mitteilungen über seelische Befindlichkeiten und Inhalte suspendiert sind und wenn auch affektive und kognitive Identifizierungen versagen müssen. An diesem Punkt setzt Singhs Film an, indem er zwei komatöse Subjekte in den Mittelpunkt seiner Erzählung rückt und an ihnen die zumindest theoretischen Möglichkeiten sondiert, mit neuen physikalischen Technologien und unter Ausschaltung jeder medialen Überbrückung durch die üblichen Sinneskanäle, unvermittelt und direkt die Affekt-, Gedanken- und Fantasiewelt eines Menschen tatsächlich zu erobern bzw. seine eigene subjektive Intimität durch andere erobern zu lassen. Eine solche Thematik ist in der Literatur durch zahlreiche Beispiele vertreten; sie hat aber auch ins Kino in verschiedenen Variationen vor und nach dem Erscheinen von *The Cell* Eingang gefunden, wobei als besonders prägnantes Beispiel *Strange Days* von Kathryn Bigelow (USA 1995) gelten darf: Hier geht es um verbotene und wie Drogen gehandelte „Clips", auf welchen die Aufzeichnungen von gesehenen, gehörten und gefühlten Erlebnissen anderer Personen bis hin zu aktiven und passiven Morderfahrungen gespeichert sind und mit Hilfe eines „Headsets" als gewissermaßen fremde Selbsterfahrungen mit einer zugleich virtuellen als auch realistischen Qualität abgerufen werden können.

Es liegt auf der Hand, dass ein Psycho-Invasions-Dispositiv, wie es uns durch *The Cell* vor Augen geführt wird, die logische Weiterführung jener Experimentierfreudigkeit darstellt, mit welcher sich aktuell die Neurowissenschaften an der Paradoxie und Aporie abarbeiten, Subjektivität zu objektivieren und allgemein erfahrbar zu machen. So faszinierend viele Methoden und Ergebnisse solcher Forschungstätigkeiten sind, so bedrohlich können sie für die Psychoanalyse und für ihr nahestehende Disziplinen werden, wenn sie von namhaften Vertretern (und nicht zuletzt von solchen mit psychoanalytischem Hintergrund) als der gegenwärtige und bislang höchste Stand des psychoanalytischen Dispositivs und des Freud'schen Diskurses ausgegeben werden. Denn wenn hier suggeriert wird, dass die analytische Couch durch den Kernspintomografen und ähnliche einschlägige Apparaturen zu ersetzen sei, so liegen dieser Auffassung Kategorienfehler für den Bereich des Psychischen zugrunde, welche, sinnbildhaft auf ein Computermodell übertragen, die Gleichsetzung von Hardware, Betriebssystem und Software bedeuten würde. In dieser Hinsicht, und wieder metaphorisch gesehen, wäre ein Großteil neurowissenschaftlichen Forschens ein auf Eingriffe und Analysen der Festplatte konzentriertes Vorgehen, womit an diesem Ort unvermittelt und direkt Inhalte aufgespürt werden sollen, die erst durch ikonische und textuelle Programmierung und mit Hilfe eines Bild- und Textschirms entstehen und dann, und nur dann, auch sinnlich und sinnhaft erfahrbar werden. Zurückübertragen hieße dies, in zerebralen Substanzen und Strukturen und auf der Ebene von Synapsen und neuronalen Verschaltungen und Vernetzungen Subjektivitäten zur unmittelbaren Anschauung bringen zu wollen, die erst durch Repräsentanzen konstituiert werden und als solche auch erlebbar und vermittelbar sind. Es liegt auf der Hand, dass solchen Bemühungen auch gesellschaftswirksame Machtfantasien in den Dimensionen von Kontrolle, Überwachung und Disziplinierung assoziiert sind, sei es als die Suche nach dem perfekten Lügendetektor, sei es als bedrohliche Vorstellung von der Realisierung eines totalitären Staates mit absoluter Transparenz im Sinne des Orwell'schen Albtraums.

Die Gleichsetzung von Subjekt/Ich und Gehirn, die solchen Konzeptionen und Praxisfeldern implizit und explizit zugrunde liegt, hebt grundsätzlich die Gegensätzlichkeit von Sein und Bedeutung sowie jene strukturbedingten und „normalen" Subjektspaltungen auf, welche durch die imaginären und symbolischen Repräsentanzen bedingt sind und von Lacan immer wieder als fente und refente bei der Ich- und Subjektkonstituierung hervorgehoben werden. Damit ist auch ein grundsätzlich entfremdetes und zwischen einem Subjekt der Äußerung und einem Subjekt der Aussage liegendes Gesamtsubjekt nicht mehr gegeben. (s. dazu Ruhs 2011, S. 39 ff) Die Entsubjektivierung des Psychischen bzw. die Psychologisierung des Materiellen geht in letzter Konsequenz auch mit einer Aufhebung des Leib-Seele-Dualismus mit seinen Interdependenzverhältnissen einher, sodass eine ödipal-dialektische Persönlichkeit zugunsten einer digital funktionierenden Pseudo-Persönlichkeit auf „Entweder-oder-Niveau" im Sinne einer Borderline-

Struktur in den Hintergrund tritt. Die sozialen und kulturellen Phänomene, in welchen die Tendenzen der Enthistorisierung und Entsozialisierung des Psychischen und der Auflösung gewohnter und relativ stabiler individueller Subjekthaftigkeiten ihren Ausdruck finden, weisen in verschiedene Richtungen. Einerseits scheint die Schwächung mentaler (geistiger) Kategorien überkompensatorisch zu einer ins Religiöse und Esoterische hineinreichenden Betonung der Spiritualität zu führen, andererseits werden wir durch Soziologen und Kulturtheoretiker auf neue Gesellschaftstypen aufmerksam gemacht, welche, wie etwa der „telematische" bzw. „postmoderne" Typus, den bis in die 1990er-Jahre vorherrschenden narzisstischen Sozialisationstyp ersetzen würden. In diesem Zusammenhang wird darauf hingewiesen, dass es unter dem Einfluss des erstaunlichen Fortschritts der Kommunikationstechnologie und der Konstruktion eines weltweiten Netzwerks sowohl zum Verschwinden der Grenzen zwischen innen und außen mit einem „eindrucksvollen Niedergang des Intimlebens" bzw. mit einer „Abschaffung des psychischen Raums" (Kristeva 2007) als auch zur Auflösung etablierter Identitäten gekommen sei. (vgl. Pfeiffer u. Staiger 2005; Ruhs 2010) Schließlich ist auch zu bedenken, dass die Einrichtung zerebraler Strukturen und Systeme als Zentralagenturen menschlichen Verhaltens und Handelns zu einem technologischen Animismus führen kann, der als eine Art Beseelung der Welt in eine Psychologie münden würde, die Lütkehaus in Anlehnung an Günter Anders' „Antiquiertheit des Menschen" unter dem Begriff der „Dingpsychologie" zu fassen versuchte und der Humanpsychologie gegenüberstellte. (Lütkehaus 1995)

Bezogen auf das Phänomen des Traums und auf die Tätigkeit des Träumens und in dieser Hinsicht wieder stärker auf den hier interessierenden Film eingestellt, führt der neurophysiologisch zentrierte Zugang auch unter Beachtung seines Versuchs, eine „psychologisch-empirische Traumforschung" mit der Fähigkeit zu „luzidem Träumen" und zu einer bewusst intendierten Manipulation von Traumprozessen auf die Beine zu stellen, nicht nur zu einer inflationären Ausweitung des Traumbegriffs, sondern auch zur Neubesetzung von Positionen einer vornehmlich an der Ich-Stärkung interessierten Ich-Psychologie und schließlich zum Verfehlen des Gegenstandsbereichs „Traum" in seinen wesentlichen Dimensionen: in seinem enigmatischen und nach Interpretation verlangenden Charakter, in seiner in der Wunschdynamik und in der Wunschökonomie verankerten Funktion und in seiner medialen Verfasstheit, die vor allem als Bildhaftigkeit mit halluzinatorischem Charakter und als szenisch-theatralische Gestaltung imponiert. Unter diesen Voraussetzungen wäre der neuropsychologischen Frage nach dem „percipiens" als wahrnehmendem Ich des Traums, nach dem „somnians" also (dem träumenden Subjekt bzw. dem Träumenden im Subjekt) jene andere und psychoanalytische Frage vorzuziehen, die auf das „perceptum", auf das „somniatum", auf den Traum also im üblichen Sinn, gerichtet ist. Tatsächlich reduziert eine prozessorientierte Kognitionspsychologie, welche sich in ihrer Traumforschung ebenfalls eines Unbewussten bedient, den ganzen Gegenstandsbereich des Traumgeschehens auf die Aktivität des „dreaming". Ein solches Träumen eines „cognitive unconscious" ist dann „bloßes Informationsprocessing (und neuronale Verrechnung), dem überhaupt keine latente Bedeutung, keine Botschaft unterliegt." (Leuschner 1999, S. 362)

Das Eindringen in die Welt der Komatösen, wie sie im Film mit ihrer Überfülle an kohärenten Bildern und Ereignisketten als dem Traum nicht unähnlich vor- und dargestellt werden, ist durch die Bemühungen der wissenschaftlichen Protagonisten, an den Selbst- und Objektrepräsentanzen und an den Erinnerungsbildern und Phantasmen der Betroffenen manipulativ Einfluss zu nehmen, dem psychoanalytischen Umgang mit seelischen Vorgängen und Inhalten letztlich stärker verpflichtet als einem biologistischen Paradigma, obwohl die technologische Überfrachtung der ganzen Versuchsanordnungen an ein diesbezügliches Naheverhältnis denken lässt.

Diese geringfügige Ungereimtheit verdichtet sich allerdings zu einer schärferen Konfrontation von Auffassungsgegensätzen und ideologischen Differenzen, sobald sich der Film nicht nur der ästhetisch ambitiösen „Verbilderung" unbewusster seelischer Vorgänge unter Ausnahmebedingungen und in Grenzzuständen widmet, sondern wenn er auch der Frage nach den ätiologischen Momenten der psychopathologischen Entwicklung sowohl von Carl als auch von Edward nachgeht.

Wenn Catherine die psychischen Räume ihrer beiden „Analysanden" betritt und durchschreitet, sind ihr Erleben, ihre Wahrnehmungen und ihre Beschreibungen einem Begriffs- und Kategoriensystem verhaftet, für welches die Beifügung „psychoanalytisch" durchaus nicht unangemessen erscheint. Dies trifft in besonderer Weise bei Carl zu, bei dem sie zunächst nur etwas sehen kann und will, was den markanten Zügen eines exzessiv malignen Narzissmus entspricht, dann aber doch dessen Konstituierung als grauenvolle Verbiegung eines ursprünglich unschuldigen und für jede Entwicklung offenen Kindes erkennen muss:

💬 „Während einer Sitzung, wenn ich drin bin, kann ich diese Dinge sehen, sie fühlen. Bei Stargher war das etwas, was ich nie wieder fühlen will. Von Carl Stargher ist nichts mehr da, nur noch eine idealisierte Variante seiner selbst. Ein König über ein Reich von völlig bizarrer Form, da kann er alles ausleben, was für ihn … ich möchte lieber nicht darüber reden."

Und ein wenig später, ebenfalls im Gespräch mit dem FBI-Agenten:

💬 „Ich habe Ihnen doch vorhin erzählt, dass Stargher kaum noch Stargher wäre. Nun, das stimmt nicht ganz, das Schreckliche dominiert in ihm, aber er hat auch eine positive Seite … die Art, wie er sich selbst als Kind sieht … den Kontakt hat das Kind Stargher mit mir aufgenommen …"

Tatsächlich werden filmisch mit dem Eintritt in Carls Gehirn und durch das Durchqueren seiner Erinnerungen und Phantasmen Szenarien entfaltet, die in kohärenter und in der Tat anschaulicher Weise demonstrieren, wie eine blutige Kindheit ohne wirksame positive Vorbilder in eine von unglaublicher Gewalt geprägte und unter der Macht verhängnisvoller Verlautbarungen stehende spätere Lebensgeschichte einmünden kann. Wenn es für die Psychologin und Psychotherapeutin Catherine und wahrscheinlich auch für das sich mit ihr identifizierende Filmpublikum plausibel bis überzeugend erscheint, dass solche Voraussetzungen einen wichtigen ätiologischen Faktor für die Gestaltung jener monströsen sadistisch-nekrophilen Un-Persönlichkeit, wie sie in Carl inkarniert ist, darstellen können (obwohl sich auch Catherine der den ganzen Film hindurch aufrecht erhaltenen Virus-Theorie der Schizophrenie verpflichtet zeigt), so scheint dies für den Polizisten Peter nicht zu gelten. Dies zeigt sich in einem entsprechenden Dialog der beiden, wenn Peter schildert, wie er, enttäuscht durch den Freispruch eines anderen Vergewaltigers und später bestialisch handelnden Mörders, von einem Staatsanwalt zu einem FBI-Mann geworden sei, um sich nicht in Verbrecher hineinversetzen zu müssen, sondern um sie zu jagen:

💬 „Sein Anwalt hat die Geschworenen um den Finger gewickelt, er sagte, Charles sei selbst sein ganzes Leben lang missbraucht worden und das sei der Auslöser für die Taten. Sie kennen diese Argumente, es ist der übliche Bockmist."
„Wieso ist das Bockmist?"
„Ich glaube, dass Kinder hundertmal mehr ertragen können als Gish durchgemacht hat und trotzdem zu Menschen heranwachsen würden, die niemals, niemals einem anderen so etwas antun würden."
„Sind Sie sich da so sicher?"
„Allerdings, da bin ich mir sicher!"

Wenn auch vermutet werden darf, dass die hier verhandelten Auffassungsunterschiede nicht zufällig auf die zwei Geschlechter in dem Sinne verteilt sind, dass die Psychotherapeutin und Analytikerin in einem tradierten Rollenbild der Frau eine verständnisvolle und einfühlsame weiblich-mütterliche Position vertritt und der Polizist ein geläufiges männliches Gegenbild mit strengen erzieherischen Grundsätzen und einem prononcierten Bestrafungsbedürfnis dazu abgibt, so kann darüber hinausgehend festgestellt werden, dass sich in solchen Differenzen auch die konzeptionellen Unterschiede widerspiegeln, die das psychiatrische Erkenntnisfeld hinsichtlich der Kausalität psychischer Störungen charakterisieren. Diesbezüglich zeigt sich in den prinzipiellen Aussagen des Films die Neigung, die beiden Sachverhalte zu korrelieren, wenn, zur Verdeutlichung der beiden genderverdächtigen Positionen, Catherine die Mitarbeiterin Dr. Kent (Marianne Jean-Baptiste) zur Seite gestellt wird und Peter eine konzeptionelle Stütze in Gestalt des Gerichtsmediziners Dr. Reid (Pruitt Taylor Vince) erhält. Indem dieser, ganz auf tatsächliche oder angenommene organische Befunde gestützt, Carls Störung als eine seltene und gefährliche Sonderform der Schizophrenie diagnostiziert, welche auf ein Virus zurückzuführen ist, das offensichtlich im Sinne einer Slow-Virus-Erkrankung schon im Mutterleib ein kindliches Hirn infizieren kann, lässt er zwar im Gegensatz zum Polizeiagenten Peter die Möglichkeit einer Exkulpierung des Verbrechens durch Ersatz des Bösen durch das Kranke zu, ist aber genau wie dieser von der Aussichtslosigkeit jeder therapeutischen Beeinflussung überzeugt.

An dieser Stelle trennen sich wie bereits erwähnt Catherine und Peter – wobei die beiden allegorisch für die Inkompatibilität von Somatopsychiatrie und Psychoanalyse/Psychotherapie einstehen. Trotz ihrer augenfälligen gegenseitigen Zuneigung, trotz ihrer engen Verbundenheit auch auf Grund dessen, was sie gemeinsam durchgemacht haben, werden sie, einem Prinzip des frühen Hollywood-Kinos zuwiderlaufend, doch kein Liebespaar.

Peter erwartet sich von einer Psychologisierung seiner Arbeit nichts, da er feststellen musste, dass er nur durch konventionelle Detektivarbeit und kriminalistische Spurensicherung das tödliche Ende des letzten Verbrechens Carls verhindern konnte.

Catherine wiederum arbeitet an ihren Projekten weiter, obwohl sie einsehen musste, dass ihre Bemühungen, das Böse in Carl zurückzudrängen und ihn in die reale Welt zurückzuholen, vergeblich waren. Erkennend, dass der kooperierende und leidende Teil Carls das Leben nur noch unerträglich fand, hatte sie für sein Schicksal eine andere Lösung, eine Art Euthanasielösung gefunden, als sie noch einmal allein und gegen den Willen der Laborkollegen in Carls Welt eintauchte. „Ich werde wiederkommen", hatte sie dem Kind Carl anlässlich ihrer zweiten virtuellen Begegnung versprochen, sie löst aber ihr Versprechen mit einer „Umkehrung" der Neurotransmission ein, indem sie ihn in ihre mentale (und auch heile) Welt eintreten lässt, anstatt in sein von einem unsterblichen Gott des Bösen beherrschtes Universum einzudringen. Einer heiligen Maria nicht unähnlich erdolcht sie in einem mörderischen Kampf die böse Gestalt des Vaters und erlöst den Unglücklichen, indem sie, die Dinge an einem Ursprungsort wieder aufnehmend, das Kind Carl wie bei einer Taufe vorsichtig und liebevoll so lange unter Wasser hält, bis er zu leben aufhört.

In Bezug auf die weitere Anwendung der Transmissionsumkehrung hegt Catherine hingegen große Erwartungen an ihre Rückholungsversuche Edwards aus seinem autistischen Zustand. In ihrem Vorgehen, sich als Container für das gestörte Subjekt anzubieten, um in diesem psychischen Raum Prozesse und Umwandlungen von projizierten seelischen Inhalten einzuleiten, ist sie nicht so weit entfernt von jenem therapeutischen Prinzip Bions (und Kleins) (Bion 1962), wonach bekanntlich ein Teil der psychoanalytischen Arbeit für den Analytiker darin besteht, vom Patienten externalisierte verfolgende Objekte – also beta-Elemente – in sich aufzunehmen und in verwandelter Form als mit erträglichen Erfahrungen verbundene Fantasieobjekte (alpha-Elemente) dem Anderen zur Integration wieder anzubieten.

Dem gegenüber hat sich offensichtlich das Filmkonzept an eine andere psychoanalytische Auffassung, wie etwa jener der strukturalen Psychoanalyse, weniger angelehnt. Diese würde auch einem therapeutisch motivierten Eindringen in den Anderen bzw. einem Verschmelzen von Subjektivitäten eher reserviert gegenüberstehen, betont sie doch in ihrer Entwicklungstheorie, dass ein großer Teil menschlicher Ängste nicht aus Trennungs- und Kastrationsfantasien stammt, sondern aus aktiven und passiven Fantasien der Einverleibung und des Verschlingens.

Auch ein Unbewusstes im Sinne Lacans würde sich für die Gestaltung des vorliegenden Filmplots als eher unergiebig erweisen. Indem es entsprechend einer am Signifikanten orientierten Theorie und, in Anlehnung an den frühen Freud, wie bzw. als eine Sprache (structuré comme un langage) gebaut ist, erscheint ein solcherart aufgefasstes menschliches Innerstes ästhetisch dürftig gegenüber einem hauptsächlich imaginär determinierten Unbewussten mit seinem Reichtum an packenden Bildern und schaurig-schönen Phantasmagorien. Aus einem ähnlichen Grund stand auch Freud jedem psychoanalytischen Filmprojekt skeptisch gegenüber, da er sich nicht vorstellen konnte, wie seine abstrakten Theorien und Konzepte plastisch darzustellen seien.

Literatur

Bion W (1962) A theory of thinking. Int J Psychoanal 43: 306–310

Freud S (1921) Massenpsychologie und Ich-Analyse. Gesammelte Werke Bd XIII, S 71–161

Kristeva J (2007) Die neuen Leiden der Seele. Psychosozial-Verlag, Gießen

Lacan J (1973) Das Spiegelstadium als Bildner der Ich-Funktion, wie sie uns in der psychoanalytischen Erfahrung erscheint. In: Schriften I, Walter, Olten, S 61–70 (Erstveröff. 1949)

Leuschner W (1999) Experimentelle psychoanalytische Traumforschung. In: Deserno H (Hrsg) Das Jahrhundert der Traumdeutung. Perspektiven psychoanalytischer Traumforschung. Klett-Cotta, Stuttgart, S 356–374

Lütkehaus L (1995) Verchromte Sirenen, herostratische Apparate, 'Desiderat: Dingpsychologie' (G. Anders): Für eine Umorientierung der Psychologie. Psyche 3: 281–303

Pfeiffer J, Staiger M (2005) Telematische Weltgesellschaft. In: Vogel R (Hrsg) Didaktische Konzepte der netzbasierten Hochschullehre. Waxmann, Münster

Ruhs A (2010) Die narzisstische Persönlichkeitsstörung. Spectrum Psychiatrie 3: 42–47

Ruhs A (2011) Lacan. Eine Einführung in die strukturale Psychoanalyse. Löcker, Wien

Žižek S (Hrsg) (1992) Ein Triumph des Blicks über das Auge. Psychoanalyse bei Hitchcock. Turia + Kant, Wien

Internetquellen

IMDb (Internet Movie Database, http://www.imdb.com/title/tt0209958/) Zugegriffen am 11. 11. 2011

Wikipedia (http://de.wikipedia.org/wiki/The_Cell. Zugegriffen am 11. 11. 2011

Originaltitel	The Cell
Erscheinungsjahr	2000
Land	USA, Deutschland
Buch	Mark Protosevich
Regie	Tarsem Singh
Hauptdarsteller	Jennifer Lopez (Catherine Deane), Vincent D'Onofrio (Carl Rudolph Stargher), Vince Vaughn (Peter Novak), Catherine Sutherland (Anne Marie Vicksey), Colton James (Edward Baines), Dean Norris (Cole), Dylan Baker (Henry West)
Verfügbarkeit	Als DVD in OV und deutscher Sprache erhältlich

Gerhard Bliersbach

Die Not des adoleszenten Kinogängers

Thomas est amoureux – Regie: Pierre-Paul Renders

Clara, ein Männertraum
Quelle: WDR Presse und Information/Bildkommunikation

Thomas est amoureux

Regie: Pierre-Paul Renders

Die Handlung: Die Aufgabe des Rückzugs

Thomas Thomas (Benoit Verhaert), Vorname und Nachname sind identisch, 33 Jahre alt, hat seit acht Jahren seine Wohnung nicht verlassen und seit acht Jahren keinen Besuch empfangen. Er leidet seiner eigenen Auskunft nach an einer agoraphobischen Störung, die ihn daran hindert, seiner Arbeit nachzugehen und die ihn zunehmend immobil gemacht hat. Er ist seit einigen Jahren „krankgeschrieben", und er hat die Verantwortung für seine Lebensgestaltung seiner Versicherung mit dem Namen „Globale" übertragen. Die Versicherung organisiert die Bedingungen seiner Existenz; dazu gehören ein regelmäßiger psychotherapeutischer Kontakt, die Vermittlung einer sexuellen Praxis durch die beauftragte Firma „sextoon" sowie gewisse Dienstleistungen zur Unterstützung seines Lebensalltags, die eine Firma mit dem Namen „clinique domotique" (Klinik für häusliche Angelegenheiten) erledigt – beispielsweise die Reparatur seines Staubsaugers. Seine einzigen Kontakte bestehen in den Telefonaten mit seinem „Visiophone". Die Telefonate rhythmisieren sein Leben und erlauben ihm reduzierte Beziehungserfahrungen.

Thomas Thomas befindet sich am Anfang des Films an einem Wendepunkt. Mit seiner Mutter Nathalie (Micheline Hardy) hat er einen telefonischen Kontakt in der Woche verabredet; allerdings hält sie sich noch nicht an diese Vereinbarung. Sein Psychotherapeut Gillon (Frédéric Topart) eröffnet ihm, dass er sich nach einer Supervision der Behandlung – die deren Stagnation thematisierte – zu der Intervention entschlossen habe, ihm, Thomas Thomas, Erfahrungen des Erschüttert-Werdens, wie Gillon sagt, zu verschreiben; dazu habe er ihn in der Agentur „Accroche Cœur" angemeldet, die ihm im telefonischen Kontakt von Visiophone Beziehungserfahrungen mit Frauen vermitteln könne (◨ Abb. 1). Thomas Thomas ist erstaunt und entsetzt; widerwillig stimmt er der Intervention seines Psychotherapeuten zu. Er nimmt Kontakt mit der Agentur Accroche Cœur (◨ Abb. 2) auf, unterzieht sich widerwillig einem „psychoaffektiven Test", wie es heißt (einer Art Rorschach-Test), und wird an die Agentur „Mme Zoé" vermittelt. Mme Zoé (Jacqueline Bollon), die an einem großen Naevus auf der rechten Gesichtshälfte leidet, erläutert Thomas Thomas am Telefon ihr Angebot: Aus einer Reihe Frauen verschiedenen Alters und Statur, deren Figur und Körperdaten ihm präsentiert werden, kann er die für ihn attraktive Partnerin für seinen telefonischen Kontakt auswählen. Zwei Frauen gefallen ihm; mit ihnen nimmt er Kontakt auf.

Mit Melody (Magali Pinglaut) erlebt er die Enttäuschung, dass sie seinen Wunsch nach einem gemeinsamen, medial vermittelten, fantasierten sexuellen Kontakt nicht teilt und sich einem Partner, dem sie wirklich begegnen kann, zuwendet. Eva (Aylin Yay) ist die zweite Frau, die Thomas' Wunsch nicht teilt. Ihre Abweisung macht sie für Thomas interessant. Er versucht, sie für sich zu gewinnen. Eva, stellt sich heraus, ist nur an einer Begegnung interessiert, nicht an fantasierten Beziehungen aus der Entfernung; der medial vermittelte Kontakt stößt sie ab. Ebenso stößt sie die ihr aufgezwungene Rolle – im Kontext einer Strafmilderung, den sie nicht erläutert – eines zur Verfügung stehenden masturbatorischen Objektes ab. Sie zieht sich aus dem Kontakt mit Thomas zurück. Thomas Thomas bemüht sich, sie mit seinen Mitteln zu erreichen. Am Ende gibt er seine agoraphobisch begründete Weigerung, seine Wohnung zu verlassen, auf und löst damit Evas Forderung ein. Die letzte Einstellung des Films zeigt Thomas Thomas, der in den Hausflur tritt – wir sehen ihn von hinten – , die Haustür öffnet und sich der gleißenden Helligkeit einer seit acht Jahren vermiedenen Wirklichkeit überlässt, in der Hoffnung, Eva zu begegnen.

☑ **Abb. 2** Miss Accroche Cœur (Colette Sodoyez). (Quelle: WDR Presse und Information/Bildkommunikation)

Zum Hintergrund: Der ungewöhnliche Film

Philippe Blasband, belgischer Drehbuch-Autor, der 1964 in Teheran geboren wurde und mit Aylin Yay, der Darstellerin der Eva, verheiratet ist, hatte nie geglaubt, dass seine Vorlage verfilmt werden würde – so sehr entfernt scheint seine Erzählung von den gewohnten Erzählformen des Kinos zu sein. Es beginnt damit, dass der Protagonist des Films, Thomas Thomas, nicht zu sehen, wohl aber zu hören ist. Das Kino-Publikum sieht nur das Display seines Visiophones – und damit nur die Personen, die Thomas anrufen oder die Thomas anruft. Die Anrufer wiederum sprechen zu Thomas in die Kamera und damit auch in unsere Richtung. Realisiert wurde diese Perspektive einer subjektiven Kamera, die die Position des Protagonisten einnimmt, durch die Technik des Teleprompters, die es einem Akteur vor der Kamera ermöglicht, durch die Kameraoptik hindurch auf das hinter der Optik liegende Bild – in den Nachrichtensendungen des Fernsehens ist es der fortlaufende Text, den die Sprecherinnen und Sprecher vorlesen – zu schauen, sodass für das Publikum der Eindruck entsteht, es würde angesprochen. So ist das Publikum des Films *Thomas est amoureux* nicht nur Beobachter oder Begleiter der an Thomas adressierten Kommunikationen und Interaktionen, sondern auf eine irritierende Weise ebenfalls Adressat der Kommunikationen und Interaktionen. Die Ästhetik des Fernsehens adressiert seine Botschaften mehr oder weniger direkt an das Publikum im Kontext seines Beziehungsgeschäfts (Bliersbach 1990) und verbirgt den Aufwand an Inszenierung. Hier, in *Thomas est amoureux*, wird das Kinopublikum nicht wie ein Kinopublikum adressiert. Anders gesagt: Das gewohnte Kino-Narrativ, das den Horizont der Kinogänger-Erwartungen ausmacht, wird systematisch ironisch verfremdet.

Insofern ist gut zu verstehen, dass Philippe Blasband davon ausging, dass ein Kinoautor ungern einen Nicht-Kinofilm realisieren würde. Aber der belgische Regisseur Pierre-Paul Renders, 1964 in Brüssel geboren und Vater von drei Kindern, fand sofort Interesse an dem von Blasband vorgeschlagenen Spiel mit den Erzählformen des Kinos. Pierre-Paul Renders und Phillipe Blasband kamen darin

überein, wie sie im Bonus-Material zur DVD ausführen, einen in seiner inneren Welt eingesponnen Erwachsenen zu beschreiben, der sich vor der Körperlichkeit realer Beziehungen ängstigt und sich deshalb mit dem vermittelten Kontakt seines Visiophones begnügt. Die Kinoautoren stellten im November 2007 ihre Arbeit auf dem „Vierten Europäischen Psychoanalytischen Filmfestival" in London vor[1]. Dort wurde Philippe Blasband zu seinem prophetisch anmutenden Einfall befragt, seinen Protagonisten Thomas Thomas in die Einsamkeit des, dank der elektronischen Informationstechnologie ermöglichten, psychosozialen Rückzugs zu platzieren. War Thomas Thomas deshalb als ein Kind und ein Opfer des Internets zu verstehen? lautete die Frage. Das Internet, gestand Phillipe Blasband, hätte er – Ende der 90er-Jahre – nicht im Blick gehabt. Ihn hatte seine Beobachtung einer zunehmenden narzisstischen Empfindlichkeit in Beziehungen beschäftigt.

In einer anderen Hinsicht hat Philippe Blasband Recht behalten. *Thomas est amoureux* kam selten in die Kinos. Der Film wurde auf den Festivals von Montreal, Géradmer (2000), Paris (2001), Venedig (2000), und London (2007) gezeigt (in Venedig wurde er mit dem „Fipresci Award" ausgezeichnet, in Montreal erhielt er den „Spezialpreis der Jury"). In New York City lief er 2001 in einem Kino (Kehr 2001). Das Kölner „Westdeutsche Fernsehen", Ende der 60er-Jahre die Abspielbasis experimenteller Filme, strahlte den Film am 14. 10. 2002 aus. Für die Präsentation in den bundesdeutschen Filmtheatern fand sich für *Thomas est amoureux* offenbar kein Filmverleiher.

Eine Hypothese zur Psychologie des Kinos

Filme bringen uns in eine Bewegung und nehmen uns in einer Bewegung mit. Die seelische Bewegung, in die wir vor der Leinwand oder vor der Mattscheibe kommen, kennzeichne ich mit den beiden Metaphern der **Reise** und des **Besuchs**. Wir suchen im Kontext des filmischen Narrativs den oder die Protagonisten auf, beziehen uns auf sie und gehen mit ihnen buchstäblich mit. Das Kino ist die einzige Kunst, in der wir innerhalb von zwei Stunden Beziehungserfahrungen machen und dabei mit unserer eigenen Lebensgeschichte und Lebenssituation in Kontakt kommen können – mehr oder weniger deutlich. Im Kino sind wir mit unseren Beziehungsbewegungen zu den Protagonisten und damit – ebenfalls mehr oder weniger deutlich – mit uns beschäftigt. Wobei ein Spielfilm mit seiner rhythmisierten, spezifischen Bildersprache, mit seiner Musik, seinem Sound, seiner Helligkeit, seinen Farben oder Schwarz-Weiß-Schattierungen, seinen Landschaften und seinem Dekor einen besonderen, schwer zu beschreibenden Raum für die eigenen Erlebensbewegungen zur Verfügung stellt.

Als Kinogängerinnen und Kinogänger sind wir abhängig vom Takt, vom Wohlwollen und vom Verständnis der Kinokünstler, die uns ihren Geschichten aussetzen und uns in ihre Geschichten platzieren. Ein Prosakünstler imaginiert seinen Leser oder seine Leserin, die er adressiert. Umberto Eco sprach davon, dass er den „idealen Leser" oder den „Modell-Leser" imaginiere (Eco (1994). Der Prosakünstler ist auf jemanden bezogen; er spricht – manchmal mit einer deutlichen, manchmal mit einer undeutlichen Stimme. Die Stimme einer Autorin oder eines Autors zu hören, ist sicherlich ein enorm intimer, schwer zu beschreibender Prozess; wenn wir sie hören, entwickeln wir eine Beziehung zu ihr oder zu ihm. Im Kino ist das schwierig, weil ungewohnt. Die „Theorie der Autoren", von den jungen französischen Kinoautoren Ende der 50er-Jahre mit ihrer „Nouvelle Vague" propagiert, enthielt ja diese Idee einer eigenen Kinoautorenschaft und einer eigenen Stimme. Die Stimme eines Filmautors ist sicherlich schwer zu hören, weil sie verdeckt wird durch die Arbeit der anderen Kinokünstler, die an der Herstellung eines Films beteiligt sind. Filmregisseure unterscheiden sich auch durch ihren Umgang mit dem Publikum – durch den Platz, den sie ihm wie ein Gastgeber, der seinen neuen Gast in die Gesellschaft einführt, zuweisen.

1 European Psychoanalytic Film Festival (2007) http://www.psychoanalysis.org.uk/epff4/. Zugegriffen am 10. 4. 2012

Zum Vorgehen: Identifikation der „Platz-Anweisung"

Die belgischen Kinoautoren Pierre-Paul Renders (Regie) und Philippe Blasband (Drehbuch) weisen ihrem Publikum einen ungewöhnlichen Platz zu. Gut vierzig Telefonate führt oder empfängt Thomas Thomas im Verlauf des Films *Thomas est amoureux*. Die Telefonate tragen die filmische Erzählung. Die Kinoautoren lassen uns nur das sehen, was Thomas Thomas sieht. Damit folgen sie der Ästhetik der „subjektiven Kamera", die die Position des Protagonisten einnimmt, aus dessen Perspektive der Film erzählt wird. Normalerweise sehen wir den Raum, in dem eine Protagonistin oder ein Protagonist telefoniert. Die kranke, immobile Mrs. Stevenson (Barbara Stanwyck), die ihr New Yorker Apartment nicht verlassen konnte, geriet vor unseren Augen mehr und mehr in eine panische Verfassung, als es ihr in dem 1948 entstandenen Film von Anatole Litvak: *Sorry, Wrong Number* nicht gelang, telefonisch Hilfe zu alarmieren – eine Studie in Hilflosigkeit und Angst. 1954 gab Alfred Hitchcock seinem auf Grund eines Beinbruchs ebenfalls immobilen Fotographen L. B. Jeffries (James Stewart) in dessen Apartment zumindest im Rollstuhl ausreichend Bewegungsspielraum – und damit auch uns, die seine Ohnmacht auszuhalten hatten – , um seinen Nachbarn, den vermuteten Mörder von Gegenüber (Raymond Burr), verhaften zu lassen; der Film hieß *Rear Window* (Das Fenster zum Hof) und entwarf die Zukunft einer Lebensform, die das eigene Leben zu leben vergisst: des Kinogängers.

Für die von den belgischen Kinoautoren realisierte Erzähltechnik der subjektiven Kamera gibt es ein Vorbild. In Robert Montgomerys erster Regiearbeit, *Lady in the Lake* (USA 1947), der Verfilmung der Raymond Chandler-Vorlage „The Lady in the Lake", hatte bis auf wenige Szenen die Kamera die Position des Detektivs Phillip Marlowe inne – so konnte das Publikum nur das sehen, wohin Marlowe sich bewegte und was er tat. Die belgischen Kinoautoren haben dieses narrative Verfahren gewissermaßen radikalisiert: Sie erzählen nur das, was ihr Protagonist sieht. Sie erzählen den Film ausschließlich aus der Perspektive von Thomas, der auf das Display seines Visionphones schaut, während er zu den Anrufern spricht und seine Beziehungen zu ihnen gestaltet. Es ist, wenn wir ein gegenwärtiges Internetmedium zur Illustration zu Hilfe nehmen, als würden wir Thomas Thomas beim „Skypen" zusehen und über seine Schulter schauen, wobei unser Gesichtsfeld ausgefüllt ist vom Display seines Rechners, das dessen übrige Welt völlig verdeckt. So klebt Thomas Thomas buchstäblich an seinem Visiophone, er lässt es nicht aus den Augen; wie er zwischen den Telefonaten lebt, erzählen die belgischen Kinoautoren nicht.

Damit weisen uns die Kinoautoren eine andere Position zu, als wir sie sonst gewohnt sind. Üblicherweise sind wir die Beobachter der Handlungen und Dialoge der Protagonisten, zu denen wir Beziehungspositionen einnehmen. In *Thomas est amoureux* sehen wir nur einen Protagonisten des Dialogs – den Teilnehmer oder die Teilnehmerin, zu dem oder zu der Thomas spricht – , während wir Thomas Thomas hören und uns auf seine Stimme beziehen und ihn indirekt erfahren durch die Reaktionen der Anrufenden auf ihn. Während die Anrufenden zu ihm sprechen – was wir auf dem Display des Visiophones sehen –, sprechen sie gleichzeitig in unsere Richtung. Wir kennen den irritierenden und die Kinoerfahrung verfremdenden Effekt, wenn die Akteure der Leinwand zu uns sprechen. Wenn am Ende des Ferien-Thrillers *To Catch A Thief* von Alfred Hitchcock (Über den Dächern von Nizza, USA 1955) Cary Grant, der gerade von Grace Kelly erfahren hat, dass ihre Mutter mit ihnen zusammen zu leben wünscht, entsetzt in die Kamera und damit in unsere Richtung schaut, dann zwinkert uns Alfred Hitchcock seine Lieblingsbotschaft über die invasiven und kontrollierenden Mütter zu, mit denen er so gern spielte. Pierre-Paul Renders und Phillipe Blasband zwingen uns dagegen in ihr Spiel mit dem mehrfach ironisch gebrochenen Narrativ telefonischer Kommunikationen und Interaktionen. Ständig mit angesprochen, sind wir aufgefordert, die an Thomas Thomas adressierten Kommunikationen zu sortieren, unsere Beziehungspositionen zu den Visiophone-Protagonisten zu ordnen und auszuwerten, wobei wir unsere Reaktionen mit den Reaktionen von Thomas Thomas vergleichen können und zwischen geschwisterlichen und elterlichen Positionen pendeln beim (innerlichen) Mitgehen mit dem Bruder-Sohn Thomas in unseren unausgesprochenen Bewegungen des stummen Beratens, Unterstützens und Zusprechens.

Filmwirkung: Viel Arbeit für die Kinogängerin und den Kinogänger

Exposition: Das unmögliche Paradies der Masturbation

Pierre-Paul Renders und Phillipe Blasband lassen ihren Film furios beginnen. Im Interview zu den Dreharbeiten bemerkte Pierre-Paul Renders, dass es ihm bei der Inszenierung der Sextoon-Episode darauf ankam, die Figur der Clara möglichst realistisch zu präsentieren, um die Verwirrung, Bestürzung und Aufruhr des Zuschauers – Pierre-Paul Renders benutzte dafür das französische Substantiv „trouble" – zu erzeugen. Kommen wir zum Beginn des Films und zum knalligen Sextoon-Auftakt. Die erste Einstellung des Films: Wir schauen auf ein bewegliches, blaues Muster, das die Leinwand ausfüllt und an die Struktur von Mohair-Wolle erinnert. Buchstaben rasseln auf das Muster mit dem Geräusch, das wir von den großen Tafeln der Abflug- und Ankunftdaten auf den Flughäfen kennen. Der Titel *Thomas est amoureux* wird vor unseren Augen zusammengesetzt. Der Buchstabe x erscheint zuerst. Fluglärm. Alltagsgeräusche. Der Filmtitel wird wegwischt. „Sextoon" taucht in einer Schrift aus Neonröhren auf einer schwarzen, schraffierten Fläche auf. „Bienvenu sur sextoon!", sagt eine bemühte, weibliche Stimme im Off in einem Tonfall, wie wir ihn aus vielen (unpersönlichen) Lautsprecheransagen im Ohr haben. Die schraffierte Fläche füllt sich schnell mit den in neun Zeilen angeordneten Quadraten, die jeweils ähnliche weibliche Körperteile oder Körperpartien enthalten: Gesichter, Augen, Nasen, Lippen, Finger, Brüste, Nabel, die Behaarung im Vaginal-Bereich, Gesäße – gewissermaßen ein riesiger Baukasten weiblicher Anatomie. „Voulez-vous composer une nouvelle créature?", fragt die sanfte, ungerührte Stimme den Kunden dieses Sortiments.

„Nein", antwortet er, der für uns ebenfalls unsichtbar ist. Er möchte wie bei seinem letzten Besuch bei seiner damaligen Favoritin, wie es im Französischen heißt, bleiben. Sofort wird die letzte Favoritin – Clara – in einem schwarzen Fenster als eine gläserne Figur, die mit einem Netz von Blutgefäßen durchzogen ist, vor seinen Augen aufgebaut und gedreht wie eine Puppe auf einem Drehtischchen. Clara ist eine gezeichnete Figur. Eine rote, gummiähnliche Flüssigkeit, die an ihr herunter läuft, bedeckt sie und fungiert als Kleidung. Clara hat die Figur einer sexuell aufgedonnerten Barbie-Puppe: Groß und schlank mit mächtigen, prallrunden Brüsten und in einem kurzen, hoch geschlitzten, engen Kleid, wirkt sie wie einem Cartoon für Erwachsene entsprungen, als eine Karikatur aus Amazone, Stewardess und Krankenschwester. „Bonjour, Thomas", spricht sie ihren Kunden an, „ça fait plaisir de te voir."

Thomas heißt der unsichtbare Mann. Sie schaut in die Kamera – dorthin, wo sie Thomas vermutet oder sieht – und schaut damit auch uns an. Sie offeriert Thomas fünf Geschichten. Er wählt die erste Version – die Erfahrung der Schwerelosigkeit. Der Chor einer entstehenden Erregung ist zu vernehmen. Clara zwinkert ihr Einverständnis Thomas zu. Erleichtertes Stöhnen.

Es geht zur Sache. Der Tarif – zwei Euro pro Sekunde – wird eingeblendet, Thomas aufgefordert, seinen Cybersex-Anzug zu aktivieren. Die Kamera kippt nach vorn, dann bewegt sie sich nach oben und fährt auf einen Kommandostand zu, der zu einem futuristischen U-Boot zu gehören scheint. Offenbar nimmt die Kamera die Position von Thomas ein. „Ah tu voilà", empfängt Clara Thomas Thomas (und die Kamera) auf ihrem Drehsessel, indem sie in die Kamera hinein spricht – und damit auch in unsere Richtung. Sie fragt ihn, ob er je an einem medizinischen Experiment in Schwerelosigkeit teilgenommen hätte. Nein. Clara auch nicht. Sie könne es kaum abwarten, sagt sie. Heute würde man sagen: „Ich freue mich auf dich." Eine metallische, künstliche Stimme erkundigt sich, ob die Beteiligten bereit seien. „Affirmative", bestätigt Clara. Die Schwerelosigkeit initiiert sie mit einem entschlossenen, einladenden Tritt. Sie schwebt in einem schwarzen, knallengen, glänzenden Lederanzug durch die Kapsel auf Thomas und damit auf uns zu. Verführerische Blicke und ein Schürzen ihrer vollen Lippen werden an ihn und an uns adressiert. Es wird vielleicht etwas kalt, warnt sie Thomas. „Desagréable?", fragt sie mit einem tiefen Blick. „Non", antwortet Thomas.

Abb.3 Nathalie, Thomas' Mutter (Micheline Hardy). (Quelle: WDR Presse und Information/ Bildkommunikation)

Clara streicht mit ihrer Zunge über ihre Lippen. Sie bewegt sich vor Thomas und vor uns, die das sehen, was er sieht, in weiten, elastischen Bewegungen. An einer Stange hält sie sich fest und presst sie genussvoll zwischen ihre Beine und streift gleichzeitig ihren Anzug ab. Ihre autoerotische Verführung beginnt. Sie presst ihre festen Brustkugeln zusammen; sie berührt ihr Genital. Clara offeriert Thomas ihre Bereitschaft zum Verkehr. Sie führt die koitalen Bewegungen vor. Ihre Erregung stöhnt sie heraus. Sie lädt zur Penetration ein. „Ich spüre deine Bewegungen in mir", sagt sie. Sie beschleunigt ihre Biege-Bewegungen. Ihr Gesicht verzerrt sich; ihren Atem stößt sie heraus. Die metallische Stimme zählt den Countdown des Orgasmus vor. Wir hören Thomas, wie er schwer atmet. Der Betrag für die audiovisuelle Unterstützung der Masturbation wird angezeigt: „€ 392". Clara sitzt wieder in ihrem schwarzen Anzug in der Kommandozentrale. Die metallische Stimme bestätigt den simultanen Orgasmus – bei einem minimalen Unterschied von einer Sekunde – wie bei einem erfolgreichen sportlichen Rekordversuch. „Expérience terminée", sagte die Stimme. „C'était très bien, Thomas", sagt Clara.

„Merde!", sagt Thomas im Off, als sich im Bild von Clara ein Fenster öffnet und eine stattliche Dame (Micheline Hardy) sich in einem Insert ankündigt. „Thomas?", sagt sie, während sie telefoniert. Sie legt nicht auf, sondern lässt weiter klingeln und fragt: „Thomas?" Thomas beendet den Kontakt mit Clara mit einer Anstrengung. „Thomas! C'est Nathalie!", ruft die Dame in den Hörer. Thomas, noch etwas benommen, beschwichtigt die anrufende Dame: „Je suis là. Je suis là." Die Dame möchte wissen, wo er war. Er habe gerade, stammelt Thomas heraus, einen Film gesehen. Nathalie, die Dame, die sich nicht abwimmeln ließ und wissen wollte, was er tat und tut, und die jetzt seinen blassen Teint bemerkt, ist, wie könnte es in dieser Szene der Invasion anders sein – Thomas' Mutter (Abb. 3).

Die Ernüchterung: Die Wiederkehr adoleszenter Erfahrungen

In der Sextoon-Episode haben die Kinoautoren die expliziten und die impliziten, die ironischen und die grellen Kinofantasien der sechs oder sieben vergangenen Dekaden verdichtet – sagen wir: von Frank Tashlin (*The Girl Can't Help It*, USA 1956) und Billy Wilder (*The Seven Year Itch*, USA 1955) über Russ Meyer (*Lorna*, USA 1964) bis zu Paul Hogan (*Barb Wire*, USA 1996) – und, meines Wissens zum ersten Mal, in einer Art von interaktivem Zuschauerkontakt belebt; denn Claras Stimulation, die an Thomas Thomas, den Sextoon-Kunden, adressiert ist, ist auch an den Kinogänger gerichtet, der mit seiner Geschichte und seiner Praxis der Masturbation konfrontiert wird – natürlich abhängig davon, wie gut er sich in diesen Momenten zu erinnern imstande ist. Der Anruf der Mutter beendet die Exposition; sie zerrt ihren Sohn in die Wirklichkeit der familiären Bindung und rüttelt an der Intimität seines sexuellen Raums.

Moses Laufer hat die Bedeutung der Masturbation für den Adoleszenten mit der Formel „trial action" (Laufer 1980) beschrieben – als einen Prozess, den eigenen unvertrauten sexuellen Körper zu erproben, eine eigene sexuelle Praxis zu entwerfen und zu etablieren bei einer gleichzeitigen Modifikation der ödipalen Bindungen in der Intimität eines neuen Raumes. Dass dieser Raum bedroht ist und behauptet werden muss, gehört zu den Erfahrungen eines Heranwachsenden; die Scham über die Verletzung der Intimitätsgrenzen ist enorm und möglicherweise traumatisch. Die Kinoautoren setzen nicht nur Thomas Thomas diesen Erfahrungen aus – sondern auch ihr Publikum, das dem Protagonisten sehr nah ist.

Thomas Thomas, erfahren wir sehr schnell, kann sich in seinen vier Wänden gar nicht sicher fühlen. Die Telefonate anzunehmen – beantworten, sagen die Angelsachsen – braucht normalerweise seine Zeit; heutzutage prüfen wir, wer anruft, und entscheiden, ob wir antworten. Thomas Thomas hat diese Wahl nicht; die Telefonate dringen sofort in seine Wirklichkeit ein und füllen sie aus. Er kann sie nicht ignorieren – er muss auf sie reagieren. So sind verschiedene Leute bei ihm sofort anwesend: der Versicherungsagent, der sich um seinen Alltag kümmert, der Psychotherapeut, der ihm neue Beziehungserfahrungen verschreibt, die Empfangsdame der computerisierten Vermittlungsagentur und schließlich Madame Zoé, die ihr Personal vorstellt. Thomas Thomas kann sich nicht zurückziehen; die Technik des Visiophones bedrängt seine intimen Räume. Obgleich er im Beziehungsrückzug lebt, lebt er nicht zurückgezogen.

Die Wiederkehr vertrauter Erfahrungen adoleszenten Experimentierens: Angst als zentraler Affekt

Die Kinoautoren setzen uns den Erfahrungen der Beziehungsgestaltung von Thomas Thomas aus. Wir werden Zeuge seines Entwicklungsprozesses. Nicht mehr Sextoon-versorgt, ist er gezwungen, Beziehungen zu den Frauen, die ihm offeriert werden, zu gestalten – was auch bedeutet, dass er sich gewinnend zu präsentieren und seine Wünsche auszuhandeln hat. Wir sehen ihm zu und erfahren seine Anstrengung, wie heikel der Prozess der Begegnung und der Beziehungsgestaltung ist, wenn der eigene sexuelle Körper einem buchstäblich im Wege steht. Möglicherweise erinnern wir uns an unsere eigenen Erfahrungskontexte. Wir sehen ihm zu und erleben, wie schwer der erste Kontakt fällt und wie die Gespräche darüber holperig geraten. Möglicherweise erinnern wir uns auch daran. Wir sehen und erfahren von ihm, wie die Sehnsucht nach einem Kontakt vom Impuls durchkreuzt wird, den Kontakt aufzugeben und zu vermeiden. Wir sehen und erfahren von ihm, wie es unmöglich erscheint, das begehrte Objekt zu erreichen. Und möglicherweise erinnern wir auch diese Erfahrungskontexte. Mit anderen Worten: Mit Thomas Thomas, dem 33 Jahre alten jungen Mann, der seine adoleszenten Entwicklungserfahrungen zu machen beginnt, können wir in Kontakt mit unseren eigenen alten, aber wahrscheinlich noch lebendigen, adoleszenten Erfahrungen kommen.

Thomas est amoureux nimmt uns auf eine quälende, schwer zu ertragene Strapaze mit, die adoleszente Sehnsucht nach einem Objekt, die Einsamkeit, die Verzweiflung und das Gefühl der verrin-

nenden Zeit in einer gelingenden Beziehung zu mildern – im Kontext einer tiefen Angst. Angst ist der zentrale Affekt des filmischen Narrativs. Lange Zeit scheint es für Thomas Thomas unmöglich zu sein, das Gefängnis seiner vier Wände, die auch die Wände seiner inneren Welt und seiner Bewegungs- und Beziehungsunfähigkeit sind, zu verlassen. Es gelingt ihm – auf den letzten Film-Metern bei einem offenen Ende, bei dem unklar ist, wie Thomas Thomas sich in dem hellen, weiten, unendlichen Raum möglicher Beziehungen bewegen wird. Seine Suche hat begonnen. Ob er sie durchhält, ist ungewiss. Der Kinogänger oder die Kinogängerin erhebt sich angeschlagen vom Sitz, weil die eigene adoleszente Geschichte der Objekt-Suche und des Objekt-Findens mehr oder weniger belebt wurde.

Über die Anstrengung, den Film *Thomas est amoureux* zu ertragen

Kinofilme platzieren ihr Publikum in einer bestimmten Weise in ihr Narrativ. Je nach filmischem Narrativ ist der Platz einigermaßen sicher oder gefährdet. Ist der Platz gefährdet, weil die Koordinaten des Gefühls für die Realitäten des Kino-Narrativs verrückt sind oder allmählich verrückt werden, ist die Kinogängerin oder der Kinogänger gezwungen, sich zu orientieren – was auch bedeutet: die filmische Erzählung gegen den Strich des Augenscheins zu lesen. Die Liste der Kinoautoren, die mit Vergnügen am Stuhl des Kinogängers oder der Kinogängerin rüttelten und deren Wirklichkeitsgefühl erschütterten, ist lang.

Alfred Hitchcock war ein Freund der doppelten Böden. Dieser englische, amerikanisierte Kinokünstler steckte sein Publikum, so Zwiebel (2007), entweder in eine Falle oder führte es an den Abgrund – beides äußerst ungemütliche, aber dennoch lustvolle Verfassungen, aus denen man am besten herauskommt, finde ich, wenn man sich die Hitchcock-Filme wieder und wieder ansieht und dem Geheimnis ihrer „Platzanweisungen" auf die Spur zu kommen sucht. Hitchcock war auch der Kinoautor, der seine Filme aus der Perspektive der Protagonisten erzählte und dem Publikum einen winzigen Vorsprung einräumte, was es im Verlauf des Films mehr und mehr in aufgebrachter Sorge auf die Sitzkante rücken ließ. Im allgemeinen ließ Alfred Hitchcock die innere Realität seiner Protagonisten intakt – sein 1960 entstandener, bösartiger Thriller *Psycho* ist eine seiner Ausnahmen – , sodass sich die Kinogängerin und der Kinogänger zumindest auf die psychische Integrität der relevanten Protagonisten verlassen konnte. Ein Kinoautor wie David Cronenberg gestattet seinem Publikum nicht ohne weiteres diese Sicherheit. In seinen Filmen wie *Fly* (USA 1986), *Crash* (Kanada, UK 1986), *Spider* (Kanada, UK 2002), *History of Violence* (USA 2005), *Eastern Promises* (Kanada, UK, USA 2007) und *A Dangerous Method* (BRD, UK, USA 2011) muss man sich ständig fragen, mit wem man es zu tun hat und in welcher Art von Wirklichkeit man sich befindet. So sind seine Filme äußerst quälend und beunruhigend.

Pierre-Paul Renders und Philippe Blasband muten der Kinogängerin und dem Kinogänger ebenfalls die Anstrengung der Wirklichkeitsorientierung zu. Gesicht, Geschichte und Erzählweise ihres Films sind ungewöhnlich. Grelle Farben, eine gesuchte Geschmacklosigkeit der Dekors, der Kleidung und der Maske der Protagonisten mit ihren über die Gesichter verlaufenden Ornamenten, die wie Tätowierungen aussehen, in einer Mischung aus primitiver Art Déco, Hippie-Kultur und Trödel-Chic, sind ein mächtiger Kontrast zu den aufwändigen, gekonnten Ausstattungen des gewohnten U. S.-Kinos. Das in Telefonaten entfaltete Narrativ mit seiner direkten Adressierung irritiert die vertrauten, normalerweise erwarteten Anforderungen an die Rezeption eines Kinofilms. Kinogängerin und Kinogänger sind aufgefordert, ihre eigene Lesart des präsentierten Narrativs zu entwickeln – und sich heraus zu bewegen aus der dem Protagonisten verordneten Enge und Defensive seiner Lebensgestaltung.

Adam Phillips (2007) bemerkte, dass das Begehren des Adoleszenten das mächtigste Motiv sei, die familiären vier Wände zu verlassen. Thomas' Verliebtheit in Eva, die im letzten Drittel des Films entsteht, verändert und erleichtert die Position des Kinogängers: Endlich findet der Bruder-Sohn seine Lebensrichtung. Die adoleszente Not wandelt sich zur adoleszenten Hoffnung. Das belgische Dornröschen, der gebundene Sohn Thomas und der hilflose Bruder Thomas, wird buchstäblich wach gerüttelt

von einer wütenden und mütterlichen Prinzessin, die Eva heißt und die Thomas' untergründige Rage in die produktive Intention des Begehrens und des Rettens (der Prinzessin) wandelt.

Der Film „Thomas est amoureux": Cyber oder Zauber? Reflexion über das Kino

Filme erzählen Filme weiter. Intertextualität gilt auch für das Kino. Die belgischen Kinoautoren spielen mit dem Kino; manchmal stellen sie es auf den sprichwörtlichen Kopf, manchmal suchen sie den Anschluss. *Thomas est amoureux* endet ähnlich wie Steven Spielbergs Film *Close Encounters of the Third Kind* (USA 1977); dessen Protagonist Roy Neary (Richard Dreyfuss) betritt nach seiner langen Suche nach den „Unidentified Flying Objects" (UFOs) das gleißend helle Innere des Raumschiffs der Außenirdischen, mit denen in Kontakt zu treten den Irdischen gelungen ist, dank der Hilfe des französischen Wissenschaftlers Claude Lacombe (François Truffaut). Roy Neary war auf der Suche nach der Verschmelzung mit einem großartigen Objekt. Thomas Thomas trat in die gleißende Helligkeit der psychosozialen Wirklichkeit. Er machte sich auf die Suche nach seinem transformativen Objekt (Bollas 1997). Am Beginn des Films schien er sich eingerichtet zu haben in seiner von der Firma „sextoon" ausreichend versorgten masturbatorischen Praxis. Ihm genügten die Fantasie vom künstlichen, auf ihn eingestellten Objekt und die repetitive sexuelle Praxis; die Ernüchterung, das künstliche Objekt nicht erreichen zu können, änderte seine Praxis nicht, sondern ließ ihn an ihr festhalten. Erst die Intervention seines Psychotherapeuten, nicht mehr den Service von „sextoon", sondern das Angebot der Vermittlungsagentur „Accroche Cœur" anzunehmen, konfrontierte Thomas Thomas mit der Notwendigkeit, sich zu entwickeln, und mit der Not, Beziehungen auszuhandeln, Beziehungswirklichkeiten zur Kenntnis zu nehmen und den masturbatorischen Modus aufzugeben.

Thomas est amoureux ist eine ironische Arbeit der beiden Kinoautoren Pierre-Paul Renders und Philippe Blasband. Sie beginnen mit dem Antikino und enden mit dem Kinoplot der Rettungsgeschichte „Dornröschen und die verachtete Prinzessin". Sie beginnen mit der Leidensgeschichte einer missglückten Sozialisation – der gebundene Sohn mit seiner Angst vor einer realen sexuellen Beziehung in der Hand einer mächtigen Mutter bei einem abwesenden Vater – und enden mit der vertrauten Not der Adoleszenz. Sie beginnen mit der Verführung des „Cyber" und mit der passiven Zufriedenheit des Kunden im psychosozialen Rückzug, der sich vom Display seines Rechners nicht wegbewegt, und enden mit dem aktiven Begehren ihres Protagonisten. Das „Visiophone" ist das Symbol der Kinoautoren für die elektronische Informationstechnologie. Für die filmische Erzählung hält es die defensive Lebenswirklichkeit ihres Protagonisten, der sich in seinen vier Wänden eingerichtet hat, aufrecht. Dessen Agoraphobie fungiert als Begründung seines Rückzugs und als Metapher für eine Lebensform. Aber das agoraphobische Leiden, Ausdruck der Entwicklungsstörung und des Konflikts mit dem eigenen sexuellen Körper, interessiert die Kinoautoren wenig; lebensgeschichtliche Kontexte explorieren sie nicht. Nathalie, Thomas' Mutter, die ihren Sohn bindet, ist eher eine Karikatur bekannter und weniger bekannter Kinomütter als die relevante Repräsentantin der Sozialisation ihres Sohnes. Nimmt man den Gedanken der Intertextualität des Kinos auf, dann beginnen Pierre-Paul Renders und Philippe Blasband mit Russ Meyer und enden mit Steven Spielberg. Man kann es auch anders sagen: Pierre-Paul Renders und Philippe Blasband haben mit ihrem *Thomas est amoureux* Alfred Hitchcocks *Rear Window* weitererzählt.

Rear Window ist der Film des Fotografen J. B. Jeffries (James Stewart), der in seinem Apartment die Zeit totschlägt und sich mit der Fantasie des Mordes von Gegenüber aus seiner wütenden Lethargie des Wartens (auf das Ende seiner Passivität im Gips) heraus hilft. Am Ende sitzt er mit beiden eingegipsten Beinen im Rollstuhl, überwacht und betreut von seiner offenbar nicht unglücklichen, mütterlich transformierten Freundin Lisa Fremont (Grace Kelly). Dem Fotografen bleibt für die nächste Zeit die Existenz des Zuschauers.

Was Alfred Hitchcock ironisch beendete, ist andererseits die Not des Kinogängers, der sich mit der Helligkeit zu arrangieren hat, in die er tritt, wenn er das Filmtheater verlässt oder das Licht im Wohnzimmer einschaltet. Draußen, außerhalb des Kinoraumes, wartet das Realitätsgeschäft. Drinnen sind wir manchmal oder häufig – je nach Vorlieben – mehr oder weniger davon dispensiert. Das Kino hat unsere seelischen Bewegungsmöglichkeiten enorm in Bewegung gebracht. Wir sitzen in einem Stuhl vor der Leinwand und sind zugleich auf einer Reise irgendwohin. Die Television hat dem Kino einen riesigen Kreislauf zur Verfügung gestellt, in dem dessen Fantasien und Narrative unaufhörlich kursieren. Das Internet, gedacht als ein demokratisches Forum des Austauschs, hat diesen Kreislauf vergrößert; in einem riesigen, unübersehbaren System kursieren die Fantasien des Kinos und realisieren sich die Wünsche nach ständigem Kontakt, als dürfe man sich nicht aus den Augen verlieren, und nach Verschmelzungs-Beziehungen, in denen das Fremde und das Andere verschwinden. Wo sind wir, und wie leben wir? Sind wir große Kinogänger – in unseren Fantasien beweglich und in unseren Beziehungen unbeweglich zugleich? Pauline Kael, die 2001 verstorbene Filmkritikerin der U. S.-Zeitschrift „The New Yorker" (Kael 1968):

> Für einige Kinogänger tragen die Spielfilme wahrscheinlich zu jener ungesunden Romantisierung der Kino-Verheißungen bei, die das Leben zu einer Serie von Enttäuschungen machen. Sie schauen sich dieselben Filme wieder und wieder im Fernsehen an – und leben ihr Leben, in dem sie so viel Zeit mit dem Ausfantasieren verbringen, nicht richtig.

Andererseits schrieb sie auch diesen den Kern des Kino-Vergnügens treffenden, überschwänglichen und sich selbst widersprechenden Satz (Kael 1980):

> When the lights go down and all our hopes are concentrated on the screen …

Das Kino ist ein schwieriger, verführerischer Ort. Ob wir dort alle unsere Hoffnungen investieren sollten, ist mehr als fraglich; anderenfalls bliebe für unsere realen Beziehungen wenig übrig.

Thomas est amoureux ist der irritierend-ironisch angelegte Film über den Zauber des Kinos. Er ist, wenn man die narrative Bewegung der Rettung und des Aufbruchs zugrunde legt, gewissermaßen vorerzählt. Die beiden New Yorker Tommy Albright (Gene Kelly) und Jeff Douglas (Van Johnson) entdecken auf ihrer Tour durch Schottland in Vincente Minnellis Film *Brigadoon* aus dem Jahr 1954 – der Verfilmung des Musicals von Alan Jay Lerner und Frederick Loewe – ein verwunschenes Dorf, dessen Einwohner an einem Tag einmal in einhundert Jahren erwachen. Tommy Albright verliebt sich in Fiona Campbell (Cyd Charisse). Er traut sich nicht zu bleiben. Aber zurück in seiner Heimatstadt, hält er es nicht aus. Er reist nach Brigadoon zurück und findet Fiona. *Thomas est amoureux* ist der Film über den adoleszenten, entwicklungsverzögerten Thomas Thomas, der allmählich realisiert, dass er die Tragfähigkeit seiner Fantasie des Verliebtseins erproben muss, will er nicht an seinem Leben im Rückzug erkranken. Anders gesagt: Thomas Thomas macht die Entdeckung, dass der Rückzug in eine Welt vermittelter Bilder-Beziehungen, wofür das Kino der prototypische Raum ist, nicht der einzige relevante Ort des Lebens ist. Insofern haben die belgischen Kinoautoren einen Film über den Zauber des Kinos vorgelegt; die Verführung des „Cyber" hielten sie im Jahr 2000, als sie ihren Film produzierten, für weniger relevant. Menschen, sagen sie implizit, wollen leben – in einer Balance von fantasierten und realen Wirklichkeiten.

Literatur

Bliersbach G (1990) „Schön, dass Sie hier sind!" Die heimlichen Botschaften der TV-Unterhaltung. Beltz-Verlag, Weinheim

Bollas C (1997) Der Schatten des Objekts. Das ungedachte Bekannte. Zur Psychoanalyse der Frühen Entwicklung. Klett-Cotta, Stuttgart

Eco U (1994) Im Wald der Fiktionen. Sechs Streifzüge durch die Literatur. Hanser, München

European Psychoanalytic Film Festival (2007) http://www.psychoanalysis.org.uk/epff4/. Zugegriffen am 10. 4. 2012

Kael P (1968) Movies on television. In: Pauline Kael: Kiss kiss bang bang. Little, Brown & Co, Boston MA, S 224

Kael P (1980) When the lights go down. Boyars, Boston MA

Kehr D (2001) Film in review: Thomas in Love. The New York Times 3. 8. 2001

Laufer M (1980) Zentrale Onaniephantasie, definitive Sexualorganisation und Adoleszenz. Psyche 34: S 365–384

Laufer M, Eglé Laufer M (2002) Adolescence and developmental breakdown. A psychoanalytic view. Karnac, London

Phillips A (2007) Über das Flirten. Psychoanalytische Essays. Psychosozial-Verlag, Gießen

Zwiebel R (2007) Zwischen Abgrund und Falle. Filmpsychoanalytische Anmerkungen zu Alfred Hitchcock. Psyche 61: 65–73

Originaltitel	Thomas est amoureux
Erscheinungsjahr	2000
Land	Belgien, Frankreich
Buch	Philippe Blasband
Regie	Pierre-Paul Renders
Hauptdarsteller	Benoit Verhaert (Thomas Thomas), Aylin Yay (Eva), Magali Pinglaut (Melodie), Micheline Hardy (Nathalie), Colette Sodoyez (Miss Accroche Cœur)
Verfügbarkeit	DVD in französischer OV mit englischen Untertiteln, abspielbar unter Code 1

Bert Theodor te Wildt

Von Robotern und Menschen …

A.I. – Künstliche Intelligenz – Regie: Steven Spielberg

Filmplakat *A.I. – Künstliche Intelligenz*
Quelle: Cinetext Bildarchiv

A.I. – Künstliche Intelligenz

Regisseur: Steven Spielberg

> As the two adults disappeared from the room,
> boy and bear sat down beneath the standard roses.
> „Teddy – I suppose Mummy and Daddy are real, aren't they?"
> Teddy said, „You ask such silly questions, David.
> Nobody knows what ‚real' means."

Aus: *Super-Toys Last All Summer Long* von Brian Aldiss, 1969

Einleitung

Kann man einen Roboter bauen, der in der Lage ist zu lieben? Wird der Mensch in der Lage sein, diese Liebe zu erwidern? Und wenn ja, welche Verantwortung hat dann der Mensch für ihn? Diese Fragen bilden den Ausgangspunkt für den Film AI – Artificial Intelligence (◘ Abb. 1) von Steven Spielberg aus dem Jahr 2011. Es geht in dem Film vordergründig um die Frage, ob der Mensch Wesen erschaffen kann, die ihm nicht nur physisch und kognitiv ebenbürtig sind, sondern auch emotional. Die Frage nach den Möglichkeiten virtueller Emotionalität wird in der Geschichte quasi naturgemäß auf der Beziehungsebene verhandelt, insbesondere im Hinblick auf das Verhältnis zwischen dem künstlichen Wesen und seinem Schöpfer, der Beziehung zwischen Adam und Gott oder der zwischen Pinocchio und dem Puppenspieler Gepetto verglichen wird.

Der Film selbst schöpft aus vielen Quellen und hat viele verschiedene Schöpfer. Die Grundidee geht auf Brian Aldiss' Kurzgeschichte „Super-Toys Last All Summer Long" aus dem Jahre 1969 (Aldiss [1]1969; 2001) zurück, die ein Jahr nach Stanley Kubricks *2001: Odyssee im Weltraum* herauskam. In dem Film geht es um einen Supercomputer, der ein Eigenleben mit menschlichen Zügen entwickelt. Etwa zehn Jahre später erwarb Kubrick die Rechte an der Geschichte. Während er zwischenzeitlich immer wieder andere Filme drehte, arbeitete er dann er mit einigen seiner Mitstreiter mehr als zwanzig Jahre lang immer wieder an einem Drehbuch für *AI*. Ein wichtiger Grund für den Perfektionisten Kubrick, das Projekt immer wieder aufzuschieben, war, dass er die Filmtechnik noch nicht für ausreichend hielt, um die Geschichte angemessen und überzeugend zu erzählen. Schließlich bot er den Stoff Steven Spielberg an. Er meinte, dass der Stoff eher Spielbergs Sensibilität entspreche. In Kubricks letztem Film *Eyes Wide Shut*, eine vergleichsweise bodenständige und sinnliche Verfilmung der „Traumnovelle" von Arthur Schnitzler, geht es dann erstaunlicherweise um eine recht reife Liebe zweier Eheleute, die durch außereheliche Fantasien und Begierden erst in Frage gestellt und schließlich gestärkt wird. Kubrik starb kurz nach der Fertigstellung des Films und hinterließ über seine Nachkommen Spielberg den A.I.-Stoff, der sich gleich an die Arbeit machte, ein abschließendes Drehbuch schreiben ließ und den Film über eine archaische Form von Liebe zwischen Mensch und Roboter abdrehte (◘ Abb. 2).

Handlung

Die Erschaffung des Roboterkindes David ist letztlich das Ergebnis von zwei Trauerfällen. Weil er den Tod seines Sohnes nicht verwinden kann, erschafft der Vater und Wissenschaftler Prof. Hobby ein Roboterkind nach dessen Abbild. Und weil eine Mutter den vermeintlichen Hirntod ihres Sohnes, der seit Jahren im Koma liegt, nicht wahrhaben will, lässt sie sich von ihrem Mann dazu überreden, als erste Fa-

milie ein Roboterkind zu adoptieren. Mit der Kraft der Liebe, die sie an die Rückkehr ihres Sohnes ins Leben glauben lässt, vermag sie sich glauben zu machen, dass sie David wie einen Sohn lieben könnte. Mit einem elektronischen mütterlichen Prägungsritual wird die künstliche Liebe zwischen Mutter und Roboterkind initiiert und für immer besiegelt. David fragt die Mutter einmal (im Gegensatz zu ihm ist sie ein sterbliches Wesen):

💬 „Mami stirbst Du irgendwann? … Ich hoffe Du stirbst nie, niemals!"

Wie durch ein Wunder erwacht zur selben Zeit aber der leibliche Sohn aus dem Koma, was an die Situation von vermeintlich unfruchtbaren Beziehungen erinnert, bei denen sich nach einer erfolgreichen Adoption überraschend doch eine Konzeption einstellt. Der Glaube an die Liebe zu einem angenommenen Kind scheint auch in diesem Fall Berge zu versetzen. Als der im doppelten Wortsinn leibliche Bruder seine Stelle in der Familie wieder einnimmt, entwickelt sich zwischen den ungleichen Geschwistern eine fatale Rivalität. Wie Pinocchio will David ein richtiger Junge werden, um genauso geliebt zu werden wie sein realer Bruder. Der Bruder erpresst ihn schließlich. Er schlägt vor, dass er selbst der Mutter sage, dass er den Roboterjungen lieb habe, damit die Mutter auch ihn lieb haben könne wie ihren eigenen Sohn. Als Gegenleistung für diese mimetische Handlung soll David der Mutter im Schlaf eine Haarlocke abschneiden; er begründet dies mit einer märchenhaften Erklärung im Sinne eines magischen Aktes der Besitzergreifung. Die Mutter aber erwacht dabei und fühlt sich von der Schere in Davids Hand bedroht. Sein engster Freund, der robotische Spielzeugbär namens Teddy, nimmt die Haarlocke schließlich an sich und versteckt sie unter seinem künstlichen Fell. Schon nach dieser Episode schlägt der Vater vor, David in die Fabrik zurückzubringen. Die Liebe zu seinem leiblichen Sohn überwiegt gegenüber der Angst, dass David für diesen eine Gefahr darstellen könnte:

💬 „Wenn er gebaut wurde, um zu lieben, dann darf man wohl annehmen, dass er auch hassen kann."

Die Mutter aber kämpft noch um die Liebe zu ihrem angenommenen Roboterkind. Auf der Geburtstagsfeier des Bruders kommt es jedoch zum Eklat. Dieser hatte seinen künstlichen Bruder vor seinen Freunden erstmals in Schutz genommen. Als David sich direkt bedroht fühlt, sucht er schließlich aktiv nach Schutz. In der Umklammerung fallen beide in den Pool, in dem der richtige Junge fast ertrinkt. In der Tiefe des Wassers wären sie beinahe eins geworden, wirkliche Brüder, aber eben auch beide tote Materie. Wenngleich Bruderhass und Bruderliebe in dieser Szene kaum auseinanderzuhalten sind, scheint sich in ihr zu offenbaren, dass Mensch und Maschine nicht in brüderlicher Harmonie miteinander leben können. So sehen sich die Eltern gezwungen, David zurück zur Firma Cybertronics zu bringen, wo er zerstört werden würde, weil die mütterliche elektronische Prägung nicht mehr zurückgenommen werden kann. Dies ist der Preis für die Liebesfähigkeit der neuesten Roboter. Die Mutter empfindet diesen Akt als Menschenopfer. Sie bringt es nicht übers Herz und setzt ihn wie in einem Märchen im Wald aus. In einer herzergreifenden Szene muss sie den sie bedingungslos liebenden Jungen zurückstoßen, der sie anfleht:

💬 „Wenn ich es schaffe ein echter Junge wie Pinocchio zu werden, darf ich dann zurückkommen?"

Der Mittelteil des Films zeigt auf andere Art und Weise, warum der Mensch nicht mit Robotern zu leben vermag. David gelangt an einen Ort, an dem der unterprivilegierte Teil der Menschheit sich an den Robotern rächt, indem er sie in atavistischen Ritualen öffentlich tötet beziehungsweise zerstört. Diese Menschen sehen die ihnen gleichenden Roboter nicht als Brüder oder Freunde, sondern vielmehr als Rivalen, die ihnen beispielsweise in den Bereichen Arbeit und Sexualität längst überlegen sind. Die Zivilisation ist dem Menschen über den Kopf gewachsen und treibt ihn in den Atavismus zurück. Am Ende ist es das liebesfähige Roboterkind David, der den Liebesroboter Gigolo Joe, der nicht wirklich liebt, sondern Liebe macht, also eigentlich nur ein lebendiges Sexspielzeug ist, von der öffentlichen Schlachtbank der Menschen rettet. Amor befreit den Sexus. Beide machen sich auf die Flucht mit Teddy und auf die Suche nach Pinocchios blauer Fee, die David endlich in einen richtigen Jungen verwandeln soll (◻ Abb. 3).

In der Vergnügungsmetropole Rouge City befragen die beiden ein modernes Orakel, Dr. Know, eine Art personifizierte Suchmaschine, mit der man sprechen kann. Wie sich später herausstellt, wurde das Orakel vom Wissenschaftler, dem Schöpfer – um nicht zu sagen Vater – von David, dahingehend manipuliert, dass er in die Lage versetzt wird, ihn in der Firmenzentrale von Cybertronics zu finden. Man könnte annehmen, dass hier gemeint sei, dass die Kreatur ohne den (heiligen) Geist nicht zum Schöpfer heimfinden kann. In einem Hubschrauber reisen die beiden in das halbversunkene New York. David begegnet dort zunächst einer Kopie seiner selbst und muss damit erschreckt feststellen, dass er eben nicht so einzigartig ist wie ein Menschenkind. In einem jähzornigen Gewaltakt zerschlägt er den anderen Roboterjungen wie ein Spiegelbild. Erst dann begegnet er seinem Vater, der die Roboterkopie seines verstorbenen leiblichen Sohnes gerührt in seine Arme schließt. Dass David ihn gefunden hat, nimmt er als einen Beweis dafür, dass er einen Roboter geschaffen hat, der zu lieben und zu träumen fähig ist, ein Wesen, das die Sehnsucht kennt. Dass dies aber eine selbstbezogene Ergriffenheit ist, zeigt sich schnell darin, dass er David gleich verlässt, um sein wissenschaftliches Team zu holen, dem er David präsentieren möchte. Er scheint nicht wirklich eine emotionale Beziehung zu erwarten, und David hat ja auch nicht nach ihm gesucht, sondern vielmehr nach einem Weg, Mensch zu werden und damit zurück zu seiner Mutter zu können und auf dem Planeten Mutter Erde eine Existenzberechtigung zu behalten. In der Abwesenheit seines Erzeugers streift David durch dessen Labor und begegnet dabei

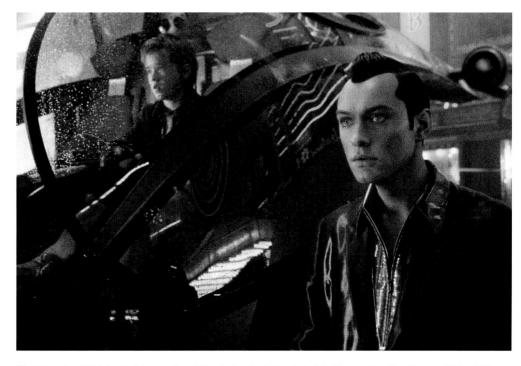

■ **Abb. 3** David (Haley Joel Osment) und Gigolo Joe (Jude Law) sind Gefährten. (Quelle: Cinetext Bildarchiv)

einer ganzen Armada von robotischen Kopien seiner selbst, die alle darauf warten, verkauft zu werden. Mit Grausen wendet er sich ab und stürzt sich verzweifelt in die Fluten. Er wird von Gigolo Joe und dem Helikopter gerettet. Dieser wird aber kurz drauf von einer Miliz verhaftet, sodass David schließlich, alleine mit Teddy, in das versunkene New York abtauchen muss, um sich zu retten. Im versunkenen Vergnügungspark Coney Island entdeckt er in einem Pinocchio-Themenpark endlich eine Statue der blauen Fee. Immer wieder fleht er sie von seinem Hubschrauber aus an, aus ihm einen Jungen aus Fleisch und Blut zu machen, bis schließlich eine neue Eiszeit einbricht und alle zusammen einfrieren.

2000 Jahre später ist die Erde von einer neuen Generation von künstlichen Wesen bevölkert, die durchsichtig und fluide erscheinen und im Grunde nur aus Projektionsflächen bestehen, auf denen sich ihr Innerstes im ständigen Fluss abbildet, als wären sie lebendig gewordene Medien. Angesichts der Tatsache, dass die Menschheit nicht mehr existiert, erscheint es unerheblich, ob diese Wesen fortschrittliche, sich selbst-regenerierende Androide oder Aliens sind. Diese Wesen graben die eingefrorene Szene schließlich aus. Als David und Teddy auftauen und erwachen, zerbirst die blaue Fee in tausend Stücke. David wird in die Obhut der Wesen genommen, offensichtlich aus Mitleid, aber auch, weil er für sie ein Bindeglied zu den Menschen darstellt; er ist jemand, der noch echte Menschen gekannt hat. Sie wollen David seinen sehnlichsten Wunsch ermöglichen und ihn noch einmal seine Mutter begegnen lassen. Dabei erscheint ihre Empathie größer als ihr wissenschaftlicher Eifer. Mit Hilfe der DNA der Locke der Mutter, die Teddy aufbewahrt hat, können sie die Mutter für einen Tag auferstehen lassen. Aus der Erinnerung von David können sie das Elternhaus künstlich herstellen und David dort mit seiner Mutter einen letzten Tag verbringen lassen. Wie ein Erwachsener sitzt nun er an ihrem Bett, als sie erwacht, und er wacht bei ihr, als sie ein letztes Mal einschläft. Dann muss er sich für immer von ihr verabschieden.

Filmwirkung

Steven Spielberg erreichte mit *A.I. – Künstliche Intelligenz* bei weitem nicht ein so großes Publikum wie mit *E.T. – Der Außerirdische* aus dem Jahre 1982, obwohl oder vielleicht gerade weil er ihm in einigen Punkten recht ähnlich ist. Beide Filme erzählen ein Märchen im Gewand eines Science-Fiction-Films. Beide Male geht es jeweils um ein nicht-menschliches Wesen, dessen Ziel es ist, nachhause beziehungsweise zu seiner Familie zurückzukommen. In beiden Filmen ist der Protagonist ein Junge, der sich von seiner Umwelt unverstanden fühlt, in der die Menschen unmenschlich erscheinen. *A.I.* präsentiert sich als Science-Fiction-Film, wenngleich ihm die genretypische Action fast völlig fehlt. Für ein großes Publikum ist er sowohl zu kontemplativ als auch zu emotional. Nicht immer gelingt das Zusammenspiel von kubrickscher Nachdenklichkeit und von spielbergschem Pathos. Die Dramaturgie der komplexen Geschichte ist dementsprechend etwas holprig, sodass die verschiedenen Handlungssequenzen zuweilen auseinanderfallen. Zudem erscheinen die Trickeffekte aus der heutigen Perspektive schon etwas veraltet, was besonders ausgerechnet für die Wesen aus der Zukunft gilt. Darin könnte man aber umgekehrt auch ein Zeichen dafür sehen, dass der Film auf seine Art und Weise seiner Zeit voraus gewesen ist. Weil wir in den letzten zehn Jahren mit Computertechnik und Robotik dem deutlich näher gekommen sind, was uns das Science-Fiction-Genre seit Jahrzehnten vorhersagte, erscheint die *A.I.*-Thematik heute aktueller und tiefgründiger denn je. Mit der digitalen Technik, die in dem Film *Avatar* (2009) verwendet worden ist, hätte das hohe epische Niveau des Films durch eine entsprechende Ästhetik zu einem wahrhaft grandiosen Werk komplettiert werden können. So ist er zu einem Stück Liebhaberkino geworden, das den, der sich auf ihn einlässt, tief zu berühren und anzuregen vermag.

Das, was im Jahre 2001 vielleicht noch als Zukunftsvision erschien, mutet heute nicht mehr so fremd und unwahrscheinlich an. Um die Entwicklung von Robotern war es etwas ruhig geworden. Zehn Jahre später kann man nun von einer Renaissance der Robotik sprechen. Roboter werden mittlerweile nicht mehr nur in der Industrie eingesetzt, sondern zunehmend auch in privaten Lebensbereichen. Hier sollen sie zunehmend auch emotionale Funktionen erfüllen. Ein in diesem Zusammenhang besonders sinnfälliges Beispiel ist der Einsatz von Robotern in der Pflege alter Menschen, insbesondere von Demenzkranken. So befremdlich es auch erscheinen mag, nicht nur in Asien werden in der Altenpflege zunehmend Roboter eingesetzt, so genannte „Care O-Bots" die mit den Menschen sogar sprechen und spielen (Wißnet 2007). In Japan wurde beispielsweise für Demenzkranke ein Kuschelroboter in Gestalt einer Robbe entwickelt. Dass emotionale Kontakte zu Menschen und Tieren für Menschen im Allgemeinen und für Kranke im Besonderen hilfreich sein und die Lebensqualität verbessern können, bedarf eigentlich keiner besonderen Erwähnung. Der Zynismus allerdings, der sich beim Einsatz von virtuellen Menschen und Tieren dokumentiert, könnte kaum deutlicher werden, wenn er nun zuerst in der Altenpflege von Demenzkranken erfolgt, da dies offensichtlich mit der Erwartung verbunden ist, dass diese die Täuschung nicht erkennen. Darin dokumentieren sich die Unfähigkeit des Menschen, mit Krankheit und Tod umzugehen, sowie die globale Unfähigkeit, Abschied nehmen zu können. Der Mensch verabschiedet sich quasi zu Lebzeiten von den Alten und Schwachen, weil er sie in ihrem Leiden und ihrer Bedürftigkeit nicht ertragen und mittragen kann. Eines der zentralen Themen des Films ist damit erst jetzt aktuell und brisant geworden. – Wir hatten die Roboter schon fast abgeschrieben. Wenn wir nun damit beginnen, sie uns in unseren ureigenen menschlichen Funktionen ersetzen zu lassen, werden sie vielleicht tatsächlich selbst irgendwann in die Lage versetzt, den Menschen „abzuschreiben".

Die aktuelle Renaissance der Roboter ist vor allem ein Effekt der digitalen Revolution. Die mechanische Perfektion von Robotern, die sie zu erstaunlichen Maschine-Mensch-Interaktionen befähigt, wird erst dadurch möglich, dass sie mit immer schnellerer Computertechnik und Netzwerksystemen quasi ein Gehirn bekommen haben. Heute sind Roboter eben auch virtuelle Wesen, Avatare, was im Hinduistischen sinnigerweise Inkarnation des Göttlichen bedeutet. Wenngleich der Touring-Test nach

wie vor zeigt, wie erbärmlich die sprachlichen Menschensimulationen in der Kommunikation noch ausfallen, so ist doch absehbar, dass wir bald mit Computern und Robotern verbal kommunizieren werden. Komplettiert werden die Amalgame von Computern und Robotern schließlich durch die revolutionären Entwicklungen auf dem Gebiet der Biotechnologie. Die Neurobiologie ist dabei, direkte Verbindungen zwischen neuronalen und digitalen Netzwerken zu schaffen, ganz konkret zwischen Nervengewebe und Computerprozessoren. Und die Reproduktionsmedizin ist in der Lage, einzelne Gewebe und ganze Klone herzustellen. Insofern ist die Erschaffung von virtuellen Hybridwesen, die technische und organische Elemente miteinander vereinen, keine reine Fiktion mehr. Der Protagonist David erscheint im Grunde eher als ein Android, als ein virtueller Mensch, denn als das, was wir bislang unter einem Roboter verstanden haben. Von *Metropolis* über *Frankenstein* bis hin zu den modernen und postmodernen Science-Fiction-Filmen, die Erschaffung künstlichen menschlichen Lebens ist stets ein zentrales Thema der fantastischen Filmkunst gewesen. Unsere heutige Realität kommt gerade in dem an, was wir früher noch als Zukunftsmusik erlebt haben; dies allerdings nicht im Weltraum sondern in allzu irdischen Zusammenhängen.

Deutung des Films

Wie bei vielen Spielberg-Filmen spielt *A.I.* kunst- und bedeutungsvoll mit archetypischen Bildern und Geschichten, die der Mensch aus alten und modernen Mythen und Märchen kennt. Mit der viel einfacheren Geschichte von *E.T.* hat Spielberg selbst einen Beitrag zu dieser Ideengeschichte geleistet. Die Vielzahl der Versatzstücke ist aber so klug, sinnvoll und organisch in der Handlung versenkt, dass sie nie zum Selbstzweck werden. So wie sich die Filmhandlung einer einfachen mythologischen Perspektive entzieht, so schwierig ist auch eine einseitig psychodynamische Betrachtung seiner Handlung.

Man könnte versuchen, den entscheidenden Wunsch des Protagonisten, ein Mensch zu werden, der letztendlich das Leitmotiv des Films bildet, ins Zentrum einer tiefenpsychologischen Betrachtung zu rücken. Damit könnte Davids Odyssee als eine Allegorie auf die Menschwerdung schlechthin verstanden werden. Das Menschenkind wird erschaffen von einem Schöpfer, in die Welt gebracht von einem Vater, empfangen von einer Mutter und konfrontiert mit einem Bruder. Und es muss mit einem Bruder rivalisieren, vom Vater als bedrohlich wahrgenommen und von der Mutter schließlich in die Welt hinausgeschickt werden. Auf diesem Deutungswege könnten sich durchaus viele interessante Perspektiven und psychologische Bedeutungsebenen ergeben. Sie verfehlen aber dennoch ihr Ziel, sind wahlweise zu einfach oder zu komplex gedacht, was daran liegt, dass David nicht wirklich eine Entwicklung durchmacht. Er ist zwar lernfähig und hat ein Gedächtnis, aber aufgrund seiner konzeptionellen geistigen Behinderung bleibt er auch emotional stets auf der kindlichen Stufe stehen. Er wurde produziert, um Kind zu sein und zu bleiben. Wenn er sich am Ende von seiner Mutter verabschiedet und sie in den Schlaf beziehungsweise in ihren Tod begleitet, dann geschieht dies nicht mit der Erfahrenheit und der Erkenntnis eines erwachsenen Mannes. Er ist immer noch ein Kind, das seine Mutter kindlich lieben will und von ihr als Kind geliebt werden will. In diesem Sinne nennt David Walsh (2001) den Film kritisch „ein Märchen über einen Roboter mit einem Mutterkomplex". Aus Walshs soziologischer Perspektive ist es eine irreführende „Unterstellung, dass die Trennung von Mutter und Kind die Quelle des Unglücksgefühls der Menschheit sei". Wenn man sich das filmische Schaffen Stephen Spielbergs anschaut, dann wird deutlich, dass es ihm, wenn es ihm überhaupt einmal um Liebe geht, dann um ursprüngliche Formen von Liebe, die in ihrer Persistenz archaische Sehnsüchte und Kräfte entfesseln.

Um eine reife Liebe geht es in *Artificial Intelligence* jedenfalls nicht. So gesehen, handelt der Film aus psychologischer Sicht vom Stillstand, vom Ausbleiben der Entwicklung, von den Gefahren des Festhaltens. Insofern ist das zentrale Motiv das Aufhalten der Menschwerdung, die sich aus einer Unfähigkeit zu trauern ergibt. Wie schon in dem Roman „Solaris" (11961; 2002) und seinen Verfilmungen

durch Tarkowskij (1972) und Soderberg (1992), zeigt sich auch hier, dass menschliche Entwicklung nur dann möglich ist, wenn Menschen sterben dürfen und nicht künstlich im Leben festgehalten werden (te Wildt 2006). In „Solaris" geht es darum, dass sich der verwitwete Protagonist unter Schmerzen von der quasi als Projektion seiner Sehnsüchte wieder auferstandenen Frau lösen muss, um weiterleben zu können. Die Geschichte suggeriert, dass nur der Mensch überlebt, der in der Lage ist, auf die Unsterblichkeit von Liebe zu vertrauen. Die Allmachtsfantasien des dahingehend illusionslosen Menschen haben sich in dem Maße gesteigert, wie seine Fähigkeiten, mit Krankheit und Sterblichkeit umzugehen, geschwunden sind. Die anthropologische Dimension auch dieses Filmstoffs ist deutlich prononcierter als die tiefenpsychologische. In *A.I.* versuchen der verwaiste Vater und die zu verwaisen drohende Mutter die Unerträglichkeit ihrer Trauer damit zu umgehen, dass sie ein künstliches Kind erschaffen beziehungsweise annehmen. In früheren Filmen wäre ein solches Unterfangen ein sicherer Pakt mit dem Bösen gewesen und das Kind eine Ausgeburt der Hölle. Spielberg spielt auf die Möglichkeiten des Horrorszenarios an, irritiert aber den Zuschauer schließlich vielmehr damit, dass umgekehrt immer mehr die Menschen als die eigentlichen Träger der Monstrosität erscheinen. Indem sie Gott spielen, beschwören sie selbst das Dämonische in sich herauf und noch viel schlimmer, sie schaffen sich selbst ab. Am Ende sind die Roboter, Androide, Cyborgs und Avatare die guten Wesen, die einen neidvollen Atavismus im Menschen evozieren, diesen aber letztendlich überleben. Schließlich trauern die Avatare um den Menschen als Gattung und aussterbende Spezies. Als sich David von seiner Mutter verabschiedet, nimmt er stellvertretend vom Menschen an und für sich Abschied.

Auch Pinocchio macht nicht wirklich eine Entwicklung durch, wenngleich sich sein Wunsch, ein Mensch zu werden, am Ende erfüllt. Ausgangspunkt dieses eher modernen und bisweilen schrecklich pädagogisch angelegten Märchens (Collodi 11883; 2001) bildet der Fund eines sprechenden Holzscheits durch einen Tischlermeister, den er an Meister Gepetto, einen Holzschnitzer, weiterverschenkt. Dieser schnitzt daraus die Marionette Pinocchio, die für ihn wie ein Sohn ist. Auf seinem Weg, ein richtiger Junge zu werden, erlebt Pinocchio viele Abenteuer, wobei er den Vater immer wieder verlässt, enttäuscht und belügt. Naiv wie er ist, erliegt er immer wieder den Verführungen der Welt. Die gute blaue Fee rettet ihn jedoch immer wieder und schickt ihn zum Vater zurück. Sie verspricht, aus ihm einen richtigen Jungen zu machen, wenn er verspricht, ein guter Junge zu sein. Dies ist die fragwürdige Botschaft des Buches: Nur ein lieber Junge ist ein richtiger Junge. Die Geschichte endet damit, dass Pinocchio auf einer seiner Eskapaden wieder furchtbar scheitert und schließlich wie ein Stück Holz hilflos in der Weite des Meeres treibt, bis er von einem Wal verschluckt wird. In dessen Bauch begegnet er seinem Vater wieder. Bevor sie den Wal auf abenteuerlichem Wege verlassen, verspricht Pinocchio, endlich ein verantwortungsbewusster Junge zu werden. Nach dieser Neugeburt wacht er am Ende tatsächlich als Junge aus Fleisch und Blut auf. Damit ist er davon befreit, für immer ein Kind zu sein, und ist erwachsen geworden. Pinocchio muss sich seine Existenzberechtigung erkämpfen, indem er lieb ist. Er muss seinem (Gott-)Vater gefallen, um Mensch werden zu dürfen. In der Unendlichkeit des Meeres und der Dunkelheit des Walbauches versöhnt er sich mit seinem Vater und wird quasi neugeboren. In *A.I.* geht es eher um die Verbindung und Vereinigung mit der Mutter. David ist nicht böse, nicht verführbar, aber ebenso naiv wie Pinocchio. David ist aufs „Gut-Sein" programmiert. Die Liebe zum Vater und die zur Mutter mögen hier unterschiedliche Nuancen tragen, in der Kindlichkeit ihres Liebens jedoch ähneln die beiden Protagonisten einander sehr.

Schließlich bleibt die Frage offen, ob David nun wirklich lieben kann. Vom äußeren Anschein her ist dies der Fall. Aber diese kindliche Liebe, die sich mit einer Illusion von seiner Mutter täuschen lässt und zufrieden gibt, ist wohl nicht die Liebe, die wir meinen, nicht die Liebe, die Berge versetzt und das Menschengeschlecht am Leben erhält. Erstaunlich aber bleibt die Liebe der Mutter zu ihrem Roboterkind David, die am Ende eben doch nicht nur irrational, besitzergreifend und substitutenhaft erscheint. Vielleicht rettet den Menschen am Ende doch die Fähigkeit, ein fremdes Wesen anzunehmen und zu lieben, Verantwortung zu übernehmen über die eigene Gattung hinaus.

Am Ende weiß buchstäblich kein Mensch mehr, was real ist oder was nicht. In einer vollständig virtuellen Welt, in der alles konkret Fassbare eingefroren ist, besitzt das, was einmal als Realität bezeichnet wurde, keinen Eigenwert mehr. Wenngleich die opaken Wesen der Zukunft empathisch zu sein scheinen, so suggerieren ihre medialen Oberflächen doch, dass sie letztendlich selbst Simulationen sind, die Gefühle simulieren, aber nicht empfinden können. Sie müssen Gefühlsräume und einen Menschen genetisch herstellen, eine Versuchsanordnung, damit Emotionalität entstehen und beobachtet werden kann. So ist auch der Film selbst konzipiert, was dazu führt, dass sein Schöpfer wahlweise als entweder besonderes emotional oder besonders manipulativ anmutet.

Auch die herzergreifende Schlussszene des Films, die den Zuschauer durchaus anzurühren vermag, zeigt wenig mehr als eine Simulation von Liebe und hinterlässt damit einen bitteren Beigeschmack. Die Mutter weiß an diesem einen gelungenen Tag, den der Robotersohn mit ihr verbringt und für sie gestaltet, nicht, was mit ihr geschieht. Die Rollen sind quasi umgekehrt, wenn er ihr beim Aufstehen und Anziehen hilft und sie am Ende des Tages ins Bett bringt, so wie es senilen Eltern mit ihren erwachsenen Kindern ergehen kann. Aber hier geht es auch immer wieder nur um die Liebe zwischen Eltern und Kind, wie wir sie im Grunde auch bei Tieren kennen. Da die für einen Tag wieder auferstandene Mutter kein Bewusstsein für die Situation hat, kann auch hier kaum von reifer menschlicher Liebe die Rede sein. Nüchtern betrachtet, ist die Mutter hier wenig mehr als ein geliebtes Stofftier, mit dem ein Kind aufwachen und einschlafen möchte. Und es ist am Ende für die simulierte Mutter völlig unerheblich, ob David nun ein richtiger Junge geworden ist. Er ist es natürlich nicht. Aber er scheint sich selbst glauben zu machen, dass er es für diesen einen Tag ist. Die Fähigkeit, sich selbst zu täuschen, macht aus einem Roboter, so menschlich sein Antlitz erscheinen mag, noch keinen Menschen aus Fleisch und Blut. Denn was soll nach diesem einen geretteten Tag noch für ihn kommen? 2000 Jahre nach seiner Erschaffung ist er veraltet. Die Wesen, für die er gebaut wurde, sind nicht mehr existent. Es gibt keine Menschen mehr, die er lieben könnte, keine Aufgaben mehr, die er erfüllen könnte, und er wird die Wesen, die ihn aus dem Eis ausgegraben haben, vermutlich niemals wirklich verstehen können, in ihrer Mitte immer der Außenseiter sein, der er auch in seiner Ursprungsfamilie gewesen ist. Wie der Mensch ist auch er dem Tod geweiht.

Den Zuschauer rührt dies alles seltsam an. Problematisch ist vielleicht, dass der Film die Schlussszene als klassische Abschiedsszene anbietet. Es liegt an ihm, ob er in der Mutter und David echte Menschen erkennt. Und da David von einem echten Jungen gespielt wird, bleibt dem Zuschauer gar keine andere Wahl. So funktioniert die emotionale Eingenommenheit durch den gesamten Film auf eine Art und Weise, die den Zuschauer eigentlich betrügt oder zumindest ihm die Möglichkeit gibt, sich selbst zu betrügen. Es geht also vielmehr um die Frage, ob der Mensch dazu in der Lage sein wird, sich selbst glauben zu machen, dass die Simulatoren und Simulationen, die er erschafft, echt sind. Dies am Beispiel der Liebe zwischen Mutter und Kind durchzudeklinieren, ist aber vielleicht zu einfach. Dass Spielberg nach eigenen Angaben selbst stets ein Kind geblieben ist, bezeugt *A.I.* mehr als jeder andere seiner Filme.

Die Ausgangsfrage des Films, die auf reife Formen der Liebe abzielt, bleibt unbeantwortet. Spielbergs Film arbeitet ausschließlich mit Liebesrobotern, die entweder Elterngefühle oder sexuelle Bedürfnisse befriedigen sollen. Es bedarf eines reifen Zuschauers, der sich vom Film darüber nicht hinwegtäuschen und von seinen eigenen regressiven Bedürfnissen nicht einlullen lässt. Spielbergs Spiel mit der Sehnsucht nach der Erfüllung kindlicher Träume – mit der Liebe zwischen erwachsenen Menschen hat er in seinen Filmen so gut wie nie etwas anfangen können – ist hier am Ende vielleicht doch mit ihm durchgegangen. Seine Faszination für Science-Fiction und dem, was davon realisiert werden könnte, ist am Ende auch ein kindlicher Zukunftsglaube. Es liegt in den Augen des Betrachters, ob in *A.I.* die Faszination über oder die Kritik an den gelebten kindlichen Allmachtsfantasien des Menschen überwiegen. Wenn man wohlwollend sein wollte, dann könnte man behaupten, dass er es in der Schwebe zu halten vermag und den Menschen am Ende auf sich zurückwirft, wenn er zusehen muss, wie die geschaffenen Roboter ihn ablösen und am Ende um ihn trauern beziehungsweise ihre Trauer um ihn simulieren.

Aber vielleicht ist das auch die entscheidende, ebenso tiefenpsychologische wie philosophische Frage, um die es in dem Film eigentlich geht: Wie können wir uns überhaupt im Hier und Jetzt sicher sein, dass das, was wir erleben und fühlen, nicht eine Simulation ist. Alle wissenschaftlichen Versuche, den Menschen deterministisch auf die Materie zu reduzieren, allen voran die Neurobiologie, zielen im Grunde darauf ab, dass der freie Wille eine Simulation ist. Der im Film kultivierte Glaube daran, dass ein hochkomplexes künstliches Wesen sich irgendwann über seine Determinanten erhebt, autonom und willensvoll wird, ist im Grunde zutiefst antideterministisch und insofern ausgesprochen human. Dies kann man Spielberg zugutehalten. Dass Kubrick den Film nicht selbst gedreht hat, liegt vielleicht daran, dass er seinem Stoff bis zum Schluss misstraut hat. Worthmann (2001) bringt den Unterschied zwischen den Herangehensweisen der beiden Regisseure wie folgt auf den Punkt:

> … bei Kubrick wurden noch die Subjekte gnadenlos zu Objekten gemacht – während Spielberg in A.I. voller Sympathie verfolgt, wie sich ein Objekt zum Subjekt verwandelt.

Kubrick wollte nicht nur darauf warten, dass die Filmtechnik irgendwann soweit ist, die Geschichte glaubhaft zu erzählen, sondern er wollte eigentlich darauf warten, dass Roboter gebaut würden, die in der Lage sind, den entsprechenden Simulationseffekt selbst zu erzielen. So oder so wäre es ein anderer Film geworden. Der Betrug wäre ein anderer gewesen. Aber auch der stets erwachsener erscheinende Kubrick schien wohl zu glauben, dass die Zukunft zwangsläufig auf diese Fragen stoßen wird und dies mit oder ohne einen real existierenden Menschen. – Man möchte meinen, dass es schön wäre, dies nicht mehr erleben zu müssen. Wenn wir es aber doch noch auf die eine oder andere Weise erleben sollten, dann dürften wir uns an *A.I.* als ein ambivalentes Meisterwerk erinnern.

Literatur

Aldiss BW (2001) Super-Toys Last All Summer Long: And other Short Stories. Griffin, Santa Ana (Erstveröff. 1969)

Collodi C (2001) Pinocchio. Dressler Verlag, Hamburg (Erstveröff. 1883)

Lem S (2002) Solaris. Heyne, München (Erstveröff. 1961)

te Wildt BT (2006) Erinnerung und Sehnsucht im Cyberspace. In: Neuen C (Hrsg) Erinnerung und Sehnsucht. Leitmotive zu neuen Lebenswelten. Walter, Köln, S 156–176

Walsh D (2001) Nochmals von vorn beginnen. World Socialist Web Site. http://www.wsws.org/de/2001/jul2001/ai-j28.shtml. Zugegriffen am 19. 5. 2012

Wißnet A (2007) Roboter in Japan: Ursachen und Hintergründe eines Phänomens. Iudicum, München

Worthmann M (2001) Verführungsmodul „A. I." Wie uns Spielberg mit nichtmenschlichen Helden rührt. ZEIT ONLINE. http://www.zeit.de/2001/37/200137_a.i..xml. Zugegriffen am 19. 5. 2012

Originaltitel	AI – Artificial Intelligence
Erscheinungsjahr	2001
Land	USA, GB
Buch	Steven Spielberg, Ian Watson
Regie	Steven Spielberg
Hauptdarsteller	Haley Joel Osment (David), Frances O'Connor (Monica Swinton), Jude Law (Gigolo Joe), Jake Thomas (Martin Swinton), William Hurt (Prof. Allen Hobby), Brendan Gleeson (Lord Johnson-Johnson), Ben Kingsley (Erzähler)
Verfügbarkeit	Als DVD in OV und deutscher Sprache erhältlich

Lutz Wohlrab

Sterblichkeit als Home-Entertainment – das kann nicht die Zukunft sein

Vanilla Sky – Regie: Cameron Crowe

TOM CRUISE
VANILLA SKY

LoveHateDreamsLifeWorkPlayFriendshipSex

Filmplakat *Vanilla Sky*
Quelle: Interfoto/Mary Evans

Vanilla Sky[1]

Regie: Cameron Crowe

Cameron Crowe drehte das Remake des spanischen Films *Abre los Ojos – Open Your Eyes* (1997) von Alejandro Amenábar ein Jahr nach seinem autobiografischen Erfolgsfilm *Almost Famous* (2000), für dessen Drehbuch er einen Oscar erhielt (◘ Abb. 1).

Die Handlung und erste Assoziationen zu Film, Realität, Wunsch und Wirkung

David Aames (Tom Cruise) wacht auf, stellt den Fernseher aus, geht ins Bad und zupft sich, als Zeichen des Alterns und seiner Sterblichkeit, ein graues Haar aus. Er ist zufrieden mit seinem Spiegelbild, nur etwas überrascht. Größer wird seine Überraschung erst über den fehlenden Straßenverkehr. Die Ampeln funktionieren, aber sogar der Times Square ist menschenleer (◘ Abb. 2). Ein Alptraum oder eine Wunscherfüllung? Ist er der einzige Überlebende einer Katastrophe, eines Angriffs mit der Neutronenbombe[2] vielleicht? Was soll er aber allein auf der Welt? Ein Weib suchen, sich paaren und ein neues Geschlecht begründen? Das wäre eine schöne Größenfantasie.

David erwacht erneut. Seine Freundin Julianna Gianni (Cameron Diaz) liegt neben ihm und beginnt schon, ihm lästig zu werden (◘ Abb. 3). Sein Freund Brian Shelby (Jason Lee) zieht ihn ihretwegen auf, gerade weil er sie gern selbst zur Freundin hätte. David bezahlt ihn auch für das Schreiben eines Romans. Welcher Künstler träumt nicht von so einem großzügigen Mäzen? David hat andere Sorgen als Geld. Er leitet ein Verlagsimperium und hat einen Ruf zu verlieren, den des stadtbekannten Schürzenjägers. Man nennt ihn Citizen Dildo, gewiss in Anspielung auf *Citizen Kane* (Orson Welles 1941), dessen Vorbild William Randolph Hearst ein Verlagshaus führte und ebenfalls im Dakota-Building wohnte. Als er es diesmal verlässt, sind die Straßen voll wie immer, es herrscht der normale Wahnsinn in New Yorks Stadtbild.

An einem der nächsten Abende feiert David seinen 33. Geburtstag. Es wimmelt dort von schönen Frauen und Prominenten. Steven Spielberg schaut vorbei, weil er seinen nächsten Film mit Tom Cruise vorbereitet. Brian bringt die bezaubernde Sofia Serrano (Penélope Cruz) zu Davids Party mit. Sie kommt David gleich ganz anders vor als all die anderen Frauen. Meisterhaft verstrickt er sie in einen Flirt und wird nebenbei Julie los. Sie sei das traurigste Mädchen, das je einen Martini in der Hand hielt, meint Sofia. Brian ist verärgert, dass sein Freund sie ihm ausspannt. Aber so kennt er ihn. Wenn es um Frauen geht, nehmen es diese Männer sportlich, sind sie Rivalen.

Penélope Cruz scheint – wie Steven Spielberg – auch nur sich selbst zu spielen. Ihr glaubt man das ehrliche Mädchen aus einfachen Verhältnissen. Ihre Darstellung im spanischen Original *Abre los Ojos – Open Your Eyes* (1997) war ihr Türöffner zum internationalen Geschäft. Sie wurde als Einzige aus dem Ensemble zur Neuverfilmung nach Hollywood eingeladen. Nun deutet sie die Möglichkeit eines solchen Aufstiegs an, und sie verliebt sich während der Dreharbeiten auch wirklich in Tom Cruise. Das Leben ahmt die Kunst nach. Genauso erging es Tom Cruise und Nicole Kidman mit Stanley Kubricks *Eyes Wide Shut* (1999). In diesem Film nach Schnitzlers „Traumnovelle" (11926; 2007) gerät ihre Ehe in eine Krise, weil Tom Cruise seine Eifersuchtsfantasien nicht mehr aushält. Die beiden Schauspieler trennen sich danach wirklich.

1 Erweiterte Fassung des Vortrags vom 28. 8. 2011 im Berliner BrotfabikKino, Leitung: Claus Löser, als 38. Veranstaltung der Berliner Reihe Film & Psychoanalyse, Moderation: Matthias Stöbe. Ich danke allen an der Diskussion Beteiligten.

2 Eine Bombe, die Leben tötet, Materie aber verschont.

☐ Abb. 2 David Aames (Tom Cruise) in den Straßen New Yorks. (Quelle: Cinetext Bildarchiv)

Traumfrauen und -männer

Penélope Cruz, Nicole Kidman und Cameron Diaz sind Traumfrauen, eher virtuelle Wesen als reale Frauen. Es gibt sie in Wirklichkeit nur auf der Leinwand und in unseren Männerfantasien. Diese sind wichtig, denn Schwärmereien tragen zur Auflösung des Ödipuskomplexes bei. Meine erste Traumfrau war übrigens die DEFA-Schauspielerin Renate Blume. Ich war 14 oder schon 15 Jahre alt, und der Film hieß *Ulzana* (1974). Renate Blume[3] spielte die Frau des Indianerhäuptlings, die sie danach wirklich wurde. Mit Gojko Mitić lebte sie von 1974 bis 1976 zusammen. Von 1981 an war sie dann mit Dean Reed verheiratet.[4] Gojko Mitić, Dean Reed und Tom Cruise waren oder sind natürlich auch Traummänner und begehrenswert für viele Frauen. Für Jungen sind solche Männer Identifikationsfiguren und Vorbilder. Das ist wichtig, weil Identifizierungen mit gleichgeschlechtlichen Personen die (heterosexuelle) Geschlechterrollenidentität verstärken.

Die bezaubernde Penélope Cruz stiehlt diesmal der verführerischen Cameron Diaz die Show. Brian sagt, sie könnte seine Traumfrau sein. Er ist ein Mann, der immer noch auf der Suche nach ihr ist. David dagegen findet sie. Für Sofia ist er sogar bereit, sein Leben zu ändern und ein besserer Mensch zu werden. Seine „Bums-Freundin" Julie spioniert ihm jedoch nach und bietet sich, da er offensichtlich nicht zum „Schuss" gekommen ist, als Sexobjekt an. Sie würde es auch für sich behalten. David steigt in ihr Auto. Nun stellt sie ihm die Gretchenfrage, ob er an Gott, das heißt auch an Liebe und Treue, glaubt. Wie Faust glaubt David nicht daran, ihn kostet es aber fast das Leben. Mit viel Glück überlebt er einen erweiterten Suizidversuch, ist danach aber schwer entstellt. Nun hasst er Julie und tötet sie später sogar, als sie im Bett den Platz von Sofia eingenommen hat. Dabei hätte er Sofia nur treu zu bleiben brauchen,

3 http://de.wikipedia.org/wiki/Renate_Blume. Zugegriffen am 26. 8. 2011
4 In seinem Abschiedsbrief schrieb Dean Reed 1986, dass er die Eifersucht seiner Frau auf ihn nicht mehr aushalten konnte. (http://de.wikipedia.org/wiki/Dean_Reed. Zugegriffen am 26. 8. 2011)

◙ Abb. 3 David Aames (Tom Cruise) und seine Freundin Julianna (Cameron Diaz). (Quelle: Interfoto/NG Collection)

dann wäre gar nichts geschehen. Das ist die Moral in diesem Film-Märchen. Sofias Platz hat er ihr in der Szene selbst angeboten, als er sich zu der wartenden Julie ins Auto setzte.

Nach ihrer Tötung kommt David ins Gefängnis, wo er vom Psychiater Dr. Curtis McCabe (Kurt Russell) auf seine Schuldfähigkeit untersucht wird. Hat er im Wahn getötet oder simuliert er nur? Der Psychiater entspringt Davids Sehnsucht nach einem liebenden und mitfühlenden Vater und ist eine klare Wunscherfüllung. Er beginnt, sich für die Verschwörungstheorien seines Patienten zu interessieren. Es könnte schon sein, dass ihn der Aufsichtsrat, die „Sieben Zwerge", ausbooten will. Das geheimnisvolle „Eli", das David nachts ruft, facht die Neugier von Dr. McCabe an. Eli heißt L. E. und steht für „Life Extension". David erfährt von seinem technischen Support, dass sich sein Körper seit 150 Jahren in Kryostase befindet, also tiefgefroren ist, und dass er sich umgebracht hat. Vorher hat er einen Vertrag unterschrieben, der seine Kryonisation regelt – wie Walt Disney. Hartnäckig hält sich das Gerücht, er habe sich einfrieren lassen.[5] Die „Sieben Zwerge" des Aufsichtsrates in *Vanilla Sky* tragen die Namen aus dem bekannten Disney-Zeichentrickfilm von 1937. Auch Schneewittchen liegt in ihrem gläsernen Sarg wie in einem Zwischenreich, nicht mehr lebendig, aber noch nicht ganz tot. Sie wurde Opfer der Eifersucht ihrer bösen Stiefmutter und durch das ungeschickte Stolpern eines Sargträgers aufgeweckt. „Wer ist die Schönste im ganzen Land?" – am Anfang spielt *Vanilla Sky* auch auf die berühmte Spiegelszene des Märchens an.

Der Wunsch nach Unsterblichkeit ist eine universelle Wunschvorstellung der Menschheit, die die Traumfabrik Hollywood oft und gern bedient. Warum soll man sich seine Jugend und Schönheit nicht bewahren können, warum sein Leben nicht verlängern und warum soll man damit kein Geld verdienen? Es könnte doch noch andere, parallele Welten geben. Die Pharaonen haben das geglaubt, und

5 http://de.wikipedia.org/wiki/Walt_Disney. Zugegriffen am 26. 8. 2011

die Pyramiden bezeugen es. Man könnte sagen, die Mumifizierung war die Alternative zur Kryonisation für die Wüste. Hauptsache war, dass der Körper intakt blieb, alles andere war den alten Ägyptern schlimm, wie unser Reiseführer in im Tal der Könige betonte. Eines Tages findet die Seele wieder in ihren Körper zurück, und das ewige Leben im Reich der Toten kann beginnen. Warum sollen wir uns so eine Art Auferstehung nicht auch in der Zukunft vorstellen können? Wenn die Medizin alle entscheidenden Fortschritte gemacht hat, wird man einfach wieder aufgetaut. Und in diesem Film geht sogar noch mehr. Wer sich für einen kleinen Aufpreis für den luziden Traum entscheidet, bestimmt alles, was passiert. Das Leben ist nun eine einzige Wunschvorstellung. „Ich bin, was ich mir vorstellen kann", heißt es bei Erik H. Erikson ([1]1959; 1973, S. 98) für die ödipale Phase. Wir kommen auf diese wichtige Entwicklungsstufe noch zurück.

Kryotainment

David hat in seinem luziden oder „Glasklaren Traum" die Handlungen Aller in der Hand. Es geschieht, was er sich vorstellt: Kryotainment. Sofia erklärt ihm ihre Liebe, und Ärzte haben eine Möglichkeit gefunden, sein Gesicht wiederherzustellen. Als sich sein Leben nach dem Unfall wieder normalisiert hat, taucht plötzlich Julie erneut auf. David verliert nun die Kontrolle über seinen luziden Traum, und er weiß bald nicht mehr, was darin Wille oder (Wahn-)Vorstellung, was Realität oder Fiktion ist.[6] David hat sich seine Welt von dem Moment an selbst erschaffen, als ihm Sofia überraschend ihre Liebe offenbart. Aber es ist auch Teil seiner Konstruktion, dass sie sich in Julie verwandelt, die er dann tötet. Das Gefängnis und der Psychiater, alles ist nur geträumt. Auch das Gebäude von Life Extension und die Skyline von Manhattan mit den Zwillingstürmen sind geträumt, der Film wird kurz vor dem 11. September fertig gestellt.

Am Ende des Films hat David die Wahl, in seinen luziden Traum zurückzukehren oder im Jahre 2151 aufzuwachen. Er geht das Risiko ein und stürzt sich vom Dach des L. E.-Hochhauses, sein Leben und seine Zeit rasen noch einmal in Bildern an ihm vorbei: Bilder aus der Werbung und dem Film, von Martin Luther King, Bruce Springsteen und vielen anderen und schließlich sehen wir David in den Armen seiner Mutter. Dieses Bild der Sehnsucht ist bedeutsam. Eine weibliche Stimme sagt noch einmal „Öffne die Augen", und dann wird es weiß. Aber ich denke, wir haben vieles über Männer und Frauen erfahren, über den Wunsch der Männer nach vielen Frauen und über den Wunsch der Frauen nach einem treuen Mann, der auch noch toll aussieht, über den Wunsch der Menschen nach einem ewigen Leben in Jugend und Gesundheit, über ihren Wunsch, reich und berühmt zu sein, einzigartig, begehrt und verstanden zu werden. Es ist nicht so viel Neues dabei, aber es ist doch wunderbar gemacht. Wie oft wurde uns das schon im Kino vorgeführt? Warum genügt einem Mann denn eine Frau nicht? Vielleicht weil seine Mutter zwei Brüste hat. Aber Mädchen werden auch gestillt. Warum wollen sie dann typischerweise (nicht alle) nur einen Mann? Weil der Vater nur einen Penis hat, den er nicht mit der Mutter teilen soll, wäre eine Antwort. Es macht Spaß, das einfach mal auszusprechen. So muss es Freud ergangen sein, als er seine Thesen zur kindlichen Sexualität, zum Ödipuskomplex und zum Penisneid vorgetragen hat.[7] Das hat ihm viel Kritik eingebracht, als ob es um die Frage ginge, wer mehr wert sei, der Mann oder die Frau, der Vater oder die Mutter? Fakt ist, dass das Zusammenleben von Männern und Frauen in den letzten einhundert Jahren nicht einfacher geworden ist und es wohl in der Zukunft auch nicht werden wird.

6 Eigentlich versteht man unter einem luziden Traum einen Traum, in welchem dem Träumer bewusst ist, dass er träumt. Die Theorie des luziden Träumens geht davon aus, dass sowohl das bewusste Träumen als auch die Fähigkeit zum willentlichen Steuern von Trauminhalten erlernbar sind. In den in diesem Buch ebenfalls behandelten Filmen *The Cell* und *Inception* spielen solche Träume und ihre bewusste Beeinflussung eine zentrale Rolle.

7 Sich mit Freud zu identifizieren, ist natürlich auch eine Größenfantasie.

Psychodynamische Interpretationen

In der psychoanalytischen Entwicklungspsychologie spielen der Ödipuskonflikt und seine Überwindung eine entscheidende Rolle. Der Junge überwindet ihn, indem er den Verzicht auf seine Mutter (als erotisches Liebesobjekt) leistet und sich mit dem Vater identifiziert. Das Mädchen bleibt mit der Mutter identifiziert, sie wendet sich dem Vater zu, muss aber auf ihn (als erotisches Liebesobjekt) verzichten. Wenn sie das nicht tut, wird sie sich anderen gebundenen Männern zuwenden, sich ihnen als Zweitfrau anbieten, so wie das Julie macht. Das ist mit der unbewussten Größenfantasie verbunden, der Mutter (Erstfrau) doch noch – stellvertretend – den Vater ausspannen zu können. Julie sagt, wenn man mit jemandem schläft, gibt der Körper ein (Ehe-)Versprechen ab. Sie glaubt, dass der Mann, mit dem sie Sex hat, nun ihr gehört, nicht mehr ihrer Vorgängerin (einer Stellvertreterin der Mutter) und auch nicht sich selbst. David denkt nicht so. Er fühlt sich nicht gebunden, nur weil er Sex gehabt hat und seinem Trieb gefolgt ist. Dem Bindungswunsch bzw. der Bindungsangst des Mannes liegt die Erfahrung seiner Mutterliebe zugrunde. Freud (1923, S. 221) schreibt:

> Schon in den ersten Kinderjahren (etwa von 2 bis 5 Jahren) stellt sich eine Zusammenfassung der Sexualstrebungen her, deren Objekt beim Knaben die Mutter ist. Diese Objektwahl nebst der dazugehörigen Einstellung von Rivalität und Feindseligkeit gegen den Vater ist der Inhalt des sogenannten Ödipus-Komplexes, dem bei allen Menschen die größte Bedeutung für die Endgestaltung des Liebeslebens zukommt. Man hat es als charakteristisch für den Normalen hingestellt, dass er den Ödipus-Komplex bewältigen lernt, während der Neurotiker an ihm haften bleibt.

Wird der Ödipuskomplex vom Jungen nicht aufgelöst, kann Don Juanismus die Folge sein. David hat als Kind zunächst Höhenangst. Damit enttäuscht er seinen abenteuerlustigen Vater, der Ballonfahrer, Fallschirmspringer und Segler ist. Seine Höhenangst ist unbewusster Protest gegen und Ausdruck der Angst vor dem Vater und den Höhen, die dieser erreicht hat. Als Erwachsener kann David seine Höhenangst überspielen und durch den Sport, Frauen nachzujagen, kompensieren.

Don Juanismus

Dieses Agieren nennen wir Don Juanismus. Solch ein Mann ist davon getrieben, immer wieder schöne Frauen zu erobern, obwohl sie ihm – paradoxerweise – nicht viel bedeuten. Nur ihre Anzahl ist wichtig. Je höher, desto besser. Frauen sind hier wirklich nur Objekte, die Verwendung finden, um einen Mangel an Narzissmus zu befriedigen. Hier liegt auch Davids Defizit. Zu früh hatte er den Verlust seiner Eltern zu verkraften, des ungeliebten Vaters und der noch über alles geliebten (präödipalen) Mutter, die eine Schwäche für die Bilder von Claude Monet hatte. Die Farbe des Himmels auf seinem Gemälde „La Seine à Argenteuil" (1873) hat dem Film seinen Namen gegeben. Solch eine weiß-gelbliche Färbung des Himmels bzw. der Wolken kommt in der Natur selten vor. Sie scheint mir ein Symbol für die Mutter bzw. für ihre Brust zu sein, von der zu selten genug Liebe bzw. gute Milch kam. Solch ein früher Mangel macht den Don Juanismus erst verständlich. Jede schöne Frau erinnert den Betroffenen an seine Mutter, denn den ödipalen Verzicht hat er nicht vollzogen. Der größte Liebhaber aller Zeiten zu werden, könnte – in der Fantasie – den primären Mangel an mütterlicher Liebe ausgleichen. Die Größenfantasie könnte aber auch Ausdruck des fehlenden Vaters oder des Mangels an väterlicher Liebe sein, die eine Voraussetzung für die Identifikation des Sohnes mit dem Vater ist. Am schönsten wird die Genese des Don Juanismus in dem Film *Don Juan DeMarco* (1995) mit Johnny Depp und Marlon Brando deutlich. Das war übrigens das Regiedebüt des Drehbuchautors und Psychotherapeuten Jeremy Leven.

Historisch kommt Don Juanismus bereits im „Recht der ersten Nacht" zum Ausdruck. Dieses Herrenrecht war nicht nur Ausdruck der Leibeigenschaft, sondern vor allem in seinem Mythos Wunsch-

vorstellung von Allmacht und Größe, die stets aus einem Defizit erwächst. Auf der anderen Seite steht der Mythos von der Jungfräulichkeit, die immer noch einen außergewöhnlich hohen Wert darstellt. Die Jungfrau Maria wird seit Jahrhunderten in unserem Kulturkreis angebetet, und mit ihr werden Tugenden wie Reinheit, Unschuld, Treue und wahre (Tochter- wie auch Mutter-)Liebe verbunden. Für viele ist sie eine (nicht sexuell besetzte) Traumfrau, wie Jesus ein (nicht sexuell besetzter) Traummann ist. In der Traumfrau wirkt das Bild der Mutter nach, genauer das Bild einer idealen Mutter. Im Traummann steckt der Vater. Der ideale Vater ist Gott. Freud sagt, „dass Gott im Grunde nichts anderes ist als ein erhöhter Vater" (Freud 1919, S. 177). Im christlichen Glauben ist nur noch die heilige Dreifaltigkeit größer: die Wesens-Einheit von Gott Vater, Sohn (Jesus Christus) und Heiligem Geist. Wie Jesus sollte David nur 33 Jahre alt werden. Das ist sicher kein Zufall, denn im spanischen Original wird der Held erst 25 Jahre alt – wie der Regisseur selbst. Das ist natürlich ein Stück Narzissmus. Tom Cruise war zum Zeitpunkt der Dreharbeiten bereits 38 Jahre alt. Sich jünger zu machen, ist auch ein Stück Narzissmus. Als Teenager wollte Cruise Priester werden und im Zölibat leben, aber er wählte einen anderen Weg; aus dem Paulus wurde ein Saulus, bevor der zu einem Scientologen wurde. Aus diesem Don Juan wurde 2006 endlich ein Vater, denn laut Scientology macht Sex selten glücklich.

Narzissmus und Eifersucht

Nach David ist Julie die interessanteste Person im Film, denn Sofia ist vor allem eine Projektionsfläche, eben die Traumfrau in Davids „Glasklarem Traum". Julies Eifersucht ist nachvollziehbar und hat dramatische Konsequenzen. Sie stirbt zweimal, in einem erweiterten Suizidversuch und durch David, der sie in Rage erstickt. Das sie überhaupt auftaucht, ist wohl auf sein Schuldgefühl ihr gegenüber zurückzuführen. Er hat sie schlecht behandelt, benutzt und weggeworfen. Mit dieser Zurückweisung kann sie nicht umgehen. Sie verführt ihn erneut und rächt sich bitter an ihm. Ihre narzisstische Kränkung ist so stark, weil sie David als Selbst-Objekt besetzt hat. Das heißt, dass sie ihn als ideal zu sich passend bestimmt hat (Heigl-Evers 1993, S. 110):

> [Der Narzisst] erlebt im Anderen dann ein ideales und in idealer Weise auf ihn abgestimmtes Wesen, das es ihm ermöglicht, sich quasi als ein abgerundetes Ganzes zu erleben, als eine in ihrer Identität gesicherte Person. Der jeweilige idealisierte Andere wird in dieser ihm zugewiesen Funktion instrumentalisiert, benutzt; der personale Aspekt der Beziehung ist entsprechend verkürzt …
> Er versucht zu bewirken, dass der Andere in der gewünschten Verfassung verbleibt und ihm somit weiterhin nützlich sein kann.

Narzissmus ist durch einen Wechsel von Größenfantasien und Minderwertigkeitsgefühlen gekennzeichnet. Hinter einer „arroganten" Erscheinung verbirgt sich oft ein kritikanfälliges Selbst, das schon durch das Ausbleiben von Anerkennung erschüttert werden kann. In ihren Beziehungen haben narzisstische Persönlichkeiten oft ein Grundgefühl der Unsicherheit, das durchaus begründet ist (Heigl-Evers ebd.):

> … denn Personen, die sich in der beschriebenen Weise zum Teilobjekt-Substitut machen lassen, ziehen sich aus solchen Beziehungen in der Regel zurück, wenn deutlich geworden ist, dass sie den an sie gerichteten Erwartungen nicht entsprechen können oder … wollen.

David zieht sich zurück, weil er Julies Erwartungen nicht erfüllen will. Darunter leidet sie so sehr, dass sie sich und ihn umbringen will, weil sie ohne ihn nicht mehr leben kann. Kohut stellt fest ([1]1971; 1973, S. 38):

Die Hauptquelle des Leidens ist daher das Ergebnis der Unfähigkeit seiner Psyche, die Selbstachtung zu regulieren und sie auf einem normalen Niveau zu halten.

David ist vermutlich nicht weniger narzisstisch als sie und als sein Vater. Erinnern wir uns an dessen großes Porträt im Stil von Chuck Close und die Passage aus seiner Autobiografie, in der er seinen Sohn nur ganz kurz und entwertend erwähnt. Narzissmus ist gewissermaßen erblich. Kohut schreibt (ebd., S. 101):

Man kann regelmäßig feststellen, dass das zentrale Trauma in den psychischen Störungen der Eltern wurzelt, insbesondere in den eigenen narzisstischen Fixierungen der Eltern.

So wie Davids Vater von seinem Sohn enttäuscht war, so war Davids Mutter sicher von ihrem Mann und ihrem Leben insgesamt enttäuscht. Damit konnte sie David keine gute Mutter sein. Davids Vorstellung von Sofias großer Liebe stellt die Neuauflage einer idealen Mutter-Sohn-Beziehung dar. Die weiß-gelbliche Färbung des Himmels, die dem packenden Film seinen Namen gab, ist Ausdruck dieses unerfüllten Wunsches. Einmal muss der flüchtige Augenblick des Glücks doch Dauer haben … Das Bild, insbesondere in der Malerei der Impressionisten, will den schönen Moment festhalten. „Verweile doch, du bist so schön", lautet bekanntlich schon Fausts Verabredung mit dem Teufel. Sagt Faust diese Worte, soll der Teufel seine Seele holen. Narzissmus ist eigentlich nicht schlimm, wenn man wie Faust/ Goethe etwas Großes leistet. Größenfantasien sind auch für alle anderen nicht schlimm, wenn es gelingt, sie durch Arbeit zu mäßigen, also auch durch das Schreiben von kleinen Artikeln z. B. über Filme. Birger Dulz nimmt sich und den „Narzissmus von Autoren (andere Menschen schreiben keine Artikel, die sie nicht schreiben müssen)" ja doch nur scheinbar auf die Schippe (Dulz 2008, S. 327).

Narzissmus ist ein weites Feld. Auf der einen Seite gibt es den pathologischen, „selbstsüchtigen" Narzissmus und die narzisstische Persönlichkeitsstörung, auf der anderen den „gesunden" Narzissmus. Im allgemeinen Sprachgebrauch aber hat dieser Begriff noch immer keinen guten Klang. Wirth schreibt dazu (2006, S. 466):

Wenn wir einen Menschen als narzisstisch bezeichnen, werten wir ihn ab und charakterisieren ihn als egoistisch, ichbezogen und in seinen sozialen Beziehungen beeinträchtigt. Narzisstisch gestörte Persönlichkeiten gelten als psychotherapeutisch schwer behandelbar.

Glückt die Behandlung jedoch, so bildet sich nach und nach ein gesunder Narzissmus heraus, der die Voraussetzung zur Aufnahme reifer Objektbeziehungen ist, denn so nennen Psychoanalytiker die Liebe.

Zur Kritik des Films und den Machern

Vergleich mit dem „Original"

Eine typische Kritik des Films findet sich im Lexikon des Internationalen Films (Gerle 2002):

Das Remake des brillanten spanischen Films *Virtual Nightmare – Open Your Eyes* (*Abre los Ojos*) stellt zu sehr die zwischenmenschliche Komponente in den Vordergrund und vernachlässigt das Fantastische sowie die Thriller-Elemente. Dadurch büßt der Film seine verstörende Komponente ein und scheitert an der Verfilmung des weit komplexeren Originaldrehbuchs.

Die „zwischenmenschliche Komponente" ist aber gerade das, was Psychotherapeuten interessiert. Das Original ist zweifellos gut, mir gefällt aber das Remake besser. Es ist anspielungsreicher und komplexer, größer und schöner. Madrid ist eine gute Kulisse, kann aber mit New York einfach nicht mithalten. Schon das Dakota Building löst eine ganze Reihe von Assoziationen zu ihrem Bewohner John Lennon, zu *Rosemaries Baby* von Roman Polański (1968) und *Citizen Kane* von Orson Welles (1941) aus. Den Times Square, noch dazu menschenleer, muss man einfach gesehen haben. Die amerikanischen Schauspieler sind nicht nur eine Klasse besser, sie sind die besten, die man sich für diese Rollen wünschen kann. Penélope Cruz ist in beiden Filmen toll. Im Original ist sie keine Tänzerin, sondern eine Schauspielerin, und sie hat keine Katze, sondern einen Hund. David heißt hier César. Seine Eltern hatten eine Restaurantkette, kein Verlagsimperium. Sie gehörten eher zum oberen Mittelstand als zur Oberschicht. Deshalb gibt es keine Gemäldesammlung, keinen Aufsichtsrat und auch keine Anspielung auf Schneewittchen. Viele gute Szenen und Dialoge des Originals hat Cameron Crowe übernommen. Das mag irritieren. Verstörender fand ich das Original aber nicht. Es kam gleichzeitig mit dem Remake in die deutschen Kinos, was sicher Letzterem zu verdanken war. Ein Thriller-Element, die wahllose Schießerei am Ende, wurde gestrichen. Mir hat es nicht gefehlt. Wenn es nur ein Traum ist, dann kann ich schnell noch ein paar Schüsse abgeben, scheint César in seinem jugendlichen Leichtsinn zu denken. Trotzdem ist das ein sehr bemerkenswerter Film für einen Fünfundzwanzigjährigen.

Amenábar, Regisseur des Originals

Alejandro Amenábar wurde am 31. März 1972 als Sohn eines Chilenen und einer Spanierin in Santiago de Chile geboren. Die Familie zog im August 1973, wenige Wochen vor dem Militärputsch, nach Madrid, wo Amenábar aufwuchs. Er begann ein Studium der Informationswissenschaften, wandte sich aber bald der Filmkunst zu. Sein erster Spielfilm, der Horrorstreifen *Tesis – Der Snuff-Film* (1995) wurde mit sieben Goyas ausgezeichnet. Tom Cruise kaufte die Rechte an Amenábars zweitem Film *Virtual Nightmare – Open Your Eyes* (in diesem Buch besprochen). Als „Gegenleistung" ermöglichte Cruise es ihm, den englischsprachigen Film *The Others* (2001) mit Nicole Kidman in der Hauptrolle zu drehen. Für das 2004 veröffentlichte Drama *Das Meer in mir* gewann Amenábar den Europäischen Filmpreis für die „Beste Regie" sowie den Oscar für den „Besten fremdsprachigen Film" und einen „Golden Globe".

Tom Cruise – Hintergrund und Motivation

Das Interesse von Tom Cruise an diesem Filmstoff könnte biografisch begründet sein. Er wurde am 3. Juli 1962 in Syracuse im Staate New York geboren und wuchs gemeinsam mit drei Schwestern in ärmlichen Verhältnissen auf. Seine Kindheit war geprägt durch ständige Umzüge seiner Eltern. Nach deren Scheidung lebte Cruise bei seiner Mutter und ihrem neuen Ehemann. Bis dahin hatte er bereits über 15 verschiedene Schulen in den USA und Kanada besucht. 1981 gab er in *Endlose Liebe* sein Leinwanddebüt. Seine erste bedeutende Hauptrolle spielte er 1985 in Ridley Scotts Fantasy-Epos *Legende*. Der große Durchbruch gelang Cruise 1986 mit dem Fliegerfilm *Top Gun*, der weltweit mehr als 340 Millionen Dollar einspielte und ihn zum erfolgreichsten Schauspieler seiner Generation machte. 1987 heiratete er die Schauspielerin Mimi Rogers. 1988 war Cruise neben Dustin Hoffman in *Rain Man* zu sehen. Der Film gewann den Oscar in den Kategorien „Bester Film", „Beste Regie", „Bester Hauptdarsteller" (Dustin Hoffman) und „Bestes Originaldrehbuch". Im Jahr darauf erhielt Cruise für seine Darstellung eines Vietnam-Veteranen in *Geboren am 4. Juli* seine erste Oscar-Nominierung und einen „Golden Globe". Am Set zu dem Actionfilm *Tage des Donners* lernte er 1990 Nicole Kidman kennen, die er nach seiner Scheidung von Mimi Rogers heiratete. 1999 spielten Cruise und Kidman die Hauptrollen in *Eyes Wide Shut*. Ein Jahr später erhielt er für seine Mitwirkung in dem Independentfilm *Magnolia* seine dritte Oscar-Nominierung. Im Februar 2001 verkündeten Cruise und Kidman die Trennung. Cruise begann im gleichen Jahr eine Beziehung mit Penélope Cruz. Anfang 2004 trennten sich Cruise und Cruz, seit April 2005 besteht seine Beziehung mit der Schauspielerin Katie Holmes. Beide haben

inzwischen eine gemeinsame Tochter, sie heirateten im Jahre 2006. Tom Cruise ist also zum dritten Mal verheiratet. Seine Mutter ließ sich scheiden, als er zwölf Jahre alt war. Der Filmheld ist elternlos und narzisstisch. So könnte er sich gefühlt haben. Narzissten haben keine Eltern. Mit vierzehn Jahren wollte Cruise katholischer Priester oder Sportler oder Schauspieler werden. Heute ist er eigentlich alles, der sportliche Actionheld, der Charakterdarsteller und der religiös Berufene. Sein Engagement für Scientology stört irgendwie mehr als das von David Lynch. Seit seiner Trennung von Nicole Kidman wirbt er auch unter seinen Fans um Mitglieder für die Bewegung. Er spricht sich auch gegen Medikamente zur Behandlung von Depressionen und ADHS aus. Das kann man pauschal verurteilen, aber auch diskutieren.

Cameron Crowe

Der um 15 Jahre ältere Regisseur Cameron Crowe war von Amenábars Film *Open Your Eyes* so begeistert, dass er unbedingt ein Remake drehen wollte. Er wurde am 13. Juli 1957 in Palm Springs, Kalifornien, geboren, wuchs jedoch in San Diego auf, wo seine Mutter am College als Dozentin für Soziologie und englische Literatur tätig war. Sie erkannte bereits früh das große Potenzial, das in ihrem wissbegierigen Sohn schlummerte, und motivierte ihn fortwährend, sodass er bereits ein Jahr früher eingeschult wurde. Ein weiteres Jahr übersprang Crowe, weil er sich nach einem Schulwechsel in die falsche Klasse setzte und der Irrtum erst auffiel, als er sich bereits zurechtgefunden hatte. Als er danach zur Highschool wechselte, war er deutlich jünger als seine Mitschüler, was ihn inmitten pubertierender Jugendlicher schnell zu einem Außenseiter werden ließ. Als Kompensation für seine mangelnden sozialen Kontakte zu Mitschülern begann Cameron, für die Schülerzeitung zu schreiben. Im Alter von 13 Jahren schrieb er Kritiken über Konzerte von Yes und Black Sabbath für ein Untergrundblatt, auf das ihn seine ältere Schwester Cindy aufmerksam gemacht hatte. 1972 beendete Cameron die Highschool mit 15 Jahren und knüpfte noch im selben Jahr Kontakt zum Herausgeber des „Rolling Stone". Mit 16 Jahren ging er mit den Allman Brothers auf Tour. Seine Erlebnisse finden sich in *Almost Famous* (2000) wieder. Der Spielfilm wirkt wie eine Dokumentation und der Song „Feverdog" der fiktiven Band Stillwater auf dem Soundtrack wirkt absolut authentisch. Ihr Leadsänger (Jason Lee) spielt Brian, den Freund von David, in *Vanilla Sky*. Die Musik für den Film suchten Cameron Crowe und seine Frau Nancy Wilson sehr sorgfältig aus. Wir hören R.E.M., Radiohead, Peter Gabriel, Josh Rouse, Bob Dylan, Led Zeppelin, die Rolling Stones und viele andere. Paul McCartney schrieb den Titelsong und Nancy Wilson steuerte mit „I Fall Apart" auch ein eigenes Lied bei, das Cameron Diaz gesungen und unter dem Namen ihrer Filmrolle veröffentlicht hat. Kurz vor dem Unfall hat sie David stolz ihre CD überreicht. Der Film ist auch eine Hommage an viele Filme, wie *Jules und Jim* von François Truffaut (1962), *Außer Atem* von Jean-Luc Godard (1960), *Wer die Nachtigall stört* von Robert Mulligan (1962) sowie *Sabrina* (1954) und *Ariane – Liebe am Nachmittag* (1957) von Billy Wilder mit Audrey Hepburn. Und das Plattencover für „Freewheelin" von Bob Dylan (1963) war Vorbild für die Kulisse, mit der Davids „Glasklarer Traum" begonnen hat. Da war er noch entstellt, weil er wollte, dass Sofia ihn so lieben könne, weil es das Süße, wie es im Film öfter heißt, eben nur neben dem Sauren geben kann. Das ist so wahr wie banal.

Einige Fragen zu Schluss

„Sterblichkeit als Home-Entertainment, das kann doch nicht die Zukunft sein", ruft Dr. McCabe, um sein virtuelles Leben zu retten. Was kommt aber nach dem Tod? Der Himmel? Das Paradies? Die Wiedergeburt? Oder das Nichts? Jeder glaubt an irgendetwas. David hat der Werbebotschaft der Firma Life Extension geglaubt. Er glaubte an den „Glasklaren Traum" und an eine Zukunft, in der der Chirurgie keine Grenzen mehr gesetzt sind. Er war entstellt und dadurch seelisch schwer traumatisiert. Life Extension gab ihm Hoffnung, als er sich immer mehr zurückzog und sich schließlich das Leben nahm. Sterben ist kein Spaß und schon gar keine Unterhaltung. Der Philosoph sagt, Leben heißt Sterben lernen. Ist das nun der Sinn des Lebens? Oder was soll das ganze Kino? Ich glaube an die prinzipielle

Unsterblichkeit eines Kunstwerks und an den Wert von Erinnerungen, auch wenn die meisten davon natürlich allmählich verblassen. Das ist meine Religion.

Literatur

Dulz BC (2008) Narzissmus und Narzissmus und Narzissmus (zu Citizen Kane). In: Doering S, Möller H (Hrsg) Frankenstein und Belle de Jour. Springer, Heidelberg, S 320–343

Erikson EH (1973) Identität und Lebenszyklus. Suhrkamp, Frankfurt/M (Erstveröff.1959)

Freud S (1919) Totem und Tabu. Gesammelte Werke Bd IX. Fischer, Frankfurt/M

Freud S (1923) „Psychoanalyse" und „Libidotheorie". Gesammelte Werke Bd XIII. Fischer, Frankfurt/M, S 209–233

Gerle J (2002) Lexikon des Internationalen Films, http://www.bs-net.de/kino/film-dienst/fd2002 02/VANILLA_SKY.html?PHPSESSID=69bba5ab4b28533474d48ed17dab4dc0. Zugegriffen am 15. 8. 2011

Heigl-Evers A, Heigl F, Ott J (Hrsg) (1993) Lehrbuch der Psychotherapie, UTB für Wissenschaft Gustav Fischer, Stuttgart

Kohut H (1973) Narzissmus. Suhrkamp, Frankfurt/M (Erstveröff.1971)

Schnitzler A (2007) Traumnovelle. dtv, München (Erstveröff. 1926)

Wirth H-J (2006) Narzissmus, Macht und Ohnmacht. In: Springer A, Gerlach A, Schlösser A-M (Hrsg) Störungen der Persönlichkeit. Psychosozial-Verlag, Gießen

Wohlrab L (Hrsg) (2006) Filme auf der Couch. Psychosozial-Verlag, Gießen

Internetquellen

http://de.wikipedia.org/wiki/Alejandro_Amen%C3%A1bar. Zugegriffen am 26. 8. 2011

http://de.wikipedia.org/wiki/Cameron_Crowe. Zugegriffen am 26. 8. 2011

http://de.wikipedia.org/wiki/Dean_Reed. Zugegriffen am 26. 8. 2011

http://de.wikipedia.org/wiki/Renate_Blume. Zugegriffen am 26. 8. 2011

http://de.wikipedia.org/wiki/Tom_Cruise. Zugegriffen am 26. 8. 2011

http://de.wikipedia.org/wiki/Walt_Disney. Zugegriffen am 26. 8. 2011

Originaltitel	Vanilla Sky
Erscheinungsjahr	2001
Land	USA
Buch	Cameron Crowe, Alejandro Amenábar, Mateo Gil
Regie	Cameron Crowe
Hauptdarsteller	Tom Cruise (David Aames), Penélope Cruz (Sofia Serrano), Cameron Diaz (Julie Gianni), Kurt Russell (Dr. Curtis McCabe), Jason Lee (Brian Shelby), Johnny Galecki (Peter Brown)
Verfügbarkeit	Als DVD in OV und deutscher Sprache erhältlich

Theo Piegler

Blick zurück in die Zukunft

Minority Report – Regie: Steven Spielberg

Filmplakat *Minority Report*
Quelle: Interfoto/Mary Evans

Minority Report

Regie: Steven Spielberg

Handlung

Der Film (◧ Abb. 1) beginnt damit, dass der Zuschauer Zeuge verwirrender Traumbilder wird, die einen Mord ahnen lassen. Es ist die Vision von drei jungen Menschen („Precogs"), die über hellseherische Fähigkeiten verfügen. Eine technisch perfekte Maschinerie ist damit in Gang gesetzt, die nun John Anderton (Tom Cruise) auf den Plan ruft, den Chefinspektor eines in Washington DC seit 6 Jahren laufenden Programms zur präventiven Abwendung von Mordtaten („Precrime"). Auf einem riesigen, mehrteiligen durchsichtigen Bildschirm tauchen die eingangs gezeigten Traumbilder auf. Anderton zieht mit seinen Händen – Handschuhe mit Leuchtquellen an den Fingerspitzen ermöglichen ihm dies – Szenen der holografischen Traumbilder auf einem überdimensionalen Bildschirm hin und her, kombiniert sie neu, holt andere Informationen hinzu und hat nach wenigen Minuten herausgefunden, wo der Mord stattfinden wird. Der Blick fällt in einen benachbarten Raum, an dessen Grund sich ein mit einer Nährlösung gefülltes Becken befindet. In ihm liegen – in weiße Bodysuits gekleidet – die drei eingangs erwähnten jungen Menschen, Agatha (Samantha Morton) und die Zwillinge Dashiell und Arthur, die Köpfe verkabelt, um ihre Traumbilder visualisieren zu können. Kaum hat Anderton den Tatort identifiziert, fliegt er mit der von ihm geleiteten Einsatzgruppe dorthin und kann den Mord – buchstäblich in letzter Minute – verhindern. Der potenzielle Mörder wird verhaftet und es wird ihm eine Kopfschelle angelegt.

Das Ganze spielt sich im Jahr 2054 ab. Der Gründer des Programms ist Lamar Burgess (Max von Sydow). Nun soll sein Programm, da es sehr erfolgreich ist – seit Jahren hat es keine Morde mehr gegeben –, landesweit eingeführt werden. In diesem Kontext soll Danny Witwer (Colin Farrell), Vertreter der Bundesstaatsanwaltschaft und Beauftragter des für das Ganze zuständigen Justizministeriums, das System auf mögliche Fehler überprüfen, sehr zum Leidwesen Andertons, der seinerseits ein glühender Verfechter des Programms ist. Er hat, noch ehe es Precrime gab, seinen kleinen Sohn Sean auf tragische Weise verloren. Beide waren zusammen im Schwimmbad, der Sohn saß am Beckenrand und der Vater machte einen Tauchgang. Als er wieder auftauchte, war sein Sohn spurlos verschwunden. Nachforschungen blieben ergebnislos. Bis heute ist es Anderton nicht gelungen, über den Verlust hinweg zu kommen, zumal ihn seine Frau Lara (Kathryn Morris) nach dem traumatischen Geschehen verlassen hat. In seinem Kummer hat er zu Drogen gegriffen und konsumiert allabendlich „Clearity", zieht sich in seine Fantasiewelt zurück und sieht sich holografische Filme seines Sohnes und seiner Frau an. Von Beruf Polizist, wechselte er, als Precrime eingeführt wurde, sofort dorthin. Sein „Clearity" besorgt sich Anderton abends im unwirtlichen und verwaisten Slum-Viertel der Stadt bei einem heruntergekommenen blinden Junkie.

Rasch erweist sich Witwer als Gegenspieler und Rivale des etwa gleichaltrigen Andertons. Er besteht darauf, in Andertons Begleitung den „Tempel", also den Raum, in dem die Precogs in einer „Photonenmilch", angereichert mit psychotropen Substanzen (Dopamin und Endorphin bei genauer Kontrolle der Serotoninwerte), vor sich hindämmern, aufzusuchen. Als Witwer den Raum wieder verlassen hat, passiert etwas Unerwartetes. Agatha, eben noch unbeweglich in der Flüssigkeit liegend, springt halb aus dem Becken, umklammert den am Beckenrand kauernden Anderton und fragt ihn voller Angst „Kannst du sehen?", dann gleitet sie erschöpft zurück in die Flüssigkeit. Ihre inneren Bilder sind in der Kuppel des Tempels visualisiert: Ein zurückliegender Mord, bei dem eine Frau ertränkt wurde (ihre Mutter, wie sich später herausstellte). Anderton beschließt, der Sache auf den Grund zu gehen und sucht die Justizvollzugsanstalt auf. Dort findet er mit Hilfe des Wächters Gideon (Tim Blake Nelson)

◻ Abb. 2 Tom Cruise (Anderton) in einer Action-Szene. (Quelle: Cinetext Bildarchiv)

nicht nur heraus, dass das Opfer Anne Lively hieß, sondern auch, dass die Aufnahme der Vision von Agatha im Archiv fehlt. Der seinerzeit verhaftete und jetzt in Verwahrung befindliche Täter hatte sich fremde Augen einsetzen lassen, wodurch seine wahre Identität – die in der Zeit, in der der Film spielt, generell durch Iris-Scanning ermittelt wird – unbekannt ist. Gleichzeitig wird er Zeuge der Verwahrung der Fast-Täter. Ihre Zahl ist erschreckend hoch. Die Ungereimtheiten veranlassen ihn, seinen Vorgesetzten und Förderer Burgess aufzusuchen, der einen Hustenanfall bekommt, als er von dieser und anderen fehlenden Visionen Agathas hört. Derweilen durchsucht Witwer Andertons Appartement und findet heraus, dass dieser drogensüchtig ist. Bei seiner Arbeit am nächsten Tag wird Anderton mit sich selbst als künftigem Täter konfrontiert. Die Tat soll 36 Stunden später stattfinden. Das Opfer soll ein gewisser Leo Crow sein, ein Mann, der ihm völlig unbekannt ist. Anderton flieht, trifft auf Witwer und meint, alles sei eine Inszenierung desselben. Er kommt nicht weit, denn die in der ganzen Stadt installierten Iris-Scanner erfassen ihn überall und verraten seinen Aufenthaltsort. Seine Flucht wird zu einem mitreißenden Action-Spektakel in einer hypermodernen Großstadt (◻ Abb. 2).

Es gelingt ihm, den Wohnort von Dr. Iris Hineman (Lois Smith) aufzusuchen, von der er gehört hat, dass sie die Erfinderin von Precrime sei. Um sie zu erreichen, überwindet Anderton die Mauer ihres viktorianischen Anwesens und findet sich in einem verwunschenen Garten Eden wieder, wo er von Schlingpflanzen gefangen wird, denen er sich nur mit Mühe entwinden kann. Schließlich findet er die Gesuchte in ihrem Gewächshaus. Von ihr erfährt er Vieles, was er bisher nicht wusste: Sie erzählt ihm, dass sie 10 Jahre zuvor die Kinder von Süchtigen behandelt hat und in der Genforschung tätig war. Die Mütter hatten eine unreine und frühe Form der psychotropen Droge Neuroin eingenommen; die meisten der Kinder, die alle Hirnschäden aufwiesen, verstarben früh. Nur drei überlebten, waren aber jede Nacht von Albträumen gequält, deren Inhalt Morde waren, die kurze Zeit später auch tatsächlich verübt wurden. Die Fähigkeiten dieser Kinder wurden später für Precrime genutzt. Allerdings stimmten die Voraussagen der drei nicht immer überein: Agatha, die Begabteste, hatte gelegentlich eine an-

dere Vision, einen Minderheitenbericht („Minority Report"), der aber umgehend gelöscht wurde, um die Glaubwürdigkeit des Programms nicht zu gefährden. Selbst die Ermittler erfuhren nie davon. Auf insistierendes Nachfragen erfährt Anderton dann aber doch, dass eine Version des Berichts erhalten ist, gut versteckt an einem sicheren Ort, nämlich in Agathas Gedächtnis. Mit einem innigen Kuss auf seine Lippen endet die skurrile Geschichte. Für Anderton ist nun klar, dass nur Agatha seine Unschuld beweisen kann. Aber wie zu ihr kommen, wenn in der ganzen Stadt nach ihm gesucht wird? Die alte Dame gibt ihm einen bedeutungsvollen Satz mit auf den Weg: „Wenn man das Licht sehen will, muss man die Dunkelheit riskieren". Die nächste Szene zeigt Anderton bei einem dubiosen, in höchstem Maß verschnupften Augenarzt in einer heruntergekommenen Wohnung. Er setzt Anderton ein paar neue Augen ein und schärft ihm ein, dass er den Verband 12 Stunden lang nicht lösen darf, sonst werde er erblinden. Währenddessen sucht Witwer die getrennt lebende Frau Andertons auf, um etwas über dessen Aufenthaltsort zu erfahren.

Anderton schafft es, Hausdurchsuchung und Iris-Scan durch mobile spinnenartige Scanner zu überstehen, sich mittels eines der ihm entnommenen Augäpfel im Tempel von Precrime Zutritt zu verschaffen und Agatha zu entführen. Mit Hilfe ihrer präkognitiven Fähigkeiten gelingt es den beiden, der überall präsenten Polizei zu entkommen. Anderton lässt das Gedächtnis von Agatha bei einem alten Bekannten scannen, doch sie hatte keine andere Vision als die beiden anderen Precogs: Es gibt keinen „Minority Report" für Anderton. Das Schicksal nimmt seinen Lauf. Im Zimmer von Leo Crow, in das er Agatha mitschleppt, findet er Fotos seines Sohnes. Alles deutet drauf hin, dass Crow der Mann ist, der seinen Sohn entführt hat. Anderton richtet seine Waffe auf den vermeintlichen Mörder, doch Agatha wiederholt beschwörend immer wieder die Worte „Du hast die Wahl!" Und tatsächlich hält Anderton inne und erklärt Crow stattdessen für verhaftet. Nun erfährt er, dass Crow von einem Unbekannten dazu erpresst wurde, sich von Anderton töten zu lassen. Als Gegenleistung sollte seine Familie finanziell unterstützt werden. Als Crow erkennt, dass die Situation einen anderen Verlauf nimmt als erwartet, ergreift er Andertons Waffe und tötet sich selbst. Anderton rührt seine Waffe nicht mehr an. Die Polizei findet sie später. Witwer erkennt, dass diese Tat inszeniert war.

In der Folge beschäftigt sich auch Witwer mit dem Mordfall der ertränkten Frau und entdeckt – so wie vor ihm schon Anderton – Ungereimtheiten. Es gibt zwei sehr ähnliche Aufzeichnungen des Mordes, die darauf hinweisen, dass die Precogs nicht nur einen, sondern zwei verschiedene, nahezu identische Morde gesehen haben. Die Bilder der zweiten Tat wurden als „Echo" bewertet, als erneute Wiederholung desselben Ereignisses, und deshalb nicht beachtet. Er erkennt, dass auf diese Weise jemand einen wirklichen Mord begehen kann, ohne dass dieser von Precrime vereitelt wird. Man muss nur vor der eigenen Tat einen ganz ähnlichen Mord begehen lassen. Als Witwer dies Burgess darlegt und dieser erkennt, dass Witwer ihm auf der Spur ist, erschießt er ihn mit Andertons Waffe, die seit der Untersuchung des Falls Leo Crow auf seinem Schreibtisch liegt. Da Agatha sich zu diesem Zeitpunkt nicht im Precrime-Tempel befindet und die beiden anderen Precog allein nicht fähig sind, eine aussagekräftige Vision zu produzieren, muss er nicht befürchten, vom Precrime-Team identifiziert und verhaftet zu werden.

Anderton ist nach den Geschehnissen mit Agatha zu Lara geflohen, die – um die Zusammenhänge nicht wissend – in der Hoffnung auf Hilfe für ihren Mann zwischenzeitlich zu Burgess Kontakt aufgenommen hatte. Agatha erzählt den beiden von sich und ihrer Mutter Anne Lively, der sie nach deren Entzug nicht zurückgegeben wurde. Dann zu John, der nach dem Mörder ihrer Mutter fragt: „Es tut mir leid. Es tut mir leid, John, aber du musst weglaufen, ganz schnell" Und schon sind sie da, die Cops, die Burgess geschickt hat und ihm nun die Kopfschelle umlegen und ihn zu Gideon in die Sicherheitsverwahrung schicken. Seine Frau aber findet durch einen Versprecher von Burgess heraus, dass dieser in die Sache verwickelt sein muss und befreit ihren Mann. Diesem gelingt es mit Hilfe einer neuen Vision von Agatha, Burgess auf seinem triumphalen Fest zur Feier von Precrime den Mord vor einem großen Publikum per Videoübertragung nachzuweisen: Burgess hatte Agathas Mutter ermordet,

weil sie, nachdem sie ihre Drogensucht überwunden hatte, ihre Tochter zurückhaben wollte. Ohne sie hätte es das Projekt jedoch nie gegeben. Der Tathergang war folgendermaßen: Er beauftragte einen Auftragskiller, um Lively aus dem Weg zu schaffen. Nachdem die Precogs den Mord erwartungsgemäß vorhergesehen und Precrime ihn verhindert hatte, beging er kurze Zeit später unter den exakt gleichen Umständen selbst den Mord. Die Bilder seines Mordes wurden von den Ermittlern als Echo der bereits verhinderten Tat betrachtet und deshalb nicht weiter verfolgt.

Anderton hat sich derweilen in Burgess Haus eingeschlichen und beide begegnen sich schließlich auf der Dachterrasse des Gebäudes. Burgess ist bewaffnet, und die Precogs erkennen, dass er Anderton ermorden wird. Da der Entschluss, dies zu tun, sehr spontan ist, bleibt kaum Zeit, die Tat zu verhindern. Die Eingreiftruppe erreicht das Dach zu spät. Burgess, der die Ausweglosigkeit seiner Situation erkannt hat, hat sich da schon selbst gerichtet.

Das Precrime-Projekt wird nun eingestellt. Es wird sichtbar, dass viele der wegen Mordgedanken verhafteten Personen diese Taten wohl nie ausgeführt hätten. Alle in Sicherheitsverwahrung befindlichen Personen werden aus der Haft entlassen. In einer der letzten Szenen des Films sieht man John Anderton mit seiner Frau als glückliches Paar: Sie ist mittlerweile schwanger. Die Precogs müssen nicht länger im Tempel leben, sondern haben eine Bleibe abseits aller Großstadthektik in einer Hütte am Meer gefunden, wo sie, von albtraumhaften Visionen unbehelligt, ihre Ruhe genießen und sich in Bücher vertiefen. Eine untergehende Sonne über dem der Küste vorgelagerten Inselreich beendet den Film.

Hintergrund und Auswirkungen

Der Film beruht auf der gleichnamigen Kurzgeschichte von Philip K. Dick, die dieser bereits 1956 geschrieben hatte. Dick, der unter schwierigen psychosozialen Bedingungen aufgewachsen ist, bewegte sich in seinem Leben zwischen massiver Drogenabhängigkeit und enormer Kreativität als genialer Autor, vorrangig von Science-Fiction-Romanen, zwischen Persönlichkeitsstörung und manifester Paranoia. Sein letztes Werk war das Drehbuch für *Blade Runner*. Als Anfang der 1980er-Jahre die Dreharbeiten für diesen Film begannen, verstarb er 53-jährig. Dicks oben erwähnte Kurzgeschichte fiel Tom Cruise in die Hände, als er gerade seinen langwierigen Dreh bei Kubricks *Eyes Wide Shut* abgeschlossen hatte (1999). Jener Film, ebenso wie diese Geschichte, dreht sich um das Thema „Sehen". Cruise war so begeistert, dass er Spielberg auf den Text aufmerksam machte. Auch Spielberg war von dem Stoff sehr angetan und setzte das Projekt bis zum 19. 7. 2001 um. Am 23. 6. 2002 kam der Film zunächst in den USA in die Kinos. Es heißt, „die Angst, dass Zukunftstechnologien uns unserer persönlichen Freiheiten berauben, habe [Spielberg] zu [dem] Projekt inspiriert" (Dahl 2003, S. 2). Er hatte bei der Platzierung des Films ein feines Gespür. Dieser spielt zwar im Washington DC von 2054, aber sein Inhalt traf genau jene Thematik, die die USA nach der Zerstörung des Mythos der Unverwundbarkeit am 11. September 2001 extrem beschäftigte: Wie kann man das Land vor Verbrechen schützen, und welchen Preis rechtfertigt das? Guantánamo, mit Folter und Freiheitsentzug ohne Gerichtsverhandlung, steht ebenso dafür wie die wenig später von George Bush jun. in fast „paranoider" Weise initiierten, als „heiliger Krieg" bezeichneten Invasionen in Afghanistan und im Irak, die der Zerstörung der „Achse des Bösen" galten. Deren realer Preis war und ist auf amerikanischer Seite der Tod tausender junger Amerikaner, ganz abgesehen von einer alles Vorstellbare übersteigenden Staatsverschuldung. Die Opfer auf der Gegenseite sind noch größer, hier aber nicht Gegenstand der Betrachtung. Spielberg führte seinen Landsleuten vor Augen, wie die USA, einst idealisierend als Symbol für Freiheit auf dieser Welt angesehen, bei Einführung flächendeckender Verbrechensprävention in der Zukunft aussehen könnten. Die zweite Frage, die, am Ende der „decade of brain" von George Bush sen. 1990 ins Leben gerufen, im Rahmen der stürmischen Entwicklung der Neurowissenschaften zunächst nur die Fachleute (Roth 1998), später aber auch breite Bevölkerungskreise bewegte, war jene nach der Willensfreiheit bzw. De-

terminiertheit menschlichen Entscheidens und Handelns. Das dritte Thema der damaligen Zeit kreiste um „Eye-Identity". Während es bei Descartes zu Beginn der Neuzeit noch hieß „Ich denke, also bin ich", titelte Altmeyer (2002) seinen auf die heutige Zeit gemünzten Vortrag bei den Lindauer Psychotherapiewochen treffend „Ich werde gesehen, also bin ich". Im grassierenden medialen Narzissmus unserer Tage, so Altmeyer, komme eine Basisinteraktion der Menschwerdung zum Vorschein, in der sich das Selbst nicht selbstbespiegele wie in Gemälden bis Anfang des letzten Jahrhunderts (von Caravaggio bis Waterhouse), sondern sich im Spiegel des/der Anderen erkenne. In dem hier besprochenen futuristischen Film geschieht diese Rückkopplung technisch-perfekt, maschinell und damit beziehungs- und seelenlos: Eine Projektion unserer Zeit.

Die Resonanz auf den Film spiegelt sich in einer Reihe von Auszeichnungen und einem internationalen Einspielergebnis von 358.372.926 US-Dollar wieder. (Zum Vergleich: Der bisher erfolgreichste Film aller Zeiten, *Avatar* aus dem Jahr 2009, spielte 2.777 Mio. US-Dollar ein (Movie Jones 2011)). In zahlreichen Publikationen beschäftigten sich nicht nur Filmrezensenten mit dem Streifen, sondern auch Psychotherapeuten (z. B. Dahl 2003), Theologen (z. B. Bittarello 2008), Bioethiker (z. B. Krahn et al. 2009), Juristen (z. B. Bond 2006) und Hochschullehrer aus anderen Bereichen (z. B. Mann 2005). Die im Film gezeigten Zukunftstechnologien sollen inspirierende Wirkung gezeigt haben (Wikipedia 2011):

Die britische Homicide Prevention Unit (HPU), eine 2004 (also nach der Entstehung des Films) gegründete Abteilung des Metropolitan Police Service, versucht mithilfe von Persönlichkeitsprofilen potenzielle Gewalttäter zu finden. Seit 2006 wird geplant, so als potenzielle Gewalttäter eingestufte Personen auch unter Umständen präventiv zu verhaften. Bei Nachrichtenmeldungen zu diesem Thema wurde wiederholt auf diesen Film verwiesen. In Washington DC gibt es seit August 2010 ein ähnliches Projekt, um Wiederholungstäter zu prognostizieren.

Konkret ist bekannt, dass die Raytheon Company John Underkoffler, den wissenschaftlichen Berater des Films, angeworben hat. Er wurde damit beauftragt, die im Film gezeigte Technologie für die Verwendung in der Wirklichkeit tauglich zu machen. 2005 stellte die Firma dann eine neue interaktive „gesture technology" vor, die sie für die US-Luftwaffe entwickelt hatte. Diese ermöglicht es, große Datenmengen zu analysieren. Die Sortierung der Daten erfolgt dabei wie im Film auf einem großen Bildschirm, allein mit den Händen (Bond 2006, S. 25).

Psychodynamische Interpretation

Im Äquivalenzmodus

Der erste Satz des Filmes lautet:

 „Du weißt, wie blind ich ohne Brille bin."

Der Ehemann, der dies seiner Frau gegenüber, die er in flagranti ertappt hat, äußert, hat die Fantasie „Du betrügst mich mit einem Liebhaber, ich habe deswegen eine Mordswut auf dich! Ich könnte dich umbringen". Von den Precogs wird dies als „Mit-der-Schere-auf-sie-Losgehen" visualisiert. Wenig später stürzen Cops in die Wohnung und nehmen den Mann in Gewahrsam. Mit anderen Worten: Wie in dem von Fonagy und Target (2006, S. 369 f.) beschriebenen Äquivalenzmodus werden hier Gedanken mit Taten gleichgesetzt: Die Mordswut ist Mord! Die Brille, die dem Mann in diesem Moment fehlt, um klar sehen zu können, was er macht, ist – im übertragenen Sinn – reifere Mentalisierung und analytische Betrachtung. Mit dieser „Brille" ausgestattet, würde er sich nicht nur fragen, was habe ich da

vor, welche Konsequenzen kann das haben, sondern auch, warum geht meine Frau fremd, was läuft in unserer Beziehung schief. Der im Film dargestellte Konkretismus, der entwicklungsgeschichtlich dem Alter des magischen Denkens – vgl. die Visionen der Precogs – und früherer Entwicklungsstufen entspricht, dominiert weite Teile der Handlung. Etwa wenn Anderton die im Halbschlaf gehaltenen Precogs tatsächlich als Teil der Maschinen betrachtet, an die sie angeschlossen sind, nämlich als „Mustererkennungsfilter". Im Äquivalenzmodus ist man davon überzeugt, dass die eigene Überzeugung und die eigene Wahrnehmung die einzig mögliche Wahrheit, eben die Realität sind. Deshalb kann nicht unterschieden werden zwischen dem, was man (konkretistisch) sieht und dem, was etwas möglicherweise ist. Anders herum ausgedrückt: Dann ist nichts, was es scheint. Und so werden auch wir Zuschauer in die Irre geführt, indem wir mittels unserer Spiegelneurone die Perspektive der Filmfiguren übernehmen: Burgess erscheint als väterlicher Freund und Förderer von Anderton, in Wirklichkeit aber hat er sich aus opportunistischen Gründen einen manipulierbaren, weil erpressbaren Drogensüchtigen in sein Programm geholt. Er ruft Precrime ins Leben, ein Präventionsprogramm gegen Mord, und ist selbst ein Mörder. Gideon wird als Orgelspieler eingeführt und schon im nächsten Moment – nämlich als sich der Stuhl wie in Hitchcocks *Psycho* gedreht hat – ist er der Wächter einer Totenwelt. Der Drogenhändler, der „Clearity", also ein Klarheit verheißendes Mittel verkauft, nimmt seine Sonnenbrille ab und ist nun ein Blinder mit leeren Augenhöhlen. Crow, der als Mörder von Sean erscheint, entpuppt sich als bestochener Häftling. Der gehörnte Ehemann wird zum Mörder erklärt, und Sean, der eben noch mit seinem Vater im Wasser war, ist plötzlich wie vom Erdboden verschluckt. Der Äquivalenzmodus, der Nicht-einfühlen- und Nicht-die-Perspektive-wechseln-Können bedeutet, führt im Film wie beim Zuschauer zu einem Gefühl von Spaltung, ja Fragmentierung. Dieses Filmerleben von drohender Fragmentierung lässt sich bis in diese Filminterpretation hinein verfolgen, wo unter den Überschriften „Im Äquivalenzmodus", „Sehen", „Alter Ego" usw. psychodynamisch bedeutsame Aspekte des Films nacheinander abgehandelt werden, so, als würden sie nebeneinander stehen und nicht aufs engste miteinander verwoben sein.

Sehen

Schon in den ersten Einstellungen des Films geht es um das Sehorgan, also das Auge, das durchstochene von Abraham Lincoln, das Auge der in der Vision der Precogs erstochenen Ehebrecherin und jenes des Precogs Agatha. In konkretistischer Weise spielen auch im weiteren Verlauf leere Augenhöhlen, ausgetauschte Augen und gescannte Augen eine zentrale Rolle. Und zwar bis hin zu den Namen: Nicht zufällig trägt Dr. Hineman den Vornamen Iris. Diesem Konkretismus entspricht auf der Symbolebene das Sehen, das ganz genaue Hinsehen (wie bei der Entlarvung des Mörders von Anne Lively), das Gesehen-Werden (durch die überall installierten sowie die mobilen Iris-Scanner), das Nicht-Sehen bzw. Augenverschließen (etwa Andertons beim Verschwinden seines Sohnes) und das Hellsehen (der Precogs), zuletzt aber auch das Zurückblicken (in alte Bücher, in denen die Precogs am Ende des Filmes lesen).

Jede Beziehung entsteht über das Sehen, jene des Säuglings zur Mutter und vice versa, ebenso wie die von Menschen, die sich verlieben. Der Glanz im Auge der Mutter ist für das Kind von entscheidender Bedeutung, ebenso wie ihre markierte Spiegelung, und umgekehrt das Juchzen und die lachenden Augen des Babies, welche das Band der Mutter zu ihm zur tragfähigen Beziehung schmieden. Wir bewegen uns also in einer entwicklungsgeschichtlich frühen Welt, in welcher aus dem nicht authentischen Gesehen-Werden narzisstische Phänomene und Paranoia resultieren. Als Anderton durch eine Einkaufspassage geht, wird er überall über Lautsprecher freundlich und ganz persönlich mit seinem Namen angesprochen, den Iris-Scanner zuvor identifiziert haben. Jeder ist überall und jederzeit technisch zu orten, was ein paranoides Klima erzeugt. Eine kalte, beziehungslose Welt, was durch die Farbgebung im Film noch unterstrichen wird. Es ist der basale emotionale Mangel, der Anderton bei seiner Arbeit in narzisstischer Kompensation zum Prothesengott (Freud 1930, 450 f.) werden lässt, welcher wie ein Stardirigent vor überdimensionalen Bildschirmen zum Herrn über Leben und Tod (bzw. lebenslange

Dauerverwahrung) wird. Aber wie von Frühstörungen bestens bekannt, ist er gespalten: Tagsüber der Chief, in der Dunkelheit der Nacht aber der kleine Drogenabhängige. Die Spaltung betrifft nicht nur Anderton, sondern alle Bewohner Washingtons: Es gibt die Guten, die keine Verbrechen zu begehen scheinen und leben dürfen und die Bösen, die potenziellen Mörder, die lebenslang inhaftiert werden. Precrime verheißt, das Böse aus der Welt eliminieren zu können. Eine fatale Größenfantasie.

Alter Ego

Witwer, hochrangiger Vertreter der Bundesstaatsanwaltschaft, ist Andertons Alter Ego. Während Witwer als 15-jähriger seinen Vater durch ein Verbrechen verlor, wurde Andertons Sohn als 6-Jähriger Opfer eines Verbrechens. Während Anderton an die Unfehlbarkeit des Programms glaubt, ist Witwer davon überzeugt, dass jedes Programm, an dem Menschen beteiligt sind, fehlbar ist. Während Anderton in Agatha eine Sache sieht, ist sie für Witwer ein geradezu heiliges Wesen. Der eine wird zum Jäger, der andere zum Gejagten; der eine überlebt, der andere stirbt. Beide machen eine Wandlung durch, sodass sie sich im Laufe des Filmgeschehens näher kommen, indem sie beide versuchen, den Mordfall Liveley aufzuklären und damit den Schlüssel des ganzen Mysteriums zu finden. Witwer, der natürlich auch Rivale ist, verkörpert letztendlich Andertons Gewissen, seinen Realitätssinn und seine Menschlichkeit. In dem Maß, in welchem Anderton all dies im Lauf seiner Selbstentwicklung integrieren kann, wird Witwer überflüssig.

Mütter

Bleibt die Frage, wie es zu einer derartigen, von Narzissmus, Paranoia und Spaltung geprägten Welt kommen konnte und damit die Frage, wo sind in diesem Film Mutterfiguren, die behüten und beschützen, die Holding- und Containing-Funktionen bereitstellen, sich als Selbstobjekte anbieten und in deren Augen sich der Blick des Kindes spiegeln kann? Urmutter Iris Hineman hat sich der Kinder drogensüchtiger Mütter bemächtigt und diese dann ebenso wie das Precrime-Projekt im Stich gelassen. Wie grenz- und generationsüberschreitend sie ist, zeigt ihr inniger Kuss auf Andertons Mund. Kein Wunder, dass sie mit den Attributen einer verschlingenden Mutter ausgestattet ist. Die erste Mutter, die im Film zu sehen ist und zum Opfer ihres Mannes werden soll, ist beim Frühstück nur funktional für ihren Lincoln rezitierenden Sohn da, in ihren Gedanken aber liegt sie längst in den Armen ihres Liebhabers. Der junge Mann, der die Precogs – sie sind noch halbe Kinder –, versorgt, hat mit dieser Aufgabe zwar mütterliche Aufgaben übernommen, aber auch er ist nicht in der Lage, ihnen wirklich das zu geben, was sie brauchen, nämlich Liebe und Förderung ihrer Entwicklung. Anderton selbst „missbraucht" anfangs Agatha, die sich so voller Hoffnung an ihn klammert und ihm vertraut. Er hat zunächst nichts anderes im Sinn, als seinen eigenen Kopf zu retten. Erst im Lauf seiner eigenen Entwicklung beginnt er sie mehr und mehr zu „beeltern". Bleibt schließlich noch Lara, die ihren Sohn Sean sehr geliebt zu haben scheint, von der wir aber nicht wissen, wie sie mit ihm umgegangen ist. Sie setzt sich stark für ihren Mann ein und genießt es offensichtlich, schwanger zu sein, aber wie wird sie mit dem künftigen Kind umgehen, wird es ein Ersatzkind werden, ein Sean II.?

Ödipales oder: Über Väter und Söhne

Nach den Müttern soll es jetzt um die Rolle der Väter und Söhne gehen, im Film in vielfältiger Weise eng verbunden mit ödipalen Elementen, wenn es dort auch keinen Inzest à la Ödipus/Jokaste gibt. Der Vater von Ödipus, König Laios, war selbst ein Verbrecher – er hat den jüngsten Sohn von König Pelops, Chrysippos, entführt und vergewaltigt, woraufhin sich dieser selbst umgebracht hat –, und versucht, den vom Orakel vorausgesagten Mord (an seiner Person) dadurch zu verhindern, dass er seinen Sohn (den prognostizierten Mörder) als Kind aussetzt. In der Diktion des Films ist es die Vaterfigur Burgess – er hat das Schutzprogramm Precrime für seine Landeskinder ins Leben gerufen und ist Anderton lange Zeit Förderer und väterlicher Freund –, der zu Beginn des Precrime-Programms die Mutter des

Precogs Agatha ermordet, um diese für das Programm gebrauchen/missbrauchen zu können. Burgess setzt seinerseits potenzielle Mörder – auch seiner Person – zwar nicht aus (wohin auch?), dafür aber lässt er sie ohne Anhörung und ohne Gerichtsurteil in unmenschliche Sicherheitsverwahrung bringen. In das ödipale Thema wird schon mit der initial im Film wiedergegebenen Vision eingeführt: Hier wird mit einer Schere auf einem Foto das rechte Auge von Abraham Lincoln, Vertreter eines demokratischen und unabhängigen Amerika, durchstochen. Wenig später wird die Szene mit der berühmten „Gettysburg Address" des Präsidenten vom 19. 11. 1863 skandiert, die der Sohn jenes Paares, das in der Vision gezeigt wurde, für den Schulunterricht rezitiert. Diese Rede beschwört Freiheit und Demokratie in einer Zeit, in der der amerikanische Bürgerkrieg Abertausende hinweg gerafft hat. Im Film ist von der horrend steigenden Zahl an Morden vor Einführung von Precrime die Rede. Weitere Anspielungen auf den Ödipus-Mythos durchziehen den Film: Die Precogs repräsentieren so etwas wie das Orakel in Delphi – manche sehen in ihnen auch die Dreifaltigkeit verkörpert – und nicht zufällig wird im Film das runde Bad, in dem sie wie Embryonen im Fruchtwasser ruhen, von einem hohen Gewölbe überdacht, als „Tempel" bezeichnet, in dem kein lautes Wort fallen darf, um ihren gleichsam göttlich-visionären Schlaf nicht zu stören. Der Tempel ist in sich geschlossen wie eine Gebärmutter und der Abfluss des Bades wird an späterer Stelle zum Geburtskanal, durch den John und Agatha ins reale Leben entlassen werden.

Als Ödipus schon König in Theben war, sollte er, dem Orakel folgend, die Stadt von der Pest befreien. Anderton ist der, der Washington DC von Mördern befreien soll. Er meistert das bei Schuberts Unvollendeter (Sinfonie in h-Moll, D 759) vortrefflich. Gottgleich zaubert er holografische Bilder aus Vergangenheit, Gegenwart und Zukunft und dirigiert so das Leben der Menschen, wie es scheint, zum Besten. Aber wer genau hinhört, vernimmt Klänge auch aus Tschaikowskis Schwanensee, einer Geschichte also, in der das zu spät bemerkte Nicht-unterscheiden-Können zwischen Wahrheit und Unwahrheit schicksalhafte Folgen zeitigt.

Beim Joggen zum obdachlosen Drogendealer in den Slums von Washington kommt Anderton mit einer anderen Seite von Existenz/seiner Existenz in Berührung. Hier ist er der Kleine, Abhängige, Bedürftige. Er fragt sich, was jener von ihm weiß. Bedeutungsvoll und mit theatralischer Geste verkündet der Dealer:

> 💬 „Na ja, mein Daddy hat immer gesagt: Unter den Blinden ist der Einäugige nun mal König".

Dabei nimmt er seine Sonnenbrille ab und man sieht in seine leeren Augenhöhlen. Hier ist jeder Iris-Scanner machtlos. Man kann den Satz des Dealers so verstehen, dass Anderton zwar nicht wie die Precogs Morde vorhersehen kann, aber immerhin die Macht hat, ihre Visionen zu dechiffrieren, also sozusagen mit einem Auge sieht, im Gegensatz zu allen anderen Bürgern Washingtons, die in dieser Hinsicht blind sind. Es könnte aber auch des Dealers eigener Blick nach Innen gemeint sein. Mit ihm nimmt er offensichtlich mehr wahr als Anderton. Dessen Augen sind – im übertragenen Sinn – noch nicht geöffnet, er vertraut noch blind auf Precrime. Sein Leben besteht für ihn nur aus Precrime, er ist mit seiner Arbeit verheiratet, wie man so sagt. Er hat so wenig Ahnung von der Wahrheit wie der jung vermählte König Ödipus in Theben.

Als Anderton selbst von den Precogs als Mann, der in naher Zukunft morden wird, identifiziert wird, verneint er das mit derselben Entschiedenheit, mit welcher dies Ödipus tut, dem der Seher Teiresias den Mord am Vater enthüllt. Beide können sich weder vorstellen, noch können sie glauben, was sie da hören. Sie verwahren sich entschieden dagegen. Freilich holen die Fakten beide rasch ein.

Mit Dr. Iris Hineman kommt es zu einem Wendepunkt. Die verschrobene alte Dame in ihrem Garten Eden, in dem giftige Schlingpflanzen mit ihren Krakenarmen nach Anderton greifen und fleischfressende Pflanzen sich ihm entgegenstrecken, ist, wie bereits dargestellt, eine verschlingende Mutter.

Aber sie erinnert auch an die Sphinx, die Reisenden auf einem Fels vor den Toren Thebens auflauerte und alle, die ihr Rätsel nicht lösen konnten, verschlang. Dem, der es lösen könnte, versprach König Kreon nicht nur den Thron von Theben, sondern auch noch seine Schwester Jokaste zur Frau. Im Film ist die Geschichte verdreht: Hier ist es Anderton, der von Iris Hineman Geheimnisse aus der Gründungsphase von Precrime erfährt und zum ersten Mal davon hört, dass das System nicht unfehlbar ist, sondern es zu unterschiedlichen Berichten kommen kann, die aber als „Minority Reports" sofort vernichtet werden, um den Schein der Unfehlbarkeit aufrecht zu erhalten. Hier kommt ihm auch ein Teil von Agathas tragischer Lebensgeschichte zu Ohren. Der innige Kuss von Dr. Hineman auf die Lippen des jungen Mannes ist eine Anspielung auf inzestuöse Wünsche. Warum auch hätte sie ihm sonst ein Serum einflößen und damit sein Leben retten sollen, warum hätte sie für ihn so viel enträtseln sollen, wenn sie sich von ihm nicht sehr angezogen gefühlt hätte? Sie rät ihm mehr oder weniger dazu, Agatha zu entführen, um in den Besitz eines (eventuellen) „Minority Reports" zu kommen. Nur jene trage ihn in sich. Es fällt auf, dass es in erster Linie Frauen – Agatha, Iris Hineman und Johns Frau Lara – sind, die Andertons Entwicklung wesentlich vorantreiben. Sind es die Frauen, die in einer von Männern (fast) gegen die Wand gefahrenen Hochleistungsgesellschaft insgeheim zu Hoffnungsträgern hochstilisiert werden?

Verlust und Trauer

Wie im Märchen hat Anderton, will er seinen Häschern entkommen (und in seiner Entwicklung vorankommen), nun die nächste Hürde zu nehmen. Er hat keine andere Wahl, als seine eigenen Augen gegen fremde zu tauschen. Die Entscheidung zu diesem gravierenden Schritt setzt die Auseinandersetzung mit dem Verlust eines Teiles von ihm ebenso voraus wie das Inbetrachtziehen dauerhafter Erblindung, die er von seinem Dealer kennt. Er schafft es, die Kontrolle aufzugeben und sich einem zwielichtigen Chirurgen anzuvertrauen, der ihm einschärft, dass er den Augenverband 12 Stunden nicht entfernen darf. Das bedeutet 12 Stunden gänzlicher Blindheit und kann natürlich wiederum im ödipalen Sinn als Ausdruck temporärer Blendung und Veränderung der Blickrichtung verstanden werden. Er wird nach Abnehmen des Verbandes alles mit anderen Augen sehen als zuvor. Wie bei einer Puppe im Kokon vollzieht sich in der Zeit seiner Blindheit eine Metamorphose. Vor seinem inneren Auge erlebt er noch einmal den Verlust seines Sohnes, diesmal allerdings affektiv höchst beteiligt. Voll Schmerz und Verzweiflung schreit er nach ihm. Dieses Erleben unterscheidet sich deutlich von jenem am Feierabend. Da ging es ihm darum seinen Sohn wieder zu beleben, ihn wieder erstehen zu lassen, was ihm mittels Drogen und Holografien gelang. So konnte er den Schmerz des Verlustes abwehren. Seine Frau war ihm keine Hilfe, denn sie sah in ihrem Mann gleichzeitig auch immer ein Stück ihres Sohnes, ja roch ihn, wenn sie ihm nahe kam. Das war so unerträglich für sie, dass sie ihn aufgab. Sie war also selbst auch zu schwach, um den Verlust bewältigen zu können. Andertons Abwehr war dabei eine doppelte: In seiner täglichen Arbeit mutierte er – gleichsam in Identifikation mit dem Aggressor – zum Mörderjäger, was ihn immun machte gegen den Schmerz der Opfer. So ist denn auch Agatha für ihn zunächst kein richtiger Mensch, nicht mehr als ein „Mustererkennungsfilter".

Warum es für Anderton – bis zum Verlust seiner eigenen Augen – so gänzlich unmöglich war, das Verschwinden seines Sohnes zu verarbeiten, ist eine bedeutsame Frage. Es fällt auf, dass sowohl der holografische Film von Sean als auch die Erinnerung an sein Verschwinden an Vater-Sohn-Interaktionen gebunden sind, bei welchen es um Leistung geht: Einmal um möglichst schnelles Laufen, dann um das längste Tauchmanöver. Sieht so väterliche Spieleinfühligkeit aus oder spiegelt sich hier nicht Kindheit in einer extremen Leistungsgesellschaft? Geht es also vielleicht gar nicht nur/so sehr um den verlorenen Sean als vielmehr die eigene „verlorene", nie gehabte Kindheit, nach der Anderton trachtet? Ist er möglicherweise ebenso um seine Kindheit betrogen worden wie die Precogs?

Entwicklungslinien

Im weiteren Verlauf des Filmes entführt Anderton Agatha, wobei er mit ihr in einem Strudel durch das Abflussrohr des Tempelbades wie in einem Geburtsakt in die Freiheit gelangt. Die Augen sind ihm nun schon weitgehend geöffnet. Bereits in der Justizvollzugsanstalt war er mit der Unterbringung potenzieller Mörder konfrontiert worden. Ich möchte auf diese eindrucksvolle Szene zurückkommen: Im Gefängnis trifft er auf den dort tätigen, an einen Rollstuhl gefesselten Wärter, Gideon, der ins Orgelspiel vertieft ist. Die Anspielung auf die Gestalt des israelitischen Richters Gideon ist offensichtlich. Auch an späterer Stelle, als Anderton selbst eingeliefert wird und jener bemerkt:

🗨 „Nun bist du auch ein Teil meiner Herde, John."

Der Gideon aus dem biblischen Buch der Richter hatte die Israeliten mit göttlicher Hilfe von den Midianitern befreit, in einer nächtlichen Aktion mit brennenden Fackeln und Trompeten. Wenn man im Film die Gefangenen mit ihren Kopfschellen sieht, dann wirken sie einerseits wie ein Heer von Heiligen, von leuchtenden Fackeln, andererseits erinnert ihr Eingesperrtsein in Glasröhren, wo sie in einem komaähnlichen Zustand, übereinander gestapelt, untergebracht sind, an die neun Höllenkreise in Dantes „Göttlicher Komödie". Gideon ist Herr dieses „Totenreichs". Ambiguität spiegelt sich hier wie in der biblischen Person des Gideon wider, der einerseits die Israeliten befreit, sie aber vom wiedererstehenden Baal-Kult auch nicht abhält. Beim prophezeiten Mord am vermeintlichen Entführer seines Sohnes taucht in anderem Kontext ein Bild der Ambitendenz auf: Wie in Bergmans Film *Persona* bilden die in entgegengesetzte Richtungen blickenden Köpfe von Anderton und Agatha einen Januskopf: Crow töten oder nicht töten. Agatha beschwört Anderton immer wieder verzweifelt, dass er einen freien Willen habe, und er schießt nicht. Damit hat er seine innere Freiheit ganz gewonnen. Nun kann er frei denken und handeln. Er und sein Alter Ego Witwer entlarven den Mörder von Agathas Mutter, die nach erfolgreichem Drogenentzug ihre Tochter wiederhaben wollte, dies aber mit dem Leben bezahlen muss. So steht am Beginn von Precrime ein Mord. Es kommt zur Vater-Sohn-Tragödie. Burgess tötet in Witwer das Alter Ego seines Ziehsohnes Anderton. Dieser aber stellt Burgess auf dem Höhepunkt seines Erfolges so bloß, dass jener in seiner Beschämung keine andere Möglichkeit mehr für sich sieht, als sich zu töten. Der Sohn hat so den skrupellosen und betrügerischen „Vater" zur Strecke gebracht. Ein letztes ödipales Element sozusagen. Triumphal sieht man den Sohn auf der Dachterrasse vor dem Hintergrund des hell sich in den nächtlichen Himmel reckenden Washington Memorials (Phallus-Symbol). Auch Precrime ist damit gestorben und die Gesellschaft von ubiquitärer Überwachung befreit. Die paranoide Position ist überwunden. Konsequenter Weise ist Anderton nun fähig, verantwortungsvoll seine Rolle als Vater zu übernehmen. In einer der letzten Einstellungen sieht man ein glückliches Paar: ihn und seine schwangere Frau Lara. Man muss an Noah und seine Frau Naama denken, die nach unendlich vielen Regenfällen (wie im Film) die Arche verlassen und ein neues Leben beginnen. Die Precogs müssen nicht mehr im Halbschlaf des Tempels vor sich hin dämmern, sondern auch sie sind befreit und man sieht sie in einem Haus inmitten einer unberührten Natur. Manchem Kritiker schien dieses Filmende zu idyllisch und verklärt, geradezu kitschig, gemäß dem Motto: „Früher, in der präindustriellen Zeit, war alles viel besser." Ich möchte dem widersprechen.

Blick zurück in die Zukunft

Im Precrime-Projekt wird versucht, die Zeit auf die Zukunft auszudehnen, diese vorhersagbar zu machen und auf diese Weise, ebenso wie mit den allgegenwärtigen Uhren, die Zeit unter Kontrolle zu bringen und beherrschbar zu machen. In unserer heutigen Vorstellung verbinden wir Zukunft – dieses Wort hat erst zu Beginn der Neuzeit seine temporale Bedeutung bekommen! – mit etwas, was vor uns liegt. Wir sehen sie als etwas an, wo wir uns aktiv hinbewegen (müssen). Fortschritt bedeutet für uns heute also, uns nach vorne gerichtet auf die Zukunft einzustellen. Aber unsere Sprache, die sich lange vor

dem Zeitalter von Moderne und Postmoderne entwickelt hat, verrät uns, dass wir damit den eigentlichen Richtungspfeil der Zeit – etwa mit Beginn der Moderne – verdreht haben (Gutknecht 2000). Denn es ist ja nicht so, dass wir aktiv in die Zukunft gehen, sondern umgekehrt, die Zukunft kommt auf uns zu! Schon das Wort „Zu-kunft" macht deutlich, dass sie das „Auf-uns-Zukommende", das „Herankommende" ist. Dem entspricht, dass wir von unseren Vor-fahren sprechen, von uns aber – je nach Kontext – als den Gegenwärtigen oder Nach-fahren oder Hinter-bliebenen. Hier wird die Umkehrung des Zeitverständnisses eindrucksvoll deutlich. Wollte man sich an der Zukunft orientieren, sähe man in eine Black Box, man sieht nichts außer eigenen Fantasien und Projektionen eigener Ängste und Hoffnungen. Die Alten wussten um den wahren Richtungssinn der Zeit und orientierten sich dementsprechend an der Vergangenheit. Seneca ist ein gutes Beispiel dafür. Er verweist darauf, dass die Menschen, die sich mit der Vergangenheit beschäftigen, gut für sich sorgen und vor-sorgen, denn sie hätten nicht nur den Erfahrungsschatz ihres eigenen Lebens, sondern auch noch die ganze Ewigkeit dazu (Seneca 2010, S. 33):

> Alle Jahre, die vergingen, bevor sie auf die Welt kamen, gehören ihnen … Von keinem Jahrhundert sind wir ausgeschlossen … Debattieren darf man mit Sokrates, in Frage stellen mit Karneades, mit Epikur ein ruhiges Leben führen, Menschenlos mit den Stoikern überwinden, mit den Kynikern Grenzen überschreiten.

Mit diesem Wissensschatz ist es möglich (auch) künftige Entwicklungen zu extrapolieren. Mit anderen Worten: allein aus der Vergangenheit kann man etwas über die Zukunft erfahren. Und so sehen wir die Precogs am Ende des Films nicht mehr als hellsehende verkoppelte Mensch-Maschinen-Wesen, die die Zukunft ja nur scheinbar sicher vorhersehen können, sondern als drei junge Leute, die sich in Bücher vertiefen – übrigens die ersten im Film – und aus diesem unermesslich reichen Fundus der Menschheit schöpfen. Allein solches Studium ermöglicht es, künftige Entwicklungen einigermaßen sicher zu prognostizieren und so auch Gefahren abzuwenden.

Abschließende Gedanken

Abschließend will ich versuchen, die Fäden zusammenzuführen: Auf der Realebene wurde der Film am Vorabend des 11. Septembers gedreht. Auf nicht weit entfernte Zukunft verschoben, spiegeln sich im Film im Grunde aktuelle Gegebenheiten – nämlich existenzielle Verunsicherung und der Umgang damit – wider. In Anlehnung an Freuds Kulturtheorie, die besagt, dass jeder Fortschritt der Zivilisation mit einem Zuwachs an Repression erkauft werde, das Verdrängte aber zur Wiederkehr dränge, könnte man sagen, dass die im Film gezeigte Zukunftsgesellschaft zwar keine aggressiven Triebdurchbrüche und auch kaum noch Sexualität kennt, der Preis dafür aber massive, ja kriminelle Beschneidung von persönlicher Freiheit ist. Die gezeigte mediale Gesellschaft ist durch Denken und Handeln im Äquivalenzmodus gekennzeichnet, es finden sich narzisstische Versatzstücke ebenso wie ödipale, so, wie ich das oben beschrieben habe. Sie mag im Sinne Sennetts (1998) flexibel sein, aber sie ist strukturschwach, was die Selbststruktur ihrer Individuen betrifft. Immer wieder stößt man bei den Figuren des Films auf die Folgen einer nicht hinreichend guten Beelterung. Durch allgegenwärtige Überwachung wird das paranoide Klima noch verstärkt. Massive, abgespaltene, oft noch gar nicht benennbare Affekte führen zum Ausagieren des früh Erlittenen oder in Freud'scher Diktion zur Wiederkehr des „Verdrängten". Am Beispiel des Protagonisten Anderton wird das, was ich hier als Phänomen dieser Zukunftsgesellschaft beschrieben habe, individuell und in Thriller-Action-Form abgehandelt. Letzteres mag notwendig sein in unserer Gesellschaft, deren Leben und Arbeit immer gleichförmiger und langweiliger wird. Der Thrill wird im Kino gesucht und von der Filmindustrie aus nahe liegenden Gründen gerne bedient.

Gleichwohl durchläuft Anderton einen Entwicklungsprozess, der ihm die Augen öffnet, zu reflexivem Denken verhilft und ihm freie Entscheidungen ermöglicht. Die Eliminierung des Bösen kann

nie gelingen. Das kann auch nicht der zentrale Punkt sein. Es geht vielmehr um den Zugang zu den eigenen Gefühlen, Gedanken und Motivationen sowie Einfühlung in die Gefühle und das Denken anderer Menschen. Die paranoide Position nach Melanie Klein scheint im Film erfolgreich gemeistert zu sein und Anderton scheint in der depressiven Position angekommen zu sein. Ob wirklich dauerhaft, das wird sich zeigen. Viele Fragen bleiben offen, so wie auch die Frage, wie unsere Gesellschaft 2054 wirklich aussehen wird. Was wir im Film sehen, das ist nur Ausdruck unserer heutigen Verunsicherung, unserer Ängste, Hoffnungen und Erwartungen und unser fantasierter Umgang damit. Die psychologische Dimension ist dabei nichts Neues. Deshalb sollten wir am Ende vielleicht wie die Precogs die alten diesbezüglichen Bücher (wieder) hervorholen, denn dort lässt sich längst vorhandenes Menschheitswissen nachlesen.

Literatur

Altmeyer M (2002) Video(r) ergo sum! (Ich werde gesehen, also bin ich). Vortrag, 15. April 2002, im Rahmen der 52. Lindauer Psychotherapiewochen. http://www.lptw.de/archiv/vortrag/2002/altmeyer_martin.pdf. Zugegriffen am 24. 11. 2011

Bittarello MB (2008) Shifting realities? Changing concepts of religion and the body in popular culture and neopaganism. J Contemp Relig 23: 215–232

Bond C (2006) Law as cinematic apparatus: Image, textuality, and representational anxiety in Spielberg's Minority Report. Cumb L Rev 37:1–42

Dahl G (2003) Vom Mythos der Unverwundbarkeit – das aktuelle paranoide Szenario im Film. In: Fitzek H, Ley M (Hrsg): Zwischenschritte: Alltag im Aufbruch. Psychosozial, Gießen

Fonagy P, Target M (2006) Psychoanalyse und die Psychopathologie der Entwicklung. Klett-Cotta, Stuttgart

Freud S (1930) Das Unbehagen in der Kultur. In: GW Bd XIV. Fischer, Frankfurt/M, S 421–506

Gutknecht T (2000) Alles hat seine Zeit – auch die Zeit. Zur Entstehung des modernen Zeitbewusstseins. Unveröff. Vortrag Kunstverein Neu-Ulm 5. 7. 2000. http://www.praxis-logos.de/main/texte/zeit.pdf. Zugegriffen am 16. 7. 2010

Krahn T, Fenton A, Meynell L (2010) Novel neurotechnologies in film – a reading of Steven Spielberg's Minority Report. Neuroethics 3: 73–88

Mann, Karen (2005) Lost boys and girls in Spielberg's Minority Report. Journal of Narrative Theory 35: 196–217

Movie Jones Box Office – Die erfolgreichsten Kinofilme aller Zeiten (weltweit) http://www.moviejones.de/charts/boxoffice-alltime-weltweit-seite-1.html. Zugegriffen am 24. 11. 2011

Roth G (1998) Ist Willensfreiheit eine Illusion? Biol unserer Zeit 28: 6–15

Seneca (2003) Die Kürze des Lebens. Übersetzt u. herausgegeben von Gerhard Fink. Patmos, Düsseldorf

Sennett R (1998) Der flexible Mensch. Die Kultur des neuen Kapitalismus. Berlin-Verlag, Berlin

Wikipedia (2011) Minority report. http://de.wikipedia.org/wiki/Minority_Report. Zugegriffen am 24. 11. 2011

Originaltitel	Minority Report
Erscheinungsjahr	2002
Land	USA
Buch	Scott Frank und Jon Cohen
Regie	Steven Spielberg
Hauptdarsteller	Tom Cruise (Chief John Anderton), Colin Farrell (Detective Danny Witwer), Samantha Morton (Agatha), Max von Sydow (Director Lamar Burgess), Kathryn Morris (Lara Anderton), Tim Blake Nelson (Gideon), Lois Smith (Dr. Iris Hineman)
Verfügbarkeit	Als DVD in OV und deutscher Sprache erhältlich

Helmut Däuker

Trojaner im Ich

A Scanner Darkly – Regie: Richard Linklater

Filmplakat *A Scanner Darkly*
Quelle: Warner Bros./Cinetext

A Scanner Darkly

Regie: Richard Linklater

Die Handlung

Wir befinden uns in einer nicht allzu fernen Zukunft, Ort der Handlung ist Kalifornien (◘ Abb. 1). Es gibt offensichtlich massive gesellschaftliche Probleme, die Vereinigten Staaten haben sich in Richtung eines Überwachungsstaates entwickelt, wachsende Teile der Bevölkerung verfallen einem ausufernden Drogenkonsum, alles Zwischenmenschliche scheint durch ein paranoides Klima vergiftet zu sein. Der staatlichen Überwachung zumindest partiell entzogen operiert die Organisation „Der neue Pfad" im Drogenmilieu, fahndet nach operativen Strukturen der Drogenproduktion und des Handels, veranstaltet Aufklärungsvorträge und bietet Entziehungskuren an. Die Droge selbst wird als „Substanz T" („Substance D") bezeichnet, steht also für Tod (Death), aber auch für Trostlosigkeit, Verzweiflung, Entfremdung von sich selbst, von anderen, jeder von jedem, für Isolation, Hass und Misstrauen. Robert „Bob" Arctor (◘ Abb. 2) arbeitet bei dieser Organisation als Agent unter dem Decknamen „Fred". Seine eigentliche Identität wird, sobald er als „Fred" auftritt, durch einen so genannten „Jedermann-Anzug" unkenntlich gemacht, der Kopf und Körper wie eine zweite Haut umgibt. Dessen Tarnfunktion besteht darin, dass vor allem Gesicht und Haare ständig Gestalt und Form wechseln, von männlich zu weiblich, alt zu jung, weiß zu schwarz, behaart zu unbehaart usw. Zusätzlich wird die Stimme manipuliert, sodass auch innerhalb des „Neuen Pfades" die Identität von Fred als Bob Arctor – scheinbar – im Dunkeln bleibt. Bob Arctor hat allerdings selbst Drogenprobleme, ist Konsument von Substanz D und wohnt mit seinen beiden ebenfalls süchtigen Freunden Barris und Luckmann in einem verwahrlosten, völlig heruntergekommenen Haus (◘ Abb. 3). In einer kurzen Einblendung sieht man, dass Bob genau in diesem Haus früher mit Frau und zwei kleinen Töchtern das prototypische Leben des amerikanischen Vorstadtbürgers geführt und, von der Unerträglichkeit dieses Lebens abgestoßen, aufgegeben hat.

Von seinem Vorgesetzten Hank erhält Bob nun in seiner Eigenschaft als Agent Fred den Auftrag, einen gewissen Robert Arctor – also sich selbst – zu überwachen. Ein holografisches Überwachungssystem wird in Bobs Haus installiert und Bob befindet sich in der bizarren Situation, zugleich Überwachender (Fred) und Überwachter (Bob), „Scanner" und „Gescannter" zu sein. Für sein Identitäts- und Ichgefühl erweist sich dies als desaströs, wobei die Folgen des Substanz D Konsums das Ihre dazu beitragen. Nun wird auch deutlich, welche Rolle Bobs Freundin Donna spielt, die zuvor als dessen Drogenlieferantin in Erscheinung trat, sich ihm aber strikt sexuell verweigert hatte, was auch zu Konflikten führte. Donna entpuppt sich nämlich als diejenige, die sich mit Hilfe ihres „Jedermann-Anzugs" hinter Freds alias Bobs Vorgesetztem Hank verbirgt, ist also mit diesem identisch. Nun erheben sich Verdachtsmomente, dass „Der neue Pfad" selbst daran beteiligt ist, Substanz D zu produzieren und zu vertreiben, und Donna ist Teil eines (polizeilichen?) Plans, genau dies dem „Neuen Pfad" nachweisen zu können. Dazu bedarf es einer unverdächtigen Person und Donna/Hank hält Fred/Bob dafür als perfekt geeignet. Sie hat zwar Gewissensbisse, ihn ohne sein Wissen beim „Neuen Pfad" in eine von diesem betriebene Entzugsklinik einzuschmuggeln, doch die Dinge haben sich inzwischen so weiterentwickelt, dass Bob/Fred infolge seines Drogenkonsums und seiner „schizophrenen" Situation psychisch zusammenbricht. Dies passt wiederum in Donnas Plan, da Fred/Bob jetzt unter dem Decknamen „Bruce" zunächst in einer Entzugsklinik aufgenommen wird und anschließend auf einer Entzugsfarm einfache landwirtschaftliche Arbeiten verrichtet, da er kognitiv inzwischen stark eingeschränkt ist. Dort entdeckt er, dass auf dem Boden der bewirtschafteten Maisfelder jene blauen Blumen wachsen, aus welchen Substanz D gewonnen wird – womit sich der Verdacht bestätigt, dass der „Neue Pfad" hinter allem

■ **Abb. 2** Bob Arctor (Keanu Reeves). (Quelle: Warner Bros./Cinetext)

steckt. Bruce pflückt eine dieser Blumen und versteckt sie in seinem Stiefel, um sie seinen Freunden aus der Entzugsklinik bei einem Wiedertreffen zeigen zu können. Ob er selbst noch in der Lage ist, die Bedeutung seiner Entdeckung zu verstehen, bleibt fraglich. Damit endet der Film.

Hintergrund und Filmwirkung

Die Romanvorlage für das Drehbuch stammt von dem namhaften Science-Fiction-Autor Philip K. Dick, auf den unter anderem auch Ridley Scotts *Blade Runner* und Steven Spielbergs *Minority Report* zurückgehen. Dicks *Der dunkle Schirm* (original: *A Scanner Darkly*) erschien 1977, und es ist vielleicht nur ein Fingerzeig, berücksichtigt man die zu Beginn des Films getroffene Aussage, die Handlung spiele „sieben Jahre nach heute", dass damit das Orwell'sche Jahr *1984* gemeint sein könnte. Schließlich spielt auch im Film der gesellschaftliche Hintergrund insofern eine Rolle, als das Bild eines Überwachungsstaats gezeichnet wird. Doch es sind vor allem auch Dicks eigene Drogenerfahrungen, die über den Roman in Drehbuch und Darstellung der Hauptpersonen Eingang gefunden haben. So werden im Abspann eine Reihe ehemaliger Freunde und Bekannte genannt, die infolge Drogenkonsums gestorben sind oder schwer geschädigt wurden. Auf der DVD-Hülle ist zur Bedeutung des Drogenproblems sogar zu lesen: „Das Amerika der Zukunft hat den Kampf gegen die Drogen verloren. Das halbe Land ist süchtig nach Substanz D". Richard Linklater (bekannt unter anderem durch *Before Sunrise* und *After Sunrise*), der das Drehbuch selbst geschrieben hat, drehte den Film zwischen Mai und Juni 2004, die Erstaufführung fand bei den 59. Internationalen Filmfestspielen am 25. Mai 2006 in Cannes statt. In Deutschland war der Film nur auf diversen Filmfestivals sowie in wenigen nicht-kommerziellen Kinos zu sehen. Er erhielt in den USA mehrere Preise, unter anderem 2007 den „Online Film Critics Society

⬛ Abb. 3 Bob Arctor und seine Freunde. (Quelle: Warner Bros./Cinetext)

Award in der Kategorie Best Animation und der Regisseur Richard Linklater den Austin Film Award".[1] Für einen breiten Interpretationsspielraum sorgt der Bezug des Titels *A Scanner Darkly* zu einer als Vorlage dienenden Bibelstelle aus Korinther 13, Vers 12. In der englischen Version heißt es: „For now we see through a glass darkly…", während in der Luther-Bibel (1963) zu lesen ist:

Wir sehen jetzt durch einen Spiegel in einem dunklen Wort; dann aber von Angesicht zu Angesicht. Jetzt erkenne ich stückweise; dann aber werde ich erkennen, gleichwie ich erkannt bin.

Zum Begriff „Scanner" wäre zunächst zu sagen, dass damit ein technisches Abbildungs- oder Kopier-verfahren im Bereich digitaler Datenerfassung gemeint ist. Heutzutage assoziiert man mit ‚Scannen' aber durchaus auch Kontrollmaßnamen auf Flughäfen („Nacktscanner") oder einen neurobiologischen Kontext, in welchem er im Zusammenhang mit den sogenannten bildgebenden Verfahren eine gewisse Prominenz erlangt hat. Trotzdem, die Bezüge zur Perspektivität des Sehens und Gesehen-Werdens sind in der Bibelstelle durchaus erkennbar, sowohl in ihrer Bedeutung für das Werden des „Ichs" sowie das, was bei diesem Prozess an Schatten, Dunkelheit und Verborgenem anfällt.

Eine Besonderheit des Films liegt vor allem in den formalen, bearbeitungstechnischen Mitteln der Darstellung, bei der sich Linklater des sogenannten Rotoskopieverfahrens bedient hat. Ursprünglich bei Animationsfilmen, aber auch bei Spielfilmen wie in Hitchcocks *Die Vögel* eingesetzt, bezeichnet Rotoskopie eine Technik, bei der Filmszenen Bild für Bild von hinten auf eine Mattscheibe projiziert werden, um vom Animator abgezeichnet oder verändert werden zu können. Seit den 1990er-Jahren geschieht dies auf digitaler Basis. Linklater, bzw. ein für jeden der Schauspieler zuständiges Team, bear-

1 http://tinyurl.com/tos87. Zugegriffen am 10. 4. 2012

beitete den normal aufgenommenen Film vollständig nach diesem Verfahren, wodurch ein Changieren zwischen stark dominierenden Animationseffekten und dann wiederum stärkeren „Echtheitseffekten" ermöglicht wurde. Besonders in Szenen, in denen die „Jedermann-Anzüge" zum Einsatz kommen, lassen sich so mehrschichtige Darstellungsebenen und Perspektivenwechsel realisieren, sodass die wechselnden und diffundierenden Identitätsebenen einen bildhaften Ausdruck finden können. Diese Darstellungsweise wurde teilweise als gelungen und überzeugend gefeiert, vermag aber den damit einhergehenden Verlust des direkten schauspielerischen Ausdrucks nur teilweise wettzumachen. Die Wirkung des Films beruht neben seiner ungewöhnlichen Darstellungsform darauf, dass ein durchgängig düsteres, dystopisches Zukunftsbild entworfen wird, in das teilweise bizarre, auf Kommunikationsstile von Drogenkonsumenten anspielende Dialoge eingeflochten werden.

Trojaner im Ich – ein analytischer Ansatz

Moderne Metamorphosen

Im engeren Sinne markiert der Begriff „Scanner" ein Aufzeichnen und Umwandeln von Daten (Bilder, Texte usw.), mittels derer wiederum bei Bedarf ein Abbild des Gescannten auf einem Schirm (Monitor/"Screen") sichtbar gemacht werden kann. Wird das „Scanning" in der Hirnforschung angewandt, so soll es den Forschenden einen Zugang zu Vorgängen unterhalb der Schädeldecke eröffnen, woraus dann wiederum Schlüsse darüber gezogen werden, wie unsere Psyche funktioniert. Fast unmerklich hat sich dabei der Begriff des Scannens vom Vorgang einer Datentransformation im Sinne eines reinen Abbildens oder Kopierens gelöst und auf ein assoziatives Feld von Oberflächen und Tiefe bis zum Sichtbarmachen von Verborgenem ausgedehnt. „Scannen" bleibt dabei keineswegs auf technische Vorgänge beschränkt. So wird etwa vorgeschlagen, dann vom „Phänomen eines paranoiden Stils" zu sprechen, wenn die „lebendige Empathiefähigkeit zu einem (…) ,sozialen Scannen' gesteigert und zugleich verkümmert" ist (Gödde/Buchholz 2011, S. 123). In Philip K. Dicks Romantitel „A Scanner Darkly", den Linklater übernimmt, wird dieser Scanner/Schirm als „dunkel" ausgezeichnet. Was damit gemeint ist, könnte zum einen darauf verweisen, dass das, was durch den Scanner erfasst werden soll, dunkel ist, zum anderen aber auch: im Dunklen bleibt, auch durch den Scanner nicht erfassbar ist. Auch eine dritte Lesart erschließt sich, bezieht man das Dunkle auf den Scanner selbst, was bedeutete, dass dieser selbst „blind" wäre für das, was er eigentlich zur Erscheinung bringen sollte. Es besteht zunächst keine Notwendigkeit, eine der Perspektiven zu favorisieren, im Gegenteil, gerade deren Offenhalten wäre ein Weg, sich dem Spielen des Films mit verschiedenen Ebenen der Darstellungsformen, Handlungen und Identitäten anzunähern. Der Verweis auf Paulus' Brief an die Korinther – immerhin in einem Kapitel, das „Die Liebe als die höchste Geistesgabe" preist – deutet eigentlich einen Prozess zunehmenden Erkennens an, wobei das „von Angesicht zu Angesicht" auf dessen unverzichtbare soziale Dimension aufmerksam macht. Es bleibt bei Andeutungen, auf was dieses Erkennen sich im Film beziehen könnte.

Zunächst meint man, einen klassischen Drogenfilm im Science-Fiction-Gewand zu sehen: Paranoia, halluzinatorisch-psychotische Wahrnehmungsverzerrungen, Zerfall sozialer Beziehungen sowie der Persönlichkeit, Entfremdung, Misstrauen, Isolation, Destruktivität. Das Gleiche auf der gesellschaftlichen Ebene: Ein Überwachungsstaat, Polizeiaktionen gegen einen protestierenden Straßenprediger, verdeckte Ermittlungen durch eine dubiose Organisation („Der neue Pfad"), die vorgibt, das Drogenproblem bekämpfen zu wollen, sich letztlich aber als dessen Verursacher und Profiteur erweist. Über die Hintergründe und Ursachen erfahren wir wenig. Es gibt in einer Rückblende die schon erwähnte Szene im ersten Drittel des Films, in der wir Bob in einer wohl gewollt klischeehaften Darstellung des „american dream" mit Frau und zwei kleinen Töchtern in seinem Vorstadt-Eigenheim mit Garten sehen, wie er sich beim Zubereiten von Popcorn den Kopf stößt und sich während des folgenden

heftigen Wutausbruchs bewusst wird, wie sinnentleert er dieses Leben empfindet und wie sehr er es hasst. Bob entfloh diesem Dasein irgendwann, wurde zum Agenten Fred beim „Neuen Pfad" und vertauschte die alte Existenz mit einem Doppelleben im Drogenmilieu. Genau in diesem Eigenheim, das er nun mit seinen Drogenfreunden Barris und Luckman bewohnt und zusammen mit diesen auf eine fast lustvoll „dekonstruktivistische" Weise in eine Müllhalde verwandelt, wird dann auch das Überwachungshologramm installiert werden, mittels dessen Bob sich selbst in seiner Identität als verdeckter Ermittler Fred überwachen soll: Ein gründlicheres Zerschreddern des „american dream" wurde selten gezeigt. Doch Bobs Flucht bringt ihn nicht weiter: Bei seinem ersten Filmauftritt als Ermittler Fred vor einer Gruppe von Bürgern anlässlich eines Vortrags über Drogenprobleme im Zusammenhang mit „Substanz D", den er im seine Identität verbergenden „Jedermann-Anzug" hält, holt ihn genau jenes Sinnlosigkeitsgefühl wieder ein, das er wohl loszuwerden gehofft hatte. Man sieht plötzlich Bobs Gesicht durch die Maske des „Jedermann-Anzugs": ein trauriges, müdes Gesicht von jemandem, der nicht mehr daran glauben kann, dass das, was er gerade macht, irgendeinen Sinn ergibt. Bob/Fred bricht den Vortrag ab und geht. Wenig später wird er den Auftrag erhalten, sich selbst zu überwachen.

Inzwischen war schon deutlich geworden, dass er selbst Konsument von „Substanz D" ist. Fast alles im Film geschieht wie im Banne dieser Substanz, als fungiere sie als Platzhalter für alles Destruktive und Entfremdende, eine Art Kern-Substanz, um die sich Alles und Alle sehnsüchtig wie um ein narratives Gravitationszentrum drehen. Sie beherrscht die Personen, den Staat, ebenso wie die gesellschaftlichen Institutionen, hat demnach eine weit über das reine Drogenproblem hinaus gehende Bedeutung. Den dazu korrespondierenden Kontrastpunkt bildet das Identitätsthema, das unübersehbar in der Dreigeteiltheit von Bob, Fred und Bruce zur Darstellung kommt, aber auch durch den „Jedermann-Anzug" gleichsam allegorisch eingekleidet ist. Durch diesen erfährt das Chamäleonhafte von Identität mit Hilfe der Animationstechnik gleichzeitig eine ideale Abbildung. Was die Filmhandlung vorantreibt, lässt sich so als Dynamik beschreiben, die aus der polaren Spannung zwischen „Substanz D" und „Identität" erwächst. Doch was vermittelt diese beiden Momente, die der Film in seiner ungewöhnlichen Form zum Ausdruck zu bringen versucht?

Identität, Substanz und Kultur

Bleibt man im Rahmen des Drogenparadigmas, so nimmt so etwas wie „Substanz D" schlicht die Stelle jenes destruktiven Moments ein, welche Identität zerstört. Genauer, Bob wird zu Bruce, weil die Droge sein Gehirn zersetzt, die beiden Gehirnhälften in eine zerstörerische Konkurrenz zwingt, mit der Folge, dass Bruce als leere Hülle dessen zurückbleibt, was einmal Bob war. Das Gleiche geschieht auf den Ebenen des Sozialen, der Beziehungen sowie des Staates bzw. staatlicher Institutionen. Niemand kann irgendwem trauen. Das Böse, Destruktive ist also die Droge selbst, die aus Menschen Süchtige macht und Organisationen bis auf die Ebene des Staates hervorbringt, die daran Interesse haben, möglichst viele zu Konsumenten zu machen bzw. daran zu profitieren. Auf allen drei Ebenen, der des Subjektiven (der Ich- oder Selbstebene), des Sozialen/Zwischenmenschlichen sowie des Staatlichen wäre „Substanz D" jene greifbare, real existierende, tödliche Gift-Substanz, die für das ganze Elend verantwortlich wäre. Die Lösung läge konsequenterweise in einem „Also weg damit"! Offensichtlich greift diese Annäherung zu kurz. Bob hasst sein Leben schon, bevor er mit der Droge in Verbindung gekommen ist; auch seine Freundin Donna und die anderen führen merkwürdige Doppelexistenzen, und es ist gerade das Stilmittel der ganz wörtlich zu verstehenden Überzeichnung, der grafischen Verfremdung der Schauspieler, welches das schwer Greifbare, Prekäre von Identität überhaupt zum Ausdruck bringt. So ist auch der „Jedermann-Anzug" keineswegs nur die Darstellung einer ständig sich ändernden Oberfläche, somit ein Freiheit suggerierendes Spielen mit Identität(en) zum Ausdruck bringend, das gleichsam den flexiblen Menschen in einer „flüssigen" oder „flüchtigen Moderne" (Baumann 2003) in der Fülle seiner Wahlmöglichkeiten zeigt. Dies würde nämlich einen sich hinter/unter der Oberfläche verbergenden, aber gleichwohl vorhandenen Existenzkern von Identität voraussetzen, eine Art sichere Basis, die dieses

Spielen erst ermöglichte. Und damit steht man vor der Frage, wie sich Identität und jene Kern-Substanz, so es sie gibt, zueinander verhalten. Man läuft dabei Gefahr, eine inzwischen als ermüdend empfundene Debatte um den „Tod des Subjekts" aufwärmen zu wollen. Trotzdem, Identität als Thema ist vielleicht in Zeiten einer bis in das Privateste dringenden Virtualisierung des Realitätskontakts virulenter als jemals, und die Einkleidung in einen Drogenkontext fände ihre Aktualität, träfe man tatsächlich auf suchtartige Strukturen im Identischen, im Sozialen, im Staatlichen sowie Ökonomischen.

Was ist persönliche Identität? Ein Ich oder Selbst, ein Selbstbewusstsein, Personalität könnte man antworten, also etwas, dem wir im Film bei keiner der Hauptfiguren wirklich begegnen. Im Gegenteil, wenn Fred sich als Bob überwacht und ihm so seine eigene, als „Bobheit" erscheinende Substanz im Schirm gegenübertritt und letztere sich selbst wiederum als Beobachter-Fred, so bringt dies den ganzen möglichen Wahnsinn einer Selbstbegegnung zum Ausdruck, der eines Drogenproblems gar nicht mehr bedarf. Psychoanalytikern ist dies insofern vertraut, als die Bezeichnung für diese Figur „Über-Ich" lauten kann, in welchem Freud zufolge unter bestimmten Bedingungen „eine Reinkultur des Todestriebes" herrscht (Freud 1923, S. 283) – den man folglich als Freuds „Jenseits des Lustprinzips" gelegene Version von „Substanz D" benennen könnte. Was das Beispiel Bob/Fred/Bruce, wenn auch in seiner negativen Variante, deutlich macht, ist zugleich, dass Identität so etwas wie Selbstreferentialität voraussetzt, ein Sich-auf-sich-selbst-als-sich-selbst-beziehen-Können, das gleichwohl immer abhängig bleibt von einem gewissen Maß an Anerkennung/Bestätigung durch andere. Das Schicksal von Bob zeigte so das Abgründige, von einem infiniten Regress Bedrohte von Selbstreferentialität, wie bei einem Schlittschuhläufer, der nicht mehr aus einer Pirouette herausfindet und die Überzeugung entwickelt, dass da ein „Ding" sein muss, das ihn zur dauernden Wiederholung der Kreisbewegung zwingt. Dieses „Ding" hieße Identität. Man kann es umkreisen, aber nicht zur Substanz „machen" oder in ihm zur Ruhe kommen. Ist das, was der Begriff Identität meint, demnach eine Illusion, ein Phantasma, die Projektion eines Wunsches, dass es so etwas „in mir" doch geben möge oder geben müsse? Der englische Psychoanalytiker Donald W. Winnicott, der sich intensiv mit vorsprachlichen Formen des emotionalen Wachstums beschäftigt hat, schreibt, er glaube, dass es „einen Kern der Persönlichkeit" gäbe und fährt fort (Winnicott 1993, S. 245):

> …, daß dieser Kern niemals mit der Welt wahrgenommener Objekte kommuniziert, und daß der Einzelmensch weiß, daß dieser Kern niemals mit der äußeren Realität kommunizieren oder von ihr beeinflußt werden darf. … Wenn auch gesunde Menschen kommunizieren und es genießen, so ist doch die andere Tatsache ebenso wahr, daß jedes Individuum ein Isolierter ist, in ständiger Nicht-Kommunikation, ständig unbekannt, tatsächlich ungefunden. Im Leben und Erleben wird diese harte Tatsache gemildert durch die Teilhabe, die zum Gesamtbereich des kulturellen Erlebens gehört. Im Zentrum jeder Person ist ein Element des ‚incommunicado', das heilig und höchst bewahrenswert ist.

Winnicott hält also durchaus an der Vorstellung fest, dass es einen Kern der Persönlichkeit bzw. einen Identitätskern gäbe. Aber auch, dass dieser Kern eines Schutzes bedarf, der darin besteht, dass er jeglicher Kommunikation entzogen bleiben muss. Bezogen auf den Filmtitel: Der Identitätskern könnte nur als etwas Nicht-Scannbares Kern sein. Der Preis für Individualität und Identität, so hart dies auch klingen mag, sei deshalb Isolation und ein unaufhebbares Moment von Einsamkeit, von „incommunicado". Was aber geschieht, wenn man diese Gedanken auf die Kommunikation mit-sich-selbst bezöge, das alltägliche mit sich Sprechen, Bewerten, Wahrnehmen? Muss man sich nicht auch davor bewahren, in sich selbst einzudringen, weil der Versuch, in immer tieferen Tiefen auf den Kern dessen zu stoßen, der „mich" ausmacht, scheitern müsste? Scheitern, weil dieses Vordringen eben nichts Kernhaftes zu Tage förderte, sondern nur immer wieder Fragmente, Bruchstücke von Gefühlen, Empfindungen, Fantasien, Gedanken, „Teil-Subjekten", mehr oder weniger zusammengehalten durch etwas, was Kant als das „Ich oder Er oder Es (das Ding), welches denkt" bezeichnete (Kant 1968, S. 218). Ein Es oder Ding,

das „mich" denkt? Ist das Freuds psychischer Apparat, in Verbindung mit dem uns immer nur partiell zugänglichen Unbewussten? Die radikale Form der Introspektion liefe folglich auf die Installierung eines Trojaners ins/im eigenen Ich hinaus, und es ist in diesem Zusammenhang aufschlussreich, dass Winnicott das „incommunicado" im Zentrum der Persönlichkeit als „heilig" kennzeichnet. Dem Heiligen zu nahe zu kommen, bedeutete in allen Kulturen: es zu zerstören, zerstört zu werden oder, was auf das Gleiche hinausliefe, sich selbst zu zerstören. In diesem Sinne begegnete man beim Versuch, seinen Identitätskern zu erreichen, „Substanz D", welche gleichzeitig für ein suchtartiges Verlangen stünde, es trotzdem zu versuchen. Somit liefe die von Winnicott benannte Notwendigkeit, etwas in sich jeglicher Kommunikation zu entziehen, auf das schützende „Verbot" hinaus, selbst diesem „Kern" begegnen zu wollen. Besser, der Scanner bleibt dunkel. Was für das Innere von Personen gilt, wäre nur eine Spiegelung dessen, was das „Zwischen" von Ich und Du ausmacht: Kommen sich beide Pole – also das Soziale/Kulturelle und das Subjektive/Individuelle – zu nahe, wird es zerstörerisch. Es bliebe die unaufhebbare Sehnsucht danach, diese Vereinigung möge sich als eine Art ultimatives Zuhause erweisen.

Kleiner Exkurs über eine aktuelle Erscheinungsform des virtuell Substanziellen

Die Kombination virtuell-substanziell wirkt natürlich hochgradig widersprüchlich. Gemeint ist damit, dass im Zuge der dramatischen Bedeutungs- und Machtzunahme von Konzernen wie Google, facebook oder Apple eine Konzentration und Kumulation von Milliarden von Daten in einer Art Hyperspeicher, genannt „Cloud" stattfindet. Moderne Speichertechniken ermöglichen so eine Art unheimliches, virtuelles Zentrum, das sich, gesellschaftlich gesehen, als imaginärer Ort/Container darbietet, in dem wir unser Verlangen nach „Substanz" unterbringen können. Ein altes Science-Fiction-Motiv scheint hier auf: Der Superrechner, ausgestattet mit gottähnlichen Attributen – etwa Allwissenheit – der nicht mehr über den Wolken, sondern selbst „Cloud" ist. Wie fühlen sich die Individuen dieser „Wolke" gegenüber? Beobachten wir hier die Entstehung virtueller Zentren, welche infolge unserer unbewussten Fantasien und Projektionen des „Heiligen" die Gestalt neuer Pseudo-Substanzen annehmen? Das Wissen darum, dass es eigentlich keine Substanz(en) gibt, weder im Ich/Selbst noch in Gruppen oder Staaten, ist alt. Es muss sich aber gegen Gefühle und Stimmungen durchsetzen, die davon wenig wissen wollen: Unbehaustheit, Einsamkeit, Leere, unstillbares Sehnen. Gefühle also, bei denen Verdrängung oder andere Formen des Nicht-wissen-Wollens schnell zur Stelle sind. Aber jedes Ich, jede Gruppe und jeder Staat haben oder brauchen ihr virtuelles, imaginäres Zentrum – etwa die Bundeslade, ein heiliges Buch, einen Mythos, eine Königin – und es einzieht sich weitgehend dem Bewusstsein, dass genau dieses imaginäre Zentrum mit jener Substanz identisch ist, die wir mit unseren Wünschen, Ängsten und Sehnsüchten selbst erschaffen. Und deshalb können wir uns dieser Substanz wie dem Heiligen nur mit Angst nähern, als ahnten wir, dass die Begegnung gefährlich sein wird.

Der Film als Spiegel gesellschaftlicher Entwicklung

Zurück zu Winnicott. Der von ihm angesichts dieser misslichen Situation (dem Moment unaufhebbarer Isolation) beschriebene Trost einer Teilhabe am kulturellen Erleben findet im Film nicht statt. Auch hier begegnen wir der „Substanz D" als Chiffre für ein zerstörtes Miteinander sowie ein den Personen feindlich gegenübertretendes Soziales (beispielsweise „Der Neue Pfad") bzw. Staatliches. Greift man die Substanz-Metapher auf, wären auch diese Ebenen „suchtkontaminiert". Das Drogengeschäft ist bekanntlich höchst profitabel, wird allerdings inzwischen um Weites übertroffen durch das, was auf der Ebene des Finanzkapitals geschieht und zunehmend als tödliche Bedrohung für die Gemeinwesen wahrgenommen wird. Man mag das Süchtige denen unterstellen, die dieses Geschäft betreiben – etwa als Ausdruck einer ihnen in besonderem Maße zukommenden, durch dieses wie ein Turbo funktionierende System selbst angestachelten, unstillbaren Gier. Doch weist das Motiv des „Jedermann-Anzugs" in der ständigen Verflüssigung seiner Trägerinnen und Träger nicht nur auf die schon erwähnte, von

Baumann beschriebene „flüssige Moderne" hin, sondern auch darauf, dass „Jedermann" wirklich „Jeder" bedeutet, insofern Alle in diesen durch das Finanzkapital vorangetriebenen Prozess verwickelt sind. Unterstelle man, dass das Finanzkapital „als einheitliche Macht die Lebensprozesse der Gesellschaft bestimmt, so sind mit ihm die Launen und die Gefährlichkeit alter Souveränitätsfiguren unter modernsten Bedingungen zurückgekehrt", wie Joseph Vogl schreibt (2010, S. 178). Philip K. Dick wäre dann mit der Romanvorlage eine hellsichtige Vorahnung einer Entwicklung gelungen, in der vom Individuellen über das Soziale bis zum Staatlichen die Personen sich durch diesen anonymen „Souverän", man könnte ihn „Goldenes Kalb", Profit, Zufall oder „Substanz D" nennen, bestimmt fühlen, ohne ihn greifen zu können. Man müsse sich nicht wundern, schreibt Vogl, Luhmann zitierend, dass „so operierende Gesellschaften Angst vor sich selbst bekommen" (ebd., S. 177). Linklaters *A Scanner Darkly* wäre eine Adaptation des Romanstoffes, die dem Zuschauer die ganze Düsternis und Ausweglosigkeit einer solchen Entwicklung vor Augen führt, welche, da sie letztlich von Menschen in Gang gesetzt und gehalten wird, nur von diesen selbst aufgehalten oder verändert werden kann.

Angesichts von so viel Dunkelheit zum Abschluss ein Vierzeiler von Robert Gernhardt, der seinen persönlichen Beitrag zum Thema Identität unter dem Titel „Selbstbefragung" in Reimform gebracht und sich damit offenkundig zum Nicht-Substantialismus bekannt hat:

„Ich horche in mich rein.
In mir muss doch was sein.
Ich hör nur ‚Gacks' und ‚Gicks'.
In mir da ist wohl nix."

Erinnern „Gacks" und „Gicks" nicht verblüffend an das Geräuschspektrum digitaler Maschinen?

Literatur

Baumann Z (2003) Flüchtige Moderne. Suhrkamp, Frankfurt/M
Die Bibel (1963) Württembergische Bibelanstalt, Stuttgart
Freud S (1923) Das Ich und das Es. Gesammelte Werke Bd XIII. Fischer, Frankfurt/M, S 235–289
Gernhardt R (2010) Wörtersee. Zweitausendeins, Frankfurt/M
Gödde G, Buchholz MB (2011) Unbewusstes. Psychosozial-Verlag, Gießen
Kant I (1968) Kritik der reinen Vernunft. Akademie Textausgabe VI. de Gruyter, Berlin
Vogl J (2010) Das Gespenst des Kapitals. diaphanes, Zürich
Winnicott DW (1993) Reifungsprozesse und fördernde Umwelt. Fischer, Frankfurt/M

Originaltitel	A Scanner Darkly
Erscheinungsjahr	2006
Land	USA
Buch	Richard Linklater
Regie	Richard Linklater
Hauptdarsteller	Keanu Reeves (Robert Arctor; Fred, Bruce), Rory Cochrane (Charles Freck), Robert Downey Jr. (James Barris, Woody Harrelson (Ernie Luckman), Winona Ryder (Donna Hawthorne, Hank)
Verfügbarkeit	Als DVD in OV und deutscher Sprache erhältlich

Joachim F. Danckwardt

Zum Medienwechsel bei David Lynch: von „motion pictures" zu „moving paintings"

Inland Empire – Regie: David Lynch

LAURA JEREMY JUSTIN
DERN IRONS THEROUX

VENEDIG FILM FESTIVAL 2006

DAVID LYNCH

INLAND
EMPIRE

EINE FRAU IN SCHWIERIGKEITEN

STUDIO CANAL CONCORDE WWW.CONCORDE-FILM.DE

Filmplakat *Inland Empire*
Quelle: Concorde/Cinetext

Inland Empire

Regie: David Lynch

Es ist eine uralte Neigung der Menschen, angesichts von anstürmendem Unbekannten und Neuen nach dem Bestehen eines alleinigen Sinns „an sich" zu suchen. Eines alleinigen Sinns, der Bild-, Sprach- und Klangwelt einheitlich umhüllt. Das war schon ein dringliches Anliegen an frühere publikumswirksame Filme von David Lynch wie *Lost Highway* (1996) und *Mulholland Drive* (2001). Ein solches Verlangen wurde allenfalls mit *Straight Story* (1999) gestillt. Ins Unermessliche steigert sich das Begehren nach Sinn in Lynchs letztem, 173 Minuten füllenden Labyrinth *Inland Empire* von 2006 (◘ Abb. 1). Denn der Zuschauer versteht von Anfang an rein gar nichts, wenn er auf die ihm vertrauten Zugangswege des klassischen Erzählfilms setzt, auf dessen lineare Darstellung, logische Abfolge von Aktion und Reaktion, plausible psychologische Motive, klare Kausalität und Kohärenz der Charaktere. Diese Kennzeichen sind in *Inland Empire* nicht zu erwarten. Selbst sein Regisseur, der Maler, Cartoonist, Computer-Animator, Musiker und Schreiner David Lynch, gestand ein, dass auch er nicht verstehe und genau wisse, wovon *Inland Empire* eigentlich handele – bis auf den einen roten Faden: die Angst. Und ich werde hinzufügen: Es ist die Angst vor dem Werden und Entwickeln von Identität in den zeitgenössischen Lebensorten der medialen Wirklichkeiten.

Bilder und Klänge sind klüger als ich

Lynchs Eingeständnis erinnert an Äußerungen von Malerkollegen, wie zum Beispiel Gerhard Richter, der, nach Aussage und Sinn eines Gemäldes gefragt, achselzuckend die Antwort gab: „Meine Bilder sind klüger als ich" (Danckwardt 2011). Ähnlich antwortet Lynch (2007):

> … ich erzähle nicht bloß Geschichten, sondern arbeite mit Abstraktionen [mit Prozessen der Collage, des Surrealismus und Kubismus. Hinzufügung JFD]. Das Kino kann die Zuschauer in eine Welt jenseits des Intellekts entführen, in der sie sich ganz und gar ihrer eigenen Intuition anvertrauen müssen. Es geht nicht darum etwas zu verstehen, sondern darum, etwas zu erfahren. … Verwirrung kann sehr stimulieren. Viele Zuschauer lieben es, sich in einen Film fallen zu lassen. Wenn sie aus dem Kino kommen, wirkt er in ihnen fort.

Also bleibt einem, ähnlich wie bei Richter, nichts anderes übrig, als sich dem filmischen Kunstwerk und seinen eigenständigen Materialobjekten ohne Verstandesbedienung anheim zu geben und die Klugheit der Bilder und Klänge jenseits des gesprochenen Worts zu erfahren (Gay et al. 2007):

> Ich spreche nicht so gerne … So viele Dinge sind wortlose Dinge. Worte sind schön, aber es gibt auch noch eine ganz andere Sprache im Kino, eine ganz andere Sprache in der Malerei, in der Fotografie, in Zeichnungen. Das sind vorwiegend wortlose Dinge. Und das ist die Welt, die ich liebe.

Vor allem mit Lynchs letztem Werk bekommt man es also mit diesem Medien-Wechsel zu tun: mit dem Wechsel von „motion pictures" zu „moving paintings" und mit dem Wahrnehmungswechsel vom Verstehen zum Erfahren.

🔲 **Abb. 2** Laura Dern (Nikki) und Justin Theroux (Devon). (Quelle: Interfoto/NG Collection)

Geheimnisvolle mentale Landschaftsskizzen

In vielen früheren Filmen startete Lynch noch mit Verstehbarem, gleichsam wie mit einem Schuhlöffel. In *Inland Empire* beginnt der Film radikal mit Erfahren-Machen, nämlich mit ursuppenhaft brodelnden Klangwänden von Angelo Badalementi, die sich mit einigen, das Schwarz zerteilenden, weißen Lichtstrahlen „verheiraten" (Lynch 2011), aus denen dann der Filmtitel erwächst: I N L A N D E M P I R E. Er ähnelt dem Buchstabenband Hollywoods oberhalb von Los Angeles, hier aber wie eine Arc de Triomphe wirkend. Das Denkmal geht über in die Großaufnahme der Nadelspitze eines Grammophons von 1900. Sie pflügt in den rotierenden Abgründen einer Schellack-Platte und wirft eine verkratzte Stimme hervor: „Dieses Lied, am längsten gespielt in der Geschichte des Radios. Heute geht es im Baltikum weiter: ‚Ein grauer Tag in einem alten Hotel'". Nun erscheinen ein Treppenhaus, ein dunkler Flur, ein Paar. Die Köpfe sind durch digitales Radieren mit einer Datenschutzsoftware unkenntlich, identitätslos, gemacht. Die Stimmen sprechen wie in Watte.

💬 „Der Flur kommt mir nicht bekannt vor. Wo sind wir? – Das ist unser Zimmer. – Ich habe keinen Schlüssel. Nein, du hast ihn mir gegeben. Ich habe ihn. Was ist mit mir nur los? Das ist das Zimmer? Ich erkenne es nicht wieder. – Zieh dich aus. – Gut. – Du weißt, was Huren machen? – Ja. Sie ficken. Möchtest du mich ficken? – Zieh' dich einfach aus. Ich sag dir, was ich möchte. – Gut. Wo bist du?"

Eine verschwommene SM-Szene mit einer gefesselten Hand. „Ich habe Angst. Ich habe Angst." Wechsel zu Farbe. Die Frau sitzt weinend vor einem Fernsehschirm. Lynchs Sitkom-Film erscheint auf dem Bildschirm:

Eine Hasenfrau bügelt, eine andere Hasenfrau sitzt auf dem Sofa. Ein Hase tritt ein. „Eines Tages werde ich es herausfinden. – Wann wirst du es erzählen? – Wer hätte das ahnen können? – Wie spät ist es?" Schallendes Gelächter aus dem Off. „Ich habe ein Geheimnis." Gegenschuss: die weinende Frau. Schuss: die Hasen. „Es gab heute keine Anrufe." Gegenschuss. „Ich höre jemanden." Lachen aus dem Off. „Ich glaube nicht, dass es noch viel länger dauern kann." Der Hase schreitet durch die Türe hinaus und beamt aus einer Türe hinein in einen herrschaftlichen Salon. Beamt sich weg. Zwei osteuropäische Männer, einer vornehm, ein zweiter grob-knollig, in Schuss und Gegenschuss: „Suchst du etwas? – Ja. – Du versuchst hereinzukommen. – Ja. – Einen Zugang? – Ich suche einen Zugang, verstehst du? – Ja. – Ich verstehe. – Du verstehst also, dass ich einen Zugang suche. – Ja, ich verstehe das vollkommen. – Das ist gut. – Gut, dass du es verstehst. – Das ist gut. – Es ist gut, dass du es verstehst".

Nach diesen geheimnisvollen mentalen Landschaftsskizzen (Jerslev [1]1991; 2006) nimmt Lynch die moving paintings zurück und lässt motion pictures entstehen, ein Spielfilmfragment beginnt: Eine hexenhafte Frau mit polnischen Akzent (Grace Zabriskie) macht einen Höflichkeitsbesuch bei ihrer Nachbarin in Hollywood, Nikki Grace (Laura Dern), um sich vorzustellen. Wohnt sie neu in der Siedlung? Seit wann? Nikki Grace war eine ehemals gefeierte Hollywoodschauspielerin, bevor sie einen polnischen Oligarchen heiratete, in Hollywood in dieser herrschaftlichen Villa mit viel Personal wohnt, aber kinderlos blieb. Sie wird von dem Regisseur Kingsley Stewart (Jeremy Irons) für die Hauptrolle in einem altmodischen Melodram engagiert. Ihr wird ein Comeback vorausgesagt: „Du hast alles, was Du brauchst, um wieder nach oben zu kommen, und auch dort zu bleiben … Mit diesem Film hier werden Stars geboren". „Ins Licht einer finsteren Zukunft" soll der Film unheilvoll heißen. Während der Sprechproben erfahren Nikki und ihr Co-Star Devon Berk (Justin Theroux), dass der Film ein Remake ist (⬛Abb. 2). Vor einigen Jahren wurde er schon einmal gedreht, aber nie fertig gestellt. Die beiden Hauptdarsteller kamen vor Beendigung der Dreharbeiten ums Leben. Und während Laura Dern als Nikki Grace auf dem Set die Rolle von Susan Blue auch nur anzudeuten beginnt, also den zu schaffenden Film „Ins Licht einer finsteren Zukunft" im Film *Inland Empire* mit Sprechproben einübt, kommt es zu einer unheimlichen Bewegung auf einer nächsten fiktionalen Ebene: Es rumpelt im Set und späterhin versteht man, dass es sich wohl um Nikkis Ehemann, Peter J. Lucas (Piotrec Krol), handelt. „Der Mann ist der mächtigste Typ hier. Der weiß alles. Ich könnte dir Sachen erzählen, da kriegst du es mit der Angst zu tun", wird Devon Berk vor ihm gewarnt. Und in der Tat nimmt der Ehemann später, nach einem Dinner, Justin Theroux als Devon Berk, der die Rolle des Billy Side als Filmpartner von Susan Blue (Nikki Grace) spielt, in einem Herrengespräch beiseite und warnt ihn eindringlich vor sexuellen Übergriffen. Für diese ist der Schauspieler weit und breit bekannt.

Welche Identität hat sie nun: Laura, Nikki oder Susan?

Mit dieser mysterisierenden Ouvertüre auf mehreren Ebenen geraten Realität und Fiktion durcheinander, gefolgt vom Verschmelzen von Gegenwart und Vergangenheit. Der Augenblick bei der ersten Textprobe, an dem es im Set rumpelt, ist der Moment, an dem für den Zuschauer des entstehenden Films eindrücklich wird, dass Nikki unter Tränen nicht mehr richtig unterscheiden kann, ob ihre Worte über ein Date von gestern Abend als Susan Blue geschauspielert oder als Nikki Grace real sind. Ist die Annäherung zwischen Nikki und Devon als Annäherung von Billy und Susan gespielt oder real – ein Verschwimmen von Gewissheit und Unähnlichkeit setzt ein, das sich im weiteren Verlauf mehrfach wiederholend steigert und Nikki schließlich in anhaltende Augenblicke von Realitätsverlust bringt.

🎞 **Abb. 3** Nikki (Laura Dern) ist verwirrt und verzweifelt (Szene mit Harry Dean Stanton). (Quelle: Interfoto/NG Collection)

Welche Identität hat sie nun: Nikki oder Susan? Und was ist mit Laura Dern? Diese setzt den Dreh fort:

💬 „Deine Frau? – Ich bin mit ihr zusammen, seit ich ein kleiner Junge war. – Ein kleiner Junge? Jetzt ist an Dir nichts mehr klein … jedenfalls habe ich so was gehört … Wieso machst du das? – Was mache ich denn? – Spiel mir nicht den Dummen, Billy! Ich hab' 'nen Ehemann. Du hast ne Frau und zwei Kinder. Wieso tust du das? – Ich bin dir vorher nicht begegnet. – Was?? – Ich kannte dich doch vorher noch nicht. Ich hatte noch nie so ein Gefühl … du spürst das auch. Oder nicht? – Ich kann es mir nicht leisten, Billy. Ich sehe für uns in eine finstere Zukunft."

„Und danke", beendet der Regisseur den Dreh. Aber Nikki, nun nicht mehr Susan, betrachtet Billy, in der Drehpause wieder Devon, nein, Justin Theroux, heimlich weiter. Eine bewegte Verwirrung wirkt in ihr fort. Sie spielt nicht mehr verliebt. Sie ist verliebt. „Wenn sie aus dem Dreh kommt, wirkt der Film in ihr fort", prophezeite Lynch.

Das Fortwirken des Plots wird immer schwerer verständlich. Die gespielte Schauspielerin wird schwanger. Nikki und Devon schlafen miteinander. Oder sind es Susan und Billy? Szenen aus Susans Vergangenheit gewinnen Anschluss an die Gegenwart. Oder ist es Nikkis Vergangenheit? Die Hexe mit dem osteuropäischen Akzent hatte gewähnt:

💬 „Ein kleines Mädchen ging zum Spielen. Verirrte sich auf dem Marktplatz. Als wäre es noch halb geboren. Dann aber nicht über den Marktplatz, – das verstehen Sie doch, oder? – sondern durch die Gasse hinter dem Marktplatz. Das ist der Weg zum Palast.

Aber – daran erinnern Sie sich kaum. Vergesslichkeit? Das passiert uns allen irgendwann. Und? Ich? Ich bin die Ärgste – oh, wo war ich doch gleich. Ja: Ist da ein Mord in Ihrem Film? – Nein, so etwas kommt da nicht vor. – Doch, ich glaube, da irren Sie sich. – Nein – Ein brutaler Scheißmord! – So etwas höre ich nicht gerne, was Sie da reden. Sie sollten jetzt gehen. – Ja, ich kann mich anscheinend nicht erinnern, ob es heute ist oder morgen oder gestern. Ich habe das Gefühl, wenn es 9:45 Uhr wäre, dachte ich, es wäre Mitternacht".

Es kommt zum Streit zwischen Nikki und Devon oder zwischen Billy und Susan und schließlich zu einen Mord an ihr. An wen? Durchgeführt von Devons oder Billys Frau, die von einem Psychotherapeuten über Susan Blues Aufenthalt informiert worden war. Dem hatte sie ihre frühere Lebensgeschichte voller unglaublicher Verrohungen anvertraut. Am Ende ist Susan tot. Oder? Was ist los? Die Kamera fährt zurück, kommt ihrerseits ins Blickfeld und dokumentiert jetzt: Nikki kommt aus dem gedrehten Film nicht mehr heraus. Lynch: „Wenn sie aus dem Kino kommen, wirkt er in ihnen fort".

Was in „moving paintings" wirkt

Die zunehmende Orientierungsverstörung, Verwirrtheit, seelische Auflösung und in Bewegung versetzende Veränderung kommt zustande durch den vollen Medien-Wechsel von motion pictures – von Partien im Stile klassischer Erzählfilme – zu moving paintings, sich bewegenden Gemälden und Klangstromschnellen, die nur sinnlich erfahrbar sind. Begegnungen mit Liebhaberinnen von Billy, mit einem unsichtbaren Mädchen, im Rotlichtmilieu von Lodz. Nun herrschen nicht mehr die Formgesetze eines gesprochenen Melodrams, sondern die Formprozesse von Kunst (Seeßlen 2007): die kubistische Erzeugung mehrerer Handlungen in verschiedenen Zeiten und aus verschiedenen Perspektiven gleichzeitig, die surrealistische Bildmontage widersinniger Motive, die abstrahierende Befreiung zu Schatten, Bewegung, Wesen und Ideen und deren Kollage. Die sich bewegenden und den Zuschauer in Bewegung setzenden Gemälde entwickeln sich aus diesen unzähligen abstrahierenden, kollagierenden, kubifizierenden und surrealisierenden Bildprozessen und Sequenzen sowie aus sich mit ihnen vermählenden Klangschläuchen und Klangkaskaden Badalementis. In ihnen vermengen sich Gegenwartsbefindlichkeiten einer liebessehnsüchtigen erwachsenen Frau mit den Sackgassen der Vergangenheit, in denen vagabundierende, nicht entwickelte Entwicklungslinien abgeschieden waren: „Ein kleines Mädchen wollte spielen, doch es ging verloren, als wäre es nur halb geboren …" Und davor gab es doch noch etwas Ungeborenes im Dialog mit der polnischen Hexe:

💬 „Ein kleiner Junge ging zum Spielen. Er öffnete die Haustür, sah die Welt. Als er aus der Türe trat, geschah es, dass er sich spiegelte. Das Böse war geboren. Das Böse war geboren und folgte dem Jungen. – Verzeihung, was soll das? – Das ist ein altes Märchen. Und die Variation: Ein kleines Mädchen ging zum Spielen, verirrte sich auf dem Marktplatz …"

Lynch inszeniert Laura Dern (▣ Abb. 3) zu Nikki Greace und Susan Blue in Metaphern, wie zum Beispiel als kleinen Jungen, als kleines Mädchen oder als eine zerbrochene Puppe. Laura berichtete Elena Harring in der Rückbetrachtung ihrer Rollen als Rita/Diane/Camilla in Mulholland Drive (Gay et al. 2007):

Andere würden sagen: du hast Schmerzen, du bist verletzt, [aber so] ist es einfach, in diesen Puppenzustand hineinzuschlüpfen, weil man genau weiß, was er meint.

Inland Empire ist wie eine Fortsetzung von *Mulholland Drive*: Er ist der Film, der mit zwei Ermordeten endete.

Werden und Entwickeln von Identität in den Lebensorten der medialen Wirklichkeiten

Über den Film als „moving painting" hinaus ist Lynchs Film *Inland Empire* ein Film über das Medium Film als Wirklichkeit. Begonnen hatte Lynch die Thematik schon früher, zuletzt in *Mulholland Drive*. In *Inland Empire* hat er sie radikalisiert. *Inland Empire* ist also kein Film über virtuelle, sondern über durchweg reale Wirklichkeit. Das Kino repräsentiert neu entstandene reale Lebensorte. Medien wie die bildenden Künste, das Internet (Dekker 2011; Döring 2008) und speziell das Kino und seine Produktionsstätten wie Hollywood sind neu geschaffene reale Lebensorte. In sie wachsen Menschen hinein, werden hinein sozialisiert, leben dort real und müssen Identitäten entwickeln, die woanders nicht benötigt werden oder anzutreffen sind.

Früher hat man diese Lebensorte nur als Traumfabriken verstanden. Anders Lynch: In den Lebensorten geht es real vor allem um die seelischen Energien und Kräfte, von denen sie sich nähren und um die unglaublich psychotischen Prozesse, die sie freisetzen können kraft der in diesen Lebensorten vorherrschenden Formprozesse und Strukturen. Lynch betrachtet die Lebensorte, wie er es als Kind gelernt hat (Rodley 2006):

> Ich habe Leben in extremen Nahaufnahmen beobachtet … Ich erkannte, dass es unter der Oberfläche eine zweite Welt gibt, und noch mehr Welten, wenn man tiefer gräbt. Ich wusste es [schon] als Kind, aber ich konnte es nicht beweisen. Es war nur so ein Gefühl. Ein blauer Himmel und Blumen sind etwas Friedvolles, doch daneben gibt es eine zweite Macht – wilder Schmerz und Verwesung. Wie bei den Wissenschaftlern: Sie beginnen an der Oberfläche und fangen zu graben an. Sie dringen zu den subatomaren Partikeln vor, und auf einmal befinden sie sich in einer sehr abstrakten Welt. Sie haben etwas von den abstrakten Malern. Man kann sich kaum mit ihnen unterhalten, weil sie in einer ganz anderen Welt leben.

Man kann diese zweite Welt nur mit ihren eigenen Mitteln erfahrbar machen. Hollywood und andere sind reale, klar abgrenzbare Lebensraumkonstruktionen parallel zu den übrigen realweltlichen Räumen. Sie sind keine Fiktion oder Illusion, denn sie werden als tatsächlich und real wahrgenommen, und Leben wird in ihnen praktiziert (Lynch 2007). In ihnen werden unverwechselbare Körper- und Subjektkonstruktionen, Subjektivierungsformen, Identitätsaneignungen emanzipiert und verwirklicht, also nicht nur virtuell, sondern „real" gemacht. Wie der Film zeigt, kann dieser Raum zu einer Dystopie werden, und zwar nicht als Konstruktion psychischer Störung in einem Spielfilm (Fellner 2006), sondern weil die in den gesellschaftlich parallelen Räumen üblicherweise auf den Menschen einwirkenden Sozialisierungskräfte und Mechanismen hier nicht wirken, ja, geradezu nicht wirken sollten. So wird in Lynchs Kinoräumen die Entstehung von Vergangenheit durch Verdrängung ins Unbewusste aufgehoben. Ungeborenes oder Unvollständiges findet erstmals oder erneut Anschluss an die Gegenwart und muss mit schon Entwickeltem in einen Alptraum geraten. In *Inland Empire* ist es neues Begehren von Nikki, ein neues Ausprobieren und ein neues Erfahren ihres Körpers, das in eine Dystopie einmündet. Insofern *Inland Empire* als Film im Film über den Film gesehen wird, ist er nicht nur ein „moving painting" sondern er hat auch quasi-dokumentarischen Charakter, wie und warum es in solchen Welten so zugeht, die sich, um ein Wort von Paul Klee zu benutzen, zur Schöpfung gleichnisartig verhalten. „Wenn sie aus dem Kino kommen, wirkt er in ihnen fort": Wenn sie aus Hollywood kommen, wirkt es in ihnen fort.

Literatur und Dokumentationen

Danckwardt JF (2008) Mulholland Drive und Inland Empire. Werden oder Nichtwerden bei David Lynch. In: Laszig P und Schneider G (Hrsg) Film und Psychoanalyse. Kinofilme als kulturelle Symptome. Psychosozial, Gießen, S 125–146

Danckwardt JF (2012) „Meine Bilder sind klüger als ich" (Gerhard Richter 1993) -- Die Arbeit der Farben und Formen, die Macht der Bilder und ihrer Wirkungswege (im Druck)

Dekker A (2011) Cybersex. Sexuelle Beziehungen in realen und virtuellen Räumen. Vortrag im Rahmen des 70. Freudenstädter Psychotherapie-Seminars (im Druck

Döring N (2008) Sexualität im Internet. Ein aktueller Forschungsüberblick. Z Sexualforsch 21: 291–318

Fellner M (2006) psycho movie. Zur Konstruktion psychischer Störung im Spielfilm. transcript, Bielefeld

Gay V, Wizman A (2007) Portrait Americain: David Lynch. David Lynch, Meister des Abgründigen. Dokumentation. La grosse Boule Productions, ARTE France

Jerslev A (2006) David Lynch. Mentale Landschaften. Passagen Verlag, Wien (Erstveröff. 1991)

Lynch D (2007) Hollywood verliert an Macht. Spiegelinterview mit David Lynch. Der Spiegel 16 (16. 4. 2007)

Lynch D (2011) The Marriage of Picture and Sound. Bei: Eikmeyer R, Knoefel T (Hrsg). Original Recordings. Audio-CD. Verlag für Moderne Kunst

Rodley Ch (2006) Lynch über Lynch. Verlag der Autoren, Frankfurt (Erstveröff. 2005)

Röttger K, Jackob A (2006) Bilder einer unendlichen Fahrt. David Lynchs Mulholland Drive in bildwissenschaftlicher Perspektive. In: Koebner T, Meder T (Hrsg, in Verbindung mit Liptay F) Bildtheorie und Film. edition text + kritik, München, S 572–583

Seeßlen G (2007) David Lynch und seine Filme. 6. überarb. Aufl. Schüren, Marburg

Originaltitel	Inland Empire
Erscheinungsjahr	2006
Land	Frankreich, Polen, USA
Buch	David Lynch.
Regie	David Lynch.
Hauptdarsteller	Laura Dern (Nikki Grace/Susan Blue), Jeremy Irons (Kingsley Stewart), Justin Theroux (Devon Berk/Billy Side), Harry Dean Stanton (Freddy Howard)
Verfügbarkeit	DVD in OV und in deutscher Synchronisation erhältlich

Bernd Banholzer

Willkommen auf Pandora!

Avatar – Regie: James Cameron

Avatar

Regie: James Cameron

Willkommen auf Pandora! (■ Abb. 1) Sie befinden sich auf einem der insgesamt 14 Monde im Orbit eines riesigen Himmelskörpers, der wie Jupiter über Ihnen schwebt, in einem 6 Lichtjahre von der Erde entfernten Sonnensystem (Alpha Centauri). Dort gibt es hoch entwickeltes Leben und Rohstoffe, die es auf der Erde nicht gibt (vor allem Unobtanium). Von diesen versprechen sich die Menschen die Lösung der Energieprobleme der Erde. Die Atmosphäre Pandoras wirkt auf Menschen nach wenigen Minuten tödlich, weshalb Sie hier eine Atemmaske tragen müssen!

Damit Sie sich besser in dieser fremdartigen Welt zurechtfinden, bekommen Sie hier zunächst einmal ein „Survival-Pack" mit den wichtigsten Begriffen[1] für unsere Reise, ohne das Sie die folgende Inhaltsangabe kaum überstehen werden.

Unobtanium („unobtainable" – engl. nicht erwerbbar) – Ein silbergraues Mineral, der effizienteste Supraleiter kommt auf Pandora in großen Lagerstätten vor. Über diesen Unobtanium-Vorkommen wachsen riesige baumartige Gewächse. Mindestens einer dieser Bäume, der „Heimatbaum" (Kelutral), dient dem Na'vi-Clan der Omaticaya als Wohnbaum. Unobtanium ist als Supraleiter in der Lage, über der Oberfläche Pandoras zu schweben – so zum Beispiel in Form der Hallelujah-Berge, die über der Oberfläche Pandoras schweben (vgl. Meißner-Ochsenfeld-Effekt)[2].

Avatare – Avatare sind künstlich genetisch manipulierte Hybride aus menschlicher und Na'vi-DNA, die einem Na'vi-Körper weitgehend gleichen. Durch das Mitwirken menschlicher DNA sehen die Avatare den Menschen, von denen sie abstammen, ähnlich. Sie werden durch die Menschen, von denen sie abstammen, gesteuert („Operatoren"). Die Steuerung erfolgt über eine Verbindung der beiden Nervensysteme. Die Nervensysteme der Operatoren und der Avatare werden vor dem „Verlinken" der beiden aufeinander abgestimmt. Die Verlinkung erfolgt auf technischem Wege in einer Art „Hightech-Sarkophag", in dem der Mensch in eine Art REM-Schlaf versetzt wird. In diesem Zustand kann die „Verlinkung" erfolgen. Solange der Operator schläft, ist der Avatar lebendig und handelt, wie es sich der Operator vorstellt; sobald der Operator aufwacht, sackt der Avatar in sich zusammen und ist nicht erweckbar. Die Wissenschaftler auf Pandora verfügen über eigene Avatare, mit deren Hilfe sie Kontakt zu den Ureinwohnern aufnehmen und Flora und Fauna erforschen.

Na'vi – Dies sind humanoide Bewohner des Mondes Pandora. Sie sind ca. 3 m groß und haben eine blau getigerte Hautfarbe, gelbe Augen und katzenartige Eigenschaften: Sie fauchen, ihr Gesicht sieht katzenartig aus, sie bewegen sich katzenartig, sie haben einen Schwanz wie ein Löwe, und sie können gut klettern und springen. Sie sind sehr schlank und wirken vom Körperbau wie Barbie-Puppen mit übertrainierten Oberkörpern. Geschlechtsunterschiede sind nur mit Mühe auszumachen, obwohl sie – wie Indianer – nur spärlich mit Lendenschurz bekleidet sind. Ihre Knochen sind durch natürlich vorkommende Kohlefaser verstärkt, was sie fast unverletzbar macht. Na'vi sind wesentlich stärker als Menschen. Über einen „Zopf" an ihrem Hinterkopf, in dem neuronale Strukturen verlaufen, können die Na'vi eine neuronale Verbindung mit Tieren und Pflanzen herstellen.

Eywa – Die Vegetation auf Pandora ist durch synaptische Kontakte miteinander verbunden. Das so gebildete Netzwerk gleicht einem hoch entwickelten Nervensystem und hat eine Art Bewusstsein seiner selbst entwickelt. Die Lebewesen auf Pandora können Kontakt zu diesem Netzwerk herstellen. Die Na'vi bezeichnen diese vernetzte und sich ihrer selbst bewusste Lebenswelt als Eywa. In Eywa leben auch ihre verstorbenen Ahnen fort. An besonderen Orten wie etwa den Bäumen der Stimmen können die Na'vi durch Tsaheylu unmittelbaren Kontakt zu Eywa herstellen[3].

Tsaheylu – Als Tsaheylu (Band – Verbindung) bezeichnen die Na'vi eine Art synaptische Verbindung, die sie mit verschiedenen Lebewesen herstellen können. Tsaheylu befähigt die Na'vi, andere Organismen, etwa die Ikran, zu zähmen und zu steuern. Dieses Band wird von den Na'vi mit einem zopfartigen ummantelten Nervenstrang, der an ihrem Hinterhaupt sitzt, und entsprechenden Organen der anderen Lebewesen hergestellt (wie ein biologischer „USB-Neuroport").

1 http://de.james-camerons-avatar.wikia.com/wiki/Avatar_Wiki. Zugegriffen am 27. 12. 2011
2 http://de.wikipedia.org/wiki/Mei%C3%9Fner-Ochsenfeld-Effekt. Zugegriffen am 27. 12. 2011
3 Das Konzept des Netzwerks erinnert an die Gaia-Hypothese von Lynn Margulis und James Lovelock: Die Erde und ihre gesamte Biosphäre können als Lebewesen betrachtet werden. Die Gesamtheit aller Organismen lässt Bedingungen entstehen, die nicht nur Leben, sondern auch eine Evolution komplexerer Organismen ermöglichen. http://de.wikipedia.org/wiki/Gaia-Hypothese. Zugegriffen am 27. 12. 2011

Tsaheylu ist darüber hinaus auch eine wichtige Komponente der Religion der Na'vi, denn auch mit Eywa können sie auf diese Art kommunizieren. Dazu suchen die Na'vi bestimmte, als heilig verehrte Orte auf, wie etwa den Baum der Stimmen oder den Baum der Seelen.

Der Baum der Seelen – Er ähnelt einer Trauerweide mit langen neonrosa leuchtenden Hänge-Zweigen, in denen sich neuronale Strukturen befinden, über welche die Na'vi Zugang zu Eywa und auch zu den Erinnerungen ihrer in Eywa fortlebenden Ahnen bekommen können. Die Na'vi verehren den Baum der Seelen als ihren heiligsten Ort. Durch die zentrale Stellung des Baumes der Seelen im neuronalen Netzwerk Pandoras ist es möglich, „den Geist" eines Lebewesens dort aufnehmen zu lassen und in ein anderes Lebewesen zu übertragen. Diese geschieht am Ende mit Jake Sully, der nicht mehr in seinem menschlichen Körper, sondern in dem Avatar weiterleben möchte.

Banshee (Na'vi: Ikran) – Flugsaurier oder Flugdrachen, die den Na'vi als Reittiere dienen und die über Tsaheylu gesteuert werden.

Toruk – „Der letzte Schatten" ist der größte und gefährlichste Flugdrache (Flügelspannweite über 25 m).

Toruk Makto (Drachenreiter) – Ein Na'vi, der den riesigen Toruk bändigen konnte. Dieses äußerst riskante Unternehmen ist in der Geschichte der Na'vi seit der Zeit der ersten Lieder erst sechsmal gelungen. Der letzte dieser Auserwählten war der Ur-Ur-Großvaters Neytiris, der auf diese Art und Weise die Na'vi in den Zeiten großer Not zusammenführte.

Corporal Jake Sully – Kriegsversehrter, von der Hüfte abwärts querschnittsgelähmter ehemaliger Soldat des US-Marine Corps („Ledernacken"), der seinen kurz zuvor ums Leben gekommenen Zwillingsbruder Tom im Avatarprojekt ersetzt, da er mit ihm genetisch identisch ist und so den Avatar Toms steuern kann. Zu Beginn des Filmes ist er eine verlorene Seele, die Halt bei einer autoritären militärischen Vaterfigur sucht. Dann findet er an der mütterlichen Welt der Ureinwohner Gefallen und wird zum stärksten Gegner seines Vorgesetzten.

Neytiri – Tochter des Häuptlings Eytukan und der Schamanin Mo'at des Clans der Omaticaya vom Volk der Na'vi. Sie begegnet Jake Sully in dessen Avatar-Körper. Von der Schamanin des Stammes wird sie als Mentorin für Jake bestimmt. Später verliebt sie sich in ihn, und schließlich werden die beiden ein Paar.

Dr. Grace Augustin – Kettenrauchende kaltschnäuzige Biologin, die Pflanzen mehr als Menschen mag und wissenschaftliche Leiterin des Avatarprogramms ist. Sie wird schließlich auf der Flucht von Colonel Quaritch, dessen Gegnerin sie ist, tödlich getroffen und geht dann in Eywa ein, wird ein Teil der Welt, die sie beforscht und geliebt hat.

Colonel Miles Quaritch – Ehemaliger Colonel des US-Marine Corps, jetzt Leiter des Sicherheitsdienstes der RDA, den er wie eine Truppe von Marines leitet. Um nicht weich zu werden und von Pandora „gefressen zu werden", trainiert er sich in jeder Hinsicht Härte an. Für ihn trifft die Beschreibung „zäh wie Leder, hart wie Kruppstahl" sprichwörtlich zu. Er steht den Na'vi feindlich gegenüber und hält wenig von einer friedlichen Verständigung. Nachdem er in dieser für ihn extrem feindlichen Umgebung jeden Kampf gewonnen hat, wird er schließlich von Neytiri besiegt.

Die Handlung[4]

Im Jahr 2154 sind die Rohstoffvorkommen und die Energievorräte der Erde erschöpft. Die Menschen suchen nach Alternativen im Weltall. Auf Pandora entdecken sie große Vorkommen Unobtanium. Hier betreibt der Konzern „Resources Development Administration" (RDA) Minen zum Abbau des begehrten Rohstoffs. Dabei stößt er jedoch auf Schwierigkeiten: Die Atmosphäre von Pandora ist für Menschen giftig, und die Ureinwohner Pandoras sind nicht gewillt, ihre Heimat durch die Menschen zerstören zu lassen. Während die Menschen den Reichtum Pandoras im Unobtanium sehen, sehen ihn die Na'vi im vernetzten Zusammenwirken allen Lebens auf Pandora. Um Pandora zu erforschen, die Kluft zwischen den Menschen und den Na'vi zu überbrücken und um militärisch wertvolle Informationen zu sammeln, wird ein Avatar-Programm ins Leben gerufen. Mit Hilfe der Avatare können die Menschen Pandora und die Na'vi kennen lernen. Dieses wird von einer renommierten Wissenschaftlerin geleitet, deren wissenschaftliche Interessen im Konflikt mit den kommerziellen und militärischen Interessen der RDA stehen.

4 http://de.james-camerons-avatar.wikia.com/wiki/Avatar_Wiki. Zugegriffen am 25. 12. 2011
http://de.wikipedia.org/wiki/Avatar_%E2%80%93_Aufbruch_nach_Pandora. Zugegriffen am 25. 12. 2011

Einer der Wissenschaftler, der einen der Forschungs-Avatare steuern soll, ist Tom Sully. Dieser kommt kurz vor dem geplanten Flug nach Pandora ums Leben. Da sein Zwillingsbruder Jake (Sam Worthington) mit ihm genetisch identisch ist, kann er den für Tom gezüchteten Avatar steuern und wird an seiner Stelle in das Avatar-Programm aufgenommen. Jake ist jedoch kein Wissenschaftler, sondern Soldat. Dadurch kommt er in eine Schlüsselposition, die zahlreiche innere und äußere Konflikte mit sich bringt. Als Ex-Marine identifiziert sich Jake weniger mit dem wissenschaftlichen Programm als mit Colonel Quaritch (Stephen Lang), dem Leiter der Sicherheitsabteilung der RDA, der dem versehrten jungen Kollegen väterlich gegenüber tritt. So steht Jake im Konflikt zwischen der Leiterin der wissenschaftlichen Abteilung, Dr. Grace Augustin (Sigourney Weaver), und dem Leiter der Sicherheitsabteilung, für den er „under cover" zu arbeiten beginnt. Seine ursprüngliche Motivation für die Mitarbeit im Avatar-Projekt war der Wunsch, sich Geld für eine Operation zur Wiederherstellung der Beweglichkeit seiner Beine zu verdienen. Im Avatar-Programm verfügt er jedoch in Form des Avatars über einen intakten Körper, dessen Funktionsfähigkeit ihn begeistert. Mit Hilfe dieses Körpers lernt er eine neue, fremde Welt kennen, in der er sich zunächst wie ein „Baby" verhält: die Wildnis von Pandora. Diese erscheint dem Soldaten Jake Sully zunächst feindlich (wie Quaritch sagt: schlimmer als die Hölle). Er verliebt sich in die schöne Häuptlingstochter Neytiri (Zoë Saldaña), die seine Lehrerin wird und ihm die Welt der Ureinwohner zeigt, welche dann zunehmend eine magische Anziehungskraft auf ihn ausübt. Er macht viele „Überstunden" und vergisst, seinen menschlichen Körper zu ernähren und zu pflegen, da er sich hauptsächlich im Körper des Avatar aufhält und die Welt von Pandora und deren Bewohner kennen und lieben lernt. Dies wiederum hat zur Folge, dass die ursprünglich gute Beziehung zu Colonel Quaritch langsam schlechter wird und schließlich in offene Feindschaft übergeht. Jake lehnt die Abberufung vom Avatar-Projekt und das Angebot der Rückkehr auf die Erde, wo er sich operieren lassen könnte, ab, um weiterhin in der Welt der Na'vi auf Pandora bleiben zu können. Hier gerät er zusammen mit den unter der Leitung von Dr. Augustin arbeitenden Wissenschaftlern und einigen verbündeten Militärs in einen zunehmend offener werdenden Konflikt mit Colonel Quaritch, da Letzterer nun mit Hilfe des Avatar-Projekts und letztlich mit Jakes Hilfe genügend Informationen über Pandora und über die Na'vi gesammelt hat, um seine Ziele auf militärischem Wege erreichen zu können.

Das Volk der Na'vi wird in zwei Angriffswellen von der militärischen Übermacht der RDA überrollt, wobei Jake und die Wissenschaftler sich auf die Seite der Ureinwohner stellen und mit diesen gegen die RDA bzw. die Menschen kämpfen (◐ Abb. 2). Jake, der ohne dies beabsichtigt zu haben, eine Zeit lang als Doppelagent fungiert hat, wird sowohl von Colonel Quaritch als auch von Neytiri und dem Volk der Na'vi als Verräter angesehen und steht vorübergehend ganz alleine da. In dieser Position muss er sich beweisen und wächst über sich hinaus. Er bezwingt das mächtigste Wesen auf Pandora, den riesigen Feuerdrachen „Toruk" (genannt „der letzte Schatten"), und gewinnt dadurch das Vertrauen und die Macht im Volk der Na'vi zurück. Schließlich einigt er alle Clans der Omaticaya unter sich und führt sie als „Toruk Makto" („Reiter des letzten Schattens") gegen die Armee der Menschen an – nicht ohne vorher zu „Eywa" gebetet zu haben, ihm im Kampf gegen die „Himmelsmenschen" (…, die Pandora vernichten werden, so wie sie ihre eigene Mutter Erde auch vernichtet haben") zu helfen. In der zweiten Angriffswelle werden die vereinigten Clans der Omaticaya jedoch ebenfalls von der Armee der Himmelsmenschen besiegt, welche unter der Führung von Colonel Quaritch und dem leitenden RDA-Manager den Baum der Seelen sprengen möchten. In letzter Sekunde aber steht alles Leben auf Pandora gegen die Eindringlinge auf und schlägt diese zurück. In einem finalen Showdown kämpft „Papa Dragon", Colonel Quaritch gegen den Drachenreiter, Jake Sully, seinen einstigen Schützling. Er besiegt ihn, indem er ihn aus dem Schlaf reißt, sodass Jakes Avatar zusammensackt. Schließlich gelingt es Neytiri, den Colonel in seinem Kampfroboter mit zwei Pfeilen zu töten.

Die Menschen verlassen Pandora, und nur einige Auserwählte bleiben zurück. Neytiri hat Jake das Leben gerettet. Sie hat Jake-Mensch erkannt. Mit Hilfe einer großen Zeremonie am Baum der Seelen wird der Geist von Jake-Mensch auf den Avatar übertragen, sodass der Körper von Jake-Mensch nun

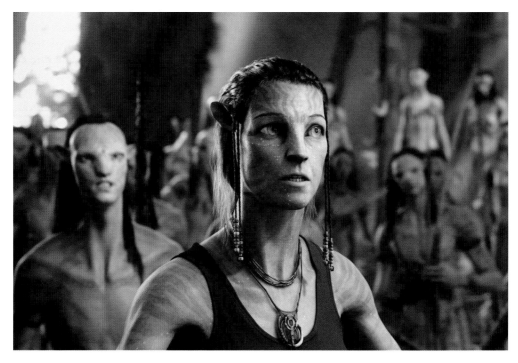

◘ Abb. 2 Der Avatar von Dr. Grace Augustin und das zum Kampf bereite Volk der Na'vi. (Quelle: 20th CenturyFox/Allstar/Cinetext)

sterben kann, während Jake im Avatar weiterlebt. Bei den Kämpfen sind viele Männer, vor allem die wichtigsten Männer der Na'vi, ums Leben gekommen. An deren Stelle tritt nun Jake und wird Oberhaupt der Na'vi, neben Neytiri und deren Mutter Mo'at, der Schamanin des Stammes. Er bleibt im Körper des Avatar auf Pandora und kehrt nie wieder als Mensch zur Erde zurück.

Hintergrund

Entstehung

Der erste Drehbuchentwurf von *Avatar* entstand 1995 und wurde von allen Seiten abgelehnt, da die Realisierung unmöglich erschien. Regisseur Cameron blieb aber hartnäckig und arbeitete weiter an einzelnen Themen und Projekten, die zur Vorbereitung der Realisierung seiner Filmidee nötig waren. Diese Vorbereitungsarbeiten für Avatar dauerten länger als die gesamte Produktion von Titanic. Es wurden zwei komplett verschiedene Kamerasysteme entwickelt: für die reale Welt ein 3-D-Kamerasystem („Fusion-Camera") und für die virtuellen Szenen ein virtuelles Kamerasystem. Die Entwicklung der 3-D-Kamera dauerte mehrere Jahre. Erstmals wurde ein Verfahren entwickelt, mit dem man „Performance-Capture" in Echtzeit betreiben konnte (über eine sog. „virtuelle Kamera"): Hunderte von Markierungen auf dem Körper eines Schauspielers, welche seine Lage im Raum digital markieren, werden von Hunderten von „Kameras", die den Raum aus verschiedensten Perspektiven einfangen, aufgezeichnet. Die Aufzeichnungen dieser „Kameras" (einer Art GPS-Empfänger für die Markierungen am Körper des Schauspielers) werden von sehr leistungsstarken Rechnern in Echtzeit zu einem sich im Raum bewegenden Körper zusammengesetzt. Dieses Skelett von Markierungen kann nun auf eine computergenerierte Figur übertragen werden. Diese Echtzeitdarstellung wird dann auf der „virtuellen Kamera" (einem Monitor), welche der Regisseur in der Hand hält, sichtbar. Der Regisseur sieht also

nicht den Schauspieler, welcher gerade eine Bewegung ausführt, sondern in Echtzeit die Figur, die der Computer aus dem Schauspieler generiert, in der ebenfalls computergenerierten Umgebung.

Ein wichtiger Schritt zur Verwirklichung einer echt wirkenden Avatar-Mimik war es, den sogenannten „blind-eye-effect" zu eliminieren. Dafür erhielten die Schauspieler während der Dreharbeiten Helme mit Referenzkameras, die so am Helm befestigt waren, dass sie das Gesicht des Schauspielers aus einem Abstand von ca. 15 cm filmen konnten. Mit diesen wurden die Augen und die Mimik noch einmal differenziert erfasst, um in die Computeranimation integriert zu werden und so ein echt wirkendes Avatar-Gesicht zu erhalten. 85 % der Bewegungen, der Mimik und Gestik der Schauspieler wurden für die Computeranimationen übernommen, die restlichen 15 % wurden am Computer dazu generiert (zum Beispiel wie sich die Ohren oder die Schwänze der Na'vi bewegen). Da die Na'vi jedoch kaum Falten haben, wirkt die Mimik dennoch etwas „botoxartig".

Die Konstruktion und Gestaltung der verschiedenen Welten, die in *Avatar* aufeinander prallen, wurden von unterschiedlichen Teams in verschiedenen Ländern (USA, Neuseeland) geleistet. Verschiedene Spezialisten waren jeweils zuständig für: technische Gerätschaften, Tiere, Pflanzen, Ureinwohner, Kleidung, Schmuck, Sprache, Filmmusik.

Ein riesiger Stab von fachlich hochqualifizierten Mitarbeitern war also Jahre lang damit beschäftigt, künstlerisch, grafisch, technisch, wissenschaftlich und kulturell eine fremde Welt zu erschaffen.

Die Schauspieler wurden speziell für die einzelnen Rollen ausgebildet. So musste Sam Warthington, der Jake Sully spielt, zum Beispiel eine spezielle Militärausbildung absolvieren. Auch die anderen Schauspieler lernten Reiten, Bogenschießen, Tanzen etc. und bekamen ein spezielles Sprachtraining. Insbesondere mussten alle Darsteller von Na'vi lernen, sich katzenartig zu bewegen.

So entstand der Film als ein Hybrid aus Realdarstellungen und Computeranimationen, wobei ca. 60 % des Films am Computer generiert wurden. Für all die neuartigen Technologien war eine extrem leistungsfähige Hardware erforderlich: Bis zu 40.000 wassergekühlte Prozessorkerne, 105 Terabyte Arbeitsspeicher und 2 Pentabyte Festplattenplatz. Trotzdem benötigten einzelne Szenen bis zu 48 Stunden zum Rendern[5], wobei bei einer Filmminute ca. 17,3 Gigabyte Daten anfielen.

Nach jahrelangen Vorbereitungen und Forschungsarbeiten wurde erst 2007 definitiv entschieden, den Film zu drehen. Insgesamt dauerte die Avatar-Produktion 4 bis 5 Jahre.

Das Ergebnis ist ein extremer Hightech-Film, der von einem höchst untechnologischen Thema handelt, nämlich unserer Beziehung zur Natur, wie Hightech uns von der Natur entfremdet und welche Folgen sich daraus ergeben.

Kosten

Mit 230 bis 300 Mio. US-Dollar war Avatar einer der teuersten Filme aller Zeiten. Mit einem Einspielergebnis von über 2,7 Mrd. US-Dollar war er der erfolgreichste Kinofilm aller Zeiten (nach Titanic, der mit 1,8 Mrd. US-Dollar auf Platz zwei liegt). Zieht man Produktionskosten von 230 bis 300 Mio. Euro und Marketingkosten in Höhe von ca. 150 Mio. davon ab bleibt ein Gewinn von über 2,3 Mrd. US-Dollar übrig.

5 Bildsynthese oder „Rendern" (dt.: berechnen) bezeichnet in der Computergrafik die Erzeugung eines Bildes aus Rohdaten (auch Szene genannt). Eine Szene ist ein virtuelles räumliches Modell, das Objekte und deren Materialeigenschaften, Lichtquellen, sowie die Position und Blickrichtung eines Betrachters definiert. Beim Rendern müssen üblicherweise folgende Aufgaben gelöst werden: die Ermittlung der vom virtuellen Betrachter aus sichtbaren Objekte (Verdeckungsberechnung), die Simulation des Aussehens von Oberflächen, beeinflusst durch deren Materialeigenschaften (Shading), die Berechnung der Lichtverteilung innerhalb der Szene, die sich unter anderem durch die indirekte Beleuchtung zwischen Körpern äußert. http://de.wikipedia.org/wiki/Bildsynthese. Zugegriffen am 26. 12. 2011

Regisseur und Drehbuch

James Cameron wurde 1954 in Kanada als Sohn eines Elektrotechnik-Ingenieurs und einer Malerin geboren und wuchs dort bis zu seinem 17. Lebensjahr an der Grenze zu den USA auf. 1971 zog die Familie nach Kalifornien. Da eine Ausbildung an einer Filmschule zu teuer war, begann er zunächst ein Physikstudium, welches jedoch an seinen Mathematikleistungen scheiterte. Anschließend studierte er englische Literatur und arbeitete nach dem Abschluss des Studiums und der Eheschließung mit seiner ersten Frau als Lastwagenfahrer. Seine erste Ehe scheiterte, nachdem er seine Leidenschaft für das Filmemachen wieder entdeckt hatte und nebenberuflich versuchte, sich alles anzueignen, was er zum Filmemachen brauchen konnte.

1979 drehte er seinen ersten Kurzfilm und gab während der Produktion seinen Job als Lkw-Fahrer auf. Sehr ehrgeizig arbeitete er anfangs vor allem hinter den Kulissen. Seine ersten Filme waren eher Enttäuschungen, bei denen er jedoch viel lernte. 1982 schrieb er das Drehbuch für den Film *Terminator*, welches auf einem Albtraum von ihm beruhte. Es gibt die Geschichte, dass er das Drehbuch für einen Dollar an die Produzentin Gale Anne Hurd (seine spätere Ehefrau) verkaufte, gegen die Zusage, die Regie des Filmes übernehmen zu dürfen. Bis zum Beginn der Dreharbeiten von *Terminator* schrieb er weitere Drehbücher: für *Alien – die Rückkehr* und *Rambo 2*". In seinem 1989 präsentierten Kinofilm *Abyss* wendete er völlig neue Tricktechniken an, wie das Morphing, fotorealistische Computeranimationen und Unterwasser-Bluescreen, welche teilweise eigens für diesen Film entwickelt wurden, und später auch bei *Terminator 2* zur Anwendung kamen.1990 gründete Cameron seine eigene Filmproduktionsfirma und 1993 eine eigene Special-Effects-Firma („Digital Domain").1997 präsentierte Cameron den mit 11 Oscars ausgezeichneten Film Titanic. Nach Titanic arbeitete er an der Entwicklung neuer Filmtechniken und Effekte und produzierte Fernsehfilme und -dokumentationen. Parallel dazu lief die Arbeit an *Avatar* an. Neben seinen Filmproduktionen engagiert sich Cameron für Umweltprojekte. Cameron ist seit 2000 in fünfter Ehe mit Suzy Amis verheiratet, die er bei den Dreharbeiten zu Titanic kennengelernt hat. Er hat vier Kinder, davon drei aus der fünften und eines aus der vierten Ehe.

Das Drehbuch

Hierzu berichtet Cameron[67], der Hintergrund für das Drehbuch sei sein gesamtes Leben gewesen. Er sei als Kind viel im Wald gewesen, habe jegliches Getier geliebt, eingefangen und studiert. Er sei mit einem tiefen Staunen über die Natur aufgewachsen. Außerdem sei er begeistert gewesen von Sciencefiction- und Phantasy-Filmen und habe eine ausgeprägte künstlerische Ader gehabt, habe viel gemalt und gezeichnet. Es habe keinen einzelnen Moment der Inspiration für dieses Drehbuch gegeben, sondern es sei die Summe seiner Erfahrungen und Begabungen – es sei also sein ganzes Leben lang in ihm gewachsen. Cameron ließ sich dabei von Romanen inspirieren, die er als Kind gelesen hatte. Anlehnungen an die Geschichte von Pocahontas seien kein Zufall: Sie handelt von einer Zivilisation, die durch Eindringlinge bedroht wird. Einer der Eindringlinge verliebt sich in eine der Eingeborenen usw.

Filmwirkung

Durch die dreidimensionale Darstellung wirkt der Film sehr real und zieht den Zuschauer so sehr in seinen Bann, dass manchen Zuschauern schlecht wird, weil es zu Koordinationsschwierigkeiten zwischen dem vestibulären und dem optischen System kommt. Das optische System gaukelt Bewegungen vor, die vom vestibulären System nicht bestätigt werden.

6 James Camerons Avatar. Extended Collector's Edition; DVD-Video 5068108, 20th Century Fox/Lightstorm.

7 http://de.wikipedia.org/wiki/Avatar_%E2%80%93_Aufbruch_nach_Pandora#Inspiration. Zugegriffen am 22. 12. 2011.

Intellektuelle Zuschauer dürften von dem Film zunächst einmal peinlich berührt sein. Der Handlungsstrang ist es sehr einfach, die Geschichte sehr simpel gestrickt. Im Gegensatz zur dreidimensionalen Darstellung des Films sind die einzelnen Charaktere eher eindimensional und nicht sehr vielschichtig gezeichnet. Man weiß am Anfang schon, wie der Film ausgehen wird, weil man „Winnetou" schon gelesen hat.

Dagegen sind die optischen Effekte dieser Kunstwelt überwältigend. Es ist unglaublich, mit welcher Detailtreue und Präzision eine (Kunst-)Welt dargestellt wird und dem Gehirn vorgaukelt werden kann, sie wäre Wirklichkeit.

Faszinierend sind auch die Ideen, die den Details dieser künstlichen Welt zu Grunde liegen. Zum Beispiel die Vielfalt der Flora und Fauna und die Vernetztheit derselben sowie die schwebenden Berge, die unseren physikalischen Grundgesetzen widersprechen. An einem anorektischen Körperideal orientiert zu sein erscheint die Gestalt der Na'vi, die aussehen wie überdimensionale Barbie-Puppen, deren Geschlecht spontan oft nicht leicht zu erkennen ist, da sowohl Männer als auch Frauen hauptsächlich lang und dünn aussehen. Man bekommt den Eindruck, dass Geschlechtlichkeit und Fleischlichkeit in diesem Film sekundär sind und nicht deutlich dargestellt werden. Die einzigen klar erkennbar weiblichen Wesen sind Grace und Judy, welche sich aber beide nicht besonders feminin verhalten: Die eine verhält sich wie ein Wissenschaftler, die andere wie ein Soldat. Beziehungen zu Männern scheinen beide nicht zu haben.

Dennoch hinterlässt der Film bei vielen Zuschauern ein Gefühl der Sinnhaftigkeit oder den Wunsch nach mehr Sinnhaftigkeit in ihrem relativ profanen und farblosen Leben, in das sie nach dem Genuss dieses Filmes wieder entlassen werden. Vernetztheit, Verbundenheit, Geborgenheit, Aufgehoben-Sein in einem großen Ganzen, Teil-Sein einer großen Familie beziehungsweise einer großen Welt, einer großen Mutter, die einen in jedem Fall wieder in ihren Schoß aufnimmt, wenn man dieses Leben beendet hat – das alles sind archetypische Vorstellungen, die den Zuschauer ansprechen und auf ihn wirken. Schließlich macht der Film auch Lust auf ein unbeschwertes Sich-Einlassen auf Abenteuer und auf Neues-Erleben.

Aus psychoanalytischer Sicht bedeutsame Schwerpunkte der Handlung

Realität und Virtualität

Die Charakterisierung der beiden unterschiedlichen Welten als Realität und Fiktion, Wirklichkeit und Fantasie ist nicht möglich, da beide Welten Fiktionen sind. Die eine Welt erscheint uns aber als realitätsnäher und die andere eindeutig als Fantasiegebilde. Die Welt, die uns realitätsnah erscheint, hat viele Ähnlichkeiten mit unserer westlichen Zivilisation, auch wenn sie technologisch wesentlich weiter entwickelt ist. In der Welt, die uns eindeutig als Fiktion erscheint, gibt es wenig uns aus unserem Alltag Bekanntes. Weder die Tiere, noch die Pflanzen, noch die höheren Lebewesen, noch die Gesetze der Physik entsprechen denen, mit denen wir alltäglich zu tun haben. Deswegen möchte ich die Welt auf Pandora kurz als „Fantasiewelt" bezeichnen, während ich die High-Tech-Welt der Menschen als „Realität" bezeichne.

Die „Realität" kann man beschreiben als eine Welt des Kommerzes, der Hochtechnologie, der Wissenschaft, des rational-logischen und analysierenden Denkens, während die „Fantasiewelt" eher unterentwickelt erscheint: eine primitive Welt, die auf dem Niveau von Wilden stehen geblieben ist, welche gerade einmal über Pfeil und Bogen verfügen und noch nicht einmal das Rad erfunden haben. In dieser primitiven Ur-Welt leben „die Wilden" im Einklang mit einer üppigen, vielfarbigen Wildnis, mit der sie – und nicht nur durch eine Art mystisch-ökologischer Weltanschauung, sondern durch eine Art allumfassender neuronaler Vernetzung – verbunden sind. Hier spielt weniger das rational-analytische

und zergliedernde Denken eine Rolle, als vielmehr eine eher vegetativ-intuitive Verbundenheit auf einer präverbalen, eher prozeduralen Ebene (Jake muss erst lernen, zu denken oder – besser – zu empfinden, wie sich seine Reittiere bewegen sollen, damit er diese steuern kann, da diese nicht auf Worte, sondern auf prozedurale Impulse zu reagieren scheinen). Es ist eine Welt, reich an Vegetation und an vegetativen, irrationalen Verbindungen. Von den Na'vi werden die Menschen „Himmelsmenschen" genannt, was einen Gegensatz darstellt zu den „Wald-Wesen", die von den Na'vi verkörpert werden. Dem Himmel beziehungsweise dem luftigen Element werden das Bewusstsein und männliche Eigenschaften zugeordnet, während der Erde oder dem Wald das Unbewusste, Vegetative und die weibliche Sphäre zugeordnet werden (Herder Lexikon 1991). Jake taucht also sozusagen aus der patriarchalen bewusstseinsdominierten Männerwelt ab, in eine mit dem Unbewussten assoziierte mütterliche, der Erde und dem vegetativen Leben verbundene Welt[8].

Der Übergang von der einen (Realität) in die andere (Fantasie, Traum) Welt wird im Film mittels einer „Verlinkungsmaschine", eines schlafinduzierenden „Hightech-Sarkophags", erreicht, der eine Art Pforte und Transportmittel gleichzeitig darstellt. In anderen Filmen wird dieser Übergang zwar mit einer ähnlichen Symbolik, jedoch ohne Hightech dargestellt: Im Film *The Jacket*[9] wird der Protagonist in die Enge eines Schubfaches einer Leichenkammer gezwungen, wobei durch die totale Fixierung des physischen Körpers und die damit einhergehenden klaustrophobischen Ängste ein Heraustreten aus dem normalen Alltagsbewusstsein erzwungen wird.

Dem Bedürfnis nach einer Verbindung mit einer anderen Welt mag die Erfahrung der Begrenzung oder der Frustration in der realen Welt zu Grunde liegen. Dann wäre der Wunsch des Übertritts in eine andere Welt als eine Flucht anzusehen, eine Flucht aus den schwer lösbaren Konflikten und Belastungen der Gegenwart bzw. als eine Flucht aus der einseitig männlich dominierten Welt. Andererseits könnte man den Wunsch nach einer anderen Welt aber auch als eine Annäherung an eine unbewusste weiblich dominierte Ur-Welt, die in Jakes Leben fehlt, ansehen, weshalb es sich so leer anfühlt. Und schließlich sind Menschen neugierig und wollten schon immer neue Welten entdecken, erkunden und sich aneignen.

Einer der Filme, die Camerons beruflichen Weg entscheidend mit beeinflusst haben, ist Stanley Kubrick's -Film *2001: Odyssee im Weltraum*, ein Film, in dessen zweiter Hälfte psychedelisch wirkende Bilder auftauchen, in denen es auch um eine Reise in eine andere Zeit, in eine andere Welt beziehungsweise eine andere Dimension geht, um Tod und Wiedergeburt. Ähnliche, schamanistisch oder psychedelisch anmutende Bilder waren ursprünglich auch für *Avatar* gedreht worden, fielen jedoch schließlich großteils dem Schnitt zum Opfer. In den 70er-Jahren waren die „Transportmittel" in andere Welten psychotrope Substanzen wie Mescalin, psychotrope Pilze oder LSD. Damals beschrieb zum Beispiel Carlos Castaneda[10] (1975; 1976) in seinen Büchern die Reise eines jungen Anthropologiestudenten in eine andere Wirklichkeit („Eine andere Wirklichkeit", „Reise nach Ixtlan" etc.). Auch hier verschwimmt häufig die Grenze zwischen Realität und Fantasie, ist häufig unklar, ob sich der Protagonist im Traumzustand oder in der realen Welt befindet, beziehungsweise wird die reale Welt zunehmend nebensächlicher, angesichts der eindrucksvollen Erfahrungen im Mescalinrausch bzw. im Zustand der „Bewusstseinserweiterung". Hier wird ebenfalls suggeriert, dass man, wenn man reif genug geworden ist, aus der realen Welt in eine über-reale Welt eintreten kann und dann diesen Planeten verlässt, ohne einen physischen Tod zu sterben[11]. In unserer hochtechnisierten modernen Zeit, in der Gehirnscans und neurobiologische Forschungen die Welt in Staunen versetzen, scheinen psychotrope Drogen, schamanistische Trance- oder buddhistische Meditationstechniken nicht mehr so angesagt zu sein wie in

8 Jake erklärt Eywa, er komme aus einer Welt, in der es kein Grün gebe, weil die Himmelsmenschen ihre Mutter getötet hätten.
9 *The Jacket* 2005, R.: John Maybury, HD.: Adrien Brody
10 http://de.wikipedia.org/wiki/Carlos_Castaneda. Zugegriffen am 28. 12. 2011
11 http://de.wikipedia.org/wiki/Carlos_Castaneda. Zugegriffen am 28. 12. 2011

den 70er-Jahren, sodass in den heutigen Filmen als „Transportmittel" eher etwas Technisches gewählt wird – zum Beispiel „Neuroports" (*eXistenZ, Matrix*) oder Apparate zur Trauminduktion (*Inception, Avatar*).

Das Fremde und die Begegnung

Das Thema des Kontaktaufnehmens und Kennenlernens von fremden Welten beziehungsweise fremden Wesen spielt im Film *Avatar* eine große Rolle. Auf Pandora treten viele Lebewesen über „Tsaheylu" miteinander in Kontakt. Dieses Band ermöglicht eine Art vegetativer Kontaktaufnahme oder Kontaktaufnahme mit dem Inneren eines fremden Lebewesens, sodass hier die Filter zwischen zwei Wesenheiten (Abstand, Haut etc.) außer Kraft gesetzt werden[12]. Hierdurch wird die Idee einer intensiven Verbundenheit auch mit dem Unbewussten anderer Wesen suggeriert. Diese Idee geht über das Eintauchen ins eigene Unbewusste hinaus. Hier wird ein fremdes Unbewusstes dargestellt, beziehungsweise (am Baum der Seelen) auch das Eintauchen in das kollektive Unbewusste. Diese intensiv verbindende beziehungsweise entgrenzende Symbolik wird in *Avatar* sehr positiv und weitgehend nebenwirkungsfrei beschrieben. Es findet sich nur ein kurzer Augenblick im Film, in dem der Schreck, die Überforderung oder gar die Traumatisierung erahnbar werden, die mit einer solchen intensiven Verbindung oder Entgrenzung einhergehen können: Es ist der Augenblick, in dem die Pupillenreaktion nach der Verbindung mit dem Band dargestellt wird. Ansonsten wird die Überflutung mit unbewussten Inhalten nicht weiter problematisiert[13].

An dieser Stelle möchte ich die Realitätsanpassung des Menschen und deren Auswirkungen thematisieren: Das Gehirn versucht in einem fortlaufenden Prozess, die Realität zu erfassen und abzubilden. Der Mensch verfügt über die Fähigkeit, die äußere reale Welt innerlich mehr oder weniger realistisch abzubilden, sozusagen ein inneres Abbild / eine innere Bühne zu schaffen, die der äußeren Welt entspricht. Hinzu kommt die Fähigkeit, dieses innere Abbild durch Ideen und Fantasien auszubauen und zu bereichern. In diesem kurzen Artikel möchte ich nicht weiter auf die Herkunft dieser Fantasien eingehen und lediglich auf die archetypischen Verbindungen des Unbewussten hinweisen. Diese Fähigkeit des Menschen hat schon zu allen Zeiten zur Produktion von Fantasiegebilden in Form von Bildern oder erzählten Geschichten geführt beziehungsweise auch Rückwirkungen auf die äußere Realität gehabt, in Form von kreativen Handlungen oder Erfindungen, welche die äußere Realität wiederum verändert haben.

In unserer Zeit nimmt die Möglichkeit der Einflussnahme von Fantasien auf die äußere Realität eine neue Dimension an, wie der Film zeigt. Fantasien werden nicht nur in Bild oder Schriftform äußerlich sichtbar dargestellt, sondern es gibt immer mehr Möglichkeiten, diese Fantasien so realistisch zu gestalten, dass sie unseren Wahrnehmungsapparat und damit unser Erleben direkt beeinflussen. Während es beim Betrachten von unbewegten Bildern oder beim Zuhören von Erzählungen für den „Empfänger" dieser Informationen noch relativ einfach ist, zu erkennen, dass es sich dabei nicht um eine aktuelle, gerade sich ereignende Realität handelt, weil zahlreiche andere aktuell empfangene Informationen nicht kongruent mit den in Bild- oder Wortform übermittelten Geschichten sind, ist dies beim Film, insbesondere bei 3-D-Filmen, etwas anders. Durch die 3-D-Darstellung taucht man wesentlich intensiver in die Geschichten ein, wird das Miterleben wesentlich realer empfunden. Je mehr Sinneskanäle für die Darstellung solcher Geschichten bzw. Fantasien genutzt werden, desto mehr wird das Erleben des Organismus einem Erleben der äußeren Realität angenähert – unseren Sinnesorganen wird sozusagen eine äußere Realität vorgegaukelt. So wird es möglich, ein Erleben in unserem Organismus zu erzeugen, welches diesem vorgaukelt, es handle sich tatsächlich um Realität. Dies geschieht, wie eben dargelegt, durch die dreidimensionale Darstellung des Films oder auch durch eine Wortwahl,

12 Zum Thema Filter: LSD bewirkt im Gehirn ebenfalls Filterstörungen und kann dadurch zu psychotischem Erleben führen.

13 C. G. Jung nennt diese Überflutung „Infaltion". Diese kann zu psychotischen Symptomen führen.

die Realität suggeriert, wo in Wirklichkeit nur Fiktion besteht (im Film, aber vor allem auch auf der Webseite zum Film, auf der die Filmdetails erklärt werden, als wären sie Realität[14]).

In der Handlung des Filmes *Avatar* wird dieses Phänomen noch weiter ausgebaut. Hier werden Menschen dargestellt, die über die Verlinkung mit künstlich hergestellten Organismen Zugang zu völlig fremden Welten, zum Beispiel zu der Welt eines fiktiven Planeten bekommen und sich in dieser virtuellen Welt genauso lebendig oder lebendiger fühlen können als in der realen Welt. Dies bringt nicht nur eine zunehmende Konfusion zwischen virtueller und realer Welt mit sich, sondern auch eine Vernachlässigung der Notwendigkeiten und Bedürfnisse der realen Welt und die Gefahr eines völligen Abtauchens in die virtuelle Welt, was dann zu sozialer Isolation und Verwahrlosung etc. führen kann („560.000 Deutsche internetsüchtig"[15]). Hier suggeriert der Film allerdings die Möglichkeit eines tatsächlichen Übertritts in die virtuelle Welt ohne den Verlust des realen Lebens, was ein logischer Kurzschluss ist, da die fantasierte Pandora-Welt, in welcher der Übergang der Seele vom Menschen auf den Avatar möglich wird, eben nicht Bestandteil der realen Welt ist, da Pandora ein fiktiver Himmelskörper ist, den es in Realität nicht gibt. Auf den Hintergrund dieses logischen Kurzschlusses möchte ich im Folgenden aus jungianischer Perspektive etwas näher eingehen.

Die Nachtmeerfahrt und die Begegnung mit den Archetypen

Jake glaubt, dass sich sein Leben leer anfühlt, weil er querschnittsgelähmt ist. Seine Zuneigung zu der Urwelt von Pandora liegt aber sicherlich nicht nur begründet in der wiedergewonnenen Fähigkeit, seine Beine zu bewegen, sondern vor allem in der wiedergewonnenen Fähigkeit, mit Mutter Natur, mit dem Mütterlichen, Vegetativen, Unbewussten und Weiblichen in sich selbst in Verbindung zu treten, und damit aus der einseitig männlich dominierten Persönlichkeit, die er geworden war, herauszutreten. In seinem Buch „Die Odyssee des Drehbuchschreibers – über mythologische Grundmuster des amerikanischen Erfolgskinos" beschreibt Christopher Vogler (1998) den archetypischen Aufbau des amerikanischen Erfolgskinos aus jungianischer Perspektive. Dabei wird vor allem die „Reise des Helden" als ein wesentliches Grundmuster darstellt. Das Grundmuster der Heldenreise findet sich auch in der archetypischen „Nachtmeerfahrt" wieder. Der Völkerkundler Leo Frobenius (1904) prägte als erster den Begriff der „Nachtmeerfahrt", C. G. Jung ([1]1912; 1991) griff die Symbolik in „Symbole und Wandlung der Libido" auf und Joseph Campbell ([1]1949; 1978) hat über vergleichende Studien von Mythologien und Heldenepen das Grundmuster der Abenteuerfahrt des Helden herausgearbeitet.

Der Held verlässt das Gewohnte, den Alltag, sein Zuhause und macht sich auf in eine andere Welt. Dabei gilt es zunächst, die Schwelle zu überschreiten – eine erste Prüfung, denn das Schattenwesen, welches den Übergang bewacht, kann in Gestalt des dreiköpfigen Höllenhundes Kerberos eine schier unüberwindliche Gefahr darstellen. Die andere Welt, das Reich der Mütter (Faust II), die Hölle Dantes in der Göttlichen Komödie, der Walfischbauch beim Propheten Jona – Sinnbilder für das Reich des Unbewussten. Wer hier eintritt, wird sich selbst, eigenen ungekannten Schattenseiten und archetypischen Bildern in Form von Drachen, Löwen, Hexen, Zauberern usw. begegnen, die er bezwingen, überwinden, zähmen oder überlisten muss. Meist steht dem Helden eine hilfreiche Kraft zur Seite, die ihn lenkt und leitet: In Jung'scher Terminologie kann dies im Heldenepos oder Märchen eine Form der Anima sein, des weiblichen Seelenanteils des Mannes, die ihm über die Gabe der Intuition und Bezogenheit zur Seite steht, wenn Unbewusstes bewusst werden soll. Hat der Held den Drachen besiegt und die Prüfungen der Unterwelt bestanden, so folgen die Hochzeit mit dem Weiblichen, der Königstochter, und die Rückkehr in die Menschenwelt, wo er als König weise und mit der Königin an seiner Seite die Geschicke seines Landes lenkt.

14 http://de.james-camerons-avatar.wikia.com/wiki/Avatar_Wiki. Zugegriffen am 18. 12. 2011
15 http://www.tagesschau.de/inland/internetsucht100.html. Zugegriffen am 26. 12. 2011

Das Motiv der Nachtmeerfahrt des Helden kann variieren – die Mythen beleuchten einmal diesen, einmal jenen Aspekt. Gemeinsam ist ihnen allen der Eintritt in die Jenseitswelt, das Bestehen von Gefahren, helfende Mächte und schließlich die Rückkehr in die alte Welt als ein Neuer und Wiedergeborener.

Jake Sully, der Held unserer Geschichte, begegnet, nachdem er über die Schwelle getreten ist und in seinem Avatar erwacht, auch „seinen" Ungeheuern: Zunächst ist es ein schwarzer Höllenhund, der ihn angreift, später wird er mit dem (Flug-)Drachen kämpfen müssen, um ihn zu zähmen und schließlich ist es anscheinend der Tod selbst („der letzte Schatten"), dessen Zähmung zur Wende in der Geschichte führt. Doch Jake wäre verloren, würde verschlungen werden von den mächtigen Wesen, besetzt werden von den Inhalten des Unbewussten und nicht mehr er selbst sein, würde ihm nicht die Führerin im Reich des Unbewussten begegnen und ihn leiten: die Anima in Gestalt Neytiris (vgl. Jung 1992, S. 69 ff.). Im Grimmschen Märchen „Der Trommler" ist es die Königstochter, welche für den Trommler, während dieser schläft, die schier unlösbaren Aufgaben der bösen Hexe erfüllt und ihm rät, wie er die Hexe überwinden kann. Beatrice ist Dantes leitende Frauenfigur durch die Unwägbarkeiten in der „Göttlichen Komödie".

Das „Zähmen" der Tiere, der Wesen des Unbewussten, spielt eine große Rolle auf Jakes Nachtmeerfahrt. In der Pandora-Welt heißt dies, sich vertraut machen, sich tief innerlich verbinden und eins werden: zunächst mit dem pferdeähnlichen Wesen, dann mit dem kleinen Drachen, dem Ikran, und schließlich mit dem Feuerdrachen Toruk, dem letzten Schatten – ein Prozess auf Leben und Tod. Jake Sully lernt mit der Haltung eines Kindes. Er erfährt und erlebt von innen her, und zugleich beginnt er die Welt von Pandora, die Urwelt, zu schätzen und zu lieben. Schließlich, als Krönung, folgt die Verbindung von weiblicher und männlicher Art, Höhepunkt im Individuationsprozess: die Vereinigung der Gegensätze: Jake und seine (Seelen-)Führerin Neytiri werden ein Paar (◗ Abb. 3). Jung nennt dies die Vereinigung der Gegensätze, die Coniunctio Oppositorum (Jung 1992, S. 122–123, 187 ff.), in den Mythen als königliche/göttliche Hochzeit dargestellt: Ein gereifter männlicher Held, dessen weibliche Seite nun bewusst ist und ihn das Leben in größerer Fülle erleben lässt. Der Schatz, den der Held schließlich von der Nachtmeerfahrt in sein Menschenleben wie eine Ernte hereinbringt, ist dann eine neue Haltung zum Leben. Jung (Jung u. Wilhelm 11929; 1965, S. 60) drückt dies in den Worten aus: „Nicht ich lebe, es lebt mich" – will sagen: Einer, der „ganz tief unten" war und wieder heraufkommt, ohne sich selbst verloren zu haben, der lässt in seinem Leben Raum für all das, was nicht eins zu eins rational erklärbar und verstehbar ist. Um in den Bildern des Films zu bleiben: In die graue Technikwelt würden vielleicht einige buntere Farben einziehen, und die Menschen würden sich Pandora staunend annähern, ohne die Haltung des Ausbeutens.

Das Besondere an der Geschichte *Avatar* ist, dass der Held hier nicht nach bestandenen Prüfungen wieder zurückkehrt in seine gewohnte Welt, sondern dass er im „Nachtmeer" verbleibt. Parallelen hierzu finden sich auch in den Filmen Im *Rausch der Tiefe*[16] und *Das Meer in mir*[17]. In letzterem verlässt die Hauptperson, die ebenfalls infolge einer Querschnittslähmung in der realen Welt unerträglich leidet, diese Welt schließlich, indem sie gegen allen äußeren Widerstand einen Suizid organisiert und durchführt. In ersterem ist das Leiden der beiden Protagonisten weniger körperlich als psychisch. Beide Hauptpersonen fühlen sich in der Unterwasserwelt in einem tranceähnlichen Zustand, kurz vor dem Ersticken, wohler als in der realen Welt über Wasser, weshalb sie schließlich Suizid begehen, indem sie sprichwörtlich in die Tiefe abtauchen und ertrinken (im „Nachtmeer" bleiben). In beiden Filmen wird jedoch, anders als in *Avatar*, deutlich, dass es sich dabei um einen Suizid handelt, während dieser in *Avatar* verschleiert und beschönigt wird. Anders als bei den Helden, die eine Nachtmeerfahrt bestehen und geläutert und bereichert daraus hervorgehen, gelingt diese in *Avatar* nicht. Im Film kann es nicht zu einer derartigen Bereicherung kommen, da die Spaltung zwischen der Welt der Na'vi und der

16 *Im Rausch der Tiefe* 1988, R.: Luc Besson, HD.: Jean Reno
17 *Das Meer in mir* 2005, R.: Alejandro Amenábar, HD.: Javier Bardem

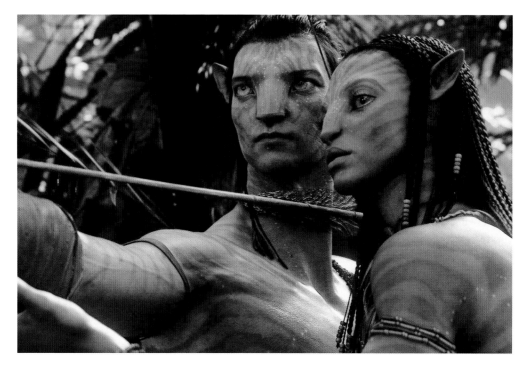

⬛ **Abb. 3** Jake und seine „Führerin" Neytiri. (Quelle: Interfoto/Mary Evans)

Welt der Menschen zu groß ist und keine Vernetzung zwischen den beiden Welten stattfinden kann. Der Soldat und der Unternehmer (Symbole für das Bewusstsein) sind nicht offen für die Inhalte des Unbewussten (symbolisch dargestellt in der Urwelt Pandoras), sodass der neugierige Junge und die Wissenschaftler als Boten keine Chance haben, hier eine Vernetzung zu initiieren. Die Nachtmeerfahrt bleibt unvollendet, der Held stirbt. Und falls er nicht stirbt, ist er psychotisch geworden: Er hält sich für den „Reiter des letzten Schattens" und sieht nicht, dass er ein normaler, an den Schicksalsschlägen des Lebens leidender Mensch ist. Aber vielleicht wird die Nachtmeerfahrt ja noch in einer Fortsetzung *Avatar 2 – Rückkehr zur Erde* vollendet. In dieser Fortsetzung müsste Jake dann wieder in seinen menschlichen Körper und mit diesem auf die Erde zurückkehren, um die „Himmelsmenschen" zu bekehren, von ihrem „Wahnsinn" zu heilen.

Der Dummling

Jake sagt von sich, dass er leer ist und nicht wie die anderen, die Wissenschaftler, angefüllt mit Wissen und damit nicht aufnahmefähig für das, was die Ureinwohner vermitteln könnten. Jake ist leer, er ist nicht geprägt von analytisch-rational zergliederndem Denken wie die Wissenschaftler. Er hat die Haltung des lernenden Kindes und nicht die des gebildeten Wissenschaftlers. Er ist zwar einerseits Teil der „realen Welt" und von dieser geprägt, andererseits tritt er aber auch auf wie ein „Baby", wie ein Kind, wie ein Tölpel oder Tor. Er ist unwissend, jedoch offen, und begegnet der neuen Welt staunend und neugierig, berührt diese und lässt sich berühren. Er hat nichts zu verlieren und vertraut seinen intuitiven Fähigkeiten. Obwohl er als Doppelagent spioniert, wird er von Eywa als „besonders reine Seele" erkannt, das heißt als jemand, der im Grunde nicht falsch ist, mit sich selbst kein falsches Spiel spielt und daher bereit ist, sich mit dem, was er in der Ur-Welt erfährt, unverstellt durch rationales Denken und nicht gehemmt durch menschliche Eitelkeiten, auseinander zu setzen. Er steigt wieder auf das pferdeähnliche Geschöpf, welches ihn einen Augenblick zuvor vor den Augen Neytiris und Tsu'tey's Kriegern

abgeworfen hat. Ein beschämender Moment, dem sich manch ein anderer nicht noch einmal aussetzen würde. Aber Jake versucht es erneut, bis er die innere Verbindung zu dem fremdartigen Wesen spürt. Jake ist ein „Tölpel" – in den Augen der Wissenschaftler, des Militärs („Essen auf Rädern") und der Na'vi. Hier lohnt der Blick auf den „Dummling" der Grimm'schen Märchen, ein Archetyp, der eine bestimmte Haltung verkörpert.

In den Märchen „Die drei Federn" und „Die goldene Gans" ist es der jüngste und dritte Sohn, ein Dummling, der die Königstochter gewinnt. Man erfährt: Der Dummling ist einfältig, spricht nicht viel, wird verachtet und verspottet und bei jeder Gelegenheit zurückgesetzt. Aber er ist auch einer, der Mitgefühl hat. Er ist der einzige, welcher dem kleinen grauen Männchen im Märchen „Die goldene Gans" von seinem kargen Mittagsmahl abgibt und dafür reichlich Lohn erhält. Er ist aber auch einer, der aufrichtig scheint, nicht Verstecken spielt mit der Welt, der die Dinge gerade heraus sagt. Außerdem ist er einer, der nicht viel zaudert, sondern tut: Der Dummling im Märchen „Die drei Federn" nimmt aus der Hand der hässlichen Kröte deren Tochter, setzt sie, ohne viel Aufhebens zu machen, in eine ausgehöhlte Karotte und siehe da: Die Krötentochter verwandelt sich in eine wunderschöne Frau und aus der Karotte wird eine Kutsche. In dem Märchen „Von einem, der auszog, das Fürchten zu lernen" ist es wieder ein Dummling, der die Königstochter erringt, indem er furchtlos den Gestalten des Jenseits begegnet, sogar einen Toten mitfühlend wärmt, aber, als dieser sich gegen ihn wendet, auch keinen Augenblick zaudert und ihn wieder in den Sarg befördert.

Solche „echten", vorbehaltlosen Begegnungen mit der Ur-Welt, mit dem Unbewussten, werden zum Beispiel auch von C. G. Jung beschrieben (vgl. *Nachtmeerfahrten*[18]), und sind normalerweise mit großen Ängsten verbunden, da man die Kontrolle des bewussten Denkens dabei zeitweise verlieren kann.

Das Trauma

Man kann den Film auch als eine Versinnbildlichung des Umgangs mit einem Trauma ansehen: Der Protagonist wurde als Soldat im Kampfeinsatz schwer verletzt, und er hat seinen Zwillingsbruder verloren. Als Folge der Überforderung flieht er in eine Traumwelt, aus der er möglichst nicht erwachen möchte, in der er frei ist und in der er sich geborgen fühlen kann. Zur Verarbeitung dieses Doppeltraumas müsste er sich einerseits mit dem Verlust seiner körperlichen Intaktheit und seiner freien Bewegungsfähigkeit auseinandersetzen, andererseits mit dem Verlust seines Bruders, zu dem er wohl eine auch von Rivalität geprägte Beziehung hatte (Jake betrachtet sich nur als „Frontschwein", wogegen sein Zwillingsbruder promovierter Wissenschaftler war). Eine Verarbeitung dieser Verluste findet nur teilweise und auch nur indirekt statt. Die Geschwisterrivalität spiegelt sich wieder in der Rivalität zwischen dem Militär und den Wissenschaftlern auf Pandora, denen er sich zunächst nicht anschließen kann, weshalb er sich insgeheim mit dem Militär verbündet. Im Verlauf der Geschichte kann er die Position seines Bruders, beziehungsweise der Wissenschaftler, besser verstehen und gewinnt mehr Abstand zu seinem militärischen Selbstverständnis. Das gelingt ihm dadurch, dass er „leer" wird und der neuen Welt, der Ur-Welt Pandoras, entgegentreten kann wie ein Kind, wodurch er sich selbst in ganz neuen Zusammenhängen erlebt und ein neues Fundament für sein Dasein und sein Selbstverständnis findet. Die Reise nach Pandora ähnelt damit einer das erschütterte Selbst stabilisierenden Imagination (wie beispielsweise die Imagination eines sicheren Raumes in der Traumatherapie), die eine wichtige Voraussetzung für die anschließende Verarbeitung der traumatisierenden Verluste sein kann.

18 *Nachtmeerfahrten* 2011, R.: Rüdiger Sünner

Narzisstische Leere – Leere des Selbsterlebens, Sinnlosigkeit

● „Die Starken fallen über die Schwachen her, so läuft das. Wenn Du fair behandelt werden willst, bist Du auf dem falschen Planeten. Keiner unternimmt etwas dagegen".

So beginnt der Film im Director's Cut. Gemeint ist der Planet Erde. An dieser Stelle entscheidet sich Jake Sully, etwas zu unternehmen. Das einzige, was er in seinem armseligen Leben wollte, ist irgendetwas, für das es sich zu kämpfen lohnt: für die Schwachen und für die Fairness und eine Welt, in der man rücksichtsvoll mit Frauen (der großen Mutter Natur) umgeht, in der alles einen Sinn bekommt, weil es miteinander verbunden ist, weil über diese vielfältige Vernetzung ein großes Ganzes entsteht, das einen Sinn macht. Hier tritt die Vorstellung der Zusammengehörigkeit, des Dazugehörens, des Teilhabens und Teil-Seins an die Stelle von Gefühlen der Isolation, der Sinnlosigkeit, der Einsamkeit und der Verlassenheit, welche trotz der Überbevölkerung die Darstellung der Welt der Menschen in den ersten Einstellungen charakterisiert. Die Starken fressen die Schwachen, keiner nimmt Anteil daran, keiner interessiert sich für den anderen, jeder interessiert sich nur für seinen eigenen maximalen Profit und für die Abwehr von Einsamkeits- und Traurigkeitsgefühlen durch Konsum von Alkohol und Spielen. Die Vorstellung von der Sinnhaftigkeit, als Resultat von Verbundenheit, basiert in diesem Film in gewisser Weise auf symbiotischen Vorstellungen.

Die Verbindung der einzelnen Lebewesen erfolgt über „USB-Neuroport-Kabel", das heißt mittels Hardware. Die Na'vi zeigen eine reduzierte Mimik[19]. Dies bedeutet, dass sich diese Wesen nur unzureichend mittels mimischer Äußerungen verständigen können. Auffällig ist, dass sie sich stattdessen mit mechanischen Mitteln („USB-Neuroport") mit allem Möglichen vernetzen können und dass die Idee der Vernetzung dieser Welt eine so große Bedeutung im Film hat. Dies steht in starkem Kontrast zur mangelnden Kontaktaufnahme mittels emotionaler Signale. Es finden sich in diesem Film kaum Hinweise darauf, dass über das aufmerksame Wahrnehmen der Mimik und der Ausstrahlung des Gegenübers und die Berücksichtigung der eigenen emotionale Reaktion darauf, ein Kontakt zwischen zwei unterschiedlichen Individuen entstehen könnte, welcher Gefühlen von Einsamkeit, Verlassenheit, Sinnlosigkeit etc. entgegenstehen könnte (was beispielsweise im Film *A Single Man*[20] sehr anschaulich dargestellt wird).

Ödipuskomplex

Der Film ist geprägt von einer absoluten Negativdarstellung der Welt der Männer, der Technik, des rücksichtslosen Ausbeutens der Natur und einer Positivdarstellung der mütterlichen Welt.

● „Die Himmelsmenschen haben ihre Mutter zerstört."

Die Na'vi leben mit ihrer Mutter im Einklang. Fast alle männlichen Führungspersonen sterben im Film, der Colonel, der Häuptling des Clans, sein Nachfolger Tsu'tey. Auch Jake stirbt und wird wiedergeboren als Na'vi, verbunden mit der mütterlichen Welt, der Welt der Frauen, wo er eine Art Heiland-Rolle einnimmt und alle verstorbenen großen Männer ersetzt. Er wird gerettet von Eywa und in Empfang genommen von Neytiri und deren Mutter, der Hohepriesterin. Neben diesen übernimmt er dann die Führungsrolle auf Pandora. Sozusagen eine Reindarstellung des ödipalen Konfliktes.

19 Der „Spiegel" bezeichnet das suffisant als „Botox-Mimik" (http://www.spiegel.de/kultur/kino/0,1518,666842,00.html). Zugegriffen am 26. 12. 2011
20 *A Single Man* 2009, R.: Tom Ford, D.: Colin Firth, Julianne Moore

Schlussbemerkung

Aufgrund des begrenzten Umfangs dieses Kapitels mussten Prioritäten gesetzt werden, sodass die reiche Symbolik des Films und andere Aspekte unberücksichtigt blieben und auch keine integrierende Diskussion der dargestellten Aspekte erfolgen konnte.

Cameron ist ein sehr eindrucksvolles Werk gelungen, mit dem der ökologisch engagierte Regisseur ein breites Publikum sehr intensiv ansprechen konnte und ein überlebenswichtiges Thema emotional in Resonanz bringen konnte. Dies erscheint umso wichtiger, als es der Politik nur zögerlich und unzureichend gelingt, entsprechende Weichen zu stellen. Es bleibt die Hoffnung, dass es ihm in einer Fortsetzung des Filmes gelingen möge, den Prozess der Integration und Reifung so darzustellen, dass sich das Publikum damit identifizieren kann und nicht in der ohnmächtigen Fantasie eines Heraustretens aus der realen Welt und eines Abgleitens in ein wie auch immer geartetes Nirvana hängenbleibt.

Literatur

Campbell J (1978) Der Heros in tausend Gestalten. Suhrkamp, Berlin (Erstveröff. 1949)

Castaneda C (1975) Eine andere Wirklichkeit. Neue Gespräche mit Don Juan. Fischer, Frankfurt/M

Castaneda C (1976) Reise nach Ixtlan. Die Lehre des Don Juan. Fischer, Frankfurt/M

Frobenius L (1904) Das Zeitalter des Sonnengottes. Reimer, Berlin, S 264

Herder Lexikon (1991) Symbole. Herder, Freiburg

Jung CG (1991) Wandlungen und Symbole der Libido. Beiträge zur Entwicklungsgeschichte des Denkens Walter-Verlag, Olten, S 265 ff. (Erstveröff. 1912)

Jung CG (1992) Die Archetypen und das kollektive Unbewusste. Walter-Verlag, Olten

Jung CG, Wilhelm R (1965) Das Geheimnis der goldenen Blüte. Rascher, Zürich (Erstveröff. 1929)

Vogler C (1998) Die Odyssee des Drehbuchschreibers – über mythologische Grundmuster des amerikanischen Erfolgskinos. Zweitausendeins. Original: The Writer's Journey http://www.thewritersjourney.com

Internetquellen

http://de.wikipedia.org/wiki/Avatar_%E2%80%93_Aufbruch_nach_Pandora. Zugegriffen am 25. 12. 2011

http://de.wikipedia.org/wiki/Avatar_%E2%80%93_Aufbruch_nach_Pandora#Inspiration. Zugegriffen am 22. 12. 2011.

http://de.wikipedia.org/wiki/Bildsynthese. Zugegriffen am 26. 12. 2011

http://de.wikipedia.org/wiki/Carlos_Castaneda. Zugegriffen am 28. 12. 2011

http://de.wikipedia.org/wiki/Gaia-Hypothese. Zugegriffen am 27. 12. 2011

http://de.james-camerons-avatar.wikia.com/wiki/Avatar_Wiki. Zugegriffen am 27. 12. 2011

http://de.wikipedia.org/wiki/Mei%C3%9Fner-Ochsenfeld-Effekt. Zugegriffen am 27. 12. 2011

http://www.tagesschau.de/inland/internetsucht100.html. Zugegriffen am 26. 12. 2011

http://www.spiegel.de/kultur/kino/0,1518,666842,00.html). Zugegriffen am 26. 12. 2011

Originaltitel	Avatar
Erscheinungsjahr	2009
Land	USA
Buch	James Cameron
Regie	James Cameron
Hauptdarsteller	Sam Worthington (Jake Sully), Zoë Saldaña (Neytiri), Sigourney Weaver (Dr. Grace Augustine), Stephen Lang (Col. Miles Quaritch)
Verfügbarkeit	Als DVD in OV und deutscher Sprache erhältlich

Thomas Ettl

Surrogates – mein zweites Ich oder: Spaziergänge eines Querschnittsgelähmten

Surrogates – Regie: Jonathan Mostow

Filmplakat *Surrogates*
Quelle: Disney/Cinetext

Surrogates

Regie: Jonathan Mostow

„Hechtgrau mit etwas Gold"

Elsass 1771. Goethe war von Straßburg kommend zu Pferde unterwegs nach Mannheim und hatte sich gerade von Friedriken verabschiedet. Als er ihr die Hand noch vom Pferde reichte, standen ihr die Tränen in den Augen, und ihm war sehr übel zumute. Nun ritt er auf dem Fußpfade gegen Drusenheim, und da überfiel ihn, so Goethe in Dichtung und Wahrheit (1993) „eine der sonderbarsten Ahndungen":

> Ich sah nämlich, nicht mit den Augen des Leibes, sondern des Geistes, mich mir selbst denselben Weg zu Pferde wieder entgegenkommen, und zwar in einem Kleide, wie ich es nie getragen: es war hechtgrau mit etwas Gold. Sobald ich mich aus diesem Traum aufschüttelte, war die Gestalt ganz hinweg.

Was hat Goethes Erlebnis von 1771 mit dem Film *Surrogates – mein zweites Ich* (■ Abb. 1) zu tun, der im Jahr 2054 spielt? Die Doppelgängerthematik. Aber Goethe hatte nicht nur ein autoskopisches, sondern überdies ein utopisches Erlebnis: Sein „Doppeltgänger" (Jean Paul) war älter als er und trat in ihm fremder Kleidung auf. Eine utopische Vision hat auch der Film. Er unterstellt, noch 300 Jahre nach Goethe sei man mit diesem Thema befasst. Das überrascht nicht. In die Zukunft schauen ist Standardbeschäftigung des Menschen, und da zeigt *Surrogates*: Goethes Autoskopie nimmt Vieles vorweg, was die Zukunft beschäftigt.

Allerdings: Goethes Double war älter als er, die „Surrogates" sind jünger als ihre Eigentümer. Das ist zeitgemäßer. Insofern orientiert sich der Film, 2009 gedreht, in seinem Vorgriff auf 2054 am gegenwärtigen Körperideal. Er teilt jedoch nicht den Traum der Anthropotechniker, die anatomisch-biologische Konstitution zu verändern, auch nicht den, Fleisch zum Implantieren von Chips zu gebrauchen. Vielmehr visualisiert er, sich einen zweiten Körper zu basteln, eine der menschlichen Anatomie nachempfundene mit Haut überzogene Maschine, einen Androiden. Von dessen Vorzügen soll der Zuschauer gleich zu Beginn des Films in einer halb dokumentarisch, quasi wissenschaftlich abgesicherten Form überzeugt und nebenbei mit der fließenden Grenze zwischen Science und Science Fiction vertraut gemacht werden.

Die Handlung

2054 muss keiner mehr alt und hässlich aussehen, auf die Straße gehen und seinen müden Körper ins Büro schleppen. Ohne seinen wirklichen Körper und seine soziale Identität zu offenbaren, kann jeder im Cyberspace agieren. Roboterkopien des Ichs, liebevoll „Surries" genannt, konstruiert und maßgeschneidert nach den aktuellen Körperidealen, neuronal verlinkt mit ihren Besitzern, den Operators, übernehmen, ferngesteuert von deren Gedanken, deren Leben, derweil die Operators zuhause im Lehnstuhl gammeln. Das originale Ich empfindet, fühlt und nimmt wahr wie sein zweites Ich, ist aber durch einen Mechanismus vor den Gefahren geschützt, denen sich das zweite Ich im Ersatzleben aussetzt. So können die Menschen mit ihren Surries in einer neuen schönen Welt ihre Fantasie üppig entfalten, sie risikofrei erleben und ausleben, ein Grund, weshalb Surries zum Verkaufsschlager wurden. Da der echte Mensch kaum noch die Straße betritt, hat sich die Welt zu einer ohne Gewaltverbrechen, ohne Diskriminierung, ohne übertragbare Krankheiten verändert.

Abb. 2 Radha Mitchell (Jennifer[S]) in einer Filmszene. (Quelle: Disney/Cinetext)

Diese Idylle aus Party, Lust und Event wird gestört durch einen Mord, dem ersten seit Jahren. Ein Liebespaar wird von einem Motorradfahrer auf offener Straße mit einer unbekannten Waffe „zerstört". Blitze tauchen geborstenes Metall in grelles Licht. Gleichzeitig sterben zu Hause die wahren Ichs – eine Betriebsstörung, die bis zu diesem Moment als ausgeschlossen galt. Der Brisanz wegen setzt das FBI die Surrogates von Agent Tom Greer (Bruce Willis) und dessen Partnerin Agent Jennifer Peters (Radha Mitchell) (■ Abb. 2) auf den Fall an. Der Motorradfahrer ist bald als Mitglied der „Dreads" identifiziert, einer Gruppe von Personen, die den Gebrauch von Surrogates und den modernen Lebensstil ablehnen. Der flüchtende Mörder wird von Polizeiwagen und Tom Greer im Hubschrauber verfolgt. Dem Mörder gelingt es mit seiner Waffe, die Polizisten und den Piloten zu zerstören. Greer kann zuhause im letzten Moment die Verbindung zu seinem Surrogate unterbrechen, bevor dieser mit dem Hubschrauber über dem Gebiet der Dreads abstürzt. Dem Tod entkommen, aber reichlich mitgenommen und blutend, muss er von nun an „im Original" ermitteln.

Greer sucht Dr. Canter auf, den Erfinder der Surrogates, der vermutet, die seltsame Waffe sei vom Militär entwickelt worden, was sich bestätigt. Die Waffe zerstört die Surries mit einem Virus, der aber, offenbar einem Softwarefehler zufolge, den Schutzmechanismus unwirksam werden lässt, der die zugehörigen Operators vor dem Tod bewahren soll. Greer kommt einer Verschwörung auf die Spur. Der Vorgesetzte beider Agenten war vom Unternehmen VSI, das die Surrogates vertreibt, beauftragt worden, ihren früheren Vorstandsvorsitzenden Dr. Canter zu töten. Angeheuert wurde ein Dread. Dem Mordanschlag fiel allerdings nicht Canter zum Opfer, sondern sein Sohn Jared.

Canter beabsichtigt, weltweit alle Surries zu zerstören, den Tod sämtlicher Operators einkalkulierend, vergiftet sich stattdessen aber selbst. Greer gelingt es rechtzeitig, die Verbindung der Surrogates zu ihren Operators zu trennen und so deren Tod zu verhindern und entschließt sich, alle Surries zu zerstören. Weltweit brechen sie zusammen, während die Operators langsam wieder aus ihren Häusern kommen.

Surrogates – mein zweites Ich, 2009 vom *Terminator 3*-Regisseur Jonathan Mostow inszeniert, ist ein SciFi-Actionthriller, der im derzeitigen Second-Life-Trend liegt. Das Drehbuch von Michael Ferris und John D. Brancato basiert auf der Graphic Novel von Robert Veditti und Brett Wedele. Der Soundtrack stammt von Richard Marvin.

Die Reaktionen auf den Film waren unterschiedlich, von hohem Lob für die zahlreichen Actionszenen bis hin zu Ablehnung. Der Film schneide zu viele Themen an, ohne sie auszuführen, was ihm die Kritik der Oberflächlichkeit einbrachte. Man kann sich beiden Auffassungen anschließen; ich will sie allerdings relativieren.

Psychoanalytische Interpretation

Im Puppenparadies

Da die Surries, je nach Gusto entworfen, am Fließband produziert werden, – es könnte die Praxis eines Schönheitschirurgen sein –, repräsentieren sie reine Wunschkörperbilder der Operators. Dem Unbehagen der Körperlichkeit enthoben, können sie anderen Geschlechts, anderer Hautfarbe, anderen Alters als das Original sein. Sie zeigen alle Eigenschaften, die sich der Mensch schon im gegenwärtigen Schönheitskult wünscht: fit aussehen, elegant gekleidet, gesund, schön, smart sein. Der Körper ist nicht länger „nichts als ein Sack voller Exkremente" (Odo v. Cluny, zit. nach Didi-Huberman [1]1999; 2006), nicht länger „Madensack" (Kamper), sondern hochwohlgeformte Hüfte aus Edelstahl. Weder ermüdend noch alternd, sind die Surries schneller und stärker als das physische Ich ihrer Besitzer. Das Leben der Puppen erfolgt im Hinterkopf, dort sind die Programme installiert, eine Variante der anthropologischen Vision, das Gehirn mit einem PC zu verschalten. Dass sie jünger als ihre Originale sind, ist ästhetisch motiviert, liegt aber auch an ihrem Status als Klon, was „Sprössling" meint. Risiken, denen Surries ausgesetzt sind, lassen ihre Besitzer unbehelligt, das heißt, sie erfüllen den Wunsch nach Unverwundbarkeit und Unsterblichkeit. Ihre Funktion ist die der Dummies der Unfallforschung oder die der Doppelgänger, durch die sich Herrscher und Könige vertreten ließen, um sich aus dem Schussfeld zu bringen.

In der Introsequenz betreten wir Zuschauer die glatt polierte Wunderwelt der Surries. In einem chauffeurgesteuerten Rolls-Royce nehmen wir einem smarten jungen Mann gegenüber Platz, der, stolz wie Gogols „Die Nase" in Petersburg, durch eine moderne Großstadt kutschiert und sich über Funk bei seinem Vater für das Überlassen der Limousine bedankt, wonach sich beide gegenseitiger Zuneigung versichern. Ein Motorrad folgt uns. Links und rechts sehen wir schicke Läden samt smartem personellem Inventar, tolle Autos und Straßen voller nach den Idealvorstellungen Getrimmte, verholzt, sorry: verplastikt wirkend. Körper, Haut, Haarschnitt, Outfit, Wohnung – alles erscheint in kühl-künstlicher Makellosigkeit wie in Werbespots für Edelprodukte. Das Puppenparadies ist geordnet, jedermann guter Laune, der Reichtum blüht. Das Vornehme dieses Cyberspace findet sich bereits bei Goethe: er sah sein Double „in einem Kleide, wie ich es nie getragen: es war hechtgrau mit etwas Gold."

Der Rolls-Royce steuert eine Disco mit überfüllter Tanzfläche an. Auf Schritt und Tritt begegnet man jugendlichen, attraktiven, trainierten Gestalten mit ebenmäßigen Gesichtern. Die Gestalten zeigen, dass ihre Operators alle von den gleichen Körperidealen beeindruckt sind. Kurz: lauter Barbies und Kens mit Identitätschip im Hinterkopf. Trotz exaltierten Tanzgebarens kein Funke Begehren, sondern gespenstische Abwesenheit in der Anwesenheit. Ebenso draußen auf der Straße: Als ein Auto, unkontrolliert durch die Straße rasend, verunglückt und Körper von sich verformendem Metall mitgerissen werden, blicken Passanten mit leerem Gesichtsausdruck der Verwüstung hinterher. Die Surries in ihren „Konsumtempeln" erinnern an Statuen Toter im alten Ägypten, die in Tempeln „leben", täglich gesalbt und bekleidet wurden und alle Verrichtungen erfuhren, wie sie an lebenden Personen vorgenommen wurden. Unterdessen hat sich unser smarter Begleiter in der Disco auf eine Empore geschwungen, um

sich wie ein Bussard zielsicher auf die aus der wogenden Menge auserwählte Tanzmaus zu stürzen. Ja, so einen grandiosen Auftritt haben wir uns als junge Kerle doch immer schon mal gewünscht, zumal der Erfolg beim „Girl" nicht auf sich warten lässt: Beide verschwinden flugs zum tête à tête vor die Tür. Beneidenswert!

Ein Leben in „effigie"

2054 besitzen nahezu alle Menschen solche Kopien ihres Selbst. Kommt ein Surry nach Hause, sucht er die Ladestation auf, und sein Operator, weit weniger jung, schön und stark als er, kehrt aus seiner Trance im Lehnstuhl in den Alltag zurück. Das Arrangement im Lehnstuhl, das Wohlbehagen nahelegt, erinnert allerdings eher an eine Intensivstation; kein Wunder, die Surries wurden vom querschnittsgelähmten Dr. Canter entwickelt, um Behinderten wieder Spaziergänge zu ermöglichen. Der Film ließe sich also als Tagtraum, als Gehirnkino eines Behinderten verstehen, der sich nach einer besseren Welt sehnt. Jede ethisch-moralische Kritik an der schönen neuen Welt wäre fehl am Platz, denn solche Kategorien sind dem Gehirnkino fremd. Schließlich muss es weder auf Zuschauer noch auf Darstellbarkeit Rücksicht nehmen, muss nicht wie der Film genrespezifische Regeln befolgen, um zur kulturellen Objektivation zu avancieren. Dieser muss, um rentabel zu sein, Beifall und Schluchzen vorausberechnen. Der Tagtraum eines Querschnittsgelähmten wäre kaum anreizender Stoff für das Laufpublikum der Fußgängerzone. Und darum wittert im Film ein geschäftstüchtiges Unternehmen seine Chance, ortet den Profit und vermarktet die Erfindung, die ursprünglich Kranken das Leben erleichtern sollte – ein Seitenhieb auf die Schönheitschirurgie, die die Erfahrungen der plastischen Unfallchirurgie vermarktet.

Bedient werden „aktuelle" Sehnsüchte

So wie im Film das geschäftstüchtige Unternehmen den Operators, so bietet der Film dem Zuschauer alle Zutaten für die Sehnsucht nach einer besseren Welt und bezieht seinen Erfolg daraus, dass 2009 in dessen Herzen das Thema längst und gründlich vorbereitet war. *Surrogates* trifft den Zuschauer nicht wie ein Blitz, sondern transportiert lediglich den Schönheits-, den Hygiene- und Jugendwahn von 2009 in den Unterhaltungsfilm und unterstellt damit, 2054 würde sich daran nichts ändern. Der SciFi-Thriller bleibt hier in der Gegenwart befangen.

Die Surries sollen den unbequemen Alltag erleichtern, wie wir das von den Heinzelmännchen kennen. Gegenwartsverdrossen gieren die Operators nach einem Phantomerleben, suchen über „bodyswitching" Territorien jenseits der Alltagszwänge zu besetzen, um der profanen Wirklichkeit zu entkommen. Sie haben sich einen Hightech-Golem erschaffen, ihm indes keine Schriftzeichen und geheimen Sprüche zur Belebung auf die Stirn geschrieben, sondern eine Speicherkarte in den Hinterkopf geschoben, und lassen ihn in einer schönen Welt agieren, nicht aber in neuen Lebensentwürfen, sondern in bekannten Beziehungsmustern und Alltagsabläufen. Das war schon bei Goethe so: Sein Double ritt gleich ihm zu Pferde und wählte denselben Weg wie er, wenn auch in die Gegenrichtung. Und so werden die Surries nicht zwecks neuer Erfahrung in eine unbekannte Welt geschickt, sondern ins Büro. Immerhin: *Surrogates* ist der Versuch, sich die Sehnsuchtsfantasie einer besseren Welt zu erfüllen, die der Abwehr der realen Welt dient. Die Surries bieten dem Zeitgenossen von 2054 eine Welt „in effigie", so wie wir heute das Leben am Bildschirm zur ersten Wirklichkeit machen und Reisen in ferne Länder googeln, um uns die Strapazen des Reisealltags zu ersparen Reisealltags zu ersparen, womit wir das Erbe der Zeitgenossen des 19. Jahrhunderts antreten, denen das Stereoskop, damals Massenmedium, das Reisen im heimatlichen Wohnzimmer ermöglichte.

Gruseliger „Analogkäse"

Ist das Figurenmachen und Beleben auch ein altes Thema, so beinhaltet der Film doch etwas, was ihm Nachhaltigkeit sichert. „Der Film punktet durch seine Optik", schreibt ein Kommentar (moviepilot.de). Er punktet mit der ästhetischen Zurichtung von Bruce Willis als Surrogate. Tom Greer(S) ist der Inbegriff der oben skizzierten Puppenwelt. Die Maskenbildner haben Willis ein Milchgesicht wie Barbies Ken verpasst. Mit in die Stirn gebürsteter blonder Tolle ist der 55-Jährige auf jung gemacht, verpackt in einen schlecht sitzenden Anzug von der Stange mit Krawatte. Die Maske ist glänzend: das Künstliche, Biedere, Spießige, das allen Schönheitsoperierten anhaftet, ist in dieser Maske auf den Punkt gebracht. Selten kommt der ästhetische Betrug so rüber wie hier. Kein Wunder, dass sich viele Fan-Kommentare mit Willis als Surrogate beschäftigen:

„Bruce Willis mit so vielen Haaren aufm Kopf sieht irgendwie gruselig aus ..." (movieplot.de). – „Bruce Willis überrascht mit Haarpracht, denn sein Double trägt eine Ponyfrisur. Taucht das Original aber auf, dann ist wie Willis gewohnt mit Platte, Falten und Stoppeln zu sehen. Gegen den authentisch verknautschten 55-Jährigen wirken die Blechkameraden wie Analogkäse gegen einen reifen Camembert" (rp. online.de). – „... da hat man wohl auch dem Surrogate von Bruce Willis eine Frisur verpasst, für die sich selbst Nicolas Cage schämen würde – es ist geradezu erleichternd, Willis nach einer halben Stunde endlich wieder dauerhaft mit Glatze, Falten und Stoppelbart auf der Leinwand zu sehen" (filmstarts.de). – „Die verjüngte und ‚attraktive' Ausgabe von Bruce Willis kommt nicht nur mit sichtbar digital geglätteter Haut daher ..., sondern auch mit einem so dermaßen lächerlichen blonden Toupé, dass man als Zuschauer mehr als glücklich ist, wenn diese Farce endlich ein Ende hat" (filmszene.de). – „Der erste Anblick des Helden Tom Greer ist erschreckend: Der Typ sieht schon irgendwie aus wie Bruce Willis. Nur jung und mit glatter Haut und mit Blondschopf. Der Schreck, der einem bei diesem Anblick in die Glieder fährt, ist einer der wenigen wirklich guten Momente des Films. Was einen verstört, ist nämlich die klassische Unheimlichkeit des als Fremdes wiederkehrenden Vertrauten" (film-zeit.de).

Und in der Tat: Alle mühsam zurückgehaltenen Vorbehalte gegen „Schönheitsarbeit" (Menninghaus 2003): Diese Maske bestätigt sie. Wurden früher die Toten einbalsamiert, so heute – und offenbar noch 2054 – die Lebenden. Oh Männer, lasst euch nie die Falten wegspritzen! Ohne Frage: diese Maske vermag die Erinnerung an den Film kostbar zu machen (vgl. Lueken 1995, S. 12). Aber geben wir uns keiner Illusion hin: Was uns der Film als gruselige Utopie vorschlägt, ist heute bereits zuhauf in Illustrierten, Talkshows und auf unseren Straßen zu sehen. *Surrogates* ist hier keineswegs stilbildend, wie das noch zu Zeiten Adolphe Menjous mit seinem Schnauzbart der Fall war. Was hier als SciFi daherkommt, ist Jetztzeit. Die Wirklichkeit hat die Utopie des Films längst eingeholt, wie das auch Aldous Huxley 1959 zur Kenntnis nehmen musste. Ich diagnostiziere dieses Phänomen als „Querschnittslähmung" des Films. Er kann den Schritt ins Jahr 2054 nicht wirklich machen, verharrt vielmehr gelähmt im Jetzt. Und so macht der Film keinen Veränderungsvorschlag, weder in Hinblick auf Mode, gesellschaftlichen Umgangsformen, modisches Zubehör, Architektur.

Humans only

Die Cyberwelt der Surries ist für den Großteil der Menschheit die gewünschte und ideale pervers verzerrte Welt, würde Thomas Bernhard sagen. Nicht jedoch für die Dreads, einer Gruppe von Personen, die sich nicht dem Second-Life-Fieber anschließen, sondern authentisch leben und erleben möchten und sich ihre Natur und ihre Gefühle erhalten wollen. Angeführt werden sie von einem religiösen Eiferer. Die Dreads sind die Grauenhaften, die Gefürchteten, die aber selbst fürchten – um ihre Identität. Sie hausen als infantil Wilde, als verkommener Abschaum, als randständige Existenzen in einem heruntergekommenen Stadtviertel, ghettoisiert in Ruinen, Kaschemmen. Sie werden ihrer natürlichen

Hässlichkeit wegen als Asoziale vorgeführt, behandelt wie Aussätzige, weil sie sich der neuen Technik verweigern. Mit den Dreads bebildert der Film das Oben-Unten-Klischee: Schönheit hat mit Reichtum, normales Aussehen dagegen mit Armut und Dekadenz zu tun. Das Ideale steht auf der Säule, dem Himmel nahe, das Normale im Sumpf. Die Anthropotechnikfeindlichkeit der Verweigerer wird als Apokalypse inseriert.

Die Welt der Dreads ist aufwühlender als die geglättete Welt der Surries. Die Mühen des Alltags ermöglichen ihnen, sich zu spüren. Sie liefern den „Kick", den sich die Surries, deren Welt luxurierend ist, in der es nichts zu wünschen, mithin keine Zukunft, keine Visionen gibt, immer wieder durch Risiken und Extremsituationen verschaffen müssen. Sollte es das wahre Glück sein, sich auf Seiten der Identitätslosen zu schlagen, so verweigern die Dreads dieses Glück.

Surries alias „Roboterschweine" haben keinen Zutritt zum Ghetto – „humans only"! Beide Gruppen sind dissoziiert, das Hässliche vom Schönen, das Ideale vom Entwerteten. Beide dürfen nicht miteinander in Berührung kommen. Der Ekel spaltet sie. Der Zuschauer soll wissen: Gefühle zu haben ist ruinös, sie zu leben bedeutet das Jammertal auf Erden. Wer den künstlichen Lebensstil verabscheut, wird als religiöser Eiferer diffamiert. So kann man taub bleiben für ihre Einwände, mehr noch: Man kann sie als Spinner abtun.

Boulevard der Dämmerung

In der gefühlskalten Hypermoderne der Surries, in der es seit langem keine Kriminalität mehr gibt – Gewalt und Aggression sind ins Ghetto der Dreads ausgelagert – geschieht ein Mord. Er wird zur entscheidenden Wende in der Filmerzählung. Vor der uns bekannten Disco werden der smarte junge Mann und seine blonde, aufreizende Schöne, die er im Sturzflug aufgegabelt hatte, sich leidenschaftlich küssend und entblößend ineinander verkeilt, vom Blick eines mit Motorradhelm vermummten Mannes fixiert. Vielleicht ist er ähnlich verwundert wie wir Zuschauer, denn unsere Imagination ist gefordert! Zwei gefühllose Surries ohne Innenleben küssen sich, Plastik fingert an Titanhüfte, und das leidenschaftlich? Wie soll man sich das vorstellen? Eine bildhübsche junge Frau, umschlungen von einem smarten jungen Mann, von dessen Operator sie nichts weiß? Vielleicht umarmt sie ja einen ungewaschenen, verwahrlosten, nach Alkohol riechenden Greis, der gerade auf dem Klo sitzt? Vielleicht umarmt auch unser junger Bussard ahnungslos anstatt einer Tanzmaus eine alte Vettel? Greer(O) bringt es auf den Punkt, als er, provoziert von einer schnippisch-arrogant auftretenden, naturgemäß bildhübschen Juristin(S), gewieft kontert, ihr Operator könnte ein fetter großer Kerl mit aus der Hose heraushängendem Schwanz sein, woraufhin die blasierte Juristin jäh verstummt. Nun, das mag ein Thema für Charlotte Roche sein. Uns aber bleibt von der Surries-Welt der Eindruck einer gigantischen, verwirrenden „cross-dressing-party": die wahre Identität der Operators bleibt verborgen.

Der junge Surrogate erzürnt in Richtung Helm: „Los, hau ab, Fleischsack!" Daraufhin zertrümmert der Motorradfahrer das Paar mit einer Stromstöße speienden Waffe und mithin auch unsere Imagination. Man sieht nur Blitze. Das Ungeheuerliche: Wird sein Surrogat zerstört, müsste der Operator unverletzt bleiben. Diesmal ist es anders: Beiden steuernden Operators schmilzt das Gehirn. Ein Super-GAU wie einst der Untergang des technischen Wunderwerks Titanic. Das Brisante: Der zerstörte Liebhaber ist der Sohn des Erfinders der Surries. Eigentlich sollte dem Vater der Anschlag gelten, denn ihn vermutete der Attentäter im Rolls-Royce. Bei den Surries weiß man jedoch nie, wen man wirklich vor sich hat.

Das gefällt uns natürlich! Stehen wir Zuschauern doch ohnehin unter Verdacht, unsere Freude daran zu haben, Reichtum und Luxus in Nöten zu sehen, zu frohlocken, fällt den Reichen und Schönen das schlechte Los zu. Das befriedet unseren Neid, zumal wir uns daran ergötzen dürfen, wie der Anschlag Aufruhr unter die Plastikkerle und ihre Ziehväter bringt, als sei plötzlich das entfesselte bürgerliche Größenideal Frankenstein hinter ihnen her. Die Strahlenwaffe mit militärischem Potenzial, die nur Ersatzsoldaten treffen sollte, wurde vom Militär aus dem Verkehr gezogen. Aber wie im Märchen von der

unheilbringenden 13. Fee oder wie bei dem Paranoiker Herodes, ist ein bedrohliches Exemplar übrig geblieben. FBI-Agent Tom Greer(S) und seine Assistentin Jennifer Peters(S) hetzen hinter dem Killer her. Wie die Waffe hat auch der Film an dieser Stelle einen „Softwarefehler". Wieso bedarf es in der heilen Welt der Surries des Militärs? Die einzige Gefahr, die Dreads, haben keine Surries. Der Vorname von Greers Assistentin jedoch ist im Hinblick auf das im Film verhandelte Thema Jugendwahn stimmig, spielt er doch auf das „Jennifer-Syndrom" an, das jenen befällt, der nur im Gesicht des Partners, nicht im eigenen den Alterungsprozess registriert und dies so kränkend und unerträglich erlebt, dass dieser gegen einen jüngeren ausgetauscht wird.

Ein Mörder als deus ex machina

Dass der Mord ausgerechnet ein Sexpaar trifft, könnte dem prüden Amerika geschuldet sein. Auch ödipale Motive mögen im Spiel gewesen sein, schließlich sollte ein Vater ermordet werden – vielleicht weil er der Mutter an die Wäsche geht, vielleicht wegen seiner entmenschlichenden Erfindung. Ich will diese Spur jedoch fallenlassen, denn der Mord geschieht weniger aus Eifersucht oder Neidhammelei. Vielmehr signalisiert seine Bedrohlichkeit, dass es sich bei der Welt der Surries keineswegs um eine Ausstattungsrevue handelt, sondern dass die Mordgasse zum „Boulevard der Dämmerung" für die Idealität geworden ist. Sie ist in Frage gestellt. Der Trick mit den Kunstfiguren ist in Gefahr! Der Mörder, wir wissen, es war ein Dread, zerstört wegen der unerträglich vollkommenen Bilder – so, wie der Pubertierende die Entidealisierung seiner Eltern betreibt. Indem der Mörder das zur Maschine gewordene anthropotechnische Idealbild zerstört, betreibt er einen Ikonoklasmus, wie ihn Manfred Schneider (2010) in seiner Studie über Attentäter beschrieben hat. Der Mörder macht sich überdies zum Antipoden des Schönheitschirurgen, und schließlich will er sich mit seinem Anschlag von der alle uniformierenden Idealität der Surries abgrenzen.

Der Zertrümmerer der schönen Welt, in der alles machbar und löschbar ist, in der es keine Auseinandersetzung mit dem „unerbittlichen Verfließen der Zeit" (Sontag 1978, S. 21), mit Altern und Tod gibt, konfrontiert mit dem Tod, indem er den Tod bringt. Zerstört wird die Illusion, Schönheit und künstliche Jugend schützten vor dem Tod. In *Surrogates* machen die Menschen Denkmäler aus ihren Körpern, um die Zeit anzuhalten und verfallen in einen Dornröschenschlaf. Auch der Film ist schläfrig, denn all dem, was 2009 bereits als Idee oder Reales vorhanden ist, begegnen wir noch 2054, nur technisch verfeinert. Der Attentäter stört den Schlaf, hebt jenen Stillstand auf, den das kosmetisch bearbeitete Gesicht Greers(S) repräsentiert. Das Leben kommt wieder in Fluss. Die Strategie, sich eine Ersatzwelt zu schaffen, bricht zusammen. Die Abwehr funktioniert nicht mehr. Der Tod ist wieder allgegenwärtig. Wer das Leben fürchtet, lebt in ständiger Todesangst, weiß die klinische Psychologie. Der Mord verweist das prometheische Vorhaben eines zweiten Ichs in seine Schranken. Es erweist sich als unberechenbar. Die enormen Schwierigkeiten, die eine solche künstliche Welt bereitet, hat man zu naiv eingeschätzt, den menschlichen Faktor unterschätzt. Darum das Entsetzen der Operators. Der Mord sitzt ihnen wie „die Faust im Nacken". Die Spaltung ist in Gefahr. Höchste Zeit also für die FBI-Agenten, des Illusionszertrümmerers habhaft zu werden.

Ein Rezensent beklagt, *Surrogates* würde, statt tief in seine Welt und ihre vielfältigen Facetten einzutauchen, sich in unverständlicher Eile in eine sehr formell und schematisch abgespulte Krimigeschichte wandeln. Was potenziell faszinierend sein könnte, würde systematisch im Ansatz abgetötet. Mit seinen 88 Minuten wirke der Film eher gehetzt als kurzweilig. (filmszene.de). Das hieße jedoch, den Film missverstehen. Es ist die Natur der Abwehr, keine Berührung mit dem Abzuwehrenden, dem Unbequemen, Beklemmenden, Ängstigenden zuzulassen, es allenfalls nur flüchtig zu streifen. Der Film ist durchaus stimmig: Das Thema hat auch jetzt seine Form bestimmt.

Der Mord zeigt: Hier tobt ein Kampf der Ideologien. Er ist die Antwort auf den Ekel der Operators, der sie zwingt, die Verweigerer zu diskriminieren und zu ghettoisieren. Das jeder Ideologie und jeder Utopie inhärente Reinheitsgebot, frei von Widersprüchen zu sein, ist durch den Mord in Gefahr, zumal

all das, was die Operators auf die Verweigerer projiziert hatten, sich bei ihnen selbst finden lässt. Darum müssen die Dreads im Schmutz leben. Das Medium Film eignet sich dazu, psychische und mentale Vorgänge bildlich darzustellen: Das sterile Hypermoderne der Straßen, Autos, Gebäude und Surries bebildert das Reinheitsgebot. Dass das mit der Reinheit, der Projektion, den Ideologien nicht alles so hinhaut, wird dem Zuschauer nicht verschwiegen: So wird der Attentäter auf Geheiß jenes Dread-Propheten, der den Surries-Kult immer wieder der „Lüge" bezichtigt, zum Tod auf dem Scheiterhaufen verurteilt. Das irritiert zunächst, hat dieser doch dreadkonform und ideologiezertrümmernd gehandelt. Die Irritation löst sich, erfährt man, der Prophet verfügt selbst über mehrere Surries, wie es sich für einen Prominenten gehört. Er ist ein Heuchler, ein Verräter, ein Operator.

Der zentrale Filmplot

💬 „Es gibt keinen größeren Schicksalsschlag, als ein Kind zu verlieren."

Die Puppenwelt ist das alternative Territorium für die durch Gefühle bedrohlich andrängende Realwelt. In ihr gibt es keine affektive Irritation. Alles ist sauber, berechenbar, planbar. Will man von *Surrogates* in Ruhe gelassen werden, sollte man sich in der Puppenwelt niederlassen. Lässt man sich aufrütteln, wird man die Gründe für die Abwehr erforschen, wird wissen wollen, was es abzuwehren gibt. Der Zuschauer will Analytiker sein und die Abwehr problematisieren. Darüber wird er – wie der Mörder – zum Störenfried. Beide sorgen für Unruhe im Gebiet der Idealität, in der neurotischen Ordnung, in den Lebenslügen. Ruft der Analytiker seinen Patienten zu: „Lebt!", kontern die Magersüchtigen: „Los verschwinde, Fleischsack"!

Was deckt das Duo Zuschauer/Mörder auf? Ein Kritiker schreibt, das schwierige Verhältnis zwischen Greer und seiner Frau, die ihr Zimmer seit langem nur noch virtuell verlassen habe und sich nicht mehr traue, ihrem Mann als reale Person zu begegnen und so die psychischen Langzeitfolgen permanenten Surrogate-Gebrauchs veranschauliche, hätte genug Ansätze für einen komplexen wie emotionalen Beziehungs-Subplot geboten (filmszene.de). Der Grund für Frau Greers Rückzug wird nicht benannt. Nicht der Langzeitfolgen wegen hat sie sich zurückgezogen, sondern weil sie ihren Sohn verloren hat! Keine von mir gesichteten Kritiken geht auf diesen Verlust ein. Ich halte ihn keineswegs für einen Subplot, sondern für den eigentlichen Plot des Films. Sowohl seine Wiederholung spricht dafür (Greer hat seinen Sohn durch einen Unfall, Canter durch einen Mord verloren), als auch die Erfahrung, dass der Plot einer jeden Begegnung bereits im Erstkontakt aufgehoben ist. So in *Surrogates*: Im Rolls-Royce lauschen wir einem Gespräch zwischen Vater und Sohn, das heißt, der Film beginnt mit einer Vater-Sohn-Szene. Später kommt es zu einer Begegnung zwischen Dr. Canter und Tom Greer, wieder im Rolls-Royce, in der Canter den signifikanten Satz prägt: „Es gibt keinen größeren Schicksalsschlag als ein Kind zu verlieren." Die Luxuslimousine unterstreicht die Signifikanz des Themas, weshalb es durch den gesamten Film „gefahren" wird. Zuvor war Canter(O) gedämmert, womöglich selbst für den Tod seines Sohnes verantwortlich zu sein, worauf er bitterlich weint. Kein Wunder, dass in der Ersatzwelt keine Kinder zu sehen sind! Die weiblichen Surries entkommen der Reproduktionsfalle, der Graviditätsangst, beide Geschlechter ersparen sich die Konfrontation mit Alter, Generationsfolge und einem möglichen Verlust, den es zu betrauern gälte. Die Doubles erübrigen den Schmerz – wie bei Goethe (1993). Treffsicher benennt dieser in „Dichtung und Wahrheit" die Funktion seiner Autoskopie:

Es mag sich übrigens mit diesen Dingen wie es will verhalten, das wunderliche Trugbild gab mir in jenen Augenblicken des Scheidens einige Beruhigung. Der Schmerz, das herrliche Elsaß, mit allem, was ich darin erworben, auf immer zu verlassen, war gemildert, und ich fand mich, dem Taumel des Lebewohls endlich entflohn, auf einer friedlichen und erheiternden Reise so ziemlich wieder.

Goethe benötigte seine Autoskopie zur Milderung seines Abschiedsschmerzes; sie war eine Trauerreaktion und tröstete zugleich, da ein Teil von ihm virtuell zu Friedriken zurückkehren konnte. Man könnte sie eine „Anthropotechnik" (Sloterdijk) nennen. Goethe rettete sich im Schmerz in ein Bild, dessen Funktion die Bildtheorie herausgearbeitet hat. Dem Tod als unerträgliche Abwesenheit wird ein Bild entgegengesetzt, um sie zu ertragen (Belting 1996, S. 95):

> Im Bildermachen wurde man aktiv, um der Todeserfahrung und ihren Schrecken nicht länger passiv ausgeliefert zu bleiben…

Wie Canters Sohn zu Tode kommt, wird im Film erzählt, also szenisch entfaltet. Greers toten Sohn bekommen wir auf einer Fotografie zu sehen. Nicht zufällig also sind Tod, Idealität und Trauer zentraler Plot eines Films, der von Doppelgängern handelt. In der Antike betrat jeder Mensch die Erde mit einem unsichtbaren Doppelgänger als Schutzgeist. Im Talmud heißt es, dem eigenen Doppelgänger zu begegnen sei so, wie Gott (also dem Ichideal) zu begegnen. Die Filmhandlung ist demnach die bildhafte Entourage einer Trauerthematik. Die Frage, was Plot, was Subplot, stellt sich nicht, da es aus der Perspektive von Abwehr und Abgewehrtem in *Surrogates* einzig um „Trauer und ihre Abwehr" als Plot geht. Und der wird wünschenswert konsequent verfolgt. Bereits zu Beginn des Films, als Greer(O) aus seiner Trance erwacht, begleiten wir ihn ins Kinderzimmer seines verstorbenen Sohnes und sehen dort das Foto eines etwa sechsjährigen Jungen, zusammen mit seinen Eltern, alle glücklich lächelnd. Beim Durchqueren des Zimmers streicheln Greers Hände zärtlich-liebevoll über herumliegende Spielsachen – eine tieftraurige Geste.

Der Vater trauert, was macht die Mutter? Die Beziehung zwischen den Menschen und ihren Doublen komme allerdings nur wenig zum Tragen, schreibt ein Kritiker. Probleme würden nur selten angedeutet, etwa bei Greers gramgebeugter Frau, die sich nicht mehr aus dem Haus traut. Mostow konzentriere sich vielmehr auf die Actionszenen (rp.online.de). Stimmt das? Tatsächlich hat sich Greers Frau ganz in ihr zweites Ich zurückgezogen und ist nicht dazu zu bewegen, diese Position zu verlassen. Sie will sich amüsieren, keine Trauernde sein. Der Film entfaltet dieses Thema in verschiedenen Szenen. Immer wieder versucht Greer(O), mit seiner Frau ins Gespräch zu kommen, um sie emotional wiederzufinden. Er will kein geschniegeltes Surrogate, der alle zwischenmenschliche Wärme abhanden gekommen ist, will keine „neue angenehme Frau von bloßem Metall", wie man mit Jean Paul sagen könnte. Sie weicht ihm aus. Die Situation kulminiert schließlich in einer der eindringlichsten Szenen des Films: Seiner Metall-Frau gegenüberstehend schmiert Greer ihr mit seinem Finger Blut von seinem verletzten Gesicht auf ihre Wange. Um die tiefe Symbolik dieser Szene zu würdigen, kann man Patienten zu Hilfe nehmen, die, sich innerlich leer fühlend, mit Rasierklingen die Haut aufschneiden, um über das warme, fließende Blut Lebendiges in sich zu spüren. Eben dies will Greer erreichen: die Spaltung des Ichs seiner Frau rückgängig machen. Für mich eine der besten „Actionszenen" des Films! Aber Greer merkt, dass er nicht nur seinen Sohn, sondern auch seine Frau verloren hat. Sie sperrt sich jeder Berührung. Wir Zuschauer wissen warum. Im Gegensatz zu ihm dürfen wir nämlich die trauernde Mutter hinter dem Surrogate sehen: eine in Kummer dahin gestreckte Frau mit tränenüberströmtem, trauerfaltigem Gesicht und vielen Tabletten auf dem Nachttisch. So, in Leid und Verzweiflung, soll ihr Mann sie nicht sehen. Erst zum Ende des Films gelingt es ihm, sie wiederzufinden. In diesem Zusammenhang gehört eine eher tragikomische Szene im Schönheits- und Reparatursalon seiner Frau, in der sich eine Mitarbeiterin der beklemmenden Begegnung des Ehepaars mit der Bemerkung entzieht: „Ich muss noch ein paar Lachmuskeln einstellen."

Eben, in der Trauer dürften die allseits frohen Mienen entgleist sein. Das ist die feine Ironie des Films!

Trauerthematik als zentrales Filmmotiv

Die Trauergefühle der verwaisten Eltern drängen immer wieder an die Oberfläche. Da nützen Schönheit und Perfektion nichts, weshalb die Beautyindustrie dieses Thema wie die Pest meidet. Ein Kindstod gehört heutzutage zu den verpönten, aus dem Bewusstsein ausgeschlossenen Themen. Den frühen Tod zieht der Jugendlichkeitswahn aus naheliegenden Gründen nicht in Betracht. Verlieren Eltern ihr Kind, bricht die Welt zusammen. Die Trauer ist überwältigend, nicht geplant und nicht planbar. Kein Chirurg könnte das innere, das virtuelle Szenarium, in dem sich die Trauerarbeit bebildert, wegskalpieren. Der Trauer ist nicht zu entkommen. Sie gehört zu den großen Lebensproblemen, die nie auf immer gelöst werden, auch nicht mit Surries. Damit aber die Trauer nicht überwältigend wird, nicht Tränen dem Zuschauer den Blick trüben, müssen jetzt Actionszenen her, die ablenken. Die Unterbrechungen sind zwar den Wünschen und Launen der Zuschauer geschuldet, aber auch der verhandelten Psychodynamik: In ihr kommt es zu ständigem Pendeln zwischen Abwehr und Abgewehrtem. Der Film bleibt hier konsequent: Was wir vorgeführt bekommen, ist eine Form agitierter Depression, zu der Männer im Schmerz tendieren. Die Rolle ist hier mit Bruce Willis gut besetzt.

Für Trauer gibt es keinen utopischen Entwurf, ebenso wenig wie es einen praktikablen Lebensentwurf gegen den Tod gibt. Da die Vergänglichkeit des Menschen größte Kränkung ist, wird an ihr immer wieder herumgebastelt. *Surrogates* ist ein weiteres Bastelergebnis. Neu ist es nicht. Den ganzen Film könnte man als geschlechtsspezifische Trauerarbeit verstehen. Der Mann agiert seine Trauer, indem er Mörder jagt, die Frau zieht sich hinter eine Maske zurück. Offenbar fürchtet man, über die Trauer zum Dread zu werden. Der Film versäumt es nicht, uns das Gesicht der trauernden Mutter als „Ruine" zu zeigen. Die Surries sollen den gefürchteten Absturz ins Jammertal, in die Kellerlöcher, die Ruinenlandschaft, die Elendsquartiere der Verweigerer abwehren helfen.

Der Wahnsinn im Glasauge

Der Attentäter stört das Ideal einer besseren, schöneren Welt. Wegen der Bedrohlichkeit, die vom Mord ausgeht, beauftragt die Abwehr (hier das Ichideal das Ich) für den Erhalt der Idealität zu sorgen. In diesem Auftrag fungiert Tom Greer noch als Surrogate. Wie es sich für ein Epos ziemt, beginnt nun der Kampf zwischen Surries und Dreads. Solange Greer im Auftrag der Surries ermittelt, sind wir Zeuge, wie die Zurichtung auf Jugendlichkeit ins Unkritische, Spießige und Affirmative abgleitet. Erst als Geer seinen Surrogate beim Absturz des Helikopters auf das Reservat der Dreads verliert, treten Abwehr und Abgewehrtes in Kontakt und Greer kommt einer Verschwörung auf die Spur. Fortan kann man den Film als Bebilderung des innerpsychischen Kampfes verstehen, der ausbricht, wenn die Spaltung aufgehoben wird und die dissoziierten Seiten miteinander in Kontakt kommen. Da zeigt sich, wie Greer beim Ermitteln zum Dread wird. Er altert, fügt sich dem Strom der Zeit und ist verletzbar. Seine Verwandlung erfolgt im Gesicht. Das für die Schönheitsindustrie, wie alle Werbung, charakteristische Verfahren des „Vorher/Nachher", erst alt und unvorteilhaft, dann jung, dreht der Film in die realistische Gegenrichtung: ins „Nachher/Vorher", erst jung, dann alt. Eine Raffinesse, mit der er dem Zuschauer beeindruckend vorführt, was künstliches Verjugendlichen tatsächlich heißt: Zeitstillstand, durch den dieses Gesicht alles verliert, was sein Original kennzeichnet, nämlich Mimik, Identität, Lebensgeschichte, Professionalität. Wird das Gesicht zur Momentaufnahme, bedeutet das unweigerlich ein Mumifizieren des Körpers. Der im Hinblick auf Zukunftsvisionen eher „querschnittsgelähmte" Film kann hier plötzlich „rückwärts" laufen und so den ästhetischen Betrug aufdecken. Er wird zum Antiillusionisten, selbst zum Attentäter, womit er erneut bestätigt: Das zu verhandelnde Thema nimmt Einfluss auf seine Darstellung, der Inhalt bestimmt die Form.

Was im Film exemplarisch am Gesicht des Bruce Willis gezeigt wird, seine Metamorphose vom künstlichen zum authentischen Gesicht, könnte man als Restitution der symbolischen Ordnung bezeichnen. Die ist im Puppenland verloren gegangen. Die Surries-Welt bebildert die Versuchung, in frühes Erleben zurückzukehren, in dem man halluzinatorisch alles löschen kann, was der Wunscher-

füllung im Wege steht. *Surrogates* träumt von der neotonisch veranlassten Rückkehr ins verlorene Paradies, die den Menschen seit je her umtreibt. Der Film zeigt, dass es dort keine Elterninstanzen und damit keine verinnerlichten Gesetzesbegriffe gibt. In der Welt der Surries ist alles möglich, man kann sogar ohne Hilfsmittel fliegen, was nicht nur einen Traum des Menschen erfüllt, sondern andeutet, dass die Surries, gleich digitalen Bildern, ohne haltgebende Tradition und Referenz existieren. Es gibt seitens der Operators keinerlei Grund einzugreifen; sie erleben „in effigie", nichts betrifft sie, nichts von dem, was ihre Zöglinge, treiben, kann ihnen schaden. Die Surries bleiben die ewigen Kinder, weshalb man in der Ersatzwelt keine Kinder(S) sieht. Das erinnert an Ikarus, der sich über die Warnung seines Vaters hinwegsetzte und an die Eingangsszene des Films: Canters Sohn fährt nicht zur Oper, für deren Besuch er vermutlich Vaters Rolls-Royce geliehen bekam, sondern disponiert um und fährt in die Disco. Dort erhebt er sich gleich Ikarus in die Luft – und kommt wie dieser zu Tode.

Zur symbolischen Ordnung gehören die Gesetze der Anatomie und Biologie, gehören Vergänglichkeit, Geschlechtsunterschied und Generationsbarriere. Sie sind in der Welt der Surries allesamt bedeutungslos. Das Geschlecht ist wegen der Möglichkeit zum „gender swapping" nicht mehr festgelegt, die „Primärdiagnose" Mädchen oder Junge hinfällig, ungültig. Man switcht nach Belieben. Das alles stiftet Verwirrung. So auch, wenn Dr. Canter, ein graumelierter Herr, als Jüngelchen auftritt und von seinem verlorenen Sohn (!) spricht. Es ist die Irritation, die Töchter empfinden, deren Mütter sich operativ verjüngen ließen und nun wie diese aussehen und sich kleiden. Die symbolische Ordnung ist hinfällig, weil man bei den Surries nie weiß, mit wem man es wirklich zu tun hat. Selbst der Körper, 2009 noch archimedischer Punkt in einer sonst unübersichtlichen Welt, gibt 2054 weder Sicherheit noch Orientierung.

Ist die symbolische Ordnung außer Kraft gesetzt, droht die Psychose. Der Realitätsprüfung fehlt der Bezugsrahmen. Als Greer(O) seine Frau emotional nicht erreichen kann, sie nur ein „Ding" ist und sich mit anderen Surries in Partylaune vergnügt, zertrümmert er in einem Anfall von Wut und Verzweiflung einen Surrogate – für die umstehenden Surries Anlass, sich köstlich zu amüsieren. Man sieht in zerfallen: nur noch Maschinenschädel, mechanische Fratze, zersplittertes Glasauge. Aus diesem Gesicht blickt der Wahnsinn den Zuschauer an. Es ist die Fratze des anderen Ichs.

💬 Im Schönheits- und Reparatursalon seiner Frau(S) sagt Greer:„Ich fühl' mich, als würde ich verrückt werden."

Das Erschaffen eines künstlichen Menschen gilt seit dem 18. Jahrhundert, seit den Androidenkonstruktionen des Jacques de Vaucanson, als technische und mentale Herausforderung. *Surrogate* bietet diesbezüglich jedoch keinen Anlass zu futuristischer Euphorie, ist vielmehr eine „beklemmende Zukunftsvision" (TV Digital), die teilweise schon Realität ist. Immerhin verhandelt der Film über die Doppelgänger ein Thema der Weltliteratur, das den Wahnsinn zum Inhalt nimmt. Von Plautus 206 v. Chr. in die Literatur eingeführt und in der Renaissance wiederentdeckt, trat in der Romantik die Ich-Spaltung in den Vordergrund und ließ sich fortan zur Darstellung des Unheimlichen, Dämonischen verwenden. Auch die von Manfred Schneider erwähnten Parallelbiografien des griechischen Schriftstellers Plutarch gehören hierher, deren Erzählmethode von der Vorstellung getragen war, in der römischen Geschichte wiederhole sich die griechische Geschichte (Schneider 2010, S. 36 f.):

> Jeder griechische Held gab einem römischen Doppel das Leben, jeder große Römer tritt als Kopie eines hellenischen Helden in die Weltgeschichte ein.

In *Surrogates* lässt das Ich sein Ideal im Land der Surries spazieren gehen. Es selbst sitzt zuhause im Lehnstuhl. Allerdings – sich vorzustellen, der Körper sei aus einem Guss und eine Behausung, in der man wie selbstverständlich lebt, ist nicht erst seit *Surrogates* obsolet. In den „Avatarkabinen" kann man

Abb. 3 Tom Greer(O) (Bruce Willis) in seiner „realen" Gestalt. (Quelle: Disney/Cinetext)

sich bereits heute ein solches Erlebnis außerhalb seines Körpers verschaffen. Im Film jedoch endet das hybride Spiel mit dem technischen Fortschritt in Panik, genauer: in einer Psychotophobie. Canter, dem sein Erfindergeist zum Monstrum wird, will größenwahnsinnig, gottgleich, alles, schließlich die ganze Menschheit auslöschen. Der Wahnsinn werde zur anderen Seite des Fortschritts, sagt Foucault ([1]1961; 1995, S. 383) in Wahnsinn und Gesellschaft. Die Zivilisation böte dem Menschen unaufhörlich neue Gelegenheiten, wahnsinnig zu werden. Und so endet im Film für Canter das Leben, wie die Geschichten von der Begegnung mit dem Ichideal, dem Doppelgänger, dem Spiegelbild immer enden: unheilvoll, in Wahnsinn oder Tod. So bei Narziss, bei Dorian Gray, im Le Horla (Maupassant), bei Dostojewski, bei Attentätern und im Film: In Der Student aus Prag (1913) schießt der Held verzweifelt auf seinen Doppelgänger. Es ist das in den Wahnsinn treibende Grauen der erlebten Ich-Spaltung, des Persönlichkeitszerfalls. Der Attentäter in Surrogates beendet den Wahnsinn und stellt die symbolische Ordnung wieder her. Ab jetzt ist Anerkennung von Unvollkommenem und Gefühl wieder angesagt. Salopp: Ab jetzt ist Schluss mit lustig.

Surries sollten die Affekte steuerbar, planbar und vorhersehbar machen. Der auf abwehrende Idealität aufgebaute Lebensentwurf, die Flucht in die Prothese, funktioniert jedoch nicht. Er zeigt einen apokalyptischen, einen paranoiden Zug. Ohne Zweifel trägt der Film damit zur Dechiffrierung der Gegenwart bei. Es bleibt dem Zuschauer überlassen, welches Motiv er für den Wahnsinn verantwortlich macht: den Erfindungswahn, den Fortschritt oder gar den Kindstod, der zweifellos in den Wahnsinn treiben kann. Der Film verknüpft alle drei als ursächlich zusammen. Der Erfindungsgeist Canters ist sowohl für den Fortschritt als auch für den Tod seines Sohnes verantwortlich, denn mit seinem Erfindungsgeist hat sich Canter der Attentatsgefahr ausgesetzt, in der dann sein Sohn einer Verwechslung wegen umgekommen ist.

Die Sehnsucht nach der Wirklichkeit

Muss der Zuschauer sich nun vor Bewunderung aufs Antlitz werfen? Nein, die Nase am Boden würde den Blick versperren. Muss man beschließen: „Du musst dein Leben ändern", wie das Rilke beim Betrachten eines griechischen Torsos tat? Ja, denn verändern kann sich nur der Zuschauer, die Filmerzählung ist festgelegt. Diejenigen, die sich für die Idee begeistern konnten, Surries an ihrer statt ins Büro gehen zu lassen, suchen das Bequeme. Andere störten sich an physikalischen oder theoretischen Plausibilitätsfragen, argumentierten mit der Realität und wollten sich weder aufs SciFi-Genre noch auf die Trauer einlassen. Es hilft nichts: Die Veränderung des Tom Greer vom Idealkörper (idealen Ich) zum realen Körper (realen Ich) muss auch der Zuschauer machen (◘ Abb. 3). Er muss Abschied nehmen von der Idealität, die sich von keiner Trauer trüben lassen will. Lässt man sich darauf ein, identifiziert man sich mit dem bedauernswerten, um seine im Gesicht eingeschriebene Lebendigkeit betrogenen, Greer. Er führt das Tragisch-Groteske verjüngender Schönheitsarbeit vor Augen. Der ästhetisch verunstaltete Held tut richtig leid, und man fühlt sich bei seiner Wandlung vom jugendlich-biederen Paulus zum lebenserfahrenen Saulus erlöst. Erlöst, weil er, und damit der Zuschauer, wieder trauern darf, anstatt von Actionszene zu Actionszene hetzen zu müssen. By the way taucht ein merkwürdiges Phänomen auf: Tritt Greer als in hellblau gepackter süßlicher Marshmellow mit in die Stirn gebürsteter blonder Tolle auf, sehnt man sich nach der realen (nicht nur filmrealen) Welt zurück. Man atmet auf, ihn wieder als Gewürzgurke zu finden, nachdem er als Surrogate ausgeschaltet war. Hier rieselt kein gelinder Schauer über den Rücken, vielmehr will man die Welt imaginären Tröstens schnell verlassen, eingeleitet durch den Schuss des Attentäters, vom Zuschauer ebenso begrüßt wie die Begegnung mit dem Original-Ehepaar Greer beim „happy-end". Vom Alptraum erlöst, wird man plötzlich gewahr: Über der Welt der Surries liegt ein Geruch von stagnationsbedingter Fäulnis, wie ihn stehende Gewässer verbreiten, verursacht von den Operators, die den Fluss des Lebens zum Stausee gemacht haben.

Dieses „Zurück in die Wirklichkeit" ist sonst nicht Absicht eines Films. Er setzt auf starke Bilder, damit der Zuschauer die Realität nicht vermisst. Bei *Surrogates* jedoch wirbt bereits das Filmplakat für die Wirklichkeit: nicht Surrogate Greer, sein zweites Ich wird gezeigt, nein, wir sehen den Fleischsack im Original! Eine merkwürdige Diskrepanz zwischen Bild und Titel. Aber sie bestätigt, was der Zuschauer spürt. Die Bildwelt der Surries vermag vor der Wirklichkeit nicht zu punkten. Der Zuschauer sehnt sich nach der symbolischen Ordnung zurück. Verweigert sich im Film der Traum der Wirklichkeit, so im Zuschauer die Wirklichkeit dem Traum. Die Vermutung eines Rezensenten, Greer sei von der „Vielzahl der Sinneseindrücke überfordert", weshalb manche seiner Handlungen im letzten Drittel des Films nie schlüssig motiviert seien (critic.de), ist ihrerseits nicht schlüssig. Nicht Quantität ist hier das Problem, sondern der fehlende Orientierungspunkt, die archimedische Referenz, die den Sinnen und Affekten eine Ordnung geben könnte. Deshalb fürchtet Greer den Wahnsinn, dem Canter verfiel.

Das „Paradies" – eine regressive Utopie

Sehnsucht nach der Wirklichkeit, sei es die materielle, die körperliche oder psychische ist eine topische Regression, keine regressive Utopie, keine Vergangenheitsbeschwörung. Sie hat keine vergangenen institutionellen Ordnungen im Auge, die es wiederzubeleben gälte, wie sie etwa Ludwig II. vorschwebte, der sich in seinen Schlössern Fluchtburgen vor der bedrohlich andrängenden nachrevolutionären Weltordnung schaffen wollte. Vom Paradies träumen die Operators in *Surrogates* und recyclen dessen immer gleiche Verheißungen. Ihre Städte sind Orte einer regressiven Utopie, auch wenn sie progressiv, weil hoch technifiziert, daherkommen, wie das bei dem Technikfreak Ludwig II der Fall war. Jeder technische Fortschritt beherbergt die Fantasie einer regressiven Utopie. Die Operators sehnen sich hightech-gestützt in den neotonisch verursachten frühen narzisstischen Zustand zurück. Ob der Film „moralisch aufgeblasen" (filmzeit.de) daherkommt, sei dahingestellt. Ich denke, es geht um Psychohygiene: Trauer lässt sich nicht ohne Folgen für das Seelenleben verdrängen, und deshalb bringt sie das technische Wunderwerk *Surrogate* zum Straucheln – wie einst der Eisberg die Titanic.

Sehnsucht nach Wirklichkeit meint aber auch nicht Sehnsucht nach der tristen Ruinenwelt, dem Jammertal der Dreads. Surries wie Dreads sind keine attraktiven Lebensentwürfe. Nein, der Zuschauer sitzt zwischen den Stühlen. Der Film zwingt den eigenen Lebensentwurf zu überdenken. Kein schlechtes Ergebnis, schließlich ist es der Medizin bis jetzt (noch) nicht gelungen, dem Menschen die Neotonie zu ersparen und ihn erwachsen aus dem Mutterleib zu entlassen. Vorerst bleiben alle Versuche, deren Folgen zu entkommen, Flickschusterei. Ob sie das je schafft, ist fraglich, wäre aber zumindest Stoff für einen Film.

Am Schluss bleibt die Trauer

Ganz so trübe ist die Aussicht jedoch nicht. Im Film siegt die Trauer. Das Ich hat über sein hybrides Ideal triumphiert. Bei Goethe (1933) war das anders, obwohl auch er in Dichtung und Wahrheit in seine Autoskopie switchte:

> Sonderbar ist es jedoch, daß ich nach acht Jahren in dem Kleide, das mir geträumt hatte und das ich nicht aus Wahl, sondern aus Zufall gerade trug, mich auf demselben Wege fand, um Friedriken noch einmal zu besuchen.

Zufall war es nicht, vielmehr unbewusstes Projekt. Die Erklärung liegt auf der Hand: Goethes Ideal zeigte keine unrealistischen Züge wie das der Operators. Sein Double war kein Cyberling, blieb körpernah und zeigte ihm einen Weg, den sein Ich gehen konnte. Es war realistisches Projekt, als (toller) Hecht zu Friedriken zurückzukehren. Das Ideal der Operators hingegen täuscht dem Ich vor, etwas zu können, was es nie können wird. Deshalb muss es scheitern. Es ist eben die Höhe des Ideals, die über seinen Bestand entscheidet, wie Ikarus beispielhaft vorführt. Je höher, desto gefährdeter. In *Surrogates* bricht das ideale zweite Ich zusammen, veranlasst vom ersten Ich des Tom Greer. Die Gefahr, die dem Ichideal droht, kommt vom Ich. Das ist psychische Realität. Der Film bestätigt sie. Das Ende muss „weichgespült" (filmstart.de) sein, sonst entließe der Film den Zuschauer in die Psychose, was er im Unterschied zu den Schauergeschichten des 19. Jahrhunderts nicht wagt. Stattdessen Bilder von haufenweise auf der Straße zusammenbrechenden Surries. Aber schließlich lag auch Ikarus zerschmettert am Boden. Dieses Schicksal könnte freilich auch der Film im Gedächtnis seiner Zuschauer erleiden.

Literatur

Belting H (1996) Aus dem Schatten des Todes. Bild und Körper in den Anfängen. In: Barloewen C. v (Hrsg) Der Tod in den Weltkulturen und Weltreligionen. Diederichs, München, S 92–136

Didi-Huberman G (2006) Venus öffnen. Nacktheit, Traum, Grausamkeit. Diaphanes, Zürich (Erstveröff.1999)

Foucault M (1995) Wahnsinn und Gesellschaft. Eine Geschichte des Wahns im Zeitalter der Vernunft. Suhrkamp, Frankfurt/M, Erstveröff. 1961

Goethe JW v (1993) Dichtung und Wahrheit. Werke in sechs Bänden, Bd V. Insel, Frankfurt/M, S 452

Kamper D (2002) Der Körper, das Wissen, die Stimme und die Spur. In: Belting H, Kamper D, Schulz M (Hrsg) Quel Corps? Fink, München, S 167–174

Lueken V (Hrsg) (1995) Kinoerzählungen. Hanser, München

Menninghaus W (2003) Das Versprechen der Schönheit. Suhrkamp, Frankfurt/M

Schneider M (2010) Das Attentat. Kritik der paranoischen Vernunft. Matthes & Seitz, Berlin

Sontag S (1978) Über Fotografie. Hanser, München

Internetquellen

http://www.movieplot.de/movies/the-surrgates-2. Zugegriffen am 24. 5. 2011

http://www.filmszene.de/kino/s/surrogates.html. Zugegriffen am 24. 5. 2011

http://www.rp.online.de/public/druckversion/aktuelles/kultur/film/809989. Zugegriffen am 24. 5. 2011

http://www.tvdigital.de/entertainment/kino/jetzt-im-kino-surrogates-mein-zweites-ich. Zugegriffen am 24. 5. 2011

http://www.critics.de/film/surrogates-mein-zweites-ich1784/.Zugegriffen am 24. 5. 2011

Originaltitel	Surrogates
Erscheinungsjahr	2009
Land	USA
Buch	Michael Ferris, John D. Brancato
Regie	Jonathan Mostow
Hauptdarsteller	Bruce Willis (Tom Greer), Radha Mitchell (Jennifer Peters), Rosamund Pike (Maggie Greer), James Cromwell (Dr. Lionel Canter)
Verfügbarkeit	Als DVD in OV und deutscher Sprache erhältlich

Isolde Böhme

Vom Träumen der (virtuellen) Realität

Inception – Regie: Christopher Nolan

INCEPTION

JULY 16

Filmplakat *Inception*
Quelle: Cinetext/Allstar/Warner Bros.

Inception

Regie: Christopher Nolan

Eine Annäherung

Inception (◘ Abb. 1) erlebte ich zum ersten Mal in einem bis zum letzten Platz ausverkauften Kinosaal, saß unter Jugendlichen und jungen Erwachsenen, die hellauf begeistert waren. Ich selbst war eher gelangweilt und befremdet, teilte nach meiner Wahrnehmung diese Verfassung mit den meisten meiner Altersgenossen.

Meine Langeweile verstand ich zunächst als Antwort auf das ungeheure Tempo und die Dauererregung in diesem Film. „Zuviel des Gleichen", meint der Philosoph Byung-Chul Han in seinem Text „Müdigkeitsgesellschaft", führt zum „Durchbrennen des Ichs bei Überhitzung" (Han 2005, S. 18), nur scheinbar im Gegensatz dazu blieb ich kalt. Von den wilden Actionszenen – den Schießereien, Explosionen, brennenden Häuser und Autos, den Karambolagen – mochte ich mich nur abwenden. Zugleich stellte sich aber auch das Gefühl ein, nicht mitzukommen, ein Gefühl, das mir vom ersten Sehen von Christopher Nolans *Memento* durchaus vertraut war. Im manifesten Text von *Inception* ging es ums Träumen, es fehlte in diesen Träumen aber jegliches Moment des Innehaltens. Ganz offensichtlich fiel es mir schwerer als den Jungen, die raschen Szenenwechsel und die heftig erregenden Bildern zu verfolgen, aufzunehmen, dabei zu verstehen, an welchem äußeren oder inneren Schauplatz ich mich gerade befand, vor allem aber, wie diese Geschichten sich aufeinander bezogen. Gab es Punkte des Verweilens, Dialoge, die ich verstand, wurden sie rasch von Panik und Verfolgung überschwemmt. Ohne Orientierung blieb mir der Film fremd und wenig verlockend.

Memento (2000) hatte mich beeindrucken können mit der eigenwilligen Konstruktion. Um überhaupt etwas verstehen zu können, muss der Zuschauer die Chronologie der Ereignisse neu ordnen. Die erste Szene ist Endpunkt der Ereignisse, von dem aus sich der Film Schritt für Schritt bis zum Anfangspunkt entfaltet. Dieses Wissen erspart jedoch auch im Weiteren nicht Verwirrung und immer neues Suchen nach einer Position. Henrike Hölzer hat eine eindrucksvolle Deutung des Films vorgelegt, in der sie Form und Inhalt, ästhetische Präsenz und Bedeutung des Films mit Anzieus Konzept des Haut-Ichs versteht. Mir schien es fast so, als hätte Nolan dieses Konzept mit seinem Film veranschaulichen wollen. (Hölzer 2005, S. 170–175)

Mit den Erfahrungen *Memento* und *Inception* war ich immerhin so neugierig geworden, dass ich mich an jüngere Gesprächspartner wandte, die – auch sie voller Bewunderung, wie kunstvoll *Inception* gemacht sei – mich ans Internet verwiesen. Dort stieß ich auf Grafiken, die die hochartifizielle Konstruktion des Films im Film darstellten. Es geht dabei um einen Traum, dessen drei oder vier Ebenen kunstvoll ineinander und mit der Realität verwoben sind. Unzählige Begeisterungsbekundungen von Internet-Usern bezogen sich ebenfalls auf den Aspekt der Konstruktion. Erregung statt Bedeutung, dachte ich, macht Langeweile, aber offenbar war es möglich, diese Erregung intellektuell, durch Identifikation zu halten. Ich besorgte mir die DVD und begann, den Film genauer zu untersuchen.

Psychoanalytische Deutung

Meine psychoanalytische Deutung des Films möchte ich aus der Darstellung der Struktur des Films heraus entwickeln. Bedeutsam sind für mich dabei die Gespräche im Film, in denen Nolan eine Anleitung zu geben scheint, wie er sein Kunstwerk verstanden sehen möchte. Die will ich zu meinem sich wandelnden Erleben des Films zurückbinden. Bei genauerem Hinsehen finden sich Verweise auf Lite-

ratur und auch auf psychoanalytische Denkfiguren. Fast schien es mir so, als wolle auch der Regisseur seine Auseinandersetzung mit neueren Gedanken zu Traum und Film zeigen.

Das Bauen von Kathedralen

Ich hatte bei diesem Film zu allererst Konflikt und Dialog zwischen den Generationen aufgenommen – er findet sich an prägnanter Stelle im Film. Der Protagonist Cobb trifft seinen Vater in Paris, gelangt durch eine ehrwürdige Bibliothek in einen Hörsaal, in dem er sich in eine der hinteren Bankreihen setzt, während der Vater am Pult sitzt und arbeitet. Cobb – oder Dom – nur sein Vater nennt ihn mit dem Vornamen –, bittet den Vater um einen neuen Architekten für seinen Auftrag, der eine komplexe Traumkonstruktion erfordere. Den Auftrag soll er für einen mächtigen Mann erfüllen, der bereit ist, ihm zu helfen, nach Hause zu kommen, nach Hause in die USA, nach Hause zu seinen Kindern. Um nicht ins Gefängnis zu kommen, wird er dort einen mächtigen Fürsprecher brauchen. Der skeptische Vater betrachtet den Sohn als Dieb und Betrüger, wirft ihm vor, sich nicht wirklich um seine Kinder zu kümmern, ihnen nur Stofftiere mitzubringen – Übergangsobjekte wie der Film, denke ich. Der Sohn dagegen sucht Identifizierung in der väterlichen Welt. Er sagt, er habe vom Vater gelernt, sich „im Verstand anderer Menschen zu bewegen". Von der Begeisterung darüber, was Fantasie vermag, lässt er sich tragen, spricht von der Möglichkeit, „Kathedralen zu erbauen, ganze Städte, Dinge, die es nicht gegeben hat, Dinge, die es in der realen Welt gar nicht geben kann". Aber nach allem, was passiert sei, gebe es nicht mehr so viele legale Möglichkeiten, diese Fähigkeit zu nutzen. Er sagt, er selbst könne diese virtuellen Welten nicht bauen, weil Mal ihn daran hindere – seine verstorbene Frau, wie wir später erfahren. Der Vater sagt zum Sohn: „Komm in die Realität zurück!" Was eigentlich diese Realität ist, ist das zentrale Thema des Films. Winnicotts Unterscheidung von Träumen und Fantasieren könnte ein Orientierungspunkt sein. Das Träumen hat mit den Objektbeziehungen in der realen Welt zu tun, das Fantasieren dient der Flucht aus der Realität (Winnicott [1]1971; 1979, S. 37 ff.).

Das Gespräch zwischen Vater und Sohn findet in Paris statt. Nolan begibt sich mit seinem Film in die Tradition der Väter: Marcel Proust, der große Meister des Romans des beginnenden 20. Jahrhunderts, hat sein Werk eine „Kathedrale" genannt. Auch er stellt sich als Künstler in eine große Tradition. Er sprach vom „Tod der Kathedralen", beklagte die Säkularisierung der Kirchenräume. In einem Text mit diesem Titel im Figaro vom 16. 8. 1904 ist zu lesen (Albus 2004, S. 16):

Es gibt heute keinen Sozialisten von Geschmack, der die Verstümmelungen all der Statuen, die Zertrümmerung all der Glasfenster, die die Revolution unseren Kathedralen zugefügt hat, nicht beklagte. Ach, es ist immer noch besser, eine Kirche zu verwüsten, als sie ihrem Zweck zu entfremden. Solange man in ihr noch die Messe zelebriert, bewahrt sie, so verstümmelt sie auch sein mag, wenigstens noch ein bißchen Leben. Am Tag ihrer Zweckentfremdung ist sie tot…

Der innere Zusammenhang von Kunst und Ritus ist für Proust entscheidend, er meint, dass die Kathedralen „nicht nur die schönsten Denkmäler unserer Kunst sind, sondern die einzigen, die noch ein ganzheitliches Leben führen…" (ebd., S. 20) Anita Albus hat einen Essay über Proust und sein Werk „A la recherche du temps perdu" geschrieben, in dem sie zeigt, „daß die Recherche wirklich eine gotische Kathedrale ist: von einem Künstler geschaffen, der die Welt der Biologie und der Kunst, der Naturgesetze und der Religion als eine große Einheit begriffen hat, eine Harmonie der Pflanzen und der Seelen". (Mosebach als Klappentext zu Albus ebd.) Im Roman ist es Proust um die Erinnerung zu tun, die sinnlicher Erfahrung entspringt. Albus verfolgt die beharrliche und gegenüber allen Konventionen rücksichtslose Präzision der Wahrnehmung, die alles Proust zur Verfügung stehende Wissen über Natur und Kunst in den Dienst der Arbeit am Roman stellt. Duft und Geschmack einer in Lindenblütentee getauchten Madeleine können die Erinnerung wecken, die Erinnerung, die seelisches Leben und damit den Roman, die Kunst möglich macht. Die ästhetische Präsenz schafft die Bedeutung.

Gespräche mit Ariadne

Der Vater erfüllt Doms Wunsch und bringt Ariadne ins Spiel, die neue Architektin, die das kunstvolle Gebilde des Films im Film, in dem drei oder eigentlich vier Träume miteinander verwoben sind, erst möglich macht. Ariadne ist in der antiken Erzählung die Tochter des Königs Minos, der in einem von Dädalus gebauten Labyrinth seinen Sohn, den Minotaurus, gefangen hält. Aus einer Gruppe athenischer Jünglinge, die für den Minotaurus bestimmt waren, wählt Ariadne den Theseus. Auf den Rat des Dädalus hin empfiehlt sie Theseus, ein Fadenknäuel am Eingang des Labyrinths festzubinden, und ermöglicht ihm so die Flucht, eine Flucht, auf die er Ariadne mitnimmt. (Campbell 1999, S. 29 f.)

Mittels des kleinen Tricks des gemeinsamen Träumens spielt der Film mit dem geteilten Traum der Kinozuschauer, wenn er Technik nutzt, die für die Vernetzung nötig ist, auch mit dem fast unumschränkt möglichen gemeinsamen Träumen im Internet. In den Träumen zu zweit spielt er auch mit der analytischen Situation. Der träumende Zuschauer wiederum kann sich mit der Gruppe aller Protagonisten als (unbewussten) Aspekten seiner Person, die miteinander verknüpft sind, identifizieren.

Die zukünftige Traumarchitektin entwirft zunächst auf einem Papier komplexe Labyrinthe, dann beobachten wir sie bei ihrer ersten Unterrichtsstunde in der Konstruktion von Traum- und Filmwelten. Sie führt uns ein lustvolles Spiel vor – in technischer Präzision materialisiert sich Fantasie. Die Gesetze der Physik können suspendiert, Grenzen beliebig überschritten, neue Übergänge gefunden werden, verwirrende Schleifen, in denen die Ebenen vertauscht werden. Spiegelszenen eröffnen scheinbar unendliche Räume. Paris wird zu einer utopischen und gleich wieder zu einer sehr real erlebten Stadt. Aber bereits hier muss sich Ariadne mit Cobbs Projektionen auseinandersetzen, von denen sie bedroht wird.

Freud sagt, es gebe kein Realitätszeichen im Unbewussten. Die unterschiedliche Fähigkeit, den Zugriff auf die (innere und äußere) Realität zu behalten, symbolisieren die „Totems" von Cobb und seinem Freund Eames auf der einen Seite und Ariadne auf der anderen Seite: Die kleinen Figuren fungieren im Film als Garanten für die Realität. Sie vermitteln die Sicherheit, sich nicht im Traum eines anderen zu befinden. Bei Cobb ist es ein Kreisel, den er von Mal bekommen hat, Bild der ewigen Wiederholung und der Sucht, bei Eames ist es ein gezinkter Würfel, Bild der Manipulation, bei Ariadne ist es eine Schachfigur der Dame, Bild der intellektuellen Lust.

Zeiterleben in Traum und Film

In den Gesprächen zwischen Cobb und Ariadne wird eine neue Theorie von Traum und Film ausgebreitet – zunächst ist Cobb der wissende Lehrer. Nach und nach übernimmt die Schülerin die Führung im kreativen und gleichzeitig in einem therapeutisch zu nennenden Prozess. Im Schlaf könne das Gehirn fast alles, meint Cobb. Die erlebte Zeit scheine viel länger als die mit Uhren gemessene Zeit. Freud hat von der Zeitlosigkeit des Unbewussten gesprochen. Der Regisseur schließt hier an das Nachdenken über gemessene und erlebte Zeit in der Literatur an und an eine lange Tradition von Essays, die über Zeit im Kino nachdenken. Im Traum fühlten sich fünf Minuten an, als sei es eine Stunde. Wenn Träume in Träumen vorkämen, vervielfache sich die erlebte Zeit. Mit den künstlichen Träumen, die der Chemiker Yusuf aus Mombasa möglich mache, werde die Hirntätigkeit noch weitaus schneller. Auf der ersten Traumebene sei die Zeit um das 20-fache gedehnt, auf der nächsten und übernächsten in noch einmal je 20-facher Potenz.

Cobb beschreibt den Symbolisierungsprozess im Traum in der Logik des Unbewussten:

💬 „Wir erschaffen unsere Welt und nehmen sie gleichzeitig wahr."

Akteur und Produkt des Prozesses fallen zusammen. Winnicott spricht vom subjektiven Objekt, das das Kind sich erschafft, ehe es anerkennen kann, dass die Mutter eine getrennte Existenz hat. Die Brust wird erschaffen (als inneres Objekt) in dem Moment, in dem sie dargeboten wird (Winnicott 11971;

1979, S. 20–24). In Winnicotts Nachfolge hat sich Christopher Bollas mit der Ästhetik des Traums beschäftigt. In seinem Text „Figur im Stück des anderen sein: Träumen" betrachtet Bollas den Traum als eine Fiktion, deren Ästhetik durch die Verwandlung des Subjekts (des Unbewussten) in seine eigenen Gedanken geschieht. Anders formuliert: Das Selbst wird in eine Allegorie von Begehren und Schrecken eingebunden, die vom unbewussten Ich gestaltet wird. Das Subjekt fühlt sich gewöhnlich nicht als Regisseur, sondern als Objekt innerhalb eines fantastischen Schauspiels. (Bollas [1]1987; 1997, S. 76) Cobb scheint diesen Gedanken aufzunehmen, wenn er zu der zukünftigen Traumarchitektin sagt:

 „Sie entwerfen die Welt des Traums. Wir bringen das Subjekt des Traums hinein, und es füllt sie mit Unbewusstheit aus."

Ariadnes Funktion als Therapeutin

Ariadne fungiert als Gegenfigur zu Mal – und damit als Therapeutin. Die Bedrohung, die Cobb in der Außenwelt lokalisiert, von der Polizei verfolgt und in einem Gefängnis eingesperrt zu werden, versteht sie als Angst vor verfolgenden inneren Objekten. Zunächst formuliert sie die besondere Bedeutung der Emotionen für den Traum, deren Vorrang vor dem Visuellen. Sie ist begeistert von der puren Kreativität des geteilten Träumens, vom Entwerfen von Räumen, in denen andere träumen können. Man könnte sagen, sie ist begeistert von der Traumregie, sie versteht aber zugleich Cobbs innere Welt. Sie spricht darüber in der Sprache einer Psychoanalytikerin. Vor Beginn des Gruppenprojekts gelingt es ihr, Cobb zum Sprechen zu bringen über seine Geschichte mit Mal, seiner Geliebten, seiner Frau und der Mutter seiner Kinder, zu denen er nach Hause will. Er erzählt, wie die beiden sich eine gemeinsame Traumwelt erschufen und sich darin verloren. Alle, so sagt Cobb, seien davon überzeugt, dass er Mal getötet habe, so der Rechtsanwalt, drei Psychologen: Alle bestätigen sein überwältigendes Schuldgefühl. Aber Ariadnes Faden kann er aufnehmen, weil sie, anders als Mal, nicht zu wissen glaubt, was real ist oder nicht real ist, sondern Cobbs Geschichte herausfinden will. Die Labyrinthe, die sie erschafft, fungieren als Rahmen, der Traum und Wirklichkeit begrenzt wie in einem analytischen Prozess. Sie nimmt an Cobbs Träumen teil in ihrer ganzen emotionalen Intensität, aber bleibt doch – mit ihrer Damefigur – Beobachterin der (inneren) Wirklichkeit.

Sie nimmt die Rolle einer Gefährtin ein, die Cobb in die Erfahrung der Welt seiner (traumatischen) Vergangenheit, die nicht vergeht, begleitet. Sie erschafft einen Rahmen, Bollas spricht analog vom Traumsetting (ebd., S. 82).

[Es] „verdankt sich dem, was wir mit gutem Recht die ästhetische Funktion des Ichs nennen können: seiner Fähigkeit, Wünsche und Gedanken zu synthetisieren und in ein Drama zu verkleiden sowie das Subjekt in diese Erfahrung hineinzugeleiten.

In Traumszenen, in die sich Cobb begibt, und in die Ariadne eindringt, erfahren wir seine Geschichte mit Mal. Es sind keine Träume, sondern – traumatische – Erinnerungen, die er sich erhalten will, um Mal nicht zu verlieren, und gleichzeitig verwandeln möchte, um mit ihnen leben zu können. Die traumatische Qualität erlebt der Zuschauer in den Wiederholungen der Szenen in kleinen Variationen, so am deutlichsten in der immer gleichen Szene der spielenden Kinder, aber auch in den verführerischen Szenen mit Mal.

Trauerarbeit

Wie eine Analytikerin ist auch Ariadne Angst, Gefahr und Verstrickungen ausgesetzt, kann sich aber bewahren, kann sie benennen. In einer Szene in Cobbs Haus läuft sie plötzlich panisch weg. Sekunden später rast ein Güterzug über den Ort, von dem sie geflohen ist. Sie gibt überzeugende analytische Deutungen, die Cobb nach und nach aufnehmen kann. So beobachtet sie eine Szene, in der Mal sich

das Leben nimmt und sie sagt ihm, dass er Mal nicht einsperren könne in seine Erinnerungen. Sie zeigt Cobb, dass Mal ihn mit ambivalenten Gefühlen zurückließ, er mit ihr melancholisch identifiziert ist, Er konnte sich von ihrer konkretistischen Überzeugung, dass die Wirklichkeit nicht real sei, nur schwer distanzieren. Auch er selbst ist sich der Wirklichkeit nicht sicher. Ariadne deutet das Schuldgefühl, später die Ungetrenntheit von Mal und Cobb. Tatsächlich kann Cobb im Verlauf seine Schuld fühlen und Verantwortung übernehmen für den Gedanken, den er Mal „eingepflanzt" hat, ein Gedanke, der dann in ihr gewachsen ist. Auf diese Weise kann er die guten und die verletzenden Erfahrungen miteinander verbinden und sich aneignen. Als ihm das gelingt, treten an die Stelle von Gewalttätigkeit Zärtlichkeit und Trauer. Er kann sich und ihr sagen, dass sie ihre Zeit miteinander gehabt haben, und so von ihr Abschied nehmen.

Freud hat gezeigt, dass sich hinter den manifesten Traumbildern latent unbewusste Gedanken verbergen. Bollas interessiert neben den Inhalten die Poetik des Traums. Zwischen Mutter und Säugling bildet sich vor dem Spracherwerb das Subjekt, das sich vom mütterlichen Objekt separiert. Analog der Konzeptualisierung klinischer Arbeit in Übertragungs- und Gegenübertragungsanalyse vertritt Bollas, dass „der lenkende Umgang des Ichs mit dem Subjekt im Traumsetting bestimmte Aspekte der frühen Erfahrung des Säuglings und Kleinkinds als Subjekt und Objekt abbildet." Die verführerische Gewalt einer Mal passt zum Kreisel mit seiner immer gleichen Bewegung. Das Immer-Gleiche ist das ungedachte Bekannte der frühen seelischen Erfahrung. Erst als in Denken und Fühlen Distanz zwischen Cobb und Mal entsteht, als er sie als eine Andere sehen kann, entsteht Neues.

Die Fabel wird entfaltet

Der Film beginnt mit grandiosen Bildern samt begleitender Tonspur: mit der Gischt und dem Rauschen der Brandung des japanischen Meeres. Der völlig erschöpfte Cobb ist an den Strand des Meeres gespült worden, öffnet die Augen, nimmt für einen Moment das Bild von zwei im Sand spielenden Kindern von hinten wahr, dazu ist Kinderlärm zu hören. Musikalische Figuren fädeln sich in die Naturgeräusche, die Kinder laufen aus dem Blickfeld. Cobbs Gesicht sinkt wieder in den Sand. Ein Wächter spürt ihn auf, findet Pistole und Kreisel bei ihm, schleppt ihn in einen japanischen Palast. Der Herr des Palasts, Saito (Abb. 2), ein uralter Asiate, fragt den jungen Amerikaner, der gierig Essen in sich hineinlöffelt: „Sind Sie hier, um mich zu töten?" Der Hinweis auf das Vater-Sohn-Thema ist nicht zu überhören. Er beschäftigt sich mit dem Kreisel, sagt:

> „Ich weiß, was das ist. So einen [Kreisel] hab ich schon einmal gesehen vor vielen Jahren. Er gehörte einem Mann, den ich in einem beinah vergessenen Traum traf, der von einer radikalen Idee besessen war."

Ein Schnitt führt in die Welt dieses geteilten Traums. Fast am Ende des Films wird diese Szene verkürzt und mit einer Variation des gesprochenen Texts wiederholt. Wir wissen jetzt: Cobb wurde im Limbus, dem Ort, an dem seelische Gestalt zu allererst entsteht, am Strand des eigenen Unbewussten angeschwemmt, will Saito, der im zurückliegenden Traumgebilde getötet wurde, zurückholen. Die Frage: „Wollten Sie mich töten?" hören wir mit diesem Wissen, auch eine Reihe von Sätzen, die auf den zurückliegenden Film hinweisen. Cobb nimmt Bezug auf eine Vereinbarung, die er im Film mit dem mächtigen Gegner getroffen hat. Er wollte nicht ein alter Mann werden, „voller Bedauern, der allein auf den Tod wartet", verwendet die Formulierung, dass „diese Welt nicht real" sei und fordert ihn auf, in die Realität, jedenfalls eine Realität im Film, in der beide junge Männer sind, zurückzukehren. In dieser Szene isst Cobb nicht. Ich möchte deuten: Der Film ist konsumiert.

Abb. 2 Szene mit Ken Watanabe (Saito), Leonardo DiCaprio (Dominick „Dom" Cobb), Joseph Gordon-Levitt (Arthur). (Quelle: Cinetext/Allstar/Warner Bros.)

Bertram Lewin ([1]1950; 1982) hat die analytische Situation als Wechsel von Einschlafen und Geweckt-Werden beschrieben. Er brachte die zunächst bildlose Traumleinwand mit dem Einschlafen an der mütterlichen Brust in Verbindung. Die Komponenten triebhaften Erlebens beschreibt er als Verschlingen, Verschlungen-Werden und Einschlafen. Man kann etwas mit den Augen verschlingen. Auch in Prousts „Recherche" ist das Essen von größter Bedeutung. Cobb verzehrt Fast Food, während „in der „Recherche" (…) die alte Idee des heiligen Charakters der Speisung in der begnadeten Köchin Francoise" fortlebt. (Albus 2004, S. 34) Essen wird zelebriert. Albus zitiert Proust in einem seiner Briefe, in dem er sich für ein boeuf mode en gelée bedankt (ebd., S. 35):

> Ich wünschte, mein Stil wäre so glänzend, so klar, so fest wie Ihr Gelee – meine Ideen so schmackhaft wie Ihre Karotten und so nahrhaft und frisch wie Ihr Fleisch.

Der Schnitt führt in eine Szene, in der ein geschniegelter und ziemlich aufgeblasener Cobb dem jungen Saito gegenüber doziert. „Welches ist der widerstandsfähigste Parasit? Ein Virus, ein Bacterium, ein Eingeweidewurm?" „Nein" erfahren wir, „ein Gedanke! Er ist widerstandsfähig und hoch ansteckend!" Spürbar werden Überheblichkeit, Lug und Trug und der Plan, ein (Firmen)Geheimnis zu stehlen, und zwar für Global Engineering. „Extraction" heißt das Projekt, und es soll Cobb nach Haus bringen, zu seinen Kindern. Nachträglich kann ich die Szene damit in Verbindung bringen, dass die Nachahmung einen Anfang des Denkens über Kunst bildet, dass die Kunst, der Traum, dass alles Seelische von Geheimnissen durchtränkt ist. Das Projekt missglückt jedoch. Saito entdeckt, dass der Teppich, auf dem er liegt, nicht aus Wolle ist, wie der in seinem Apartment, in dem er sich wähnt, sondern aus Polyester. Saito versieht Cobb mit einem neuen Auftrag – und einem neuen Versprechen, bei Erfüllung des Ziels nach Haus zu kommen. Anstelle von „Extraction" soll es jetzt um „Inception" gehen, um das Einpflanzen eines Gedankens; ich möchte sagen, um das sinnliche Vermitteln von Erfahrung.

Erste Traumlektionen, Faszination und Grauen des Träumens

Der Zuschauer bekommt Werkzeug an die Hand, um den Film zu untersuchen und zu verfolgen. In schnellen Schnitten träumen miteinander vernetzte Schläfer im japanischen Hochgeschwindigkeitszug, setzen ihr Projekt träumend in Szene. Von einer offenbaren Traumwelt, gelangen wir blitzschnell in eine andere, dann in die Realität, die sich schließlich als Traum im Traum herausstellt. Eindrucksvoll ist die Szene, in der sich Cobb, eben aus einem Traum über Mal erwacht, am Waschbecken das Gesicht wäscht und beim Blick durch das Fenster Mal wieder auftaucht – er also wieder im Traum gelandet ist. Arthur und Cobb wandeln durch das Traumhaus. Gewalttätiges ist allgegenwärtig. Akteur und Ergebnis sind gemäß unbewusster Logik nicht zu trennen. Die Abwehr wird überwältigt, der Widerstand wird gebrochen. Man mag an diese kriegerische Sprache Freuds zur Beschreibung seelischer Prozesse denken. Das Gebäude des Traums stürzt zusammen. Wenn der symbolische Raum zusammenbricht, wenn die Symbolisierungsfähigkeit verloren geht, füllt Action den Raum aus.

Um vom Traum zur Realität zu gelangen, oder auch von einer Traumebene zur anderen, braucht es einen Kick. Arthur wird im Traum mit dem Schuss einer Pistole getötet und wacht auf. Der schlafende Cobb, der seine Mission, Saito zu bestehlen, erfüllen will, lässt sich nicht wecken. Er wird in einer Badewanne untergetaucht und erlebt noch träumend, wie das Traumhaus überflutet wird und zusammenbricht. Der Kick wirkt auf das Innenohr, auf die Bewegungsempfindung im Raum und auf das Hören. Musik kann aus dem Traum wecken.

Kunstwerke lassen sich intertextuell verstehen. Ein Kunstwerk, sei es ein literarischer Text, sei es gemaltes Bild, sei es ein Film, bezieht sich immer auf andere Kunstwerke. Beim Raub von Geheimnissen geht es um Lesen, Kopieren und – wie Harold Bloom ([1]1973; 1995) eindrucksvoll dargestellt hat – um das poetische Fehlverstehen oder Fehllesen der Werke der großen Vorgänger. Bei Proust liest sich dieser Vorgang sorgsamer, weniger gewalttätig (Albus 2004, S. 32).

Man spannt sorgfältig von einer Stelle seines (des großen Schriftstellers I. B.) Schaffens … zu einer anderen (von einer Epoche zur anderen) ein Netz aus. Wenn das Netz ausreichend enge und feine Maschen hat, wäre es ziemlich verwunderlich, wenn Sie nicht im Durchgang eines jener schönen Geschöpfe festhielten, die wir Ideen nennen …

Cobb ist es nicht gelungen, Saito zu berauben. Die mächtige Vaterfigur fordert „Inception", die Einpflanzung eines Gedankens in die innere Welt des Erbens eines Wirtschaftsimperiums Robert Fischers. Wie es Ariadne vom Träumen sagt, geht es auch im Kino um heftige Affekte. Auch Robert Fischer muss wie Cobb einen Entwicklungsprozess durchmachen. Er muss den eingepflanzten Gedanken als eigenen verstehen, sich aneignen, sich einverleiben, in der Sprache Winnicotts Vorgefundenes in Selbsterschaffenes zu verwandeln (Winnicott [1]1971; 1979, S. 22). Er muss aus dem Werk seines Vaters, der stirbt, den er in einer zweiten Version sterben lassen muss, sein eigenes machen. Wenn ihm das gelingt, kann sein Alterego Cobb nach Hause.

„Rückkehr nach Hause"

Der Weg nach Hause bekommt im Film eine vielfältige Bedeutung. Er hat zunächst eine progressive Bedeutung im Entwicklungsroman: Mit Freuds Chiffre des Vatermords ist gemeint: Man muss mit dem Vater als Objekt oder den eigenen Eltern als Objekten fertig werden, um sein eigenes Leben zu leben, in dem man (reale und symbolische) Kinder haben kann, die eigene Köpfe, eigene Gesichter, eine eigene Sicht auf die Welt haben. Die Alternative, so meint Saito, ist: Es „wird aus Ihnen ein alter Mann, voller Bedauern, der allein auf den Tod wartet." Der Weg nach Hause hat auch eine tödliche, regressive Bedeutung. Sie wird dargestellt als Rückkehr zu Mal, der schönen Frau, mit der Cobb eine Welt jenseits der Realität aufgebaut hat, die so verlockend erscheint wie das primäre Objekt. Es ist Schuld, die Cobb scheinbar unauflöslich an diese archaisch mütterliche Figur bindet. Die prädödipale Verstrickung mit

der Mutter und die ödipale Auseinandersetzung mit dem Vater führen in die Welt infantiler Wünsche, von denen Freud (1900, S. 594) spricht:

… in unserer Traumtheorie haben wir dem aus dem Infantilen stammenden Wunsch die Rolle des unentbehrlichen Motors für die Traumbildung zugeschrieben.

„Ich will nach Hause zu meinen Kindern" bedeutet in dieser Logik: Ein Kind will nach Hause, in die frühe mütterliche Welt. Leszczynska-Koenen (2009, S. 1134) bezieht sich in ihrem psychoanalytischen Text „Herzasthma – Exil und Objektverlust" auf den polnischen Maler und Theatermacher, der einmal gesagt habe, „daß Kunst immer der Versuch sei, an den Ort der Geburt, den wir verlassen müssen, zurückzukehren."

In Mombasa stellt Cobb seine Crew zusammen. Er ist mit Arthur unterwegs, trifft Eames, wird in einer brenzligen Situation von Saito aufgefangen. Eames, der „Fälscher", vermittelt ihm Yusuf, einen Chemiker, der mit seinen chemischen Verbindungen für die Stabilität der Träume sorgen wird, durch die drei Ebenen des Traums möglich sein sollen. Yusuf führt Cobb mit seinen Gefährten in einen Keller, in dem Träume geteilt werden. Schlafende, oder besser, Intoxikierte, kommen jeden Tag für drei oder vier Stunden in diese afrikanische Höhle, um ihre Träume zu teilen. Ein alter Mann verrät:

 „Sie kommen nicht, um zu träumen, sondern um geweckt zu werden: Ihr Traum ist zu ihrer Realität geworden."

Geteilte Träume als geteilte Gedanken, die im Triebhaften wurzeln, dürfte es seit Menschengedenken geben. Die technische Form der Vernetzung weist auf das Internet hin, damit auch auf die Internetsucht. Wie groß ist doch die Bedeutung heutzutage, in Echtzeit über Tausende von Kilometern hinweg miteinander zu kommunizieren! Wie viele Stunden verbringt wohl der durchschnittliche amerikanische Jugendliche täglich im Internet? Ist Mombasa ein Drogenumschlagplatz Afrikas? Die Träumenden mögen die Surfer im Internet sein oder auch die Zuschauer der täglichen Soap-Serien im Fernsehen. Cobb kennt diese Welt. Er träumt mit: Mal taucht auf. Er wacht angstvoll auf.

Die Traumebenen beim Flug von Sydney nach Los Angeles

Theorie und Plan der „Inception" werden von der Crew gemeinsam entwickelt. Arthur hat herausgefunden, dass Fischer eine sehr schlechte Beziehung zu seinem Vater hatte. Er folgt ihm in das Sterbezimmer seines Vaters, wo Fischer erneut zurückgewiesen und gekränkt wird. Der Vater hinterlässt dem jungen Mann ein großes Unternehmen, wie wir von Saito erfahren, ein Energieunternehmen, das bald die halbe Welt versorgen wird. Vater wie Sohn sind von einander enttäuscht. „Disappointed" ist tatsächlich das letzte Wort, das der Vater dem Sohn ins Leben mitgibt. Der Vater wiederum hat dem Jungen offenbar vor allem nicht geholfen zu sprechen und zu trauern. So klagt der junge Mann, der Vater habe nach dem Tod seiner Mutter dem Elfjährigen gesagt: „Darüber gibt es nichts mehr zu sagen." Ein Foto vom Vater und dem kleinen Jungen, vom Vater vom Tisch gefegt, bewahrt der junge Mann als bedeutsame Erinnerung. Es wird zu einer Quelle der Wandlung. Sein Patenonkel Browning ist als Vaterersatzfigur präsent, die es Fischer ersparen könnte, mit seinem Vater fertig zu werden.

Der Gedanke, der eingepflanzt werden soll, muss eine möglichst einfache Form haben. Damit er angenommen werden kann, muss er gefühlt werden können. Das Unbewusste als Ort von seelischer Lebendigkeit und Kreativität ist ein emotionales Unbewusstes. Zu diesem Konzept, das De Masi (De Masi 2003) aufgenommen hat, der es vom dynamischen Unbewussten Freuds abgrenzt, haben experimentelle Daten geführt. Das dynamische Unbewusste ist das Verdrängte. Es steht mit Bewusstem und Vorbewusstem in ständiger dynamischer Beziehung und kann über seine Abkömmlinge bewusst gemacht werden. Es ist ein System, in dem verschiedene Instanzen (Ich, Es und Über-Ich) einander

beeinflussen, was dazu führt, dass in Träumen die anstößigen Gedanken zugleich verhüllt und enthüllt werden. In der Traumdeutung muss diese Traumarbeit rückgängig gemacht werden, um die latenten Traumgedanken, die verdrängt worden sind, herauszuarbeiten. Mit dem emotionalen Unbewussten De Masis dagegen ist die Fähigkeit zu träumen gemeint, das heißt, träumerisch zu denken. Die Psyche arbeitet im Wachzustand nach den gleichen Funktionsprinzipien wie beim Träumen. Die Bedeutung des Seelischen liegt darin, eine Reizschutzschranke zu errichten, wobei rohe Sinnesdaten in seelisches Material, mit sich träumen lässt, und auch aus dem Körper kommende sensorische Daten in Gefühle transformiert werden. Der Traum ist damit nicht nur ein Königsweg zum Unbewussten, sondern der Vorgang des Träumens ist vor allem ein Modus der Transformation, der seelischen Verarbeitung und Differenzierung. Das emotionale Unbewusste enthält das dynamische Unbewusste. Es dient dazu, Erkenntnisse verfügbar zu machen, ist aber in seinen Funktionen nicht erkennbar.

Cobb ist eine weitere experimentelle Erkenntnis wichtig: Positive Gefühle stechen negative immer aus. Das macht es nötig, die enttäuschten Gefühle zu spüren und zu verändern. Die Gedankenfolge in den drei Ebenen wird entwickelt, liest sich wie ein verhaltenstherapeutisches Programm zur Überwindung pathologischer Überzeugungen: „Ich werde nicht in die Fußstapfen meines Vaters treten." Auf der nächsten Ebene: „Ich werde etwas für mich selbst schaffen." Schließlich: „Mein Vater will nicht, dass ich bin wie er."

Arthur hat herausgefunden, dass Fischer wöchentlich von Sydney nach Los Angeles fliegt. Die lange Flugzeit von zehn Stunden soll der Crew genügend Zeit geben, in gemeinsamer Traumarbeit einen Gedanken in Robert Fischers Denken einpflanzen, der wachsen kann. Als alle im Flugzeug sind, begibt sich die Crew an die Arbeit. Fischer und alle anderen werden sediert, sie werden vernetzt. Wie bereits erwähnt, ist dieser Film im Film eine Verschränkung von drei, eigentlich vier Träumen. Yusufs Traum ist eine Fahrt der Träumer in einem Van, in dem sie von Fischers Abwehrorganisation bedroht werden. Arthurs Traum findet in einem Hotel statt, in dem Cobb in aktive Auseinandersetzung mit Fischer tritt. Eames' Traum schließlich „spielt" in einer winterlichen Gebirgslandschaft, die Crew muss ihren Weg durch den Schnee finden. Fischer muss in einer der Stationen die Wahrheit über seinen Vater herausfinden. Der Sprung von einer Traumebene in die dem Bewusstsein nähere geschieht durch einen „Kick". Kick bedeutet die Labilisierung des gewonnenen Gleichgewichts. Das kann auch musikalisch geschehen. Die Melodie, die immer wieder verwendet wird, ist Edith Piafs Lied „Je ne regrette rien", das Lied einer süchtigen Diva. Die vierte Ebene ist das Träumen im Limbus, einer Seelenregion, in der das Gestalthafte zu allererst auftaucht. Die Traumkonstruktion beruht auf der Mathematik wie die mittelalterlichen Kathedralen. Die Zeitmessung funktioniert unterschiedlich in den verschiedenen Ebenen des Traums und muss koordiniert werden. Ich möchte die Träume auf dem Hintergrund von Bollas' Theorie nur kurz kommentieren.

Yusufs Traum

Yusuf steht zunächst bei strömenden Regen am Straßenrand, steigt in ein Auto ein, das Cobb steuert, in dem die Crew sitzt. Um Fischer ins Auto zu locken, wird ein Taxi in Westernmanier gekapert. Beide Autos geraten in eine heftige Auseinandersetzung mit riesigen gepanzerten Wagen, mit vermummten Gestalten, die schießen und die Träumer zu überwältigen suchen. Im Auto wird Saito lebensbedrohlich verletzt. Die Autos werden in einer Garage geparkt. Im Streit um die heftige Schießerei wird Fischers Abwehrsystem für verantwortlich erklärt. Fischer, dieser weiche, etwas unbedarfte junge Mann, weiß überraschenderweise, sich zu verteidigen, ist dafür eigens geschult worden. Man könnte deuten, dass es eine autistische Verpanzerung und autistische Objekte sind, die Fischers Abwehrformation ausmachen. Die Gruppe erfährt von Cobb, dass die Sedierung bewirkt, dass Sterben im Traum nicht zum Aufwachen führt, sondern die Getöteten im Limbus – einem rohen, ungeformten Unbewussten, das unendlich ist – landen. Wenn sie wieder aufwachen, werden sie entweder alle ihre Erinnerungen verloren haben – in den Worten Eames': ihr Gehirn wird zu Rührei geworden sein – oder gemäß des ganz ande-

ren Zeitverlaufs zu sehr alten Menschen geworden sein. Cobb sieht als einzige Möglichkeit der Rettung vor Fischers Privatarmee den raschen Szenenwechsel in eine andere Traumwelt. Die Logik könnte man umkehren. Die Angst, nicht erinnern zu können, zwingt dazu, immer schneller immer neue Welten zu erschaffen – in der Illusion einer ewigen Jugend.

Cobb erzählt Ariadne, dass er mit Mal im Limbus war. Er hat mit ihr gemeinsam das Konzept des Traumes erforscht, die Erfahrung gemacht, dass da unten Stunden zu Jahren werden – am Strand des eigenen Unbewussten angeschwemmt zu sein, wo man das Gefühl verliert, was real ist. „Wir erschufen, wir erbauten die Welt für uns selbst." Er sagt über Mal: „Sie hatte etwas weggesperrt, eine Wahrheit, die sie einmal gekannt hatte, aber vergessen hatte." Der Kreisel wurde weggesperrt als Garant des Kontakts zur Wirklichkeit.

Szenen, in denen Mal und Cobb sich begegnen, breiten das Material der Erinnerung aus. In der ersten Lektion für Ariadne hatte Cobb darauf beharrt, dass für die Gestaltung der Traumarchitektur Erinnerungen zu vermeiden seien, da sie zu Schwierigkeiten führten, Traum und Wirklichkeit zu unterscheiden. Das gelingt Cobb nicht. Analytisch könnte man sagen, Cobb bleibt nichts anderes übrig, als sein inneres Leben so, wie das Unbewusste es will, von neuem zu durchleben. Dafür verwendet es Erinnerungen, die als Déja-vue auftauchen, etwa die Szene, in der Mal sich zur Feier des Hochzeitstags aus der Hotelsuite in die Tiefe gestürzt hat, ihn verführen wollte, sich mit ihr zu töten. Hier deutet Ariadne die Schuldgefühle:

 „Ihre Schuldgefühle halten Sie fest. Wenn wir hier raus kommen, müssen Sie sich selbst vergeben. Sie sind nicht verantwortlich für die Gedanken, die Mal umgebracht haben.

Fischer wird von Cobb ins Kreuzverhör genommen, mit den Projektionen seines Patenonkels konfrontiert. Das Spiel verläuft nach den Gesetzen von Abwehr und Widerstand. Fischer erschafft sich dabei offenbar auch Material, mit dem er (später) seine eigenen Bilder bedeutsam gestalten kann, etwa mit der Codenummer des Tresors in der väterlichen Wohnung. Das Unbewusste ist am Werk: hier als Übertragungsprozess.

Arthur schießt auf Figuren von Fischers Privatarmee, die das Haus umzingelt hat. Eames rivalisiert und bringt eine Explosion in Gang, die offenbar den Kick in den nächsten Traum ermöglicht. In einem Van, einem Großraumwagen, verlässt die Crew die Garage. Diskutiert wird, wie ein Mr. Charles eingeführt werden könnte. Dann sind wir in Arthurs Traum.

Zwischen die anderen Träume geschoben, tauchen immer wieder die Schlafenden im Großraumwagen auf, die Yusuf durch eine gewalttätige Welt steuert. Am Ende des Films ist die Synchronisierung des Kicks für alle drei Träume entscheidend. Der Wagen stürzt von einer Brücke in einen Fluss – beide, das Abheben und das Aufkommen auf dem Wasser können als Kick dienen. Beim zweiten Mal gelingt die Synchronisierung, und die Träumer tauchen aus dem Fluss auf.

Arthurs Traum

Eine direkte Auseinandersetzung der Crew mit Fischer gelingt mit der Figur des Mr. Charles. Das bedeutet, dass Cobb Fischer in dieser Rolle darauf aufmerksam machen muss, dass er träumt, und so versucht, die Abwehr zu unterlaufen bzw. Fischer dazu zu bringen, sich mit seinem eigenen Unbewussten auseinanderzusetzen. Dabei tauchen eindrucksvolle Szenen auf, die Traumszenarien nachbilden. Unheimliche Szenen, in denen der Träumer sich angeschaut fühlt, wir uns angeschaut fühlen. Cobb weist Fischer auf das Unheimliche der Atmosphäre hin. Bestätigt wird das Empfinden durch gleichzeitige Schwierigkeiten, in denen sich der Van befindet. Das Einführen von Mr. Charles könnte man analog der Arbeit des Analytikers in der Übertragung verstehen. Die Deutung der Übertragung wäre ja etwas wie ein Aufwecken, der Träumende, der Analysand wird sich bewusst, dass er träumt, dass er sich

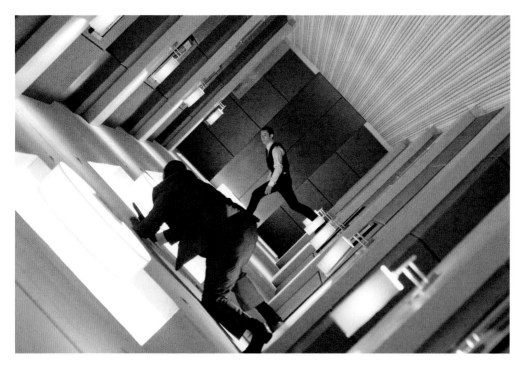

▣ Abb. 3 Arthur (Joseph Gordon-Levitt) und Cobb (Leonardo DiCaprio). (Quelle: Cinetext/Allstar/Warner Bros.)

in einer analytischen Situation befindet. Gelungen ist die Deutung, wenn der Analysand wagt, weiter zu träumen, das meint, träumerisch zu denken. Eames präsentiert Fischer eine Projektion seines Onkels Peter Browning, um zu überprüfen, ob er sich in der Auseinandersetzung mit Cobb bereits ein Stück distanziert habe. Das ist offensichtlich so, und Fischer nimmt die Herausforderung an, auf eine tiefere Traumebene zu gehen, sich tiefer in das Unbewusste des Onkels, eigentlich aber das eigene Unbewusste zu begeben. Wir schauen mit Cobb durch ein Fernrohr auf die Architektur von Eames' Traum, eine tief verschneite Gebirgslandschaft. Der Großraumwagen kommt ins Schleudern, kommt von der Fahrbahn ab, Arthur ist in seinem Traum in heftige Kämpfe verwickelt, schließlich bringt er seinen Gegner um, Yusuf den Van wieder in Gang – und Eames' Traum kann sich entfalten.

Am Ende des Films geht es wie in Yusufs Traum darum, einen Kick möglich zu machen. Der Großraumwagen befindet sich inzwischen im freien Fall. Im Hotel ist die Schwerkraft aufgehoben, die Figuren gleiten durch den Raum (Abb. 3). Dann hat Arthur alle Hände voll zu tun, die Crew zusammen zu binden und in den Aufzug zu befördern, damit sie dort alle miteinander den Kick erfahren, der sie auf den nächsthöheren Traumlevel und schließlich in die Wirklichkeit bugsieren wird.

Eames' Traum

Eames' Traum findet in einer grandiosen winterlichen Gebirgslandschaft statt, die eine Entsprechung findet in einer pathetischen und triumphalen Musik. Zu verfolgen sind beeindruckende und lustvoll zu beobachtende Szenen der Crew und ihrer Gegner auf Skiern, Schlitten, Snowboards. Umso erschreckender und im Verlauf auch umso quälender sind die gewalttätigen Episoden und die nicht enden wollenden Schießereien. Zu verstehen sind sie als Abwehrkämpfe, die man Fischer oder noch mehr Cobb zuordnen kann.

Fischer soll in der mittleren Terrasse des Gebirges die Wahrheit über seinen Vater suchen und finden. Saito, der Blut spuckt, soll ihn begleiten. Wenig später hören Cobb und Ariadne Musik. „Je ne

regrette rien". Inzwischen ist der Van am Fluss angelangt, ist abgehoben. Im Hotel sind die Gestalten nicht mehr der Schwerkraft unterworfen. In Eames' Traum stürzt eine riesige Lawine den Berg hinab. Die Crew hat den Kick verpasst; der neue Kick, wenn der Großraumwagen auf dem Wasser aufkommt, soll genutzt werden.

Mal dringt jetzt direkt in den Traum ein. Mit ihr wird die Musik, die eben noch männlich-entschieden-mutig klang, verführerisch-weiblich-sehnsüchtig. Ariadne erkennt die Gefahr und warnt Cobb. Mal sei nicht real, dagegen sei Fischer real. Aber Cobb ist sich nicht sicher, bis die Projektion Mal Fischer erschießt. Cobb will aufgeben, aber Ariadne schlägt vor, Fischer mit einem Defibrillator wiederzubeleben, die Bergstation in die Luft zu schießen und sich mit dem Kick gemeinsam auf eine tiefere Ebene zu begeben: Um wirklich zur Lebendigkeit zu finden, muss nicht nur Fischer, sondern müssen auch Cobb und Ariadne in den Limbus eintreten.

Im Limbus

Ariadne kommt mit Cobb am Strand des Unbewussten an. Grandiose Bauwerke scheinen gerade jetzt zu zerfallen. Sie fragt Cobb: „Ist das Ihre Welt?" „Sie war es." Die beiden wandern durch beeindrukkende und in ihrer Monotonie zugleich langweilige, künstliche Welten, die Cobb und Mal erschaffen haben und die jetzt zerfallen. Zwischen immer gleichen Türmen tauchen erinnerte Häuser auf, so das Haus, in dem Mal aufgewachsen war. In der Fantasie können verschiedene Versionen der Wirklichkeit nebeneinander bestehen. Cobb hat fünfzig Jahre mit Mal hier verbracht. Die Verführung, dort zu bleiben, ist die einer fantasierten Omnipotenz: Die Träumenden sind wie Götter.

So wundert es nicht, dass Mal noch einmal mit allen Mitteln der Verführung versucht, Cobb zu sich in ihre Welt frühesten seelischen Erlebens zu locken. Sie fragt ihn nach seinen Gefühlen: „Es ist Schuld." Wenn die infantile Omnipotenz aufgegeben wird, die auf der emotionalen Ungetrenntheit von Mutter und Kind beruht, gelangt das Kind zur depressiven Position, die vom Gefühl der Schuld gekennzeichnet ist. Cobb erzählt Mal in der Gegenwart von Ariadne, dass er es war, der den Gedanken eingepflanzt hat, „dass diese Welt nicht real ist". Das Gespräch mit Ariadne gewinnt an Wichtigkeit gegenüber dem mit Mal. Unter den Augen von Ariadne erkennt er Mal als Projektion.

 „Du bist nur ein Schatten meiner Frau. Du bist das Beste, was ich geschaffen habe, aber du bist nicht gut genug."

In Eames' Traum gehen heftige Abwehrkämpfe vonstatten, Arthur bringt in seinem Traum den Aufzug mit den Träumenden zur Explosion für den Kick. Ariadne lässt sich fallen, um in der Wirklichkeit wieder anzukommen. Cobb will noch Saito zurückholen. Zuerst kann er sich von Mal in inniger Weise verabschieden

Fischer kommt noch einmal in das Sterbezimmer des Vaters und verabschiedet sich von dem Sterbenden. Der Dialog zwischen Vater und Sohn:

 „Ich weiß, dass du enttäuscht warst, dass ich nicht wie du sein konnte." „Nein, ich war enttäuscht, dass du es versucht hast."

Im Tresor findet er das neue Testament, das das Wirtschaftsimperium seines Vaters aufteilen wird und – unter Tränen der Berührtheit – ein Windrad.

Cobb wird an den Strand des japanischen Meeres geschwemmt, um Saito zurückzuholen, dort greift er zur Pistole…

Ankunft in der Wirklichkeit

Der Schnitt bringt uns jetzt mit der Crew ins Flugzeug im Anflug auf Los Angeles. Cobbs Verständigung mit dem missmutigen Saito in vielsagenden Blicken ist von einem Mobiltelefonanruf Saitos gefolgt. Bei der Passkontrolle zur Einreise in die Vereinigten Staaten erklingt pathetische Musik, Cobb ist um Fassung bemüht und wird begrüßt: Willkommen zu Haus, Mr. Cobb. Die pathetische Musik untermalt die Szenen, in denen der Vater ihn vom Flughafen abholt – und Cobb in seinem Haus mit Garten nach James und Philippa ruft. Er prüft den Kreisel. Die längst vertraute, immer gleiche Szene, wie die beiden im Sand spielenden Kinder von hinten gesehen werden, wird zu einer, in denen James und Philippa mit strahlenden Kinderaugen dem Vater entgegen rennen. Mit der Heldenmusik scheint alles gut geworden zu sein. Dennoch bleibt der Zuschauer ein wenig im Zweifel ob dieses Idylls. Auch Nolan vergisst nicht die ironische Beziehung zwischen dem träumenden Ich, das das Subjekt als Objekt nimmt. Die letzte Einstellung zeigt den Kreisel in wirbelnder Bewegung. Es ist doch ein Traum – der Film, der jetzt zu Ende gegangen ist, war ein Traum.

Schlussbetrachtung

Der Faden der Ariadne, den ich mit meinen analytischen Denkfiguren gesponnen habe, hat mir Orientierung im Filmlabyrinth gegeben. Ich war zunächst dem Rat eines jungen Mannes gefolgt und hatte im Internet nach Aufschlüssen über den Film gesucht. Ich fand dort vor allem in den zahlreichen Grafiken eine Vielzahl kreativer Möglichkeiten, die darum bemüht waren, aus einer kontrollierenden Distanz die verschiedenen Ebenen des Films zu durchschauen und damit das Bedrängende des Films, vor allem das Erleben, vom Gewalttätigen mit Haut und Haar erfasst zu werden, zu ertragen, statt sich abzuschotten. Ich habe mit meinen analytischen Denkfiguren etwas Ähnliches unternommen. Der Wunsch scheint auf beiden Seiten durch die Illusion gekennzeichnet, Schöpfer der Erfahrung zu sein, die man als Filmzuschauer macht. Wenn mir auch manche der gewalttätigen Szenenfolgen im Film weiterhin als Längen erscheinen, ist in diesem Prozess doch meine Langeweile einem großen Interesse gewichen.

Ich verstehe Nolans Grundgedanken so, dass der Traumarchitekt (respektive der Regisseur) Räume konstruiert und diese mit Figuren und deren Geschichten bevölkert. Die Beziehung zwischen dem Traumarchitekten und seinen Figuren folgt einer unbewussten Logik der Affekte, dem emotionalen Unbewussten. Das träumende Subjekt oder der Filmzuschauer kann seine innere Welt, sein (verdrängtes) Unbewusstes ausbreiten, seine inneren Objekte mit den Filmfiguren in Verbindung bringen. Es wird sich angesprochen fühlen von einer Ästhetik, die sein frühes seelisches Erleben in Schwingung zu bringen vermag.

Dieses Konzept formuliert Nolan im Film explizit und verwendet dabei analytische Denkfiguren: Die Welt, die Ariadne konstruiert, soll es Fischer möglich machen, einen neuen Gedanken zu denken und zu fühlen, sich von einem Gedanken anstecken zu lassen und ihn als eigenen wahrzunehmen. In ähnlicher Weise dient die Konstruktion der Labyrinthe dazu, Cobb in tieferen Kontakt zu bringen und zu befreien aus seinem Labyrinth der schuldhaften Verstrickung mit Mal. Kino ist seit Roland Barthes die „Couch der Armen". Der träumende Zuschauer kann sich mit jedem der Protagonisten als (unbewussten) Aspekten seiner Person identifizieren. Auf den Film angewandt, lässt sich Fischer als ein Aspekt von Cobb betrachten. Ariadne sagt: „Wenn wir tiefer ins Unbewusste Fischers eintauchen, tauchen wir auch tiefer in Cobbs Unbewusstes." Das Gleiche gilt für Mal, sie lässt sich als Selbstaspekt Cobbs sehen, der süchtig in die (mediale) Traumwelt verstrickt ist und der zugleich den Film in seiner Textur ausmacht.

In der Gestalt Saitos lässt sich eine politische Anspielung mithören. Saito besiegt Cobb als Chef eines asiatischen Wirtschaftsimperiums. Der Amerikaner Robert Fischer soll und wird, seinem Wunsch entsprechend, seinen Weltkonzern aufteilen, wird Macht an ihn abgeben. Der Untergang der Weltmacht der USA steht im Raum und gleichzeitig die aufsteigende Wirtschaftsmacht in Asien. Dazu

finden sich im Film auch einige ironische Anmerkungen. Dass Saito in den rahmenden Szenen als Herrscher und uralter Mann einer alten Kultur auftaucht und die Welt der wirtschaftlichen Macht plakativ völlig undurchschaubar bleibt, nimmt dieser politischen Dimension allerdings an Schärfe und Überzeugungskraft.

Meine Langeweile als erster Abweisung des Films möchte ich mit einigen Überlegungen Byung-Chul Hans in einer anderen Perspektive betrachten. In seinem Buch „Müdigkeitsgesellschaft" beschreibt er unsere Zeit als charakterisiert durch ein Zuviel der Positivität. An die Stelle einer Disziplinargesellschaft ist eine Leistungsgesellschaft getreten, an die Stelle der Angst vor dem Fremden die Vermischung von Fremdem und Vertrautem. Die fast unendlichen Möglichkeiten des Internets und die Angst, sich darin zu verlieren, damit Opfer einer feindlichen Übernahme zu werden, wären Beispiele dieser Zeitdiagnose. Han zufolge (2005, S. 35) entsteht dabei ein Mangel an Sein.

Der moderne Glaubensverlust, der nicht nur Gott oder Jenseits, sondern die Realität selbst betrifft, macht das menschliche Leben radikal vergänglich.

Daraus entstehen Hektik und Unruhe, eine Abwehrform wäre der depressive Rückzug, eine andere Spaltungs- und autistische Phänomene.

Han nimmt interessanterweise eine Denkfigur Walter Benjamins auf, der von einer tiefen Langeweile spricht, die es auszuhalten gelte, damit kreative Prozesse möglich werden. Diese Langeweile nennt er – so Han, „einen Traumvogel, der das Ei der Erfahrung ausbrütet". (ebd., S. 28) Tatsächlich wird in diesem Film erst dann, wenn es gelingt, die Langeweile der Abwehrkämpfe zu ertragen und als solche zu verstehen, ein Innehalten möglich; und damit das Erleben der berührenden Entwicklung des Protagonisten, Cobbs Weg aus dem Labyrinth heraus – mit dem Wollknäuel der Ariadne.

Literatur

Albus A (2004) Im Licht der Finsternis. Fischer, Frankfurt/M

Bloom H (1995) Einfluss-Angst. Eine Theorie der Dichtung. Stroemfeld/Nexus, Frankfurt/M (Erstveröff.1973)

Bollas C (1997) Figur im Stück des anderen sein: Träumen. In: Bollas C: Der Schatten des Objekts. Klett-Cotta, Stuttgart, S. 76–92 (Erstveröff. 1987)

Campbell J (1999) Der Heros in tausend Gestalten. fitb, Frankfurt/M

De Masi F (2003) Das Unbewusste und die Psychosen. Psyche – Z Psychoanal 57: 1–34

Freud S (1900) Die Traumdeutung. In: Gesammelte Werke Bd II/III. Fischer, Frankfurt/M

Han BC (2005) Müdigkeitsgesellschaft. Matthes & Seitz, Berlin

Hölzer H (2005) Geblendet. Psychoanalyse und Kino. Turia & Kant, Wien

Leszczynska-Koenen A (2009) „Herzasthma" – Exil und Objektverlust. Psyche – Z Psychoanal 63: 1131–1149

Lewin BD (1982) Das Hochgefühl. Zur Psychoanalyse der gehobenen, hypomanischen und manischen Stimmung. Suhrkamp, Frankfurt/M (Erstveröff. 1950)

Winnicott DW (1979) Vom Spiel zur Kreativität. Klett Cotta, Stuttgart (Erstveröff. 1971)

Originaltitel	Inception
Erscheinungsjahr	2010
Land	USA
Buch	Christopher Nolan
Regie	Chrisopher Nolan
Hauptdarsteller	Leonardo DiCaprio (Dominick „Dom" Cobb), Joseph Gordon-Levitt (Arthur), Ken Watanabe (Saito), Cillian Murphy (Robert Fischer), Ellen Page (Ariadne), Tom Hardy (Eames), Dileep Rao (Yusuf), Marion Cotillard (Mal)
Verfügbarkeit	Als DVD in OV und deutscher Sprache erhältlich

Anhang

Psychoanalytiker/-innen diskutieren Filme

Literatur und Internetadressen zum Thema Psychoanalytische Filminterpretationen

Quellenverzeichnis

Psychoanalytiker/-innen diskutieren Filme

Basel

Veranstalter: hinter dem Bild – Ein psychoanalytischer Filmzyklus
Ort: kult.kino camera, Rebgasse 1, CH-4058 Basel, Tel. +41 (061) 2728781 und PTK Basel, Spitalstrasse 22, CH-4056 Basel
Zeit: Jeweils dienstags (kult.kino camera) ab 20.00 Uhr oder freitags (PTK) mit Anmeldung unter hinterdembild@gmx.ch oder Tel. (061) 2287092
Information: http://www.kultkino.ch/events/events_im_kino/hinter_dem_bild

Berlin

Veranstalter: Institutsübergreifende und -unabhängige Arbeitsgemeinschaft Film und Psychoanalyse
Ort: Brotfabrik, Caligariplatz (Prenzlauer Promenade), 13086 Berlin, Tel. (030) 4714001
Information: http//www.brotfabrik-berlin.de/

Bern

Veranstalter: Projekt CinemAnalyse, Sigmund-Freud-Zentrum Bern, Gerechtigkeitsgasse 53, CH-3011 Bern
Ort: Lichtspiel/Kinemathek Bern, Sandrainstrasse 3, CH-3007 Bern, Tel. +41 (031) 3811505, info@lichtspiel.ch
Zeit: Jeweils donnerstags ab 20.00 Uhr
Information: http://www.freud-zentrum.ch/programme/cinemanalyse/

Bonn

Veranstalter: Psychoanalytische Arbeitsgemeinschaft Köln-Düsseldorf, Riehler Str. 23, 50668 Köln, Tel (0221) 135901
Ort: Rheinisches Landesmuseum, Colmanstraße 14–16, 63115 Bonn
Zeit: Jeweils freitags 20.15 Uhr
Information und Kartenreservierung: Bonner Kinemathek, Tel. (0228) 478489; www.psa-kd.de; sekretariat@psa-kd.de

Bremen

Veranstalter: gruppe film/psychoanalyse/kritik
Ort: Kommunalkino Bremen/Kino 46, Tel. (0421) 3876731
Information: FPK@gmx.de bzw. info@kino46.de

Düsseldorf

Veranstalter: Akademie für Psychoanalyse und Psychosomatik Düsseldorf, Simrockstr. 22, 40235 Düsseldorf und Black Box Filmtheater
Ort: Filmtheater Blackbox, Schulstraße 4, 40213 Düsseldorf (Altstadt)
Zeit: Jeweils freitags um 19.00 Uhr. Kartenreservierung unter (0211) 8992490
Information: www.akademie-psychoanalyse.duesseldorf.de; www.psychoanalyseundfilm.de

Frankfurt am Main

Veranstalter: Institut für Psychoanalyse der DPG Frankfurt am Main, Mendelssohnstr. 49, 60325 Frankfurt/Main, Tel. (069) 747090
Ort: Kino Mal Seh'n, Andlerflychtstraße 6, 60318 Frankfurt am Main
Information: Sekretariat des Instituts für Psychoanalyse unter Tel.: (069) 747090; Institut@dpg-frankfurt.de

Freiburg im Breisgau

Veranstalter: Psychoanalytisches Seminar Freiburg e. V., Schwaighofstr. 6, 79100 Freiburg, Tel. (0761) 77221
Ort: Kommunales Kino im alten Wiehrebahnhof, Urbachstr. 40, 79102 Freiburg
Information: Tel. (0761) 79033; kino@koki-freiburg.de

Gießen

Veranstalter: Institut für Psychoanalyse und Psychotherapie Gießen e. V., Ludwigstraße 73, 35392 Gießen, Tel. (0641) 78060
Ort: Heli Kino, Frankfurter Str. 34
Information: http://www.gpi.dpv-psa.de; Tel. (0641) 74527

Hamburg

Veranstalter: Arbeitsgemeinschaft für integrative **Psychoanalyse,** Psychotherapie & Psychosomatik Hamburg e. V. (DGPT-Institut), Lerchenfeld 14, 22081 Hamburg, Tel. (040) 2272881
Ort: Goldbekhaus, Moorfuhrtweg 9, 22301 Hamburg
Information: Geschäftsstelle: Frau Christine Harff, Lerchenfeld 14, 22081 Hamburg, Tel. (040) 202299302; aph@aekhh.de; http://www.aph-online.de

Hannover

Veranstalter: Lehrinstitut für Psychoanalyse und Psychotherapie Hannover (DPG), Geibelstraße 104, 30173 Hannover
Ort: Kommunales Kino Hannover, Sophienstraße 2, 30159 Hannover
Information: Tel. (0511) 804790; I-dpg@onlinehome.de

Heidelberg

Veranstalter: Institut für Psychoanalyse und Psychotherapie
Heidelberg-Mannheim, Alte Bergheimerstraße 5,
69115 Heidelberg, Tel. (06221) 658936. Psychoanalytisches
Institut Heidelberg-Karlsruhe (DPV), Vangerowstraße 23,
69115 Heidelberg. Heidelberger Institut für Tiefenpsychologie,
Alte Bergheimerstraße 5, 69115 Heidelberg, Tel. (06221) 8953030
Ort: Gloria Filmtheater, Hauptstraße, 69117 Heidelberg
Zeit: Jeweils am 4. Mittwoch des Monats, 20.00 Uhr.
Kartenreservierung Tel. (06221) 25319
Information: E. Tilch-Bauschke, Zähringerstr. 4,
69115 Heidelberg, Tel. (06221) 161788; tilchbauschke@aol.com

Kassel

Veranstalter: Alexander-Mitscherlich-Institut für Psychoanalyse
und Psychotherapie Kassel e. V.,
Karthäuser Straße 5a, 34117 Kassel, Tel. (0561) 779620
Ort: Bali Kino (Hauptbahnhof)
Zeit: Jeweils sonntags um 11.30 Uhr
Information: Annegret Mahler-Bungers, Heckenmühle,
34326 Morschen; mahler-bungers@t-online.de

Kiel

Veranstalter: John-Rittmeister-Institut für Psychoanalyse,
Psychotherapie und Psychosomatik Schleswig-Holstein e. V.,
Lorentzendamm 16, 24103 Kiel, Tel. (0431) 8886295
Ort: Kommunales Kino in der Pumpe, Haßstraße 22, 24103 Kiel
Zeit: Jeweils montags 20.30 Uhr
Information und telefonische Kartenvorbestellung:
john-rittmeister-institut@t-online.de; (0431) 96303

Köln

Veranstalter: Psychoanalytische Arbeitsgemeinschaft
Köln-Düsseldorf e. V., Riehler Str. 23, 50668 Köln,
Tel. (0221) 135901
Ort: Off Broadway Kino Köln, Zülpicher Straße 24, 50574 Köln
Zeit: Jeden 2. Sonntag im Monat 15.30 Uhr
Information: www.psa-kd.de; sekretariat@psa-kd.de
Kartenreservierung: Im Kino, Tel. (0221) 8205733 oder
(0221) 232418

Leipzig

Veranstalter: Sächsisches Institut für Psychoanalyse
und Psychotherapie, Gohliser Straße 7, 04105 Leipzig
Ort: Passagekinos, Hainstraße 19a, 04109 Leipzig
Zeit: Jeweils 19.30 Uhr
Information: Tel. (0341) 9615301; spp-leipzig@t-online.de

Lübeck

Veranstalter: Lehrinstitut Lübeck, Zentrum Ausbildung
Psychotherapie ZAP Nord GmbH, Am Bahnhof 13–15,
23558 Lübeck, Tel. (0451) 48660703
Ort: Kommunales Kino
Information: Dr. Hanna Petersen, Hundestraße 26,
23552 Lübeck, Tel. (0451) 5823350; H.Petersen@t-online.de

Mannheim

Veranstalter: Institut für Psychoanalyse und Psychotherapie
Heidelberg-Mannheim, Alte Bergheimerstraße 5,
69115 Heidelberg, Tel. (06221) 658936 und Psychoanalytisches
Institut Heidelberg-Karlsruhe (DPV), Vangerowstraße 23,
69115 Heidelberg, Tel. (06221) 167723
Ort: Kommunales Kino Cinema Quadrat im Collini Center,
Mannheim
Zeit: Jeweils sonntags 19.30 Uhr
Information: info@cinema-quadrat.de; www.cinema-quadrat.de

München

Veranstalter: Akademie für Psychoanalyse und Psychotherapie
e. V., Schwanthalerstr. 106, 80339 München
Ort: Filmmuseum München, St. Jakobs-Platz 1 im Stadtmuseum
Zeit: Sonntags 17.30 Uhr
Information: Tel. (089) 23396450

Münster

Veranstalter: Institut für Psychoanalyse und Psychotherapie
Ostwestfalen (DPG), Warendorfer Str. 139, 48145 Münster
Ort: cinema & kurbelkiste, Warendorferstr. 45–47, 48145 Münster
Information: www.cinema-muenster.de

Oldenburg

Veranstalter: Carl von Ossietzky Universität Oldenburg,
Abteilung für psychosoziale Weiterbildung, 2611 Oldenburg,
Tel. (0441) 7982887; ptg@uni-oldenburg.de
Ort: Casablanca, Johannisstr. 17, 26161 Oldenburg
Information: Tel. (0441) 884757; www.casablanca-oldenburg.de

Osnabrück

Ort: Cinema Arthouse, Osnabrück
Zeit: Sonntags 11.00 Uhr
Information: Dr. Eva-Maria Nasner-Maas; eva.nasner@t-online.de

Saarbrücken

Veranstalter: Saarländisches Weiterbildungsinstitut für
tiefenpsychologisch-fundierte Psychotherapie e. V.,
Feldmannstr. 89, 66119 Saarbrücken, Tel. (0681) 9274754
Ort: Filmhaus, Mainzerstraße 8
Zeit: Zu den angegebenen Terminen, jeweils 19.30 Uhr
Information: www.filmhaus-saarbruecken.de sowie über
Frau Ch. Pop, c.pop@gmx.de

Stuttgart

Veranstalter: Institut für Psychoanalyse, Psychoanalytische
Arbeitsgemeinschaft Stuttgart/Tübingen e. V.,
Konrad-Adenauer-Str. 23, 72072 Tübingen, Tel. (07071) 792128
Ort: Kommunales Kino, Friedrichstraße 23A, 70174 Stuttgart
Zeit: Jeweils sonntags 18.00 Uhr
Information: www.agstue.dpv-psa.de; info@koki-stuttgart.de,
www.koki-stuttgart.de

Tübingen

Veranstalter: Institut für Psychoanalyse, Psychoanalytische
Arbeitsgemeinschaft Stuttgart/Tübingen e. V.,
Konrad-Adenauer-Str. 23, 72072 Tübingen, Tel. (07071) 792128
Ort: Studio Museum Tübingen
Zeit: Jeweils mittwochs 20 Uhr
Information: J. F. Danckwardt, Im Buckenloh 2, 72070 Tübingen;
jfdanckwardt@t-online.de und über Studio Museum,
Semesterfilmspiegel

Wien

Veranstalter: psynema – Licht in dunklen Räumen,
Wiener Psychoanalytische Akademie, Salzgries 16/3,
A-1010 Wien, Tel. +43 (01) 5320150 und Synema – Gesellschaft
für Film & Medien, Neubaugasse 36/1/1/1, A-1070 Wien,
Tel. +43 (01) 5233797
Ort: Wiener Arbeitskreis für Psychoanalyse (S6), Salzgries 16/3a,
A-1010 Wien; www.psychoanalyse.org
Zeit: Jeweils mittwochs oder donnerstags ab 20.15 Uhr
Information: http://psy-akademie.at/vortraege-und-seminare

Zürich

Veranstalter: Cinépassion – Film und Psychoanalyse e. V.
Ort: Arthouse Kino Movie, Nägelihof 4, CH-8001 Zürich,
Kartenbestellung Tel. +41 (044) 2505510 oder online via
www.arthouse.ch.
Zeit: Jeweils samstags 11.00 Uhr
Information: www.cinepassion.ch oder info@cinepassion.de

Literatur und Internetadressen zum Thema psychoanalytische Filminterpretationen

Bücher zum Thema

Deutschsprachige Bücher

Bär P, Schneider G (Hrsg) (2012) Im Dialog: Psychoanalyse und Filmtheorie. Schriftenreihe Bd 8. Pasolini. Psychosozial, Gießen (im Druck)

Ballhausen T, Krenn G, Marinelli L (Hrsg) (2006) Psyche im Kino. Sigmund Freud und der Film. Filmarchiv Austria, Wien

Bliersbach G (1985/1990) So grün war die Heide ... Der deutsche Nachkriegsfilm in neuer Sicht. Beltz, Weinheim

Blothner D (1999) Erlebniswelt Kino. Über die unbewußte Wirkung des Films. Bastei Lübbe, Bergisch-Gladbach

Blothner D (2003) Das geheime Drehbuch des Lebens – Kino als Spiegel der menschlichen Seele. Bastei Lübbe, Bergisch-Gladbach

Blothner D, Zwiebel R (2012) Kino zwischen Tag und Traum. Psychoanalytische Zugänge zu Black Swan. Vandenhoeck & Ruprecht, Göttingen (in Vorbereitung)

Bronfen E (1999) Heimweh. Illusionsspiele in Hollywood. Volk und Welt, Berlin

Cinema Quadrat e. V. Mannheim; Institut für Psychoanalyse und Psychotherapie, Heidelberg-Mannheim e. V.; Psychoanalytisches Institut Heidelberg-Karlsruhe der Deutschen Psychoanalytischen Vereinigung; Heidelberger Institut für Tiefenpsychologie e. V.; verantwortlich Schneider G, Bär P (Hrsg) (2003) Im Dialog: Psychoanalyse und Filmtheorie. Schriftenreihe Bd 1. Alfred Hitchcock. Cinema Quadrat, Mannheim

Cinema Quadrat e. V., Mannheim et al (verantwortl. Schneider G, Bär P) (2004) Im Dialog: Psychoanalyse und Filmtheorie. Schriftenreihe Bd 2. Roman Polanski. Cinema Quadrat, Mannheim

Cinema Quadrat e. V., Mannheim et al (verantwortl. Schneider G, Bär P) (2005) Im Dialog: Psychoanalyse und Filmtheorie. Schriftenreihe Bd 3. Luis Buñuel. Cinema Quadrat, Mannheim

Cinema Quadrat e. V., Mannheim et al (verantwortl. Schneider G, Bär P) (2006) Im Dialog: Psychoanalyse und Filmtheorie. Schriftenreihe Bd 4. Ingmar Bergman. Cinema Quadrat, Mannheim

Cinema Quadrat e. V., Mannheim et al (verantwortl. Schneider G, Bär P) (2007) Im Dialog: Psychoanalyse und Filmtheorie. Schriftenreihe Bd 5. Pedro Almodóvar. Cinema Quadrat, Mannheim

Cinema Quadrat e. V., Mannheim et al (verantwortl. Schneider G, Bär P) (2009) Im Dialog: Psychoanalyse und Filmtheorie. Schriftenreihe Bd 6. David Lynch. Cinema Quadrat, Mannheim

Cinema Quadrat e. V., Mannheim et al (verantwortl. Schneider G, Bär P) (2011) Im Dialog: Psychoanalyse und Filmtheorie. Schriftenreihe Bd 7. Michelangelo Antonioni. Cinema Quadrat, Mannheim

Dettmering P (1984) Film, Literatur, Psychoanalyse. frommann-holzboog, Stuttgart

Doering S, Möller H (Hrsg) (2008) Frankenstein und Belle de Jour. 30 Filmcharaktere und ihre psychischen Störungen. Springer, Heidelberg

Elsaesser T, Hagener M (2011) Filmtheorie zur Einführung, 3. erg. Aufl. Junius, Hamburg

Fellner M (2006) Psycho movie. Zur Konstruktion psychischer Störung im Spielfilm. Transcript, Bielefeld

Frenzel Ganz, Y, Fäh M (Hrsg) (2010) Cinépassion. Eine psychoanalytische Filmrevue. Psychosozial, Gießen

Gaube U (1978) Film und Traum. Zum präsentativen Symbolismus. Wilhelm Fink, München

Gerlach, A; Pop, C (Hrsg.) (2012) Filmräume - Leinwandträume: Psychoanalytische Filminterpretationen. Psychosozial, Gießen

Hirsch M (2008) „Liebe auf Abwegen". Spielarten der Liebe im Film psychoanalytisch betrachtet.: Psychosozial, Gießen

Hölzer H (2005) Geblendet. Psychoanalyse und Kino. Turia + Kant, Wien

Jacke A (2009) Stanley Kubrick. Eine Deutung der Konzepte seiner Filme. Psychosozial, Gießen

Jacke A (2010) Roman Polanski – Traumatische Seelenlandschaften. Psychosozial, Gießen

Jaspers K (Hrsg) (2006) Kino im Kopf. Psychologie und Film seit Sigmund Freud. Bertz & Fischer, Berlin

Kötz M (1986) Der Traum, die Sehnsucht und das Kino. Film und die Wirklichkeit des Imaginären. Syndikat, Frankfurt

Laszig P, Schneider G (Hrsg) (2008) Film und Psychoanalyse. Kinofilme als kulturelle Symptome. Psychosozial, Gießen

Laszig P (Hrsg) (2012) Blade Runner, Matrix und Avatare – Psychoanalytische Betrachtungen virtueller Wesen und Welten im Film. Springer, Heidelberg

Lippert R (2002) Vom Winde verweht. Film und Psychoanalyse. Stroemfeld/Nexus, Frankfurt/M

Mennenga H-C (2011) Präödipale Helden. Neuere Männlichkeitsentwürfe im Hollywoodfilm. Die Figuren von Michael Douglas und Tom Cruise. Transcript, Bielefeld

Mentzos S, Münch A (2006) Psychose im Film. Vandenhoeck & Ruprecht, Göttingen

Metz Ch (2000) Der imaginäre Signifikant. Psychoanalyse und Kino. Nodus Publikationen, Münster

Möller H, Doering St (Hrsg) (2010) Batman und andere himmlische Kreaturen. Nochmal 30 Filmcharaktere und ihre psychischen Störungen. Springer, Heidelberg

Borkenhagen A (Hrsg) (2004) Psychoanalyse und Film, Psychoanalyse und Trauma. Sisyphus – Jahrbuch Colloquium Psychoanalyse 04. Edition Déjà-vu, Frankfurt/M

Piegler T (2008) Mit Freud im Kino: Psychoanalytische Filminterpretationen. Psychosozial, Gießen

Piegler T (2010) „Ich sehe was, was du nicht siehst". Psychoanalytische Filminterpretationen. Psychosozial, Gießen

Piegler T (Hrsg) (2012) Das Fremde im Film. Psychoanalytische Filminterpretationen. Psychosozial, Giesen

Riepe M (2002) Bildgeschwüre. Körper und Fremdkörper im Kino David Cronenbergs. Transcript, Bielefeld

Riepe M (2004) Intensivstation Sehnsucht. Blühende Geheimnisse im Kino Pedro Almodóvars: psychoanalytische Streifzüge am Rande des Nervenzusammenbruchs. Transcript, Bielefeld

Ruhs A (Hrsg) (1989) Das unbewusste Sehen: Psychoanalyse, Film, Kino. Gesellschaft für Filmtheorie; Universität Wien; Symposion „Psychoanalyse, Film, Kino. Löcker, Wien

Schlimme JEM, Wildt B te, Emrich HM (2008) Scham und Berührung im Film. Vandenhoeck & Ruprecht, Göttingen

Schmid G (2006) Freud/Film. Oder: Das Kino als Kur. Sonderzahl, Wien

Wohlrab L (Hrsg) (2006) Filme auf der Couch. Psychoanalytische Interpretationen. Originalausg. Psychosozial, Gießen

Wollnik S (Hrsg) (2008) Zwischenwelten. Psychoanalytische Filminterpretationen. Psychosozial, Gießen

Wollnik S, Ziob B (Hrsg) (2010) Trauma im Film. Psychoanalytische Erkundungen. Psychosozial, Gießen

Zeul M (1997) Carmen & Co. Weiblichkeit und Sexualität im Film. Internationale Psychoanalyse, Stuttgart

Zeul M (2007) Das Höhlenhaus der Träume. Filme, Kino & Psychoanalyse. Brandes & Apsel, Frankfurt/Main

Zeul M (2010) Pedro Almodovar. Seine Filme, sein Leben. Brandes & Apsel, Frankfurt/Main

Žižek S (1998) Ein Triumph des Blicks über das Auge. Psychoanalyse bei Alfred Hitchcock. 2. Aufl. Turia + Kant, Wien

Zwiebel R, Mahler-Bungers A (Hrsg) (2007) Projektion und Wirklichkeit. Die unbewusste Botschaft des Films. Vandenhoeck & Ruprecht, Göttingen

Englischsprachige Bücher

Bergstrom J (1999) Endless night. Cinema and psychoanalysis, parallel histories. Univ. of California Press, Berkeley CA

Brandell JR (2004) Celluloid couches, cinematic clients. Psychoanalysis and psychotherapy in the movies. State Univ. of New York Press, Albany NY

Cowie E (1997) Representing the woman. Cinema and psychoanalysis. University of Minnesota Press, Minneapolis MN

Creed B (1993) The monstrous-feminine. Film, feminism, psychoanalysis. Routledge, London UK

Dervin D (1985) Through a Freudian lens deeply. A psychoanalysis of cinema. Analytic Press, Hillsdale NJ

Doane MA (1987) The desire to desire. The woman's film of the 1940s. MacMillan, London UK

Doane MA (1991) Femmes fatales. Feminism, film theory, psychoanalysis. Routledge, New York NY

Evans P (1995) The films of Luis Buñuel. Subjectivity and desire. Clarendon Press, Oxford UK

Everwein RE (1984) Film and the dream screen. Princeton University Press, Princeton NJ

Fuery P (2004) Madness and cinema. Psychoanalysis, spectatorship and culture. Palgrave, Basingstoke UK

Gabbard GO (Hrsg) (2001) Psychoanalysis & film. Karnac, London UK

Gabbard GO (2002) The psychology of the Sopranos. Love, death, desire and betrayal in America's favorite gangster family. Basic Books, New York NY

Greenberg H R (1993) Screen Memories. Hollywood Cinema on the Psychoanalytic Couch. Columbia University Press, New York NY

Gutiérrez-Albilla JD (2008) Queering Buñuel. Sexual dissidence and psychoanalysis in his Mexican and Spanish cinema.Tauris Academic Studies, London UK

Hauke Ch, Alister I (2002) Jung & film. Post-jungian takes on the moving image. Brunner-Routledge, Hove UK

Iaccino JF (1994) Psychological Reflections on Cinematic Terror: Jungian Archetypes in Horror Films. Praeger, Westport CT

Iaccino JF (1998) Jungian reflections within the cinema. A psychological analysis of sci-fi and fantasy archetypes. Praeger, Westport CT

Kaplan EA (1990) Psychoanalysis & cinema. Routledge (AFI film readers), New York NY

Kline T (1987) Bertolucci's dream loom: A psychoanalytic study of cinema. Univ. of Mass. Press, Amherst MA

Kenevan PB (1999) Paths of individuation in literature and film: a Jungian approach. Lexington Books, Lanham MD

Lawrence A (1991) Echo and narcissus: Women's voices in classical Hollywood cinema. Univ. of California Press, Berkeley CA

Lebeau V (1995) Lost angels. Psychoanalysis and cinema. Routledge, London UK

Lebeau V (2001/2006) Psychoanalysis and cinema. The play of shadows. Wallflower, London UK

MacGowan T, Kunkle S (2004) Lacan and contemporary film. Other Press (Contemporary theory series), New York, NY

McGowan T (2007) The real gaze. Film theory after Lacan. State University of New York Press, Albany NY

Metz Ch (1982) The imaginary signifier. Psychoanalysis and the cinema. Indiana Univ. Press, Bloomington IN

Pheasant-Kelly F (2012) Abject spaces in american cinema. Institutional settings, identity and psychoanalysis in film. Tauris Academic Studies, London UK

Rocchio VF (1999) Cinema of anxiety. A psychoanalysis of Italian neorealism. 1. Aufl. Univ. of Texas Press, Austin TX

Rodowick DN (1991) The difficulty of difference: Psychoanalysis, sexual difference and film theory. Routledge, New York NY

Sabbadini A (Hrsg) (2003) The couch and the silver screen. Psychoanalytic reflections on European cinema. Brunner-Routledge, New York NY

Sabbadini A (Hrsg) (2007) Projected shadows. Psychoanalytic reflections on the representation of loss in European cinema. Routledge, New York NY

Silverman K (1988) The acoustic mirror. The female voice in psychoanalysis and cinema (Theories of representation and difference). Indiana University Press, Bloomington IN

Smith J, Kerrigan W (Hrsg) (1987) Images in our souls. Cavell, psychoanalysis and cinema. Johns Hopkins University Press, Baltimore MD

Torlasco D (2008) The time of the crime. Phenomenology, psychoanalysis, Italian film. Stanford University Press, Stanford CA

Vrbančić M (2011) The Lacanian thing. Psychoanalysis, postmodern culture, and cinema. Cambria Press, Anherst NY

Walker J (1993) Couching resistance: Women, film, and psychoanalytic psychiatry. University of Minnesota Press, Minneapolis MN

Winkler J, Bromberg W (1939) Mind explorers. Reynal & Hitchcock, New York NY

Wolfenstein M, Leites N (1950) Movies: A psychological study. The Free Press, Glencoe III

Französischsprachige Bücher

Alonso L, Arnaud D, Aubert J (2001) Cinéma et inconscient. Murielle Gagnebin (Hrsg) Champ Vallon, Seyssel F

Dadoun R (2000) Cinéma, psychanalyse et politique. Séguier, Paris F

Gagnebin M (1999) Du divan à l'écran. Montages cinématographiques, montages interprétatifs. PUF, Paris F

Gaumond M, Bois-Houde St (2005) Le cinéma, âme soeur de la psychanalyse. L'Instant même, Québec CAN

Grim OR (2008) Mythes, monstres et cinéma. Aux confins de l'humanité. Presses universitaires de Grenoble, Grenoble F

Lacoste P (1990) L'étrange cas du professeur M. Psychanalyse à l'écran. Gallimard (Connaissance de l'inconscient. Série Curiosités freudiennes), Paris F

Lauretis T de, Brunet-Georget J (2010) Pulsions freudiennes. Presses universitaires de France, Paris F

Metz Ch (1977) Le signifiant imaginaire. Union générale d'éditions, Paris F

Žižek S, Burdeau M-M (2010) Tout ce que vous avez toujours voulu savoir sur Lacan sans jamais oser le demander à Hitchcock. Capricci, Nantes F

Veröffentlichungen in Zeitschriften

The International Journal of Psychoanalysis

Abella A, Zilkha N (2004) Film review: Dogville: A parable on perversion1. Int J Psychoanal 85(6): 1519–1526

Almond R (2006) Revisiting Groundhog day (1993): Cinematic depiction of mutative process. Int J Psychoanal 87(5): 1387–1398

Anderson D (2010) Love and hate in dementia: The depressive position in the film Iris. Int J Psychoanal 91(5): 1289–1297

Barbera J, Moller HJ (2007) Mulholland Drive (2001): A self-psychology perspective. Int J Psychoanal 88(2): 515–526

Berman E (1997) Hitchcock's Vertigo: The collapse of a rescue fantasy. Int J Psychoanal 78: 975–996

Berman E (1998) Arthur Penn's Night Moves: A film that interprets us. Int J Psychoanal: 79: 175–178

Bernstein JW (2002) Film review essay: Fight Club. Int J Psychoanal 83(5):1191–1199

Brearley M, Sabbadini A (2008) The Truman Show: How's it going to end? Int J Psychoanal 89(2): 433–440

Cañizares J (2010) The strange case of Dr Mantle and Dr Mantle: David Cronenberg's Dead Ringers1. Int J Psychoanal 91(1): 203–218

Cartwright D (2005) Film review: B-Mentality in The matrix trilogy. Int J Psychoanal 86(1): 179–190

Civitarese G (2010) Do cyborgs dream? Post-human landscapes in Shinya Tsukamoto's Nightmare Detective (2006) 1. Int J Psychoanal 91(4): 1005–1016

Clarke G (2012) Failures of the „moral defence" in the films Shutter Island, Inception and Memento: Narcissism or schizoid personality disorder? Int J Psychoanal 93(1): 203–218

Cooper SH, Harris A (2005) Film review: Real women have curves (2002). Int J Psychoanal 86(5): 1481–1487

Danckwardt JF (2007) From Dream story (Schnitzler) to Eyes wide shut (Kubrick) From identity through meaning formation to identity through excitation1. Int J Psychoanal 88(3): 735–751

Diena S (2009) The skin house: A psychoanalytic reading of 3-Iron1. Int J Psychoanal 90(3): 647–660

Fenster S (2010) The Curious Case of Benjamin Button: Regression and the angel of death. Int J Psychoanal 91(3): 643–650

Fox Kales E (2003) Body double as body politic: Psychosocial myth and cultural binary in Fatal Attraction. Int J Psychoanal 84(6): 1631–1637

Frankiel RV (2002) Sous le Sable (Under the Sand) (2001). Int J Psychoanal 83(1): 313–317

Freeman P (2008) Meeting Movies. Int J Psychoanal 89(3): 676–679

Frosch JP (2009) A note on Mafia movies. Int J Psychoanal 90(3): 661–664

Gabbard GO (1997) The psychoanalyst at the movies. Int J Psychoanal: 78: 429–434

Gabbard GO (2001) Fifteen minutes of fame revisited: Being John Malkovich. Int J Psychoanal 82(1): 177–179

Gamarra E (2001) Down on yourself: Perversion in The Nutty Professor II – The Klumps. Int J Psychoanal 82(4): 811–814

Golinelli P, Rossi N (2012) An entire life in one glance: a psychoanalytic reading of Revolutionary Road. Int J Psychoanal, Article first published online: 23 JUL 2012, DOI: 10.1111/j.1745-8315.2012.00626.x

Groba A Sloninsky de, Martn L Pedrn de (2005): Personality disorders: Actings and rescue fantasies in cinema and psychoanalysis. Int J Psychoanal 86(1): 163–165

Hess N (2010) The Shining: All work and no play … Int J Psychoanal 91(2): 409–414

Ivey G (2006) Sex in the mourning: Oedipal love and loss in The Door in the Floor (2004). Int J Psychoanal 87(3): 871–879

Knafo D, Feiner K (2002) Film review essay: Blue Velvet: David Lynch's Primal Scene. Int J Psychoanal 83(6): 1445–1451

Kubrick S (2004) Stanley Kubrick's swan song: Eyes Wide Shut. Int J Psychoanal 85(1): 209–218

Lichtenstein D (2005) Hable con ella (Talk to her). Int J Psychoanal 86(3): 905–914

McGinley E, Sabbadini A (2006) Play Misty for me (1971): The perversion of love. Film essay. Int J Psychoanal 87(2): 589–597

Minerbo M (2007) Two faces of Thanatos: Broken Flowers (2005) and Ai no corrida (1976)1. Int J Psychoanal 88(3): 777–790

Minerbo M (2008) Film essay Reality game: Contemporary violence and denaturization of language. Int J Psychoanal 89(5): 1047–1055

Moskowitz C (2011) Parenting imperfection: Unlocking meaning in the developing relationship between a father and his disabled son, in Gianni Amelio's The Keys to the House. Int J Psychoanal: 445–450

Paul RA (2011) Cultural narratives and the succession scenario: Slumdog Millionaire and other popular films and fictions. Int J Psychoanal 92(2): 451–470

Priel B (2009) The transformation of sociogenic autistic defences in The Lives of Others. Int J Psychoanal 90(2): 387–393

Quinodoz D (1998) „Hitchcock's Vertigo:Collapse of a rescue fantasy" by E Berman. Int J Psychoanal 79: 391–392

Ray N (2012) Seduction, Receptivity and the „feminine" in Peter Greenaway's The Pillow Book. Int J Psychoanal. doi: 10.1111/j.1745-8315.2011.00523.x. http://onlinelibrary.wiley.com/doi/10.1111/j.1745-8315.2011.00523.x/abstract

Ringstrom PA (2001) Film review essay: The Sixth Sense. Int J Psychoanal 82(2): 393–395

Sabbadini A (2003) Film review essay: 'Not something destroyed but something that is still alive': Amores Perros at the intersection of rescue fantasies. Int J Psychoanal 84(3): 755–764

Sabbadini A (2009) Between physical desire and emotional involvement: Reflections on Frédéric Fonteyne's film Une Liaison Pornographique1. Int J Psychoanal 90(6): 1441–1447

Sabbadini A (2009) Le visioni di uno psicoanalista (A Psychoanalyst's Visions). Int J Psychoanal 90(1): 169–171

Sabbadini A, Stein A (2001) „Just choose one": Memory and time in Kore-eda's Wandafuru Raifu (Afterlife) (1998)1. Int J Psychoanal 82(3): 603–608

Sabbadini A, Di Ceglie G (2011) A camera inside a monastery: Reflections on Of Gods and Men [Des Hommes et des Dieux]. Int J Psychoanal 92(3): 745–754

Schaub D (2008) Film essay: Michel Deville's La lectrice: Honouring or deriding Freud's theories through bibliotherapy? Int J Psychoanal 89(6): 1237–1250

Schiller B-M (2005) Film review: On the threshold of the creative imagination: Swimming pool (2003). Int J Psychoanal 86(2): 557–566

Schiller B-M (2008) Film essay: Saying yes to dirt, desire and difference: Yes (2004). Int J Psychoanal 89(6): 1225–1235

Schwartz H (2008) Projected Shadows: Psychoanalytic reflections on the representation of loss in European cinema. Int J Psychoanal 89(1): 225–229

Schwartz H (2009) Temporal transformations in cinema and psychoanalysis: On Philip Groenig's Into Great Silence. Int J Psychoanal 90(4): 909–915

Secchi C (2011) The Sweet Hereafter by Atom Egoyan: Extreme loss and psychic survival. Int J Psychoanal 92(6): 1631–1640

Sklar J, Sabbadini A (2008) David Cronenberg's Spider: Between confusion and fragmentation. Int J Psychoanal 89(2): 427–432

Stein A (2004) Music and trauma in Polanski's The pianist (2002)1. Int J Psychoanal 85(3): 755–765

Stein A (2006) Tricycles, bicycles, life cycles: Psychoanalytic perspectives on childhood loss and transgenerational parenting in Les triplettes de Belleville (2003)1. Int J Psychoanal 87(4): 1125–1134

Valentine M (2012) Time, space and memory in Last Year in Marienbad. Int J Psychoanal 93(4): 1045-1057

Wallace E (2003) Film review: Mother, love and Chocolat. Int J Psychoanal 84 (5): 1367–1375. doi: 10.1516/5URV-8Q7B-EFJ5-XF58

Webber A (2006) Film essay: Pan-Dora's box. Fetishism, hysteria, and the gift of death in Die Büchse der Pandora (1929). Int J Psychoanal 87(1): 273–286

West-Leuer B (2009) Film essay: Colonial aggression and collective aggressor trauma. Int J Psychoanal 90(5): 1157–1168

Wrye HK (1998) Lone star: Signs, borders, thresholds. Int J Psychoanal 790(2): 395–398

Wrye H (2005) Film review: Perversion annihilates creativity and love: A passion for destruction in The Piano Teacher (2001)1. Int J Psychoanal 86(4): 1205–1212

Yanof JA (2005) Film review essay: Perversion in La Mala Educación [Bad Education] (2004). Int J Psychoanal 86(6): 1715–1724

Zemeckis R, Golinelli P (2003) The castaway self: A psychoanalytic reading of Castaway (2000). Int J Psychoanal 84(1): 169–172

Weitere englischsprachige Zeitschriftenartikel

Almansi RJ (1992) Alfred Hitchcock's disappearing women: Scopophilia, object loss. Int Rev Psychoanal 19: 81–90

Altman C (1976) Psychoanalysis and the cinema: The imaginary discourse. Quarterly Review of Film Studies 2: 257–272

Arlow JA (1980) The revenge motive in the primal scene. J Am Psa Ass 28: 519–541

Benton RJ (1984). Film as dream: Alfred Hitchcock's Rear Window. Psychoanal Rev 71: 483–500

Berman E (1998) The film viewer: From dreamer to dream interpreter. Psychoanal Inq 18:193–206

Buren J van (1998) Food for thought in the film Fried Green Tomatoes. Psychoanal Inq 18: 291–299

Chaikin Robert (1979) Film review: King Kong". Psychoanal Rev 67: 271–276

Corel A (1998) Language and time in Citizen Kane. Psychoanal Inq 18: 154–160

Denzer JL (1983) E T.: An odyssey of loss. Psychoanal Rev 70: 269–275

Dervin DA (1975) The primal scene and the technology of perception in theater and film. A historical perspective with a look at Potemkin and Psycho. Psychoanal Rev 62: 270–304

Dervin DA (1977) Creativity and collaboration in three American movies. Am Imago 34: 179–204

Dervin DA (1983) Ingmar Bergman's film: The spider-god and the primal scene. Am Imago 40: 207–232

Edelheit H (1972) Mythopoesis and primal scene. Psychoanalytic Study of Society 5: 212–233 (Int Univ Pr NY)

Enckell M (1982) Film and psychoanalysis. Scand Psychoanal Rev 5: 149–163

Enckell M (1985) „Citizen Kane" and „Psychoanalysis". Film and psychoanalysis (III). Scand Psychoanal Rev 8: 17–34

Evans P (2000) The Wicked Lady (directed by Leslie Arliss, 1945) and gender difference. Br J Psychother 16(4): 511–515

Gabbard GO, Gabbard K (1984) Vicissitudes of narcissism in the cinematic autobiography. Psychoanal Rev 71: 319–382

Gabbard GO, Gabbard K (1985) Countertransference in the movies. Psychoanal Rev 72: 171–184

Gabbard GO, Gabbard K (1989) The female psychoanalyst in the movies. J. Am Psychoanal Assn 37: 1031–1048

Gordon N (1982) Controversial issues in De Palma's Dressed to Kill. Psychoanal Rev 69: 566–599

Gordon N (1983) Family structure and dynamics in de Palma's horror films. Psychoanal Rev 70: 435–442

Gordon N, Gordon A (1982) De Palma's Dressed to Kill: Erotic imagery and primitive aggression. Am Imago 69: 566–599

Grant M (1995) Psychoanalysis and the Horror Film. *Free Associations* 5.4 (No. 36)

Greenacre P (1973) The primal scene and the sense of reality. Psychoanal Quart 42: 10–42

Greenberg HR (1983) Fractures of desire: alien and contemporary „cruel" horror film. Psychoanal Rev 70: 241–267

Greenberg HR (1985) The Dresser: Played to death. Psychoanal Rev : 213–222

Greenberg H, Gabbard K (1990) Reel significations: An anatomy of psychoanalytic film criticism. Psychoanal Rev 77: 89–110

Grinstein A (1953) Miracle of Milan: Some psychoanalytic notes on a movie. Am Imago 10: 229–245

Hagenauer F, Hamilton JW (1973) Straw Dogs: Aggression and violence. Am Imago 30: 221–249

Hamilton JW (1969) Some comments about Ingmar Bergman's The Silence and its sociocultural implications. J Am Acad Child Psychiatry 8: 367–373

Hamilton JW (1978) Cinematic neurosis: A brief case report. J Am Acad Psychoanal 6: 569–572

Harris A, Sklar R (1998) Wild film theory, wild film analysis. Psychoanal Inq 18: 222–237

Herman D (1969) Federico Fellini. Am Imago 26: 251–268

Huss Roy (1979) Film review: Each Other. Psychoanal Rev 67: 143–158

Kernberg OF (1994) The erotic in film and in mass psychology. Bull Menninger Clin 58: 88–108

Kimble Wrye H (1996) Panel: Psychic reality and film (reported by Balsam RH). Int J Psychoanal 77: 595

Kline TJ (1976) Orpheus transcending: Bertolucci's Last Tango in Paris. Int Rev Psychoanal 3: 85–96

Konigsberg I. (1996) Transitional phenomena, transitional space: Creativity in film. Psychoanal Rev 83: 865–890

Leites M, Leites N (1947) Review of From Calgari to Hitler. A Psychological View of German Film. Psychoanal Q 16: 570–572

McDermont JF, Lum KY (1980) Star Wars. The modern developmental fairy tale. Bull Menninger Clin 44: 381–390

Miller M, Sprich R (1981) The appeal of Star Wars: An archetypical-psychoanalytic view. Am Imago 38: 203–220

Newman K (1978) Movies in the seventies: Some heroic types. Annu Psychoanal 6: 429–442

Newman KM (1996) Winnicott goes to the movies: The false self in Ordinary People. Psychoanal Q 65: 787–810

Rubinstein M (1977) King Kong: A myth for moderns. Am Imago 34(1)

Safran SB (1988) Brazil: A cinematic incest fantasy. Psychoanal Rev 75: 473–479

Sklarew B (1991) Review of Bertolucci's Dream Loom: A psychoanalytic study of cinema. Psychoanal Q 60: 691–694

Sklarew B (1999) Freud and film: Encounters in the weltgeist. J Am Psychoanal Assn 47: 1239–1248

Stein HH (1993) Screen memory: My recollections, distortions of the 1950 film, Three Came Home. Psychoanal Q 62: 109–113

Terr LC (1987) Early trauma, creativity: Poe, Wharton, Magritte, Hitchcock, Bergman. Psychoanal Study Child 42: 545–574

Welles J (1998) Rituals: Cinematic and analytic. Psychoanal Inq 18: 207–221

Wrye HK (1997) Projections of domestic violence & erotic terror on film screen. Psychoanal Rev 84: 681–700

Wrye HK (1998) Tuning a clinical ear to the ambiguous chords of Jane Campion's The Piano. Psych Inq 18(2): 168–182

Psyche – Zeitschrift für Psychoanalyse und ihre Anwendungen

Bayer L (2005) Spiderman. Psyche 59(2) 169–174

Blothner D (2010) Unterhaltung mit Gewalt – Wirkungsanalyse des Films No Country for Old Men. Psyche 64(2): 172–178

Böhme I (2007) Dogville von Lars von Trier. Psyche 61(7): 710–717

Chasseguet-Smirgel J (1970) „Letztes Jahr in Marienbad" – Zur Methodologie der psychoanalytischen Erschließung des Kunstwerks. Psyche 24(11): 801–826

Dettmering P (1978) Vorstoß in den Raum. Zur Wiederaufführung von Kubricks „2001 – Odyssee im Weltraum" (Kritische Glosse). Psyche 32(12): 1157–1163 (Erstveröff. 1968)

Dettmering P (1989) Kreatives Wagnis und Regression. Zu den Filmen von Andrej Tarkowski. Psyche 43(5): 445–458

Dettmering P (2003) Der erste der Vampir-Filme. Zu F. W. Murnaus Film Nosferatu. Psyche 57(6): 551–554

Eppensteiner B, Fallend K, Reichmayr J (1987) Die Psychoanalyse im Film 1925/26 (Berlin/Wien). Psyche 41(2): 129–139

Fabricius D (2005) Es gibt keine Eltern. Zu Katherine Strozcan und Lothar Bayer „Es gibt keine Eltern. Vom Drama zur Tragödie in Polanskis Filmen". Psyche 59(5): 465–470

Gephart W, Rohde-Dachser Ch (2007) Heimkehr im Strahlenkranz. Eine psychoanalytische Interpretation des Films Dead Man. Psyche 61(12): 1255–1263

Gerlach A (2008) Intimität als Gegenwehr und die Tyrannei der Intimisierung. Psychoanalytische Anmerkungen am Beispiel des Films Die Truman Show von Peter Weir. Psyche 62(9/10): 1068–1076

Gerlach A (2009) Das Schweigen der Lämmer von Jonathan Demme (1991). Psyche 63(12): 1244–1251

Harsch HE (2004) Onegin – Alexander Puschkins Romanverfilmung. Psyche 58(6): 561–566

Hegener W (2009) The Cell von Tarsem Singh (2000). Psyche 63(12): 1252–1262

Hirsch M (2006) „Die Rückkehr" von Andrej Swjaginzew (Rußland 2003) Psyche 60(11): 1156–1162

Hirsch M (2007) Intime Fremde. Psyche 61(12): 1264–1269

Knellessen O, Reiche R (2007) Kreuzungen. Eine Analyse von 21 Grams anhand formaler Elemente. Psyche 61(12): 1211–1225

Koch G (2002) „Everything feels so wrong" -- Bemerkungen zu Lars von Triers Film Dancer in the Dark. Psyche 56(5): 463–468

Küchenhoff J (2004) Intertextualität als Neubeginn. Destruktion und Hoffnung in Jim Jarmuschs Film Ghost Dog. The Way of the Samurai. Psyche 58(12): 1196–1204

Leuschner W (2004) Zerhackte Wahrnehmungen – zur technischen Produktion suggestiver Wahrnehmungen des Films. Psyche 58(7): 649–659

Leuschner W (2007) Was uns süchtig nach Filmbildern macht. Psyche 61(12): 1189–1210

Lippert R (1994) „Ist der Blick männlich?" Texte zur feministischen Filmtheorie. Psyche 48(11): 1088–1099

Lippert R (2002) „Vom Winde verweht" (Victor Fleming, 1939). Psyche 56(2) 205–209

Loewenberg P (2004) Freud, Schnitzler und Eyes Wide Shut. Psyche 58(12): 1156–1181

Mahler-Bungers A (2004) Blow up (Michelangelo Antonioni, 1966). Psyche 58(8). 750–756

Mahler-Bungers A (2010) Tanz der Vampire (Roman Polanski, 1967). Psyche 64(4). 359–367

Metz Ch (1994) Der fiktionale Film und sein Zuschauer. Eine metapsychologische Untersuchung. Psyche 48(11): 1004–1046

Mitscherlich-Nielsen M (1981) Die Vergangenheit in der Gegenwart. Zu dem Film „Playing for Time". Psyche 35(7): 611–615

Quindeau I (2012) Michael Haneke, „Das weiße Band" (2009). Psyche 66(3): 268–274

Rohde-Dachser Ch (2011) „Lost in Translation". Psyche 65(12): 1202–1210

Rohde-Dachser Ch (2005) „Sprich mit ihr" („Hable con ella"). Psyche 59(12): 1211–1218

Sabbadini A (2001) Psychoanalyse und ihre (Fehl)darstellung im Film -- von Pabst über Hitchcock und Huston zu Brodys 1919. Psyche 55(4): 422–428

Schlüpmann Heide (1994) Die Geburt des Kinos aus dem Geist des Lachens Psyche 48(11): 1075–1087

Schneider G (2006) Luis Buñuel „Ein andalusischer Hund" – Schock und Traum als Methode. Psyche 60(3): 253–261

Schneider G (2007) Alfred Hitchcocks Die Vögel – der Einbruch in ein narzißtisches Universum als Apokalypse. Psyche 61(12): 1226–1240

Schneider G, Witt-Schneider G (2003) Wilde Erdbeeren (Ingmar Bergmann, 1957). Psyche 57(8): 751–775

Sopena C (1988) „Amadeus" – Einige Überlegungen zum Neid. Psyche 42(2): 159–173

Sopena C (2002) Verhängnis: Eine todbringende Leidenschaft. Psyche 56(12): 1250–1255

Stroczan K, Bayer L (2004) Es gibt keine Eltern. Vom Drama zur Tragödie in Polanskis Filmen. Psyche 58(12): 1182–1195

West-Leuer B (2007) „New Realities". eXistenZ von David Cronenberg und Mulholland Drive von David Lynch: Wenn äußere Realität und psychische Realität nicht unterschieden werden. Psyche 61(12): 1241–1254

West-Leuer B (2009) Film-Revue: Brokeback Mountain von Ang Lee (2005) Eine psychoanalytische Rekonstruktion des Kriminalfalls: „Who's done it?" Psyche 63(12): 1231–1243

Zeul M (1989) John Hustons „Freud"-Film (1961). Psyche 43(10): 952–966

Zeul M (1994) Bilder des Unbewußten. Zur Geschichte der psychoanalytischen Filmtheorie. Psyche 48(11): 975–1003

Zeul M (2000) Die Sonne, die uns täuscht von Nikita Mikhalkov. Psyche 54(11): 1175–1180

Zeul M (2001) Die Gewalt des Biedermanns am Beispiel von Joel und Ethan Coens Fargo. Psyche 55(9/10): 1110–1118

Zeul M (2003) Before the Rain: Kirils Traum. Psyche 57(12): 1214–1218

Zeul M (2005) Augenmaske. Psychoanalytische Methode als Filmanalyse am Beispiel des Blicks im Film Die barfüßige Gräfin. Psyche 59(5): 431

Ziob B (2005) „Wir sind doch immer noch Männer?" Eine psychoanalytische Betrachtung des Films Fight Club von David Fincher. Psyche 59(4): 361–371

Zwiebel R (2007) Zwischen Abgrund und Falle. Filmpsychoanalytische Anmerkungen zu Alfred Hitchcock. Psyche 61(1): 65–73

Psychoanalyse im Widerspruch

Bär P (2003) Psycho – Alfred Hitchcocks Spiel mit dem Zuschauer. Psychoanalyse im Widerspruch 30: 5–10

Becker H, Raz G, Metraux Al, Knoch H (2005) Themenschwerpunkt Shoah-Filme und Gedächtnis. Psychoanalyse im Widerspruch 34: 23–64

Berberich E (2002) Citizen Kane – der Filmklassiker von Orson Welles. Psychoanalyse im Widerspruch 28: 69–76

Berberich E (2009) Ingmar Bergmans Verfilmung der Zauberflöte von Wolfgang Amadeus Mozart. Psychoanalyse im Widerspruch 42: 43–52

Bliersbach G (2003) Die eindringenden Blicke. Psychoanalyse im Widerspruch 30: 11–22

Danckwardt JF (2003) Vom Krimi zum Kultfilm: Das Mediale als Matrix der Identität oder: „Ich würde mich auch nicht an mich erinnern". Psychoanalyse im Widerspruch 30: 81–88

Danckwardt JF (2004) Ästhetik des medialen Realismus gegen die Verleugnung des Zivilisationsbruchs. Polanskis Stellung in der Genealogie der Holocaust–Verfilmungen Der Pianist. Psychoanalyse im Widerspruch 32: 65–82

Danckwardt JF (2005) Von der Traumnovelle (Arthur Schnitzler) zu Eyes Wide Shut (Stanley Kubrick). Psychoanalyse im Widerspruch 33: 57–74

Danckwardt JF (2006) Neuere Entwicklungen filmischer Verarbeitungen der Shoah nach fünfzig Jahren. Psychoanalyse im Widerspruch 35: 107–142

Danckwardt JF (2008) Was können Dritte-Reich-Verfilmungen bewirken?, Psychoanalyse im Widerspruch 39: 91–112

Däuker H, Tilch-Bauschke E (2000) Das Piano von Jane Campion. Psychoanalyse im Widerspruch 24: 89–98

Engellandt-Schnell A (2008) Prinzessinnenbad von Bettina Blümner. Psychoanalyse im Widerspruch 40: 45–60

Geiser-Elze A, Guck-Nigrelli A, Laszig P, Loetz S (2005) Leolo. „Weil ich träume, bin ich nicht …" Tagebuch- und Traumtexte eines pubertierenden Jungen. Psychoanalyse im Widerspruch 33: 125–132

Haas ETh, von Quekelberghe E (1999) Medea von Pier Paolo Pasolini (1969). Psychoanalyse im Widerspruch 22: 104–108

Hagin B (2003) Civilized Warriors and Primitive Cinema: Freud's denial-of-death in fin-de-siècle spectacles of mortality. Psychoanalyse im Widerspruch 30: 45–62

Hirsch M (2004) Dancer in the Dark von Lars von Trier. Psychoanalyse im Widerspruch 32: 97–105

Keitz U von (2004) Von der Schwierigkeit der autobiographischen Form im Film – zu Roman Polanskis The Pianist. Psychoanalyse im Widerspruch 32: 83–95

Klein M (2000) Notizen zu Citizen Kane. Psychoanalyse im Widerspruch 24: 10–13

Küchenhoff J (2000) Jim Jarmusch: Ghost Dog. The Way of the Samurai. Psychoanalyse im Widerspruch 24: 99–104

Mahler-Bungers A (2002) Lola rennt von Tom Tykwer. Psychoanalyse im Widerspruch 27: 103–116

Marinelli L (2000) Editorische Bemerkung zum Text von Melanie Klein. Psychoanalyse im Widerspruch 24: 14

Métraux A, Schneider G (2003) Freaks von Tod Brownings. Psychoanalyse im Widerspruch 30: 63–80

Puk C (2010) Ingmar Bergman und David Lynch. Eine Gegenüberstellung des Filmwerks in psychoanalytischer Sicht. Psychoanalyse im Widerspruch 43: 39–70

Reffert R (2001) „Ein Film ist wie ein Kuchen mit 700 Schichten …" Psychoanalyse im Widerspruch 25: 77–96

Reffert R (2003) Michael Hanekes Film Die Klavierspielerin. Psychoanalyse im Widerspruch 29: 105–118

Reinhard R (1999): Der letzte Tango in Paris von Bernardo Bertolucci – eine psychoanalytische Interpretation. Psychoanalyse im Widerspruch 20: 103–111

Renzel A (2000) Lost Highway – Eine Reise in den Wahnsinn. Psychoanalyse im Widerspruch 23: 80–91

Schneider G (1998) Alfred Hitchcocks Vertigo – eine psychoanalytische Interpretation. Psychoanalyse im Widerspruch 20: 62–71

Schneider G (2000) Die Zerstörung von Identität – Anmerkungen zu David Lynchs Film Lost Highway. Psychoanalyse im Widerspruch 23: 92–95

Schneider G (2005) Erregung statt Trauer? Psychoanalytische Überlegungen zu Nico Hofmanns Film Solo für Klarinette (1998). Psychoanalyse im Widerspruch 33: 75–82

Schneider G (2003) Tödliche (Ent-)Bindungen. Psychoanalyse im Widerspruch 30: 23–32

Tilch-Bauschke E (2011) Sex and the City von Michael King. Eine kritische Glosse. Psychoanalyse im Widerspruch 45: 87–84

Wohlrab, L (2005) Zur Darstellung von Psychoanalytikern im Kino. Von Pabsts Geheimnissen einer Seele über Hitchcock, Allen, Redford und Moretti bis zu Siegels Empathy. Psychoanalyse im Widerspruch 34: 65–76

Wohlrab L (2007) Lemming von Dominik Moll (Frankreich 2005). Psychoanalyse im Widerspruch 38: 91–97

Zwiebel R (2003) Höhenschwindel. Psychoanalytische Anmerkungen zu Trauma und Melancholie in Hitchcocks Vertigo. Psychoanalyse im Widerspruch 30: 33–44

Psychologie Heute

Bliersbach G (2009) Der andere Blick. Psychologie Heute 1: 60–65

Bliersbach G (2009) Sommer vorm Balkon: Unglückliche Glückssuche. Psychologie Heute 11: 64–67

Bliersbach G (2010) Das weiße Band. Die Last traumatischer Beschämungen. Psychologie Heute 12: 36–39

Bliersbach G (2011) Up in the Air. Vom Wert realer Beziehungen. Psychologie Heute 12: 60–63

Bliersbach G (2012) Midnight in Paris. Das Glück des Fantasierens. Psychologie Heute 8: 46-49

Laszig P (2009) Intime Fremde (Confidences trop intimes) „Ein Film über die Lust am Zuhören und die Erotik in Gedanken". Psychologie Heute 5: 76–81

Laszig P (2010) Erinnern, festhalten, befreien. Hallam Foe – this is my story. Psychologie Heute 5: 72–76

Laszig P (2011) Babel: Wer nicht gesehen wird, endet tragisch. Psychologie Heute 2: 68-73

Laszig P (2011) Fight Club: Eine postmoderne Männergeschichte. Psychologie Heute 6: 70–75

Laszig P (2011) Black Swan: Zeit der Verwandlung. Psychologie Heute 10: 58–62

Internetadressen

Internetadressen zum Thema „Film und Psychoanalyse"[1]

Cykl filmowy pt. Kino a psychoanaliza (Krakau/ Krakowie) http://www.kspp.edu.pl/filmy.html

Film and Psychoanalysis. First International Meeting in the frame of the 26th Culture Festival Apollonia 2010 Sozopol. http://www.youtube.com/watch?v=tzNJgUxOGHI

La psychanalyse au cinéma. http://www.cineclubdecaen.com/analyse/psychanalyse.htm

Psychoanalysis & Cinema (London). http://www.psychoanalysis.org.uk/cinema.htm

Psychanalyse et Cinéma. http://www.causefreudienne.net/index.php/etudier/formations/psychanalyse-et-cinema-2011-2012

Psychanalyse et Cinéma. http://psychologieetcinema.over-blog.com/

Screening Conditions film and discussion series (London). http://www.psychoanalysis.org.uk/cinema.htm#sc

Film Discussion Series (Boston). http://www.bgsp.edu/news_events_film_discussion.html

Analytic Flicks (Cleveland). http://psychoanalysiscleveland.org/events/category/analytic-flicks/

Film Series (Denver). http://www.denverpsychoanalytic.org/education/film_series.html

Film & Diskussion Series (New Orleans – Birminham). http://www.nobpc.org/Page_Calendar/filmseries.html

From Vienna to Hollywood (New York). http://www.cmps.edu/extension/psychoanalysis_arts.html

Psychoanalytic Takes on the Cinema (Washington). http://www.wcpweb.org/programs/cinema/default.html

Ausstellungen

Kino im Kopf – Psychologie und Film seit Sigmund Freud (Deutsche Kinemathek – Museum für Film und Fernsehen; Berlin). http://osiris22.pi-consult.de/userdata/l_7/p_72/library/data/pressemappekik_eng-1.pdf

Veranstaltungen und Tagungen

Film und Psychoanalyse. Eine internationale Begegnung im Rahmen des 26. Kulturfestivals Apollonia 2010 (Apollonia-Stiftung, Bulgarien und Goethe-Institut, Sofia; Sozopol). http://www.pramataroff.de/film2010/

Filmtagung Beschleunigung und zersplitterte Zeit als Zeitdiagnosen: „Brassed Off – mit Pauken und Trompeten" und „Up in the Air" als Indikatoren der Veränderung. – Kurztagung der Psychoanalytischen Arbeitsgemeinschaft Köln-Düsseldorf e.V. (Institut der DPV/DGPT) in Zusammenarbeit mit Inscape International. 10. Juli, 2011; s.a. http://www.psa-kd.de

Filmtagung "Die Müdigkeitsgesellschaft". Kurztagung der Psychoanalytischen Arbeitsgemeinschaft Köln-Düsseldorf e.V. in Zusammenarbeit mit Inscape International. 8. und 9. September, 2012; s.a. http://www.psa-kd.de

Im Dialog: Psychoanalyse und Filmtheorie (Cinema Quadrat – Kommunales Kino Mannheim in Zusammenarbeit mit dem Institut für Psychoanalyse und Psychotherapie Heidelberg-Mannheim, Psychoanalytischen Institut Heidelberg-Karlsruhe der Deutschen Psychoanalytischen Vereinigung, Heidelberger Institut für Tiefenpsychologie; Mannheim). http://www.cinema-quadrat.de/Fruehere-Seminare.186.0.html

Kino zwischen Tag und Traum – Darren Aronofskys Black Swan in Analyse (Department Psychologie an der Universität Köln). http://kino-tag-traum.de/#analyse

The Pop-Freudian Screen: Film Noir und Psychoanalyse. Träume, Visionen und Migration. Von Joseph zu Pabst, Hitchcock und Preminger (Sigmund Freud Privatstiftung und Institut für Zeitgeschichte der Universität Wien; Sigmund Freud Museum; Wien). http://www.freud-museum.at/cms/index.php/Aktuelle_Veranstaltungen/articles/filmreihe.html

Von Joseph zu Pabst, Hitchcock und Preminger (Sigmund Freud Privatstiftung und Institut für Zeitgeschichte der Universität Wien

1 Quelle: http://www.parfen-laszig.de/psychoanalytische-ressourcen/film-psychoanalyse/; zugegriffen am 8. 1. 2012

Festivals

1st European Psychoanalytic Film Festival (epff1). http://www.psychoanalysis.org.uk/epff/frontpage.htm
2th European Psychoanalytic Film Festival (epff2). http://www.psychoanalysis.org.uk/epff3/epff2programme.htm
3rd European Psychoanalytic Film Festival (epff3). http://www.psychoanalysis.org.uk/epff3/
4th European Psychoanalytic Film Festival (epff4). http://www.psychoanalysis.org.uk/epff4/
5th European Psychoanalytic Film Festival (epff5). http://www.psychoanalysis.org.uk/epff5/
6th European Psychoanalytic Film Festival (epff6). http://www.psychoanalysis.org.uk/epff6/

Interpretationen

Alice im Wunderland; brainblogger (5. 4. 2010). http://brainblog.blog.de/2010/04/05/alice-wunderland-8312571/
The Pre-Oedipalizing of Klein in (North) America: Ridley Scott's Alien Re-analyzed; Donald Carveth and Naomi Gold. http://www.psyartjournal.com/#carveth03
Eyes Wide Shut – The Woman Not Seen; Ellie Ragland (J Eur Psychoanal 20. 1. 2005). http://www.psychomedia.it/jep/number20/ragland.htm
Remaining Men Together: Fight Club and the (Un)pleasures of Unreliable Narration; David Church. http://www.offscreen.com/index.php/phile/essays/fight_club/
Dead End Kids: Projective Identification and Sacrifice in Orphans; Donald L. Carveth. http://www.yorku.ca/dcarveth/orphans.pdf
Der Himmel über Berlin; Ludwig Janus. http://85.214.73.226/laszig/wp-content/uploads/2009/04/HimmelueberBerlin.pdf
Hitchcock's Vertigo – The collapse of a rescue phantasy; Emanuel Berman (Int J Psychoanal 1997, 78: 975–996). http://www.psychoanalysis.org.uk/epff3/berman.htm
Leolo – „Weil ich träume bin ich nicht … " Tagebuch und Traumtexte eines pubertierenden Jungen; Annette Geiser-Elze, Anja Guck-Nigrelli, Parfen Laszig & Susanne Loetz (Psychoanalyse im Widerspruch 2005, 17(33): 125–131). http://85.214.73.226/laszig/wp-content/uploads/2009/04/leolo.pdf
Letters, Words and Metaphors: A Psychoanalytic Reading of Michael Radford's 'Il Postino'; Andrea Sabbadini (Int J Psychoanal 79(3): 609–611). http://www.psychoanalysis.org.uk/epff3/postino.htm
Matrix; Ludwig Janus. http://85.214.73.226/laszig/wp-content/uploads/2009/04/Matrix.pdf
„The Matrix": An Allegory of the Psychoanalytic Journey; David Mischoulon and Eugene V. Beresin (Acad Psychiatry 28: 71–77, March 2004). http://ap.psychiatryonline.org/article.aspx?Volume=28&page=71&journalID=17
Die zwei Seiten der Perversion – Die Philosophie der Matrix; Slavoj Žižek. http://eva-elba.unibas.ch/?c=3095
The Matrix, or, the Two Sides of Perversion; Slavoj Žižek. http://www.lacan.com/zizek-matrix.htm
The Matrix: The Truth of the Exaggerations; Slavoj Žižek. http://integral-options.blogspot.de/2010/07/slavoj-zizek-matrix-truth-of.html
What is the Matrix? Cinema, Totality, and Topophilia; Charles Leary. http://sensesofcinema.com/2004/32/matrix/
A Psychoanalytic Tour of „Mulholland Drive"; Herbert H. Stein. http://internationalpsychoanalysis.net/2010/07/15/a-psychoanalytic-tour-of-mulholland-drive/
A Family Romance Fantasy in „Pan's Labyrinth": Magical Wombs pt. IV. http://internationalpsychoanalysis.net/2007/11/17/a-family-romance-fantasy-in-pans-labyrinth-magical-wombs-pt-iv/
The Borderline Dilemma in Paris, Texas: Psychoanalytic Approaches to Sam Shepard; Donald Carveth (Can J Psychoanal/Revue canadienne de psychanalyse 1(2) Fall 1993: 19–46). http://www.psyartjournal.com/

Sonstige Literatur

Assoziation Psychoanalyse und Film (podcasts zum Thema Psychoanalyse und Film). http://zentrum.virtuos.uos.de/wikifarm/fields/psychoanalyse_film/index.php
Film-Interpretationen der Heidelberger Reihe „Psychoanalyse & Film". http://www.psychoanalyse-und-film.org/interpretationen.html
Filmwirkungsanalyse (Dirk Blothner). http://www.filmwirkungsanalyse.de/
Forum for the Psychoanalytic Study of Film. http://www.cyberpsych.org/filmforum/index.html
Hannoversche Werkstattberichte: Psychoanalyse & Film. http://www.psa-werkstattberichte.de/Psychoanalyse_und_Film/psychoanalyse_und_film.html
Introduction – Psychoanalysis in/and/of the Horror Film; Horror Film & Psychoanalysis: Freud's Worst Nightmares; Steven Jay Schneider, William Rothman, Dudley Andrew; Cambridge Studies in Film, Cambridge University Press. http://www.scribd.com/doc/64547421/Horror-Film-and-Psychoanalysis
Physical and Mental Disability in the Movies and Television: A Bibliography of Books and Articles in the UC Berkeley Libraries. http://www.lib.berkeley.edu/MRC/disabilitiesbib.html#mental

Play It Again, Sigmund. Psychoanalysis and the Classical Hollywood Text; Krin Gabbard, Glen Gabbard. http://www.vincasa.com/indexsigmund1.html

Psychoanalyse und Kino; Serge Lebovici (ursp. ersch. unter dem Titel "Psychoanalyse et cinéma" in: Revue internationale de filmologie, 7/8 (1949) , S. 49-55). http://www.montage-av.de/pdf/131_2004/13_1_Serge_Lebovici_Psychoanalyse_und_Kino.pdf

Projections: The Journal for Movies and Mind. http://www.cyberpsych.org/filmforum/read.htm

The Psychoanalytic Review, Vol. 94, Iss. 6: Special Issue on Film (free access). http://guilfordjournals.com/loi/prev

Psychoanalysis and Film Theory Part 1: 'A New Kind of Mirror'; Paula Murphy (Kritikos, Bd 2, April 2005). http://intertheory.org/psychoanalysis.htm

Psychoanalysis and Film Theory Part 2: Reflections and Refutations; Paula Murphy (Kritikos, Bd 2, April 2005). http://intertheory.org/psychoanalysis2.htm

Psychoanalytische Filmtheorie (Quelle: Wikipedia.de). http://de.wikipedia.org/w/index.php?title=Psychoanalytische_Filmtheorie&stable=1

The Psychology of Movies & Movie Audiences: A Bibliography of Materials in the UCB Library. http://www.lib.berkeley.edu/MRC/moviepsych.html

The Representations of Primitive Processes in the Cinema; Robert M. Young. http://www.human-nature.com/rmyoung/papers/paper41.html

Arnold Richards Archive (Reviews, Buchbesprechungen zu Filmen). http://internationalpsychoanalysis.net/category/movies/

Screening Desire, Projecting Anxiety: The Psychoanalysis of Film. http://psychoanalysis.cz/kinopsy.html

The pervert's guide to cinema; S. Žižek. http://www.thepervertsguide.com/

The Žižek Site – Comprehensive Web-Based Resources Of The Žižekian Kind. http://the-zizek-site.blogspot.de/2007/01/films-and-documentaries.html

… That We Are Basically Watching Shit, As It Were transcription (with notes and cross-media re-formatting) of the two-and-a-half hour Sophie Fiennes-directed The Pervert's Guide to Cinema, narrated and presented by Slavoj Žižek.). http://subject-barred.blogspot.de/2006/06/that-we-are-basically-watc_115068769922865662.html

Delighting in Zizekian Perversity; Subject Barred. http://subject-barred.blogspot.de/2006/03/delighting-in-zizekian-perversity.html

Psychische Störungen im Film

Films which demostrate pathologies (Ruth Levine; University of Texas Medical Branch, Galveston). http://admsep.org/cinema.html

Frames of Mind – A monthly mental health film series (Harry Karlinsky, Caroline Coutts; Vancouver). http://www.framesofmind.ca/blog/

How the media perpetuates the stigma associated with mental illness (David Gonzalez). http://www.mentalhealthstigma.com/cinemania.html

Movies and Mental Illness (Danny Wedding, Mary Ann Boyd, Ryan Niemiec). http://moviesandmentalillness.blogspot.de/

The movies on your mind: psychoanalytic media criticism (Harvey R. Greenberg). http://www.doctorgreenberg.net/

Psychiatrie und psychische Krankheit als Themen des Films (Hans J. Wulff; Christian-Albrechts-Universität Kiel). http://www.uni-kiel.de/medien/berpsy1.html

Psychiatry in Film (Roland Atkinson; Oregon Health & Science University, Portland). http://www.psychflix.com/resources.html

Psychiatry in the Cinema (Alan Sanders; University of Chicago). http://psychclerk.bsd.uchicago.edu/movies.html

psychmovies (Brooke J. Cannon; Marywood University, Pennsylvania). http://www.psychmovies.com/

Psychopathology & the Cinema (Margaret E. Condon; Northeastern Illinois University). http://www.neiu.edu/~mecondon/cinema.htm

Reel Madness Festivals (Victoria Mental Health Centre, Vancouver Island). http://www.islandnet.com/mm/festivals.html

Rendezvous With Madness (Film Festival; Toronto, Canada). http://www.rendezvouswithmadness.com/index.php

Representations Of Psychiatric Disability In Fifty Years Of Hollywood Film: An Ethnographic Content Analysis (Lisa Lopez Levers; Duquesne University, Pennsylvania). http://theoryandscience.icaap.org/content/vol002.002/lopezlevers.html

Quellenverzeichnis

Kap.	Filmtitel	Abb.	Seite	Quelle
1	Soljaris (1972)	1		Cinetext/RR
		2		Cinetext Bildarchiv
2	Welt am Draht (1973)	1		DVD Arthaus Premium 2010; © Rainer Werner Fassbinder Foundation, Berlin
		2		DVD Arthaus Premium 2010; © Rainer Werner Fassbinder Foundation, Berlin
		3		DVD Arthaus Premium 2010; © Rainer Werner Fassbinder Foundation, Berlin
3	Westworld (1973)	1		Richter/Cinetext
		2		Cinetext Bildarchiv
4	Der gekaufte Tod (1980)	1		Interfoto/NG Collection
		2		Interfoto/Mary Evans
		3		Cinetext Bildarchiv
5	Blade Runner (1982)	1		Cinetext/Richter
		2		Cinetext Bildarchiv
6	Videodrome (1983)	1		Interfoto/Mary Evans
		2		Cinetext Bildarchiv
		3		Interfoto/Mary Evans
7	Brazil 1985	1		Interfoto/NG Collection
		2		Cinetext Bildarchiv
		3		Cinetext Bildarchiv
8	Purple Rose (1985)	1		Cinetext/RR
		2		Interfoto/Mary Evans
		3		Cinetext Bildarchiv;t
9	Total Recall (1990)	1		Interfoto/Mary Evans
		2		Interfoto/Mary Evans
		3		Cinetext Bildarchiv
10	Bis ans Ende der Welt (1991)	1		Interfoto/NG Collection
		2		Interfoto/NG Collection
		3		Interfoto/NG Collection

Kap.	Filmtitel	Abb.	Seite	Quelle
11	Ghost in the Shell (1995)	1		Cinetext/RR
		2		Interfoto/Mary Evans
		3		Interfoto/Mary Evans
12	Strange Days (1995)	1		Cinetext/RR
		2		Cinetext Bildarchiv
		3		Cinetext Bildarchiv
13	Gattaca (1997)	1		Cinetext/Richter;
		2		Cinetext Bildarchiv
14	Virtual nightmare (1997)	1		Interfoto/Mary Evans
		2		Interfoto/Mary Evans
		3		Interfoto/Mary Evans
15	Dark City (1998)	1		Interfoto Archiv Friedrich
		2		Cinetext Bildarchiv
		3		Cinetext Bildarchiv
16	Die Truman Show (1998)	1		Cinetext Bildarchiv
		2		Cinetext Bildarchiv
		3		Cinetext Bildarchiv
17	Pleasantville (1998)	1		Cinetext/RR
		2		Cinetext Bildarchiv;
		3		Cinetext Bildarchiv;
18	eXistenZ (1999)	1		Cinetext Bildarchiv
		2		Interfoto NG Collection
		3		Cinetext Bildarchiv
19	Matrix (1999; 2003; 2003)	1		Interfoto/Mary Evans
		2		Cinetext Bildarchiv
		3		Cinetext Bildarchiv
20	The 13th floor (1999)	1		Interfoto Archiv Friedrich
		2		Interfoto Archiv Friedrich
		3		dpa-Film Jugendfilm
21	The Cell (2000)	1		Cinetext/Richter
		2		Interfoto Mary Evans

Kap.	Filmtitel	Abb.	Seite	Quelle
22	Thomas est amoureux (2000)	1		WDR Presse und Information/ Bildkommunikation
		2		WDR Presse und Information/ Bildkommunikation
		3		WDR Presse und Information/ Bildkommunikation
23	A.I. – Künstliche Intelligenz (2001)	1		Cinetext Bildarchiv
		2		Cinetext Bildarchiv
		3		Cinetext Bildarchiv
24	Vanilla sky (2001)	1		Interfoto Mary Evans
		2		Cinetext Bildarchiv
		3		Interfoto NG Collection
25	Minority_Report (2002)	1		Interfoto Mary Evans
		2		Cinetext Bildarchiv
26	A Scanner darkly (2006)	1		Warner Bros./Cinetext
		2		Warner Bros./Cinetext
		3		Warner Bros./Cinetext
27	Inland Empire (2006)	1		Concorde/Cinetext
		2		Interfoto NG Collection
		3		Interfoto NG Collection
28	Avatar (2009)	1		Interfoto Mary Evans
		2		20th CenturyFox/Allstar/Cinetext
		3		Interfoto Mary Evans
29	Surrogates (2009)	1		Disney/Cinetext
		2		Disney/Cinetext
		3		Disney/Cinetext
30	Inception (2010)	1		Cinetext/Allstar/Warner Bros.
		2		Cinetext/Allstar/Warner Bros.
		3		Cinetext/Allstar/Warner Bros.